CW01022829

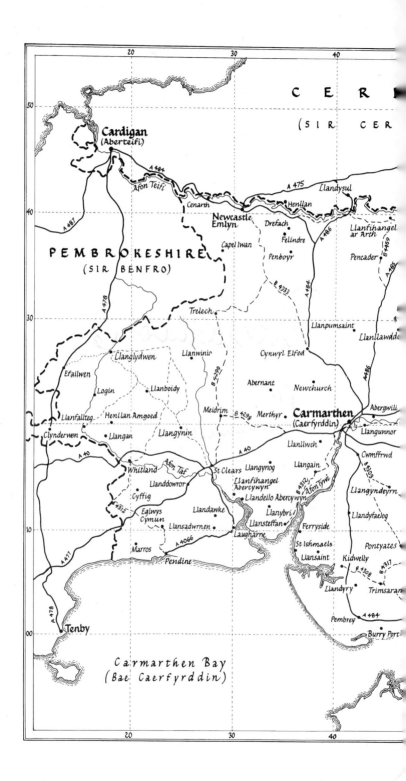

THE BUILDINGS OF WALES
FOUNDING EDITOR: NIKOLAUS PEVSNER

CARMARTHENSHIRE
AND
CEREDIGION

THOMAS LLOYD, JULIAN ORBACH
AND ROBERT SCOURFIELD

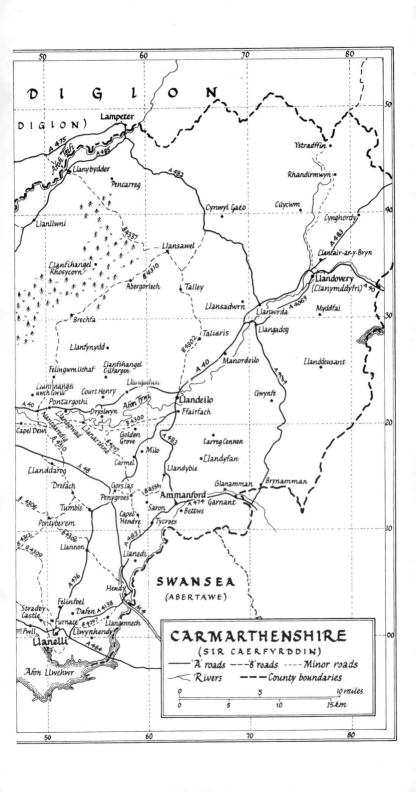

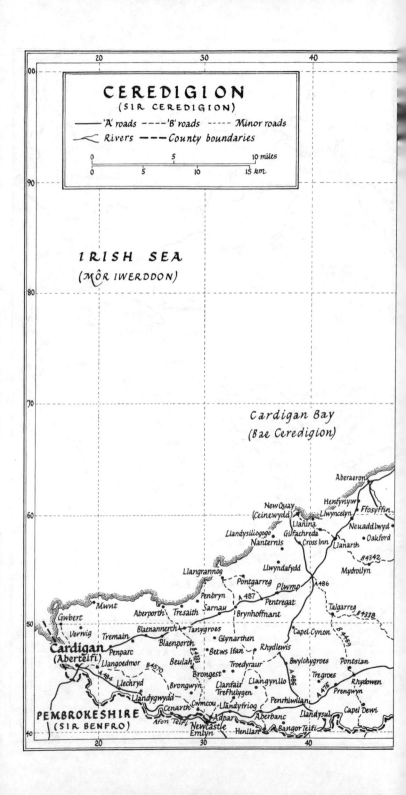

CEREDIGION
(SIR CEREDIGION)

——— 'A' roads ----- 'B' roads ---- Minor roads
⌒ Rivers --- County boundaries

0 5 10 miles
0 5 10 15 km

IRISH SEA
(MÔR IWERDDON)

Cardigan Bay
(Bae Ceredigion)

Aberaeron

New Quay Henfynyw
(Ceinewydd) Llwyncelyn Ffosyffin

 Llanina Neuadd lwyd
Llandysiliogogo Gilfachreda Oakford
 Nanternis Cross Inn Llanarth

 Llwyndafydd B4342
 Mydroilyn
Llangrannog Pontgarreg Plwmp
 Penbryn A487 Pentregat A486
 Mwnt Aberporth Tresaith Sarnau Talgarreg
Gwbert Brynhoffnant B4338

Verwig Blaenannerch Tanygroes Capel Cynon
 Tremain Blaenporth • Glynarthen Rhydlewis Pontsian
Cardigan Penparc Betws Ifan Bwlchygroes Tregroes
(Aberteifi) Llangoedmor Beulah Brongest Troedyraur Rhydowen
 B4570 Brongwyn Llanfair Llangynllo A486 A475 Prengwyn
 Llechryd Trefhelygen Penrhiwllan Capel Dewi
 Llandygwydd Cwmcou Llandyfriog Llandysul
PEMBROKESHIRE Cenarth Adpar Aberbanc Bangor Teifi
(SIR BENFRO) Afon Teifi Newcastle
 Emlyn Henllan

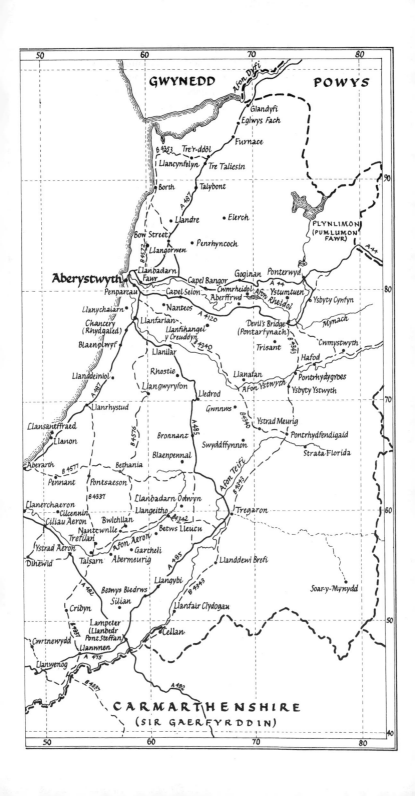

PEVSNER ARCHITECTURAL GUIDES

The Buildings of Wales series was founded by
Sir Nikolaus Pevsner (1902–1983) as a companion series
to *The Buildings of England*. The continuing
programme of revisions and new volumes has
been supported by research financed through
the Buildings Books Trust since 1994

The preparation of this book has been greatly helped
by grants from

THE TRUSTEES OF THE DAVIES CHARITY

from

THE BOARD OF CELTIC STUDIES OF
THE UNIVERSITY OF WALES

from

THE BRITISH ACADEMY

and from

CADW: WELSH HISTORIC MONUMENTS

Assistance with photographs has been generously provided by

THE ROYAL COMMISSION ON THE ANCIENT
AND HISTORICAL MONUMENTS OF WALES

Carmarthenshire and Ceredigion

BY

THOMAS LLOYD,

JULIAN ORBACH

AND

ROBERT SCOURFIELD

WITH CONTRIBUTIONS BY

RICHARD AVENT,

STEPHEN HUGHES,

HEATHER JAMES

AND

JOHN KENYON

THE BUILDINGS OF WALES

YALE UNIVERSITY PRESS
NEW HAVEN AND LONDON

YALE UNIVERSITY PRESS
NEW HAVEN AND LONDON
302 Temple Street, New Haven CT 06511
47 Bedford Square, London WC1B 3DP
www.pevsner.co.uk
www.lookingatbuildings.org
www.yalebooks.co.uk
www.yalebooks.com

Published by Yale University Press 2006
2 4 6 8 10 9 7 5 3 1

ISBN 0 300 10179 1

Printed in China
through World Print
Set in Monotype Plantin

To

PETER SMITH
former Secretary to
the Royal Commission on the Ancient
and Historic Monuments of Wales,
an inspiration to us all

and

RICHARD AVENT
contributor, friend,
tragically killed as this book
was going to press

LIST OF TEXT FIGURES AND MAPS

Every effort has been made to contact or trace all copyright holders. The publishers will be glad to make good any errors or omissions brought to our attention in future editions.

PHOTOGRAPHIC ACKNOWLEDGEMENTS

A special debt is owed to Royal Commission photographer Iain Wright for taking most of the photographs for this volume. Photographs are reproduced by kind permission of the Royal Commission on the Ancient and Historic Monuments of Wales (© RCAHMW, Crown Copyright), with the exception of the following:

A. F. Kersting: 117
Cadw, Welsh Historic Monuments, Crown Copyright: 23, 92, 118
Graham Rankin, Aberglasney Restoration Trust: 37
National Trust Photographic Library/Andrew Butler: 60, 61

MAP REFERENCES

The numbers printed in italic type in the margin against the place names in the gazetteer of the book indicate the position of the place in question on the index map (pp. ii–v), which is divided into sections by the 10-kilometre reference lines of the National Grid. The reference given here omits two initial letters (formerly numbers) which in a full grid reference refer to the 100-kilometre squares into which the county is divided. The first two numbers indicate the *western* boundary, and the last two the *southern* boundary, of the 10-kilometre square in which the place in question is situated. For example, Kidwelly (reference 4106) will be found in the 10-kilometre square bounded by grid lines 40 (on the *west*) and 50, and 00 (on the *south*) and 10; Pentregat (refence 3552) in the square bounded by the grid lines 30 (on the *west*) and 40, and 50 (on the *south*) and 60.

The map contains all those places, whether towns, villages, or isolated buildings, which are the subject of separate entries in the text.

ACKNOWLEDGEMENTS

The sixth volume of the *Buildings of Wales* series was prepared in conjunction with *Pembrokeshire*, issued in 2004. The area originally proposed, the short-lived county of Dyfed, proved too large for a single volume, and so this second volume covers the old counties of Carmarthenshire and Cardiganshire, the latter revived under the ancient regional name of Ceredigion. This volume like its predecessor has been produced under the editorship of Bridget Cherry, whose retirement has been delayed to see this next piece of the Welsh jigsaw in place.

Particular thanks are due to many owners and occupiers of houses who generously allowed us to view their homes and gave us invaluable information. It should be firmly stated that mention of a building in the text, or reference to internal features, does not in any way imply that it is open to the public. We are also grateful to incumbents, ministers, secretaries and churchwardens for help with churches and chapels.

We are grateful to the specialist authors who have made important contributions. In this introduction, the Prehistoric, Roman and Dark Age section is by Heather James, the Castles section by John Kenyon, and the Industrial Structures section has been rewritten from an essay covering the whole of the former Dyfed by Stephen Hughes. John Kenyon has provided the entry in the text for Kidwelly Castle and Richard Avent that for Laugharne Castle.

The initial documentary research was undertaken by Thomas Lloyd with help from his late wife Juliet, who scoured a remarkable range of published and unpublished material, most notably family papers and hitherto unexplored West Wales newspaper archives. In London, the Incorporated Church Building Society papers at Lambeth Palace shed light on church restoration projects from the early C19, supplemented by the very rich collection of faculty plans and parsonage papers in the St Davids archive at the National Library of Wales. London architectural publications, *The Builder*, *Building News* and their rivals noticed some if not a huge number of West Wales projects. The library of the Royal Institute of British Architects gave access to these and also to the nomination papers of architects, which list their works. The National Library of Wales holds collections of specific architects' drawings related to Wales. Staff there have always been exceptionally helpful, as also have been the archivists and

staff of the two County Record Offices in Carmarthen and Aberystwyth.

Special thanks are due to the staff of the Royal Commission on the Ancient and Historic Monuments of Wales in Aberystwyth, who patiently endured many visits, while their photographer, Iain Wright, took most of the photographs that illustrate this volume. Almost every member of staff there at some point was prevailed upon for some piece of assistance and their help is gratefully acknowledged, with particular thanks to Peter Smith and Peter White, former secretaries to the Commission, and to Hilary Malaws who oversaw the endless calls on the archive of the National Monuments Record. Thanks as ever need to be made to Cambria Archaeology for expert opinion on so many things, particularly archaeology, urban development and church buildings. Heather and Terry James have given endlessly, also Louise Austin and Neil Ludlow. The staff at the historic buildings section at Cadw have provided listed building information and advice whenever requested, and particular thanks are due to David McLees, Judith Alfrey, Bill Reid and Peter Wakelin. The employment of Julian Orbach and, for a short period, Robert Scourfield in compiling the lists of historic buildings for Cadw led to many new discoveries. The help of the National Trust with relation to its properties is acknowledged, particularly from Richard Keen and Margaret Evans at the Llandeilo office.

Persons whom we would like to thank for special expert knowledge include: Neil Ludlow, Nigel Yates and John Morgan Guy (churches), David Robinson (abbeys), Peter Howell (Victorian buildings), Terry James, Edna Dale-Jones and the Rev. Towyn Jones (Carmarthen), Canon James Cunnane and Glen Johnson (Cardigan), Richard Suggett (John Nash), Canon W. Price (Lampeter University), Richard Garnier (Sir Robert Taylor), Caroline Kerkham and Stephen Briggs (Hafod), Diana Bevan (Llansteffan), Olwen Jenkins (chapels), Elizabeth Whittle and Caroline Palmer (gardens and landscapes), Tim Palmer and John Davies (building stones), Nicky Evans (Llanerchaeron), Emma Plunkett-Dillon and Lord Dynevor (Dinefwr), Caroline Palmer (Nanteos), Sir David Mansel Lewis (Stradey Castle), Martin Harrison and Michael Kerney (stained glass), Peter Wakelin, Peter Claughton and Stephen Hughes (industrial structures), Gerallt Nash, Martin Davies and Judith Alfrey (vernacular buildings). Architects whose advice or information we wish particularly to acknowledge include Roger Clive-Powell, Prys Edwards, Griff Davies and the late Dale Owen.

Collation of this volume was in the safe hands of Sally Salvesen and Emily Winter at Yale, with the collection of pictures organized by Emily Lees and Emily Wraith. Street plans and text figures were drawn by Alan Fagan. We are grateful to Emily Jenkins for typing and to Charlotte Chapman for copy-editing.

In spite of all this help, many gaps and mistakes will surely remain and judgements will not necessarily be agreed with now or as time passes. It has been a first attempt for many buildings not noticed before, as even the Cadw listing process was going

on side-by-side. Corrections and supplementary information will be welcomed by the authors and the publisher and will be incorporated in a subsequent reprint or edition. In particular we hope that buildings noted as being in disrepair and at risk are soon mended.

INTRODUCTION

THE TWO COUNTIES

Carmarthenshire and Ceredigion, with Pembrokeshire, make up the south-west of Wales. Both counties have sea coasts, Carmarthenshire faces s to the Bristol Channel, the coast deeply cut by the estuaries of the Loughor, Gwendraeth, Tywi and Taf rivers. The Ceredigion coast, less indented, faces obliquely across to Ireland, bounded by the Teifi estuary on the s and the Dyfi on the N. Ceredigion is some three-quarters the size of Carmarthenshire, some 180,000 hectares to the other's 240,000, but has only two-fifths of the population, 72,200 in 2001, whereas Carmarthenshire had 173,600. Both counties are predominantly agricultural, with the better land in the river valleys, but only the southern edge of Carmarthenshire is significantly industrial. The towns are all small by national standards, Llanelli by far the largest, having 23,435 inhabitants in 2001, Carmarthen 13,157, Aberystwyth 11,529 and Cardigan 4,198. The barren upland of the Cambrian Mountains, the 'great desert of Wales', extends N of Llandovery up through eastern Ceredigion into mid Wales. The highest point is Plynlimon (Pumlumon), behind Aberystwyth, and outliers of the range extend almost to the coast in the NW of the county. s of Llandovery, the Brecon Beacons run W into Carmarthenshire, with that county's highest point, the Carmarthen Fan, just on the Brecon border. These hills run SW to the Black Mountain between Ammanford and Swansea and continue on as a limestone ridge into s Pembrokeshire. Between these uplands the rivers cut their courses, those of Ceredigion running W, those of Carmarthenshire mostly s. In Ceredigion, richer land follows narrowly the northern rivers, the Leri, Rheidol and Ystwyth, and more amply the central Aeron and southern Teifi. Aberystwyth, Aberaeron and Cardigan are coastal towns, the only inland towns are all along the Teifi in its sweep from the hills behind Strata Florida to Cardigan, Tregaron, Lampeter and Llandysul on the Ceredigion bank, Llanybydder and Newcastle Emlyn on the Carmarthenshire side.

The headwaters of the Tywi and Cothi are in the Carmarthenshire hills to the SE of the Teifi valley. The Tywi valley with the richest farmland in the region has always been the main route across Carmarthenshire from the E, with a series of towns in line: Llandovery, Llangadog, Llandeilo and Carmarthen. The Tywi estuary, with no bridge below Carmarthen, isolates the SW corner of the county from the through route, Llansteffan and

Laugharne reached by branch roads off the main route w into Pembrokeshire. This crosses rolling country cut by the Taf and its tributaries, and passes through two towns, St Clears and Whitland. SE Carmarthenshire, on the historic approach from Swansea, is the most industrialized part of the region. Llanelli, Ammanford and the Upper Gwendraeth valley are part of the South Wales coalfield, with opencast anthracite mines and the relics of the industry that followed the coal. Settlements here are typical of industrial South Wales, close-spaced, centred on and often named after chapels, with late C19 and early C20 housing.

Carmarthenshire has long been linked by main transport routes to the rest of Britain, the modern A40 being the old mail-coach route from London and Gloucester to the Irish ferries at Pembroke Dock, and the modern A48 and M4 mark another old route up from Swansea and Glamorgan, the route also of Brunel's South Wales Railway, sweeping through to his Irish ferry port at Neyland, Pembrokeshire, in the 1840s and 1850s. By contrast the rail link from Carmarthen to the E and N was much slower in achievement, and the transport history of both counties was affected by the ultimate failure of the Manchester to Milford line. Carmarthen was the most populous town in Wales until the Industrial Revolution. Llanelli outstripped it in the late C19, being by then 'Tinopolis', the world centre of the tin-plate industry, an industry begun in the earlier C18 at Kidwelly. The smaller towns were the market towns of their immediate areas, though Llandovery served the cattle drovers of a wide area, on their way E. Laugharne, Llansteffan and Ferryside were holiday resorts in a small way from the early C19. Nucleated villages are commoner in the richer countryside, but most are late developments around an existing crossroad or chapel. Llanelli principally, and Burry Port in a smaller way, served as the ports for the coal-mining area. Meanwhile the historic ports of the C16 to early C19, Carmarthen and Kidwelly, declined with the silting of their estuaries. In the coalfield, rural settlements developed into small towns rapidly in the late C19 and early C20, as at Ammanford, Tumble, Pontyberem and Trimsaran, linked by enlarged villages (Gorslas, Cross Hands, Pontyates).

Ceredigion was always isolated by the hills, reached with difficulty before the present main road (A44) was opened to Aberystwyth in the early C19. Travellers in the C18 commented on the hardships of travel and noted that the wheeled vehicle was almost unknown in the uplands, farming being assisted by horse and sled. Its coast was open to different worlds, trading herrings and corn across the Irish Sea in the C18, and as the British Empire expanded sending mariners across the globe. In the early C19 the port of Cardigan exported the rural poor to the New World, some five or six thousand between 1790 and 1860. Aberystwyth grew at that time as the principal port for the lead mines, and New Quay and Aberaeron flourished on coastal trade. The development of Aberystwyth first as a holiday resort, and then as the centre of Welsh intellectual life with the University College, founded 1872, and the National Library, founded 1907, was

anomalous. The one was the product of the Late Georgian taste
for the picturesque, the other of the town's geographical, and
thus political, position between North and South Wales. The
railway reached the town from Shrewsbury in the 1860s, prompt-
ing hotel-building, but the railways otherwise affected the county
little. The attempt to drive a line through eastern Ceredigion to
link Manchester and Milford Haven failed, and Carmarthen was
linked piecemeal to Aberystwyth in the 1860s. Cardigan was not
reached until the 1880s from the s, and Aberaeron was connected
to Lampeter in 1911.

The heyday of the coastal trade passed by the late C19. Cardi-
gan, Aberaeron and New Quay were typically the retirement
homes of sea-captains who had worked from elsewhere, a char-
acter still prominent in the 1940s, when Dylan Thomas was living
at New Quay, and pictured in *Under Milk Wood*.

The principal towns of the rural county, Lampeter and Tre-
garon were gathering points for the drovers. Cattle, sheep, horses,
pigs and geese all took the long walks over the hills to South Wales
or England, until better roads and rail ended the practice, and
from the late C19 both counties sent dairy produce to London.
Lampeter's university was an accident of history when Bishop
Burgess settled on the site for his theological college by chance,
giving that town the status of being the smallest university town
in Britain with the third oldest university in England and Wales.

The population of the county peaked in the mid C19, despite
emigration, because of the lead mines of the N of the county, and
declined with their decline from the late C19. The scars of the
industry remain on the hillsides, but operations were too short-
lived and scattered to leave settlements of the scale of those of
the Carmarthenshire coalfield. The largest nucleated villages of
a county characterized more by scattered settlement do however
derive from the mines: Talybont, Penrhyncoch, Pontrhydygroes,
Pontrhydfendigaid and Bow Street.

The political divisions of the region are very ancient indeed.
The boundaries of Ceredigion have remained fixed since the C5
when Ceredig received it as his portion of the lands of his father
Cunedda, and survived the shifting supremacies of the Welsh
dynasties of North and South Wales to be absorbed intact into
royal control in the settlement of 1284, and to become the county
of Cardiganshire in the Act of Union of 1536. Those of Car-
marthenshire have changed more, but apart from some adjust-
ment in the w the county encompasses the five pre-Norman
divisions, or *cantrefi*, Emlyn in the NW, Cydweli in the s, the
Cantref Gwarthaf in the sw, and the Cantref Mawr and Cantref
Bychan in the E, respectively N and s of the Tywi. All formed part
of the dominions of the South Wales princes, the princes of
Deheubarth, ruling from Dinefwr. In the two centuries after the
Norman invasion, the ruling dynasty was gradually constricted
back into the heartland of the Cantref Mawr. The rest was
divided among marcher lords: Newcastle Emlyn, Kidwelly, St
Clears, Laugharne, Llansteffan, Kidwelly, Llandovery and Iscen-
nen (Carreg Cennen). Carmarthen became the centre of royal

administration for SW Wales, and ultimately the Cantref Mawr
was taken under royal control. The marcher lordships gradually
reverted to the crown, a process accelerated by the Wars of the
Roses and complete before the Act of Union. Carmarthenshire
and Cardiganshire remained single counties except between 1974
and 1995, when joined with Pembrokeshire as Dyfed. Cardigan-
shire chose the ancient name of Ceredigion when Dyfed was
dissolved.

The two counties remain predominantly Welsh-speaking,
though the numbers have declined from 1901, when 97 per cent
spoke Welsh in Cardiganshire. Since the later C20, an emphasis
on correct written Welsh, and necessary standardization, has
pushed into disuse many phonetic English spellings of place
names – Aberayron, Llanybyther, Llandilo, Llanelly – that survive
mainly on old milestones.

BUILDING MATERIALS

Building Stone

The varied geology of Carmarthenshire and Ceredigion yielded
little in the way of freestones suitable for ashlar or mouldings,
but a great variety of rubble stones, some readily squared and
suitable for hammer-dressing. Generally, buildings were rough-
cast, rendered or limewashed, with exposed stonework a rarity
until the Victorian fashion for revealed constructional materials.
The lamentable modern fashion for stripping renders often
shows up poor rubble construction. Roughcasts and renders were
ancient traditions, based on lime – burnt in the many kilns still
surviving – mixed with sand, fine gravel, clay, ash or coal dust
and covered with limewash, brilliant white, or with earth or
mineral pigments added to provide yellow and pink washes. The
charming tradition of limewashing the house with a colour and
outbuildings in white has all but died out. Limewashing directly
onto stone was the practice for buildings of lower status, cottages
or outbuildings. Most churches were lime-rendered and lime-
washed until the C19, as can be seen from churchwardens'
accounts.

CEREDIGION. The older rocks of Ceredigion which provided
building stones are from the SW corner, from Cardigan to Llan-
wenog and most of adjacent NW Carmarthenshire. The remain-
der of the county is formed by younger rocks of the Silurian age,
also shared with adjacent parts of Carmarthenshire. Among the
best building stones are the distinctive yellow-brown ASHGILL
sandstones which occur on the Ordovician side of the Ordovi-
cian–Silurian boundary in an irregular curve from Llangrannog
through Cwrtnewydd to the Teifi and into Carmarthenshire. The
Pwntan quarry at Tanygroes produced a fine grained stone that
could be crisply cut, even to Gothic detail as at Capel y Ffynnon,
Pentregat, 1849, and Aberporth church, 1856. In Llanarth, N of
the boundary, houses along the main road show a mixture of this

yellow-brown stone and the dark grey Silurian Aberystwyth grits. However the bulk of the building stones of the SW part of the county comprises grey ORDOVICIAN SLATES, generally of poor quality, but just in Pembrokeshire, at Cilgerran, yielding a fine slate. The grey squared blocks can be seen along the lower Teifi valley, notably at Cardigan, where they were used from medieval times, in the castle, the C15 chancel of the church, and in the 89 Guildhall of 1858. The grey slate is frequently attractively banded in Cardigan with a hard grey-brown Ordovician sandstone in blocks, whose provenance is probably the Pembrokeshire coast nearby. The best Cilgerran stone could be used for carved features, as on the spire at Llangoedmor church, but suffers lami- 57 nation. Generally it was used for copings, sills and gatepiers, and slabs were used for dairying and salting slabs, flooring and grave-yard memorials. The slate quarry at Cymerau, Eglwys Fach, in the N of the county does not seem to have yielded a building stone in its short working from 1887.

The SILURIAN building stones of the rest of the county are dominated by strongly graded sandstones with grains cemented with silica giving great tensile strength, and in some quarries allowing blocks of great length, up to 10 ft (3 metres) from the Llanddewi Brefi area. There are two parallel bands, the Aberys-twyth Grits following the coast and extending up to 7 m. inland (to Blaenpennal and Lledrod) and the Cwmystwyth Grits, a nar-rower band running from Llanllwni Mountain in Carmarthen-shire through Llanddewi Brefi and into the bare upland E of Strata Florida. Between the two areas of sandstone are poor slaty-mudstones, in part corresponding to the area of earth-walling around the Aeron valley. The Aberystwyth Grits yielded a dark stone that characterizes for example Llanon and much of Aberys-twyth. The CWMYSTWYTH GRITS from Llanddewi Brefi were particularly prized for a bluish shade, as seen on the former St Paul's Welsh Wesleyan Chapel, Aberystwyth. The lead-bearing hills NE of Aberystwyth show the same Silurian sequence but with older Ordovician inliers forming the Plynlimon massif and the separate area E of Eglwys Fach, site of the only slate quarry in Ceredigion, but did not yield so good a building stone.

NORTH CARMARTHENSHIRE. In Carmarthenshire, the NE part of the county continues the horn-shaped outcrop of the Sil-urian of the Central Wales Syncline down from eastern Ceredi-gion, through Ystradffin, Caio, Llansawel and Llanpumsaint to Cynwyl Elfed. As in Ceredigion, the rough grey slaty stone is very widely used, generally rendered, while the cut stone from Cil-gerran appears notably in Cenarth and Newcastle Emlyn. The ORDOVICIAN YELLOW-BROWN SANDSTONE follows the line of the Silurian boundary, appearing in Drefach Felindre (notably on the church), Pencader and through the hills N of the Tywi from Newchurch to Llanfynydd, Talley and Cilycwm. Eastwards, however, the equivalent of the Ordovician sandstones of Cered-gion are coarser-grained sandstones and pebbly beds (conglom-erates) used for the dressings at Talley Abbey in the C13 and for 103 the Cynghordy Viaduct in the 1860s.

The rocks of the Tywi valley and SE Carmarthenshire are much more complex, consisting of sub-parallel strips varying in age south-eastwards from the oldest Ordovician, through the Silurian and Devonian to the upper and lower Carboniferous (Dinantian-Westphalian). The central strip extending from Whitland through Carmarthen and the Tywi valley to Llandovery comprises the oldest Ordovician rocks, with local areas of even older rocks (Pre-Cambrian at Llangynog). The oldest rocks run in a ridge from Llangain, cross the Tywi and continue through Llangunnor to Llanarthne. This consists of several bands of hard sandstone, but much thicker deposits of shales. N of these are three separate bands of Ordovician limestone (Llandeilo, Meidrim and Sholeshook-Birdshill) separated by shales. They are of various shades of grey colour and were used in Dinefwr and Dryslwyn castles and in the C19 recasing of Newton House, Dinefwr.

The oldest SILURIAN SE of the Tywi consisting mostly of dark olive-green to dark grey silty shales and mudstones of Llandovery age, forms the hills from the Breconshire border almost to Llangadog. SE of this extending to the National Botanic Garden site, Llanarthne, are grey mudstones and thin sandstones of Wenlock age, and SE of these is another narrow strip (no more than a mile wide) of more flaggy Ludlow rocks, forming the higher ground. A band of purplish to red sandstones of marine origin and Ludlow age then form a strip from the Usk Reservoir in Breconshire to Paxton's Tower, Llanarthne, used in Llangadog and Llandovery College (Sawdde stone). The stone widely used in Llandovery town came from the ridge SE of the town, and in the C19 terraces of New Road one group of houses shows the olive green, another the purple. A feature of the boundary between the marine Silurian and the non-marine red sandstone is a very narrow (about 10 metres wide) vertical bed of Tilestone that runs back up to Builth Wells, used for roofing flags, as at the Dinefwr Home Farm, and probably for C19 church roofs at Llandyfan and Llandybie.

The oldest part of the OLD RED SANDSTONE is of the youngest Silurian age but most is of the Devonian age. The Old Red Sandstone commences with a very hard sandstone from Green Castle, Llangain (part of the Green Beds), fine-grained enough to be polished for steps inside the chapel of the Carmarthen asylum (St David's Hospital), and also the walling stone there. It is followed immediately by a large thickness of red mudstones of no use for building (Raglan Marl Group). Forming the next band to the SE are greenish-grey hard sandstones of the Senni beds, the oldest half of the Brownstone Group. This strip crosses the Taf and Tywi estuaries from Laugharne to Llansteffan and Ferryside (visible on the castles and St Ishmaels church) and stretches, almost a mile wide, to the northern flanks of the Black Mountain. SE of this line where the ground slopes steepen to the ridge from Allt Cunedda N of Kidwelly to the northern slopes of the Black Mountain are the hard maroon sandstones of the Brownstones, whose characteristic colour can be seen in the farm buildings along the line. The best quarries were to the N of

Llandybie, and the red stone is prominent on Kidwelly church tower, the late C19 church at Gwynfe and the additions of 1901 to Llandovery College. The top layer of Brownstones, from near Crwbin, Llangyndeyrn, to E of Carreg Cennen Castle is a striking rock composed of white pebbles in a maroon-green-yellow background, the Pebbly Brownstones, which could be dressed, and were used from medieval times. They can be identified in the walls of Llandybie church, in dressings at Carreg Cennen and Dinefwr castles, corbels at Kidwelly castle, at Llanarthne church and, presumably imported, in the W door of Llanelli church.

Parallel is the important band of CARBONIFEROUS LIME-STONE that follows the N slope of the Black Mountain, the high ground N of Llandybie, and the Mynyddygarreg ridge to dip under the sea at Kidwelly, reappearing N of Marros before continuing into Pembrokeshire. The pale grey stone was almost too hard for working until the C19, when it appears in prestige buildings like Lord Cawdor's Golden Grove, 1826–34, built of stone 64 from Llangyndeyrn Mountain, and the Picton Monument, Car- 82 marthen, 1847–9. It is prominent in the C20 retaining wall to the Carmarthen County Hall. Primarily though the stone was burnt for lime, and limekilns dot the outcrop, those at Cilyrychen, 105 Llandybie the most notable. One site near Llangyndeyrn produced a 'Black Marble' that could be polished, used for chimneypieces and memorials.

The variety of colours available is shown to advantage in some C19 houses in Llangadog, that achieve a tweedy mix of purple, grey, green and brown, the mixture enriched by stones brought down by the river Sawdde which crosses the various bands. A similar mix produced by the Gwendraeth rivers can be seen in Kidwelly castle, church and town.

A narrow strip of MILLSTONE GRIT along the S edge of the Carboniferous Limestone, skirting the Gwendraeth Fawr coalfield, was used for walling at Kidwelly Castle and appears in villages along its course like Carmel and Meinciau. Because of the high silica content it was quarried for making fire-bricks for the iron and tin-plate industries. The remainder of the NW side of the Gwendraeth and Amman valleys are formed of Coal Measures, which included brown-grey, weathering black sandstones for building, and clays for making bricks. The high ground to the S of the Gwendraeth, forming the hills between the coast at Pembrey and Llanelli through Tumble to Ammanford and Bettws Mountain is the Pennant Sandstone of the upper Carboniferous Coal Measures. This area provided the grey Pennant stone, weathering to brown, that characterizes most of the industrial towns of South Wales, and seen for example on Llanelli Town Hall.

IMPORTED STONE. Building stone was imported from early times – the Jurassic Limestones of N Somerset, mostly Dundry, and white Sutton stone from Glamorgan were used for church fonts in the C12. Dressed stone at Whitland Abbey came from Dundry and Sutton. At remote Strata Florida building stone seems to have been carried for prodigious distances: external

dressings including those of the W doorway are of Dundry stone, Anglesey Grit sandstone was used for carved work, purple Caerb-wdi from St Davids banded the nave piers, and isolated blocks of Egryn freestone from Barmouth and Nolton sandstone from Pembrokeshire have also been identified. Sutton stone was used in the chapel windows at Kidwelly Castle, and greenish Quarella
30 from Bridgend in the gatehouse. The very fine S doorway at Llan-badarn Fawr appears to be of Anglesey Grit, as also the small ashlar quoins. The banded maroon and grey sandstone ashlars in the C13 crossing piers at Kidwelly may be imported from an unidentified source. The late C15 red sandstone chancel windows at Llanbadarn Fawr are probably from Cheshire, as the church was then under the abbey of Vale Royal in that county.

In the C16, Sir John Perrot's great windows at Laugharne were of a Somerset limestone. C17 surviving work is so scanty that no assumptions can be made. In the C18 Bath stone was the chosen material for the fittings of the grandest houses, the fireplaces and cantilevered stone staircases, though rare in the region. The S
43 front of Taliaris, c.1725, is wholly of Bath stone, as are the Palla-
49 dian windows at Carmarthen Guildhall, 1767, and was much of Hafod mansion. The cantilevered staircase by Nash at Llaner-chaeron is of Bath stone, probably imported ready-carved. The fine-grained Grinshill sandstone of the Shrewsbury area was used
46 in the earlier C19 by Edward Haycock, in the portico at Nanteos, and also on the stables there. The early C18 scroll pediments at Nanteos are notably made of rather small pieces of an unidenti-fied sandstone, suggesting difficulties in procuring freestone at that date.

The Victorians used the Bath-area limestones (Box Ground, Corsham, Dundry and Doulting) plentifully for dressings and
99 carved work. The portico of the English Baptist chapel, Car-marthen, 1870, is entirely of Bath stone. The railway age brought in the specialized decorative stones: Aberdeen granites for columns and memorials, Caen stone, Derbyshire alabaster and Devon marble for pulpits and fonts, and also a great range of building stones and roofing slates. Thomas Savin could use his railway to bring Cefn sandstone from his quarries in NE Wales to
88 use on his hotel (the Old College) at Aberystwyth. The College shows notably early use of CONCRETE or artificial stone by J. P. Seddon in the 1880s: concrete for stairs and balconies inside, and imitation stone showing as greyish blocks in the upper façade. The last addition, of the 1890s, by Ferguson, is of Grinshill stone. Red sandstone from Hollington in the Peak District was used at Ystrad Meurig church in 1898 and Llanelli parish church in 1904–6. The extent of choice available to architects is well illus-trated at Aberystwyth parish church, 1889, where most of the materials came from outside Wales: walling stone from Yorkshire, ashlar dressings from Bromsgrove and roofing slates from Westmorland.

The major public buildings of the earlier C20 were faced with imported stone: white Portland on a base of grey Cornish
115 granite on the National Library, and grey Forest of Dean stone

at the Carmarthen County Hall and on the first buildings on 117
the Penglais site at Aberystwyth University. But in the same
period the use of imitation stone indicates the economic
pressures that would shortly end the use of fine building stones.
An imitation Portland or silver granite clothes Aberystwyth
Station and imitation Bath stone provides the dressings on the
1930s additions to the Carmarthen Grammar School (Parc
Myrddin).

Other Materials

BRICK is not common in either county before the late C19. It
appears as a facing material on the early C18 No. 2 Quay Street,
Carmarthen, the later C18 Black Lion Hotel, Cardigan, and on
Iscoed mansion, Ferryside, begun 1772. It commonly lined the
more expensive walled gardens, as at Llanerchaeron, of the
1790s. The first substantial brickworks seems to have been the
one at Cardigan set up by the Miles family of The Priory in the
late 1850s. The bricks are orangey-red and still distinctive in the
town. They were apparently exported in quantity to Dublin. The
firm also made pressed terracotta details and a remarkable large
L-section hollow brick which seems to have had a limited use
around Cardigan, notably at Glanhelyg, Llechryd, 1860. From
the late C19, bricks were made where clay occurred along the
Carmarthenshire coalfield, e.g. at Penygroes and Trimsaran, but
these bricks were not of good facing quality. Much late C19 brick
is imported – the red and yellow in evidence in Aberystwyth came
from Flintshire – Ruabon and Buckley, as did the TERRACOTTA
detail so extensively used, for example on the Coliseum. The rail-
ways and the Bristol Channel provided more southern areas with
a hard brick from South Wales or Bristol, and probably the glazed
tile much used in Llanelli in the early C20 (as on Exchange Build-
ings, the Y.M.C.A. and the former Llanelly Cinema), though the
provenance remains unknown.
 EARTH, or CLOM as it is known in Wales, was used in areas
without good building stone. In Ceredigion, a suprising number
of clom cottages survive, mostly in the Aeron valley, e.g.
Ffynnon-oer, Ystrad Aeron, recently restored, and many may
remain hidden under cement render. Clom is also found in the
upper walling of some farm buildings, used as an economy. Less
remains in Carmarthenshire, chiefly in the w.
 TIMBER. Framed timber houses may be assumed to have
existed, as suggested by the construction of the Angel Vaults, Car-
marthen, but all were lost in subsequent rebuilding in stone. Roof
trusses are overwhelmingly of the A-frame (collar-truss) type and
not necessarily of oak, as whatever timber was available was used
in cottage roofs, often in thin and rough pieces. (*see also* p. 75)
 IRON was manufactured in the C18 at Carmarthen and else-
where, but apart from the fine railings of 1761 at the Public
Library, Carmarthen, no other locally made C18 architectural
work has been identified. From the earlier C19 iron railings were
made in Carmarthen, eventually to have three foundries, and

there were similar foundries in Aberystwyth, Cardigan, Llanelli and Burry Port. They made the columns for chapel galleries and railings in large quantities, still identifiable by their stamps: Priory Foundry Co.; Moss & Co.; The Old Foundry Co.; Thomas & Clement; Eagle Foundry; Bridgend Foundry, etc. Cast iron was also imported, bought from the catalogues of Coalbrookdale in Shropshire, Macfarlane in Glasgow, or Baker in Newport. The massive Ionic porch columns at Neuadd Fawr, Cilycwm, of the 1830s, must have come from Shropshire with the architect, Haycock. It is hard to guess the route that brought a second-hand water wheel from Galway to the Vale of Towy Mill, Llan-wrda. CORRUGATED IRON was a cheap form of cladding from the late C19, used for small houses, churches (until funds enabled their replacement in stone) and halls, as at Eglwys Fach. It was also the cladding for the C20 hoop-topped hay-barns so typical of upland Welsh farms.

ROOFING MATERIALS. Slates have been imported since the C18, but THATCH was almost universal into the 1840s for cot-tages, and continued in use well into the C20. Rowlandson's late C18 view of Newcastle Emlyn shows that it was used on sub-stantial town houses also. What little survives was covered in cor-rugated iron, and suggests that techniques were often very basic – the straw not always wheat, but sometimes rye, oats, water-reed or sedges. A few roofs have been re-thatched: Aberdeunant at Llansadwrn; Ffynnon Oer at Ystrad Aeron; Troedrhiwfallen at Cribyn; and Llwyndrissi, Pencarreg, the last three with the thatched round chimneys special to the region. SLATE came into widespread use from the earlier C19, with slates from Pem-brokeshire. Llansantffraed (Llanon) church was roofed in 1840 with slate shipped from Newport, Pembs. Pembrokeshire slates varied in quality and colour, the poorest being from the coast, the better ones from Cilgerran and Rosebush. Gilfach quarry, Efailwen, yielded a fine grey slate (still on churches at Brynam-man, Dafen and Llanbadarn Fawr) sold all over southern Britain, and used, to local anger, on the University College of North Wales at Bangor in 1907. The more durable North Wales slate did not become ubiquitous until the earlier C20, but had entirely ousted the Pembrokeshire slates by the 1950s, before themselves being supplanted by imported slates from all over the world. The one Ceredigion slate quarry was in the N at Cymerau, Eglwys Fach, worked in the late C19, and a small amount of slate was quarried in NE Carmarthenshire at Ystradffin. STONE TILES are rare now, though of ancient usage. They were quarried along an almost continuous band of workings from the Cennen gorge near Ffairfach to the Wye valley near Builth Wells, from beds known as the Tilestones, and can be seen on Llandybie and Llandyfan churches, and Pethr Cadfan, Llangathen. An area of quarrying has also been identified near Llanddewi Brefi.

The second half of the C20 saw the end of local building pecu-liarities, new buildings not differing from those in any other part of Britain and, with modernization, old buildings lost traditional detail. Serious conservation has come slowly, and has to over-

come the lack of traditional building materials. Building stone and slates have had to be recycled from demolitions, and lime, thatch and building timber to be imported, all awaiting the level of demand that will revive local production.

PREHISTORIC AND ROMAN
CARMARTHENSHIRE AND CEREDIGION

BY HEATHER JAMES

Caves in the limestone that outcrops on Caldey Island and around the shores of Carmarthen Bay have yielded skeletal, and artefactual evidence for our remote PALAEOLITHIC ancestors. Coygan cave, near Laugharne, now quarried away, produced three 'Mousterian' handaxes, named from the type of site associated with Last Glaciation Neanderthals. Small groups hunted over vast areas of arid grassland during an inter-glacial period. There was a long period of overlap between *Homo neanderthalis* and *Homo sapiens sapiens*. The relatively recent date (50,000 B.C.) for their presence at Coygan might indicate a western refuge for a population close to extinction by their rivals. Centuries after this brief occupation, Coygan Cave was a hyaena den. Excavations of these levels have recovered a large assemblage of animal bones of species both extinct (woolly rhinoceros, mammoth), or now confined to higher latitudes (wolf, arctic fox, reindeer) and some still present in our British fauna (polecat, common fox, red deer).

Human occupation resumed in West Wales at the end of the last Ice Age some ten thousand years ago by groups of hunter-gatherers living in a post-glacial climate characterized by developing forest vegetation and rising sea levels. Changes in environment and thus prey led to smaller flint tools and weapons; the period from *c.* 10,000 to *c.* 4000 B.C. is thus termed the MESOLITHIC. The fossil pollen record from a number of sample locations across Wales gives the general sequence of climatic and vegetational change from scrub vegetation of birch, juniper and pine to the appearance of hazel as the climate continued to warm. In the warm, dry conditions of the pollen zone termed the Late Boreal (8200–7500 B.P.) extensive forests of oak and elm developed. From this time a wetter climate prevailed, the Atlantic (7500–4500 B.P.) when lime, ash and alder were added to the forest cover. On the Brecon Beacons on the eastern border of Carmarthenshire, a pollen sequence through peat bog deposits at Waun Fignen Felen records changes in the upland environment that could be the result of human intervention. There, an early Mesolithic flint knapping site seems to be associated with clearance of birch woodland, mainly by the use of fire. Clearings would help flush out game, and scatters of small flint arrowheads in a former lake edge location have been interpreted as traces of wildfowling. Most evidence for the Mesolithic however comes from coastal sites, and their date and location help chart the

steadily rising sea levels and changing coastline. Many areas of Mesolithic occupation must now lie below sea level in Cardigan and Carmarthen Bays. Telling evidence for the rise in sea levels comes from the expanse of tree stumps and peat shelves visible at low tides in locations like Ynys Las, near Borth; similar remains inland now lie deep below Borth Bog. Part of a deer antler shaped for use as an axe or adze found at Ynys Las hints at tree clearance. Indications of probably seasonal use of the plentiful coastal shellfish (nutritious only when consumed in large quantities) comes from limpet hammers found with flints and flint cores in Aberystwyth Harbour. No artefacts have yet been associated with the 'submerged forests' on the Carmarthenshire side of Carmarthen Bay but at Lydstep, Pembrokeshire, two microliths were found embedded in the neck of a pig whose skeleton was preserved in the submerged peat forests.

A recent, speculative interpretation of the Lydstep pig – namely that it was a domesticated Neolithic pig killed by Mesolithic hunters – encapsulates the current debate on whether it was indigenous populations that made the transition to a predominantly farming economy or whether such a fundamental change was due to incomers. The two distinct lifestyles could have co-existed. A change in flint tools and the emergence of stone axes, 'traded' over large areas, pottery, stone or timber houses, field systems and, above all, new cultural traditions in the disposal of the dead in megalithic tombs are the defining archaeological characteristics of the early NEOLITHIC (4400–2900 B.C.). Chambered tombs are few in number compared to Pembrokeshire, confined to w Carmarthenshire and a few possible sites known only from antiquarian record in Ceredigion. Yet other evidence, mainly from sites with later prehistoric material, suggests Neolithic occupation over a much wider area. At Gogerddan, Penrhyncoch, a single pit produced carbonized grains of emmer wheat and barley, as well as hazelnut and crab apple, suggesting cereal cultivation but also significant and continuing use of wild woodland plants. A radiocarbon date of around the beginning of the fourth millennium B.C. from hazelnut shells found with bones of domestic cattle and sheep, pottery and flints, in a pit below later rampart material at Coygan promontory fort is as early in the Neolithic period as any in Ireland or Britain.

The chambered tombs in w Carmarthenshire do not fit easily into standard types and furthermore their much disturbed condition makes analysis of their plan forms difficult. The two traditions for West Wales are those of the 'portal dolmen' and the passage grave, the former with a stone box often formed by stone uprights and a massive capstone giving both a 'doorway' to the tomb and a forecourt for ritual and ceremonial use, the latter characterized by a passage between the burial chamber or chambers and the outside world. Both were surmounted by cairns, often now wholly or partly lost. Twlc y Filiast, Llangynog, sited unobtrusively near a stream, has a small trapezoidal chamber of upright slabs and a large, now displaced, capstone. Excavation showed that it had once been enclosed within an oval-shaped

stone cairn but with a forecourt and antechamber thus linking it
to the portal dolmen tradition. Gwal y Filiast, Llanglydwen, now
within woodland, still has its capstone in place supported by four
sidestones and outlying scattered stone may indicate the former
extent of its enclosing cairn and a passage entry. The tomb over-
looks the steep-sided valley of the River Taf. At Morfa Bychan,
Marros, prominently sited on the edge of the limestone scarp
ending at Ragwen Point, is a line of three, possibly four, cham-
bered tombs, excavated in the early C20. The box-like chambers
formed by upright slabs are still discernible, but only one retains
its capstone. The former extent of covering cairns has been partly
established and one tomb has a short passage between the burial
chamber and the edge of the cairn.

From about 2900 B.C. there are changes in the ritual and funer-
ary monuments that constitute the bulk of our evidence for
Neolithic and early BRONZE AGE society. One important theme
is the replacement of communal by individual burial monu-
ments, of interment by cremation. Circular forms in houses,
ritual and burial monuments become paramount. Though few in
number, stone circles in West Wales are in upland areas, close to
cross-mountain routes and may have seen seasonal ritual use by
predominantly pastoral groups. Just into Breconshire are two
small circles near the source of the Usk, and another pair are just
E of the Pigwn Roman camp, Myddfai, on an important route.

Far more prominently sited in the uplands are massive burial
cairns, frequently in groups. They often provide panoramic views
and are themselves visible on the skyline over great distances and
from several vantage points. Intervisibility seems to have been an
intention in their siting and these must surely be interpreted as
monuments of power, territorial markers and celebrations of
ancestral lineage. Two groups – Tair Carn Isaf and Uchaf, Carreg
Cennen, at the western end of the Black Mountain – are excel-
lent examples. These stone cairns have been subject to centuries
of erosion, stone removal and rearrangement, as well as ill-
recorded antiquarian investigations. Surprisingly therefore, the
much eroded summit cairn of Fan Foel, E of Llyn y Fan Fach,
Llanddeusant, was found, on excavation in advance of consoli-
dation, still to contain burial traces. A cremation within a 'food-
vessel' urn, flint tools and weapons and possibly a bronze object
were found within a stone-slabbed box-like cist in the centre of
the cairn. Similar hilltop groups survive at Crugiau Edryd, on
Llanybydder Mountain (Llanllwni). In Ceredigion, a linear
group of four prominent burial mounds at Trichrug, Cilcennin,
is now once again visible after forestry clearance. Similar groups
of cairns on Pen Pumlumon Arwystli, at some 2,500 ft (760
metres), on the E edge of the Plynlimon range, Ponterwyd, over-
look the source of the River Wye. Nevertheless the better survival
of such monuments in upland or marginal land means that our
picture of the density of prehistoric settlement is skewed.
Recently Neolithic, early Bronze Age and Iron Age pottery and
radiocarbon dates from Cwm Meudwy, Llandysul, came from
ring ditches (the ploughed-down remains of Bronze Age round

barrows) and a palisaded enclosure showed a long continuum of land use and occupation. Another chance find at Llanilar also hinted at Neolithic precursors to Bronze Age occupation, evidenced by burials, in this case cremations in long urns.

Individual, or more rarely, paired standing stones are the most common field monuments of the Bronze Age and these survive in quantity in upland and lowland locations. Excavations at sites like Stackpole Warren, Pembrokeshire, have shown that they are often the only upstanding element of complex, long-lived ritual and funerary monuments. On Llangyndeyrn Mountain, a small timber structure attached to one of a pair of prominently sited standing stones has been suggested as a possible shrine. The Abercamddwr kerbed cairn (now re-erected on the edge of the Nantymoch reservoir, Ponterwyd) showed incorporation of two upright stones into the kerb of a ring cairn forming a symbolic entrance perhaps to a burial monument whose form recalled that of a timber roundhouse – linkages between the living and the dead.

A conservatism in ritual and funerary practice has been suggested for prehistoric Wales and this may well be exemplified by continuing use of certain locations clearly of burial and ceremonial significance. On the foothills of the Preselis, at Glandy Cross, Efailwen, seventeen stone uprights of the Meini Gwyr embanked stone circle were recorded by Edward Lhuyd in 1695; two remain. A poorly preserved possible henge monument nearby, Castell Garw, may be earlier still. Other monuments in the area include two sites where standing stones are associated with pit circles or timber circles. Cropmarks, spreads of finds or charcoal and sample excavation all hint at complex activities in spaces between as well as around the monuments. The date range known so far for the complex extends from the late Neolithic well into the Bronze Age. At Gogerddan, an even longer period of use, or periods of reuse, is evidenced by a remarkable sequence of Bronze Age ritual and funerary monuments sited along a low gravel ridge above the River Clarach with slight evidence of earlier Neolithic use. Standing stones and low earth barrow mounds were the only visible features before excavation and the original alignment of the former had been disturbed by c18 repositioning as racecourse markers! Two more barrows, long ploughed flat, were identified in excavation, with secondary cremation burials. Numerous other pits and timber features of Bronze Age date lay nearby. These monuments were reused for much later Iron Age crouched burials. Finally there was a cemetery of early Christian oriented graves, some within special timber surrounds E of the prehistoric monuments.

The widespread occurrence of Bronze Age ritual and funerary monuments in the uplands is not accompanied by much evidence of occupation. Hut circles and field systems are known but are not common. Groups of clearance cairns are by their nature difficult to date. However, in a location like Bettws Mountain, Cms., a close association between groups of clearance cairns and presumed Bronze Age burial cairns at least links land improvement,

if only for pastoral use, with ritual and funerary monuments for the dead. A detailed study of uplands between Eisteddfa Gurig (Ponterwyd) and Cwmystwyth added many more Bronze Age burial monuments to the previously known total but no evidence for occupation. It was concluded that the sheltered valley sides of the upper Ystwyth valley were the most likely location for dwellings. This is of particular interest because evidence is growing for Bronze Age exploitation of copper and other minerals in mid and North Wales. Radiocarbon dates now attest the antiquity of an opencast, stone tools and spoil heaps exploiting a copper lode at Copper (Copa) Hill, Cwmystwyth, substantially worked for its lead in the modern period.

The earliest evidence in Wales for copper and bronze working can be dated to around 2500 B.C. but it was not in widespread use for weapons, tools or ornament until the middle Bronze Age. Stone implements continued in widespread use, some forms actually imitating metal prototypes. Early bronze tools and weapons, as well as objects of gold, may have been imported from Ireland. Some spectacular finds of Bronze Age metal work, such as the Llanychaiarn shield, testify to the growing competence of Welsh bronzesmiths. Use may well have been more ceremonial than practical and its discovery in a bog suggests that it is one of several finds of aristocratic equipment from Wales offered to the gods in watery locations in both the Bronze and Iron ages. By the C9 to C8 B.C. there appears to have been considerable quantities of bronze weapons and tools in circulation. From the C7 B.C., iron begins to occur in the archaeological record marking the beginnings of the IRON AGE, though this was a gradual process. These centuries mark considerable changes in society, economy and religious practice. The main causal factors may have been a deteriorating climate, reducing the agricultural capacity of the uplands and pressure on what had become a well-populated countryside. Settlements now become visible in the modern landscape because of the need to provide them with defences. A more hierarchical and combative society is implied.

West Wales has a dense distribution and a diversity of types and sizes of Iron Age hill-forts. The earthen banks and ditches and, less commonly, stone defences survive as upstanding monuments. Often air photography can reveal ploughed down outer defences or annexes or complete sites. The earliest defences around settlements may well have been simple timber palisades which are found only when sites are excavated. The reconstructed site at Castell Henllys, Pembs., with its round-houses had such early origins. The small but strongly defended coastal site of Pendinas Lochtyn, Llangrannog, produced radiocarbon dates of the C9 B.C. for its earliest internal timber buildings.

Large hill-forts are uncommon in West Wales and unevenly distributed so it is difficult to suggest that they controlled mutually exclusive tribal territories. Pen Dinas, Aberystwyth, strikingly sited on a steep-sided ridge between the rivers Rheidol and Ystwyth on the coast, has a complex history. The northern knoll was the first to be defended by a timber-revetted bank and ditch. 12

Later the southern enclosure was enclosed with more complex defences and entrances, subject to frequent modification. Merlin's Hill, Abergwili, suggested as a pre-Roman tribal capital replaced by the nearby Roman town of Moridunum (Carmarthen), shows signs of early origins. Simple defences for a smaller enclosure can be distinguished from developed features including a complex entrance defended by a barbican and formidable banks and ditches, and skilful enhancement of natural defences. Stone-walled forts are not unknown. Garn Goch, Llangadog, encloses some 27 acres (11 hectares) and, even ruinous, the drystone ramparts are impressive. In parts their face survives. Eight narrow entrances through the circuit are lined with upright slabs and may have held wooden gates in their entrance passages. These are unusual features and some have even suggested a Neolithic date for the site by analogy with Carn Brea in Cornwall. Two smaller, more conventional forts lie to the W and it is hard to see how the three could have been occupied at the same time or indeed fulfilled the same functions.

Smaller defended sites may have functioned as defended farmsteads albeit ones owned by local notables. There is little doubt that imposing palisaded banks and ditches and elaborate entrances were peacetime marks of status as well as defences against attack. Smaller defended enclosures are particularly numerous in Pembrokeshire and western Carmarthenshire. Air photography is filling what seem to be gaps in the distribution of such sites by the discovery and mapping of rectilinear enclosures, which cluster in southern Ceredigion and northern Pembrokeshire. Most have been ploughed out but geophysical survey followed by excavation on a sample group has already shown that these are Iron Age, occupied into the Romano-British period with little sign of change. It is difficult from archaeological evidence alone to decide whether this distinctive regional group of sites reflects ethnic or socio-economic differences with surrounding areas and other site types.

The total excavation of a small enclosure at Penycoed, Llangynog (in an area with a dense distribution of defended Iron Age sites) revealed a sub-rectangular enclosure with a long funnelled entrance and internal divisions around a large roundhouse. This was a simple late Iron Age farmstead where the internal yards and entrance divisions are best explained as means of corralling and managing stock – a predominantly pastoral economy. But even here there was evidence of cultivation of cereals – oats and rye. The occupation of the site can be dated to between the late C2 B.C. and the C3 or C4 A.D. Total excavation of a group of defended enclosures at Llawhaden, Pembs., demonstrated a sequence of replacement of small hillforts perhaps of late Bronze Age origins by circular ring-forts. The date range is 200 B.C. to A.D. 200, thus spanning the Roman Conquest.

The extension of ROMAN military control into West Wales seems to have been accomplished fairly rapidly in the early to mid A.D. 70s. Well-preserved marching camps on the Car-

marthenshire border at Y Pigwn, Myddfai, and the large Arosfa Garreg, Llanddeusant, some 2 m. to the S, both straddle important routes between the Usk and Tywi valleys. They suggest probing campaigning on the borders of the territory of the *Demetae*. Conquest was possibly achieved by a two-pronged assault down the Tywi valley from the Usk watershed and by sea up the Tywi estuary. Auxiliary forts are known at Llandovery, Pumsaint (Cynwyl Gaeo), Llandeilo (newly discovered) and Carmarthen. These were connected by well-engineered all-weather roads substantial lengths of which can be traced on the ground. Recently, long stretches of Roman road have been discovered extending westwards from Carmarthen to an as yet unknown destination in Pembrokeshire, suggesting the likelihood of more forts, one perhaps in the Whitland area.

An important objective however seems to have been the gold mine at Dolaucothi (Cynwyl Gaeo). Roman penetration of Ceredigion seems to have been from here with a Roman road (Sarn Helen) extending due N from the Cothi to the Teifi valleys. High on the uplands between the two a circular earthwork, Carreg y Bwci, Cellan, has been identified as a Roman watchtower. Forts at Llanio (Llanddewi Brefi), at Trawsgoed (Llanafan) and Penllwyn (Capel Bangor), are strung out along the road, which skirts the western flanks of the Cambrian Mountains and crosses the Dyfi to Pennal well inland of the estuary. Recently it has been suggested that much of the surface evidence of opencast mining at Dolaucothi actually predates the Roman conquest, by analogy with similar and numerous mines in southern France worked by Iron Age Celts. Received wisdom is that pre-Roman working was small-scale, restricted to surface outcrops and alluvial deposits. By analogy with Roman gold mines in Spain, whose operations were described by Pliny the elder, early Roman working at Dolaucothi involved opencast mining followed by the construction of leats supplying water to storage tanks. These could be discharged in vast quantities over rock surfaces broken up by fire setting, a technique known as hushing. At a certain depth, it was necessary to resort to underground mining as fragments of a wooden drainage wheel of Roman date in a deep gallery prove.

By the early C2 A.D. the military garrison in Wales was much reduced and several civilian settlements attached to forts withered away. At Carmarthen, however, the Roman *Moridunum*, excavations have shown that a planned town with a regular street layout and, late in the C2, enclosing defences, was established. These are characteristics of so-called *civitas* capitals and the town is assumed to have been the administrative centre for the Demetae of West Wales. The existence of an amphitheatre just E of the town is another indication of status, the only civil amphitheatre found in Wales. Large open-area excavations have shown a range of building types with many examples of rectangular timber houses and workshops; iron-smithing and baking were the dominant occupations in these relatively humble structures. Larger timber-framed buildings on dwarf stone walls are

known and small-scale and antiquarian finds attest town houses with underfloor heating systems and painted plaster walls. The outline of the Roman town defences is now preserved in the modern street pattern of E Carmarthen and no upstanding remains survive. Nevertheless it is clear that the substantial bank and ditch defences of the late C2 were remodelled in the C3 and C4 by a stone facing and towers. Pottery, metalwork and coins, and a long sequence of buildings all demonstrate that town life in Carmarthen continued well into the C4.

The impact of Roman lifestyles and a market economy in West Wales, as elsewhere in Roman Britain, are conventionally measured by changes in building styles and the volume and range of Roman coinage, metalwork, pottery and glass on 'native' sites. Rectangular stone buildings, which might be termed villas, are very few. Defended enclosures of the late Iron Age continue into the first two centuries of Roman rule relatively unchanged and with small quantities of Roman goods. A major change however, as yet not wholly understood, seems to have occurred between the C2 and C3, shown clearly thanks to the large scale of excavation at the Llawhaden sites. By analogy with Iron Age/Romano-British-defended farmsteads like Trethurgy in Cornwall, it may also be the case that native landowners and settlements may have only taken from the Roman world what suited them best. Although our evidence is thin, there are grounds for thinking that the two major legacies of Roman rule in Britain – the Latin language and Christianity – had both taken hold in areas at least of West Wales in the late Roman period and survived the end of Roman rule.

THE MEDIEVAL
HISTORICAL BACKGROUND

The early post-Roman history of the region is obscure. Iron Age sites occupied through the Roman period continued in use after the Romans left. Place-name evidence shows Irish colonizing of the SW, particularly Pembrokeshire, in the C4, but checked in the late C5, when Cunedda recovered the E part of Carmarthenshire. The genealogies suggest a Romano-British revival in the C5–C6, to be associated with King Arthur. There is a revived-Roman note to the titles of two named rulers, Agricola the Tribune, and his son, Voteporix, called 'Protector' on his stone in the Carmarthen Museum. For all that, he and contemporary warlords are blamed by the historian Gildas for the post-Arthurian collapse of authority. He, while castigating bishops for siding with warlords, praises the monastic settlements, if not the extreme asceticism of St David, and it is with the saints rather than the rulers that the history of the C6 to C9 is written. The story of St David begins in Ceredigion, David being reputedly of the ruling dynasty and brought up at Henfynyw (Old Menevia). David dedications are spread through the three SW counties, with a particularly

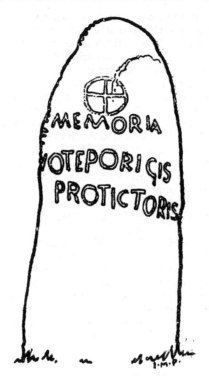

The Voteporix Stone.
Engraving

important site at Llanddewi Brefi, where at a synod *c.* 519, David
refuted the Pelagianism of St Cadog. Sites linked to St Padarn
spread inland from Lanbadarn Fawr into mid Wales, and those
linked with St Teilo run E from eastern Pembrokeshire to Llan-
deilo. The names in *llan* record the sites of churches established
by saints, some being the only record of the individual. Tangible
evidence of the C5 to C8 period is in the inscribed stones.

In the C7 church organization coalesced around the monastic
settlements of St Davids, Llanbadarn Fawr and Llandeilo, abbots
being styled bishops. The estates of the monastery at Llandeilo
are claimed to have been of thousands of acres. Secular organi-
zation in the SW only really emerges in the C9. Rhodri the Great
(†878), of North Wales built up a kingdom that included part of
the SW. His grandson Hywel Dda (the Good), †950, founded the
kingdom of Deheubarth, roughly the present three SW counties
with the Gower, and controlled much more of Wales. His is the
first known Welsh coinage, and his name is permanently linked
with the codification of Welsh law. Deheubarth, weakened by
feuds among the descendants of Owain ap Hywel Dda, †988, and
by Viking attack, had begun to be reunited by Rhys ap Tewdwr
when the Normans first came, restating a claim to overlordship

made by their Anglo-Saxon predecessors. It was as much for this as pilgrimage to St Davids that William I came in 1081. Rhys was killed in 1093, and William II felt no longer bound by any agreement. Norman lords drove through Wales to establish forts at Cardigan, Carmarthen (Rhydygors) and Pembroke. From 1100 further strong points were established, e.g. at Kidwelly, Llandovery and Laugharne, confining Gruffudd ap Rhys to Caio, the remotest corner of the Cantref Mawr, the area N of the Tywi that had been the heartland of Deheubarth. Carmarthen became the seat of royal administration and Pembroke the heart of Norman baronial power 'beyond Wales'. From Pembroke, Gerald of Windsor established a castle at Cenarth Bychan in 1108, and Gilbert de Clare over-ran Ceredigion in 1110. When Henry I died, the native principality was all but extinguished, to revive with the civil war of 1135–54 between Stephen and Matilda. The Normans were heavily defeated at Crug Mawr, near Cardigan, in 1136, and Gruffudd ap Rhys (†1137) and his sons retook most of Deheubarth. Henry II sought to regain what had been lost, first against Owain Gwynedd in North Wales, and then Rhys ap Gruffudd, 'the Lord Rhys,' in the South, securing the homage of the Welsh rulers at Woodstock in 1163. But Wales was too remote to control and Henry, in 1171, with his eye on Ireland, came to terms with the Lord Rhys.

Rhys, the most successful of South Wales's princes, sought accommodation with the Norman marcher barons, was careful to protect the rights of captured settlements and promoted Norman monastic foundations at Strata Florida, Whitland and Cardigan, even over older Welsh ones. The evidence of stone castles being built at Cardigan and Dinefwr, of church building at Strata Florida and Talley, and from the courtly competition for poets and musicians held at Cardigan in 1176, points to a realm in the making under the *princeps Sudwalliae* or Prince of South Wales, as Rhys styled himself. This interlude ended with the death of Henry II in 1189. Rhys, distrusting Richard I, initiated attacks – against the barons of the South and South-West, NE into the Marches, and against the royal castle at Carmarthen. His successes were soon undermined by family strife and after his death in 1197 territorial dismemberment came fast, with raids from other Welsh rulers in alliance with one or other of Rhys's heirs. The sale, by Maelgwn ap Rhys, of Cardigan castle to King John in 1200 was a particularly notorious betrayal.

Leadership of native Wales passed to Llywelyn ap Iorwerth (Llywelyn the Great) of Gwynedd. His remarkable campaign of 1215 cleared the Normans from all but Pembrokeshire strongholds. Llywelyn partitioned Deheubarth among the heirs of the Lord Rhys, who thus retained Dinefwr and Dryslwyn, and continued to be buried at Strata Florida, but were essentially without power. It was from Pembroke that the Normans recaptured Cardigan and Carmarthen in 1223, but royal power advanced little more before Llywelyn died in 1240. Visible symbols were the rebuilt castles at Carmarthen and Cardigan, with their walled towns. But again in the next decade Welsh resurgence pushed the

English back. Llywelyn ap Gruffudd (Llywelyn the Last) of Gwynedd over-ran much of Wales in 1256–7, his conquests confirmed by treaty in 1267. As before, the royal castles at Carmarthen and Cardigan and the castles of the marcher barons held out. Royal power was re-established in 1276–7 by Edward I, the beginning of the final conquest of Wales. Edward's new castle at Aberystwyth, the southernmost of the ring of castles around Gwynedd, denoted the new determination. In Llywelyn's great uprising of 1282, Aberystwyth, Llandovery and Carreg Cennen castles fell, but Edward's response far outweighed the campaign of 1276–7, bringing forces from all over the Angevin lands. By the end of the year Llywelyn was dead and dispossession of the native princes followed quickly. The revolt in 1287 of Rhys ap Maredudd of Dryslwyn ended the line of Deheubarth.

The Statute of Rhuddlan in 1284 established the conquest, and significantly it was taxation for foreign wars that gave rise to the last serious uprising for a century, in 1294–5. By the C14 the pattern of authority in the region had settled: there were two royal shires, part of the principality bestowed on Edward's son in 1301, the one comprising the modern Ceredigion, the other, based on Carmarthen, comprising the old Cantref Mawr. There were eight small Marcher lordships: Emlyn, St Clears, Ystlwyf, Laugharne, Llansteffan, Kidwelly, Iscennen (Carreg Cennen) and Cantref Bychan (Llandovery). Two, Ystlwyf and St Clears, soon disappeared, but in the others the castles underwent major rebuildings in the late C13 and early C14, ironically soon to be recorded as in disrepair as the region moved to the periphery of national events. Marcher lordships fell to absentee great lords, as Kidwelly and Carreg Cennen to the house of Lancaster, and others were rarely in Wales, like Guy de Brian VII of Laugharne, distinguished soldier, admiral and ambassador.

The fortunes of monastic foundations varied according to their association with the native princes: the ones most associated with the house of Deheubarth, the Cistercians at Strata Florida and Whitland, and the Premonstratensians at Talley declined in the C14, a decline hastened by the Black Death. By contrast the bishopric of St Davids flourished under the energetic episcopacy of Henry de Gower (1328–47), and the urban foundations of the Augustinians and Franciscans at Carmarthen prospered with the town.

Towns grew especially around the royal castles at Carmarthen, Cardigan and Aberystwyth, but also around those of the lordships. Infant towns around the castles of the Welsh princes, Dinefwr and Dryslwyn, disappeared, but there is plenty of evidence for expansion at Kidwelly, with the rebuilding of the church, in the C14. The names of traders from Carmarthen and Kidwelly occur in the mercantile records of the Bristol Channel. Towns were largely reserved for English settlers, but infiltration occurred early. With peace some native Welshmen found fortune in military service abroad, such as Sir Rhys ap Gruffudd †1356, who became virtual royal governor of sw Wales. It was in the halls of native landowners, or *uchelwyr*, that the great poets of the C14

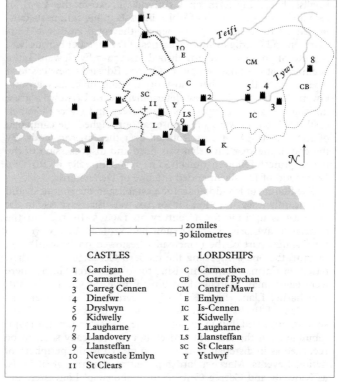

Castles and Lordships in Carmarthenshire and Ceredigion.

such as Dafydd ap Gwilym flourished. The Black Death consol-
idated land holdings in fewer hands, the beginnings of a local
squirearchy, but no trace remains of domestic buildings of pre-
1400, a sign perhaps that the halls eulogized by the bards were
very small, or perhaps subject to extreme destruction in the
Owain Glyndwr uprising.

Exploitation and exclusion were major causes of the uprising
which began in 1400 and extended with devastating speed into
s w Wales in 1403. The sieges which Owain was able to lay on the
castles of Aberystwyth and Kidwelly assisted by French warships
showed that this was a rising of a different order. It was a French
force, landed at Milford in 1405, that secured the capture of Car-
marthen on the way to England. But the alliances with France,
Scotland and the disaffected Percy and Mortimer families failed
to cohere, and by the end of 1406, Carmarthenshire and Ceredi-
gion had been retaken, apart from Aberystwyth, which only fell
to Prince Henry in 1408, the recapture secured with cannon, one
of the first uses in Britain. The destruction wrought by the upris-
ing is still hard to quantify, but the absence of pre-c15 buildings
may be related to this. The settlement though under Henry V was

generous enough to heal relations and draw many native squires into royal service. In the C15 the Dwnn family of Kidwelly, relations of Henry Don who had sacked Kidwelly in the cause of Glyndwr in 1403, included one who fought at Agincourt and another who, as a Yorkist ambassador, was painted by Memling. The Wars of the Roses generally passed the region by, though it was Lancastrian in sympathy. Aberystwyth Castle was seized by Yorkists in 1456, promptly expelled by Lancastrians led by Jasper Tudor. Carreg Cennen Castle was dismantled by Yorkists in 1462. Henry Tudor's march from Milford Haven to the battle of Bosworth in 1485 passed through Ceredigion, gathering support. His main supporter was Rhys ap Thomas of Dinefwr and Abermarlais, who became the principal royal officer in South Wales, as justiciar, and perhaps the leading Welshman of the new administration. The new dynasty secured Welsh acceptance of the nation state, embodied in the Act of Union of 1536.

THE EARLY MEDIEVAL MONUMENTS

INSCRIBED STONES are the principal evidence for the C5 and C6. Several have inscriptions both in Latin and Ogam, the Irish system of straight cuts on the edges of stones. The inscriptions are generally grave markers, giving the name and father's name, AVITORIA FILIA CUNIGNI at Eglwys Cymun, and the Ogams generally follow, giving the Irish 'Mac' or 'Maqi' for the 'filius'. Other notable Ogam and Latin stones are the Ulcagnus stone at Llanfihangel ar Arth, the Trenacatus stone from Llanwenog, now in the National Museum of Wales, and the stone from Castell Dwyran (now at the Carmarthen museum) to Voteporix, ruler of *p. 19* Demetia in the earlier C6. The latter has an incised cross, indicating early Christianity, but most of the crosses on early stones are added, even overlaid. The Penbryn stone, CORBALENGI 13 IACIT ORDOUS, is without Ogams, but similar C6 lettering. The 'Ordous' has been suggested since the C17 as meaning Ordovicus, the North Wales tribe.

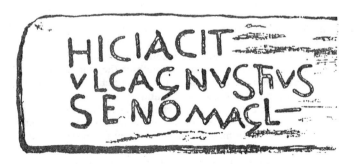

The Ulcagnus Stone, Llanfihangel ar Arth.
Engraving

The location of many stones at church sites may represent continuity of use, but is confused by churchyards being the repository for moved stones. There is no surviving evidence of very early church buildings, partly for lack of excavation, possibly because the use of religious sites did not require permanent structures. So the dynamic monastic history of the c6 when David, Padarn and Teilo were active and so many of the *llan* sites were established must be read in place names and the numerous surviving CIRCULAR CHURCHYARDS, as at Eglwys Cymun, Llansadwrn, Llansaint, Llanilar and Penbryn. Undateable, but often associated with early saints are the HOLY WELLS, as at Llangybi.

CROSS-INSCRIBED STONES are numerous, from the simple incised linear crosses to the more complex double-lined crosses, often with wheel-heads. The more Irish lettering on the Cenlisini stone at Llanddewi Brefi suggests a c7–c8 date, and Irish minuscule letters characterize the much more complex stone at Gwnnws dated to *c.* 800, with its wheel-headed cross and terminal Celtic knots. This seems a precursor of the fully developed Celtic plait and knotwork of the c10–11, seen at its best in the Pembrokeshire CROSSES at Nevern, Carew and Penally. The one at Llanbadarn Fawr, dated to the c10, is less fine than the Pembrokeshire examples, being made of a NW Wales granite that took carving less well. It has typical panels of knotwork and key-pattern, and a more remarkable small human figure with Irish style drapery. The two cross-heads at Llandeilo with unusual square forms of the wheel-head, and the carved panels on stones at Llanilar and Silian all display Celtic knotwork. The small cross at Laugharne has a cable-mould border and knotwork within. Intense Celtic ornament of the Pembrokeshire type appears only on the Cross of Eiudon, a cross-base found near Court Henry, now in the National Museum, Cardiff. There is some interlace on the Llanarthne cross, possibly as late as the c12.

MEDIEVAL CHURCHES AND MONUMENTS FROM THE TWELFTH TO THE SIXTEENTH CENTURY

The NORMAN reorganization of the Welsh church created a vast diocese over all of SW Wales, with its cathedral at St Davids, in Pembrokeshire. The cathedral, inconveniently sited so far to the W, was immovable due to the strength of the cult of the saint, recognized from the beginning by the Normans, the Conqueror himself visiting St Davids in 1081, and strengthened by the canonization of St David shortly after 1115. Thereafter two pilgrimages to St Davids were considered equal to one to Rome. Following the Reformation, Bishop Barlow (1536–48) failed to transfer the see from 'a barbarous desolate corner' to Carmarthen, a proposal strongly resisted by the canons. Church building in the c12 was on a large scale, with the rebuilding of the cathedral after 1182, and the foundation of abbeys at Whitland, Cms., 1151, Strata Florida, Cd., 1164 and Talley, Cms.,

Cross of Eiudon, C10 or C11, once at Court Henry.
Engraving

1184–9, and priories at Carmarthen, St Clears, Kidwelly and Cardigan. These were foundations both of marcher lords and native princes, the flow of power from 1135 back to the native princes apparently giving added support to the French monastic orders. The three abbeys were built to the typical Cistercian cruciform plan with a square E end with chapels on the E side of each transept, even though Talley was a Premonstratensian foundation. Although this plan generally did not have crossing towers there is documentary evidence for a bell-tower at Strata Florida that was not detached, and at Talley the crossing tower was the 21 principal feature. Architectural ornament is almost completely lost from Whitland, and there is very little at Talley, where the initial plans for a church the size of St Davids Cathedral were curtailed by politics. So one must look at Strata Florida where there are the remains of a remarkable transitional style between Celtic and Norman in the surviving W door with its five orders 19 of shafts broken not by capitals, but by shaft-rings, some radiating around the arch itself. The many stones with raised fat rings suggest that these ornamented vaulting ribs in the presbytery, and some of these have been found at Whitland. The arcades at Strata Florida were raised on walls some 5-ft (1.5-metres) high, and what little is left of the nave piers suggest some sophistication with three identified types, all of Transitional Norman type.

The abbeys were mother houses to foundations further N and W in Ireland. Welsh was spoken at Tracton, Co. Cork, founded from Whitland in 1224. It is notable however that Duiske Abbey, Graiguenamanagh, Co. Kilkenny, built to precisely the same plan as Strata Florida from 1204 (the monks moved into Strata Florida in 1201) for William Marshal, Earl of Pembroke, exhibits a much more advanced E.E. architecture, with much Dundry stone, suggesting an architectural link to Bristol rather than Wales. The heavily detailed late C12 chancel arch at St Clears, 20

Cms., a small Cluniac priory, is a single example of that famil-
iar Norman type with column shafts and thick stepped orders
to the arch. The crossing piers at Kidwelly, Cms., with their
stepped quarter-round profiles, suggest an abandoned ambitious
late C12 or early C13 scheme. A short-lived priory at Llanfair ar
y Bryn may have left evidence in the form of some very narrow
and crude lights in the parish church.

The parish churches of the C12 were probably single or two-
cell, and of very modest scale. With the survival of so many Celtic
dedications, one assumes that early sites were reused and that
they dictated, at least in part, the setting up of the parish system.
Dedications to St Mary, St Michael and biblical saints are typi-
cally Norman, but some of these are re-dedicated older sites. The
extent of lost early medieval building is difficult to gauge. It
seems likely that only those churches close to castles (such as St
Clears and Kidwelly) would have had access to workable build-
ing stone. However, against this, the survival in very remote dis-
tricts of C12 FONTS, all of imported stone, suggests a robust
interchange of materials and skills. The most remarkable fonts
are in southern Ceredigion and the Teifi valley, of a crude yet vig-
orous character that might be termed Celtic, but perhaps equally
Welsh Romanesque. Those that have carved heads have the oval
heads with wedge-shaped noses found also in Radnorshire. The
Llanwenog font has twelve such heads, the one at Cenarth, Cms.,
five. Another group of fonts have the heads projecting (as at Llan-
wrthwl, Breconshire): Pencarreg, Cms. has four, with greater
detail, one crowned, one tonsured, and the fonts at Maestir, Llan-
fair Clydogau and Silian have recognizable symbols of the Evan-
gelists. Those at Betws Bledrws, Henfynyw and Llanon are
square with chamfered corners and a band of incised roundels,
while the one at Penrhiwllan is square with chamfered corners,
each face with three carved bosses. The more typically Norman
scalloped square bowl, found over most of Pembrokeshire,
appears at Penbryn and Mwnt, Cd., and Llansteffan and St
Ishmaels, Cms. The bowl at Llangoedmor, Cd., is shaved on
four sides to make a kind of cushion capital form, and the
very odd one at Troedyraur, Cd., looks like a section through a
shafted square pier. Llanfihangel Abercywyn, Cms., has a large
tub with interlaced arcading, typically Norman, but not found
elsewhere in Wales, and Llanarth, Cd., with four lions under a
trapezoid bowl is unique in shape and of a quite different quality
of carving.

The EARLY ENGLISH period has less surviving detail. Neither
county is blessed with stone for carving, and patronage from St
Davids for church building was largely reserved for Pem-
brokeshire, where the Bishops held large and productive estates.
One outstanding piece is the s door of Llanbadarn Fawr, Cd.,
finely carved, with three orders of keeled shafts and stiff-leaf
capitals of high quality, all in such contrast to the severely plain
cruciform church that it has been suggested, without particular
evidence, that it is re-set from Strata Florida, where fragments
suggest some high-quality C13 work in the chapter house (the

Font at Troedyraur.
Engraving

reused arcade at Llanidloes, Montgom., from Abbey Cwmhir, indicates that such a thing was possible in the C16). The rest of the church is of a heroic simplicity that defies dating: it should be C13 if it goes with the door, and if so would give a similar date for the crossing towers at Llanddewi Brefi and Llanfihangel y Creuddyn, though caution suggests a C14 date. The much-reconstructed chancel at Llanfair ar y Bryn, Cms., has what Caröe judged to be the base of two tall E.E. lancets, suggesting a church of elaborate and impressive scale. Among the fragments displayed at Strata Florida are C13 capitals with an intriguing mixture of modern stiff-leaf and archaic Celtic detail. MEMORI-ALS of this period are scarcely encountered, except for the splen-didly unique so-called PILGRIMS' GRAVES by the ruined old church at Llanfihangel Abercywyn, Cms., carved slabs with low uprights each end, set in two groups of three. Each group has two slabs carved with crude low-relief figures, their arms crossed around Maltese crosses. The history of these is totally unknown. C13 FONTS include the octagonal one at Llanbadarn Fawr with Gothic panels, like the one at St Davids Cathedral. The unusual seven-sided bowls at Llanilar and Tregaron, Cd., and Pendine,

Cms. are possibly C14. C13 ceramic TILES remain at Strata
Florida and have been found at Whitland.

 Less remains from the DECORATED PERIOD of the C14 than
in Pembrokeshire, where the building zeal of Bishop Henry
Gower is much in evidence, both at the cathedral and in some
parish churches. One exception is Kidwelly where the comple-
tion of the church included some fine carved work – window
tracery, the triangular-headed sedilia and ogee-headed piscina.
The tower at Kidwelly has a vault with flat ribs, like that at St
Mary, Pembroke, and may be later C14, with a C15 spire.
VAULTED CHAMBERS other than tower bases are far less
common than in Pembrokeshire, the lovely barrel-vaulted nave
at Eglwys Cymun, is close to the county border. TOWERS of the
C14 are difficult to identify, the Ceredigion crossing towers
(above) may be C14. The towers at Llanfair ar y Bryn, Cms., and
Tregaron, Cd., have possibly C14 detail, and are on a large scale,
with high vaults. The one at Llanilar, Cd., may be early, but is
cut down. Dec TRACERY is rare, apart from at Kidwelly; there is
a late C14 two-light window at Pendine. The two neighbouring
WELL-CHAPELS, Capel Erbach, Llanarthne, and Capel Begewdin,
Llanddarog, Cms., are thought to be C14.

 Much rebuilding, often very extensive, occurred in the PER-
PENDICULAR PERIOD of the C15 and early C16. It included re-
roofing of older work, as well as the addition of porches, aisles
and towers. This was the era of the TOWER, particularly in Car-
marthenshire, typically tapering, battlemented and set on a
battered plinth with a distinct string course. Most may have been
rendered, as has been restored at Carmarthen St Peter. They
generally have rough stone vaults, though unvaulted exceptions
include Carmarthen St Peter, Llanddowror and Cyffig. The
towers vary in scale, larger ones being at Cynwyl Gaeo, Llanst-
effan, Llanybydder and Cyffig, Cms. In Ceredigion there are
fewer towers. Llanwenog may be dated by the arms of Sir Rhys
ap Thomas †1525, and seems to be of a kind with Llandysul,
sharing the small Celtic carved heads under the battlements that
hark back to the C12. Others are at Llanarth, Llanon, Aberarth
and Llanrhystud. Nearly all these towers are at the W ends, the
most convenient place to add one. The Laugharne tower is
central, those at Pembrey and Cyffig to the NW at the ends of
added aisles. Towers tend to be a feature of richer areas, making
isolated examples such as Cynwyl Gaeo, set high in the north-
ern hills, all the more unexpected and dramatic.

 Growing wealth and increase of population in the late medieval
period led to the enlargement of churches with AISLES. In
Ceredigion, only Llandysul was aisled, but dating here is con-
fused by subsequent rebuilding. In Carmarthenshire, enlarge-
ment by adding a parallel-roofed vessel of similar size to the
original results in the double-nave plan, common across South
Wales. Examples include Carmarthen, Llandovery, Cilycwm,
Cynwyl Gaeo, Cynwyl Elfed, Llanddeusant, Llandybie and
Myddfai. These aisles sometimes have their own defined chancel.
The most basic arcades were simply pointed arches cut through
existing masonry, as at Llanybydder and Cynwyl Gaeo. Where

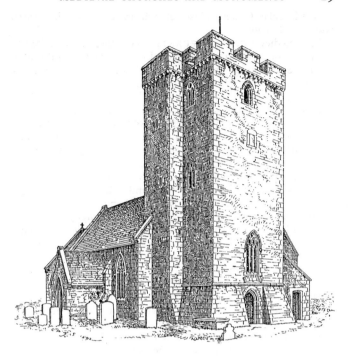

C15 tower, St Dingat, Llandovery.
Engraving

better stone was available conventional octagonal piers with pointed or segmental-pointed arches were usual, as at Cilycwm, Llanddeusant or, best of all, Myddfai.

Carved detail is largely confined to standard panel-traceried windows, often crudely executed, as at Cynwyl Gaeo and Myddfai, Cms. or, more commonly, straight-headed mullioned windows, as at Llanddeusant, Myddfai and Cilycwm, Cms., the last with crudely carved heads on the hoodmoulds. More accomplished are the chancel windows at Llanbadarn Fawr, dateable between 1476–1516. The chancel at Cardigan is a rare example of a late medieval rebuilding with large traceried windows, but is much restored. DOORWAYS remained chamfered and pointed, often without moulding. The ogee moulded doorway at Llanfynydd, Cms., may indicate an early C15 date.

Of the few late medieval TIMBER ROOFS, the panelled barrel type can be found at Myddfai and Llanddeusant, Cms. (both close to the Breconshire border where such roofs are common), and at Llanwenog, Cd., all with moulded ribs and simply carved 33 bosses. Two unusual roofs are in nearby coastal churches at Penbryn and Mwnt, Cd., with cusping in the apex above the collar-trusses, a type found in late C15 to early C16 roofs on the Lleyn peninsula, N W Wales, indicative of coastal contacts on pilgrimage routes to St Davids and Bardsey. The much-restored C15

roof at Llanilar, Cd., has close-set arch-braced trusses, kingposts, and wind-bracing.

Late medieval CHURCH FURNISHINGS are largely limited to a number of conventional octagonal FONTS. The several timber SCREENS mentioned as late as the early C19 have gone, leaving fragments at Llanina and Mwnt, Cd. Of medieval STAINED GLASS a few fragments survive at Cardigan of what seems to have been a very important window, removed to Hafod and lost in the fire there in 1807. There are fragments of PAINTED DECORATION at Carmarthen, and geometric patterns at Eglwys Cymun, dated to as early as the C13, but overlaid by texts at least three times during the C16–C17. The little C15 statue of the Virgin at Kidwelly also suggests riches that have gone. Much more rustic are the small carved C15 plaques at Llandysul, Llanwenog and Llanwnen, Cd., all perhaps by the same hand.

Medieval CHURCH MONUMENTS are suprisingly rare. Cross slabs with foliated incised crosses, sometimes with low relief heads are found at Abergwili, Carmarthen (inscribed in French), Kidwelly and Laugharne from the late C13 or C14. At Llandawke is the later C14 effigy of a lady, said to be St Margaret Marlos, and there are damaged C14 effigies at Laugharne and Carmarthen. Only the much restored memorial to Sir Rhys ap Thomas †1525, moved to Carmarthen church from the Greyfriars in 1535, is a major work, in full armour on a tomb-chest with canopied figures. The female effigy beside him is contemporary, though clearly not made as part of a pair.

34

CASTLES

BY JOHN R. KENYON

Carmarthenshire, with Pembrokeshire, is one of the best counties in which to study the development of the medieval castle. The visitor's experience has been greatly enhanced in recent years by the taking into state care of a number of strongholds including Dinefwr and Dryslwyn, both built by Welsh lords, the study of which has greatly advanced our knowledge of native Welsh castle building. Ceredigion's castles pale into insignificance by comparison.

The NORMANS built castles from the incursion of 1093, with sites established adjacent to what became the two county towns. The number of EARTH CASTLES identified is large, some forty-three in Carmarthenshire, thirty in Ceredigion, the majority thought to date from the C12 and probably abandoned in favour of better sites in the C13. Both mottes and ringworks, with baileys, are to be found, with good examples of mottes at St Clears and Castell Gwallter (Llandre). Tanycastell (Llanychaiarn), built *c.* 1110 on a commanding ridge, is assumed to be the first castle of Aberystwyth, and consists of a fine ringwork and bailey. A number of castles that began as earth and timber were later rebuilt in masonry; indeed, some came to number among the greatest castles of their day. Kidwelly, Laugharne and Llanstef-

25, 24

fan began as ringworks, positioned, as so many castles were in the initial period of occupation, close to the sea or tidal rivers.

There is little evidence for C12 MASONRY. Excavations at Laugharne found evidence for a late Norman hall block within the ringwork, and a section of Kidwelly's outer curtain probably dates to *c.* 1200, either built in the 1190s when the Lord Rhys had captured the castle, or in the early C13 when Kidwelly was back in English hands. At Llansteffan, where a Norman ringwork occupied an Iron Age fortification, a stone wall, much of the W side of which is still standing, replaced the timber palisade in the late C12. The remains of a small stone keep can be traced at Ystrad Meurig, Cd., a good example of a C12 stronghold often changing hands before its final destruction in 1208. The Lord Rhys was also responsible for work at Cardigan and Dinefwr, although masonry of this period cannot be identified with any certainty.

Castle-building in the first half of the C13 is marked by the construction of a group of Welsh castles at Dinefwr, Dryslwyn and Carreg Cennen, although what survives at Carreg Cennen is an English rebuild of the late C13 and early C14. At the same time further improvements were made to English Laugharne and Llansteffan. Both Dinefwr and Dryslwyn castles consisted originally of a polygonal ward dominated by a round keep, and it was Rhys Grug, a son of the Lord Rhys, who may have built both – certainly Dinefwr. Besides Pembroke's great circular keep, a number of English castles in South Wales were being re-fortified with addition of such TOWERS in the first half of the C13, and this fashion was clearly being adopted by the Welsh. Making use of their hilltop positions, it was felt that there was no need to strengthen the curtain walls further with mural towers, as was being done at most English castles at this time. Even the later outer wards at Dryslwyn, the middle one of which was added soon after the initial phase, were simply defended by curtain walls. In the late C13 the gateway was enlarged, but was still simple in form. Besides discovering the circular keep, recent excavations at Dryslwyn uncovered the domestic buildings in what became the inner ward, including a large hall, together with a structure that may have been the kitchen.

Following the recapture of Llansteffan from the Welsh in the 1220s, improvements were made by the de Camville family to the upper ward. The entrance was reinforced with a gate-tower with portcullis, and the addition of a small round tower on the line of the curtain wall. Both buildings reinforced the vulnerable section of the upper ward, which was approached via the sloping ground to the NE. The cliff to the S and banks and ditches to the W protected the rest of the upper enclosure. More impressive is the work at Laugharne undertaken by Guy de Brian IV, of a family recently established in SW Wales. He brought his castle up-to-date by enclosing it within a new curtain wall surrounded by a ditch, while on the landward side two large round towers were raised, the larger to the NW flanking a simple gateway. In design this new work has been compared with the slightly earlier build

by the Marshals of Pembroke at Cilgerran, Pembs. The NW tower
would have served as the castle's main tower, and consisted of a
basement and three upper storeys, the topmost of which was
roofed with a fine stone dome. A hall lay on the seaward side
of the courtyard. Having briefly lost Llansteffan to the Welsh
in 1257, William de Camville made further improvements in
the 1260s, fortifying the lower ward with a stone curtain and
mural towers. Soon after, possibly started before the Welsh war
of 1276–7, the Edwardian style great gatehouse was built,
mirroring in design Gilbert de Clare's inner E gate at Caerphilly,
Glamorgan and thus also the de Clare gate at Tonbridge, Kent.
Cardigan was rebuilt as a royal castle in 1244–54, with a keep or
principal tower, but the site needs full investigation to understand
the remains.

The later C13 saw major rebuilding and refurbishment at a
number of castles, and the construction of one totally new
stronghold. This was Aberystwyth, built by Edward I following
the first Welsh war of 1276–7. Apart from Builth, Aberystwyth is
the most fragmentary of Edward's Welsh castles, but the plan is
clear, lozenge shaped and, after a change of plan in the 1280s,
fully concentric. The approach from the town had a small
twin-towered gatehouse on the outer ward immediately
before the Great Gate, another Edwardian gatehouse, much
reduced due to slighting in the C17 Civil War. This gave access
to the inner ward, with large mural towers at the four corners.
Smaller gateways survive on the NW side of the inner and outer
curtains, while round towers cap the N and S points of the outer
ward.

Shortly before work began at Aberystwyth, the de Chaworth
brothers, Pain and Patrick, had begun the total transformation
25 of Kidwelly. Only a small section of the outer curtain was
retained, with a more substantial new wall built with four mural
towers. A twin-towered gatehouse was added on the N side, with
presumably one at the S or town end of the castle (replaced by a
26 larger gatehouse in the late C14). A new (inner) ward was built
within the original ringwork enclosure, with a massive round
tower at each of the four corners, the towers also serving to
protect the simple gateways in the N and S walls of the square
enclosure.

Guy de Brian V also made improvements at this time at
Laugharne, with a new curtain wall along the seaward side of the
inner ward, while the outer ward's defences were built in stone.
However, the main features of this phase were the GATEHOUSES.
The rather simple gate of the inner ward was replaced by a pro-
jecting gatehouse, while on the N side of the outer ward a new
gatehouse was built, of two storeys, and with spur buttresses, a
characteristic of many castle gates and towers built in the closing
years of the C13 and early C14. Of the chain of native Welsh castles
E of Carmarthen, Edward I allowed Dryslwyn to remain in the
hands of Rhys ap Maredudd, until it was captured in 1287 fol-
lowing Rhys's rebellion. Little was done to the castle subse-
quently apart from routine repairs and maintenance. The story

was different at Dinefwr and Carreg Cennen. Royal work at
Dinefwr saw the construction of a new chamber block, with a
hall added to one side of it later in the c14. As far as the defences
were concerned, a new entrance to the inner ward was built, the
approach to which was accessed through a barbican that had its
own gate.

The work at Dryslwyn and Dinefwr is modest compared to the
transformation of Carreg Cennen by John Giffard from the late 23
1280s. The Welsh castle here seems to have been totally removed,
leaving Giffard to create one of the most spectacularly positioned
castles in Britain. Perched on its limestone crag, the main
defences of the inner ward lay on the entrance front, with a spur-
buttressed gatehouse flanked by a round tower to the NW and a
large square tower to the NE, also with spur buttresses. Soon
after the inner ward had been built (and presumably planned
from the start), its immediate approach was defended by a
barbican leading up to the middle gate-tower via a series of
drawbridges. An outer ward of little defensive merit was built
around the same time. The domestic range ran along the E wall
of the inner ward, with the main accommodation on the first
floor, including a hall and solar. N of Carreg Cennen lies Llan-
dovery, and John Giffard was also responsible here for the now
fragmentary remains of a masonry structure on the motte, con-
sisting of a D-shaped tower, with the remains of a twin-towered
gatehouse to the N.

At about the time that Giffard was building at Carreg Cennen,
William de Valence was improving Kidwelly. Not only did he
heighten the inner and outer ward towers and add masonry walls
to the back of the outer curtain towers, but he added a number
of buildings to the inner ward: the existing hall range on the E
side of the inner ward, the great chapel tower that projects down
the slope towards the river Gwendraeth, and the kitchen block
in one corner. Little remains of the hall and solar block.

A new gatehouse was built at the former Welsh castle of
Newcastle Emlyn in the first half of the c14. Guy de Brian VII
undertook the refurbishment of Laugharne castle in the later c14,
enlarging the hall and heightening the inner gatehouse, among
other things, creating a home fit for a man who was a friend of
King Edward III, made a Knight of the Garter in 1370. The most
spectacular c14 building programme was begun about 1390, by
John of Gaunt, at Kidwelly, now part of the Duchy of Lancaster.
A new gatehouse was built at the town end of the castle, surely
replacing an earlier gate, and it was to be one of the largest built,
with over twenty rooms, ranging from a prison and a large
kitchen to a handsome hall and solar. The gate would appear to
have been virtually finished when in 1403 Henry Don of
Kidwelly, Owain Glyndwr's principal supporter in the region,
took and sacked the town and set siege unsuccessfully to the
castle. During the next five years small-scale works were under-
taken, but in 1408 a major programme of works was started that
was to cost several hundred pounds and to run on until 1422
when the gatehouse was re-roofed in lead. There seems to have

been a fire in the gatehouse, although it is unclear whether this was during the renovations or whether the renovations were a result of it. Various rooms were vaulted, the central staircase was blocked, with a new stair-turret built in the NW corner of the gate and a grand entrance was built on the NE side, and the gate was refenestrated virtually throughout. The defences were not ignored either, as the sections of the outer curtain on either side of the gatehouse were totally rebuilt. Later in the C15 a new bake-house was added against the outer curtain and two large rectangular buildings were inserted into the outer ward, one possibly a stable, the other perhaps a hall or even a court house.

27 A new gatehouse was built at Carmarthen, possibly around 1410, to some extent a smaller version of the one at Kidwelly. Recent work has revealed more of the fabric, although what survives has still to be fully understood. The desire to make the gatehouse at Llansteffan a more comfortable lodging was the apparent reason for the gate passage being blocked up, with a small gateway built to one side of the original entrance. A more domestic side to the castle is implied with the addition of a large barn in the lower ward, perhaps in the C16. Carreg Cennen was much damaged in the Glyndwr uprising, repaired and held by Gruffudd ap Nicholas for the Lancastrian cause in the Wars of the Roses, for which it was dismantled by the Yorkists in 1462. Llandovery Castle was burnt in an attack in 1532, and was probably dismantled by the townspeople.

Sir John Perrot, whose conversion of Carew Castle in Pembrokeshire into a grand mansion was halted by his arrest and death in 1592, sought to do the same at Laugharne on a smaller scale. Improvements were made to the hall, but the most obvious work visible today is the series of windows in the inner gatehouse, and the N range with its stair-tower, set between the C13 NW and NE towers, with the principal room on the second floor, the only one with a fireplace. Stripped of many of its fittings after Perrot's death, the castle was still defensible in the autumn of 1644, resisting a Parliamentarian siege for a few days, but slighted thereafter. Several castles were of military use in the Civil War, notably Aberystwyth, Carmarthen, Cardigan and Newcastle Emlyn

Town Defences

Aberystwyth, Carmarthen and Cardigan were walled, but nothing now remains apart from features of the street plans, nor does anything remain of the gates at Laugharne. At Carmarthen there are remains of Civil War defences on the SW side of the town, known as The Bulwarks. Traces of the ditch that surround the tiny borough on hilltop Dryslwyn can still be seen. It is at Kidwelly that there survives the best evidence for TOWN WALLS. A short section, with a ditch, runs W from the outer defences of the castle, while at the southern end of the small medieval town stands the Town Gate, the only survivor of three gates. Its spurred buttresses suggest a date of about 1300. The gatehouse is

rectangular, with a tower on each side of the central passage, and there were two storeys above the ground floor.

MEDIEVAL DOMESTIC ARCHITECTURE

Very little has survived, and what does is in the richer pasture lands around the Tywi Valley. Unlike Pembrokeshire, building stone was often poor and one is tempted to speculate that the woodlands of river valleys such as the Tywi, Teifi and Cothi produced oak for timber building, but that nothing survived rebuilding or the damp climate. It is certain that medieval houses of note did exist in the prosperous parts of Carmarthenshire and Ceredigion, even though in the latter nothing is currently known to remain in town or country. The planted settlers in the NEW TOWNS at Carmarthen, Cardigan, Aberystwyth, Kidwelly and elsewhere were granted burgage plots, traceable still today. Continuous rebuilding has left little tangible, apart from some vaulted under-crofts and cellars in Carmarthen. Here later rebuildings may conceal traces of medieval timber-framed buildings. At the Angel Vaults, Nott Square, no framing survives but the construction of the façade shows the progressive replacement of a jettied timber structure. The fine traceried c15 window on this building is unique in the region, but there is uncertainty over its provenance.

That native Welsh landowners lived in houses with HALLS is testified in poetry, but the encomiastic tradition means that no detail can be relied on. Dafydd ap Gwilym in the c14 mentions the stone hall of Ieuan ap Gruffudd, father of the lovely Dyddgu, and in the c15 there are numerous poems in praise of hospitable patrons. Beyond the conclusion that such houses had a principal hall little else can be deduced. In s Pembrokeshire, first-floor hall houses were being built by the c14 by wealthy landowners and farmers. In Carmarthenshire there are remnants of first-floor halls, but it is probable that many smaller gentry houses had very basic ground-floor halls. The medieval bishops of St Davids concentrated their building work on their richly endowed estates in Pembrokeshire. The Bishop's Palace at Abergwili was converted from a college of priests after the Reformation. Cwrt Brynybeirdd, Carreg Cennen, has the remains of a late medieval courtyard house with a first-floor hall with lancet windows and late medieval trusses with trefoil cusping over the collars. The s range is also medieval, perhaps earlier, with ogee-headed windows, but alterations make it difficult to reconstruct the plan. In 1613 there was a great hall and two upstairs parlours, which may suggest a second, ground-floor, hall, and also a gatehouse, the symbol of late medieval and early modern status. But there seems to have been no defensive intention here, unlike the strongly defended houses and towers of Pembrokeshire, where possibly pirate attack was more of a concern. Much altered first for farm use and then back to domestic use is the Pilgrims' Rest at Llandeilo Abercywyn, originally three floors, now two, with prominent exterior stair on the w front. This gives access to a

Details from Cwrt Brynybeirdd, Carreg Cennen.
Engraving, 1858

probable first-floor hall, raised on vaulted undercrofts. The date
would appear to be C15. Rhydarwen, Llanarthne provides a
well-preserved but puzzling case of two adjacent ranges (later
confusingly subdivided), each with a first-floor room of consid-
erable importance, the w room clearly once a first-floor hall with
35 a fine open arch-braced roof and two superb re-set carved oak
doorways with the shield of Sir Rhys ap Thomas providing a
date between 1505 and 1525; do these date the building of the w
hall, assuming the doors are original to the house? The E range
looks C15, the upper room also clearly of status with open collar-
truss roof, lateral fireplace and wall paintings. Was this the
predecessor of the w hall? Court Henry, with a surviving trefoiled
window, was probably also a first-floor hall house. Leland notes
Sir Rhys as builder of the new apartments at Newcastle Emlyn
castle and also at Abermarlais, Llansadwrn, 'a well-favoured

stone place moated, new mended and augmented by Sir Rhys ap Thomas'.

Across Wales, GROUND-FLOOR HALL HOUSES rarely survive unaltered. Talhardd, Ffairfach, much altered, and burnt in 1997, was a late C14 hall with pointed arches from the hall to the cross-range and to a mural stair. At King's Court, Talley, externally C18, structural damage in 1998 revealed substantial medieval fabric, probably a ground-floor hall, the s parlour with hooded fireplace. Does this example suggest that there were a number of medieval halls lost to alterations or replacement, or is it connected to the Abbey across the road? In Ceredigion, Plas y Wern, Llanarth was a house of medieval importance, where Henry Tudor stayed in 1485 en route to Bosworth. The rubble stone rear range may be C15, with arched collar-trusses to a first-floor hall, but is much altered. At Castell Hywel, Pontsian, a cor-belled chimney and some massive beams may be late medieval or C16. The small farmhouse at Crug, Verwig, has reused late medieval collar-trusses. Cruck trusses may indicate a late medieval date, but in smaller houses could be C16. Gwastad Gwrda, Abermeurig, has a central stack inserted in the C17 within a late medieval or C16 cruck-roofed range with three fine raised crucks surviving. Ynys-felen, Dihewid, appears to be a hall house retaining three pairs of smoke-blackened scarfed crucks with high lapped collars, perhaps late medieval, but the use of scarfed crucks went on into the later C18. Although it is hard to date them, the late survival of this type of roof truss may suggest a tradition of ongoing repair and replacement. For example, Gellicefnyrhos, Talley, was remodelled in the C17 when a floor and chimney were inserted and the new scarfed cruck roof may be an echo of a medieval cruck-framed hall house.

CHURCHES FROM THE SIXTEENTH CENTURY

Churches to 1750

The visible remants of CHURCH BUILDING in the C16 and C17 are minimal. Church building is unlikely to have come to a complete standstill after the Reformation but what work was done then has been replaced. Two new churches were built for gentry estates, at Golden Grove, 1616, for Sir John Vaughan, and at Hafod, 1620, for the Herberts, both since rebuilt. Thomas Dineley, touring with the Duke of Beaufort in 1684, drew several churches, including Cilcennin in its circular churchyard, a very rare view of a small rural church in the C17, the church entirely rebuilt since.

The nave roof of Bettws is perhaps dateable to the C17, and the arch-braced trusses in the aisle of Llanfynydd may be of 1684. The roof of the N transept at Carmarthen is C17 and those at Llandovery and Llanfair ar y Bryn are late C17 or early C18. Competition from Nonconformity began in the late C17 as the Baptists and Independents started to build their own meeting-houses. The tower at Cardigan collapsed in 1705 and was rebuilt

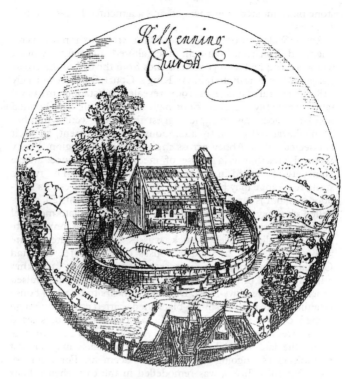

St Cenwyn, Cilcennin.
Drawing, 1684

in 1711–48 in convincingly medieval style with stepped diagonal
buttresses and battlements; only the rounded mouldings of the
cornice and bell-lights suggest the date. The nave ceiling is prob-
ably of the same date. The wall PAINTINGS at Cilycwm, dated
1724, signed by the local mason *John Arthur* comprise a series of
texts in architectural frames and a very crude skeletal Death,
harshly over-painted in 1986. FURNISHINGS of the period
are rare: the simple Faculty Pew and Lloyd family pew at
Carmarthen both date from 1709.

MONUMENTS are the main survival of the period, though
almost nothing of the C16 after the tomb of Sir Rhys ap Thomas
†1525 apart from a carved heraldic floor slab to Morgan Jones of
Tregib †1580, at Llandeilo. There is a remarkable absence of
memorials to the major landed families before the later C17. The
one example of the monumental canopied chest tomb is to
Anthony Rudd, Bishop of St Davids, †1616, at Llangathen, of
painted Bath stone. The ensemble is a Jacobean set-piece deriv-
ing from the Mary, Queen of Scots monument in Westminster
Abbey, 1607–13, and more immediately is very like memorials at
Bredon, Worcs., and Cirencester, Glos., both attributed to the

Gloucester carver *Samuel Baldwin*. On a much smaller scale, the Bath stone memorial at St Ishmaels to Catherine Mansell †1631, has paired Ionic columns and a big heraldic cartouche.

Some larger churches of Carmarthenshire have later C17 BAROQUE memorials, mostly formulaic, but no less charming for that. At Llandybie, the monument to Sir Henry Vaughan †1676 has the familiar if old-fashioned Baroque composition of twisted columns flanking a fashionably dressed half-length figure, as does that to Jonathan Oakley †1677 at Carmarthen, where there is also the kneeling figure of Lady Anne Vaughan †1672 in a columned niche. These carved figures are rare, more typical are the plaques with Baroque twisted columns, as those to Jonathan Scurlock †1682 at Carmarthen, and to Walter Vaughan †1683 at Llanelli. More up-to-date is the tablet to Elizabeth Brigstock †1667 at Llandybie, pedimented with carved side scrolls, a type lasting into the mid C18. The lettered brass plate to Dame Bridgett Lewis †1643 at Penbryn is very unusual, if in itself unexceptional.

EARLY C18 MONUMENTS soon began displaying a more restrained classical taste. At Carmarthen, the memorial of William Lloyd †1710, crisply pilastered, contrasts with that to Rev. Richard Prichard †1730, still Baroque, with carved bust set against scholarly books. The draped cartouche to Thomas Lloyd †1720 at Llangadog, that to David Gwynne †1721 at Taliaris and the two at Llanbadarn Fawr to Cornelius Le Brun †1703 and John Jones of Nanteos †1708 all have a Baroque energy. The elaborate memorial at Llanbadarn Fawr to Thomas Powell of Nanteos †1706, with scrolled pediment over a draped plaque, is signed by *Robert Wynne* of Ruthin, but designed by the Oxford master mason and architect *William Townesend*. IMPORTED SIGNED TABLETS begin to appear in early C18, as that of Catherine Rice †1717 at Llandeilo, signed by *John Randall* of Bristol, which has sober Doric detail and good lettering and, at Carmarthen, the large tablet to Richard Vaughan †1724, of veined marble with Corinthian pilasters, is signed by *William Palmer* of London, as are two plaques to Stepney family members, both †1733, at Llanelli. At Laugharne, that to Sir Thomas Powell †1726 has Ionic columns and broken pediment with figures of Justice and Fortitude, characteristic of the period. More ambitious but employing typical detail is the tripartite memorial at Carmarthen, actually two similar large plaques, to John and James Phillips †1730, and to Ann Phillips †1720, linked by an arch over a little portrait plaque to Rachel Lloyd †1723. Also at Carmarthen, the memorial to Mary Howell †1724 has a portrait bust; the double plaque to John Williams and family, 1739, is scroll-sided with a double segmental head, and that to Mary Osborne †1730 has tiny broken halves of a curved pediment and gadrooned base, the neat fluted pilasters and Doric frieze representative of the more refined architectural taste of the second quarter of the century. There is a similar frieze on the memorial to Thomas Pryse †1745 at Llanbadarn Fawr. The memorial at Laugharne to Arthur Bevan †1749, pedimented with an oak-leaf frieze, is already Palladian. It is signed by *Benjamin Palmer*.

LOCAL MASONS are rarely recorded before the late C18; *John Arthur* signs a simple pedimented tablet to Mary Lloyd †1732 at Cilycwm. One unusual item, presumably made locally, is the painted timber scroll-pedimented surround to the plaque to Anna Wotton †1719 in the vestry at Carmarthen.

Churches from 1750 to 1840

The later Georgian era was a period for repairs and minimal REBUILDINGS. In upland areas where churches were small and poorly built, disrepair was a constant theme of diocesan reports. Many parishes were poor and losing congregations to Methodism (and in places to Unitarianism) much more rapidly than the C17 losses to the older Dissent. Co-existence however was more usual than confrontation. Daniel Rowland, pioneer of Methodism, built his reputation while curate at Llangeitho. Denied the rectorship there in 1760, he was able to secure it for his son, an absentee rector until his death in 1815. The people of Llangeitho still attended church, but no-one took communion there for fifty years, as they were all Methodists in the parish.

Ciliau Aeron church was rebuilt *c.* 1750 with plain arched windows; a pair of ashlar arched windows at Cyffig were inserted to light the pulpit; Talley was built new in 1773 (since altered) and Llandre (Llanfihangel Geneu'r Glyn) was rebuilt to a cruciform plan in 1793–5 (rebuilt again in 1885). *John Nash* re-roofed Carmarthen church on his arrival in Wales in 1785 (replaced in 1861), and probably designed the estate church at Llanerchaeron in 1798, in a stuccoed, minimal Gothic. A similar perfunctory Gothic characterized *James Wyatt*'s estate church at Hafod, 1800–3 (altered since).

The regeneration of the church in the diocese of St Davids began with Thomas Burgess, bishop from 1803. As early as 1806 he initiated the process that led to the new college for the training of clergy at Lampeter, built in 1822–7. He was not however an architectural pioneer, and the era of more than utilitarian rebuilding belongs to the episcopate of Connop Thirlwall, 1840–74, the first bishop for centuries to be both resident in the diocese, and not to have more important preferments elsewhere, and the first to learn Welsh. In Burgess's time many churches were re-windowed with Georgian Gothic sashes and refurnished with box pews, two- or three-level pulpit and w gallery. At Llangunnor, *Thomas Humphreys* replaced the medieval arcade with a Tuscan colonnade, 1815–16, crude but striking, and at Llanarthne the arcade was entirely removed *c.* 1810 to form a preaching box. NEW CHURCHES of this era tend to be very economical: Llanfair Orllwyn (1808), Penboyr (1809), Strata Florida (*c.* 1815), Llangeitho (1819–21), Ystradffin (1821), Ysbyty Cynfyn (1827), Newchurch (1829). Some of these were notably meagre by contrast with chapels in the same parishes: at Trelech, the church of 1833–4 is a poor box beside Capel y Graig, of 1827, and at Gwynfe, the church (now hall) of 1812 is tiny beside Jerusalem chapel, 1827.

Ferryside church.
Drawing by H. W. Ayres, 1826

The only pre-Victorian churches of any scale were urban – at Aberystwyth, 1829-3, Carmarthen St David, 1835, and Aberaeron, 1835; all three by an outside architect, *Edward Haycock* of Shrewsbury, a portent for the Victorian age. All have been replaced, apart from the tower at Carmarthen, though Haycock's reconstruction of the double-naved Llannon (1839–41) as a big preaching box survives. A thin Tudor characterizes the works of the other new churches of the 1830s by lesser architects of professional standing: *George Clinton's* Eglwys Fach of 1833, *William Coultart's* Llanafan of 1836, and *Robert Ebbels's* Cwmamman (Garnant), 1839–42. *Clinton* probably designed the minimal classical church at Capel Bangor, 1833, a rare exception to the Gothic. Another such was the long-demolished church at the new resort of Ferryside, 1827, by *H. W. Ayres*, cabinet-maker, a standard Georgian box with hipped roof, but with a charming octagonal tower.

Local builder-architects built in a minimal Georgian Gothic. The stone Y-tracery windows of *Rees Davies* of Llandysul appear at Llandysul, 1829, Betws Bledrws, 1831, Capel Dewi, 1833, Llanfihangel Rhosycorn, 1848, and, by an unknown follower, as late as 1854 at Pontsian. Big Gothic lancets without tracery typified the unambitious churches of *J. L. Collard* of Carmarthen, at Newcastle Emlyn, 1841, Llanwinio, 1844 and Llanllawddog, 1848. Troedyraur, 1850, by *Charles Davies* of Cenarth, still has timber Gothic tracery, but he had bent to new ways by 1857, at Llangeler, where the lancets and buttresses are correct, if dull. It was a local architect, *David Evans* of Cardigan who showed the most charming evidence of the gulf between the local and the metropolitan when he set a miniature copy of the Neoclassical

spire of St John, Waterloo Road, London, presumably taken from
57 an engraving, on the roof-ridge at Llangoedmor, 1830–2.

The Gothic Revival, 1840–1914

In 1839, remote Llangorwen gained a Tractarian church designed
by J. H. Newman's Oxford architect, *H. J. Underwood*, because the
patron was brother to Newman's curate, Isaac Williams. Under-
wood's architecture would soon be pushed aside, but Llangorwen,
as much as Newman's own church at Littlemore, Oxon, illustrates
a moment of transition in Anglicanism that would move within a
couple of years to the correct Gothic of Pugin and the Ecclesiolo-
gists. Bishop Thirlwall himself was no Ecclesiologist; he chose a
London friend of limited talent, *C. C. Nelson*, to design the church
by his palace at Abergwili, 1842–3, although he had consulted a
leading Goth, *G. G. Scott*. Nelson's church was both old-fashioned
and mechanical. *Scott* himself rebuilt Llandeilo in 1847–50, and
designed two new churches in 1849, at Golden Grove and Llanelli
St Paul (long demolished). None is a major work, but they were
liturgically correct with chancels of proper length, and correct in
detail, if bearing no relation to the medieval architecture of the
region. This same Gothic came to Ceredigion through a Scott
assistant, *John Jones*, at Tremain, 1846. A portent of the times was
when, at Llancynfelyn, a new church was wanted in 1844, the vicar
secured a design from a member of the 'Oxford Architecture
Society', almost certainly the future bishop and architectural
scholar, Basil Jones. As put up by a local builder, it has a gawky and
almost certainly unintentional charm.

For the NEW CHURCHES of the 1850s, funds usually deter-
mined whether choice would fall on the lancets of the Early
English or the tracery of the Decorated, and hence lancets are
the more common. The small R.C. church at Carmarthen, by *C.
F. Hansom*, 1851–2, has lancets, whereas *R. K. Penson*'s St David,
in the same suburb of Carmarthen, but for a richer congrega-
tion, 1853–5, is much larger with a very large Dec w window. It
was to have been even more ambitious, with a broach spire, a
mid-Victorian favourite, but rarely affordable. Penson achieved
two, at Llanrhystud, 1852–4, and Llanddarog, 1854, and a shin-
gled spire on the crossing at Felinfoel, 1857–8 (re-clad since in
copper), and *R. J. Withers*'s demolished church at Llandygwydd,
1856, had another.

In general, the churches were all minor works by metropolitan
standards, being conditioned by cost, and often by lack of appro-
priate building stone and craftsmen. Few new churches cost as
much as £2,000, many restorations cost less than £1,000.
Notably expensive were *Street*'s All Saints, Llanelli, estimated at
£4,800 when work started in 1872, and *E. M. Bruce Vaughan*'s
parish church at Llanelli, 1904–6, which cost £8,000. For com-
parison, Butterfield's church at Penarth, Glamorgan, cost about
£10,000 and his All Saints, Margaret Street, London, some
£70,000. Even when a church-restoring landowner was involved,
monies were not lavished: the Cawdors employed *Scott* at

Golden Grove, 1849, and *J. L. Pearson* at Rhandirmwyn, 1878, but gave neither the funds for a major work. The three leading Ceredigion families, the Earls of Lisburne at Trawsgoed, the Pryses at Gogerddan or the Powells at Nanteos, were not notably generous church-builders. Medievalism animated Sir Thomas Lloyd of Bronwydd, who impoverished his estate in Gothic building and pursuit of medieval title, but his ornate estate church at Llangynllo, 1867–70, by *John Middleton*, cost only about £2,000, that shared with neighbours. Swansea wealth allowed H. J. Bath of Alltyferin to commission Pontargothi from *Benjamin Bucknall*, 1865–78 and Llanelli tin-plate money paid for *G. E. Street*'s Dafen, 1871, and All Saints, Llanelli, 1872. ^95 ^94

From the 1850s CHURCH RESTORATION became the preserve of professional architects, increasingly from outside the area, as the issue of correctness became harder to evade, especially if funds were sought from the Incorporated Church Building Society (ICBS). The jobs, mostly small, tended to go to a small number of architects, whose involvement must have been remote. In Ceredigion, *R. J. Withers* of London, *John Middleton* of Cheltenham and *R. K. Penson*, originally of Oswestry, and his successor, *Archibald Ritchie*, had the bulk of the work. All three had work in Carmarthenshire, Penson the most, followed by Middleton, and *E. H. Lingen Barker* of Hereford. A few restorations stand out, more for the quality of their Victorian fittings than the care for the historic fabric: *J. P. Seddon* at Llanbadarn Fawr, 1868–85, *John Prichard* at Pendine, 1869. The barrel roofs added by the *Middleton* firm at Llanddeiniol, 1883, and Capel Dewi, 1886, transform bleak churches of the 1830s, and are sympathetic to the medieval churches at Llandysul, 1874, and Kidwelly, 1885–9. The roofs by *W. H. Lindsey* at Carmarthen St Peter, 1860, are vigorously ornate, if more C17 than Gothic. The additions made by *William Butterfield* at Llangorwen 1849, give a wiry intensity to Underwood's original, though his work at Llanafan, 1862, fails to enliven Coultart's church. *R. J. Withers*' restorations are best considered as new works, few retaining significant old fabric. His work at Llanddewi Brefi, 1873 and 1885, restored a simple dignity to a mutilated building, but had his plans been used at Pembrey, 1874, the attractive mixed character of that church would have been lost. There was little criticism of these sweeping restorations. One early cry of pain was from James Allen, later Dean of St Davids, at *Penson*'s proposals for Llanrhystud, 1852–4, where all was swept away apart from the tower, and that lost under the new spire. In general, dire condition and the lack of significant medieval detail allowed most rebuilding before the late C19 to pass without criticism, and smart church buildings were seen as a check on Nonconformity. The ICBS in London was more likely to be a restraint, if any there was, than local opinion.

The High Victorian tide of the 1860s and 1870s did not lap strongly in the region, largely because neither bishop nor clergy were of the High Church party. The NEW CHURCHES were mostly stylistically of the middle of the road, like *Penson*'s Christ Church, Carmarthen, 1864–9, or Drefach Felindre, 1862, by

David Brandon, though Christ Church has lost a wedge-shaped slate spire that had a certain vigour. *Penson* shows unusual elegance at Llandyfan, 1864–5, with its skirted wooden spirelet. The two new churches by *Butterfield*, at Elerch and Aberystwyth, 1865, show the High Victorian feeling for solid geometry, the N side of Elerch particularly well, but are not major works. Butterfield's detail appears ascetic compared to the overblown carved detail of *Middleton*'s tougher churches, Llangynllo, 1867, Cenarth, 1868–72 and Aberaeron, 1871–2. The extraordinary estate church at Pontargothi, by *Benjamin Bucknall*, 1865–78, is plain externally but has a powerful simplicity within, the boarded roof with massive painted tie-beams and kingposts, reminiscent of William Burges. The interior is unique in Wales in combining narrative paintings with stained glass, the paintings the major work of *Alfred Stansell* of Taunton. Of *G. E. Street*'s two new churches, the smaller, at Dafen, 1871, has the more interesting external form, the varied play of roofs on the N, and the sheer S wall. The little church at Ferryside, 1875, by *T. E. C. Streatfeild*, who died young, could be mistaken for one by Street. That subtlety eluded *Wilson, Willcox & Wilson* at Burry Port, 1875, which has tough Early French detail, but the tower and spire are underscaled. *R. J. Withers* proves consistently the master of economical detail. At Blaenporth, 1864–5, the little bell-turret is a jewel of solid geometry, and the turrets at Silian, Henfynyw and New Quay are all interesting. His major work, St Peter, Lampeter, 1867–70, is probably the best of the High Victorian churches, solid, clear-cut in detail and without excess of carved work. The tower was intended to have a broach spire. A late church still of High Victorian character is the chapel at St David's Hospital, the former insane asylum at Carmarthen, 1883–9, by *E. V. Collier*, with its tall proportions and extremely stripy brick interior. Polychromy is rare, Llangynllo is one example and there are striped piers in St Michael, Aberystwyth, 1886–90, by *Nicholson & Son* of Hereford, a large and old-fashioned town church.

The Gothic Revival left its muscular phase for the gentler detail of LATE MEDIEVAL GOTHIC in the 1870s, but the tide reached SW Wales late. A first work in the region was the remodelled college chapel at Lampeter, 1878–9, by *T. G. Jackson*, with its aesthetic green-painted stalls. Holy Trinity, Aberystwyth, precisely contemporary with St Michael, 1886–9, by *Middleton & Son*, was the first new church, designed by the younger Middleton, an important work that suffers from being incomplete. Architects such as Penson's partner *Archibald Ritchie*, *E. H. Lingen Barker* and *David Jenkins* of Llandeilo continued to build churches in Decorated Gothic, mostly utilitarian, Ritchie's occasionally with an angular character, as at Llanychaiarn and Borth, both 1878. *R. J. Withers*'s last church, Penrhyncoch, 1880, shows a Late Victorian sensibility, its weatherboarded bell-tower and tiled roofs deriving from the vernacular of SE England.

Most of the new churches of the turn of the century are in the industrial S of Carmarthenshire. *E. M. Bruce Vaughan*'s Christ Church, Llanelli, 1886, with its slim Irish round tower and cross-

gables, was the first of a series he built in the tin-plate region: Llangennech, 1900, Llanelli parish church, 1904–6, and St Alban, Llanelli, 1911. The parish church has a noble interior, in contrasted colours of stone, and St Alban has the long low lines and late Gothic large windows of G. F. Bodley's late churches. A late Gothic with free Edwardian detail appears at All Saints, Ammanford, 1911–26, by *W. D. Jenkins*, a large church whose eventual cost of £14,000 far exceeded the intended £5,000. One rural church, in a sensitive late Gothic, is Ystrad Meurig, 1897–9, by *Harold Hughes*, of Bangor. However, Gwynfe, 1898, by *E. H. Bruton*, shows that sensitivity was not always the hallmark of the period.

The era of CAREFUL RESTORATION may be said to have come when protest from the Society for the Protection of Ancient Buildings was able to change the architect employed at Cyffig in 1889. The mere threat of SPAB intervention may thereafter have stayed the hand of some restorers. The Society's own architect, *William Weir*, under the eye of *Philip Webb*, co-founder with William Morris of the SPAB, restored the barrel-vaulted church at Eglwys Cymun, 1900–1, a work that remains a model of careful intervention. Two unexpected Arts and Crafts restorations in remote churches are at Cellan, where *Herbert North* added the painted roofs, 1909, and Llanfihangel Uwch Gwili, 1910, by *Arthur Grove*. The long incumbency of *W. D. Caröe* as cathedral architect led to several careful restorations in the diocese, notably at Pembrey, 1904–5, Llandovery, 1904–6, Cilycwm, 1905–6, and Llantair ar y Bryn, 1913. 32

Churches after 1914

The best work after the First World War was done by *Caröe*, where in a series of works he showed how a bleak interior could be remodelled or refurnished with style. Newcastle Emlyn was reshaped in 1924–5 from box-like emptiness to a powerful aisled interior dominated by square grey stone piers. Capel Cynon, to which a chancel was added in 1929, has a luminous white interior and Capel Bangor, 1932–3, was transformed by an altered ceiling and new fittings. Caröe's rebuilding of the burnt-out church at Hafod, 1933, made a unity of an interior spoilt by *Ritchie* in the 1880s. An assured but astonishingly old-fashioned work was the big stone chapel at Trinity College, Carmarthen, 1932, by *E. V. Collier*. A modern sensibility first appears with the R.C. church at Lampeter, 1940, by *T. H. B. Scott*, where the whitewashed simplicity of the exterior gives no hint of the complex spaces of the brick-lined interior. The only notable post-war churches are Roman Catholic, at Penparcau, Aberystwyth, 1968–70, by *Tom Price*, built on a quarter-circle plan, and Cardigan, 1970, by *Weightman & Bullen*, octagonal with laminated roof trusses. A small work of character is the lychgate at Llanfihangel ar Arth, by *Roger Clive-Powell*, 2001. 112

RESTORATION of churches was alarmingly *ad hoc* until the late C20, with as many problems being caused by harsh pointing as

were solved. The Church in Wales has in recent years put in place
a good system of quinquennial inspection, and the availability of
money, notably from the Heritage Lottery Fund, has transformed
many churches. The experiment of re-cladding the tower of
Carmarthen church in a lime render was a bold and public rebut-
tal of the stripped stone aesthetic in place since Victorian times,
and extremely controversial. But it appears to have remedied the
problem of water coming through the poor-quality stonework.
Capel Bangor, an early C19 church of equally poor stone, was
limewashed a bright and staring white, to good effect, but the
longevity of the limewash is in doubt. The interior of Pembrey,
a victim of plaster-stripping, has been brought to life with new
lime render and limewash. The memorials of Carmarthen church
have been carefully cleaned and restored to great effect, empha-
sizing their quality as the finest collection in the region. The C15
church at Llanwenog has been slowly and carefully restored
since the 1990s, the stone water-spouts on the tower here and at
Tregaron an individual touch of *Roger Clive-Powell*.

Redundancy looks likely to become a major problem in coming
years, but at the time of writing relatively few churches have been
closed. Llandygwydd was demolished in 2000 for structural
reasons, and Nantcwnlle recently closed, but the extreme isola-
tion of many church sites, especially in the uplands, must put
many more at risk. Rhostie, Llanilar, stabilized as a roofless shell
in the later C20, may be a harbinger. Carmarthen, Llanelli and
Aberystwyth, all towns with three or more churches, may not be
able to sustain the number.

Church Fittings from 1750 to the Present Day

51 The few LATER C18 FITTINGS can be enumerated: box pews at
Talley, a *Coade* stone font of 1792 at Hafod, and two good organ
cases, one of 1762, by *Thomas Warne*, at Kidwelly (from Swansea),
and one at Carmarthen St Peter, 1796, by *George Pyke England*.
The latter church has an unusual marble altar table of 1829,
by *Daniel Mainwaring*. Pre-Ecclesiological BOX PEWS and
74 GALLERY survive at Strata Florida *c.* 1815, Eglwys Fach, 1833,
there made striking by the black paint applied by the poet *R. S.
Thomas* during his incumbency in the C20, and at Llanon,
1839–41. The box pews at Llangunnor were refitted as late as
1870. Llanddewi Brefi has panelled pews of the 1840s given by
the dowager Queen Adelaide. There are small former country-
house organs at the R.C. church, Aberystwyth, of *c.* 1800, and at
Laugharne, of 1819. The Regency Gothic organ at Llandeilo, by
Postill of York, reputedly came from Ripon Cathedral, and the
Gothic one at Aberystwyth St Mary of *c.* 1840, by *T. J. Robson*,
came from Haycock's St Michael.

The standard VICTORIAN EQUIPMENT of pulpit, lectern, altar
table, reredos, rails, stalls and pews rarely achieves the excep-
tional. Llangorwen, 1839, although a Tractarian church with the
first fixed altar in Wales since the Reformation, has fittings still
of a Georgian simplicity. The two neo-medieval chandeliers

though, given by either Newman or Keble, are exceptional pieces of Gothic Revival metalwork. The architects of the Victorian period had their signatures: Scott's fittings at Golden Grove, 1849, Llandeilo, 1850, and Llandybie, 1853–5, are conventional, patterned in trefoils and quatrefoils. *Penson's* are heavily cusped and chamfered, as at the consistory court in Carmarthen St Peter, Felinfoel, Llanfihangel y Creuddyn, Myddfai and Llanilar. *Withers'* timber rails, stalls and pulpits are models of minimal Gothic design, as at Henfynyw, Llanarth and Llangain, and his stone pulpits and fonts massively plain, as at Lampeter, Silian and Penrhyncoch. *Butterfield's* timber fittings are similarly minimal at St Mary Aberystwyth and Elerch, and his fonts massively geometrical, as at Llanafan. *Seddon's* oak fittings at Llanbadarn Fawr are more heavily moulded, there combined with a richly carved stone drum pulpit, and some exceptional mosaic floors. The woodwork of the *Middleton* firm can be elegant, as in the stalls and pews at Llansadwrn and Llanybydder, and the vestry screens with coloured glass at Llandysul and Llanddeiniol. The splendid six-lobed font by *Street* at All Saints, 97
Llanelli is the finest in the region, powerful in both shape and colour, challenged only by the tapered grey marble font at Elerch, by *Butterfield*. This use of rich materials is necessarily restricted, and most CARVED WORK is of Caen or Bath stone, if with marble shafting. There is though a sumptuous polygonal alabaster font at Burry Port, by *Wilson, Willcox & Wilson*, and marble and alabaster reredos and pulpit at Manordeilo, by *S. W. Williams*. The severe pulpit at Pendine by *John Prichard* is banded in grey stone. Rhandirmwyn by *J. L. Pearson* has a fine ten-sided font with angle shafts. The only R.C. High Altar is at Carmarthen, by *C. F. Hansom*, with typical crocketed gables.

Pavements of encaustic tiles are common, those at Golden Grove, with the Cawdor arms probably by *Minton*, 1849, and those by the Consistory Court in St Peter's, Carmarthen with bishops' mitres, by *Maw & Co.*, 1876. Late Victorian decorative tile MOSAIC or *opus sectile* appears to have been made exclusively by *Powells*, an early example in the reredos at Ferryside, and a later one in the Coomb chapel, Llangynog, 1912. Glazed tiles as wall decoration appear at Gwynfe, 1898.

At the turn of the century, the more interesting work was of the hand-made ARTS AND CRAFTS SCHOOL, as the panelling at the back of Eglwys Cymun by *Philip Webb*, rough-hewn to the 32, III
point of excess, and the simple pews by *William Weir*. The delicate oak lectern there shows both relief carving and fine lettering. Other similar work includes the fittings at Ystrad Meurig by *Harold Hughes*, 1897, the simple screen at Cellan, 1909, by *Herbert North*, and the stalls and tower screen at Llanfihangel uwch Gwili, 1910, by *Arthur Grove*. The blue-glazed ceramic eagle lectern at Penrhyncoch, 1880, by *Doulton* stands alone in an aviary of brass eagles. There is a delicately carved bowl font at St Alban, Llanelli, 1911, by *E. M. Bruce Vaughan*, and good fittings at his Llanelli St Elli, 1904–6, which has a carved Last Supper reredos by *Harry Hems* of Exeter. The taste for altar carvings is seen expensively at

Penrhyncoch, the Last Supper in alabaster, *c.* 1920. The Belgian
refugee, *Jules Bernaerts* carved a striking Last Supper at Llanfi-
hangel y Creuddyn, 1919, in oak. Another Belgian, *Joseph
Reubens*, carved the remarkable screen at Llanwenog, 1915, and
invigorated the carving by the squire, *Col. Herbert Davies-Evans*,
his wife, the vicar and the curate, that eventually filled the church
in one of the more extraordinary craft partnerships of the era.
W. D. Caröe's elegant oak fittings appear in many churches from
1904 to the late 1930s, typified by delicate detail and hallmark
quirks like the omnipresent little ribbed scroll. The post-war work
at Newcastle Emlyn, Capel Cynon, Capel Bangor, New Quay,
and the college chapel at Lampeter is most assured: the font at
Newcastle Emlyn, 1925 with its copper cover, the screen at Capel
Bangor, 1932–3, in a delicate classical style. But Caröe also
designed some oddly gauche pulpits at Cilycwm, Pembrey, Kid-
welly and Llanfair ar y Bryn. The Anglo-Catholic taste for gilded
and painted Gothic REREDOS found late expression in the
region, with examples by *W. Ellery Anderson* at Aberystwyth Holy
Trinity, 1932, and Llanelli St Peter, 1934, and by *Kempe & Co.*
at Aberaeron, 1933. The R.C. church at Lampeter, 1940, is simply
furnished, the relief over the altar by *P. J. Lindsay Clarke* in the
manner of Eric Gill, but many of the fittings crafted locally. The
same is true, for different reasons, at the remarkable Italian pris-
oner-of-war chapel at Henllan. After 1945 there is little to seek.
The exhibition space and chapel made in the S transept at Llan-
badarn Fawr, 1987, by *Peter Lord*, has a courageous aesthetic,
setting the C10 carved crosses on a tile floor of white bordered
in red, with rough-hewn granite altar and prie-dieu.

Stained Glass

The first REVIVED STAINED GLASS in the two counties came
relatively late it seems. There are tiny painted figures on glass at
Heol Awst chapel, Carmarthen, that may date from 1827. The
earliest Gothic Revival glass may be the window with Welsh texts
put up by Bishop Thirlwall at Abergwili, 1843, and the first with
figures is probably the vivid blue window at Llanboidy, 1849, by
Joseph Bell of Bristol. Windows of the 1850s are at Llangorwen,
Whitland, 1853, Llancynfelyn 1854, by *Hardman*, Llangybi, 1854
by *Thomas Ward*, and Laugharne, by *William Wailes*. There is
early glass by *N. W. Lavers* at Aberporth, 1857, designed by *Alfred
Bell*, made before they separated to form the two firms, *Lavers
& Barraud* and *Clayton & Bell*. The former were used by R. J.
Withers, who designed their studios in London, and they made
for him windows at Llangoedmor, 1859, and Blaenporth, 1864,
the latter quite outstanding. *Clayton & Bell* did two outstanding
series, one at Pontargothi, *c.* 1870 and the other at Dafen, 1871
in the C14 Gothic style. The other firm with a strong Gothic
drawing style rooted in the C14 was Pugin's favoured firm,
Hardman of Birmingham, represented, apart from at Llancynfe-
lyn, at St Ishmaels, 1870, and with a powerful series at Cenarth,
1871. The firm's work then became more lush, as in the E

windows of Burry Port, 1877, and Llangynllo, 1878, deteriorating in the 1880s. *William Wailes* of Newcastle used typically strong colours in the 1860s, at Laugharne, Carmarthen St Peter, Llanarthne, and Llandeilo, the Carmarthen window particularly good. There *Joseph Bell* did three strongly drawn windows of 1864–6. He himself reputedly thought his three windows at Aberaeron, 1875, among the best he had done. Butterfield's favoured designer, *Alexander Gibbs* made the E window at Elerch, 1868, a lovely work, and the E window at Carmarthen St Peter, 1873. R. J. Withers turned, at Lampeter, to *Daniel Bell* of *Bell & Almond*, for some excellent C14-style windows, 1870–5. *Heaton, Butler & Bayne*, good at Drefach Felindre, 1863, and Carmarthen St Peter, 1870, could still be striking at Llanychaiarn, 1879, though their later glass is brown and dull. Yet to be attributed are good windows at Llanafan and Llanrhystud, both of 1865, and Pendine, 1869.

The glass at Llanbadarn Fawr designed by *J. P. Seddon* and made by *S. Belham & Co.*, 1884–5, is especially dramatic in the E window, where the painter *Frederick Shields* was involved, but there is an intriguing quality to two windows of *c.* 1878–80, with distinctively classical figures and a thick drawing line, experimental pieces by *Seddon* perhaps. Remarkably experimental too is *Seddon*'s E window at Cynwyl Elfed, 1877, a cross with head, heart, feet and hands of Jesus. The taste of the late 1870s, to deeper greens and blues, and more Renaissance figure drawing, can be seen in two good unattributed windows at Ystrad Aeron, 1877 and *c.* 1880. 96

The later C19 left hot colours and emphatic leadwork for a gentler style based on C15–C16 Netherlandish and English precedent, characterized by softer colours, delicate drawing and much use of silver and gold. Typical of this period are the windows by *Burlison & Grylls* at Ferryside, and those by *Clayton & Bell* at Llanddeiniol and Llanegwad, all of 1883. Not all followed this path: *Joseph Bell*'s work at the Williams Memorial Chapel, Llandovery, 1887, is richly coloured, the most church-like windows in any chapel in the region. Two very fine E windows at Aberystwyth St Michael, by *A. O. Hemming*, 1889, combine a rich colour with late Gothic drawing style.

A distinct strand is represented by the glass of *Morris & Co.* Llandyfaelog, which has three typical languid figures by *Burne-Jones*, 1895, and something of the lovely colouration for which the firm was renowned. After the death of Burne-Jones the firm continued to use his designs, on intensely coloured backgrounds, as in the two large and very fine windows at Llanelli St Elli, of 1911, and the war memorial window, 1919, at Llandyfaelog. Of a delicacy reminiscent of Morris & Co. is the lovely glass by *Carl Almquist* for *Shrigley & Hunt* at Betws Bledrws, 1886–7, and the influence of Burne-Jones shows in the window at Lledrod, 1902, by *Sylvester Sparrow*. Of the same period are windows by *A. J. Dix* at Llanddowror, 1901, and Carmarthen St John, 1902, the latter designed by *E. P. Warren*. Advanced Arts and Crafts work characterized by thick and bubbled glass is not much repre-

sented, one good example at Llanbadarn Fawr by *Hugh Arnold*, 1904. The glass by *F. C. Eden* at Eglwys Cymun, 1906–17, is in a separate class, with clear colours, beautifully drawn, and quietly humorous.

Dull colours typify much TURN-OF-THE-CENTURY GLASS, by for example, *Heaton, Butler & Bayne*, *R. J. Newbery* or *Powell*. *A. L. Moore*'s glass has a particularly dense drawing and rich colour, as at Ferryside, 1901, and Llangynllo, 1919. The firm of *Kempe & Co.* dominated British glass making from the early C20, and glass by the firm, detailed with much silver and gold, appears all over the region: as at Llandysul, 1919; Henfynyw, 1922; Llanfair ar y Bryn, and Aberaeron, as late as 1932. Other interwar artists tended to a simplified palette and clear backgrounds: *C. C. Powell* at Cynghordy, Kidwelly and Llanllwni; *H. Wilkinson* at Cardigan, Pembrey and Newcastle Emlyn; *Christopher Webb* at Llangrannog; *Geoffrey Webb* at Llangunnor; *A. K. Nicholson* at Llanybydder and Llangeitho. Glass by *Powell* could be more dramatic, as at Borth, 1925, Aberystwyth Holy Trinity 1934 and Llandre 1935. But so much is conventional that the few unusual talents stand out: the lovely semi-abstract window by *Leonard Walker* at Llandovery, 1924; the angel of Justice by *Martin Travers* at Llancynfelyn, 1938; the naïve colouring of *A. E. Lemmon* at Silian, 1936. One window 116 outshines all the others: the great w window by *Wilhelmina Geddes* at Lampeter, commissioned in 1938, product of the more vibrant Irish glass-making tradition. The muscular strength of the major figures is enhanced with strong colours, and their scale contrasts with miniature figures beneath their feet.

POST-WAR GLASS is dominated by the work of *Celtic Studios* of Swansea, founded by *Howard Martin* in the late Forties. The early work tends to clear backgrounds, the figures a little modern. Later the leadwork becomes more emphatic and the colours more strident. Windows in the region show the range, early ones at Betws Ifan, Llangorwen and Gartheli, a fine w window at Kidwelly, 1960, and series at Borth, 1962–72, Brynamman, 1957–91, and Tumble, 1947–80. *Powell* remained the major national maker, represented by the window at Llanddewi Brefi, 1962, a period piece with heavy leading, and a complete set at Strata Florida, 1961–7, with a companion piece in Pontrhyd-fendigaid, 1964. There are good figurative windows by *John Hayward* at New Quay and Llanllawddog, 1960 by *Lawrence Lee* at Bettws, 1960 and Aberystwyth St Michael, 1962, and by *Kenneth Baynes* at Talybont, 1959. Three remarkably intense windows by *Roy Lewis* are at Llandre and Llanbadarn Fawr, 1962–3, the palette restricted almost to single colours. The windows at the R.C. church, Newcastle Emlyn, by *Frank Roper*, show a metal armature around the glass more emphatic than the glass itself. The glass of *John Petts* of Llansteffan is of particularly high quality, the colours often restricted, the designs flowing and 121 abstract. The E window at Llansteffan, 1980, is particularly good, and there are fine works at Bettws, Llanddarog and Pontyberem. *Tim Lewis* of Swansea made windows for the new church at Hendy from 1980, principally a powerful semi-abstract Crucifix-

ion. The exhibition area at Llanbadarn Fawr, 1989, by *Peter Lord* includes attractive lettered glass by him in the screen, and a window by *Elizabeth Edmundson*, with drawing based on Celtic manuscripts. The windows by *Caroley Bergman-Birdsall* at Llangunnor, 1990 and by *Gabriel Loire* of Chartres at Llanfihangel ar Arth, 1995, are Modernist-figurative, the former with lovely colour, the latter rather subdued. The big window at Llandovery College chapel, 1991, by *Amber Hiscott & David Pearl* of Swansea, is a bold abstract modern piece.

Church Monuments from 1750 to the Present Day

The first native monumental sculptor to emerge as an individual was Daniel Mainwaring (1776–1839) whose work principally dates from after 1809 (*see* below). The unsigned later c18 monuments going through the changes from the mid-c18 Baroque or Palladian types to the typical urns and oval plaques of the later c18 are probably not locally made. Typical of English provincial work are the two mid-c18 examples at Llanarth, to a Lloyd of Wern Newydd, with pediment and side scrolls, and to Jane Davies †1753, with Baroque scrolled pediment. Carmarthen parish church has a sequence of the conventional types, but two of a much richer sophisitication are at Llanbadarn Fawr, those to John Pugh Pryse †1774, with cherubs and portrait, possibly by *Van der Hagen* of Shrewsbury, and to Lewis Pryse †1779, the latter surely a metropolitan piece, large-scale, in grey and white marble and unusually architectural. The memorial to the Rev. Griffith Jones |1761 at Llanddowror is notable, with carved books and coloured marbles. Contrasted colours of marble appear also on the memorial to Anne Lloyd †1778 at Strata Florida and that to the Rev. William Powell †1780 at Llanbadarn Fawr, with delicate Adamesque detail. By the end of the c18 the competent works of Bath and Bristol sculptors begin to appear: that to Erasmus Williams †1785, at Myddfai, is by *Thomas Paty* of Bristol, and works by other Bristol firms, *Tyley*, *Drewett* and *Wood* are also found along with *King* of Bath, who signs three memorials at Llandybie. The leading London sculptor, *John Bacon Sen.* made the memorial to Lady Dynevor †1793 at Llandeilo, with a Grecian lady at an altar, and another leading Neoclassical sculptor, *Joseph Nollekens* made the beautiful marble sarcophagus at Taliaris to Lady Anne Seymour †1804. The one memorial of national significance was that at Hafod to Mariamne Johnes, commissioned in 1811 from *Sir Francis Chantrey*, with the dying girl attended by her parents, a work both Neoclassical and romantic. It cost the enormous sum of £3,150, but only fragments survive, ruined by fire in the 1930s. *Chantrey* also carved a memorial at Aberystwyth to Martha Davies †1815. *John Flaxman*'s mourning gentleman on the memorial to Harriet Pryse †1813 at Llanbadarn Fawr is in a Gothic frame, an early example.

Daniel Mainwaring's work tends from the Adamesque to the Neo-Grec, both styles apparent in the Admiral Laugharne

memorial at Laugharne, 1832, with conventional ornament, urns and sarcophagi. The very large black sarcophagus monument to Sir James Hamlyn Williams †1829 at Carmarthen is unusual, that to Bridget Bevan at Llanddowror, 1837, shows his skill as a sculptor and weaknesses as a designer. His work compares well with the standard of the prolific memorial sculptors of the era: *Foster* of Bristol, *Reeves* of Bath, *Lewis* of Cheltenham, *Gaffin* and *Bedford* of London. There are a few memorials by leading sculptors of the earlier to mid C19: *E. H. Baily* did a charming kneeling child to M. D. Williams †1833 at Llanbadarn Fawr, *Richard Westmacott Jun.* a mourning female with the portrait of John Jones †1836, on his memorial at Betws Bledrws. *Edward Davis* was born in Carmarthen but had a successful London career. His pensive relief of Bishop Richard Davies at Abergwili, 1849, is an attractive work. Another successful London sculptor, *John Evan Thomas*, was the son of *John Thomas* of Brecon whose memorials are found in Carmarthenshire from 1810–45, and himself signs memorials from 1839–52, notably that to John Jones at Blaenos at Cilycwm, *c.* 1840, and the deeply romantic one to Catherine Pryce Lloyd †1852 at Llangadog with the married couple ascending.

The rural CHURCHYARDS tend to have rustic memorials of the C18 and early C19 generally with charmingly carved winged-head or hourglass motifs. By the 1840s slate memorials had become the norm, but it seems against all expectation that these were often painted in bright colours, of which flakes still remain. In s Ceredigion some tombs were railed with ornate and rather wild scroll-work. In the same region are late C18 to early C19 churchyard memorials where the gravestone is encased in a round-headed frame of sandstone blocks, as at Penbryn.

The memorials of the later C19 rarely rise beyond the conventional. There is a big lion-footed sarcophagus in the churchyard at Bangor Teifi to A. Lloyd Davies †1853, and a good bronze plaque by *Baron Marochetti* of his marble memorial in St Paul's Cathedral to Lt-Col. J. Cowell †1854 at Llanelli. The most striking later C19 works are the memorial to E. L. Pryse †1888 at Llanbadarn Fawr, an Early Renaissance tabernacle, the doors being opened by a seated angel, and the grief-stricken female in the churchyard at Llanboidy, 1891, by *W. Goscombe John*. For the C20 very little stands out: the memorial to Ivor Buckley †1929 at Felinfoel by the Florentine sculptor *Antonio Maraini*, and the bronze portrait relief by *Gilbert Bayes* at Pontrhydfendigaid of Catherine James †1939. The marble angel holding the girl in ATS uniform, to Mollie Davies †1940 outside Cwmamman (Garnant) could have come from Italy.

Church Schools and Vicarages

No early SCHOOL BUILDINGS survive; the Circulating Schools founded by the Rev. Griffith Jones †1761 have left no structures. The widely famed school founded by Edward Richard in 1735 at remote Ystrad Meurig was rebuilt in 1812, as a large single room

with Gothic windows. The school at Lampeter, sufficiently
renowned for Sir Walter Scott to send his son there, was prob-
ably held in the gallery of the church before the present school-
room was built in 1823, and that surprises, as it is no more than
a single room, like the school at Llanddeiniol, 1827. Early C19
two-storey schools survive, generally with a classroom on each
floor, as at Cilycwm, 1833, but at Cenarth there was a stable and
teacher's accommodation under the Gothic-windowed school-
room. Llangoedmor, 1849, had a classroom each floor and
teacher's house to one side, in a minimal Tudor, also adopted for
the National Schools at Aberaeron, 1848, by the builder *Jenkin
Pugh*; Aberbanc, 1848, by *Charles Davies*; and Llanarthne and
Llanafan, both 1856. The two similar schools at Capel Bangor,
1852, and Tre Taliesin, 1856, by *Roderick Williams*, are long single 84
rooms with a porch each end, for boys and girls, and were
arranged with tiered benches or 'forms' against the windowless
back wall, and a single central fireplace on the front wall. The
more elaborate schools tended to be for the gentry estates; that
at Golden Grove, 1848, by *Henry Ashton* has a single schoolroom
and teacher's house, picturesquely asymmetrical, as are the pretty
Gothic former schools by G. G. Scott's partner, *William Moffatt*
at Lampeter, 1850. Moffat's schools at Cardigan, 1847, built for
the Priory estate, are larger, a two-storey block with boys on one
floor, girls on the other and the teacher in a wing. The little High
Victorian group by *R. J. Withers* at Llanarth, 1859, had character,
with some polychrome banding, but the schoolroom has been
badly altered. The most exotic of the National Schools is at
Llandeilo, 1860, by *W. M. Teulon*, built for Lord Dynevor, with an 85
array of Gothic gables. Cilycwm, 1866, another Cawdor school,
by *John Harries*, is ornamented with a saddleback tower.

The VICARAGES of the early C19 were neat Late Georgian
houses; the best is at Trefilan, 1829–32, pyramid-roofed and
planned around a central stair-hall, more conventionally gable-
ended at Betws Bledrws, 1838, by *Rees Davies*, and the one at
Bangor Teifi, as late as 1857, is still Georgian in style. *George
Clinton* at Llanilar, 1833, was minimally Tudor. Tudor became the
norm in the 1840s and there are good examples at Cwmamman
(Garnant), 1842, by *R. Ebbels*, and by *Charles Davies* at
Llandygwydd, 1847. The solid mid-Victorian vicarage, in stone
with a Gothic doorway and asymmetrical plan, is oddly rare:
R. K. Penson at Carmarthen St Peter, 1856, provided a tower,
and at Llanedi, 1860, a complication of roofs. *R. J. Withers* is gen-
erally attractively minimal as at Tremain, 1867, and Llanfihangel
y Creuddyn, 1869. Aberaeron, 1862, is more conventionally
Gothic, as there was more money. *G. E. Street* at Llannon,
1870, and Llanelli All Saints, 1871, designed two of the best Vic-
torian houses in the region, carefully asymmetrical, with subtle
and studied emphasis to the principal rooms. The *Middleton*
firm played interestingly with hipped roofs, a Georgian form, in
the 1880s, but with small asymmetries to show that this
was something different, at Newcastle Emlyn, Llanpumsaint
and Llanllawddog. In the early C20, *Herbert North*'s vicarage

at Llanybydder, 1912, has a interesting geometry of plain gables.

NONCONFORMIST CHAPELS FROM THE SEVENTEENTH TO THE TWENTIETH CENTURY

Nonconformity established itself early in sw Wales, Independent (also known as Congregationalist) and Baptist congregations forming from the 1650s. In Carmarthenshire there were early Independent congregations at Heol Awst (Carmarthen), Crugybar (Cynwyl Gaeo), Cefnarthen (Llanfair ar y Bryn), Henllan Amgoed, Pencader and Capel Isaac (Manordeilo). Early Baptist foundations include Bwlchyrhiw (Cilycwm), Tabernacle (Carmarthen) and Rhydwilym (Efailwen). The first meeting-houses were built after the Toleration Act of 1689, although none survive of this period.

Welsh Methodism reached the two counties through the tours of Howell Harris from Breconshire after 1739 and took deep root in Carmarthenshire, with several Methodist societies flourishing by the mid 1740s, including Cilycwm, Llandeilo, Carmarthen, Kidwelly, Talley and Llansawel. The hymnodist William Williams of Pantycelyn (Llanfair ar y Bryn) was an apostle of Methodism in Carmarthenshire, and Daniel Rowland, curate at Llangeitho, in Ceredigion, where Methodism overtook the older Dissent to become the largest denomination by 1820. The Wesleyan branch of Methodism was brought by John Wesley himself on his preaching tours of the later C18, with causes set up in the 1760s and 1770s at Carmarthen, Kidwelly and Llanelli, but remained restricted, although boosted by Cornish workers in the lead mines of N Ceredigion. The co-existence of Methodism with the Established Church ended in 1811 in conflict over the ordination of ministers. The break established Calvinistic Methodism as the dominant form of Welsh Methodism, with Wesleyanism largely restricted to urban or industrial areas where there was substantial English immigration.

From the 1730s Calvinism was challenged by a number of young intellectual Arminian Unitarians, inspired by liberal and rationalist ideas at the Dissenting Academy at Carmarthen. The first Unitarian chapel in Wales was built at Rhydowen in 1734 by Jenkin Jones and, despite much opposition, thrived, but only in that locality, known to other denominations as *y smotyn du*, the 'black spot'.

By the mid C19 the pattern was of three major denominations, each with parallel Welsh and English strands: Baptists, Calvinistic Methodists (the English strand known as Presbyterians) and Independents (the English strand known as Congregationalists), with two smaller denominations, the Wesleyan Methodists and the Unitarians. The large number of chapels in towns such as Llanelli and Aberystwyth is partly explained by the duplication of chapels for Welsh and English speakers and partly by the tendency of congregations to split, either for missionary

reasons where a part left to set up a new branch, or from seces-
sion, where a part would leave, voluntarily or not.

Architecturally little survives even of the C18, testimony to
explosive growth that could see up to four rebuildings on the same
site, as at Henllan Amgoed. The early RURAL CHAPELS were
cottage-like, a long-wall façade, generally with two doors and one
or two raised central windows lighting the pulpit. Penrhiw Uni-
tarian chapel, Drefach Felindre, 1777, the earliest survivor, was
moved to the Museum of Welsh Life, St Fagans, in 1957.

The LONG-WALL FAÇADE remained the principal type from
the late C18 to the mid C19, the two-door and two-window model
enhanced by two outer windows at an upper level to light gallery
stairs. Bethel, Garnant, 1825, is probably the earliest survivor
with outer gallery windows, and probably the majority of chapels
follow the pattern up to about 1860. Remote chapels like
Cefnarthen, Llanfair ar y Bryn, 1853, can seem wholly Georgian
in form and detail. The last example, Brynmoriah, Brynhoffnant,
1884, is Victorian in its rock-faced masonry and glazing, but still
to the same plan form, influenced by C17 English chapels in their
turn influenced by the meeting-houses of the Low Countries.
Early chapel roofs were gable-ended, but hipped roofs were
common from the 1820s, as at Heol Awst, Carmarthen, 1826 and
Capel y Graig, Trelech, 1827, and half-hipped roofs became
popular in the 1830s, as at Rhydowen, 1834. 71

Many variants of the lateral façade exist. Penygraig,
Cwmffrwd, 1831, and Tabor, Llanwrda, 1842, have a simple pair
of doors with a window over each. Seion, Myddfai, 1844, and
Siloam, Pontargothi, 1848, are more domestic, with central door
and windows on two levels. A single central window rather than
the usual pair appears at Alltyblaca near Llanwenog, 1837,

Alltyblaca Unitarian Chapel, Llanwenog.
Engraving

Bethel, 1841, and Gosen, 1844, both at Cynghordy, and at Capel
Mair, Llanfair Clydogau, 1845. Capel y Graig, Trelech, 1827, has
the largest number of openings, adding windows on the ground
floor beyond the doors. It also has exterior gallery steps, now a
rarity, but found also at Henllan Amgoed. There is no denomi-
national pattern in design, and indeed records of the design
process are very rare.

 TOWN CHAPELS of the earlier C19 are similar but larger. The
finest, Heol Awst, Carmarthen, by *William Owen* of Haverford-
west, 1826, has a plain exterior with big hipped roof and two
arched windows over two Ionic doorcases, but a spacious and well-
fitted interior, with deep gallery, box pews and a remarkable 'wine-
glass' pulpit with curving steps up. One other such pulpit survives
at Heol Dwr, Carmarthen, 1831, but they are exceptionally rare
due to later changes. Tabernacle, Llandovery, 1836, has a similar
broad interior, but a gabled roof and big Gothic windows.

 From the 1820s GALLERIES became part of the design,
although some not actually inserted at the time of building. Gen-
erally, the gallery is around three sides, facing a pulpit on the
front wall, between the two entries. In front of the pulpit was an
area of seating for the deacons or elders, known in Wales as the
sedd fawr, or great seat, and then the pews, normally a central
block and two side blocks, sometimes raked up to the back and
side walls. Earlier C19 galleries are usually simply panelled, occa-
sionally richer, as at Heol Awst and Jerusalem, Gwynfe, 1827,
where there are arched panels with a rustic Gothic moulding.
From about 1830, five-sided galleries are sometimes found,
perhaps a distant echo of Wesley's preference for octagonal
chapels, but more probably to increase the seating in square-plan
chapels. The Hen Gapel, Llechryd, 1830, is a particularly good
early example, and the one of 1871 at Rhiwbwys, Llanrhystyd,
the last, but this may replace one built with the chapel, 1832.

 The move from long-wall to end-wall or gable façades began
outside the region, with the architectural possibilities of the
temple front in mind, and first appears in the region as a variant
on the hipped-roof chapels, with the narrower wall to the front.
The plan suggests relocating the pulpit on the back wall, though
this was not always the case. The hipped-roof series runs from
Salem, Llandovery, 1829, and Bynmair, Aberporth, 1833, up to
Nebo, Efailwen, 1861, and Ffynnonbedr, Tremain, 1865. Nebo is
something of a hybrid, its pulpit oddly backing onto the entrance
lobby. Among the best preserved is Rhydyceisiad, Llangynin,
1857, with its charmingly rustic interior, still with box pews.

 A hybrid type kept the lateral façade, but the seating was ori-
entated to the gable-end, without galleries. These are found
mostly in the lead-mining areas of Ceredigion during the mid
C19, and contemporary examples survive in the industrial areas
of S Pembrokeshire. Among the best are the Hen Gapel, Tre'r
Ddol, 1845; Penllwyn, Capel Bangor, 1850, five bays long, and a
close copy at Salem, Penrhyncoch, 1864. A smaller example is
Capel Cynon, Llanfihangel y Creuddyn, of the 1850s. From the
1860s some lateral-façade chapels were refitted with the pews

orientated to an end pulpit, as at Pennant, 1832, remodelled inside in 1883. At Ty Newydd, Caio, Cynwyl Gaeo, 1837, the gable was recast as the façade in 1907, but the lateral front to the road is still discernible.

The GABLE FRONT was explored from the 1840s, with a suggestion of earliest interest from the Baptists. Libanus, Llansadwrn, 1841, has a central door, two arched windows and a charming galleried interior with box pews and a rear pulpit. Zion, Carmarthen, 1849, by *R. G. Thomas* is among the first classical fronts, with giant Tuscan pilasters and entablature. Full temple-fronted chapels are rare, but a group was in Llanelli in the 1850s. Bethel, altered in 1850, and nearby Siloah, altered in 1855, have stuccoed pilastered fronts. Zion and Greenfield, 1857–58, both by *Henry Rogers*, have grander stone pilastered fronts, and the tradition continues though to Caersalem, 1893, with two-storey pilasters. For some reason most of these classical chapels were Baptist, as is Bethania, Cardigan, 1847, by *Daniel Evans*, particularly impressive, with Doric porch and rusticated flanks carrying a broad segmental arch under a pedimental gable. Inside, there are Doric columns to the gallery and good plasterwork with classical detail. Capel y Wig, Pontgarreg, 1848–9, has a handsome sandstone façade with pedimental gable and Venetian window.

GOTHIC of the minimal Georgian type, with pointed small-paned windows, appears on a few lateral-façade chapels such as Bethel, Garnant, 1825, Tabernacle, Llandovery, 1836, and Salem, Rhandirmwyn, 1852. Y Ffynnon Chapel, Pentregat, is a surprise, designed 1849 by *Charles Davies* of Cenarth, it attempts a more sophisticated Gothic with moulded stonework and a big traceried window.

Prior to the 1860s, worked stone was rare, stuccoed or whitewashed rubble being the norm, often replaced later by render. Among exceptions are Llandyfaelog, 1846, a lateral façade of squared and tooled limestone. Interiors up to 1860 were of the Late Georgian type with painted panelled gallery fronts and pews, the painting often imitating wood-grain, box pews with doors, and small panelled pulpits with steps. As there were no publications on chapel architecture, and almost no trained architects before the 1860s, stylistic change was slow, and conservatism especially apparent in woodwork.

With the larger congregations that followed the revival of 1859, and increased public participation in worship, came changes, primarily the introduction of the platform pulpit with room for several ministers, and the enhancement of the 'great seat' or elders' enclosure in front of the pulpit. Hence, while surviving original pews and galleries are not uncommon, pulpits and great seats are generally later C19 replacements.

The Later Nineteenth Century

After 1860 architectural design becomes more important though no strong links between denomination and style emerge. The

Welsh-speaking congregations tended to prefer classical to Italianate styles whereas English-speaking congregations tended towards an ecclesiastical Gothic. The series of Baptist chapels in the Italian Romanesque style built by *George Morgan* of Carmarthen after 1875 may echo the Central Baptist Church, Shaftesbury Avenue, London, 1845–8, by John Gibson, but the Baptists were classical in Llanelli.

Surprisingly little was written on the issue of STYLE for designers of chapels. The majority of classical or Italianate chapels were designed by Welsh architects such as *Richard Owens* of Liverpool, *John Humphrey* and the *Rev. Thomas Thomas* both of Swansea, and *George Morgan*, whereas English chapel specialists, *James Wilson* of Bath, *Lander & Bedells* of London, *Poulton & Woodman* of Reading, and *H. J. Paull* of Manchester gained Gothic commissions. The distinction between the two is most clear in roof pitches, for otherwise the picture of classical chapels is clouded by the introduction of Romanesque or Gothic forms to the basic Italianate, characteristic of Owens, Humphrey and Morgan. The box form of the chapel began to evolve in both camps, the Goths with their high roofs tended to add an asymmetrical tower or spire to one side, the others experimented with the winged façade, where the centre was clasped between outer bays (often stair-towers) with roofs at right angles to the main roof. Even so, the basic box remained, as a look to the side as many an ornate chapel shows.

The potent Italianate design where a giant arch breaks into the pediment in a triumphal arch motif, associated with the prolific 100 *Rev. Thomas Thomas* all over Wales, appears on his Seion, Llandysul, 1870 and Salem, Llangennech, 1878. The more economical Ebenezer, Llanelli, 1881, keeps the arch but dispenses with the pilasters. *David Davies*, of Penrhiwllan, who acted as builder to Thomas at Llandysul, adopted the manner thereafter in a series of similar chapels in S Ceredigion and N Carmarthenshire into the early C20. *Thomas* also refaced Tabernacle, Aberaeron, 1869, adding a heavy but effective pediment. This way of turning a lateral façade into a temple front was also done at Capel Mawr, Llanon, 1865, and Saron, Llanbadarn Fawr, 1879.

99 *George Morgan* began his career with the English Baptist Chapel, Carmarthen, 1869–70, displaying a High Classical style absent from Thomas's work. Its giant portico is arresting, but had few successors, apart from Morgan's own temple-fronts at 101 Newtown and Swansea. At Tabernacle, Llanelli, 1873, another apparently self-taught chapel architect, *John Humphrey*, combined a giant Corinthian arcade with a pediment, mixing Classical and Romanesque with bold originality, this chapel ranking with his great chapels at Morriston and Llanidloes. Humphrey's rural chapels at Llanycrws and Llansadwrn show a remarkable imagination, High Victorian in vigour, but boldly original. Monumental stone columns appear on the St Paul's Welsh Wesleyan chapel, Aberystwyth, 1878, by the little-known *W. W. Thomas*, a chapel of exceptional richness and cost, that had also French pavilion roofs when first built.

Richard Owens of Liverpool, who built four chapels in Aberystwyth for four different denominations in the 1870s, varied his styles. The two earlier chapels of 1869 and 1871 are in the two variants of the Gothic, low-roofed and high-roofed; Seion, 1877, 102 is Italianate with pediment and paired giant pilasters, and Tabernacle, 1878–9, while mostly Italianate, includes Gothic plate tracery, a hybrid Owens termed 'Italo-Lombard'. Soar, Tre'r Ddol, 1874, is similarly hybrid, and looks like Owens's work, and the very rich Bethel, Aberystwyth, 1888, by the local architect, *T. E. Morgan*, clearly derives from Tabernacle.

George Morgan's Italian Romanesque was seemingly born already mature at Priordy, Carmarthen, 1875 and flowered intensely in the next five years. Although the Bloomsbury Temple may have been the root, Morgan's work is surely the principal flowering in Britain, seen in major works at Haverfordwest and Swansea, and also at Ferryside, Login, Llandeilo, and Cardigan, all 1877–8.

Hall Street Wesleyan Chapel, Llanelli, 1856, by *James Wilson*, with proper Gothic tracery and detail, was the first counter to the classic or Italian styles. The ecclesiastical dress was made even more Anglican by Wilson in 1870, when he added transepts, an apse and the base of a tower. Gothic chapels for English congregations came quickly in the 1860s. The English Congregational chapel, Carmarthen, 1861, by *Poulton & Woodman* employs a very spiky Gothic vocabulary with complex stair-tower and spire. Park Congregational chapel, Llanelli, 1864, by *Lander & Bedells*, and the demolished Wesleyan chapel, Aberystwyth, by *W. H. Spaull*, 1869, followed, both with spires. Two other very Gothic chapels were built in Aberystwyth: the English Congregational chapel, 1865, by *Paull & Ayliffe* of Manchester, very up-to-date with a forked slate spire (now removed) borrowed from G. E. Street's famous church in Vauxhall Bridge Road, London, and *Richard Owens*'s English Presbyterian Church, 1871, with a big gable between turrets. The first Welsh-speaking chapel to be seriously Gothic was probably the Williams Memorial chapel, Llandovery, 1886, by *J. H. Phillips* of Cardiff, with remarkably church-like fittings, including stained glass by *Bell* of Bristol.

The INTERIORS of the later chapels show increasing richness. The massive platform pulpits allowed Gothic, Romanesque and Italianate arcading, fretwork piercings and giant turned newels with all manner of finials, in varnished pitch pine or sometimes contrasted hardwoods. Notable too is the wealth of cast-iron work: columns, panel inserts into gallery fronts and also the fine continuous pierced iron gallery fronts, exceptional at Moriah, Llanelli. The simple timber pulpit-back gave way to a giant plaster or timber aedicule, and that in turn to an added organ loft. The passion for choral singing, which swept through Wales and created the great massed choir events of the late C19, required pipe-organs and choir space, often placed in choir galleries behind the pulpits. Ceilings were elaborated with large plaster roses, by the late C19 often set in a framing of timber ribs and matchboarding. Tabernacle, Llanelli, has an elliptical-

curved, ribbed, plastered ceiling and curved gallery around all sides, articulated in an ironwork band above walnut veneer. Capel Als, Llanelli, was sumptuously refitted in 1894 by *O. Morris Roberts* of Porthmadog, the quality of the woodwork quite superb.

102 Seion, Aberystwyth, 1877, by *Owens*, has a fine curved gallery with thin cast-iron arcading creating the effect of aisles (similar to the 1874 interior at Tabernacle, Haverfordwest, Pembs.).

By the end of the C19, the pace of building had slowed, and the great religious revival of 1904–5 does not seem to have altered this. Gothic chapels started to show fashionable Perpendicular Gothic motifs, as at Rhydybont, Llanybydder, 1911, by *W. Beddoe Rees*, or the chapels of *William Griffiths* in Llanelli and Llwynhendy. Bethel, Meidrim, 1904, by *Arthur Jones* of Carmarthen, mixes styles with complete abandon. Capel Newydd,

110 Llandeilo, 1901, and Brynseion, Glanamman, 1909, both by *Henry Herbert* of Ammanford, are more conventionally Gothic, but very richly detailed inside. Classical chapels followed Edwardian taste towards first the Baroque and then Beaux-Arts French classicism. Capel Newydd, Llanelli, was richly refronted in 1901 by *J. Davies & Son* with ashlar pilasters and outsize keystones. Bethlehem, St Clears, remodelled 1909 by *D. E. Thomas*, is more severe, in stucco, and the chapel at Saron, 1913, by *Beddoe Rees*, the best in the series, has a hooded entry and Diocletian window. Rich interiors continued to be made, as at the Christian Temple, Ammanford, 1910.

J. Howard Morgan, George's son, specialized in an up-to-date Free Style, expressed at Bethania, Carmarthen, 1902, and more overtly at Gosen, Llangadog, 1907, with its Diocletian window above the pedimented entry. Typical of Morgan are complex open roofs and galleries incorporating little turned balusters. Bethania, Ferryside, 1911, Smyrna, Llangain, 1915, and Y Drewen,

109 Cwm Cou, 1921, show a modernizing side to Morgan, the spare square window mullions echoing the work of Voysey, and some interesting plans, such as subsidiary spaces that can be opened into the main chapel.

Most *interwar* work was refitting, and most of that conservative. Morgan's extraordinary reuse of a Victorian villa as a chapel at Capel Sul, Kidwelly, 1924, deserves mention, as does Penmorfa, Penbryn, remodelled in 1938 by *T. Edmund Rees* of Merthyr Tydfil, the woodwork with a slight Art Deco touch.

The *post-war* years were largely static before the present era of chapel closures began in the 1990s. Demolition has not been the wholesale solution once feared, reuse is often an option, albeit rarely with preservation of interiors. Seilo, Aberystwyth, demolished for structural reasons, had the newest chapel façade of all, a lightweight timber portico added in the 1960s after earlier subsidence problems. The English and Welsh Wesleyan chapels there were replaced by the St Paul's Wesleyan Centre, 1991. Listing has at least secured a period in which a new use can be sought, as with Parc y Felfed, Carmarthen, now a dental surgery, or the Welsh Wesleyan chapel, Aberystwyth, converted to a bar. Llanelli with its extraordinary rich legacy of chapels has seen Shiloh

converted to a sports hall, and Glenalla to a civic hall. In 2005
Dock and Calfaria are closed, but most continue in use. The new
trust for the preservation of historic chapels has taken into care,
as its first building, Libanus, Llansadwrn. 72

Schools and Vestries

Chapels tended to have ANCILLARY BUILDINGS, the most
charming the stables for the minister's horse at remote chapels 73
like Soar y Mynydd, often with a meeting room above, called the
'long-room'. These grew into the Sunday Schools, vestries and
chapel-keeper's house attached so often in a row to the original
chapel, as at Tabor, Llangwyryfon. New chapels sometimes fos-
silized the previous chapel as a schoolroom, as at Bethesda, Llan-
gennech. The larger chapels of the later C19 might be built over
basement schoolrooms but more often these were in separate
buildings. A few stand out, the extraordinary octagonal building
behind Park chapel, Llanelli, also by *Lander & Bedells*, 1889, the
enormous schoolroom with galleried interior at Heol Awst, Car-
marthen, 1888, by *George Morgan*, and the vestries and school-
room designed as part of one rambling composition at Y Drewen, 109
Cwm Cou, 1921, by *J. H. Morgan*. The British Schools, the sep-
arate school system set up in the earlier C19 to provide an alter-
native to the National Schools of the Anglicans, have left few
buildings. Some were incorporated in the state Board School
system after the 1870s, as at Castle School, Kidwelly, 1858.

COUNTRY HOUSES,
1485 TO THE TWENTIETH CENTURY

The country houses of the two counties have not fared well,
Carmarthenshire in particular having lost the majority of its
important houses, mostly in the C20.
 The victory at Bosworth in 1485, which brought a Welsh
dynasty to the throne, raised morale in Wales, many Welsh
gentlemen following Henry to London and being rewarded.
Henry's first supporter in 1485, Sir Rhys ap Thomas of Dinefwr
(1449–1525), built extensively in Carmarthenshire and Pem-
brokeshire. His greatest effort was at Carew Castle, Pembs., but
he also created grander domestic arrangements in the castles at
Narberth, Pembs., and Newcastle Emlyn, Cms. We know little of
what he did at Dinefwr itself, perhaps therefore there was little.
His chief purely domestic work was at nearby Abermarlais,
Llansadwrn, where Leland described 'a well-favoured stone
place, moated, new mended and augmented by Sir Rhys ap
Thomas'. Nothing remains, but a late C18 map shows a court-
yard house with gravel court, bowling green and walled gardens.
 Sir Rhys ensured that his issue were well housed too, and at
Rhydarwen, Llanarthne, the best surviving evidence of his archi-
tectural legacy are the carved door-heads reused from a lost 35

screen. The house, though not large, is almost certainly of Sir
Rhys's day, but major alteration, which must have followed soon
after first building, has confused the layout, with two first-floor
halls, each side of the entrance. The earlier, late C15 hall appears
to remodel something older; the later one has a fine arch-braced
roof with a distinctive continuous chamfer to blade and collar
found also in the contemporary part of Derwydd, Llandybie and
at the mostly earlier Cwrt Brynybeirdd, Carreg Cennen. Aber-
glasney at Llangathen, long rebuilt, is recorded in an encomium
of Lewis Glyn Cothi as 'a proud hall, a fortress made bright with
whitewash and encompassing it all around, nine green gardens'.

38 In the early C16 the Vaughans of Llethr Cadfan, Llangathen,
built a storeyed hall with lateral chimney, while at Green Castle,
Llangain, ruins remain of an Elizabethan house of some preten-
sion, though not large. It had a stair-tower probably topped by a
cross-gabled belvedere, and a separate gatehouse, long converted
to a farmhouse. On the hill above coastal Pembrey is the over-
grown shell of Cwrt, a rambling multi-period house adorned with
good C16 to C17 mullioned windows and tall chimneys. Also
derelict, nearby Lletyrychen, Burry Port, was simpler, rectangu-
lar with a pointed stone doorway and, just inland, Llechdwnni,
Llandyfaelog, part of a small C17 house, with a carefully made
flat-headed stone entrance and the remnants of a terraced garden
above. Ruined also is Plas Mawr, Llanedi, a downhill-sited
storeyed hall house once with lateral chimney and Bath stone
chimneypiece. Ceredigion has no surviving C16 domestic work,
in marked contrast to Merioneth to the N. Why is this?

The remodelling of Laugharne Castle for Sir John Perrot, the
great courtier responsible for the sumptuous new wing at Carew
Castle, Pembs., was on a much larger scale, though Laugharne
was a lesser work beside Carew. Perrot in two campaigns before
his downfall in 1592 remodelled the inner gatehouse with mullion-
and-transom windows and inserted a new domestic range
between two existing round towers. This range, while plain, marks

Ceiling from Vicar Prichard's house, Llandovery, now at Llwynybrain.
Engraving

the introduction of RENAISSANCE SYMMETRICAL PLANNING
to the county. The new symmetry is first seen elsewhere in the
early C17 wing at Llethr Cadfan, added to the C16 storeyed hall. 38
The contrast could not be more instructive, with two big cross-
mullioned four-light windows placed evenly, lighting the big first-
floor parlour, and an outer pair of smaller windows with
hoodmoulds, long blocked. The parlour had panelling and a
ribbed plaster ceiling, that may have been like the one once at
Neuadd Newydd, Llandovery, the demolished house of the
famous Vicar Prichard (1579–1644). His house, of c. 1620, was of
a type familiar in Cotswold towns: two storeys and attic with
dormer gables on the wall face, and big wood mullion-and-
transom windows, as at Llethr Cadfan. The ceiling in panels
between moulded beams had thick plaster ribs forming diamond
compartments enclosing fleurs-de-lys and other devices. A section
survives reused at Llwynybrain, Llandovery, but no interior dec-
orative work of the pre-Civil War period remains *in situ* apart from
a weathered overmantel at Green Castle. Thomas Dineley in 1684
noted stone-carved heraldry and Latin verse at Muddlescwm,
Kidwelly, and there is a remarkable lateral chimney at Gwempa,
Llandyfaelog, with saw-tooth ribbing, but lack of workable stone
must have discouraged display. The greatest house of the period,
Golden Grove, begun in the 1560s, had thirty hearths by 1670,
but was destroyed by fire in 1729 without record save Lord Ash-
burnham's comment of 1687, 'a fine, wholsom place'.

The most distinctive example of RENAISSANCE PLANNING is
at derelict Edwinsford, Talley, square in plan with a pyramid roof
and apex stack. It has been dated to before the Civil War by
analogy with other Welsh examples (themselves deriving from
Holland via Sir Richard Clough's Bachygraig, Flints. of 1567),
and also because the added range had ceilings typical of the post-
Restoration period. Trawsgoed, Llanafan, as depicted by Dineley
in 1684, had a symmetrical three-bay single-pile main house over-
looking a courtyard flanked by ranges with typically Cotswold
gables. As the family fortune was made by Sir John Vaughan
(1603–74), who was buying land in the 1630s, there is the possi-
bility that the central range is a pre-Civil War building. But
Vaughan's London career was at its peak after 1660, and it is
more probable that the central block, damaged in the war, was
rebuilt then. The courtyard ranges may have been earlier C17.

When rebuilding began after the Civil War, Newton House, 39
Dinefwr seems to have been an early double-pile house in the
region, with a date of 1660 (now lost). Newton House has one
of the series of heavily decorated later C17 CEILINGS that are the
finest single architectural legacy among the country houses of the
region. The others are at Derwydd at Llandybie and Plas Taliaris
at Taliaris, with lost examples at Edwinsford and at Coalbrook,
Pontyberem (dated 1670). All are panelled, with thickly moulded
beams and wreaths in the panels and winged cherubs' heads in
the corners. The detail suggests that the same hand was involved
in most, if not all, and probably not a locally trained one. Plas y
Wern at Llanarth, the one example in Ceredigion, is in the same

Newton House.
Water colour

tradition, but different in detail. Newton House and Plas Taliaris
have staircases with thick turned balusters and big finials and
pendants to the newels, and similar staircases are found in
smaller gentry houses, such as Pentre Meurig and Neuadd Fawr,
both at Llanwrda. The latter pair are interesting as, although of
similar scale, the former has the fashionable large hipped roof
while the latter has the gables typical of the earlier C17. Ynys
Greigiog, Furnace, Ceredigion, illustrates even more dramati-
cally this older tradition, with a window on each floor of the tall
front gable and a massive side-wall chimney. In the same region,
the Pryses of Gogerddan built two up-to-date houses. Plas
Gogerddan, Penrhyncoch, rebuilt in the late C17, has a hipped
roof and symmetrical front (much altered since), and Lodge
Park, Tre'r Ddol, is a small hunting lodge, of three bays to a
double-pile plan. The double-pile plan is rare in the region
because many houses were remodelled older buildings, and tra-
dition well into the C18 was for single ranges. Staircases by the
end of the C17 dispensed with the newel finials and tended to
barley-sugar twist balusters, as at Edwinsford and Plas y Wern.
The much thinner twisted balusters at Gogerddan must indicate
an earlier to mid-C18 date for the staircase there.

In the early C18, the minor gentry houses probably still had
timber cross-mullioned windows, with leaded lights, as survive
44 at Gelli, Trefilan. Those of higher status like Llanelly House,
Llanelli, dated 1714, had large sash windows, token of a new sen-
sibility. The complex façade at Llanelly House, with alternate bays
advanced, urned parapet and thickly moulded cornices in the
advanced bays, has a Baroque movement which cannot be found
43 in other houses. By the time Plas Taliaris, Taliaris was recased
c. 1725, with a complete façade of Bath stone, a more static regu-
larity had taken hold, still with the urns and parapet, but a rusti-
cated ground floor, pediments over the main windows and the

upper floors delineated in quoins or channelled piers. The detail at Taliaris is suggestive of the Bristol region. Nanteos, of 1739–54, is similar in outline, double-pile, with urns, parapet and rusticated ground floor, but more provincial in detail. The scrolled pediments are apparently reused from another house, and the narrow ashlar centrepiece has arched first-floor windows and attic roundels, more Vanbrugh than Palladian. Much more elaborate, but also between Baroque and Palladian, was Glanbran, Cynghordy (dem.), a double-pile of seven bays and three storeys with quoins, balustrades and a big central Palladian window over a Baroque broken-pedimented doorcase. Aberglasney, Llangathen, a plain double-pile house of three storeys and nine bays, with hipped roofs, had a Baroque tall doorcase with roundel above, removed for the present portico. Plainer still were the houses of two of the leading Carmarthenshire families, Stradey and Golden Grove, known only from illustration. Both were single-pile houses of nine and seven bays respectively, without ornament or parapets. Minor gentry houses like Fforest at Brechfa, 1724, and Erryd, Cilycwm, have had regular façades without ornament, and steep roofs. Fforest is a double-pile house with massive chimneys on four end gables, but is the result of adding a front range to an earlier house. Erryd has a single front range with a rear kitchen wing.

INTERIORS of the first half of the C18 tended to panelled rooms, as in the upstairs drawing room at Cwmgwili, Abergwili and in Llanelly House, the panelling in large panels. The dining room at Plas Llangoedmor, Llangoedmor, as late as *c.* 1760, has swan-neck scrolled pediments over the wall panels but Kentian or Palladian pedimented doorcases. The best earlier or mid-C18 staircase is at Nanteos, *c.* 1750, with broad treads and balusters of the column-on-vase type. Similar if simpler balusters are found at Plas Llangoedmor. Painted overmantels and overdoors survive at Llanelly House, Plas Taliaris and also at the remote Strata Florida (now Great Abbey Farm).

Two houses had domed corner towers of the 1760s attached to the outer angles, a romantic feature that must have been especially notable at Peterwell, Lampeter, where the house was a relatively small cube, but only the ruin remains. Newton House, Dinefwr, a stone house only a century old, was given corner towers apparently in brick with copper elongated domes, but is only readable in outline now, as the house was cased in Gothic stonework in the 1850s. The work was paralleled by improvements to the park, apparently designed by the owner, *George Rice*, with advice from *Capability Brown*, whose role is still not fully understood.

Ty Glyn, Cilcennin, probably of 1768, with straightforward proportions of five bays, two storeys and three dormers, plus the added wings, all whitewashed, is a rare survivor of the houses of Ceredigion minor gentry, seen also in simple stuccoed houses of three bays and three storeys built towards the end of the century, as at Abermeurig, and the Henblas at Abermad, Llanilar.

The mid 1770s, a period of feverish building nationwide, produced several substantial rectangular boxes, only one of which was ambitious. This is Iscoed, Ferryside, a ruined shell now but still bespeaking quality. Begun in 1772, most probably by *Anthony*

Keck, its brick walls were unique to the area and the big hipped roof behind a parapet set it apart from the standard double-pile carpentry of the other three. Photographs of the vanished interior indicated a refined hand, as do the pavilion wings attached by screen walls. Keck was assisted at least once by *John Calvert* of Swansea who designed Highmead, Llanwenog, as a standard five-bay, three-storey house, now smothered in Victorian alterations and additions. The same basic form appears still today at Castle Hill, Llanilar, of 1777, by an unknown hand, and Plas Cwmcynfelin, Llangorwen, which C. R. Cockerell's diaries tell us was by a London architect named *Dixon*, of the same period. Uplands, Llandyfaelog, of three storeys and five bays, survives least changed externally. It has delicate interior cornices similar to those lost at Iscoed, close by, and could be by *Calvert*. The fact that an ornamental plasterer, *Stephen Poletti*, was based at Carmarthen in the later C18 shows that the region could support craftsmanship of quality, but all his documented work has gone.

58 Plas Llansteffan can now be dated to 1780. This was the domain of a rich London lawyer, set on a hillside terrace with coastal views. A long low two storeys, originally with a central Palladian window, it is externally plain but the entrance hall is the grandest Late Georgian work in either county, with Corinthian two-column screens. The stable block, awaiting restoration, dated 1788, has a quite different and remarkable spare architectural character, Neoclassical stripped to the minimal, with pyramid-roofed centre cube and low wings. No architect is known but *John Nash* was newly arrived in Carmarthen.

The defining moment that can be used to mark the advent of the REGENCY PERIOD in West Wales was the flight of *John Nash* from London to Carmarthen in 1785. He re-emerged as an architect in the early 1790s and his talent blossomed, putting West Wales for a brief moment at the forefront of innovative small country house design, before he returned to London in 1796. Sadly little survives – two good houses in Pembrokeshire, one good house and one barely recognizable in Ceredigion, and none 60 in Carmarthenshire. The Ceredigion house, Llanerchaeron, carefully restored by the National Trust, is an older house remodelled, so not allowing externally the invention of Nash's new free-standing villas, like the demolished Llysnewydd, Llangeler, 61 but the interior, upstairs in particular, is delightfully contrived. The exterior had much in common with one of Nash's first houses, Llanvaughan (Llanfechan), Llanwenog, *c.* 1790, long demolished.

The awakening of interest in romantic landscape gave Ceredigion two houses of great importance, both demolished. Thomas Johnes's Hafod was built in the remote upper Ystwyth valley, in the centre of an estate of wild but impoverished beauty. The house, by *Thomas Baldwin* of Bath, 1786, was Georgian Gothic, more pretty than sublime. It was enlarged in 1793–4 by *Nash*, burnt in 1807, and rebuilt by *Baldwin*. The Picturesque enhancements of the landscape attracted multitudes of visitors, includ-

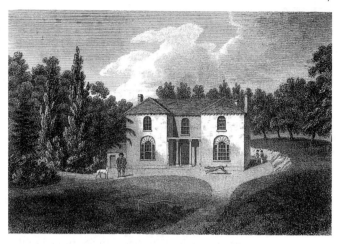

Llanvaughan, Llanwenog, attributed to John Nash.
Engraving

ing artists, to this most remote county, and Johnes's achievements
were widely celebrated. The landscape survives with some fea-
tures of Johnes's time restored, but few buildings. The same sen-
sibility that created Hafod created also *Nash*'s long-demolished
Castle House, the triangular villa for Uvedale Price, theorist of
the Picturesque, on the foreshore at Aberystwyth, 1791–4. This
was a villa of remarkable modernity, not a castellated folly but a
complex experiment in solid geometry.

Other than Hafod and Castle House, it was not Nash's dis-
creet rural retreats which caught the eye of travellers, but rather
it was Middleton Hall, Llanarthne, by *S. P. Cockerell*, 1793–5. This
opulent classical hilltop palace (not actually large but effective
from its grand proportions) was considered the best house in
West Wales, the more so after the completion of its landscaped
park by *Samuel Lapidge*, and the huge folly, Paxton's Tower, also 62
by *Cockerell*, *c.* 1808. The house has gone but the park has come
back to life as the National Botanic Garden of Wales, and Cock-
erell's fine stable courtyard has been restored.

The first LOCALLY BASED ARCHITECTS appear soon after
1800. Some were outsiders who saw opportunity in the area, like
Thomas Bedford from London who came to Llandeilo *c.* 1805,
possibly to oversee Abermarlais, Llansadwrn (dem.), but little is
known of his ten years' residence. Others were home-grown
talent from building backgrounds, like *David Evans* of Cardigan
and Fishguard, whose Castle Green House, Cardigan, 1827, is a
competent Regency villa. Someone not yet identified in the
Cardigan area had taken note of Nash's work. Gelli, Trefilan,
c. 1800, uses an elegant Nash vocabulary but the simplified plan
is not like Nash and there are three villas with centralized
plans like Nash's, but lacking Nash's finesse: Glandwr, Tresaith, 59
1809, Treforgan, Llangoedmor, *c.* 1810, and Plas Trefilan, Trefilan,

1828–30. Glandwr was for the Lloyd Williams family of Gwernant, Troedyraur, whose classical house of *c.* 1805, now ruined, may have been by the same hand, as also the first part of nearby Plas Troedyraur, Beulah. Alltyrodyn, Rhydowen, though well arranged within, has an unrelieved seven-bay, three-storey façade, probably by a local hand, even if the service courtyard is almost a copy of Nash's at Llanerchaeron. Glansevin, Llangadog, has some affinity to Nash, but the tall proportions may pre-date his time, as the house is remodelled from something older. The cantilevered stone stair and reeded door surrounds suggest good Regency work after Nash's departure.

Lord Cawdor, who inherited the Golden Grove estate in 1804, might have been a transformative patron in the region, but falls short of that. He first employed *William Jernegan* of Swansea for repairs and improvements, then *J. P. Pritchett* of York, son of his private chaplain. Pritchett designed farmhouses and the agent's house, Moreb, Llandeilo, an early example of Neo-Tudor. But for rebuilding Golden Grove itself in 1826 Cawdor turned to the architect then highest in court circles, *Jeffry Wyatville*. Cawdor showed the plans to the King, who expressed admiration, Cawdor was raised to an earldom the next year, but the resulting house is more solid than inspiring, Neo-Elizabethan with an appropriate Scottish touch.

The dominant name in West Wales in the early C19 is that of Haycock, the architectural dynasty from Shrewsbury. Edward Haycock had a great deal of work across most of Wales from the 1820s to the 1850s, but his father *J. H. Haycock* may have preceded him in the w, at Glandyfi Castle, Glandyfi, *c.* 1812, a small romantic castellated house set high over the Dyfi. *Edward Haycock* produced a series of neat Late Georgian stuccoed houses, for reasons of economy not reaching for the grander classical embellishment of his larger houses elsewhere. His first in the region was probably Neuadd Fawr, Cilycwm, *c.* 1828, now a shell, but a good design with giant pilasters on the outer bays. It has a most remarkable cast-iron porch with four big fluted columns in a scholarly Ionic, of unknown provenance. Giant pilasters feature also on Plas Llangoedmor, 1833, and Monachty, Pennant, *c.* 1835, which with Alltlwyd, Llanon, 1832–4, form a coastal Ceredigion group that shows why Haycock was so popular with gentry of middling fortune. Neat, very functional, well built, their elevations have a pleasing dignity. *C. R. Cockerell*'s demolished Derry Ormond, Betws Bledrws, 1824, was more subtle than any of Haycock's houses, a free-standing villa with varied façades and deep overhanging eaves.

After the building spree of the early C19, the next generation achieved less. *Edward Haycock* continued to be called back. He may have been responsible for the tall and elegant porte cochère at Aberglasney, Llangathen, *c.* 1840, and may be the hand responsible for the intriguing interiors at Nanteos, where his name occurs from the 1830s to the late 1840s, but he found less inspiration in the Neo-Tudor and Italianate of the 1840s and 1850s. His first fully considered essay in the Tudor, Stradey Castle,

1847–55, is gabled and mullioned in smooth sandstone, and entirely symmetrical in an Early Victorian way. Penylan, Llandyg-wydd, 1854, is stuccoed Italianate with deep eaves and a two-storey canted bay. There are good large rooms and an impressive stair hall (later grandly decorated), but the architecture is essentially bland.

The only other architect building country houses regularly in Carmarthenshire was *William Wesley Jenkins* of Carmarthen. His work, as at Hafod Neddyn, Llangathen, 1855, and Brynmyrddin, Abergwili, 1857–8, lacks finesse. Bolahaul, Llangunnor, 1855, is the most appealing – a square villa in grey limestone with Baroque touches. Gellideg, Llandyfaelog, 1852, has a tiny campanile based on Prince Albert's at Osborne House. Another Osborne derivative was Pantglas, Llanfynydd, 1853–5, by the London architect *E. L. Blackburne* for David Jones, banker and M.P., but only the campanile survives. In Ceredigion, *William Coultart*, based at Aberystwyth in the 1840s, did minor work at Llanerchaeron and Nanteos, and supervised *Anthony Salvin*'s very large Italianate addition to Hafod, 1846–51, dramatic from a distance, although it overwhelmed Johnes's Gothic house. This had the largest Osborne tower of the region. Coultart may have designed the additions of *c.* 1840 to Trawsgoed, Llanafan, more remarkable for the decoration of the library than the rather cramped exterior. A smaller but charming Italianate tower appears on *R. K. Penson*'s lodge at Nanteos, 1857 and an even smaller one on the service wing at Castle Hill, Llanilar, *c.* 1862.

92

The GOTHIC REVIVAL with its high building costs was unlikely to appeal to a mostly modest squirearchy. A few gambled their fortunes for a high-status house, which their heirs came to regret, so that most have gone. *R. K. Penson* was the principal provider from the 1850s. Bronwydd, Llangynllo (dem.) of 1853–6 was a dramatic remodelling of a Georgian house in a Camelot style, based on the Rock of Cashel, for Sir Thomas Lloyd, enthused by things medieval. At the same time Penson was re-casing Newton House for Lord Dynevor in a stone-faced Gothic that was not quite Venetian and won little approval. Rejected schemes show that he hoped to build something grander. Penson's Penywern, Llanfihangel y Creuddyn, 1859, was praised in *The Builder* as 'a good, serviceable-looking house . . . to which character is given without effort'. The comment is based on a perspective shown at the Royal Academy, but, as built, the house is laboured with a complexity of roof shapes typical of Penson. Coomb, Llangynog, 1864–5 and Cwmrhuddan, Llandovery, 1869–71, both have multiple roofs and look like Penson's work, though the former is perhaps a little too muscular. The latter has a massive square addition that may be by Penson's younger partner, *Archibald Ritchie*.

Outside architects built most of the prominent houses. *T. Talbot Bury* wrapped Italianate detail around Falcondale, Lampeter, 1859, for the Bristol banker, Harford. The style is unexpected both from this former associate of Pugin and for the owner of Nash's Blaise Castle, Bristol. *Benjamin Bucknall* enlarged

Danyrallt Park, Llangadog, 1864–5, in a Gothic to Tudor mix,
now demolished. Alltyferin, Llanegwad, 1869, also demolished,
was by *Raphael Brandon*, not known for country houses. The best
90 houses of the later C19 were High Victorian Gothic: Abermad,
Llanilar, 1870–2, by *J. P. Seddon*, and the now-ruined Tegfynydd,
Llanfallteg, 1873–5, probably by *F. R. Kempson*. Abermad,
without the flamboyant insouciance of Seddon's Castle Hotel,
88 Aberystwyth (now the Old College), is remarkable for careful
asymmetric design, Puginian in form that follows function,
Ruskinian in the primacy of sheer wall and the touches of struc-
tural colour. Significantly the library stained glass depicts
Ruskin's Seven Lamps of Architecture. The additions to Stradey
Castle of 1874 include a dramatic and romantic tower (conceal-
ing a practical water tank) and equally romantic top-lit Gothic
91 stair hall, an exercise in artistic bravura appropriate for the artist
owner, who may have contributed to the design. Much less
successful, though impressive in length, were the additions of
the same period, also apparently designed by the owner, at
Highmead, Llanwenog.

 Late Victorian houses of interest are few. Lovesgrove, Llan-
badarn Fawr, 1882–3, by *John Macvicar Anderson*, was built for
the brother of the owner of Abermad, but could not be more dif-
ferent. Long and low with homely gables, it is softened internally
with touches of the new Aesthetic movement. *John Middleton* of
Cheltenham replaced John Nash's pretty Emlyn Cottage, Adpar,
with the unlovely Cilgwyn, 1881–5, a mass of grey masonry a little
relieved by some half-timbering on the skyline. Local architects
built few country houses: *George Morgan* designed Glanolmarch,
Llechryd, 1883–5, with a pair of large bargeboarded gables, and
David Jenkins of Llandeilo glumly refronted Derwydd, Llandy-
bie, in 1890. There are late C19 schemes of painted decoration,
at Penylan, Llandygwydd, by *Morant & Co.*, added to a scheme
92 of the 1850s, and in the library at Trawsgoed, Llanafan, also
added to existing work, possibly by *Maples*, 1900.

 The early C20 has left few houses of significance. Penrallt,
Aberporth, 1906–7 by *J. H. Morgan*, is red roofed with the turned
woodwork typical of Edwardian villas. It has good heraldic
stained glass. Cilymaenllwyd, Pwll, 1911–13, is memorable for
size more than design, a doubling of a mid-C19 house. By far the
most ambitious was Maesycrugiau Manor, Llanllwni, by *Arnold
Mitchell*, but only the service court was built. It would have been
one of the largest houses of any period in the region, an Eliza-
bethan E-plan mansion, and the quality of what was built makes
the unfulfilled ambition regrettable.

VERNACULAR HOUSES AND FARM
BUILDINGS

Before the later C19 the rural buildings of both counties were
made of materials available locally: either stone, or in areas with
little building stone, such as the Aeron valley, earth walling, called

clom. Some early timber framing is likely, but none survived the rebuildings of the C18 and C19. The stone tended to be porous, and buildings were sheltered from wind-borne damp by lime renders and limewash. Making a feature of stone was not common until the later C19. While houses were generally rendered and limewashed, outbuildings were commonly limewashed only. Thatch was the dominant roofing material before the later C19, now vanished except where surviving under corrugated iron, or in a few restorations. The age range of smaller rural houses is relatively narrow, most surviving from the C19. In Ceredigion, houses of the C18 are rare, those of the C17 exceptionally so, and are probably all of gentry status. Carmarthenshire has more early houses, but again those are mostly likely to be houses of the minor gentry.

FARMHOUSES were either detached or joined to outbuildings. Where the house was attached to the byre, the true long-house had the house and byre entered by the same door, into the top end of the byre, from which a door gave access to the principal room of the house, next to the chimney. If there was a loft, there would be a winding stair on the other side of the chimney-breast. This type survived into the C19 especially in the uplands of Carmarthenshire.

Early examples, C17 and later remodellings of what perhaps were late medieval cruck-framed halls are Aberdeunant, Llansadwrn and the much smaller Gellicefnyrhos, Talley. Most of the byres are later rebuildings, presumably due to changes in agriculture, and many farmhouses are altered to a central entry or other direct entry from the yard. Good examples in Carmarthenshire are Ty'n Coed, Cynwyl Gaeo; Cwm Eilath, Llansadwrn; Maescastell, Talley; and Cwm Cynwal, Llanwrda. Some LONG-HOUSES were very small indeed, as at Ty'r Heol, Felinfoel, a house with a half-loft, or *crogloft*, rather than a full loft. Rhiwson Uchaf, Llanwenog, the best long-house example in Ceredigion, is on a larger scale, comparable to Aberdeunant, and early – late C17 or early C18. Ynys Eidiol, Furnace, Cd., is a long-house with entry moved to the centre.

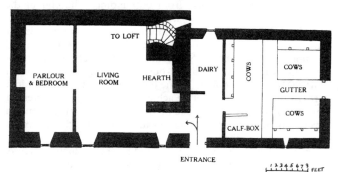

A Carmarthenshire long-house.
Plan

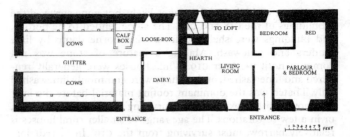

Cwm Eilath, Llansadwrn.
Plan

Long-houses typically had a single chimney between house and byre, but were often modified to have a small heated parlour at the other end, which with an inserted central door converted them to the other typical farmhouse plan, the house with end chimneys and a near-symmetrical front. Façades were rarely precisely symmetrical before the later C19, as the kitchen chimney was much larger than the one in the parlour, giving more wall to the kitchen end. Cwm Eilath, Llansadwrn has the typical modified plan, with new entry.

Ty'rllandre, Llanegwad, is a small early end-chimney house, single-storey, with some clom, probably early C18. The two-storey type is found from the mid C18, with big fireplace offsets sometimes pierced for a tiny fire window, as at remote Alltgochymynydd, Talybont. Substantial two-storey stone farmhouses, often facing over their farmyards, include Foelallt, Ciliau Aeron, of the mid C18, Glanmarch, Betws Leucu, later C18, and Coedfoel, Prengwyn, dated 1832. The conventional plan has kitchen and parlour divided by a central passage aligned on the staircase, sometimes with outshuts behind for the stair and narrow service rooms. Gables over rear staircases appear on larger, probably minor gentry, houses, as at Pantydefaid, Prengwyn.

The separation of house from outbuildings, the end of the long-house tradition, can be seen in two houses of similar dates at Talley. Rhydarwen, 1777, is still a long-house, though larger than usual, but Danycapel, 1774, is nearly symmetrical, with end chimneys, and separate. Separation, increasingly a feature of convenience, as in the well laid-out Late Georgian farmstead at Barley Mount, Llandovery, or the big farmyard at Cefn Gwyddil, Cross Inn, often could not be achieved on tight hillside sites. At Treglog, Llansawel, the house of 1819 is at the downhill end of a very long row of outbuildings, presumably added there because there was no alternative.

From the early C19, window size and height gradually increase, the farmhouses of the C18 having very low upper floors with small windows at floor level, those of the C19 raising the upper floor to a full storey. The Late Georgian small-paned sash remained the typical window into the later C19, often economically with only

one half opening, and that regulated by chocks, not sash cords and weights.

The house-plan with a central chimney and a small lobby inside the front door, common elsewhere in Wales, is almost unknown. Troedyrhiw, Cwm Cou, is one example, perhaps an estate cottage, representing the interest in varied plan forms shown by early C19 landowners. The house-plan with the door in the end wall by the main chimney was not reserved for long-houses and is found into the mid C19 in small cottages, as at Llangorwen Cottage, Llangorwen.

Farmhouse INTERIORS were most often divided by thin par-titions of lath and plaster or timber boarding. These partitions are successors to the plank partitions of the C17 and early C18, common in SE Wales, but very rare here; one exists of the later C17 at Blaensawdde, Llanddeusant, a gentry house. The winding stair by the kitchen fireplace is found especially in upland farm-houses, like Cwm Eilath, and in many cases a recess by the main chimney indicates one removed when the house was raised to a full upper storey and given a central stair.

ROOF TIMBERS tended to be thin with much use of elm, sycamore and ash except in high status houses. The majority used the A-frame or collar-truss. A few cruck trusses survive, gener-ally also rather thin, and raised on blocks in the wall rather than full crucks. Aberdeunant, Llansadrwn, appears to have a pair, 6 perhaps indicating medieval origins as a hall house, and Gwastad Gwrda, Abermeurig, dated to the C16, a very rare date in Ceredi-gion, has three raised crucks; the fact that the central chimney is clearly inserted indicates that it began as an open hall. The typical cruck type is the rough scarfed or jointed cruck, each blade in two pieces with an elbowed wall-post jointed to the principal. It seems that this arose from structural necessity of avoiding outward thrust by transferring the load from roof trusses down into walls of poor materials. The scarfed crucks have a long period of use, starting later than the true cruck, in the later C17 and continuing through the C18. One example is dated 1739. They are sometimes associated with the remodelling or rebuild-ing of older structures, where a loft was inserted into an open hall, as at Ynys Felen, Dihewid, or Aberdeunant. Cwm Cynwal, Llanwrda, has them as original.

Most of the SMALLEST HOUSES built before 1800 have been demolished or rebuilt. In the upland areas they were very rudi-mentary structures, especially those built on marginal land encroaching onto common land. No example of the legendary *tai un-nos*, or 'one-night houses' (built between sunset and sunrise and claiming an axe-throw of land around), supposedly legitimated by a law of Hywel Dda, can be identified either actual or in documents, but the early C19 tithe maps show many tiny holdings pushing into marginal uplands. It is likely that many a Ceredigion lead-miner's cottage originated as a squatter's hovel, and hovels to shock the tourist were readily found. One at Pon-terwyd in 1800 had just a single room with a small hole to admit the light, and an entrance with no door, but a blanket. The 1847

Vernacular house near Strata Florida.
Print, 1888

survey of education found the schoolmasters at Strata Florida
and Cynwyl Gaeo in similar hovels. A long-house at Strata
Florida, drawn in 1888, provided the most dramatic visual evi-
dence of poverty, with its complete lack of comforts and almost
complete lack of daylight. These houses, associated with small
holdings were single-storey, some with no internal subdivisions
save those created by furniture such as beds. Orfa Ddu, Cilcen-
nin, Cd., is of the smallest type, a single room with a lath-and-
plaster fireplace hood. These fireplace hoods were topped with a
chimney of woven hazel or other material, and thatched to a
cone, as restored at Troedrhiwfallen, Cribyn, and Llwyndrissi,
Pencarreg. The smallest houses had enclosed beds in the main
room, and developed in size with a narrow room at the other end,
divided by a partition, this room often unheated and used as a
bedroom. Above this smaller room could be a sleeping loft or
croglloft reached via ladder. The type was extremely common in
both counties, but good surviving examples are now rare; Llanon
Cottage, Llanon, is much restored, but preserved as a museum.
Here both rooms are heated, and there are cobble floors and
ladder access to the *croglofft*. Clyn, Henllan Amgoed, is a small
earth-walled cottage, formerly thatched. The final phase was for
the loft floor to be extended right across, with stairs either by the
main fireplace or in the centre, and for small rear outshuts to be
added for a dairy and pantry. Many such cottages were raised to
two full storeys with enlarged outshuts in the later C19.

Materials in the smallest cottages were basic – floors of beaten
earth, hardened with animal blood, or cobbles as at Llanon, later
replaced with slate flags or clay tiles. The partitions when plas-

tered tended to use hedgerow thinnings instead of split laths, woven hazel, even bramble. Roof timbers were simple collar-trusses of roughly halved trees with hedgerow poles for rafters. By the later C19 sawn pine was usual for roof trusses. Single-storey cottages survive in large numbers, but most are altered. Good single examples include Talfan, Llanddowror, and Clyn, Henllan Amgoed. Rows of cottages survive on roadsides, particularly in Ceredigion. Cnwc Coch, Llanfihangel y Creuddyn, is a settlement of cottages, apparently established by squatters in the late C18 on unenclosed land. Ceredigion lead miners were often housed in single-storey rows, called barracks, close to the mines. These are all ruined, but look little different in plan to those shown in William Waller's drawings of the mines in 1704.

The FARM BUILDINGS divide between those of the poorer uplands and those of the richer more fertile river valleys, such as the Tywi, Teifi, Cothi and Aeron. Much of the uplands remained unenclosed, despite activity by C18 improvers like Thomas Johnes of Hafod and the drive to produce crops during the Napoleonic Wars. Much of the farmland was tenanted until the later C19 and C20, owned by estates varying from large ones such as Edwinsford, Nanteos, or Golden Grove down to those of the lesser gentry. The farms themselves varied in size from an average of 100 acres (40 hectares) in upland areas in the late C18 and early C19, to smaller more concentrated farms in the fertile river valleys. Below this tier came many smallholdings of just a few acres where the tenant might be tied to a local farm or be occupied in another trade. Both counties were predominantly pastoral, with sheep and cattle reared in upland areas and dairying in lowland areas. Cereal was grown on most farms for domestic use, but the wet acid soils, particularly of N and E Ceredigion, prevented cultivation on a wide scale. The alluvial soils of river valleys such as the Tywi, Cothi and Aeron were much more favourable for corn growing, as can be seen from the many C19 high-door barns still remaining in these areas, a type almost entirely absent from the uplands.

From the early C18, farms were generally let on long leases, often for three lives, the onus being on the tenant to maintain their farmsteads. By the early C19, improving landowners changed to shorter leases or tenancies, taking direct responsibility for house and buildings. This, and the general improvement of agriculture in the C19 between the depressions of the post-Waterloo years and the 1880s, meant that few farms were left unmodernized and C18 buildings are the exception. With the exception of very large or home farms, the buildings erected by the estates differed little from those on privately owned farms. The standard equipment of most farmsteads was a cow-house or *beudy*, distinguished by a row of doors for beasts, feed and mucking-out. Cows were tethered in short rows at right angles to the entrance wall until the later C19, when tethering in line along the rear wall (in front of a rear feed-passage) became the standard system. Cow-houses were often single-storey, though by no means always, while the stable, distinguished by one or two

small windows flanking the door, was generally under a hay-loft, which might extend over a cart-shed. These two ranges make up the typical farm, often in an L-plan arrangement with the farm-house on a third side and the lower end of the yard left open. The storage of crops was of lesser significance, hay being stored outside in ricks; grain in quantities too small to require a granary could be stored in the house or over the cart-shed. Barns in upland farms, if present at all, were small, single-storey ranges, distinguished by opposed doors at one end and narrow ventila-tion slots, the doors not large enough for a cart. By contrast the farms on richer Carmarthenshire land, notably in the Tywi valley, have large later C19 barns with high doors for carts, full thresh-ing floors and often large lofts within.

Sheep farming has left almost no impact in terms of buildings, as sheep were kept and shorn outside. On the bare hillsides dry-stone walls enclosing sheep-folds can be seen. All farms had one or several pigsties, generally attached to the end of a building. Dove nesting-boxes are frequently built into the gables and front wall of farm buildings. The large free-standing dovecotes are a rare feature of larger gentry houses, the one at Coleman Farm, Kidwelly, thought to relate to Penallt, Llansaint.

ESTATE FARMS are quite different from the average farmstead in scale, range of building types and fittings. Henllys, Cilycwm has a pedimented stable of 1829 and a fine estate yard with bailiff's house, cow-shed, high-door barn and coach-house/stable range, the latter dated 1831. At Manorafon, Ffairfach, the court-yard has buildings on all four sides, built c. 1800, the w stable range containing the entrance arch with a timber lantern. Castell Du, Llanwnen has an extensive set of whitewashed buildings around a large yard, mostly early C19, incuding barn and cart-house, cow-house, loose boxes, stables and duck-house. Alltyro-dyn, Rhydowen, has a home farm around a courtyard flanked by lofted granary and barn, the latter with arched gable openings for doves, dated 1834. At Blaenpant, Llandygwydd, is a mid-C19 model farm enclosing a courtyard, with two arcaded ranges of cow-houses behind opening onto walled yards. At Edwinsford, Talley, is a charming dairy with bellcote, dated 1743, a formal stable-court, dated 1802, and home farmhouse of 1822 with attached early C18 cow-house. At Llanerchaeron is an unusually complete series of early–mid C19 courts carefully restored by the National Trust. The first court has stables and coach-house, the second the estate farmhouse, and the main one the cow-house, granary, high-door barn, workshops and kennels. On a smaller scale, the three courts at Noyadd Trefawr, Llandygwydd, are suc-cessively kitchen, stable and farm. Ty Glyn, Cilcennin, has an unusual C19 timber granary on staddle stones.

Pattern-books influenced the design of estate farmhouses, most notably the mid-C19 Dolaucothi farms around Cynwyl Gaeo, with their pretty latticed windows and steep gables. *J. P. Pritchett* designed for the Cawdor estate the stuccoed hipped farmhouse at Bremenda Isaf, Llanarthne, *c.* 1817, and probably also Berllandywyll, Llangathen. Later C19 MODEL FARMS repre-

sent substantial agricultural investment. The major examples are for the Cawdor estate, at Tanylan, St Ishmaels, 1862 by *J. W. Poundley* who probably also designed the farm at Gelligatti, Cenarth, with cruciform model cow-house. A similar model cow-house is at Bath House Farm, Cardigan. At Trefenty, Llanfihangel Abercywyn is a late C19 model farm with centralized barn and projecting ranges allowing for feeding and milking under cover, and at Gellifaharen, Prengwyn, the farmyard of 1872 also has a covered cattle-yard. Around Cardigan in the 1860s the Priory estate, Cardigan, experimented with farm buildings, as at Treprior, Tremain, built of hollow terracotta blocks, made at the brickworks which the estate owned.

INDUSTRIAL STRUCTURES FROM EARLIEST TIMES TO MODERN TIMES

BY STEPHEN HUGHES AND JULIAN ORBACH

The two counties, though primarily agricultural, have long industrial histories based on mining, lead predominantly in Ceredigion, some also in Carmarthenshire, and coal in s Carmarthenshire. The extraction of lead, silver and gold may go back to prehistoric times, Roman interest in all three is certain, and the gold mine at Dolaucothi (Cynwyl Gaeo) may have been a major reason for Roman interest in Wales. Lead-smelting on a large scale dates from the C17, iron and tin-plate works began early in the C18. Extraction of coal is known from the C16, with one of the first canals in Britain, built in the C18 to bring coal to the coast. Tin-plating began in Kidwelly and moved to Llanelli, by the later C19 the world centre for the industry, and copper smelting spilled westward to Llanelli in the early C19 from its international centre at Swansea. The industries of South Wales sustained the later C19 woollen mills of inland Carmarthenshire and Ceredigion, mostly producing flannel for the industrial population. Quarrying of limestone was a major industry in s Carmarthenshire, burnt in kilns for agricultural lime, whitewash and mortar, and shipped all around the coasts. The coasts supported fishing and trading fleets and small-scale shipbuilding. Ports to serve industry developed at Llanelli and Burry Port on the s coast, while older ports at Laugharne, Kidwelly and St Clears declined through silting. On the w coast Cardigan was a major port for emigration in the early C19, New Quay and Aberaeron were sustained by coastal trade and fishing, and Aberystwyth shipped out the products of the lead mines.

Early Industry

The earliest beginnings of industry are obscure, but the working of copper and bronze may date from 2500 B.C., coming into widespread use by the Middle Bronze Age. No less than nine non-ferrous mine sites in N Ceredigion have finds of stone tools: these

include Llancynfelyn, Borth Bog, Darren (Penrhyncoch) and
Cwmystwyth. Four, including Copper (Copa) Hill, Cwmystwyth,
have been radiocarbon-dated to the Bronze Age. At several sites
large opencast workings can be seen, the most spectacular the
large rift down the SW side of Copper Hill where traces of fire-
setting and a timber drainage launder dated to the Bronze Age
have been found. The latter leads to a shallow channel down the
hill, possibly a sign of prehistoric 'hushing', the practice of scour-
ing away topsoil with controlled release of water to reveal ore-
veins below. But positive dating is difficult, as the practice was
used on the site as late as 1785. Traces of setting fires to fragment
the rock being mined have been found at the Dolaucothi (Cynwyl
Gaeo) gold mines and suggest a Bronze Age beginning here also.
At Dolaucothi the large opencast pit may, by comparison with
Continental examples, date from before the Roman period. The
long earthwork aqueducts attributed to the Romans supplied a
series of tanks or reservoirs used for scouring. The only parallel
for these silted rectangular tanks in Wales are those surround-
ing the opencast lead mine at Craigymwyn, Llanrhaeadr-
ym-Mochnant and at the lead mine near the Roman camp at
Dylife, both in Montgomeryshire.

Post-Roman mining is associated with the Cistercian abbey at
Strata Florida which earned a considerable income from lead
mines on its lands, and evidence of smelting has been found at
the abbey site. A radiocarbon date on the long leat on Copper
Hill that has further scoured out the great trench shows that it
had been used at a date prior to the late C15. An account for 1300
suggests that some three thousand pounds of ore had been
obtained that year, though commenting that only four miners
could be found to work the deposit, probably at Cwmystwyth.
Leland, visiting in the 1530s, said that there had been 'great
digging for Leade, the smelting whereof hath destroid the woodes
that sometimes grew plentifully thereabout', which confirms
extensive working, though possibly then in decline.

Early coal working is attested also by Leland, who noted two
types of coal: bituminous 'ring coles' from Llanelli, used for
blacksmithing, as they could be 'blowid and waterid', and
anthracite 'stones coles' from the Gwendraeth Fawr valley, that
are 'never blowen for blowing extinguishit them'.

The Land

Agriculture transformed the landscape from the earliest times.
Leland's remark about lead smelting deforesting the hills around
Cwmystwyth is followed by a perceptive comment that the bare
hills above Strata Florida had been wooded as evidenced by tree
roots, but had been denuded because proper coppicing was not
practised and that goats were allowed to eat any re-growth. He
also noted that the great woods had been destroyed so that they
should not harbour thieves. Travellers in the C18 tended to note
the backwardness of agriculture, and comment on the almost
complete absence of wheeled vehicles, missing perhaps the point

that in the upland terrain the sled was often more practical than the cart. Improving landlords included Thomas Johnes of Hafod, whose tree planting was on a large scale, though not obviously successful, no more than was his farming, in which he experimented with improving hill grazing and sheep breeding. Model farms of the C18 were followed by the more industrialized farms of the later C19, generally using water power for a range of processing and handling tasks. Farm water wheels survive in some numbers, made in local foundries in Aberystwyth, Cardigan and Carmarthen. Industrialized farmsteads are rare; Lord Cawdor built two – at St Ishmaels and at Cenarth, probably both by *J. W. Poundley*, who published designs for farmyards.

The Sea

Much coastal trading was to beaches and estuaries, formal harbours being restricted to a few protected sites and quays on the estuaries. Records of harbours date from medieval times, when estuarial quays existed at Carmarthen, Laugharne, Kidwelly, Cardigan and Aberystwyth. The stone PIERS and QUAYS tend to date from the later C18 to earlier C19: the harbour at the end of the canal at Kidwelly from the 1760s, Llanelli from *c.* 1799, Carmarthen quay 1803–6, Aberaeron 1807–9, Aberystwyth 1836–40, Burry Port 1834–6, and New Quay 1835. There were quay-end lighthouses at New Quay and Burry Port, the former surviving. There are a number of stone-built warehouses, of which the best are the two at Cardigan of 1745 and *c.* 1830, and the ruined one by the bridge at Kidwelly, that may be associated with C18 tin-plate shipment. Aberystwyth has a late C18 or early C19 corn store by Trefechan Bridge, and had four stores for lead-ore on the harbour, now gone. Shipbuilding was undertaken on many sites, including open beaches, as at Llangrannog and Aberporth. New Quay retains a pitch-house and Aberystwyth the stone wall flanking one of its two substantial C19 ropewalks.

Of the four DOCKS at Llanelli, three were kept permanently flooded or 'floating'. The New Dock of 1834 was the first public floating dock in Wales, largely infilled, the channel and mud-scouring reservoir remain. The North Dock, 1898–1903, was much the largest of the region, handling 700,000 tons a year, primarily coal and tin-plate. Burry Port, 1834–6, replaced a harbour at Pembrey at the end of the coal canal that failed through silting, and is the most intact surviving example of a tidal port in Wales with a mud-scouring reservoir, converted to the West Dock in 1888.

Water Power

The rivers of the two counties powered CORN-MILLS from very early times, and large numbers survive, a few restored, as at Cenarth, Llanwnen, Cwm Cou and Cynwyl Gaeo. Most mills were re-equipped in the mid C19 with an iron water wheel made in local foundries, the iron sometimes restricted for economy to

rims or hubs, driving a pit-wheel with spur-wheel gearing to a pair of mill-stones. Most had an attached corn-drying kiln necessitated by the damp climate. The primitive 'Vitruvian' direct drive from pit-wheel to a single stone survived well into the c19 in Ceredigion, one surviving example at Felin Hafodwen, Cribyn.

Water-powered SAWMILLS were introduced in the later c19, with examples built for the Trawsgoed estate at Abermagwr, Llanafan, the wheel dated 1868, and for the Llanerchaeron estate. A second wheel added to Felin Geri mill, Cwm Cou, in the 1880s powered a circular saw.

The concentration of population in the c19 in South Wales resulted in a booming demand for flannel, fed from WOOLLEN MILLS on the rivers of the region. The densest cluster of mills, waterpower leats and housing for workers and managers is at Drefach Felindre, but the tributaries of the Teifi were all used, and there was a cluster of mills at Talybont in N Ceredigion (serving the local lead mines). There were isolated mills all over the region, the most rural run in conjunction with a single farm, processing the wool of sheep from a small hinterland. Most of the surviving mills are later c19 or early c20 purpose-built, of stone with brick dressings, of two and sometimes three storeys. The mills are much smaller than the woollen mills of Yorkshire. Even the one at Maesllyn, Llangynllo, 1881–4, built to emulate Yorkshire mills, only employed fifteen in 1916. The era of the mills was from the 1870s until the 1920s, with greatest production during the First World War, and rapid decline thereafter. A revival during the Second World War meant that in 1947 there were still some fifty mills in production. Water power was not always essential, and some later large mills were built close to the railways to be powered by gas engines run on coal. The Cambrian Mills, Drefach Felindre, have become the national museum of the woollen industry, and small-scale craft production contin-
ues, notably at Rock Mills, Capel Dewi, Ceredigion, an intact mill of 1896.

Water-powered electricity generation was a by-product of the textile industry, and early local schemes using water wheels or turbines provided street lighting in Newcastle Emlyn and Talybont. On a much larger scale were the HYDRO-ELECTRIC schemes. The Rheidol scheme of 1957–64 retained water in the huge Nantymoch Reservoir (Ponterwyd) to be piped over several miles to the power station at Cwmrheidol, generating 49,000 kilowatts. The outflow of the Llyn Brianne reservoir, Ystradffin, 1968–73, created for water supply, was subsequently adapted for electricity generation.

Wind Power

The two counties had not been noted for windmills, but from the late c20 became prime sites in Britain for WIND TURBINES, much more so than neighbouring Pembrokeshire where sites were denied for landscape reasons. The most prominent group

are around Aberystwyth, eleven turbines at Llangwyryfon, 1994, nineteen at Mynydd Gorddu (Elerch), 1998, eight at Ponterwyd, 1997, and most recently thirty-nine at Cefn Croes, on the high ground E of Ponterwyd, 2005, these being the largest 1.5 MW turbines, their landscape impact muted by the extreme isolation of the site. Carmarthenshire has eleven turbines at Dyffryn Brodyn, Llanwinio, 1994, five at Parc Cynog, Marros, 2001 and three much larger ones, of 1.3 MW at Blaen Bowi, Newcastle Emlyn, 2002.

Extractive Industries

LIMESTONE QUARRIES AND KILNS. Lime was used for improving acid soils, for whitewashing buildings and in mortar for construction. The narrow limestone belt through S Carmarthenshire into Pembrokeshire provided both the lime and the grey limestone for building. Farmers built LIMEKILNS on the outcrop itself to burn the quarried stone, and a large coastal trade developed, with small boats taking the stone to coastal limekilns for burning. A particularly good group of early C19 kilns is at Craiglas, Llanon, and Aberystwyth harbour had no less than thirteen. The kilns were generally built into a bank to provide insulation and a ready-made ramp to the crucible, which was filled with layers of coal and limestone. From the mid C19 the railways all but ended the coastal trade and introduced an era of very tall large-capacity kilns at the quarries from which sealed wagons could safely convey the volatile product. The finest of all, the bank of kilns built by the architect *R. K. Penson* on his quarry at Cilyrychen, Llandybie, 1856, were spectacular enough for him to exhibit a perspective view at the Royal Academy.

SLATE. Slate was quarried mostly outside the two counties, though the quarries at Cilgerran on the Teifi and on the S side of the Preselis were close to the county borders. The only Ceredigion slate quarry was at Cymerau, Eglwys Fach, from 1887–1909, minimally industrialized.

COAL. The band of hard anthracite coal that finishes in S Pembrokeshire crosses S Carmarthenshire from the Amman valley across the watershed around Tumble and follows the valley of the Gwendraeth Fawr to the sea at Kidwelly. There were also deposits of a quite different, softer, bituminous coal further S fom the Loughor estuary to Llanelli and beyond. Anthracite was principally extracted from the very late C19 and into the C20, although it is mentioned by Leland in the 1530s and was prized for drying hops. It was of sufficient value in the 1760s for Thomas Kymer to build his canal down the Gwendraeth Fawr to Kidwelly. The oldest railway bridge in Wales, a rubble stone single arch over the river at Pwll y Llygod, Trimsaran, of *c.* 1770, was built for a coal-carrying horse-tramway to the canal. The anthracite mining settlements from Pontyates and Pontyberem in the W through Tumble and Gorslas to Tycroes, Ammanford and the upper Amman valley tend to have a more scattered character than those of the South Wales valleys, without the dominant structures of

deep mining. Post-industrial landscaping has smoothed away
most of the large waste tips, but opencast mining continues at
Cynheidre, SE of Pontyates.

Mined coal in the Llanelli seam has all ceased and the remains
have been mostly cleared. The winding engine and head-frame
from one of the last sites, the Morlais colliery, NE of Llangen-
nech, is re-erected at the Kidwelly Industrial Museum. Llanelli
coal was exploited early, and the area heavily capitalized in the
C18 with water and steam-powered pumps and winding engines,
erected with London capital. There were stone engine houses of
early date, one at Genwen, E of Llwynhendy, dated from 1806.
Horse-drawn tramways took coal from the collieries down to the
coast, the raised embankment of one surviving at Pembrey. Coal
brought metal-working (*see* below) and the world's third iron
railway bridge (after the two at the Cyfartha Ironworks, Merthyr
Tydfil) was made by the ironmaster Alexander Raby at his works
at Furnace. It crossed the River Lliedi and dated from 1798–
1802, and was follwed by a second bridge upstream, *c.* 1801, pro-
bably also of iron, but both have disappeared since the course of
the river was changed.

LEAD, COPPER, SILVER AND ZINC. The lead-mining area was
principally in N Ceredigion, though there were important mines
in Carmarthenshire. The recovery of lead and the associated
silver, copper and zinc is a remarkable story of industrial orga-
nization from an early date. German miners are recorded in the
C16, reputedly introducing the railway, in the form of hand-
propelled wagons in a mine near Talybont. A German mining
engineer, Cornelius Le Brun, leased the Cwmystwyth mine from
1664 and married the heiress of the Nanteos estate. In the early
C17 it was mostly the silver that was the primary attraction. Sir
Hugh Myddelton, who leased the mines from the Crown in 1617,
sent half a ton to the Tower of London in 1625–6. His successor,
Thomas Bushell had enough to mint coinage at Aberystwyth for
Charles I. After the Civil War there was a slowing of activity until
silver-lead was found in the late C17 at Esgair Hir, Talybont,
initiating a new phase of exploitation.

A Description of the Mines in Cardiganshire, written *c.* 1704 by
the engineer William Waller, illustrates the state of the industry
at the point when very large sums had been subscribed for mining
ventures promoted by Sir Humphrey Mackworth of Neath and
his Company of Mine Adventurers. The accompanying plans
show operations of great sophistication, for example a water-
powered stamping-mill at Cwmystwyth; large scale silver mills at
Furnace, apparently built in the 1620s, the mill with five fur-
naces, a mint house, a stamping mill, a refining mill and a red
lead mill; and a large lead-smelting works at Glandyfi begun in
1703 and intended to have sixteen furnaces, with nearby a pair
of refining-mills with eight furnaces. Mackworth's enterprise,
with twenty-eight different mines, foundered after 1710 and for
much of the C18 the mines struggled in face of excessive profit-
taking and conflicts between landowners and the Crown, which
took new interest in the area in the mid C18.

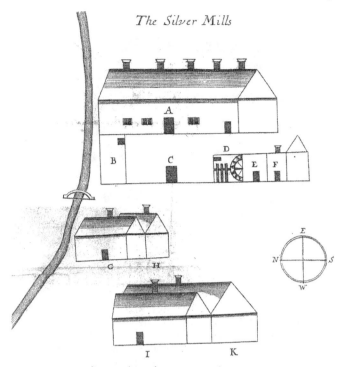

The Silver Mills

A *The Silver Mills with five furnices*
B *The Old Mint House*
C *The Yard*
D *The Stamping Mill*
E *The Mill to Grind the Bone ashes*
F *The Smiths forge*
G *The old Refining house*
H *The Reduceing house*
I *The old Red-lead Mills*
K *The house where we now mould ye Starbright Brick*

A Scale of Yards 10 in an Inch

The Silver Mills at Furnace, c. 1704.
Engraving

From the later C18 several entrepreneurs became involved; the most successful, Thomas Bonsall from Derbyshire, reopened numerous mines and earned a fortune and a knighthood. The heyday of mining was from the 1830s to the 1870s when stable prices led to reasonable returns, though failures were still frequent, due to profit-taking and the unpredictability of lodes. Mining continued fitfully to the First World War, with more emphasis on zinc, and died out between the wars.

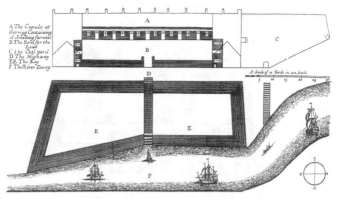

A The Cupulo at
Garregg Containing
is Smelting furnaces
B The Yard for the
 Lead
C The Coal yard
D The Highway
EE The Key
F The River Dovey

A Scale of 10 Yards in an Inch

Garreg Furnace, Glandyfi, *c.* 1704.
Engraving

The remote upland landscape has kept the remains of lead-mining far more than the equivalent in the coal-mining areas. The spoil heaps remain, still bare of vegetation as toxic to plant life, there are remnants of structures, wheel-pits, shafts and adits, and the scars in the landscape left when water was used to scour off topsoil. The leats that followed the contours to bring water to power often successions of water wheels in different mines can be traced for miles, and water-storage ponds remain. Llywernog mine, Ponterwyd, is restored as a mining museum, most of the others retain eroding fragments of poorly built structures. The site at Bryndyfi (Furnace), where a mine was built *de novo* in 1881 and rapidly abandoned under suspicious circumstances, gives the most complete picture of the industrial processes. Temple mine (Ysbyty Cynfyn) deep in the gorge of the upper Rheidol is remarkable for the difficulty of the site. Most evocative of the scale of lead-mining is the vast and desolate Cwmystwyth site.

Early mining was probably opencast on top of the veins. Impressive deep cuts can be seen at several early sites, including Cwmystwyth, Cwmsymlog and Darren (Penrhyncoch). Short prospecting trenches can be seen all over the landscape and earthworks of waterholding tanks for scouring can be seen along the upper edge of Cwmystwyth. Steep mountain sites made horizontal access into the veins an obvious device. Cwmystwyth has over a hundred such tunnels, some assumed to be of early date. Some tunnel entrances had ashlar and rubble portals, the best that to the Level Fawr at Pontrhydygroes, 1785, eventually the longest of all the levels, draining several mines over a distance of 4 m.

Water power was the principal means of pumping out under-ground workings and crushing rock, and considerable ingenuity was used in bringing water to often waterless sites. The system of LEATS brought water often from purpose-made reservoirs over great distances, but even so the flow was rarely sufficient for

continual use (it took 6 million gallons a day to run a 40-ft wheel) and many mines relied on a storage pond for intermittent use. Mine reservoirs dot the hills and the horizontal line of a water channel can easily be made out on many a high contour. The greatest achievement of the water engineer was the leat system that finally ran from Llyn Conach, a very remote reservoir N of the Esgair Fraith mine (Talybont) to the Cwmerfyn mine (Penrhyncoch), that David Bick has estimated ran some 19 m., serving ten mines and forty or fifty water wheels. The difficulty and expense of bringing coal to the mines meant that steam power was used at very few sites, although favoured by Cornish engineers. At Cwmsymlog, Penrhyncoch, the surviving chimney may relate to a 20-in. (51-cm.) engine installed in the 1840s. At Blaenceulan, Talybont, a second-hand steam engine from the bankrupt Castle Hotel, Aberystwyth was installed in the underground workings in 1870.

Mine structures were built of the poor slaty stone generally available and have suffered badly because of the exposed sites. Also WHEEL-PITS and CRUSHER-HOUSES were subject to enormous vibration and shock, dissipated somewhat by large timbers and long wrought-iron bolts. The wheels could be up to 50 ft (15 metres) in diameter, as at Llywernog, and there could be a dozen on a site like Frongoch (Trisant). Wheel-pits are the most easily identifiable feature of most mine sites, with the crusher-houses, which held heavy cast-iron ore-crushing rolls. The bases of these were massive and tend to survive, where the superstructures often do not. At Llywernog the restored crusher-house has rolls from the remote Llawrycwmbach mine, Elerch. Usually above the crusher-houses were rubble-built ORE-BINS that funnelled the ore into the crushing rolls, and were themselves filled by carts drawn along a tramway from the mine itself. Bryndyfi mine has a good example. Below the crusher-house were processing floors in the form of terraces, often under a sloping tin roof, and below again were the highly distinctive BUDDLES, circular timber-floored pits with water-powered sweeps that separated the heavier lead ore from the lighter waste material. These are clearly seen at Bryndyfi and Temple mines.

Of ancillary structures, there were mine offices, stables, circular powder magazines, as well as the mine shafts themselves, often with balance-bob pits where the counter-balance weights for the heavy timber pumping rods rose and fell. The barrack-housing for miners has all but gone, but ruins survive at several sites. The Plynlimon & Hafan tramway of 1897 was an ill-fated attempt to link the lead mines and quarries E of Talybont to the main railway. There were steam engines and passenger excursions even, but it failed in two years.

The largest remaining structures date from the early C20 and relate to novel processes. The crusher-house at Gwaithgoch by the Ystwyth was built during the First World War to reprocess waste from the Frongoch mine, brought here by aerial tramway. Frongoch itself was re-equipped in 1899 by a Belgian firm to extract zinc blende and galena, for which a dressing-mill was built

on the Wemyss mine site to the w, and a large electricity-
generating station further w again.

Lead was transported from Aberystwyth for smelting else-
where, usually in the coalfields of s Wales or Flintshire. The early
C18 works at Glandyfi never seem to have entered production,
and lead was transported to Mackworth's works at Neath. There
was a leadworks of 1754–5 on the banks of the Loughor to which
Carmarthenshire lead was sent.

Carmarthenshire lead and silver was generally a more scattered
industry with a major site at Rhandirmwyn and minor sites at
p. 371 Trelech, Llangunnor and Llangadog. The Rhandirmwyn site was
known from the C17 and yielded huge profits in the late C18 for
Lord Cawdor, and was worked until 1900 by the Cornish firm
of Williams of Scorrier. An expensive reopening in 1930 by the
Sulphide Corporation to mine for concentrates of zinc failed due
to the collapse of prices in 1931. The best Cornish engine houses
in the two counties were in Carmarthenshire, as Ceredigion
was largely water-powered, and a good example of 1854 is at the
Cae Sarah mine, Llangadog and a large one of the 1880s at
Rhandirmwyn.

GOLD. The gold mine at Dolaucothi has been mentioned as a
Roman and possibly earlier site. The huge amount of material
moved before modern times and the lack of later reference to the
mine points to major activity in the Roman period. Interest
restarted in the later C18, with a stone-breaking mill erected after
1888 and continuing with little success until 1900. The revival
that has left most visible trace is that of 1933–8, when up to two
hundred were employed.

Manufacturing

79 IRON. Both counties have a settlement named Furnace. The Dyfi
Furnace at the Ceredigion village is probably the best remaining
charcoal-fuelled works in Britain, built *c.* 1755 to smelt ore from
Cumbria with oak off the surrounding hills. The tall square
masonry furnace is linked to the high bank behind by a charg-
ing floor above a high vaulted ground floor in which were the
giant water-powered bellows. The charcoal storage barn survives
further uphill. There were blast furnaces at Carmarthen, where
Robert Morgan made cannon from 1748–60 before changing
to tin-plate, and at the other Furnace, near Llanelli, set up
by Alexander Raby in 1795. Raby's furnace was fuelled with
coal.

There was iron working before the blast furnaces, in the C17,
when imported pig-iron was transformed into wrought iron at
charcoal-fuelled forges, as at Llandyfan, Cwmdwyfran (New-
church), and Pontyates. The working of iron into useful or dec-
orative items first becomes visible in the fine railings outside
Robert Morgan's house in Carmarthen (now the Library), dated
1761. The main towns had iron works producing railings,
columns and decorative ironwork, also water wheels and machin-
ery for farming and industry. The foundries are identifiable by

the name on their products: Aberystwyth had some six, Carmarthen three or four, Cardigan two or three, and there were several in Llanelli and at least one in Burry Port.

TIN-PLATE. The region can claim to be the world centre of tin-plate. The industry of rolled, as opposed to hammered, tin-plate originated in Pontypool in the late C17 but by the later C19 had relocated to Llanelli, known as 'Tinopolis'. The tin-plate works at Kidwelly were erected in 1737 on the site of an earlier iron forge and was the second such works in Britain. Some masonry substructures remain at the site, which was extensively rebuilt for tin-plate working in the later C19, and is now an industrial museum. The tinning process involved hot-rolling iron bar into sheets which were then pickled in acid, cold-rolled to burnish the surface, then tin-coated and finally polished. The characteristic long tinning-sheds with rows of chimneys down each side wall have gone, the last was at the Old Castle works, Llanelli.

Llanelli remained a metal-working town through the C20. In the post 1945 re-organization of the steel industry under the Steel Company of Wales, the giant tin-plate rolling mill was built at Trostre, similar in design to the demolished Felindre works outside Swansea, 1952–6 (and to the steel works at Port Talbot and Llanwern), all to the designs of *Sir Percy Thomas & Partners*, among the best large industrial buildings of their time. Notable also is the large automotive parts factory of *c.* 1960 at Felinfoel.

COPPER. The world centre for copper smelting from the late C18 was at Swansea with important groups of works along the coast to the E and the W. Charles Nevill, who came to Wales to manage copper-works in Swansea in 1795, set up the Llanelli copper-works in 1804–5, the foundation of the town as a metal working centre. The Nevill family dominated Llanelli industry through the C19, branching into iron tin-plate, gold, silver, lead, coal, shipbuilding, railways and docks. The copper-works had a chimney of 320 ft (97.5 metres), erected in 1861, but have been demolished as have the nearby Cambrian Works built for copper, converted to lead and silver in 1849 by R. J. Nevill. The best surviving copper-works building is by the dock at Burry Port, where the Elkington family of Birmingham set up a factory in 1849. The surviving building is later, the walls banded in copper slag.

BRICK. The industrialized making of bricks came late in the C19, concentrated in the S Carmarthenshire coalfield. The best surviving industrial feature is the large multi-chambered Hoffmann kiln at the Eclipse Brickworks, Horeb (Furnace) of *c.* 1907. The site of the important Cardigan brickworks is built over, but the product is visible in the town, including in North Road some of the large L-shaped hollow blocks made *c.* 1860, and a great deal of the dust-pressed patterned bricks.

Transport

The TURNPIKE road system established itself through the later C18, characterized by the painted milestones, and some early C19

cast-iron ones, made by *Moss* of Carmarthen. There are some surviving TOLL-HOUSES, as at Cwmduad (Cynwyl Elfed), though the best, from Aberystwyth, is at the Museum of Welsh Life, St Fagans. Toll-houses and gates were the focus of the Rebecca riots of 1843, with particular action around Carmarthen. The BRIDGES of the two counties are generally utilitarian, built by county bridge surveyors, but achieving a dignity on the wider rivers, the Tywi and the Teifi. There are two medieval
36 bridges over the Gwendraeth Fawr, Spudder's Bridge at Llandyry and Kidwelly Bridge, the latter hidden by later widening, and a third at Devil's Bridge, twice over-leapt by later bridges. Llechryd Bridge is the oldest of the large bridges, C17, of five low arches.
77 The finest bridge of the region is undoubtedly Pont Dolauhirion, Llandovery, 1773, by *Thomas Edwards* of the Pontypridd bridge-building family, a single arch characterized by its delicately thin crown and weight-reducing spandrel holes. There are similar holes on Edwinsford (Talley) and Cenarth bridges, both by *David Edwards*, 1783 and 1785. The bridge at Llandeilo, 1843–8, by *William Williams*, impressively spans 145 ft (44 metres), the third widest in Britain at the time. The only significant iron bridge of the region, the Chain Bridge at Llandovery of 1832, was replaced in 1882, and is now at Buckland House, Breconshire.

The first RAILWAYS came early, the horse-drawn lines of the coalfields, while locomotive railways came relatively late. The 15-m. Carmarthenshire Railway was one of the first to be authorized by specific Act of Parliament, 1802 (preceded only by the Surrey Iron and Lake Lock Railways). This ran from the Carmarthenshire Dock in Llanelli Harbour NE to limestone quarries at Castell y Graig, Llandybie, and was a horse-drawn plateway. It closed in 1844, though much of its course can be traced, as it was overlaid by the Llanelli & Mynydd Mawr Railway of 1877. The railway N from Llanelli to Pontardulais opened in 1839, initially horse-drawn, soon converted to steam as it extended to Ammanford 1840, with a small station in the style of *I. K. Brunel* at Pantyffynnon, reaching Llandeilo in 1857. From there the line was extended through Llandovery and central Wales to Craven Arms in Shropshire, 1868. It was on this section that the single outstanding railway monument of the region, the
103 Cynghordy Viaduct, stands, designed by *Henry Robertson*, engineer to the Central Wales line. The line remains open from Llanelli to Shrewsbury as the Heart of Wales line. The now-closed Vale of Towy line linked Llandeilo back to Carmarthen. Carmarthen was on *I. K. Brunel*'s South Wales Railway which ran W from Swansea, 1845–52, to Llanelli, Kidwelly and Carmarthen, and on to Haverfordwest by 1853. The line is still operational but few Brunel structures survive, the timber substructure of the viaduct across the Loughor (Llwynhendy), and the Goods Shed of 1852 at Llanelli. From Clunderwen the Whitland & Taf Vale railway branched N up the Taf to reach Cardigan in the 1880s, but is long closed. A coal railway superseded the canal from Burry Port up the Gwendraeth Fawr valley in 1866–9, part of which is still operating.

The first railways of Ceredigion were tramways to carry stone for harbour works in the 1830s at Aberystwyth and New Quay. The steam railway came in 1864 with Thomas Savin's line to Aberystwyth from Machynlleth, still in use, with original stations at Aberystwyth, Llandre and Borth. The saga of the Manchester to Milford railway occupied many over the mid-Victorian period. The plan was for the goods of Lancashire to be exported from Milford Haven in Pembrokeshire, weakening the hold of Liverpool on trade, and also assisting the woollen mills of Newtown in mid Wales. The Carmarthen & Cardigan railway built a broad-gauge line from Carmarthen to Pencader in the 1850s, intending to take it to Newcastle Emlyn (not reached until 1895) and on to Cardigan. In the event the railway entrepreneur David Davies took the line up through Llandysul and Lampeter to Strata Florida (1866), but then turned to follow the Ystwyth valley to Aberystwyth (1867), and the mountain section across to Llangurig was never built. Rail preservation societies maintain fragments at Cynwyl Elfed and Henllan, but otherwise the line is long closed.

The last railways of the region were the branch line from Lampeter to Aberaeron, 1911, and the 2-ft (61-cm.) gauge Vale of Rheidol Railway from Aberystwyth to Devil's Bridge, 1901-2, built primarily for the lead mines, but carrying also tourists, and for that reason still surviving. Two early C20 significant railway structures are the White Bridge W of Carmarthen, a rolling lift bascule bridge of 1908-11 that replaced a Brunel drawbridge, and the eleven-arch brick viaduct over the Loughor, near Hendy, of 1913.

CANALS. The 3-m. long canal built by Thomas Kymer, 1766-8, to carry coal to Kidwelly was the first of any length in Wales and was subsequently incorporated into a more extensive system extended on to Pembrey and Burry Port in 1812-4 and 1837. Its most interesting engineering feature was that it used inclined planes rather than locks to change level. Three were built in 1833-7 on the recommendation of the engineer *James Green*, but the canal was converted to a railway in 1866-9. Nevertheless its course is still clear and bridge abutments survive, the arches rebuilt higher, and the Glanstony Aqueduct, 1814, that carried the canal over the Gwendraeth Fawr, remains near Llandyry.

THE TOWNS 1550-1830

At the end of the Middle Ages there were significant walled towns at Carmarthen, Cardigan and Aberystwyth, the principal centres of royal power. There were small towns associated with the S coast marcher castles at Kidwelly and Laugharne, the former with town walls, but only to the tiny old town by the castle, in decay in the 1530s. A larger new town was across the river, around the church. Inland there were very small towns outside the marcher castles at Newcastle Emlyn on the Teifi, and Llandovery on the Tywi. Two Tywi valley towns, by Dinefwr and Dryslwyn castles,

had faded by the C16, the former replaced by nearby Llandeilo. Carmarthen and Cardigan were mapped by John Speed in 1610. Carmarthen was then the principal town of all Wales, with a population of about two thousand in 1566, but despite this and the breaching of two of the medieval town gates, Speed's map indicates little new growth. Similarly the Cardigan map shows the medieval extra-mural development towards the priory church, but much empty space within. The town is said to have had just fifty-five houses in 1565, when Laugharne by contrast had ninety.

Aberystwyth grew in the early C17, probably overtaking Cardigan, due to the lead and silver in the hills behind, for which a royal mint was established in the castle in 1637. The town lost impetus after the Civil War, not to regain it before the mid C18. The Civil War saw military action right across the region, with castles stormed and walls breached, and after the war most of the defensible structures were dismantled. There is very little visible of the C17 in any town of the region.

Carmarthen has town houses of the early C18 in Quay Street that connected the old centre with the riverside warehouses. The best remaining pair have brick fronts, a piece of significant display in a stone area, and possibly the earliest surviving brick in the region. Later C18 tourists noted how comparatively well built the town was. As well as river trade, the iron industry was important from 1748, when a furnace was built by Robert Morgan, producing 400 tons of bar iron by 1788. The façade of his house survives, as the Public Library, with fine iron railings of 1761. The town's civic status was appropriately enhanced with the refined Palladian Guildhall, 1767–77, by *Sir Robert Taylor*, an early case of a London architect working in Wales, and possibly the reason for his pupil, *John Nash*, taking refuge there in 1785.

Cardigan acquired a Shire Hall with handsome assembly room in 1764, token of the revival of the port, which traded mostly over to Ireland and along the coast. The Irish trade was mostly fish – 1,734 barrels of herring were shipped out in 1702 – and corn was the staple of the coastal trade, about 50,000 bushels cleared in 1754. In 1789 there were 228 ships registered at Cardigan, rising to 275 by 1835, the second largest number in Wales, after Beaumaris, Anglesey.

The harbour at Aberystwyth was hampered by a sand-bar and although the Customs House was transferred here from Aberdovey in 1763, a signal of revival in the lead mines, the harbour was not improved until the early C19. The town expanded beyond the line of the medieval walls with tourism, promoted from the 1780s by local gentry, notably the Powells of Nanteos. Growth was slow despite the fame of the triangular Castle House, by *John Nash*, 1791–4. It was built dramatically on the seafront for Uvedale Price, one of the triumvirate whose ideas formed Picturesque theory, with Thomas Johnes of Hafod, and Johnes's cousin Richard Payne Knight. The renown of Price and Johnes made mid Wales a goal for tourists in search of the archetypal wild and romantic landscape of the Picturesque imagination, and Aberystwyth was where they could water after the excitement of

the passage across the hills, which set the scene for the redevel-
opment of the town.

Inland Ceredigion had towns only in the s along the Teifi.
Llandysul and Lampeter were crossing-points with no real
growth until the early C19, and Tregaron in the remote eastern
uplands functioned as a small market for a sparsely populated
hinterland. Their remoteness was countered by being gathering
points for the droving of cattle and other animals to England and,
for example, early banking followed the great cattle herds. The
Black Ox bank at Llandovery, the principal Carmarthenshire
droving centre, opened as early as 1799. Other inland Car-
marthenshire towns, Llandeilo on the Tywi, and Newcastle
Emlyn on the Teifi, were market towns to a rural hinterland and
have a little evidence of pre-1800 prosperity. Laugharne and
Llansteffan, on the Carmarthenshire s coast, had by the late C18
begun to attract retired or half-pay officers who made the begin-
nings of resorts, and on a smaller scale, Ferryside, opposite
Llansteffan, was similar. Laugharne has a particularly strong C18
character, with good houses, some like the Great House dating
back to the early C18, when the port still prospered. The two other
s coast towns, Llanelli and Kidwelly, grew in the C18 with coal-
mining and the associated tin-plate industry. In the early C18
Llanelli was very small, but opposite the church, Llanelly House,
rebuilt in 1714 for the mine-owner, Sir Thomas Stepney, was
designed as much as an office as a country seat. Kidwelly had
been a tidal port since medieval times, but was increasingly
hampered by silting. One of the first tin-plate works in Wales
was established inland in 1737, and there were coal pits beyond,
sufficiently important to be linked to the sea below the town by
canal in 1765–8. However, this early prosperity has left relatively
little of architectural note.

The later Georgian period saw the first PUBLIC AMENITIES.
The Parade, overlooking the Tywi, was built at Carmarthen in
1782, and the castle ruins at Cardigan and Aberystwyth were
landscaped as walks and bowling greens. *John Nash* by 1796 had
prospered enough to be rated for a theatre next to his dwelling
house in Spilman Street, and another theatre is recorded in
Aberystwyth in 1789, probably in the old Town Hall. The major
public works of the period were Nash's two county gaols at Car-
marthen and Cardigan, 1789 and 1791, robustly and confidently
classical, both demolished (though fragments of both remain).
There are some Late Georgian houses in Carmarthen, much
altered, a few in St Mary's Street, Cardigan, and several at
Laugharne, notably Castle House. Typically they are stuccoed
with large sash windows and ornament confined to doorcases.
The most coherent early C19 urban development was at
Aberystwyth, where an open area behind Castle House was sur-
rounded by the Assembly Rooms (1818–20 by *George Repton*), 65
the terraced houses of Laura Place, *c.* 1827, and the parish church
(1829–33 by *E. Haycock*), soon followed by the terraced houses
along the seafront. The streets of the old core, Great Darkgate,
Pier Street, Bridge Street and Eastgate, were mostly rebuilt with

Late Georgian houses, and new streets of similar houses extended out beyond, North Parade and Portland Street. The elegant Late Georgian house type with deep eaves and large sash windows colonized every town of the region, notable in the High Street at Lampeter, and the Market Square in Llandovery, but identifiable also in smaller towns like Llandysul, Newcastle Emlyn or Saint Clears. Carmarthen has a distinct small suburban development of Late Georgian houses on Picton Terrace, and Llanelli a few such houses in Goring Road, but suburban outreach was generally piecemeal.

While the style may be Late Georgian, the houses are often Victorian, as shown at Aberaeron, the only planned town of the region. This town originated from a Parliamentary Act of 1807, but the layout and form of the buildings date from the 1830s, when *Edward Haycock* was called in by the landowner. Although the form is consistent, maps show that the date-range of these 'Georgian' houses is from 1830 to 1870, with surprisingly little marked as built on the 1845 tithe map. Similarly at New Quay, a fishing port improved by the quay of 1835, the Aberaeron-style houses terraced up the hillside date from the 1840s and later.

The urban VILLA of the earlier C19 is relatively rare, Llandingat House, Llandovery, 1813–14, a conspicuous example, also Milestone House, Carmarthen, and Castle Green House, Cardigan, 1827. Some detached seaside villas were built in Laugharne, Llansteffan and Ferryside, but not significantly in the Ceredigion coastal towns. One pretty exception is Sandmarsh Cottage, Queen's Road, Aberystwyth, with two shallow bow windows.

Private enterprise supplied the coaching HOTELS, often with assembly rooms, at the centre of towns. On the older turnpike roads these could date from the C18, like the Castle at Llandovery, and the Black Lion at Cardigan. The latter has a fashionable brick front, also a feature of the Lion Royal Hotel at Carmarthen of *c.* 1802 (demolished). There are several stuccoed earlier C19 hotels in Late Georgian style, of which the Cawdor Arms at Llandeilo, enlarged after the bridge was rebuilt in the 1840s, is the best, but also the Talbot, Aberystwyth, the Black Lion at Lampeter, the Feathers at Aberaeron, and the Talbot at Tregaron, the date range running up to 1850, in the case of the Tregaron inn. The hotel at Devil's Bridge, though not urban at all, should be mentioned as a very early tourist hotel, first built in 1803 for visitors to the falls, but given the appropriately Swiss roof in 1838–9 by the Duke of Newcastle, who presumably had toured himself. The Red Lion in Llangadog, built in the 1840s in a Tudor style, is an estate-built coaching inn that stands out from the ordinary.

THE TOWNS 1830–1914

With the growing towns came the PUBLIC BUILDINGS: market halls at Aberystwyth, 1823 and 1832, Llandovery, 1839, by *George Clinton*, Carmarthen, 1846, by *F. E. H. Fowler*, Llanelli (dem.),

1864; town halls at Lampeter, 1813 (replaced in 1880), Llanelli (dem.), 1821, Aberaeron (with market), 1833, Aberystwyth, 1848, by *W. Coultart*, Llandovery, 1857, by *R. K. Penson*, Cardigan (with market), 1858-9, by *R. J. Withers*, Kidwelly (with market), 1877, by *T. W. A. Evans*, and Llanelli, 1895, by *William Griffiths*. Some were very minor, the market hall at St Clears, 1851, minimal indeed, but the two Llandovery buildings indicate growing civic pride, and the Cardigan Guildhall is a remarkably advanced Ruskinian Gothic complex, possibly the first Ruskinian civic building in Britain, and an extremely interesting combination of functions: with public hall, corn exchange, library, news-room, council-room, grammar school and two storeys of market. Llanelli Town Hall is the proudly towered and ornamented symbol of a wealthy industrial town, akin to those of similar English industrial towns. Only Llanelli acquired an Athenaeum, but Carmarthen had Assembly Rooms of similar function, both Italianate buildings by the Bath architect, *James Wilson*, 1854-5. The Carmarthen one was completely altered as the Lyric Cinema in the 1930s.

Other urban amenities arrived only gradually. Aberystwyth alone has a purpose-built library, a competition victory in 1905, by *Walter G. Payton* of London. The Carmarthen Infirmary dates from 1858, by *W. W. Jenkins*; it was not until the 1880s that two matching hospitals were built by *E. M. Bruce Vaughan* at Llanelli and Aberystwyth (dem.). Workhouses followed the Poor Law Act: those at Carmarthen, Llandovery, Llanelli, Aberaeron, Aberystwyth and Cardigan dated from the late 1830s, but the original buildings have mostly gone, apart from the remarkably intact Cardigan workhouse (just in Pembrokeshire at St Dogmaels) and the altered one at Aberaeron. The gatehouse that survives at Carmarthen may be a relic from the previous Poor House, and is notable as the site of one of the larger confrontations of the Rebecca riots in 1843. Lampeter (dem.) and Tregaron workhouses were not built until the 1870s. There is a good court house of 1870 at Newcastle Emlyn, in finely detailed Cilgerran stone. Carmarthen was the site for the lunatic asylum for three counties, a vast complex in a bald Italianate style by *David Brandon*, begun in 1863, now St David's Hospital. The largest public building project of the region, and one of the major public buildings of Wales, was the National Library of Wales at Aberystwyth, a competition victory for *S. K. Greenslade* in 1909, an interesting design mixing elements of Parisian Beaux-Arts classicism with Edwardian Baroque. The library was part of that political counter-action of Welsh-speaking Wales to the economic dominance of South Wales expressed also in the establishment of the university college (*see* below) in 1872.

CHAPELS took their part in the urban fabric slowly, early ones on restricted sites, as the original Tabernacle, Lampeter behind the High Street. *William Owen*'s Heol Awst, Carmarthen, 1826, set back in its forecourt announces a more prominent phase, though chapels as focal points of urban townscapes are rare and fortuitous. The demolished Seilo faced down North Parade,

Aberystwyth. The sheer number of chapels in Llanelli, Carmarthen and Aberystwyth, many of them later c19 buildings of architectural quality, make them integral to the special urban character of these towns.

Public MEMORIALS are restricted in number. Carmarthen's memorial to General Picton, hero of Waterloo, was commissioned from Nash in 1824, but was built of such inferior materials that it had to be replaced by the present obelisk as early as 1846. Carmarthen also has a good bronze statue of General Nott, hero of the Afghan War, 1851, by *Edward Davis*. At Tregaron, the square is distinguished by a bronze statue of Henry Richard, the Apostle of Peace, by *Albert Toft*, 1893, a good example of the more relaxed monumental style of the end of the c19.

It was only in Aberystwyth that the Victorian grand HOTEL made its mark, with two heroic failures built in 1864: the Castle Hotel (now the Old College), and the Queens Hotel (now County Offices), and a third, the Hotel Cambria, 1896, which also failed shortly after opening. *J. P. Seddon*'s Castle Hotel, now the Old College, is one of the great tragi-comedies of c19 architecture. The haste with which it was built meant that the architect struggled to keep pace with the five hundred builders: 'I was never able to make any complete drawings,' he said. It is hard to see how the promoter, Thomas Savin, the railway entrepreneur, reconciled a luxury hotel with suites of rooms on the American model with a clientele of railway passengers from the English North-West. Seddon's plans were so gloriously spendthrift, his tower with its ten storeys mostly of storerooms, with a plethora of staircases and levels – not Seddon's fault, as the two halves of the hotel were separated by Nash's horribly awkward Castle House. When Savin was bankrupted in 1866, £5,000 was the highest offer for an unfinished building that was said to have cost £80,000. The Queen's Hotel is a far more lumpish design, both outside and in, perhaps because *C. F. Hayward* was engaged at the same time on the Duke of Cornwall Hotel at Plymouth, and the designs here seem to be by his partner, *H. D. Davis*. The Hotel Cambria was built by the company that refurbished the pier and constructed the cliff railway, a Victorian seaside package, all under the engineer *George Croydon Marks*, and was a theological college by 1906. Town inns are numerous but undistinguished, generally simple buildings similar to the surrounding housing. Occasional examples of Late Victorian display include the half-timbered Cambrian Hotel, Alexandra Road, Aberystwyth, and the former Mansel Arms, by the parish church in Llanelli.

LATER c19 HOUSING is characterized by two-storey terraces in stucco or hammer-dressed stone, found all over industrial s Carmarthenshire. At Llanelli the more affluent Late Victorian house, on Old Road, New Road and the Glenalla district, has ornate gabled bays and bargeboards, mostly designed by *William Griffiths*. At Aberaeron the sway of the Late Georgian lasted into the 1870s, broken then, as might be expected, by bay windows with gables. At Aberystwyth, *J. P. Seddon* proposed in 1865 what

would have been a spectacularly different terrace on the seafront, Gothic, in polychrome brick, intended to have twenty-five houses. But only three were built, and the coloured bricks are painted over. The terrace was continued in stone with Gothic bay windows after 1874. Queen's Terrace, Queen's Road, has a similar character, but from the 1880s terraced houses tended to a lighter bay-windowed and gabled style, as those above North Road and those on the Buarth, which have a nice end of the century mix of stone, red brick and terracotta. Semi-detached and detached villas are a feature of the Llanbadarn Road, the ponderous stone and yellow brick of the 1870s and 1880s giving way to gentler combinations of stone, red brick, half-timber and plaster. Carmarthen has the most alarmingly eclectic single group of Late Victorian semi-detached houses, at Penllwyn Park, 1893–7, displaying most of the available styles. Llanelli has the largest and most overwrought of industrialists' villas, the Italianate Bryncaerau Castle (Llanelli Museum), built for the Buckleys of the brewery, by *J. Buckley Wilson*. Aelybryn, Felinfoel, a little-known work of *G. E. Street* for the tin-plate Phillips family, is in complete contrast, an ascetic Gothic composition in red brick. The houses of the leading dynasty, the Nevills, have fared badly, the principal one, Westfa at Felinfoel, by *R. K. Penson*, is now demolished. In general the proximity of country to town meant that industrial and commercial money went into country rather than urban villas, with a noticeable ring around Aberystwyth, Llanelli and Carmarthen.

COMMERCIAL BUILDINGS were modest in the early part of the C19, with Late Georgian small-paned shop windows in conventional house façades, and are now very rare. One survives at No. 5 Castle Street, Newcastle Emlyn. The principal commercial streets have a mix of Victorian and later fronts, in King Street, Carmarthen, many refronting C18 and older town houses, as also in High Street, Cardigan and Great Darkgate Street, Aberystwyth. Purpose-built commercial buildings include a narrow façade of 1846 at No. 57 King Street, Carmarthen, by *J. L. Collard*, and a brick Gothic front at No. 18 High Street, Cardigan, by *R. J. Withers*, 1863, that inspired a generation of brick façades in that town, notable for displaying the wares of the town brickworks. Aberystwyth and to a lesser extent Llanelli show a great deal of glazed and matt terracotta, apparently all imported. At Aberystwyth, Nos. 34–36 Terrace Road, 1895, the *Cambrian News* offices, by *T. E. Morgan*, and the Coliseum Theatre (now museum) opposite, 1904, by *J. Arthur Jones*, are the best examples, while in Llanelli, *William Griffiths* used terracotta on the Y.M.C.A., 1909, and Exchange Buildings, 1915. Of different types, the Jubilee Stores, 1897, in Llandovery is a little-altered late C19 emporium, and the Towy Works builders' merchants, 1909, by *G. Morgan & Son*, prominent on the Quay at Carmarthen, stands out for its modern lack of period reference.

BANK premises are among the most prominent buildings of the late C19 to early C20, and are remarkably varied. *Wilson & Moxham* chose unusually the tile-hung style of Norman Shaw

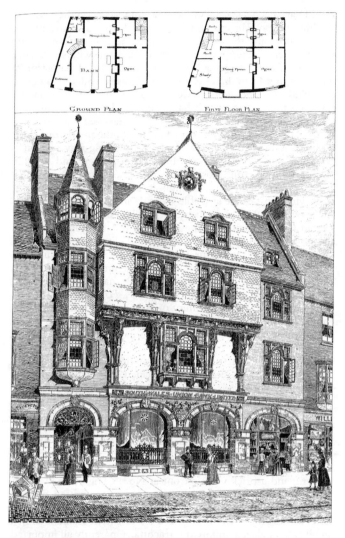

South Wales Union Bank at Llanelli, by Wilson & Moxham, 1890.
Engraving

and the Queen Anne movement for the South Wales Union Bank
at Llanelli, 1890. Lloyd's Bank at Llanelli, 1894, is a particularly
refined Italian palazzo in Portland stone, while the branch at
Llandeilo, 1910–11, by *A. Lloyd Oswell* is notably inelegant. The
108 London & Provincial (Barclays) displays a riot of free C17 detail
at Carmarthen, by *George Morgan & Son*, 1903, but is Italianate
at Aberystwyth, 1904–6. The National Provincial (National
Westminster) architect, *W. W. Gwyther*, mixes Italianate and C17
mullions at Aberystwyth, 1903, and Carmarthen, 1903–4. Stylish

Edwardian Baroque characterizes the North & South Wales Bank (HSBC) branches at Aberystwyth, 1908–9, and Llandeilo, 1913, by *Woolfall & Eccles*, of Liverpool, also the Midland Bank (HSBC) at Cardigan, 1914, and more crudely, the Metropolitan Bank at Llanelli, 1912, by *W. Griffiths*.

SCHOOLS AND COLLEGES

There are no early SCHOOL buildings surviving, though grammar and private schools are recorded for the principal towns from the C16 or C17. (For schools attached to churches see under churches and for Nonconformist schools see under chapels). Much C19 education was provided privately, rarely in purpose-built buildings. The Grammar schools at Carmarthen and Cardigan moved to new premises designed in both cases by *George Morgan & Son* in the 1890s, the Carmarthen site combining separate boys' and girls' schools. Board Schools built under the 1870 Education Act include only one of particular note, that at Aberystwyth, by *Szlumper & Aldwinckle*, 1874, mainly because most Board Schools took over existing church or chapel schools. The Aberystwyth Board School was the first in Wales to adopt the separate desk, as opposed to the long bench or 'form'. Intermediate or county schools were set up under the 1889 act at Aberaeron, Llanelli, Llandovery and Aberystwyth, the latter with the most elaborate buildings. The National or church schools were allowed to become state funded under the 1904 Act, which ensured the survival of many church school buildings, though two notable large urban National School buildings of the 1860s, at Aberystwyth and Llanelli, both by *R. K. Penson*, were demolished in the later C20. The best surviving urban National Schools are those at Cardigan, 1847, and Lampeter, 1850, both by *W. Moffatt*, and the one at Llandeilo by *W. M. Teulon*, 1860. 85

COLLEGES. The need for educated ordinands for the Anglican ministry drove the cause of further education through the C18 and earlier C19. St David's College at Lampeter, now the University, was a bold foundation of Bishop Burgess. Previously the very small but renowned establishments at Ystrad Meurig and Lampeter had provided what little education was available, with students going from there to Oxford or Cambridge. The Tudor Gothic college at Lampeter, 1822–7, by *C. R. Cockerell*, is an eco- 66 nomical version of an Oxbridge quadrangle, stressing Anglican continuity, in contrast to the near-contemporary University College, London, where classicism was a badge of modernity.

Nonconformist education for ministers was generally according to denomination, but the Presbyterian College on the Parade at Carmarthen, despite the name, was not affiliated to a single denomination. It was successor to an Independent or Unitarian establishment that had been peripatetic from the late C17. This also is Tudor Gothic; the modest building of *c.* 1840 belies the record of the establishment, affiliated to London University in 1842, the first institution in Wales to be so. The Calvinistic

Methodist United Theological College was housed in the Hotel Cambria, Aberystwyth, from 1906 to 2001.

88 The University College at Aberystwyth opened in 1872 in *J. P. Seddon*'s hastily completed Castle Hotel. It carried great hopes, not least of Nonconformist Wales, but struggled in its early years, and was severely tested by a fire in 1885. It was only in 1889 given its charter as the University College of Wales, the title recognizing its primacy in Wales. The post-fire reconstruction was ambitious, and while it may be regretted that there was never the money to finish Seddon's tower, the survival of the building is entirely due to the college. *C. J. Ferguson*'s central range, on the site of Nash's Castle House, 1896–8, successfully links the two very different parts of Seddon's buildings. *Ferguson* designed the severe Alexandra Halls for women students in 1896–8. The principal additional building before 1914 was the Edward Davies laboratories, now the School of Art, 1905–7 by *A. W. S. Cross*, a notably handsome Edwardian building, and handsomely appointed within. The School of Art, Carmarthen, 1891–2, by *George Morgan*, now Oriel Myrddin, clothes well-lit large studios in a Northern Renaissance skin of brick and stone.

86 Trinity College at Carmarthen, founded for the training of teachers for the Anglican National schools, with buildings of 1847 by *Henry Clutton* in the asymmetrical Gothic of Pugin, is among the earlier and best examples of the style in Wales. The only private boarding school, Llandovery College, had Anglican roots and the building, 1849–51, by *Fuller & Gingell*, is asymmetrical Tudor Gothic, about a tall tower.

THE ARCHITECTURAL PROFESSION
1800–1914

The profession of architect within the region emerges at the end of the c18 with *John Nash*'s arrival in Carmarthen in 1785. A few local practitioners were accorded or accorded themselves the title in the Late Georgian period. *David Evans* of Cardigan is hailed as 'ingenious architect' in 1810, but for the most part designers were builders, and called that, like *David Morgan* and *Thomas Humphreys* in Carmarthen. Often their names are on the record because they sign the completion certificates for church repair work or are commissioned at the Quarter Sessions for work on assize court buildings or bridges. *Daniel Evans*, son of David, was

75 paid £2 for the design of Bethania chapel, Cardigan in 1847, and at his death in 1852 he was recorded as architect and innkeeper.

Outside architects appear for country-house work, notably *John Nash* in the 1790s and *Edward Haycock* of Shrewsbury from about 1830. *William Jernegan* of Swansea was employed a little earlier by Lord Cawdor for estate work, but the known commissions are not many. There are several early c19 country houses

59 built in the Nash manner, like Treforgan, Llangoedmor, and Alltyrodyn, Rhydowen, for which no architect has yet been identified. Church work from the 1840s was dominated by outside

architects as the demand for correct Gothic implied a specialism. With chapels the carpenter or mason designer lasted longer, but from the 1860s the specialists took over, though most of these were Welsh if not local, like *John Humphrey* and the *Rev. Thomas Thomas*, from Swansea, and *Richard Owens* from Liverpool. *George Morgan* was the only local man with a wider practice, with major commissions in Swansea, Merthyr Tydfil, Haverfordwest, Abergavenny and Newtown.

The growth of Aberystwyth as a resort allowed professional architects such as *George Clinton* in the 1830s and *William Coultart* in the 1840s to settle briefly before moving on, but much of the building work must have been done by local dynasties of builders such as the *Lumley* family. Later in the C19, *George Jones* was the principal professional, joined by the end of the century by his son *J. Arthur Jones* and *T. E. Morgan*, but the architects of much of domestic Aberystwyth remain unidentified. It seems likely that *J. P. Seddon*'s association with the town from 1864 influenced local practice, though his polychrome brick Victoria Terrace had no followers. Several High Victorian Gothic villas on the outskirts look like Seddon work, but may be by *George Jones*, or *James Szlumper*, railway engineer and architect, who both made use of a robust Gothic in the 1870s. After 1900 *George Bassett* built up a large and largely unidentified domestic practice that must include some of the terraced houses and villas of the Buarth and Llanbadarn Road.

In Llanelli, the Rogers family emerge in the 1820s when *John Rogers*, carpenter, designed the Town Hall, while *Henry Rogers* was architect of two fine chapels in 1857–8. It was probably not until the 1850s that most towns could support an architect, and many combined trades like Daniel Evans. *Edward Bagot*, in Llanelli, was town surveyor, surveyor to the coal-mines, engineer to the water board, architect and latterly minister of the gospel, but was not given major commissions, which in mid-C19 Llanelli went mostly to *James Wilson* of Bath, married to a Buckley of the brewery. Wilson secured the Athenaeum and the Wesleyan church, and his son *J. Buckley Wilson* had work in the town through the later C19, associated with *Glendinning Moxham* of Swansea. By the late C19 tin-plate wealth supported several architects, *J. B. Morgan*, *John Davies & Sons*, and principally *William Griffiths* who had the lion's share.

In Carmarthen, *John Collard* emerges in the 1840s and 1850s as the leading figure, but is most noted for utilitarian churches in the hinterland. *R. G. Thomas* returned from Adelaide in the 1840s, but failed to make a career in Carmarthen, moving on to Newport. *George Morgan* is first noted in 1870 designing the chapel at which he was deacon, and for the next half-century he and his son, *J. Howard Morgan*, were the leading architectural practice. Of their work, the chapels are the most visible, but there were banks, churches, schools, commercial buildings, houses and farms. Another son, *W. V. Morgan* was schools architect at the same time, and *E. V. Collier* moved to the town from Hampshire in the 1880s, building a sizeable ecclesiastical and general practice.

In Cardigan after the mid C19 the few local architects were outshone by the engineer *William Woodward*, brickmaker, iron-founder and probable designer of many of the later C19 buildings in Cardigan brick. The public buildings of the town notably went to *R. J. Withers*, the London church architect, and it seems probable that Withers' hand is visible in town and farm buildings for the Priory estate, Cardigan.

At Llandeilo, the London architect *Thomas Bedford* was tantalizingly present for a decade from *c.* 1803, with almost no identified work. The builder-architect *John Harries* acted for several of the larger estates in the mid to later C19, succeeded by *J. W. Jones*, known mostly for chapel designs, and by the dull *David Jenkins* whose 1907 obituary shines light on a prolific practice rather like that of the Morgans in Carmarthen, but with more church work.

The smaller towns occasionally supported professional architects. At Ammanford, where anthracite wealth came at the end of the C19, *Henry Herbert* established himself as a mining engineer before taking on architectural work, and *J. O. Parry*, City Engineer at Pietermaritzburg, returned to his home town in 1913, as architect, surveyor, civil engineer and mining engineer. In Lampeter, *Llewellyn Bankes-Price* worked at the turn of the century, responsible for utilitarian county schools at Aberaeron and Fishguard. There are still smaller towns that barely supported a resident architect, or had surveyors and land agents capable of some design work. Llandovery, Llandysul, Aberaeron, Llansteffan, St Clears and Newcastle Emlyn are in this category. Llandysul was the home of *Rees Davies* who did church work before 1850. Around Newcastle Emlyn, *Charles Davies* of Cenarth designed churches in the 1840s and 1850s, and was noted by *R. J. Withers* as a good builder. *David Davies*, based at Penrhiwllan near Llandysul, designed numerous chapels in the region from the 1870s, also farm buildings and probably more. At Laugharne *Thomas David* progressed from builder to architect, and at Kidwelly *T. W. A. Evans*, as architect and mayor, was able to design the ungainly town hall.

The career of *E. M. Goodwin* illustrates the difficulties of making a career in the region. He appears in the 1850s as partner of *H. E. Coe*, an obscure figure now, but winner of the major competition for the War Office, London, in 1856. It would seem that Goodwin stayed and survived by a mixture of architectural work and speculation. He is recorded successively between 1867 and 1892 working from addresses in Laugharne, Narberth, Haverfordwest, Burry Port, Kidwelly, Leatherhead and Saundersfoot, the work occasionally quirky and interesting, increasingly turning to cheap terraced houses, barely interrupted by bankruptcy in 1874.

1914–2006

The commemoration of the Great War left several notable WAR MEMORIALS, particularly the splendidly sited obelisk at

Aberystwyth, 1923, with its bronze by the Italian sculptor, *Mario* 114
Rutelli, responsible also for a delicate small memorial outside
Tabernacle Chapel in the same town. There are bronze soldiers
by *Sir William Goscombe John* at Carmarthen, Llanelli and Lam-
peter, the Llanelli memorial the least conventional with its high-
relief figures. Of the many Memorial Halls, the one at Aberaeron
with a Palladian window stands out, by *L. Bankes-Price*, 1923,
and the nearby one at Llanrhystud, has a charming roughcast
front wall, but is all of corrugated iron behind.

Following the war, traditional styles of building continued to
be favoured most obviously with churches and chapels (discussed
under their separate headings), but also with commercial build-
ings such as banks. The best interwar commercial buildings are
indeed the banks designed for the National Provincial Bank by
their architects, *Palmer & Holden*, at Llandeilo, 1923, Tregaron, 113
1924 and Newcastle Emlyn, 1930, in three different styles, the
Wren of Hampton Court, C16 timber frame and suave Late
Georgian. A little Art Deco or Jazz Modern can be seen at com-
mercial premises as in King Street, Carmarthen, and in the
Burtons menswear shops in Aberystwyth and Llanelli, but only
a little.

Public Buildings

The National Library, Aberystwyth, spanned the first half of the 115
century. *S. K. Greenslade*, who had won the competition in 1909
and built the two side wings with the reading rooms and art
gallery, 1911–16, resigned in 1927 and was replaced by *Charles
Holden* of *Adams, Holden & Pearson*. Holden modified the design
of the front range, built 1934–7, and redesigned the central hall,
1950–5. The library was one of the three major public buildings
in Wales, with the Cardiff City Hall (1897) and National Museum
(1910), that wrapped formal centralized plans in classical eleva-
tions of Portland stone. Greenslade's original design was deli-
cately mannered, simplified by Holden to a more masculine
severity of giant piers, the Ionic columns and porch a homage to
C. R. Cockerell.

Contemporary with Holden's work is that of *Percy Thomas* at
Aberystwyth University and Carmarthen County Hall. At the
University, Thomas supplanted *H. V. Lanchester* whose rejected

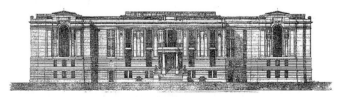

The National Library, Aberystwyth, 1909. Design by S.K. Greenslade.
Elevation

1930 design was grandly classical and formally axial on a giant eleven-bay colonnaded centrepiece. Thomas's 1935 design substituted a Neo-Georgian to 'moderne' style with hipped roofs but windows in bands, of which only one block was built on the main Penglais campus. Thomas also designed more fully Neo-Georgian accommodation blocks to front the drive to the National Library, the Pantycelyn Halls, reminiscent of American work of the period, but as built in 1948–60 much detail and a central square pavilion were lost. The Carmarthen County Hall, 1938–56, uses the same element as the Pantycelyn Halls – sheer walling in grey stone, regular large windows and steep roofs with dominant chimneys, but here the style hints at the French C17, with cross-mullioned windows on the wall face and tower-like curved projections, to monumental effect. The lack of the extraneous detail of most contemporary civic buildings, the towers, porticos and cupolas, gives the County Hall a robust solidity appropriate to its castle site.

 Other pre-war buildings of note are few and mostly traditional. The long stone-built school at Ammanford, 1924, by *W. V. Morgan*, and the additions to the Boys' and Girls' Grammar Schools at Parc Myrddin, Carmarthen, of the 1930s, are notable. The railway station at Aberystwyth, 1924, by *Harris & Shepherd*, is formally Neo-Georgian, in imitation stone, but thrown out of symmetry by a weak turret on one end. Amid the traditional buildings, the Modern Movement is represented by two seaside villas at Borth, by *R. H. Franks*, 1935, and *Percy Thomas*'s swimming pool at Aberystwyth University, an amusing illustration of the view that modernism had its place, but not in the forecourt of a modern university. Modernism of the Art Deco sort animates the remodelling of the Carmarthen Assembly Rooms as a cinema, now the Lyric Theatre, 1936, by *W. S. Wort*, and the curved brick Odeon cinema, now Theatr Elli, Llanelli, 1938, by *Harry Weedon*. The working-mens' halls of the coal-mining area have a varied character, the one at Cross Hands more Art Deco, the much larger one at Ammanford, 1935, by *J. O. Parry*, with monumental columns, the one at Pontyberem somewhere between the two.

 The Second World War left few permanent structures of note; the gunnery-training dome at the airfield at Pembrey, the strange line of concrete blocks of the stop-line at Penboyr, some prominent pillboxes, one atop the walls of Cardigan Castle.

 After 1945 both counties had SCHOOL-BUILDING programmes. That of Ceredigion has a more coherent character thanks to the county architect, *G. R. Bruce*, who designed flat-roofed secondary school buildings, those at Lampeter and Tregaron with an entrance tower, and many primary schools, of which the two-storey school at Aberporth, 1957, is notable. School buildings of the last quarter of the C20 tend to the utilitarian, as for example the secondary schools at Newcastle Emlyn and Carmarthen. The large additions at Penglais, Aberystwyth, of 1973–5, are of brick with monopitch roofs. Significant later works included the courtyard-plan Richmond Park Primary School, Carmarthen,

1987–8 by *Alex Gordon Partnership*, the large Graig Tertiary College, Llanelli, 1992–5, with a full-height entrance hall, and Bro Myrddin school, Cwmffrwd, near Carmarthen, 1993–6, both major schemes by *Dyfed County Council Architects*, before that body was disbanded. Ysgol y Bedol, Garnant, 2000–5, is the largest new work by *Carmarthenshire County Council Architects*.

The HOSPITAL BUILDINGS at Glangwili, Carmarthen, 1958, by the *Percy Thomas* firm, have lost all coherence in later additions. Bronglais Hospital, Aberystwyth, 1966, had two large brick-clad blocks in line, starkly utilitarian, but re-clad to better effect *c.* 2000. The Prince Philip Hospital at Dafen, Llanelli, 1989, is by contrast low-rise, to a grid plan with two-colour brick facing and hipped roofs, a Neo-Victorian aesthetic.

Of CIVIC BUILDINGS, Aberystwyth Town Hall, remodelled in 1961–2 by *S. Colwyn Foulkes*, is still traditional, offering a portico squarely to the street, but the detail is minimal apart from the columns. More modern but utilitarian were the offices for Carmarthen District Council of the 1970s. Ty Elwyn, Llanelli, 1981, and Neuadd Ceredigion, 1989–90, at Aberaeron, are both council office blocks designed within the respective councils, Ty Elwyn, a well-designed tower with banded windows and distinguished by good craft work, and Neuadd Ceredigion hinges office ranges on an octagonal-roofed council chamber block. Bands of windows and concrete characterize the Magistrates' Courts at Llanelli, by *J. M. Harries*, and the Cardiganshire Water Company offices at Aberaeron, by *J. I. Ceri Jones*, both of 1971, but this particular later C20 type is rare in the region.

After the Second World War, the era of TOWN-CENTRE REDEVELOPMENT hit Llanelli hard with the replacement of the market by a multi-storey car park in 1969 and heavy-handed road schemes that destroyed half the commercial heart of the town. In Carmarthen the Coracle Way road scheme cut the town from the river in the 1960s, damaging even the medieval castle, and 1973 was the year for the demolition of Red Street, redevelopment spreading thence up to the market, replaced in 1981, but here at least the tower of the old market was kept. With the 1990s came change, the centres of Carmarthen, Llanelli and Cardigan were partly or fully reserved for pedestrians. The new shopping centre at Llanelli, Canolfan Elli, 1996–8, by *BDG McColl*, linked into a revived central square and is distinguished by two dramatic glass-roofed concourses within.

The major location for modern buildings has been Aberystwyth University. Under the *Percy Thomas* firm haphazard building spread up the slope from the first building of 1937, the formality of Thomas's 1935 plan abandoned in 1957 for something more amorphous by *Sir William Holford & Partners*. Two science buildings of 1958–60, by *Bill Marsden* of *Sir Percy Thomas & Son*, have short tower blocks with mosaic end-wall cladding. In 1964–5 the site was replanned by *I. Dale Owen*, of the same firm, and it is his work that still stands out. The main piazza, 1967–70, overlooked by the Great Hall, students' union and library, and overlooking the town and sea, has a monumental

120

character from the overhang of the Great Hall, and a unity of grey aggregate panels. Dale Owen continued the range beyond the library, 1973–6, creating the cliff-like range over the approach drive. After the single hand was removed, buildings became more varied, with the Arts Centre (*see* below), the Media Studies building by *Patel Taylor*, 1999, and the large student village, Pentre Jane Morgan, 1992–4 by *James & Jenkins*, whose loose suburban layout contrasts starkly with *Dale Owen*'s grim Cwrt Mawr halls of residence of 1967. The university rebuilt a row of seafront houses after a fire, with replica façades but an innovative timber-framed construction behind, 1999, by *Harry James*. Lampeter University has been a poor relation, its buildings of the 1960s needing re-cladding and re-roofing to remedy failures and none of the later buildings are of special note. At Trinity College, Carmarthen, the block of student rooms, 1964, remains the only tower block in the county. The library, 1994, by the *Welsh School of Architecture*, is a well-lit structure with metal roof, extended out as a front canopy. The same architecture school was responsible for a demure addition to the National Library, 1992. Within the library the cylindrical Drwm lecture theatre has been neatly inserted into a courtyard, by *James & Jenkins*, 2004, and the Greenslade interior of the s range restored.

The National Heritage Lottery and Millennium funds have radically changed the landscape in two counties where publicly funded monuments were unknown. Wales has acquired several buildings of national importance, the most significant the
123 National Botanic Garden, Llanarthne, with its Great Glasshouse by *Norman Foster & Partners*, the largest in the world. The gardens were overwhelmed by financial crisis, but seem set to survive, and in the long term the glasshouse will be seen as one element in a much larger project including the restored c18 landscape, walled gardens and stable court, and the landscape design by *Hal Moggridge* and *Kathryn Gustafson*, not to mention commissioned works of art, such as the water sculpture by *William Pye*. The Millennium Coast, the 14-m. coastal park from the Loughor estuary to Pembrey created out of industrial wasteland, was the largest such project in Britain, its monument the sweeping land-form by *Richard Harris* between Pwll and Burry Port, and its architectural identifier the yacht-like visitor centre at
122 Llanelli, by *Powell Dobson*, 2004. The remarkable Arts Centre at Aberystwyth University, by *Peter Roberts*, 1998–9, in a wholly different aesthetic to the monumental Great Hall behind, nevertheless manages to be both contextual and independent, its interpenetration of spaces a model of design for public enjoyment. The Theatr Mwldan at Cardigan, a small but renowned local facility was more than doubled in size by *Lawray* in 2004 and at the same time the National Woollen Museum, Drefach Felindre, was wholly overhauled. On a smaller scale, the Co-operative warehouse at St Clears became a crafts centre and gallery, 1999. In fairness to the struggles of pre-lottery eras, the far-sighted decision of Llanelli Borough Council to buy the Odeon cinema in 1978 and refurbish it as Theatr Elli, and the

creation of a theatre out of a slaughterhouse in Cardigan, 1985, should be recognized.

Domestic Architecture

The interwar years were characterized by HOUSING SCHEMES initiated by the various urban and rural councils. Few deserve special mention. The Garden Village at Burry Port was a wartime scheme, 1915–19, by *T. Alwyn Lloyd* for munitions workers at Pembrey, but is very heavily altered. A crescent of Neo-Georgian council houses at New Quay was built after the Second World War, *c.* 1953, but the loss of the sash windows has spoilt them. Individual ARCHITECT-DESIGNED HOUSES of note are very rare, the two Modernist seaside houses at Borth, 1935, by *R. H. Franks*, are matched only by a little mild modernism among the suburban houses on the edges of Carmarthen and Llanelli. After the war there is little before the 1960s, and afterwards the best examples are built for and by the owners. Bryn Aberoedd, Aberystwyth, 1967–8, built for himself by *I. Prys Edwards*, is international Modern in style, and the house at Gorsfach, Pennant, built for themselves from 1974 by *Alexander & Margaret Potter*, is an agglomerative jigsaw, the white roughcast elements gathered like tents, appropriate to a holiday house, and outside the streams of current architecture. The sensitive contextual style of the late C20 is well shown in the oak-framed additions to Blaencamel, Ciliau Aeron, 1998, by *David Lea*. Oak boarding, the rustic material of choice, appears on the curved-roofed No. 4½ Quay Parade, Aberaeron, 1999, by *David Thomas* and on the twin blocks of sheltered housing at Burry Port, 2003, by *PCKO Architects*.

Conservation

Conservation as a priority might be said to date from 1975, when the newly repainted houses of Aberaeron were featured on postage stamps for European Architectural Heritage Year. But it advanced very slowly through the later C20. The resurvey programme initiated by Cadw in the 1980s, revising the lists of protected buildings, prevented much demolition, and the Historic Buildings Council was able to give financial aid to a tiny percentage of the listed buildings. Grant aid for townscape schemes was available from the 1980s, but it is only since the millennium that such schemes have made an impact, revitalized the centres of Llandovery and Cardigan. Many buildings sliding towards dereliction for lack of use have been refurbished, often with funds from the Welsh Development Agency; good examples are the former Board School at Aberystwyth, now offices, and the Market Hall at Llandovery, now shops. Public-house use of the former Llanelly Cinema and the railway station at Aberystwyth, both by the Wetherspoon chain, specialists in such reuse, mark a nationwide urban trend. Drinking has replaced religion in the St Paul's Welsh Wesleyan Chapel in Aberystwyth, banking in the

Metropolitan Bank, Llanelli, and postal counters in the Llanelli Post Office.

The beginning of careful use of traditional materials in the restoration of vernacular buildings (discussed in the vernacular section) dates from the last decade of the C20, and similar return to traditional materials can be seen in the work of the church restorers, as at Pembrey and Llanwenog. Chapels have not fared so well, partly because most fell outside the criteria for grant aid until the late C20. Major country-house restorations, as at Llan-erchaeron, Newton House and Llanelly House,* are now done to a conservation standard previously unknown and specialist firms are slowly following specialist architectural practices into the region. Castles and abbeys have benefited hugely from an ambitious and well-founded programme of repairs initiated by Cadw, including at Dinefwr and Dryslwyn excavations that have rewritten in part the histories of the two castles.

Against the more optimistic picture it must be said that the tide of harsh repair, unforgiving renders and plastic windows reached as high in West Wales as anywhere in the country, swamping particularly the rural vernacular.

* To start in 2007.

FURTHER READING

Ceredigion was well served by its first historian, the antiquary S. R. Meyrick, whose *History and Antiquities of the County of Cardiganshire* was published in 1810. G. E. Evans' *Cardiganshire*, 1903, was a compilation of his newspaper essays on individual parishes. Modern county histories include W. J. Lewis' *Cardiganshire County Atlas*, 1969, and Gerald Morgan's well-written *Ceredigion: a wealth of history*, 2005. The *Cardiganshire County History* produced by the Cardiganshire Antiquarian Society lacks still one volume of the three planned, that on the medieval period. The prehistoric and Roman volume dates from 1994 and the early modern and modern volume from 1998. The domestic architecture of the county is especially well covered by Peter Smith in the third volume. *A History of Carmarthenshire* came out in two volumes, 1935 and 1939, edited by Sir John E. Lloyd and a modern summary is *Carmarthenshire The Concise History*, by Dylan Rees, 2006. The Royal Commission inventories of ancient monuments extended only to *Carmarthenshire*, 1917. The county archaeological journals are the *Carmarthenshire Antiquary* and *Ceredigion*, heirs in both cases to earlier Transactions of the respective county archaeological societies. Both contain a wealth of articles of architectural and archaeological interest. The volumes of *Archaeologia Cambrensis* are an enormous resource with too much of importance to enumerate.

The Shell Guides with their evocative black and white photographs remain a delight: Ceredigion is included with Merioneth in *Mid Western Wales*, 1971, and Carmarthenshire with Pembrokeshire in *South-West Wales*, 1974, both by Vyvyan Rees. *The Companion Guide to South Wales*, 1977, by Peter Howell and Elizabeth Beazley has a fine architectural eye. Collections of old photographs are invaluable: the series *Britain in old photographs* published by Alan Sutton includes several volumes on the region, as do collections from the archives of Francis Frith.

Three volumes of the series *The Visual Culture of Wales*, written by Peter Lord, cover different aspects of the art and artefacts of the country: *Medieval Vision*, 2003, *Imaging the Nation*, 2000, and *Industrial Society*, 1998.

The best gazetteer of ancient monuments, prehistoric to medieval is the Cadw guidebook by Sian Rees, *Dyfed*, 1992. Description of individual sites will be found in the national and county archaeological journals and also in *Archaeology in Wales*, the *Bulletin of the Board of Celtic Studies*, and the *Proceedings of the Prehistoric Society*. The overview of prehistoric material is Lynch,

Aldhouse-Green & Davies, *Prehistoric Wales*, 2000; specific to sw Wales are C. T. Barker, *The Chambered Tombs of South-West Wales*, 1992, and Children & Nash, *Neolithic Sites of Cardiganshire, Carmarthenshire and Pembrokeshire*, 1997. For the Roman period, Heather James, *Roman West Wales*, 1982, gave an overview, supplemented in great detail by her *Roman Carmarthen: Excavations 1978–1993*, 2003. For the Early Christian Monuments V. E. Nash-Williams, *The Early Christian Monuments of Wales*, 1950 is the standard work, but the 1993 reprint of J. O. Westwood, *Lapidarium Walliae*, 1876–9, gives access to Victorian illustrations and interpretations.

The general outline of medieval history is R. R. Davies, *The Age of Conquest, Wales 1063–1415*, 1991, and for medieval church history, Glanmor Williams, *The Welsh Church from Conquest to Reformation*, 2nd ed. 1976. Many churches, mostly before their Victorian restorations, were visited by the antiquarian, Sir Stephen Glynne, in the mid c19, and his notes, published in *Archaelogia Cambrensis* in the 1890s, are very valuable. A systematic modern survey of all the churches of medieval origin in Carmarthenshire was undertaken by Neil Ludlow for the Cadw Historic Churches Project. Two crucial and overlapping works on Welsh ecclesiastical architecture and history, *Romanesque Architecture and Sculpture in Wales* by Malcolm Thurlby, 2006, and D. M. Robinson, *The Cistercians in Wales*, 2006, published just as this volume was going to press, are outstanding contributions to the architectural history of Wales, challenging many interpretations, including some in this volume. The unusual carved fonts of Ceredigion are highlighted in Peter Lord's *The Visual Culture of Wales: Medieval Vision*, 2002, and given unexpected prominence in E. Tyrrell-Green's *Baptismal Fonts*, 1928, a work that covers all of England and Wales.

For the church in the c19, the files of the Incorporated Church Building Society at Lambeth Palace and those of the diocese of St Davids in the National Library of Wales cover almost every restoration and many new church buildings. The National Library faculty papers also deal with minor additions to churches, including much stained glass, mostly c20, and the Queen Anne's Bounty papers deal with parsonages. Thomas Lloyd gave a catalogue of the sculptors and masons known to have worked on Carmarthenshire church monuments, in the *Carmarthenshire Antiquary*, 1989. The archaeology and medieval history of Carmarthen have been the specialism of Terrence James, in articles and in *Carmarthen: An Archaeological and Topographical Survey*, 1980. Individual church histories of quality are rare but those for Llanbadarn Fawr; Holy Trinity, Aberystwyth; St Peter's Carmarthen; and Llangunnor stand out. The guide book to Pembrey of 1898, is still worth seeking out. For chapels, Anthony Jones, *Welsh Chapels*, 1996, remains the overview. The chapels database set up by the Royal Commission and National Library has greatly increased available information. *Capeli Cymru*, 2005, by D. Huw Owen illustrates a selection of chapels from across Wales. Stephen Hughes' catalogue of the works of the Rev. Thomas Thomas in

Archaeologia Cambrensis, 2005, exposes the enormous output of one of the important chapel designers. David Farmer's *The Remarkable life of John Humphrey*, 1997, is a revealing short work on another. Rees & Thomas, *Hanes Eglwysi Annibynol Cymru*, 1870–5, gives the history of every Independent or Congregational chapel to that date, with an update in the fifth volume of 1894. Carmarthenshire Calvinistic Methodist chapel histories are in Rev. J. Morris, *Hanes Methodistiaeth Sir Gaerfyrddin*, 1911, and those of South Ceredigion covered in Rev. John Evans, *Hanes Methodistiaeth De Aberteifi*, 1904. B. J. Rawlins, *The Parish Churches and Nonconformist Chapels of Wales*, 1, 1987, gives a checklist of every church and chapel in sw Wales with the location of their records. There are some good chapel historians, among them B. G. Owens for Bethel, Aberystwyth, 1989; C. O. Devonald for Bethesda, Ponthirwaun, 1990; Mair Davies for Blaenannerch, 1994; J. Geraint Jenkins for Penmorfa, Penbryn, 1996, and Evans & Gravelle, for the English Congregational Church, Carmarthen, 1996.

The Cadw guides to castles and abbeys in their care have expanded to become important works of scholarship: *Laugharne Castle*, by Richard Avent, 1995; *Strata Florida and Talley Abbeys*, by David M. Robinson & Colin Platt, 1998; *Dinefwr and Dryslwyn Castles*, by Sian Rees and Chris Caple, 1999; and *Kidwelly Castle*, by John Kenyon, 2002. The old Ministry of Works guides are still well worth rediscovering, and remain in use for *Carreg Cennen Castle*, by J. M. Lewis, 1960, and *Llansteffan Castle*, by D. J. Cathcart King, 1963. The best exploration of the Whitland Abbey site is Neil Ludlow's article in *Archaeologia Cambrensis*, 2002.

The best modern town histories are J. and V. Lodwick, *The Story of Carmarthen*, 1994, and two by W. J. Lewis: *Born on a Perilous Rock* (Aberystwyth), 1980, and *The Gateway to Wales* (Cardigan), 1990. Lewis's booklet *New Quay and Llanarth*, n.d., is also useful. A. T. Arber-Cooke's *Pages from the History of Llandovery*, 1994, is exceptional for the detailed analysis of ownership of individual houses. John Nicholson produced a series of very detailed books on Pembrey and Burry Port through the 1990s. *Looking around Llanelli with Harry Davies*, ed. Gareth Hughes, 1985, collects that journalist's essays on the town, and similar newspaper essays, by Donald Davies on Cardigan, are collected in his *Those Were the Days*, 1991–2.

Older town histories include G. E. Evans's essays on *Lampeter*, 1905, occasionally useful, as is his *Aberystwyth: Its Court Leet*, 1902. Llanelli's early history is covered in John Innes, *Old Llanelli*, 1902, reprinted 2005. *Llandeilo Present and Past*, 1868, by W. Samuel; *A History of Kidwelly*, 1908, by Rev. D. D. Jones, and *Tregaron* by the Rev. D. C. Rees, 1936, are of interest. One of the very best C19 histories is Mary Curtis's *The Antiquities of Laugharne, Pendine and their Neighbourhoods*, 1880.

Older parish histories are voluminous, like the Rev. T. M. Morgan's history of *Newchurch*, 1910; *Hanes Llanwenog* by D. and Z. Cledlyn Davies, 1939; *Hanes plwyfi Llangeler a Phenboyr* by D. E. Jones, 1899; *Hanes Plwyf Llandysul* by the Rev. W. J. Davies,

1896; and *Hanes Plwyf Llandybie*, by Gomer Roberts, 1939. More modern ones include *The Story of a Parish* (Llanfihangel Abercywyn), 1975, by the Rev. Conrad Evans; *Llanfihangel Genau'r Glyn*, 2002, by Randall Evans Enoch; *The Story of Llangrannog*, 1973, by Mervyn Davies; the article by J. G. Jenkins on Penbryn, in *Ceredigion*, 1983; David Jenkins, *Bro Dafydd ap Gwilym* (Penrhyncoch), 1992; and E. T. Lewis, *Local Heritage Efailwen to Whitland*, 1975.

For country houses, Thomas Lloyd's *Lost Houses of Wales*, 1986, records the losses, Herbert Vaughan's *The South Wales Squires*, 1926, the last heyday. Architectural studies are rare; the country houses of John Nash are particularly well analysed in Richard Suggett, *John Nash*, 1995, with a great deal of material unknown to previous authors on Nash. The gentry of the Teifi valley are covered in Leslie Baker-Jones, *Princelings, Privilege and Power*, 1999, and the Lloyd family of Bronwydd specifically in his *The Wolf and the Boar*, 2005. Gerald Morgan has edited one house history in *Nanteos: A Welsh House and its Family*, 2001, and written the history of another, Trawsgoed, in *A Welsh House & its Family: The Vaughans of Trawsgoed*, 1997. Llanerchaeron has a good National Trust guidebook, 2004, by Jane Gallagher and Oliver Garnett. The tragic history of Hafod is delightfully told in Elisabeth Inglis-Jones' classic *Peacocks in Paradise*, 1950. D. S. Yerbrugh's *An Attempt to Depict Hafod*, 2000, borrows his title from George Cumberland's *An attempt to describe Hafod*, of 1796, and reprints many early views, including some from Sir James E. Smith, *A Tour to Hafod*, 1810. Jennifer Macve's *The Hafod Landscape*, 2004, is a guide to what remains. Francis Jones in a lifetime of writing covered the gentry families and their houses, collected and itemised house by house in his *Historic Carmarthenshire Homes*, 1987, and posthumous *Historic Cardiganshire Homes*, 2000. A list of his many essays on the subject was published in the *Journal of the Pembrokeshire Historical Society*, 1994–5.

Monographs on particular architects are exceptionally rare, those on John Nash, John Humphrey, the Rev. Thomas Thomas are all mentioned above.

The major parks and gardens of SW Wales have been admirably investigated in the *Cadw Register of Landscape, Parks and Gardens of special interest*, 2002, by Elizabeth Whittle, and the story amplified for Ceredigion in Palmer, David & Laidlaw, *Historic Parks and Gardens in Ceredigion*, 2004. *The National Botanic Garden of Wales*, 2000, edited by Andrew Sinclair, celebrated the opening of the millennium project. The restoration of Aberglasney garden is described in Penny David, *A Garden Lost in Time*, 2000.

Peter Smith's *Houses of the Welsh Countryside*, 1988, remains the bedrock of the study of domestic architecture in Wales, with his chapter on houses and building styles in *Settlement and Society in Wales*, ed. D. Huw Owen, 1989, as a general introduction. The houses of Ceredigion are covered in his article in the Cardiganshire county history and those of Carmarthenshire in his essay in *Carmarthenshire Studies*, 1974. Martin Davies' booklet *Save the Last of the Magic: the Traditional Qualities of West Wales Cottages*,

1991, remains an inspiration to the preservation of the smallest houses. Small cottages are also covered in Eurwyn Wiliam's booklet, *Home Made Homes*, 1988, and in Iorwerth Peate's *The Welsh House*, 1944. For buildings on the farm, Eurwyn Wiliam's *Historic Farm Buildings of Wales*, 1986, is the essential overview.

School buildings are generally covered by Malcolm Seaborne in *Schools in Wales*, 1992. The original university buildings in Aberystwyth have an exceptionally good architectural history in *The Old College*, by J. Roger Webster, 1995. E. L. Ellis's *The University College of Wales, Aberystwyth 1872–1972*, is the centenary history of the institution. Canon D. T. W. Price, *A History of St Davis's College, Lampeter*, 1977 and R. Grigg, *A History of Trinity College, Carmarthen 1848–1998*, are valuable for those two institutions. The booklet, *The National Library of Wales*, 1994, by Daniel Huws, gives a useful architectural history.

For industrial history there are the files of the National Monuments Record, the Cadw Ancient Monuments files, and the Sites and Monuments Register held by Cambria Archaeology. The lead mines of the county are covered in David Bick's, *The Old Metal Mines of mid-Wales*, parts 1–3 and 6, 1974–91. The C17 and C18 mining history is covered by Bick in *Waller's Description of the Mines in Cardiganshire*, 2004, and in *Lewis Morris and the Cardiganshire Mines*, 1994 (with P. Wyn Davies). Specific monographs are Bick's *Frongoch Lead and Zinc Mine*, 1996, and S. S. J. Hughes, *The Cwmystwyth Mines*, 1993. The mines of Carmarthenshire and S Ceredigion are detailed in G. W. Hall, *Metal Mines of Southern Wales*, 1971. W. J. Lewis gives an overview in *Lead Mining in Wales*, 1967. There is a National Trust guide book to the gold mines at Dolaucothi. The slate quarries are covered in A. J. Richards, *Slate Quarrying in Wales*, 1995. J. Geraint Jenkins, *The Welsh Woollen Industry*, 1969, is the primary work on the industry, supplemented by his booklet *Dre-fach Felindre and the Woollen Industry*, 1976.

Books on transport history include E. Jervoise, *The Ancient Bridges of Wales & Western England*, 1937. Among the railway histories produced by the excellent Oakwood Press are several by M. R. C. Price, including *The Whitland & Cardigan Railway*, 1976; *The Lampeter, Aberaeron and New Quay Light Railway*, 1995; and *The Gwendraeth Valleys Railway*, 1996.

CARMARTHENSHIRE

ABERGORLECH

Compact upland village on the N bank of the Cothi, the chapel at the W, the church at the E. The PLAS, now merely the end house of the terrace opposite the bridge, was home of a high sheriff in 1649.

ST DAVID. Rebuilt in 1885 by *E. H. Lingen Barker*, retaining the walls of the church rebuilt in 1834. This had been a simple box 25 ft by 16 ft (7.6 metres by 4.9 metres), Barker added all the details and the chancel. The matching W bay, with bellcote, rose window and S porch, dates from 1906. Plain interior with Bath stone chancel arch.

CAPEL NEWYDD INDEPENDENT CHAPEL. 1827, altered 1872–3, probably by the *Rev. Thomas Thomas*. Long-wall façade with two arched windows, gallery sash windows and two doors. The stucco and the galleried interior are of the later date.

PONT COTHI. Rugged and ancient-looking three-arched bridge, possibly C17 or early C18, with cutwaters carried up as refuges. Two distorted but slightly pointed arches. A plaque records repairs in 1792, possibly to the third arch, which is more regular.

ABERGWILI

A long main road village now bypassed. The church is to the S of the street and the former bishops' palace at the E end, in walled gardens. In 1287 Bishop Bek founded a college of priests at Abergwili, 1 m. E of Carmarthen, which was relocated to Brecon by Henry VIII. In 1542 Bishop Barlow converted the buildings to a bishop's palace, in preference to the remote St Davids. He planned to move the cathedral also. Abergwili has been the bishop's residence ever since.

ST DAVID. 1842–3, by *C. C. Nelson* of London, who built little in a long career, chosen by the newly installed Bishop Thirlwall, though G. G. Scott had surveyed the old church. Papery E. E., with tall lancets and thin buttresses. Two-stage NW tower with big triplets of belfry lancets and a Bath stone broach spire. Double-naved with N porch, echoing the previous church, which had no tower. Nelson's interior was

old-fashioned, with very short chancel, lengthened in 1871 by
Ewan Christian. Broad nave with a six-bay arcade, chamfered
all the way down the piers; blind arches at W and E ends. Blind
arcades also in the S and N walls, in anticipation of future
enlargement. No chancel arch. Wide complex, open-timbered
roof, with two sets of inelegant tie-beams and kingposts. Chris-
tian's E wall has superimposed arcading with polished black
marble colonnettes, in contrast with Nelson's thin detail. –
FONT. 1843, octagonal, with quatrefoil panels and cusping in
the pedestal. – Also of 1843, the tall Gothic PLAQUES of
painted slate at the W end of the church, the Commandments,
Creed and the Lord's Prayer, in Welsh. Thirlwall was the first
bishop actively to promote the language. – FURNISHINGS.
Mostly of 1871–5, the heavily-carved oak PULPIT, a memorial
to Thirlwall, who died in 1875. – STAINED GLASS. W window,
1843, formerly the E window, given by Thirlwall. Symbols and
Welsh texts. By *Bell* of Bristol a richly coloured group of the
1860s: chancel S, the Empty Tomb; chancel SE, Miracles, and
an aisle window, dated 1861, Christ healing. Contrasting
sombre colours to the three-light E window, 1889, the Cruci-
fixion, by *Heaton, Butler & Bayne*.

MONUMENTS. Large COFFIN-LID with foliated cross, late
C13 or early C14. Bishop Richard Davies †1581, a fine piece of
1849 by *Edward Davis*, a native of Carmarthen, working in
London. Marble, with a relief of Davies, who translated the
New Testament into Welsh, seated before his books. Inscrip-
tion in Welsh, composed by the Rev. John Jones, the bard
'Tegid'. Aisle W wall, square tablet to a member of the Philipps
family †1671, the frame with scrolls, skulls and an hourglass.
Thomas Lloyd †1713. Baroque with Corinthian columns, an
open pediment framing huge winged cherub heads, a shield
above flanked by cherubs, and foliage below. John Griffiths
†1722. Veined marble, curved pediment and shield. Herbert
Lloyd †1806. Tapered, with tall urn. Similar memorials to Anne
Blome †1807 and Thomas Blome †1810. John Philipps †1816.
Wreathed urn, and a small painted shield below, by *Daniel
Mainwaring*. Urned plaques to Rev. David Davis †1831, by
Mainwaring, and to Frederick Philipps †1838, by *D. James* of
Carmarthen. Elizabeth Johnes †1842. Hybrid Gothic, with
cusping and pinnacles, but also pilasters, by *Thomas & Son* of
Brecon. Charles Philipps † 1854. Plain, signed both by *D. James*
and *Evan Harries*. Mary Lloyd †1862. Old-fashioned female
mourner and vase of drooping branches, by *G. Maile* of
London.

ABERGWILI PALACE, NE of the church. A college of the bishops
of St Davids since medieval times, and their principal residence
since the C16, when Bishop Barlow also wished to move the
cathedral to this more convenient location. A new house for
the bishop was built in the grounds in 1978 and the palace
became the County Museum. The present appearance is early
C19, simplified after a fire in 1903, but it incorporates the
earlier building. This was called ruinous in the later C16, but

Bishop Laud consecrated a new chapel in 1625. It is known to
have been to a courtyard plan, broadly covered by the present
building. In 1801 Bishop Lord George Murray, started a
remodelling, by *James Foster* of Bristol, which involved reori-
enting with a new E front range sited to overlook the Tywi valley
landscape. But Murray died in 1803 and it is not clear how
much was done. The entrance remained on the W side. Bishop
Burgess consulted *C. R. Cockerell* on repairs in 1821, but the
major work was for Bishop Jenkins, 1825–30. This was by
Cockerell's contractor at Lampeter, *John Foster* (no relation of
James), who died in 1828. It is not clear whose was the design.
The main W front was E-plan with three shaped gables and a *p. 19*
central cupola, and elsewhere there were bay windows with
battlements or candle-snuffer roofs. A new hall was made by
roofing over the small courtyard. After the fire, *W. D. Caröe*
repaired it in 1904–7, substituting roughcast for the stucco
and scraping extraneous detail except from the W porch,
which looks fussy against Caröe's dour grey. The loss of
the cupola though has taken away the key vertical note. The
mullion-and-transom windows remain but without the hood-
moulds and string courses. On the other façades, the canted
bays have lost their original roofs or battlements. The interior
is by *Caröe*, the hall top-lit. The best feature is the first-floor
CHAPEL, with Caröe's characteristic carved oak woodwork.

In the museum, is a stone bas-relief panel intended for
Nash's Picton Memorial of 1825–8, by *E. H. Baily*, to replace
his original in Roman cement, which had decayed. Never
used as the whole memorial was taken down. Also notable
INSCRIBED STONES, including that to Voteporix, from Castell
Dwyran, Clunderwen, the C6 ruler castigated by Gildas, with
inscription in Latin and Ogam.

The grounds were being laid out in 1803 for Bishop Murray,
with a fine lake made from an oxbow cut-off by the Tywi in
1802. The drive entrance, through *John Foster*'s Tudor GATE has
been moved away from his attractive octagonal LODGE, its
steep roof in part over a veranda.

LLYS ESGOB, the new bishop's house. 1978 by the Diocesan
architects *Mercer & Howells*. Modernist in the style of the
1960s, with monopitch roofs. The diocesan office adjacent is
in the former stable block by *John Foster*.

EBENEZER CONGREGATIONAL CHAPEL, at the W end of the
village. 1927, by *Gilbert Davies*. Large, old-fashioned Gothic
with a big cusped triplet over the entry. Coursed grey lime-
stone, but only up as far as the cement inscription under the
gable, as if funds had dried up. Well-appointed interior with
panelled gallery of mahogany and pine, on iron Corinthian
columns. Elaborate Gothic pulpit, gallery stairs each side, and
Gothic organ recess.

PENIEL CONGREGATIONAL CHAPEL, 2m. N. 1884, probably
by *George Morgan*. Rendered front, arcaded in three bays, with
giant plain pilasters. Tall outer windows, and a wider central
one with simple timber tracery. Gallery with continuous bowed

pierced ironwork. Wide pulpit with ironwork in cusped panels.

PANT-TEG INDEPENDENT CHAPEL, 3½ m. NE. Deeply rural, as it was a very early cause, founded 1669 by the Rev. Stephen Hughes. The chapel of 1856 has a traditional long-wall façade with two centre arched windows and outer doors. Later C19 stucco. Complete interior of 1856, the woodwork all painted wood-grain. Gallery on thin iron posts, with long panels in two tones. Painted box pews raked up to the back. Pulpit, with squat balustrade, closely enclosed by box pews, and with pretty pulpit-back with marbled pilasters and ogee Gothic head. Added stable with vestry over to l. By the stream, a double PRIVY, segregated for the sexes.

CWMGWILI, 2 m. N. Perched on the E side of the Gwili, an L-plan house of C16 origins, mostly late C17 to early C18, in striking yellow render. W front of two storeys and attic, five bays, with panelled end chimneys and tall narrow sashes of early C18 proportions. The big gabled stair tower behind has been formalised in the late C18, and is prominent on the main approach, with diagonal buttresses, a Palladian first floor window and big attic lunette. The main range extends a further bay to the N with a single-bay cross-wing running W for one bay, and a further two bays downhill beyond. The cross-wing is hard to fathom, it contains a C19 service stair of which the front wall proved to be of thin C19 timber-framing, but behind, overlapping both the cross-wing and the downhill section, is a massive chimneybreast which may be a C16 survival. The ground floor has two rooms with panelling in large panels of c. 1700 and pilastered chimneybreasts. The stair was replaced about 1900, copying the original twisted balusters. One origi-
45 nal rail survives at the top. On the first floor S, a former ladies' withdrawing room, panelled with deep arched niches each side of a bolection-moulded fireplace and an overmantel with a painted landscape.

BRYNMYRDDIN, ½ m. ENE. 1857–8, by *W. W. Jenkins*, for the Carmarthen banker Thomas Morris. His wife insisted that the original name, Penybanc, would not do for a banker. Bryn Myrddin, or Merlin's Hill, behind is an Iron Age HILL-FORT long associated with the magician and possibly the site of the pre-Roman tribal capital. The house, of grey limestone, two storeys and seven bays, with a canted centre and iron veranda, was described by H. M. Vaughan in 1926 as 'without preten-sion to architecture but happily without much attempt at orna-ment'. The service wing was the old Penybanc. Divided into flats in the 1970s.

ABERNANT

ST LUCIA. A small church in a huge churchyard. Abernant was a traditional place of burial for several surrounding parishes. Nave and chancel, with W bellcote. Basically medieval, with restored C15 cusped lancets to the chancel side windows,

another to nave N, and jambs to the W door. The large W double
bellcote may be of 1706, but with top rebuilt in the heavy
restoration of 1899 by *David Jenkins*. Of 1899, the W porch,
hipped vestry, most of the windows and the roofs. The plas-
tered rounded chancel arch could be early. Corbels for a rood
beam above, and a squint on the S, possibly indicating a lost
transept. – FONT. Rough square bowl, possibly C12 or C13. –
FURNISHINGS by *Jenkins*. – MONUMENTS. Evan Beynon
†1783. Shaped top. John Howells †1819. Oval. Rev. David
Lewis †1850. Large Gothic frame with colonnettes, oddly
enclosing a tablet with an urn, by *John Mainwaring*. John
Phillips †1867. Shield shaped.

PANTYCENDY HALL, ½ m. E. Much-altered stone house of the
1830s, remodelled in the late C19 to a three-bay front with two-
storey canted bays. The Carmarthen racecourse was in the
grounds in the early C19.

AMMANFORD/RHYDAMAN

6313

Ammanford developed from a crossroads settlement, Cross Inn,
in the late C19 and early C20. As late as 1880 there was just a
cluster of houses, three chapels and a foundry. The largest indus-
try then was a chemical works at Pontamman. Anthracite and
tin-plate were the main engines of growth, and the town was
largely built in a bare quarter century. Unusually, the industrial
sites were outside the town, S of the Amman in Bettws parish and
W of the Loughor, leaving the town without industrial scars.
There are more semi-detached houses than terraces, reflecting
the late date and spacious valley site.

ALL SAINTS, Brynmawr Avenue. 1911–15, by *W. D. Jenkins* of
Llandeilo, who won a local competition. Tower completed in
1924–6 by *Charles Mercer* of Swansea. A proud town church
well set on the hillside, in an unexpectedly lavish late Perp,
deriving from J. D. Sedding. NE tower, aisled nave, and chancel
with transept-like vestry and organ chamber. The original
plans were too expensive; this reduced version was intended to
cost £5,500 but finally cost £14,077 by 1926. A larger version
was built at Gorseinon, Glamorgan, in 1911–13. Though hard
and mechanical masonry denies the lightness of touch that this
late Gothic requires, there is an inventiveness here, seen in the
chequered gables, the full-height batter applied to the tower
buttresses, and the W apsidal baptistery. The hoodmoulds of
the W and S doors have finials surging upwards into curved
parapets. The odd placing of the clock stage above the tower
bell-lights was a war memorial afterthought. Conventional but
handsome interior: octagonal piers and chamfered arches,
the big hammerbeam nave roof the best feature. A little Art
Nouveau sweetness in the carved heads of the chancel arch
corbels, a little High Victorian vigour in the Dec Gothic sedilia.
– FITTINGS, by Jenkins, made by *Haughton* of Worcester,

well-designed late Gothic. The naturalistic eagle LECTERN seems to be from a different source. Total immersion FONT under the nave floor.

ST MICHAEL, Wind Street. 1884–5 by *David Jenkins*. An entertaining example of multi-coloured crazed masonry, called 'snailwork style' at the time. Various shades of brown mixed with purple, with yellow Bath stone tracery, purple relieving arches and grey plinth and buttresses. Otherwise wholly conventional; nave and chancel with lancets and bellcote. Sanctuary FITTINGS of 1936 by *W. Clarke* of Llandaff.

OUR LADY OF THE ROSARY (R.C.), Margaret Street. 1914. Plain brick and roughcast box. One STAINED GLASS window of 1985, by *Elizabeth Edmundson* of Swansea.

BETHANY CALVINISTIC METHODIST CHAPEL, Wind Street. 1881, with façade of 1928–9, by *J. O. Parry* of Ammanford. The front marks the end of the classical chapel tradition, expensively done in stone with ashlar details, but handled without coherence. A thin pediment, thick centre Venetian window and paired pedimented doors, relating uneasily to the narrow wings with stepped-up parapets. Panelled gallery on very Victorian iron columns, and a handsome build-up from great seat to pulpit to organ.

Y GWYNFRYN INDEPENDENT CHAPEL, College Street. 1902–3 by *Henry Herbert* of Ammanford. Stone gable front with Gothic tracery, identical to Herbert's Capel Newydd, Llandeilo. The interior has a compact richness, the gallery front curved and heavily panelled with carved work on the piers, and fluted iron columns. Panelled great seat, and pulpit, fronting the organ in a Gothic arch on classical pilasters. Novel introduction of large gabled windows to the centre of each side wall, to increase the light. Ceiling with ornate plaster roses surrounded by a broad timber ventilation border.

CHRISTIAN TEMPLE (Gellimanwydd) INDEPENDENT CHAPEL, High Street. Dated 1782, 1836, 1865 and 1910. The front is a muddle with Grecian acroterial ornament on a heavy pediment, a classical porch, and a big Perp Gothic window, but may all be of 1910. Certainly the 1865 façade, possibly by the *Rev. Thomas Thomas*, had just two arched windows and arched doors. Rich interior of 1910, possibly by *H. Herbert*, near-square, with heavily panelled gallery, like that at Gwynfryn, on old-fashioned lotus-capital iron columns. The gallery detail is echoed more thickly on the great seat and pulpit. A very large organ behind. Coved ribbed plaster ceiling, the ribs ornamented and framing ornate plaster lozenges and centre ring.

EBENEZER BAPTIST CHAPEL, Baptist Lane. 1877, brown stone gable front, quite plain, the centre slightly projected with broad centre window over an arched doorway. Interior altered in 1924 by *J. O. Parry*, but the effect still late C19. Gallery with long cast-iron panels, on iron columns like those at Bethany. Thickly detailed pulpit, like those at Gwynfryn and the Christian Temple.

ENGLISH CONGREGATIONAL CHAPEL, Iscennen Road. 1913, by *H. Herbert*. Small and simple red brick, with some inset grey-green tiles.

ENGLISH WESLEYAN CHAPEL, Wind Street. 1875, bleak Gothic stone front in purple and grey. Disused.

TOWN HALL, Iscennen Road. 1964 by *W. H. Lock-Smith*, the Borough Architect. Sub-Georgian, in red brick. Slightly modern recessed doorway and balcony, the cheeks veneered in green stone.

REGISTRY OFFICE, Iscennen Road. Built as the YMCA, 1909, by *David Thomas* of Ammanford. Red brick and terracotta, lumpish with an oriel window, not helped by plastic glazing.

POST OFFICE, Quay Street. 1925. A good example of that quiet but original Neo-Georgian used by the *Office of Works* at this period (cf. Lampeter, Cd.). Three storeys, four bays, in yellow stucco with Bath stone pilastered ground floor. Long arched first floor windows in early C18 vein, updated with metal glazing bars.

PANTYFFYNNON STATION, Pantyffynnon. A typical small station in the style of *I. K. Brunel*, hipped with deep overhanging roof and arched windows (cf. Chepstow, Monmouths.), but this line was built for the Llanelly Railroad & Dock Co. in 1840, and no Brunel connection is known.

AMMANFORD COLLEGE, Dyffryn Road. 1960s yellow brick, the façade stepped back in three tiers.

AMMAN VALLEY COMPREHENSIVE SCHOOL, Church Street. 1924–5 by *W. V. Morgan*, County Architect. One of the best schools of its date in the area, a model of careful handling of repetitive detail. Exceptionally long façade in grey stone. Two classroom blocks of two storeys (boys l., girls r.) with long windows arranged in a triple 1–2–1 rhythm, the pairs accented with shouldered gables. The centre and wings, for stairs and offices, are of three compact storeys, the wings tall and gabled, the centre Cotswold C17 style, with mullioned windows, three plain gables and a classical doorcase. Behind, a centre assembly hall, outer wings for laboratories (boys) and cookery (girls), and a detached gym dividing the playgrounds.

PARCYRHUN COUNTY PRIMARY SCHOOL, Villiers Street. 1907–9, by *W. D. Jenkins*. Red brick and yellow terracotta, the set-back centre with three yellow curved gables.

AMMANFORD COUNTY PRIMARY SCHOOL, High Street. 1925, probably by *W. V. Morgan*. Brick, single-storey, with two cast-stone entrances and a centre gable with lunette.

MOTTE, Tirydail Lane. In the grounds of Tirydail. Overgrown 20-ft (6.1-metre) motte with deep ditch and counterscarp to the N. Probably built by the Lord Rhys, and occupied for about a decade in the later C12.

The town centre is an irregular crossroads, where originally there were two pubs, the Cross Inn from which the settlement was first named, and the thatched New Inn opposite. Urban scale came in 1898–9 with THE TERRACE, College Street, by *Henry Herbert*, three-storey in red brick and yellow terracotta,

enlivened by a row of curved dormers (removed on the range to r.) and the ornate red terracotta entry to the ARCADE. The arcade is charmingly simple, low timber upper floor over original shopfronts. The New Inn was replaced by LLOYDS BANK, 1908–10, by *David Thomas*, also suitably urban in red brick and Bath stone with a squat corner dome trapped between two Baroque gables. In WIND STREET, running E, only No. 4, next to Lloyds Bank, the former National Provincial Bank, *c.* 1910, keeps the urban scale. In QUAY STREET, running S, the Lloyds Bank front was continued in a row of shops with two-storey curved oriels above, the detail mostly lost. Opposite, Nos. 2–4, *c.* 1910, red and yellow brick and some red terracotta, and the POST OFFICE (q.v.), keep to three storeys for a short distance. Quay Street was pedestrianized in 1995, with multi-coloured paving patterns. A sculpture by *Howard Boucott* is to be installed in 2006. HIGH STREET, to the W of the crossroads, has no buildings of any urban scale, and COLLEGE STREET, to the N, little after the arcade. Red and yellow brick and terracotta on Nos. 20–22, and on the former CO-OPERATIVE STORES, 1906, by *David Jenkins*, on the corner to Margaret Street. Further down WIND STREET, on the S, the CHURCH HALL, *c.* 1890 by *David Jenkins*, an acid mix of half-timber with crazed stonework, like St Michael's church opposite. By the churchyard, MINERS WELFARE HALL, by *J. O. Parry*, *c.* 1935, screened from the road by the featureless earlier club building, by *Parry*, 1933. Classical front in brick with giant Ionic columns *in antis* and entablature, all in cast stone, the best piece of public architecture in the town. Restored from dereliction in 2000. Behind, in Ammanford Park, BANDSTAND, 1935, by *J. O. Parry*.

MYDDYNFYCH, Llandybie Road. Surrounded by modern housing, a minor gentry house possibly of the earlier C17, on a medieval site. Cruciform with one massive lateral stack, and a stone winding stair in the E wing.

PONT AMMAN, 1 m. E. Broad single-arched bridge over the Amman, now disused. The thin stonework of the arch looks late C18 or early C19. Could this be the bridge at Bettws, of 45-ft (13.7-metre) span built in the 1770s, by the *Rev. William Edwards*, of Pontypridd, the great bridge-builder? Heavy late C19 parapets.

At Pontamman, three industrialist's villas: PONTAMMAN HOUSE, on the main road, *c.* 1870 for the owner of the chemical works, stucco, three-bay with outsize eaves brackets; WERNOLEU on the hillside to the S, Italianate, stucco, of similar date, badly decayed; and TYCOCH, Maesquarre Road (*see* Bettws).

There is very little of industrial interest within the town. One very large stone building, part of the ABERLASH TIN-PLATE WORKS, 1888, survives, derelict, N of Dyffryn Road. Dyffryn was an unexpectedly large two-storey C18 house of nine bays with centre pediment, demolished in the 1950s. At the foot of Quay Street, the former AMMANFORD ELECTRIC SUPPLY,

1909, red and yellow brick with the remnant of an electrically illuminated plaque in the gable.

BETTWS/BETWS

Across the river from Ammanford, Bettws is the older settlement, but shares the same late C19 history of anthracite mining.

ST DAVID. Small and basically medieval, as the battered wall-base shows, in a colourful mix of local stones with stone-tiled roofs. Nave and chancel, with large W bellcote, containing a bell of 1696. Medieval S porch, with an oak collar-truss with cusping above. Red sandstone pointed S door with a hollow-and-roll moulding, possibly C14, and small circular stoup to r., said to have been found in the churchyard. Cambered and chamfered W door with stone voussoirs, possibly late medieval. There was an arched window above, post-medieval, altered to a roundel. Cusped lancets, buttresses and other detail date from the restoration of 1872 by *John Harries* of Llandeilo, his plans altered by *R. K. Penson*, whose own more drastic scheme was not used. Inside, the nave roof has close-spaced collar-trusses of arched profile, with crude trefoil apex cusping, perhaps C17. The chancel roof, continued without a chancel arch is similar but thinner, possibly C19. – ORGAN of *c.* 1900, in two cases, each side of the chancel, with painted pipes. – Delicate oak ALTAR RAILS and sanctuary panelling, 1937, pulpit of 1963 to match. – STAINED GLASS. Some good C20 windows: E two-light, 1960, by *Lawrence Lee*, with a febrile medieval energy, achieved without historicism, a strong diagonally emphasized figure of the Great Deliverer over two sinners, the faces delicately drawn. In the nave S windows, The Real Light, by *John Petts*, 1976, radiating circles of pale blues with haloed doves, and the Tree of Life, by *Petts*, 1977, quite different, thickly drawn tree with Christ figure superimposed, a strong image in yellow-green. Nave N window of 1961, by *Celtic Studios*. W roundel with thick brightly coloured glass of *c.* 1990 to an abstract pattern.

CAPEL NEWYDD CALVINISTIC METHODIST CHAPEL. 1898. Two-storey front in rock-faced stone with ashlar dressings. Centre arched triplet in an elliptical-arched recess, and plaque in a fancy arched surround. Interior with panelled gallery fronts.

AMMANFORD COLLIERY, by Pont Amman. Altered red brick late C19 buildings, a long workshops range with power house/fan house at one end, a small office and the baths of the 1930s, now an engineering works. On the roadside, TY COCH, 1899, colliery owner's house of some scale, but much altered. English domestic-revival style in bright red brick with a little half-timber and tile-hanging in the gables.

PONT AMMAN *see* Ammanford.

BRECHFA

Attractive village in the Cothi valley, with the church in the centre. N of the church, stone and yellow brick CHURCH HALL, 1909 by *D. Davies & Son* of Penrhiwllan. The FOREST ARMS was two C19 three-bay cottages, that to the r. clearly later. To the S, the PRIMARY SCHOOL, 1878, by *George Morgan*. Four bays, with large bargeboarded porch, big round window at the N end and gabled master's house, to the S, of 1900.

ST TEILO. 1892–3, by *E. H. Lingen Barker*. The previous church of *c.* 1800 was just E, demolished 1894. Nave and chancel with N porch. The only notable feature is the triple-lancet bellcote, which echoes the W window. Chancel arch on wall-posts with foliage caps. – FONT. Very small square bowl, probably medieval, reduced and retooled. – STAINED GLASS. E window, 1922, by *Powell & Son*. – MONUMENTS. Daniel Prytherch †1800. White and grey marble, with roundel of a mourning woman and sarcophagus. – David Griffiths † 1808. Well-shaped limestone tablet.

CALVINISTIC METHODIST CHAPEL. 1879. Gabled with two arched windows. No gallery. Pulpit with fretted panels and curving stair. Big plaster ceiling rose.

PANT MANAL, S of the school. 1909–10. Stone cottage, built as a shooting box for Cyril Joynson. By *Clough Williams-Ellis & Scott*, the perspective signed by *James Scott*. One and a half storeys, with a steep mansard roof and brick ridge chimneys. A sensitively crafted work, if at odds with the local vernacular. The mansard or gambrel roof is an early revival of an E of England type, popular in the 1920s. Three bays, the broader centre bay projecting, and wide casement windows. L-plan STABLE RANGE with swept eaves.

TY MAWR. Three-bay house of *c.* 1700, with a massive projecting E end chimney. Colourwashed rubble walls and later sashes. The rear stair gable has been enlarged, and the four-bay W range added, late C18 or early C19. Interior modernized.

FFOREST, ½ m. N. A double-pile house, on a hillside shelf, victim of an astonishing breach of listed building control, when the original three-bay front was altered to five and the white-washed render removed. Over the door a splendid inscription of 1724 with heraldry, states that 'This house was built by the Hon the Lady Rudd and by ye directions of Richard Gwynne Esq' (her son-in-law). Her arms quarter those of the Lloyds, baronets of Fforest and Woking, Surrey. Their C16 house is the back range of the present two, with big N stack. A blocked two-light window with Tudor heads in the spine wall and a small single light in an attic gable remain. Also a wall-cupboard seems to be framed with a former screens passage doorway. A broad stair fitted into the back range in 1724 has been replaced.

ABERGOLAU, 1 m. SW, on the side of a steep valley. Dated 1774, for Daniel Prytherch. Five bays, with arched windows in the centre, one with Gothic glazing in the shallow pedimental gable. Much modernized.

BRYNAMMAN/BRYNAMAN 7214

The uppermost of the Amman valley industrial settlements, with
the Black Mountain to the N, and moorland to the E. The moun-
tain was quarried for limestone, the sites easily visible from the
Llangadog road. The coal-wastes, all cleared now, were just
across the river in Glamorgan. On the hill up from the river to
Gibea Chapel, plain pilastered MINERS'WELFARE HALL of the
1920s (a grand design by *C. T. Ruthen* of Swansea, 1914, was
never built). Terraced houses out on the road E.

ST CATHERINE. Down a lane opposite Gibea Chapel. 1880–1,
by *E. H. Lingen Barker*. Brown stone with Bath stone Early Dec
tracery, a characterful W end lean-to porch and baptistery,
plate-traceried roundel in a Gothic arch and small ridged bell-
cote. – STAINED GLASS. All conventional: E window, 1924, late
Gothic style. Five nave windows by *Celtic Studios*, 1957–91,
bright colours and good compositions within their limits.

 Above the church, stone and yellow brick Gothic VESTRY
HALL, 1897, by *J. Hay* of Swansea, two storeys to the ravine
behind.

GIBEA INDEPENDENT CHAPEL. 1856–7, altered 1889. Broad,
stucco two-storey front, with a pedimental gable. The arched
windows re-glazed in plastic. Galleried interior of 1889.
Outside, two Gothic MEMORIALS to past ministers, later C19,
with crocketed spires.

BRYN BRAIN, Cefnbrynbrain. Early C18 three-storey house, with
storeyed porch, unusual in an upland area.

HENLLYS VALE COLLIERY, ¾ m. N of Brynhenllys Bridge, in
extreme isolation. Just two remnants on a steep rocky slope, a
tall brick chimney of *c.* 1900, and a late C19 bank of four very
large LIMEKILNS. These were connected by a still-traceable
tramway to the quarries in the Black Mountain behind. Built
in two parts, the very high limestone front has brick arches
tunnelling back to high circular brick-lined crucibles. The SE
corner kiln has the crucible inside an inner square of brick with
narrow passage around.

BURRY PORT/PORTH TYWYN 4501

Developed from docks of 1834–6, linked to the Gwendraeth
valley coal-field by an extension of Thomas Kymer's C18 canal
(cf. Kidwelly). The South Wales Railway came through in the
1840s. In 1849 a large copper-works was built by the dock for
Mason & Elkington of Birmingham, with a 270-ft (82.3-metre)
chimney. The canal was replaced by the Burry Port and Gwen-
draeth Valley Railway in 1866–9.

 The station is the centre. S of the line, on cleared industrial
land, PLAS Y MOR, sheltered housing, by *PCKO Architects*, for
Tai Cantref, 2003. H-plan, parallel two-storey blocks with glazed
link, institutional, but softened by balconies and oak boarding.
The DOCKS remain, stone-lined small harbours, with a low

lighthouse of 1842 on the W pier. The floating E dock was added in 1840 and the reservoir for water to scour out the silt was converted to the W dock in 1888. The line of sunken iron tub boats were seized from a colliery in 1870 for unpaid fees. To E, on the copper-works site, C19 industrial buildings, heavily banded in copper slag. N of the railway, on Stepney Street, MEMORIAL obelisk, 1930, to Amelia Earhart's transatlantic flight from Newfoundland in 1928. Mostly two-storey stuccoed houses: the architect *E. M. Goodwin* was involved in 1873–7, Pemberton Avenue and Carway Street were part of an intended Goodwin's Town. N of the church, GARDEN VILLAGE, of 204 houses, 1915–19, by *T. Alwyn Lloyd*, built for the explosives factory at Pembrey. Roughcast houses, every detail lost apart from plaques in English and Welsh: 1919 THE YEAR OF PEACE. On the slope N of the main road, PLAS KENRHOS, hipped early C19 villa built for George Bowser †1835, promoter of the harbour.

ST MARY. 1875–7, by *Wilson, Willcox & Wilson* of Bath, built as a memorial to George Elkington of the copper-works, to plans drawn up in 1860. Rock-faced brown stone with Bath dressings, C13 Gothic style, with a tinge of Early French. Nave with aisles and clerestory, and chancel with S side tower and spire. Mechanical detail, the tower and broach spire too thin for the scale of the nave, but the tower stair-turret and the E end niche with dragon have a certain punch. More attractive inside, with Early French Gothic nave arcades of round piers with foliage capitals, open nave roof, and scissor-rafter chancel roof. Low chancel arch stone screen. Marble shafted sedilia. – FONT. Alabaster polygonal bowl on a column-ringed base, a powerful design. – PULPIT. Gothic, with diaper-patterned panels, on a squat clustered base. – REREDOS. 1927, gilded and painted, late Gothic, in the manner of Comper. – STAINED GLASS. Good E window of 1877, Ascension, by *Hardman*. W window, 1978, by *Celtic Studios*, Last Judgement. S aisle, second window, 1949, by *Powell*; third, by *Celtic Studios*, c. 1958. N aisle second, 2000, by *Janet Hardy*.

JERUSALEM INDEPENDENT CHAPEL, on the main road. 1858, altered 1888 and in the 1920s. Large gable front with giant pilasters and rusticated arch.

METHODIST CHURCH, SE of the station. 1866, by *D. Stringer* of Burry Port. Small, yellow brick with triangular window heads.

TABERNACLE BAPTIST CHAPEL, SW of the station. 1857, renewed 1887, and again 1901–2, by *G. Morgan & Son*. Two-storey with four arched upper windows.

ZION INDEPENDENT CHAPEL, NE of the station. 1873. Gable front with arched windows.

LLETYRYCHEN, 1 m. NE. Ruinous two-storey house of c. 1600 with pointed doorway and arch-braced collar-trusses. It may be a hall house of c. 1500, raised, with inserted floor and chimney.

CAIO *see* CYNWYL GAEO

CAPEL DEWI
1½ m. w of Llanarthne

4720

CAPEL DEWI (Calvinistic Methodist). Now a house. Built by the
Wesleyans *c.* 1800, sold to the Calvinists in 1834, who refitted
it in 1850. Long-wall front with outer doors and two central
arched windows. The interior had box pews.

CAPEL DEWI HALL, ½ m. w. Three-bay hipped villa, called
'modern' in 1815. Later two-storey bay windows.

CAPEL DEWI ISAF, ½ m. NE. Large farmhouse, with a long,
modernized façade of five bays. The three centre bays are
clearly the earliest, with a massive chimney. On the rear wall
is the corbelled base of a fireplace, missing its chimney, indi-
cating a late medieval or C16 first-floor hall. Modernized
inside.

CAPEL DEWI UCHAF. Two-storey early C18 house with steep
roof and massive kitchen chimney. High rooms with heavy
beams, some simple plasterwork in the entrance and full-height
oak stair with thick turned balusters. Heavily-moulded under-
stair door with a lozenge panel.

CAPEL HENDRE
2 m. w of Ammanford

5912

CAPEL HENDRE (Calvinistic Methodist). 1900, by *J. W. Jones* of
Llandeilo. Rock-faced sandstone with ashlar centre. Triplet
above paired doors and tall outer windows, all round-arched.
Gallery of long boarded panels divided by pilasters, on cast-
iron columns with foliage caps. Coved ceiling with a big centre
rose and boarding around the margin. The showy SCHOOL-
ROOM has a wide Dutch gable and a Diocletian window over
the porch.

CAPEL IWAN
Cenarth

2836

Village on the high ground above the Cych valley. A green in
front of the chapel.

CAPEL IWAN (Independent). 1846. Hipped roofed chapel with
long-wall façade. Arched windows and doors, all with cut Cil-
gerran grey stone heads. Glazing and interior of 1883, proba-
bly by *John Humphrey*. Pitch-pine gallery with a band of
pierced cast iron.

REHOBOTH BAPTIST CHAPEL, ½ m. S, above the Cych valley.
1859. Charmingly simple with slate-hung gable front and long
narrow windows. Disused. It had a painted grained gallery and
balustraded pulpit.

PONTGARREG CALVINISTIC METHODIST CHAPEL. 1 m. NW.
 1845, altered 1893. Stuccoed, the entrance to the rear; two
 arched windows to the road.
PANTEG UNITARIAN CHAPEL. ½ m. SE. Derelict. Originally
 Baptist. Dated 1764, but probably early C19. Long-wall façade
 with arched centre windows and outer doors, one changed to
 a window in the late C19.
GLASPANT. ½ m. W. Rebuilt c. 1800–10 for Thomas Howell, with
 a lunette in a broad centre pediment, a local pattern from the
 mid C18. The removal of the original ochre roughcast is a pity,
 but reveals that the house was enlarged from three bays to five.
 Broad entrance with traceried fanlight and side-lights. Late
 Georgian interior detail, but a 1741 date on a fireplace beam
 in the low rear wing. Late C18 or early C19 whitewashed BARN
 and STABLE range with scarfed cruck trusses.
CWMORGAN. 1 m. S. A hamlet in the Cych valley, with C19
 houses and cottages above a much altered mid-C19 former
 MILL at Maesyfelin. Down a track upstream, DREIFA MILLS,
 1896, a woolen mill to the larger scale of the late C19. Three
 and a half storeys with two big free-standing water wheels, fed
 by overhead leats. N of the village, GODREMAMOG MILL,
 1885, similar scale, with undershot wheel.

CARMARTHEN/CAERFYRDDIN*

Carmarthen may justly claim to be the oldest town in Wales. The
name Moridunum (sea-fort), recorded in Ptolemy's *Geography*,
was first applied to the Roman fort, and later to the town. Exca-
vations have established the general location of the fort in the
King Street–Spilman Street area, and suggest a short-lived mili-
tary base, established in *c.* 75 A.D., abandoned by *c.* 110–120,
after being reduced in size. The Roman town, the centre for the
Demetae, the Iron Age people of West Wales, was established to
the E of the fort, and the outline is preserved by suburban streets
E of the centre (Richmond Terrace, Oak Lane, Llwybr ar Arth,
The Esplanade, The Parade, Parade Road and Little Water
Street). This quadrilateral encloses some 82 acres (33 hectares),
making the town one of the smallest in Roman Britain. Excava-
tions have revealed a grid layout, and buildings, ranging from the
grandest with a hypocaust and painted wall plaster, to rectangu-
lar artisans' shops and houses. No trace has yet been found of
the central forum or basilica and it is likely that this westerly
outpost of Roman administration always had a somewhat home-
spun appearance. Occupation continued well into the C4. The
only above-ground monument is the earth amphitheatre, further
E (*see* p. 139), most unexpected so far west.
 The later town developed on two contiguous but separate sites.
Well NE of the present centre was Old Carmarthen, governed by

* The help of Terry and Heather James is much acknowledged, especially for the
introduction. Edna Dale Jones and David White also gave useful comments.

the Priory of St John and St Teulyddog, of which almost nothing remains. This seems to have been a Celtic foundation, perhaps on a Roman cemetery. After a short attempt to impose Benedictine rule, the incoming Normans founded a house of Augustinian canons, more akin to Welsh ecclesiastical practices. Several priors were Welsh, and the *Black Book of Carmarthen*, the celebrated collection of Welsh poems, tales and prophecy, came from its scriptorium. The Priory may have been responsible for the early association of the town with Merlin the magician, Caerfyrddin meaning the fortress of Merlin, Myrddin. The site of the Roman town to the SW, bisected by Priory Street, seems to have been the town fields of Old Carmarthen, with some houses around St Peter's church to the SW. The church was an early Norman foundation of *c.* 1110, contemporary with the first castle, but not built under its close protection. The area between St Peter's and the new Norman castle, the present King Street and Spilman Street, was an intermediate zone disputed between Old Carmarthen and New Carmarthen, the Norman royal borough, W of the castle. The castle, first established in 1109, became the centre of royal authority in SW Wales, the counterweight to the power of the marcher lords. New Carmarthen developed outside its gate, with murage grants from 1233. The early borough was small, and its burgesses all incomers. Its plan was simple: a market place (Nott Square), with a parish church of St Mary (long gone), and three radiating streets, Bridge Street, Quay Street and Guildhall Square, or Clos Mawr, each leading to a gate in the town walls. Extramural building in Lammas Street, the road running W outside the walls began in the C13, quickened by the later C13 foundation of the Greyfriars, the largest Franciscan house in Wales, now entirely gone (*see* p. 153). By 1268 there were 112 named burgesses, some of them Welsh. The various areas were slowly linked. The town walls were extended to the E from 1415, after Owain Glyndwr's uprising, enclosing the area up to the church, though nothing is now left of the walls.

In medieval times, and no doubt earlier, Carmarthen relied heavily on the river for trade, used in the early C13, for exports including wool, hides, leather and tin. A bridge was already being replaced in stone in 1233, and the new borough opened onto the river quay. Hardly any medieval buildings survive, though most of the town centre is built on medieval plots. The houses were probably timber-framed (*see* the Angel Vaults, Nott Square), on vaulted cellars (*see* the Ex-Servicemen's Club, Bridge Street).

C16 Carmarthen was prosperous from sea trade up the river. It was the largest town in Wales, with 328 households in 1566, a population of probably over 2,000. Despite this, Speed's map of 1610 shows little expansion beyond the walls, although the gates in Bridge Street and Quay Street had already been demolished. During the Civil War, Carmarthen surrendered to Parliament in 1644 after weak resistance, although its defences had been reinforced with a 'mudd wall', presumably the Bulwarks, a rare survival of C17 earthworks, around the areas outside the town gates to the W and N.

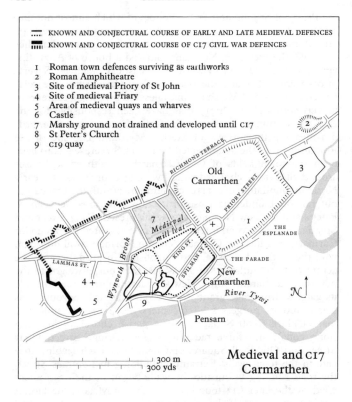

KNOWN AND CONJECTURAL COURSE OF EARLY AND LATE MEDIEVAL DEFENCES
KNOWN AND CONJECTURAL COURSE OF C17 CIVIL WAR DEFENCES

1 Roman town defences surviving as earthworks
2 Roman Amphitheatre
3 Site of medieval Priory of St John
4 Site of medieval Friary
5 Area of medieval quays and wharves
6 Castle
7 Marshy ground not drained and developed until C17
8 St Peter's Church
9 C19 quay

Medieval and C17
Carmarthen

From the first half of the C18, some town houses survive, most notably in Quay Street. The Guildhall, a refined Palladian building of 1777, was designed by *Sir Robert Taylor*, his only known work in Wales. The old E gate at Spilman Street was demolished in 1768, and the bridge widened in 1777. The Parade was constructed by public subscription in 1782, providing a walk to enable the townspeople to enjoy the scenery over the valley.

There was an important local iron industry from 1748 when Robert Morgan set up his furnace E of the town. His Furnace House, St Peter's Street, has fine iron railings of 1761 from the foundry. In 1750 around 150 tons of bar iron were being produced, rising to 400 tons in 1788. Morgan also produced high-quality tin plate. The works continued through the C19, despite a disastrous fire in the 1820s, and closed in 1900. High-quality iron railings made in several C19 foundries can be seen throughout the town.

In 1783 the young and bankrupt *John Nash* fled to Carmarthen, perhaps because he had earlier supervised the building of the Guildhall, by his master, Robert Taylor. His first recorded job, in 1785, with *Samuel Saxon*, was the reroofing of the church. His major public work, in 1789, was the County Gaol

on the site of the Norman castle, which had a competent classi-
cal front, appropriately rusticated. Nothing now survives of the
few buildings known to be by Nash, although several buildings
from the early years of the C19 are traditionally ascribed to him.
Two early C19 projects designed by Nash after he had left Wales
were the memorial to General Picton (1825–7, replaced in 1846),
and the proposed St Paul's church, Lammas Street, 1824. Nash
intended a Gothic church with a 230-ft (70-metre) tower and
spire. The foundations were begun, but taken up after legal and
financial difficulties.

In the early C19, Late Georgian houses were built in Picton
Terrace, along the main road w up to the Picton memorial, but
most of the streets around the core of the town were built up
with small artisan housing. Later C19 suburban housing is chiefly
to the N and E, much designed by *George Morgan*. C20 develop-
ment continues to encroach up the N slope of the valley. In 1801
the population was 5,548; in 2001 it was 13,157.

In the earlier to mid C20 the Tywi Bridge was rebuilt and
Nash's gaol was demolished for *Percy Thomas'* dominating
County Hall. The later C20 has not been kind to Carmarthen,
with particularly poor redevelopment in the 1970s and 1980s,
most notably between Lammas Street and the Market. Equally
noticeable is insensitive alteration, now slowly being addressed.
The town centre has been relieved of traffic by the bypass, and
extensively pedestrianized, and the castle remains opened up to
view.

CHURCHES

ST PETER, Church Road. Unsophisticated, but large, with the
presence of an old county town church. The dominant late C15
or C16 W tower was lime-rendered to very mottled effect in
2002. It is typical, tapering with battered base and battlements,
the latter rebuilt in 1868, but the gargoyles look original.
Double-naved church with N transept and s porch, externally
plain with low roofs, and windows with coarse Perp detail of
1846. The two big E windows and the N transept window are
of 1865–6, by *R. K. Penson*. Dating is difficult: the N nave may
have come first, perhaps C13 or C14, and the s nave added in
the C14, as suggested by the former s door, with its hollow
between roll and keel-type mouldings, the stones alternately
red and white. The s porch is vaulted, perhaps late medieval.
Along the N wall of the nave, a line of four low tomb recesses,
visible outside as blind arches. Broad interior with a five-bay
plastered nave arcade of chamfered pointed arches on octago-
nal piers with simple caps. Plain pointed chancel arch, prob-
ably inserted, see the awkward way it abuts the E end of the
arcade. The rather Jacobean low-pitched roofs in both nave and
aisle with heavy tracery above tie-beams carried on timber
shield-bearing brackets, date from 1861, by *W. H. Lindsey* of
Haverfordwest, following the collapse of the ceiling erected in
1785 by *John Nash* and *Samuel Saxon*. W GALLERY, 1789, by

Thomas Humphreys, the pine front of 1865, by Penson, when the organ was placed here. The N transept has thin C17 roof trusses with false hammerbeams and carved raking struts. Boarded panelled chancel ceiling, 1865–6 by *Penson*. Traces of C17 WALL PAINTING were found at the E end of the aisle in 2000.

Much better than the architecture are the FURNISHINGS and monuments. – In the W porch, a ROMAN ALTAR, a square pillar with moulded top, on a large square base. Probably one of two noted in 1804 outside a house in Priory Street; another is in the museum at Abergwili. – FONT. Octagonal late medieval. Reworked in 1857. – ORGAN. 1793 by *George Pyke England*, the case partly original. – PEWS of 1855 by *James Wilson* of Bath, with poppyheads. At the front, MAYOR'S SEAT, a heavily carved chair of 1851, by *Isaac Davies*. Against the S respond of the chancel arch, FAMILY PEW of Griffith Lloyd, dated 1709, but mostly remade to match Wilson's pews, retaining a little fielded panelling. – Under the W gallery, the FACULTY PEW of 1709, a remarkable survival, with turned columns, big moulded cornice and fielded panels to the lower part. – CHANCEL STALLS. 1892. – At the E end of the aisle, formerly known as the 'town chancel', the CONSISTORY COURT where ecclesiastical law was administered, an enclosure with a table, a canopied seat for the bishop on one side and four ornate pews on the other, 1866 by *Penson*. Handsome TILE pavement in front by *Maw & Co.*, 1876 with border of mitres. – PULPIT, 1892. Richly carved in oak, on marble shafted base; oak REREDOS, 1892; and brass winged angel lectern, 1888, all three by *Jones & Willis*. – ALTAR RAILS and low panelled chancel SCREEN, 1866, by *Penson*. – Black marble ALTAR TABLE (*ex situ*), dated 1829, by *Daniel Mainwaring*. Quite a refined piece, with a square pedestal. – COMMUNION TABLE (also *ex situ*), 1716, with gadrooned legs. – STAINED GLASS. E window, 1873, by *Alexander Gibbs*, five scenes from the Crucifixion. – Chancel N by *John Petts*, 1979. – N transept, dazzling N window of 1866 by *Wailes*: Call to Peter, Feed my Sheep, and Stilling the Waters. Three S aisle windows by *Bell* of Bristol, 1864–5, the big E window, Christ, St Peter and the Evangelists, Neoclassical drawing style; Faith, Hope and Charity in the fourth window, and six scenes of Works of Mercy in the third. Second window, warrior saints, 1926, by *Shrigley & Hunt*, and first, by *John Petts*, 1987, the Tree of Life. The SW window has earlier C19 armorial glass. – Nave N second window, *c.* 1920, Courage and Victory; third Christ and St Peter, 1903, probably by *Powell*, 1903; and fourth, 1870 by *Heaton, Butler & Bayne*, Crucifixion and Resurrection, good High Victorian drawing.

The fine array of MONUMENTS represents all periods from the C13 onwards. During restoration work of 2000, traces of paintwork indicated that most of the C18 monuments had black painted surrounds. – In one of the nave tomb recesses, a C13 coffin-lid, with foliate cross and mask above, the marginal

inscription thought to read RICAR ROSB(U) CIT ICI DEU DE LALME EIT MERCI. Also a C13 carved stone boss, said to come from the Priory. In the fourth recess, a very damaged upper portion of a C14 recumbent effigy. – By the S aisle door, a stone C15 shield with royal arms, found in 1878 near the Priory site. – In the S aisle, Sir Rhys ap Thomas †1525. Large chest with effigies, originally in the Friary, moved in 1535, moved again before being drastically restored by *Field* of London in 1865, for Lord Dynevor. Sir Rhys is in armour, his bare head resting on his mantle and tilting helmet. Surcoat with heraldry. Does this grand dress refer to the great tournament Sir Rhys held at Carew in 1507, to celebrate his Knighthood of the Garter? The female effigy beside him is much smaller, and probably not either of his wives, though contemporary. The chest has double canopies with cusped and crocketed heads over praying robed figures (almost wholly renewed on the N side). Pilasters between with shields and figures above. Three bays at the W end, with a priest-like central figure, flanked by females. At the E end, a shield set in a traceried rose. Old photographs, and a sketch of 1803 by John Carter, show that the shield was originally asymmetrically placed on the S side. John Nash infamously caused other old monuments to be broken up for lime mortar in 1785.

WALL MEMORIALS. Clockwise from Nave N: Thomas Morris †1839, Neo-Grec by *Tyley*; H.P. Ball †1798, sarcophagus plaque, by *Wood*; Oakley family, 1801, by *Foster & Co.*, with urn; – John Phillips †1730. A group of three family memorials. Tablets with scrolls and gadrooning, linked by an arch oversailing the smaller monument to Phillips's granddaughter, which has a bust set in an oval roundel. Over John's tablet, two putti bearing likenesses of him and his son James †1730. Over his wife's tablet, a cartouche. An unusual but sophisticated arrangement. N transept: W wall: large black stone plaque to Anne Philipps †1720 and family to 1734. Plaque in big ashlar frame to David Lloyd †1752. Elizabeth Evans †1765, coloured marble with pilasters. N wall: Neoclassical plaque to Thomas Cookes †1802, by *John Bacon Jun.* oval plaque with urn to Eliza-Maria-Ann Miers †1772. E wall: massive black sarcophagus to Sir James Hamlyn Williams †1829, by *D. Mainwaring*; matching plaque to Miers memorial, to Jane Philipps †1766. Nave E wall: George Lewis †1715. Fluted Corinthian pilasters with curved pediment and large cartouche. Oval plaque with cherub heads above, a rich piece of work.

Chancel N wall: oval plaque with urn to Thomas Jones of Jobs Well and descendants to 1810, by *Mainwaring*. Marble plaque with willow and urn, to John Jones M. P., of Ystrad, 1856, by *Gaffin*, probably not the design by the painter *Thomas Brigstocke*. Rev. Richard Prichard †1730. Bewigged bust of Prichard in a pilastered frame, with his books in the background, and an open Bible in front: an old-fashioned formula. Mary Howell †1724, plaque with side scrolls, and a bust above.

Richard Vaughan M.P. †1724. Large Baroque monument with
Corinthian pilasters of veined marble, and curved pediment
over cherub heads. An accomplished work by *William Palmer*
of London. William Lloyd †1710. Grey marble pilasters, cor-
niced with carved arms above, flanked by urns. Palms, trum-
pets and cherubs below. Rev. Edmund Meyrick †1713. Similar
to the Lloyd memorial. Well-lettered Latin inscription and
cartouche above; Elizabeth Lloyd †1814, with draped urn, by
Drewett & Co. of Bristol. Edward Davids †1758. Pedimented.
Chancel E wall: James Hughes †1803, large oval monument,
with woman mourning over an urn, by *Henry Wood*. Esther
Williams †1802. Small oval tablet by *Drewett & Co.* Mary
Harries †1700. Oval plaque with twisted columns, missing its
pediment. Chancel s wall: Lady Anne Vaughan †1672. Fine
painted kneeling figure in an apsidal recess framed by
Corinthian columns. Paired tablets with big scrolls and
urn to the Lawrence family and J. Hughes, 1841, by *John
Mainwaring*. John Williams of Edwinsford †1687, oval with
urns and scrolls, recording naval action against Algerine
pirates. Mary Mansel of Iscoed †1811. Lozenge-shaped, by
Cooke of Gloucester; Mary Holliday †1792. Scroll-type tablet
with flaming urn, by *R. Isbell*, of Stonehouse. Chancel floor:
slab to Charlotte Dalton †1832 by *D. Mainwaring*.

s side Consistory Court N wall: Rowland Philipps †1726.
Corinthian pilasters with broken pediment and cartouche.
Capt. H. Harding †1830, Neo-Grec. John Williams of Bwlchg-
wynt †1739 and his wife †1744. Fluted pilasters and double
curved-pedimented marble tablets. s aisle E wall: George Bevan
†1768 and the Rev. G. W. Havard †1782. Oval tablet in
coloured marble with pediment, by *R. Morgan*; Frances Diggle
†1797, Neoclassical, with urn, by *W. Paty*; John Lewes †1742,
open pediment over cherub heads. Mary Osborne †1730.
Fluted pilasters, with finely carved skulls below and broken
curved pediment. s aisle s wall: Jonathan Scurlock †1682.
Baroque framed tablet, twisted columns, skulls and broken
curved pediment; Jonathan Oakley †1677, half-length figure,
bewigged, and holding a scroll. Twisted columns and curved
pediment. Major-General Sir William Nott †1845, tall taper-
ing tablet with record of his career in India and Afghanistan,
with sword above, by *J. Loft*. Two similar sarcophagus plaques,
probably by *D. Mainwaring* to M. Roch †1819 and D. Davies
†1818. Sir Richard Steele †1729, the essayist and editor of the
Spectator, who had married into the Scurlock family. Brass
tablet of 1876; Bishop Robert Ferrar, burnt at the stake in Car-
marthen in 1555: Tapering white marble tablet of 1843, by *J.
Evan Thomas*. Catherine Morgan †1767, wife of the iron-
founder Robert Morgan: large, with Corinthian pilasters and
open pediment. John Thomas †1731, crudely carved in Bath
stone, with curved top and urn. Dr John Morgan †1784,
Grecian woman and urn, by *T. Paty*. Rev. W. Higgs Barker
†1816, shield plaque with sarcophagus, by *D. Mainwaring*.
Fanny Shirley †1764, pedimented, with verse epitaph to a nine-

year-old. Sarah Shirley †1783, damaged draped urn; Richard Philipps, organist, †1823: typical sarcophagus by *D. Mainwaring*. Susanna Richards †1742, in three colours, with fluted pilasters and broken pediment. Maria Warlow †1809, matching the Oakley memorial on the nave N wall, so by *Foster & Co.* James Hills †1818, with large urn on pedestal, by *D. Mainwaring*.

In the vestry: unusual painted wood Baroque memorial, with scroll pediment, to Anna Wotton †1719. Rev. J. Thomas †1793, plaque with draped urn, by *F. Lancashire* of Bath.

LYCHGATE. 1879, by *Francis E. Jones* of London. Good later Victorian Gothic, in red Runcorn sandstone, vaulted within. Wrought iron gates by *T. Jones* of Carmarthen.

ST JOHN, Priory Street. 1889–90, by *Middleton, Prothero & Phillot*, built as the Welsh church. Late Perp style, reminiscent of late C19 churches in the South Wales Valleys. Nave and short chancel of equal height, with clerestory, lean-to aisles, and a bellcote over the chancel arch. Gabled porch and organ chamber to animate the N side to the road. A light interior: arcades on octagonal piers, similar chancel arch, and chancel S arcade. Scissor-truss roofs. – Carved stone REREDOS, 1921. – IMMERSION FONT under the floor. – STAINED GLASS. E window 1902 by *A. J. Dix*, designed by *E. P. Warren*, the Oxford architect, Crucifixion and Evangelists, sombre against patterned glass. Chancel aisle E, *c.* 1906, by *Burlison & Grylls*, late Gothic style. S aisle SE window, 1926, and centre window, *c.* 1966, both by *Shrigley & Hunt*.

Good cast-iron RAILINGS, 1893, by *T. Jones & Sons*.

CHRIST CHURCH, Lammas Street. 1867–9 by *R. K. Penson*. Near the site of Nash's aborted St Paul's church. Quite complex: nave, chancel with a tower over the W end and a polygonal E end, N transept and a parallel-roofed S aisle. The church was large, to accommodate soldiers from the garrison. Penson intended a W tower with spire, but the chancel tower was cheaper. Rectangular, with big Dec bell-lights; it had a slated wedge-shaped roof, replaced by dull battlements, 1965, by *A. D. R. Caröe*. Forceful build-up to the tower: the transept with a rose window over lancets, and a NE pyramid-roofed turret, the apse with long narrow windows. Inside, S arcade on round piers, the aisle screened off, 1990, by *Roger Clive Powell*, with coloured glass roundels by *Glasslight* of Swansea. Big open roof, two pointed arches under the tower, and five-sided apse. – FONT. Quatrefoil-shaped, by *Penson*. – Carved oak PULPIT, 1928, by *Wippell & Co.* – Oak REREDOS, 1914, by *E. V. Collier*. – STAINED GLASS. Five apse windows, 1915, and one S aisle S, 1917, by *Kempe & Co.* – Nave N window 1955, *Powell & Son*, Resurrection.

DEWI SANT/ST DAVID, Picton Terrace. Set back in a large churchyard and closed 2006 for structural problems. A complicated story. In 1835–7 *Edward Haycock* built a long box church aligned N–S, behind a S tower. In 1853–5 *R. K. Penson* added a very wide nave with aisles, keeping Haycock's church

as transepts, though he wanted to replace it with a grand spired crossing tower and chancel. The present muddled E end is the chancel of 1886, by *Middleton & Son*, and fragmentary remains of Haycock's church, mostly tidied away in 1938, by *W. Ellery Anderson*, leaving a low link to the S tower. This is tall and rather gaunt, in grey and purple sandstone, with angle buttresses, single bell-lights and battlements. Penson's nave, in brown stone, is Dec, with alternating two-light and rose windows in the clerestory, and steeply gabled S porch. Exceptionally large W window, set high. Inside, tall and light nave with arcades of alternate round and octagonal piers, but thin roof (boarded in 1913). Chancel arch, 1886, on triple granite shafts, and two-bay chancel arcades. – Ashlar FONT, on marble columns (in a screened enclosure, 1913, by *E. V. Collier*) and PULPIT with open cusped front, both 1886, by *Middleton & Son*. – Stone REREDOS, 1914 by *Clarke* of Llandaff, with canopied figures of the Evangelists added 1915, by a Belgian refugee, *Clopert*. – STAINED GLASS. E window, 1962, by *Blakeman* of London, Christ in Glory. S aisle E, 1988, by *Celtic Studios*. – MONUMENTS. George Vigor †1847, plain, by *Tyley* of Bristol. Rev. David Williams †1858, pedimented. Jeremiah Hancocke †1858, shaped tablet, by *Edwards & Co.*, London.

ST MARY (R.C.), Union Street. 1851–2 by *Charles Hansom*, economical, though the first plans were grander. Nave and short sanctuary, with lancets and a little plate tracery. On the SW angle, buttresses support a spirelet. Inside, blocked arcades of an intended four-bay N aisle and a two-bay S chapel. The boarded roofs and W organ gallery are of 1889 by *Albert Vicars*. – Ornate stone HIGH ALTAR by *Hansom*. Altar with marble columns and vine-carved spandrels, under a crocketed five-gabled reredos, with carved saints flanking a brass crucifix in a taller niche. – Small FONT by *Vicars*. – STAINED GLASS. E window, 1853, strongly coloured scenes in three sexfoils. Nave N: first, *c.* 1911; third and fourth, *c.* 1910 by *Mayer* of Munich, by whom also the S second window *c.* 1894.

Large PRESBYTERY, by *Hansom*, 1852. Sandstone and Bath stone, of four bays and three storeys, with plain wide mullion-and-transom windows under relieving arches.

CHAPELS

BETHANIA CALVINISTIC METHODIST CHAPEL, Priory Street. 1902, by *George Morgan & Son*. Stuccoed, in *J. H. Morgan*'s Free Style. Typical stubby columns and broad voussoired arch to the entry, and a small lunette in the gable. Typical interior too, the end gallery with short balusters above the panels, and the beamed panelled ceiling, stepped up in the centre to give a longitudinal axis.

99 ENGLISH BAPTIST CHAPEL, Lammas Street. 1869–70, by *George Morgan*, who was a deacon here. Morgan began his career with this dramatic Bath stone temple front, the more arresting for being raised up at the end of a narrow courtyard.

The classicism is not pure, the giant Bath stone columns are wider spaced in the centre, and the arched openings behind give a quite different, and interesting rhythm. The façade is of five bays, the centre three in the portico, the narrow outer bays with matching full cornice. Emphatic horizontal lines from channelled rustication up to impost level of the centre doorway, but then contradicted by the narrow side stair windows being at half-level, with a blind roundel above, quite unrelated to the centre windows. Morgan's three temple fronts stand alone among Welsh chapels, and this one is the most concentrated. The others, Mount Pleasant, Swansea, 1874–6, and Newtown, Mont., 1881, are altogether more ample. The interior is rather plain, with a deep-coved plaster and timber ceiling. Corinthian pilasters frame the organ arch. Rear gallery with pierced cast-iron panels.

Good cast-iron GATEPIERS with Corinthian capitals, by *Baker* of Newport.

ENGLISH CONGREGATIONAL CHAPEL, Lammas Street. 1861–2. Very Gothic, by *Poulton & Woodman* of Reading, chapel specialists (cf. their Presbyterian Church, Brecon, 1872). It is angled to the street to make it more prominent. Rock-faced brown stone with Bath stone dressings. All extremely angular, with some surprising junctions. Steep gable, tall four-light window with attenuated Dec tracery, and to r. a fiercely complex stair-tower with needle spire on an open bell-stage, each face with a sharply gabled narrow two-light. This stands on a tower assaulted with gabled buttresses, and pierced with acutely pointed lights. Multi-cusped door-heads, with bi-colour voussoirs, one door to the tower, the other in a balancing position on the other side, with some random diagonal lines, linking it for no apparent purpose to the main buttress. Contrastingly sober interior, with arch-braced roof trusses, pointed apsed organ recess, and single gallery, with diagonally boarded front. Polygonal pulpit (*ex situ*). – STAINED GLASS. One 1914–18 war memorial window.

HEOL AWST INDEPENDENT CHAPEL, Lammas Street. Very early cause, founded in the later C17 by the Rev. Stephen Hughes. The first chapel, 1726, was the first in the town. Rebuilt 1826–7 by *William Owen* of Haverfordwest to seat a thousand, at a cost of £2,582, the largest in the region at the time. Set back in a courtyard, with good late C19 railings by the *Old Foundry Co.*, with the later schoolroom on the l. Plain rendered, hipped front, with two pedimented Ionic doorcases, each with an arched window above. Spacious square interior, still remarkably Georgian. Panelled gallery on marbled wooden Ionic columns, the arched panels with a simple cusping (also at Jerusalem, Gwynfe, 1827), barely but significantly Gothic. Box pews in two large centre ranks with ramped side blocks facing inward. – PULPIT. Of the wine-glass type, on a wooden column with an Ionic capital. Such early C19 pulpits are very rare (cf. Heol Dwr Chapel). Pulpit-back panelled like the gallery. Pretty ceiling rose with lacy radiating pendants, of

1860. – STAINED GLASS. The small figures in the ogee-headed lobby windows are probably of 1827, perhaps the earliest stained glass in the county. – Two large pulpit windows, glaringly out of place here, 1922, by *Abbott & Co.*, and another, *c.* 1946, by the same. – MONUMENTS. John Corrie (who gave the land and was buried under his own seat) †1731, moulded frame. Rev. Samuel Thomas †1766, shaped top. Edward Bowen Jones †1879, Gothic, cusped with coloured marble shafts, 1885, by *Burke & Co.*, London.

Exceptionally large SCHOOLROOM, on the E side of the courtyard. 1888–9, by *George Morgan*. Italianate, five bays to the courtyard, and four to the street, the windows on both storeys contained within giant arcading, a device often used by Morgan. Inside, a gallery on three sides, as if it were a chapel. Square cast-iron pillars, and long strips of pierced cast-ironwork above panels.

HEOL DWR CALVINISTIC METHODIST CHAPEL, Water Street. An early Methodist foundation, by the Rev. Peter Williams, who converted in 1743. This chapel dates from 1831. Long-wall front, with matching pedimented porches on Tuscan columns, and a large arched window above each, slightly further out. The stucco detail and glazing of 1891–2, and the inelegant central canted organ projection, of 1922, by *J. H. Morgan*. Three good slate MONUMENTS attached to the front, pedimented, 1863, by *Evan Harries*. Gallery of 1831 inside, five-sided, with alternating broad and narrow panels. One of the iron Corinthian columns is dated 1813, the date of the previous chapel, this being the fourth since the 1760s. Box pews, radiating to follow the line of the gallery. Superb mahogany panelled pulpit, with concave corners, standing on a splayed, fluted pedestal.* Like that at Heol Awst, a rare early survival. Boarded and ribbed ceiling, with huge plaster rose, 1892. – STAINED GLASS. Above the doors, small roundels, Crucifixion and dove, probably 1831. Lilies and roses in the front windows, 1892, by *Farmiloe & Son*. – MONUMENTS. Rev. David Charles †1834, Grecian, with urn, by *Daniel Mainwaring*. John Wyndham Lewis †1895, matching the Charles monument, by *W. Davies*.

Earlier C19 GATES with openwork iron piers.

PARC-Y-FELFED UNITARIAN CHAPEL, Mansel Street. 1849. Converted to a dental surgery 2005, by *Nicole Jones*. Stuccoed gabled front with giant Ionic angle pilasters, and Ionic doorcase, but two large pointed windows: so a happy mix of Gothic and classical. Plaque with Unitarian creed: TO US THERE IS BUT ONE GOD. . . . The interior was of 1915 by *Ronald Potter Jones* of London.

Gates and railings of 1849 with fearsome arrow-head finials.

PENUEL BAPTIST CHAPEL, Priory Street. Set back, behind good iron Gothic railings and gates, by *Thomas Jones*, 1872.

*An engraving by Hugh Hughes of the 1830s, the earliest of any Welsh chapel interior, shows a similar but taller pulpit: has it been cut down?

Broad gabled front of 1851, but the Edwardian detail, stucco on roughcast, of 1910, by *J. H. Morgan* of *George Morgan & Son*. Fine interior of 1910, in a free classical vein, interestingly varying the standard interior space. Galleried on four sides, with timber posts above creating quasi-aisles, though the longitudinal emphasis is muted by having a wider centre space between the posts. Balustraded gallery panels, quadrant-curved in the front corners, for access to the organ recess. Below the organ gallery, free classical arcaded pulpit against a curved pedimented panelled back.

Behind, on Penuel Street, SCHOOLROOM, 1886, by *George Morgan*, minimal Romanesque, in rock-faced brown stone, banded in blue and red brick, with Bath stone windows, and terracotta hoodmoulds, unusually polychrome for Morgan. Single gallery with long cast-iron panels.

Y PRIORDY INDEPENDENT CHAPEL, Priory Street. 1875–6 by *George Morgan*, the first of his remarkable series of Romanesque chapels. Rock-faced stone with Bath dressings. Taut façade with gabled centre slightly advanced, and wings with steep pavilion roofs. Interesting detail: stepped triple arched window echoed below by the doorway and side lights, each with a broad centre arch on fat ashlar columns. The arches are two-tone in yellow Bath and silver-grey local lime-stone. Rusticated piers frame the centre, up to the impost level of the upper triplet, giving a vertical emphasis. The outer bays have long arched stair lights at the half level and blind roundels above (the scheme as in Morgan's otherwise wholly different English Baptist chapel, 1870). Gallery with narrow ironwork bands of trefoils, on iron columns, half-fluted and half-spiralled. – PULPIT with arcaded front, and vast ORGAN behind of 1933. – STAINED GLASS. Lobby window by *Abbott & Co.*, Lancaster, early C20.

Gothic cast-iron GATES and railings by *Baker* of Newport.

TABERNACLE BAPTIST CHAPEL, Waterloo Terrace. 1841. Stuccoed and hip-roofed, minimally Gothic. A decorative parapet has been removed. Three bays divided by plain strips, a tall four-centred arched window each side of a Tudor doorway, added in 1884 by *George Morgan*, who had refitted the interior in 1878. Deep coved ceiling. Gallery on three sides, with continuous bowed front of pierced cast-iron, by *Baker* of Newport. Broad pulpit platform, over immersion font, with iron rails. Big organ recess, 1900, by *George Morgan & Son*, with a gallery to match the rest. – STAINED GLASS. 1959–62, by *Powell*. – Attached SCHOOL, 1883–84 by *Morgan*, simple Tudor detail.

ZION CALVINISTIC METHODIST CHAPEL, Mansel Street. 1849–50, by *R. G. Thomas* of Newport, and very different from his vigorous later chapels. Simple but elegant classical stuccoed façade, with pairs of tall Tuscan pilasters each end, and a broad entablature with inscription. Parapet and minimal centre pediment. Corniced central doorcase, arched window each side, and a triplet above, all with delicate glazing patterns. Plain

interior, with box pews. Gallery at the entrance end, 1875, with
pretty front of scrolled cast-iron thin panels. Organ recess
added 1889, the organ by *Hele & Co.*, 1895, rescued in 2000
from St Matthew, Fulham, London.

RAILINGS of 1850, wrought iron, with crude twodimensional
spearheads.

UNION STREET CONGREGATIONAL CHAPEL, Union Street.
1846, by *J. L. Collard*, altered in 1873. Gabled, minimal Gothic,
in unpainted stucco. Three-sided panelled gallery, apparently
of 1873. The box pews must be of 1846. Arcaded pulpit, with
a plaster Gothic frame behind. – MONUMENTS. Rev. William
Morgan †1884, and Dr John Rees †1878, both by *Bedford* of
London.

CARMARTHEN CASTLE

The first mention of a castle, in 1094, is thought to refer to a dif-
ferent site. By 1109, almost certainly, the castle was on its present
site, a rocky bluff over the Tywi. It soon passed into the hands of
the Crown, becoming the administrative centre for SW Wales.
Destroyed in 1137 by Owain Gwynedd, and again by Llywelyn
the Great in 1215. Rebuilt after 1223 under William Marshal II,
Earl of Pembroke. This rebuilding was almost certainly of stone,
on the site of the original motte, for in 1243 it withstood a siege
of three months. A survey of 1275 refers to a great tower, gate-
house, hall, kitchen and chapel, all then out of repair. Royal
expenditure from 1288 probably included repairs, and the build-
ing of the curtain wall. References in the C14 to the King's Hall
and chambers, the King's Chapel, the Queen's apartments, a
chapel for the knights and esquires, and exchequer offices,
suggest extensive building campaigns. After capture in 1405
during the Glyndwr uprising, more repairs were needed, and
nearly £100 was spent on rebuilding the gatehouse. Defended by
Royalists in the Civil War, it was referred to as 'now quite demol-
ished' in the later C17. *John Nash* built the GAOL on the outer

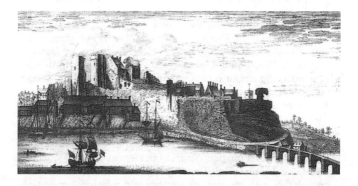

Carmarthen Castle.
Engraving by S. & N. Buck, 1740

ward, 1789–92, and, much extended in 1869, it eventually covered the site apart from the gatehouse and SW perimeter wall. Nash's façade faced Spilman Street with three rusticated bays, each with strongly voussoired arched openings, but only some perimeter walling now survives, the rest demolished in 1935 for the new County Hall.

The principal surviving element is the fine GATEHOUSE facing 27 Nott Square. This was rebuilt shortly after 1410, and provided accommodation for the constable. Three storeys, with two D-plan towers flanking a tall four-centred centre arch with machicolation below the parapet. The present gateway is inserted. Outer portcullis slot, the inner entry partially blocked. The design is similar to the gatehouse at Llawhaden, Pembs. Running N, a stretch of CURTAIN WALL, much rebuilt. This connects with the remains of the MOTTE, accessible from The Mount, a lane N of the County Hall entrance gates. The original earth mound was faced in stone, in the C13 or C14, with curved towers at the NW and SW angles, of which the bases survive. S from the gatehouse, rebuilt wall, and then, at the corner, circular early C14 SW TOWER, surviving to a full three storeys, with spurred base. To the E, the base of a square tower with a barrel-vaulted basement and a piece of curtain wall attached. The wall enclosing the County Hall car park just behind the gatehouse, is the perimeter wall of the gaol. The castle was opened up to Nott Square and restored by Cadw, 2002–5, with further work continuing.

THE PRIORY, Park Hinds. Very little survives above ground. There was almost certainly a pre-Norman monastic site, as is indicated by the dedication (along with St John the Evangelist) to St Teulyddog. A Benedictine community was first established, changed in 1125 to an Augustinian priory. Ruinous by the C18, and mostly cleared in 1781 for a lead-works. Excavations in 1979 in the SW corner of the park uncovered partial footings of the church, chapter house and prior's house, and stained glass, and glazed tiles of the C15–C16. All that is visible is a modest stretch of precinct wall on the N side of the park and the gatehouse, utterly disguised as a row of modernized cottages, Nos. 6–7 OLD PRIORY ROAD. The centre through-way may be the entry described in 1804 as having carved Tudor roses. In 1993 two late medieval fireplaces and a blocked four-centred arched doorway were found on the first floors.

ROMAN AMPHITHEATRE, in a small park E of the centre, N of 11 Priory Street. The only visible remnant of the Roman town, partially excavated in 1970. Probably built in the C2 A.D., outside the E boundary of the town. The seating bank on the N was cut out of the natural slope, the spoil used to build the S bank. The seats were wooden tiers, of which stain marks were found. There were entrances each end. The elliptical arena floor measured some 33 yds by 55 yds (30 metres by 50 metres), but to the W and S the site is still obscured.

COUNTY HALL. 1938–56, by *Sir Percy Thomas*. A surprising
French chateau high over the Tywi, the detail pared to the
minimum, but effectively massive, with steep roofs crowned by
towering chimneys. Basement and two tall storeys, four office
ranges enclosing a central council chamber. Rock-faced grey
Forest stone, with roofs of Pembrokeshire grey-green slate;
sprocketted eaves. The two main fronts – to s, overlooking the
river, and the N entrance front – are of thirteen bays flanked
by tourelles with conical roofs, the side ranges of twelve bays.
The grey mass is subtly broken by two white Portland stone
moulded courses, under the eaves and as a plinth moulding
above the basement, and leavened by repetitive white cross-
windows, flush with the wall face. The only variation, French
windows with balconies, on the towers, and in the five centre
bays of the main fronts, does not greatly disturb the regular-
ity. Main entrance framed in Portland stone, with relief shields,
by *David Evans*, charmingly illustrating the various office func-
tions (education, motor-taxation, weights-and-measures etc.).
The horseshoe COUNCIL CHAMBER has a coffered ceiling
with diamond-shaped panels, the deep cove carried on Gothic
corbelled arcading.

GUILDHALL, Guildhall Square. 1767–77. An understated and
much altered work of national rather than local significance. It
is by *Sir Robert Taylor*, the commission probably coming
through the M.P. for Carmarthen, Lord Verney, and his rela-
tion Sir William Clayton of Harleyford, Bucks. Clayton, who
became a burgess of the town in 1764, had employed Taylor at
Harleyford in 1755. The Guildhall, overlooking the sloping
square, has been stripped of stucco back to the rubble stone,
disastrous in so precise a design. Three bays, two storeys, the
upper storey of double height with a blind attic, finished with
a timber cornice under a hipped roof. Taylor in the 1760s had
begun to omit the parapet in his country houses and uses the
form here, presumably as appropriate to a rural market town.
A trio of giant first-floor arches frame large Palladian windows
with Ionic columns and there are three blind panels above. The
end elevations are windowless with similar panels. Taylor used
triple Palladian windows in arches with panels above in his
major metropolitan work of the same period, the Bank of
England Court Room. The source is Lord Burlington's N front
at Chiswick House, 1727, deriving from an unpublished
drawing by Palladio in Burlington's collection. Its first use on
a public building may have been here. The form of the ground
floor is unknown, but it was open, for a market, perhaps with
tripartite divisions echoing the windows above. Such divisions
are shown in the side bays in the earliest view of 1860, when a
clumsy horseshoe of external stairs, added in 1811 by *John
Roberts*, gave access to the upper chamber, as the original stairs
at the back proved too cramped. The present ground floor is
enclosed, of rusticated Bath stone with attached Tuscan

columns and balustrading, and breaks forward as a broad porch, so wide as to interfere with the relation of the first floor windows to the ground floor. This is all of 1860-2, when *W. H. Lindsey* took away the outside stairs. The heavy iron gates and grilles are of this date, and also the clock turret on the roof. The ground floor had been enclosed in the early C19: *John Jenkins* of London won a competition for renovations in 1842, but died, and *Edward Haycock* was appointed. Behind in Hall Street, a stuccoed four-storey, three-bay building was added, by *David Morgan* in 1827-8, for jury and other rooms. The interior is nondescript on the ground floor. The narrow curved stair at the back is of cantilevered stone, presumably earlier than the balusters of *c.* 1860. The council room has a deep coved ceiling, the centre with a Neo-Grec border, presumably not of Taylor's time. The fittings date from 1908-9, when *W. V. Morgan*, remodelled it as a court room with panelled woodwork, raked public seating and a little minstrels' (press) gallery over the entrance.

PUBLIC LIBRARY, St Peter's Street. Built as Furnace House, *c.* 1760, for Robert Morgan, who established the ironworks in 1748, and tin-mills in 1761. The façade and forecourt only survive, the rest demolished for the library in 1972-3. Three storeys, five bays, with a Bath stone Corinthian porch. The small forecourt is flanked by walls with a niche and big pineapple finials on the outer piers. Remarkable cast-iron front railings, dated 1761, signed *M. Busteed*. The rails are each a fluted column on a pedestal with gadrooned urn finial, of the type of the early C18 rails at St Paul's Cathedral, divided into bays by clusters of five. In the centre, a double stack with iron overthrow, and double cast-iron gates.

MARKET, Market Way. Large hip-roofed market hall, 1981, by *John Vergette*, of the *Percy Thomas Partnership*, with shops around an open court on the S: functional if utilitarian. The market is proposed for replacement (2007). In the courtyard, the characterful CLOCK TOWER of the previous market, 1846, by *F. E. H. Fowler* of London. Italianate, in brown stone, bereft of its stucco. Splayed base, arched triplet on the first floor, and two-stage pyramid roof, the top a timber clock-turret, both stages on big timber brackets.

TYWI BRIDGE. The present bridge of 1936–7 replaces a stone seven-arch bridge, first mentioned in 1223, rebuilt at an uncertain date, widened in 1777 and 1828. Three ferro-concrete segmental arches, the roadway rising from N to S to clear the railway on the S side. Designed by *Clough Williams-Ellis*, with parapets and keel-shaped cutwaters in grey sandstone, to leaven the bulk. Neo-Georgian iron lamps. A plaque by *H. Tyson Smith* depicts the old bridge.

PEDESTRIAN BRIDGE. 2006, by *John Mowlem Engineering*. White tubular steel cable-stayed suspension bridge.

WEST WALES GENERAL HOSPITAL, Glangwili. Begun 1958–9, by *Percy Thomas Partnership*. The original curving plan with linked ward blocks is hard to discern under later alterations and additions.

CARMARTHENSHIRE INFIRMARY, Priory Street. Disused. 1858, by *William Wesley Jenkins*. Stuccoed Italianate, of two storeys and seven bays, with a hipped roof. Poorly detailed, with chanelled pilasters and a pedimented doorcase.

In front, the COUNTY WAR MEMORIAL, 1923, a fine bronze soldier in an active stance, by *Sir W. Goscombe John*. Granite pedestal and hemi-cycle stone bench by *E. V. Collier*.

ST DAVID'S HOSPITAL, Job's Well Road. The former Joint Counties Lunatic Asylum, built to serve the three SW counties, by *David Brandon*, 1863–5. Designed to hold 600 patients at a cost of £24,950. Repaired after structural problems, and wings added, probably to Brandon's design, 1870, by *Martin & Chamberlain* of Birmingham. Further large extensions 1878–80 by *Giles & Gough* of London. Corridor-plan layout on the usual very large scale, the plan very like the Buckinghamshire Asylum at Stone, of 1850–3, by Wyatt & Brandon. Three storeys, astylar in rock-faced stone with camber-headed windows in painted Bath stone, and hipped roofs to the various projections that break up the length. At each end, ventilation towers with steep pyramid roofs, at the junction with two-storey cross-wings. Said to have been built with a detached brick inner skin, an early cavity wall.

Centre S block of 3–5–3 bays, residences for the superinten-dent and matron, visiting-rooms, and in the attic, rooms for 'better-class' convalescents and their attendants. Long ward ranges each side of 5–3–6 bays, for males to E, females to W, the three-bay sections containing day rooms. The towers have belfry-lights of orange terracotta, presumably of 1870. They were for ventilation and had bath-rooms in the ground floors. Enclosed exercise yards in front, each side of courtyard with railings by *T. Bright* of Carmarthen. Two-storey short cross-wings with cross-gabled ends and a Palladian window each floor on each of the three sides; each with dormitory and day room for quiet, aged and infirm patients. More utilitarian outer rear ranges, running back to former laundries (female), and workshops (male) for carpenters, tailors, cobblers and painters. Larger centre wing with steep half-hipped roof to the dining hall, and the admissions range across the end, hipped with grouped windows in a mildly Italianate way. This was the offi-cial entrance, with offices, receiving rooms for new patients, and the original chapel on the first floor. The big octagonal building to the E was the store for incoming supplies.

Linked by a corridor, to W, former FEMALE HOSPITAL, 1898, by *E. V. Collier*, large and utilitarian.

CHAPEL, opposite the N front, 1883–9, by *Collier*, built to seat 500. Surprisingly ambitious, and remarkable for having cost the authorities nothing, the money coming from the profits of the private patients, and all the labour including quarrying and care of haulage from the Green Castle quarry, unpaid, by the inmates. Large scale, aisled cruciform church with tall flèche on the crossing. Grey sandstone in large blocks, with bands of red stone. Dec detail. Dramatic polychrome interior, in a

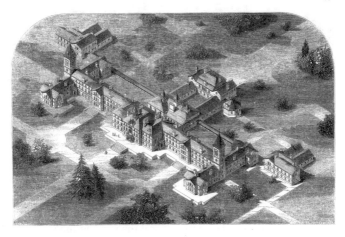

The Joint Counties Asylum, original design.
Engraving

brown glazed brick banded and diapered in black and white (painted over). Arcades on octagonal piers with taller transept arches. Similar chancel arch. Richer chancel with tiled floors, polished Green Castle stone steps and E wall shelf. – REREDOS with relief floral tiles. – Semicircular stone PULPIT with marble shafts.

w of chapel, large LAUNDRY BLOCK, 1914, by *George Morgan & Son*. Free-styled, in stone with steep roofs. Further w, former INFECTIOUS DISEASES HOSPITAL, *c.* 1890, by *Collier*, domestic group, near-detached ward blocks linked to a centre building by passages. Brick NURSES' HOME, to SW, 1930s, modern Neo-Georgian. Small Italianate ENTRANCE LODGE by *Brandon*, 1864.

HEALTH CENTRE, St Peter's car park. 1990–1, by *Llewelyn Lewis & Sennick*. Single-storey wings, cranked each side of the entrance, and big dormer canopy over the door with a canted bay window. All on a homely scale.

TRINITY COLLEGE, College Road. 1847–8, by *Henry Clutton*. Built as the South Wales & Monmouthshire Training College, to train teachers for the National Schools. So an Anglican foundation, and designed in a suitably monastic Puginian Gothic style, advanced for the date. Long two-storey rubble stone façade, subtly asymmetrical, balanced between two gables. Particularly monastic the fourteen narrow trefoiled lancets of the first floor, and the steeply gabled dormers on the eaves above. On the ground floor, hall and library differentiated, three ecclesiastical Dec traceried windows to the one, and three flat-head Perp windows to the other, and similar-headed entrance in the final bay to r., evoking a slowly evolved medieval building. The flanking gables are quite different, though of matching size, the l. one of three storeys, the r. one

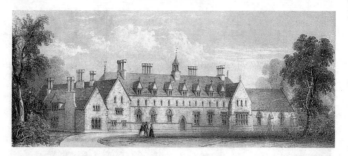

Trinity College, original design.
Engraving, 1847

of two, with large mullion-and-transom windows. Beyond this, the former chapel, less ecclesiastical than in Clutton's original drawing (perhaps because it was intended from the first to be replaced by a larger building), with two mullion-and-transom windows. To the l. of the l. gable, is the principal's house, Puginian, with gable to the front and big wall-face chimney on the long W side. The E side, with parapet, facing across the main college range, looks like an addition, perhaps part of works in 1860, by *Clutton*. The long rear wing is original in the two l. bays, the other six bays added in 1860. This is symmetrical about a first-floor chimney, with four four-light windows below six two-light windows. At right angles, Archdeacon Childs Hall, freely styled late Gothic with big canted bay, *c.* 1910, probably by *E. V. Collier*.

Utilitarian or altered interiors: a very plain stone stair with iron rail in the entrance hall. The former chapel has stencilled late C19 decoration on the ceiling.

The CHAPEL, appropriate to such a college, was not added until 1932, grandly sited at right angles to the end of the former chapel, so aligned N–S. A serious, and very conservative work, without a hint of the C20, by *E. V. Collier*. Nave and chancel, each bay with parapets, big buttresses, and ogee Dec tracery. Only the S and N ends (liturgical E and W) stand out, with unusual window groupings. Dominant roofs inside, of close-spaced arch-braced trusses, the alternate ones with hammer-beams, and big shafted chancel arch. Cream and green marble floors to the chancel. Grey and buff marble altar. – STAINED GLASS. E window of 1873 by *Bell & Son*, Ascension, flanked by two lancets each side of a slightly later date, possibly 1880s (from the old chapel). – Nave window of 1996, by *Gareth Morgan* of Llanelli, illustrating the *Black Book of Carmarthen*. Clear colours on a turquoise ground.

Additions were made in 1906–12 by *Collier*, and a residential wing, 1925, by *Seely & Paget*. The hostel blocks, 1964, by *Architects Co-Partnership* are scattered, with a single point block, the only one in the county. The communal block has an auditorium with high sweeping roof. LIBRARY, 1994, by

the *Welsh School of Architecture* (executant architect, *Norman Robson-Smith*). L-plan, clad in white laminated panels with deep overhangs to the roofs. Roof lanterns, a continuous clerestory, and lean-to ground floor. Well-lit interior with much exposed white-painted metalwork, a theme picked up in the metal canopies over the entrance and projecting from the end gables.

PARC MYRDDIN, Richmond Terrace. The former Boys' and Girls' Grammar Schools, set back above a playing field, is being adapted for offices and civic purposes. In the centre, the Boys' School and headmaster's house, a gaunt four-storey block, of *c.* 1894, by *George Morgan*, with off-centre and end gables. To the E, the platform site of the first boys' school, 1883 by *F. E. Jones*, burnt in 1969. The former Girl's School, to W, is much more cheerful, 1899, by *Morgan & Son*. Free C17 style, shaped gable, over a big canted projection, with mullion-and-transom windows, and a roof lantern. At each end of the site additions of 1931-5 with ground floor arcades in imitation Bath stone. Added to the girls' school a domestic science block, now the COUNTY RECORD OFFICE, and for the boys, a butterfly-plan science block, at the E end, with a Cotswold gable, now the REGISTRY OFFICE. The quality of finishes within is remarkable by modern standards.

RICHMOND PARK PRIMARY SCHOOL, set back N of Priory Street. 1987-8 by the *Alex Gordon Partnership* (executant architect, *Graham Bailey*). Low, with spreading pantiled roofs, walls of blockwork with brick of a slightly different tone, and pedimental gables with roundels. Clever plan, with nursery, infants, juniors and main hall in four wings around a central courtyard. The slightly Roman feel of the building and plan is intentional, for it is located within Roman Carmarthen.

ORIEL MYRDDIN, Church Lane. Former Art School, 1891-2, by *George Morgan*, converted to art gallery 1991, by *Alex Barry* of *Cedric Mitchell Architects*. 'Modern Renaissance style', i.e. not Gothic, in red brick with Bath stone. Three bays with shaped gable to r., over tall tripartite studio windows. Much moulded brick detail. Inside, the ground floor had the 'elementary room' and modelling room, the first floor the studio and master's room. Grand open-well stair with ball finials and coloured glass stair light.

FORMER WORKHOUSE, Brewery Road. Long fifteen-bay three-storey range, 1908, by *A. I. Jones*, replacing the 1837 workhouse, which had burnt down. Parallel late C19 stone range in front, with blue and yellow brick, probably part of works by *George Morgan*, *c.* 1880-96. On PENLAN ROAD, rendered GATEHOUSE, marked on the 1834 map, so possibly from the poorhouse of 1805-6, with ashlar elliptical arch. The scene of a dramatic action during the Rebecca Riots, 1843.

CARMARTHEN PARK, Morfa Lane. Laid out in 1900, by *F. Finglah*, Borough Surveyor, with handsome cast-iron gates made at *Coalbrookdale*. Octagonal iron bandstand, 1900. Of the 1920s, the embanked concrete cycling track.

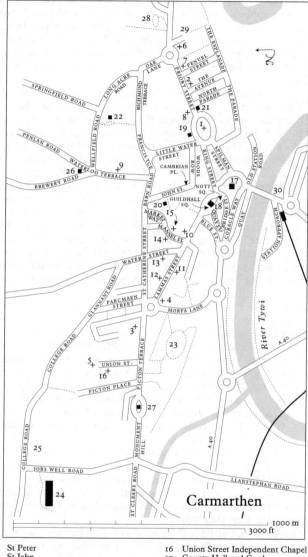

Carmarthen

1000 m
3000 ft

1	St Peter	16	Union Street Independent Chapel
2	St John	17	County Hall and Castle
3	St David	18	Guildhall
4	Christchurch	19	Library
5	St Mary (R.C.)	20	Market
6	Priordy Independent Chapel	21	Infirmary and War Memorial
7	Penuel Baptist Chapel	22	Parc Myrddin
8	Bethania Calvinistic Methodist Chapel	23	Carmarthen Park
9	Tabernacle Baptist Chapel	24	St David's Hospital
10	Heol Awst Independent Chapel	25	Trinity Cottage
11	Capel Heol Awst (Welsh Congregational)	26	Former Workhouse
12	English Congregational Chapel	27	Picton Memorial
13	Capel Heol Dwr (Calvinistic Methodist)	28	Amphitheatre
14	Zion Calvinistic Methodist Chapel	29	The Priory Site
15	Parc-y-Felfed Unitarian Chapel	30	Tywi Bridge

PERAMBULATIONS

1. From Nott Square East: a roughly circular route leading E towards the site of Old Carmarthen, the Roman amphitheatre, returning via Castle Hill and the riverside

NOTT SQUARE, in front of the CASTLE GATEHOUSE, was the market place of the medieval New Carmarthen, with a church of St Mary at the top of Hall Street. Founded in the 1240s it became a chantry chapel and as such was closed in the C16. The market cross was taken down in 1783 for a small octagonal market hall, itself removed in 1846 for the STATUE of Major-General Sir William Nott †1845, national hero for avenging the Afghan disaster of 1842. Bronze figure of 1851, by *Edward Davis*, on a pedestal by *J. L. Collard*. Plaque of 1902 to Bishop Ferrar, burnt at the stake here in 1555. To the w, the ANGEL VAULTS, roughcast, three storeys, with early C20 inn front. The fabric is medieval: the upper floors had a jettied timber frame, later faced in stone. On the E wall, a late-medieval single light, found in 1983, with cusped ogee head and shields in the spandrels, possibly reused. On the N side a corbelled first floor chimney. The square funnels E towards King Street, with mixed C19 buildings each side, those flanking the top of Hall Street, 1892, by *George Morgan*. 83

King Street to Priory Street

In KING STREET, on the N side, Nos. 62 and 61, earlier C19 stucco, and No. 60, late C18 painted brick, before the much larger No. 59, NATIONAL WESTMINSTER BANK, 1903–4, by *W. W. Gwyther* of London. Three storeys and five bays, red Ruabon brick with yellow Cefn sandstone ground floor and window frames. Mixed detail: mullion-and-transom bank windows, sashes above and deep balustraded cornice. On S side, w of Queen Street, Nos. 2–3, CLOTH HALL, curved corner building with pilasters, simplified in 1935 for Burton & Co., from a late C19 drapers. Further E, and with a façade in Queen Street, LYRIC BUILDINGS, later 1930s, built to match the adjoining LYRIC THEATRE, a remodelling of 1936 by *W. S. Wort* of Cardiff of the Assembly Rooms of 1854 by *James Wilson* of Bath. The office building is of four storeys, with higher stair-tower on the r., the bays separated by triangular shafts. The theatre is of three storeys, five bays, with pilasters from the 1854 building, and applied triangular fins. Italianate detail of 1854 on Bank Lane. The auditorium has minimal Art Deco motifs. No. 10, POST OFFICE, 1906–7, by the *Office of Works*, has a good Bath stone, Edwardian Baroque façade. Three storeys and five bays, with big triple keystones, and curved pediments. The 1955 addition to r. replaced No. 9, a fine late C18 town house. No. 14, PROBATE OFFICE, 1879, by *G. A. Hutchings*, the Town Surveyor, is rubble stone with Bath dressings, minimally Gothic.

Opposite, by Jackson's Lane, No. 57, 1846 by *J. L. Collard*, stuccoed, just one bay, the windows between broad panelled outer piers. No. 53, externally undistinguished, four bays, has a good early C18 staircase to the rear, with thick turned balusters and pulvinated string. No. 51, plain, four-storey, has the best earlier C18 interior in the town. Its history is obscure, it was owned by minor gentry, the Lewis family of Barnsfield, Abergwili, too close surely to need a fine town house. Remnants of fielded panelling on the ground floor, and a scrolled pedimented overmantel. A good arched doorway on l., to the staircase with turned balusters. Fully panelled first-floor room, with scrolled frieze to the fireplace and ornate scrolled-pedimented overmantel. Behind, a near-detached whitewashed stone house, with massive N end chimney, probably early C18, with oak collar-truss roof. Nos. 49–50 are early C19, brick-fronted, clad in roughcast, No. 49 with a delicate Portland stone frieze of beavers, minks, etc., for the National Fur Co., 1930s. No. 46 is mid C18, four bays, painted brick, with prominent rusticated window heads. The spoilt ground floor had a fine broken-pedimented doorway. No. 45, two bays, 1881, by *Hutchings*, with original shopfront. Nos. 42–43 LLOYDS BANK, three storeys and four bays, is the recased C17–C18 town house of the Rev. Edmund Meyrick †1713. Stucco detail of 1892 by *George Morgan*, with the bank architect, *J. A. Chatwin*. Good later C18 Ionic pedimented doorcase. The single-storey banking hall, to l., of five bays with tall windows appears to be the remodelled 'long room' of Meyrick's house, as shown on a later C18 deed. The house has a rear wing with massive external chimney-breast, possibly C17.

On the S side: No. 15 looks mid C18, small-scaled, three storeys, the shopfront an inaccurate replica of the C18 original. No. 16 is mid C19, three storeys, two bays, with outer pilaster strips. No. 19 is altered, two storeys, four bays, with late C19 bookseller's shopfront, masks of Shakespeare and Chaucer on the brackets. C18 panelled room upstairs. No. 20, of three bays and storeys, is dated 1806, with fluted lead rainwater head. Late C19 shopfront like that on No. 19. No. 23 has an Art Deco bronze and glass shopfront, 1932, with sunburst leading in the upper panes. Nos. 24 and 25, each side of Conduit Lane, are similar to No. 20, with tripartite sashes. No. 24 was the office of George Morgan & Son. Staircase with square balusters, some fielded-panelled doors upstairs. No. 25 was rebuilt in 1864, after a fire. Later C19 chemist's shopfront and fittings. The medieval E gate, the White Gate, stood here until 1792.

Opposite on the N side of King Street, No. 40, former Co-operative Stores, 1930s cinema-Modern, with bold wave mouldings above the centre, which has recessed octagonal columns. The shop level all new. No. 35, plain stuccoed C19 to the street, has a 1930s-Modern rear with metal curved windows on the corner. No. 34, plain two-storey, has an earlier C18 staircase with turned balusters, and a thick dividing wall in the cellar to No. 33, possibly part of the 1415 town wall.

At the E end, the Public Library, Parish Church and Oriel Myrddin (*see* above).

E of the Library, in ST PETER'S STREET, FOREST HOUSE, *c.* 1817, the town house of the Hughes of Fforest and Tregyb. Three bays and storeys, the bowed centre with Palladian sashes. Characterful, but the windows crudely redone in 1980. s of the church, in CHURCH STREET, Neo-Georgian terraces, rebuilt after 1981, in vague replica of the Late Georgian originals, and the VICARAGE, 1856, by *R. K. Penson.* Domestic Gothic, in coloured rubble stone, with pyramid roof over the entrance bay, paired with a gable. PRIORY STREET runs E. Some larger stucco houses at the W end, No. 144 on N a later C19 re-fronting of two C18 houses, but the scale rapidly diminishing. On N, Bethania Chapel (q.v.). s, the former Infirmary and War Memorial (q.v.). By St John's church (q.v.), the former SCHOOL, 1870, by *Penson,* used also as a church before St John's was built. Stone, Gothic, with an off-centre gable flanked by a pyramid-roofed turret. Traceried E window with good STAINED GLASS, 1870, the Education of Christ. Further up, on the s, Penuel and Y Priordy Chapels (q.v.), and Old Priory Road, the site of the medieval Priory. On the N, at corner of Old Oak Lane, No. 97, OAK HOUSE, C18, colourwashed stone, three bays. Staircase with turned balusters and thick rail, stripped of early C20 alterations in 1998 by *Bailey Roberts Jones.*

An excursion of some 500 yds (457 metres) further, finds, first, in a park on l., the Roman Amphitheatre (p. 139), then Y GARREG FILLTIR (Milestone House), a three-bay hipped villa, said to date from 1801, built for the manager of the Carmarthen IRONWORKS. The works, on Furnace Bank, are a little further E, below the road, in a builders' merchants yard. Built by Robert Morgan in 1748, the foundry made guns and shot for the Board of Ordnance until 1760, tin-mills were added in 1761, and tin-plate production continued to 1900. The big double-gabled building is the UPPER TIN MILLS, rebuilt *c.* 1855–60, after a lower site was taken by the railway. Stone, with a row of large brick-arched openings in the spine wall within. Behind, in the bank, is the C18 BLAST FURNACE, with high battered stone sides and furnace arches, joined, under a C20 roof, to the much altered CASTING SHED.

From Priory Street via the Esplanade, The Parade and Spilman Street to Castle Hill

Returning down Priory Street, past Penuel Chapel, Penuel Street runs s to THE ESPLANADE, an extension to the walks laid out on The Parade in 1782, overlooking the Tywi valley (and now the bypass). Nos. 1–8, 1879, possibly by *G. Hutchings,* stuccoed, double terrace of two-storey, two-bay houses, with heavily corniced bay windows. Good cast-iron railings. To E, THE OLD GRAMMAR SCHOOL, now four houses. Built as Sir Thomas Powell's Charity School, 1846 by *F. E. H. Fowler.* Deep-eaved

and hipped, two storeys, with minimal Neo-Grec to Italian detail. Thin pedimented doorways, and a triple arched E window. W of Nos. 1–8, BRYN ROMA, No. 9, in similar style but gabled, added 1897. A Roman bath-house was found on the site. DYFFRYN, to W, 1892, three-bay pyramid-roofed villa in harsh red and yellow brick, with eccentric iron railings. On THE PARADE, though laid out in 1782, the houses are C19. No. 6, earlier C19, two-storey, a coach-house door to the l.; Nos. 7–8 are a three-storey pair called 'recently erected' in 1885, each with a top-floor triple arched window, and a two-storey canted bay. Good cast-iron balcony railing to a radiating pattern. No. 11 was the PRESBYTERIAN COLLEGE, founded to train students for Nonconformist ministry in the later C17, not linked to a particular denomination. The college was built here in 1840, affiliated to London University in 1842, and closed in 1963. Five bays, the two r. bays and the E side, of 1840; the central porch and two l. bays added 1894, by *George Morgan*. Stucco, Tudor, with shouldered gables and hoodmoulds. Finely detailed Bath stone oriel window on the E end. Thicker detail in the 1894 part.

PARADE ROAD leads up to SPILMAN STREET, running W to the County Hall, parallel to King Street. On the s, Nos. 18–19 are early C19, restored 1988, No. 18, with a fine Bath stone doorcase, was the house and workshop of the early C19 monumental sculptor Daniel Mainwaring. No. 17 is later C19 infill. No. 16, of two storeys and four bays, has an open-pedimented doorcase, and earlier C19 staircase and plasterwork. Nos. 12 and 14, a pair of pyramid-roofed early C19 houses with later C19 detail; frame the forecourt of NAPIER HOUSE, No. 13, built *c.* 1807 for Lord Cawdor (No. 12 was the Cawdor estate office). The narrow two-bay tall front with giant arched recesses looks as if intended as part of something longer. It was originally stuccoed. Opposite, CARMARTHEN JOURNAL, 1993–4, by *Lance Taylor* of the *Taylor Partnership*, Cardiff. A well-designed modern contribution to the street, with glazed gabled recessed centre, and flanks glazed above the wall-plate level, allowing light to the heart of the open-plan interior. To l. No. 36, SPILMAN HOTEL, earlier C19, three storeys, three bays, and MASONIC HALL, 1911, by *George Morgan & Son*, stripped classical, the windows divided by pilasters. Opposite, on s, IVY BUSH HOTEL, set far back, with a wing up to the street. The siting reflects the house that *John Nash* built for himself in 1796 at the end of the plot, for the valley view. In the bar, a stained glass window, 1974, by *John Petts*. Nos. 9–10 are early C19, three-storey, Nos. 5–8 were similar, but now crude replicas of 1990–1, by *Carmarthen District Council Technical Services Department*. Opposite, No. 41, BANK HOUSE, an intriguing building, built 1812 for Waters, Jones & Co. but taken over by the Morris bank. A cliff-like stuccoed front of four bays and storeys. On the end wall a giant blind arch and a broad stone staircase up to a big arched doorway, as, perhaps for security,

the main floor is over a full basement. Inside some battered, elegant detail, including a half-elliptical staircase.

On s, the former DISTRICT COUNCIL OFFICES, remodelled from Late Georgian houses, with outrageously bad plastic portico of the 1980s. Grim 1970s four-storey square block behind, horribly prominent from the river. No. 2, is small, early C19, with windows in blind arched recesses and a good pedimented doorcase. No. 1, CASTLE HILL HOUSE, 1815, was built and no doubt designed by *David Morgan*. Substantial three-bay villa, with a long axial chimney on a pyramid roof. Early C19 staircase and reeded cornice detail inside. Opposite was the former Lion Royal Hotel, *c.* 1802, demolished 2006, with No. 18 QUEEN STREET. It is to be replaced by an office by *Lawray* of Cardiff. In Queen Street, No. 17 of five bays and three storeys, looks mid C18, heavily renovated. The QUEENS HOTEL was part of an uncompleted street widening of 1865–7, probably by *J. L. Collard*, who lived here. Opposite, another façade of the Lyric Buildings, King Street.

CASTLE HILL curves down below the County Hall to the Tywi Bridge (q.v.). Across the bridge, RAILWAY STATION, 1902, by *J. C. Inglis*, in the typical brick of the later Great Western stations. W of the bridge, THE QUAY, recorded from medieval times, extended and refaced in 1803–4. TOWY WORKS, 1907–9 by *G. Morgan & Son*, ironmonger's premises on three storeys, white stucco with flat roof, modern for the date. N of the modern Coracle Way, BRIDGE STREET runs back to Nott Square. On l., former EX-SERVICEMEN'S CLUB, 1958, by *Harold Metcalfe*, wholly of the 1950s with typical glazed tiles, but actually a refronting. In the basement are two parallel medieval vaulted cellars. Small C18 to C19 houses further up, mostly altered. No. 17 has an early C18 plank partition and fielded panelled doors.

2. From Nott Square West, Quay Street, Guildhall Square, Lammas Street, to Picton Terrace

Two streets run down from Nott Square to Guildhall Square, Hall Street and St Mary's Street, the latter preserving the name of the vanished church. In ST MARY'S STREET, Nos. 3 and 4, built as one in 1830, three storeys, with open pedimented doorcases. No. 2 is later C18, three storeys, three bays, with galleried AUCTION ROOM of 1899 behind, the gallery with pierced cast-iron bowed front. QUAY STREET has the best C18 houses of the town, though too many marred by heavy-handed restoration. The street is medieval, originally running down to the river, but now truncated by Coracle Way, losing the best house, dated 1697. Nos. 2 and 3 are earlier C18, each originally brick-fronted, of five bays and two storeys, on a high stone basement, with heavy modillion cornice. No. 2 has only three upper windows, two others blocked, and the central sash still has original thick glazing bars. No. 3 is still of five bays, but has

late C19 cement cladding, with mock-timbering. Both houses have wide staircases with pulvinated strings. Nos. 4–5 were a late C18 mirrored pair, with double pedimented doorcase, but are now an inaccurate replica of the 1980s. No. 6, GWYNNE HOUSE, town house of the Gwynnes of Glanbran, has a three-storey, five-bay front, probably C18, but the doorcase, staircase and interior detail are early C19, much renewed. Nos. 7–8 are a later C18 mirrored three-bay pair, with paired doorcases, like that on No. 6. Both have staircases with turned balusters. No. 9 is late C18, three storeys, four bays, much restored in the 1980s with replica doorcase. Staircase like those in Nos. 7–8. No. 10 was an Early Georgian two-storey house of some distinction, heavily and inaccurately restored in 1985. Five bays, with stone steps to the front door. The staircase with turned balusters and pulvinated string is mostly replica too. Nos. 11–12 are the remnant of a row of four, truncated for the new road. Mirrored pair, No. 11 with early C19 staircase, No. 12 with C18 stair, turned balusters and thick rail.

Opposite, No. 26 is three-storey, three bays with full basement, later C18, with original staircase. No. 28 is C18, but externally late C19, altered 1922 by *J. H. Morgan*. The interior, lost in the 1980s had a good C18 staircase. No. 30 is earlier C19, three-storey, three bay, with contemporary staircase. It may have been the Biddulph & Co. bank marked on an 1834 map. No. 31 is C18, two-bay, with top floor added perhaps when No. 30 was built. Later C18 pedimented doorcase, panelled doors inside and staircase. No. 33 is of four irregular bays, with steep roof and big stone chimneys, suggesting an early C18 date. Interiors all lost in 1995. No. 34 on corner of St Mary's Street has undulating walls, suggesting an early date, but the features are C19.

GUILDHALL SQUARE slopes down from the Guildhall. BOER WAR MEMORIAL, 1906. White marble soldier on a sandstone and granite base, by *E. V. Collier* and *W. D. Jenkins*. On the NW corner, BARCLAYS BANK, 1903, by *George Morgan & Son*. Florid Northern Renaissance style, in brown stone with much Bath stone detail, scattered with enthusiasm over three storeys. Shell motifs over the narrow outer bays, two broad shallow-curved oriels in the first floor centre, arched banking-hall windows below with sunbursts in the spandrels, and outer doors with little columns in the overlights. The bank door to l. has a little more detail than the manager's door to r., to prevent confusion. Coffered banking hall ceiling on square Ionic pillars. Opposite, a nice early C19 group in red brick, three storeys. No. 12, two bays, has a modern shopfront, but good early C19 staircase. No. 11, has the frame of a good Georgian double-bowed shopfront and, on the chamfered corner to Blue Street, a large hanging coffee pot, as this was a coffee tavern from 1850. Three bays to BLUE STREET, where No. 36, to r., is similar, three bays. Opposite, heavily restored, No. 1, the former Half Moon Hotel, established 1806. Stuccoed, three storeys, with mid-C19 building to r., former Nag's Head, on

the corner of DARK GATE. The N side of Dark Gate and RED
STREET, to N, are a thoroughly depressing redevelopment of
1973, with a later, but no more attractive spur, Cambrian Way.

Lammas Street

Dark Gate is the foot of the broad and straight LAMMAS
STREET, shown as built up on Speed's 1610 map, with a
preaching cross. On l., GREYFRIARS, 1998, a street of mock-
traditional rendered fronts, leading to the earlier Tesco store,
on the site of the medieval Greyfriars, of which nothing is
visible. It was founded before 1282 when William de Valence
was buried there. Excavation in 1998 revealed two cloisters,
part of the choir, the refectory and infirmary. It was the largest
Franciscan house in Wales, and a favoured burial place of the
Welsh nobility, including the father of Henry VII. The BOAR'S
HEAD has a plain front of nine bays, three and four storeys.
Earlier C18 core, the staircase with turned balusters, and later
enlargements, partly in 1819, by *David Morgan*. Opposite, the
English Baptist Chapel (q.v.) with forecourt symmetrically
flanked by small later C19 houses. No. 12, on the corner of
Mansel Street, 1892, by *George Morgan*, is stuccoed, with
arcaded chemist's shopfronts to both streets. No. 18, on the
corner of Water Street, was the North & South Wales Bank,
1904, by *George Morgan*. Red brick and Bath stone, with
crowded early C18 style detail: arched windows, blocked
pilasters and balustrades. The original front is to Water Street,
the r. three bays on Lammas Street added in the 1930s. In the
centre, CRIMEAN WAR MEMORIAL, 1858, by *Edward Richard-
son*, London sculptor. An improbable Gothic obelisk, in Port-
land stone with ballflower angle decoration and plume of
feathers finial. Remarkable railings of crossed muskets. Oppo-
site, Heol Awst Chapel and schoolroom (q.v.). Beyond, stuc-
coed terraced buildings, and the English Congregational
Chapel, on r., and Christchurch, on l.

MORFA LANE has early C20 brick suburban houses opposite the
Park (q.v.). Further down, on l. are the BULWARKS, remains
of Civil War defences, the 'mudd wall' referred to in 1644, that
defended the parts of the town beyond the medieval walls. This
is the best surviving piece of such defences in Wales: a length
of ditch and a bastion-like projection to the NW, protected by
a rampart. How far these extended is uncertain: a stretch of
bank and ditch N of the town was filled in for Francis Terrace,
1860.

PICTON TERRACE continues Lammas Street to the W, a small
fashionable suburb, with terraced houses of 1825–34 and St
David's church, 1835, on the N. The S side had militia barracks,
now gone and St David's Vicarage, of the 1860s, by *Penson*, is
now the CROWN COURT OFFICE. *David Morgan* was proba-
bly responsible for most of the houses. The wrought-iron rail-
ings are Carmarthen-made. No. 12, CASTLE HOUSE, 1836, by
Thomas Rowlands of Haverfordwest, is larger than the others,

four storeys and basement, the centre slightly recessed, with cornice below the attic storey. Behind is LLYS PICTON, a small housing association development of 1986 by *Alex Gordon & Partners* (job architects *Graham & Sally Bailey*). Two-storey houses, rendered with lead-roofed trellised porches and deep-eaved roofs. They complement Picton Terrace without pastiche. The houses after No. 12 were all there by 1834: three-storey, then two-storey, and the last two three-storey again. Nice details: arched ground floor sashes and open pedimented doorcases with reeded pilasters or half-columns. The staircases have thin square balusters and scrolled rails. Nos. 13–14 are a pair, Nos. 15–17 a terrace of three. No. 17 has an ornate later C19 iron balcony on columns. Nos. 18–19 are a mirrored pair of two-bay houses, Nos. 20–21 larger, of three bays. Between Union Street and Picton Place, two-storey houses: No. 22 with late C19 bays, as on Nos. 1–9 The Esplanade; No. 23 has a date of 1833. No. 27 echoes No. 26, with roof hipped to the corner of Picton Place.

82 The PICTON MONUMENT, 1847–9, in the middle of the road, on the crest of the hill, is a very large grey limestone obelisk on a square base. The sorry story of the memorial to General Picton, killed at Waterloo, ran for decades. The obelisk replaces an ungainly memorial of 1825–8, by *John Nash*, which cost £3,000. The statue, by *E. H. Baily*, was on a tapered unfluted Doric column, on a fortress-like square base with martial banners on the corners, and a bas-relief panel on the front. The design was one Nash had made in 1816 for a London memorial to Wellington's victories. It was all of Roman cement, apparently painted in martial colours, and did not stand the climate. Repairs were needed by 1831, *E. H. Baily* made a new bas-relief in stone, but this was never installed (now in the County Museum, Abergwili), and the memorial was dismantled in 1846. *F. E. H. Fowler* made designs for an elaborate obelisk, simplified probably by *J. L. Collard*. The diagonal spurs were to have had lions.

N of the monument, PENLLWYN PARK, a row of varied large semi-detached houses, built 1893–7. *George Morgan & Son* were architects for the development, but may not have designed them all. Two pairs are in an accomplished Queen Anne manner, Nos. 8–9, and 12–13, with red tile-hanging and wooden balconies. Nos. 6–7 are in a harsh Gothic. The last and largest, No. 16, GWYNFRYN, must be by *Morgan*, with gables, arches and a corner turret, in pinkish Pennant stone, with Bath stone and some half-timber. For Monument Hill and Johnstown *see* Outer Carmarthen w.

Returning down Picton Terrace, ST CATHERINE STREET runs NE, with mainly two-storey houses. LLYS MODEL, set back on N, was the Model School, 1847, built so that students of the Training College (Trinity College) could practise on real children. Probably by *Henry Clutton*, architect of the College – he certainly made enlargements in 1856. Gothic, originally L-plan, with additions. Converted to flats in 1989, with loss of detail.

The street continues E, past the Market. On the corner of John Street, railed GRAVEYARD of the former Ebenezer Wesleyan Chapel, replaced in 1995 by a Job Centre to roughly similar dimensions. From John Street, return s to Guildhall Square.

OUTER CARMARTHEN

NW *of the Centre*

Water Street runs NW to LIME GROVE AVENUE. On r., THE GRANGE, 1890 by *G. Morgan & Son*, red brick hipped villa, three bays, with moulded brick detail. LIME GROVE HOUSE, on l., was a mid-C19 villa, probably by *W. W. Jenkins*, altered and much elongated to rear in late C19, with prominent yellow brick chimneys. Stucco short s front with late C19 canted bays. In the grounds, derelict shell of ALL SAINTS CHURCH, the former chapel of the gaol, dismantled and moved here in 1939, when the house was a girls' school. Further N, the CEMETERY, Elim Road, with small chapel, 1855, by *W. W. Jenkins*, and, beyond, ELIM INDEPENDENT CHAPEL, 1849–50. Hipped with arched openings, the stucco detail of 1887. Interior of 1887 with inset pierced iron panels to the gallery front. Fretwork decoration on the pulpit.

N *of the Centre*

Waterloo Terrace runs N, past Tabernacle Chapel (q.v.). On r., in WELLFIELD ROAD, large stuccoed villas of 1890–1900 by *Morgan & Son*. WELLFIELD HOUSE, in its own grounds, is an earlier C19 stucco three-bay villa with pedimented doorway flanked by niches. Large added red brick gabled bays of *c.* 1900 on the garden side with balcony between. Further villas in SPRINGFIELD ROAD, HENDRE, on l., *c.* 1840, two-bay, with the entrance on the side wall. Early C20 semi-detached villas in LONG ACRE ROAD, down to RICHMOND TERRACE, lined with late C19 terraced houses. Parc Myrddin, the former Grammar School, set back to W.

E *of Centre*

Priory Street runs NE toward some early C20 villas on BRON-WYDD ROAD. GLANGWILI BRIDGE, on the Lampeter road, N of the Hospital, is earlier C19, broad single arch over the Gwili, with small circular spandrel holes.

W *of the Centre*

Monument Hill runs W to JOHNSTOWN. TOLL-HOUSE, in the centre, is earlier C19, elongated octagon plan, altered. To W, on ST CLEARS ROAD, PETERWELL, a large earlier C19 hipped villa in its own grounds. Roughcast, with arched ground floor windows, the marginal panes suggesting the 1840s, but a Rev.

David Peter was there in 1830. Top-lit centre stair. NANTYFE-
LIN, on the road, is a smaller hipped villa of similar date, with
good wrought-iron railings in front. PONTGARREG is an
altered C18 farmhouse, with small upper windows. Some polite
early C19 detail, reeded cornices. It was owned by the Nott
family, who came to Carmarthen as proprietors of the Ivy Bush
Hotel in 1794.

NW of the toll-house, JOB'S WELL ROAD runs up to St David's
Hospital (*see* p. 142). This was built on the estate of JOB'S
WELL, the home of General Sir William Nott. He bought it as
an Indian Army major in the 1820s, but lost it in 1829 after
the Calcutta Bank failure. He bought it back in 1844, and
began to rebuild, but died. Stuccoed, three-storey tall narrow
main block, the top storey probably added, with the Tudor
porch, and the gabled wings, in 1844–5 by *J. L. Collard.*

On the Towy, s of Johnstown, WHITE BRIDGE, a rolling bascule
bridge of 1908–11 carrying the railway line w from Car-
marthen. Five fixed spans and one lifting span, a balanced
cantilever. Built by the *Cleveland Bridge Co.*, Darlington.

5817

CARMEL

2 ½ m. w of Llandybie

CARMEL BAPTIST CHAPEL. 1913. Large, for a rapidly growing
colliery population. Rendered, with hoodmoulds, the upper
outer windows arched, the wide centre one with a flat head.
Gallery on fluted columns with large foliage caps, boarded
panelled front with marginal mouldings. Coved ceiling with
arched braces and ribs above.

6618

CARREG CENNEN

Llandeilo Fawr

CARREG CENNEN CASTLE

23 Above the Cennen valley, E of Trap. The spectacular setting, high
on a limestone cliff, some 300 ft (91.5 metres) above the river is
unforgettable. Despite the relatively large size and obvious mili-
tary strength of the castle, it does not figure prominently in the
history of medieval Wales, perhaps due to its remoteness. The
naturally fortified site was occupied before medieval times. In the
cave beneath the castle, human remains, perhaps prehistoric,
have been found. Roman coins found suggest an Iron Age fort,
even if nothing is now evident.

Carreg Cennen was the centre of the commote of Iscennen,
part of Deheubarth, but no Welsh castle is recorded in the time
of the Lord Rhys. That one existed is suggested by the first
mention, in 1248, when Rhys Fychan seized it back from the
English. It changed hands regularly during the C13, falling in the
Edwardian conquest of 1277, though twice briefly retaken, in

1282 and 1287. Small sums were spent in 1277 at Dinefwr and Carreg Cennen, not enough for major works. The castle was probably rebuilt entirely by John Giffard, granted it in 1283. No mention of works exists, but the details – cruciform loops, polygonal towers and spur buttresses – suggest the late C13, being virtually identical to work at Caerphilly. The Giffards had probably completed the castle by their downfall in 1322, when it was given to their enemies, the Despensers. Hugh le Despenser's occupation was short, and Carreg Cennen passed via John of Gaunt to the Crown. Repairs are recorded in 1369. The entire castle required repairs in 1414–21, costing over £500, after damage in 1403, during the Owain Glyndwr uprising. During the Wars of the Roses, Gruffudd ap Nicholas, Deputy Justiciar of Wales and a powerful Lancastrian supporter, had Carreg Cennen repaired and garrisoned, 1454–55. After the Yorkist success of 1461, a force of 500 men under Sir Richard Herbert spent four months in 1462 dismantling the castle.

Ownership passed via Sir Rhys ap Thomas to the Vaughans and Cawdors of Golden Grove. Antiquaries and artists came from the late C18 (Turner in 1798), and in the C19 the second Earl Cawdor began an extensive restoration, possibly using *David Brandon*. In 1932, the castle was given to the guardianship of the Office of Works, and it is now maintained by Cadw.

The plan is of a square inner ward to the SW, on the edge of the precipice, and outer ward on the weaker N and E sides, entered from the E. N of the inner ward, separated by a deep rock-cut ditch, is an elaborate barbican.

Of the early C14 OUTER WARD only the footings remain: the rest was presumably dismantled in 1462. The footings clearly show the two main enclosures, one to the N and one to the E. The OUTER GATE is marked by the bases of a pair of small turrets, and there were round turrets at the NW, NE and SE corners, the footings of those on the N visible. The two parts of the outer ward were divided by a wall running from the outer gate to the barbican, possibly to confine raiders to either enclosure: the slightly unwieldy plan of the outer ward seems to be an exercise in confusing the enemy. In the SE corner, a circular LIMEKILN, unusually with three instead of two drawing-arches. Its date is uncertain.

The well-preserved BARBICAN consists of a sloping ramp along the N side of the castle ditch to a tower added in front of the N entrance to the inner ward, late C13 or early C14, a new element in defence, not found in other castles of the region. The ramp begins with a dog-leg stair, so that attackers approaching from the outer gate would come under fire from the NE tower before entering the barbican. Next there was a drawbridge, controlled by a small gate-tower; semicircular footings clearly visible each side of a deep stone-lined pit. Beyond was another drawbridge, before the square MIDDLE GATE-TOWER, which only partly survives at ground-floor level. No doubt the upper storey controlled the inner drawbridge. A

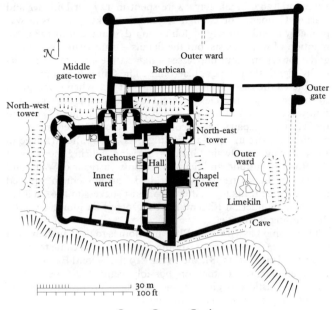

Carreg Cennen Castle.
Plan

deep pit-like cellar below. The tower also gave extra defence to
the W side of the outer ward.

To enter the INNER WARD, one must turn at right angles across
yet another drawbridge into the GATEHOUSE. From the
modern bridge one can appreciate the depth of the rock-cut
ditch. When this was cleared, traces of clay-lining were found,
suggesting that the ditch may have retained rainwater for the
castle's water supply. The massive polygonal towers of the gate-
house dominate the ruins, their bases with spur buttresses,
similar to those at Caerphilly, as are the cross-slit loops, most
of which were heavily restored in the C19. The W tower is the
better preserved, standing to two storeys on a high basement.
Of the gateway, only the springing of an arch survives, sup-
ported on an elaborate trefoil-shaped corbel. Portcullis slots at
both ends of the gate passage, so defensible from both sides,
as at the other keep-gatehouses of the late C13, e.g. Caerphilly
and Harlech. Guardrooms with cross-loops looking into the
passage. Access to the upper floors was from a big newel stair
in the W tower, projecting into the inner ward.

Between the gatehouse and the NW TOWER, against the
curtain wall is a large domical oven, and a cistern, for rain-
23 water from the roofs. The NW tower is circular, unlike the
others, the first storey (probably reached from the wall-walk to
the E) destroyed. In the ground floor, cruciform loops, and a
C15 GUN-PORT, a small round hole piercing the W embrasure,
so that a musket could cover the W curtain wall (possibly

related to the 1454–5 garrisoning). The much-depleted W curtain wall is built directly on a rocky outcrop. No wall-walk: probably the cross-loops, only one of which survives, were manned from a timber platform. The better-preserved S curtain needed less defending as it is built right at the edge of the sheer limestone cliff. The wall stands full height, with a wall-walk. There was no SW tower, just a slight rounded projection. On the E side was the domestic range raised on cellars: kitchen to the N, then the first hall with access to the chapel, and private chambers beyond to the S. The outer E face is dominated by the polygonal NE TOWER with spur buttresses and the small square CHAPEL TOWER. An arched opening below parapet level was probably an outlet for water from the roof, and it is likely that there was a series of these: if so, might they be the embryonic stage of the early C14 grand arcaded parapets at Swansea Castle, and the Palaces at Lamphey and St Davids?

Little remains of the KITCHEN above basement level, except for a large fireplace, which was reduced in width in the C19 restoration. The S door led into the screens end of the hall. Beyond the kitchen is the NE TOWER. The first floor, which had a latrine, is much depleted, but was originally reached from the wall-walk to the gatehouse. The ground floor chamber was vaulted and had a fireplace and latrine. As access originally was only via a mural stair to the hall, it may have been a private chamber, whereas the room above was probably for the use of the garrison. Of the HALL, the shell remains, ruinous on the courtyard elevation, with stone steps, probably replacing wooden ones. Towards the S end of the undercroft is the rectangular base of the central hearth. Corbels for the hall floor survive. At the N end of the hall, the screens passage gave access to the kitchen as one would expect, and at the E end, to a mural stair, up to the CHAPEL, on the upper floor of the CHAPEL TOWER. Oddly, this is the only chamber in the tower, even though it is at second-floor level: a latrine shaft visible on the exterior suggests that a chamber was intended at hall level also. The base of the altar is clearly visible. Traces of barrel vaulting survive, but otherwise much restored in the C19: the cross-loops for example are surely of this date.

S of the hall are two chambers. First the scant remains of a chamber behind the dais end of the hall, but the connecting door was blocked at some unknown date, and access was then from below, by a staircase. This chamber was bypassed by a mural passage from the dais end of the hall to the SOLAR, probably the room referred to in 1369 as the 'Lord's Chamber'. This is a large square room, with a fireplace, the mullioned windows being Cawdor restorations. In the SW corner, a doorway led into a small room, set within the thickness of a buttress, which strengthens the S curtain at this point.

For many, the most memorable feature of the castle is the CAVE, reached from a doorway in the SE corner of the inner ward. Pembroke Castle is famed for its Wogan Cave, which is much larger, but the access here is much more dramatic: via

steps through the base of the s buttress and the massively thick s turret, and then through a long barrel-vaulted passage along the edge of the cliff. The mouth of the cave, a deep fissure high up in the cliff-face, was walled across probably in the C13, complete with rows of pigeon holes. The walling of the cave and the construction of the passage were probably to defend a weak spot where marauders could undermine the s curtain wall of the outer ward.

CARREG CENNEN HOUSE, ¾ m. WNW. 1807–8, built on a carefully chosen site looking across to the castle, for T.W. Lawford, East India Company lawyer and friend of Sir William Paxton of Middleton Hall, Llanarthne, which leaves open the possibility that *S.P. Cockerell*, then working on Paxton's Tower, was involved. The plain three-bay roughcast façade is very slightly bowed and has tripartite ground floor windows and arched door. The interior is well-planned with cantilevered open-well stair and pretty openwork piers to the landing arcade. Outside, two walled gardens, the kitchen garden terraced and with beeboles.

CILYMAENLLWYD, ½ m. N. Much altered small C17 gentry house, whitewashed with dripstones over some windows.

CWRT BRYNYBEIRDD, ½ m. S. The intriguing remains of a C15 courtyard house, designed apparently without defensive intention. The house belonged to a cadet branch of Dinefwr in the C15 and C16, passing to the Vaughans of Golden Grove before 1613. There was a gatehouse, great hall, and two first floor parlours in 1613, and Fenton in 1809 described a 'gateway, not arched' but this has gone. Both house and outbuildings were altered in the later C19. The house has a plain, colourwashed two-storey E front with C19 windows, but there is a centre projection with corbelling under the first floor, perhaps a porch or the hall bay of a late C16 or early C17 remodelling. That this range is still earlier is shown by the small pointed window under the corbelled chimney of the s end wall. The chief medieval survival is behind the N end, a first floor hall altered externally to an outbuilding but still with lancets on the first floor rear. A straight flight of stone steps apparently replaces an earlier spiral stair. The upper room has three late medieval roof trusses with trefoil cusping above the collars. Only a small amount of blackening, so an open hearth is unlikely, but its relation to the main house is uncertain. It would not have extended further N for the N end wall has a blocked medieval pointed door. The first floor N end room of the front range has a corbelled C16 fireplace, and the big fireplace below with stone voussoirs is presumably of the same date, the rest of the front range is later C19 internally. The yard is enclosed by outbuildings, largely C19. The COW-SHED on the s side is of medieval origin, witness the three fragments of window heads, two with ogee heads, perhaps early C15. The range was illustrated more complete in 1858, when it had a roof with wind-bracing and cusping. The ornate roof suggests a hall. As a range larger than the main house, a kitchen and services function does not seem

correct, but internal evidence has all been swept away apart
from a blocked very broad fireplace with stone voussoirs in the
E gable-end.

TAIR CARN UCHAF and ISAF, 2 m. SE. Prominent on the ridge
of the Black Mountain, two groups of three Bronze Age large
burial cairns.

CASTELL DWYRAN *see* CLYNDERWEN

CENARTH *3242*

Village on the Teifi, by the Cenarth falls, one of the smaller pic-
turesque sights of Wales since the C18. The N part of the village
is in Ceredigion. By the bridge, the POST OFFICE, mid C19,
Cilgerran grey stone, in blocks. Painted rubble stone to the
three-bay WHITE HART INN, later C18 or early C19. Reached by
a footpath, upstream, CENARTH MILL, late C18 gabled flour-
mill, restored 1984–6, with big C19 undershot iron wheel, and
added drying kiln. Scarfed cruck roof trusses inside. Outbuild-
ings were rebuilt in 1990 as the NATIONAL CORACLE CENTRE,
coracle-fishing being a Cenarth tradition.

On the main road, the THREE HORSESHOES INN, earlier C19,
stuccoed, with small arched windows. In the yard, a small cottage
with restored thatch roof, possibly the 'alehouse by the church'
mentioned in 1760. Inside, a massive fireplace, and blackened
gorse under-thatch. Opposite, THE OLD SMITHY, earlier C19
former school, two-storey, Georgian Gothic windows marking
the schoolroom, with master's room and coach-house below. The
smithy to r. was added after 1860. In the field behind the Old
Smithy, early C12 MOTTE, overgrown with trees. This may be the
Cenarth Bychan built in 1108 by Gerald of Windsor, from which
his bride, Nest, was abducted by Owain ap Cadwgan. Behind the
church, the successor SCHOOL, 1860, by *David Jones*, two tall
storeys, the upper windows under gables and the end windows
pointed. Further out, YET FARM has a pretty mid to later C19
grey stone front, but is older, a date of 1835 was found within.
On the Boncath road, MILL LODGE, mid-C19 estate cottage with
deep slate hoodmoulds over the two windows and Gothic door.

ST LLAWDDOG. Rebuilt 1868–72, by *Middleton & Goodman*.
Small but with High Victorian vigour. Grey Cilgerran stone
and Bath stone, steeply roofed nave, canted apse, and a big
plate-traceried W round window. Over-scaled carved detail:
big fleshy leaf capitals to the porch and to the chancel arch,
where they are on stubby shafts from massive corbels. Single
leaves project from the splay of the arch. – PULPIT. Marble
shafting and a carved saint under a canopy. – LECTERN.
Bookrest of iron and brass. – FONT. A remarkable small C12 *18*
bowl, one of the group of Teifi area fonts with Celtic faces.
Here there are serpentine raised lines and corner faces, paired
at one corner. The font came from Llandysiliogogo, Cd. The

original Cenarth font is at Penbryn, Cd. – STAINED GLASS. W
rose and E apse windows of 1872, probably by *Hardman*, deep
blue and red backgrounds. Two W windows, 1917, conventional
C16 style. – MEMORIAL. W end, sarcophagus plaque to Harri-
ette Brigstocke †1833. – INSCRIBED STONE. The CURCAGNUS
stone, C5 to C6, originally from Llandeilo Llwydiarth, Pembs.,
inscribed CURCAGNI FILI ANDAGELL, and clearly related to
the two stones at Maenclochog, Pembs., to Andagellus and
Curmagnus, sons of Cavetus.

CENARTH CALVINISTIC METHODIST CHAPEL, on the Ceredi-
gion side. 1872, by *Richard Owens*, plain lancet Gothic, in grey
Cilgerran stone.

PONT CENARTH. A bridge worthy of the site. 1785–7, by *David
Edwards*, of the Pontypridd bridge-building family. Three
broad elliptical arches, with big cylindrical spandrel holes,
deriving from the elder Edwards's Pontypridd bridge. N end
widened in 1852, by *R. K. Penson*.

OLD VICARAGE, ½ m. E. 1855, the main windows in the end
gables and a show front of two long blank Gothic lights and
centre chimney over a Tudor porch, an odd design also found
at Brunant, Cyffig (q.v.).

GELLIGATTI, 1 m. E. A Cawdor estate farm, rebuilt in the 1870s.
Big hipped-roof square farmhouse and large model farm build-
ings. These are cruciform with hipped gables, the main spine
a large, steeply roofed cow-house. The architect, *J. W.
Poundley* designed two other model farms for Lord Cawdor,
and may have designed this one.

PONT TRESELI, Abercych. 1 m. SW. Single-arched bridge over
the Cych, the spandrels pierced in the manner of Cenarth
Bridge.

BRYNSEION INDEPENDENT CHAPEL, Pont Treseli. 1831, long-
wall façade in stone, with Cilgerran stone dressings. Arched
centre windows, broad outer doors and gallery lights. Raked
box pews and three-sided gallery on marbled columns of 1831,
pulpit of 1870.

CILYCWM

A large parish W of the upper Tywi, extending into the bare
uplands by the Llyn Brianne reservoir. In the upper part the
farms are confined to the deep clefts of the Doethie and Gwenf-
frwd valleys, N of the empty table of Mynydd Mallaen. The attrac-
tive, closely grouped village is in the widened valley where the
Gwenlais joins the Tywi.

In the main street, cobbled pavements and gulleys, the houses
in short terraces, earlier to mid C19, still relatively unspoilt. At
the S end, THE OLD POST OFFICE, with a small C19 shop
window, opposite the NEUADD FAWR ARMS, 1855, with Victo-
rian larger proportions and tripartite sashes. Opposite again,
footpath to Capel y Groes (q.v.) and CWM HOUSE, mid C19 with
small-paned sashes. On the other side, past the churchyard, Nos.
1–3 CHURCH STREET, 1842, once uniform whitewashed stone

with small-paned windows, an object lesson in how easily such things may be spoilt. On w, LAMB HOUSE and LAMB SHOP, a mid-C19 pair, closing the view down SHIP STREET. Here CORNER HOUSE, *c.* 1860, strikes a more Victorian note with dormer gables. Further N, a pair on the w, one badly altered, and NEW HOUSE, are later C19 Neuadd Fawr estate houses with iron lattice windows.

ST MICHAEL. A rewarding church, double-naved with hand-some w tower, and twin parallel roofs. The N nave is possibly late C14, with plain pointed w door (now inside the tower) and N door. The tower is a C15 addition: see the batter of the earlier w wall inside. Tudor-arched w door, plain single bell-lights, and slightly corbelled parapet. Unusually access to the upper part is via a stair in the nave NW angle, entered from the C14 N door. The base is barrel vaulted. Later C15 s nave: two-light s windows in pink conglomerate, three-light E window with crudely heavy hood and three carved heads. A similar hood is over the otherwise early C19 w window. *W. D. Caröe* restored the church in 1904–6, his are the N windows, one on the s, and the s door. Inside, C15 five-bay arcade, chamfered arches on octagonal piers with plain chamfered caps, a thick-ened fourth pier marks the chancel. The w pier is built around a C14 decagonal bowl FONT on decagonal shaft. Plain collar-trusses to the N nave, possibly C17, embellished by Caröe. The s aisle has a good C15 wagon roof, formerly panelled, with moulded longitudinal ribs. All the FITTINGS are *Caröe*'s, plain pews, stalls and screens, gawky five-sided pulpit, and tapered columns to the altar rails. – WALL PAINTINGS. In the s aisle a remarkable series of framed texts, dated in a cartouche 1724, but with another date of 1795, and all heavily over-painted in a misconceived youth-employment scheme of 1986. Nicely crude lettered inscriptions in architectural frames, the Creed with yellow-robed Aaron figure to l. dated 1795. At the E end a bold Hanoverian royal arms and at the w end a haunting skeletal Death. Two churchwardens and *John Arthur* of Cilycwm 'pinxerunt' according to the cartouche. – STAINED GLASS. E window, 1876, by *T. Baillie* of London, dull; s aisle w, 1887, by *Hardman*, unusually in painterly Renaissance style; N window of *c.* 1893, probably by *Mayer* of Munich, old-fash-ioned. – MONUMENTS. An unusually large number. N wall: W. Jefferys †1848 and Rear-Admiral D. P. Price †1854, with draped urns, both by *D. Beynon* of Cilycwm. Fine relief mourn-ing female figure, to John Jones of Blaenos †1813, *c.* 1840–5, probably by *J. E. Thomas*, who did the plaques to David and Ann Jones nearby. E end plaque with broken pediment to Mary Lloyd of Mandinam †1732, by *John Arthur* of Cilycwm. s aisle E: large early C19 plaque with urn to the Davys family of Neuadd Fawr.

Outside, LYCHGATE, 1858 by *D. Beynon* who also did several of the tombs, the most impressive the Jones of Blaenos urned memorial, on a tapered base, *c.* 1840.

E of the churchyard, YR YSGOLDY FACH, 1833. Small hipped two-storey schoolroom, built into a bank, with access from both levels.

CAPEL Y GROES INDEPENDENT CHAPEL. 1859–60. Pink-washed simple Gothic with small-paned pointed windows and wavy bargeboards. Single gallery within, Gothic pulpit and low painted pews.

BWLCHYRHIW BAPTIST CHAPEL, 6 m. NNW. An early foundation, 1717, in a lovely remote setting. Disappointingly remodelled in 1901, in stucco with the entry moved to the gable-end.

CWMSARNDDU BAPTIST CHAPEL, 2½ m. S. Small lateral-fronted chapel with arched windows, dated 1814, altered 1858, 1876 and 1926. Of the latter date the hard cement finish. Outdoor baptistery.

SOAR CALVINISTIC METHODIST CHAPEL, ½ m. E. One of the first Methodist chapels in the county, founded c. 1740 (the deeds give 1746), rebuilt 1786 and 1836, remodelled 1859 and 1876. The yellow-washed gable front with two long narrow windows and arched door looks of 1876 as also the three-sided gallery with curved corners and long horizontal panels, the graining in three different tones.

PRIMARY SCHOOL, S of the village. Built as the National School, 1866–7, by *John Harries* of Llandeilo. Gothic and more elaborate than usual, a gable each side, one for the master's house, one for a schoolroom, and a saddlebacked tower over the side entrance.

PONT NEWYDD, 1 m. S. 1822. A single arched Tywi bridge, echoing Pont Dolauhirion, Llandovery, just downstream, but less elegant. Elliptical arch with cylindrical spandrel holes.

ERRYD, 1½ m. SW. Mid-C18 five-bay, two-storey house with steep roofs, the tall narrow windows showing the date. C19 cement render. Inside, a four-flight broad stair with turned balusters. First floor has a panelled cupboard with ornamented top and stencil patterning inside. A good survival.

Earlier C19 FARM to the SW, the cow-shed with the semicircular lights as at Henllys (*see* below), triple-arched lofted cart-shed, and a plain late C18 farmhouse backing onto the yard.

HENLLYS, 2½ m. SW. Double-roofed five-bay house rebuilt c. 1825–30 for William Jones, but with the steeper C18 roof of the earlier house oddly surviving within. Pleasing low two-storey front with timber Doric porch, the cornice Greek, the paired columns Roman. Earlier C19 plasterwork, and dog-leg stair with square balusters. The room to the r. was opened out to the hall with arches in the C19.

Attractive Late Georgian outbuildings. Facing the house, a former lofted STABLE, 1829, with centre pedimental gable, arched windows, the stables entered from a centre broad arch. In the gable, a pair of carved doves over a roundel. Behind, a delightful farmyard, with BAILIFF'S HOUSE at one corner, BARN with two high doors, and CARTHOUSE and STABLE range, dated 1831, with cut grey limestone piers and unglazed loft lunettes. COW-HOUSE to the W also with lunettes.

NEUADD FAWR, 1½ m. N. The derelict shell of the best Neo-
classical house of the region, much enlarged in the late 1820s
for Captain Richard Davys, probably an early work by *Edward
Haycock*. The existing house was of 1784, and the present large
front range is added around it. Two storeys, 1–3–1 bays, in
unpainted stucco with pairs of giant pilasters on the wings,
while the recessed centre has a loggia with square piers, simple
cornice and iron balcony rail, severe but elegant. The entrance
on the S end wall is elliptical-arched, within a Greek Ionic
porch of four massive cast-iron columns, under an iron cornice
with wreaths, presumably Shropshire-made, quite remarkable
for both scale and correctness.* Rear additions dated 1889.
The interior has collapsed: there was a central square hall with
stair hall behind a screen and a stone cantilever stair, typical
of Haycock. The rich plasterwork is now lost.
 Of the outbuildings, a pretty COACH-HOUSE survives,
derelict, *c.* 1830, very like the stables of 1829 at Henllys (*see*
above). Two-storey, hipped, with pediment over a pair of ogee-
headed centre windows, and big lunettes. Across the drive,
STABLE, of the same date, with loft lunettes and arched
windows with remnants of cast-iron glazing. Late C19 cast-iron
stable fittings. Gothic entrance LODGE, early C19, raised a
storey in the late C19. Attached finely lettered MILESTONE.
The fine PARK is set against a backdrop of high hills.
FARMS. The farms of the more fertile parts of the parish are char-
acterized by high-door barns of the late C18 and C19, with a
good example at LLWYNYBERLLAN, prominent on the slope
E of the Tywi. Few houses of distinction, CEFNTRENFA, S of
the village, on the crest looking E over the Tywi, is late C18 with
gabled centre and a minimally Venetian centre feature. Out-
buildings with the half-round openings of Erryd and Henllys.
S of the village, ABERGWENLAIS and HENLLYS FACH, are big
square late C19 farmhouses, full-height back and front, without
the older outshuts or more usual late C19 rear wings. ABERG-
WENLAIS MILL is hipped, earlier C19, three-storey, prettily
grouped with later house and barn.

CILYMAENLLWYD *see* LOGIN AND EFAILWEN

CLYNDERWEN/CLUNDERWEN *1219*

A settlement created by Brunel's South Wales Railway. Known
as Narberth Road from 1854 to 1875, it was briefly the terminus
of the line. The first building was a corrugated iron hotel brought
from Bristol in 1853, replaced before 1869 by the present DUKE
OF WELLINGTON inn, hipped stucco, three bays. Near the
railway bridge, some brick railway COTTAGES of the 1860s.

*The Ionic order, as Craig Hamilton has pointed out, is the Ilissus order from
Stuart & Revett's *Antiquities of Athens*.

St David. 1860, by *John Evans* of Narberth. Roughcast, small
and plain, nave only, with iron latticed windows.

Castell Dwyran Church, 1½ m. se. Derelict, and sadly
attractive, by Castell Dwyran farm. A medieval chapelry of
Llandissilio, Pembs. The present small cruciform church
looks earlier c19, altered in 1876 (date on the outsize bellcote),
with straight joints indicating that porch, transepts and chancel
are all added. The nave arched w window and pointed w
door look early c19, earlier than the other windows, which
are slightly cusped, with iron lattice glazing. Could the
enlargement all be rustic mid-c19 work (cf. Clynderwen,
above), with the e window of 1876? Atmospheric whitewashed
interior with stone-flagged floors, low pointed arches to the
transepts, and higher narrow chancel arch. Later c19 boarded
roofs. – font. Set in the middle of the church. Medieval,
whitewashed, square bowl, chamfered beneath. The round
shaft has an inserted octagonal piece. Twin pulpit
and reading desk, with crude fretwork panels, one each side
of the chancel arch. – stained glass. e window, c. 1876,
of very high quality, Crucifixion, possibly by *Clayton &
Bell*.

In the circular churchyard, Celtic cross to the Rev. Bowen
Jones †1887. A plaque in front reads: 'Here lie the remains
of a "classical ass"/The accursed of his sons by the name of
Jabrass/In the earth he is ammonia and triphosphate of
calcium/On earth a home demon and a ferocious old ruffian.'
One of his sons was responsible.

Clynderwen House, ½ m. e. The house after which the
village was named, owned from 1825 by the Gowers of Castell
Malgwyn, Pembs. Rebuilt in the 1860s in red brick, three bays,
plus a gabled cross-wing, but an c18 L-plan house behind, now
an outbuilding.

Grondre, ¼ m. sw. Double pile c18 two-storey house, turned
in the c19 such that the entrance is on the end, with added
hoodmoulds.

Y Gaer. se of village (SN 123 189). Iron Age oval enclosure with
a single bank.

Egremont, 2 m. w, was a tiny medieval parish. Llandre,
the large whitewashed three-storey, three-bay farmhouse, is
dated 1788, with arms of the Protheroe family. The cow-
shed incorporates part of an earlier house. In the garden, a
pyramid-roofed early c19 stone summer-house: doves in the
roof, and a four-seater privy in the basement. Charming
detail: triangular-headed basement door and windows with
lattice glazing, and a simplified Palladian window above. The
colourful cockerel weathervane comes from Cilwendeg,
Pembs.

Egremont Church, by the house, is ruinous. It was dated
1537 and 1782 on roof trusses, and rebuilt in 1838–40 by *John
Evans*. There was a c6 inscribed stone, marked caranta-
cus. On the hill behind, a rectangular earthwork, said to
be medieval.

COURT HENRY/CWRT HENRI 5523

ST MARY. Prominent on a hill. 1833. Built as a private church by the Rev. G. W. Green of Court Henry. Originally a simple rendered preaching box with three pairs of arched windows but a respectably scaled embattled w porch tower. Altered in two phases after 1890 by *David Jenkins*. Gothicized with added chancel, transepts and organ chamber, the tower, now pinnacled, flanked by non-matching porch and vestry. The new tower entrance copies the w arch of Strata Florida Abbey, Cd., possibly because the medieval FONT, C12, scalloped, was thought to come from there. – STAINED GLASS. E and S chancel windows by *Mayer* of the 1890s.

COURT HENRY. On the flat below the church, facing w down the Dulas valley. Of medieval origin, the core of Henry ap Gwilym's house *c.* 1460 surviving. He was father-in-law to Sir Rhys ap Thomas, and a soldier. Outwardly now mid C18, for a branch of the Herbert family, with two storeys of equal height and a big double roof with attics lit from the gable-ends. Seven bays, the outer ones set forward in hipped wings. A two-storey wing to the S is set back a little. The rear range and the interior are of the 1830s for the Rev. G. W. Green, with advice from a friend, *Thomas Richardson* of Iron Acton, Glos. The thick walls of the front range and s wing are medieval, and at first floor is a blocked pointed stone doorway and a small window with trefoiled head, which point to an outside stair to the upper floor with a gallery to the offset S wing, perhaps the solar. Green converted this room to a chapel. In the corner, a squint to the front bedroom, fronted by an ogee-headed red sandstone window, brought perhaps from Dryslwyn Castle. The squint allowed servants to hear family prayers. The plaster ceiling is earlier, barrel-vaulted, and with the feet of three roof truss principals breaking through in the cornice, presumably from an original arch-braced timber roof. A very large wooden Gothic window is on the end wall, of the 1830s.

The LODGE. Thomas Richardson sent Green sketches based on Nash's Blaise Hamlet types. The small rectangle with pointed door and paired Tudor windows is a much reduced version. The iron gates, with openwork piers are by *J. Moss* of Carmarthen.

CALVINISTIC METHODIST CHAPEL, ¼ m. S. 1830, altered 1878. Long-wall façade, but with full-height outer windows. Interior of 1878, the gallery with long panels, on iron columns with leafy caps. Schoolroom, 1903, by *David Jenkins*.

PONT CWRT HENRI, ¼ m. NW. 1835. High single-arched bridge, over the Dulas, by *Morgan Morgan*, for the Rev. G. W. Green. The parapet is spoilt by concrete blocks.

SCHOOL, beyond the bridge. 1878, by *George Morgan*. The C10 or C11 Eiudon Stone, now in the National Museum, Cardiff, *p. 25* the best example of Celtic interlace from the county, was found near here in the C19.

CWMAMMAN/CWMAMAN *see* GARNANT
AND GLANAMMAN

CWMBACH *see* LLANWINIO

CWMFFRWD
Llandyfaelog

Modern settlement s of Carmarthen, on the Kidwelly road.

St ANNE. 1866, by *T. W. A. Thompson*, engineer, possibly based on a design by *R. K. Penson*. Single vessel with canted apse and two N gables – a transept and an organ chamber. Plate tracery. – FITTINGS. Pews and stalls of 1868, pulpit, lectern and desk of 1912. – ORGAN. A handsome earlier C19 case with rounded angles and Regency Gothic panels. From where? – STAINED GLASS. E window, 1955, feeble. Nave N window, 1961, *Celtic Studios*, four scenes, much worked in black, presumably by *Howard Martin*. By the same firm, nave s window, 1972, more conventional. Nave s window, 1996, by *Janet Hardy*.

PENYGRAIG INDEPENDENT CHAPEL, 1 m. w. 1831. Long-wall façade with just two arched windows over doors. Pretty early C19 interior with painted grained gallery on wooden columns, and box pews. Early C20 pulpit.

OAKLANDS, ½ m. s. Stucco villa of 1861, extended in late C19. Four-bay asymmetrical front.

PIBWRLWYD, 1 m. NW. Large disused house of late medieval origin, built for the Dwnn family, resident until the mid C17. Long, broad rendered N–S range of two storeys. At the s end, a blocked pointed doorway. Corbels at first-floor level to the l., either of a garderobe or, more likely, a chimney, suggesting that the massive off-centre stack is secondary, probably C17. Square lateral stack to the w side, and another projecting chimney at the N end. Extensive and eccentric alterations, *c.* 1810, replaced most windows with large sashes, some with Gothic detail, others oddly grandiose, set within elliptically headed openings. A little hipped wing was added to the E. The interior detail is mostly early C19, with rare painted wall patterns, once a common substitute for printed wallpaper. C17 collar-truss roof, re-set, suggesting that a storey was removed in the C19.

Purchased in 1919 by the County Council, who built the Agricultural College, now PIBWRLWYD CAMPUS, to the NW. Neo-Georgian two-storey rendered main building, completed in 1927, by *W. Vincent Morgan*.

YSGOL BRO MYRDDIN, w of Pibwrlwyd Campus. 1993–6, by *Dyfed County Council Architects*, project architect *Charles Parry*. A Carmarthen secondary school on a greenfield site, densely grouped, to leave maximum space for playing fields and car parks. Hipped-roofed buildings in yellow brick, on a modular scheme of squares. Glass and metal porch on imitation stone piers.

BOLAHAUL *see* Llangunnor.

CYFFIG

On the ridge s of Whitland, with no village.

St Cyffig. The first thing that strikes one on approach is the exceptional size of the tower at the w end of the n aisle, the reason for such scale unknown. Typical battered base and corbelled parapet, with nw stair-tower. c16 detail: Tudor-arched door and two-light w window, with arched lights. Low nave and chancel, with added n aisle. The nave and chancel, perhaps c14, have been heightened in the c15, *see* the arched bell-openings preserved below the present ones. In the s wall, a pair of large arched c18 windows with iron glazing and ashlar jambs light the pulpit. Cool whitewashed interior, spatially complex with one wide arch between aisle and nave, two simple arches to the chancel, on a square pier, and an exceptionally wide arch between the nave and the tower. The tower has no vault, and no longer any floors, a strange sight from below. Plain pointed chancel arch with s squint. Restored 1889–91, initially under *F. R. Kempson,* but after a row with the SPAB over buttresses, completed by *H. Prothero.* Prothero's are the flat-headed windows and the roofs, all carefully understated. *The Welshman* noted that the church 'has not undergone the change of style so noticeable in other local churches'. – FONT. Probably medieval, square, drastically re-dressed. – FURNISHINGS by *Prothero.* – STAINED GLASS. E window of *c.* 1920, by *Jones & Willis.* – MONUMENTS. William Lewis †1811. Polished lime-stone tablet, 1814, the shaped top with an incised urn.

Bwlchgwynt Baptist Chapel, ½ m. e. Inscriptions record a busy century: rebuilt 1799, enlarged 1841, altered 1861, re-seated 1883, and renovated in 1904 probably by *G. Morgan & Son.* The character of the last date: rendered, with gable entry. Rear gallery, with a band of balustrading, typical of 1904, on iron columns by *T. Jones* of Carmarthen.

Brunant, 2 m. s e of Whitland. A mid-c19 stone shooting box built for Morgan Jones of Penylan, Cd., to a very curious Tudorish design, also used at the Old Vicarage, Cenarth, 1855. The porch and small window above are pierced through a big central lateral chimney, between two long blank windows. The fenestration, two storeys and attic, is in the gable-ends.

CYNGHORDY

Llanfair-ar-y-Bryn

On the main road, the GLANBRAN ARMS, built as an estate farm, mid c19, whitewashed, three bays, with hoodmoulds. Extensive outbuildings. Beyond are the church (q.v.), the former VICARAGE, *c.* 1885, by *David Jenkins,* stuccoed with centre gable, and Bethel Chapel (q.v.). N of the main road, a settlement around the SCHOOL, and a lane NE past Cynghordy Hall to Gosen Chapel and the viaduct.

ST MARY. 1882–3, by *Archibald Ritchie*. Nave and chancel, big S porch and half-hipped N vestry, in rock-faced stone from Knighton. The W bellcote has gone. Bare interior with deep arch-braced nave roof, chancel arch on square capitals with harshly stylized leaf carving. – STAINED GLASS. E window, 1933, by *C. C. Powell*, conventional late Gothic style. Long tradition sites a Cistercian grange here, the possible source of the two remarkable C12 carvings, now in the county museum of Adam and Eve in the explicit tradition of the sheila-na-gig.

BETHEL INDEPENDENT CHAPEL, 1841. Lateral façade with single long centre window, outer doors and gallery lights, all arched, as at Gosen (*see* below). Stuccoed and re-windowed in 1874. Panelled gallery of 1874, with pulpit on the back wall.

GOSEN CALVINISTIC METHODIST CHAPEL, 1½ m. N. Memorably set under the railway viaduct. 1844, lateral façade, with single long centre window, outer doors and gallery lights, as at Bethel, but here the original glazing bars remain. Inside, painted panelled pews, still with doors. Gallery in long panels, perhaps later C19, as is the pulpit on the back wall. Attached chapel house, 1922 by *J. O. Parry*, with arched windows in sympathy.

GLANBRAN, 1 m. S. Nothing now remains of the county's finest early C18 house, home of the Gwynne family from the early C16 to 1875, anciently with a fenced deer-park. It was of three storeys, the two façades of seven and six bays, sandstone with quoins and parapets with balustraded panels and ball finials. It was Palladian with Mannerist touches: the main doorcase with blocks with fielded panels, mask keystone and a broken curved pediment enclosing a helmeted bust. There was an ornamented Palladian window above and a top window with paired pilasters. The hall had a Gibbsian chimneypiece with

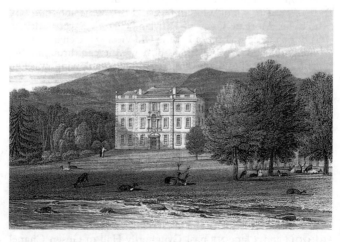

Glanbran.
Engraving after J. P. Neale, C19

pedimented overmantel, and the staircase beyond had turned balusters and a painted ceiling. The drawing room had Corinthian pilasters about the chimney and pedimented door-cases. A rear wing was dated 1777. The outbuildings included a huge barn and an octagonal three-storey dovecote. The ruins were cleared in 1987.

CYNGHORDY HALL. ½ m. N. Hipped roughcast five-bay early C18 house, with long sashes. A branch of the Gwynnes of Glan-bran were here from the C16. The uneven window spacing and the off-centre Tudor-arched doorway in the boldly projecting storeyed porch suggest a complicated older history. Renovated in 1886. Broad staircase of that date and also the painted ceiling in the dining room, the centre C19 panel with cherubs presumably imported, and the rest (stencilling and birds) made to match. Plastered coffered ceiling in the drawing room, perhaps reworking something of the late C17, and some early C19 panelled doors.

CLYNSAER HOUSE. 1½ m. NE. 1936. Of note for containing half of the fine 1730s staircase from Glanbran, with turned balusters.

CYNGHORDY VIADUCT, 1½ m. N. 1868, by *Henry Robertson*, engineer to the Central Wales line. Slim and elegant eighteen-arch viaduct, of massively rock-faced stone blocks in splayed piers with tooled edges, and yellow brick arches. One thousand ft (305-metres) long, 109-ft (33.2-metres) high, and the whole subtly curved, one of the finest railway monuments in S Wales. The contrast between the viaduct and Gosen Chapel at its feet is somehow poignant and endearing.

103

CYNWYL ELFED

3727

Large village in the Gwili valley, the chapel prominent at the head of the street. By the river NE of the church, the ELVET MILL, woolen mill of 1885.

ST CYNWYL. Double-naved late medieval church with more sur-viving features than at first apparent. The detail is late C15, when an existing nave was altered to match a new narrow N nave. Flat-headed windows with arched lights. The heavy ashlar bellcote with ungainly skirts is by *J. P. Seddon*, part of a restoration begun in 1863 but abandoned until 1876–7 for lack of funds. The crude porch and vestry are not by Seddon. Two-bay C15 arcade with double-chamfered segmental arches dying into rough chamfered centre pier and responds; similar but lower chancel N arch. Arch-braced roofs by Seddon to a barrel profile and new chancel arch on heavy corbels. Eroded cusped PISCINA at W end of nave, and a small crude STOUP to l. of the arcade. – FONT. Octagonal, late medieval, heavily retooled. – FITTINGS by Seddon: the pews with his unusual butterfly joint; pine pulpit on an ashlar base, and vestry screen in N aisle. – STAINED GLASS. Extraordinary E window by *Seddon*, 1877. A simple cross across three lights, with centre and terminal

96

roundels showing the head, hands, heart and feet of the cru-
cified Jesus, drawn with extreme delicacy on black grounds.
Seddon also put in the tinted glass elsewhere.

Timber LYCHGATE, by *Seddon*, 1876, just a hipped roof on
two posts, with much arched bracing.

BETHEL CALVINISTIC METHODIST CHAPEL. 1857, long-wall
façade with arched openings, and stucco detail of 1881. Inte-
rior of 1881: pitch-pine gallery with long cast-iron panels by *T.
Jones*, of Carmarthen, and great seat and platform, with much
fretwork, notching and moulding. RAILINGS outside also by
T. Jones.

BRYN IWAN INDEPENDENT CHAPEL, Bryn Iwan, 3 m. NW.
Hipped stone chapel of 1851–2, the long windows in the centre
arched, the outer gallery lights square. Nice painted and
grained interior, panelled pulpit, and panelled gallery front in
contrasted tones.

Y GANGELL, 2 m. NW. Single-storey cottage preserved as the
birth place in 1860 of the bard Elfed, the Rev. Howell Lewis.

At CWMDUAD, 2 m. N, a TOLL HOUSE, single-storey with three-
sided front, early C19, reputedly rebuilt in the 1840s after
burning by Rebecca rioters.

CLAWDD MAWR, 1 m. N of Cwmduad, W of the A484. A long
defensive bank facing E on the crest of the slope, extending
possibly for 2 m. Its date and function are unknown. Nearby,
CERRIG LLWYDION (SN 374 326) a ruined sequence of
Neolithic burial chambers.

CYNWYL GAEO

Once one of the largest parishes in Wales, sparsely populated
(especially in the NE), centred on two small villages, Caio and
Pumsaint, the latter on the site of a Roman fort on Sarn Helen,
the road to North Wales (and probably linked to the gold mines).
Much of the land was owned by the Dolaucothi estate.

ST CYNWYL. Attractively set above a cluster of C19 cottages.
Nave and chancel with no division, C15 added S aisle, and C15
battlemented W tower of the local type, but unusually massive,
with vaulted base. The aisle has a square labelled three-light W
window, and a crude panel-traceried E window, both C15. In
the N wall, an INSCRIBED STONE, possibly C6, read in 1878 as
REGIN FILIUS NV(V) INTI. In the C17 there were so many
recent burials in the church that it was 'offensive to the living',
4 ft of earth was brought in to seal the floor, but no-one could
then stand upright. Restored 1891, by *Ewan Christian*.
Entrance through the tower, with large STOUP (mysteriously
self-supplying), and then up steps to the uncluttered nave and
chancel. Broad ribbed wagon roofs of 1891, with dormers in
the nave. Simple arcade of four bays, knocked through when
the aisle was added. – FONT. C15 octagonal bowl, chamfered
down to the pedestal, which has angle stops. – FURNISHINGS.

By *Christian*, the timber PULPIT with blind tracery, on a Bath stone base. – MONUMENTS. William Lloyd †1786, oval with urn; John Bowen †1814, draped urn, by *J. Thomas & Son*, of Brecon, by whom also the Grecian memorials to William Morgan †1838 and to the Baskerville family, 1845. Henry and Mary Davies, 1872, Gothic, by *D. Davies* of Llanwrda. Lt. James Beek, 1875, by *W. M. Thomas* of London (son of J. Thomas), draped tablet with portrait, and sword and drooping lilies below. General Sir James Hills Johnes VC, early c20 plaque.

Against the N wall, the Dolaucothi FAMILY VAULT, 1815. Fine wrought-iron RAILINGS, the arches over the gates with lively scrolls and finials; the inventive work of an estate blacksmith. LYCHGATE, 1932, of grey rock-faced sandstone, with square Perp windows, unusually solid for the date.

TY NEWYDD CALVINISTIC METHODIST CHAPEL, Caio. 1837, lateral façade, remodelled to gable entry in 1907, by *David Jenkins*. The original front had two tall windows, outer doors and gallery lights, still discernible. Jenkins's gable entry has a wide triplet over the door. Thick stuccoed detail, typical of the architect. Gallery with Jenkins's favourite panels of pierced cast iron. Pedimented timber pulpit-back.

BETHEL BAPTIST CHAPEL, Ffarmers, 3 m. N. 1836. Simple lateral front with single centre window, outer doors and gallery windows. Half-hipped roof, typical of the 1830s. Stuccoed and refitted in 1896: panelled gallery with pulpit on the rear wall.

CWRT CALVINISTIC METHODIST CHAPEL, Cwrt y Cadno, 3½ m. NE. In a beautiful isolated setting. 1899, by *David Jenkins*. Broad half-hipped gable with cupola. Ugly angular heads to the openings, linked by angular hoodmoulds. The chapel name crazily interrupted by the windows. Simple interior with rear gallery.

CRUGYBAR INDEPENDENT CHAPEL, Crugybar, 1½ m. SW. 1837, refitted 1893. Attractive stuccoed lateral front with outer doors and one tall centre window. Slate-hung side and rear. Good interior of 1893, the gallery on simple iron columns, pulpit with fretwork and ribbed ceiling, picked out in contrasting colours. The cause at Crugybar is early, i.e. mid c17, the chapel built *c.* 1688, flourishing by 1715. Opposite, a row of simple stuccoed two-storey COTTAGES, three of 1867, the fourth added *c.* 1900.

SALEM BAPTIST CHAPEL, 1 m. N of Pumsaint. 1871, probably by *D. P. Davies* of Caio, cf. Shiloh, Llansawel. Gothic, in coursed stone, with a stepped triplet over the door, and long outer windows. Raised outer piers which continue to follow the gable to good effect. Lavish interior, the gallery with long panels of cast iron. Ironwork of different patterns in the great seat and the pulpit.

DYFFRYN, ¼ m. S. The former vicarage of 1823, stuccoed and hipped, three bays.

PUMSAINT, 1 m. W, has some attractive earlier c19 Dolaucothi estate cottages with latticed windows, a CHAPEL of 1875, and

a corrugated iron VILLAGE HALL of 1903. Astride the main road is the site of a ROMAN FORT, begun c. 75 A.D., reduced a century or so later. Excavation has revealed barracks in the Dolaucothi Arms car park, later replaced by workshops, the stone footings of the fort granary, demolished when the fort was reduced, and the site of a N gate-tower, initially of wood, rebuilt in stone, a little N of the hotel. A brick and tile bath-house was found in the C19 outside the fort to the SW. The road N to Ffarmers roughly follows the line of Sarn Helen, the Roman road to N Wales.

DOLAUCOTHI GOLD MINES, SE of Pumsaint, on a steep site by the Cothi. The mines were developed by the Romans, but may have existed earlier. Roman working seems to have begun about 75 A.D. and declined in the C2, but evidence of the extent is very scanty. The mines were largely opencast, with gold-bearing material exposed by scouring off the top material with water, called 'hushing', but there were also hand-cut adits driven into the hillside. Part of a timber man-powered drainage wheel has been found, that could be Roman, and Roman pottery and gold artefacts have been found in the area. As mining continued intermittently up to 1938, it is uncertain which of the visible working is Roman, but the trapezoidal section of the two adits is similar to Roman excavations else-where. Almost certainly Roman are the two impressive leats, stretching 7 m. up the Cothi valley and 4 m. up the parallel Annell valley; the water was held in tanks and released to scour the workings.

In modern times, attempts to find gold were made in 1797 for John Johnes of Dolaucothi, in the 1850s, and in 1871, when crushing machinery was introduced. Larger efforts were made in 1888–92 by the South Wales Gold Mining Co., in 1905–10, and most notably in 1933–8, when Britain's abandonment of the gold standard led to much greater interest in native gold. Roman Deep Ltd set up a new plant, employing some 200 men by 1938, when work ceased and the site was cleared. The National Trust has erected early C20 equipment and buildings from Halkyn lead mines, Flints. Nearby is CARREG PUM-SAINT, a large quadrangular boulder with four or five basin-like cavities in each side, used for quartz crushing, possibly Roman.

DOLAUCOTHI, 1 m. NW. Former home of the Johnes family from the late C16, mostly demolished c. 1955. The house had an early C18 five-bay, three-storey front, with older parts to the rear. *John Nash*, working at Hafod for John Johnes's cousin and brother-in-law, Thomas Johnes, added a porch and two low wings, each with a window set in a recessed arch in 1793–5. In 1871, Nash's wings were raised and bay windows and balustrading added to disguise new service ranges, one of which remains as the farmhouse. The very long, but unexcit-ing STABLE RANGE survives, the E portion with central gable c. 1840, extended c. 1870. Owned by the National Trust since 1955.

ESTATE FARMS. Several earlier to mid-C19 Dolaucothi estate farms with iron latticed windows. GLANYRANNELL, ½ m. SW, *c.* 1845, is three-bay, stone with projecting steeply gabled centre. Mullion-and-transom windows, the porch with cruciform loops. The farmyard in front has the BARN to the S and a five-bay COW-SHED to the N, making a delightful group from the road. BRYNTEG, 1½ m. NE, dated 1843, is almost identical. CEFNGARROS, SW of Brynteg, is smaller, with more humble latticed casements.

TY BRASIL, 1½ m. SW. Originally called Froodvale. 1869. Unequal gables and wide mullion-and-transom ashlar windows.

PENARTH GANOL, ½ m. SW of Pumsaint. Long whitewashed early C19 farmhouse, unspoilt. The three N bays are original, entered at the chimney end, a common plan type in the area. Another bay was added *c.* 1860, and the entry relocated in the rear outshut.

LLYSTROYDDIN, 1½ m. NW. A shooting lodge of 1903, by *David Jenkins*, for Colonel Methuen. Sprawling, brick with stucco and timbered gables.

CEFNCOED MAWR, ½ m. NE of Pumpsaint. Splendidly unspoilt upland farmstead – an increasingly rare sight. Three-bay whitewashed house raised a storey in the C19, probably C18. Opposite, a whitewashed BARN, with a massively battered base. On the S side, eight-bay COW-SHED, the two upper bays added, including some PIGSTIES.

BRUNANT, 1 m. N. Hipped stuccoed villa, *c.* 1830, brutally altered *c.* 1975. Two storeys and five bays, the centre one wider. It had a sophisticated Regency interior with a delicate dividing staircase behind two Ionic columns.

PANTCOY, ¼ m. S of Cwrt y Cadno. Former home of the Harries family, widely renowned as wizards in the C19. Dr John Harries predicted that he would die on a certain day in the manner of the prophet Elijah. On that day, the thatch caught fire, and Harries died. The present simple late C19 cottage was an earlier farm building; the old house destroyed with Harries in 1839 was some distance away.

FELIN NEWYDD, Crugybar. Restored late C18 to early C19 cornmill in whitewashed stone. Complete mechanism of the later C19 driving two pairs of stones, one pair purchased in 1810, driven by a water-wheel dated 1907.

TROEDYRHIW, Hafod Bridge, 2 m. SSE. Farm with excellent whitewashed BARN, its roof with five pairs of scarfed crucks and some thatch, under corrugated iron. Probably C18. The COW-SHED is similar, with four-bay roof, slightly curved principals and remnant of thatch.

TY'N COED, Hafod Bridge, 2 m. SE. Altered late C17 or C18 three-bay farmhouse of long-house type, with byre downhill to l. The entry was originally from a cross-passage behind the chimney, until the central entry and stair were created in the late C19, superseding the entry and stone stair each side of the wide fireplace. Roof of three pairs of scarfed crucks. The byre was rebuilt in the C19 and reuses some cruck blades in the roof.

DAFEN
Llanelli

North-eastern suburb of Llanelli, site of the first tin-plate works
in the area, opened 1846 and closed in 1959, nothing visible now.

St Michael, Bryngwyn Road. 1871–4, by *G. E. Street*, for the
 Phillips family of the tin-plate works, patrons of Street also at
 All Saints, Llanelli and for their house, Aelybryn, Felinfoel. Of
 moderate size but considerable character, in brown stone with
 ashlar dressings. Nave and chancel, with N aisle and N vestry.
 Dec cusped tracery. The N side affects a harsh boldness, the
 aisle roof slung between the gables of the vestry and porch,
 and a thin octagonal spirelet unexpectedly shoots through the
 slates at the l. end. The aisle-less s side, by contrast, has a noble
 rhythm, from fine buttresses, stepped to the nave, then closer-
 spaced and gabled, framing the high, narrow chancel windows.
 The interior has a fine seriousness, walls of tooled dark stone
 with ashlar arcade and dressings (now painted), chancel arch
 on corbels above a low screen wall. In the chancel, triple arch
 over the piscina and two sedilia, E wall with embossed tiles and
 alabaster REREDOS, with marble inlay. Good FITTINGS by
 Street: PULPIT with marble shafts and diaper patterning,
 round FONT on marble shafts, and delicate STALLS with qua-
 trefoils and poppyhead ends. – STAINED GLASS. An excellent
 series by *Clayton & Bell* of 1874, in their best C14 style, the
 figures animated, and unusually on white backgrounds. E
 window, of the Crucifixion over three lively scenes each with
 serpent. The other three windows, two to nave s, and the w
 window, have a multitude of small scenes, illustrating the Para-
 bles, the Miracles, and the life of Jesus. Several later windows
 by *Celtic Studios*, 1947–1966.

Maescanner Baptist Chapel, Bryngwyn Road. 1863. Stone
 gable front with outer pilasters, cramped stepped arched triplet
 over the door and long arched window each side. In the door-
 case, inset fluted columns. Interior of 1912, by *W. Griffiths*, with
 high-quality joinery typical of the date. Gallery front with long
 cast-iron band over panels, panelled pulpit with turned
 columns. Ribbed ceiling with boarding and moulded plaster
 panels.

Prince Philip Hospital, Dafen Road. 1989–90. General
 hospital on a grid plan with corridors linking two-storey ward
 blocks, rising an extra floor for plant at the main intersections.
 Hipped or pyramid roofs. Yellow brick with dark purple metal
 sheet under the eaves. Inside, seven tile panels of nursery
 rhymes, *c.* 1900, by *Doulton*, from the previous hospital. Oppo-
 site, Ty Bryngwyn, hospice, 1998 by *W. & P. Lewis*, low
 courtyard complex with gabled centrepiece and hipped pavil-
 ions, in pink and yellow brick, Neo-Victorian.

DINEFWR PARK

6322

1 m. w of Llandeilo

Dinefwr is historically of the utmost importance as the seat of the princes of medieval South Wales, or Deheubarth. The remains of the CASTLE stand on a steep crag over the Tywi, and to the N is its successor, NEWTON HOUSE, in rolling C18 parkland. It is uncertain how early there was a castle, but as Llandeilo was a religious centre from the C6, it is likely that Dinefwr also has early origins. Deheubarth was a shifting territory, covering all of SW Wales under Rhys ap Tewdwr (1078–93), but partitioned after his death and reduced to little more than the district of Caio. The resurgence in the confusion of the Stephen and Matilda wars was checked by Henry II after 1154. Rhys ap Gruffudd, the Lord Rhys, was confirmed in the Cantref Mawr, which included Dinefwr, in 1163, and expanded his dominion in the later C12. Dinefwr became his seat, and it is likely that he began rebuilding the castle. Although no masonry can be definitely dated earlier than the early C13, Rhys's fortification may have been of stone, as was his Cardigan Castle, rebuilt after 1171. The castle remained the seat of his descendants until the Edwardian conquest of 1277, after which it was in royal hands, withstanding several attacks, including a siege by Owain Glyndwr in 1403.

There was a Welsh township, which by 1280 had a weekly market and annual fair, probably located in the immediate vicinity of the castle. A 'newe towne', established probably in 1289, and populated by English families, stood on level ground to the N. By 1360 the New Town had forty-six burgages, and it was made a borough in 1363. Decline set in after 1433, when the lordship was leased. Gruffudd ap Nicholas acquired the lease for sixty years in 1439, and had built a house called Newton on some of the burgage plots before 1454. Dinefwr was granted to his grandson, Sir Rhys ap Thomas, in reward for his support of Henry VII. Although Sir Rhys lavished his attentions on Carew Castle, Pembs., he also improved the domestic ranges at Dinefwr. After the execution in 1531 of Sir Rhys's grandson, the estate did not return to his family until 1635. Thereafter it was held by them, the name Rhys anglicized to Rice.

Although the town of Newton was still occupied, both townships were in decline by the C16, Leland noting that 'at Dinefwr, there was sumtime a long streat nowe ruinus'. The Rices gradually cleared the burgage plots, Edward Rice rebuilding Newton House in 1660, with a small formal garden, depicted in two paintings thought to be of that date. At this time the castle, in disrepair since the early C16, was repaired and a belvedere built on top of the C13 round keep. Between 1750 and 1780, George Rice, Treasurer of the King's Chamber, landscaped the area to the E and S of Newton House, with advice from *Capability Brown*. Topographical writers of the late C18 and early C19 all extolled Newton's Picturesque quality. R. Clutterbuck in 1794 noted that 'art and nature have contributed numberless beauties to the scenery of the place, where the former has not introduced any of

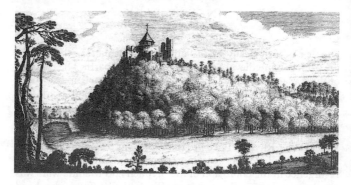

Dinefwr Castle.
Engraving by S. & N. Buck, 1741

its formalities, and the latter has been suffered to run luxuriantly
wild'. Malkin in 1804 found Newton 'unquestionably to be the
first finished place in Wales', even if the year before he had noted
that the house 'had no striking qualities'. The C17 house, a plain
double pile of three storeys and seven bays, despite some late C18
alterations, was 'a great disgrace', according to Thomas Lip-
scombe in 1802. It was recased in 1856 to plans by *R. K. Penson*,
in a stolid Venetian Gothic, which pleased nobody. The estate was
broken up in the later C20, the house fell into decay before being
excellently restored by the National Trust, which is restoring the
landscape, bringing back the ancient herd of white cattle. The
castle, which is in the care of Cadw, has also been excellently
restored.

DINEFWR CASTLE

The Lord Rhys probably began building after 1163, but none of
the present stonework can be dated to the C12 with confidence.
It is possible that some of the much-rebuilt curtain incorporates
early work. Following a dispute between Rhys's heirs, the castle
was taken by Rhys Ieuanc in 1213. An account mentions the
slighting of walls and a tower, which suggests that there were
stone structures. Rhys Grug is said to have dismantled the castle
on the orders of Llywelyn the Great, or to prevent it falling to
him. The circular keep may have been built by Rhys Grug †1233
or his son, Rhys Mechyll †1244. The polygonal curtain wall of
the inner ward, the small circular NW tower, and the apartment
block were all probably built by Rhys Fychan †1271 before the
surrender to Edward I in 1277. Repairs were done in the 1280s:
in 1282–3, the ditches were cleaned, the keep, bridge, hall and
'little tower' repaired, a new gate was built, and five buildings
were erected within the outer ward.

Dinefwr was attacked in 1321 by John Giffard and other
Marcher lords, after Edward II had granted the castle to his
favourite, Hugh Despenser, for life. After 1326 it was restored to
the Hakeluts, constables since 1310, and they rebuilt the inner

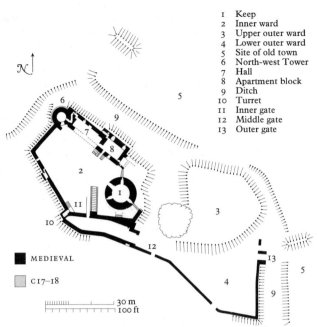

1 Keep
2 Inner ward
3 Upper outer ward
4 Lower outer ward
5 Site of old town
6 North-west Tower
7 Hall
8 Apartment block
9 Ditch
10 Turret
11 Inner gate
12 Middle gate
13 Outer gate

MEDIEVAL

C17–18

30 m
100 ft

Dinefwr Castle.
Plan

ward, together with a new hall block, between the NW tower and the apartment block. There were major repairs in 1409, after Glyndŵr's ten-day siege in 1403, but the castle was allowed to decay in the mid C15. Some repairs were done to the domestic ranges by Sir Rhys ap Thomas, c. 1500.

The ruin then became a romantic feature of the grounds of Newton House. Edward Rice built a belvedere on the keep, probably c. 1660, when he rebuilt Newton. Unfortunately making access to it destroyed the inner gatehouse, but no doubt preserved the keep. By the time the castle was taken on by Cadw in 1977, it was in a deplorable condition. Consolidation works were carried out 1994–8.

The castle sits on a high rocky ridge, with ditches on three sides, and a sheer stone-faced slope to the S. Inner and outer wards in line, the OUTER WARD to the E in two parts, a higher roughly oval piece that may have had ancillary buildings and a narrow part below to the S, the access from the outer gate to the middle gate and the inner ward. The outer gate was across a rock-cut ditch, but nothing is left. The curtain wall has disappeared, but the falling ground to the S and the inner faces of the ditch are stone-revetted. The next ditch, in front of the MIDDLE GATE has been widened by later quarrying. Of the gate, only a stub survives, with remnant of the outer door rebate. Beyond, the BARBICAN, a narrow wedge-shaped passage, crammed

22

between the curtain of the inner ward, and a curtain wall to the s, which has a wall-walk with battlements. Several joints on the face of the inner curtain wall show extensive periods of repair, the earliest masonry probably of the mid to late C13. The barbican leads to the simple arched INNER GATE, reduced in size at a later date. Little is left of the gatehouse passage, following the C17 construction of steps to the new belvedere above the keep; two loops and the C13 chamfered stops of the gate. The INNER WARD is five-sided, and is dominated by the circular early C13 KEEP to the E. This survives to two storeys, the basement with an inserted doorway, the blocked first-floor entry to the s visible from within. Splayed base, with a fine Bath stone roll moulding above. In the basement, three high windows, with stepped bases. It is likely that there was another storey, replaced by the circular BELVEDERE of c. 1660, which originally had a high conical roof and large windows onto the views. It was burnt in the late C18. Access is by a dog-leg stone stair, connected to the keep by a bridge.

The NE corner walling is C20, the curtain wall probably ran around the E of the keep. On the N, the rectangular APART-MENT BLOCK, probably late C13, the fine exterior masonry of the outer side of the curtain dating from the 1326 repairs. Two storeys and a basement, much remodelled c. 1500 by Sir Rhys ap Thomas, when the basement was added, and large, regularly spaced windows were inserted. A blocked first-floor lancet survives. NW latrine turret providing access from the first floor to the wall-walk. Both storeys are heated, and originally connected to further rooms to the E. The circular NW TOWER is mid to late C13, possibly pre-1277, on a high solid rock base, with a turret leading to the wall-walk. The original access, probably via a stair from the ward, was blocked by the insertion of the HALL RANGE between tower and the apartment block, probably in the early C14. The inner wall has fallen, but the fireplace and large window on the N side confirm a first-floor hall.

From the NW tower to the inner gate, there is a continuous wall-walk along the C13 curtain, the small TURRET adjacent to the inner gate was converted to a summer-house probably in the C17, also destroyed by fire, in 1823.

NEWTON HOUSE

The present appearance derives from the Gothic recasing in 1856–7 by *R. K. Penson*, for the fourth Baron Dynevor. But it keeps the C17 double-pile plan with axial chimneys, and indeed some splendid C17 interior features.

The plan of the C15 house is known from the Act of Attainder of 1532. There was a rectangular hall, 33 ft by 20 ft (10 metres by 6 metres), reached by twelve steps, with chambers at the w end and a chapel to the s, built over a vaulted basement. The out-

buildings were then in decay. Letters of *c.* 1630 mention a middle chamber, a chamber over the gate, a hall and a parlour.

The house was replaced in 1660 (the date said to be on a roof timber) by Edward Rice, with a fashionable double-pile hipped house, of three storeys and basement, and seven bays. Two paintings, probably commissioned shortly after the rebuilding, show the house and small formal garden. Both show outbuildings behind, some of which survive in the present service court.

Griffith Rice carried out alterations *c.* 1720, mostly internal, and built the N courtyard. Between 1760 and 1780, George Rice added battlements and corner turrets with cupolas, part of a campaign to romanticize the house, which also involved landscaping the grounds. There is a letter from *Capability Brown* who visited in 1775, saying, 'I wish my journey may prove of use to the place, which if it should, it will be very flattering to me,' which indicates at least advice on the landscaping, and perhaps also the house. The landscaping was complete by the time of the death of Rice's widow in 1793, though some projects were not realized.

In 1856 two plans for remodelling the house were made by *R. K. Penson*, both rejected. One was Puginian Gothic, with turrets, a huge square N tower, and a large porte cochère, the other was a less drastic Jacobean scheme, the shape of the old house recognizable, but with the same tower as the Gothic design. Lord Dynevor chose a cheaper option (which even so was financially embarrassing), recasing the house in a somewhat bald Gothic, with steep slate roofs on the corner turrets. Happily this had no impact on the interior. A billiard room was added in 1896. The house was in very poor condition when acquired by the National Trust, and the stripping of the Victorian casing was suggested but rejected. Restored from 1994, by *Michael Garner* of *Garner Southall Partnership*, including the return of Penson's pyramid slate roofs, removed in 1932, and very skilful support of the drawing-room ceiling.

Penson re-windowed the E front, as five bays instead of seven, with tall pointed windows on both main floors, with blank tympana, those on the ground floor with uncarved shields. He added the parapet with open quatrefoils and the large porte cochère, both machicolated. The stonework is a mixture of rock-faced grey limestone from Penson's quarries at Llandybie, and grey Forest of Dean ashlar. The turrets have narrow top windows and sprocketed pyramid roofs. The garden front is similar, but with a two-storey, three-bay loggia to draw the eye away from the irregular C17 bay spacing. It is Penson's best feature: the open ground floor with polychrome arches and rib-vaulting, the first floor with glazed trefoil-headed windows under big quatrefoils. Openwork parapet above flanked by tall pinnacles linked to the house by flying buttresses.

Inside, the later C17 double-pile plan, a novelty in the area, is clearly discernable. There is a thick spine wall containing the chimney-flues, and the staircase is central, to the rear. The hall and old dining room occupy the front half of the ground floor, the new dining room and the drawing room behind. The HALL was remodelled *c.* 1720, the five-bay colonnade of Doric columns marking the position of the original passage. The ribbed ceiling with leafy bosses is C19, of papier mâché. The OLD DINING ROOM has a plaster ceiling of wonderful quality and richness, of the same late C17 school as the one at Derwydd, and the lost ones at Edwinsford and Coalbrook, Pontyberem. Three main compartments: the centre with an oval panel, the outer with lozenges, and plenty of guilloche and acanthus decoration. The DRAWING ROOM has fielded pan-elling in large panels, pulvinated frieze with bands of rosettes and an even richer panelled ceiling. Centre oval, the outer bays divided into two, with circular panels. Within the oval are leaf motifs, blank cartouches in the circles. The NEW DINING ROOM was formed from the library in 1911, as more conve-nient for the kitchen in the N courtyard. The STAIRCASE is magnificent, of 1660, rising three storeys around an open well. Thick carved balusters, their bases with carved foliage, and gadrooning above. The string and handrail are also carved (some later replacements of the pendants and finials). Fine C17 plasterwork on the undersides with foliage patterns. C19 cof-fered ceiling with glazed panels. Many upper rooms have detail of *c.* 1720, including panelled dados and plaster ceilings with low relief decoration. In the BASEMENT, some small barrel-vaulted cellars.

39

There are two large service courts to the N, in brown rubble stone. The inner NORTH COURTYARD was created by linking two C17 buildings: a lofted stable to the S and a barn to the N. A late C17 view shows two high doors to the barn and oval lights in the stable back-wall. One barn door is now the through way to the outer court, and the oval lights remain visible from within the stable, converted to a kitchen. The linking W range is probably early C18, but not of one build. The taller centre block has three long openings and some thick glazing bars. The E range is late C18 or early C19, two-storey with big chimneys. Five upper windows mark a guest bedroom corridor and the ground floor had sevice rooms. Inside, the two C17 ranges have heavy oak collar trusses, with morticed collars. The E range has a stone-vaulted room just S of the centre, which may indicate a more complex history, and some late C18 fielded panelled doors.

The OUTER COURT is probably late C18, formed by adding two new ranges beyond the former barn. The nine-bay W range has a shallow gable over three big arched entries, and three Diocletian windows each side, lighting stables. The N range has hipped dormers and three big arches, to coach-houses and a way through. The C17 barn on the S has dormers and a stable with Diocletian windows.

The GARDENS around the house were laid out in the 1850s by *Penson*, with a ha-ha on three sides, bowed to the w. The formal w garden has a central twelve-sided FOUNTAIN on colonnettes. Against the wall of the N courtyard, a C19 SUMMER-HOUSE, of red sandstone, with an open canted front of three bays on rusticated columns. N of the house, a circular ICE HOUSE, with a domical stone-tiled roof, probably late C18 or early C19, and also an octagonal DOVECOTE of similar date. Also of this date, the picturesque DAIRY COTTAGE to the w of the outer courtyard. Single storey and attic, with simple central pediment, and sweeping stone-tiled roof. On the N side, an elaborate lattice balcony. Just NE, C18 HOME FARMHOUSE, of three bays and two storeys, with attic dormers and large projecting end chimneys. The stair is in a small projecting rear wing, and has plain slat balusters.

Near here, a long-suspected ROMAN FORT has been detected. Survey showed a larger fort reduced by reorientating it by ninety degrees, and abandoned by 150 A.D. The fort is on the road w from Llandovery and seems to have had a civilian settlement associated.

THE PARK*

Castle, house and Llandyfeisant church are essential components of the park, a complex designed landscape that takes advantage of the rugged landforms in the Tywi valley. Within the park walls are an Iron Age hill-fort, two Roman forts and two medieval townships, but apart from the earthwork nothing is visible. When George Rice began to create his park in the mid C18 there was a small deer-park to the w, thought to date from after 1659, that contained several stands of mature trees. Dinefwr Castle provided the necessary romantic ruin. It is clear that the basic structure of the park was complete by 1770. A sinuous drive from Llandeilo had been laid out, and the farm moved away from the house. C17 formal plantations and existing tree cover had been altered and enhanced. Lawns swept up to the house against a backdrop of mature trees. Capability Brown visited in 1775, but was not invited to produce a plan. He did advise on a series of additional works, only some of which were accepted. Rice's widow, Cecilia, continued to improve the park, realigning the drive to the N and planting additional clumps. After her death in 1793 very little more was done, apart from the wall, ha-ha and Fountain Garden, of the 1850s.

Two types of composition converge at Newton House. To the w and sw open spaces are enclosed by continuous woodland with tightly framed external views. In contrast, to the E, there are wide vistas towards distant hills, with planting confined to regimented clumps. Some intermingling occurs with fingers of woodland extending towards Llandeilo. All the drives, principal walks and

*By Dr E. Plunkett-Dillon.

views survive, including the circular walk devised by *Capability Brown*. The E drive, which replaced the S drive in the late C18, provides snatches of views of the castle through woodland and swings dramatically to bring the house into view. Linear remnants of earlier formal planting survive in lines of evenly spaced limes, sweet chestnuts and oaks, some lines through later clumps. The C18 boundary plantations are depleted, and much of the C18 park wall has collapsed or been removed, but the earlier deer-park wall survives.

DOLAUCOTHI *see* CYNWYL GAEO

3542

DREFACH FELINDRE
Llangeler/Penboyr

The twin settlements of Drefach and Felindre and the surrounding hamlets of Cwmpengraig, Drefelin, Pentrecwrt and Cwmhiraeth were one of the main woollen manufacturing centres of Wales from *c.* 1870 to 1930, with some forty-three mills by 1900, all water-powered, generally manufacturing flannel. The two settlements are separated by the river N of Felindre church. Felindre was an older settlement, site in the early C19 of the large nurseries of Hindes & Williamson that supplied trees in tens of thousands to Welsh estates. The houses are generally late C19, stone with yellow brick, or stuccoed. For the mills, *see* below. In Drefach, to the N, the RED LION HOTEL, three-storey, stone and brick, built for commercial travellers to the mills. To the S, MEIROS HALL, hipped later C19 villa, built for the owner of Meiros Mill, with an unusual ogee-roofed conservatory. In Felindre, N of the church, VELINDRE HOUSE, by the river, is an earlier C19 three-bay farmhouse, pre-dating the settlement.

ST BARNABAS. 1862–3, by *David Brandon*. Built for Lord Cawdor (whose birthday was St Barnabas' day). Decent lancet Gothic, in Pwntan sandstone with yellow ashlar dressings. Nave, chancel with polygonal apse, S porch and an open timber W bellcote. Inside, high thin trusses on corbels, and a shafted apse arch (carving by *P. Ford* of Cheadle). – Good ENCAUSTIC TILES with the Cawdor arms. – STAINED GLASS. Three fine apse windows, 1863, by *Heaton, Butler & Bayne*, among the best of the period in the region. Expressive drawing in an angular C14 style. Three windows by *Celtic Studios*, 1962, 1965 and 1967, and one of *c.* 1920.
BETHEL BAPTIST CHAPEL, Drefach. 1889–90, by *David Davies*. Typical pilastered front with centre arch and Florentine timber tracery.
CLOSYGRAIG CALVINISTIC METHODIST CHAPEL, Drefelin. 1900. Big stucco gable front, with angle pilasters and the pediment outlined in raised strips. Three arched windows over two doors, and two long arched windows each side. Mid C19 chapel house to r.

(PENRHIW UNITARIAN CHAPEL, Drefach. 1777. The earliest chapel of the region, is reconstructed at the Museum of Welsh Life, St Fagans.)

SOAR INDEPENDENT CHAPEL, Cwmpengraig. 1894–5. Rock-faced stone with yellow brick bands and details, the three centre windows gathered under an arch.

TABERNACLE CHAPEL, Pentrecagal. Later C19 stuccoed tiny chapel, just two side windows and an end porch, but of great charm in its railed courtyard.

WOOLLEN MILLS. In DREFACH, CAMBRIAN MILLS, now the Museum of the Welsh Woollen Industry, 1902, an extensive group, three parallel ranges in stone and red brick, the largest reduced a storey after a fire in the 1920s. SQUARE HALL MILL, further s, on the r., in stone and yellow brick, is of the 1890s, and MEIROS MILL, beyond, is earlier C20 in red brick and concrete. On the steep E side of the valley, five-bay with unusually large windows. Down a footpath w of Cambrian Mills, CILWENDEG MILLS, big stone ranges of the 1880s.

In FELINDRE, past the church, on the r., RHYDWERN, 1895, seven bays, and DYFFRYN MILL, rebuilt in the 1920s, one of the principal mills of the area. DANGRIBYN, a small late C19 mill, was converted to houses after 1945. Opposite Dyffryn Mill, a road leads to DREFELIN, where FELIN NEWYDD, restored in 1994, is a mid-C19 corn-mill with roof hipped at one end and small-paned windows. GILFACH VALE, down a track to the s, in the same valley, had two mills, the first now derelict, the second an interesting row of managers' cottages, quite small, owner's house and seven-bay mill under the same roof. s of Felindre, on the l., OGOF MILL, a row of small sheds, shows the first phase of industrialization, in the mid C19, for this was a weaving shop. At CWMPENGRAIG, 1 m. s, Capel Soar (q.v.), and GREEN MEADOW, a terrace of mill-workers' cottages associated with DOLWERDD MILL opposite. ESGAIR VIEW MILL upstream, is late C19, three storeys, six bays, the end wall rebuilt. On the hill out to the w, a row of five single-storey COTTAGES, 1875. At CWMHIRAETH, 1½ m. sw, two mills in the valley bottom and another on the hillside NE.

DOLHAIDD, 1 m. N, in meadows by the Teifi. Stucco four-bay front of c. 1859, with little gables over the upper windows, and decorative niches and roundels in the gable-ends. Behind, at right angles, the lower five-bay range with eaves dormers may be the C18 house, altered.

See also Llangeler and Penboyr

DRYSLWYN

2 m. SW of Llangathen

DRYSLWYN CASTLE. The remains of the castle, on a steep rocky bluff above the Tywi valley, are visible from afar. Although the ruins look intriguing from below, disappointingly little survived dismantling in the early C15. Like Dinefwr (q.v.), Dryslwyn is

centred on an early C13 circular keep, but has a much less pres-
tigious history, and is less preserved. Its early history is vague.
It was a seat of the princes of Deheubarth; Maredudd ap Rhys
Grug, was called lord of Dryslwyn when he died in 1271. It is
likely that the keep and curtain wall of the inner ward are
earlier to mid C13. There was a township at Dryslwyn, indi-
cated by the grant by Rhys ap Maredudd in 1281 of a charter
to hold a fair. Traces of a defended settlement are visible on
the N side. When Rhys ap Maredudd rose against Edward I
in 1287, the castle was besieged by a force of 11,000. Sappers
undermined the wall by the chapel, the sudden collapse of
which killed some of the attackers including the Earl of
Stafford. The castle was then held by the crown, and repairs
by the custodian, Alan de Plucknett, no doubt included the
rebuilding of the curtain wall on the S and E sides of the inner
ward, and the building of a new hall range. It was kept in repair
by successive constables. Rhys ap Gruffudd, constable in 1402,
joined forces with Owain Glyndwr in 1403. Either during that
rebellion, or shortly after, the castle was dismantled. It is now
in the care of Cadw who have undertaken extensive excavation
and consolidation.

The plan consists of inner, middle and outer wards, arranged
in serpentine-like fashion along the ridge of the bluff. The
township occupied the lower slopes to the N W, enclosed by a
deep ditch and a wall, now a low bank, against which are earth-
works of small rectangular houses and gardens. Traces only
survive of the WEST GATE, which defended the entry to the
town. Documents of 1356–9 show that there were thirty-four
burgage plots, with another fourteen outside the walls. Habi-
tation probably ceased after the demolition of the castle in the
early C15.

Little of the OUTER and MIDDLE WARDS survived the
demolition, but the base of the OUTER GATE is intact, its
passage walled up. Evidence of a portcullis slot, and footings
of stairs to the upper floor. Probably mid or late C13. Nothing
is left of the MIDDLE GATE, but a stub of masonry to its N may
be the base of a square tower.

The standing remains are mainly confined to the INNER
WARD. The footings of the INNER GATE survive, clearly
extended to the E, probably in the late C13, complete with
portcullis slot. Hard against this, crammed in the N E corner
of the inner ward, the circular KEEP of the early C13, with foot-
ings of massively thick walls. Inserted door at basement level,
nothing surviving above. The curtain wall S of the keep appears
to be of a later build, probably a late C13 repair. The early HALL
cuts across the ward, aligned E–W. Rectangular plan, the base-
ment level surviving, approached by an impressive flight of
steps on the N side. Just W of centre, a rounded stub of masonry
no doubt associated with the open hearth in the hall above.
Excavation here found fragments of a fine red sandstone
window of two cinquefoiled lights and, remarkably, fragments
of window glass. Parallel to this is the later hall block, abutting

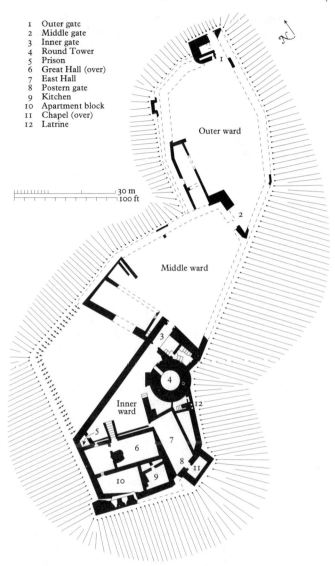

1 Outer gate
2 Middle gate
3 Inner gate
4 Round Tower
5 Prison
6 Great Hall (over)
7 East Hall
8 Postern gate
9 Kitchen
10 Apartment block
11 Chapel (over)
12 Latrine

30 m
100 ft

Outer ward

Middle ward

Inner ward

Dryslwyn Castle.
Plan

the curtain wall on its s side. The extent of the late C13 repairs
can be seen in this part of the curtain, where the new walling
is built out slightly beyond the line of the older masonry. The
later C13 wall survives at this point to two storeys in height.
The late C13 rebuilding of the curtain wall included the rec-
tangular CHAPEL TOWER on the s side of the ward, the outer

face of which remains to two storeys, the upper one with three widely spaced lancets. The tower was entered from the mid-CI3 rectangular block which abuts the E end of the early CI3 hall.

EFAILWEN

Llandissilio East and Cilymaenllwyd

Small main road settlement on the Narberth to Cardigan road; scene of the first Rebecca riots when the toll-gate here was thrice destroyed in 1839.

NEBO INDEPENDENT CHAPEL, Efailwen. ¼ m. NE. 1861. Solid, square, hipped stuccoed chapel, with two long arched windows, arched door and fanlight. The old-fashioned interior has box pews. Four-sided gallery on thin iron columns with long panels to the front, and an elaborate pulpit, covered in fretwork, backing on to the lobby, an echo of earlier chapel planning.

RHYDWILYM BAPTIST CHAPEL, 2 m. w, by the Eastern Cleddau. Founded in the 1660s, the parent church of the Baptist cause in the area. The picturesque and remote loca- tion, on the county boundary, is typical of early Nonconformist sites. Baptism took place in the river. Rebuilt in 1875, similar to Baptist chapels at Letterston, Pontyglasier and Mynachlogddu, Pembs., and so possibly by *Joshua Morris* of Newport. Open pediment gable, and arched openings, a little pair over the door. Cut grey limestone quoins and surrounds, the glazing still small-paned with radiating bars. Panelled three-sided gallery on iron columns by *T. Jones* of Carmarthen. Grand Ionic pulpit-back with a broken curved pediment. Pre- served is an inscribed foundation stone of 1701, Welsh, Latin and English in one sentence, the earliest chapel inscription in the region.

PREHISTORIC REMAINS. This high ridge running NE into Pem- brokeshire seems to have been of special importance in pre- historic times. MEINI GWYR (SN 142 266), just w of Glandy Cross, was an important embanked stone circle, of which the 120-ft (36.6-metre) diameter bank survives, but only two of the original seventeen stones. Fifteen were there in 1695. Pottery shards found have been dated to *c.* 3000 B.C. STANDING STONES include three w of the Meini Gwyr circle; the Capel Nebo Stone, s of the chapel; and Maen Pica, sw of Efailwen crossroads. Out to the NE, by the main road are the CASTELL GARW (SN 146 269) a possible henge monument and the CARN BESI Burial Chamber (SN 156 277), both Neolithic. *See* also Login.

EGLWYS CYMUN

Rural parish N of Pendine, the church and vicarage on opposite sides of the road, but no village. Traces have been found of a

deserted medieval village. In the parish, a series of tall three-storey late C18 to early C19 farmhouses, with centre porch and one-window range each side, perhaps connected with the Westmead estate, Llanmilo. MIDDLE POOL is the best survivor; COMMON CHURCH, EAST POOL, WEST POOL and TREMOILET are altered.

ST MARGARET MARLOES. Dedicated to the niece of a C14 de Brian lord of Laugharne, a nun at Llandawke. One of the most remarkable churches of the county, though not apparent from the exterior, just nave and chancel with a substantial s porch, and an undersized w bellcote. Dating is difficult; the C14 seems likely for the nave (although the wall painting inside has been dated to the C13). A low pointed arch with stone voussoirs is partly covered by the porch, and is presumably of the first period. It looks too low and broad for a door. The N side of the nave is stepped out at the w with a pointed N door and rectangular window, both blocked from the inside. Was the stepping out an attempt to strengthen the wall against the thrust of the vault, or was there a mural passage or cell? Local tradition mentions an anchorite. Odd too is the ogee-moulded eaves cornice, which looks C18. E and W windows, 1848 with Y-tracery, other windows and the bellcote, 1856 by *Thomas David*. Chancel mostly rebuilt in 1877–8 by *C. C. Rolfe* of Oxford.

What makes the church remarkable are the stone barrel vaults of the porch and the nave, and the subtle and careful restoration of 1900–1 by *William Weir*, architect to the SPAB, under the eye of none other than *Philip Webb*, founder with William Morris of the Society. G. G. T. Treherne, an early member, instigated the work, with support from Morgan Jones of Llanmilo. The repairs were conservative, hence the survival of features of 1840, and the decoration subtly timeless. Webb told Weir that 'truly it looks more "ancient" than before you laid hands on it'.

In the porch the vault is limewashed, and a panelled door of 1900 screens a nice s door of *c.* 1848, with both flush and fielded panels, the top panels imitating Y-tracery. The porch anticipates the vault of the nave, for once boat-like in the true sense, almost parabolic, and given a glowing unity from the cream limewash. The windows are small and deep set, hardly interrupting the curve, and the floor is of rough stone flags, harmonious with the vault. Low rounded arch to the chancel and square-headed recess to the l. Two steps into the chancel, with heavy open rafter roof of 1878, exposed stone walls and arched ashlar reveal to the E window. Good ENCAUSTIC TILES at the E end.

WALL PAINTING. On the nave N wall remarkable overlay of texts in a rectangle, restored in 1996 by *Donald Smith*. The lowest layer has been dated as early as the C13, a coloured geometric pattern. The Commandments are overlaid three times, first in Gothic ochre letters, in English, perhaps C16, then, in

black letters, English again, perhaps C17, then again in Welsh, C17. A small panel to the r. is dated 1637. – FONT. Shallow square bowl with chamfered rim, retooled medieval, on a monolith round shaft and square base. Of 1900–1, and very quirky indeed, is the oak work at the W end, designed by *Webb* himself, and somehow also rather nautical, like a stage-set ship's cabin. A seat with high iron-bound back is set between two splay-sided narrow enclosures of emphatically hand-crafted character: rough-hewn posts, plank doors and black-smith ironwork. On the outside, well-lettered lists of the Lords of the Manor. The back of the seat opens to reveal a late C5 or C6 INSCRIBED STONE inscribed AVITORIA FILIA CVNIGNI. It also has clear Ogham strokes reading AVITTORIGES along the top and INIGINACUNIGNI along the bottom. The function of Webb's work is vague, too small for vestries, barely storage spaces.

FITTINGS. PEWS, 1900, by *Weir*, nicely simple in oak. Lovely LECTERN, 1903, by *George Jack*, with lettering on the bookrest and a carved front of St Margaret of Antioch. By *George Jack*. Conventional PULPIT, 1925 by *Clarke* of Llandaff. Simple oak ALTAR RAILS, probably of 1900. LIST OF PATRONS, Floren-tine-style gessoed and painted framed board with good letter-ing, 1911, by *F. C. Eden*. – STAINED GLASS. Some exceptionally fine glass of 1906–17 by *F. C. Eden* in a range of late medieval styles, characterized by delicacy and humour in the drawing. E window of 1906, three St Margarets, C15 style with figures against clear quarries with gold emblems. Beneath, Joan of Arc on the l. and Sir Guy de Brian with Llandawke church to the r. Two chancel S single lights of 1907, St Michael and St Nicholas. Nave S first window, single light of St Cynin, two diamond panels of Cynin as a Bishop and as a knight, in gold and grisaille, Netherlandish C16 style. The next, a single broad light of St George, 1907, late Gothic style, with a fine use of colour. Lovely drawing of the castle behind and the eager horse. The third window, two-light, of SS Teilo & Brychan, 1915, C15 style, the background quarries clear with gold emblems. St Teilo sits episcopally with two white harts and a model of Llandaff Cathedral, over a charming scene of his rescue of seven brothers from the river, St Brychan sits regally with three children in his lap. The W window, 1917, shows Sir Guy and Lady Elizabeth de Brian, C15-style figures with heraldic lions and banners. N window, by the pulpit, St David, 1909, more conventional.

MEMORIALS. Over the chancel arch painted plaque of 1798 to Sir John Perrot who 'died of Grief in London Tower' in 1592; nave S painted plaque to Jane Price †1854, aged seventeen: 'The aged they are warnd from every tomb/Muse here ye young on Jane's more early doom'. Chancel W: headstone to Peter Chapman †1718. Re-set C18 floor slab to Edward Phillips of Sandyhaven. Chancel S: small well-lettered ashlar-framed slate plaque to G. G. T. Treherne †1923.

Circular churchyard, almost within an Iron Age fort, of which some embankments survive. Fragmentary remains of a medieval CHURCHYARD CROSS, also a fine MEMORIAL CROSS, some 10-ft (3-metres) high, to G. G. T. Treherne, 1926, by *T. G. Clarke* of Llandaff. Well-carved crucified Christ. Many C19 gravestones by a local mason, *T. Morris*. Oak LYCHGATE of 1930.

THE OLD RECTORY. 1869–70, probably by *E. M. Goodwin*. Five bays, stuccoed, Italianate, with gables each side, and a porch turret with pyramid roof in the fourth bay.

EGLWYS FAIR A CHURIG *see* LLANGLYDWEN

EGREMONT *see* CLYNDERWEN

FELINFOEL
Llanelli

A suburb of Llanelli, mostly terraced housing, though there were larger houses on the Llannon road, optimistically called Swiss Valley. On the w side, the VICARAGE, 1884, by *J. B. Wilson*, rendered to the detriment of the detail, but originally a well-designed house, illustrated in *The Architect*. E of the village, the large automotive parts FACTORY built for Nuffield Motors *c.* 1960. The main factory has a glazed clerestory and box-section ridged roof-lights; a curtain-walled office at the N end. Westfa, the house by *Penson* for R. J. Nevill of the copper-works, has been demolished.

HOLY TRINITY. 1857–8, by *R. K. Penson*, at his most inventive, for the Nevill family. Cruciform, with squat crossing tower and a spire. The red tiles are presumably C20, as also the copper cladding of the rather Germanic spire, which originally had a slated base, a timber bell-stage, and shingled spire. Broad, aisleless interior with arch-braced trusses on corbels. Painted frieze under the wall-plates. Chamfered nave E arch to the tall crossing lit by high lancets, the chancel arch lower and shafted. – FITTINGS. By *Penson*, apart from altar and reredos, 1950. – MONUMENT. Ivor Buckley †1929, by *Antonio Maraini* of Florence, lovely sheltering angel. – STAINED GLASS. Late C19 chancel s. Third in nave N by *Celtic Studios*, 1950.

ADULAM BAPTIST CHAPEL, Long Row. 1879, by the *Rev. Henry Thomas* of Briton Ferry. Large and plain externally, but with excellent interior ironwork. The gallery front is continuously railed in double-curved ironwork, very theatrical. The great seat and pulpit also have iron balustrades, in semicircles. Part-boarded ceiling, with three big plaster roses. Adjoining SCHOOLROOM, 1932–4, by *J. & B. Evans* of Llanelli, stucco Italianate with pedimented porch.

106 FELINFOEL BREWERY. A relatively small but complete example
of a later C19 brewery. Not of a single build, a good grouping
of roofs at different levels. Brown stone with yellow brick. The
earliest part, to l., is hipped, four bays, with an originally open
top gallery. The lower three-bay, two-storey, centre is probably
of 1878, the date of the tower-like corner block. This has arched
windows on four floors and a hipped roof, over a gallery.
The slightly taller pyramid-roofed section behind, with gabled
hoist, may be a little later. Across the yard to the S, single-storey
stuccoed office building.

 The plant was built to maximize the use of gravity in pro-
duction, the wort being pumped to the top after grinding and
stirring, dropped for boiling with hops and straining, and
dropped again for fermentation and storage.

AELYBRYN (Diplomat Hotel), Felinfoel Road. 1865–8, by *G. E.
Street*, for E. N. Phillips, tin-plate manufacturer, and Street's
patron at Dafen and All Saints, Llanelli. Perhaps the least
known of Street's domestic works, the house is larger than his
vicarages, though the economy of parsonage design seems to
underlie this design more than the expansiveness of a country
house. Modern Gothic, without period detail, the house has a
stern simplicity, sheer stone walls without mouldings, plain red
brick window dressings and half-hipped gables. On the S front,
to the road, an unequal pair of gables project, with plain broad
windows linked vertically by red brick, the upper windows
cambered-headed. Set back to l., and taller by a floor is the
end of the W front, with smaller windows, the lower one with
Gothic relieving arch, the only overt Gothic touch. The W front
plays with near-symmetry: three bays, but the first floor l.
window broader so that the middle is off-centre, though
aligned with the single dormer. The ground floor is built out
in ashlar, a grid of fenestration with parapet, the r. bay set back,
so distinct in materials and rhythm as to seem an afterthought.
The interior is much altered.

TY'R HEOL, 1 m. N, N of the lower Lliedi reservoir. Disused
single-storey farmhouse and byre of long-house type. The
house was originally entered from the cross-passage at the top
of the byre. Under the tin roof, the remains of straw-rope
under-thatch.

CWMLLETHRYD FAWR, 1½ m. N. Minor gentry house, dated
1655 in a shield, with the initials of Francis Howell. Downhill
sited, whitewashed, with a big upper end chimney, next to
which is a stone stair, lit by small windows with dripstones.

5125 FELINGWM
 Llanegwad

Two settlements, Felingwm Uchaf on the Nantgaredig to Brechfa
road, Felingwm Isaf just off, to the S.

ST JOHN, Felingwm Uchaf. 1896, built to serve the remote N
part of Llanegwad parish. Slightly Arts and Crafts Gothic,

low single nave and chancel, with half-timbered porch. Arch-braced roof on low corbels. – Circular FONT. – MONUMENT. Rev. Evan Thomas †1917. Alabaster and mosaic, cf. Llanegwad, probably by *Powell*.

SITTIM BAPTIST CHAPEL, Felingwm Isaf. 1845, an early example in the area of a gable-fronted chapel. Four-centred door, round-headed window each side, with later tracery. Good interior, the rear gallery with alternating wide and narrow panels. Box pews and later pulpit.

YNYSWEN, ½ m. E. Minor gentry house, of 1718, built for Thomas Lewis. Three bays, with massive projecting end chimneys. The veranda and bay windows were added *c.* 1900. The house was remodelled in 1831 when the rear wing with dining room was added. This has a dentil cornice and side-board recess with fluted pilasters. Cellar beneath. Staircase of 1831. Some C18 rough beams in the original house. So many houses of this type in the area have been completely spoilt: this is a happy exception.

FERRYSIDE/GLANYFFERI

Saint Ishmaels

On the Tywi estuary, opposite Llansteffan, Ferryside was a minor sea-side resort from 1804, when Colonel Robert Brigstocke built a villa, called Robert's Rest. Others followed, though most of the houses date from after 1852, when the railway came. Along the railway, a ribbon with church, school, modest terrace housing and two chapels. Larger villas on the higher ground behind and to the S, overlooking the spectacular view.

ST THOMAS. 1875–6, by *T. E. C. Streatfeild*, replacing a Georgian church of 1825–8 with an octagonal tower, by *H. W. Ayres*, Carmarthen cabinet-maker. Streatfeild was a pupil of A. W. Blomfield, and died young in 1882. The church shows the influence of the advanced Gothicists, most obviously G. E. Street. Brown stone with Bath dressings: nave with lean-to S aisle and N porch, chancel, transepts, and a conical-roofed turret between nave and N transept. The windows are mostly uncusped, at the W end a pair of two-lights with quatrefoils, and a small rose above, gathered under a pointed arch defined by flush voussoirs. Inside, rock-faced stone walls and arch-braced rafter roofs, to an arched profile, boarded in the chancel. Three-bay plain S arcade, chancel arch on elongated corbels, and the E end enriched with marble-shafting, a good Victorian hierarchy of decoration. – REREDOS. A fine example of *opus sectile*, matt-glazed painted tilework with gold highlights, 1876, by *Powell*, specialists in this type of work. – LECTERN. Ornate brass of 1876. – MEMORIALS. E. Picton of Iscoed †1838, by *D. Mainwaring*, marble with Adamesque fluting and urn, from Llansaint church. – STAINED GLASS. Chancel E and N, and one nave N window, by *Burlison & Grylls*, 1883, late Gothic, finely

drawn. The chancel N window is a memorial, with portrait, to the architect. Nave s window 1991, by *Janet Hardy*. First nave N window, 1901 by *Albert Moore*. s transept window by *Celtic Studios*, 1965.

BETHANIA CALVINISTIC METHODIST CHAPEL. 1911–13, by *J. H. Morgan*. A departure from convention, a loose agglomeration of elements, in the Edwardian Free Style. Roughcast with unmoulded mullion windows. The chapel has a copper ventilator on the ridge, and two projecting gables, a hall to l., and a porch with the gallery stair, to r. Inside an interesting play of arches: one over the end gallery, echoed behind the pulpit, and a twin arch to the hall on the l., with a single arch to an organ chamber opposite. Inventive woodwork: complex roof open down the centre to give a longitudinal axis, with tie-beams, collars and posts; free classical detail to the gallery front and the pulpit. MAESYFFYNNON, the house to the l., was the former chapel, 1860, altered to a manse in 1912.

SALEM BAPTIST CHAPEL. 1877–8, by *George Morgan*. One of the remarkable sequence of Romanesque chapels that Morgan launched with the very similar Y Priordy, Carmarthen, in 1875. Brown stone with ashlar dressings. Narrow centre gable flanked by steep hipped roofs at right angles, giving the effect of wings, where actually the plan is the standard rectangle. A blind stepped arcade in the gable, and a stepped triple arch each floor to the same rhythm though varied in form: door and sidelights below, windows above, both with fat column shafts, stilted main arch and two-tone voussoirs. There is a confidence to the punchy detail, no mouldings, three roundels over the main window, echoed in the door-head. Inside, boarded gallery front with narrow cast-iron open panels. Iron columns by *Bright & Garrard*, of Carmarthen. Gothic pitch-pine arcading to the great seat and pulpit platform, which is over the total immersion pool. Behind the pulpit a big arched feature with blind triplet within the arch.

PRIMARY SCHOOL. 1856–7 by *R. K. Penson*. Gothic stone group of a large house to the l. (for the schoolmaster, schoolmistress and the curate) and schools to the r. The house has a half-hipped gable to the front and canted bay to the side, the schools' Gothic windows in gables. Originally a fine composition, spoilt by plastic glazing and concrete tiles: there were stone tiles, and a bellcote on the ridge.

In the square by the church, stuccoed WHITE LION HOTEL, early C19. The larger villas are in a row on the slope to the s; ROBERT'S REST, stone, three storeys, originally of 1804, but much altered; BRONDEG, 1852 by *W. W. Jenkins*, twin-gabled, minimal Elizabethan; and ROYSTON COURT, much the best, black, white and red, in an English Domestic Revival way. Gabled half-timbered upper floor with red-tiled roofs and a corner turret. A remodelling of 1906 by *Glendinning Moxham* of Swansea, of a stucco villa of 1864. Fireplace tiles by *William de Morgan*.

ISCOED, 1 m. ENE. A roofless shell now, but one of the impor-
tant Georgian mansions of the county, begun in 1772 for Sir
William Mansel, probably by *Anthony Keck*. Splendidly sited
with views over Carmarthen Bay. The house was not finished
when bought by General Sir Thomas Picton in 1812. He
regretted the purchase and had decided to sell before his death
at Waterloo. It had white marble chimneypieces of the 1830s
so was probably finished then. Big cubic three-storey, five-bay
main block, remarkably in red Bridgwater brick, similar to
Whitson Court, Monmouths. Minimal detail: just a plinth, sill
band, cornice and parapet, though old photographs suggest
stucco window heads. Lower windows in arched recesses, the
door in an added porch. The three-bay sides have low links to
the hipped ends of the long courtyard ranges behind, treated
as pavilions, each with arched recess and attic window
cover. The rear ranges each have a pedimental gable to the
courtyard.

FFAIRFACH
Llandeilo Fawr

6323

The suburb of Llandeilo over the bridge to the s. On the cross-
roads, the TREGYB ARMS, earlier C19 three-bay, three-storey inn,
and CAWDOR FARM, originally Ffairfach, later C18 farmhouse,
with C19 dormers. To s, the chapel (q.v.), and early C20 electric-
ity power station with a brick chimney. On the s edge, CAEGLAS,
1786, three-storey, three-bay house, much altered. To E, TREGYB
SCHOOL, of the 1970s, replaces Tregyb, a large house of the Jones
and Gwynne-Hughes family, remodelled by *David Jenkins c.* 1885
but with a medieval cellar. The heraldic overmantel dated 1657
is now at the Museum of Welsh Life, St Fagans.

TABERNACLE INDEPENDENT CHAPEL. 1860–1, by the *Rev.
Thomas Thomas*. Three-bay stucco Italianate front, taller than
the chapel behind, with giant pilasters, and pediment between
parapets. Palladian centre window and long arched side win-
dows. Inside, gallery of 1860 in long panels with arch-panelled
piers. Pulpit and organ of 1889, with columned arcading.

BETHEL BAPTIST CHAPEL, 3 m. E, down a track by Pontbren
Araeth. Secluded location but, typical of the Baptists, close to
a stream. 1842 long-wall chapel, changed to a gable entry in
the late C19. The old front had two windows and outer doors,
all arched. Late C19 three-sided gallery on fluted iron columns.

TALHARDD. 1 m. SSW, on the w bank of the Cennen. An unpre-
possessing L-plan house burnt in 1997, and repaired, but inside
a late C14 house of high status. Stone pointed arches from the
hall range to the cross-wing, one hollow-moulded. Above, on
five corbels a beam under a reused moulded medieval beam,
possibly from a cross-passage screen. On the rear wall a broad
arch to a recess at the foot of a mural stair, the recess with
pointed arches l. and r. Lateral fireplace on the front wall. The

cross-wing has a c16 s end fireplace. The fire removed a late
c17 or early c18 stair.

EAST LODGE, 1 m. w, *see* Golden Grove.

FARMHOUSES. A good series of large Tywi valley farms. To W,
PENYCOED, prominent on the hill, with long range of white-
washed outbuildings, and LLYS CARIAD (Love Lodge), in the
valley; both late c18 three-storey, three-bay Golden Grove
estate farms. SE, along the Llangadog road: LLYSHENDY, pret-
tily remodelled in the 1860s, for the Dynevor estate, with iron
lattice windows and bargeboarded dormer gables. At PENTRE
PARR, s of the road, a hipped five-bay house, externally mid
c19, with c18 barn. On another outbuilding, a finely carved
plaque of 1730, by *John Arthur* of Cilycwm, with the arms
of Thomas Phillips. Beyond, on the N side, MANORAFON, a
four-sided estate farm court, perhaps the 'complete farm-yard'
advertised in 1807. Lofted W front range with a gable over the
entry arch and a timber lantern, hipped-roofed barn on the E,
cow-sheds N and S, and a hipped building in the centre. The
original house, now called CRYMLYN MANOR, lies s of the
road. Altered, but the centre a late c18 two-storey, three-bay
house with a centre Palladian window, flanked by gabled wings
of the 1840s, with arched lower windows. The entrance is in
the side of the E wing.

FURNACE
Llanelli

Northern suburb of Llanelli, named from the iron industry estab-
lished in the later c18 on Stradey estate land.

THE RABY FURNACE, N of the Stradey Park Hotel. In 1795
Alexander Raby set up a coal-fired forge linked to the coal-
mines by a horse-drawn tramway. Raby's house, The Dell,
has been demolished, but the furnace survives 100 yds (91.4
metres) N of the STRADEY PARK HOTEL, a much-altered
house, Brynarymor, built for Raby's son. It was stuccoed and
castellated in the 1880s for himself by the Llanelli builder, *J.
B. Harries*. The furnace has a large stone tapering tower, linked
to the rock behind by a long stone vault, about 25-ft (7.6-
metre) square at the base. Broad arch to the front and
narrower side arches, brick lining within. Some 130 yds (119
metres) N is the dam that controlled the water power.

BETHLEHEM BAPTIST CHAPEL, Pwll. 1 m. w. 1875. Stone,
gable-fronted chapel with panelled gallery. The panelled pulpit
with Ionic pilasters and panelled arch behind may be of as late
as 1931.

HOREB BAPTIST CHAPEL, Horeb, 2½ m. N. 1868. Gabled stone
chapel with panelled end gallery, and panelled pulpit with
balustrades each side.

ECLIPSE BRICKWORKS, SSE of Horeb Chapel, by the disused
railway. Late c19, the sheds mostly gone but the very large

Hoffmann kiln, *c.* 1907 survives. It is about 130 ft by 40 ft (39.6 metres by 12.2 metres), multiple-chamber, the chambers fired in sequence, for continuous production. The first models were circular, the later ones, as here, rectangular. Arched access to each of the sixteen kilns, which are square internally with low brick vaults. Nearby, a tall CHIMNEY, linked by an underground flue.

GARNANT
Cwmamman

One of the industrial settlements in the upper Amman valley that grew in the late C19, around anthracite mines and tin-plate works. Houses in short terraces along the main road S of the Amman, less development on the N, the church setting still rural. Beyond on both sides are the open hills. On the main road, New Bethel Chapel (q.v.) at the W end and a large red brick WORKMEN'S HALL, 1922, by *Gilbert Davies*.

CHRIST CHURCH, Vicarage Road. Built early in the industrial history of the valley, 1839–42, by *Robert Ebbels* of Wolverhampton, as a subdivision of the large parish of Llandeilo. The vicar of Llandeilo had been curate at Ettingshall, Staffs., where Ebbels built the church in 1835. This was the only 'Commissioners' church' in SW Wales, built with funds from the commission for new churches, to provide places of worship in new industrial areas. Minimal Gothic, roughcast, with grey limestone. Low roofs, broad nave with a front projection for a gallery, and thin bellcote. Short chancel. The interior, refitted in 1888, is a large preaching box with utilitarian roofs. – STAINED GLASS. Faded E window, 1888, by *W. G. Taylor*. Nave N fourth window, 1911, by *Jones & Willis*. Three by *Celtic Studios*: 1957, 1958, and 1972. N of the church, MONUMENT to Mollie Davies, †1940, a dying girl in ATS uniform on the lap of an angel, like Italian cemetery sculpture of fifty years earlier.

VICARAGE, prettily grouped with the church. 1842, minimal Tudor, presumably by *Ebbels* also. Pale brown stone with grey limestone dressings.

BETHEL INDEPENDENT CHAPEL, off Heol Felen, to NW. 1825, an early survivor. Whitewashed stone with Georgian Gothic centre windows and outer gallery lights. Delightful simple interior, one of the best of its date in the region. Stone flags, painted panelled box pews, and gallery with simple wood balustrade. The tall pulpit on a wine-glass stem is an exceptional rarity.

NEW BETHEL INDEPENDENT CHAPEL. 1875, rock-faced stone banded in sandstone. A big arched window of five lights with three circles, long arched side windows, and a triplet of arched doorways. Galleries on three sides. One stained glass window by *Celtic Studios*, 1966.

YSGOL Y BEDOL. By *Meirion Jones* of *Carmarthenshire County Council Architects*, 2000–5. Brick-walled, steel-framed single-storey large school building, with trapezoidal roof.

GLANAMMAN/GLANAMAN
Cwmamman

A compact late C19 industrial settlement in the Amman valley, but the sites of the colliery and tin-plate works barely visible now. In the centre, by Brynseion Chapel, the short HIGH STREET runs back to the foot of the landscaped spoil heap. On the l., later C19 stuccoed INSTITUTE, with florid lettering and pilastered giant arch.

ST MARGARET, N of the river. 1933, by *A. F. Webb*, of Blackwood, Mon. Roughcast with shouldered w gable, a single roof carried down low, and s transept, with bellcote, now lowered. Simple in an Arts and Crafts way, and unexpected in this area. – STAINED GLASS. One window by *Celtic Studios*, 1956.

BETHANIA CALVINISTIC METHODIST CHAPEL, Brynlloi Road. 1906–7, by *Williams* of Swansea (probably *W. W. Williams*). Striking stone and stucco front, between Baroque and Beaux Arts. Pairs of channelled pilasters carry a big open pediment over an elliptical arch to the stuccoed centre. Three cambered-headed windows, but part of a larger Palladian composition, which leaves some curious loose ends. Channelled stucco below, and a big arched door under a splendid open pediment on outsize brackets. Inside, the arched head of the main window proves to have vanished above the ceiling. Curved-cornered galleries with pretty scrolled iron panels, and leafy stencil work in the cove below. Sumptuous end wall, with tall organ recess behind a pulpit with sweeping balustraded steps. – ORGAN by *Conacher*.

BETHESDA BAPTIST CHAPEL. 1882. Stuccoed pedimented front with three large arched windows.

BRYNSEION INDEPENDENT CHAPEL. 1909–10, by *Henry Herbert*. The centre of the settlement, and a chapel of real presence, closed 2004. Brown rock-faced local stone with grey sandstone, with a conventional later C19 winged façade, but Gothic in detail. Traceried main window, battlements to the wings, and little corner spires on pedestals. Very good interior, typical of expensive chapels of the date, galleried all around. The woodwork, sometimes Gothic, displays contrasts of wood tones: pitch-pine in the larger panels contrasted with hardwood small panels. The front pews curve to follow the line of the great seat, and the pulpit backs onto the organ, in a monumental pointed arch. – ORGAN by *Norman & Beard*, 1911. Deep-coved and ribbed ceiling, with plaster roses.

TABERNACLE CALVINISTIC METHODIST CHAPEL, Tabernacle Road. N of the river. 1840, small stucco lateral façade, with modern windows.

GOLDEN GROVE/GELLI AUR 5820
3 m. SW of Llandeilo

The name of the parish is Llanfihangel Aberbythych. The modern
name comes from the surrounding estate.

ST MICHAEL. 1849, by *George Gilbert Scott*, for the first Earl
Cawdor, who as at Stackpole, Pembs., employed Scott for the
church by the family seat, and other architects elsewhere. The
medieval church was down by the Tywi, replaced up here in
1616. Scott's church is relatively small with an unusual amount
of timber, but effortlessly superior to what was being designed
locally. Attractive colours: red and brown sandstone with grey
limestone. Nave, chancel, N porch, N transept and vestry. Oak
N porch and louvred timber bell-turret with steep slate pyramid
roof. Dec windows. The interior suffers from a gloomy cement
render. Wagon roofs, open in the nave, boarded in the chancel,
and a moulded arch between, on stone brackets. The bellcote
is on braced tie-beams, on wall-posts, and a timber arch frames
the N transept (organ chamber). In the chancel, good encaus-
tic TILES with the Cawdor arms, probably by *Minton*. – Octag-
onal FONT, by Scott. – FURNISHINGS, almost all by *Scott:* oak
pulpit with trefoiled panels on a stone base, oak pews, and altar
rails with open quatrefoils in a trellis pattern. – Painted metal
COMMANDMENT BOARDS. – Oak ALTAR and REREDOS,
c. 1920. – STAINED GLASS. E window, 1928, by *F. C. Eden*; gri-
saille glass elsewhere, 1849, by Powell. – MONUMENTS. R. and
S. Vaughan, 1811, by *J. Bacon Jun.*, grieving woman in an
arched frame. No memorial to the Duchess of Bolton †1751,
the only duchess buried in Wales. By the porch, an eccentric
spired MONUMENT topped with a hand pointing heavenward.
 Simple rendered LYCHGATE, with a tunnel-like entry, prob-
ably early C19.

GOLDEN GROVE. The seat of the Vaughans from *c.* 1560 to 1804,
and then the centre of the Cawdors' Carmarthenshire estate.
The house had thirty hearths in 1670, with Aberglasney the
largest in the county. It burnt in 1729, and was rebuilt in
1755–7 as a plain seven-bay house with dormers. John Vaughan,
who inherited in 1780, commissioned designs for a new house
and stables from *John Johnson*, but cancelled the project at a
late stage. He bought marble chimneypieces from *King* of
Bath, and dallied with minor projects, employing *Robert Adam*
in 1785 and *Nash* in 1788 to make plans for bath-houses, not
built. When he died in 1804, he left the estate in poor repair
to his friend, Lord Cawdor of Stackpole Court, Pembs.
Cawdor then employed *William Jernegan* of Swansea to put
things in order, though his work has gone. He repaired the
house, built a small stable block, and a home farm by the Tywi.
 The low-lying site had been criticized by visitors, and the
second Earl decided to build anew in 1826–34 on the hillside
to the SW. His architect was *Jeffrey Wyatville*, then working at
Windsor Castle, with *Henry Ashton* supervising. The new house
is Elizabethan, with crowstepped gables, perhaps a nod to

Scotland. It is indeed similar to Wyatville's Lillieshall, Salop,
built for the Duke of Sutherland, to whom Cawdor was related.
The house was bought by the County Council in 1952 as an
Agricultural Institute, but has recently been sold, possibly for
conversion to a hotel. The grounds are a country park.

Though not large, being a secondary seat to Stackpole, the
house is impressive when seen as intended from the disused
front drive. The present access from the village, past the service
ranges, gives a very mundane impression. Close to, the detail
is mechanical though finely worked in grey Llangyndeyrn
64 limestone. Mullion-and-transom windows. Symmetrical three-
bay entrance front, with twin crowstepped gables and big bat-
tlemented porte cochère. The junction with the service range
is marked by a tower with steep cross-gables, one with a shafted
chimney. The N garden front set on a steep terrace is symmet-
rical too, with central canted bay window, uncomfortably
extending up between the outer gables to a third storey. Service
court to the w, plain to the point of harshness, but still expen-
sively built of limestone, the s façade canted in two narrowing
stages to meet the house. The steep drop behind precluded it
being set back more deferentially. Near the junction, a splen-
didly large bridge-like double chimney with shafted flues. w
again, a large stable courtyard, the pavilion-like corner turrets
cross-gabled, to echo the main tower.

Conventional interior, centred on a rectangular top-lit hall,
with Jacobean staircase. Ribbed Jacobean style ceilings to the
main ground-floor rooms, by *Ellison* of York. The fitting up was
by *Armstrong & Siddon*. The secondary stair is c18, with turned
balusters, reused from the old house.

Extensive GARDENS were laid out in the 1860s by *Mr Hill*,
Cawdor's gardener. To the s is a formal terraced garden, the
grassed terraces following the curve of the drive. Up the slope
is a pinetum, fernery and small hexagonal summer-house.

The village, though pretty, has too few buildings to make a
coherent impact. Next to the church, the former SCHOOL,
1848 by *Henry Ashton*. Tudor-style, rubble, with grey lime-
stone. Off-centre gabled master's house, and a big schoolroom
on the l., with heavy hammerbeam roof. Across the road, a
little DRINKING FOUNTAIN, 1872, in a stone niche. APRIL
COTTAGE, *c.* 1840, by *Wyatville*, is a Tudor single-storey
almshouse range, to the same plan as the Widows' Cottages at
Stackpole. Five bays, bay-windowed and gabled each end,
centre porch, latticed windows and shafted flues. AWELAUR
was the vicarage, 1878–9, by *Ewan Christian*. No particular
style: generous mullion-and-transom windows, and big brick
chimneys. At the entrance to Golden Grove, single-storey
WEST LODGE, of stock bricks, with bargeboarded gable and
a veranda, now glazed in.

NORTH LODGE. Deftly designed single-storey lodge, *c.* 1870,
pink and brown sandstone, with steep sprocketed roofs.

EAST LODGE, 1½ m. E. Similar to the North Lodge, *c.* 1870,
sandstone, with a gable jettied on timber posts. Both lodges

show a softening from the High Victorian Gothic, suggestive
of the work of George Devey in the 1860s.

COLLEGE FARM, ½ m. N. The former home farm, now part of
the agricultural college, with extensive modern buildings. The
farm first built by *William Jernegan*, after 1804, for Lord
Cawdor was replaced with large mid-C19 limestone buildings
and a later C19 farmhouse.

GORSLAS
3 m. SW of Llandybie

5714

Village on the fringe of industrial Carmarthenshire. Coal was
being mined here from the C17. Cross Hands, 1 m. SW, is late C19
to early C20 and Cefneithin 1 m. W also later.

ST LLEIAN. Nave of 1866 by *E. M. Goodwin*, and chancel of
1879, by *David Jenkins*. Red sandstone with grey limestone;
lancets, W bellcote and N porch. – STAINED GLASS. By *Celtic
Studios*, the W window, *c*. 1960, and nave NW, 1978. Some glass
of the 1930s by *Shrigley & Hunt*.

TABERNACLE CONGREGATIONAL CHAPEL, Cefneithin, 1 m.
W. 1870. Rock-faced stone with a giant arch and arched
windows. Gallery with bands of pierced cast iron over long
panels, on fluted Corinthian columns. Later organ recess
behind the pulpit.

CROSS HANDS PUBLIC HALL, Cross Hands. Working-men's
hall of *c*. 1930. Stuccoed, in stripped and squared Parisian Art
Deco style, the motifs suggestive of early films. Appropriately
it has been restored as a cinema.

GWYNFE

7323

A small hamlet on the ridge between the Tywi and the Black
Mountain. The church of 1899 is behind its much more humble
predecessor of 1812.

ALL SAINTS. 1898–9 by *E. H. Bruton*. An elaborate if ham-fisted
essay in free late Gothic, unexpected in so remote a setting.
Strident red rock-faced stone with grey limestone. Nave and
chancel in one, with substantial but squat porch tower, stark
gargoyles and crude bell-lights. Broad interior with roof open
over the nave and boarded to the chancel, a single truss to mark
the division. On the E wall, GLAZED TILES in an unexpected
palette of pale brown, pale blue and yellow, with floral motifs
and symbols in Gothic panels. – PULPIT, by *W. Clarke*, Caen
stone with panels of alarming flesh-pink alabaster. – STAINED
GLASS. E window, 1899, by *R. J. Newbery*, densely drawn with
subdued colours. – MONUMENT. Rev. Lewis Lewis †1826, with
urn, by *P. Rogers* of Swansea.
 In the churchyard, CHURCH HALL, the church of 1812, a
little three-bay building with centre porch and rebuilt bellcote.

In 1871 there was an altar-table with 'two drawers full of black lead, dusters and sardine boxes', a screen of two flat wooden arches and a 'pretentious' wine-glass pulpit.

JERUSALEM INDEPENDENT CHAPEL. ½ m. SE. An attractive row: the chapel of well-dressed rock-faced grey stone, dated 1827, flanked by whitewashed stable, schoolroom and vestry. Lateral façade with an even rhythm of four arched windows. Inside, the gallery front has arched panels with cusping like tear drops (cf. Heol Awst, Carmarthen). Panelled box pews and matching great seat. Late C19 pulpit.

CAPEL Y MAEN INDEPENDENT CHAPEL. 1 m. E. 1864. Red sandstone, with a Palladian window in yellow brick and grey limestone. Charming narrow interior with gallery, pews and pulpit, all grained in a startling pale yellow.

HENDY
Llanedi

Settlement across the Loughor from Pontardulais, Glamorgan, begun by the bridge-head on the old main road to Swansea, but expanded by later C19 industry. Of the early C19, the RED LION INN, a posting inn from the C18, and NEUADD FACH, a hipped villa with veranda, E of the church. The population rose from fifty to 1,600 in just four years, 1867–71.

ST DAVID, Iscoed Road. 1980, by *John Davies* of Swansea, replacing a church of 1902–4 by *W. Griffiths* of Llanelli. Pale brick with roof carried low over the feet of concrete A-frames, and a big glazed gabled side entry. – FONT. Red sandstone, octagonal, probably medieval, of uncertain provenance. – STAINED GLASS. Impressive Crucifixion over the door, one of the best late C20 pieces in the region, by *Timothy Lewis*, with swirling Michelangelesque figure, *c.* 1980. Opposite, Baptism, a composition in red and blues, also by Lewis.

CALFARIA BAPTIST CHAPEL. 1889, two-storey front with arched windows.

CAPEL NEWYDD (Independent). 1900, by *D. L. Jones* of Llanelli, stuccoed with centre arch. Paired doors under a cornice.

LIBANUS CALVINISTIC METHODIST CHAPEL, Sawel Road. 1868 and 1880. Rock-faced stone and stucco with two centre arched doors, a triplet above with pilaster mullions, and corbelling under the pedimental gable.

YR HEN GAPEL, 1 m. W, on high ground W of the M4. An early Independent chapel founded 1712 by David Penry of Plas Mawr, Llanedi. Set in a church-like walled burial ground with stone lychgate, the lateral-fronted chapel has a church-like bellcote. Remodelled *c.* 1900, to a gable entry plan.

YSTUM ENLLI, ¼ m. S. At the neck of the big loop of the Loughor are two very different medieval defensive works, only 100 m. apart. They are unlikely to be contemporary. On the E is a roughly rectangular MOATED ENCLOSURE, with a now

slight outer bank, then a ditch, the earth thrown up to make a platform. The other, to the SW, is a regular Norman MOTTE. They probably defended a lost bridge or ford on the key route into Gower.

RAILWAY VIADUCT, Morlais Junction East. 1913. An impressive eleven-arch brick railway bridge over the Loughor. Prosaically, the line was built, bypassing Swansea, to bring Ammanford coal to the main line near Neath, but romantically to cut minutes off the new New York to London route, via Fishguard, that Cunard tried from 1909–14.

HENLLAN AMGOED
3541

ST DAVID. Isolated small church. Nave, chancel and s porch, mostly rebuilt in 1866 by *Thomas David* of Laugharne, who added the bellcote and vestry. Lancets, a pair to w with a little roundel above. Moulded chancel arch on corbels. – FONT. Square bowl, much reduced. – Bath stone PULPIT, 1866.

HENLLAN AMGOED INDEPENDENT CHAPEL, ½ m. SW. Remotely sited but one of the most ancient and influential Independent causes in the region, founded 1697. Now a large, box-like, hipped chapel of 1830, oddly reworked in 1927 by *J. H. Morgan*, with dour exterior detail. Square windows above sentry-box porches. The four-bay original façade is on the s, with arched windows. Outside steps to the gallery, an unusual survival. Inside, the 1830 gallery remains on two sides, the fielded panels with scalloped corners. Fanlight over the inner gallery door with sinuous glazing bars. Morgan re-orientated the interior through ninety degrees and partitioned off the area beneath the gallery to form a vestry. The result did not find favour. New pulpit, the large pedimented pulpit-back with scrolls and balls, as at Sion, St Clears, and a recess for the minister.

CLYN, just s of the chapel. A rare surviving earth-walled cottage, the front walls buttressed. Corrugated iron roof over thatch. Probably early C19.

PARCIAU INSCRIBED STONE, ¾ m. SW. (SN 177 198) C6 stone in a field, inscribed QVENVENDAN– FILI BARCVN–.

KIDWELLY/CYDWELI
4106

Kidwelly Castle stands memorably on a low bluff on the N bank of the Gwendraeth Fach, with the soaring spire of the parish church on the other side. The town grew with the castle, the castle site chosen like so many for accessibility from the sea. The tiny medieval town outside the castle gate is still defined by the town gate. It was peopled by Normans, English and Flemings. The commercial success of the town led to its expansion across the river, close to the priory, and this led to a decline of the original settlement, so that by 1401 it was described as 'des-

olate'. Kidwelly was a significant port in medieval times, with quays close to the town bridge, exporting wool. Trade declined with the silting of the estuary in the C16, revived in the later C17 with trade in cloth and coal from the Gwendraeth Fawr valley to the E. Coal increased in importance in the C18, and one of the earliest Welsh tin-plate mills was established N of the town in 1737. The later C18 was a prosperous period. The storehouses and quays along the river have mostly gone, but the terminus of the coal canal of 1765–8 remains at Kidwelly Quay (*see* below). Trade declined with silting again, and the opening of a branch of the canal to a new harbour at Burry Port in 1836. Tin-plate manu-facture continued, but Llanelli soon overtook Kidwelly as the main centre.

KIDWELLY CASTLE
by John Kenyon

25 On a scarp above the upper tidal limit of the Gwendraeth, Kidwelly Castle is one of the most imposing ruins to be seen in Britain, especially when viewed at a distance from the E. Most of the walls stand to their full height, and floors and roofs still survive where stone vaulted; it looks almost habitable, were some floors, doors and windows to be added. What we see today is largely the product of two building periods: the second half of the C13 and from *c.* 1388 to 1422.

The first castle was a crescent- or D-shaped ringwork of earth and timber, the line of the rampart dictating the position of the later outer curtain wall. It was built for Roger, Bishop of Salisbury (1102–39) who had been entrusted with the Welsh commote of Cydweli by Henry I in 1106. The first mention is in the foundation charter of the small Benedictine priory of Kid-welly, dated between 1107 and 1114, which was issued from the hall of the castle. Apart from the remains of the outer bank, no trace remains of Bishop Roger's castle, so it is not known whether it included masonry buildings. A reused piece of Romanesque stonework (now missing) was found when the castle was being conserved. In view of what Bishop Roger achieved at his castles in England, such as Sherborne Old Castle, Dorset, it would not be surprising, even in this frontier area, for his castle to have had some fine stone buildings, such as a hall.

Maurice de Londres, Lord of Ogmore in Glamorgan, appears to have held Kidwelly by the late 1130s, the castle being held by the family until 1216, although there were periods when Kidwelly was in Welsh hands, following its capture. It is possible that the earliest existing section of masonry, in the outer curtain wall, may date to when the Lord Rhys held Kidwelly, in the 1160s, although the wall may well date to the early C13 when the castle was back in English hands (cf. Laugharne and Llansteffan, qq.v.). The castle passed to the de Chaworth family, when the heiress Hawise †1274 took as her third husband Patrick de Chaworth. He fell fighting the Welsh in 1258. There were two sons, Payn †1279 and

Patrick †1283. Payn accompanied the future Edward I on crusade and was one of his commanders in the 1277 war against Llywelyn the Last. Payn and his brother were thus more than qualified to begin the transformation of the castle, possibly assisted by loans from the king.

The first Chaworth phase was the construction of the square inner ward, squeezed somewhat awkwardly within the enclosure. Its two entrances are simply gateways in the N and S walls. These relatively unsophisticated gates (for a late C13 castle) are flanked by four great circular towers, with arrowslits of varying designs, the SE tower originally taller than the other three. Around the same time attention turned to the simple curtain wall built in the late C12 or early C13, which was now the outer ward's defence. Part of the central section of the curtain was retained, but the remainder was rebuilt, with four D-shaped mural towers, the N gatehouse, and possibly the original S gate. The surviving walling of this phase runs from the tower closest to the great gatehouse to the N gate and the collapsed tower adjacent to it, meeting the inner ward's NE tower. The backs of the mural towers were added slightly later, but as the towers had fireplaces, it would seem that the rear walls were originally timber-framed.

This phase made Kidwelly a concentric castle, like Caerphilly and Beaumaris, with a tall inner curtain wall towering above a lower outer curtain. Of the internal buildings we know little, the existing hall and chapel being built slightly later. However, by 1283 the castle was fit for the king to stay for several days, as well as to serve as a storehouse for the king's money on its way to Carmarthen. At the same time the defences of the small borough adjacent to the castle were rebuilt in stone, with the town S gate completed about 1300.

On the death of Patrick de Chaworth in 1283 the king granted Kidwelly to his uncle William de Valence, Earl of Pembroke (1247–96) to offset a debt of over £1,000. On the Earl's death the lordship reverted to the de Chaworth heiress, Matilda, whom Edward had granted in marriage to his nephew Henry, Earl of Lancaster †1345, the ceremony taking place in 1298. It was probably William, having built for himself a range of buildings at Pembroke Castle and transformed Goodrich Castle, Herefs., who continued the works at Kidwelly, although no documentary evidence survives from before it passed to John of Gaunt, Duke of Lancaster, in 1362. In the late C13 a new hall with solar was built along the E side of the inner ward, and a new kitchen on the W, opposite. Around the same time, a chapel was built in a tower that projected down the scarp below the SE tower, there being no room elsewhere in the castle to build such an impressive building. At the same time, the tops of the outer ward towers and curtain walls between them were raised and the towers enclosed with stone walls at the rear; in order to maintain their position in overlooking the outer defences, the NE and the two W towers of the inner ward were heightened.

The chief role of the castle as part of the Duchy of Lancaster, of which it remained a part until the early C17, was as a centre

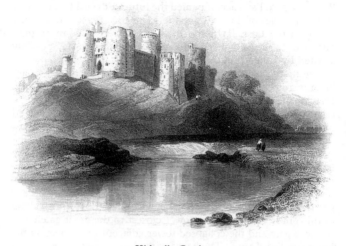

Kidwelly Castle.
Engraving, C19

of administration of the Duchy estates. There are frequent records in the C15, for example, of the castle being placed in preparedness for the visit of the auditors and other Duchy officials. It was in John of Gaunt's closing years that the decision to build the existing great S gate was taken, presumably replacing an earlier gate in the C13 outer defences. A quarry was acquired in 1388–9 'for the work of the new tower' and a detailed account book survives for 1402, so that on the eve of the siege of the town and castle in 1403 by the supporters of Owain Glyndwr the gatehouse must have been almost finished, as it was being fitted out with locks and chains for its prisons. Although the town fell in 1403, the castle held out.

Apart from routine repairs, little was done until 1408 when it was decided to improve the access and accommodation in the new gatehouse, the considerable sum of £500 being expended by 1422. This covered the construction of a stair-tower in the NW corner of the gate, linking the floors in a more convenient way than the original central stairs, and alterations between 1408 and 1415 following a fire, which led to the rebuilding of several rooms with stone vaults, including a new kitchen, the rebuilding of the N wall of the upper storey, and a new roof over the gate. Also almost all the windows were enlarged, making the gatehouse, also known as the 'constablery', a fitting residence for the constable of a royal castle for, on the accession of Henry Bolingbroke as Henry IV in 1399, the castle had become part of the royal estates.

Two large buildings in the outer ward are probably C15; their function is uncertain, but the one to the W of the inner ward may have been the court house, and that by the N gate the great stable, two buildings frequently referred to in C15 accounts.

In 1630 the Vaughans of Golden Grove acquired the castle, by then dilapidated, and by descent it passed to the Earls Cawdor,

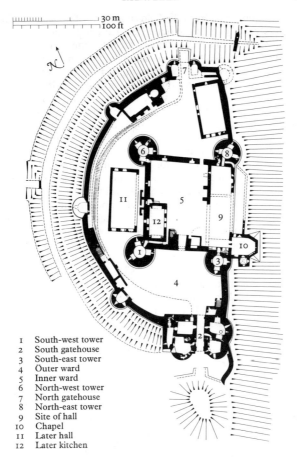

1 South-west tower
2 South gatehouse
3 South-east tower
4 Outer ward
5 Inner ward
6 North-west tower
7 North gatehouse
8 North-east tower
9 Site of hall
10 Chapel
11 Later hall
12 Later kitchen

Kidwelly Castle.
Plan

who undertook some repairs in the middle of the C19. The castle
and town gate passed into state care in 1927, and both are now
maintained by Cadw.

The Exterior from the South and West

The castle can be approached from Castle Street, via the S gate
of the medieval borough, or Castle Road, at the entrance to
which would have stood another town gate. A footpath from
near the later medieval bridge that links the two parts of
Kidwelly runs along the river and also leads to the great S
gatehouse of the castle, and continues on below the E side,
providing an impressive view up to the ruins, dominated by
the gatehouse, the Chapel Tower and the two E towers of the
inner ward. The best view of the outer curtain and its mural

25 towers is obtained from the field to the NW of the castle, which
originally was part of the outer defences, and later housed two
rabbit warrens, a source of fresh meat for the castle.

The GREAT GATEHOUSE has a mound in front of it, on
which a tower is said to have stood, and to the r. a BARBICAN
wall runs from the gate towards the mound, built in the mid
C15. The gatehouse consists of five levels: basement, ground
floor, two floors above that, and then the battlements. Round
towers flank the entrance, but the building lacks the
symmetry of most gatehouses, with a curved projecting wall
on the E side and to the W a tall rectangular chamber block.
The small putlog holes for scaffolding are a conspicuous
feature. Most of the windows, cusped and set below hood-
moulds, were improvements of the early C15, but the one that
lights the first-floor drawbridge chamber immediately above
the entrance is narrower than the original opening. The arched
doorway of the entrance itself is set in a rectangular recess into
which the drawbridge would have rested when raised. Cover-
ing the entrance at battlement level is a set of machicolations
or murder holes from which missiles could be dropped, and
the battlements themselves are set, as elsewhere in the castle,
on a corbel table, which allowed the masons to build a wider
wall-walk than would otherwise have been possible.

The outer CURTAIN WALLS that run W from the gatehouse
to the first tower, then N to the SE tower of the inner ward were
built at the same time as the gatehouse, replacing stretches of
the C13 curtain. Three TOWERS are visible from the W,
although the middle one, opposite the N wall of the town
defences, has largely collapsed. Arrowslits in the curtain close
to the first tower represent a narrow mural passage. At the N
end of the castle are the remains of the small twin-towered N
GATE built in the later C13. The battlements of the towers and
curtain from the first tower to the N gate represent the height-
ening undertaken towards the end of the C13.

The river walk below the E walls of the castle affords the
best view of the CHAPEL TOWER, with the small abutting
SACRISTY on its S side. The large spur buttresses that help
support the tower, built as it was down a steep scarp, are a
feature to be found in several castles in Wales and the Marches
c. 1300.

Within the Castle Walls

27 THE GATEHOUSE is one of the largest of its kind, with over twenty
rooms. It was a fortress, administrative office and fine residence
all in one. The vaulted entrance passage was defended by a
double-leaf door at each end, two portcullises and murder
holes. Three doors on each side of the passage gave access to
basements and ground-floor chambers, the furthest on the r.
leading to what was once thought of as a prison. This room
is now interpreted as a household official's office, such as for a
receiver or cofferer, with the pit set into the room built as a safe

or strongroom to hold valuables.* Except for the receiver's office, all the rooms on the ground floor could be secured on the inside. The main chamber with its fireplace and latrine, probably the porter's lodge, lay on the W, accessed through the first door; the larger chambers on each floor are all on the W side. The original staircase that ran up the middle of the gatehouse was reached from this room, but was blocked in the C15, and the other chamber on this side could also be entered from the lodge, as could the stair-turret added in the early C15. There is evidence for timber shuttering in the vaulted ceiling of the main chamber on the E side, where timber planking had been secured against the original wet plaster while it dried.

The main entrance to the rooms above is via the external flight of steps on the NE side of the gatehouse, over an inner porter's lodge, the stone staircase possibly having replaced an earlier one of timber during the reconstruction of the gatehouse after 1408. The stairs open into what would have been a SCREENS PASSAGE that divided the KITCHEN to the E from the constable's HALL to the W, which runs across most of the width of the rear of the gatehouse. The kitchen was altered in the second phase of the gate, with an oven replacing the first fireplace and the new fireplace built adjacent, lacking most of its hood; there is also a cupboard. A single window lights the kitchen, below which is a drain. Access to the outer curtain and on to the SW TOWER of the inner ward can be gained through a narrow door in the kitchen, seemingly part of the post-1408 reordering of the gatehouse.

The hall contains a fireplace and two windows, and in the easterly window is located the groove for the inner portcullis, which would imply that the portcullis, if fitted, would have been kept lowered. A murder hole is also evident in the floor. A row of stone corbels mark the line of the floor above, the private chamber or SOLAR of the constable with its fireplace and lamp brackets, to the E of which is a small BEDCHAMBER with its own latrine, window and fireplace. The second-floor apartments were entered from the central staircase situated in the short passage that runs between the hall and the chambers at the front of the gatehouse; there is a handsome ogee-headed door at the top of the stairs.

Doors lead off from either end of the hall to the first-floor CHAMBERS, the westerly of which is a later feature; the blocking of the original door is apparent. Between the E and W chambers are two small rooms, one above the other, and over the entrance passage. These rooms would have housed the mechanisms for the raising and lowering of the drawbridge and the outer portcullis, and that on the first floor has a murder hole set in the floor. The first- and second-floor chambers on the W side were well lit and heated; access to latrines was through the small adjacent rectangular chambers. It was through this rectangular block that the main outer curtain wall was reached from the gatehouse.

*John Kenyon is indebted to Peter Brears for the re-interpretation of this room.

The OUTER WARD is a D-shaped enclosure, surrounding the square inner ward. The mural towers along the outer curtain are all of a similar design, and the internal arrangements are best seen in the first TOWER, to the W of the gatehouse. It has a first-floor fireplace, adjacent to which is a latrine, which projected out from the tower wall, supported on corbels. Between the latrine and the back of the tower is a blocked door that originally gave access to a short mural passage equipped with arrowslits. Between this tower and the steps that led to the battlements there is a late medieval LODGING with fireplace and two chambers. Lying between the inner ward and the second TOWER stands a rectangular building, possibly the COURT HOUSE mentioned in the C15 or a STABLE. Only the gable-ends survive to any extent, and the foundations of a latrine block are squeezed in between this building and the inner curtain.

The lower third of the curtain between the second and third TOWERS is the earliest masonry to be found in the castle, part of the curtain wall of the late C12 or early C13. Beyond the third tower is the late medieval BAKEHOUSE that abuts the curtain wall; the bakehouse has two large ovens, one of which still has its domed roof. Beyond lies the remains of the N GATE, which may have had a timber-framed inner wall. Through the gate passage can be seen the earthworks of the N ward, or BAILEY, at the end of which lies the scrub-covered bank and ditch raised and dug soon after the 1403 siege to cut off the extreme N end of the original C12 enclosure. At the extreme NE corner, beyond the N gate, lies the fourth TOWER, now collapsed, the remains blocked from view by a later wall.

Between the N gate and the inner ward lies another late medieval rectangular building, of unknown purpose, but perhaps a second stable, on the ground floor, with accommodation and storage above. The gable-ends contain windows at first-floor level, with seats.

Apart from being a strong fortress in its own right, the INNER WARD contained the lord's domestic accommodation, chapel and kitchen, and certainly by the C15 a garden. The four great towers flank both entrances, the southern of which was extended and raised in the late C13; both gates had portcullises. The blocked openings that are particularly visible near the tops of the westerly towers represent the original battlements as built by the de Chaworth family; they were infilled and new battlements built in the late C13 to improve the view over the newly heightened outer curtain wall. The best section of curtain wall lies on the N side, with room for crossbowmen (not longbows) to fire through the gaps in the crenellations as well as slits in the merlons. The strongest tower in terms of potential firepower is that at the NW corner, with a range of arrowslits at all levels, of varying designs.

The upper rooms and roof of the SW TOWER are accessible, being stone vaulted. The first and third floors have fireplaces, with a latrine on the second floor that would have opened into a pit in the outer ward. The stair continues to the roof, at the

top of which stood a turret for a sentry, with its own flight of steps; the equivalent turret in the NW tower is an even finer example. From the roof top a good view is obtained of the N section of the TOWN WALL to the W; the wall runs to the outer edge of the castle ditch; there is no evidence for it having continued across the ditch to the second tower, even though the gap would have made it easier for an enemy to gain access to the town.

The flooring of the other three towers no longer remains, although differences in the provision and quality of the accommodation is readily apparent. The basement of the NW TOWER may have been a prison, and the first-floor entrance to the tower itself may have been through a small forebuilding, the foundations for which survive against the N and W curtain walls. The NE TOWER, which still has the sockets below the battlements for a timber hourd or projecting gallery, adjoined the lord's SOLAR, and had chambers on the second and third floors with fireplaces; there was also a latrine. A short passage may have led to a mural passage in the original de Chaworth curtain wall, before the late C13 HALL was built; later it opened into what may have been a roofed timber gallery outside and abutting the hall, leading to the CHAPEL TOWER.

The SE TOWER is the best appointed, with fireplaces on all the upper floors, and clearly was designed originally as the main residential tower. Above the basement door three doorways provided access to various parts of the tower: that on the r. to the chamber on the first floor; the middle door to the staircase to the upper levels; the l. door led to the chapel. There are two recesses of unknown purpose by this tower, one with a bench, and between them and the S gate is the site of the small room described in 1442–3 as the 'little kitchen at the door of the king's hall'.

The late C13 HALL range, which at basement level utilizes the de Chaworth outer curtain wall, survives least well of all the main buildings. The height of the hall roof is evident from the outline of the gable that abutted the SE tower. The main feature that remains is the SOLAR at the N end, with its lancet window and fireplace. The foundations of the stairs up to the hall, which lay on the first floor, lie at the southern end. The basement, lit by windows facing the inner ward, contained storerooms and a C14–C15 malt kiln, while the remains of a circular pillar may denote support for a central fireplace for the hall above. The buttresses that support the hall on the inner ward side were added in 1442–3.

The CHAPEL TOWER is one of the finest features of the castle, and dates to the end of the C13, presumably replacing an earlier chapel. Access to the chapel could be gained from the SE tower, as well as from the timber gallery that linked it to the NE tower, mentioned above. The tower consists of a basement and ground floor, with the chapel itself on the upper floor lit by two tiers of trefoil lancet windows, and finely dressed with white Sutton stone. Between the clerestory (upper)

windows are the corbels that would have supported the roof timbers. In the s wall, to the r. of the site of the altar, there is a double piscina and a wide sedile. There is no trace of wall painting, so the chapel seems to have been simply white-washed, although colour may have come from stained glass. The ground floor, now entered through what was originally a window, contained the priest's room, and was later used to accommodate the Duchy of Lancaster's auditor on his visits. The small building on the s side, with its roof intact, housed the SACRISTY on the upper floor, with an equally small ground-floor room below, with access to a latrine adjacent. It is known that the sacristy housed altar frontals, chalices, vestments, a bell and candelabra in the C15.

Opposite the hall, in the sw corner of the inner ward, lies the late C13 KITCHEN, with a fireplace in each of the gable walls, an oven and various cupboards; a link was later made through the curtain wall to the rectangular building in the outer ward, the possible court house or stable. Abutting the kitchen on the n side lies a small roofed latrine.

The C15 accounts mention a number of other buildings in the castle, which have either disappeared or were situated in some of the extant buildings. These include a wine cellar, buttery, pantry, granary and hay house. The castle also had a well and a fountain.*

THE TOWN WALLS AND TOWN GATE. The original town was defended by rampart and palisade until the late C13, when the stone wall and three gatehouses were built. Streets and prop-erty boundaries mark the line of both the defences and the burgage plots. On the n side of the town lies a short stretch of town wall, running w from the edge of the castle ditch; here the ditch that fronted the town defences is most evident.

To the s lies the surviving TOWN GATE, of *c.* 1300, with part of the town wall to its E. The gatehouse, seriously damaged in 1403, is rectangular in plan, with chamfered, spur buttressed towers on either side of the entrance. At least one set of doors and a portcullis defended the gate passage, although the portcullis was blocked later in the C15 during refurbishment of the gate. It is impossible to ascertain from the ruinous interior whether there was an inner set of doors and a portcullis. The gate had a ground floor and two upper floors, the uppermost linked to the town wall by a door in the NW corner.

29 ST MARY. The exceptionally tall tower and spire and quality of the interior detail make this the best medieval church of the county. Probably the site of a Celtic *clas*, Kidwelly Priory was founded *c.* 1110 by Roger, Bishop of Salisbury, as a cell of the Benedictine abbey at Sherborne. The priory history is unevent-ful and obscure. John Pecham, Archbishop of Canterbury,

* Recent work on the fabric and the documentary history has led to major reap-praisal (*see* the current guidebook, 2002). The study of the castle's later medieval documentation, especially of the Duchy of Lancaster period, owes much to the research of Stephen Priestley, funded by Cadw.

Kidwelly Town Gate.
Engraving, after drawing of 1771

found affairs in 1284 far from satisfactory, and sent the prior, Ralph de Bemenster, back to Sherborne in disgrace 'because of his manifest faults'. The 1291 *Taxatio* indicates that it was not well endowed; there seems never to have been more than a prior and one or two monks. The lordship of Kidwelly was particularly unstable before the conquest of 1277. Payn and Patrick de Chaworth both died early, in 1279 and 1283, but it is likely that some building dates from their time, the main work probably dating from the Lancaster lordship after 1298. Decline followed the Black Death and the plagues of 1361 and 1369; there was one monk resident in 1377. However the tower and spire must post-date the body of the church, suggesting a major building campaign around 1400. The tower and spire were built by 1481 when the church was struck by lightning, which probably caused the demolition of the w end of the nave, and the rebuilding of the spire. In the early C16 the priory was 'much bound in debt' and 'suffering from great and manifest decay'. It was dissolved in 1539. Although the church continued in parish use, little repair was done, with dilapidations recorded through the C17, including damage from lightning in 1658. With Early Georgian prosperity came repairs, in 1713–15, 1725 and 1767. There was lightning damage again in 1854 and 1884, the latter prompting the major restoration, 1885–9, by *Middleton & Prothero*. There had been repairs including new nave windows in 1873. Nothing survives of the priory buildings.

The church is cruciform, with the tower over the N porch, a large S porch, and NE chapel, now vestry. The porches would originally have been halfway down the nave before the nave was shortened. It is clear from the interior that a major

C12–C13 building project, probably with a crossing tower, was abandoned, and most of the detail is C14, Dec. The tower may be later C14 to early C15, with the spire, S porch and NE chapel, now vestry, perhaps similar in date, possibly slightly later.

The tall but severely plain five-stage tower is on a scale quite unlike any other in the county. Battlements, long gone, are shown in Dineley's late C17 view. The masonry is relatively crude, with a tall splayed base, disguised by the massive angle buttresses that reach right up to the top. These may be added after 1481, as there is a change in the stonework, with more red sandstone higher up, but there are no clear joints. The stair-tower, capped with a tiny stone broach-spire is clasped rather clumsily by the SW buttresses. Double-chamfered N door, small lancets and plain pointed double bell-lights. Good quadripar-tite groined vault within (like that at St Mary, Pembroke). The double wave-moulded inner doorway looks earlier C14, and was presumably the original external N door. The broached spire is immensely impressive, particularly from afar, but the junction to the tower, with or without battlements, appears crude. It is of Bath stone, much rebuilt in the late C19.

The ragged ends of the lost W bays of the nave remain; the new W wall has a rather crude late C15 panel-traceried window, copied in the C19. The sides have added buttresses of uncer-tain date and cusped tracery of 1873. The N transept has blocked side windows and a C14 pointed surround to the N window. The S transept has a C19 S window, traces of a C14 E window and a C16 flat-headed W window. The chancel S wall has one C19 window and two remarkable Dec windows: a small two-light with ogee tracery and a big three-light with three mouchettes in the head, the best of what little Dec tracery sur-vives in the county. Dec also the blocked N chancel windows, and the moulded surround of the E window, with tracery of 1885–9. Truncated polygonal rood stair in the angle to the S transept. Large S porch, with wide entry, the arch and roof rebuilt in 1712. C14 STOUP, with ogee head and big bowl, and S door, like the N door, moulded with two deep hollows and broach stops. Pointed niche over.

Inside the scale is impressive, especially the wide nave: at its original length it must have been an exceptionally fine space. Two C14 tomb recesses. Corbels at the W end, presumably for an C18 gallery. Good wagon roof of 1885–9. The greatest puzzle is the chancel and transept arches. The piers are triple stepped with finely executed, quadrant-curved angles with small keeled stops.* These must be early C13, but the chancel piers are on over-large plinths, seemingly designed for something earlier still and more complex. The piers do not relate to the broad and low arches, which must be C14, with three orders of shallow wave mouldings, dying uncomfortably into the piers. So, do we have a C12 start, amended almost as soon as begun, and then abandoned in favour of a broad nave in the C14? Can the placing of the piers be related to a crossing tower? To the

* There are similar piers in the crossing at Grosmont, Mon.

r. of the arch, C14 rood stair, also a niche and PISCINA. There are mural stairs also on both sides of the nave, but W of the transepts – was there another loft? The S transept was altered in 1767: the oak trusses hidden by later boarding may date from then. Dec trefoiled PISCINA and two tomb recesses.

Arch-braced chancel roof, similar to the porch roof, i.e. early C18. Corbels remain from the former roof. Good C14 detail in the chancel: remarkable triple SEDILIA with unornamented tri- 28 angular heads, cusped spandrels and shafts threaded through the bench. To the l. a richly moulded ogee PISCINA with tiny naturalistic mask stops, a lamp bracket and cusped head. Big tomb recess to each side of the chancel, with sill courses stepped over. C14 cusped Y-tracery to one of the blocked N windows; richer roll-moulded hoods at the E end. Fine C14 door to the NE chapel, with delicate lamp brackets. Above, a plaster panel with fleur-de-lys, C17? The NE chapel, made into a vestry in 1725, with C18 roof, restored 1975, may have been a later C14 chantry or prior's chapel. Blocked E window and broken piscina. Inserted corbelled mural stair to a former upper floor, lit by a small wheel window to the chancel. Small squint into the chancel. – Octagonal FONT, 1887, Caen stone with marble colonnettes. – Rare and well-carved ORGAN CASE with big cherub heads, by *Thomas Warne*, 1762, from St Mary's, Swansea. – DOOR to the tower, HAEC EST DOMUS DEI PORTA COELI, 1713, very like one at Pembrey. – Heavy hexagonal oak PULPIT, 1910, by *W. D. Caröe*. – Ashlar REREDOS, and S transept SCREEN and ALTAR, and oak chancel fittings, all *c.* 1963. To the r. of the E window, rare C15 alabaster CARVING of the Virgin and Child, reinstated after being ejected *c.* 1860, by the vicar, annoyed at the reverence paid by parishioners. – STAINED GLASS. E window by *C. C. Powell*, 1939. S chancel window 1993. S transept S window, *c.* 1925. W window, 1960, by *Celtic Studios*, life of Christ, close leading and bold colours.

MONUMENTS. In the S transept tomb recesses, a fine C14 incised floriated Latin cross, and a slab with female mask. Nearby, a damaged C14 effigy. Thomas Pardo, †1728, Baroque tablet with urn. Anthony Jones †1777, polished limestone with large rustic coat of arms. Some good late C18 and C19 floor slabs of polished limestone, one to John Hale †1799, signed *J. M.*, as is the wall tablet to Cartwright Morris †1800, both the work of *John Maliphant*. Catherine Thomas †1809, oval, by *D. Mainwaring*. Margaret Dixie †1810. Rev. Charles Bowen, 1835, ogee-headed frame and sarcophagus, mixed classical and Gothic, by *D. Mainwaring*. John Clement †1831, by *Tyleys* of Bristol, slightly Gothic. Kymer family, *c.* 1840, wreathed tablet. T. Evans †1858, by *Joseph Edwards*.

The CHURCHYARD WALL to Lady Street is capped with moulded blocks of industrial slag, presumably early C19.

CAPEL SUL INDEPENDENT CHAPEL, Bridge Street. An odd-looking chapel with a very odd history. Built as a stuccoed three-storey five-bay house, Rumsey House, in 1862, by *T. W. A. Evans*, architect and mayor, for himself. Sold after a notorious murder, and most surprisingly converted to a chapel,

1924–6, by *J. H. Morgan*, using the ground floor as a school-room and the upper floors as the chapel. Complex interior with the aisled effect that Morgan liked, with piers up from the gallery to carry a higher central roof with much timberwork. Panelled gallery front with dwarf balustrades. Good woodwork of late C17 type: twisted rails, shell head to the pulpit-back. In the grounds, a small belvedere by the river, decorated with glass bottle bases.

MORFA CALVINISTIC METHODIST CHAPEL, Morfa Lane. 1830, rebuilt in 1907–8 by *W. D. Morgan* of Pentre Rhondda, keeping the long-wall front. Half-hipped, two storeys and rather bleak, with four big arched upper windows. Good square interior with panelled gallery fronts and ceiling that mixes boarding and plaster roses.

SILOAM BAPTIST CHAPEL, New Street. 1892–3, by *George Morgan & Son*. Plain rendered gable front with arched windows.

TRINITY WESLEYAN METHODIST CHAPEL, New Street. 1866, by *T. W. A. Evans*. Gothic, with a spirelet. The front was of 'Bodmer's Patent Stone brick', but this cannot be seen, as all is rendered. A fire in 2002 destoyed a late C18 organ by Snetzler, moved here in the 1950s from an unknown site.

KIDWELLY INDUSTRIAL MUSEUM, N of the bypass. The former Gwendraeth Tin-plate Works, on the site of one of the earliest tin-plate works in Britain, established in 1737 by Charles Gwynn. There had been a stamping mill here from 1717, pro-cessing ores from the Mynyddygarreg ridge behind. The via-bility was precarious, with several closures in the C18. Little is left of this period apart from a much-renewed weir. Re-started by Jacob Chivers in the 1860s with steam power, this tin-plate works survived until 1941. The remaining buildings were restored from 1983–8, with additional items introduced from elsewhere (including the winding engine and headgear from Morlais Colliery). The process used iron bar, heated, then hot-rolled into sheet, pickled and annealed to remove impurities, cold-rolled to burnish the surface, annealed and pickled again, then tin-coated, cleaned and polished. The surviving buildings are the COLD-ROLL ENGINE HOUSE, 1919, containing a massive horizontal tandem compound engine, with an 18-ft (5.5-metre) flywheel, the ASSORTING ROOM where sheets were sorted, polished and packed, and the BOXING ROOM, where they were stored, both *c.* 1880. Tall brick CHIMNEY, 1912. The new shed covers, the hot-rolling machinery of the 1870s, on a cast-iron floor. The tinning house was demolished in 1974.

WAR MEMORIAL, New Street. 1924, white marble soldier, on a big Portland stone plinth by *Glendinning Moxham*.

THE KIDWELLY CANAL. Thomas Kymer built a three-mile canal in 1765–8 from his coal-pits at Carway to the E to a quay below Kidwelly. In the early C19 the canal was extended up the valley, and a spur begun in 1815–16 running S towards Llanelli, under *J. Pinkerton*, engineer. As silting at Kidwelly worsened, *John Rennie* advised a new terminus, either by ship-lock into

the Tywi to the w or by a new port near Pembrey. The port at
Pembrey, 1819, also silted, and a new harbour was built just E,
at Burry Port in 1832–6. The canal remained open until 1934,
though a railway was laid on the towpath in 1873. At
KIDWELLY QUAY, Quay Road, a tidal dock backs onto the
end of the canal. The quay must be, in part, of the 1760s,
but clearly of several phases, and clumsily restored in the
1980s.

PERAMBULATION

Outside the castle, the tiny medieval town funnels down
Castle Street to the Town Gate. At the upper end, the OLD
MALTHOUSE, single-storey late C18 or early C19, much
enlarged. No. 6 is C18, altered, whitewashed rubble, with oak
roof trusses and the remnant of thatch visible in the loft.
CASTLE SCHOOL began as a British School in 1858, by *D.
Davies* of Llanelli, enlarged as a Board School, 1887, by *G.
Morgan*, stone and yellow brick, the original with large
diamond panes to the windows. For the TOWN GATE *see* above.
A footpath runs l. to CASTLE MILL, a large corn-mill of 1804,
on the medieval mill site, stone and red brick, three storeys,
the mill to l. of the house. The BRIDGE over the Gwendraeth
Fach, though apparently early C20, is a widened C15 structure
of two arches, one segmental-pointed, the other arched, orig-
inally with full-height cutwaters. By the bridge, ruins of a late
C18 WAREHOUSE, thought to be for trans-shipment of tin-
plate. Three storeys, three bays, with brick dressings. w of the
bridge, in NEW STREET, BRIDGE HOUSE, on r., altered late
C18 with stone doorcase, Trinity Chapel, the war memorial,
and Siloam Chapel. Beyond, the MASONS ARMS, WATER
STREET, C18, three-bay, with the last consistently maintained
thatched roof in the region.

e of the bridge, BRIDGE STREET is the principal street of
the medieval borough around the priory, and of the modern
town. Capel Sul on r. and terraced houses, early to mid C19 in
character, but heavily altered. No. 16, MORFA HOUSE, three-
storey, three-bay, has a good late C19 chemist's shopfront.
Further up, the large three-storey, five-bay TOWN COUNCIL
OFFICES, is late C18 altered, the former Pelican Inn. There
were late medieval houses beyond Station Road, and some
survive, altered almost beyond recognition, like the RUGBY
CLUB, with a corbelled front chimney, and No. 8 with
rendered-over corbelling. The best pair with pointed doors and
lateral chimneys were demolished after the Second World War.
At the crossing, the TOWN HALL, 1877, by *T. W. A. Evans*, the
mayor, who had trained as an architect, and took no payment.
Heavy plate-traceried Gothic, in rock-faced stone with ashlar.
The hall is raised over a market, with gable to LADY STREET
and flat-topped entrance tower to l., no concession to delicacy.
In Lady Street, terraced houses, including one C19 three-storey
house unusually faced in yellow brick.

COLEMAN FARM, W of Kidwelly on the Ferryside road. In the woods NW of the farm, a ruined large circular DOVECOTE, with corbelled shallow dome open to the sky at the centre, lined with nesting boxes. Difficult to date; 1571 is said to have been seen inscribed. It is possibly linked with Penallt, Llansaint, an important C16 house further W.

MUDDLESCWM, I m. E. A former mansion of consequence, passing from the Dwnns in medieval times to the Morgans and thence to a branch of the Mansels, baronets, in 1621. It had eighteen hearths in 1670, carved heraldry and Latin inscriptions. Little remains in the present farm courtyard. The long low farmhouse looks mid C18. The derelict building at right angles with very thick lower walls is older. Corbelled chimney base on the gable-end, various blocked openings and a thin arched braced roof of c. 1700.

COMMISSIONERS BRIDGE, ½ m S. 1842, by *W. McKiernin*. Grey limestone low, broad, four-arched bridge over the Gwendraeth Fawr.

MYNYDDYGARREG, NE of Kidwelly. A rocky ridge quarried for grey limestone from early times. Several C19 LIMEKILNS survive in the undergrowth along the summit.

HOREB CALVINISTIC METHODIST CHAPEL, Mynyddygarreg. 1936, by *J. H. Morgan*. Prominent on the hillside, with red brick two-storey front, divided by piers with hump-backed finials. Darker red brick arched openings. Panelled gallery fronts, and a pontifical pulpit, in imitation stone, backed by a giant arch with outsize radiating feathers in the head.

3010

LAUGHARNE/TALACHARN

An ancient and attractive town, on the Taf estuary, with the castle just above the shore, and the town running inland up the valley of the Coran to the church. The Norman castle dates from the early C12, but the security of castle and settlement was uncertain until the 1277 conquest, falling in 1189, 1215–23, and 1257–8. An annual fair was granted by the first of the De Brian (or De Brienne) lords, Guy IV, in 1247 and a borough charter after 1278 (under which the corporation still operates). The town defences appear to have been of earth and timber: a licence of 1464 to build stone walls and a ditch was apparently not carried out. In 1566, Laugharne was a 'village of ninety houses', and during the late C16 was a noted centre of piracy. The siege of the castle in 1644, by Maj. Gen. Rowland Laugharne, was one of the larger Civil War actions in Wales. The harbour silted up in the C18 and Laugharne became a watering hole and retirement place, as shown by the attractive Georgian houses along the wide main street. It was recommended to those 'desirous of combining economy with comfort'. Among the visitors thereby attracted was Mary Wollstonecraft, with her cash-strapped husband. The resort and retirement character was maintained in the C19, when villas fringed the old centre. Its inaccessibility by rail maintained an

apartness, savoured by writers in the C20, notably Richard Hughes and Dylan Thomas.

LAUGHARNE CASTLE
by Richard Avent

One of a string of coastal strongholds, the castle controlled the crossing of the River Taf on the route along the coast. Still dominating the foreshore, although no longer accessible by sea, the surviving remains consist of a well-built medieval stone castle rescued from ruin and converted to a Tudor mansion by Sir John Perrot, only to be partially demolished following a Civil War siege. Behind this summary lies a far more complex story which emerged as the demolition rubble was archaeologically removed and ivy stripped from the castle walls between 1973 and 1995.

Before the Norman Conquest the site consisted of a ploughed headland sloping down towards the coast from the hillside to the N but with a much steeper fall to the Coran stream on the W, and with low rock-exposed cliffs on the riverside to the E and S. The earliest reference to a castle on the site is in the *Brut y Tywysogyon* (Chronicle of the Princes) where, in 1116, a local Welshman, Bleddyn ap Cadifor, was entrusted with the castle of the Norman lord, Robert Courtemain. Archaeological evidence has now been found of a castle dating to the first half of the C12. The Normans constructed a bank and external ditch stretching across the headland. This first castle may have consisted of either one very large enclosure, covering a slightly smaller area than the present outer ward, or two baileys with defences on approximately the same line as those of its masonry successor. Initially, the buildings would have been of timber.

In 1172 Henry II and Rhys ap Gruffudd, the prince of Deheubarth, came to terms at Laugharne, presumably in the castle, but following the king's death in 1189, this accord broke down and Rhys captured this castle and those at St Clears and Llansteffan. Archaeological evidence of a major conflagration at the castle might be associated with this. Whatever may have been the case, the castle was remodelled in the later C12 with the construction of a large rectangular hall-block within what, by then, must have been an inner ward.

In 1215, Llywelyn the Great overran much of SW Wales and 'overthrew to the ground' the castles at Laugharne, Llansteffan and St Clears. Archaeological evidence in the form of burnt buildings and numerous arrowheads may be associated with this attack. There is no record of who owned the castle after Robert Courtemain, but it was probably restored to its owner around 1223 when William Marshal II recovered Cardigan and Carmarthen castles.

A reference in 1247 to Guy de Brian receiving a grant to hold a yearly fair at his manor of Talacharn is the first mention of the family that owned the castle until the late C14. The de Brians are recorded at their home of Torbryan in Devon from the mid C12,

and it was the fourth Guy who established the family in sw Wales, acquiring the lordships of Laugharne and Walwyn's Castle in Pembrokeshire. The earliest upstanding masonry of the castle dates to this period. Guy de Brian IV reconstructed the inner ward by building two strong round towers on the vulnerable N side with a relatively low curtain and a plain gateway. For the time being, he appears to have continued to rely on, or perhaps strengthened, the existing outer defences. In June 1257, after the English defeat in the Tywi Valley by forces under the general leadership of Llywelyn the Last, the Welsh went on to attack English garrisons including Laugharne, where they burnt the castle and town and took Guy de Brian prisoner. Ransomed in 1258, he died in 1268.

In the late C13 Guy de Brian V strengthened the defences of both the inner and outer wards. A new curtain wall was built along the s side of the inner ward, a round tower added to its sw corner and the inner entrance was reinforced with a two-storey projecting gatehouse. The outer ward defences were rebuilt in stone with a fine new gatehouse. Guy de Brian VI succeeded in 1307, but in about 1330 management of his s Wales estates was transferred to his son, who succeeded to the lordship in 1349.

Guy de Brian VII was the most distinguished member of his family. A close confidant of Edward III, he held a variety of important posts, becoming a Knight of the Garter in 1370. He modernized the castle, greatly improving the overall standard of accommodation. The outer gatehouse was refaced while that leading into the inner ward was heightened. The sw tower was also raised by a further storey and the upper part of the w end of the inner ward remodelled. On the s side of the inner ward, the hall was extended and a new se tower and postern entrance added at the e end of the curtain.

Guy de Brian VII died in 1390 and, with inheritance disputes throughout the next century, no work appears to have taken place beyond the most basic repairs. Eventually, in 1488 Laugharne passed to Henry Percy, fourth Earl of Northumberland. Minor repairs were carried out but the picture that emerges is one of a fairly ruinous castle, parts of which were maintained to provide limited accommodation for a sub-constable.

In 1575 Elizabeth I granted the castle to Sir John Perrot with an annual rent of £80 to be paid to the earls of Northumberland. The Queen confirmed Perrot's tenancy in 1584. Perrot transformed the castle into a Tudor mansion and the two stages of his tenancy are reflected in two building phases. Perrot was a colourful figure acquiring many enemies both at Court and elsewhere. Falling foul of the Queen, he was condemned to death for treason but died in the Tower of London in 1592 before sentence could be carried out. An inventory of his property recorded that, at the time of its conversion into a Tudor mansion, the medieval castle had been very ruinous and that the building works had almost been completed at the time of Perrot's death but that 'the whole castle by reason of the bad buildings thereof (without excessive charges) is like within few years to run to utter ruin again'.

Laugharne Castle.
Engraving, C19

For the next thirty-five years the castle had a turbulent history, progressively being stripped of anything of value and the subject of constant legal disputes. It was bombarded by Parliamentarian cannon during a week-long siege late in 1644, captured and partially slighted. From henceforth it was a neglected ruin until, at the end of the C18, the then owner, Richard Isaac Starke, laid out the grounds as a garden. His descendant, Anne Starke, handed the castle into state care in 1973. It is now managed by Cadw and open to the public.

The overall castle enclosure is five-sided with the short S wall forming part of the inner ward curtain. Most of the building stone is taken from beds of Old Red Sandstone. Up until the mid C14, mainly red stone had been quarried, but for the final phase beds of green stone were exploited. Given the lack of surviving early architectural detail due to later Tudor alterations, this distinction is of considerable assistance in sorting out the later medieval building phases. To appreciate the castle's location on the edge of the estuary and its defensive strength, a visit needs to start at the foreshore car park. From here it is possible to walk around the S and E sides of the exterior, up a path to Market Lane and past the Town Hall to the castle entrance.

Exterior

A fine view of the castle and its overall setting can be obtained from the S side of the foreshore. In the medieval and Tudor periods the castle would have been directly accessible from the sea and this would have been the main way of provisioning it.

Three building periods can be seen in the SW OUTER WALL to the l. of the tall rounded SW tower. The lower part, to a point just beyond a change in alignment, is all of medieval date and includes a blocked doorway, originally providing access from the foreshore to the inner ward ditch. The upper part of this wall, and all the stretch extending NW to the next offset, form part of the later garden wall although on the same line as the medieval outer curtain. The wall between this point and the NW corner of the outer ward is a modern repair.

Nowhere is the use of different sources of stone and building techniques better illustrated than in the construction of the SW TOWER. The first thing to note is the survival of external rendering. Most of the surviving render throughout the castle is of Tudor date although patches of earlier, medieval, rendering have been detected in a few well-sheltered areas. The base of the tower, with its triangular spur buttresses, is the late C13 work of Guy de Brian V and characterized by the use of red stone. Two generations later, Guy de Brian VII heightened the tower in green stone. The uppermost third, with its mock battlements, formed part of Perrot's Tudor mansion. Despite this being the most recent work and protected for much of its life by external render, much of the mortar had washed out of the joints in this upper masonry 'by reason of the bad buildings thereof'.

The building sequence seen in the tower continues to the E with the lower part of the towering S CURTAIN and the pent garderobe projection also dating to the late C13. The set-back masonry to the r. of the upper part of the projection is a later estate repair. Immediately above this the small blocked window, with a trefoil head, in the C14 green masonry is the only surviving medieval window in the castle; all other such openings having been blocked or re-fenestrated in the late C16. To the E of this, and extending up to a point just W of the postern doorway, the main stretch of curtain wall, from ground to wall-walk, is all late C13. The main hall of the castle was built against the inner face of this wall and, in the late C16, its E end was lit by what must have once been a fine oriel window. The chimney and battlements also date to this final period in the hall's history. The rectangular SE tower and the postern entrance were added to this corner of the inner ward in the C14.

A very short stretch of mid-C13 SE OUTER CURTAIN survives immediately to the E of the SE tower but from there to the gazebo a garden wall follows the line of the former curtain. The GAZEBO was built upon the base of a medieval tower incorporated into the stretch of curtain wall closing off the E end of the inner ward ditch. Dating to the late C18 or early C19, it commands fine views out over the estuary and was a literary retreat for two leading C20 writers. It was here, while renting Castle House, that Richard Hughes wrote his second novel, *In Hazard* (published in 1938) and Dylan Thomas, while

staying with Hughes, his series of short stories in *Portrait of the Artist as a Young Dog*. Part of the NE OUTER CURTAIN beyond the gazebo is built of the C14 green stone and incorporates a blocked doorway similar to that previously described through the outer curtain at the SW end of the inner ditch. The more recent doorway through the garden wall in the NE corner of the outer ward provides access from the castle to a small external terrace, once part of the garden, to the NE of the gazebo.

Proceed, via Market Lane, to the outer gatehouse, today, as in the past, the main entrance to the castle. To the l., within the garden of Castle House, but visible from inside the castle, is a short length of the medieval NE OUTER CURTAIN. Beyond, and extending to the NE corner of the outer ward, this has been replaced by a garden wall. The area now occupied by Castle House and its garden was acquired by Sir John Perrot and turned into a Tudor garden in 1588–90. Later, this side of the castle was subjected to sustained cannon fire during the Civil War siege and both the gatehouse and outer curtain were damaged and probably subsequently slighted. The whole of the NE side of the castle, to a point just W of the outer gatehouse, was fronted by a defensive ditch. Although a new inner skin with mock-battlements was added during the garden period, the NW CURTAIN is the most complete surviving length of the original medieval outer enclosure wall. Outside, the natural slope, now seen in the descent of Wogan Street to the Grist, substituted for a ditch.

Archaeological excavations have shown that in the late C13 the ditch in front of the OUTER GATEHOUSE was crossed by a wooden bridge, replaced by a stone causeway during the C14. Three construction phases can be seen in the gatehouse, always a low structure of only two storeys. The original work dates from the late C13 and is characterized by chamfered front corners with triangular or spur angle buttresses, small triangular stops to the remains of the door jambs and the use of cross-oillet arrowslits, all in the now familiar red stone. No evidence has been found for either a drawbridge or a portcullis although the inner end of the entrance passage must, like the outer, have had a pair of doors. Doorways lead into guard-chambers on either side of the passage with that on the N side being the best preserved, still with its stone vault. A now ruinous garderobe, accessible from both ground- and first-floor level, occupied the NW corner of the gatehouse. During the second phase, in the mid C14, the rear wall of the gatehouse was rebuilt and the rest of the structure refaced in green stone. Access to the upper floor and the battlements was from the NE curtain wall-walk. The present straight flight of garden stairs outside the SE corner of the gatehouse, leading up to this wall-walk, may occupy the same position as a timber or stone medieval predecessor. In the late C16 the gatehouse became the formal entrance to Sir John Perrot's mansion and was described as 'a faire gatehouse, having in it two lodgings'.

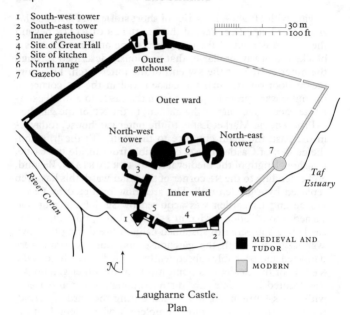

1 South-west tower
2 South-east tower
3 Inner gatehouse
4 Site of Great Hall
5 Site of kitchen
6 North range
7 Gazebo

30 m
100 ft

Outer gatehouse

Outer ward

North-west tower

North-east tower

6

3

7

River Coran

Taf Estuary

Inner ward

5

1

4

2

N

■ MEDIEVAL AND TUDOR

▨ MODERN

Laugharne Castle.
Plan

Interior

The castle's interior is a complete surprise with Cadw's visitor
centre, of summer-house design, merging into the tranquil
setting of a re-created Victorian garden encircled by a battle-
mented wall, and consisting of lawns, parterre, shrubberies and
mature trees through which cockle-shell paths thread their way.
The present ground levels in the OUTER WARD are deceptive,
particularly on the W side where, in the C12, the original
surface sloped steeply down to the stream of the Coran.
Archaeological excavations have also shown that the inner
ward, occupying the S half of the castle enclosure, was origi-
nally encircled by a large defensive ditch and the area of the
medieval outer ward and, later, the Tudor outer court would,
therefore, have been much smaller than appears at present.

The buildings of the inner ward will be described in clock-
wise order, beginning with the INNER GATEHOUSE, the first
phase of which dates to the late C13. Built forward from the
plain mid-C13 doorway, the entrance passage was decked in
timber over a deep basement. At the front of the basement a
doorway led out to a path on the side of the newly aligned
ditch and hence to another doorway (previously described)
through the outer SW curtain to the foreshore. The S gatehouse
tower was solid throughout its height while the N one con-
tained a stair, rising up from first-floor level. The height of this
first gatehouse can be determined from within by the offset
for its wall-walk and on the N exterior face by a line of
blocked-up arrowslits with a row of large square holes below,

perhaps for a hoard. In the middle of the C14 the timber surface of the entrance passage was removed and the basement filled in. The gatehouse was also raised by another storey and the offset for the higher wall-walk can be seen on the interior of the S wall. The two final phases of work date to the castle's conversion into a Tudor mansion. A large blocked window and a gabled roof-creasing on the inside of the E wall are all that remains from the first phase but the final Tudor work is very distinctive and best viewed from the lawn outside the gatehouse. Beneath the new heightened gable are fine W-facing freestone windows on each of the three floor levels with a Tudor doorway leading to a cobbled entrance passageway.

The cobbling extended to the entire COURTYARD. Entering this area today, one gains a false impression of space due to the loss of the buildings of the S and E ranges. In both the medieval and Tudor periods, this would have been quite a small, enclosed courtyard. An impression of this is provided in the 1592 survey of the castle when the area is described as 'a little Inner court of ffowerscore and tenn yards compass; in the middest whereof is a very proper fountaine'. The foundations of the fountain and evidence for lead water-pipes were discovered in the centre of the courtyard during the excavations which also revealed the foundations of the C12 stone hall-block, the E wall of which has been consolidated.

Proceeding in a clockwise direction, the next building is the strongly fortified round NW TOWER. Built as part of the first de Brian works in the middle of the C13, this now contains an exhibition on the history of the castle. Originally, the tower must have served as the medieval keep. The upper part of the tower was restored early in the C20 with new battlements and window openings. The medieval arrow slits, most now visible, were blocked and the external face of the tower re-rendered in the Tudor period. As with other contemporary towers, the entrance was at first-floor level via an external timber stair from the courtyard. The sides of the lower part of this C13 doorway can be seen below a later, blocked, Tudor window. A first-floor trap door provided access to the basement which can now be reached from the courtyard through a Tudor doorway created at the same time as a new stair was provided to the first-floor of the tower and the various floors of the gatehouse. As the castle's principal stronghold, this was a formidable fighting tower with arrowslits facing in all directions on each of its three upper floors. Stone floors at first- and second-floor levels and a stone-vaulted roof, the quality of which is only matched elsewhere in Wales at Pembroke Castle, made the tower more or less fireproof. None of the rooms contained garderobes and the only concession to any form of comfort was a small fireplace in the upper, third-floor room. The most striking subsequent alteration came at this upper level. As part of the new N Tudor range, the floor of the upper room, the only one in the tower constructed of timber, was removed and a massive arch inserted through the E wall of the tower. The second floor then

became the apsidal end of a long chamber extending into the tower from the upper-floor level of the N Tudor range. Clearly these modifications created a point of structural weakness and this area of the tower was walled up as part of the early C20 restoration.

During the castle's conversion to a Tudor mansion, the medieval curtain linking the two round towers on the N side of the inner ward was taken down and replaced by a new N RANGE. Of three storeys, this originally had large windows facing S into the courtyard but these were subsequently blocked up and the dressings removed. The long upper room is the only one within the range with a fireplace. As with the inner gatehouse, there are two phases of Tudor work at roof level. The original low roof probably had a lead covering but this was subsequently raised with a full pitched roof and the insertion of an attic. The most prominent feature of this range is the tall and very elegant rounded stair-tower projecting forward from the N wall. This provided access from the interior of the building to each floor level.

The now ruinous NE TOWER has had a chequered history with extensive alterations at almost every period. As originally built, its plan form matched that of the NW tower. However, unlike that tower it only had two upper storeys and the basement was always directly accessible from the courtyard. Well equipped with arrowslits, at some point in the medieval period, a garderobe was inserted at first-floor level. A second-floor doorway in the SE side of the tower led out onto the wall-walk of the now missing E curtain. The most significant Tudor addition involved removing the medieval battlements to wall-walk level and then adding two further storeys to the top of the tower.

In the late C12 century the E side of the inner ward was defended by a Norman ringwork bank with the hall block built into its rear. In the mid C13 the hall block was demolished and the E curtain constructed. Foundations survive of the inner wall of the medieval SE range but the whole of this end of the castle was remodelled in the Tudor period with the construction of new E and SE RANGES, perhaps similar to that still standing on the N side of the inner ward. The E side of the castle was damaged by cannon fire during the Civil War and appears to have been deliberately slighted sometime after the castle's fall to Parliamentarian forces. A short length of the outer wall of the SE range can be seen extending from the SE tower and the first floor may have contained the 'great dyning chamber' described in the 1592 Survey as being at the upper end of the hall.

The outer wall of the SE TOWER still stands to full height and is visible in cross-section with its gabled roof and three internal floors, the lowermost of which was vaulted. The tower and the postern through the curtain near its foot were constructed in the mid C14 by Guy de Brian VII, the postern probably replacing that in the inner gatehouse basement, which was blocked at this time.

The straight stretch of curtain wall along the s side of the inner ward always seems to have formed the outer wall of the GREAT HALL, situated, from at least the late C13, at first-floor level over a basement. The Tudor hall was demolished after the Civil War and all internal walls and floors were destroyed. Much of the curtain is of medieval date and the great Tudor oriel window at the E end of the hall almost certainly had a medieval predecessor. The foundations of what was referred to in the 1592 Survey as 'a stately round stairs of hard lymestone wrought, and a porch over a part thereof leading into a faire hall' can be seen at the NW corner of the hall and fragments of the Tudor doorcase have also been found on the site. As elsewhere, two Tudor phases were detected during the excavation of the basement plaster floors. The foundations of walls belonging to the various medieval hall phases, including, the stone column to support the C14 first-floor hearth have been revealed by excavation, along with the medieval well, housed in a small structure at the NE corner of the hall basement.

From at least the late C13, the castle's KITCHEN was at first-floor level at the W end of the inner ward. As part of the C14 improvements, a massive new kitchen fireplace was inserted into the E wall. The archaeological excavations revealed impressive pitched stone floors at basement level along with a kiln and brewing furnace, so this was the brewhouse. A modern flagstone path, running from E to W across the inner ward marks the line of the S wall of the C12 hall block. A cockle-shell path then leads to the gazebo.

ST MARTIN. Outside the town in a large hillside graveyard, thickly studded with old gravestones and table tombs under yew trees, that still evokes the romantic gloom that enthused Victorian tourists. One of those large churches associated with medieval castles (cf. Kidwelly), said to have been rebuilt by Sir Guy de Brian VII in the later C14. However, the nave masonry – squarish limestone rubble – suggests some later C15 rebuilding, as does surviving Perp tracery in the N transept. Cruciform with battlemented crossing tower, the tower apparently raised in the C15 by 20ft (6 metres), but lowered again as unstable in 1872–4, by *Penson & Ritchie*. Taller SW stair-turret. Steep pitched roofs, three-step nave buttresses and angled ones to the transepts, an unusual elaboration for the area. The N porch, its doorway blocked, is probably C16 or C17. The N vestry and Perp windows were added 1853–7, by *R. K. Penson*, who returned in 1874–6 to rebuild the top of the tower, the S transept and S porch.

Lofty interior, with bare stone walls, stripped in 1874, which, with the abundance of stained glass, makes it difficult to see the fine monuments. Plain crossing arches, the chancel arch chamfered for the stair-tower, entered from the S transept via an arched door with broach stops. Wagon roofs of 1853–7, by *Penson*, said to follow what was there, but creases of earlier roofs are visible. Due to the steep site, there are three steps to

the crossing, and three to the chancel. Dec PISCINA to S
transept, and blocked squint. – SEDILIA. 1853–7, cusped arches
on colonnettes. – FONT. 1857, octagonal, with quatrefoils, the
ornate timber cover of 1874. – PEWS mostly 1876, the num-
bered ones in the S transept of 1855. – SCREEN. 1909, by *C. E.
Ponting* of Marlborough, elaborate Perp, with loft. Matching
PULPIT of 1925. – RAILS. 1855, said to have been made from
timber from the former nave roof. – CHANDELIER, under
the crossing. 1763, brass. – REREDOS. C14, the only one in
SW Wales, restored in 1853–7, with stone figures of 1901, by
R. Bridgeman of Lichfield. Seven bays, cusped and crocketed
ogee niches, the central one larger. – CELTIC CROSS. In the S
transept, a small C10 or C11 cross with splayed arms, knotwork
to the stem, and marginal cable moulding. – ORGAN. 1819, for-
merly in a W gallery. – Large PAINTING of Jeremiah, by *Ben-
jamin West*, one of eight commissioned in the 1780s for the
Royal Chapel at Windsor. – ROYAL ARMS. Small painted panel,
1762, by *Joseph Lewis*. – STAINED GLASS. A brightly coloured
series by *Wailes*, the Old Testament in the W window of 1857,
saints in the nave windows of the 1860s, and the life of Christ
in the chancel, also 1860s. The nave NE window has some frag-
ments of C14 glass, including the head and coat of arms of
Edward III, and the arms of Sir Guy de Brian VII. S transept
windows, 1888, saints, by *Wailes, Son & Strang*.

MONUMENTS. In a cusped recess in the N transept, a
damaged C14 effigy of a lady. In the chancel, a small chest tomb
with the de Brian arms, *c.* 1600. In the porch, Elizabeth Beynon
†1670, small with strapwork and flowers to the frame. Sir John
Powell †1696, of Broadway, a judge in the trial of the Seven
Bishops, 1688. Erected after 1726 by the will of his son,
Thomas. Veined marble with segmental pediment and fluted
Corinthian pilasters. Sir Thomas Powell †1726, large, with
Ionic columns and broken pediment with figures, including
Justice and Fortitude. Some good C18 floor slabs in the
chancel, unusually of white marble. George Owen †1736, small
tablet with crude winged cherub head. Arthur Bevan M.P.
†1749, large, square, and of white marble with a pediment and
oak-leaf frieze, by *Benjamin Palmer*. George Elliot †1799, in
Coade stone, by *Coade & Sealy*, mourning woman, badly
cracked. Margaret Elliott †1811, below, draped urn, possibly
also of Coade stone. William Griffiths †1799, slate tablet,
signed *J. Hughes*. Anne Williams †1804, oval. Bingham
Hamilton †1815, by *Wood* of Bristol. Admiral John Laugharne
†1819, an unusual design, admired by Gunnis *c.* 1832 Wide
tripartite tablet with urn and arms, and Adamesque radial
fluting, by *Daniel Mainwaring*. Owen Lewis †1824, mourning
woman, by *W. Ewings*, apparently the only church monument
by this refined but little-known sculptor, sadly hard to see over
the inner porch. John Edwardes †1825, by *Tyley & Co.*, tall
wreathed urn. William Thomas †1826, by *Mainwaring*, sar-
cophagus type. Also by him, Rev. John Williams, with an
urn. Charlotte Edwardes †1838, Gothic tablet by *Gardener* of

Cheltenham. Anne Shickle †1840, by *H. Maile*. Neoclassical.
Abiah Hill †1844, urn, by *Mainwaring*. Anna George †1845,
Gothic, by *Gardener*, as also Courtland Skinner Shaw †1854,
scroll type. Captain William Laugharne's charity, *c.* 1858, by
the local *John Hugh*, plain elegant oval. Several competent
gravestones in the churchyard by him also. – Dylan Thomas
†1953, replica of the memorial in Westminster Abbey.

CONGREGATIONAL CHAPEL, King Street. 1890, by *George
Morgan*. Simplified Romanesque, in grey stone, with ashlar big
wheel window and porch on colonnettes. The end gallery has
cast-iron panels over boarded panels. Coved ceiling with arch
braces.

CASTLE HOUSE, Market Street. Beside the castle gate, and
facing grandly down Wogan Street. Probably early to mid C18
originally, from which a rear wing with a massive chimney sur-
vives, but remodelled apparently as late as *c.* 1800–10 for Col.
Richard Starke, who married the heiress. This date suits the
interior but not the exterior of three storeys and five bays,
which looks more of the 1780s. The centre three bays are set
forward with a three-light window over the door and a
Venetian one above that. A distant watercolour of the 1780s
may suggest a lost central pediment. The gables are mildly
shaped with a raised parapet. Closer inspection shows much
of the display to be façadism: the window to the l. of the door
was always blank, both of the grand central windows only ever
functioned as single lights, and the flanking top-floor windows
are also blank. Late C18 work is shown within in the secondary
staircase with Chinese Chippendale rails, unique in the county
but found often in S Pembrokeshire from *c.* 1770–80. The other
interiors are all Regency, the entrance hall with good plaster-
work and massive panelled doors, folding back to create a front
ballroom. Arch to the stair hall with cantilevered stair. Altered
by *Clough Williams-Ellis* for Richard Hughes, who lived here
1934–46, the rear cross-range given tall sashes. Iron gates and
railings by *Moss* of Carmarthen.

GREAT HOUSE, King Street. An early C18 double pile, excep-
tional in the county. Two storeys on the front, behind old rail-
ings, three to the back. Five bays, with a little central pediment
enclosing a Gothick window. On the S gables, original brick
chimneys, square with sunk panels. Elaborate doorcase, the
broad bracketed cornice with carved foliage, on Corinthian
pilasters with crudely carved capitals. A similar one was at Rhyd-
ygors, Carmarthen, now demolished. Panelling survives exten-
sively inside, notably in the entrance hall and front rooms, that
to the r. with two large shell niches, and that to the l. with
fluted pilasters flanking the chimney. Panelled arch to the
central stair hall with strangely moulded wooden keystones.
Handsome dog-leg staircase with turned and fluted balusters,
three to a tread, enlarged for the newels, moulded handrail and
foliage scrolls to the tread ends. The stair is almost identical to
that at Panteg, Llanddewi Velfrey, Pembs. On the landing, a
handsome two-bay arched screen. The garden was sold for

housing in the 1980s with no agreement to repair the house,
which is only now (2006) being restored.

ROCHE CASTLE, Broadway (SN 294 103). Scant remains of a
medieval fortified house, now surrounded by modern housing
and partly built over. Set by a stream in a low banked enclo-
sure, the house appears to have been a rectangle with two small
towers (of 7 ft (2.1 metres) internal diameter) at each end of
the rear wall. A small part of one survives with adjacent
walling. The lower floor had been a vaulted undercroft. Built
for the de Rupe or de Roche family, of Roch Castle, Pembs.,
owned by the Reed family in the C16, it was dismantled to build
Broadway.

BROADWAY, Broadway. Demolished in the C19. It was a C17
house built for Sir John Powell, one of the judges at the trial
of the Seven Bishops, 1688. An enclosure wall with plain rubble
gateposts remains, and a low house, probably a service wing
with a large gable chimney.

HURST HOUSE, 1 m. S, on Laugharne Marsh. Dated 1797, stuc-
coed house of three bays and storeys, with a well-planned farm
around a square court, dated 1828.

MAPSLAND, ½ m. N, and PARSONS LODGE, ¾ m. NNW, are
mid-C19 hipped and stuccoed villas.

PERAMBULATION

In CLIFTON STREET by the church at the N end of the town,
UPTON HOUSE is a replica of late C18 or early C19 house
which collapsed during works in the 1990s. Three bays, three
storeys and hipped, with pedimented doorcase. CLIFTON
HOUSE is early C19, two storeys with pedimented doorcase.
KING STREET is the unusually broad and well-built main
street, running down to the castle. Its width may be because
there were front gardens. THE LIMES and MOIR HOUSE,
1790, are a stuccoed three-storey pair, on a railed terrace, The
Limes with a fine pedimented doorcase and added full-height
bay windows on the l. side. ROSETTA, of similar scale, has
broad gable chimneys, probably a C19 reforming of an early
C18 house. Opposite is the Great House, *see* above. Next, THE
VICARAGE, 1839, of four bays and two storeys, embellished in
the later C19 with a bargeboarded jettied porch and an oriel
window. Next, TEMPERANCE HOUSE is late C18, two and a
half storeys, with small sash windows. ABERCORRAN HOUSE
has a four-bay, two-storey colourwashed stone front, the steep
roof indicating the early C18. Good early C19 small-paned
shopfront with pilasters. Opposite, DRAGON PARK, of three
bays and storeys, is Late Georgian. REDFORD HOUSE, two
bays, looks C18, with small sashes, and has a little early C19
bowed shop window. The scale is stepped up by MINERVA,
late C18, three bays and storeys, but with an earlier-looking big
gable chimney. OSBORNE HOUSE was probably built as a pair.
GAINSFORD HOUSE is lower, five bays, and strikes a decid-

edly Victorian note, built for the family chemist's shop by
Thomas David, who began his building and architectural career
working on the parish church in the 1850s. Squared limestone,
with two-tone upper window heads, and a shopfront with both
pointed and round arches. Opposite, EXETER HOUSE and
THE PINES, a C19 reworking of a late C18 house, stuccoed,
three bays and storeys, with a good C19 shopfront. ELM
HOUSE is another late C19 refronting, four bays, with storeyed
canted bay windows. BROWN'S HOTEL is dated 1752, two
storeys, with C19 glazing, including canted bays and C20
dormers. Doric porch. Across the road, THE PELICAN and
THE MANSE, a three-storey pair, both with an arched window
over a central door, with keystones. The former has a date
of 1825 in the cellar, but the slight differences suggest a
remodelling of earlier work. THE NEW THREE MARINERS,
gable-ended to the street, of three bays and storeys has C19
detail, but is probably C18. The old town gate may have stood
here.

In VICTORIA STREET, to r., VICTORIA HOUSE is C18, three bays
with a broad door and passage through to the back yard. Mid-
C18 staircase with column balusters. All the walls are lined with
horizontal boards, for fabric hanging. Opposite Victoria Street,
a lane leads to THE CORS, earlier C19 two-storey hipped house
in its own grounds. Inside a delightful imperial staircase on a
tiny scale, possibly inserted by the architect *Thomas David,*
owner in late C19.

MARKET STREET continues to the castle. The COMMUNITY
HALL was the National School, 1867, presumably by *Penson.*
Five long bays, the centre gabled, with a pointed window. Nos.
2–3 are C18, whitewashed, with steep roofs, the detail C19.
Opposite, a C19 three-storey terrace, including GLOBE
HOUSE, with small-paned bay windows to the l., and a canopy
over the door. Inside, some good Regency detail, and a small
ballroom to the rear. The big chimneys and double-pile plan
suggest the C18, but the terrace is not on an 1834 map. Across
the road, the TOWN HALL, 1747, much altered. Stuccoed, two
storeys and two bays, the Gothick upper sashes of 1814. At the
s end, a tapering clock tower, charmingly whitewashed with a
little bellcote on top a pyramid roof. Rear range of 1909 by
E. V. Collier. In the angle of this and the tower, the tiny gaol,
added 1774. Simple benched interior and dais. Iron early C19
wall safe by *Moss* of Carmarthen.

DUNCAN STREET, a three-storey, seven-bay rubble row, was
perhaps originally a warehouse. Castle House, *see* above, faces
down WOGAN STREET, running to the town's central open
space, The Grist, on the shore. ISLAND HOUSE is C16–C17,
altered in the early C19. The irregular rear faces the road, six
bays, the right-end bay gabled and advanced, with a Tudor-
headed door lintel, perhaps from the castle. Later broad
mullion- and-transom windows. The two l. bays are added, the
joint visible, marked by the massive chimney. At odds with the
vernacular character is the picturesque battlemented Gothic

gateway to the l. The other side has various cross-ranges, the main range with an extraordinary Regency bowed oriel. Earlier C19 interior detail, with later Neo-Jacobean stair. THE GRIST, a triangular open area on the foreshore, was the harbour, before silting. CELTIC CROSS, 1911 by *C. E. Ponting*, on an ancient rubble base, from which John Wesley preached. Facing E, behind a rubble wall, THE STRAND, a three-bay, three-storey C18 house. Double pile, but the ranges of different dates, as shown by masonry joints. In the front range, a first-floor panelled room and early C18 stair, probably originally for a larger stairwell. Further along, STRAND HOUSE, early C19, three-storey.

Past The Grist, up GOSPORT STREET, at the top on the l. is GOSPORT HOUSE, house of the Laugharne family from the later C17. A low three-bay, two-storey central range with a short wing running back on the l. end (the drawing room) and another set forward on the r. (the dining room). In the former, a curious early C18 wooden chimneypiece, bolection-moulded and similar to the one from Madam Bevan's demolished house in Laugharne, now at Llwyngwair, Nevern, Pembs. In the dining room, plain ceiling beams arranged to produce a central square panel and six around it. After long absence the family had it plainly restored in 1903 by *E. V. Collier*. The road then sweeps to the r. to Broadway.

To the NE of town, off CLIFF ROAD, THE BOATHOUSE, early C19, two-storey, on a stone quay, preserved as Dylan Thomas's last home, 1949–53, and above that his simple writing-shed, facing over the sea. Beyond is GLANYMOR, thoroughly altered, but once of considerable interest. It was the home from 1874 of *Edward Faulkner*, gold-medal winning architectural student, who devoted his life to travel, art, books and particularly archaeology at Pompeii. Romanticized with timber framing and a belvedere tower, the house was filled with antiquities, and surrounded by terraced gardens with statuary. Traces of the garden remain but nothing of his work to the house. A derelict boat-house has a pink stone circular gable window said to come from Fatehpur Sikri, India. On Glanymor hill to the E, a Romano-British EMBANKMENT, used by the Cromwellian battery to attack the castle.

LLANARTHNE

5520

A large parish running S from the Tywi. The site of the new National Botanic Garden, S of the village, is the park of the demolished Middleton Hall. The landscape is overlooked by Paxton's Tower, a Middleton estate folly. The roadside village, centred on the church, has some attractive buildings, and views up to Paxton's Tower. To the W, the early C19 GOLDEN GROVE ARMS, three bays and hipped, with hoodmoulded windows, possibly by *J. P. Pritchett*. Two added bays to the E. Opposite the church, the unaltered former NATIONAL SCHOOL, 1856, four

bays, in an early C19 Tudor style. E of the bridge, THE OLD SMITHY, a two-bay cottage, C17 or C18, with big end chimney and corrugated roof, over thatch. Single storey wing to r., and rear wing also. Derelict 2006.

ST DAVID. Originally double-naved, altered to a preaching box in 1826–7, when the arcade was removed and the roof rebuilt as a single span. Battlemented NW tower with a battered base, the string course carried over the W door. Probably C15, there was a barrel vault now removed. Dating of the rest is difficult; a joint at the W end suggests that the N nave is the earlier. A datestone of 1682 points to repairs. Windows of 1874–7 by *Ewan Christian*. Broad interior with coved plaster ceiling. Small N chancel with a blocked four-centred arch to a S chapel. – FONT. Octagonal: the square base may be an old font upturned. – FURNISHINGS. 1877. – STAINED GLASS. Splendidly coloured E window, *c.* 1865, by *Wailes*. – S window 1913, by *Jones & Willis*. – MONUMENTS. Elizabeth Thomas †1774, coloured marbles, urn in the pediment. Sir William Paxton †1824, erected 1847, by *W. Osmond* of Salisbury. Remarkably, Baroque, in Chilmark stone. Black marble panel in an arched recess with Ionic columns and open pediment. Finely carved arms, and medallion profiles of Paxton and his wife. Edward Adams †1842, Gothic tablet, by *E. Gaffin*, 1843. Thomas Williams †1857, an odd ensemble by *John Jones* of Llanddarog, a white marble arched frame with open pediment and a female bust. Evan Davies †1868, oval.

In the porch, a large INSCRIBED CROSS, about 7 ft (2.1 metres) high, from Cae'r Castell, an earthwork 2 m. away. The head is rounded, containing an equal-armed cross, the arms terminating in spade-like squares. Short shaft with simple interlace. The shaft has an eroded and poorly cut inscription possibly with MERCI, in Norman French, which would give a very late date, mid C12, but the lettering is indistinct.

Attractive whitewashed early C19 LYCHGATE with a wide archway, the gateposts with obelisk-like finials.

CAPEL ERBACH, 3 m. S. A ruined, possibly C14, WELL CHAPEL, the spring still flowing, held to heal sprains and spasms. Single chamber, about 36 ft by 13 ft (11 metres by 4 metres). The W wall is complete, of large blocks of stone, with a chamfered pointed doorway of two orders, and a trefoiled lancet above. The bellcote is mostly lost. The E end, built into the bank, has mostly gone, but a pointed recess survives internally, above the source – no doubt for an image. The date would appear to be C14. Another well chapel, Capel Begewdin, Llanddarog, is only 1 m. W.

SARON INDEPENDENT CHAPEL. 1868. Gabled front of two arched windows and centre door. Very unusually, it has a plaque with carved arms, of the Abadams of Middleton Hall, 1870, who gave the site. Gallery, probably later, with long painted panels, on iron columns by *T. Jones* of Carmarthen. Balustraded pulpit.

DOLGWYNON CALVINISTIC METHODIST CHAPEL. Delight-
fully small long-wall chapel, said to date from 1815, but looking
of the 1830s. Five bays, with wide centre window, outer doors,
and gallery lights, all Georgian Gothic, with original glazing.
Inside, panel-fronted gallery, cramping the entries, and box
pews.

MIDDLETON HALL. 1 m. s. Now the National Botanic Garden
of Wales (*see* below). The mansion was burnt down in 1931 and
demolished, and the park was subdivided into starter farms
owned by the county council. The imaginative vision of the
National Botanic Garden is rescuing the surviving built
features and making possible the restoration of the designed
landscape.

There was a C17 house 500 yds to the E, home of a junior
branch of the Myddletons of Chirk Castle. The estate was pur-
chased in 1789 by Sir William Paxton who had been Master of
the Mint in Bengal and established an agency there that
became a merchant bank on his return to London in 1786.
A new mansion was built 1793–5 by *S. P. Cockerell*, the grand-
est in the county, together with appropriate stables and
outbuildings, as well as the memorial tower to Lord Nelson,
Paxton's Tower (*see* below). The park was laid out by *Samuel
Lapidge*, with the engineering of the water by Paxton's agent,
James Grier. A chalybeate spring in the grounds gave rise to
a brief effort to create a spa, with accommodation in the
village. Paxton, with Cockerell again, built the sea-water baths
and assembly rooms at Tenby, Pembs., in 1805. He spent
lavishly on election to Parliament in 1806–7, but local opposi-
tion was such that he gave up the seat. On his death in 1824,
the estate was sold to E. H. Adams, with a Jamaican fortune,
and his family, restyled Abadam, owned it until the early
C20.

Paxton did not choose the exotic orientalism used by Cock-
erell for Warren Hastings' house, Daylesford, of 1789, but
rather a pure Palladian harking back to Lord Burlington. This
at least was true of the five-bay garden front with a giant
pedimented Ionic portico and three Palladian ground floor
windows with the over-arches found at Chiswick House (and
Carmarthen Guildhall). The entrance front, of seven bays, by
contrast was oddly mannerist with the superbly confident
device of broad stone stairs rising right through the front wall
under a Palladian opening whose detail was far from the
Anglo-Palladian tradition. The columns and square outer
piers had deep bands of icicle-work, and the arch was framed
with lush cornucopiae spilling flowers and fruit onto the outer
cornices. The interior was planned with the apsed staircase hall
at right-angles to the entrance hall (as Nash had done at
Ffynone, Pembs. in 1792). The entrance hall had heroic Roman
trophies of arms on the walls and giant fluted pilasters, and
the dining-room had Neoclassical arcading with antique-style
grisaille panels. There was a round bedroom over the front
door.

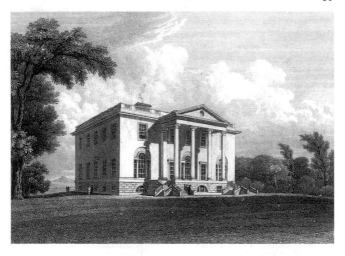

Middleton Hall.
Engraving after J. P. Neale, 1818

The house stood on an eminence looking down over the chain of lakes running to the W and S. To its N was a detached service block (now Principality House) and down the slope further N again was the large stable courtyard, also by *Cockerell* save for the rear range, not shown on the 1824 sale map. To the NW are the very large walled Gardens. For all of these *see* below. The two main bridges over the lakes have gone, but at the extreme E end in the woods are a stepped CASCADE and a fine single-arched BRIDGE and a DAM.

NATIONAL BOTANIC GARDEN OF WALES

The idea of a national botanical garden came from William Wilkins, founder of the Welsh Historic Gardens Trust. The implementation of so ambitious a project, nothing less than a botanical garden of world class for the twenty-first century, depended on the sudden availability of large funds from the National Lottery for capital projects, and the desire of the Millennium Commission to leave a lasting legacy of the millennium year. The availability of funds for building projects but not for running costs explains both the extraordinary achievement and recent extraordinary frailty of the project. The cost of some £44 million was raised with the backing of a large grant in 1996, and the major part of the garden was ready for opening in 2000. The Middleton Hall park, of 586 acres (237 hectares), owned by the county council, gave an unrivalled start: the potential for a major botanical garden within a reinstated fine C18 landscape, and the space for new woodlands and wildflower meadows. The subsequent history has been turbulent, as the maintenance of a fully staffed scientific botanical institute on cash from visitors proved

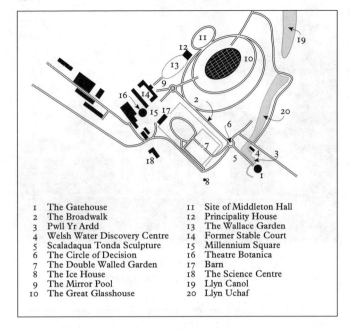

1	The Gatehouse	11	Site of Middleton Hall
2	The Broadwalk	12	Principality House
3	Pwll Yr Ardd	13	The Wallace Garden
4	Welsh Water Discovery Centre	14	Former Stable Court
5	Scaladaqua Tonda Sculpture	15	Millennium Square
6	The Circle of Decision	16	Theatre Botanica
7	The Double Walled Garden	17	Barn
8	The Ice House	18	The Science Centre
9	The Mirror Pool	19	Llyn Canol
10	The Great Glasshouse	20	Llyn Uchaf

The National Botanic Garden.
Plan

impossible. At the time of writing, 2006, the great project is making progress again but reduced to a small staff and the future plans – the restoration of the chain of lakes and the planting of woodlands and moorlands with species from climatically similar areas of the world – are delayed. The restoration of the double walled garden is a hopeful sign of recovery.

The tour begins at the GATEHOUSE by *Norman Foster & Partners*, a very large circular canopy on thin metal posts, boarded on the underside and dished to a central twelve-sided cone of glass down which rainwater runs. The panes have the repeated number 33,798, the number of species endangered in 2000. The cone design is by *Marion Kalmus*, 2001. The canopy shelters low boarded curved ticket office and toilet structures.

From here begin the gardens themselves, planned by *Hal Moggridge* of *Colvin & Moggridge*. The original contours still define the site, and the new work displays a Neoclassical liking for formal interventions in an informal frame. The plan plays down the Great Glasshouse, whose enormous scale could have become a single over-dominant element. It is not placed centrally, but rather to the r. of the main axis, appearing as the glass top to a rounded green hill. The main focus is the Broadwalk, that runs avenue-like from the Gatehouse to the top of the site, punctuated in a formal way with fountains. The hard

surfaces are particularly well handled, using different gravels, coloured granites and cobbles.

The Broadwalk runs level past the GARDEN POOL (Pwll yr Ardd), the smallest of the chain of lakes of the park, and the first to be restored. On the far side, AQUALAB, a set of teaching spaces, designed by students at the *Welsh School of Architecture* as three linked painted timber pavilions jettied over the pool. The aesthetic is lightweight and playful, but the pyramid roofs give a classical distinction. Bisected by the boardwalk is SCALA D'AQUA TONDA, a water sculpture by *William Pye*, two stepped curves of sandstone ashlar, each step a basin with brass water-spout discharging to the next.

Where the Broadwalk begins to rise the subtle way in which water is used as a linking element becomes apparent. A winding shallow stream or rill runs down the length in sinuous curves from a fountain at the top to a circular basin at the foot, the curves emblematic of the Tywi valley. The rill is prettily inlaid in small beach cobbles of black and white, and edged in pink granite. The proportion of black to white cobbles subtly changes, and the rill disappears underground and reappears at one point. The CIRCLE OF DECISION, at the base of the walk, has a classically simple sandstone fountain basin, set in a sur-round of white cobbles outlined in pink granite, through which the rill is spiralled inward, the whole shape based on that of an ammonite.

The path ascends flanked on the l. by a very long herbaceous border, along the outer side of the DOUBLE WALLED GARDEN, a survival of the 1790s. The scale of the garden is impressive, the outer wall encloses some three acres (1.2 hectares), with presumably orchards at the upper end and, at the lower end, an inner brick-walled garden of less than half the area. The inner garden has been quartered into different areas, each with a distinct paving character. At the outer SW corner, conical stone gatepiers, and a curved wall for an apiary. Just beyond the SW corner is a late C18 ICE-HOUSE, brick-lined, entered by a right-angled passage with two doors to pre-serve the temperature.

Returning to the Broadwalk, on the r. the rill diverges to link groups of ROCKS, naturally disposed, that represent a chro-nology of the geology of Wales, the earliest pre-Cambrian gran-ites at the foot to the most recent Upper Carboniferous sandstones at the top, a piece of didacticism that is delightful.

At the top of the Broadwalk, a route diverges r. to the Great Glasshouse, and the source of the rill proves to be the MIRROR POOL, a large circular basin, dry-stone walled with red sand-stone coping, the lip cut back to give a curved cascade. For the Great Glasshouse, *see* below. Behind, the final subtlety of the landscaping is revealed, the sweeping views from the site of Middleton Hall over the Tywi valley and up to Paxton's Tower. This highest point of the site has been left open, with the ground plan of the mansion laid out in grey granite. To the l. is PRINCIPALITY HOUSE, the former detached service

range, restored as a learning centre. Two-storey, colourwashed
yellow with new balustraded parapets replacing hipped roofs.
The WALLACE GARDEN to the l. was a walled kitchen garden,
highly unusual in its oval shape, now enhanced by beds to a
double-helix pattern. Below, on axis, is the large two-storey
STABLE COURT, *c.* 1795 by *S. P. Cockerell*, restored by *Austin-
Smith: Lord*. Cockerell's design deserves study for its minimal
Palladianism: the centrepiece has a tall arch under a blind attic
with pediment, flanked by half-pedimented lean-tos, echoing
Palladio's church fronts. The detail is pared down, grey stone
against white render, and the functional nature of the complex
is proclaimed at the very pinnacle, with dove-holes in the pedi-
ment. The centre projects, each side are plain single-bay wings
and hipped outer pavilions, the ends of the side ranges. These
side ranges were not attached to the long hipped range that
encloses the back of the courtyard, but have now been joined
by full-height glass links: an entrance lobby on one side, and
the restaurant on the other. Within the courtyard, purple stone
five-bay arcade with grey stone band and voussoirs. To the side
of the stable range is MILLENNIUM SQUARE, a big granite-
cobbled formal area flanked on the l. by a converted small barn
(backing onto the Double Walled Garden) and at the back by
THEATR BOTANICA. This is a circular auditorium of Japanese
simplicity, white roughcast with grey stone and low conical
slate roof. The banding is subtle: the plinth and band in grey
granite, then a dark copper recessed ring under the eaves, and
the roof itself is banded, in lead, once for the gutter and three
times on the slope.

Behind on the hill is the SCIENCE CENTRE, 2003, not yet
in use. Two glass-fronted storeys with overhanging balcony and
flat roof, between rubble stone end walls, and the front split,
in homage to Frank Lloyd Wright, by an off-centre deep stone
pier. To the N are the various buildings connected with the
operation of the gardens including an ecological WASTE-
RECYCLING PLANT and a BIOMASS FURNACE for heating the
Glasshouse and buildings.

123 THE GREAT GLASSHOUSE. Designed 1995–6, built 1997–9 by
Norman Foster & Partners. The statistics are impressive: it is the
largest single-span glasshouse in the world, 110 metres long
and 60 metres wide, the roof of 4,500 square metres covers
3,500 square metres, but the initial impression is not of gar-
gantuan size. The glasshouse lies in the landscape, smooth-
bellied and low, as most of the interior is below the level of the
visible rim, and the dome is tilted by seven degrees for sun-
light, which aligns it with the slope. The roof, an 'elliptical
torus' is carried on twenty-four tubular elliptical arches, span-
ning a widest breadth of 55 metres, and a length of 95 metres.
Externally the arches read as ribs, with the lines of the glazing
giving a secondary longitudinal emphasis. Being embanked,
the main entrances are between high splayed walls, reminis-
cent of the passage entries of prehistoric tombs. Inside, the tilt
of the roof brings the exterior landscape into view, a nice jux-
taposition. The roof is set on an oval concrete rim, carried at

the back on raking concrete piers, giving a broad slate-paved walkway beneath, backed by a white curving wall for displays, and with small exhibition and utility rooms behind. The tubular arches have steel ball-and-socket joints at the ends, for expansion, unexpectedly delicate.

The interior landscaping by *Kathryn Gustafson* replicates an arid landscape, for this is not a tropical house, displaying as it does the plants of Mediterranean climates: of Europe, South Africa, Australia, California and Chile. The space is bisected by a canyon, sloping down between terraces, then cranked to reveal an unexpected cliff-walled pool, fed from water escaping from fissures in the rock. The cliff faces are of ashlar, tooled and stepped like sedimentary rock strata, or smooth with incised cracks, the juxtapositions startling, not replicas of nature at all, indeed suggesting Piranesian ruins. The stone is a pale, fine-grained sandstone from Germany that colours well in changing intensities of light. This artificial gorge is an extraordinary conceit that almost works: as with C18 folly ruins, scale finally tells – the depth is not quite enough, and the end comes too soon. However, future plant growth may blur visible edges and enhance the illusion. The long ramp down has stepped planting beds each side, and others cover the top each side, varying the degrees of shade available. The beds are of pale brown scree, enhancing the hot and dry landscape. Temperatures are controlled from roof vents and a heating system powered by biomass fuels. Irrigation is from water collected off the roof in tanks below.

PAXTON'S TOWER, ½ m. SE. One of the major follies of Wales, 62 a hilltop eyecatcher for many miles along the Tywi valley, designed to close the view from Middleton Hall. Built in 1808 by *S. P. Cockerell* for Sir William Paxton, in memory of Lord Nelson. A triangular tower in grey-brown stone, with taller round angle turrets, and a higher hexagonal top stage with arched openings on each face (now blocked). Corbelled embattled parapets everywhere, and corbelled parapets over the battered hexagonal bases of the angle turrets. Each side has a large open Gothic arch in red sandstone, with a hood-moulded three-light window above, and then a blank plaque, to which inscriptions in honour of Nelson were affixed. The banqueting room had Gothic plaster vaulting, of which fragments remain, and three small painted glass scenes of Nelson's life, death and 'apotheosis', copied from paintings, now in Carmarthen Museum. Bought in 1964 by Viscount Emlyn to give to the National Trust. It was badly damaged by lightning, and then well restored, with an inserted stair, completed in 1972.

RHYDARWEN, 1½ m. ESE. Near the Tywi, with views across to Dryslwyn Castle. Though not large, a puzzling and complex medieval house of two halves, each with an open-roofed first-floor room of considerable importance. Leaded lights have replaced C19 sashes. The E half appears to be the earlier: a solar range at the lower end of a hall on the site of the w half, which was rebuilt in the late C15. C18 alterations, particularly to the

floor levels, further cloud the picture. The E part has three bays, with a short projecting N wing, containing a large transomed window of two trefoiled lights, late C14 or early C15. A massive gable chimney supercedes a lateral chimney on the front wall. The taller W range is also of three bays, the entrance in the E bay, the W bay projecting slightly, as a kind of oriel. Huge lateral chimney on the rear wall, with a two-light first-floor window to the W, the arched lights probably C16. A later range to the W has been demolished. Entrance passage, with simple late C18 stair. Four-centred C15 doorway into the E range, the floor of which was excavated in the C18 to provide three floors, the new ceiling cutting across the transomed window. In the chamber above, the chamfered jambs of the former lateral fireplace(s) are visible, indicating an important upper room, confirmed by the splendid open collar-truss roof with chamfered blades and collars, one of the collars with a boss. Traces of wall paintings to the W. The W range has been similarly subdivided. Large ground-floor chamber with a later C16 ceiling, the massive beams with elaborately shaped stops. Lateral fireplace with timber bressumer. There was a first-floor hall, but an inserted floor hides the open arch-braced roof of four bays, the trusses quite plain, with a continuous chamfer to blades and collars. Similar trusses survive at Cwrt Brynybeirdd, Carreg Cennen, and Derwydd, Llandybie.

35 The most remarkable survivals are the two finely carved Tudor door-heads, re-set over doors off the landing of the W range, clearly from a lost screen. Highly carved on all four sides, three have detailed coats of arms at the outer ends of the spandrels while the fourth has remarkable portrait profiles of a man and a woman, presumably the owners. In between and below these are various animals and birds (a pelican and an owl), a huntsman, foliage, a vine and a Tudor rose. Rhydarwen was the home of Margaret, a daughter of Sir Rhys ap Thomas of Dinefwr, and her husband Henry ap John, mayor of Carmarthen 1502 and constable of Dryslwyn Castle 1514–20. One shield has Sir Rhys's arms, with the Garter, which he was awarded in 1505. So the house was presumably commissioned by him. The other heraldry is personal to him: Henry ap Gwilym, of Court Henry, his father-in-law and Sir William Stanley, a close ally. A shield with two lions may represent his patron, Henry VII. The hall also has traces of wall paintings imitating tapestry, of the C16, when the floors were inserted. At the E end, intimate single-storey additions around a tiny courtyard, by *Donald Jones* of Llandeilo, *c.* 1990.

BREMENDA ISAF, 1½ m. W. Small Cawdor estate model farmhouse, the plans watermarked 1817, in the hand of *J. P. Pritchett* of York. Two storeys and bays, with little gables, originally over hoodmoulded casements, hipped roof, and a broad rear chimney. Much altered.

CLEARBROOK HALL, 2 m. S. Originally a dower or agent's house to Middleton Hall, built 1843, in a muddled style suggesting an amateur, possibly *Edward Abadam* of Middleton. As built it

Rhydarwen, door-head.
Engraving

mixed simplified classical pilasters with Tudor hoodmoulded windows of odd proportions across a front of three bays and two storeys. All this has been modified but the parapet survives, raised over the centre for the Abadam arms, and the diagonal chimneys. A tiny wing on the back has a curved lead roof. Behind is a three-bay hipped stable block with arched windows.

HEOL-DDU, Foelgastell, 3½ m. s. An exceptional c18 gentry farm group. The principal house is dated 1743, a second house, offset a few yards behind, 1773, the cow-shed on lower ground 1747, the stable 1758 and the barn, on highest ground, 1776. The estate of two successive Philip Lloyds, the younger one, agent to the Golden Grove estate, was probably the builder here. He was a prominent supporter of local education and Nonconformist causes. Straightforward and characterful buildings in limewashed rubble with rough quoins, small windows and big chimneys. The main house is of three bays and two storeys, with a lower single bay addition to the r., its big end chimney surrounded by pigeon holes. A lower range behind has an even bigger bakehouse chimney. Inside, a dog-leg stair with turned balusters and moulded rail, simple doors, and pegged collar-trusses. The secondary house must represent an expanding household. Very similar, but derelict after long farm use. The window openings are just a bit bigger than on the parent house. Behind the barn, several walled garden enclosures.

LLANBOIDY

2224

There is an estate village character to Llanboidy, the legacy of W. R. H. Powell of Maesgwynne, 1819–89, philanthropic landowner, legendary sporting squire and latterly a popular M.P. At the s entrance to the village, the imposing MAESGWYNNE ARMS, built as a hotel c. 1855 for visitors to the Llanboidy Races – a full fixture in the racing calendar, Powell having laid out the course sw of the village. Squared stone, five bays, with two tall gables flanking a lower and narrower projecting centre one, and

a large wing set back on the N. Perhaps by *John Phillips*, local builder. The hotel is at an oblique angle to the road, inviting the eye on up towards the village centre. On the l., the MARKET HOUSE, 1880–2, large enough for a small town, and allegedly paid for by Powell from a Derby-winning bet. By *George Morgan*, in a characterful Gothic, with broad roof and a slate-spired lantern. The low seven-bay front is banded in brick, and there are metal-traceried round windows in the gables. In front, a pink granite FOUNTAIN, 1890, commemorating Powell's last gift – the village water supply. Next, the plain rubble stone former BUTTER FACTORY, adjacent to which were a coffee tavern, a reading room and the office for the Llanboidy Agricultural Society, all now housing. Next, Trinity Chapel on the l. and the road sweeps round the church on the r. At the top of the village, PICCADILLY SQUARE opens unexpectedly on the r., a small courtyard of estate houses by *Morgan*, *c*. 1880, the community effect depleted by alterations. SPENCER HOUSE, beyond, is stuccoed with simple Tudor windows of the 1840s sort, but a date of 1867 was found inside. Opposite is the school.

ST BRYNACH. Much rebuilt in 1878, by *George Morgan* for W. R. H. Powell. Nave and chancel with transepts and w bellcote. w porch and N vestry of 1878. Morgan's Bath stone windows are crudely fitted into earlier openings, perhaps of the 1840s, the date perhaps of the four-light chancel s window. In a blocked s door, an INSCRIBED STONE, the C6 inscription eroded but read as MAVOHO FIL CUHARCH COCC. Inside, thin timber roofs. – Gothic FITTINGS of 1878, including the reredos, rails and stalls, also the octagonal FONT. – PULPIT, timber C19, bought from a closed church in Norwich. – STAINED GLASS. s transept window, 1849, by *Joseph Bell* of Bristol, one of the first in the region. Simple figures on vivid blue. Two transept side windows of *c*. 1880, routine, but the N transept two-light, also 1880s, is finely drawn. – MONUMENTS. Pedimented plaque in three colours of marble to the Powells of Maesgwynne, *c*. 1789. W. R. H. Powell Sen. †1834, by *Tyley* of Bristol, Neo-Grec.

In the churchyard, eroding white marble MONUMENT to W. R. H. Powell, 1891, by *W. Goscombe John*, his first major commission. Scantily draped female figure, either Truth or Despair, leaning, abandoned to grief, against a wall. The emotion is palpable, if disproportionate to the death of a sporting squire of mature years. The pose was reused for the Arthur Sullivan memorial, London, 1903.

TRINITY INDEPENDENT CHAPEL, Llanboidy. Hipped square chapel of 1848, altered in 1869 by the *Rev. Thomas Thomas*, and with stuccoed gabled front of 1903. Slate-hung sides and rear. The interior is probably of 1903. Gallery with scrolled cast-iron panels. The exceptionally broad curved pulpit platform backs onto an Italianate stucco feature of three arches (the pulpit-back and two windows), in a big three-bay corniced balustrade.

PRIMARY SCHOOL, Llanboidy. 1863–4, for W. R. H. Powell. Livelier than the Board Schools of the next decade. T-plan, gable-fronted with a tiny hipped roof carried forward over the school bell, and a large Gothic window. Gothic timber side porches. The main schoolroom is across the back.

CASTLE MOTTE, SE of the Maesgwynne Arms. Round C12 motte with bailey to the NW.

CEFNYPANT INDEPENDENT CHAPEL, Cefnypant, 2 m. N. 1873, by *John Humphrey*, an economical version of his chapel at Llansadwrn. Rock-faced stone with flush bands, and four narrow arched windows. Minimal Romanesque corbelling in the gable, over a quatrefoil of just four punched roundels. Gallery with long panels over vertical boarding. Heavy chamfering and geometric decoration on the pulpit.

CWMFELIN MYNACH BAPTIST CHAPEL, 1½ m. NE. 1905–7, by *Morgan & Son*, rendered gable front, quite large.

MAESGWYNNE. 1 m. W. Demolished. It was a five-bay hipped house with verandas each side of an enclosed hipped porch, built c. 1830 for W. R. H. Powell Sen. His son had a circular riding school, ranges of racehorse and hunter stables, carriage-houses, and kennels for hounds, terriers and spaniels, but little of this village-sized complex remains. The round LODGE of the 1840s was thatched. There was a similar one nearby at Glyntaf, now gone. Gothic iron gates, by *T. Bright* of Carmarthen.

CLYNGWYNNE. 1 m. ESE. 1858. Stuccoed three-gabled house with minimal Tudor detail. Some Gothic stonecarving in the porch was by a 'grand-son of Thomas the Bridge Surveyor ... employed in the ornamental work on the new Houses of Parliament'.

NANTYREGLWYS, 2 m. ESE. Mid C19 L-plan house with overhanging gables. Minimal Tudor, with long hoodmoulded windows in pairs or threes, and a veranda. Curved staircase with square balusters.

LAN ROUND BARROWS, 1 m. NW. A row of round barrows along the road, on both sides of Lan farm.

GLYNTAF. *See* Llanglydwen.

LLANDAWKE/LLANDOCH

2812

ST MARGARET MARLOES. A tiny church charmingly set in a hollow. To be preserved by the Friends of Friendless Churches (2006). Nave and chancel with low tapering W tower. The tower is medieval, with vaulted base, but must be truncated. It was ruinous in 1710, and has a sprocketed C18 roof. The belfry lancets are of the restoration in 1882, by *Thomas David*, of Laugharne. The chancel may be C14, the inner heads of the E and S chancel windows have wave-type mouldings, and the PISCINA, with hollow chamfer, and SEDILIA with crudely carved mask-stops, are surely Dec. Perp two-light flat-headed nave S window. The nave N wall has a strong batter, and may be earlier than the C14. Inside, the narrow round chancel arch

looks C13. Door to the l. to the former rood loft, corbels of which survive. – FONT. Retooled square bowl on a round pedestal. – FURNISHINGS of 1882. – Large oak ALTAR, 1882, by a local man, *Owen Williams*, with copious carved detail, vine and angels. – In the nave, an INSCRIBED STONE, probably C6, BARRIVEND-FILIVS VENDUBARI, with HIC IACIT added in small letters, and some eroded Ogam strokes, interpreted as DUMELODONAS MAQI MU (COI . . .). – MONUMENTS. Large C14 female effigy, said to be St Margaret Marloes, niece of Guy de Brian, lord of Laugharne. The figure wears a wimple and flowing robe, the face badly eroded. Brought in from the grave-yard, in 1902, in three pieces. Good C18 slabs on the chancel floor of polished limestone. Robert Sheild †1846, shaped tablet, by *Mainwaring*. James Eastment †1852, oval by *Thomas Morris* of Pendine.

LLANDAWKE HOUSE, N of the church. 1841–2, for Lord Ken-sington. A neat villa, stuccoed and hipped, three bays and two storeys with large windows and pedimented doorcase.

LLANDDAROG

Around the church, an early C19 LYCHGATE with tunnel-like entry, and a circular POUND. The thatched WHITE HART INN, low, five bays, is probably C18, altered.

ST TWROG. 1854–6, by *R. K. Penson*, with an alien but landmark broach spire on the W tower. Penson longed to build spires and had one of his few chances here. Indeed this is one of his most complete churches, and one by which to judge his limitations. Restored 1996, by *Roger Clive-Powell*. Nave, chancel, N aisle, and S porch, with Geometric tracery and buttresses, typical of Penson. Sparse interior with arch-braced roofs, boarded in the chancel. Three-bay nave arcade and two-bay chancel arcade, the inner chamfers dying into square piers. Chancel arch on carved corbels. Richer NE chapel, of the Puxleys of Llethrllesty and Dunboy Castle, Co. Cork. A ballflower arch on triple wall-shafts and shafted windows show a touch of the High Victorian so evident in the enormous Irish house. – Octagonal FONT, on a florid carved pedestal. – Stone PULPIT, with tre-foiled shafted panels. – FURNISHINGS, by Penson, the stalls with fleur-de-lys finials. – STAINED GLASS. E window, 1895, by *Ward & Hughes*, insipid. W window, by *Janet Hardy*, 2000, industrial and rural life. Nave SW, 1995 by *John Baker*, tradi-tional. Nave S centre, 1979, by *John Petts*, the Tree of Life, clear glass for the trunk and boughs, graduating to pinks and oranges (cf. Llanllwch). Nave SE, *c.* 1952, by *Celtic Studios*, con-ventional. – In the chapel: E window, 1908, by *T. Curtis* of Ward & Hughes, two N windows, 1903 and 1927, by *A. L. & C. E. Moore*, and a third, 1933, by *Powell*. – MONUMENT. Henry Lavallin Puxley †1828, draped urn, with palm fronds, by *Tyley* of Bristol.

VICARAGE. 1884, by *David Jenkins*. Half-hipped gable, with a sadly truncated entrance tower to one side, once conical-roofed, and so showing unexpected panache for Jenkins.

CAPEL NEWYDD (Calvinistic Methodist). 1903, probably by *J. H. Morgan*. Simple front with a narrow triplet and tall outer windows. Gallery with turned balusters.

PRIMARY SCHOOL. 1852, built as the National School. Neatly symmetrical, of colourwashed stone, with central gable and end porches. Tudor labelled windows.

CAPEL BEGEWDIN, 2m. SE. A medieval well chapel, probably C14, like the slightly larger Capel Erbach, Llanarthne, 1m. E, of similar large squared masonry. Both gables survive to full height, the W one with double-chamfered door, two-light C15 window with a flat head, and ruined bellcote. Well within.

LLETHRLLESTY, ¾ m. S. Early C18 double-pile house of two storeys and three bays. C19 detail, including an arched window over the door. Purchased in the earlier C19 by the Puxleys of Dunboy Castle, Co. Cork, who owned the Berehaven copper mine there and were interested in minerals here. An outbuilding with massive chimney is the remnant of the C16 to C17 house of the Penrys and Vaughans.

LLANDDEUSANT

Large upland parish bisected by the upper Sawdde valley and extending to the remote and romantic lake, Llyn y Fan Fach, under the highest part of the Black Mountain. The church is on the ridge S of the Sawdde, the meeting point of many ancient tracks.

SS SIMON & JUDE. In a round churchyard. Double-naved medieval church, the N nave possibly C14, but remodelled when the S nave was added in the late C15. The truncated gabled W tower may be C16, the detail all renewed. C15 windows, of red Sawdde stone, with flat heads and hood-moulds. Late medieval four-bay arcade, on octagonal piers without capitals, and two fine panelled barrel roofs, with moulded ribs, like those at Myddfai, but more typical of Breconshire. Curious baulks of timber laid across the arcade wall-head to appear like corbels each side. Well restored, for Howel Gwyn of Neath, 1885–6 by a 'London architect', but surely not his usual choice, John Norton. – FONT. C15, octagonal, in conglomerate stone. – FURNISHINGS. 1885–6, neatly designed. – STAINED GLASS. E window, 1885; N aisle two-light, *c.* 1900, by *Robert Newbery*, with more colour than usual. – MONUMENTS. John Lewes †1813, oval tablet; Mary Lewis †1834, veined marble with sarcophagus, by *Thomas & Son*, of Brecon.

TALSARN CALVINISTIC METHODIST CHAPEL, 1m. NNE. 1860. Minimal Gothic long-wall façade, in blue stucco. Four narrow pointed windows, and pointed arches over two doors. Steeply raked painted grained box pews inside.

TWYNLLANAN CALVINISTIC METHODIST CHAPEL, 1½ m. W.
1827, remodelled 1910. Externally plain, but inside attractively
varied panelling to the gallery, great seat and pulpit. Some
stencil patterns in the deep-coved ceiling.

BLAENSAWDDE, ¾ m. S E. A largely C17 minor gentry house. The
date is suggested by the N gable stack with diagonal shafts.
Cruciform, a two-room main block with single-room lower
wings in each direction off the S end. The S chimney of the
main part has a fireplace open to the S, so the S wing may be
earlier. In the main range heavy beams, and a post-and-panel
partition upstairs, with C17 scratch mouldings (there was
another similar downstairs). There is a N end winding stair,
and there was another in the SE corner. Long BARN dated 1834.

LLWYNFRON, 1 m. SW. C17 farmhouse with lateral chimney and
heavy chamfered beams, but otherwise altered in the C19.

AROSFA GARREG ROMAN CAMP, 2 m. NE. (SN 802 264). A large
marching camp, probably contemporary with the camp at Y
Pigwn, Myddfai, to the N, c. 75 A.D. Though difficult to trace
the size of the enclosure is remarkable, a rectangle of 18 ha.

LLANDDOWROR

Bisected by the main Tenby road. At the N end, the plain stone
OLD RECTORY, 1869, by *Thomas David*. By the rugby pitch, just
W of the church, two small C9 or C10 INSCRIBED STONES, with
crosses in sunk panels. Up the footpath, 300 yds (274 metres) N,
is a STANDING STONE. S of the church on the W side of the road,
PICTON HOUSE, earlier C19, stuccoed villa, of three bays, with
outer piers ornamented with sunk Gothic panels and crosses.
Chimneys to rear. Further S, TALFAN, a well-preserved early C19
single-storey whitewashed cottage, formerly thatched. The casing
of the small windows is coloured and the sashes white, a tradi-
tional scheme.

ST TEILO. Well-proportioned, tall C15 or C16 W tower with
splayed base, S stair-turret and original W two-light window
with hoodmould. The rest is of 1865, by *Thomas David* of
Laugharne. Nave, chancel, S porch and N vestry, in red sand-
stone with Forest of Dean dressings. Repaired in 1901, by *E.
V. Collier*. Scissor-truss nave roof, elaborated with arch braces
in the chancel. Tall moulded chancel arch, 1901, on triple
granite shafts. – FONT. Octagonal, late medieval, quatrefoil
panels with shields and flowers. – FURNISHINGS. In the nave
by *David*: pews with big pegged joints, and Bath stone pulpit.
In the chancel by *Collier*: stalls and reredos. – STAINED GLASS.
Good E window, 1901, by *A. J. Dix*, Good Shepherd. – MON-
UMENTS. John Dalton †1724, limestone tablet. Rev. Griffith
Jones †1761, rector, and renowned educationalist, as founder
of the Circulating Schools c. 1730, and a major figure also in
early Methodism. An excellent later C18 piece – white marble
on a veined background, and an open curved pediment with

Llanddowror Church.
Engraving, *c.* 1870

books above. Delicate side scrolls, gadrooning below, and a winged cherub head. – In the chancel, a memorial slab to Jones, re-set on an arcaded base. Bridget Bevan †1799, Jones's wealthy and tireless supporter, the 'Madam Bevan' of the Circulating Schools. Marble, by *D. Mainwaring*, 1837, with urn on pedestal, pilasters with torches, and a big shield: all a little uncertain. Good cast-iron churchyard GATE, by *W. Baker* of Newport, *c.* 1875.

TABERNACLE CALVINISTIC METHODIST CHAPEL. 1842, restored 1934 by *Isaac Jones & Sons*. Attractive, with tall, marginally glazed centre windows and outer porches, of 1934. Traditional interior, although of 1934. Gallery with canted angles, pews with doors, and a broad panelled pulpit.

CWMBRWYN, 2m. s. (SN 254 122). An embanked farmstead of the Roman era, dated to the C2–C4.

LLANDEILO 2262

A compact town set high above the N bank of the Tywi, historically the second town of the county. St Teilo, who may have been buried here in the C6, was the focus of a considerable cult. The monastery he founded had, by the C7, a surprisingly large estate of some 6,000 acres (2,430 hectares). The C8 Book of St Teilo was kept (though probably not written) here before it found its way to Lichfield in the late C11, and the carved stones in the church indicate a religious community in the C10. The town, being near to Dinefwr Castle (*see* Dinefwr), the seat of the princes of Deheubarth, was affected by their fortunes, though it was distinct from the medieval town of Dinefwr. Llandeilo passed to the Bishops of St Davids after the Norman invasion, was attacked

and destroyed in 1213 by the Welsh, but grew after the Edwardian conquest of 1277. The 'villa de Lanteilo' is mentioned in 1304, and by 1326 there were thirty burgage plots. A bridge is mentioned in 1289. The early settlement was probably around the church. The town was burnt in 1403 by Glyndwr, but by the C15 had surpassed the declining Dinefwr.

The town grew rapidly through the C19 from small beginnings. Access up the steep hill from the old bridge was a long-standing difficulty, exacerbated by the climb around the large churchyard. By 1815 a road had been made across the churchyard, widened and improved when the new bridge was built in the 1840s. The attractive line of houses climbing the hill on Bridge Street took shape early in the C19, the long views improved by the removal of cottages opposite. This is still the memorable image of the town. The three local estates, Dinefwr, Golden Grove and Derwydd, played a large role in developments. Before 1805, *Thomas Bedford*, architect from London, had settled here, to work in the area for a decade, although individual buildings in the town by him have not yet been identified. The general character is now Late Georgian to Late Victorian.

St Teilo. In a very large churchyard, bisected by the new road in the early C19. C15 or C16 w tower, with typical splayed base, and rebuilt battlements. Perp two-light belfry windows with straight heads, and another two-light on the N side. The tower was restored in 1883 by *Ewan Christian*. The rest was rebuilt in 1848–50, by *George Gilbert Scott*, in simple Dec style, in hard grey limestone. Fifty-two architects entered the hopelessly organized competition of 1846 for a large Gothic church at under £3,000. *Edward Davis* of Bath won with a peculiar Norman design, which now hangs in the church. This was rejected as not being Gothic, and it was found that no competitor had achieved the size requested within the sum. In panic the judges turned to Scott, who had not entered. Scott's estimate was £2,500, but no contractor would take the job at the price. The final cost was £4,723. *John Harries* of Llandeilo supervised on a day-rate basis. Minor alterations in 1904–5 by *David Jenkins*.

Nave, chancel, parallel-roofed N aisle, small S transept and N porch. Dec windows, some of grey limestone, no mean feat of masonry. Low buttresses. Organ chamber on the S side added 1905. The interior is disappointingly thin. Six-bay arcade on octagonal piers, and chancel arch on plain corbels. Arch-braced nave roof, ribbed and boarded wagon roof in the chancel. The aisle was crudely walled off in 1979 but has been carefully subdivided, 2003–5, by the *Regan Norris Partnership* of Carmarthen, for a meeting room, over office and service rooms. The upper part of the arcade has been left open with a glass balustrade, so that light still flows to the nave. A gallery has been added across part of the back of the nave – CARVED STONES. Found during the rebuilding. The heads of two fine

small CROSSES, C9 or early C10, with square ends to the arms
and square ring around (possibly a local variant of the Celtic
wheel-head). Both are decorated with plaitwork, and are
carved back and front. – FONT. Octagonal, by Scott, 1850. The
old font bowl survives, late medieval, octagonal. – Bath stone
PULPIT, plain PEWS, by Scott. – Oak STALLS, 1905 by *Wake
& Dean* of Bristol, for *Jenkins*. – Stone REREDOS, 1895, by *E.
Loftus Brock*. – ORGAN. The case of the early C19 organ by
Postill of York, survives. It is said to have come in 1857 from
Ripon Cathedral. Delicate Regency Gothic, with crockets,
cresting and cusping. The works were replaced by *Vowles* when
it was moved in 1905. – ALTAR CHAIRS. A pair of imposing
Gothic chairs with traceried backs and flame like crockets,
by *John Davies* of Carmarthen, 1850. – STAINED GLASS. E
window, 1921, by *Powell*, with saints, and small scenes, chancel
S, 1912. Nave W to E: Nativity, 1909, by *Kempe & Co.*, crowded
scene across three lights, in muted colours; St Luke, 1869, by
Wailes, strong colours; and Christ Teaching, 1877, possibly also
by *Wailes*.

MONUMENTS. A fine slab to Morgan Jones of Tregib †1580,
carved in strong relief with detailed heraldry and motto (await-
ing re-siting 2006). In the chancel, a large illegible early C18
monument, two tablets divided by Corinthian pilasters, under
a wide curved pediment. Catherine Rice †1717, Doric pilasters
and triglyph frieze, a pediment possibly missing. Careful italic
lettering. By *John Randall* of Bristol. George Rice †1779,
weeping woman and urn. Lady Dynevor †1793, Grecian lady
placing a lamp on an altar, a fine work by *John Bacon*
Jun. Rev. Walter Owen †1797, wreathed urn. Althea Park
†1808, black marble with arched top. Sarah Francis †1812, with
long inscription, also to Mary-Anne and Hannah Griffiths,
'awfully hurried into eternity' when their carriage plunged over
the bridge in 1840. Rev. Thomas Beynon †1833, large white
marble tablet with tapering fluted sides, and urn, by *Daniel
Mainwaring*. Catherine Lewis †1840, by *John Mainwaring*,
Daniel's nephew. Wide tablet with mushroom-like palm.
Captain George Hughes †1854, large Grecian tablet, a woman
and urn, with drooping palm. Rev. John Griffiths †1878, brass
figure on slate. There are sadly no memorials to the C17
Vaughans of Golden Grove, then Earls of Carbery, whose
vault is under the E end of the N aisle.

ST TEILO'S BAPTISTERY, Church Street. A large recess in the
churchyard wall gives access to the ancient holy well, formerly
the chief water supply of the town, unhealthily filtered through
the graveyard. A grille covers the end of a stone-lined tunnel
running back some 20 yds (18 metres) to the well, a little NE
of the chancel, in a small corbelled stone square chamber of
considerable antiquity. Was it originally open to the church-
yard? It is now at least 6 ft (2 metres) below.

CAPEL NEWYDD (Independent), Crescent Road. 1901–2, by
Henry Herbert. Large and minimally Gothic, like Gwynfryn,

Ammanford. Sandstone and ashlar, including the tall shafts with stumpy pinnacles. Three-sided gallery with elaborately panelled front, stepped down to the rear organ gallery, the organ set in a tall pointed recess.

EBENEZER BAPTIST CHAPEL, Crescent Road. 1877, by *George Morgan*. An economical N Italian Romanesque. Three giant arches, a big centre wheel window, and simple traceried side windows. Three-sided gallery and heavily beamed roof. Schoolroom, 1899, by *G. Morgan & Son*.

SALEM CALVINISTIC METHODIST CHAPEL, New Road. 1873, by *Richard Owens* of Liverpool. Brown stone with painted ashlar. Strongly composed winged façade, a relatively early example of this later C19 form, with Owens's mix of round-arched Italianate and plate-traceried Gothic (cf. Tabernacle, Aberystwyth). Big traceried roundels in the main window heads, and a colander version in the gable. Less intense interior: the galleries with long panels divided by fluted pilasters, the pulpit with arched column-shafted panels, and a flat plaster ceiling with roses.

WESLEYAN CHAPEL, Latimer Road. 1900, by *J. W. Jones* of Llandeilo. Now divided into houses. Conventional Gothic in stone but an entertaining octagonal tower with a candle-snuffer roof to one side.

SHIRE HALL, Carmarthen Street. Now Cambria Archaeology. Hardly sited to impress, in this steep narrow street. Built in 1802 by *Thomas Humphreys* of Carmarthen, as a hall for Quarter Sessions over an open market. A more elaborate design by *William Jernegan* was abandoned when the committee offended the architect. Successive county surveyors made changes through the C19 and nothing is discernible of the original save two iron columns within. In 1901, *David Jenkins* remodelled the front heavily but without panache. Rusticated ground floor with arched windows, a porch with blocked columns and balcony, and part-fluted Ionic pilasters above, under a shallow gable.

LLANDEILO BRIDGE. 1843–8, by *William Williams*, the county bridge surveyor. An extremely ambitious single arch, the third largest in Britain at the time, after the Grosvenor Bridge at Chester and the Westgate Bridge, Gloucester, with a span of 145 ft (44 metres). Massive and unadorned, with grey limestone dressings, between buttress-like giant piers. The low medieval bridge of seven pointed arches partially collapsed in 1795. A new three-arch bridge followed, possibly by *John Nash*, but parsimony allowed only a narrow structure, too narrow for carts to pass. Williams's bridge was designed to go much higher, to ease the pull up Bridge Street, but the project was well beyond his competence and that of his experienced bridge builder, *Morgan Morgan*. The entire budget of £6,000 was spent in sinking the foundations in unexpectedly soft ground. Morgan was sacked, Williams died, and *Edward Haycock* took charge in 1846. The eventual cost of what the county had nicknamed the Bridge of Sighs was £23,000.

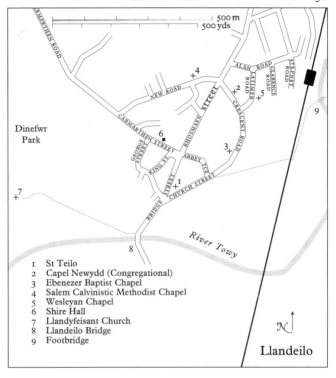

1	St Teilo
2	Capel Newydd (Congregational)
3	Ebenezer Baptist Chapel
4	Salem Calvinistic Methodist Chapel
5	Wesleyan Chapel
6	Shire Hall
7	Llandyfeisant Church
8	Llandeilo Bridge
9	Footbridge

Llandeilo

PERAMBULATION

Starting from the BRIDGE, the large twin-gabled stone house on
the l. overlooking the river is MOREB, built for Lord Cawdor's
Golden Grove agent, *c.* 1813, by *J. P. Pritchett* of York (Pritch-
ett's father was chaplain to Cawdor). Very early revived Tudor,
with mullioned windows and some hoodmoulds. The lane
running past it leads to Llandyfeisant church and into Dinefwr
Park (qq.v.). BRIDGE STREET winds up the hill with a sweep
of stuccoed three-bay houses, stepped up the slope. At the top,
the OLD KING'S HEAD, plain early C19 but of older origin,
its small front court a welcome staging post for those strug-
gling up with heavy loads. Inside, a carved stone fireplace
of the 1730s with central shell and scrolled foliage, salvaged
from Llwynybrain, Llandovery. The original main road ran
very steeply up around the large churchyard to King Street,
the former market square, and then continued up the narrow
Carmarthen Street (*see* below). The present main road was
allowed through the churchyard in the early C19, but much
widened and sunk in the 1840s, the spoil used to lessen the

gradient from the new bridge. s of the parish church (*see* above), in CHURCH STREET, a terrace of small two-storey houses, their big stone chimneys suggesting a late C18 date. They face the high retaining wall of the churchyard, halfway along which is St Teilo's Well (*see* above). Overlooking the E side of the churchyard, ABBEY TERRACE, a well-designed terrace of four, dated 1840, the outer pair projected with twin shallow bows and overhanging hipped roofs and the centre pair plain with reeded architraves and arched fanlights. The l. end house, ABBOTS HILL, was altered as aggressively as possible *c*. 1900, to display the talents of its owner, the architect, *David Jenkins*; the added parapet topped with squat red Ruabon terracotta urns. Jenkins †1907 is buried almost opposite under the white marble spired MEMORIAL. Beyond the terrace a length of high castellated garden wall divided by thin piers, the end bays with blind ogee panels.

RHOSMAEN STREET, the main street, is announced by a pair of early C20 banks. On the l., HSBC BANK, 1913, by *Woolfall & Eccles*, single-storey in sandstone ashlar, English Baroque, with big corner entry, and balustraded parapet. Opposite, LLOYDS BANK, 1910–11, by *A. E. Lloyd Oswell*, odd Baroque, in too many colours – glazed ceramic ground floor, brown sandstone above with a small tapering square corner tower, the top stage octagonal with a green-domed cupola. Dominant on the l. is the CAWDOR ARMS HOTEL, renovated 2005 and repainted a rich dark red. A big three storeys and five bays, the outer ones projecting with two-storey canted bay windows linked across the centre by a balcony over the Doric columned entry. It was the Bear Inn, owned by the Golden Grove estate, renovated for Lord Cawdor by *William Jernegan*, *c*. 1807. The façade, apart from the bay windows, echoes Jernegan's hotel at Milford, Pembs. of 1795; the wide brick chimneys are typically his. The road realignment through the churchyard brought the angled view into prominence, and the bays with big sash windows, added in the 1840s possibly by *Haycock*, allowed waiting guests a view of approaching coaches. A little on, down a narrow passage, the former HOREB chapel, 1810, enlarged forward in 1849, with entry up steps under a wooden Doric porch. Nearly opposite, another passage leads to another former chapel, of 1851, remodelled internally as a LITERARY INSTITUTE, 1892, by *A. S. Williams*. On the l. side of the main street, the first of several good mid-C19 shopfronts, with engaged Ionic columns. On the r. the former SAVINGS BANK, 1860, by *John Harries*, stone with a big Corinthian pilastered and pedimented porch. Nearly on the crest of the rise are the tall three-bay CASTLE HOTEL and the ANGEL HOTEL. The latter has the third storey in gables, but photographs of *c*. 1880 still show it as thatched and of two storeys. Next, a Regency doorcase with clustered columns, and over the brow, the lumpish three-storey former POST OFFICE, red and yellow brick, 1897–8, by *David Jenkins*. In contrast, the NATIONAL WESTMINSTER BANK, 1923, by *F. C. R. Palmer*, is a delight,

69

in Wren style, red brick and Portland stone. Single-storey, five bays, the centre with engaged Ionic columns under a balustraded parapet with urns. Tall cross-windows, with blind panels above, and a pedimented doorcase with cartouche. Quite out of place here, but a testament to the agricultural wealth still in the Tywi valley. BARCLAYS, downhill, was rebuilt at about the same time by *J. H. Morgan*, in his standard manner, with channelled ground floor and arched windows.

At the bottom crossroads, CRESCENT ROAD runs r., a new street laid out in 1854 to open up building land to the E owned by the Gulstons of Derwydd. It sweeps round past two chapels (*see* above) giving a splendid view over the Tywi before joining Church Street. Most of the detached houses are late C19 by *David Jenkins*, with shallow arched window heads and much stucco detail. Similar in the Gulston estate behind, reached through Latimer Road. The former Dinefwr Borough Council Offices, of the 1980s by *Elwyn Couser* of *Dinefwr B.C. Architecture Dept.*, on a butterfly plan, incorporate the offices of the Llandeilo Rural District Council, 1930, by *T. G. Price*, built in a domestic style with the charming idea that should they no longer be needed they could be sold as a house. Across the river below, a SUSPENSION BRIDGE of 144ft (44 metres), built for pedestrians in 1911 as a Coronation memorial by *Rowell & Co*. of London, under *A. S. Williams*.

Returning across the main road, NEW ROAD runs l., formed in the early C19 to relieve Carmarthen Street. Two large Edwardian brick and timber houses set back, by *David Jenkins*, 1905, then Salem Chapel (*see* above). Opposite on the l. a lane up to BANK BUILDINGS, Nos 13–14, an unexpectedly large five-bay, three-storey, double-pile house of the later C18, to a country house scale crammed onto a tiny site. Off to the r. from Dynevor Place is a large half-hipped VICARAGE by *Jenkins*, 1905. At the top on the corner of CARMARTHEN STREET, the barrack-like square MARKET, 1839, moved despite protests from King Street by Joseph Gulston, who then charged high rents. Built by *William Harries*, the Gulston estate builder, but the plan may be by *Haycock*. Seven by five bays with large arched openings (since blocked apart from the heads), panelled parapet and Tudor-arched entry, nicely framed in red stone. Facing this very regular square is the wildly irregular former NATIONAL SCHOOL, 1860 by *W. M. Teulon*, for Lord 85 Dynevor. Teulon, younger brother to the rogue Gothic architect S. S. Teulon, was selected as early as 1854, over Dynevor's usual architect, Penson, for reasons unknown. Brown stone with Bath dressings, in an acid and angular Gothic. Single-storey, four bays, with big twin centre gables over four-light lancets with two-tone voussoirs, and blind cinquefoils above, flanked on one side by a smaller gable with a big hipped timber porch, and on the other by a most odd tower: cross-gabled and gargoyled, the gable tops are cut off for a slated spire with open bell-lantern. *The Ecclesiologist* was surprised at the use of iron uprights between the two long classrooms. To the l., is the

MASTER'S HOUSE, formerly the Charity School of *c.* 1800, renovated in the mid 1850s for Lord Dynevor by *R. K. Penson*, with a great timber-framed storeyed porch, more appropriate to Ludlow. Past the Market, BRISKEN, early C19, L-plan, with windows in arched recesses. CYNLAIS, next door, is on a large late medieval two-bay cellar with ribbed cross-vaults on big chamfered wall-piers. The four-storey CAMBRIAN HOUSE has a good late C19 shopfront with Corinthian pilasters. Beyond is the former Shire Hall (*see* above). Opposite, HILL HOUSE, well-preserved plain late C18.

In GEORGE STREET, on r., MAESGWYNNE and MORFA, bright yellow and red brick with red tiles and timbered gables, by *Jenkins, c.* 1897, and the bulk of ABBEYFIELD HOUSE, once the George Hotel, then the vicarage until 1905, converted into a home for the elderly, 1991–4 by *Alwyn Jones* of *Penlan Design Practice*. The tall paired stone chimneys suggest that *Haycock* may have done the vicarage conversion *c.* 1840, when an upper storey was apparently removed. The five-bay former façade, to GEORGE HILL, is heavily stuccoed, *c.* 1905, clearly by *Jenkins*. George Hill runs into King Street past the DAVIES MEMORIAL HALL, 1874, a Gothic intrusion among simple rendered fronts.

KING STREET slopes down along the N side of the churchyard, the triangular space being the former market square. No. 5 was a good six-bay town house of the 1730s, known from early photographs, altered with the contemporary three-bay No. 6 in the late C19. The roof-pitch and narrow windows show the original date. No. 4 has delicate and unusual slightly Italianate stucco detail of *c.* 1860, square bays flanking a matching porch, all with balconies. At the top end of the former square, where the old main road plunges down to Bridge Street, in BANK TERRACE, the former David Jones & Co. BANK, 1887, by *J. Calder* of London. Plain but substantial three bays with emphatically iron-bound doors. The former NAG'S HEAD, to the l., was owned by the bank and remodelled in 1887, 'to be convenient for those waiting to do business', a reminder that the Jones bank was founded in a Llandovery inn. Tall early C19 houses follow, No. 5 is lower with Regency Gothic detail. The views over the large and well-planted churchyard to the Brecon Beacons are eminently picturesque. This returns one to the Old King's Head and Bridge Street.

See also Dinefwr, Ffairfach, Llandyfeisant, and Manordeilo.

3113

LLANDEILO ABERCYWYN

2 m. w of Llanybri

Just house and church on the E side of the Taf, opposite the similarly abandoned church of Llanfihangel Abercywyn, q.v., both being on a pilgrims' route to St Davids, linked by a ferry.

ST TEILO. An ivy-covered ruin in a circular churchyard. Nave and chancel in one, the chancel lengthened by some 15 ft (4.5

metres), in large squared masonry suggestive of the early C16.
Later s porch. Overgrown w end with blocked door and bell-
cote. Inserted C16 flat-headed windows with cusped lights and
hoodmoulds. Little inside: the base of the former three-decker
pulpit, and buttresses each side of the e window like short
flights of steps. Unroofed in 1957, and in need of conservation.
THE PILGRIMS' REST. Heavily modernized, but the remnant of
a medieval first-floor hall, probably C15, a form more typical
of s Pembrokeshire. Two storeys, though there was a third, and
externally featureless, apart from stone stairs to the first floor
and a shallow stair projection to the rear with re-set head of a
finely wrought window with cusped lights and a swirled
roundel. The basement had three parallel vaulted undercrofts,
the n one now unvaulted, but with a large fireplace. From the
s undercroft, a mural stair rises to the altered first floor. The
plan is lost, there may have been a parlour in the existing range,
as at Lydstep, Pembs., or in a lost cross-wing.

LLANDINGAT see LLANDOVERY

LLANDOVERY/LLANYMDDYFRI 7634

Llandovery is the uppermost town of the Tywi valley, strategi-
cally sited, the Bran and Gwdderig tributaries providing passes
through the hills to Brecon, Builth Wells and England. The Tywi
itself is to the w of the town. The Romans founded the fort of
Alabum here in the late first century (see Llanfair-ar-y-bryn). The
Normans preferred a riverside site for their castle, just below
where the two streams meet, and the present town grew around
the castle. The town has two medieval churches, neither strictly
the parish church: on the w side is Llandingat church, whose
parish includes the town, while on the n, in the Roman fort,
is Llanfair-ar-y-bryn church (q.v.), standing outside its parish,
which stretches to the NE.
 As a market town, it prospered from its pivotal position on the
great droving routes to England. This thirsty work famously led
to there being over a hundred public houses in the C19, and also
created the Black Ox Bank, founded by David Jones at the Kings
Head in 1799. Associated with the town are two great divines,
Rev. Rhys Prichard (c. 1579–1644), author of the most popular
devotional work of the age in Wales, Canwyll y Cymru, 'The
Welshman's Candle', and William Williams (1717–91), the great
hymn-writer. There were two important C19 institutions, the
Tonn Press and Llandovery College. There had been a local
history of printing, mainly reprints of Canwyll y Cymru, but the
Tonn Press was renowned for Welsh literary scholarship. The
college was founded 1847–8 by Thomas Phillips, great benefac-
tor of Welsh education, who also endowed the college at Lam-
peter. Architecturally the town has a predominantly early C19
character, with few modern intrusions.

LLANDOVERY CASTLE. By the town car park. Never large and much depleted. The motte stands high on a natural outcrop, scarped to the W and E, with a lower sub-rectangular bailey. The chief remains are of a strong D-shaped keep tower on the W edge of the motte, with part of a twin-towered gatehouse to the N, and short sections of the curtain wall around the motte.

The castle was founded in the early C12, probably by Richard fitz Pons, a knight in the train of Bernard of Newmarch, who had conquered Brecon, and who had been allowed to carve out a small marcher lordship for himself in the Cantref Bychan. Attacked in 1116 and threatened through the C12 and C13, it was not secured until after the Edwardian conquest of 1277–82. The fragmentary keep tower dates from the 1280s, built for John Giffard, whose similar tower survives much better at Bronllys, Breconshire. From 1299 the lordship was held by the Barons Audley, who also held the barony of Cemaes in N Pembrokeshire, and came with Cemaes to the Touchet family. Neglected in the C14, it was visited by Henry IV in 1400, and besieged in the Owain Glyndwr uprising in 1403. It was burnt in the localised 1532 rising of Hywel ap Rhys, and dismantled, becoming a stone quarry for the town. What was left was described by the tourist, Mrs Sinclair, in 1839 as like 'an old Stilton cheese making its last appearance on the table'.

In the outer bailey, a commanding SCULPTURE, by *Toby & Gideon Petersen* of St Clears, 2001, a shining stainless steel figure, hauntingly faceless, of Llewelyn ap Gruffudd Fychan of Caio, a Glyndwr supporter executed in Llandovery.

p. 29 ST DINGAT, Lower Road. In a large churchyard, crammed with monuments, a large double-naved church with late C15 or C16 W tower. This has the typical battered base and corbelled battlements. Both naves have lower chancels, of equal width. The N nave is earlier, as shown by a straight joint to the S nave. This has large panel-traceried windows, and the S door had in 1804 the arms of Sir Rhys ap Thomas, giving a date of *c.* 1500. The N chancel has late medieval windows on the N and E. The nave N windows are of 1842, possibly with tracery of 1850–4, from the restoration by *W. Gingell*, of *Fuller & Gingell* of Bristol. There was further work in 1867, 1882, 1899, and finally in 1904–6, by *W. D. Caröe*, who renewed the doors and W window of the S aisle. The interior is lofty, but much restored. Gingell rebuilt the arcade as a Bath stone copy of the C15–C16 chancel S arch, claiming that the old one was 'later work of a country mason'. The broad pointed chancel arch is late medieval, chamfered with curved stops, as also the chancel S arch, on half-octagonal piers with moulded caps. The nave and aisle roofs, with collar-trusses are post-medieval, possibly *c.* 1700, embellished by Caröe. – FONT. Medieval bowl font in comglomerate stone, of uncertain date, on a later octagonal stem, encased in an extraordinarily ugly grey-green stone frame, early C20. – PULPIT. Caen stone, elaborate, with marble shafting and carved figures, 1908, by *Jones & Willis*. – STAINED

GLASS. By *Mayer & Co.*, the E window, *c.* 1894, the S aisle second window, 1886, and the nave NE window, 1892. Nave N second, 1908, by *Jones & Willis.* Easily the best is the chancel N window, 1924, by *Leonard Walker*, with semi-abstract figures, close-set leadwork and good colours. – MONUMENTS. Walter Rice of Llwynybrain †1793, wreathed urn, by *Tyley.* Caroline Rice †1810, urn and drooping willow. Lt.-Col. D. Williams †1819, by *J. Thomas & Son*, Brecon, well executed, with urn. Elizabeth Rice †1829, scroll-type. Eliza Rice †1846, with beheaded lily, moth and chrysalis. Louisa Jones †1855, draped urn on a sarcophagus. Rev. Rice Rees †1839, white marble with Gothic detail, by *John Evan Thomas.* William Rees of Tonn †1873, Gothic, by *D. Beynon* of Cilycwm.

Timbered LYCHGATE of 1918. In the graveyard NW of the tower, MONUMENT to the antiquary and Egyptologist, Sir Gardner Wilkinson †1875. Tall, ashlar, with a pyramid top and acroteria above open arches. Wilkinson designed it himself, said to be based on an ancient Lycian tomb.

ST MARY, *see* Llanfair-ar-y-bryn.

SALEM INDEPENDENT CHAPEL, Queen Street. 1829–30, altered in the 1870s. Two-storey three-bay front with near-pyramid roof, the front eaves unfortunately cut back. Later C19 arched pilastered window surrounds. Squarish plan, the gallery with long panels divided by pilasters, and the pulpit with sweeping stairs, all of *c.* 1870, in the style of the Rev. Thomas Thomas. Organ gallery of 1937, organ by *Conacher.*

TABERNACLE CALVINISTIC METHODIST CHAPEL, Queen Street. Set back in a courtyard. 1836. Stuccoed lateral façade, to the usual four-bay formula, but on an unusually lofty scale, with big Gothic windows. The lower third is crisply rusticated. Large interior, focused on a giant Gothic arch framing the pulpit, the two main windows, and a blind rose. Fittings of 1869: five-sided gallery with simple long panels and broad balustraded platform pulpit. Boarded and ribbed ceiling with a spiral acanthus rose. The organ is split over the twin porches.

EBENEZER BAPTIST CHAPEL, Queen Street. 1844. Simple gabled chapel with arched windows flanking the entry. Interior of 1884–5, by *George Morgan*, with a theatrical continuous bowed gallery front in pierced cast iron. Ironwork by *Macfarlane* of Glasgow. Gothic pulpit in front of an arched organ loft, possibly of 1905, but no organ.

WILLIAMS MEMORIAL CHAPEL, High Street. 1886–7, by *J. H. Phillips* of Cardiff. Built as a memorial to William Williams of Pantycelyn, for over £3,000, raised by national appeal. One of the first Calvinistic Methodist chapels to be seriously Gothic, with remarkably Anglican fittings. Colourful Dec in grey sandstone, with greenish Bridgend Quarella dressings. Three bays, with pinnacled pilasters, column-shafted doors and traceried windows. The interior is not large, but has a lofty hammerbeam roof, an apse with a chancel arch, and the pulpit to one side. – PULPIT. Caen stone with biblical scenes, and a relief of Williams writing. – STAINED GLASS. Exceptional in a Welsh

chapel, a very ecclesiastical main window, David, Isaiah, Matthew and Miriam, 1887, by *Bell* of Bristol.

PUBLIC BUILDINGS

68 Town Hall, Market Square. 1857–8, by *R. K. Penson*. Court-room over an open market, Italianate in style, and Italian in its relation to the square. Two storeys, with grey limestone open arcades under a stuccoed and sashed first floor with simplified pediment. At the rear, police cells with iron grilles, and court-room entrance under a square clock tower, with pyramid roof, crowned by a thin open timber bell-turret. The court room is now the town library. The bench has been retained.

Market Hall, Stone Street. 1839, by *George Clinton*, a competition victory. Much smaller than the overshadowing Town Hall behind, but characterful. Simplified Greek, in stucco and roughcast, with plain pilasters. Soanean corner acroteria, and an octagonal clock turret that just about echoes the Athenian Tower of the Winds. Interior altered in late c20 with small shops.

Railway Station, on the NW edge of the town. Two-storey house, and single-storey station, of *c.* 1858, for the Vale of Towy line. Italianate, in tooled grey limestone, neatly detailed.

Llandovery College, Queensway. 1849–51, by *Fuller & Gingell* of Bristol. This was a competition victory, but a dispute over the manner of winning caused Fuller to leave the Institute of British Architects, and eventually the country, for a distinguished career in N America (the New York State Capitol at Albany; the Canadian Parliament Buildings at Ottawa). The Welsh Collegiate Institution was founded by an East India surgeon, Thomas Phillips, to provide education at moderate cost, particularly for those intending holy orders. The building, in collegiate Gothic, with an entrance tower between a main hall to the r. and dormitories and warden's house to the l., was modern in its asymmetric massing, though with echoes of P. F. Robinson's 1831 plan for Singleton Abbey, Swansea. Originally of purple and grey stone it was dourly rendered later, but cheerfully colourwashed in the late c20. Economy shows in the minimal tracery of the hall and the simple Tudor windows elsewhere. Additions of a utilitarian kind were made behind in 1875 and 1888, before major extensions in 1901–3. The strongly contrasting rear E range, dining hall with rooms above, in a well-detailed northern English c17 style, by *Austin & Paley*, of Lancaster. Red sandstone with four low gables, mullion-and-transom windows, big centre chimney-breast, and two broad canted bays in pink stone. The classroom range, also of 1901, to the l., is surely not by the same hand, but the understated link range behind, facing N must be.

Inside, the original range has spartan interiors, entrance hall with open-well timber stairs, and the big hall, now the library, with thin open-trussed roof. – BUST of Rev. J. Williams, 1858, by *J. Edwards*. The 1901–3 dining hall proclaims collegiate

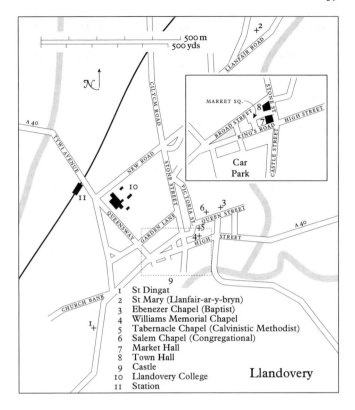

1 St Dingat
2 St Mary (Llanfair-ar-y-bryn)
3 Ebenezer Chapel (Baptist)
4 Williams Memorial Chapel
5 Tabernacle Chapel (Calvinistic Methodist)
6 Salem Chapel (Congregational)
7 Market Hall
8 Town Hall
9 Castle
10 Llandovery College
11 Station

Llandovery

antiquity, with low heavy-beamed ceiling, inglenook-style serving recess, and dark panelling to the lower walls and around marble fireplaces.

E of the main buildings, a CLASSROOM block, 1912–14, by *L. Bankes-Price* and the early C20 former GYMNASIUM, now music school. Facing over the drive, the CHAPEL, 1933, by *W. Ellery Anderson*. Originally of hard squared stone, later covered in cheerful yellow roughcast. Gothic, of an original type, squared off in the interwar way with roofs behind parapets, stark stepped lancets, and emphatic buttressing. The N transept has tiny lancets high up each side, on the S one, a round chimney paired with a bellcote. Plain interior. – STAINED GLASS. E window 1991 by *Amber Hescott* and *David Pearl*, of *Wind's Eye Studio*, Swansea, abstract shapes in strong colours.

CHAIN BRIDGE, W of the town. 1882–4, by *Thomas George*, County Surveyor. Triple arched, rock-faced stone bridge, the parapets lost to a C20 widening. It replaced an early iron chain bridge of 1832, by *Phillip Thomas*, engineer, re-erected at Buckland House, near Brecon.

PONT DOLAUHIRION, 1 m. N. 1773, by *Thomas Edwards*, and so
inscribed. The most elegant of the Edwards family bridges,
deriving from the Rev. William Edwards's pioneering bridge at
77 Pontypridd, Glam., 1756. A single arch of 84 ft (25.6 metres)
soars from rock abutments, the crown only just above the arch
stones, and the spandrels pierced by cylindrical holes, giving
an air of weightless grace. The cylindrical holes were the
startling innovation of Pontypridd, both reducing weight and
pressure on the arch.

PERAMBULATION

4 The small MARKET SQUARE makes a pleasing town centre, iso-
lated from traffic, and cobbled in front of the Town Hall. The
LEWIS FOUNTAIN, 1901, is an over-large stack of turned pink
granite bowls, the iron rails and lamps reinstated in 2003. On
the N side a good row in cheerful colours. First the KING'S
HEAD, low, three bays with an attractive C19 veranda. The core
is C17, shown by the diagonal shafts to the l. chimney. The
POST OFFICE was an early C19 draper's, four bays and three
storeys, later Victorian detail. The NATIONAL WESTMINSTER
BANK, 1876, is larger still, with pyramid roof and sober
pilastered bank front of Bath stone. No. 7 is earlier C19, three
bays. No. 9, a larger three-bay house with a Late Georgian
front, has some Regency detail inside, and a late C17 door on
the party wall to No. 11, possibly an original front door re-set.
The staircase could be C17, turning around a masonry pier.
No. 11, with C19 triangular dormers, is possibly earlier C18,
suggested by the low proportions and steep roof. No. 13,
BROADWAY HOUSE, is an earlier C19 town house on a large
scale, lined stucco, of three storeys and three bays. BARCLAYS
BANK was a Late Georgian three-storey town house, altered
for the bank in 1921 by *J. H. Morgan*. No. 19, CHURCH
HOUSE, is of similar date, with arched doorway but new door-
case. The S side is more irregular and modest in scale. The RED
LION, three-bay, two-storey with big projecting chimneys, is
early C18. The veranda is Victorian, but older timbers suggest
there was a pentice. The square opens to King Street, the main
road, with the BEAR INN, facing W. Early C19, two-storey, with
a low gable over a Palladian window.

E from the Market Place is BROAD STREET, the N side a dis-
parate terrace, facing over a narrow garden with the WAR
MEMORIAL, 1924, a bronze soldier by *Boulton* of Cheltenham,
a copy of a figure from the L.N.E.R. memorial at Euston
Station. The houses are mostly two-storey: THE OLD PRINT-
ING HOUSE, of three bays, is probably late C18, the site of the
printing office established in 1829 by William Rees. No. 3,
EMLYN HOUSE is early C19, four bays, and No. 7, BANK
HOUSE, was rebuilt after 1836, also four bays, with a good radi-
ating fanlight. No. 9, MILE END HOUSE, 1803, has mid-C19
stucco detail, also four bays. No. 11, three-storey, was the

BLACK OX inn, a C19 alteration of a late C17 L-plan house, two bays with a cross-wing, pebbledashed. No. 13, VIOLET COTTAGE, of 1864, follows the Late Georgian pattern, but heavier in detail. No. 19, CLARENCE HOUSE, a taller house on the corner with deep eaves was a hotel, c. 1830. QUEENSWAY runs N, to the College, Station, and Chain Bridge. Broad Street continues with LLANDINGAT HOUSE, the finest single house in the town. Built 1813–4, for David Lloyd Harries, attorney, it is a large three-storey hipped villa of three-by-three bays, the stuccoed elevations plain apart from a Greek eaves cornice. U-plan, with very long centre chimney of seventeen flues. Inside, good Regency detail, plasterwork in the SW room, and a half-round cantilevered stone staircase. No. 23, LLANDINGAT, is a Tudorish stuccoed house of c. 1856, with bargeboards to gabled wings. The street continues as LOWER ROAD to Llandingat church.

Returning to Broad Street, on the S side, the altered rear wing of the CASTLE HOTEL, the prinicipal coaching inn. The main front faces down the main road, here called KING STREET and is early to mid C18, large, of five bays and three storeys, with recently reinstated columned porch. But at the rear NW corner is a very large C17 lateral chimney, suggesting that the main front was to Broad Street. The front range has, inside, a good mid-C18 oak stair with thick turned balusters and heavy handrails. In the C17 range, little apart from some rough beams. To W, in King Street, Nos. 1–6, a two-storey early C19 terrace, mostly shops, with big hipped roof that looks earlier.

STONE STREET runs N, largely C19 in appearance, though with some earlier houses. No. 1, PENDRE HOUSE, with steep hipped roof is late C17, much altered. No. 3, closing a view from the Market Square, has a big arched recess to the upper floors, Late Georgian, but surely altered in the earlier C20. No. 9, of three narrow bays, with tall dormers is early C18. No. 11 is a good early C19 survival, four bays and two storeys, the doorcase open-pedimented on Doric half-columns, and also with a good mid-C19 shop window. Opposite, the King's Head rear range was the original Black Ox Bank from 1799. Nos. 2–4 was a draper's shop from the 1820s, three storeys and five bays, stuccoed. No. 6 is of similar date, three storeys, with late C19 first floor oriel windows and shopfront. Nos. 12–18 were probably rebuilt or remodelled in the 1870s by *William Harries*, builder. Original shopfronts on Nos. 12–14 and 18. No. 20, COURT HOUSE, is lower, three storeys and bays, a later C19 refronting, the upper centre window rising into a gablet. No. 30, late C18, the former Half Moon Inn, is two-storey with a roundel in a centre gable. Further N, mostly two-storey houses, modernized but several of C18 origin. No. 42, TY CERRIG, three bays, is stuccoed late C18 with a good open-pedimented doorcase. Nos. 44–52 was something of an urban experiment, a short stuccoed two-storey terrace of five, the outer houses projecting with pedimental gables and the inner ones with

lower windows in elliptical-arched recesses. They may be the
houses for which tenders were called in 1852, but old-
fashioned if so. Much altered in detail. No. 60 was the White
Hart, C18 with C19 stucco detail, four bays with a steep roof
and big chimneys. At the far end, in NEW ROAD, late C19 ter-
raced houses in red sandstone.

To NE, on LLANFAIR ROAD, the PRIMARY SCHOOL,
1908–10, by *W. V. Morgan*, stone and stucco, free Edwardian,
and the HOSPITAL, the little single-storey front block being a
remnant of the gabled workhouse of 1839 by *G. Wilkinson*.
Back down Stone Street, to the main road, now HIGH STREET,
running E. On the N side, No. 4 has a curved brick front of
1909. No. 8, BELMONT is later C19 with a three-storey canted
bay, Nos. 10 and 12 are early C19, altered when No. 8 was built.
No. 10 has pretty ironwork, No. 12 a deep shop extension,
which seems to be a layering of different periods: early C19
Doric fluted outer columns, later C19 windows behind thin
iron garlanded columns, and a corrugated-iron tent roof on
mid-C19 iron columns, by *Bright* of Carmarthen. No. 14,
LLOYDS BANK, is a late C18 detached house of three storeys
and bays, set in a railed forecourt. Remodelled in 1903 for the
David Jones & Co. bank, roughcast with stucco lugged window
surrounds above, but corniced mullioned windows below, and
a two-storey centrepiece with paired red stone pillars on both
floors and a pediment. Inside, a plaster relief of David Jones,
the founder. Further up, the Williams Memorial Chapel and
then the scale reduces to two-storey, with little of note on the
N side. Orchard Street runs N to Queen Street, with the three
chapels.

Returning on the S side, No. 33 is the reputed birthplace of
the Rev. Rhys Prichard, *c.* 1579, but appears C17. Plain rough-
cast with steep roof, small windows and two massive E chim-
neys, the main one rising in steps, and heightened, probably
in the C18. Inside, heavy unmoulded beams and rough collar-
trusses, the stair with plain square newels probably C18. The
MEMORIAL HALL, 1896, architecturally null, replaces part of
Neuadd Newydd, Llandovery's most important house, built
c. 1620, for Vicar Prichard. It was dismantled in 1904 despite
a campaign to save it, some fittings salvaged by *W. D. Caröe*
were reused, part of a ceiling at Llwynybrain (*see* below), and
more at Caröe's house, Vann, in Surrey. W of Bridge Street, the
JUBILEE STORES, 1897, for T. Roberts, general merchant, with
typically showy Late Victorian detail. No. 29, to the r. and a
short terrace around the corner in BRIDGE STREET were
also taken into the emporium, with stabling and a small ware-
house opposite. WATERLOO BRIDGE, over the Bran, 1842, by
Thomas Thomas, mason, has architectural pretension, the broad
arch with rustication. Back on High Street, No. 23, ROYSTON
HOUSE, 1841, three bays and two storeys, has a columned
pedimented doorcase. No. 19, the BLUE BELL, is lower, C18,
but with late C19 stuccoed detail. No. 17 is mid to later C18,
three storeys and bays, with early C19 detail, including a good

Doric doorcase. C18 oak stair inside. After a row of early to mid-C19 shops and houses, the WHITE HALL HOTEL, set back on a cobbled forecourt. C17, with altered windows and detail. The main range runs N–S, with two big ridge chimneys that are probably C17, and in the N end bar are late C17 ovolo-moulded beams. The haphazard quality of the building comes from the two wings at right angles, the first domestic, with an end wall in C18 brick, and the next part of a tiny stable court. CASTLE STREET runs back to the castle, probably on a medieval line. Two-storey houses, C18 to C19.

LLWYNCELYN, N of the Chain Bridge. A pretty mid-C19 river-side house with fretwork bargeboards, remodelling something older.

BLAENOS, ½ m. NW. An altered stucco villa of the 1830s built for the Jones, banking family, now a nursing home. It had a pediment over a bow on the garden front, similar to designs published by *Robert Lugar*, then working in Brecon-shire, but the house was fire-damaged and the detail is all lost.

LLWYNYBRAIN, 1 m. NW. Large three-storey five-bay rendered house of the Hughes and Rice family, reclaimed from derelic-tion by the family in the 1970s. It was described as 'a pretty box of Samuel Hughs' in 1717, by 1800 it had become a double pile with a three-storey bow against the rear r. gable-end, similar to that at Cilgwyn, Myddfai. The large glazed porte-cochère is late C19, and the roof was redone as a single span then or when the interior was refitted by *Maples* of London. One section of the plaster ceiling of the 1620s salvaged by *W. D. Caröe* from Vicar Prichard's house in Llandovery (*see* above) was installed in the dining room, with two sections made to match, between moulded beams, also salvaged. The old section happily survives, it has ribs radiating from flat rose-decorated bosses forming typically early C17 repeating diamond shapes. There are thistles, fleurs-de-lys and diamond cartouches in the spaces. A good early C18 stone chimneypiece and some panelling inserted at the same time are now in the Old Kings Head in Llandeilo (q.v.). The restoration in the 1970s was designed by the owner, *Mrs Rosemary Rooney*, née Pryse-Rice. The roof was simplified, Edwardian fittings came from a demolition sale in Eastbourne, and the very fine open-well staircase of the 1660s was salvaged from the derelict Edwinsford, Talley (q.v.). It has big twisted balusters and broad handrail.

On the courtyard behind, are ornamental iron gates of *c.* 1900, of early C18 form with scrolled wrought-iron overthrow and grey limestone piers. On higher ground behind is a neat small stable court of *c.* 1830, with pediment and a red brick walled garden. Above again, a small private race-course prop-erly graded around the hilltop. The LODGE on the main road is an altered example of Design No. 1 from P. F. Robinson's 'Lodges and Park Entrances' of 1833.

BARLEY MOUNT, NW of Llwynybrain. A small, Late Georgian
model farm built for the Llwynybrain estate. A nice grouping
of hipped-roofed buildings, vernacular in materials but formal
in arrangement. The farmhouse on the W is colourwashed, two-
storey, three-bay, with centre chimney. There is a single-storey
cow-house on the N, and a big double-doored barn to the E,
the N end altered when a lofted carthouse was added.

CWMRHUDDAN, 1½ m. SSW. 1869–71, in the style of *R. K. Penson*.
Prominent on a knoll, in stone with mullion-and-transom
windows, bargeboarded gables, and a big square corner block
with French pavilion roof, added *c.* 1885, presumably by
Penson's partner, *Ritchie*. The house is better in parts than as a
whole. Good cast-iron verandas. Inside, the original interiors
are typical of Penson with much pitch-pine, especially the stair-
case with octagonal newels (similar to Llidiardau, Llanilar,
Cd.). The later NW rooms, one each floor, are more eclectic with
touches of the Aesthetic in the tiled iron fire-grates, and many-
shelved overmantels. The panelled billiard room in the original
house looks also of the 1880s.

FELINDRE, 1 m. E. Now a plain nine-bay, two-storey row of three
houses, but originally all one. The principal part, at the N end,
has a NE wing with canted end. Good interiors of *c.* 1840,
Late Regency to Early Victorian. Open-well stair with delicate
balustrade, and NE dining room with long windows in the
canted end. Above, the bedrooms have deep coved ceilings, one
octagonal with unconventional plasterwork.

See also Llanfair-ar-y-bryn and Cynghordy.

6215 LLANDYBIE

Although Llandybie grew in the late C19 and early C20 with
anthracite mining, it still retains something of a rural village,
spoilt only by busy roads. A continuing industry is the quarrying
of limestone. The main focus of development was to the S, cre-
ating the new town of Ammanford (q.v.), originally in the parish.
The loss of the PLAS in the village centre and PIODE FAWR ½
m. W, both small late C17 houses, has removed earlier evidence
of mineral wealth. The latter had a good stair and overdoor ped-
iments. It was lost in the 1980s to opencast mining.

ST TYBIE. Medieval double-nave, with no dateable features, but
the N nave may be the earlier. The tall SW tower, of large-
coursed masonry, may be C16, with typical battered base, but
also the refinement of a string course halfway up. Large Perp
paired bell-lights. The rest, with stone-tiled roofs, was restored
1853–5 by *George Gilbert Scott*, who added the porch and Dec
windows. A N aisle proposed by *David Jenkins* in 1903 was not
built: the new church at Ammanford was built instead. The
three-bay nave arcade may be cut through an older wall:
the two W arches plain and plastered, the E one oddly tall
and narrow. The two-bay chancel arcade is also plain and

undateable. The best features are the C16 wagon roofs which
survive in their entirety, the N chancel one had carved bosses.
– FONT, by *Scott*, scalloped bowl with carved detail. Also, the
small, late medieval, octagonal former font bowl. – FURNISH-
INGS by *Scott*, including PEWS with forceful shaped ends,
PULPIT, COMMUNION RAIL, and timber REREDOS, with texts
in big cusped panels. – STAINED GLASS. N chancel E window,
c. 1880, Life of Christ in four scenes.

Some fine MONUMENTS. Elizabeth Brigstock †1667, pedi-
ment with big shield, and side scrolls with lively foliage,
repainted in pastel colours, 1971–2, based on original evidence.
Sir Henry Vaughan of Derwydd †1676, an important piece with
half-length figure in contemporary dress, military emblems
around the arched frame, twisted columns, broken pediment
with shield and large trumpeting cherub each side. Also
repainted 1971–2. Elizabeth Vaughan †1754, broad pedimented
tablet with bulbous urn. Anne Evans †1755, freely scrolled let-
tering and fluted Corinthian pilasters. Bridget Jones †1780,
coloured marbles with oval plaque and fluted urn, by *King* of
Bath. Rebecca Lewis †1782, a very large draped urn, also by
King. Elizabeth Stepney †1795, seated woman with grieving
infant and big draped urn. William Jones †1805, draped urn
against an oval backdrop, also by *King*. Eliza Williams †1787,
Gothic, with black marble colonnettes. – ROYAL ARMS. 1814,
of *Coalbrookdale* cast iron.

BETHEL CALVINISTIC METHODIST CHAPEL, on the Peny-
groes road. 1829. Small-scale lateral façade, with centre arched
windows. Renovated 1902.

At the top of HIGH STREET, the colourwashed RED LION, the
three r. bays dated 1786, the other three presumably early C19,
with sashes of *c.* 1900. Four renewed chimneys with diagonal
shafts. Opposite, low whitewashed early C19 outbuildings, the
whole group a charming entrance to the village core. Opposite
the church, was the PLAS, late C17, demolished in 1969. It had
an open well stair and doorcases with open pediments. At the
corner of High Street and KING'S ROAD, a row of shops of
c. 1900, with original shopfronts, oriel windows and barge-
boarded dormers. The SPAR grocery is Edwardian, in red and
yellow brick, with terracotta. Opposite, the former NATIONAL
SCHOOL, 1851, chequered yellow and red stone, with gabled
two-bay centre and single-storey wings. The PENSIONERS
HALL was the Wesleyan chapel, 1884, Gothic, red sandstone
banded in yellow, with grey limestone dressings. On AMMAN-
FORD ROAD, Nos. 39–41 are two clapboard houses with veran-
das, 1897, built by the *Davies* family, local carpenters, who had
spent eighteen years in America. No. 39 has the veranda on
two sides, and radiating boards in the gable, No. 41 is L-plan,
with the veranda in the angle. On the LLANDEILO ROAD, the
former VICARAGE, 1885, by *David Jenkins*, large with half-
hipped roofs, crazed rubble walls, and mullion-and-transom
windows. A wide gable to the front, and a steep-roofed porch
tower.

LIMESTONE QUARRIES, Cilyrychen, 1 m. NW. Quarrying seems
to have started in 1749, when John Owen of Cilyrychen was
granted a lease to quarry, and to build two limekilns. Leased
in 1856 to the architect, *R. K. Penson*, who built the large bank
of Gothic LIMEKILNS, an exceptional industrial structure, for
which he exhibited a perspective at the Royal Academy in 1858.
Six pointed drawing-arches, each with a pair of sub-arches
above, with the effect of giant machicolations, under a frieze
of pierced coloured brickwork, and a corbelled parapet. On the
W side of the extensive quarry, at Pentregwenlais, a large block
of three LIMEKILNS, dated 1903, the position of the datestone
showing that five were intended. The kilns have tall cylindrical
crucibles, keyhole drawing-arches and, in front of the hearths,
an internal passage, reached from the side.

CILYRYCHEN, 1 m. N. Small colourwashed farmhouse dated
1762, the L-plan perhaps indicating an earlier foundation. Pro-
jecting chimneys to both gables. Good C19 FARM BUILDINGS,
including a HAY-BARN on stone pillars.

DERWYDD, 1½ m. N. Although dwarfed by the unattractive addi-
tion of 1888–90, by *David Jenkins*, the original C16 house sur-
vives, dourly roughcast, with stone-tiled roofs and late C19
windows. T-plan with a cross-wing and a former chimney
gable on the back. It may have been longer as it had eighteen
hearths in 1670. The new house, added uphill, has mullion-
and-transom windows and little character. The owner, Alan
Stepney-Gulston, romantic antiquary, claimed to have designed
it. However, inside the old house is a revelation. The end room
has a fireplace on the back wall under an exceptional over-
mantel dated 1644. The richness of the ornament is unrivalled
in the county, a heraldic plaster cartouche with fabulous beasts
terminating two of the scrolls and outer tapering piers carry-
ing exotic herms. In a corner of the room a stone doorway of
c. 1500 with the crest of Sir Rhys ap Thomas in the spandrels,
brought in from elsewhere by Stepney-Gulston, who also
acquired the famous Sir Rhys ap Thomas Bed, now at St
Fagans. The ground floor of the cross-wing, now the library,
has a very rich later C17 plaster ceiling like those at Newton
House, Dinefwr in four large panels, each a wreath in a
lozenge, and the beams thickly plastered with guilloche mould-
ing. The enormous oak Jacobean chimneypiece was imported
by Stepney-Gulston from England, the neo-Jacobean over-
mantel was made up to match.

On the first floor, double doors with mid-C17 detail – arched top
panels and bead and reel borders – open into the King's Room.
This is without parallel in South Wales for its exuberant
plasterwork, which looks later C17 although the moulded stone
fireplace must be C16. The overmantel has an oval wreath
under a panel of fleshy scroll and is flanked by C17 renditions
of Greek gods, perhaps Orpheus (with a lyre) and Athena
(with a helmet), and the whole under a curved heraldic
pediment with festoons held by putti squashed between the ped-
iment and the ceiling. The frieze also has rich fleshy scrollwork,

interrupted by heraldic cartouches. By contrast the ceiling has low relief ornament around a pendant, in a circular frame. The adjacent bedroom, with a similar arch-panelled C17 door, has a plaster ceiling with heavily moulded beams and another over-mantel with delightfully untamed detail. The top cornice has an excess of mouldings and breaks with a fat pulvinated frieze. The outer piers have applied tapering pilasters with laurel-leaf drops like fox tails in sunk panels, and the centre pier has a niche with an androgynous sword-bearing figure, and is flanked by outsize scrolls carrying exuberant floral festoons. This fireplace and the one next door would seem to derive from an exotic source, perhaps Dutch engraving, but not yet identified. The attic above has fine C16 oak collar trusses with chamfered blades and curved collars, similar to those at Rhy-darwen, Llanarthne.

Above the new house is a large square walled garden dominated by LADY STEPNEY'S GARDEN HOUSE up steps in the centre of the upper wall. This is a square C18 two-storey summer-house with a pyramid roof.

In DERWYDD village, two bleak semi-detached estate cottages in grey roughcast, 1870 by *John Birch*, variants of a design that won a prize at the Society of Arts in 1864.

GLYNHIR, 1¼ m. E. A demesne of varied charms centred on an oddly arranged double-pile house. The core is a late C17 two-storeyed building of three wide bays under a steep-pitched stone-tiled roof, with a big W gable chimney. The back pile was probably added in the 1760s for Richard Powell. Bought in 1770 by Peter du Buisson of the Glamorgan Bank. His son William established a knife works at an unknown site nearby, and bought the New Forge at Llandyfan in 1808 to supply it. In the 1820s the house was turned around, so that the entry is from the stable yard, and the old S front aquired a central full-height canted bay with big windows. Approaching one now sees the altered 1820s coach-house and the N front is a mere side elevation to the stable yard. It is muddled, the centre recessed with a timber Doric porch and three arched windows at different heights, because the stair runs up beside the door. In the late C19 the S front was extended by one bay with an entrance under a big Queen Anne hood. The modest interior detail looks all of the 1820s.

In front of the house, remarkably, is a stone CANAL curving away. Now nearly dry but originally deep enough for boats, it measures 100 metres by 7 and dates from the mid C19. It was fed from a sluice at its N end, and was part of a complex water management system. To the W the land slopes sharply down to the narrow gorge of the Loughor. Dug into the brow is a fine ICE HOUSE, reached by a sunken dog-leg passage, once part-roofed. The stone chamber is six metres deep and four wide with a faultless domed roof. There were walks and rustic bridges, now gone, to view the much-visited waterfall in the gorge, but Victorian rhododendrons remain. Stands of trees were planted to commemorate notable events, and an avenue

along Glynhir Road, which was the front drive. There was a thatched lodge at the s end of the park. On the back drive the shell of a mid-c18 octagonal DOVECOTE, of thin limestone slabs. Fine early c19 FARM BUILDINGS to the E, on an unusually large scale, including a huge twin-doored barn, surely the biggest in the region.

4212 LLANDYFAELOG

Village s of Carmarthen, below the Kidwelly road, with the church in a large churchyard, opposite a big early c19 hipped BARN with two high doors. In the village street, the former chapel, and to the E, the stone twin-gabled VICARAGE, 1888, by *David Jenkins*. To the SE, a narrow three-arched c18 BRIDGE.

ST MAELOG. An incoherent but mainly medieval church of disparate parts, that Iolo Morgannwg in 1796 called a 'large but confused heap of rude building of addition upon addition of different ages'. Nave with triple bellcote, W and S porches, two parallel-roofed transepts, and low chancel with a parallel NE chapel. Repaired 1825, ugly plate tracery by *R. K. Penson*, 1866–9, bellcote of 1872, and E window and interior work by *E. V. Collier*, 1893–4. The chancel must be the earliest, being narrower than the arch to the nave, which could be c14, the low W porch with chamfered door may be late c15, and the NE chapel is early c16, as shown by the simple two-bay Tudor arcade to the chancel. The arched chancel S door should be medieval, but looks early c19. c15 cusped lancet in the s transept. Inside, broad pointed arches to the transepts, slightly lower chancel arch. Roofs of 1866–9, apart from the chancel roof of 1825. An early c19 painted grained screen in one bay of the chancel arcade, the organ, 1894, in the other. c14 or c15 shallow tomb recess on the S wall. – PULPIT and FONT by *Penson*, 1869. – STAINED GLASS. E window of unexpected quality, by *Sir Edward Burne-Jones*, 1895, for *Morris & Co.* Faith, Hope and Charity, a single figure in each light, against deep-blue curtains, but clear glass above and below. Red-winged cherubs' heads in the tracery. Two later *Morris & Co.* windows in the transepts: the s one, 1919, three languid armoured saints, on richly coloured backgrounds; and N window, 1928. Also chancel s two-light, Vita and Mors, c. 1903; s transept E, c. 1874, with angel roundels; and w window, by *Powell*, c. 1950, modern faces, ancient dress, and a Burmese landscape. – MONUMENTS. Mary Rees †1757, pedimented with urn, on the E wall. In the NE chapel, Mary Vaughan of Plas Gwyn, 1751, with crude open pediment, and Mary Davis of Llechdwnni †1775, slate with cherub heads.

CALVINISTIC METHODIST CHAPEL. 1846. Disused. Crisp lateral façade of squared and tooled grey limestone different from local chapels. Six arched openings, the windows small-paned.

GLANRHYDW, Cloigyn, 1½ m. NE. Originally a two-storey, five-bay and, presumably, double-pile house of 1732, raised a floor in the early C19, under a broad hipped roof. Painted stone, originally stuccoed. A C19 back wing is reached over an enclosed bridge after it was found that a right-of-way ran behind the original house. Modern interiors. The LODGE, 1876, is still Late Georgian, three-bay, with recessed centre.

PENYMAES, Cloigyn. Three-bay L-plan farmhouse probably rebuilt for the Hughes family (later of Tregyb, Ffairfach) in the mid C18, with a broad staircase up to the attic in the rear wing.

MAEN HIR STANDING STONE, Cloigyn. Twelve-ft (3.7-metre) stone, on the bank E of the main road, opposite the Glanrhydw drive.

GELLIDEG, 1 m. SE, on top of the escarpment E of the Gwendraeth Fach. Shell of an Italianate stuccoed villa of 1852, by *W. W. Jenkins*, with a campanile on the model of Osborne House. It incorporated a house of *c.* 1800. The new house, 1963–4, by the owner, *Christopher Jennings*, with advice from *Sir Martin Beckett*, is gabled with Georgian windows and a round Pembrokeshire chimney by the entry. An early C19 octagonal gazebo is incorporated as a library. The STABLE BLOCK, dated 1820, is an odd-looking, long seven-bay hipped range, the centre much raised above the carriage arch with battlements.

LLECHDWNNI, 2 m. SE. Next to the farmhouse of 1854 is a portion of a gentry house, probably rebuilt in the early C17, for the Brigstocke family. A cross-wing has been demolished, leaving half of the original, a two-storey stone range with big kitchen chimney at one end and corner chimney at the other. The tiny upper windows, rare in the region now, illustrate how modest the houses of middling gentry could be. Inside, a cross-passage, a chamfered main beam, and scarfed feet to the roof trusses, a type more typical of the C18. The cross-wing had a stone-vaulted basement. Rectangular WALLED GARDENS of two acres. Near the further, higher end is a raised terrace at each end of which stood a circular brick-lined attached gazebo, probably C17, both ruined. In the field SW of the house is a silted rectangular pond, presumably also C17.

GWEMPA, 1½ m. E. A gentry house of the Gwyn family from the C17 to 1840, then tenanted. The family provided six high sheriffs in the C17 and C18, and one was aide-de-camp to George III. Outwardly a heavily modernized tall two-storey three-bay farmhouse, but with a remarkable C17 lateral chimney with finely wrought saw-tooth ribbing and moulded cap, exceptional in the region. Inside, an incomplete mid-C18 stair, with slender balusters, columns on gadrooned urns. The roof has C18 collar-trusses as do the OUTBUILDING behind and STABLE in front. On the drive, a mid-C19 BARN with two pointed-arched porches. Remnant of a lime avenue.

UPLANDS, 1½ m. NW. A severe later C18 three-storey five-bay stuccoed house with simple columned porch, rescued from dereliction in the 1980s. Double-pile plan, just possibly the

work of *John Calvert*, whose Highmead, Llanwenog, was similar, and there was some matching plaster detail to nearby Iscoed, Ferryside, where Calvert may have worked. Inside, a stone cantilever staircase and some good doorcases. The attached STABLE has sweetly rustic Palladian windows in a pedimented centre, the arch of the upper one breaking a row of dove-holes. A pair of square, pyramid-roofed, lodges are both greatly enlarged.

6516 LLANDYFAN
 Llandeilo Fawr

At the w edge of the Black Mountain, the church and farm group prettily in a valley. Limestone quarries to the E around Cincoed (SN 646 175), where several LIMEKILNS remain.

ST DYFAN. 1864–5, by *R. K. Penson*. A small single-cell church with canted apse, much prettier than usual for Penson, though with his plate tracery. Red sandstone and stone tiles. Note the way the roof sweeps over the hipped w porch, the flow almost Arts and Crafts, but the strict geometry High Victorian. On the ridge, a slated bell-turret of unexpected subtlety, two superimposed pyramids, each layered beneath, like a petticoat. Inside, whitewashed walls with a little red ashlar. A low screen had been removed by 1868. – STAINED GLASS. Apse two-light windows, with vine, lily and rose motifs, an untypical work by *Hardman*, 1864. Fleur-de-lys quarries elsewhere, by *Powell*.

Churchyard WALLS and BAPTISMAL POOL, nicely matched to the church. The pool was a legacy from the C18 when the medieval chapel of ease had been used by Nonconformists.

LLANDYFAN. A C17 house with protruding stacks on both ends of its steep roof, that on the S particularly big. Quite irregular fenestration across its three bays and two storeys, with the entrance in the l. bay, as if still with hall-house planning inside a regular shell. The C19 sash windows have vertical but no horizontal glazing bars and the porch is of the 1860s. Simple original interior details: stone floors, chamfered beams with ogee stops and oak door frames. The stair newel from first floor to attic is an octagonal shaft, like the 'mast' stairs of Monmouthshire. Attractive modern pebble paving in the front court.

Three-sided FARMYARD behind, with later C19 S range, a small C18 stable on the N, and a handsome two-door hipped barn of 1802 facing down the yard. Behind, an exceptionally large LIMEKILN, perhaps of the 1750s, with a single big front arch over a double-arch for the two kiln-eyes.

LLANDYFAN FORGE, 2m. S of Trap. A very early ironworking site operating from the mid C17, using local charcoal and pig-iron possibly from an unknown local furnace, later from the Swansea valley. The OLD FORGE (SN 6588 1695), was men-

tioncd in 1669, and finally closed in 1807. A massive masonry dam of a holding pond survives, some 4.5-metres high, with sloping face, possibly C18, and some walls also of the forge. The NEW FORGE (SN 6563 1682) dates from the 1780s. Sold in 1808 to the du Buisson family of Glynhir, Llandybie, to supply iron for their knife-works, closed by the 1830s. Converted in the 1840s to a woollen mill. Most of the collapsed masonry structures seem of the latter period.

LLANDYFEISANT

The small parish, on the SW side of Llandeilo town, is largely the park of Dinefwr, though the living was with Golden Grove. The Dynevors only acquired this section of the park in the C19.

ST TYFEI. Set in a wooded dell, on the edge of the park, overlooking the Tywi. Converted to a visitor centre in the late C20, since closed and now in disrepair. Small nave, chancel, and shorter S aisle. Mostly rebuilt with new W porch, 1876, by the *Rev. William Wiggin*, of Hampnett, Glos., brother-in-law to Lord Dynevor. Two original Perp windows with cusped lights and flat heads, to N and S. Arcade of 1876, three bays, on octagonal piers. The Roman temple said to have been found *c.* 1800 was not rediscovered in a search in 1876. Long-ruined parsonage adjoining.

LLANDYRY

W of Trimsaran

CHURCH. A medieval chapelry of Pembrey, much rebuilt in 1869 and 1904–5. Nave with narrow transepts and a chancel distinctly out of alignment. The character is Victorian with lancets and traceried end windows. The nave was extended in 1904–5, by *William Griffiths*, with a new bellcote. He also widened the chancel arch and may have raised the transepts, which have chapel-like roundels in the gables. Open-trussed C19 roofs on corbels.

SPUDDER'S BRIDGE / PONT SPWDWR, ½ m. N. Impressive C15 causeway bridge over the Gwendraeth Fawr, much the best medieval bridge in the region, which has few others apart from Kidwelly. Essentially a long causeway of five broad segmental-pointed arches, one spanning the river, separated by generous full-height cutwaters. The proximity to the then important house of Muddlescwm, Kidwelly, may explain this expensive undertaking.

KIDWELLY & LLANELLY CANAL. W of Llandyry is the course of the branch canal from the C18 Kymer's Canal (cf. Kidwelly) to Pembrey and Burry Port constructed in 1812, by *Pinkerton & Allen*, engineers. A railway was built alongside in 1866–9. The GLANSTONY AQUEDUCT, ¼ m. W, carried the canal over

the Gwendraeth Fawr. Six low arches, with cutwaters on the upstream side. A short branch canal of 1824 ran E to Trimsaran, and a CANAL BRIDGE survives at Moat Farm, ¼ m. N.

LLANEDI

5807

Parish along the River Loughor, with industrial settlements at Tycroes and Hendy, but the church isolated and very rural.

ST EDI or ST EDITH. Well set in a sloping churchyard. Rebuilt in 1858–60, by *R. K. Penson*, who kept the bottom of the tower and, unwillingly, the NE Penry family chapel of *c.* 1800. The tower could be medieval, with typical sloping base, but it is not vaulted and the door looks early C19. There was a renovation in 1828 by *David Morgan*. The ugly stone top stage, with triple lancets and pyramid roof, is apparently a late C19 replacement for a Montgomeryshire-style timber-framed top by Penson, who first wanted a spire. The rest is in rock-faced stone with plate tracery, apart from the Penry chapel, which has a Georgian Gothic N window. Inside, corbelled shafts to the chancel arch. – Drum FONT on a shafted base with carved flowers. – Hexagonal timber PULPIT. The Penry chapel has a plain plastered curved roof. – STAINED GLASS. E window, 1904; one N window, by *Swaine, Bourne & Co.*, of Birmingham.

N of the church, the former SCHOOL, early C19, hipped, with blank arched recesses. Beyond the church, the OLD VICARAGE, 1860 by *Penson*, typical complicated hips and gables in the roofs, and no obvious façade.

PLAS MAWR (Cwrt y Ceidrim), 2 m. NE, down a track from Plas Uchaf. Ruinous house of the Penry family from the C16 to 1876. David Penry founded an early independent chapel at Hendy in 1712. Their downhill-sited, three-storeyed hall house with tall lateral chimney became a T-plan in the early C19 with short wings added each side of the upper end. This has the entrance at first floor level into the old house and a corbelled attic-storey chimney. The lower end has a winding stone stair in a projecting bay. Near the centre is a small inserted strong room, said to have been a lock-up. Substantial and well-moulded beams to both floors. The collapsed lateral chimney had a fine yellow limestone C16 chimneypiece, ovolo-moulded with panelled strips. The fittings, all but lost now, were early to mid C18 including round backed shelves framed by fluted Corinthian pilasters. At the upper end the ground floor becomes cellarage and another stone stair in a projecting sidewall bay links first floor and attic.

At the top of the track, a low four-bay COW-HOUSE, openfronted with fat round whitewashed piers, exceptional in the region.

FELIN NEWYDD, 1 m N. Mid-C19 corn-mill, with wheel by the *Priory Foundry*, Carmarthen, turning three sets of stones.

See also Hendy and Tycroes.

LLANEGWAD 5221

A pretty village on the flat valley floor N of the Tywi.

ST EGWAD. Now closed. In an ancient circular churchyard.
Rebuilt 1847–9, by *John Harries* of Llandeilo, to the old plan,
nave, chancel and full-length N aisle. Simple Perp flat-headed
windows, some reusing medieval red sandstone fragments. The
unattractive tower against the N wall added in 1902, by *David
Jenkins*, is proposed for demolition as unsafe. Inside, trans-
versely ribbed plaster barrel ceilings of 1847, and round-arched
arcades, four-bay in the nave, and two in the chancel. The
octagonal piers with scalloped capitals are of 1878. – Two fine
brass CANDELABRA, bought from St Peter's, Carmarthen, in
1849: they look late C18. – FONT. 1849, low square bowl on an
octagonal pedestal. – Timber PULPIT and pews 1887. –
STAINED GLASS. E window, 1883, by *Clayton & Bell*, the Ascen-
sion, rich reds, and chancel S, 1875, surely by the same. Nave
SE, Annunciation, *c.* 1900, by *Kempe*. Nave S, *c.* 1870, richly
coloured flowers. N aisle N, *c.* 1907, by *Kempe & Co.*, – MON-
UMENTS. Margaret Davies †1729, crude lettering, crossed
bones and cherub head. Mary Anthony †1761, cartouche-
shaped. Thomas Evans and family, 1766, pilasters with inlaid
veined marble, bulbous urn above, and cartouche below. Mary
Jones †1783, oval with tall urn, by *W. Paty*, of Bristol. Elizabeth
Richards †1801, sarcophagus type. John Jones, good lettering
on limestone. Henry Lewis †1822, large draped urn, by *D.
Mainwaring*. Rev. Evan Thomas †1917, alabaster and mosaic
frame, probably by *Powell*. – BRASSES to Leoline Jones †1822,
and Lemuel Jones †1792, the former lozenge-shaped, and
signed by *J. Jones* of Carmarthen.

The big CHURCHYARD has a timber LYCHGATE of *c.* 1885,
the cobbled pavement in front dated 1815, to commemorate
Waterloo. Good C19 memorials in grey limestone frames, a
local type, in railed enclosures with free scrolled ironwork.

By the churchyard, OAK HOUSE, 1879, built as a Temperance
coffee-house for Mrs Bath of Alltyferin, in stone and red brick,
gabled to one side. Opposite, CASTELL HOWELL, a three-bay
C19 farmhouse, with whitewashed farm buildings along the
lane. The RED LION is attractive mid to late C19. TY'R
LLANDRE is a remarkable single-storey cottage of three bays,
with big gable chimneys, that to the r. projecting massively.
Here some earth-walling is visible at the eaves. It was thatched,
and must be early C18. Tiny former SCHOOLROOM, *c.* 1862,
two bays with an end door. At the E end, TAWELFAN,
c. 1840, was the vicarage, three bays with some simple Gothic
detail to the porch, and small L-plan outbuildings.

PEN-Y-CNAP, W of the village. A prominent Norman MOTTE on
the hill overlooking the Tywi. Slight evidence of the surround-
ing ditch. The fragments of poor coursed masonry are unlikely
to be medieval.

ABERCOTHI, 1 m. SW. C18 remodelling of an earlier house, owned
by Erasmus Lewis M.P. (1670–1754). He was Under-secretary

of State in the early C18, friend of Swift, Pope and Prior, and buried in Westminster Abbey. Three storeys, with a lower kitchen wing projecting to the l. Irregular front of four bays, originally five or more, the two r. bays at a different level, probably an C18 addition. Late C18 staircase with ramped rail. Some plastered beams with simple cornices in the older part. C19 whitewashed FARM BUILDINGS, including a large barn with two high doors (now all modernised).

ALLTYFERIN, 1 m. NW. Demolished c. 1960. A spreading stone mansion of 1869, by *Raphael Brandon & H. T. Freshwater* of London, built for H. J. Bath, Swansea industrialist. It had big canted bays with mullion-and-transom windows flanking a three-bay centre with Bath stone Gothic veranda, and quite lavish interiors. The service range had a tower with a steep two-stage roof. The altered front LODGE with timbered gable is of 1892, by *Wilson & Moxham*, who also rebuilt the surviving STABLE COURT, burnt in 1891. Holy Trinity church at Pontargothi (q.v.) across the Cothi was built for the estate.
See also Felingwm, Nantgaredig and Pontargothi.

LLANELLI

Of pre C19 Llanelli little survives except the tower of the parish church and Llanelly House opposite, though that is no minor survival. The site of a C12 earthwork castle is marked by Old Castle Road, replaced probably in the same area by a 'new castle', recorded in the early C14. The principal estate, owned by a branch of the Vaughans of Golden Grove from 1605, was divided, and the part comprising the present town passed to Sir Thomas Stepney, fifth baronet, of Prendergast, Pembs., in the early C18. He rebuilt the old house as Llanelly House in 1714, and further developed the coalfields already exploited in the C16. Leland in 1536 called it a village where the inhabitants 'digge coles'. Old coal-workings are beneath a large part of the town centre and some notable buildings have been lost to subsidence (two successive R.C. churches and the National School at the suggestively named Pentip). The C18 settlement was small, situated to the N and W of the parish church (mostly swept away in the road scheme that isolated the church). Though coal-mining was the basis of prosperity, the town grew with metal-working. A blast furnace was set up at Furnace (q.v.) in the late C18, bought by Alexander Raby of Cobham Park, Surrey, in 1795, one of the first of a series of English entrepreneurs drawn by the industrial possibilities of the area. Charles Nevill came from Birmingham to manage copper-works in Swansea in 1790, but set up his own works at Llanelli. He died in 1813. The company expanded under R. J. Nevill †1856, and C. W. Nevill †1888, to include copper and lead, tin-plate, silver and gold, ship-building and coal. Tin-plate was the staple of Llanelli metal-working and the engine of its growth. The town was nicknamed 'Tinopolis', and tin-plating remained the principal industry until the mid C20. With indus-

Llanelli.
View of the village, 1785

try came the development of docks: the River Lliedi was diverted
in the late c18 to form the Carmarthenshire Dock; the Nevills
promoted the New Dock in 1828 and two smaller docks, and
finally in 1898–1902 the large North Dock was built alongside
the Carmarthenshire Dock.

The plethora of religious buildings still surprises. Llanelli was
both vibrant and competitive, which encouraged building often
to a larger scale than congregations might warrant. There were
nine Anglican churches, one Roman Catholic, nine Baptist, nine
Independent, five Calvinistic Methodist (or Presbyterian), four
Wesleyan Methodist, one synagogue, and what was only the
second Mormon church in the world, founded in the 1840s.

Industrial Llanelli is hard to find now. The extraordinary inter-
penetration of housing and industry, where factories, railway
lines and small terraced houses crowded the same spaces, has
vanished. Empty ground or new housing are the marks of old
industrial sites, the New Dock has been landscaped, and a
cordon of well-planted roadways and roundabouts circle the s of
the town, where once were major iron works and tin-mills. The
industrial zone of Machynys, s again, has been wholly razed and
will become a golf course. The transition from Tinopolis to
Millennium Coast marks a regeneration strategy based on the
long-ignored attractions of the sandy Loughor estuary. The
transformation from 1995 of the fourteen-mile coastal stretch
from Loughor to Pembrey stands as the largest land-reclamation
project in Britain.

What remains is characterized by separated areas of closely
built streets of two-storey housing. The simple dignity of stucco
or brown stone fronts with sash windows and slate roofs is largely
lost to the novelties of aluminium or plastic windows, concrete
tiles and spray-on wall claddings. Something of the feel of ter-
raced Llanelli does survive in Bigyn Road, around Bryn Road,
and in Seaside. The wealthier housing took the slope N of the
centre: along New Road, Old Road and Felinfoel Road, with

some to the E, on Glenalla Road. These later C19 houses typi-
cally were stuccoed or of stone with bargeboarded gables and
timber two-storey bay windows, many by *William Griffiths*, the
principal architect from the 1890s. *J. B. Harries* built terraced
houses in the New Dock Road, Old Castle Road and probably
elsewhere from *c.* 1894.

The commercial centre around Stepney Street was a creation
of the 1870s, when the River Lliedi was canalized. The upper end
with Park Street and Upper Park Street has suffered the effects
of traffic management and planning blight. The centre was
reformed in the 1990s as a pedestrian precinct with a central
square, Stepney Square, dominated by a new entry to the shop-
ping arcade. The arcade dated from 1968–9, when the fine market
of 1894 was demolished for a car park with market beneath. It
remained one of the more depressing town-centre schemes until
the 1990s, when remodelled as part of a new covered shopping
centre, Canolfan St Elli. Stepney Street and Vaughan Street were
then given a Neo-Victorian character with maroon-painted
metal-and-glass canopies and street lights.

The clearance of industrial sites is almost complete: with new
housing around islands of old streets at New Dock, Morfa and
Seaside, and threaded into the older fabric on both sides of
Station Road. The giant Trostre Steelworks of the 1950s remains
as the single most visible emblem of the industrial past.

CHURCHES AND CHAPELS

ST ELLI. Always a substantial church, though now mostly of
1904–6, by *E. M. Bruce Vaughan*, in local stone with red sand-
stone dressings. Sturdy C15 or C16 W tower, with corbelled
parapet and NE stair-turret, not vaulted within. The W doorway
in pitted red stone looks original, but the other detail is
replaced. The preceding church had been rebuilt in 1845–6 by
E. Bagot, town surveyor, losing the most interesting feature, a
spired turret over the chancel arch. Plans for a rebuilding by
G. F. Bodley in 1902 were rejected. Vaughan's church follows
the original plan, aisleless with transepts, and is late Dec to
early Perp, with good carved detail on the S porch, but only
the replaced turret over the crossing distinctive. The interior is
good, contrasting green-grey Bridgend Quarella stone walling
with red stone dressings, under a fine series of wagon roofs.
Big arches at the crossing, the chancel arch column-shafted.
Rich chancel with panelled ceiling, black and white marble
floor and ascent of steps to the E end altar, reredos and
column-shafted E window. – FONT, 1906. – REREDOS. Last
Supper, carved by *Harry Hems*, in pink stone, in an oak five-
bay canopied setting. – PULPIT. Panelled timber, 1906. –
ROYAL ARMS. Hanoverian. – ORGAN. A Compton cinema
organ, from the Dominion, Tottenham Court Road, London,
was installed in the late C20. – STAINED GLASS. Two big
windows by *Morris & Co.* reusing designs by *Burne-Jones*. The
E window, a superb Crucifixion with saints, 1911, against a

luminous background of deep-blue and turquoise sky, and mottled green, uses the Crucifixion and flanking figures designed for Torquay, 1877, with the outer St David and St Elli from Glasgow University 1893, and Whitelands College, London, 1891, respectively (St Elli was then St Barbara). The glowing S transept S window, the Nativity, is equally fine in colouring, the design first used at Hawarden, 1898. – MONU-MENTS. A fine series from the late C17 to the early C20. The first five from Walter Vaughan in the 1680s to Sir Thomas Stepney in the 1750s have a kind of unity, being pedimented marble plaques with column shafts, the detail moving from Baroque to Palladian: Walter Vaughan †1683, Margaret Vaughan †1703, John Vaughan Stepney, 1732, Baroque cartouche with skull below, Eleanor Stepney †1733, by *William Palmer*, with winged skulls, Lady Margaret Stepney †1733, also by *Palmer*, and Sir Thomas Stepney †1751, by *Benjamin Palmer*. In a carefully matched style are those to Margaret Cowell Stepney †1921 and Sir Stafford Howard †1916. Mary Stepney †1816, pure Neo-Grec with two elongated amphorae. E. Mansel †1809, by *Tyley*, with mourning woman. Emma Chambers †1838, with draped urn, by *Orton Rossi*. Lt. Col. J. C. M. Cowell †1854, bronze relief by *Baron C. Marochetti*, a copy of the marble original in St Paul's Cathedral.

The ornately Gothic LYCHGATE is by *Bruce Vaughan*, 1911, steep hipped red tile roof over traceried oak, nicely detailed within.

ALL SAINTS, Goring Road. 1872–4 by *G. E. Street*, the two W bays, with S porch and vestry added, to the original design, in 1887–8, by *A. E. Street*. The SE tower was abandoned below the bell-stage, before the tall stone spire could be added. It was the most expensive C19 church of the region, costing some £11,000 by 1888. Large and externally dour, in brown stone with Bath dressings. Nave with clerestory and aisles, transepts and chancel, with the three-storey base of the tower attached to the S. Lancets, with some plate tracery. A strongly detailed interior: sturdy arcades on round piers, then taller transept arches, and the nave roof carried through, with big tie-beams and arch-braced collars. The transept arches are already more delicate, slightly keeled, and the chancel arch drops lower, onto corbels. Chancel of great strength and delicacy, the walls of grey ashlar, the roof boarded and panelled at first, then with five closely spaced stone transverse arches over the sanctuary with brick between, framing the five-light E window, which has marble shafts. The altar is flanked by intersecting arcading with Purbeck marble shafting, and coloured tiles behind. Two-bay N arcade to a NE chapel, and a taller S arch to the tower. Marble shafted sedilia.

FONT, 1874, by *Street*. Rich and massive: a six-lobed grey granite bowl on clustered shafts with leaf capitals. There is also a total-immersion font in the 1887 addition. – REREDOS, 1879 by *Street*. Exceptionally rich carved stone Crucifixion, under traceried canopies. Flanking angels in quatrefoils. – PULPIT.

Panelled timber, 1924. – ROOD, carved wood, 2000, by *Jonah Jones*. – ORGAN, 1874, by *W. Hill*. – STAINED GLASS. E window, Te Deum, 1879, probably by *Clayton & Bell*, numerous small scenes over five lights, superbly drawn and coloured. Given by the Phillips family, Street's patrons at Aelybryn, Felinfoel. One S aisle window, by the same, 1876. Nave W windows of *c.* 1901, with aisle W windows of *c.* 1890. One N aisle window, to the E, *c.* 1901, by *R. J. Newbery*, another to W of *c.* 1903. N transept window of *c.* 1910, probably by *Newbery*, and S transept S window, 1906, late Gothic style. NE chapel N window, 1895, by *Herbert Davis*.

ST ALBAN, Alban Road. 1911–15, by *E. M. Bruce Vaughan*. On a prominent hillside position, the W end raised high over a basement. Influenced by Bodley: long, with aisled and clerestoried nave, and high chancel. Late Dec to early Perp in local grey-brown stone with Bath dressings. The interior, in a smooth grey ashlar with Bath stone, is long and light, focused on a pair of tall E windows, set high, presumably for an intended tall reredos. The arcade mouldings die elegantly into round piers. Big open timber nave roof, the chancel roof panelled and painted, richer over the altar. Green and white chancel paving. – FONT. Ashlar bowl with a band of delicate carving around, on marble shafts. – FURNISHINGS are scanty, but the STALLS and ORGANCASE are well-carved late Gothic.

ST PETER, Paddock Street. 1867, by *R. K. Penson*. The original church, with canted apse and thin square SE tower with broached spire, was enlarged in 1892, with cross-gabled aisles, similar to those at Christ Church, presumably by *E. M. Bruce Vaughan*. Inside, round piers to the arcades, big open roof and no division before the raftered apse. – REREDOS. 1934, by *W. Ellery Anderson*. Finely carved painted and gilded late Gothic piece of three carved panels, with another above, under a crocketed spire, installed after the church turned Anglo-Catholic. – STAINED GLASS. One brightly coloured window of *c.* 1870 and two of 1893 in the N aisle.

CHRIST CHURCH, New Street, New Dock. 1886–7, by *E. M. Bruce Vaughan*. Grey-brown stone with Bath stone, late Dec style. Externally distinctive for the row of five aisle gables and the thin round NE tower, with an octagonal top and spired cap. Uninventive interior: open timber roofs, the nave roof carried low on corbels, conventional arcades and chancel arch.

ST JOHN, Marine Street, Seaside. 1887. A plain nave and chancel with a bell-lantern over the porch. – STAINED GLASS. E window, 1974.

ST DAVID, Stanley Road. 1892. Minimal mission church, stone and brick, with bellcote.

R.C. CHURCH, Waunlanyrafon. 1994. The third on the site, the previous two, of 1858 and 1937, lost to subsidence. Externally dull, red and brown brick, pyramid-roofed with a pyramid lantern. The interior is more interesting: the square space is made octagonal by eight big laminated trusses up to the roof

lantern, and the altar is set at one corner, diagonally from the entrance.

BETHANIA BAPTIST CHAPEL, Cornish Place, New Dock. 1869. Rubble stone with Bath stone arched windows, a triplet over the door.

BETHEL BAPTIST CHAPEL, Marine Street, Seaside. 1840, altered 1850. The first of the sequence of classical Baptist chapels in Llanelli. The scale suggests the later date: big stuccoed temple front with giant pilasters and balustraded columned porch. Later C19 'Florentine' window tracery and interior with cast-iron panels to the gallery fronts. Ornate pedimented pulpit-back.

CAERSALEM BAPTIST CHAPEL, Marsh Street, 1893. A late example of the classicism favoured by Llanelli Baptists. Handsome two-storey order of pilasters and a big columned pedimented porch, the detail in a fine-grained sandstone, against the local brown stone. Cast-iron panels to the galleries and also to the curved great seat and pulpit. Big Palladian triple pulpit-back. Boarded ceiling with deep and ornate centre rose.

CALFARIA BAPTIST CHAPEL, Ann Street. Disused. 1887, by *G. Morgan & Son*. Minimal Romanesque, in the local grey-brown stone with Bath stone. Bald unmoulded windows, mainly narrow arched lights. The ascending set each side of the door express the line of the gallery stair in a nicely functional way. Galleries with cast-iron panels, and a later organ behind the pulpit (blocking a rear wheel window). The big, plain, red brick first chapel next door, probably by *G. Morgan*, is dated 1881, which seems a very short interval to the new chapel.

CAPEL ALS (Independent), Wern Road. 1852–3, by the *Rev. Thomas Thomas*, remodelled 1894 by *O. Morris Roberts* of Porthmadog. The chapel was most important in the development of the town under the Rev. David Rees, minister from 1829–69, founder of schools, chapels, library and gas-works. A big unpainted stucco front on a hipped two-storey chapel. The façade is ambitious for the date, echoed in later Thomas designs, such as Bethel, Newcastle Emlyn. Two-storey with paired pilasters each floor, and top entablature with parapet. Arched windows in moulded frames, triple in the centre. The ground floor is altered with added twin canted porches with a veranda between, like those at Siloah chapel, and the gallery stairs, projecting, hipped, from the sides, do not look original. The interior, of 1894, is very rich indeed, galleried on four sides with the organ loft fully integrated. The ceiling, with a deep cove all around, is an ornate combination of boarding and moulded plaster, in squares and circles. The gallery fronts are in rich hardwoods, long panels divided by carved panels, and with a larger pilastered arched panel at intervals. Very large platform pulpit with carved panels, and curved-cornered great seat. The organ is dated 1880, which suggests an earlier layer of alteration. Plain SCHOOL, by *Thomas*, 1870, adjoining.

CAPEL NEWYDD (Calvinistic Methodist), Felinfoel Road. 1840, altered 1901–2, by *J. Davies & Son*, of Llanelli. Does this

include the Edwardian Baroque front, which looks more of
1910? The previous façade had four long arched windows and
two pedimented porches. The new one, of local stone with
much ashlar, is ornate but ham-fisted. Central open pediment
on paired Corinthian pilasters, and windows with the outsize
keystones beloved of the Edwardians, the outer windows
cramped against the corners. Ornate early C20 interior, the
gallery with rich panelled front very like the scheme at Capel
Als, by *O. M. Roberts*. Big curved-ended pulpit platform with
carved panels, and elliptical arch behind, on fluted giant
pilasters, framing the organ. The coved ceiling has paired
plaster roses.

Dock Independent Chapel, Embankment Road, New
Dock. Derelict 2005. 1867, by *John Humphrey*. A plain stone
front with narrow centre arch and arched windows. Iron piers
to the paired centre windows. There was a gallery with pierced
iron panels.

Ebenezer Independent Chapel, Inkerman Street. 1881, by
the *Rev. Thomas Thomas*. Plain and economical, but large. A
recessed thinly rusticated giant arch is the main element, with
arched windows. A centre triplet over two arched doors.

English Presbyterian Chapel, Cowell Street. 1873, by
Bucknall of Swansea, probably *Alfred Bucknall*, rather than his
better-known brother Benjamin, though there are touches of
Benjamin's High Victorian Gothic in the gable front and porch.
Altered in 1893, by *Wilson & Moxham*, and extended back in
1902 by *W. Wilkins* of Llanelli. Barrel ceiling inside and a single
end gallery. – STAINED GLASS. Four-light front window by the
Rev H. Whomsley, the minister, 1988, made by *Janet Hardy*.

Glenalla Calvinistic Methodist Chapel, Glenalla
Road. Now Llanelli Civic Hall. 1909, by *William Griffiths*.
Elaborate façade in grey-brown stone with much Bath stone,
round-arched, between Romanesque and Italianate. The
centre has an undulating rhythm of arched windows linked by
narrow arches, over arched doors. Inside, the ground floor has
been cleared. Galleries with richly detailed panelled front, on
fluted columns by *Baker* of Newport, and an ornate ceiling
with timber boarding, two strips of floral scroll, and two lush
ceiling roses.

Greenfield English Baptist Chapel, Murray Street.
1858, by *Henry Rogers*. A handsome temple front in local grey-
brown stone with Bath stone. Well detailed for the date: giant
pilasters, good Doric cornice and pediment, columned Doric
porch, and long arched windows in architraves. Inside a pleas-
antly airy interior, the gallery front on four sides wholly of
pierced cast iron. Galleries were inserted in 1861 and 1867, but
the iron must be late C19.

Hall Street Wesleyan Chapel, Hall Street. 1856–7 by
James Wilson of Bath. Wilson is credited with introducing the
Wesleyans to the Gothic Revival in the 1840s, and the big gable
front with traceried window is similar to Wilson's New King
Street Chapel, Bath, 1847. It was subsequently made even

more ecclesiastical with transepts, chancel, and the base of a
tower, 1870 by *Wilson*. The tower top stage and slate spire were
added by *W. Griffiths* in 1896. Complex flowing window
tracery, and Gothic pierced parapets, those on the gable
removed. Inside, a big open roof, and a very Anglican apse
divided off by a low screen wall.

MORIAH BAPTIST CHAPEL, Station Road. 1870. The contrac-
tor, *John Powell*, may have designed it. A large and forcefully
simple design in squared local stone with sandstone dressings.
A strong pediment with an emphatic oval plaque, over arched
windows and two arched doors. The interior is a surprise and
is surely later. Floridly theatrical, with a curved continuous
cast-iron front to galleries on four sides, the iron thickly pat-
terned, and ramped down with verve in front of the organ. The
ceiling plasterwork, in panels, has some improbable draped
maidens. The organ is dated 1913, so the fourth gallery may
date from then; a very skilful match.

PARK CONGREGATIONAL CHAPEL, Murray Street. 1864–5, by
Lander & Bedells, of London. Very Gothic with a spire, as
English congregations liked, but far from correct. The archi-
tects must have intended this, but the aesthetic is hard to follow
now. The tower is thin, square, with pinnacles as it is shaved
in to an octagonal collar, under a stark stone spire. Surpris-
ingly low interior, with boarded roof and Gothic end gallery.
Chancel-like addition of 1909, with Gothic panelling. –
STAINED GLASS. An unusual amount, dated *c.* 1884, *c.* 1908
by *Abbott & Co.*, 1919, 1934 and one of 1974 by *Celtic Studios*.
Behind, SCHOOLS, 1889, by *Lander & Bedells*, of an engaging
eccentricity. A cross-gabled octagon with a steep slate roof and
lantern. The interior is a big octagonal space with four shallow
recesses, and the roof exhibits a wonderful complexity of thin
struts and boarded facets.

SILOAH INDEPENDENT CHAPEL, Glanmor Road, Seaside.
1840 and 1855. An attractive stuccoed temple front to pair with
Bethel nearby. Ionic pilasters, and arched windows in archi-
traves with triple keystones. The two canted porches with a
veranda between are like the porches at Capel Als, perhaps part
of works recorded in 1903.

SILOH CALVINISTIC METHODIST CHAPEL, Lakefield Road.
Now a sports hall. 1878, by *J. W. Jones* of Llandeilo. An expen-
sive classical façade in local stone and fine pinkish sandstone,
that plays havoc with classical proportion. An over-large ped-
iment bears down on a Corinthian giant order, too short for
comfort, because it stands on high pedestals, to relate to the
doors. The arched windows manage three different sill levels
in five bays.

TABERNACLE INDEPENDENT CHAPEL, Coleshill Terrace. 1873,
by *John Humphrey*. One of the group of outstanding chapels
by Humphrey, including those at Morriston and Llanidloes,
with which he took the temple front in a new direction, com-
bining arcade and portico. A giant Corinthian arcade beneath
a pediment defines the façade, but behind this the fenestration

and stone banding set up a different rhythm of horizontals. There is a bold and unconstrained originality here, evoking the Roman, Romanesque, Gothic, Italianate and Greek. Inside, a shallow-curved ribbed plastered roof and curved four-sided gallery, with continuous pierced ironwork above a band of walnut veneer. The great seat also has a cast-iron band, and the pulpit is heavily arched with fretwork detail, set in front of the organ gallery of 1901, with ORGAN by *Vowles*. Separate SCHOOL, 1885, adjoining.

TRINITY CALVINISTIC METHODIST CHAPEL, New Dock Road. 1858, refronted *c.* 1918 by *William Griffiths*. Hipped original chapel with pointed upper windows behind a Gothic front with tracery and dressings in grey ceramic.

76 ZION BAPTIST CHAPEL, Upper Park Street. 1857, by *Henry Rogers*. The largest of the series of classical Baptist chapels of the town, fully pedimented with giant pilasters, in grey-brown local stone, with dressings in brown sandstone. Three bays with arched upper windows, and a timber pedimented porch. Broad interior, galleried on four sides, the fourth added in 1929 with the very large organ. The gallery is fronted in long panels divided by pilasters. Old-fashioned box pews, the side ones raked up under the gallery. The adjacent SCHOOLS, 1913, by *William Griffiths*, are large enough to be a chapel too. Local stone with Bath dressings. Two storeys, the mixed detail typical of Griffiths: a pedimented centre, half-octagonal piers with finials, and arched windows.

SYNAGOGUE, Queen Victoria Road. 1908–9, a small Gothic box, now a chapel.

OLD ROAD CEMETERY, Sunny Hill. A small cemetery of 1850. No chapels but a large bronze Crucifix MEMORIAL to Sir Arthur Stepney †1909, by *A. G. Walker*.

BOX CEMETERY, Swansea Road. Plain Gothic chapel of 1875.

PUBLIC BUILDINGS

TOWN HALL, Town Hall Square. 1894–6, by *William Griffiths*, won in a competition where he came second. An appropriate civic symbol, set in its own park, the only hall of this scale in SW Wales. Italianate, with central clock tower, in local stone with much Bath stone. Square in plan, the first-floor council chamber is in the taller spine block, with lower office ranges each side. Balustraded parapets step up to the recessed centre with pilasters and three big arched triple windows. The ashlar tower has a square clock stage, with urns, then an ogee-domed octagonal lantern. Griffiths was liberal with his details. On the big pedimented porch are two big lions and a small blindfolded Justice. Inside, a full-width hall with end stairs to the council chamber, modernized in the 1970s.

In the grounds, the WAR MEMORIAL, 1921, by *W. Goscombe John*, bronze high-relief of a bare-chested gunner and an infantryman, not pompous at all, and more conventional BOER WAR MEMORIAL, 1904, by *F. Doyle Jones* of Newcastle, the

bronze rifleman first used at West Hartlepool. Tall GATEPIERS
with globe finials, by *Raybould & Co.* of Workington.

TY ELWYN, Town Hall Square. 1981, by *Llanelli Borough Council
Architects*. Council offices of five storeys, the centre brought
forward on piers and the angles chamfered to give a tower-like
form. Banded elevations: brown blockwork imitating rusticated
stone, and recessed bronzed window bands. Excellent carved
lettering and borough arms, by *Ieuan Rees*. Etched glass doors
by *Brian Gardiner*. On the back, an aluminium totem of rele-
vant but incomprehensible symbols, by *John Petts*.

PUBLIC LIBRARY, Church Street. Built as the Athenaeum,
1855–7, by *James Wilson* of Bath, to which was added the Nevill
Memorial Hall, facing Vaughan Street in 1864, by *Wilson* also.
Converted to a library in 1926 by *H. A. Gold*. Italian palazzo
with a true *piano nobile* containing the principal rooms, the
windows with curved pediments, a single one each side of a
tripartite centre window. There was a columned porch,
removed in 1926. The Vaughan Street addition is similar in
style with a belvedere tower over the entrance, between the two
parts. Broad centre stairs, altered 1926, to upper rooms with
coved ceilings, the top glazing presumably of 1926.

GRAIG CAMPUS, Sandy Road. 1992–5 by *Dyfed County Council
Architects*, project architect *Peter Turvey*. Large further educa-
tion college. Symmetrical long front of two six-bay hipped
ranges in orange brick with glazed band under the eaves, sep-
arated by a recessed wide entance range. This is glass-fronted,
of equal height, with a centre shallow gable and big glass porch.
The formal classicism of the C18 is hinted at.

PARC HOWARD, Felinfoel Road. Built as Bryncaerau Castle,
1882–6, by *J. B. Wilson*, now Llanelli Museum. A large Ital-
ianate mansion in its own park, of Bath stone, built for the
Buckley family, to whom the architect was related. Wilson's
father had been building Italian villas in Bath in the 1850s and
1860s, but this is on a larger scale. Two storeys, roughly square
with a heavy arched porte cochère. Balustraded roof-line with
urns, pilastered walls with big plate-glass sashes, arched on the
first floor, and the symmetry upset by a big belvedere tower,
arcaded at the top. The main rooms open off a spine hall with
the staircase at the far end. Heavy later C19 detail generally.
The fireplaces are all in *Doulton* architectural ceramic. It was
bought for the town by Sir Stafford Howard in 1912.

LLANELLY HOUSE, Bridge Street. An extraordinary house, the
restoration of which has begun (2005). Facing the church, the
location represents not so much an urban core but a lost village
centre. The house had grounds running s down to the River
Lliedi, whose course is now under Stepney Street. Dated 1714
on the rainwater heads, the house was rebuilt for Sir Thomas
Stepney, fifth baronet, newly possessed of part of the Vaughan
estate by marriage. The Vaughans had owned the estate since
1605, and their house had twelve hearths in 1670. The resi-
dence there of the Stepney family was short lived, owing to the
success of their coal-mines nearby. It was tenanted from the

1770s and eventually subdivided into tenements and shops. Despite years of neglect, much survives of the house, though nothing of the grounds.

44 The house faces N to the church, with an added wing to the l., while the rear wing survives as shops in Vaughan Street. Seven bays, three storeys, with big sash windows and parapet with big gadrooned urns. The centre and outer bays are advanced and oddly embellished with an ornate timber cornice over each first floor window. There are sunk panels under all the top windows. Parallels for this design are unknown. It is hardly of academic origin: more reminiscent of an inventive master-mason. The lead down-pipes have applied foliage decoration and the hoppers have the Stepney crest. The ground floor is altered, but the carved pilasters of the Victorian shopfront are clearly fine C18 work, presumably salvaged from indoors. Within, it is clear that the two-storey C17 house was incorporated: it comprised the centre and r. of the present front, its E end wall is now the l. wall of the entrance hall, not at all aligned. The stair hall, beyond, is an C18 insertion between thick walls, which may relate to two C17 back ranges, both added, but before 1714. A great deal of panelling survives through the first floor and panelled archways to the stair hall and upper corridor. The staircase is replaced, but a second floor landing has original bobbin-turned balusters, matching those in a corniced niche in the stair hall. The ground-floor E room had a good plaster ceiling until the 1980s, but retains panelling and an overmantel painting of the British fleet at anchor off an idealized coast (similar to the painting at No. 111 Main Street, Pembroke). The main first-floor room has fluted pilasters to the W end, and in the rear wing are two rooms, one with grisaille painted panels all round, and the further one with an C18 china cupboard and chimneypiece with a landscape overmantel painting showing Llangennech Park, the Stepney seat. The painting may be by the peripatetic artist *John Lewis*, *c.* 1770. In the attic, the gable of the C17 house was found under plaster, built into the wall from the E room and there is a C17 roof over the SE back section.

BRYNTIRION HOSPITAL, Swansea Road. The former workhouse of 1837, though little but the general plan survives unaltered. The upper storey of the front range is by *W. Griffiths*, of the 1890s.

NORTH DOCK. 1898–1903, by *Sir A. Rendel & Partners*. Built for the coal trade, a large and modern dock with hydraulically powered lock gates. Being restored 2006 as a marina, following disuse since 1945. At the NW end, the derelict embattled stone ACCUMULATOR TOWER of the hydraulic system. E of the dock is the canalized River Lliedi, with quays each side, the E one made *c.* 1799 by Alexander Raby, connected by tram-road to his works at Furnace in 1803. It was reconstructed with a new W quay in 1804–6 by *James Barnes*, the company engineer, as the CARMARTHENSHIRE DOCK. Tram-road bridge at the N end.

RAILWAY STATION, Station Terrace. Long single-storey stone range of the 1870s, with Bath stone dressings and platform canopy on cast-iron brackets. The disused GOODS STATION, E of the level crossing, includes at its E half the goods shed of 1852, designed in the office of *I. K. Brunel*. Stone with a seventeen-bay roof of bolted pine trusses. It was just W of the main station that six people were killed by troops in the 1911 railway strike.

MILLENNIUM COASTAL PARK. The Park is the transformation of a fourteen-mile stretch of highly industrialized coast, some 2,000 acres (810 hectares) in all, from the Loughor estuary E of Llanelli, past Llwynhendy, Llanelli, Pwll, Burry Port and Pembrey, to the Pembrey Country Park. It was the biggest land reclamation project in Britain, much of the capping of poisoned ground and land-forming done with power-station flyash from the former Carmarthen Bay Power Station at Burry Port, the topsoil made of the same, blended with treated sewage sludge and harbour silts. The project began in 1995, with the overall landscape design by *TACP* of Wrexham, and elements still remain to be completed (2006). The VISITOR CENTRE, North Dock, 2004, by *Powell Dobson* of Cardiff (project architect *Russell Bayliss*), deliberately echoes passenger liners in its white-rendered stepped profile. The glazed façade to the sea has curved mesh screens against sun and wind, suggestive of sails. To the NE, a steel pedestrian suspension bridge, PONT D'AGEN, by *John Mowlem Engineering*, 2000, links the Sandy Water Park, created on the site of the Duport Steelworks, to the town centre. Further W, two turfed LAND BRIDGES, one of 328 ft (100 metres), and the other, towards Burry Port, of 115 ft (35 metres), cover the railway line to link the two parts of the linear park. On the point E of Burry Port is the largest single feature, visible across the bay from Llanelli, an earth-form SCULPTURE, where fly-ash has been bulldozed into a stepped wave form and grassed over, designed by *Richard Harris*, sculptor. Beyond, Burry Port Harbour has been restored, and the sand dunes W of Pembrey Harbour have become The Saltings nature reserve. Going S and E from the North Dock, the park skirts the Machynys peninsula, to be landscaped as a golf course, passes the National Wetlands Centre, Llwynhendy, and ends opposite Loughor with another SUSPENSION BRIDGE over the A484 and railway.

TROSTRE STEELWORKS, Trostre. Very large steel rolling-mill of 1952–6 built as a sequence of giant brown brick bays divided by lower recessed sections of glass-block, the impressive streamlined design by *Sir Percy Thomas & Partners*, as at Llanwern, Mon. Off to the r. is Y BWTHYN, the former Maesarddafen farmhouse, transformed by the Steel Co. of Wales to a pink-washed thatched idyll of Welsh rural life, with a collection of Welsh country furniture. It was used for entertaining clients, a curious comment on British industry of the period. In the garden, paving of iron plate and some large pieces of industrial plant.

PERAMBULATION

From the church, Stepney Street to Station Road, the Town Hall,
Thomas Street, Felinfoel Road, Old Road and New Road.

From Llanelly House, VAUGHAN STREET runs s with the Public
Library on the w side. BARCLAYS BANK has a strong stone
façade of *c*. 1875, three storeys, palazzo-style with an Italian
Gothic edge. The maroon-painted metal and glass canopies are
part of the town centre refurbishment that created the central
STEPNEY SQUARE, 1992–8, at the junction of Vaughan Street
and Stepney Street. Dominant entrance to the ST ELLI
CENTRE, 1996–8, by *BDG McColl* of Manchester, a Post-
modern classical front raised on tall columns, already rather
dated. The arcade behind of *c*. 1969 leads into the new centre,
which has two impressive glass-roofed concourses, one roof
conical, and one pyramid-shaped, with white-painted tubular
metalwork, and white floor tiles. To the r. is the sad MARKET
of 1969, by *R. Mowbray*, under a car park, for which a fine
market hall of 1894 was demolished.

 STEPNEY STREET was built up in the late 1870s after the
river was canalized, and later covered over. The architecture
was simple, stuccoed, three-storey terraces with timber oriel
windows. Going E, on the corner of Market Street, EXCHANGE
BUILDINGS, 1913, by *William Griffiths*, very neglected, but a
powerful corner block with long fronts, meeting at a domed
corner. Three storeys and attic, red brick with grey ceramic
dressings in a Queen Anne style. The windows are in archi-
traves linked vertically, with a full cornice below the attic, and
pilasters frame the outer bays, which have big attic lunettes.
Shops divided by brown glazed-brick piers. In MARKET
STREET, a stuccoed Art Deco former CINEMA, now amuse-
ment arcade. Further up PARK STREET, Zion Chapel and
schools. Returning to Stepney Square, to the r. of the shop-
ping-centre entry, LLOYDS BANK, 1894, a particularly elegant
Portland stone palazzo, with arcaded ground floor between
pedimented entries. Further down, on the r., the STEPNEY
ARCADE, 1894, by *William Griffiths*, a delightful galleried short
arcade, mostly in painted timber, behind a three-storey brick
and stone front. Some cast-iron column mullions. Opposite,
the former BURTON'S store, 1937, tiled front in the firm's Art
Deco style. On COWELL STREET, Nos. 24–26, 1890, by *Wilson
& Moxham*, built for the South Wales Union Bank, cheerfully
tile-hung with a big oversailing gable and small-paned
windows, derived from Sparrowe's House, Ipswich, via
Norman Shaw. The ground floor had an arcaded bank front
in red stone. Only one arch survives. Opposite is the English
Presbyterian Church.

 LOWER STEPNEY STREET lost the w side to the Town Hall
Square gardens in the mid C20. On the E, the former YMCA,
1909 by *Griffiths*, red brick and much moulded red terracotta,
with Bath stone pilasters above, granite ones below. The YORK
PALACE was the Llanelly Cinema, *c*. 1920, the white ceramic

p. 96

façade has been cut down. It had an Art Nouveau tree under a curved pediment. The interior retains the curved ceiling with fat plasterwork and cheerful side-panels with fruit. The row to the r., LUCANIA BUILDINGS, 1911 by *J. B. Harries*, has also lost its top, but the shopfronts still have granite and red sand-stone piers. Across the gardens are the Town Hall and Ty Elwyn. Behind Ty Elwyn, a big 1930s former CINEMA, now snooker-hall, in artificial stone with emphatic vertical divisions, the centre flanked by square-topped towers. s of Ty Elwyn, Moriah Chapel. Opposite, a pair of ponderous early C20 Edwardian Baroque buildings, now bars. The former POST OFFICE, 1911, by the *Office of Works*, red brick and Bath stone curved three-storey front. Giant keystones, festooned bullseye windows, and the SW corner concave-curved over a domed window that reverses the curve. Across John Street, the former METROPOLITAN BANK, 1912 by *W. Griffiths*, also with a curved corner, convex here, but less subtly managed. Expensive detailing: three colours of stone, Portland stone ground floor, local grey squared rubble above, with big Bath stone pedimented windows and cornice. On the w, THEATR ELLI, the former Odeon Cinema, 1938, by *Harry Weedon*, streamlined modern, clad in tile, with striated brick above. The interior altered. On the corner of Murray Street, opposite, CASTLE BUILDINGS, 1893, *Wilson & Moxham*, stark in hard red brick with Jacobean gables, and an oddly unrelated corner tiled spire. Opposite is Greenfield Chapel. On the w side, Nos. 8–16 STATION ROAD, big three-storey late C19 stuccoed range, with first-floor square timber oriels and arcaded top windows. Little else on Station Road, churches and chapels in the side streets: Murray Street, Ann Street and Marsh Street on the l., Lakefield Road and Paddock Street on the r.

Returning past the Town Hall, CHURCH STREET curves back to the church, mostly modernized. On the r., facing the gardens, MAGISTRATES COURT, 1971, by *J. M. Harries* of Bridgend, in silver-grey brick and concrete. Formal glass-box entrance between the courtrooms to the l. and a three-storey office range to the r. Windows in vertical bands. The courtrooms are raised up with the dais end cantilevered out towards Church Street, to no obvious gain. Beyond, CHURCH HALL, 1887, by *J. B. Wilson* and the OLD VICARAGE, a heavily restored small three-bay stuccoed C18 house. The red brick former MANSEL ARMS, *c.* 1890, by the lychgate, with Gothic ground floor arcade, is all that survives of the buildings around the churchyard. To the N, at the head of THOMAS STREET, the THOMAS ARMS, mid-C19 large square inn with long brick chimney on the apex of a deep-eaved pyramid roof. To the r. at the foot of FELINFOEL ROAD, CAEFFAIR, stuccoed, two storeys of three plus two bays, Late Georgian style, but probably mid C19. On the l. an altered row of roughcast two-bay cottages, the openings linked vertically in arched recesses. Further up, Capel Newydd on the r., and Parc Howard with Llanelli Museum on the l. Opposite the park late C19 and early C20 villas: GARTH

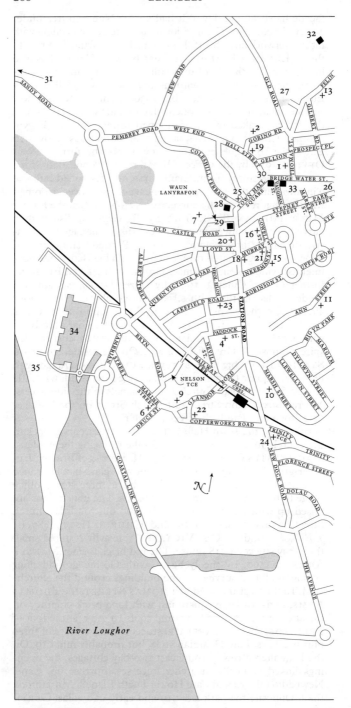

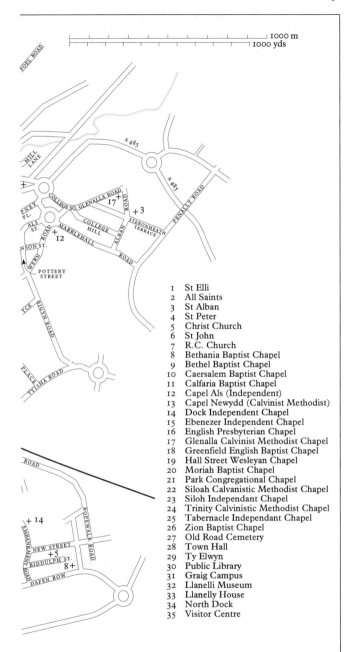

1000 m
1000 yds

1 St Elli
2 All Saints
3 St Alban
4 St Peter
5 Christ Church
6 St John
7 R.C. Church
8 Bethania Baptist Chapel
9 Bethel Baptist Chapel
10 Caersalem Baptist Chapel
11 Calfaria Baptist Chapel
12 Capel Als (Independent)
13 Capel Newydd (Calvinist Methodist)
14 Dock Independent Chapel
15 Ebenezer Independent Chapel
16 English Presbyterian Chapel
17 Glenalla Calvinist Methodist Chapel
18 Greenfield English Baptist Chapel
19 Hall Street Wesleyan Chapel
20 Moriah Baptist Chapel
21 Park Congregational Chapel
22 Siloah Calvanistic Methodist Chapel
23 Siloh Independant Chapel
24 Trinity Calvinistic Methodist Chapel
25 Tabernacle Independant Chapel
26 Zion Baptist Chapel
27 Old Road Cemetery
28 Town Hall
29 Ty Elwyn
30 Public Library
31 Graig Campus
32 Llanelli Museum
33 Llanelly House
34 North Dock
35 Visitor Centre

Llanelli

House, c. 1920, roughcast and red-tiled, cottage-style, with jettied upper floor, No. 100, c. 1900, with much half-timber, and some with the typical bay windows and fretted bargeboards of *William Griffiths*, e.g. Nos. 128–130 and Nos. 157–165. On the corner of PARC HOWARD AVENUE, No. 2, c. 1910, Neo-Georgian in the Arts and Crafts way, asymmetrical with white woodwork on red brick. Further up, No. 21, 1915, has shaped brick Tudor chimneys.

Returning to the top of Thomas Street, GORING ROAD runs w to All Saints Church. Nos. 15–19 are the best Late Georgian houses of the town, stuccoed with parapets and large timber Doric doorcases. OLD ROAD runs NW. On the l., in CYSGOD-Y-LLAN, the former All Saints VICARAGE, 1871, by *G. E. Street*, the grounds subdivided for new housing. It is a model of careful asymmetric design, in local stone with Bath stone mullioned windows. The two main gables are stepped in plan, with Gothic relieving arches over cross-windows. The surprising pyramid-roofed porch on the side lean-to was apparently added by Street, as the original entry was too draughty. Further up Old Road, on the l. CILFIG LODGE, a small Gothic lodge of the 1830s, reminder that this was then open country. On the r., OLD ROAD SCHOOLS, 1874–5 by *Wilson, Willcox & Wilson* of Bath. Gothic Board School, in stone, with infants' school of 1885 and larger schools of 1899, by *J. B. Morgan*. Beyond are later suburban houses, the semi-detached ones on the r. in the *W. Griffiths* style. On the l., WANBOROUGH, 1888, by *G. Mercer*, is large but not shapely, in red brick and half-timber. No. 45, beyond, GREYLANDS, of 1903, is sadly altered. It was an accomplished Arts and Crafts house, roughcast with steep roofs. The L-plan entrance front has a splendid gable with long stair light, the roof sweeping away on the r. over the arched doorway. The top of Old Road is Furnace, from where NEW ROAD returns to Hall Street. Similar larger, later c19 houses, with some of the best of *W. Griffiths*, designs at Nos. 76–82, and 41–47, in stone with bargeboards, bays and classical timber porches. Nos. 58–60 are a Late Georgian pair, with shallow bows each side of a centre pediment. Hall Street runs back to the parish church.

OUTER LLANELLI

See Pwll for the w, Furnace for the N, and Felinfoel for the NE. E of the centre, little on the SWANSEA ROAD apart from Bryntirion Hospital. The new road system has cut the old road that ran on past the Box Cemetery and the HALFWAY HOTEL, 1890, *Wilson & Moxham*, with big half-timbered gabled balcony, to Llwynhendy.

SE of the centre, Capel Als, faces over a roundabout. In GLE-NALLA ROAD, to the NE, stuccoed turn-of-the-century gabled houses of the prosperous sort, and Glenalla Chapel, from which ALBAN ROAD climbs to St Alban's Church. MARBLE HALL ROAD rises SE from Capel Als to the former LLANELLI

HOSPITAL, 1885, by *E. M. Bruce Vaughan*, hipped, three-bay, in local stone and painted ashlar. Gothic ogee doorway and a broad band with good Gothic lettering. There were ward blocks each side. Vaughan reused the design for the Aberystwyth hospital in 1888 (demolished). Wern Road runs SW from Capel Als to BIGYN ROAD, with long terraces climbing the hill. At the far end, in TY ISHA ROAD, HIGHFIELDS, villa of the 1860s built for the Cornish industrialist, J. S. Tregoning Jun., of the Morfa works. Two tones of brick, with complicated panelled detail. ANN STREET continues Wern Road to SW, past Calfaria Chapel and much new housing on industrial sites. The graveyard remains on the slope to the l. of the demolished St Paul's Church, 1849–50, by *G. G. Scott*.

LLANFAIR-AR-Y-BRYN

7635

A large parish NE of Llandovery, forming the NE county border, with the parish church outside the parish, on the edge of Llandovery. Cynghordy church (q.v.) was built in the C19 to better serve the parish. The remote rural area gave shelter to early Nonconformists, the cause at Cefnarthen dating from before the Civil War. Cefnarthen and Pentre Tygwyn were associated with the family of William Williams (1717–91), the preacher and hymnodist.

SAINT MARY. One of the larger medieval churches of the county, rewarding and puzzling, built within a Roman fort (*see* below). A small Benedictine cell founded from Malvern *c.* 1126 did not last long, dissolved in 1185. The present church has dateable detail from the C14 and C15, but has hints of a large earlier church. Mixed stones, typical of the region, with C15 dressings in a pitted purple-red sandstone, rounded river stones in the E end, and a few red Roman tiles reused. W tower, broad nave and chancel under a single long roof, with rebuilt S porch and lean-to N vestries. A transeptal S chapel was removed *c.* 1800, there were some repairs and new windows in 1880 and a careful restoration in 1913, by *W. D. Caröe*.

The handsome embattled tower is late C14 or early C15, with a SE stair-turret, high battered base, and small uncusped C15 two-light bell-openings. The pointed W door with corbelling over and the cusped two-light windows with quatrefoils on the W and S sides could be C14. The body of the church has some harsh windows of 1880 and red sandstone windows by Caröe. Early fragments include a single light to the W. of the porch, with a C14 red stone cusped head, and a small slit-light to the E without worked stone that could be very early, C12, with a Roman tile in the voussoirs, but is too crude to date. The porch arch and S door within are both similar to the W door, C17 plank door. C14 or C15 canted-fronted stoup. Further r. are two narrow slots, restored by Caröe, one possibly marking the site of a rood stair window, over a two-light of 1913. Next the

blocked pointed arch of the lost s chapel, probably c15 with a
c15 or c16 two-light window in the blocking, with tiny shields
in the spandrels. High in the E wall is a small c15 three-light,
restored to its original position by Caröe, as it had been moved
in 1880. The N side has a tiny opening to the W, an 1880
window on the site of the N door, and a confusion of chancel
openings: a slot window, a restored lancet, a cusped light of
1913, and a restored c15 flat-headed two-light.

Inside the exceptional width of the building impresses, with
barn-like early c18 braced collar-trusses to the nave, and
timber framing showing at the E, over the late c19 boarded
chancel roof, showing the line of the c18 chancel ceiling. The
tower has a vaulted base, narrow tower arch with a loft door
above, and a SE stair door, all pointed. Now to the puzzles.
Caröe stripped the plaster and found numerous blockings, and
the many putlog holes. There are two segmental-pointed
window reveals each side in the nave, the two on the N partly
blocked. Of the two on the s, the E one has a 1913 lancet, and
the one to the W of the porch is the one that externally looks
c12. If they were all of this date, this would have been an early
church of exceptional width and scale. Two late c15 or c16 N
doors, one blocked, one to the vestry, and a similar s rood-stair
door. In the chancel at the E end, at floor level, are a pair of
low recesses with rounded jambs and a rounded pier between,
which Caröe saw as the base of a tall c13 pair of lancets, which
the pointed piscina adjoining might confirm. This would put
an original floor level at least 1 metre lower, confirmed perhaps
by the very low rectangular window in the SE corner. But the
blocked s chapel arch, on half-octagonal piers and two tomb
recesses opposite must answer to the present floor level.
Perhaps a c13 chancel was rebuilt with higher floor in the c14
or early c15. Caröe thought that some of the blockings he
found on the N might indicate a lost N transept, and that some
joints on the s might indicate a transept earlier than the lost s
chapel. The best evidence for a c13 to c14 church of high status
comes from the Bath stone bases and a shaft-ring, all from
nook-shafts, and a carved capital, lying loose in the chancel.

WALL PAINTINGS. Remains of black-letter c16 text on E
wall, and part of a red-ochre chevron surround on the N wall.
– CARVING. On the N wall a fragment of a c14 tomb slab and
a part of a medieval bearded face with jug ear. – PULPIT. 1922,
by *Caröe*, quirky Gothic, in timber. – FONT. Octagonal late
medieval bowl in red conglomerate. – ALTAR TABLE. c17, oak,
with panelled front, restored. – STAINED GLASS. E window
1922, chancel N, 1924 and 1931, all by *Kempe & Co*. Nave s
three-light, said to be of 1865, but probably of 1880, in the style
of *Hardman*. Small tower W window by *John Petts*, 1972, a
radiant sun, also the tiny slot window in the SE corner, 1972,
lettered CARDI (Love thou), and the very different, but endear-
ing, s window of St George tangled with a Nazi dragon and a
dachshund (designed by the donor *Mary Halliday*). – HATCH-
MENTS. Two late c18 to early c19 Gwynne family hatchments,

in the tower. – ORGAN. Later C19, by *Bevington & Sons*. – MEMORIALS. Rev. W. Thomas †1853, by *D. Beynon*, with marble urn. Mary Anne Gwynne †1818, sarcophagus plaque. In the porch: a well-lettered C19 inscription, 'je remets mon ame en ta main car tu m'as racheté', but no name or date; Thomas Powell †1787; the Rev. John Williams of Pantycelyn †1828, the encomium ending A SINNER SAVED with a parenthetical note that 'the last line was inserted on the request of the deceased'; well-lettered plaque to Thomas Jones †1762.

In the churchyard to N, late C19 granite obelisk MEMORIAL to the hymnodist William Williams, Pantycelyn, †1791, the original slab in front. Hipped stone LYCHGATE with ferocious wrought-iron gates, of 1886. The church is on the site of a small ROMAN FORT, Alabum, where the Roman road from the NE joined the Tywi valley. The road below the church runs on top of a bank that may be that of the fort.

CEFNARTHEN INDEPENDENT CHAPEL, Cefnarthen. Isolated in its valley, the site testament that this is a venerable cause, founded *c.* 1642. Services were held in a cave before the first chapel was built *c.* 1689, under the leadership of Rhys Prydderch. The present chapel is of 1853, roughcast lateral façade with arched windows, the gallery lights set higher. Delightfully unaltered interior, galleried with box pews, and pulpit on a wine-glass stem in a great seat enclosure with rounded ends matching the curve of the pulpit stair. Note the grades of carpentry and graining from complex in the gallery-front and pulpit to perfectly simple in the grey-painted gallery benches.

PENTRE TYGWYN INDEPENDENT CHAPEL, Pentre Tygwyn. Founded on land given by William Williams and his mother in 1749, the present chapel of 1834, stuccoed in the later C19. Lateral façade with arched windows, and two doors. Later C19 glazing. Inside, the original gallery survives, the panels with shouldered arched heads like so many gravestones, but prettily painted in grey and white. Later C19 pulpit on the front wall. The original wine-glass pulpit, like that at Cefnarthen, survives in the detached vestry.

LLANFAIR GRANGE, by the church. An early C19 villa of the Gwynnes of Glanbran, originally Sackville Place, later St Mary's Cottage, enlarged or rebuilt, now with a late C19 character. Unpainted stucco, with a big hipped roof between projecting gables, and a hipped ballroom to the l.

PANTYCELYN, E of Pentre Tygwyn. The home of William Williams (1717–91), the hymnodist, still in his family. C16 to early C17 origins, but altered over centuries to a long roughcast range. Three-room plan, hall and parlour at the upper end, kitchen at the lower. Later C19 interiors, but a moulded curved wall-post in the lower end, and the feet of crucks in the upper end suggest that much is hidden.

In Pentre Tygwyn, at TIR PENTRE, a nice group of whitewashed FARM BUILDINGS below the chapel, dated 1865. Barn, lofted stable and carthouse in the main range, with a lower wing and an added hay-barn enclosing the yard.

MAIL COACH PILLAR, on the A40. A small grey stone obelisk on a pedestal, 'erected as a caution to mail-coach drivers to keep from intoxication'. A long inscription relates the accident to the Gloucester mail in 1833, and another that *John Bull*, Inspector of Mail Coaches, designed the memorial and *John Jones* of Llanddarog made it, in 1841.

HALFWAY, on the A40, was once the county boundary. BOUND-ARY STONE on the bridge. BETHESDA INDEPENDENT CHAPEL, 1880, small. YSGOLDY CWMDDWR, ½ m. W, former school, *c.* 1860. Schoolroom to E of a tall house with arched stair light and some cross-windows with tiny panes.

See also Cynghordy.

LLANFALLTEG

1520

Scattered village in the Taf valley, partly in Pembrokeshire. The humped bridge over the Taf has a single arch with pierced span-drels, early C19.

ST MALLTEG, to SW, on a hillside site behind Llanfallteg Farm. Disused. Small and angular, the character from a rebuilding in 1876, by *John Evans*, builder, the excessively steeply gabled bellcote the only notable feature. A stone on the chancel wall relates to repairs in 1788 and there was a rebuilding in the early C19. The interior, stripped of fittings, has plastered chancel arch, and a vaulted N transept that could be medieval. – STAINED GLASS. E window, 1901, by *R. J. Newbery*.

CAPEL MAIR, NE of the bridge. 1877. A cheaper and simple Gothic version of *George Morgan*'s larger Romanesque chapel at Login, with rose window and two-tone voussoirs. Nice jel-lymould carving over the door. No galleries.

TEGFYNYDD, 1 m. N. The shell of the most ornate High Victo-rian house in the county, though too remote to have been much noticed. It was built in 1873–5 for H.S. Morgan, probably by *F.R. Kempson*. Rock-faced stone with yellow limestone to two big canted two-storey bays. The bays are subtly asymmetrical with rich EE detail. Large traceried stair window to the rear. Inside, fine hooded stone chimney. The stair ran up through a Gothic arcade, replicated on the first floor without mouldings.

LAN, 1 m NE. Early C19 hipped villa with porch on cast-iron Ionic columns.

LLANFIHANGEL ABERBYTHYCH *see* GOLDEN GROVE

LLANFIHANGEL ABERCYWYN

3014

The ruined medieval church stands alone where the Cywyn joins the Taf, opposite the also ruined church of Llandeilo Abercywyn (q.v.). Both were on a pilgrimage route to St Davids, linked by

a ferry. A more convenient church was built in 1848 by the main road, near Bancyfelin, the main settlement that grew around the chapel, founded *c.* 1750.

OLD CHURCH, in fields below Trefenty farm. Roofless nave and chancel, with a C15 W tower. The tower has a vaulted base. The battlements have gone, as has the nave N wall. The round chancel arch with imposts could be C13. The footings of a rood stair remain on the N. The chancel has tall corner recesses, and brackets each side of the C16 flat-headed E window.

Outside, S of the church, are the extraordinary medieval PILGRIMS' GRAVES, re-set in 1907. Two groups of three, *p. 296* carved slabs with low uprights at each end, possibly late C12 or early C13. Each group has two with figures and one Latin cross. The crosses have some rope moulding, one headstone has a Greek cross also with rope mould, the other has chevrons. Two of the figure slabs show female figures, one with arms crossed at the wrists encircling a Greek cross, the folds of the skirt clearly discernible; the other, smaller, has the arms straight and a full skirt. The other two both have long arms around a Crucifix. The better preserved one has a staff, and two small animals flank the head – a hunting allusion? There is latticework below, and on the headstone a cross with lozenges around. The other has the head missing, but on each end stone, a small figure on horseback. The history of these is completely unknown. They may relate to the motte-and-bailey CASTLE, just beyond Trefenty, to the NW. Traditionally they are graves of pilgrims to Compostella, the cockle shells found in one grave in 1838 may be indicative, though commonly harvested here.

ST MICHAEL, on the A40, 2 m. w. A bare church of 1848 by *J. L. Collard* was improved, first with stone tracery in 1883, by *Middleton & Son*, and then more radically, in 1913–15, by *W. D. Caröe*. Caröe lengthened both chancel and nave, rough-cast the exterior, and added the N porch and S vestry. Most distinctive is his big slate-covered bell-turret on the ridge towards the W end, with sloping sides and steep four-sided spire. Inside, the roof of 1848 has kingposts and two pairs of curved struts. Caröe's turret is carried on timber posts, creating the effect of a short aisle. – Magnificent late C12 FONT, a big circular tub with interlaced arcading, quite untypical of the region. The Rev. Thomas Charles of Bala (see Pantdwfn below) was baptized in it in 1755. – Also from the old church, some rustic BENCHES, 1813. – Oak chancel FITTINGS, by *Caröe*, and some good iron door furniture by him. – STAINED GLASS. E window, 1895, by *Clayton & Bell*, the Last Supper.

TREFENTY. A double-pile house, each face of three bays and storeys, the detail all early C19. The E half must be older, from the chimneys, and there is a massive chimney-breast inside, without dateable detail. The house was part of the Perrot estate from the late C16, passing to the Plowdens of Plowden Hall, Salop. Interesting late C19 MODEL FARM: a massive barn with

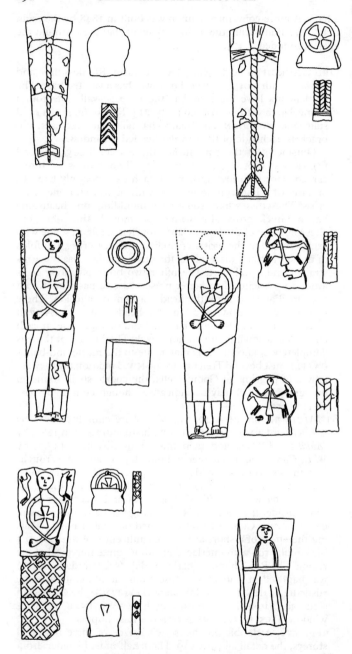

The Pilgrims' Graves.
Drawing, courtesy of RCAHMW

three projecting wings for livestock, the gable of each wing with a big brick relieving arch. The layout was so that feeding and milking could be done under cover.

PANTDWFN, I m. SW. Foundations only survive of the childhood home of the Revs. Thomas and David Charles, born 1755 and 1762, giants of Welsh Nonconformity. The present house of 1856 is on higher ground.

WENALLT, N of Bancyfelin. Early C19, probably by the owner, *William Carver*, who made plans for the new church in 1830. He was brother to the Somerset architect, Richard Carver. Five bays, gabled to the r., the rest with a veranda. Tudor casements and fancy carved eaves. COACH-HOUSE, 1884, by *George Morgan*.

LLANFIHANGEL AR ARTH 4539

Modern crossroads village, with the church to the N, on the scarp above the Teifi. VICARAGE FARM, ¼ m. W, is dated 1762, stone, three bays, the corrugated-iron covering thatch over three scarfed crucks. TANYRALLT, further on, is a later C19 single-storey cottage. Pont Tyweli or Pontweli, the Carmarthenshire part of Llandysul, is the largest settlement, with later C19 stone and yellow brick houses and warehouses, associated with woollen mills.

ST MICHAEL. Twin-naved medieval church, the earlier nave to the N, with chancel, the S one added in the C15. Restored by *David Davies* in 1871, who was said to have been 'very liberal with windows': all are C19. The nave W window and aisle E, both grouped lancets, may be renewals, and the aisle bellcote is restored C15–C16. Inside, two-bay arcades from both nave and chancel to the S aisle, with broad chamfered arches and an octagonal pier, the chancel arcade with imposts, C15, the nave without, possibly C16. – Plain whitewashed octagonal late medieval FONT. – INSCRIBED STONES. A C5 to C6 stone inscribed in capitals HIC IACIT VLCAGNVS FIVS SENOMAGL. Also a tall stone with long C7 to C9 incised cross, the stem crossed by three lines and four small crosses disposed around the head. – STAINED GLASS. E window, 1913. S aisle two-light, 1995, by *Gabriel Loire*, of Chartres, the Ascension. A swirling line across both lights begins as an imprint of feet and ends as the head of Christ, hailed by mortals and angels, more pious than vigorous. – LYCHGATE. 2001, by *Roger Clive-Powell*, showing Arts and Crafts influence with stubby Bath stone columns carrying the roof.

PENYBONT BAPTIST CHAPEL, Pont Tyweli. 1907–8, presumably by *David Davies*, as with his typical giant arch and pilasters but more confidently scaled than his other works. Theatrical interior with U-shaped gallery, the continuous bowed cast-iron front in a bold honeysuckle pattern, by *Macfarlane* of Glasgow. Pulpit and great seat backed by the organ in a giant arch.

PONT LLANFIHANGEL, ¼ m N. A muddled project of 1847–51, that did result in a handsome single-arched bridge, in rock-faced stone. A first attempt was swept away in 1848. *R. K. Penson*, as County Surveyor, designed another, but the committee found a cheaper design by *Samuel Garrett*, railway contractor, soon abandoned. Their consultant, *Brodie*, engineer to the South Wales Railway, recommended plans by *W. P. James*, of Cardiff, modified them himself, for execution by Penson who claimed, with the support of the contractor, that the design was unworkable. Penson completed the bridge, Brodie was paid, and the authorship of the design remains clouded.

DOL LLAN, facing Llandysul from across the river. C18 farmhouse altered in the 1790s with Palladian glazing in the old windows, for Dr David Stevenson, close friend of Thomas Johnes of Hafod who persuaded him to leave London for the rural idyll (his wife did not like it, they returned to the city within ten years). Stevenson built a spacious new farmyard on the hill above, the buildings described by Malkin in 1803 as 'models of ingenious contrivance', but much altered now. A lost lodge was picturesque with pointed windows, which all suggests the involvement of *John Nash*: Palladian windows were not then in the local vocabulary.

LLETHR NEUADD, 1½ m. SE. A single-storey range, formerly thatched, survives as part of the farmyard buildings. It was the home of Sarah Jacob (1857–69), the 'Welsh fasting girl' who became nationally notorious when her parents claimed that she had lived for two years without food. She died of starvation when inspection was intensified.

CRAIG GWRTHEYRN, 1½ m. W (SN 433 402). Iron Age hill-fort above the Teifi, defended by a stone wall, and on the SW entrance side by two additional banks, and a belt of pointed stones.

See also Pencader.

LLANFIHANGEL CILFARGEN
1½ m. NE of Court Henry

A medieval grange of Whitland Abbey, the smallest parish in the county, with no village.

ST MICHAEL (SN 573 240). Now a house. Small church of 1821–2, one of several rebuilt at the expense of Archdeacon Beynon of Penboyr. Nave with bellcote, and chancel. Perp windows of 1884, by *David Williams* of Llanfynydd, builder.

LLANFIHANGEL RHOSYCORN

Upland parish N of Brechfa, mostly covered by the Brechfa Forest plantations. The main settlement is at Gwernogle, the church is isolated 1½ m. E.

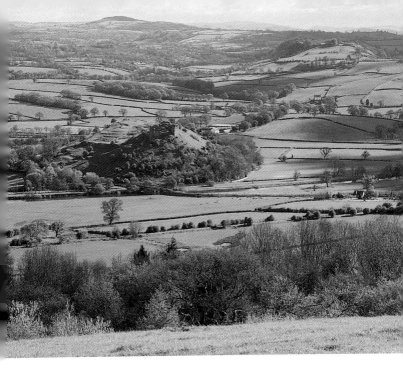

1. The Tywi valley with Dryslwyn Castle, Cms. (p. 185)
2. Bodcoll, an upland farmstead near Devil's Bridge, Cd. (p. 465)

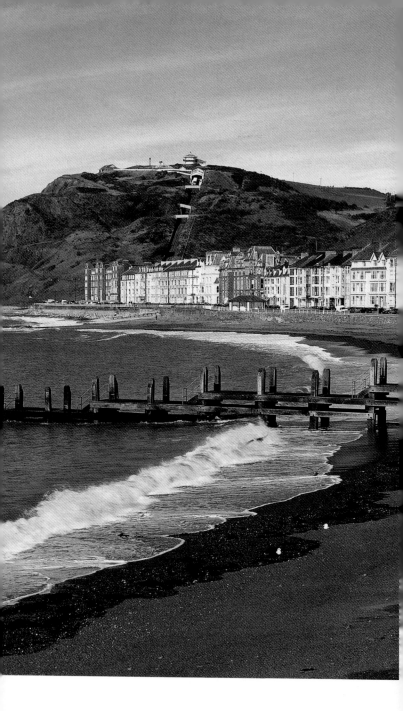

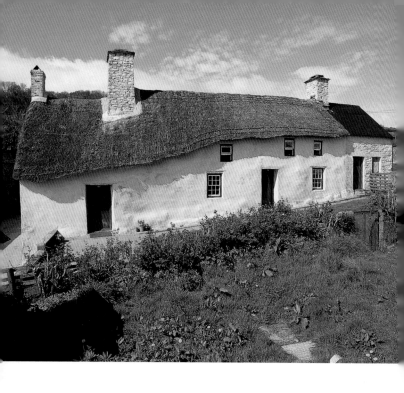

6. Vernacular: Aberdeunant, Llansadwrn, Cms. (p. 327)
7. Vernacular: Troedrhiwfallen, Cribyn, Cd. (p. 460)

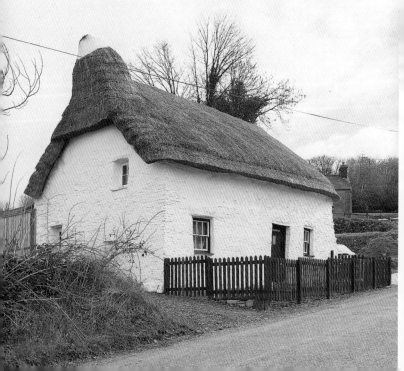

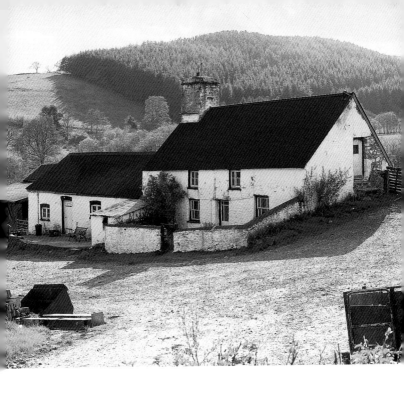

8. Vernacular: Cwm Eilath, Llansadwrn, Cms. (p. 328)
9. Vernacular: Cefn Gwyddil, Cross Inn, Cd. (p. 461)

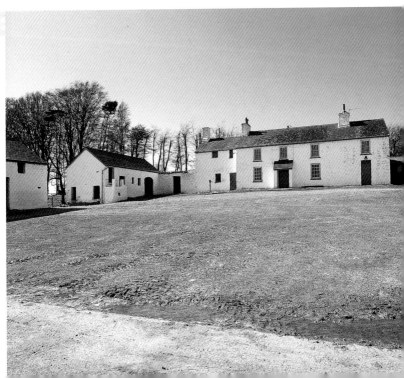

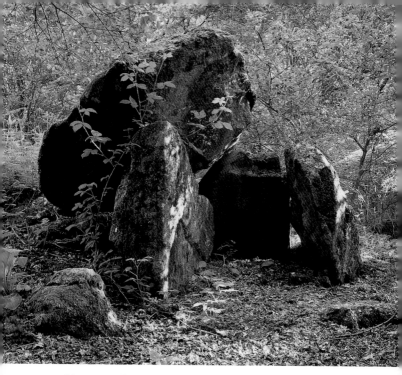

10	12
11	13 14

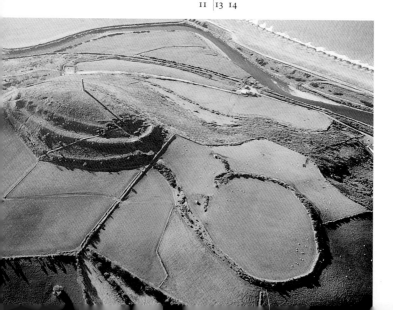

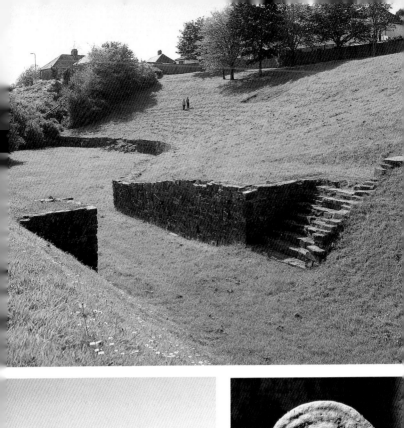

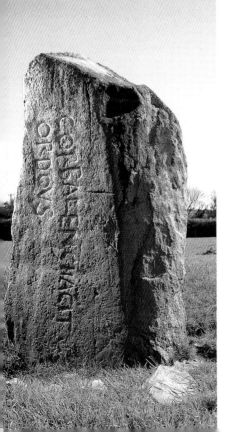

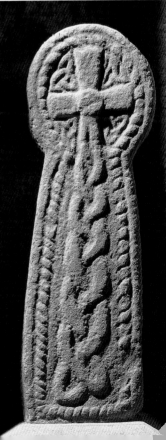

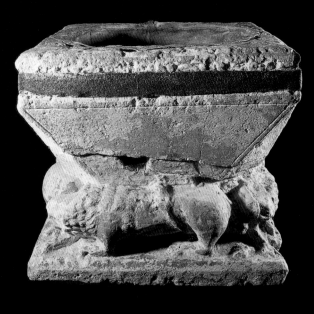

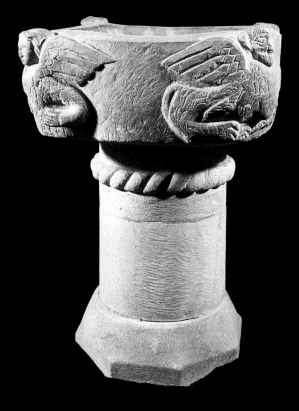

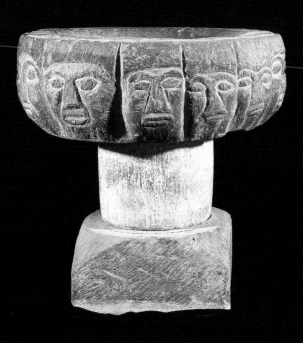

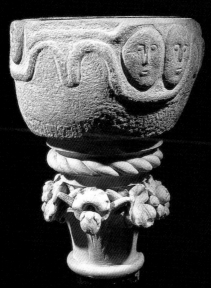

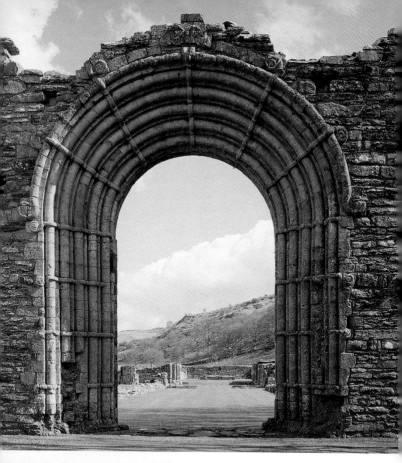

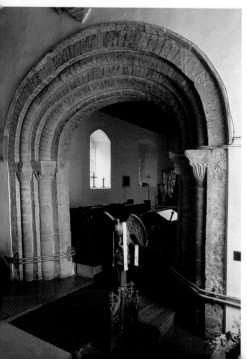

19. Strata Florida Abbey, Cd.,
 w door, late C12 (p. 574)
20. St Clears, St Mary
 Magdalene, Cms., chancel
 arch, later C12 (p. 372)
21. Talley Abbey, Cms.,
 crossing tower, late C12
 and early C13 (p. 380)
22. Dinefwr Castle, Cms.,
 round keep, early C13,
 with late C17 belvedere
 (p. 179)

19	21
20	22

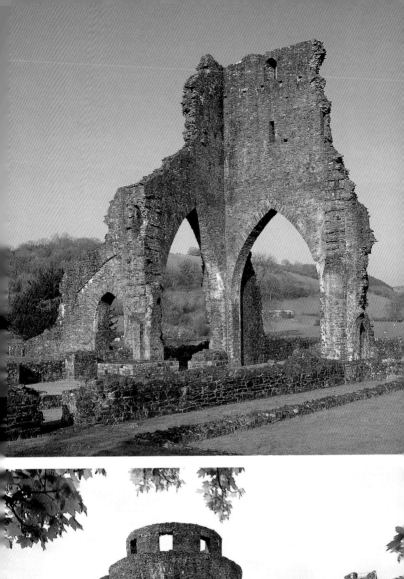

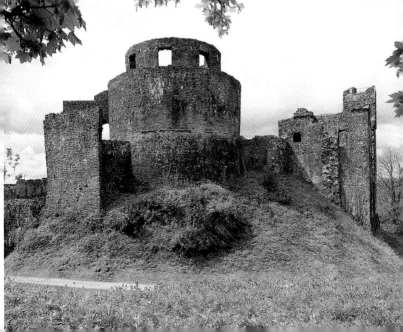

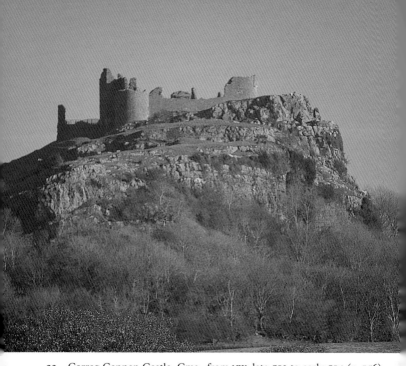

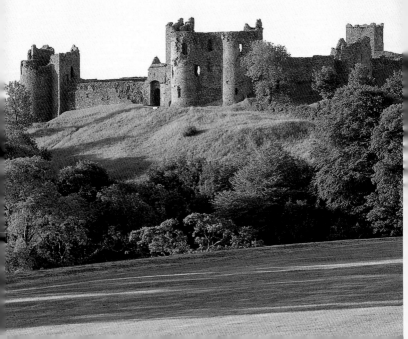

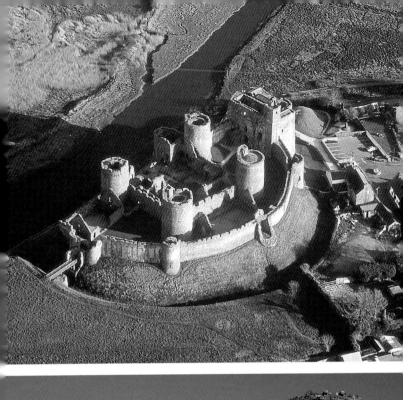
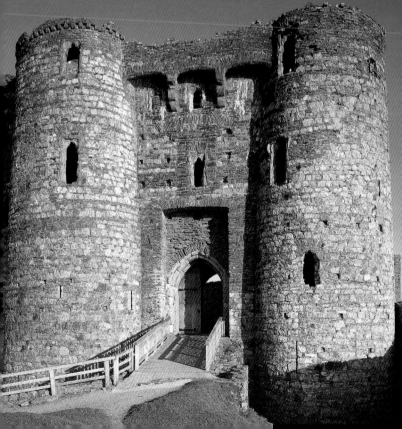

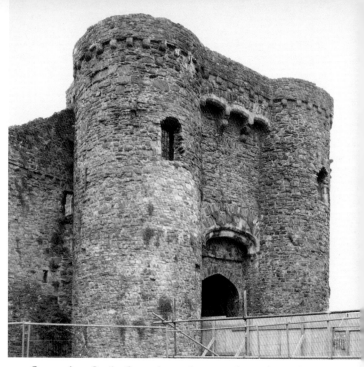

27. Carmarthen Castle, Cms., the gatehouse, early C15 (p. 208)
28. Kidwelly, St Mary, Cms., piscina and sedilia, C14 (p. 215)
29. Kidwelly, St Mary, Cms., tower and spire, late C14 to mid-C15 (p. 212)

27
28 | 29

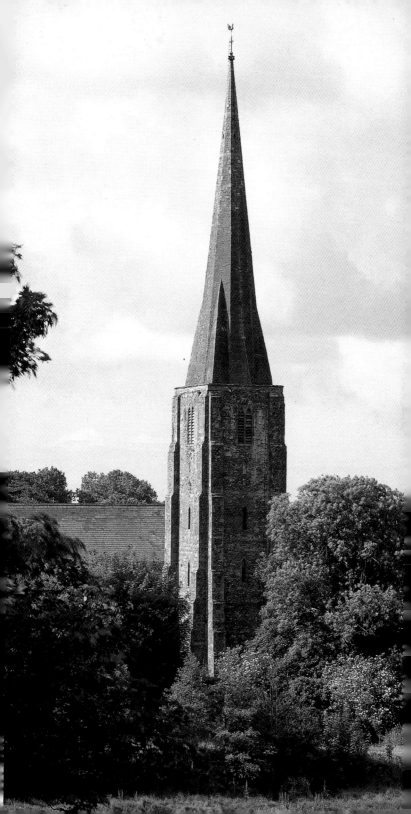

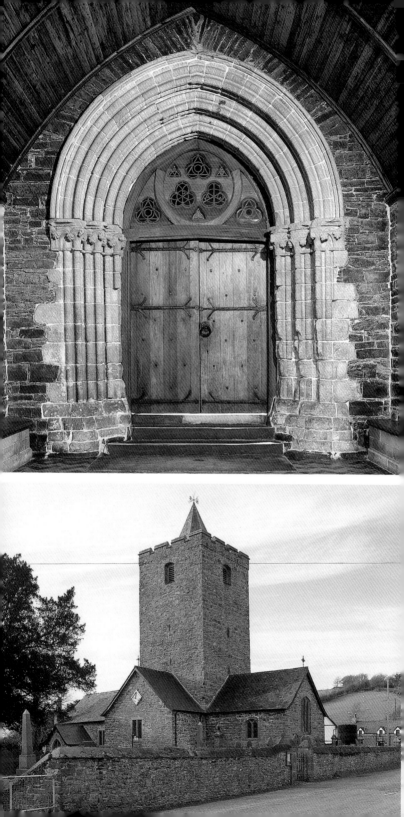

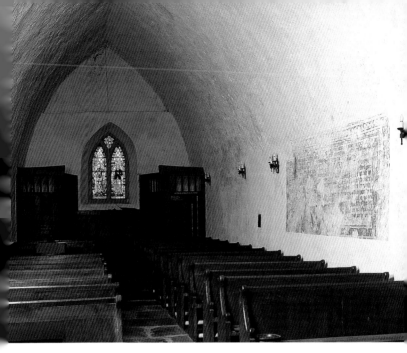

30	32
31	33

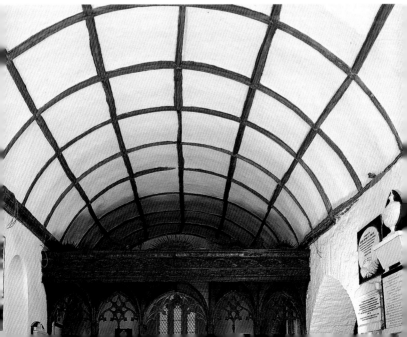

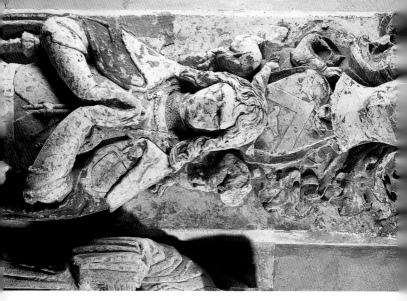

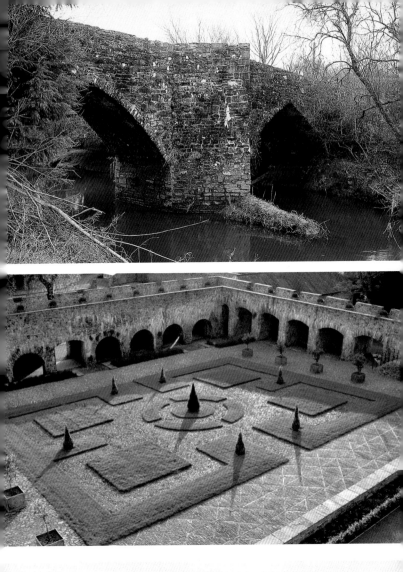

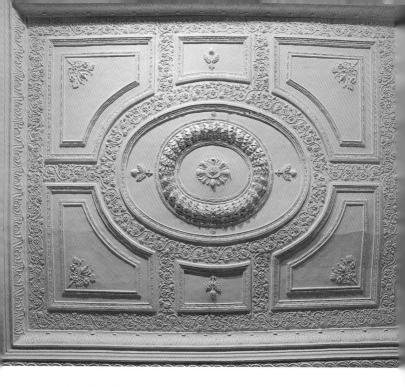

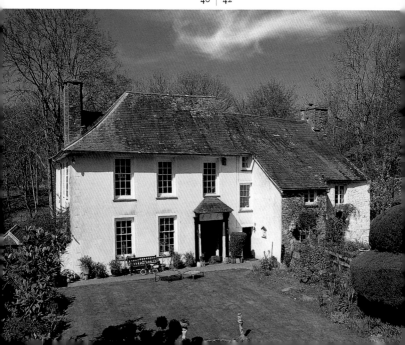

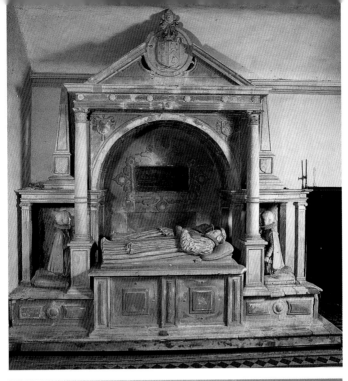

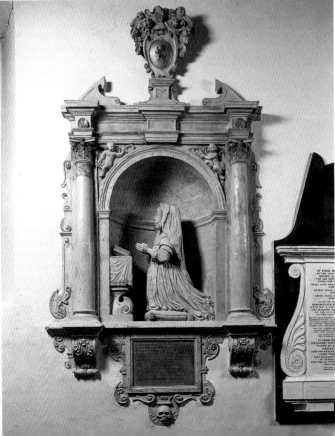

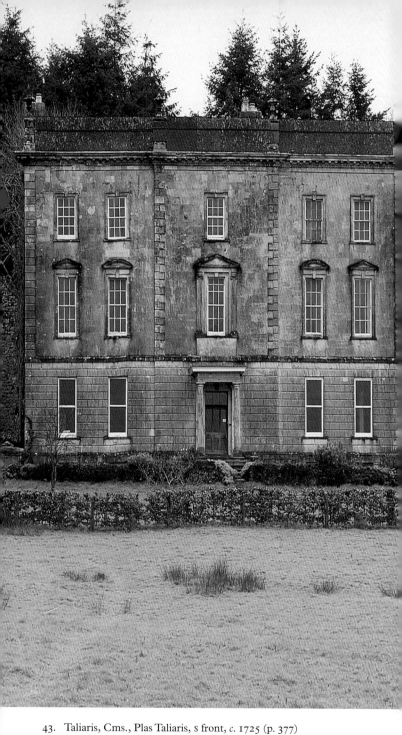

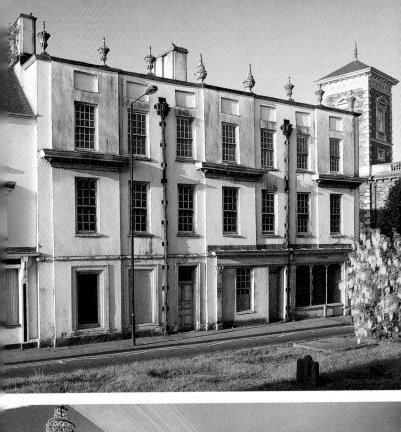

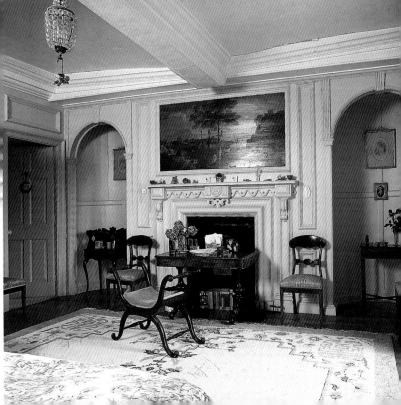

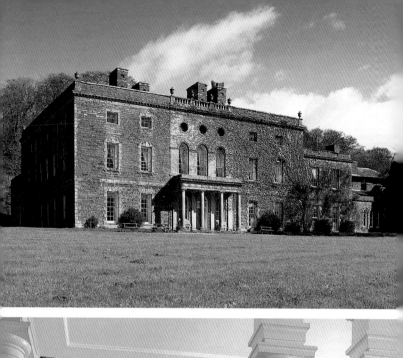

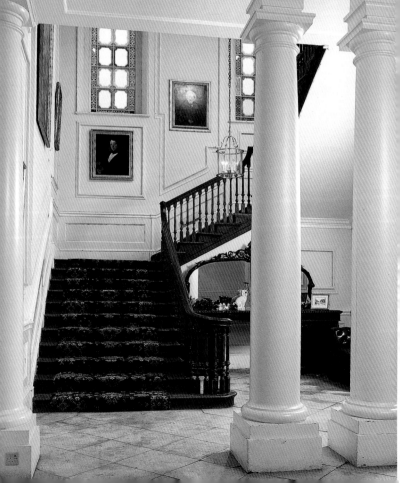

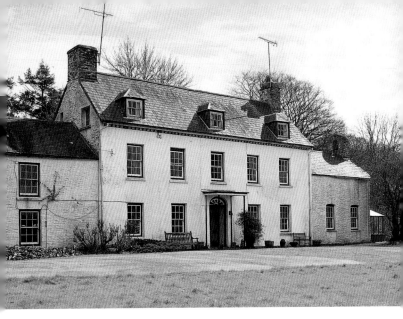

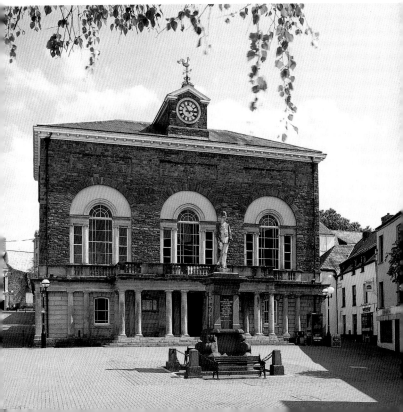

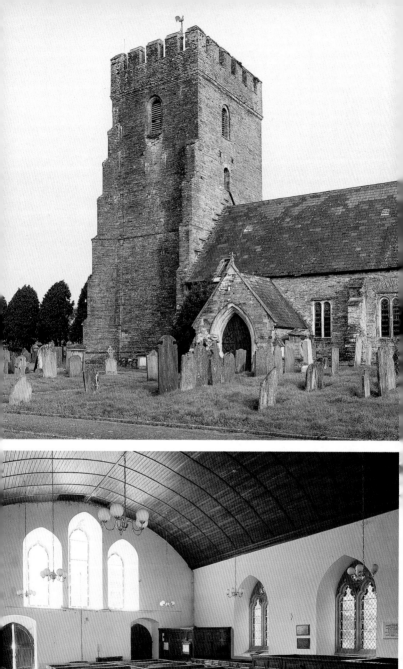

50	52
51	53

THIS MONUMENT
WAS ERECTED
BY PRYSE PRYSE
ESQ.
OF GOGERDDAN,
IN THIS COUNTY,
AS A SMALL TRIBUTE
OF RESPECT
AND REGARD,
TO THE MEMORY
OF
HARRIET,
HIS BELOVED AND
AFFECTIONATE WIFE
SECOND SURVIVING
DAUGHTER OF WILLIAM
LORD VISCOUNT ASHBROOK
OF CASTLE DURROW,
IN THE UNITED KINGDOM
OF IRELAND;
SHE DEPARTED THIS LIFE
AT GOGERDDAN,
ON THE 13TH DAY OF JANUARY 1813
IN THE 41ST YEAR OF HER AGE,
SINCERELY REGRETTED BY ALL
WHO HAD THE HAPPINESS
OF HER ACQUAINTANCE

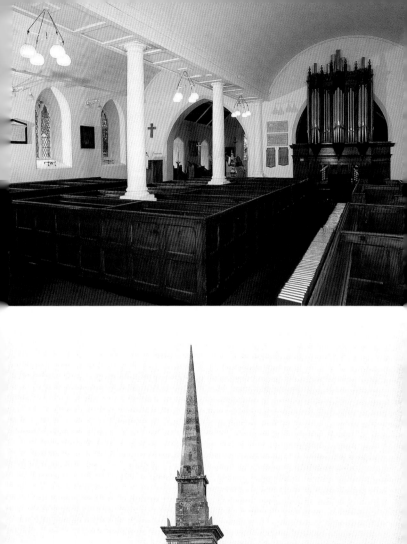

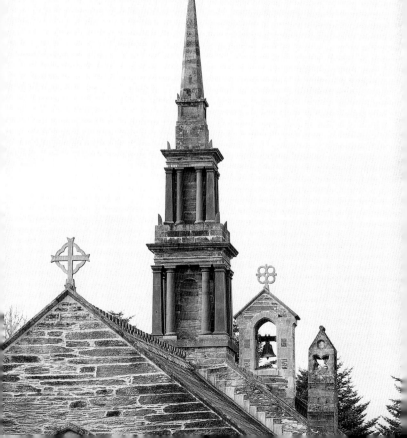

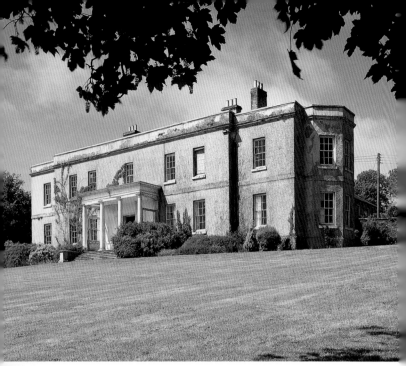

58. Llansteffan,
Cms., Plas
Llansteffan,
1780 (p. 336)
59. Llangoedmor,
Cd., Plas
Treforgan,
c. 1810, garden
front (p. 521)

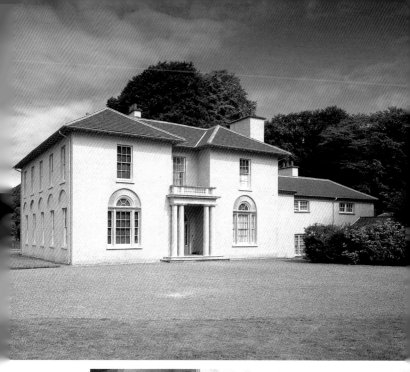

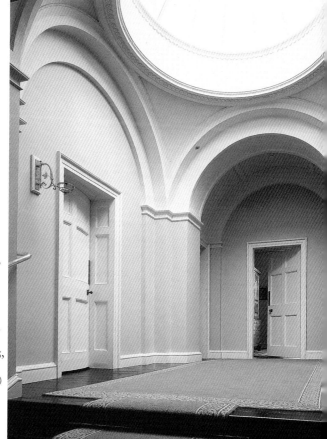

Llanerchaeron,
Cd., from SE,
by John Nash,
c. 1793–5
(p. 513)
Llanerchaeron,
Cd., by John
Nash, c. 1793–5,
first floor
landing (p. 513)

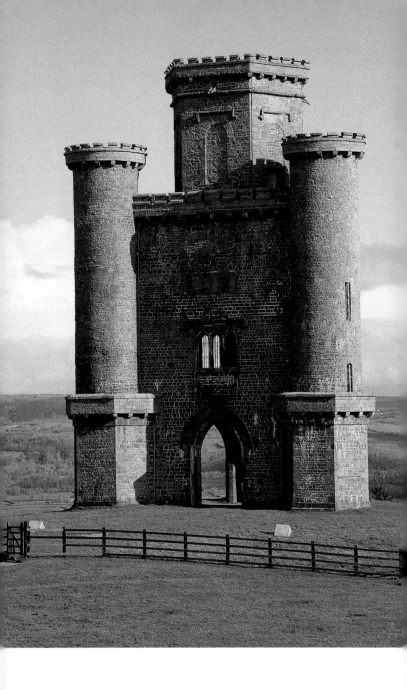

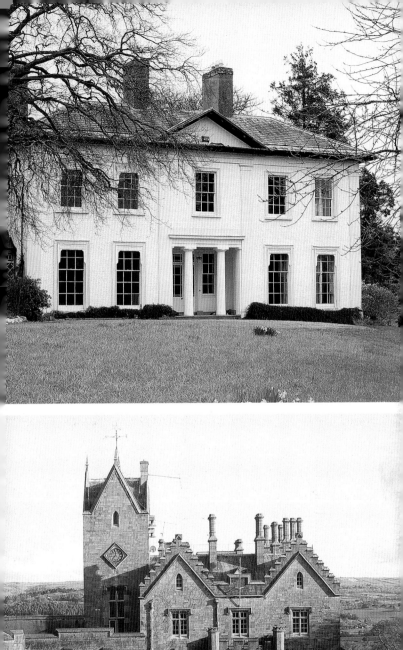

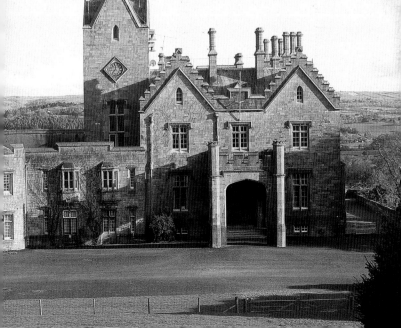

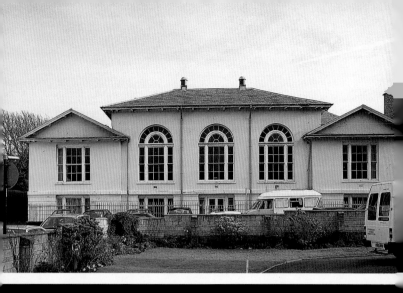

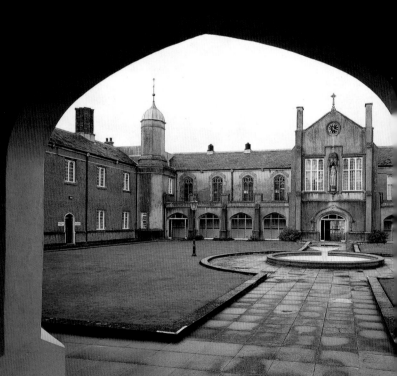

65. Aberystwyth, Cd., Assembly Rooms, by George Repton, 1818–20
 (p. 425)
66. Lampeter, Cd., University quadrangle, by C. R. Cockerell, 1822–7
 (p. 484)

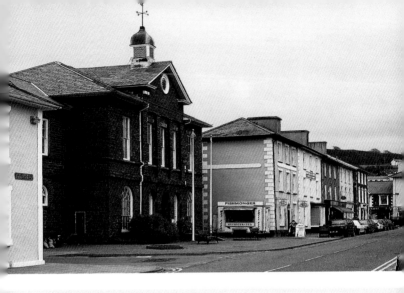

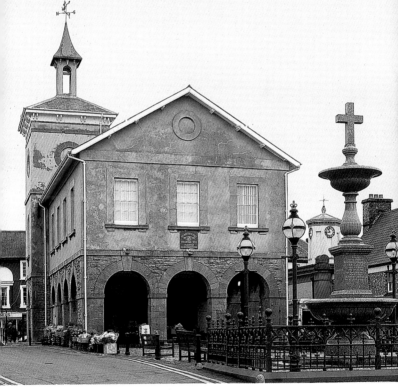

67. Aberaeron, Cd., Town Hall and Market Street, 1833–4 (p. 394)
68. Llandovery, Cms., Town Hall, by R. K. Penson, 1857–8 (p. 258)

69. Llandeilo, Cms., Cawdor Arms Hotel, c. 1807 and 1840s (p. 252)
70. Devil's Bridge, Cd., Hafod Arms Hotel, rebuilt 1838–9 (p. 465)

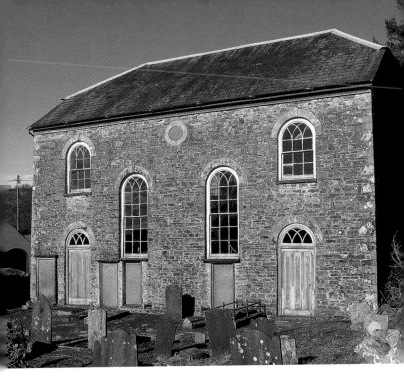

1. Rhydowen, Cd., Llwynrhydowen Unitarian Chapel, 1834 (p. 569)
2. Llansadwrn, Cms., Libanus Baptist Chapel, 1841, interior (p. 327)

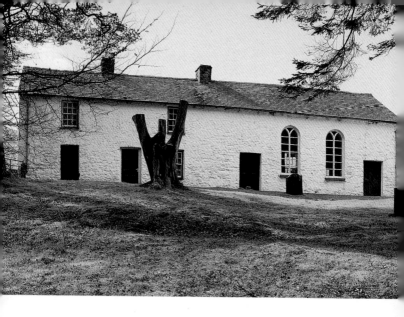

73	75
74	76

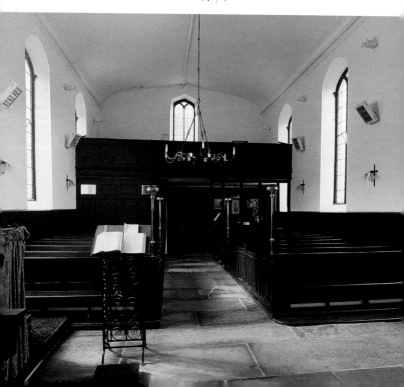

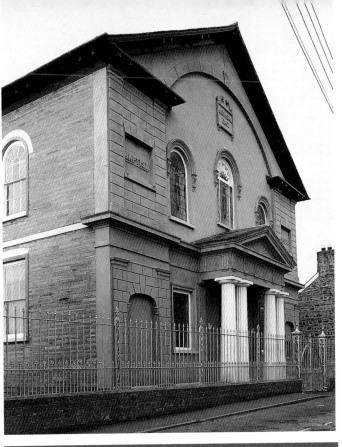

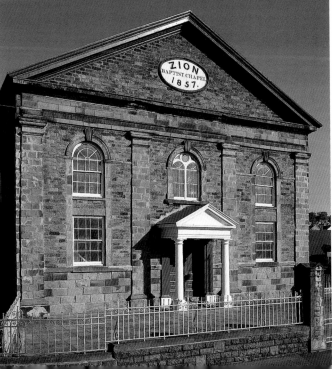

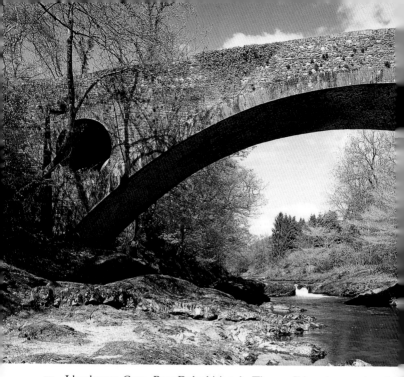

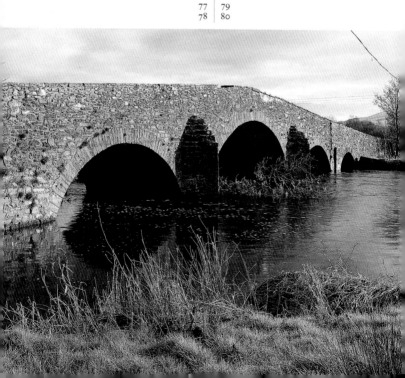

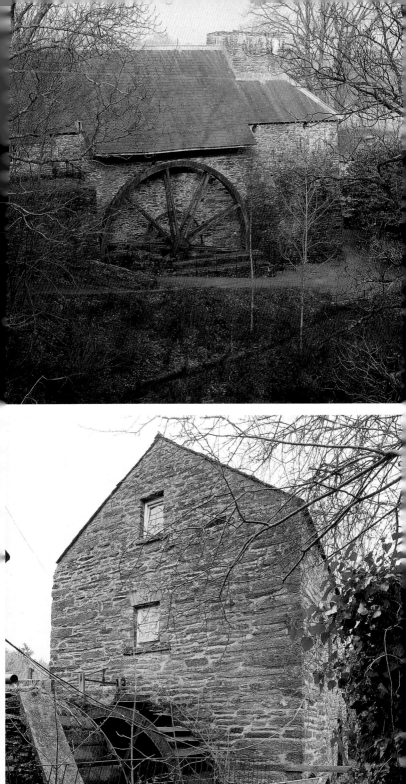

E. DAVIS

81	84
82 83	85

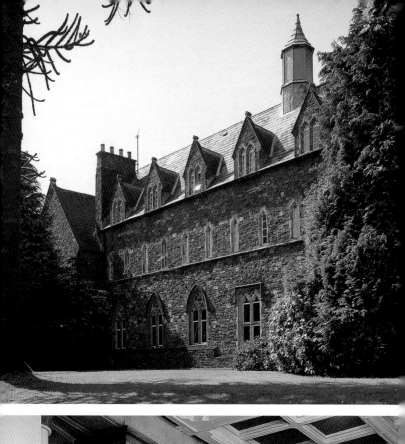

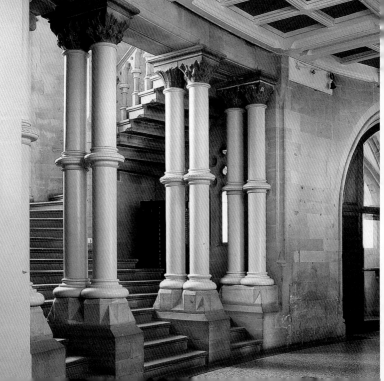

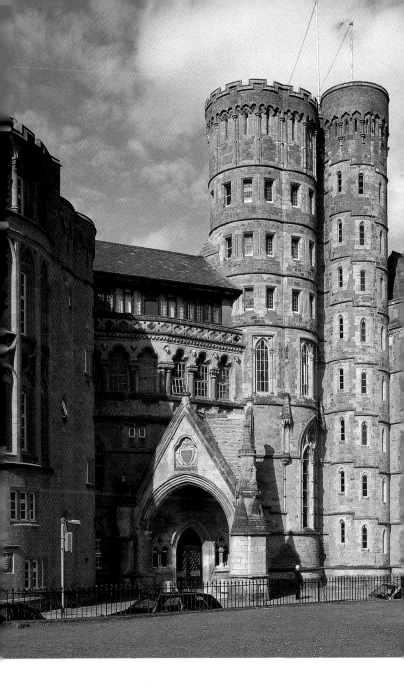

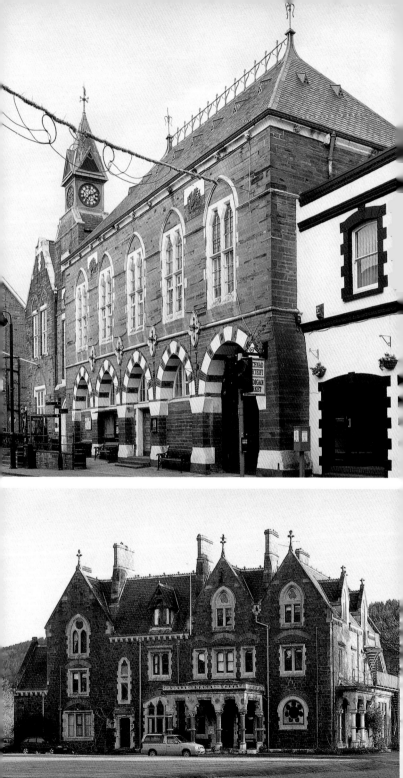

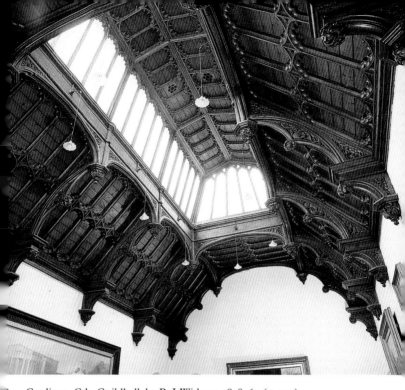

89	91
90	92

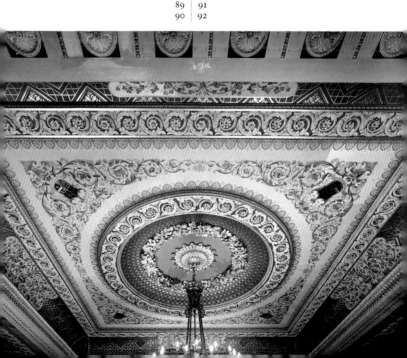

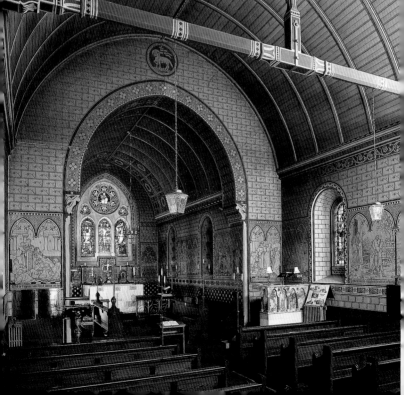

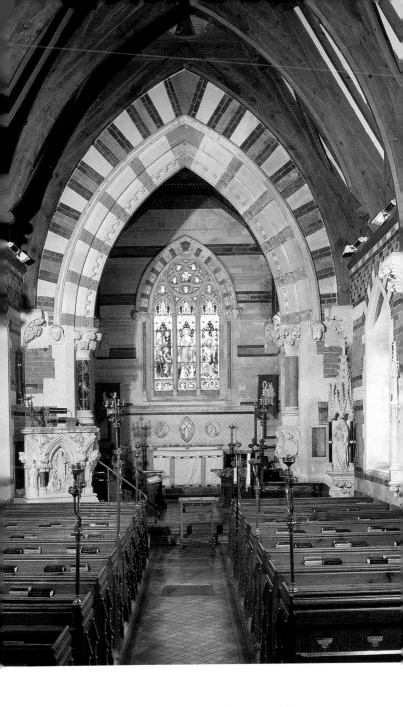

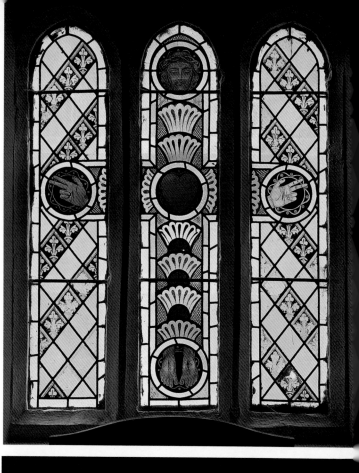

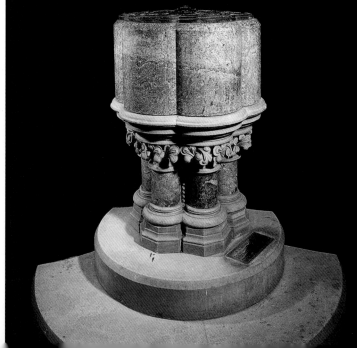

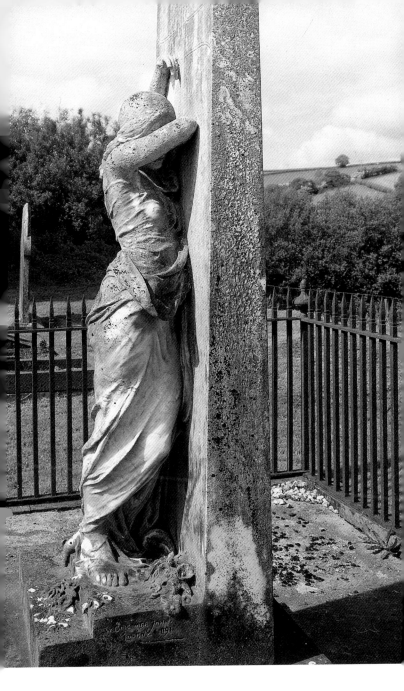

96. Cynwyl Elfed, St Cynwyl, Cms., E window, by J. P. Seddon, 1877
 (p. 171)
97. Llanelli, All Saints, Cms., font, by G. E. Street, 1874 (p. 277)
98. Llanboidy, St Brynach, Cms., memorial to W. R. H. Powell, by W.
 Goscombe John, 1891 (p. 242)

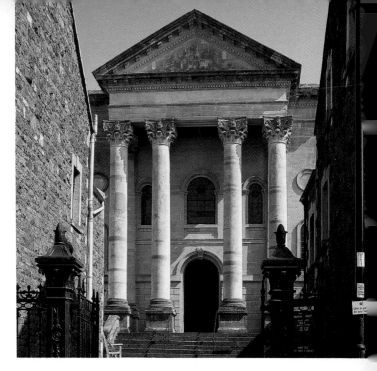

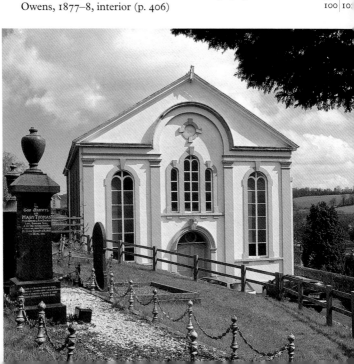

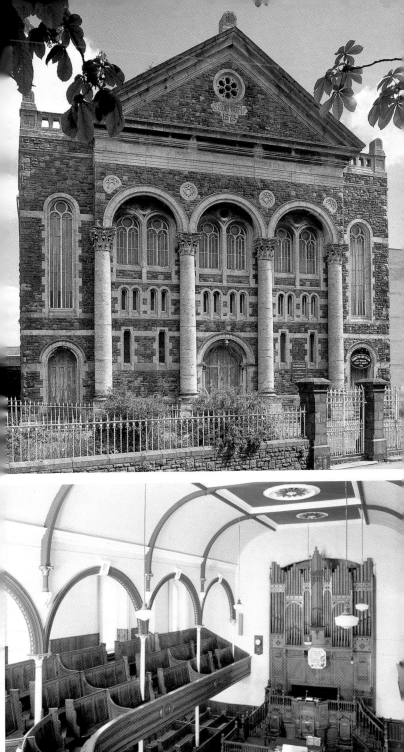

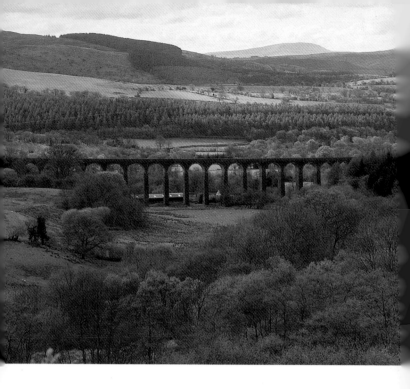

103. Cynghordy, Cms., railway viaduct, by Henry Robertson, 1868 (p. 171)

104. Rhandirmwyn, Cms., Nantymwyn lead-mine, engine-house, 1880s (p. 371)

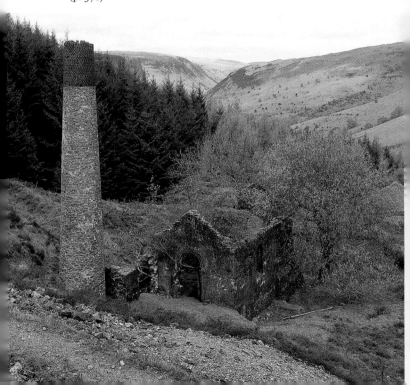

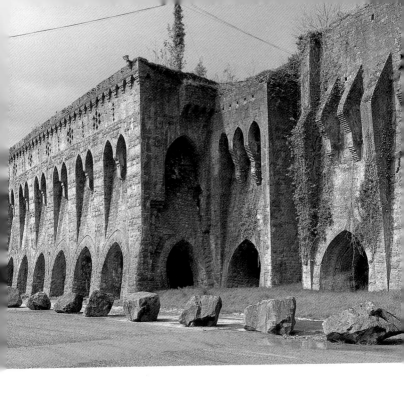

105. Llandybie, Cms., Cilyrychen lime-kilns, by R K. Penson, 1857–8
 (p. 266)

106. Felinfoel, Cms., Felinfoel Brewery, 1878 (p. 192)

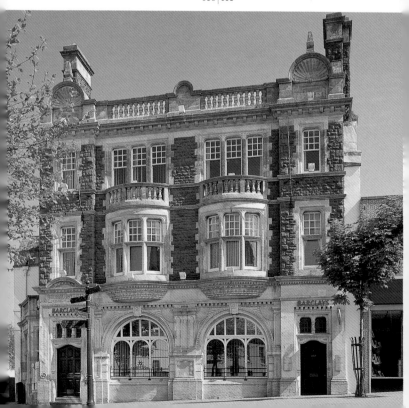

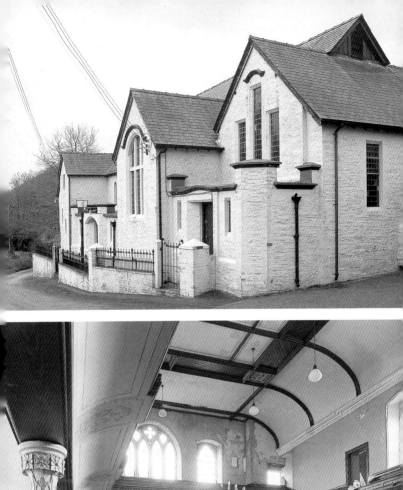
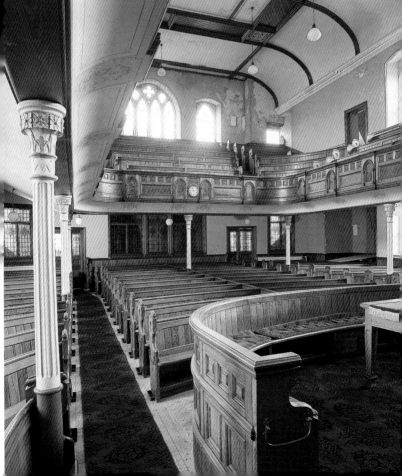

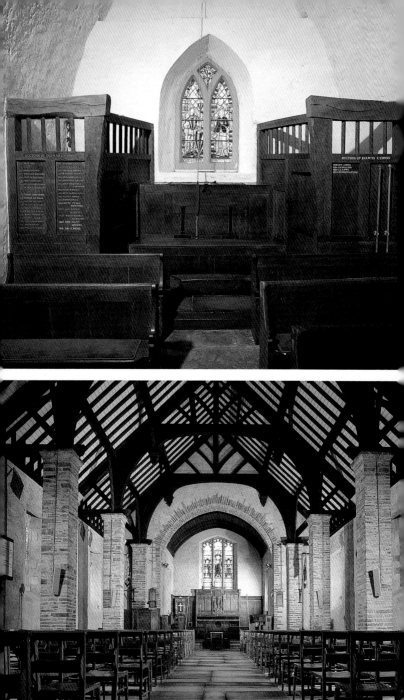

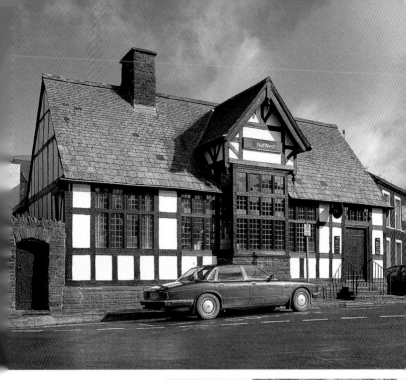

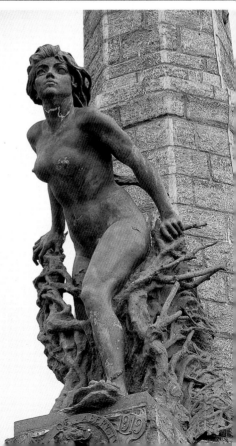

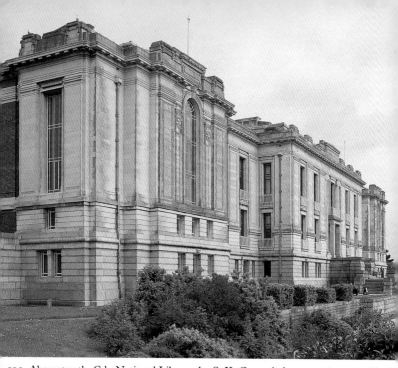

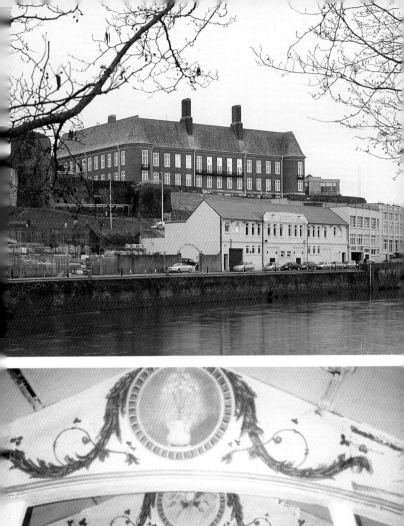

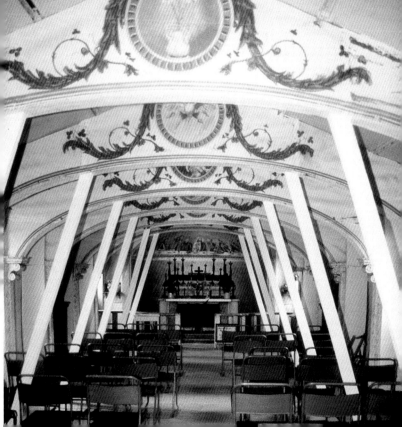

119. Aberystwyth, Cd., Bryn Aberoedd, by Ifan Prys Edwards, 1968 (p. 428)
120. Aberystwyth University, Cd., Great Hall, by I. Dale Owen, 1967–70 (p. 420)
121. Llansteffan, St Ystyffan, Cms., E window, by John Petts, 1980 (p. 334)

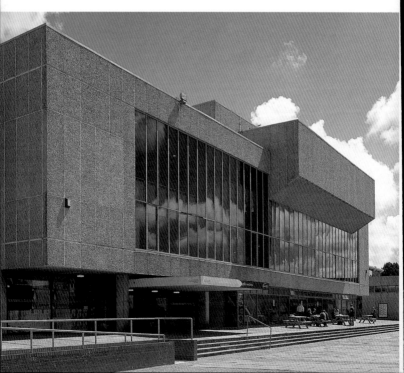

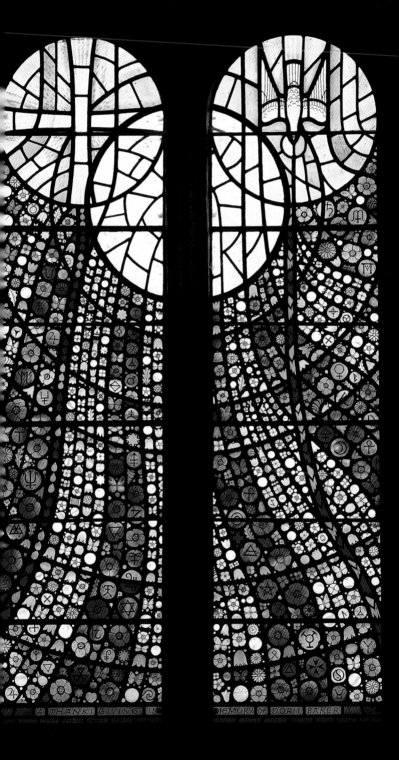

A THANKS GIVING IN MEMORY OF DORIS BAKER

St Michael. Double-naved church, the n nave with porch and bellcote, the s aisle shorter, and added, probably c15. Repaired with long Y-tracery windows and a big s door, from 1848, to plans by *Rees Davies* of Llandysul, who died and the work was not finished until 1858. The n porch was rebuilt in 1907 by *E. V. Collier*. Bare interior spoilt by a modern flat ceiling, with slate floors and whitewashed plastered arcade of segmental-pointed arches, undateable. – Small octagonal FONT.

Gwernogle Independent Chapel, Gwernogle. Small half-hipped chapel dated 1819, but looking of *c.* 1830–40. Two arched windows and two doors, renewed with a plain interior in 1890.

LLANFIHANGEL UWCH GWILI *4823*
1½ m. nnw of Nantgaredig

The church is hardly known, in its very rural sheltered valley.

St Michael. Nave, chancel, and small w tower, probably a c16 addition, with battered base, tiny belfry slits, and w flat-headed window with arched lights. Note the construction of tiny stones, and the jettied-out squint on the n side, allowing a view into the nave from the tower first-floor level. Later slated pyramid roof. The church was re-windowed in 1844 by *J. L. Collard*. In 1910 *W. D. Jenkins'* plans for repair were rejected over costs and the job passed, fortunately, to *Arthur Grove* of London, whose work, 1910–12, was done with understated Arts and Crafts care. He rebuilt the chancel n wall, added a vestry, new windows, roofs and fittings. Simple Dec windows, those on the n with trefoiled heads, the e window with intersecting tracery, all with Arts and Crafts leading. Simple plastered interior, with new chamfered chancel arch, panelled barrel nave roof, and five-sided chancel roof. Black and white sanctuary floor. – Octagonal FONT of 1910–12, on a tall stem. – Simple chancel STALLS, with cut-out motifs. – Small oak tower SCREEN, the glazing with hearts in the leadwork. – MONUMENT. Anne Davies †1851, simple Greek tablet.

Gilfach y Berthog, ¼ m. s. As unexpected as the church, and quite unlike anything in the region, a stone house with imitation timber framing of Montgomeryshire type done in stucco, and dated 1692. It was owned in the earlier c18 by the Rev. Dr Thomas Pardo, Master of Jesus College, Oxford. Two-storey, five-bay front with gable chimneys, and a three-storey rear wing. The black and white detail imitates box framing in five patterned panels alternating with the upper windows: two spurred circles, two squares with quadrant curves in the corners and, in the centre, a diagonally set square with inner square and spurs. Original cross-windows above, a rare survival. Centre passage plan, with bolection-moulded doorcases. The l. room has evidence of an earlier lateral fireplace. The r.

room has an overmantel with Ionic pilasters and a cartouche dated 1692. Coffered plaster ceiling. Late C17 fine open-well stair, with twisted balusters and square newels. The rear wing may be early C17, the beams with bold chamfers and stops, and a big fireplace with two ovens. On the upper floor, the l. front room has panelling in small squares, possibly re-set, while the other main room has a full-height chimneypiece, with crude Ionic columns.

LLANFYNYDD

Compact village SE of the Cothi, on the River Sannan. SANNAN COURT, opposite the church, was the vicarage, 1869–70, square and hipped, with no cheering detail. E of the church, over the stream, PLAS BACH, altered late C17 or early C18, with large end chimneys. PORTIS nearby has one very large chimney. Beyond the church, C19 SCHOOL, much altered, but founded in 1738. Below the church, single-arched BRIDGE, 1855, and POST OFFICE, 1868, built for the Pantglas estate. Capel Amor is by the river.

ST EGWAD (or ST JOHN). A good church with squat W tower, nave, chancel and parallel-roofed N aisle. The tower is earlier than most, c. 1400, vaulted, with corbelling over the wave-moulded W door, and a similar moulding to the arch to the nave. But the top may be C15, with single bell-lights. Nave and chancel look C15, with straight walls, though the aisle walls have a battered base, which should be earlier. The flat-headed windows with arched or barely pointed lights, and hood-moulds, look C16, even C17, one in an attractive gable on the s rood-stair projection. Surviving hinges and stays for wooden shutters, C17 or C18, and much C18 lime render. Restored in 1860–1 by *John Harries*, 1873, and in 1901–3 by *David Jenkins*. The chancel has an eroded medieval head in the s wall.

Inside, a simple four-bay C15 chamfered pointed arcade of grey stone, with no bases or capitals, and similar chancel arch. On the s side, a rood stair in the thickness of the wall, with a four-centred arched doorway, opens into the dormered bay. The square squint, r. of the chancel arch, relates to the bay, as there was never a transept. Most unusually, the chancel is two steps down from the nave, slightly off-line, and has a thick N wall, perhaps indicating a rebuild. The broad low arch to the aisle is C15 or C16. The aisle has numerous putlog holes and a good oak roof, of nine arch-braced collar-trusses, repaired in 1684. The E bay has been enclosed as a vestry, with an C18 curved ceiling. The tower has a plastered stone vault. In the tower, a fine cusped STOUP of c. 1500. The tower stairs rise from a small pointed door in the nave. The bell-loft has been raised, see the corbels at a lower level than the present beams. Fine oak bell-frame for two bells, dated 1775. – STAINED GLASS. E window, c. 1865, St John the Baptist, but in the head

a panel of C18 or early C19 painted glass of Christ with grapes, chalice and bread, probably Continental. N aisle w window, Baptism, 1968, by *Celtic Studios*. – MEMORIALS. Chancel S slate C19 plaque to many clerics of the Copner and Edmond families, 1668–1878. Marble plaque with draped urn to the Rev. W. Williams †1827. Slate plaque to W. G. Davies of Penylan †1814. A well-cut detached marble slab to the Rev. David Jones †1747, who would not abjure, being a 'perfect and truly primitive Christian'.

The large gabled stone LYCHGATE may be late C17 or C18, with round arches and collar-trusses. Scrolled wrought-iron C19 gates.

AMOR BAPTIST CHAPEL. Tiny chapel dated 1830, with twin entrances in the gable wall. Inside later C19 raked seating, great seat, and pulpit all to diminished scale.

SPITE CALVINISTIC METHODIST CHAPEL, S of the village. 1838, rebuilt 'mostly at the expence of the neighbourhood'. Stuccoed long-wall front with arched windows and doors. The stucco and the gallery of 1871; pulpit and great seat, 1894.

PANTGLAS, 2 m. SSW. A derelict tall thin stuccoed tower and a columned loggia attached are the remnants of a lavish Italianate mansion of 1853–5 built for David Jones M. P., of the Black Ox Bank, Llandovery, by *E. L. Blackburne* of London. Client, wife and architect all fell out, and Mrs Jones claimed to have completed it. The house cost the locally incredible sum of £30,000. Derived from Queen Victoria's Osborne, but disjointed in elevation, as the existing house was incorporated. There was a gilded drawing room with mirror-panelled shutters, a Persian smoking room, and finely laid-out grounds with specimen trees and a lake crossed by the drive. The large four-sided STABLE COURT survives, stone (intended for stucco) with hipped ranges front and back, and a pedimental gable over the entrance arch, dated 1851.

PENYLAN, 1 m. S. Substantial C18 hipped rendered house, altered in the late C19. Three ranges connected in a stepped plan. The four-bay E front, possibly mid C18, has a four-bay SW range behind and a longer NE range coming forward. The SW range had a big external stack, reduced in the alterations. The NE wing looks later, possibly the recorded enlargement for W. G. Davies, who died in 1814. (Panelled room in the older part.)

LLANGADOG

7029

A substantial urban village, one of Carmarthenshire's best, with good late C18 to early C19 houses. There was enough of a town in the C13 to be burnt by the English in the 1280s, and for Bishop Bek to propose a collegiate church here in 1283. Its later prosperity came from its position on the road S over the Black Mountain. The present A 4069 was built in the early C19 to connect to the Swansea Canal at Pontardawe.

ST CADOG. In a large rounded churchyard, with good mid to late C19 chest tombs by local masons. Over-restored church, with W tower, long nave, transepts and chancel, mostly in the local Sawdde red stone. The tower is late medieval, most detail lost. A two-light window on the N with arched heads looks C16. The 1694 date on the S doubtless indicates repairs. The rest was almost entirely rebuilt by *David Jenkins* in 1888–9, in mixed colours, red and brown local sandstone with white quartzite here. Nothing datably old except for a blocked Tudor N door, visible inside. No vault to the tower, plain boarded nave and chancel wagon roofs and an inserted moulded chancel arch. – Fittings mostly by Jenkins including the carved stone PULPIT, and pews, note the FAMILY PEWS, surely an exceptionally late survival. Chancel refitted *c.* 1960. – FONT. Late medieval octagonal plain bowl chamfered to square base. – STAINED GLASS. Mostly by *R. J. Newbery* 1899–1901, though only one signed. Elaborate canopy work, static drawing and staid colours. Nave N window, 1922, by *Kempe & Co.*, St Luke and Ruth.

MONUMENTS. A good selection reflecting the estates of Glansevin and Danyrallt. Fenton in 1809 mentions a fascinating lost monument to a Thomas Lloyd with niched figure and folding doors, long gone. In the N transept: Anna Lloyd of Glansevin †1738, perhaps by *Cornelius Dudley* of Bristol, veined marble, with panelled pilasters and shield in the pediment. Margaretta Hughes of Tregyb †1867, urn and sarcophagus, by *J. Williams* of Llandeilo. Edward Pryse Lloyd of Glansevin and Florentia Hughes †1766, tall stone slab with shield and careful letters. Caroline Pryse Lloyd †1839, small Greek tablet with lily, by *Lewis* of Cheltenham. Catherine Pryce Lloyd of Glansevin †1852, a marble relief by *John Evan Thomas*, husband and wife borne heavenwards by a cherub holding a coronet, beautifully executed, the rest of the memorial a little clumsy. Catherine Davies †1870, Gothic in three colours, by *Burke* of London. The S transept memorials to the Lloyds of Danyrallt are blocked by the organ. – Admiral William Lloyd †1796, urn by *T. King* of Bath. Fenton said of the encomium 'like most Epitaphs not true'. Series of C19 plaques, one to Sophia Lloyd †1873, by *E. J. Physick*. Small lettered plaque of 1672 to Thomas Lloyd. The best, in the nave S, is to Thomas Lloyd, 1727, a cartouche with swags, cherub heads and painted shield, similar to the David Gwynne memorial at Taliaris. At W end, David Lloyd Harries of Llandovery †1855, Neo-Grec draped urn on a pedestal.

GOSEN CALVINISTIC METHODIST CHAPEL, Station Road. 1840, remodelled 1907 by *J. H. Morgan*. Unpainted stucco and pebbledash. In the new gable front, Edwardian free classical detail: windows in a big lunette, and a curved pedimented doorcase. Inside, complex exposed timbered roof and galleries with a band of little turned balusters, both typical Morgan details.

PROVIDENCE INDEPENDENT CHAPEL, Dyrfal Road. 1883, by
the *Rev. Thomas Thomas*. Gable front in rock-faced sandstone
with ashlar, the windows arched. Gallery with long panels
divided by pilasters, on florid iron columns, and pulpit with
fretwork panels and a big arched pulpit-back. Railings outside
marked *Coalbrookdale*.

SEION BAPTIST CHAPEL, Walters Road. 1909. Stuccoed with
an arched triplet in a giant arch. Gallery with long and short
boarded panels, arcaded pulpit-front.

BETHLEHEM INDEPENDENT CHAPEL, Bethlehem. 1834,
altered 1872. Lateral fronted in squared stone with arched
windows.

PONT AR DYWI, 1 m. W. 1819, probably by *William Harries*. A
handsome bridge of three arches over the Tywi, with a further
two to the E. The outer cutwaters are given an architectural
touch, finished with triangular caps under half spheres.

PERAMBULATION

At the W entry, PONT BRAN, early C19, three-arched bridge,
similar to the Tywi bridge (*see* above). CHURCH STREET winds
past the church to Queen's Square. By the bridge, DELFAN,
C19 Danyrallt estate cottage, with hoodmoulds and diagonal
chimneys, the walling a display of the multi-coloured stones of
the area. CWRT-Y-PLAS, on the other side, was an estate farm,
with similar detail. In 1809 Fenton noted 'wrought stone
frames' to the windows and door. Opposite the church,
LLWYN-YR-ADAR, later C17 cottage, with steep hip to the road
end of the roof and a big square chimney at the other. Past the
church, the best sequence is on the l. CHURCH HOUSE was
refronted in the early C19, stuccoed, three-storey with parapet,
with Ionic portico salvaged from England *c.* 1950. The large
chimneys and the corbelled base of a chimney on the rambling
rear range show C16 to C17 origins. The interior has earlier C19
detail, and a top-lit staircase. NYTHFA, next door, is early C19,
five bays and two storeys, with bowed bays and a delicate
veranda between of *c.* 1900. GREAT HOUSE, built in 1766 by
William Powell (sensationally murdered in 1770), of three
storeys and three bays, was a substantial town house. The exte-
rior has changed, but the staircase survives, with turned balus-
ters. Next the RED LION, ambitious coaching inn of 1839–40,
rebuilt for the Danyrallt estate, probably using materials from
the C16 Danyrallt, then being demolished. Well-crafted
stonework in tooled black limestone. Minimal Tudor detail.
Three main bays to the r. of two at an angle, with the big
through arch to the stable yard. The latter is on heavy corbels,
with a window above on small corbels. The crude carved
plaques with Lloyd crests look much earlier, presumably from
Danyrallt. Inside, detail of the 1840s, but a beamed cellar and
a lateral stack must be older. ROSE COTTAGE, opposite, is
early C19, three bay, two storeys.

The street ends in QUEEN'S SQUARE, the former market square. On the E side two C19 pubs, probably a remodelling of earlier buildings. Opposite, the CASTLE HOTEL, five bays and three storeys, probably a mid to later C18 three-bay house enlarged, its size indicative of the importance of the market. Inside, the open-well staircase is in part original: see the moulded rail. The best building, facing down Church Street, is THE LIMES SHOP. Three bays and three storeys to the square, with a parapet and quoins. Three small upper arched windows (once sashes) and on the first floor one arched sash to the l., and unexpectedly a Palladian window to the r. The date is presumably late C18. Late C19 shop below, and plainer four-bay side to Dyrfal Road.

In DYRFAL ROAD, next, THE LIMES, a later C18 double-pile house of similar size, with earlier C19 columned porch, leaded fanlight and later bay windows. The PLOUGH INN has an offset three-bay front, probably early C19. The COMMUNITY CENTRE, opposite, incorporates a Wesleyan Chapel of 1808, altered 1841. From the Square, HIGH STREET runs E, with what appears to have been quite a formal group of three-bay, two-storey late C18 houses, all altered, four one side and two opposite. Further out are lower, more vernacular-looking houses, a one-storey building with big chimney, then BRYNGWYN HOUSE, offset from the road, largely of rounded river stones, MYRTLE HILL, mid C19, three bays, but the big chimney-breast suggesting an earlier origin, and YR HENDRE, opposite, with early C19 doorcase but older. HIGHGATE is a C19 Danyrallt estate cottage with diagonal chimneys.

On WALTERS ROAD, W of Church Street, Seion chapel (q.v.), and the former CHURCH SCHOOL, 1861, four bays with big hoodmoulded windows. Grey limestone dressings contrasted with multi-coloured stone wall. This may help date the similarly coloured estate cottages, of which BRODAWEL and PENRHYN HOUSE on the corner of Vicarage Road are another pair. THE VICARAGE, down a drive, is apparently early C19, four-bay, two-storey, with a semicircular hood over the door, unusual in the region. Inside, a closed-string stair that could be C18 reused.

CASTELL MEURIG, ½ m. s. An Anglo-Norman fort, mentioned from 1160 to c. 1210. A good tree-covered motte survives to about 33-ft (10-metres) height, and the well-preserved bailey to the SW has a single bank.

p. 306 GARN GOCH HILL-FORTS, 3 m. SW (SN 690 243). Two Iron Age hill-forts each side of a dip on the W end of the high ridge, Gaer Fawr to the E and the much smaller Gaer Fach to the W, apparently not occupied at the same time. The very large (27-acre/11-hectare) Gaer Fawr one of the largest hill-forts in Wales, may reflect on the strength and organization of the Demetae people in Roman times. An irregular oval including natural outcrops, the stone enclosure is particularly massive at the W, some 82-ft (25-metres) width of rough stones, some 21-ft (6.5-

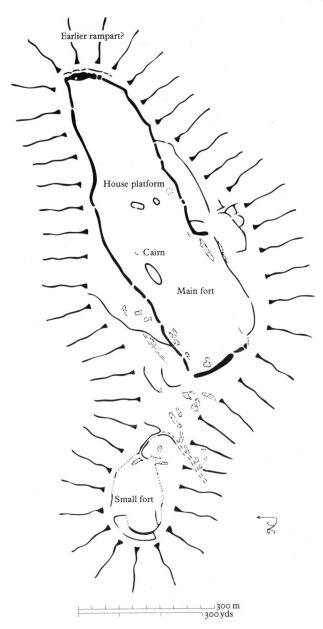

Earlier rampart?

House platform

Cairn

Main fort

Small fort

300 m
300 yds

Garn Goch hill-forts.
Plan

metres) high. There are possibly eight gates, the main ones at the
SW and NE. Traces of a round-house have been found within,
also of a cairn that is probably much older. Gaer Fach has a
low drystone enclosure and a rampart extending out to protect
an E entry. To the NE of Gaer Fach, a small HILL-FORT (SN
679 244) and the LLWYNDU STANDING STONE (SN 675 244).

DANYRALLT PARK, ¾ m. W. The first Danyrallt, C16 to C17 seat
of the Lloyds, S of Llangadog, was demolished in 1840. It
apparently had a chapel with a blue ceiling painted with stars.
The second was on the N bank of the river, built as a villa in
the 1840s, called Llwynyberllan, the name of the adjacent
farm. This was bought in 1852 by Alan Gulston of Derwydd,
Llandybie, who employed *Benjamin Bucknall* in 1864–5 to unite
the villa and farmhouse. Bucknall designed a stone circular
stair in a canted bay, a feature he proposed also for Derwydd.
Gulston renamed it Dirleton, after the castle of the earls of
Gowrie, a title to which he laid claim. He returned to Derwydd
and sold Dirleton in 1881 to the Peel family, relatives of the
original Lloyds, who renamed it Danyrallt Park. It burnt
down in 1940, and only a large lofted STABLE and coach-house
of the 1880s remains in red and grey stone, backing onto the
A40.

GLANSEVIN, 1½ m. E. A country house of *c.* 1790 with 'some
pretentions as to external' according to Fenton. Substantial
stuccoed façade of three storeys, 2–3–2 bays, with centre ped-
iment, and added Roman Doric columned porch. The older
house of the Lloyd family, which had eight hearths in 1670, is
probably incorporated, as shown by the uneven bay spacing. A
date of 1823 said to have been found on the staircase could
mark an interior refitting, e.g. the reeded door surrounds. The
half-oval stair is influenced by Nash, Bath stone, cantilevered,
with iron balusters. The stair hall is divided from the entrance
hall by an elliptical arch, and there may also have been a
columned screen, creating a cross-passage. Cornices with late
C18 detail. In the W room, the chimneypiece has a relief of a
woman with harp, classical going romantic, and the floral
drops botanical in an earlier C19 way. The landing has numer-
ous arches. The extensive back ranges may incorporate older
work, but are much altered. The giant oak on the lawn tradi-
tionally lost a branch with every family death.

GLANSAWDDE, ½ m. S. 1886, by *David Jenkins*, for Herbert
Thomas, Bristol soap-maker. Jenkins liked the rainbow colours
of the local stones, here laid like crazy paving. Asymmetrical,
with varied gables and large mullion-and-transom windows.
Contemporary FARM BUILDINGS. Opposite, a small rubble
COTTAGE, said to have been a toll house.

LLWYNDDEWI, ¼ m. N. Plain roughcast house of four plus three
bays, with a big bay window. Remodelled in 1875 by the leading
engineer *George Gordon Page*, friend of Alan Gulston, simpler
than originally planned.

MANDINAM, 2 m. E. High on a hillside, with grand views. A
whitewashed Late Georgian double-pile house of two storeys

with a triple centre window under a blank arch. But the core is mid C17, the house a post-Civil War retreat for Jeremy Taylor, the C17 divine, author of *Holy Living* and *Holy Dying*, dedicated to the Earl of Carbery of Golden Grove, his protector in Wales. Thick interior walls but early C19 detail, the plasterwork downstairs like that at Glansevin, rather cruder over the plain stair, imported from elsewhere.

CAE SARAH MINE. 2½ m. E. Ruinous Cornish engine house of 1854, built for the Great Welsh Silver Lead Mine, started with high expectations in 1851. The engine house housed a 36-in. (91-cm.) beam-engine. The company failed before 1860, and the mine, restarted as the Casara mine, was abandoned *c.* 1865.

LLANGAIN

3815

Mostly modern village 2 m. SW of Carmarthen.

ST CAIN, S E of the village. 1869–71, by *R. J. Withers*, the small w tower an exercise in solid geometry. The grey local stone has proved disastrously friable. The tower diminishes in stages and is broached at the top to an octagonal ashlar turret, the bell-lights neatly linking tower and turret. Inside, wagon roofs with open trusses and an ashlar chancel arch on polygonal shafts. In the chancel, a seat beneath the s window. – FONT. An octagonal eroded bowl, rescued in 1979 from the churchyard, with carving of the Circumcision, may be C13. – Bowl FONT by *Withers*, as also the painted stone REREDOS, with the Evangelists' symbols in the centre of inlaid work. – FITTINGS. Good simple wooden pews, stalls and rails, by Withers. – MONUMENT. – William Bevan Gwyn †1851, simple Grecian tablet by *Reeves* of Bath.

SMYRNA CONGREGATIONAL CHAPEL. Large, by *J. Howard Morgan* of *George Morgan & Son*, 1915, in his modernizing Free Style, as at Ferryside (q.v.). The porch is clasped between narrow gabled gallery stairs, above is a big square-mullioned window with a curved head.

GREEN CASTLE, ¾ m. NE. Ruin of a C15 to C16 house of the Reed family on a bluff over the Tywi, already abandoned by the late C16. Investigation has shown that it was of the type of the Vale of Glamorgan Tudor houses, though of lesser scale and finish. It was two-storey, with a lateral chimney to l. of a storeyed porch, and had a cross-gabled square stair-tower to the rear, a full storey higher than the rest, in the angle to a rear wing. Stonework of the tower, the wing and only the l. end of the front remains: in the wing, a first-floor fireplace with traces of a plaster overmantel. The adjacent FARMHOUSE is of two storeys, its five very irregular bays suggesting early origins, despite a 1797 date on the back. A tall rear archway, facing the old house, may indicate that it was a gatehouse.

PILROATH, 1½ m. SW. 1904–6, designed by the owner, *T. J. Harries*. Red brick striped in yellow, old-fashioned for the date. To W, a good courtyard of earlier C19 FARM BUILDINGS.

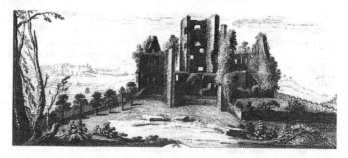

Green Castle.
Engraving by S. & N. Buck, 1740

LLWYN DU, ½ m. WSW. Hipped stuccoed house of *c.* 1840, six
 bays with hoodmoulded windows and entry in the end wall. A
 tiny whitewashed STABLE COURT has twin turret-like loft stairs
 facing outwards, with battlements.
FERNHILL, 1¼ m. W. Early C19 hipped stuccoed house of three
 bays with wide sash windows in the front, the windows all
 changed. Dylan Thomas's uncle and aunt were tenants here,
 and childhood visits inspired his poem, 'Fern Hill'.
PREHISTORIC REMAINS. At HENDY, ¾ m. SW, two STANDING
 STONES, possibly associated with a burial chamber. The three
 stones of MEINI LLWYDION, ¾ m. WSW (SN 378 174), on a
 golf course, were a cromlech, intact in the late C19. ¼ m. N of
 this, MYRDDIN'S QUOIT (SN 380 160), two remaining vertical
 stones of a cromlech. MAEN LLWYD, 1½ m. SW of the latter,
 is a prominent STANDING STONE.

LLANGAN
1718

2 m. NW of Whitland

The abandoned church stands isolated in a circular churchyard,
just in Pembrokeshire. It stands on a hilltop and aerial pho-
tographs show that the churchyard is next to but not precisely
related to two Iron Age ring ditches.

ST CANNA. Disused. Restored 1882, by *S. Lewis* of Haverford-
 west. Simple nave and chancel with W bellcote and N porch,
 minimal Dec detail.

LLANGATHEN
5823

Parish at the heart of the Tywi valley, with several important
houses in Tudor times. Hardly a village; the church and Aber-
glasney are on the side of a hill N of the Tywi. The main settle-
ments are at Broad Oak and Court Henry (q.v.).

ST CATHEN. In a churchyard of ancient yews, a double-naved
 church with large NW tower. The tower is vaulted, tapering with

corbelled battlements, paired arched bell-lights and a stair-turret that emerges part-way up. The N nave is the oldest part, the w door with ogee and hollow moulding, c. 1400. The s aisle is C15, of three bays, originally ending in a chantry chapel. The transeptal N Llethr Cadfan Chapel was added to the nave at same period. Finally the s aisle was extended with the Aberglasney Chapel, called new in 1542, when Sir William Thomas was buried. One C16 window with arched lights and flat hood was the model for windows of 1867–8, by *T. W. A. Thompson*. Inside, the arcades were rebuilt in 1813, by *Thomas Bedford* of Llandeilo: three round arches to the nave on octagonal piers (the w respond looks older), three double-chamfered arches to the chancel. Plain pointed arch to the SE Chapel. The chancel was ornately renewed in 1899, with an arch on carved angels, new roof and E window, by *R. Wellings Thomas* of Llandrindod Wells. In the N transept, a rood loft door. In the s aisle, behind the organ, a piscina and tomb recess. – FONT. 1868. The medieval bowl, square with chamfered angles, survives. – Remarkable ALTAR TABLE, late C16, tapered legs with strapwork, the central upright with an urn-bearing female, gadrooning above. It may have been brought in the mid C19. For a century the church had the altar rails from Wren's St Benet, Gracechurch Street, London (demolished 1967), but, becoming unsound, they were burnt, as church procedure then required, in 1970. The present simple rail is from Llanfihangel Cilfargen. – STAINED GLASS. Highly-coloured E window c. 1900. s aisle E, 1899, by *Hardman*. Nave NW, 1915, by *Newbery*. Nave NE, 1915, by *Florence Camm* of Smethwick.

MONUMENTS. In the Aberglasney Chapel, the outstanding Bath stone monument to Anthony Rudd, Bishop of St Davids †1616, and his wife. Rudd, disappointed of further advancement, chose to be buried in his home parish rather than in his cathedral. Twin effigies lie on a chest flanked by kneeling effigies of the bishop's two sons, all within a complex architecture, the parts interwoven or layered in a Mannerist way. The form is very similar to the Bridges monument at Cirencester, Glos. dated to c. 1620, attributed to the Gloucester mason *Samuel Baldwin*. Essentially a giant Palladian tripartite unit shelters the sculpture, but the central arch is framed by a pair of Corinthian columns on pedestals, carrying a wide entablature with rosettes and a steep pediment broken for an oval with mitred arms. Both parts stand on the same outer platforms, lower than the central tomb-chest, which is thus both independent and dominant. The arch, with a deep panelled soffit, frames an inscription bordered in strapwork, and springs from flat-topped outer aedicules that shelter the kneeling figures. These aedicules have fluted Ionic corner piers and carry a pair of large obelisks. The figures are richly dressed and finely carved. – Diones Llwyd †1777, a damaged memorial with images of death and immortality above the cornice: two eggs, an urn and a cherub holding a snake biting its tail. Captain Thomas Edwards †1808, portrait, with military equipment and

a drooping palm, by *Tyley*. Ann Walters Philipps †1818, Greek tablet, and Thomas Philipps †1824, draped urn, both by *Lewis* of Cheltenham. Elizabeth Key †1867, Bible, wreath and dove, by *P. Rogers* of Swansea. John Walters Philipps †1867, limestone floor slab.

TEMPERANCE HALL, Llangathen. Suburban Tudor, 1906, for Colonel Mayhew of Aberglasney, a supporter of the Band of Hope. Long, three bays, with bay windows, gabled in the centre. Doors each end in turrets with pyramid roofs. There was a domed cupola and appropriate painted texts.

ABERGLASNEY, ½ m. w. Until 1995, a derelict house in a wilderness. Happily both house and, more importantly, the gardens have been restored by the restoration trust formed by William Wilkins. After extensive archaeology, the gardens opened to the public in 1999. The house, originally of the Thomas family, was rebuilt after 1600 for Anthony Rudd, Bishop of St Davids from 1594 to 1615, and is known to have had a chapel in the s wing. His son, Sir Rice Rudd, was made baronet in 1628. The remarkable gardens date from the early C17. The house had thirty hearths in 1670, one of the largest in the county, but was rebuilt *c.* 1710–20 for Robert Dyer and his son Robert (elder brother of the poet John Dyer). It was altered about 1840 for John W. Philipps. The estate declined and was sold in 1955, the house being abandoned. The shell was carefully restored by *Craig Hamilton*, in 1995-9. The interior has partly been rebuilt in the simplest form, pending further phases, save at the back where a glass-roofed atrium has been created in 2005 by *Craig Hamilton* for exotic plants.

The house, built around a small courtyard, appears mostly of 1710–20, with a three-storey, nine-bay N front, typical cambered-headed sash windows, and formerly with a parapet. It incorporates parts of the earlier house. The window rhythm was broken *c.* 1840 in the centre five bays when a double-height entrance hall was made, and a large three-bay pedimented Ionic portico with flanking columns added to disguise the new window heights, probably by *Edward Haycock*. A blocked first-floor roundel, exposed under the internal plaster, suggests that it replaced a tall classical or Baroque doorcase. The garden front is of 2–4–2 bays, the outer pairs gabled, and a little C19 loggia to the r. of centre. The uneven fenestration hints at earlier fabric, and turning the corner, one sees that the three-storey gabled return is only one-bay deep, so almost turret-like. The NE corner is similar. Was there a courtyard house with corner towers, the intervening ranges raised to three storeys to the N and W in the C18? The plain E façade has three windows at stepped levels, perhaps marking the early C18 staircase, replaced with a dividing stair behind the hall *c.* 1840. The interior detail is lost apart from the remnant of a consoled C19 cornice in the hall.

To the NW is an early C17 detached GATEHOUSE, of two storeys, in rubble stone with a moulded arch to a vaulted passage. Excavation, and ragged edges suggest that the gatehouse stood

at the N side of an enclosed courtyard, with buildings E of the gatehouse. Fine cobbled roadway, the cobbles laid in triangle patterns. The relationship of the gatehouse to Rudd's house is hard to determine as it is on lower ground and not aligned to the house.

Now to the GARDENS, which lie to the SW. The first, the CLOISTER GARDEN, W of the house, is one of the most enig- 37 matic early gardens in Britain. This consists of an extraordi- nary large court, some 98 ft by 148 ft (30 metres by 45 metres), with raised walks on arcaded rubble walls on all but the house side. The walks have parapets, with scalloped embrasures on the N and W sides. They are not of a single campaign. The principal W range facing the house was probably begun by Bishop Rudd, the arches opening into a carefully built vaulted cloister, while the N and S sides have taller cambered arches, fronting only deep recesses, perhaps for statues? The arches are added, possibly for his son, Sir Rice Rudd, to plain walls. Access to the upper walk is via a C19 ramp in the NE corner, but traces of steps remain, down from the E ends of the N and S sides. Along the E side, in front of the house, was a cobbled path in a pattern of triangles continuous with the cobbled path from the gatehouse to the N. Evidence was found that the garden was cobbled with two wide linear beds, each with nine rows of planting, rather than formal parterres, and there was a terrace in front of the W cloister. Beyond, to the W, the POOL GARDEN, with large rectangular pool and small island, is possibly also C17. The large UPPER WALLED GARDEN was redesigned by *Penelope Hobhouse*, 1998, with central oval surrounded by gravel paths and herbaceous borders. The KITCHEN GARDEN, alongside, to the W, was redesigned by *Hal Moggridge*, a formal rectilinear layout of box-edged beds. These walled gardens may be C17, but had been altered in the C19. Running W from the NW corner of the house, the YEW TUNNEL, planted as a hedge *c*. 1750, and later trained over to form the tunnel. Below the gardens, to the S, a LODGE, relating to a lost driveway, probably by *Haycock*, with a veranda and gable pierced by a roundel. The STABLE YARD behind, entered by an arch imitating the gatehouse, has large plain buildings mostly of the 1870s by *George Morgan* and a new pond with water feature by *William Pye*, 2004, based on a silver sphere.

LLETHR CADFAN, 1 m. N. A rare C16 hall house with lateral 38 chimney, but the early C17 parlour block and storeyed porch added in line, are more remarkable, typical of Monmouthshire. The hall range, rendered and sash-windowed, is of four bays, with a tapering square stack towards the l. end. Beyond is the two-storey hipped porch, and then, dwarfing the rest, the splendid parlour block, still limewashed with stone-tiled roof, but becoming derelict. Two bays, two storeys, with big ovolo-moulded mullion-and-transom windows with hoodmoulds. Polygonal gable chimneys, the S one with four clustered shafts. The lateral parlour chimney is on the back, with an octagonal

shaft on a gable. Little survives inside: the parlour, which occu-
pied the whole of the first floor, had a fine ribbed plaster
ceiling, long collapsed. The vernacular upper-cruck roof is now
visible. Service rooms beneath with big fireplaces. It belonged
to the Vaughans from the late C15, passing to Rhys Williams of
Edwinsford in 1600, the parlour block an indicator of his
status. Against the S gable the outline and nesting boxes of a
dovecote. Llethr Cadfan is reputed to be on the field of Coed
Llathen, site of the rout of an English army in 1257 by forces
allied to Llywelyn the Last.

HAFOD NEDDYN, 1½ m. N. A three-bay villa of 1816, with central
canted bay, enlarged c. 1855 by *W. W. Jenkins*. He added blocks
each end, the W entrance end rising to three storeys in a gaunt
baronial style, originally with little tourelles and pavilion roof.
In the 1950s the top of this was removed and the entrance ele-
vation remodelled.

BERLLANDYWLL, ¼ m. SE. Broad, hipped early C19 model farm-
house, overlooking the Tywi, possibly by *J. P. Pritchett*, then
working for the Golden Grove estate. There was a medieval
hall in the field across the road in front.

GLANDULAIS, 2½ m. SW. Trim, three-bay, stuccoed, hipped villa
of c. 1840, with deeply bracketed eaves, and marginal glazing
bars, Victorian rather than Georgian. Contemporary stuccoed
LODGE on the A 40, with canted corners, steep hipped roof,
pierced eaves boards and inset entrance bay.

NEW GOLDEN GROVE HOUSE, ½ m. SE. 1962, for Lord
Cawdor, by *Donald Insall*. Built after the demolition of Stack-
pole Court, Pembs., the main family house in Wales. Golden
Grove (q.v.), the second seat, had been sold in 1952. Neo-
Georgian, of seven bays, in red brick with hipped roof. Some
fittings from Stackpole Court, including doors and chimney-
pieces.

ALLTYGAER, 1 m. SW. At the foot of Grongar Hill, overlooking
the Tywi. Downhill-sited medieval house, originally of three
units, with projecting downhill stack, and a big off-
centre chimney. At the uphill end, a corbelled chimney, now
truncated.

GRONGAER, ½ m. SW. Iron Age hill-fort, with a well-preserved
single bank and E and W entrances overlooking the Tywi Valley.
Given fame by Dyer's 'Grongar Hill', 1726, one of the earliest
English pastoral poems.

See also Court Henry and Dryslwyn.

LLANGELER

Church and small village on the Carmarthen to Newcastle Emlyn
road, with larger C19 settlements at Saron and Rhos to the N.

ST CELER. In a large churchyard with an early C19 stone
LYCHGATE, minimally pedimented. The church of 1858–9,
by *Charles Davies* of Cenarth, 'under the eye of Mr *Penson*',

Llysnewydd.
Engraving, 1872

replaced one said in 1695 to have been double-aisled, and with
the grave of St Celer on the s side. Quite large, but bleak, in
Cilgerran stone with regular lancets, buttresses and a bellcote.
Broad interior with narrow chancel arch, without invention. –
MEMORIALS to the Lewes family of Llysnewydd: William
Lewes †1828, and Joan Lewes †1820, both by *C. H. Smith* of
London, the former heavily Neo-Grec; a two-colour plaque to
Thomas Lewes †1769; and a draped urn to John Lewes of
Llanllyr, 1783, by *King* of Bath. By the pulpit, charming rustic
slate plaque to Edmund Pryse †1774. In the vestry, a small
plaque of 1642 with scrolled pediment, to a Catherine whose
grieving parents omitted her surname in the Latin inscription.
– STAINED GLASS. E window, 1959, by *Celtic Studios*. Nave N
and s windows, 1928 and 1939, by *Abbott & Co.*

MISSION CHURCHES. Capel Mair, Pentrecwrt, 1898–9, by *David
Davies*, and Rhos, 1902–3, by *Thomas Williams*, both cheap.

SARON INDEPENDENT CHAPEL, Saron. 1897–8, by *David
Davies*. Stuccoed façade with giant pilasters and centre arch,
typical of Davies.

LLYSNEWYDD, Henllan Bridge. The house of *c.* 1795 by *John
Nash*, built for William Lewes, was demolished in 1971. Before
brutal adaptation in 1890, by *David Jenkins*, it was the most
Neoclassical of Nash's square hipped villas, but artfully pic-
turesque with the three fronts each different. It had a top-lit
staircase.

HENLLAN BRIDGE. *See* Henllan, Cd.

PENTRECWRT, 1½ m. SE, was a woollen centre in the late C19.
DERW MILLS, to S, is a late C19 three-storey mill, in stone
and yellow brick. N of the village, by Pont Alltcafan (*see*
Bangor Teifi, Cd.), one range survives of ALLTCAFAN
MILLS, developed from the 1860s by John Lloyd Davies of

Blaendyffryn, builder of the bridge. The main mill was demol-
ished in 1990. Below the road to the bridge, HENFRYN
MILLS, stone and yellow brick, hipped, worked from 1890.
See also Drefach Felindre and Penboyr.

5602

LLANGENNECH

Industrial village NW of Llanelli. The population grew from 338
in 1801 to 2,336 in 1901, with the coal and tin-plate industries.
Several pits were sunk 1825–74 by the Llangennech Coal Co.,
the first tin-plate works opened in 1867, and the largest, the
Morlais Tinplate Works operated from 1873 to 1931. Little of
industrial interest remains.

ST GWYNOG. Prominent on top of the hill. Rebuilt 1900–8 by
E. M. Bruce Vaughan, its size testimony to the growth in pop-
ulation. The old church had been rebuilt in 1853, by *Penson*.
Long single nave and chancel with parallel-roofed N aisle and
tall embattled W tower, not in the local manner, but with
shallow buttresses clasping the lower two stages and the bell-
stage. Rock-faced Pennant stone with Bath dressings, Dec
tracery. The scale of the interior is impressive, if the detail con-
ventional. Arcade on round piers with moulded caps, and
broad moulded chancel arch. Varied roofs typical of the archi-
tect: arch-braced in the nave, scissor trusses in the aisle, and a
painted wagon roof in the chancel. – FONT. Retooled medieval
square bowl with chamfered corners. – FURNISHINGS by
Bruce Vaughan. – PULPIT. 1929, by *Clarke* of Llandaff. –
REREDOS, 1922. – STAINED GLASS. A set by *Jones & Willis*:
E window 1909, nave NE and chancel SE, 1914. Nave SW, 1955,
Ascension. – MONUMENTS. Rev. John Thomas †1838, with urn
and shield, by *P. Rogers*, Swansea. David Evans †1909, veined
marble, Doric.

Just NW, the former NATIONAL SCHOOL, 1850, single-storey
with central porch and hoodmoulded window each side.
Gabled schoolhouse to the l.

SALEM BAPTIST CHAPEL, on the corner of Bank Lane. 1878–9,
unmistakably by *Rev. Thomas Thomas*, and one of his best.
Rock-faced Pennant stone, with ashlar detail. Palladian
window within Thomas's favourite giant arch, a tall window on
each side, and paired doors reached via a ramp, bridging over
the basement level. Sturdy urn finials. Large interior with
ribbed ceiling and big plaster rose. The three-sided gallery has
long panels of intricate ironwork, and the great seat and pulpit
ironwork with quatrefoils. Fourth gallery and organ chamber,
1927–9, by *J. H. Morgan*.

BETHESDA INDEPENDENT CHAPEL, Rhandir Terrace. 1881,
also by *Rev. Thomas Thomas*, Gothic, in deliberate contrast to
Salem. Similar stone, the buttressed façade with a big Dec
window over paired doors. Outer windows with quatrefoils
over. Four-sided gallery, panelled with long strips of trefoil-
patterned ironwork. The organ gallery was added *c.* 1920, by
David Davies of Llanelli. Fine pulpit with elaborate fretwork.

Nearby, the old chapel, of 1857, Georgian Gothic, with pyramid roof, centre porch on octagonal columns and a pointed window each side. Inside, a simple panelled gallery on three sides, and an odd little niche for the pulpit, under an elaborate Gothic plaster canopy.

LLANGENNECH PARK, ½ m. N. Ruined country house, owned in the C18 by the Stepneys, a retreat from their house at Llanelli. Their house was L-plan, five plus two bays with long sashes and dormers. Sold in the late C18 to John Symmons of Slebech, Pembs., who employed *William Jernegan* to add a large but strange square block for a first-floor music room. Jernegan crenellated nearly everything, including the service and farm ranges, and the twin octagonal lodges (both gone). The perspective effect suggested Swansea Castle, probably deliberate; Jernegan had shown a similar medievalism in imitating the Margam chapter house at his Sketty Park gazebo, Swansea.

LLANGLYDWEN 1726

In the upper Taf valley, the river spanned by a single-arched BRIDGE with circular spandrel holes, 1823, by *John Thomas*, Bridge Surveyor. Plain stuccoed former STATION of the Whitland & Taf Vale Railway, of the 1880s. The church is ½ m. W, on the drive to Dolwilym, which has a papery Gothic castellated ARCH, *c.* 1840, once topped with a wooden battle-axe crest.

ST CLEDWYN. Small, nave and chancel, with detail of 1882–3 by *E. Lingen Barker*, including the bellcote, porch and windows. An unusually long stone in the W wall with a groove mark is perhaps reused early Christian. Inside, roofs of 1883, the plain chancel arch is medieval. – FONT. Square C12 tapered bowl, with rope mould on the shaft. – STAINED GLASS. E window, 1883 by *Clayton & Bell*. W window *c.* 1901.
 In the churchyard, an INSCRIBED STONE, shaped to a rough cross and with a small wheel cross in relief, possibly C6.

EGLWYS FAIR A CHURIG, 1½ m. E, by Fronganol. The church of SS Mary and Curig, a chapelry of Henllan Amgoed, was rebuilt in 1770, ruinous again by 1858, repaired in 1875 and 1889, and now abandoned. Roofless small nave and chancel, with plaque recording the work of 1770, by *Daniel David*, mason, over a low W door. Flattened chancel arch, of 1770, later windows with brick heads.

CEFNYPANT INDEPENDENT CHAPEL. *See* Llanboidy.

HEBRON INDEPENDENT CHAPEL, Hebron. 1878–9, but the big arch framing a Palladian window and a pair of arched doors is of the 1930s, in cement. Behind the chapel, Y BWTHYN, single-storey cottage.

DOLWILYM, below the church. The house of 1842–5 of the Protheroe family, demolished as derelict in 1984, was an ill thought-out assemblage of Tudor and castellated motifs, with bargeboards, by *John Phillips* of Tavernspite, the twin gables

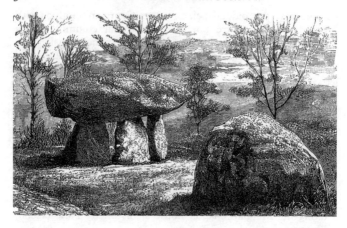

Gwal y Filiast.
Engraving, 1872

hinting at Wyatville's Golden Grove. Part of a rear wing
remains, refronted, and two large ranges of outbuildings.

GLYNTAF, 1½ m. SW. A dower house of Dolwilym. An early C18
downslope farmhouse, also transformed in the 1840s, pre-
sumably by *John Phillips*. The lower gable-end became the
centre of a three-bay front, with timber mullion-and-transom
windows and hoodmoulds, painted roughcast. Gothic open-
ings in the gable-ends. Doors with arched panels within.

GWAL Y FILIAST CHAMBERED TOMB, 1 m. SW (SN 1705 2564).
Beautifully remote, in beech woods above the E bank of the
Taf. Neolithic cromlech, the massive capstone delicately set on
four uprights, open to the S. In 1872 there were said to be five
uprights and also a ring of stones around, possibly a kerb.

⁴³²⁰ LLANGUNNOR/LLANGWNNWR

Hilltop village above the Tywi, still rural, though Pensarn below
to the W has become the industrial estate of Carmarthen.

ST CEINWR. Set on a hilltop overlooking the Tywi and Car-
marthen. Double-naved church with lower chancels. The S
nave is the earliest part, possibly C14 with added C15 chancel
(now Lady Chapel), large W bellcote, and W porch. The current
nave and chancel, to the N are also C15, the chancel distinctly
tilted to the N. Cusped Y-tracery to the windows, of *c.* 1840,
several with hinges for wooden shutters, the N chancel with
traceried E window of 1870, the S chancel with a smaller one
⁵⁶ of 1848. Vestry by *G. Morgan*, 1887. Inside, the arcade was dar-
ingly replaced by a three-bay Tuscan colonnade, in 1815–16, by
Thomas Humphreys. The columns carry no cornice, just a flat
soffit between two plain plaster barrel ceilings, and stand above
the pews on high bases, as in the churches of Wren and the

early C18. The two-bay chancel arcade with wide arches, one roughly four-centred, looks C16. Plain plastered chancel arches, the S one blocked by the organ. – FONT. Big plain C12 square bowl. – BOX PEWS, renewed as late as 1870. – Chancel FITTINGS, 1960–1, by *A. D. R. Caroe*, in limed oak. – ORGAN. C19, rescued in 1951 from Derry Ormond, Cd. Old-fashioned with cherub heads supporting the three pipe towers. – Painted BOARDS with the Lord's Prayer etc. in Welsh, earlier C19. – In the porch, C7 to C9 INCISED STONE, a Latin cross with splayed ends, within a similar outline. – STAINED GLASS. E window *c.* 1908. S aisle E, 1903, by *Kempe*. Nave NE, *c.* 1924. W window, 1936, by *Geoffrey Webb*, Good Samaritan. S aisle, 1990, a swirling pattern of leaping fish in green-blue hues, by *Caroley Bergman-Birdsall*. – MONUMENTS. Thomas Thomas †1728, careful lettering. Ann Humphreys †1778, pedimented, with columns and, unusually, of wood. Sir Richard Steele †1729, the essayist, tall black marble tablet of *c.* 1800 put up by the scholarly William Williams of Ivy Tower, Pembs., and made by his local mason *Williams* of St Florence, with a long adulatory epitaph. Steele married Mary Scurlock of Ty Gwyn and retired here. Anne Bowen †1798, tall slab in simple frame. Rev. John Jones †1827, pedimented. Charles Diggle Williams †1853, Greek sarcophagus. Great War Memorial, brass, with angels, by *F. Osborne & Co.*, London.

Good table tombs and slabs in the GRAVEYARD, a number signed by *D. Mainwaring*. S of the church, the chest tomb of Rev. Thomas Charles †1834, Methodist hymnodist. SUNDIAL dated 1720 on the dial. Timbered LYCHGATE, 1908. Next to it, a tiny derelict colourwashed COTTAGE, apparently built in 1720 as the vicarage. Single storey, with a big gable chimney.

VICARAGE. 1833, by *David Morgan*. Three bays, hipped, with added wings, 1884 by *George Morgan*.

BABELL CALVINISTIC METHODIST CHAPEL, Pensarn, 1½ m. WSW. 1906, by *J. H. Morgan* of *George Morgan & Son*. Free Style, with curved headed main window in the recessed centre. Inside, typical turned balusters to the gallery front, and the roof open down the centre, with tie-beams.

PHILADELPHIA INDEPENDENT CHAPEL, Nantycaws, 2 m. SE. 1841, altered 1931. Attractive long-wall façade, the outer door-ways with arched windows above, and a centre arched window, possibly of 1931. Rich woodwork of 1931: fielded-panelled gallery and broad panelled pulpit on the rear wall. The passage on the entrance wall is unusual: was the pulpit originally here?

TY GWYN, ½ m. WSW. Mid-C19 model farm. The plain farm-house faces a large three-sided yard, the side ranges stepped down. The cross-range is the cow-house. Behind, a square dovecote with little lunette windows. The old Ty Gwyn, called 'very low and small' in 1791, was the home of the Scurlocks, one of whom married Sir Richard Steele in 1707.

BRYNTOWY, ¼ m. E, beside the river. Big hipped villa, begun *c.* 1830, probably by *David Morgan* of Carmarthen, for William Bonville, not completed until *c.* 1850. Three bays by four, with

a two-bay wing set back, and an arched window over the door.
Later C19 bay windows.

Near WENALLT, ½ m. SE, was the VALE OF TOWY LEAD MINE,
discovered in 1770, worked mainly from 1852–66. Little
remains now except for a late C19 cobbler's shop and stores.
The mines briefly reopened in 1951 for the extraction of
barytes. Another mine, ½ m. E, CYSTANOG, was worked in the
1850s and 1889–1902.

MOUNT HILL, 1½ m. SSW. A Gothic cottage of c. 1800. Single-
storey, four bays, with Gothic sashes, and pointed-roofed
porch on octagonal columns. Paired octagonal chimneys. The
kitchen is in a basement. Gothic doors and hall panelling
inside.

BOLAHAUL, 1¾ m. SSW. 1855, by *W. W. Jenkins*, for John Lewis
Phillips, businessman. Jenkins, who worked in a variety of
styles, chose here a mild English Baroque, handled with some
flair. Fine grey limestone, with much Bath stone. The E
entrance is flanked by a mighty curved screen wall, masking
the service yard. Four-bay W front with blocky window sur-
rounds, the parapet swept up to a chimneystack, the cornice
carefully stopped each side. N front of four bays, with simpler
windows, but balustraded parapet panels. Heavily pedimented
French doors in the r. bay.

See also Cwmffrwd.

LLANGYNDEYRN

Compact village in the valley of the Gwendraeth Fach. A circu-
lar CATTLE POUND, 1815, SW of the church, Salem chapel further
W, and the VICARAGE, 1871–2, to the N. To the SE is the ridge
of Mynydd Llangyndeyrn, scarred on the N with limestone
quarries.

ST CYNDEYRN. A large church in a raised churchyard. Nave and
chancel may be C14, the tall W tower, N aisle and NE chapel
added in the C15. The vaulted tower is thinner than usual, but
has the typical battered base and corbelled battlements. Red
sandstone dressings, the W door with two crude carved faces
on the surround. Restored 1879–88, by *J. P. St Aubyn,* whose
stonework contrasts so harshly with the old as to suggest that
deliberate distinction of new and old recommended by the
SPAB. Small pieces of old stone are carefully preserved in the
window jambs and the porch. Early C16 crocketed hoodmould
over a four-centred blocked N door, and two two-light windows
on the NE chapel look even later. The S porch has red sand-
stone in the jambs and a STOUP within, another in the tower.
The interior has plastered four-centred N arcades, the arches
dying into the piers. Georgian nave and aisle roofs, of close-
spaced collar-trusses, dated 1796 and 1804. The NE chapel E
window has shields in the coved surround, C15. In one of the
arches to the chancel, a low timber SCREEN, formed from the

back of a family pew of the Lloyds of Alltycadno, dated 1676. – STAINED GLASS. E window, one light, 1979 by *Celtic Studios*. Nave S window, 1895, by *Ward & Hughes*. – MONUMENTS. Muddled in the restoration. A delicate marble plaque of a mourning female, in the chancel, may come from the nave memorial to Catherine Goldfrap †1784. In the NE chapel, a well-lettered plaque of *c.* 1726 to the Mansels of Muddlescwm, by *Prince Hoare* of Bath. Numerous incised floor slabs. – PULPIT, oak on stone, 1884, by *St Aubyn*, made by *Frith* of Gloucester. In the churchyard, the base of a CROSS.

CAPEL DYDDGEN, 1 m. SSE. Ruin of a medieval chapel. Nave and chancel with W tower, only two sides of the tower significantly upstanding, enough to show that it was vaulted.

SALEM CALVINISTIC METHODIST CHAPEL. 1837. Small and remarkably preserved, with lateral front of four windows and two doors, all arched with Georgian Gothic glazing bars. Inside, box pews and a panelled pulpit originally raised on a wine-glass stem. The galleries may be mid C19, with vertical panels, curved angles and iron columns from the *Old Foundry*, Carmarthen.

BETHEL BAPTIST CHAPEL, E of the village. 1840–1, prettily remodelled in 1904 by *Morgan & Son*. The front of two storeys and three bays has small arched windows with 'Florentine' wooden tracery of 1904. The interior has a nice play of curves, the pulpit bow fronted, the gallery opposite concave, and the pews beneath curved. Dwarf balustrading in the galleiy front.

EBENEZER INDEPENDENT CHAPEL, Crwbin. 1890–2, by *George Morgan*. A plain front in the grey limestone still quarried on this ridge. Galleries with pierced cast-iron long panels, and a Gothic pulpit.

MYNYDD LLANGYNDEYRN, W of Crwbin. On the ridge, in the bracken, numerous Bronze Age CAIRNS lie to the E of the highest point. Two BURIAL CHAMBERS on the N side of the outcrop, Bwrdd Arthur and Gwal y Filiast, side-by-side, low with capstones, the E one collapsed. Further cairns to the E, and lines of stones, possible field boundaries. W of the high point, a tall STANDING STONE, with a smaller one to the N, both re-erected. One had some kind of timber structure attached which gave a carbon date of 1140 B.C.

HENBLAS, SW of Crwbin. Site of a C16 house. In an outbuilding, a stone-domed PIGSTY about 8-ft (2.4-metres) wide and 7-ft (2.1-metres) high.

See also Llandyfaelog.

LLANGYNIN 2636

A modern village, the church isolated about 1½ m. S.

ST CYNIN. Tall Carmarthenshire embattled W tower, splayed base with a moulded course above. The large squared stones make a date *c.* 1500 likely. The base is vaulted. Nave, chancel,

s aisle and N transept. The fabric is all medieval, the nave and chancel are the earliest parts; close dating is difficult. s door with angle stops. Restored Perp E window with panel tracery. The transept is vaulted. Three-bay C15 arcade on octagonal piers, the W pier and W respond with odd bulbous angle stops. Restored 1874–6, by *John Prichard*, who removed sash windows and flat plaster ceilings of as late as 1842–3. – FONT. Medieval octagonal bowl, retooled. – FURNISHINGS by Prichard. – In the s aisle stoup, a small broken CARVED FIGURE of a robed man, perhaps a pilgrim. It may be a fragment from the tomb of Sir Rhys ap Thomas, at St Peter's, Carmarthen (q.v.). – MONUMENTS. Rice Thomas †1737, veined marble with shield above. Rev. John Lewes Philipps †1793, oval, with shield, by *Paty* of Bristol. Elizabeth Lewes Philipps †1816, sarcophagus type. John Lewes Philipps †1839, urn, by *H. Phillips* of Haverfordwest. John Lewes Philipps †1858, scrolled, by *King* of Bath.

RHYDYCEISIAID CONGREGATIONAL CHAPEL, 1¾ m. NNW. 1857. Four-square, with a pyramid roof, centre door and a tall arched window each side, the r. partly obscured by an added schoolroom. Good interior, all the woodwork painted. Panelled gallery on fluted iron Corinthian columns, box pews with ramped ends, and a later pulpit, with crudely fretted panels.

PENYCOED, 1½ m. S E. A plain five-by-four-bay hipped stuccoed house of two storeys, most of the exterior detail removed in 1926 by *J. H. Morgan*. It was built *c.* 1810 and enriched in 1832–3 for Timothy Powell in an Italianate style, early for the date, by a 'local architect', probably *William Owen* of Haverfordwest. Owen added a pedimented centrepiece with an Ionic portico over an enclosed porch, and pedimented upper window surrounds. The enclosed porch survives. Inside, delicate detail by Owen: an Ionic hall screen, stairs with branchlike scrolled iron balusters, and a library with fitted shelving. Tall STABLE BLOCK of five bays, the centre projected and gabled.

LLWYNCRWN, 1 m. W. Roughly L-plan, with a three-bay E front, the detail C19. Within are rough beams, an early C18 staircase with thick balusters and, in the NE room, big fielded C18 panelling.

CASTELL GORFOD, 1 m. NE. Well set in Victorian grounds in the Cynin valley. The house has C16 origins. In 1874 James Buckley, Llanelli brewer, added a gabled wing, by his brother-in-law, *James Wilson* of Bath, to a plain three-bay house, which looks earlier C19, and the iron veranda. Good C19 and earlier outbuildings. In the C18 the Bowen family here had helped the Methodists, converting kennels into a meeting room.

LLANGYNOG

ST CYNOG. Some ¾ m. s of the modern village in a windswept circular churchyard. Long, low, double-naved, with single N roof, and SE chapel on the s nave. The s nave is clearly added,

both have cambered-headed post-medieval window openings. Restored 1877–8 by *George Morgan*, who added the bellcote to the N nave, the S porch and most of the tracery. The N nave was lengthened in 1902, by *E. V. Collier*, as a memorial to Thomas Morris of Coomb. Four-bay C15 arcade of plastered roughly four-centred arches, the second from the E narrower. The SE Coomb chapel was restored in 1878, but *Collier* opened the arch to the chancel, on a bulbous double pier, which also carries the W arch of the chapel. The E wall of the chapel has very attractive decoration in paint and *opus sectile* (tile mosaic), by *Powell*, after 1912. – FONTS. One of *c.* 1850, with marble panels and Welsh texts (cf. Llanybri). The other, 1902, with carved foliage, and marble shafted base. – PEWS of 1878. – PULPIT. 1895, by *Jones & Willis*. – STAINED GLASS. By *Jones & Willis*, the E window, 1902, the chapel S, S aisle W, and the nave N three-light, *c.* 1913. The chapel E window, Resurrection, is by *Cox, Buckley & Co.*, 1885. Chancel N, heraldic glass, 1954, by *Powell*. – MONUMENTS. Maria Evans †1847. Convex limestone tablet with good italic lettering. Thomas Morris †1902. Brass, by *Jones & Willis*. Marteine Kemes Arundel Lloyd †1916. Alabaster, with mosaic. Alice Morris †1921. Alabaster, with dark marble. Lord Kylsant †1937. Alabaster and mosaic, these last probably all by *Powell*.

EBENEZER BAPTIST CHAPEL. 1829, remodelled 1871 with gable entry. Inside, a panelled rear gallery, unusually canted, of 1871. The box pews are probably of 1829, reassembled. The central block has doors opening alternately each side, to control the flow of people after the service.

WAR MEMORIAL, ½ m. S, on the roadside. Tall stone cross on a granite base, 1922 by *M. L. Edwards* of Llanelli.

COOMB (CWM), 1 m. SSW. Substantial Victorian Gothic house, rebuilt 1864–5 for William Morris, Carmarthen banker. Possibly by *R. K. Penson*, though not listed in his obituary, and more textured than usual for him. A typical High Victorian asymmetric design, with a corner entrance tower balanced by a gable on both main façades. Typical also the varied stonework that gives the house a tweedy sheen in wet weather – grey-green to purple-brown rock-faced Pennant stone, with dressings of green-to-brown sandstone, and some grey limestone. Plate tracery under relieving arches, the detail amplified on the ground floor with some column shafts, and a big bay window in the centre of the garden front. Marooned behind modern extensions is a very large billiard room with canted ends and a clerestoried roof in layers. The entrance tower had a wedge roof, removed in an expensive overhaul, 1921–3, for Lord Kylsant, by *Trollope & Colls*, the London builders. The Gothic was swept away for that 'period style' of interwar passenger liners: weak Neo-Georgian plaster for the feminine spaces, and oak panelling for the masculine ones. The stair hall shows the faults: although the strapwork balustrades show some vigour, the newels and pilasters are finicky, and the big roof-light has weak 'olde' detail with leaded panes. In the main S room a good

early C19 white marble chimneypiece with Greek philosophers
on the centre panel, and in the SW room a stone Tudor fire-
place, under a Jacobean overmantel with walnut panels flanked
by pillars with male half-figures, all brought in. The brick and
terracotta Jacobean-style balustrading is of *c.* 1920, by *E. V.
Collier.*

HENDRE, 1½ m. SW. Stuccoed house, of three bays and two
storeys, with a storeyed porch, and pointed arch, possibly C16.
Spoilt by new windows. Across the road, good whitewashed
farm buildings.

10 TWLC Y FILIAST, SW of the village (SN 338 161). Neolithic
burial chamber with three uprights and the capstone tumbled
to one side. Excavation in 1953 showed that it had been
covered by an oval cairn of large stones, and there may have
been a funnel-shaped forecourt and a S ante-chamber, not
visible now.

CASTELL COGAN, ¼ m. N of Hendre. Iron Age hill-top farm-
stead.

4528

LLANLLAWDDOG

2½ m. E of Llanpumsaint

Church and low-walled cattle pound of *c.* 1800 are set against a
backdrop of pine forest, in a remote location.

ST LLAWDDOG. 1848–9, by *J. L. Collard,* in his plain lancet
Gothic (cf. Llanwinio), with W bellcote and modern W porch.
On the N wall, a re-set datestone of 1725. Plaster ceilings with
transverse ribs, plain chancel arch. – FONT. Plain octagonal, of
uncertain date. – FURNISHINGS, 1878, by *D. M. Williams* of
Carmarthen. – STAINED GLASS. E window, 1879, by *H. Hughes,*
Resurrection. W window, also of 1879, glowing colours. Nave
S, *c.* 1960 by *John Hayward,* Christ in Majesty. Semi-abstract
figure and close leading. In the churchyard a large marble and
grey stone chest tomb to the Lloyd Prices of Glangwili, mid
C19, by *H. Wood* of Bristol.

CAPEL Y GROES, 2½ m. S. Chapel of ease, 1886–8, by *Middle-
ton, Prothero & Phillot,* on the site of a medieval chapel. Nave
and chancel in one, with bellcote and S porch. Simple Perp
style. Inside, a good scissor-trussed roof. – Octagonal FONT.

TREWITHIAN HOUSE, 1 m. WSW. The former vicarage, 1886, by
Middleton, Prothero & Phillot. Heavy and four-square, with a
big hipped roof.

BETHEL CALVINISTIC METHODIST CHAPEL, Rhydargaeau,
2 m. SW. 1852. A long-wall front of four bays, with arched
centre windows, outer doors and gallery windows. Interior of
1876, gallery with long panels, pews with doors, and the pulpit
on the entrance wall.

HOREB BAPTIST CHAPEL, Rhydargaeau. Rebuilt *c.* 1884.
Simple gabled front. The interior aligned on the end wall, with
three-sided gallery, the front with bands of pierced cast iron.

LIBANUS INDEPENDENT CHAPEL, 1¼ m. ESE. 1870, in an iso-
lated location. Just two sash windows to the side, and an end
door. Nonconformity at its simplest.

GLANGWILI, ¼ m. SE. One turret remains from a wedding-cake
stucco Tudor-Gothic house, a refronting of 1838 of a double
pile C18 house, for John Lloyd Price:this was the free-standing
bell-tower, but much reduced.

LLANLLWCH 3818

ST MARY. Small with low C15 W tower. The nave was rebuilt at
the expense of John Vaughan of Derllys, Merthyr, after 1710,
and there were repairs in 1827–9, but the character is of
1869–70, when the large N aisle was added by *Penson & Ritchie*.
Flat nave plaster ceiling of the 1820s, on a deep cove. Three-
bay arcade of 1869, round piers on high pedestals to allow for
a W gallery, a very old-fashioned idea. The gallery was removed
in 1923. – FONT. Small octagonal bowl, with panels in four
faces, possibly early C18. – STAINED GLASS. E window, 1952,
chancel lancet and nave S window, 1969, and N window, 1960,
all by *Celtic Studios*. Aisle E, 1974, by *John Petts*, in shades of
blue. – MONUMENTS. John Vaughan †1722. Veined marble,
with broken segmental pediment and large cartouche above.
Edwardes family, after 1813. Large oval tablet and wide draped
urn. Thomas Jones †1848. Sarcophagus tablet, by *D. James* of
Carmarthen.
 Timber LYCHGATE, 1952, and stuccoed SCHOOLROOM,
1850, by *R. Barrett* of Carmarthen, two storeys, minimal Gothic.

BOKSBURG HALL, opposite the church. Early C19 three-storey,
three-bay house, possibly on an earlier core, the name from a
late C19 owner returned from South Africa.

LLANLLWNI 4839

The church is beautifully sited on a wooded crag above the Teifi,
with the remains of a Norman MOTTE just E. Below is PONT
LLANLLWNI, an early C19 three-arched bridge, with curious
coffin-shaped reliefs on the coping of one parapet. The modern
village and Capel Noni are on the main Lampeter road.

ST LUKE/ST LLONIO. A thin C16 tower, taller than average, bat-
tered and sheer to a corbelled parapet, with NE stair-turret and
small flat-headed W window. The nave is much rebuilt, the S
wall, in a different stone in 1811, but a small blocked N window
may be medieval. Otherwise there are broad C19 lancets with
attractive lead-glazing of 1930. The chancel is low, the walling
medieval, but the E window of 1878. One C14 rectangular light
in the N wall, the S windows, one two-light, one rectangular,
may be copies of late medieval originals. Restorations in 1878
and in 1930, the latter by *W. Ellery Anderson*. Inside, vaulted

tower base, plain nave open roof with thin trusses of 1930, and a low medieval chancel arch of rough stones, with rood-loft door high up on the l. – FONT. C13 square bowl. – MONUMENT. Admiral John Thomas of Llanvaughan †1810, draped urn. – STAINED GLASS. E window, 1878. Nave S window, St Francis, 1936, by *C. C. Powell*, late Gothic style with much pretty detail.

In the churchyard, later C19 MEMORIALS to the Jones and Mansel families of Maesycrugiau, and to the Lloyds of Waunifor. The gabled MAUSOLEUM in rock-faced stone to John Jones †1877, is one of the very few in the region. Heavy rock-faced stone chest tomb to the Rev. C. Lloyd †1867, on top of the Waunifor vault.

NONI INDEPENDENT CHAPEL. 1838. Lateral front in brown-grey stone with deep eaves. Five arched openings. Painted gallery in five cants.

MAESYCRUGIAU MANOR, Maesycrugiau. This might have been the most significant early C20 mansion of the region, designed in 1903 for Sir Courtenay Mansel, by *Arnold Mitchell* of London. He planned a Neo-Elizabethan house with a near-symmetrical E-plan garden front, and asymmetrical entrance front with a broad, rather Scots tower between the house and the L-plan service court. Only the tower, one gable of the garden front and the service court were completed, in squared brown stone. The tower has a sturdy monumentality, two-bay, three-storey with small mullioned windows and an angle turret, the broad arched entry with well-carved Renaissance detail and heraldry.

CASTELL NONI, S of Capel Noni (SN 494 398). Small Norman motte, possibly C12.

CAIRNS On the high ground to the S, a series of cairns. By the mountain road, CRUG Y BISWAL and a RING CAIRN opposite. CRUGIAU LEIR (SN 502 371) has two cairns, CRUGIAU EDRYD (SN 535 395) has three.

5408

LLANNON

ST NON. A medieval double-nave church, in a steeply sloping churchyard. Drastically remodelled in 1839–41, by *Edward Haycock*, as a broad preaching box with shallow-pitched single roof and large pointed windows. There was some late C19 work by *David Jenkins*, presumably the window tracery. The late medieval W tower, off-centre, as it was at the end of the N nave, has a vaulted base, four-centred heads to the W door and the large red stone bell-lights. The chancel is aligned with the former N nave, with buttresses by Haycock and late C19 E window. The S nave has some late medieval stonework in the E wall and a small two-light C15 W window. Broad rendered interior with plaster ceilings of 1840, flat to the nave, and Tudor-arched with plaster ribs to the chancel. The plain pointed chancel arch may be medieval. – FITTINGS, of 1929–34, the reredos, pulpit, stalls and pews. – STAINED

GLASS. One window by *Celtic Studios*, 1951. – MONUMENTS. C. Griffiths Griffiths †1850, marble with urn, by *W. Thomas* of Carmarthen; Rees Goring Thomas †1821, very large pedimented, by *Daniel Mainwaring*; a copy to Sarah Goring Thomas †1832, by *D. & J. James* of Carmarthen; John Davies Thomas †1821, with kneeling mourner at a tomb, by *Tyley* of Bristol.

HERMON BAPTIST CHAPEL, ½ m. S. 1850, rebuilt 1898. Two-storey gable front with arched windows above within a giant arch.

LLWYNTEG INDEPENDENT CHAPEL, ¾ m. E. 1907. Gable front with big centre arched window, the windows each side with triangular hoodmoulds.

NATIONAL SCHOOL. A picturesque range stepping up the hill, by *Archibald Ritchie*, 1872–5, though with a date-stone of 1841. At the S end the large schoolroom gable, with a big chimney corbelled off the corner. To the right, a gable between roofs swept over a timber veranda one side and a porch the other. At the upper end, the smaller gable of the master's house, 1882, by *Ritchie*.

PLAS LLANNON, N of church. The house of the Goring Thomas family, landowners here, and developers in Llanelli. In the 1840s they began to build a new mansion at Gelliwernen (*see* below), but kept the Plas until 1913. Three-bay stone house with parapets, called completed in 1866, extended in 1880 with what looks like a Norman Shaw style terrace of gabled houses, hung with red tiles, and with fancy bargeboards, oriels and a big canted bay.

THE VICARAGE, S of the church. 1870–1, by *G. E. Street*. A spare and powerful Gothic design, in stone with steep roofs. The entrance front is more wall than window. A cross-wing gable advances to the l. with just a timber oriel, set high, while the short range set back to the r., is blank apart from a narrow gabled two-storey porch. On the side of the cross-wing, flush mullioned windows emphasize the wall plane, three below, and two above under sharp gables.

BRYNMAEN PILLAR, 1¼ m. SE. A tall standing stone, on the N side of an outcrop by Brynmaen farm.

GELLIWERNEN, 2 m. S. A double courtyard of outbuildings only. A new country house in Elizabethan style by *Edward Haycock* was begun c. 1840 for Rees Goring Thomas of Plas Llannon, but abandoned after being attacked in the Rebecca riots of 1843.

LLANPUMSAINT

4228

CHURCH. Dedicated to five saints, Ceitho, Celynen, Gwyn, Gwyno and Gwynoro. Small and single-roofed, heavily rebuilt in 1881–2 by *Middleton & Son*, and the W end, with porch and bellcote added after 1917. W window of the 1960s. Minimal timber chancel arch, of 1882, on heavy corbelled squat columns. – FONT. C13, octagonal, on a round shaft. In the

porch a re-set STOUP and, in the vestry, fragment of a C15 window head. – STAINED GLASS. E window, 1939, fey and pastoral in soft colours, inscribed as made by *Muriel Minter* to a design by *Elsie Eldridge*. W window, 1961, by *Shrigley & Hunt*, and one N window by *Celtic Studios*, 1974.

In the churchyard to the S, a CROSS-INSCRIBED STONE, the cross in a ring with a line below.

CAPEL CELYNEN, 2 m. S. Anglican chapel of ease, 1892–4 by *Middleton, Prothero & Phillot*.

CALVINISTIC METHODIST CHAPEL. 1827, stuccoed and refitted in 1873. Half-hipped, with arched windows to a lateral façade. In the gallery, a continuous band of pierced ironwork.

CAERSALEM BAPTIST CHAPEL, ½ m. N. 1904, probably by *David Davies*, stuccoed with centre arch.

VICARAGE, ½ m. N. 1885, by *Middleton & Son*. Brown stone and black brick, with big hipped roof, sash windows and centre door. Nearly Georgian but symmetry harshly denied by having no windows to one side of the door.

SKANDA VALE, 2 m. N. Hindu monastic centre founded 1972. It has grown to a 100-acre site attracting some 70,000 devotees a year. Two temples enlarged from farm buildings, the lower, larger one to Subramanium, the upper one to Maha Shakti, both with large gopuram over the shrine. Also a lake temple with statue of Ranganatha (Vishnu) emerging from the water.

LLANSADWRN

The village is around the raised rounded churchyard. By its entry, a small circular animal POUND, and the WAR MEMORIAL, a tapered pillar with slightly Art Nouveau leaf forms to the capital. N of the churchyard, Ebenezer Chapel, LONDON HOUSE, mid C19, half-hipped with sash windows, and MYRTLE HILL, earlier C19, stuccoed with columned timber porch. E of the churchyard, down a lane, the OLD VICARAGE, early C19, three bays, painted stucco, with a hipped rear stair-projection.

ST SADWRN. A long single-roofed nave and chancel, with big W bellcote, a large S porch, and a parallel-roofed SE chapel. There were transepts, the N one gone, the S incorporated into the SE chapel. The nave with plain chamfered S door may be C14, but dateable detail is late C15 or C16 both in the main body and the SE chapel: the square surround of the E window; the chapel E window, three-light with slightly ogee lights and hoodmoulds; and a small arched chancel N window. Traces of exterior limewash. The interior is confused by the chancel arch added by *Middleton & Son* in 1883–4 and the blocking off of the SE chapel. The blocked single segmental arch from the nave may relate to the S transept, and the unequal, low Tudor arches, both blocked, from the chancel, to the enlargement. The chapel floor is much lower. How did this work when the arches were open? They seem to have been blocked early, as beams in the

former transept suggest a C17 inserted floor. – FONT. Octago-
nal, C15, chamfered below. – Panelled Gothic PULPIT, 1885,
on a squat octagonal shaft. – STALLS, 1885, with roundels on
the bench ends. – MEMORIAL. In the aisle, floor slab to
Thomas Cornwallis of Abermarlais, †1699.

EBENEZER INDEPENDENT CHAPEL. Disused. 1874, by *John
Humphrey*. Rock-faced sandstone with Bath stone. Inventive
minimal Romanesque, very like his Ffaldybrenin, Llanycrwys.
The façade is emphatically banded, with roundels disposed like
planets around the façade. Two large and one small roundel in
the centre, over two pairs of very narrow arched lights, a small
one over each outer pair, and two more to flank the door. There
are subtleties – a sloping plinth, broken so that it reads as
splayed feet to wall-piers, and the ashlar banding shades from
grey to yellow. Inside, a gallery with a continuous band of
pierced ironwork, and curved angles. Behind, a vestry with Y-
tracery to arched windows, possibly the previous chapel, of
1830.

SEION CALVINISTIC METHODIST CHAPEL. N of the village.
1847. Lateral front of four bays, with stucco detail of 1874, by
Richard Owens, and coloured and etched glass. Converted to a
house 1999.

LIBANUS BAPTIST CHAPEL. 1 m. W. 1841. A very early gable-
entry chapel, with two arched windows and an arched door.
The interior is a gem, with a painted three-sided gallery on 72
wooden columns, the columns and panels stencilled, presum-
ably in the late C19, with vases of flowers. Painted box pews
and a late C19 pulpit. The first chapel to be preserved by the
Welsh Religious Buildings Trust, 2006.

ABERMARLAIS, 1½ m. S. The hipped roofed house with central
chimneys built in 1806 for Admiral Sir Thomas Foley, proba-
bly by *Thomas Bedford*, has been demolished. A lofted coach-
house and stable range survives, in a transport yard. To the E,
THE OLD BARN, 1861, former lofted stables, colourful
stonework, in purple and grey. It was lowered in 1986–8,
leaving a gable plaque recording J. Arengo Cross, tenant and
builder, and John Robert, chief mason. There had been a
medieval house described by Leland in the 1530s as 'a welle
favord stone place, motid, new mendid and augmented bi Sir
Rhese ap Thomas'. A map of 1761 showed a quadrangle of
building with bowling green. On the A 40, the ABERMARLAIS
STONE, massive unadorned boulder. To illustrate the enig-
matic nature of such things, it is said variously to have been
set up by Sir Rhys ap Thomas, to have been moved here
c. 1840, to be Bronze Age, or to be a natural erratic.

ABERDEUNANT, 1½ m. WSW. The best upland vernacular farm- 6
house in the county, with a disparate group of farm buildings;
some of which were formerly houses. Owned and restored by
the National Trust. The thatch has been reinstated, recreating
what was once typical, but is now exceptionally rare in the
county. Yellow limewashed front of one and a half storeys, three
uneven bays, the entrance roughly central. The battered ren-

dered walls conceal rubble stone raised in cob, the roof drops down to a single-storey downslope bay (once a stable, then a service room) and there is a late C19 slate-roofed store at the upper end. At the rear a rounded stair-projection. The original extent of the downslope end is uncertain, almost certainly the original entry was at this end until the façade was regularized in the C18. Big stone stack at the left end of the main house, smaller at the right end.

The appearance is of an C18 remodelling of a C17 house, but a more complex history is indicated by one substantial pair of principals embedded in the outer face of the main chimney, the other trusses being thinner scarfed crucks. This larger truss has marks of arch-bracing and may be a full cruck, an indication that the chimney was inserted into a former open hall, that would be late medieval and the only known survivor in the county. The scarfed crucks generally dated to the C17 or C18 may be much older (there are late medieval examples e.g. in the Tudor Merchants House, Tenby, Pembrokeshire) and may represent the upper (solar?) end of a hall house. The massive stone winding stair and the floor are apparently subsequent insertions. If the floor and stair were inserted in the late C17, the next phase would be the later C18 regularizing, giving the house a central entry and passage. Plenty of C18 detail, best of all an L-plan dresser fitted in the living room, with a moulded cornice and carved ends. Also panelled cupboards and doors.

An interesting scattered FARMYARD. Below the house, a whitewashed BARN range altered in the C19, but with the remnants of scarfed crucks. Lofted STABLE range of about 1880 at the entry to the yard. SE of the house, a long stone range with large end chimney, with scarfed crucks in the E end dated by dendrochronology to as late as the 1790s, and a massive fireplace. The W end is later, said to have been a TANNERY. It was once open-sided as two round stone piers are embedded in the rear wall, earlier C19, altered in the 1880s. A whitewashed outbuilding behind was once a cottage, with fireplace and remains of scarfed crucks.

GREEN MEADOW, 2½ m. WSW. Whitewashed three-bay minor gentry house, dated 1754, with initials of Griffith Beynon. Inside, three C17 beams with double ovolo mouldings and ogee stops. The heavy beams to the first floor and the chamfered collar-trusses look mid C18, as also the dog-leg stair. A late C17 ovolo-moulded doorcase and plank door to an upper room may be a front door re-set. Formal early C19 group of three OUTBUILDINGS around a court beyond the house.

8 CWM EILATH. 1½ m. N. An altered C18 long-house, with downslope byre. The original entry from the cross-passage at the top of the byre was changed to a central entry in the C19, when the byre was rebuilt. Huge gable chimney and tin roof concealing thatch. Winding stone chimney stair, and roof with three pairs of scarfed crucks.

GLANDULAIS, 1 m. SE. Three-bay whitewashed early C19 farm-house backing on a longer seven-bay later C19 stone range, added apparently for the family from Abermarlais, while that house was being renovated. Whitewashed BARN with added stables and lofted cow-house, in line.

LLANSADWRNEN

2710

4 m. N E of Pendine

ST SADWRNEN. Set in a raised oval churchyard, with views over the Pendine marshes. Rebuilt 1859–60, by *E. M. Goodwin* of *Coe & Goodwin*. Though money was tight, the quirky grouping of the SW tower and porch shows a 'rogue' touch. The tower has a little slate spirelet and, oddly, a ground-floor rose window. Red and green sandstone with grey limestone voussoirs: an attractive combination. The C15 E window, of two cinquefoiled lights and hoodmould, is reused. Also re-set, C14 PISCINA to the l. of the E window, with cinquefoiled head, and small pinnacles. The medieval church was barrel-vaulted, like Eglwys Cymun, i.e. of the S Pembrokeshire type. Restored 1919, by *E. V. Collier*. Simple interior with arch-braced roofs, and a chancel arch on fluted brackets. – FONT. Octagonal, of 1860. – FURNISHINGS, of 1860. – STAINED GLASS. E window, 1860. SS Peter & Paul, bright colours. – MONUMENT. Benjamin Reynolds †1774. Veined marble tablet.

BROADWAY, 1 m. SE. A hipped bungalow of *c.* 1880, by *Thomas David*, built as a holiday house for the Broadwood family, piano-makers, is attached at one corner to a two-storey villa with pierced parapet and octagonal corner tower, 1912, for Herbert Eccles, of the Briton Ferry Steel Co. It had verandas and a hexagonal domed conservatory, by *Messenger & Co.*

LLANSAINT

Hilltop village overlooking Carmarthen Bay, dominated by the church tower, once used as a navigation beacon, recently lime-rendered to dramatic effect. Most of the cottages have been heavily modernized. For the re-opening of the church in 1862 all the cottages were whitewashed and the cockleshell heaps removed from the streets.

ALL SAINTS. In an island-like raised churchyard. Battlemented C15 W tower, on a battered base, vaulted within, added to an earlier nave and chancel, hard to date after restoration in 1861–2, by *Penson*. He added the N transept, S vestry and the lancet windows. A fragment of a C15 to C16 two-light on the chancel s wall. Chancel arch and roofs by Penson, also the FURNISHINGS including the octagonal FONT. – Painted metal COMMANDMENT BOARDS, in Welsh. – STAINED GLASS. E window, colourful, of 1862. Nave N, 1986, by *Nicola Thorpe*,

semi-abstract, based on the life-cycle of a butterfly. – INSCRIBED STONES. Re-set in the nave s wall, c6 to c8. One reads CIMESETL . . . AVICATI, the other VENNISETL – FILIUS ERCAGN .

SION CALVINISTIC METHODIST CHAPEL. 1876. Simplest Romanesque with wheel window.

PENALLT, ½ m. s. Ruins of a late medieval house s of the farm. U-plan, apparently a first-floor hall on vaulted undercrofts. The vaults have gone, but the w wall remains to upper-floor height, with a garderobe turret. It was the home of Sir John Dwnn, courtier, buried at Windsor in 1502. The family portrait (the Chatsworth triptych), by Memling, is the earliest of any Welshman.

3807

LLANSAWEL

An attractive compact village, at the confluence of the Marlais and Melindwr rivers.

ST SAWEL. Medieval fabric, with broad, quite low c15 tower of the usual type: battered base, vaulted within, but the parapet has no battlements. Nave and short chancel, heavily restored in 1886, by *Middleton, Prothero & Phillot*, who added the steep roofs. Four c14 cusped lancets were preserved. The plain-pointed chancel arch is of 1886, but the little squint windows were found in the restoration. – REREDOS. 1890, carved stone, a memorial to Sir James and Lady Williams-Drummond of Edwinsford. – FONT. Small medieval rounded bowl re-set in the w wall. In the churchyard, tiny former SCHOOLROOM, 1805.

BETHEL CALVINISTIC METHODIST CHAPEL. 1829, altered 1904, by *David Jenkins*. Lateral front which Jenkins elaborated with a full-length shallow gable. Gallery with cast-iron panels, and pedimented pulpit-back, all of 1904.

SHILOH INDEPENDENT CHAPEL, at the top of the village. 1868, by *D. P. Davies*. Plain Gothic gable front in stone, the interior with simple painted grained woodwork.

Llansawel was a drovers' village, hence the three inns. The BLACK LION HOTEL is early c19, altered 1907. Unusual former TOWN HALL, early c19, three bays with large windows to the upper chamber, used for Petty Sessions. The ground floor was two cottages. To the E, two-arched BRIDGE over the Marlais, 1820, the wide arches flanked by pilaster strips. Probably by *John Thomas*, Bridge Surveyor. CASTLE GREEN is unusually grand for a village house. Mid-c19, five-bay, hipped and stuccoed with a big pedimented Doric doorcase, and fine iron RAILINGS. On the main road, to NW, a single-storey cottage, the thatch reinstated recently, a welcome reminder that much in this region was thatched.

TREGLOG, 1 m. SW. Humble but strikingly long whitewashed range of eleven bays, built into the hillside: carthouse, cow-

shed, barn, and calves-cot, the three-bay house unhygienically at the downslope end. The house was built in 1819–20, the rest added slightly later; the arrangement presumably dictated by the narrow sloping site.

BEILIFICAR, 1 m. ENE. Altered, but a small gentry house of *c.* 1600, home of a High Sheriff in 1618. The huge stepped end chimney and an oak attic window survive.

GLANYRANNELL, 2 m. ENE. 1857, by *Thomas Nicholson* of Hereford. Stuccoed Italianate villa, now stripped of much detail. Set in the park of its predecessor, which contains a small MOTTE.

LLANSTEFFAN

3511

Beautifully situated on the Tywi estuary, the low lying village, with the church in the middle, the beach in front, and the ruined castle away to the s, on the headland. Between the village and the castle, the late C18 Plas, positioned to command the view. The village grew with the fashion for sea-bathing in the early C19.

LLANSTEFFAN CASTLE

Spectacularly sited, especially when viewed from the other side of the estuary. This dominant site was an Iron Age PROMON-TORY FORT, its outer earthwork still visible to the w The Normans probably established a castle here soon after 1100. A ringwork was raised at the highest point to form what is now the upper ward, and the rest of the defended promontory formed the bailey. First mentioned in 1146, when taken by Maredudd ap Gruffudd, recaptured by 1158, and from the end of the C12 held by the de Camvilles. Parts of the curtain wall to the upper ward may date from after 1192 when William de Camville refortified

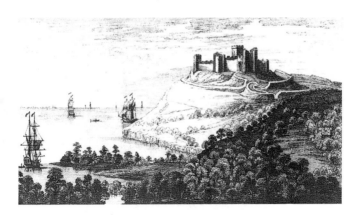

Llansteffan Castle.
Engraving by S. & N. Buck, 1740

the castle. Lost to Llywelyn the Great in 1215, it was probably restored to the de Camvilles after 1223. Of this period are probably the ruined ROUND TOWER, and the INNER GATE, both strengthening the curtain wall to the N. It was lost again, with Laugharne and St Clears, in the uprising associated with Llywelyn the Last in 1257, after the English defeat at Coed Llathen, Llangathen. In the 1260s William de Camville II appears to have enclosed the LOWER WARD in stone, with two strong D-plan towers and a bastion in the E corner. The late C13 double-towered OUTER GATEHOUSE, to the S, was probably begun under Geoffrey de Camville, who died in 1309. The castle then passed to the Penrice family of Gower. In 1367 both Penrice and Llansteffan castles were said to be 'ruinous and broken down'. In the Owain Glyndwr uprising the castle fell in 1403 and in 1405–6. From the early C15 it was mostly in the gift of the Crown, granted e.g. to Humphrey Duke of Gloucester 1416, to Queen Margaret 1454, to William Herbert Earl of Pembroke 1462–82, and to Jasper Tudor 1485–95. It was probably then that the outer gate was fitted up as a residence, and the much weaker gate built alongside. Around this date, too, the curtain wall of the upper ward was demolished, along with its round tower.

The tour begins with the older part, the UPPER WARD, where relatively little is left. Most prominent is the INNER GATE, a three-storey square tower of the early C13, with a simple pointed entry. The groove of a portcullis remains, and holes for bars. Above, a room on each storey, the first floor originally reached from the wall-walk, a stair from here to the top. Much of the curtain wall of the upper ward has gone, but the foundations remain of the early C13 ROUND TOWER, with immensely thick

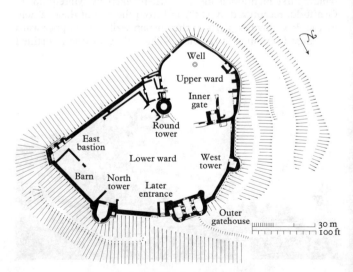

Llansteffan Castle.
Plan

walls. Around it, foundations of later buildings of uncertain date and function, the larger chamber to the s reached down steps from the upper ward. On the w side, a well-preserved stretch of curtain wall, the surviving short row of vaults indicating a strengthening, probably of the late C13, when a new wall-walk was provided. Towards the s end of the upper ward, the WELL. To the w, the outer bank and ditch of the castle are clearly visible, and just beyond, the slighter bank and ditch of the Iron Age fort.

The irregular LOWER WARD has the curtain wall preserved on three sides. The dominant feature is the splendidly large three-storey late C13 GATEHOUSE, added to the slightly earlier curtain. The segmentally arched entry is flanked by D-plan towers. The entrance was blocked in the late C15 when the gatehouse was refitted, and replaced by a simple arched entry to the w, the storey above corbelled-out, with slot for a portcullis. Barrel-vaulted passage with door-holes each end. The rear of the earlier gate was reduced in size, but its original outline is clearly visible. The courtyard elevation has small corner drum towers, containing the stairs of the two upper floors, which were reached from an external stair on the w side. Large, regularly spaced windows, with just enough tracery left to suggest a date of c. 1300. Once inside, it is clear that the basic ground-floor plan was not tampered with. The passage is barrel-vaulted with two portcullis slots, allowing internal communication, further protected by murder holes. Each side of the passage is a large barrel-vaulted chamber, the e one with fireplace, both with forward-facing loops. In plan and design, inspiration came from Gilbert de Clare's inner gatehouse at Caerphilly, of c. 1270 (also with drum towers in the front, stair-towers to the rear, and the same careful planning, so that the gatehouse could be sealed off and fortified in its own right). The first floor had a single chamber, now open to the elements. In the middle of the wall on the courtyard side, a fireplace, and on the opposite side, loops with squinted embrasures, which overlook the entrance. Above was a similar sized room, which has traces of a once splendid hooded fireplace: big corbels with carved heads and carved lamp brackets. Off the eastern newel stair, little barrel-vaulted latrines between storeys, the stair continuing up to the roof-walk. The connecting upper level of the secondary gatehouse is very ruined.

The ruinous WEST TOWER is D-shaped, barrel-vaulted ground floor, heated upper room. The EAST BASTION, when viewed from inside, has no back; it is simply a reinforcement of the SE corner of the ward. Much better preserved is the large D-plan NORTH TOWER, between the e bastion and the gatehouse, clearly built to accommodate the principal apartments. On the outer face, the stair is carried up through a polygonal turret. Simply a shell within. The ground floor and first floor are entered separately from the ward, the former room unheated. The first-floor room had a fireplace and, on the w side, a garderobe. From this floor, the stair leads up to the top chamber, which

is similarly appointed. Two carved corbels survive for the roof.
Between the N tower and the E bastion, remains of a long post-
medieval BARN, possibly replacing a hall.

CHURCHES AND CHAPELS

St Ystyffan. A substantial cruciform church in a large circu-
lar churchyard, with a chancel aisle, s porch and W tower. The
tapering tower is of unusual scale, probably C16, of the regional
type, vaulted within, with battered base, corbelled battlements,
and N stair-turret. The rest is earlier but dating is difficult. The
nave could be C12–C13 (see the blocked arched light in
the tower), with C14 chancel extended in the mid C15, with the
transepts and porch added then or in the late C15 to early C16.
The s transept is slightly smaller than the N one, which has a
squint passage. The N transept masonry suggests that it has
been rebuilt. The NE, Lloyd Chapel, was perhaps C16, rebuilt
after 1710. The E window of two arched lights under a straight
head is C16, possibly even C17. The chapel E window is a C19
copy. A restoration of 1829–30 enlarged the windows, and one
of 1872–4 added the tracery. The date 1801 is in a blocked C16
s transept E window, and the tower W window is of 1869. The
external white-washed render has recently been restored.

The interior has a refreshing pre-Ecclesiological air, with
plaster ribbed barrel ceilings, installed by *J. L. Collard* in
1844–5, though his W gallery has long gone. Plain plastered
chancel and transept arches, the arch from the N transept to
the NE chapel possibly C16, blocked in 1829. In the chancel, a
pointed PISCINA. The two-bay arcade to the Lloyd Chapel,
depressed arches on a big square pier with a simple cap, could
be C16 or even later. The simple oak roof is early C19, corbels
for an earlier roof on the s wall. – FONT. 1868, a copy of the
C13 original, which is in the s transept. Big square scalloped
bowl, cut down. The base reuses a piece of an old tomb, dec-
orated with four-petal flowers. – FURNISHINGS, 1872–4. –
WALL PAINTINGS. A few traces in the s transept of a black-
lettered inscription in Welsh, with two layers of painting under-
neath. In the N transept, traces of a late medieval painting of
a harpist. – STAINED GLASS. E window, 1980, by *John Petts*,
who lived in Llansteffan. One of the best modern windows in
the region, a swirl of leading, in varying pinks and oranges.
Nave NW, *c.* 1885, Empty Tomb, and sw, *c.* 1884, good colours,
faded detail. Nave N, Faith and Charity, *c.* 1896, painterly. s
transept s, 1881, probably by *Hardman*, Good Samaritan. NE
chapel E, 1953, by *Celtic Studios*. Chancel s single light, 1956.
Glass in the porch by *Petts*, 1974. – MONUMENTS. In the
chancel arcade, Rice Lloyd †1622, slab with marginal inscrip-
tion and shield. Rev. William Lloyd †1706, the inscription
partly in Latin. In the chapel floor, slabs of 1670, 1718 and
1795 to the Lloyds of the Plas and Laques. Richard Howell
†1820, large with oval inscription and tall draped urn, by

121

Drewett & Co., Bristol. Anne Lloyd †1831, Greek detail, by *H. Wood*, Bristol. Commander Henry Lloyd, drowned 1832, a large tablet with naval equipment. Mary Morris †1835, by *D. Mainwaring*, with fluted tapered pilasters, fluted frieze and urns. William Lloyd †1840, with open book in the pediment, by *H. Wood*. Captain Henry Davidson †1842, very large, with a weeping woman, sarcophagus, urns and palms, by *Bedford* of London. Mary Charles †1873, tall with simple Greek detail, by *Tyley* of Bristol. Rev. Benjamin Evans †1885, gabled Gothic. Robert Parnall †1885, very elaborate Gothic, with alabaster cusped frame and marble shafts. In the porch, a tablet to the restoration of 1874, at the expense of Henry Parnall, in marble, mosaic and Bath stone.

BETHEL INDEPENDENT CHAPEL. Disused. 1865, by the local builder *William Morgan*. The gallery is stopped in a theatre-like manner with quadrants about halfway along. Box-type pews.

BETHANY BAPTIST CHAPEL. 1866. Similar to Bethel, so probably by *William Morgan*, builder. Rendered with arched windows. Rear gallery with long panels. Box-type pews.

MORIAH CALVINISTIC METHODIST CHAPEL, Old School Road. 1910, by *John Morgan*. Stuccoed, giant arches framing arched windows, with some confusion of pilasters. The big window has as many as five roundels in the head. Rich interior, with pierced gallery and pulpit ironwork, probably by *W. Isaac* of Carmarthen, whose name is on the columns. Ribbed and boarded ceiling. Plasterwork behind the pulpit, framing a STAINED GLASS window, of passion flowers, by *G. Farmiloe & Son*, London.

PERAMBULATION

At the bottom of HIGH STREET, BRIDGE HOUSE, C19, three bays with a tiny smithy at one end. Up the hill, late C19 stuccoed terraced houses, some with swirly railings in front, apparently locally made. Set back is PARK VIEW, the former vicarage, early C19, hipped, with tripartite sashes on the ground floor. The rear wing looks older. THE NOLANS is a three-bay cottage with projecting hipped wings enclosing a forecourt with early C19 railings, but no clues inside or out as to date. The core must be pre-C19. TY PICTON, 1871, of three bays and two storeys helps to date similar houses in the village. ALBION HOUSE was a pub, early C19, with locally made railings. THE BRACKENS dates to 1804, but looks later. Opposite, MEMORIAL HALL, 1938–9 by *Leonard Crabbe*, gabled slightly Art Deco, with a flat porch. Inside, a contemporary wall painting by *T. C. Evans* of Carmarthen, of the castle, much overpainted. Up a driveway, THE GROVE, early C19 hipped, of three bays with Edwardian iron balcony, pedimented side porch and a carriage arch into the rear yard. THE STICKS HOTEL is C18 with big offsets, an extra bay added to the r. The three-bay RED LION, next door, is earlier, the roof dated 1699. Inside, big rough beams, a vaulted cellar with entrance dated

1736, and an altered closed-string staircase of *c.* 1700. The circular shop opposite was the animal POUND, roofed over *c.* 1880.

Along CHURCH STREET, THE ELMS and HOLMESDALE, 1871, a big pair of hipped three-bay houses with nice railings, and PLAS-Y-COED and PARK VILLA, opposite, of similar date.

Back in High Street, PHOENIX HOUSE and UNDERHILL, a pair of late C19 houses. Next, the driveway to HILL HOUSE, 1855, built for Robert Parnall, by *Dobson* of London, a prominent three-bay villa with shaped gable to the r. and bay windows. FFYNNON FAIR, named for the ancient well in the garden wall, three bays with end chimneys, the detail now C19, but with a good late C17 staircase up to the attic. Pulvinated string, twisted balusters and quite thin square newels, the bottom one with simple carved droplets. Opposite, VALLEY VIEW, an almost untouched early C18 house, of a Queen Anne type more common in England. T-plan: single pile with rear wing. Five bays and two storeys, the narrow windows still with thick glazing bars, and moulded cornice with big dentils. Open-string stair with elegant turned balusters and ramped handrails. The parlour has big-fielded panels and a heavily moulded cornice. Similar panels in the bedroom above. Some of the windows have verses dating from 1747 to 1778, scratched by John Blome in grief at his wife's untimely death in 1747. On OLD ROAD, BRYN ARLAIS is the largest of a late C19 terrace of three, three bays and storeys, with corniced doorcase, and gatepiers with ball finials. Further up, the prominent LLYS CERI looks mid C19, hipped, with an axial chimney.

THE COTTAGE. Facing the beach. An elongated Regency seaside villa, originally of 1810, a single bay each side of a big bow, but now a long and low six-bay front with the bow in the second bay (missing its ground-floor canopy), and a canopied porch on twisted iron posts. At the r. end, a three-bay billiard room, mentioned 1885, originally separated from the house by a conservatory.

ORCHARD HOUSE, Old School Road. Described as recent in 1877. Red brick, unusual in the area. Three bays with hipped roof, on a high basement.

58 PLAS LLANSTEFFAN, between the castle and the village. The long two-storey house superbly set overlooking the estuary was rebuilt in 1780 for Hugh Meares, a London lawyer from Pembrokeshire. But the present 1+5+1 bay façade may incorporate part of the triple-gabled house of the Lloyd family shown in the Buck engraving of 1740, and may have been extended by the outer bays in the earlier C19, when the tall four-column Tuscan porch and stone steps were added. Removal of the stucco revealed a central first-floor Palladian window, lost for the porch. The façade is united by a moulded cornice and a parapet carried around a full-height three-sided bay on the r. end wall. A rear wing links to a large L-plan hipped service wing, probably late C18.

The entrance hall opens into a square stairhall framed by two Corinthian columns closely paired with pilasters, and the same grand screen is repeated to the r., from the stair hall to the corridor. Open-well timber stair, the thin rail and square balusters looking more of the earlier C19, although the fine landing frieze of urns and opposed gryphons is elegantly late C18. Some fine carved wood chimneypieces in the Adam style, notably one with classical maidens on drum pedestals. There are vaulted stone cellars beneath. In the rear service range, a large arched fireplace with keystone.

Set back to the l., and urgently needing restoration (2006) is the COACH-HOUSE and STABLE block. This was also built for Hugh Meares, in 1788, but has a remarkably different character to the house. It is adventurously minimal, a pyramid-roofed cube flanked by low wings, but all the façades screen an inner plane. The centre has three very tall and unadorned arches, the outer ones fully open to the inner wall, the centre arch infilled to impost level with a door below and lunette above. The wings have outer arches flanking a completely plain wide opening with flat lintel, which looks so modern as to seem a C20 alteration until one sees that it frames three arched stable windows on the inner wall. The buildings have a spare originality reminiscent of Soane about twenty years later, so who could have designed this in 1788?

The stable block abuts a very large WALLED GARDEN and behind this is the HOME FARM, a complete late C18 model farm entered by an arched gatehouse and the yard surrounded by buildings both single-storey and lofted with arched openings. Behind the cow-houses a fold-yard divided by three walls radiating from the centre.

PANTYRATHRO, 2½ m. NE. Externally much altered. It was a hipped villa of *c.* 1870, extended *c.* 1892, by *George Morgan*. Inside a staircase of 1892 on two sides of the hall, with patterned stained glass and, in the dining room, a baronial fireplace.

LAQUES, 1 m. W. Complicated, slightly rambling house of the Lloyd family from the early C17, harshly treated in the 1980s. Roughly square, of at least three builds and no particular form. Earliest seems to be part of the s range, where the ground-floor room has a massive fireplace and rough ceiling beams. The w range was added at r. angles in 1703: three bays and two storeys, with a basement. The door was later moved from the centre to the l. bay. Tall, narrow windows, with modern glazing, large projecting chimney to the s. This part, one room deep, has the main rooms, with the staircase in a small wing to the rear. The older part became service rooms. Early C19 extensions to the E and N, providing basement service rooms and cellars, and a new main entrance on the E, with splendidly large fanlight. The junction between old and new is apparent on the E, where the new work abuts the chimney gable of the s range. Staircase of 1703 from basement to attic, closed string and twisted balusters. The main first-floor room has big fielded

panels and a deeply moulded cornice. In the early C19 part, a long passage connecting entrance to stair hall.

LLANWINIO
4 m. NE of Llanboidy

Upland parish bounded by two deep valleys running S. The main settlements, Cwmbach and Blaenwaun are modern. W of Blaenwaun, DYFFRYN BRODYN WIND-FARM, 1994, of eleven 0.5 MW turbines, the first wind-farm in SW Wales.

ST GWYNIO. Isolated, in a roughly circular churchyard. 1845–6, by *J. L. Collard*. The pedimented bellcote and paired eaves brackets show Collard an unconvinced Goth, though the windows are pointed. Broad nave, chancel, and W porch. Plain interior, the nave ceiling plastered and coved. – Simple PEWS. – Oak PULPIT, 1932. – Painted wood Gothic COMMANDMENT BOARDS, with Welsh texts. – STAINED GLASS. E window, *c.* 1926, by *Heaton, Butler & Bayne*. – MONUMENTS. Elizabeth Howell †1855. Sarcophagus type. – Mary Anne Lewis †1909. By *O. Williams* of Laugharne. Draped urn: incredibly old-fashioned. – In the porch, a crudely carved C17 SLAB with the upper part of a male figure, one hand on his heart, the other with an hourglass, from Eglwys Fair a Churig, Llanglydwen.

LLYS-Y-GWYNT, ½ m. SE. Former vicarage, 1909 by *C. S. Thomas* of Swansea. Deep red brick, with some terracotta, and steep hipped roof.

CWMBACH CALVINISTIC METHODIST CHAPEL, Cwmbach, ½ m. SW. 1828. Large hipped long-wall chapel of slaty stone in a railed forecourt. Tall centre windows, outer doors and gallery lights. Interior of 1928 by *W. Griffiths*, the gallery with fielded panels: all typically conservative. Late C19 pulpit. Cwmbach was an early cause, begun in 1742. PRIMARY SCHOOL, by the chapel, of 1867, enlarged in 1877 by *George Morgan*. Three bays, the upper windows pointed.

RAMOTH BAPTIST CHAPEL, Cwmfelin Mynach, 2½ m. SW. 1907 by *J. H. Morgan*. Stucco with Morgan's turn-of-the-century motifs. The centre is recessed in a rectangular frame, with sunburst rustication to the main window, and the door cornice arched from fat piers. Galleries with dwarf balustrading, and semicircular pulpit-front.

MORIAH CONGREGATIONAL CHAPEL, Blaenwaun, 1½ m. NW. 1883, by *George Morgan*. Simple gabled front in grey stone. Gallery with a pierced iron balustrade, and pulpit with colonnettes

CILSANT, 1¼ m. S. Early to mid C18, with substantial chimneys. Originally five-bay, with narrow windows, it was altered in the C19 to three. The rear wing may be older. Oak collar-truss roofs. An ancient site, Cadifor Fawr who died here in 1093, was the ancestor of the Philipps family, later of Picton Castle, Pembs. A letter of 1861 noted that most of the 'ancient mansion' had been pulled down.

LLANWRDA 7131

A large village where the Lampeter road joins the main road to
Llandovery.

ST CWRDAF. A single-roofed nave and chancel, with little pre-
C19 character after work in 1870, by *R. K. Penson*, and 1893–4
by *S. W. Williams* of Rhayader, who added the lean-to N aisle.
Williams's windows are in red sandstone, Penson's in Bath
stone. Three-bay arcade of Caen stone, on big round piers with
moulded caps, the hoods on carved leafy stops, typical of
Williams. His also is the good panelled barrel roof. C16 chancel
N door, now into the vestry. – FONT. Octagonal, C19, the
STOUP in the W wall may be a re-set square medieval font bowl.
– PEWS and RAILS by *Penson*. – Caen stone PULPIT, 1893,
ashlar on a red stone squat shaft. – STAINED GLASS. Chancel
S, 1878, by *Hardman*. – MONUMENTS. Well-lettered plain
plaques to Samuel Price †1808 and David Rees Price †1807.
Neo-Grec plaque to Rees Williams †1832, by *J. Thomas & Son*,
Brecon. Small tablet of 1872 to Lady Letitia Cornwallis, who
paid for work at the church in 1786.
 On the roadside, oak LYCHGATE of 1903 and small circular
animal POUND.
CAPEL DEWI SANT, 2 m. NNW. Mission church, in a simple Perp
style of 1904 by *David Jenkins*.
TABOR INDEPENDENT CHAPEL, ½ m. NE. 1842, refitted 1883
by *John Humphrey*. Slate hung long front with matching
porches, each with a window above; nothing else between.
Inside, a three-sided gallery with a narrow band of ironwork.
NEUADD FAWR, in the village, E of the river. Late C17 Renais-
sance plan house with symmetrical front and centralized cir-
culation, one of the first in the county. Two-storey, three-bay
whitewashed front, with small central gable, and massive end
chimneys, especially to the l. C19 sashes. The central passage
leads to the stair in a rear wing, rising around a well in four
flights to the attic, with thick turned balusters. Massive cham-
fered beams.
The village was on the main road from Carmarthen, now re-sited
to the S. N from the centre crossroads, on the r., the WAR
MEMORIAL, 1923, a white marble soldier. On the l., HEN
BLAS, a late C19 reworking of a C16 house with big chimney-
breast at one end, and a corbelled chimney at the other. PLAS
NEWYDD, 1866, has twin gables with pretty bargeboards.
Further up, on the r., before the church, BOREZELL, the
former Royal Oak, *c.* 1903, an improbably elaborate inn, with
very English detail. Roughcast and half-timber, with red-tiled
roofs, small-paned windows, and a little well-carved red sand-
stone for the doorway. NW of the crossroads, CORNWALLIS
HOUSE, built as almshouses 1792–5, with money left by Lady
Cornwallis of Abermarlais, Llansadwrn, in the 1730s. Remark-
ably large barrack-like two-storey block, H-plan, of two five-
bay hipped ranges separated by a short parallel centre range.
It is not clear how the almshouses were divided, as the detail

and interior plan were lost in a renovation in 1974. E of the crossroads, Neuadd Fawr, and then PLASWENALLT, *c.* 1880, purple stone with yellow and black brick, and fretted bargeboards to three half-hipped gables and two porches.

PENTRE MEURIG, just S of the A40. Late C17, of the post-Restoration type more modern than Neuadd Fawr, with a big hipped roof and large windows. Three bays, formerly with cross-windows, but all the exterior detail lost. A big rear wing contains a fine staircase, five flights with thick turned balusters and ogee pendants. The family home of Sir John Powell, a judge at the trial of the Seven Bishops in 1688.

THE OLD MILL, ¼ m. S of the A 40. Built as the Vale of Towy woollen mill, 1872. Seven bays, the mill and mill-house barely differentiated. At the W end, a very large water wheel, dated 1849, made at the *Vulcan Foundry*, Galway, so presumably second-hand.

CWM CYNWAL, 2¼ m. NNW. Upland long-house, late C17 or C18. One and a half storeys, three bays, pink-washed, with a thatched roof under corrugated iron, and scarfed cruck trusses. Massive chimney at the lower end, with a tiny fireplace window. The entry would have been from a cross-passage at the upper end of the byre, but this was rebuilt in the C19, the door to the house blocked, and a new central door made.

BLAENYCWM, 2¼ m. N. Small two-bay house with downslope byre. The house is modernized, but has a rounded stone staircase beside the fireplace. The stair is added, suggesting an open hall of the C16, later floored. The feet of two crucks are visible, and there is a planked partition upstairs. The byre has three pairs of scarfed crucks, probably C18. Opposite is a storeyed outbuilding with ground-floor arches, dated 1842 on a beam.

CEFNUCHELDRE, 1½ m. ENE. Stuccoed hipped villa, of Late Georgian type, but probably of the 1860s.

ALLTYCLORIAU, 1½ m. E. Later Victorian villa, with asymmetrical front in rock-faced stone.

LLANYBRI
3412
2 m. NW of Llansteffan

Tightly clustered hilltop village around the remains of the medieval church, which became an Independent chapel *c.* 1690.

HOLY TRINITY, W of the village. 1851. Purple sandstone church, in a very awkward Gothic, built for Miss Lloyd of Laques, Llansteffan, clearly by *J. L. Collard.* Much-buttressed nave and chancel with a confused junction of W porch and NW tower, which turns octagonal at the bell-stage, but has lost a spirelet. The lancets were altered in 1891, by *E. H. Lingen Barker.* – Of 1851, the ugly octagonal FONT with marble panels and texts, the PEWS with tall shaped ends, and the notable array of long white marble TABLETS, with texts in Welsh, others on convex curved tablets in the reveals of the chancel arch. – Chancel FITTINGS and Bath stone PULPIT of 1891.

Yr Hen Gapel, in the village. This was the medieval church, a chapel of ease to Llansteffan. In the late C17 it was repaired for use by a Nonconformist congregation, a remarkable change for the date, but fell to disrepair after they left and was unroofed in 1974. The tower is late medieval, vaulted, the battlemented top stage replaced by a pyramid roof in 1879. C16 E window of two arched lights and a hoodmould. Old photographs show a charming whitewashed building, with sash windows. On the tower, a stone clock face of 1879, fixed at five to ten, rather earlier than the eleventh hour, as sometimes found.

Capel Newydd (Independent). 1873, by the *Rev. C. Jones*, according to the foundation stone. Large rendered façade with a giant arch. Gallery on three sides with long panels. Stained-glass lobby window.

LLANYBYDDER 5344

Small Teifi valley market town, the large flat area below the main road given over to long-established monthly horse sales.

St Peter. An unusually large W tower, with battered base and corbelled parapet, missing its battlements. NE stair-tower. The only dateable detail is the small W window, that must be late C15 or early C16. The tower base is vaulted. The rest, nave and chancel with S porch and N vestry, was virtually rebuilt in 1884–5 by *Middleton & Son*. Their first plans were rejected as 'pretentious and unsuitable'. The modified design is just dull, paired lancets and a Dec three-light E window. A tiny N window, obscured by the vestry, may be C14, and a straight joint towards the W end indicates that the nave was lengthened when the tower was built. Inside, C19 open barrel roof to the nave, and panelled chancel roof. Emphatic chancel arch and window arches. – Furnishings. Of 1884–5, including nicely detailed stalls with roll-topped bench ends, and communion rails. – Oak angel lectern, *c.* 1920. – Stained glass. E window by *A. K. Nicholson*, after 1921, Christ with SS Peter & Paul, the faces still tinged with Pre-Raphaelite gloom.

Aberduar Baptist Chapel, ¼ m. E. 1892, by *David Davies* of Llanybydder. Unpainted rendered front with centre arch.

Rhydybont Independent Chapel, 1 m. E. 1911, by *W. Beddoe Rees* of Cardiff. Gothic, rendered, with Forest of Dean dressings. Big Perp main window, through which rise thin diagonal shafts. Not as grand as the architect's Glamorgan chapels, but a good interior with galleries on four sides, fronted in continuous bow-fronted ironwork, to an anthemion pattern.

The older part of the town is below the main road, towards Pont Llanybydder, an elegant three-arch sandstone bridge of the 1830s, divided by piers, the arches with alternate slate and

sandstone voussoirs. Above the bridge, LLOYDS BANK, small, painted brick, of the 1920s. On the l. the large open market space, fronted on the W by a late C19 terrace, and on the E by the remnants of the STATION of 1866, built for the Manchester & Milford Railway. At the far end, a three-storey WOOLLEN MILL, c. 1890. On the r. is the small triangular earlier market area, fronted by a varied row: two larger stuccoed buildings of c. 1870, smaller two-storey buildings beyond, and the NATIONAL WESTMINSTER BANK, of the 1930s, by *Palmer & Holden*. Small, in rock-faced sandstone, modernized Georgian, but the windows spoilt. The moulded doorcase shows the original quality. Opposite, the BLACK LION, mid-C19 stone, three bays, with arched porch, and a larger stuccoed addition of 1880, by *D. Davies* of Llanybydder. Giving shape to the space is the former MARKET HALL, Dolgwm Stores, c. 1840, in grey stone. Hipped, two-storey, three-bay, with sashes above and depressed arches below. The road continues to the church. Returning to the main crossroads, the CROSS HANDS HOTEL is mid C19, two-storey with deep eaves, the detail a little Italianate with arched triple windows. The canted corner however has a Gothic window over the door. The two chapels are on the road E.

THE OLD VICARAGE, 1 m. NE. 1912, by *Herbert North* of Bangor. A characterful house of Arts and Crafts type. Pink roughcast, roofed in small thick slates. A cross-gabled main block stands forward with long small-paned windows in the gables and a Gothic door set in a broader Gothic opening in the side wall. The service wing to the l. has a similar gable, and the roof then sweeps low at the l. end.

GLANTREN FAWR, ½ m. S. Late C17 or early C18, two-storey, three-bay stone house, a rebuilding of a house mentioned as new-built in an ode of the mid C15. Large end chimneys and a rear stair gable.

PENYGAER HILL-FORT, at the S edge of the town, E of the main road. A large Iron Age circular enclosure on a circular hill, partly with double rampart.

WEST WALES SANATORIUM. 2 m. SE, on a hillside. Built in 1905–8 for the treatment of poor consumptives, by *E. V. Collier*. Hipped whitewashed main range of two storeys and canted single storey wings. Originally a cheerful Neo-Georgian with red-tiled roofs and green shutters, now very decayed.

LLANYCRWYS

Isolated church, with a circular POUND in the corner of the churchyard.

ST DAVID. Old walls, probably a single chamber originally, much restored in 1892, by *C. H. Purday*, working for *Ewan Christian*. He added a slightly incongruous W porch, with a timbered gable. The mildly classical bellcote looks early C19. The rood

stair doorway offers no clues for a date, and neither does the small square medieval FONT, on a new pedestal of 1892.

FFALDYBRENIN INDEPENDENT CHAPEL, ¾ m. SW. Rebuilt 1873, by *John Humphrey*. Forceful façade of dressed sandstone, with painted ashlar detail, developed further at Ebenezer Chapel, Llansadwrn, 1874. Above a centre triplet of doors, a giant arch frames two pairs of narrow arched windows, each with a big roundel over, and narrow arched recesses frame the outer similar pairs. Three-sided gallery on iron columns, with pierced cast-iron panels in the gallery front. Pulpit with fretwork and pilasters. The roof is coved and ribbed, the ventilators with pendants.

RHOSYBEDW, ¾ m. WSW. Dated 1871, with the initials of Sir Robert Henry Davies, but Davies probably added dormers to an C18 house of two storeys and three bays. An added large, plain square block of 1911. The converted BARN has a charming inscription of 1826. Farm buildings in the dull red brick made at Rhosybedw brickworks in the later C19.

GELLI, 1 m. WSW. A small Victorian farmstead. The house, of 1865 by *Thomas Jenkins* of Llandeilo, of three bays, with slate-hung added bay windows, backs onto a small-scale FARM COURTYARD.

CARREG HIRFAEN, 3 m. NW, on the county boundary (SN 624 464). Very tall standing stone, some 15-ft (4.5-metres) high. Carved, for reasons unknown, with SDC NOV 5 1874 DIES IRAE.

LLWYNHENDY
Llanelli

Suburb of Llanelli on the road to Loughor.

ST DAVID, Llwynhendy Road. 1882, by *Thomas Arnold* of Llanelli. Stone and yellow brick, with bellcote and tiny canted apse. – STAINED GLASS. E window, 1939. N window, 1978, by *Celtic Studios*. There was a medieval chapel, Capel Berwick nearby, in ruins by 1800.

BEREA INDEPENDENT CHAPEL, Bynea. 1871, remodelled in 1934. Odd plan, the porch on the long E side, N end window to the road of four arched lights and a canted apse at the other end, presumably of 1934, as also the vestry on the roadside.

BRYN INDEPENDENT CHAPEL, Gelli Road. 1856–7. Quite grand stucco front with open pedimental gable, outer pilasters, Palladian centre window and arched side windows. Single storey porch addition, 1914, with recessed centre and two Doric columns. Later C19 railings by *Thomas & Clement* of Llanelli, with their typical Gothic gatepiers, incongruous here.

NAZARETH CALVINISTIC METHODIST CHAPEL, Parc Gitto. Large free Gothic chapel of *c.* 1914, probably by *William Griffiths*. Red brick with dressings of matt grey terracotta. The front, divided by buttresses, has a big five-light traceried window, unconventionally arched with a crocketed finial.

SOAR BAPTIST CHAPEL, Heol Soar. 1868, possibly by the *Rev. Henry Thomas*. Rendered gable front with rustication around three arched windows. Porch of 1921, by *J. H. Morgan*. Inside the gallery front of 1868 has Jacobean-style strapwork, painted wood-grain to the pews and pulpit, the pulpit detail Gothic. Organ recess, 1903, by *William Griffiths*.

TABERNACLE BAPTIST CHAPEL, Llwynhendy Road. 1891. Big and severe Pennant stone gable front with arched windows, long each side, and a pair over two arched doors.

LOUGHOR RAILWAY VIADUCT, 1½ m. SE. The last surviving timber viaduct by *I. K. Brunel*, for the South Wales Railway, built 1845–52. Seventeen pile trestles carry the deck, which has been replaced in steel. Originally there was an opening section.

MILLENNIUM COASTAL PARK. *See* also Llanelli. The coastal park runs through reclaimed industrial land for some 14 m. from the Loughor to Pembrey. A steel suspension BRIDGE carries the national cycle path over the A 484 and railway, with a single A-truss, 2000, by *John Mowlem Engineering*, like the one in Llanelli. Further w, the MILLENNIUM WETLANDS, a doubling in size of the Penclacwydd Wildfowl Reserve. Original octagonal pavilion building of 1991 extended with another pavilion.

LOGIN
Cilymaenllwyd

1623

Village in the Taf valley, the chapel standing prominent on the hillside. Single-arched BRIDGE, 1891, by *Daniel Phillips*, County Surveyor.

CALFARIA BAPTIST CHAPEL. 1877, by *George Morgan*, a small example of Morgan's inventive Romanesque series that began in 1875. Gable front with triple arcade, the broader stilted centre arch framing a wheel window and gabled porch, both in ashlar. Nice detail to the porch, a trilobe head and Romanesque capitals. Traceried long side windows, Florentine type with the top roundel blank. Inside, galleries with iron panels in a quatrefoil pattern, on florid iron columns, and a pulpit platform with scrolled iron in open panels. Behind the pulpit, a broad arch oversails a blind triple arcade on four long columns (a motif used at Bethesda, Haverfordwest).

SS PHILIP & JAMES, Cilymaenllwyd, 1 m. w, on the road to Efailwen. Now a house. 1843, by *J. L. Collard,* altered 1896–7 by *E. V. Collier*. Low-pitched two-bay nave with lancets and short buttresses. The original porch was into the s of the chancel, replaced more conventionally in 1897. The bellcote, rebuilt 1897, has gone.

FFYNNONWEN SCHOOL, ½ m. SW. 1879–80, L-plan Board School, with grey limestone dressings.

MANORDEILO 6726

Part of Llandeilo parish until the mid C20. In the Tywi valley, large farms with late C19 high-door BARNS, as at MAESYMEIBION, GLANRHYDSAESON at Manordeilo, and at CAEMAWR at Cwm Ifor, which has an arched open-sided hay-barn, unusual in the county. The Towy Valley railway passed through, with a gabled house of c. 1860 at GLANRHYD HALT. The main settlements are at Capel Isaac and Penybanc to the W, Rhosmaen and Salem in the centre, Cwm Ifor and Manordeilo to the E.

ST PAUL, Cwm Ifor. Begun 1852–4 as a R.C. church, but completed as an Anglican chapel of ease, with added transepts and bellcote, 1859–60 by *J. Harries* of Llandeilo (the W window of 1904 by *W. V. Gough* of Bristol). Of some character, steep-roofed with lancets. Elaborate late C19 FITTINGS, given by the Richardsons of Glanbrydan Park: marble and alabaster REREDOS and PULPIT, 1888 by *S. W. Williams*, and oak SCREEN c. 1890. – STAINED GLASS. Most by *Mayer* of Munich: the E window and two chancel N windows, 1888; N transept window 1892; nave N lancet 1902; and nave S window possibly of 1904, all very conventional. More interesting, the sombre-coloured Crucifixion in the S transept, c. 1885. Nave S, c. 1885, floral design. Nave N lancet, by *Shrigley & Hunt*, c. 1933, a poor copy of Holman Hunt. W window, 1904, richly coloured.

In the churchyard an elephantine granite-shafted memorial to David Lewis of Stradey, †1872.

ST TEILO, Maesteilo. 5 m. W. 1900–3, by *David Jenkins*, for the Mansels of Maesteilo. An expensive church in a remote location. NW tower with pyramid cap, nave and chancel with bulky gable shoulders, and a large nave E bellcote. Striking, but not pleasant textures and colours: crazed-rubble walls in grey conglomerate, with yellow stone dressings, and purple voussoirs of Sawdde stone. Broad, old-fashioned interior, with Bath stone chancel arch. Little of interest apart from a walnut PULPIT with three carved saints in a rustic Baroque style, brought from Venice.

CAPEL ISAAC (Independent), Capel Isaac. 1846–7. Large lateral façade with arched long windows, outer doors and gallery lights, spoilt by modern glazing. Late C19 interior. It was a very early cause, c. 1650, the present chapel the fourth rebuilding.

CWM IFOR BAPTIST CHAPEL, Cwm Ifor. 1836. Lateral façade with bracket eaves, two long windows and centre door. Tracery and interior of 1864, plain iron columns, three-sided gallery curved at corners, horizontal panels and dividing piers.

HERMON INDEPENDENT CHAPEL, 1½ m. N. Dated 1848 and 1868, plain roughcast gable front with arched windows, and narrower vestry gable to the l. with very long arched recesses. Interior of 1868, gallery front in long panels divided by piers with arched panels. Panelled great seat and balustraded pulpit platform.

SALEM INDEPENDENT CHAPEL, Salem. 1832, enlarged 1862, probably mostly rebuilt then. Quite large, plain roughcast gable front, the arched windows still small-paned. Gallery with stencilled coving, curved corners, grained long and short panels.

CAPEL SILOH, Penybanc 3½ m. W. 1830, lateral front with arched windows and doors. Thick glazing of 1876, by *David Jenkins*, who remodelled the interior. Curved-cornered gallery with pierced cast-iron panels.

MAESTEILO, Capel Isaac. Plain later C19 stone house of some size, with hipped roofs and bay windows, but no formal front.

CAPEL ISAF, Cwm Ifor. Built as a small villa in 1811–13, by *Thomas Bedford* of Llandeilo, for Thomas Lewis of Stradey. It had a nearly windowless N front to the old main road, very close by, and ground-floor pilasters on the E end. But when the road was moved S of the house in the mid C19, the S front, extended by a bay, became the main garden front and the N entrance façade was fenestrated.

GLANBRYDAN, Manordeilo. Mostly demolished. It was of several builds, lastly enlarged in 1885–6 by *S. W. Williams*, for J. C. Richardson of Swansea. One altered wing survives. TOWER HOUSE, the hipped two-storey coach-house and stable behind, has an extraordinary pagoda-like lead-clad lantern with clock stage and cupola, presumably of 1885. Contrasting LODGES: North Lodge, *c.* 1865 is bargeboarded Gothic, while South Lodge, *c.* 1885, is Italianate with hipped roof and arched windows.

MARROS
1¾ m. W of Pendine

The church is isolated on Marros Mountain, a high ridge along the coast, now dominated by the five turbines of the WIND-FARM, 2001.

ST LAWRENCE. Medieval single chamber, with an added C15 low W tower similar to nearby Crunwere, Pembs., with a battered base, stair-turret and battlements, heightened in 1845 (perhaps as a navigation aid). Vaulted tower base and C15 vaulted S porch, with good STOUP. N transept, 1845, by a local man, *William Garratt*, now the vestry. Restored in 1895 by *H. Prothero* of Cheltenham, with simple two-light windows and kingpost roof. – FONT. C12, square on a round pedestal. – FURNISHINGS, of 1895. – STAINED GLASS. Chancel E and SE, by *Jones & Willis*, Crucifixion, Suffer Little Children of 1924. – Nave SE, 1992 by *M. G. Lassen*.

To the E is the ruined two-bay NATIONAL SCHOOL, dated 1819. Prominent cromlech WAR MEMORIAL, two big uprights with a lintel, on a roughly stepped base, the huge blocks said to be megaliths from Morfa Bychan (*see* below). This extraordinary feat was the work of a local mason, *Thomas Harries*.

MORFA BYCHAN BURIAL CHAMBERS, I m. SE, high on Ragwen Point (SN 222 075). Four Neolithic burial chambers aligned almost in a straight line, N–S, covered in bracken. The S chamber is closely ringed by nine uprights. The second, 40 metres N is an oval of seven uprights. The third, another 75 metres N, near the natural Druid's Altar outcrop, is smaller and hard to discern. The fourth, 80 metres N, is partly underground, excavated under a naturally occurring massive slab.

MEIDRIM

2821

Substantial village, bisected by the Dewi Fawr river, the church on the hill to the W. Near the Methodist chapel was a large POOR-HOUSE, commissioned from *John Nash* by James Bowen of Castell Gorfod in 1791 and demolished *c.* 1850. At Danyrhiw, just W of the bridge, an intact small late C19 SMITHY.

ST DAVID. On a possible Iron Age site. Nave and chancel, both remarkably long, C14 to C15. Only one nave N window, tiny transepts and an unusual square battlemented bellcote. Restored in 1860, and then in 1889, the nave by *F. R. Kempson*, the chancel probably by *Ewan Christian*. S porch, 1928. Plastered interior with plastered chancel and transept arches, the S one higher and elliptical. – FONT. Octagonal, retooled. – FURNISHINGS, 1889, by *Kempson*. – Organ by *Vowles*. – STAINED GLASS. E window, 1889, by *Charles Evans*, Last Supper. Chancel S, Presentation, *c.* 1898. – W window by *Hardman*, 1927. – Nave N, by *Celtic Studios*, 1965. – MONUMENTS. Thomas family of Castell Gorfod, *c.* 1765, Baroque with fluted pilasters and cherub heads. Hester Thomas †1735, bolection-moulded. William Thomas †1740, large, of veined marble, with urn, and cartouche below. John Thomas †1752, slate plaque. Mary Gwynne Hughes †1852, draped urn, by *E. J. Physick*.

On the S of the churchyard the red brick CHURCH HALL. Nondescript mid C20, but the Gothic cast-iron windows look early C19 – are they re-set?

LLYS DEWI. Large former vicarage, 1909, by *H. J. P. Thomas* of Haverfordwest.

BETHEL CALVINISTIC METHODIST CHAPEL. An alarming Gothic design, prominently sited, of 1904, by *Arthur Jones* of Carmarthen. Grey limestone with Bath stone. The gable front has a very big Perp window, but is flanked by Italianate pyramid-roofed turrets carried on pairs of thin Gothic Bath stone columns. Confident interior, gallery with long panels of ironwork, and painted grained panels. The ceiling is coved on the long sides, with timber ribs and a plaster rose. – STAINED GLASS. 1904, by *S. Evans* of West Smethwick, Suffer the children, a rare elaboration for a country chapel.

BRYNIWL, I m. NNE. Altered four-bay farmhouse, once dated 1739. Inside, a simple Tudor-arched doorway of timber, and an oak collar-truss roof.

PENRHEOL, 1 m. E. Later C19 Italianate villa of red brick with yellow dressings, unusual in the region. Remnants behind of an elaborate garden with pond, bridge and waterfall.

SARNAU, 3 m. SE. Hipped stuccoed villa of three bays and two storeys, built *c.* 1830, for the Waters banking family. Porch with paired slim Tuscan columns, the lower windows on the garden front in arched recesses, suggestive of *David Morgan* of Carmarthen.

3521

MERTHYR
2 m. SE of Abernant

ST ENFAEL. Isolated, next to a farm, in a roughly circular sloping churchyard. 1868–9, by *R. K. Penson*, in rock-faced stone with plate tracery. Single roofed with tall bellcote, N transept and N porch. Steep arch-braced roof, and curved transept arch, blocked in 1914 by a fanfare of organ pipes. – FONT. Circular with quatrefoils, by Penson. The old octagonal font is in the porch. – FITTINGS. Pews of 1869, pulpit and chancel fittings C20. – MONUMENTS. Arabella Williams †1728, well-lettered marble with curved cornice. Elizabeth Thomas †1775, recessed tablet with shaped head. – In the porch, a C6 INSCRIBED STONE, reading CATVRVS FILI LOVERNAC.

Barn-like SCHOOLROOM, by *Penson*, surely modified in construction.

CANA INDEPENDENT CHAPEL, 1 m. S. 1862, by the *Rev. Thomas Thomas*. Stuccoed temple front, with pediment and pilasters. Corniced door, a tall arched window each side, and wide segmental three-light above. Brightly painted interior, apparently refitted in 1883, but the detail looks of 1862. Gallery on three sides, with long panels and pilasters typical of Thomas. Good panelled pulpit.

DERLLYS COURT, ½ m. SSE. 1814, enlarged 1850. Three plain storeys and bays. The datestone of the previous house of 1660 survives. It was the birthplace in 1698 of Bridget Vaughan 'Madam Bevan', the promoter of Rev. Griffith Jones's Circulating Schools (*see* Llanddowror).

5927

MILO
1 ½ m. S of Golden Grove

The two chapels opposite one another, the new much larger than the old, illustrating the change in chapel design over fifty years.

MILO NEWYDD CONGREGATIONAL CHAPEL. 1904, by *D. Lewis Jones* of Llanelli. Large roughcast gable front with simple stucco detail. Upper arched windows, paired in the centre, like the two doors below. Gallery front with long boarded panels under turned balusters. Similar pulpit. Beamed compartmented ceiling on a cove.

Opposite is the OLD CHAPEL, 1850. Typical lateral front in stucco with two arched centre windows, outer doors and gallery lights. Georgian Gothic glazing. The gallery survives with plain panels, on timber columns; the pews and pulpit have gone.

MYDDFAI

A village street with colourwashed terraces of C19 cottages, below the church in its large rounded churchyard.

ST MICHAEL. A large and rewarding double-nave church, similar to Llanddeusant and churches of nearby Breconshire. The S nave is perhaps earlier, though the detail in both is late C15 to early C16. Both have chancels, the S chancel with a corbel table, unusual in the county. Big S porch with red stone arch, possibly C17. Restored 1874, by *R. K. Penson*, who added the gaunt bellcote, and in 1926 by *C. W. Mercer*. The late C15 or C16 Perp windows, in dark red stone, mostly have flat heads, but the N chancel E window is more ambitious, if crude – three-light, with cusped panel tracery. One S window has three grotesque carved masks on the hoodmould. The S nave has a rood-stair projection, lit by a two-light upper window, that looks post-Reformation, possibly C17, over a C15 pointed stair light, the arrangement similar to Llanfynydd. There are dates for repairs: 1819 on the N wall and 1808 on the arched W window of the N nave, which corresponds also to the arch of the S chancel door. Remarkable interior with C15 plaster-panelled barrel roofs throughout, with moulded timber ribs, the longitudinal ribs missing in the S nave. Simple carved bosses, some replaced with designs by parishioners in the careful restoration, 1991, by *Roger Clive-Powell*. C15 arcade of four bays, double-chamfered arches on octagonal piers, and a single Tudor arch between the chancels with similar responds. Pointed chancel arches: the S one plastered with plain imposts, undateable, while the N one is C15, stone, matching the arcade. – PISCINA with Tudor-arched head in the S chancel. – FONT. Small octagonal C14 bowl in conglomerate stone. – A displaced medieval STOUP in the vestry. – FITTINGS. 1874 by Penson, including pulpit, vestry, screen, altar rail and pews. – WALL PAINTING. Tiny fragments found on the N chancel wall, and to the r. of S chancel arch. Black letter text on S chancel E wall. – Earlier C19 stone COMMANDMENT BOARDS. – HATCHMENT. C19 arms of Holford of Cilgwyn.

MONUMENTS. Chancel E: Erasmus Williams of Llwyny-wormwood †1785, by *T. Paty & Son* of Bristol. Of high quality, a large tablet with garlanded pilasters and a tall fluted urn on a scrolled pedestal. In the N nave, Ann Price †1835, grey and white marble, large urn with gadrooned lid and flowers, by *J. Thomas & Son* of Brecon; Rev. Lewis Williams †1843, with cherub head, by the same. In the NE chapel some well-lettered

C17 and C18 floor slabs: Thomas Rice †1691 and Henry Owen
†1727, referring to his ancestor Bishop Morgan Owen of
Llandaff, †1641, whose monument was broken in the C19;
Magdalen Price †1829, also by *Thomas & Son*. In the vestry,
Elizabeth Jones †1798, slate, with rustic cherub head and crude
but careful lettering; Magdalen Price †1831, marble oval with
Greek cup. In the porch, memorials to two of the famous
'physicians of Myddfai', David Jones †1719 and his son, also
David, †1739.

The former VICARAGE, ¼ m. W, 1862, stone with two-bay garden
front and long rear tailing to a hipped roof.

BETHANIA CALVINISTIC METHODIST CHAPEL. 1857 and
1880. Broad gable over former lateral front with arched
windows and outer doors. Gallery of 1880, with simple pan-
elled front, on iron columns.

SEION INDEPENDENT CHAPEL. 1844. Stuccoed front like a
house, with arched windows on two storeys, and centre arched
door. The panelled gallery is mid C19. The date of 1890 must
refer to the stucco, the pulpit and great seat only.

BWLCHYRHIW INDEPENDENT CHAPEL. 1871. A small chapel
in the remote hills, built as a branch of Seion, with a long-wall
façade, one of the last to that design.

CILGWYN, 1½ m. W. Earlier C18 country house with three-storey
front of seven bays, the pediment stretched across five. Rustic
Georgian, with dentilled cornice and pediment, simple quoins
and window surrounds. The house was enlarged *c.* 1805 for
J. J. Holford with a parallel rear range, and a columned porch.
The rear range ends at the E with a full-height curved bow,
almost identical to one at Llwynybrain, Llandovery. The inte-
rior is much altered. In the rear, an earlier C18 stair with alter-
nate twisted and turned balusters, closed string and tapered
fluted square newel. Immediately behind is a small house with
C18 pedimented gable, perhaps the first house on the site. To
the W, mid-C19 lofted COACH-HOUSE with hipped roof and
lattice windows. On the front lawn, STANDING STONE, known
as St Paul's Marble, moved here from Pentwyn farm in 1825.
The house is low-lying in a narrow valley, the stream dammed
in the early C19 to form a small lake. An ornamental small
BRIDGE has holes through its haunches. Up the hillside
behind, a flight of steps to a terrace which may have been a
bowling green.

LLETY IFANDDU, 1¾ m. WNW. Attractive hipped villa of the
1830s, built for Lewis Lewis and hardly altered. Three bays,
two storeys with pretty trellis porch. Restrained plaster
cornices within. The entrance gates are rescued from
Llwynywormwood.

LLWYNIAR, ¾ m. NW. A substantial three-bay farmhouse, once
the house of a minor estate called Williamsfield. Small Gothic
early C19 LODGE and, behind the house, a square hipped out-
building, with Gothic windows, much enlarged in the late C20.

LLWYNYWORMWOOD, 1 m. N. Stark ruin of a Georgian and
Regency house, the latter part built for George Griffies, who

rose through friendship with the Prince Regent to become Sir George Griffies-Williams Bt. in 1815. There was a park below with sweeping drives, lake and bridge. The hill-side opposite planted with carefully placed clumps of trees. At the HOME FARM, a long whitewashed hipped C18 barn with twelve-bay roof.

DOLGARREG, 2 m. WNW. A tall single-storey house, actually the ground floor of a mid-C19 house burnt down in 1931. Inside, fittings from an old South America clipper from Swansea docks, including stained glass of tobacco growing and landscapes.

BLAENYCWM, Sardis, 2 m. SW. Victorian villa built for T. W. Rogers, who is said himself to have carved the exotic limestone snake that curls into the numbers 1852 on the plinth of the S end wall.

Y PIGWN ROMAN MARCHING CAMP (SN 828 312). On the county border, where the Roman road from Brecon crossed the hills to Llandovery. Low banks outline two superimposed rectangles, indicating that the site was used twice as temporary marching camps, with rapidly dug ramparts, probably around 75 A.D. The second camp was rather smaller. Off to the w (SN 820 310) is a smaller rectangular earthwork, probably Roman, overlooking the road. The largest of these temporary Roman camps is to the s, at Arosfa Garreg, Llanddeusant.

NANTGAREDIG

4922

Llanegwad

NANTGAREDIG CALVINISTIC METHODIST CHAPEL, Nantgaredig, 1¼ m. w. A lateral-fronted chapel of 1817, but the detail of 1893, by *George Morgan & Son*. Triplet each side of the door, four arched windows above with thick timber tracery. Gallery with fluted pilasters between panels, the upper row filled with ironwork. Flat ceiling with big moulded beams running front to back. The first chapel was built in 1760, despite gentry opposition to the building of a 'common hotbed'.

FFYNNON NEWYDD STANDING STONES, ¼ m. s. Just E of the road, a pair of standing stones in a damaged oval enclosure.

PONT LLANDEILO YR YNYS, ½ m. s. Large three-arch bridge over the Tywi, dated 1786, but first built 1779 by *David Edwards*, who had to rebuild after a collapse. Damaged in 1931 and repaired by *T. W. Wishlake*. Old-fashioned for Edwards, narrow and rising with full-height cutwaters.

LLANDEILO YR YNYS, by the bridge. C18 three-bay, three-storey house, re-windowed in the late C19, now sadly lacking its whitewash. Reputedly the site of a C6 chapel founded by St Teilo.

NEWCASTLE EMLYN/CASTELL NEWYDD EMLYN

The town stands at an important crossing of the Teifi. After the Norman invasion it was the chief town of Emlyn, a small lordship ruled from the castle, superbly sited on a narrow spur of rock in an oxbow bend of the river. The modern town is a single street running s from the bridge, turning its back on the spectacular double turn of the Teifi. A drawing of 1797 by Thomas Rowlandson shows the street up from the bridge entirely thatched and mostly single-storey. The part N of the bridge is Adpar, in Ceredigion (q.v.).

HOLY TRINITY, Church Street. A new church of 1841–2 by *J. L. Collard*, replacing the cramped old one by the castle, its present character though due to *W. D. Caröe* in 1924–5. Collard's church was very plain, with thin w tower, thin windows with Y-tracery, and a short chancel. The committee wanted 'a church modelled on Casterton', i.e. the design for a cheap church in Westmorland in the Rev. Carus-Wilson's *Helps to the Building of Churches*, copied the same year at Bistre, Flints. Caröe rebuilt the chancel, lowered the nave walls to make a steeper roof, changed the windows, and thickened the top of the tower with angle piers, a new parapet, and tracery in the bell-lights. The tower is still gawky, but the altered roof-pitch improves the proportion of the rest. Inside, Caröe achieved a great deal with little, creating a characterful aisled church from a bare box. He introduced two rows of tall square stone piers that carry timber braces to the open roof, giving longitudinal emphasis without breaking up the space, and creating narrow passage aisles. The chancel has a broad rounded arch, panelled barrel roof and traceried E window. – Gothic end GALLERY, 1841, white painted, on cast-iron quatrefoil piers. – FITTINGS of 1925 and later: pulpit, altar rails, stalls and big reredos, all in Caröe's late Gothic style. – FONT. 1925. A fine octagonal bowl in Cilgerran stone on a vase stem, with beaten copper ogee cover. – STAINED GLASS. E window, 1924, by *H. Wilkinson*, muted colours, delicate faces. Chancel N, 1958, by *Celtic Studios*, hot and vibrant colours. The tower window has re-set glass of the 1860s, perhaps the former E window by *Cox & Son*. – HATCHMENTS. Two mid-C19 painted hatchments to the Halls of Cilgwyn, Adpar, moved from Paddington church, London.

R.C. CHURCH, Castle Street. 1968, red brick piers with recessed glazed strips between. – STAINED GLASS. Christ figure in the porch, and twelve Stations of the Cross panels, by *Frank Roper*. Simple lines with heavy leading and effective use of streaked glass in a limited palette.

BETHEL CALVINISTIC METHODIST CHAPEL, Church Street. 1869, by *Rev. Thomas Thomas*. Converted to flats in 2000. Stucco with long arched windows and centre triplet, typical of Thomas, but instead of a pediment, a parapet with

scrolls and a vase finial, more theatrical than Thomas' later works.

EBENEZER INDEPENDENT CHAPEL, Ebenezer Street. 1844, altered 1880 by *John Humphrey*. The original chapel, possibly by *C. J. Davies*, was hipped with entry in the short front wall. Humphrey extended it forward with a steep curved roof, stuccoed quarter-round side walls and a pedimented centrepiece in grey limestone. Striking, if heavyweight, with a minimally Romanesque arched window. Inside, the gallery is half-round at the back, with a pierced cast-iron band, and the bulky pulpit has stilted arches to the front flanked by balustrades. The organ, 1925, blocks the main window.

Y GRAIG BAPTIST CHAPEL, Water Street. 1875, possibly by *C. J. Davies & Son*, replacing one by *Davies* of 1846. Handsome pedimented front in stucco with long arched windows, and a big pedimented columned porch. The forecourt has striking cast-iron railings, with stylized Greek anthemion finials on the stone piers. Curved-ended gallery with arched panels. Hardwood pulpit, panelled in a diagonal cross. Some Grecian detail here too, little antefixae at the lower corners of the pulpit, and to the pedimented pulpit-back. In the vestry, a rare C18 portable PULPIT.

MARKET HALL, Market Place. 1892, by *David Jenkins* for Lord Cawdor. Dominant on its triangular site, built as a market with an assembly hall above, and an office wing at right angles. Coarsely mixed detail, in local stone with Bath stone, the main hall block Dutch-gabled with arched windows, and the office wing terminated in a clock turret that answers to no style, but effectively closes the view down Sycamore Street. On a two-storey square block, a steep pyramid roof, more maltings than chateau, rises to a tall timber lantern with arched clock face each side, under a steep ogee dome.

PUBLIC LIBRARY, Church Street. 1870, built as the County Court to the design of *Charles Reeves* of London, who died in 1866, by *George Morgan*. Two hipped parallel blocks, a single-storey office range fronting a double-height courtroom. The four-bay office range has arched windows and carved royal arms over the doorway. The courtroom shows clerestory lights, and has large arched windows to the back. Excellent cut Cilgerran stone, subtly tooled, on a grey limestone plinth.

CASTLE
Castle Street

The first Norman fort in Emlyn, built by Gerald of Windsor 1108, may have been at Cenarth or Cilgerran, Pembs. The lordship was taken by the Lord Rhys from the Fitzgeralds in the mid C12 and was largely in Welsh hands until 1288. A masonry castle was built in the early C13, either by Cynan ap Hywel, installed in the 1220s under the patronage of William Marshal, Earl of Pembroke, or more probably by Maredudd ap Rhys Grug,

in the 1240s, both grandsons of the Lord Rhys. In the revolt of
Rhys ap Maredudd, 1287–8, it was surrendered after threat by a
siege engine, suggesting that it was of some strength. It was
visited by Edward I after the revolt of 1294 and remodelled in
the C14. The royal accounts show that it had an inner and outer
ward, the outer gate of timber, the inner one only fortified with
twin towers in the C14. The inner ward had a hall with two cham-
bers, raised on a cellar, and roofed in shingles, and an adjacent
kitchen, the hall built new in 1312. This suggests that the curtain
walls at least dated from before 1287. The conflicts of Edward
II's reign halted work, and by 1343 the new hall and kitchen were
so derelict as to need complete rebuilding, the walls of the inner
bailey and a 'Wardrobe Tower' needed repair, the twin towers of
the gatehouse begun in 1307 were unfinished and the outer gate
and outer bailey were completely ruined. Repairs were estimated
at the very large sum of £340. The work done in 1347–8 under
Richard Machoun cost only £60 18s. 11d., but included finishing
the gatehouse with two chambers each floor, a new hall with
chamber linked to it by a covered way, and three 'houses', prob-
ably kitchen, brewhouse and bakehouse, all with slate roofs, and
a drawbridge.

It was in royal hands until 1382, then granted to the Burley
family. Attacked by Owain Glyndwr in 1403, it was in ruin until
restored as a secondary residence by Sir Rhys ap Thomas, *c.* 1500,
to whom must be due the present front. A survey in 1532 men-
tions a first-floor hall, a range adjoining the hall of 26 ft by 21 ft
(8 metres by 6.4 metres) with chapel, a kitchen over a basement,
and a tower on the s side 'to view and see the cuntre', a nice con-
trast to the fortress it had been. The castle was refortified
with earthworks in the Civil War, survived a two week siege in
1644 by Parliamentary forces, and was slighted shortly after-
wards.

An unconventional site, a small and narrow rocky triangle high
above a bow of the Teifi, with the gatehouse facing w and a
tiny narrowing INNER WARD behind. What remains is the low
gatehouse added to the w curtain wall in the C14 and the base
of a square sw tower, perhaps the 'Wardrobe Tower' mentioned
in the C14. This TOWER could have been the principal tower
of the C13 Welsh castle, but too little remains to be certain.
Excavation has shown that the hall was in the sw angle, but
little has yet been revealed in the narrow e end of the inner
ward. The GATEHOUSE front is C16, three-bay, with three-
sided towers linked by a broad cambered entrance arch. Each
tower has a large square-headed first-floor window. Within, it
is clear that behind the C16 work the façade is of the C14 gate-
house, there are latrine shafts in the side walls, and under the
N tower a vaulted basement, the C14 prison. The large windows
may have had stone mullion-and-transom fenestration.

The w approach is across the site of the OUTER WARD, with
no surviving structures. The outline of a Civil War pointed
earthwork, or RAVELIN, is clearly visible. Until 1840 the parish

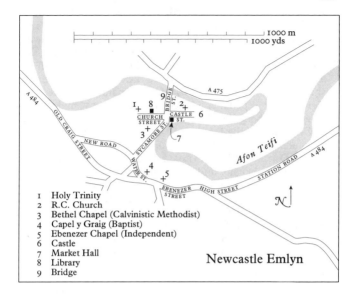

1000 m
1000 yds

1 Holy Trinity
2 R.C. Church
3 Bethel Chapel (Calvinistic Methodist)
4 Capel y Graig (Baptist)
5 Ebenezer Chapel (Independent)
6 Castle
7 Market Hall
8 Library
9 Bridge

Newcastle Emlyn

church stood just outside the castle precinct, at the head of
Castle Street.

NEWCASTLE EMLYN BRIDGE. A large three-arched bridge over
the Teifi, probably mid C18, illustrated in 1773, with full-height
cutwaters, those on the W covered by a C19 widening.

PERAMBULATION

The town has a single long street running s from the bridge to
the Carmarthen road, with just two short spurs, Castle Street
and Church Street, both from the Market Hall. In CASTLE
STREET, on the l., CASTLE HOUSE, later C19, three-bay, with
sandstone voussoirs contrasted with grey Cilgerran stone, and
GER-Y-CASTELL, three-bay mid-C18 house, revealed and
limewashed in an exemplary restoration of 2002–3 by *Jill
Wickenden*. Castle Terrace runs N to the remains of a MILL,
with a rock-cut leat parallel to the Teifi. In the early C20 the
mill made electricity, one of the earliest such schemes in Wales.
Beyond, the R.C. Church, and the Castle promontory. Return-
ing, on s side, No. 6, stuccoed with C19 detail, is C18, with
heavy beams within. No. 5 is a rare survival of a Late Geor-
gian shop, both shop door and house door with attractive
overlights. Nos. 2–4, a low two-storey row, are early C19,
altered, but with a single timber cornice.

From the Market Hall, BRIDGE STREET, down to the river,
was the core of the settlement until the mid C19. On the corner
of Church Street, VICTORIA STORES, mid C19, with inset
curved corner and deep eaves. To the r. the low former BLUE

BELL inn, probably C18, altered, with trellis porch. The BUNCH
OF GRAPES, a tall roughcast two-storey, three-bay front, is mid
C18, illustrated with a thatched roof in the 1797 drawing.
Inside, a fine staircase with pulvinated string and turned balus-
ters, up to the attic, which has scarfed trusses to the main roof
and the big rear wing. Opposite, BANK HOUSE, with two
shallow s gables, is earlier C19 and had character, as the gables
were treated as pediments. BRIDGE PHARMACY, mid C19, has
three sharp bargeboarded gables. The tall, three-storey, four-
bay building to the l. was the National Provincial Bank from
1876 and had a cut Cilgerran stone front, now rendered over.
TEIFI DENE and BRONAFON are earlier C19, with quite dif-
ferent storey heights under a single roof, Bronafon with slim
iron columns to a raised porch. A long two-storey row of the
1840s runs to the bridge, with deep bracketed eaves. On the w
side, a mixed Late Georgian row runs up from the bridge. The
EMLYN ARMS, half-hipped, stuccoed, three storeys and three
bays is a late C19 remodelling. CHURCH STREET runs w from
the Market Hall, with Bethel Chapel, the library, and Holy
Trinity church (qq.v.). Opposite the church, the former
NATIONAL SCHOOL, 1848, probably by *C. J. Davies*, who
extended it in 1856. Stone, minimal Tudor, originally sym-
metrical with low classrooms each side of a gabled teacher's
house, the symmetry upset with additions in 1856.

From the Market Hall, SYCAMORE STREET, the main
street, runs s. On the corner of Church Street, a mid-C19
hipped three-storey block, the curved corner echoing the Vic-
toria Stores opposite. ANGEL HOUSE, a butcher's shop, on the
l., has early C20 tiles inside and out. MAKERS MARK, on the
r., was the Post Office, brown sandstone, three-bay, mid C19.
The PELICAN INN further on is dated 1805, with late C19
stucco detail. Further down, on the l., W. EVANS GEORGE
premises, is mid C19, a three-storey stuccoed house in Late
Georgian style. Next, the NATIONAL WESTMINSTER BANK,
1930, by *Palmer & Holden*, Neo-Georgian, in most un-Geor-
gian rock-faced brown sandstone, and original in the detail.
Tall, three storeys, L-plan, with timber pediment to the street
gable and big moulded eaves cornices. Elongated first-floor
windows with wrought-iron shallow balconies and big arched
lower windows. Further on, two low two-storey early C19 pubs,
the THREE COMPASSES and the former WHITE HART. The
CAWDOR HOTEL, of the 1890s, has a tall five-bay façade with
three gables, defined by strips of red brick. The HSBC BANK,
1910, by *C. R. Peacock* of Swansea, has a Neo-Georgian upper
floor, in stucco and brick, with later ground floor. TIVY HALL,
a chemist's shop, of *c.* 1900, stands out, in hard red brick with
moulded terracotta, and two uneven gables topped with shell
pediments. Opposite, COLLEGE ROW is stuccoed, two-storey
rising to three at the l. end, similar to the block on the corner
of Church Street. The street curves into FOUNTAIN SQUARE,
an irregular space with a large three-storey, three-bay, rubble
stone early C19 house on the r. and Y Graig chapel (q.v.) on

the l. Finally, on the r., the little GRAMMAR SCHOOL, 1867, stuccoed, not looking Victorian at all, with an arched window each side of the door. Evan Roberts was a theology student here in 1904, when he initiated the religious revival of 1904–5 (cf. Blaenannerch, Cd.).

On the main Carmarthen road to the l., Ebenezer Chapel (q.v.), and down the Cynwyl Elfed road, at Aberarad, the DANSCO factory incorporates remnants of the workhouse of 1837. On the Capel Iwan road, the VICARAGE, on r., 1887, by *Middleton, Prothero & Phillot*, a big square hipped house, in Cilgerran stone, with cambered-headed sashes, nearly Georgian, very understated.

TOMEN SEBA, 2m. S, on the Cynwyl Elfed road (SN 325 370). Small well-preserved C12 motte.

BLAEN BOWI WIND-FARM, 3m. S on the Cynwyl Elfed road. Prominent on the Moelfre ridge, three large wind turbines, 2002, each of 1.3MW, the number proposed for increase.

NEWCHURCH/LLANNEWYDD

3724

Parish just N of Carmarthen. The main settlements are at Cwmdwyfran, in the Gwili valley to the E, and Bwlchnewydd on the W.

ST MICHAEL. Oval churchyard, with superb views to the S. The p. 358 chancel is most of the tiny single-chamber church of 1829, by *William Howell*, carpenter which had outside steps to a little gallery. The rest is of 1871, by *John Thomas*, County Surveyor of Caernarfon, who had local connections. Grey stone lancets, an oddly hooded bell canopy. Wide chancel arch and a thin roof. – FONT. Cushion bowl, possibly medieval, retooled. – STAINED GLASS. E window 1871, and nave N, 1874, both by *Charles Gibbs*. – MONUMENT. John Davies †1789. Veined marble tablet.

LLANFIHANGEL CROESFEINI, 1m. SE. Site of the first parish church, demolished in 1847.

BWLCHNEWYDD INDEPENDENT CHAPEL, 1m. NW. 1833, altered 1859. Rendered long front with tall centre arched windows, outer doors and gallery windows. The gallery is probably of 1859, plain square panels. Ceiling in compartments, with heavy beams: surely later.

CWMDWYFRAN CALVINISTIC METHODIST CHAPEL, 1½ m. E. 1861. Simple stuccoed gabled façade. Interior of 1909, by *J. H. Morgan*. Gallery and panelled pulpit, both with bands of small turned balusters, typical of Morgan.

CWMDWYFRAN MILL, 1½ m. ENE. Three-storey corn-mill, now a house, the range to the r. was a smithy. This was an important iron-working site, the forge built in the later C18, by Robert Morgan of the Carmarthen ironworks, and operating until *c.* 1810, with a brief restart in 1821.

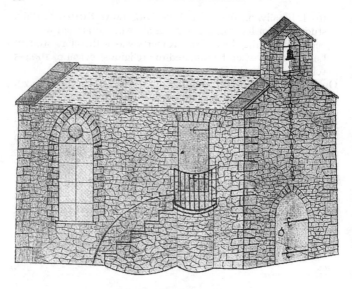

Newchurch, the church.
Drawing, 1829

TRAWSMAWR, ½ m. W. The long, altered farmhouse is an C18
gentry house of John Davies, High Sheriff in 1783. Surprisingly
formal lofted late C18 or early C19 STABLE of five bays with
first floor lunettes, now a house. TRAWSMAWR HALL, nearby,
is a stone and yellow brick gabled villa of 1887, by *George
Morgan*. Three inscribed stones now in the county museum,
one marked SEVERINI FILI SEVERI, another CUNEGN–,
were collected here from around the parish, including from
Llanfihangel Croesfeini.

CWMCASTELL FAWR 1 m. SSE. Heavily altered two-storey earlier
C18 double-pile house, unusually with wide casements in five
bays. The big S end chimney and traces of a possible corbelled
chimney at the N end suggest an older history.

GARN FAWR, ½ m. ESE. A well-preserved MOTTE, with a deep
ditch, the ground falling away steeply on the E side.

PEMBREY/PENBRE

Village above Carmarthen Bay, still distinct from Burry Port,
which grew with C19 industry. In the centre, a triangular space,
RANDALL SQUARE, with a circular animal POUND by the
churchyard.

ST ILLTYD. One of the larger medieval churches, with much to
enjoy thanks to a careful restoration in 1910–11 by *W. D. Caröe*,
and an economical one by *James Wilson* of Bath, 1856–7. A
harsh one proposed by *R. J. Withers* in 1874 thankfully did not

proceed. One of the earliest references for any church in the region records a consecration by Bishop Herwald of Llandaff in 1066. The particularly good tall tower with Irish stepped battlements is C16, added, with a parallel-roofed N aisle, to the N of a low C13 nave. The chancel may be C14 as also the parallel NE chapel, perhaps the chantry mentioned as proposed in 1366. The nave has a W window of 1857 over a blocked W door, another window of 1857 to the l. of the S porch and a big C16 four-light flat-headed window to the r. The big S porch has arch-braced roof trusses, possibly C16, and a sundial of 1775. Within, a shapeless red stone STOUP, possibly re-set. The S door is dated 1717 and identical to one at Kidwelly. The rest of the church has large square-headed windows, probably of 1818, which Caröe filled with oak tracery, a neat solution. Caröe presumably also chose the silver-grey Pembrokeshire slates. The N aisle is aligned with the tower, but not with the NE chapel, showing that it was added with the tower, though re-roofed later, as shown by a steeper roof-crease on the tower.

Luminous interior thanks to an excellent restoration in 2004 that brought back the whitewashed renders, making sculptural the misshapen forms of the various arches. Nave and chancel have arch-braced collar roofs, possibly of 1857. Asymmetrical chancel arch, narrowed probably when the N aisle was added, for a small squint, and with a rood loft opening high up to the r. A N window blocked for the tower shows that the tower is later. The best single feature is the C16 S window whose roll-moulded reveal is beautifully carved, with one shield each side and six in the soffit (arms including Butler, Basset, Beaufort and Plantagenet). The N arcade is carried on a rough octagonal pier. Both aisle and NE chapel have fine oak-panelled roofs of the late C16 or early C17, which is curious in view of the different building dates, and the evidence for the aisle roof being a replacement. Crude plastered arch from aisle to chapel, off-centre, and two-bay plastered arcade between chapel and chancel.

FONT. Red stone octagonal with quatrefoils, late medieval retooled? – PULPIT. 1911. Oak. An odd design with tapered sides, Caröe being quirky. – STALLS. Presumably by Caröe. – RAILS. An C18 balustraded set on three sides of the altar. – ORGAN. 1922, by *Nicholson & Son*, the case a creditable attempt at C18 design. – STAINED GLASS. E window, 1926, by *Horace Wilkinson*, a lovely late Gothic design, with a rare sensitivity. NE chapel E, and nave S by *Celtic Studios*. – Oak ALTAR and REREDOS, 1920s, by *J. S. Adkins*. MEMORIALS. Floor slabs re-set in the NE chapel, including David Vaughan †1579. On the nave S, earlier C19 slate plaques to the Rees family of Cilymaenllwyd. John Rees †1802, draped urn over a sarcophagus, small-scale. Nave W, eroded late C17 plaque to Bennett Richards of 'Swanzey'.

BETHEL CALVINISTIC METHODIST CHAPEL. 1876. Pilastered temple front with arched openings. Interior with much painted grained woodwork of an old-fashioned sort. Pews, balustraded

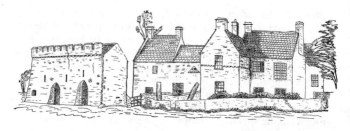

Cwrt.
Drawing, 1898

pulpit platform and gallery front in long panels divided by pilasters with arched panels. Very large plaster ceiling rose.

MEMORIAL HALL, N of the church. Large slightly Arts and Crafts hall with long tiled long roof stretching from a big roughcast gable at one end, to a small half-timbered one the other. The date is 1924, the architect unknown.

CWRT FARM, Heol y Mynydd. Ruins of a substantial medieval to C17 house, facing the sea from the hillside. It was held by the Butler family as early as 1361, passing to the Vaughans in the early C16 and to Lord Ashburnham in 1677. He called it in his diary 'an old stone house, large enough'. The ruins are now impenetrable, but the RCAHMW concluded that the core is probably a medieval tower attached to a first-floor hall reached from an external stair to the N. The hall was re-roofed and re-windowed in the late C16 when a kitchen wing was added. A second, free-standing tower at the W end of the S wing, was possibly also medieval. In front, to the S, is a barn incorporating a thick corbelled and embattled wall of a possible former gatehouse.

KIDWELLY & LLANELLY CANAL. A branch from the C18 Kymer's Canal was made in 1812–16 to Pembrey by *Pinkerton & Allen*, engineers, carried across the marsh on an embankment of some 2½ m. A harbour was opened at Pembrey in 1819, but when that proved ineffective a dock was made further E, at Burry Port (q.v.), in 1832. In 1867–9 a railway was laid alongside, requiring the raising of most of the canal BRIDGES. The canal survives remarkably intact. One bridge is visible just S of the village square, and another W of the village, both of 1834, raised later. STANLEY BRIDGE, 1834, behind the Ship Aground inn, is much wider, more of a tunnel. It carried a tram-road from John Stanley's collieries to the harbour over the canal, and survives unaltered. The HARBOUR, now silted up, is a large rectangular basin.

PEMBREY AIRFIELD, 2 m. NW. Disused Second World War airfield, site of the No. 1 Air Gunners School 1941–5. The concrete DOME was for training, a camera-gun being used to aim at silhouettes projected onto the plastered dome. Along the W side of the railway line E of the airfield, rows of CONCRETE BLOCKS, part of the Command Stop Line of 1940–1 supposed

to run from Cardigan Bay to Carmarthen Bay to impede an
invasion force landed in sw Wales (cf. Penboyr).
ROYAL ORDNANCE FACTORY, Pembrey Burrows. The Pembrey
Country Park is on the site of a major explosives factory, sited
here as sand dunes limit the effects of accidental explosion.
The Nobel Explosive Co. used the site prior to 1914, when it
was rebuilt by the Royal Ordnance to manufacture TNT.
Closed in the 1920s, it was reopened and largely rebuilt in the
late 1930s, becoming the largest production site in the country
by 1942, employing three thousand. It finally closed in 1965.
The administration buildings are now an industrial estate. The
dangerous nitration buildings were scattered through the
dunes linked by rail tracks.

PENBOYR

2636

The church stands alone on the ridge between the Bargod and
Esgair valleys, some 1½ m. s of Drefach Felindre.

ST LLAWDDOG. Rebuilt 1809 at the expense of Archdeacon
Thomas Beynon, rector here. Of his time are the high church-
yard WALL and attractive arched LYCHGATE. The church was
derelict again by 1887, restored without sensitivity by *David
Jenkins*, and roughcast in 1928. Nave and chancel, with Bath
stone windows, and an odd spired bellcote of 1887. w door of
1809. – Two FONTS. Black marble font of 1811, and a damaged
C12 square bowl with incised lines.
TOMEN LLAWDDOG, opposite the church. C12 motte, the bailey
to the NE all but gone.
PROMONTORY FORT, ½ m. s (SN 363 356). Large Iron Age
promontory fort above the Bargod, with triple bank to the s.
ROUND BARROWS. The high ground is dotted with Bronze Age
barrows: CRUG Y DDALFA (SN 354 349), NANT SAIS
TUMULUS (SN 344 339), CRUG Y GORLLWYN (SN 351 342),
CRUG PERFA (SN 355 341).
RHOS LLANGELER STOP LINE, 1 m. s (SN 359 343). A surreal
line of 5-ft (1.5-metre) cubes of concrete run N down the hill-
side from the road. They were placed here as part of the
Command Stop Line of 1940–1 intended to run from New
Quay to Burry Port, to isolate sw Wales in the event of inva-
sion. Some more blocks line the railway near Pembrey (q.v.)
but the rest seems never to have been built.
See also Drefach Felindre and Llangeler.

PENCADER

4536

A sizeable village, expanded after the railway came in 1867, part
of the ill-fated Manchester to Milford line, giving rise to woollen
mills that thrived until the 1940s. It is an ancient settlement: the
prophecy of the survival of the Welsh language told to Henry I
in 1163 was told by an 'old man of Pencader'. Along the main

road, late C19 and C20 houses, some in terraces. Marble soldier
WAR MEMORIAL, 1922, one of many by *Evan Jones*. On a lane
W, down to the river, Yr Hen Gapel (*see* below). Over the bridge
was a large later C19 stone and brick woollen mill, demolished in
2004. Uphill is the church (q.v.), the former BOARD SCHOOL,
1876, and the castle motte (q.v.).

ST MARY. 1880–1, by *David Davies*, on the site of a medieval
 chapel of ease to Llanfihangel ar Arth, ruinous in 1710.
 Minimal lancet Gothic. – FONT. C12, circular bowl with shaft
 all in one piece, from Llanfihangel ar Arth, but reputedly from
 Pencader originally.
TABERNACLE INDEPENDENT CHAPEL. 1909–10, by *Arthur
 Jones* of Carmarthen. Stucco, with Perp Gothic windows, Ital-
 ianate coupled angle pilasters, and a gable that combines a bit
 of both, a similar mix to his chapel at Meidrim.
YR HEN GAPEL. Former Independent chapel, now a commu-
 nity hall. 1827. An attractive lateral façade, with sandstone
 dressings and half-hipped roof. Georgian Gothic glazing to
 arched windows and fanlights. It was an early cause, founded
 by the Rev. Stephen Hughes in the mid C17. Archdeacon
 Tenison wrote in 1710 'the meeting-house is seated, the pulpit
 made neat, the floor even and the gallery decent. In these
 particulars it reproaches the churches in Wales, which lie gen-
 erally in a very nasty condition.'
NEW INN CALVINISTIC METHODIST CHAPEL, New Inn, 1½ m.
 E. 1832. Long-wall front with half-hipped roof and bracketed
 eaves. Stuccoed and refitted in 1893.
ALLTWALIS INDEPENDENT CHAPEL, Alltwalis, 2 m. S. 1897, by
 D. L. Jones of Llanelli. Stuccoed façade enlivened by the clus-
 tered roundels in the window heads, echoed over the door.
 Good interior with long cast-iron inserts in the gallery front,
 prettily painted.
CASTELL PENCADER, below the church, by the school. A large
 C12 motte, the school built on the small bailey. It may be the
 Dinweilir fort mentioned in the 1163 campaign against the
 Lord Rhys.
AVONDALE WOOLLEN FACTORY, ¾ m. ENE. 1870. Three-storey
 woollen mill and house, in stone and yellow brick.
BLAENBLODAU, New Inn. Derelict small early C19 country
 house. Two-storey, three-bay front with outer pilasters and a
 fat centre bow, elliptical rather than curved, obscured by a C20
 addition. Two slimmer bows on the garden front, with triple
 sashes.

5644 PENCARREG

Upper Teifi valley village, the church in a rounded churchyard on
a rocky knoll above the main road.

ST PATRICK. Medieval church of nave, chancel, W porch and
 massive W bellcote, a high rectangle with two long openings

under a low saddleback roof. Few dateable features: the nave may be the earliest, with added chancel, stone-vaulted porch and a N transept, later demolished. Restored 1878–9 by *R. J. Withers*, who raised the roofs, blocked a S door of 1833, and replaced the windows. Inside, the W wall shows the earlier roof-line. Plain plastered chancel arch with low door to the rood stair to the r. Open roofs and simple pine fittings by Withers, the ALTAR RAILS a lesson in minimal detailing. – Painted zinc COMMANDMENT BOARDS, in Welsh. – FONT. An exceptional C12 rough rounded bowl with carved mask heads at the four corners, cf. Cenarth, and Silian, Cd. – Eroded STOUP on W wall. – STAINED GLASS. E window, 1922 by *Heaton, Butler & Bayne*, still Late Victorian. – MEMORIALS. Chancel N plaque to Lady Sarah de Crespigny †1825, by *D. Mainwaring*. Her husband built Rhosduon Tower in the parish *c.* 1820, a castellated toy fort, long demolished.

In the churchyard, iron-railed tomb-enclosures, in one the tomb of the bard Daniel Evans (Daniel Ddu o Ceredigion), †1846.

ST JAMES, Cwmann. Plain mission church of 1889–90, by *David Davies* of Llanybydder.

BETHEL BAPTIST CHAPEL, Parcyrhos. 1860, by *Evan Richards*, carpenter. Stone gable front with small-paned long windows. The interior, without gallery, has nicely banked painted grained box pews.

CAER PENCARREG, 2 m. S of Cwmamman (SN 589 442). Iron Age circular hilltop settlement.

LLWYNDRISSI, 2 m. SE. Below the earlier C19 farmhouse, the previous house has been recreated from a ruin, 2004–5, by *Steve Medland*. This is a serious attempt at recreating a traditional building. Limewashed and thatched in water-reed with the regional circular thatched chimney. Inside, the chimney is carried on a very large wattle-and-daub hood and the roof has an oak collar-truss scarfed on to wall-posts. The under-floor is of lime concrete on a float of bottles.

PENDINE/PENTYWYN 2308

Coastal village on Carmarthen Bay, the older part up the hill around the church. The lower village is later C19 and once attractive, in a bowl of hills behind the long beach, but the houses all altered, and the beach-front filled with caravans and nondescript buildings. A proposal to build a railway and develop a seaside resort in 1882 to plans by *E. J. Tarver* came to nothing. Well-constructed grey limestone SEA-WALL with curved base.

ST MARGARET OF ANTIOCH. A medieval church with a Victorian character from the restoration in 1869 by *John Prichard*. W tower, nave, chancel and S porch. Thin and sheer tower with narrow louvred bell-lights, possibly as late as the late C16. The saddleback roof is Prichard's, apparently based

on evidence. It has a High Victorian sharpness, no eaves, just
the acute triangle and a stone gutter each side. To the nave he
added two uncomfortably large s windows, each side of the
porch, with trefoil heads and bi-colour jambs in yellow and
purple stone. The porch is older, possibly medieval, but heavily
restored, the inner doorway by Prichard, with incised inscrip-
tion. He rebuilt a small c15 projection on the sw corner of the
chancel, keeping the tiny arched light. There was another
opposite (removed for the organ chamber in 1891), similar to
the low chancel recesses found in Pembrokeshire (Herbrand-
ston and Johnston). Late c14 e window, in red stone, two-light
with ogee tracery. Interior overwhelmingly Prichard's: arch-
braced roofs, slightly richer in the chancel, chancel arch with
incised inscription and low ashlar SCREEN WALLS linked to
the pulpit steps. The chancel has a fine Victorian ascent: each
step faced in black fossiliferous marble, with encaustic tiles
increasingly rich towards the E. – FONT. c14 seven-sided, scal-
loped, on a round shaft. – AUMBRY. To the l. of the altar,
medieval, pointed. – c14 STOUP with square basin, by the s
door. – Drum PULPIT, 1869, with flush grey bands inlaid with
quatrefoils, and ballflower cornice. – PEWS, 1869, with pegged
joints. – Wrought-iron ALTAR RAILS, 1869. – STAINED GLASS.
e window, 1869, Christ stilling the waters. A good piece, in
strong colours. Nave sw window, 1960; se, after 1928; and n,
after 1950. In the vestry, Nativity, 1998, by *Janet Hardy*.

In the CHURCHYARD, w of the path, a Gothic cast-iron
headstone, to Bridget Hodge †1888, one of a type made by
David & Co. of Saundersfoot.

MUSEUM OF SPEED, 1m. s. 1997, by *Andrew Nicholas* of
Carmarthenshire County Council. A neatly streamlined museum
to the speed trials held on Pendine Sands. It displays 'Babs',
the car buried after Parry Thomas was killed in 1927 attempt-
ing the land speed record, and exhumed in 1979.

BIG HOUSE, n of the church. Three bays and three storeys, late
c18 to early c19, like the farmhouses of the Westmead estate
in Eglwys Cymun parish, the windows altered, but with a
massive external chimney at the w end that could be c17.

GREAT HOUSE, on the road s. A long whitewashed house set in a
high-walled garden, mid to later c17. Two storeys and four bays
with an off-centre gabled storeyed porch. The house had cross-
mullion windows in 1832, but has sash windows now. The rear
wing has a big chimney-breast, and there is a detached OUTSIDE
KITCHEN to the NW. The front courtyard has late c17 or early
c18 entrance piers with ball finials, very showy if crude.

TREMOILET NATIONAL SCHOOL. w of the village. 1875, by
Archibald Ritchie. Very Gothic with traceried windows, and
some red brick in the gables. On the site of Tremoilet, a gentry
house recorded from the c15.

GREEN BRIDGE INN, w of the school. Dated 1875 on the iron
original pub sign, a rare example. Grey limestone, four bays,
with an off-centre porch gable. It was built, and perhaps
designed by *Keary* of Bridgnorth.

GILMAN POINT FORT, 1 m. S. Iron Age promontory fort high above the sea. A massive bank and ditch on the weak N side. Outside is a circular settlement enclosure.

LLANMILO, 1 m. ENE. An unexpectedly large white house over-looking Carmarthen Bay. Although now of later C19 character, the core is of 1720, for the Edwardes family. Tall, three storeys with parapet, the ground- and first-floor windows of large and equal height, and of seven bays, the centre three advanced. The windows have curved heads of early C18 type. Only Aberglas-ney, Llangathen, remains to compare in the county. The C19 work was for Morgan Jones, of the family enriched from the sale of the Skerries lighthouse (*see* Cilwendeg, Pembs. and Penylan, Llandygwydd, Cd.). He had 11,031 acres (4,468 hectares) in 1873. The family added two four-bay, two-storey wings, the l. one first, the r. one before 1900, when both were given broad shallow bay windows. Terraced GARDENS were made *c.* 1908, much of which remain. The house was taken over for military use in 1941, the family moving to Highgrove, Glos. The interior has been entirely reconstructed.

WESTMEAD, 2 m. ENE. Demolished in 1942, but ruinous from the mid C19. A large U-plan late C17 house, built for Sir Sackville Crowe Bt †1683, whose arms were over the door. *John Nash* contracted for repairs here in 1787, one of his first jobs after arriving in Wales. The estate was of 7,280 acres (2,948 hectares) in 1821, but the house was abandoned as 'the window-tax equalled the rent'.

BROOK, 2½ m. NE. An attractive C19 farm group, on the site of a C16 house of the Perrots, the house above a yard flanked by whitewashed buildings. Behind this, the OLD SCHOOL, 1862, built as a church and school, enlarged 1876, probably by *Ritchie*. One classroom had a screened apse, for worship. Cottage-like teacher's house.

PENYGROES

2½ m. SW of Llandybie

Main-road industrial settlement, once centred on coal-mining. Bricks were also made here by the Emlyn Brick Co.

PENYGROES INDEPENDENT CHAPEL. 1882, practically rebuilt in 1914. Rendered, a wide three-light window and a hooded canopy over paired doors. Expensive interior with a curved ribbed plaster ceiling. The gallery has Ionic pilasters separating long boarded panels below delicate ironwork. Ionic pilasters also in the pulpit. Great seat with a timber trellis-like balustrade. The lobby has a barrel ceiling, with arches to the gallery stairs.

JERUSALEM CALVINISTIC METHODIST CHAPEL, Norton Road. 1905, by *William Wilkins*, rebuilding a chapel of 1879, by *J. W. Jones*. Red sandstone with grey limestone, simple front

with tall arched outer windows. Pilastered gallery front, on leafy iron columns. Pedimented pulpit-back. The ceiling coved on the long sides.

PONTARGOTHI
Llanegwad

Settlement at the Cothi crossing, where Leland mentions a 'great bridge' in the 1530s. The present BRIDGE is probably late C18, three broad low arches with full-height cutwaters, widened in 1825, and repaired in 1854 by *Penson*, presumably the date of the parapets.

HOLY TRINITY, ½ m. N, on the bank of the Cothi. A church without parallel in Wales for its interior which combines painted decoration and stained glass in a single scheme, yet hardly known as never published. The architect was *Benjamin Bucknall*, disciple and translator of Viollet-le-Duc, whom Bucknall first visited in 1861. The church was begun in 1865, for H. J. Bath of Alltyferin, Llanegwad, but delayed by Bath's early death and not dedicated until 1878, as his memorial, by which time Bucknall had left Britain for Algiers. It seems likely that the bulk of the work was completed by 1870, including the painted decoration by Bucknall's friend, *Alfred Stansell* of Taunton, and the stained glass by *Clayton & Bell*. The church is externally simple, in local stone with Bath dressings, the design influenced by Viollet-le-Duc in its styleless combination of forms: round arches, Gothic timber spirelet and modern bargeboards.

Nothing outside hints at the richness of the interior, with painted decoration to the walls and roofs, and glowing stained glass in every window. Years of oil lamps have dulled the colours, but restoration is proposed (2006). Bucknall's architecture is big boned and striking, in an Early French manner stripped to the essentials to emphasize line: two boarded barrel roofs, larger and smaller versions of the same, focus the eye on the rich colours of the E window. The nave is spanned by a great moulded and painted tie-beam with kingpost. The chancel is framed by a pointed arch on massive corbels moulded in one plane only, and the E window has a similar
94 bold simplicity: a big sexfoil rose over three broad lancets. All the surfaces are painted. The roofs are sparsely stencilled in the nave, more intensely in the chancel, increasing in richness over the sanctuary. The walls have Neomedieval masonry patterning in red ochre above the band of WALL PAINTINGS, and stencil patterns outline the main arches, particularly on the chancel arch. The painted scenes are monochrome, each in a Gothic frame within the continuous strip. Compared with the Clayton & Bell scheme at Garton-on-the-Wolds, Yorkshire, of 1865, Stansell's drawing style is more static, and the architec-

tural framing more insistent. If there is a narrative scheme in the decoration that culminates in the E window, it is not so clear as at Garton. On the W wall: New Testament scenes including the Raising of Lazarus and Suffer the children. On the N wall, from the W, are God's words to Adam; Abraham and Isaac; Moses and Job; the righteous entering the Kingdom and the poor widow. On the S wall from the E are the prodigal son, washing of feet, St Mary Magdalene. Flanking the chancel arch are the wise and foolish virgins. In the chancel, SS Peter & Paul just inside the arch, and scenes from the life of Christ, from the Annunciation to the Betrayal. The scenes here are slightly more coloured, with detail picked out in gold, and there is painted drapery in the dado.

STAINED GLASS. Outstanding E window, the Crucifixion, Resurrection, and Ascension, with Christ in majesty above in the sexfoil. Chancel side window of the Trinity. In the nave, Prophets on the S, Evangelists on the N; the W window has Christ's promise of Eternal Life, and Faith, Hope, and Charity, with kneeling figures of the Bath family, one presenting a model of the church. – Painted Bath stone REREDOS with alabaster Alpha and Omega panels flanking a taller cross. – Oak choir STALLS, pine nave PEWS. – Scrolled iron ALTAR RAILS. – Brass CANDELABRA. Later additions are the alabaster PULPIT, with arcading on green veined marble shafts, the FONT, 1900, and the brass eagle LECTERN, 1904.

The plain LYCHGATE may also be by *Bucknall*.

SILOAM INDEPENDENT CHAPEL. 1848, renovated 1902. But for the arched upper windows, just like a polite three-bay farmhouse. Three-sided gallery, upper panels of open ironwork. Imposing Doric pedimented pulpit-back.

PLAS ALLTYFERIN, 1 m. NE. C18, three bays and storeys, lower two-bay wing to the r. Dado in the dining room with fielded panels, ceiling with simple moulded plaster cornice. Rescued from near-dereliction in the late C20. The house faces an Iron Age PROMONTORY FORT across the lawn, into which was built a C12 castle. The promontory was defended from the N by a curved ditch, and the castle MOTTE, with narrow ditch and counterscarp, was added in the NE corner, the bailey N boundary on the original line. In the later C19 the motte had a thatched summerhouse on top. Victorian Alltyferin, for which the church was built, was across the Cothi (*see* Llanegwad).

PONTYWELI *see* LLANFIHANGEL AR ARTH

PONTYATES/PONTIETS
Llangyndeyrn

Former coal-mining settlement in the Gwendraeth Fawr valley, developed in the late C19. There were opencast mines just S, and at Carway to SW. Cynheidre to E remains open. Iron forges at Pontyates and Ponthenri to NE, were of early date, the latter of the 1630s. Limestone quarries in the hills to NW.

ST MARY. 1911, by *William Griffiths* of Llanelli. Nave with W porch and bellcote, and chancel with gabled S vestry. Utilitarian, in brown-grey Llanelli stone with ashlar dressings. – STAINED GLASS. Two windows by *Celtic Studios*, 1953 and 1963.

NAZARETH INDEPENDENT CHAPEL, Nazareth Road. A large hipped chapel of 1837, remodelled in 1875. Stuccoed lateral front of two long centre windows, doors each side, and outer gallery lights, all arched. The detail all of the 1870s, as is the galleried interior.

MEINCIAU BAPTIST CHAPEL, Meinciau. 1½ m. N. 1885–6, by *George Morgan*. Unpainted stuccoed front with three arches on pilasters, the middle one uncomfortably stilted to keep the capitals even.

DANYBANC, ½ m. SE. Farmhouse in two parts: the older dated 1647 on the door, two-room plan with large chimney, the rest early C19, three-bay, with cast-iron fanlight. Earlier C19 barn with a round gable vent.

GLYN ABBEY, 1½ m. W. Country house of several periods, just remaining, but all the detail lost when it fell derelict in the mid-C20. A plain three-bay early C18 house with a top storey of *c.* 1790, when the 'Abbey' name was added as a romantic fiction. In the 1850s an addition with full-height canted bay was made to the r., and the whole cloaked in Italianate stucco, since removed. Further additions in 1871 included a modest private chapel, whose brick Gothic windows remain.

FOUR ROADS LIMEKILNS, 2 m. WNW, W of Four Roads. A row of four large mid-C19 industrial limekilns with sheer grey limestone fronts and deep arched kiln entrances.

HOREB *see* Furnace.

PONTYBEREM

The largest of the coal-mining settlements of the Gwendraeth Fawr valley. The mine site, to the W, has been landscaped. The centre is largely late C19 to early C20, with the church and memorial institute opposite each other.

ST JOHN THE BAPTIST. 1893–4, by *William Griffiths*. Nave and chancel only, lancet style, with an earlier church hall across the W end. Simple interior with open roofs and chancel arch on corbels. – STAINED GLASS. E window by *Celtic Studios*, 1955. Nave N window, by *John Petts*, 1979, Suffer the children, scrolled text in a sea of childrens' faces, in Petts's favoured

purple and brown. Two N windows by *Gareth Jones*, 1991 and 1992, semi-abstract swirling designs.

CAPEL EVAN, ½ m. SW. Hilltop site of a medieval chapel of ease to Llanelli, now with a crude but endearing Gothic church of 1834, just a square W tower and short nave. It may incorporate something of the church of 1721, used by Methodists *c.* 1790–1830. The tower has outsize pointed openings, matching the nave windows, sadly re-glazed in plastic. Simple fittings, mostly of 1834: curved boarded ceiling, painted-grained pews, simple baluster rails and panelled pulpit.

CAERSALEM INDEPENDENT CHAPEL. 1884. A large three-bay front in brown stone with grey limestone quoined pilasters, the inner two carried through the pediment. Double arched doorways with granite shafts and rock-faced arches, and a triplet above. The vestry, to the l., is a minor version of the façade. The interior is galleried on four sides, with pierced iron panels. The organ, pulpit and great seat all of 1911.

SOAR CALVINISTIC METHODIST CHAPEL. 1904, by the *Rev. Cunllo Griffiths* of Pontyberem. Gable front with a giant arch breaking into a pedimental gable.

MEMORIAL INSTITUTE, 1926, by *R. S. Griffiths & Partners* of Tonypandy, like a small town hall, the centrepiece in imitation stone with balcony framed by paired pilasters. The auditorium has a curved roof, and Art Deco curved gallery front.

COALBROOK, ½ m. E. Demolished *c.* 1960, a considerable loss. It was a small but important house dated 1670, T plan, with a tall gabled porch bay and massive panelled chimneys. The interior had exceptionally rich plasterwork, probably by the same hand as at Newton House, Dinefwr, and elsewhere (*see* Introduction). The parlour had remarkable crude Composite columns flanking the fireplace, a rich guilloche frieze and ceiling with cartouches in ornamental panels and flower scroll on the beams. The dining-room ceiling was deeper-panelled with wreaths and rich frieze. The old-fashioned but impressive oak stair had tapering carved balusters, square-section with medallions on all four faces (one section in the county museum).

PUMSAINT *see* CYNWYL GAEO

PWLL
Llanelli

Ribbon village just W of Llanelli.

BETHLEHEM BAPTIST CHAPEL. 1874. Handsome sandstone two-storey front, with arched windows. Galleried interior, and a large hardwood panelled pulpit with Ionic pilasters, of

c. 1900. Iron balustrades to platform and steps. Outside, railings by *Baker* of Newport.

CILYMAENLLWYD, above the village, overlooking the bay. Now a residential home for the elderly. The longest façade in the county, but too bland to be memorable. The five left bays are the original C18 three-storey house, remodelled in 1850–1, with a small centre gable. Extended in 1913 to eleven bays by repeating the facade on the far side of a wide gabled centre with porte-cochère. This was for Sir Stafford and Lady Howard (*née* Stepney of Llanelli), by *Thomas Jones*, the Stepney agent. Neo-Georgian sashes (now plastic) and fashionable louvred French shutters to all the windows. The two-storey pavilion to the l., with pyramid roof and clock-turret seems to pre-date the enlargement. Inside, between entrance and stair halls, are squat engaged columns with oversize capitals. In the garden, CROSS-INSCRIBED STONE, C7 to C9, found on the site.

STRADEY LEVEL BRIDGE (SN 4871 0118). A small cast-iron bridge over former railway marked 'Waddle 1845 Lanmore', i.e. made at the *Llanmor foundry*, Llanelli.

The coastline has been landscaped as part of the Millennium Coast project (*see* Llanelli) 1995–2002. The fly-ash waste from the former power station at Burry Port has been used to create the LAND BRIDGE over the railway and the curving terraced EARTH-FORM, 2000, on the headland to the w, by *Richard Harris*, an effective landmark from all around the bay.

See also Furnace and Stradey Castle.

RHANDIRMWYN

Village in the upper Tywi valley, remote and barely settled before one of the most profitable lead mines in s Wales was developed by the Cawdor estate in the later C18. The mine site is some distance to the NE, but waste can be seen from levels to the SW, near the river, and on the hill above. The ROYAL OAK inn is mid C19, altered. PANNAU STREET, on the hill above, is a mid-C19 stone terrace of eight workers' houses, the end four larger than the middle ones. Just s of the inn, a small circular animal POUND. Down the lane to the church, NANTYMWYN, later C19 in character, but in the early C19 Lord Cawdor's house, then used by the mine manager.

ST BARNABAS. 1878, by *J. L. Pearson*, for Lord Cawdor. Cruciform with a w bellcote, in harsh crazed rubble stone with Bath stone lancets, little to suggest this distinguished architect. Varied roof-lines, on the N a little stone turret over a link between vestry and chancel. Bare interior, with some shafting at the E window. – FONT. A fine piece, ten-sided on a decagonal base with ringed angle shafts. – Also a BAPTISTERY for total immersion.

SALEM CALVINISTIC METHODIST CHAPEL. ½ m. NW. Now a house. 1829, enlarged in 1852, the original string course now cut by the windows. Two long centre windows and outer gallery

Nantymwyn, lead mine.
Drawing by 'Warwick' Smith, 1792 (National Library of Wales)

lights, with Georgian Gothic glazing. The five-sided gallery
with simple iron columns and panelled front looks of 1852.

TY'RYSGOL, at N end of the village. 1860. Former school with
single-storey schoolroom and a gabled teacher's house. Small-
paned glazing of 1894 apparently replacing latticed lights.

NANTYMWYN LEAD MINE, ½ m. NE (SN 787 447). The most
evocative mine site in the county, one of the richest metal
mines in S Wales. Mining may have begun in the earlier C17,
but the richest yields were in the years 1775–97, when Lord
Cawdor made over £86,000 profit and employed a maximum
of four hundred workers. An illustration by 'Warwick' Smith
in 1792 shows a dressing-floor with impressive canal-like
watercourses. Lead from here was carried to smelters in
Carmarthen and later Llanelli. The original workings are
in the valley of the Nantybai stream, over a ridge from the
village, but the lowest level, Deep Boat, emerges below the
village. This level was driven some 800 yds (730 metres) from
1785–98 to connect with the older main working. Yields
declined in the early C19, and the mine was leased from c. 1825–
1836 until closure in 1900 by the Williams family of Redruth,
Cornwall. In 1900 it was estimated that there were some 23 m.
of shafts and levels. Sporadic mining continued after 1900, but
the major new investment was in 1930, when the Sulphide Cor-
poration built a plant to exploit the waste heaps for zinc con-
centrates, but this closed in 1932.

On the still grassless site are huge quantities of waste. Con-
crete foundations remain of the 1930 plant, and at the upper
corner, an ENGINE HOUSE and CHIMNEY probably of the
1880s, over one of the shafts, the engine house with arched
windows and a big wheel-pit inside. 104

NANTYBAI MILL, 1 m. NW. Earlier C19 mill with house in line, the machinery surviving as also the 16-ft (4.9-metre) wheel, by *Thomas Bright* of Carmarthen.

ST CLEARS/SANCLER

A town of two halves, divided by the deep cutting of the modern A40. The older part, S of the road, is a single long street, High Street, running down to the River Taf. The C19 centre lines the old Carmarthen road, N of the modern one. The settlement began in the late C11 with a Norman fort guarding the highest navigable point of the Taf, followed by the priory church and a small settlement between the Taf and the Cynin. Traces of ditches on the W were found in 1989. The lordship of St Clears was a minor one, and the castle may never have been rebuilt in stone like the other Marcher castles. It was served by a riverside quay that remained in use until 1925.

ST MARY MAGDALENE, Lower St Clears. Set back, down a walled path from the High Street. Founded *c.* 1100, and granted in the mid C12 to the Cluniac priory of St Martin-des-Champs, Paris, an unusual mother house, to which it was linked until Henry V dissolved the alien priories in 1414. The priory was always poor, having only one monk in the late C12, but the chancel arch is the most significant piece of Norman church architecture in the county. No trace has been found of priory buildings. The nave must be C12, but with no early external detail, and the chancel perhaps of *c.* 1300, altered in the C15. The big battlemented and vaulted W tower is C16, with renewed Perp W window and a carved mask. The nave walls have been thickened to correct severe distortion, perhaps after 1680 when the roof fell. There is one early C17 chancel S window. The nave was restored by *R. K. Penson*, 1853–5, and the chancel by *J. Middleton*, 1883–4, his windows based on a C15 one found walled up.

Inside, the later C12 chancel arch is not delicate, but crude and robust, the head elliptical. Two orders of thick shafts, the outer with basket-like capitals articulated with vertical cable mouldings, and little scallops under the imposts. The inner capitals have similar cabling, which winds around bold corner volutes. No bases visible, due to the raising of the floor level. Marks of a door to the rood-loft stair in the S vestry. – Large round FONT, possibly C12 retooled. – Early C19 PEWS, with shaped ends, some also with doors. – ORGAN GALLERY on plain iron columns, 1909. – Carved wooden REREDOS with three steeply gabled bays, 1898, made by *T. Thomason* of Birmingham. – STAINED GLASS. E window, Crucifixion, by *Mayer & Co.*, 1901. Two chancel N windows and one each side of the nave by *Charles Powell*, 1926–9. – MONUMENTS. Many small C18 tablets, the most elaborate is John Rich †1717, limestone. Sage Powell †1720, well-lettered. Richard Chapman

†1747, limestone. Mary Chapman †1780, tall pedimented tablet with thin pilasters, by *Maliphant* of Kidwelly. Catherine Howell †1784, pilasters and urn. Thomas Howell Rees †1785, white and coloured marble, with weeping woman, by *W. Paty* of Bristol. Timber LYCHGATE of 1911, by *G. Hammer & Co.*, London.

CAPEL MAIR (Independent), High Street. 1862, by *Rev. Thomas Thomas*. An early example of his giant-arched design, with pilasters. The segmental-arched middle window sits uncomfortably with round-arched outer ones. Three-sided gallery with long panels, box pews still, and a broad serpentine-fronted balustraded pulpit platform. Boarded ceiling with plaster rose. Big organ, by *Lloyd & Dudgeon* of Nottingham, the case with simple Greek detail.

SION BAPTIST CHAPEL, Tenby Road, Upper St Clears. 1848, altered 1927, by *J. H. Morgan*. Square chapel with a pyramid roof on bracketed eaves, and a square lantern. Detail and porch of 1927, arched windows above squared ones. Interior of 1927, the gallery with open cross motifs above the panels. Pedimented pulpit-back.

TRINITY CALVINISTIC METHODIST CHAPEL, Station Road, Upper St Clears. 1872, by *G. Morgan*, altered 1924 by *J. H. Morgan*. Rendered façade divided by plain piers, with iron traceried Gothic windows.

BETHLEHEM INDEPENDENT CHAPEL, Pwll-trap, 1m. NW. 1833, remodelled extravagantly in 1909, by *D. E. Thomas & Son*, of Haverfordwest. Large and hipped, the front in Edwardian Beaux-Arts style, typical channelled pilasters with labels framing the outer bays. High parapet inscribed with an impressive list of rebuildings. Interior of 1909, with rich woodwork. Galleried on four sides, the fourth dropped in front of the organ. Panelled gallery front with a band of pierced cast-iron panels.

BANC Y BEILI, Lower St Clears. Prominent and well-preserved earth MOTTE, of a castle founded by the River Taf in the late C11. There is scant history. It was held by a William fitz Hait in the mid C12, was taken by the Lord Rhys in 1189, recaptured in 1195, lost again in 1215, and held by William Marshal II of Pembroke by 1230. No stonework, though in the late C17 Edward Lhuyd recorded that 'stone, lime, mortar and ashes have been dug up on ye top of ye tump'. The ditch has been infilled. There was a rectangular bailey to the S.

PERAMBULATION

The older settlement lines the HIGH STREET, running S to the Taf bridge. At the top, on the l., GARDDE, much altered, but a date of 1697 on a central three-storey gabled bay indicates a storeyed porch. GOTHIC VILLA on r. is early C19, hipped, with pretty pointed windows on two floors. Next, the former NATIONAL SCHOOL, 1875, single storey, in squared stone, with coloured brick windows. After Capel Mair, THE KIEFFE

and KIEFFE HOUSE, an early C19 stuccoed pair. Further down, on the r., opposite the lychgate, the TOWN HALL, converted in 1848 from a warehouse used for the river trade. Plain stone, two storeys, three bays, with wide sash windows above wide brick arches, the upper room reached by exterior steps. Then WHITE HOUSE, C18, three bays and two-and-a-half storeys, altered. Banknotes were forged here, for which William Baynes was hanged in 1818. GREEN PARK, an attractive stuccoed earlier to mid-C19 three-bay house has simple Tudor detail and a timber porch. Little else apart from the castle on the l., until the BRIDGE, 1827–8 by *William Morgan*, single-arched, with circular spandrel holes. The Taf was navigable up to this point, and the small QUAY survives to the l.

N of the A 40, the OLD BOARD SCHOOL, 1874, by *G. Morgan* on the l. and the remnant of the MARKET, 1851, on the r. before the crossing with the old road. To the w is Sion Chapel. To the NE, on the river bank, is ISLAND HOUSE, two-storey, white-washed, dated 1798 with the name of *Job Brigstocke*, builder, on one end. However the delicate curved staircase looks earlier C19. To the E, two small BRIDGES over the Cynin have decorative ironwork by *David Petersen*, sculptor, 1995, to the theme of the Twrch Trwyth, the boar of the *Mabinogion*. By the E bridge, red granite Celtic Cross WAR MEMORIAL, with mosaic late C20 eagle, and a finely lettered memorial slab, 1964, to Group-Captain J. I. Jones. Just E, the CRAFTS CENTRE, 1999, reusing a large early C20 agricultural co-operative building, with stone gable front and giant brick arches. The interior is top-lit through a galleried upper floor.

ST ISHMAELS

No village at all. The church itself clings to the hillside above Carmarthen Bay, the sea having taken away the medieval settlement of Hawton below. A stray bomb in 1940 destroyed the fine six-bay C18 vicarage, the best in the county, and left scars on the church.

ST ISHMAEL. A delightful jumble of medieval fabric. Nave, chancel, N aisle, S transept with small squint and S tower, over the porch. Earliest are the nave and chancel, the chancel arch evidently removed. The transept is possibly C14, the N aisle C15, extended later to form a NE chapel. Finally, the low saddle-backed tower, added unconventionally, to the S of the nave, due to the slope to the w. The tower was lowered at an unknown date. It has a shallow vault, and steps up to the S door. Harshly restored 1859–60 by *R. K. Penson*, with plate-traceried windows. Four-bay arcade of plain plastered arches. Heavy arch-braced roofs of 1859–60. – FONT. Square scalloped bowl, C12 or C13. Retooled. – FURNISHINGS, by *Penson*, plain, including the screens to the chancel and N chapel. Odd Bath stone BENCHING in the chancel E end, incorporating a piece

of headstone dated 1710. Fireplace of 1860 in the transept. – STAINED GLASS. E window, 1860, the Ascension. Colourful and lively, especially the whirlwind figure of Christ. N aisle NE, 1870, by *Hardman*, the Good Samaritan. N aisle NW, 1864, by *Charles Gibbs Sen.*, Good Shepherd and Suffer the Children. – MONUMENTS. Catherine Mansell †1631, large and fashionable, in Bath stone, with paired Ionic columns and a big heraldic cartouche above the cornice. Mary Ann Humphreys †1809, by *Daniel Mainwaring*. Damaged by the bomb that destroyed the vicarage.

TANYLAN, 1 m. SE. A large model farm built for the Cawdor estate in 1862, by *J. W. Poundley* of Newtown. Boxy three-bay hipped stone house, with extensive farm buildings 'on the Scotch plan' to the E. They are grouped around a long cow-house with steep hipped roof and ridge ventilator. Poundley designed a similar farm on Cawdor's Stackpole estate, Pembs., and probably also the one at Cenarth (q.v.).

See also Ferryside and Llansaint.

SARON

6013

2 m. W of Ammanford

SARON BAPTIST CHAPEL. 1913, by *W. Beddoe Rees*, the leading chapel architect of the day. Sandstone with bold Baroque ashlar detail. Door hood on big side brackets which return above the cornice as scrolls. Above, a large lunette divided by column shafts, with a triple keystone. Inside, the gallery has Rees's favourite bow-fronted pierced-iron balustrade, on columns with big moulded caps. Ceiling coved on the long sides. The previous chapel is now the SCHOOLROOM. 1865, with two storeys of arched windows. Altered 1894 by *David Jenkins*.

STRADEY CASTLE

4902

1 m. NW of Llanelli

Large Neo-Tudor country house, 1847–55, by *Edward Haycock* for David Lewis, whose family had inherited the mineral-rich estate from the Mansels in 1808. The previous house, further down the slope, was large, of nine bays and three storeys. The new house was raised on a terrace, for the sea views. Sandstone ashlar, the N entrance front with projecting centre gable and lower side gables. Porch of 1874 with octagonal corner turrets. The S garden front has two-storey bay windows under gables, each side of a four-bay centre. This relatively sober and com-modious house was grandly altered in the 1870s, to little conve-nience (apart from a water tank) but much picturesque splendour for C. W. Mansel Lewis. The bulk of the work is of 1874–5, but the remodelling of the hall and staircase may be slightly earlier. *J. C. Buckler*, was consulted, but at eighty-one felt too old,

and recommended his son, *C. A. Buckler*, though no reference to who was employed has been found. The staircase does not seem to be included in the bills for 1874–5, which include the massive new tower, the porch, the lantern over the stairs, and refitting the dining room and library. The tower dramatically overwhelms the original symmetry: buttressed and crenellated with a corbelled octagonal corner turret. Mansel Lewis was a distinguished amateur painter, friend and patron of Herkomer; the link block to the tower contained his studio, over a billiard room, but the rooms in the tower were never finished.

Inside, the entrance hall has a ribbed timber ceiling with pendants, probably of 1847, and a massive hooded fireplace of 1874. The entrance hall opens into the stair hall, which rises spectac-
91 ularly to an ornate glazed rectangular lantern in a hammerbeam roof. The oak imperial stair (made by *Rattee & Kett* of Cambridge) begins as a broad single flight, with lions on the newels, the landing carried on a timber arcade on the line of Haycock's spine corridor, and then returns in two flights to the second floor, the detail derived from Joseph Nash's engravings of old English mansions. On the garden front, the original three rooms open into each other with pedimented doorcases in line, the last smaller to enhance the effect of distance. Gilded ceilings with Rococo plasterwork to the two drawing rooms, and rich Baroque marble fireplaces, by *Boucneau* of London. The library has a ribbed ceiling of 1874, Jacobean bookcases, echoed in the pelmets, and a Baroque chimneypiece. The dining room, also of 1874, has a baronial character, panelled dado, turretted Gothic overmantel and ribbed ceiling. Also of 1874 the billiard room and Neo-Jacobean stair in the tower.

TALIARIS

6528

Small parish in the hills N of Llandeilo. No village, the church on the main road and the mansion and former park, now forested, to the w.

HOLY TRINITY. Rebuilt in 1892 by *David Jenkins*, retaining little of the previous church of 1829. Cruciform with W porch and bellcote. Local stone with red tiled roofs, and red sandstone late Gothic windows. – STAINED GLASS. E window, 1939 by *Powell*. – MEMORIALS. Anne, Lady Seymour †1804, a fine
54 white marble sarcophagus by *J. Nollekens*, his only work in the region. Elegant curved surfaces and fluted tapered pilasters. David Gwynne †1721, good Baroque cartouche. Plaques to Lord Robert Seymour †1831 and members of the Peel family all of Plas Taliaris.

WAR MEMORIAL, on the roadside S of the church. 1923. A cairn of rubble with a red granite cross, commissioned by the Peel family.

PLAS TALIARIS. The Bath stone S front, set high on its hillside looks like a house of the Bristol region transplanted to Wales.

It is a remodelling and recasing of a C17 house (once with a gatehouse, and with nine hearths in 1670), creating a regular cubic Early Georgian house of three storeys and five bays, probably done shortly after Richard Gwynne married the wealthy Ann Rudd in 1722–3. The design and stonework of the façade is consonant with the work of Bristol or Somerset mason-architects, tall and square with a slightly projected broader centre, rusticated ground floor, modillion cornice, parapet and gadrooned urns. The upper floors are defined by quoins to the centre and channelled outer piers. The ground floor has an early C19 ashlar Roman Doric porch, and the windows have masonry joints suggesting alteration, either narrowing or removal of surrounds. The upper windows have keystones and rather flat architraves, with alternating pediments on the first floor. The centre window on each floor is set back to the plane of the others, showing that the Bath stone is just a refacing, the first-floor window in a pedimented Ionic surround. The E front also of five bays is plainer, with ashlar for the channelled corner piers, bands, cornice and parapet. C19 Roman Doric porch. Altered and varied rear with one large C17 external stack and a few stone roofing slates.

Inside, hall panelling and a typical Bath area fireplace of the earlier C18. However in the SW room, a very fine panelled plaster ceiling akin to work of the 1670s at Newton House, Derwydd, Coalbrook (dem.) and Edwinsford (dem.). The beams have rich floral and vine scroll on the undersides and complex running mouldings. The square panels have thick octagonal wreaths or bordered shaped plaques. In the plaques, cruder floral and heraldic decoration referring to the Gwynne-Rudd marriage appears to have been squeezed in, and the cornice moulding introduced with the earlier C18 panelling does not match the plaster of the beams. It is strange that the sophisticated refacing should not be reflected in new plaster-work. Over the doors, C18 painted classical landscapes, and a round-backed recess on the front wall with apparently original deep blue paint. The SE room is an early C19 combination of two, with C18 fielded panelling behind the shutters. The staircase rises impressively to the attic. The crude detail is surely late C17, with shaped rail, thick column-on-vase balusters, and heavy newels ornamented with long arched panels and pairs of flat-topped ogee finials. The SW first-floor room has similar panelling to the room below. In the roof C17 trusses over the W range, C18 over the S. In one attic room are some eroding Italian landscape scenes, said to have been painted by a First World War refugee.

There was a plain five-bay earlier C19 two-storey W wing with parapet, demolished in the mid C20. In the former W courtyard, the octagonal stone surround of a C18 COCKPIT, over 4-ft (1.2-metres) high with a blocked low opening for the birds. It was later a game-larder, but the C19 superstructure has been removed. Behind the E lawn is the remnant of a large early C18 lofted STABLE, burnt in the 1960s. It had a steep hipped roof.

A number of early C19 estate houses survive, relating to the ownership of Lord Robert Seymour, here from 1787 to 1831, noted as an improving landlord. They are generally stuccoed with hipped roofs and Gothic blank arches above the windows, and include TALIARIS LODGE and CEFN CILWG, ½ m. SW; WHITE SQUARE ½ m. N of the church; and TY'R BONT.

GARLANDS, ½ m. N. 1829. The former vicarage, of a type with no centre door, particular, it seems, to parsonages in West Wales. Pyramid roof, three bays, but only two ground floor windows and a Roman Doric porch on the windowless end wall.

MAERDY, ¼ m. S. Much modernized C17 house with a massive E end external chimney. Inside, a very heavy fireplace beam, beamed ceilings with later C17 scribed joists.

RHYDYGWYDD, 1 m. SW of Plas Taliaris. Earlier C18 house with tin roof, formerly thatched. Three-room plan with massive centre chimney and winding stair. Heavy beams.

MAES Y CASTELL, ½ m. W of Plas Taliaris. Iron Age hill-fort, defended by double banks on the N. Entrances to E and W.

6433

TALLEY/TALYLLYCHAU

Small and little-spoilt village, at the foot of wooded slopes, dominated by the ruined tower of Talley Abbey. The hill to the W, Mynydd Cynros, is pockmarked with pits that may be the remnant of medieval lead mining. There was a C19 LEAD MINE, equipped c. 1880, at Penygarreg, ½ m. NW. To the N, the two large Talley Lakes are separated by TALLEY MOUND, a Norman motte-and-bailey site.

ST MICHAEL. Immediately N of the abbey ruins. Services were held in the choir of the abbey until 1773, when a new church was built.* This had a broad nave only, and was called by Malkin in 1807 'a little portable church'. Alterations included a re-roofing in 1840 by the local builder *Thomas Pritchard*, works in 1863, Gothic W end detail of 1876, and a small chancel of 1892. The paired W doors provide a clue to the chapel-like interior plan, and must be original, though the pointed heads are of 1876, as also the triple window above and bellcote. Inside, two aisles divide three ranks of oak BOX PEWS with heavy fielded panels, a remarkable survival. Those on the N were for the Williams family of Edwinsford and their retainers, the family pew in the NE corner. There was a W gallery. – Polygonal panelled Late Georgian PULPIT. – Late C19 octagonal FONT. – MONUMENT. Sir Nicholas Williams †1745, with fluted Corinthian pilasters and cartouche above.

To the S, a cottage-like SCHOOLROOM of 1803.

* An early C19 view of the abbey ruins shows a double-roofed building with chancel and tower, for which there is no other evidence.

TALLEY ABBEY

Founded in 1184–9 by the Lord Rhys for White Canons, called Premonstratensians from their first abbey at Prémontré. The order was initially forceful, establishing thirty-seven British houses, but momentum ceased with the fall of the chief patron, Ranulf de Glanville, justiciar to Henry II, in 1189. Talley was one of the last, the only one in Wales, founded from the Abbey of St Jean at Amiens. Rhys had patronized the Cistercians at Strata Florida and Whitland, but may have been influenced by de Glanville here. Cistercian opposition and the Lord Rhys's death may have curtailed an exceedingly ambitious first design for a church some 240-ft (73-metres) long, larger than the cathedral at St Davids or any other church of the order in Britain. The evidence is of drastic retrenchment: the nave was shortened by four bays, or 70-ft (21.3-metres), even though the footings were in place and the best surviving pier of the crossing tower indicates sudden economy, the rough rubble of the arches contrasting with moulded shafts. The abbey retained an allegiance to the Deheubarth princes, and after the conquest of 1277 was taken by Edward I and granted to Welbeck Abbey, Notts., an English house of the same order. Talley seems to have suffered thereafter from both poverty and misrule, being twice taken into royal hands by petition of the abbot in 1381 and 1430. Little is recorded of its last years, not even of the end in 1536. The choir and presbytery were used as the parish church, then a smaller church was created within the shell. This lasted until 1773, when the present church was built, and the abbey left as a quarry for local builders, a major collapse occurring in 1845. The architect and archaeologist S.W. Williams of Rhayader carried out some excavations in 1892–4. In 1933 the site passed to the care of the state and the ruins were cleared and consolidated in 1933–8. The site continues under the care of Cadw.

Enough survives to reconstruct the plan of the abbey church, similar to Strata Florida in the square E end, and the layout of the presbytery and transepts – all from Cistercian models. As at Strata Florida, building began at the E, with presbytery, transepts and crossing, but despite its ambitious scale, Talley lacked the architectural detail of Strata Florida. Foundations of the nave, including the arcade piers, were laid out, but shortly after 1193 work ceased, and when resumed in the early C13 over half of the planned nave had to be abandoned. Of the abandoned four W bays, the footings of plain rubble piers survive, as well as the S jamb of the W door. The footings of a thick wall between the first S pier and the S wall is probably not to be associated with W towers, as it is not bonded into the adjoining masonry. No traces of a N wall. The present nave of four bays was created by building a cross wall, halfway along its length with a plain and narrow W door, and abandoning the planned N aisle, building blocking walls between the piers. Most of the piers are plain and square, but one to the SE has round corner shafts, and stands on a chamfered plinth. Of the

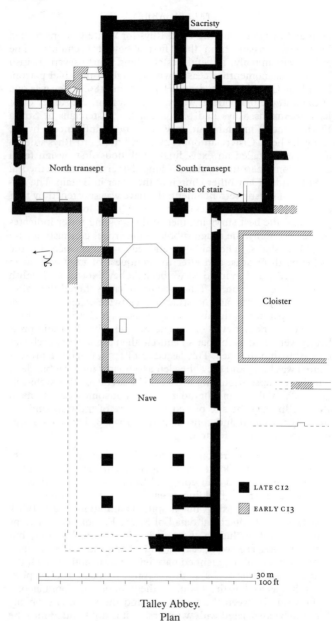

Talley Abbey.
Plan

21 crossing tower, the E and N arches remain, the total height
rising to about 85 ft (26 metres). The NE pier has moulded
angle shafts, but rough arches above, perhaps indicating the
change of fortune. Footings only of the presbytery which,
according to Williams, had an E triplet of lancets. S doorway

into a small ante-room, a chamber to its E probably the sacristry. Both transepts had three E chapels, with pointed barrel vaults: traces of one on the N can be seen against the presbytery wall, this chapel later extended E. In both transepts, the altar bases of the chapels survive; the dividing walls between the chapels were pierced probably in the early C13. In the corner of the S transept, a stone plinth, no doubt of the night stair. Only low walls survive of the cloister, which appears not to have been of great significance. There are slight traces of an E range but, despite excavation in 1903, very little has been found on the W. The S side is under farm buildings.

ESGAIRNANT CALVINISTIC METHODIST CHAPEL, 1 m. SW. 1828. Rendered lateral façade with paired central windows, outer doors and gallery lights. Refitted 1899, probably by *David Jenkins*, with panelled gallery on iron columns and plaster pulpit-back with Corinthian pilasters.

TALLEY HOUSE, at the S end of the village. Late C18, three storeys and bays, with slightly projecting, early C19 wings, of two storeys, but to the same eaves height. A Doric porch has been removed, and the windows modernized. Simple, early C19 detail inside.

Y PLAS, by the Abbey. A cheerful hipped two-storey house of c. 1832, the Gothic windows acknowledging the abbey. Stripped of the original stucco or roughcast.

KING'S COURT, near the church. An unspoilt whitewashed farmhouse, with offset three-bay façade, and a two-bay lofted byre to the r. Surprisingly much of the fabric is medieval, remodelled probably in the C17, the date of the steep roof. The S end parlour has a simple hooded fireplace and a pointed door to the former stair. The other end has a large inserted chimney between the house and byre.

EDWINSFORD ARMS, ½ m. E. A handsome estate inn of the early C19, hipped and stuccoed, the lower windows set in elliptical-headed recesses.

RHYDARWEN, 2 m. S. Three-bay farmhouse, dated 1777, for Thomas Davies. Steep roof, and end chimneys, the r. one large and projecting. Later sashes. The cow-house to the r. reuses four pairs of crucks, presumably from an earlier house.

DANYCAPEL, 3 m. SW. Three-bay whitewashed farmhouse, dated 1774. Offset façade, with larger kitchen chimney to the l., a well-preserved example of a local type.

LLWYNCELYN, 1½ m. ESE. A downhill sited long-house, now a farm-building, whitewashed with low upper floor and scarfed crucks in the roof. Significant as giving a date for both scarfed crucks and such long houses, as it is dated 1739, over the original entry from the byre passage. Later centre door.

MAESCASTELL, 2¾ m. SW. Three-bay upland farmhouse, with downslope byre. Tiny attic windows under a steep corrugated-iron roof, over thatch. The original entry, from the cross-passage at the top of the byre, was blocked when the central door was inserted.

EDWINSFORD, 2½ m. NNW. Ruined, and disastrously so, given its history and architectural interest. Beautifully sited on the banks of the Cothi, it was the seat of the Williams family, who claimed descent from Selyf, prince of Dyfed. Sold in 1970, derelict since the 1950s. The building history is complicated. The square block to the s of the entrance front is the earliest, of *c.* 1635. The central range is late C17, built, or rebuilt, probably for Sir Rice Williams, High Sheriff in 1680. Behind, in the angle of the two, a dining room and service block were added in 1842, for Sir James Hamlyn Williams, probably by *Edward Haycock*. Finally, in 1862, a tall block was added to the N end, close-up to the river, and the central range refronted.

The s range, two storeys and three bays, under a big splayed hipped stone-tiled roof, with central square shafted chimney was one of the early examples of such Renaissance planning in Wales.* The rooms were arranged around the chimney, and were panelled in large fielded panels. Small dormers and eaves replace two full dormer gables, shown in the Sandby engraving of 1776.

The long late C17 range, set back, is very ruined, originally five bays, but given a new front in 1862 providing corridors and a broad, parapeted porch. Much of this later work has fallen away to reveal the older fabric. There were two main rooms on each floor and a central stair. On the ground floor there was a fine plaster ceiling, in four panels each with an oval and surrounding cherubs (a similar ceiling at Coalbrook, Pontyberem, also gone, was dated 1670). The open-well stair with heavy twisted balusters and squared newels is happily now at Llwynybrain, Llandovery. There was C17 plasterwork upstairs also.

To the r., the tall and narrow drawing-room block of 1862, three-storey with hipped roof and steeply gabled dormer: vaguely French Renaissance in style. To the rear, the shell of the two-storey dining-room block of 1842, plain and hipped, with service rooms to s.

Some 650 ft (200 metres) NE, a fine BRIDGE, with single elliptical arch of impressive span, dated 1783, by *David Edwards*.

On the opposite side of the river is the HOME FARM. The farmhouse and former cow-house form a mellow stone-tiled L-plan group. The four-bay farmhouse is of 1822, while the cow-house is probably early C18, five bays, the remains of a longer range shown on the 1776 engraving. Massive collar-trusses scarfed onto wall-posts. At the head of the short driveway, the STABLES, 1802: formal s front with two-storey, three-bay central block, and flanking single-storey wings returning around a large courtyard. The central entrance arch

* Peter Smith notes just four such houses in Wales, the others being Cemais Bychan, Cemais, Montgom.; Tymawr, Llansilin, Denbs., and Trimley Hall, Llanfynydd, Flints., all to almost the same dimensions, as if from the same plan.

Edwinsford.
Engraving, after Paul Sandby, 1776

has been glazed in. Large early C19 WALLED GARDEN to the
N. Immediately s of the farmhouse, the charming DAIRY, with
bellcote, the bell dated 1743. Two storeys, four bays, the rear
wing with dairy outshut. The windows are largely of 1822, but
a C18 mullion-and-transom window survives in the rear wing.

w of the Home Farm, along the track, TY PEGGI, later C19
cottage with latticed iron casements. Finally, w again, to an
early to mid-C18 DOVECOTE, square in plan, with pyramidal
stone-tiled roof.

At the head of the drive, the LODGE, 1865, vaguely Italianate,
and a small pyramid-roofed house, modelled perhaps on the
earliest part of the mansion, the central dormer like one for-
merly over the front door.

GLANYRAFONDDU GANOL, 1½ m. SE. Substantial, early C19
symmetrical farmhouse, and slightly lower service range to the
l., with large lateral chimney. To the SW, near the road, is the
previous house, early to mid C18, with tiny three-bay house and
lower three-bay byre. The blocked door between demarcates
the original cross-passage. It was an important Methodist
meeting place from as early as 1735.

GELLICEFNYRHOS, 1 m. SE. Lofted upland farmhouse, largely
C17, four bays, with downslope byre, the latter rebuilt 1915.
Undulating corrugated-iron roof over thatch. End chimneys,
thicker to the l., where the front wall curves, denoting the stair
within. Cross-passage door between house and byre still in use,
the latter converted to domestic use. According to the Royal
Commission, a cruck-framed hall house was remodelled
c. 1600, with inserted main chimney and floor, and new
scarfed-cruck roof. Three-room plan with service room
between hall and parlour, divided by Georgian plank
partitions.

TRELECH

The long parish of Trelech a'r Betws is bounded by the Cynin and Cywyn valleys and cut by the Dewi Fawr. The church is near the hamlet of Penybont, some 3 m. SSE of Trelech village, centred on the chapel.

ST TEILO. In an ancient round churchyard. A minimal building of 1833–4, by *David Morgan*. It is much smaller than its double-naved medieval predecessor, in contrast to the fortunes of the Nonconformists at Trelech. Single chamber, with W porch, the windows and vestry of 1903, by *David Jenkins* who refitted the interior. Simple SCREEN and boarded roofs. – FONT. Medieval square bowl with chamfered corners. – STAINED GLASS. E window, 1910. – MONUMENTS. William Davies †1788, who established a charity school at Penybont. Painted wood, early C19 by *Job Brigstocke*, with reeded columns and a charming interior view of the schoolroom, a rare visual record. Major General Trafford †1837, plain. Edward Davids †1821, sarcophagus type. Edward Trafford †1888, brass. William Thyrkel Trafford †1912, Art Nouveau beaten metal.

CAPEL BETWS, 2 m. WNW. Ruins of a medieval chapel of ease, in disrepair by 1684, abandoned by 1710. Part of the chancel arch visible above the undergrowth. There was a nave, chancel, and a later N aisle, the arcade of two bays with an octagonal pier. Squint passage on the N side.

Y GRAIG INDEPENDENT CHAPEL, Trelech. The cause, established *c.* 1670, was one of the pioneer congregations of the county, founding numerous other chapels and repeatedly outgrowing its own. The first chapel, of 1703, was rebuilt larger three times, *c.* 1760, 1791, and finally 1827. Strikingly broad stone front of six bays, with large hipped roof on bracketed eaves. Two tall arched centre windows, doors (in added sentry-box porches) with gallery lights above, and then, most unusually, an outer window each side to light pews under the gallery. The windows have been spoilt. The survival of outside stone stairs to the gallery is also unusual. Spacious interior with panelled gallery on three sides, and box pews. The very large pulpit is later C19, with a balustraded serpentine front and sweeping side stairs.

PENYBONT INDEPENDENT CHAPEL, Penybont. 1856. Simple gabled front with an arched window each side of the door. Box pews, and a gallery front in long panels with marginal mouldings. Later small pulpit.

TY HEN CALVINISTIC METHODIST CHAPEL, 1¼ m. SSW. 1860. Small, with just a door in the gable front. The rear gallery is swept out to quadrants each side in quite a theatrical manner. Box pews.

FFYNNONBEDR INDEPENDENT CHAPEL, 4 m. SSE. 1851. Long-wall front of four bays. Opposite, is the HOLY WELL, Ffynnonbedr, the masonry comparatively recent.

PENYBONT, below the church. Hamlet around the single-arched BRIDGE of 1776, over the Dewi Fawr. On the E side, the former

SCHOOL, *c.* 1900, stone and yellow brick. Y SIOP is a colour-washed early C19 cottage, three-bay, with a tiny chimney window. Extended with a shop and a stable.

PLASPARKE, S of Capel Betws. Dated 1744, with the initials of Rev. John Bowen. Modernized, of three bays, the façade offset for a massive inglenook fireplace.

PANTHOWELL, 1¼ m. N of Gelliwen. Nothing remains of the house of Sir James Williams, knighted in Flanders by Philip II of Spain for bringing the news of Queen Mary's pregnancy. An outbuilding, dated 1765, has an eroded New Testament Latin maxim, 'Fides aequalis ex fructibus cognoscitur'. Further downhill, scant ruins of a mid-C19 Tudor-style house built for Major-General Trafford.

PLASYPARCIAU, 2½ m. NE of Meidrim. Modernized early C18 house of five bays and two storeys, with staircase in a rear wing. Inside, hallway with some panelling, a consoled cornice, and a fanlight.

TRIMSARAN
2½ m. SE of Kidwelly

Large former colliery village, with a brickworks from *c.* 1900. The most ornate terrace, 1909, was built to display the products of the Trimsaran Brick Co. Three chapels. TABERNACLE CALVINISTIC METHODIST CHAPEL, in the centre, 1874, altered 1932. Stuccoed, the façade divided by piers, with oddly small Gothic windows. NODDFA BAPTIST CHAPEL, 300 metres S, smaller, in red and blue brick, the façade similarly divided, with a metal-traceried rose. Both chapels look like Trinity Chapel, St Clears, which is by *G. Morgan.* SARDIS INDEPENDENT CHAPEL, on the Kidwelly road, is of 1874, Gothic again, in brown stone and yellow, with central triplet. Plas Trimsaran, late C17 house of the Mansel baronets described by John Wesley in 1774 as having 'a few large handsome rooms', has long vanished.

TRAMWAY BRIDGE, Pwll y llygod, 1 m. N. An early tramway bridge over the Gwendraeth Fawr, the oldest railway bridge in Wales, dating from *c.* 1770.

See also Llandyry.

TUMBLE/Y TWMBL
Llannon

C19 coal-mining village, that grew up by the Great Mountain (Mynydd Mawr) colliery. The name, The Tumble, may relate to the steep hill down to Cross Hands. Stuccoed houses in terraces run downhill NW from Upper Tumble. In the centre, the GREAT MOUNTAIN WORKING MEN'S CLUB, *c.* 1890, large hipped five-bay building with old-fashioned Gothic detail to the ground floor triple windows. By Bethel Chapel, PUBLIC HALL, 1914 by *W. Griffiths.* Stuccoed, with fat columns in the main window.

St David/Dewi Sant. 1926–7, by *William Griffiths*, built by miners during the General Strike. Brown local stone with late Gothic detail in pinkish terracotta, of some refinement. Long nave and chancel, with s porch, transept-like vestries and big five-light end windows. – STAINED GLASS. A representative set by *Celtic Studios*: E window, 1959, Sanctus, with crowded figures. The nave N third is one of Howard Martin's earliest, 1947, muted colours. Nave s second, 1966, acid colours and heavy lines; third of 1950; fourth, 1980, the mine and the church, on a latticed background. The plain HALL, behind, was the original church, 1888, by *David Jenkins*.

BETHEL BAPTIST CHAPEL. 1904, by *William Griffiths*. Stuccoed, with giant arch and arched windows.

BETHESDA INDEPENDENT CHAPEL. 1905, by *William Griffiths*. Two-storey front with a giant arch filled with a curving name-plaque.

BETHANIA INDEPENDENT CHAPEL, Upper Tumble. 1896. A big gable front with arched openings.

CAPEL SEION (Independent) 2 m. NW. 1878. Rock-faced sandstone gable front with giant arch over a roundel, a triple window and two doors. Galleries with cast-iron panels, pulpit with fretwork ornament and a big plastered curved pulpit-back.

TYCROES

2 m. SW of Ammanford

St Edmund. 1913–14, by *W. D. Jenkins* of Llandeilo. Attractive Free Gothic of the turn-of-the-century type, with a big Perp five-light E window and some chequer-work in the gable. Timber spired W bellcote. Inside, big moulded chancel arch on wall-shafts, arch-braced nave roof and wagon roof in the chancel. – FONT. Octagonal with carved panels. – FITTINGS of 1914, in oak. – STAINED GLASS. By *Celtic Studios*, the E window, 1977; W window, 1983; nave N, 1958, rich colours; and nave NW and NE 1990. Nave s, 1997, by *Toft* of Swansea.

CAERSALEM CALVINISTIC METHODIST CHAPEL, 1875–6, by *J. W. Jones* of Llandeilo. Brown sandstone and grey limestone, with a giant arch pushing up into the gable, the motif associated with the Rev. Thomas Thomas.

MORIAH INDEPENDENT CHAPEL, Penygarn Road. 1876. Similar to Caersalem but a little more elaborated in that the centre recess is quoined.

WHITLAND/HENDY GWYN A'R DAF

A small town, on the N bank of the Taf. It may predate the Cistercian abbey, founded in the valley to the N. Hywel Dda, C10 king of Deheubarth, convened a meeting at Ty Gwyn ar Daf, 'the white house on the Taf', to codify the various traditions of the

law, though the exact site is not known. The Roman road w from Carmarthen passed to the N. The settlement grew after the South Wales Railway came through in 1853, becoming the terminus of lines to Pembroke Dock and Cardigan. Development was promoted by the speculator, the Hon. W. H. Yelverton of Whitland Abbey, with *E. M. Goodwin* as architect. Goodwin speculated himself, in land and in the Whitland Abbey Slate Co. whose highly prized pale slates came in fact from Pembrokeshire. Another developer, the lawyer C. E. D. Morgan Richardson, began laying out streets from 1884, with *George Morgan* as surveyor, and E. M. Goodwin returned in 1892–5 to develop w of John Street, the main street. All the houses are typically two-storey with brick dressings. The best individual building is the small NATIONAL WESTMINSTER BANK, John Street, *c.* 1929, by *Palmer & Holden*, inventive Neo-Georgian, in two tones of rock-faced stone with silver grey roofing slates. Four tall arches, set back, with curving side walls.

ST MARY. 1850–3, by *Coe & Goodwin*. Early for correct Dec Gothic in the region, if rather harsh. The plans for a church with tower and spire were altered for economy by the vicar and the builders. Nave and chancel, with a tall bellcote, low buttresses and a bargeboarded half-timbered porch. Scissor-truss roofs, the main trusses on low corbels. Chancel arch on tapering brackets. – Oak PULPIT 1922, PEWS and STALLS 1937, by *Bertram Winship*. – STAINED GLASS. E window, 1853, Christ with SS Peter & John, strongly coloured. W window, 1989, by *Celtic Studios*. Chancel s, 1921, by *Kempe & Co.* – MONUMENT. Elizabeth Yelverton †1863, old-fashioned, Grecian, with a weeping woman. In the graveyard, a big granite Celtic cross to W. H. Yelverton †1884, designed by *Goodwin*, 1892.

BETHANIA CALVINISTIC METHODIST CHAPEL, Trevaughan. 1861. Two tall arched windows above the door. Good interior, with rear gallery curved out at each end as is sometimes found in the 1860s, and with box pews. Pulpit and great seat of 1912.

NAZARETH BAPTIST CHAPEL, Market Street. 1861. Brown local stone and yellow limestone. Tall arched outer windows, and a wider segmental-headed centre one. Enlarged 1894 by *George Morgan*, with side projections and to the rear. Interior of 1894, the gallery with strips of open quatrefoil ironwork. Pulpit with arcaded front, in a big arched recess for the organ.

TABERNACLE INDEPENDENT CHAPEL, Spring Gardens. 1873, by the *Rev. Thomas Thomas*. Handsome, stuccoed temple front with giant pilasters and arched windows. Good interior with cast-iron pierced gallery panels, and deep coved ceiling, the middle ribbed, with a large plaster rose. Broad arcaded pulpit, 1935, by *W. Griffiths & Son*.

SCHOOL, Market Street. 1875, by *George Morgan*. Characterful Gothic, one of the best Victorian schools in the county. Single-storey with three spaced gables and a corner spirelet on a tall octagonal drum.

HYWEL DDA MEMORIAL GARDEN, off St Mary's Street. 1984,
by *Peter Lord*. A well-conceived co-operation of different artists,
commemorating the Welsh laws codified at Whitland in the
C9 by Hywel Dda. Small maze-like garden, with enclosures on
different levels, within old walls. Slate sundial, and good inset
tiles by *Maggie Humphrey* depicting the life of Hywel Dda.
INFORMATION CENTRE, by *David Thomas* of the *Prys
Edwards Partnership*, with glazed front behind a veranda. Inte-
rior work in iron by *David Petersen*, ceramic by *Maggie
Humphrey*, and engraved glass and brick by *Peter Lord*.
Extended in 2004–5 by *David Thomas*, with iron gates by
Petersen.

WHITLAND ABBEY
1¼ m. NE.

On a beautiful site, the scant remnants of a Cistercian abbey
founded in the mid C12, from Clairvaux. Although there had
been earlier foundations, Whitland was the first Cistercian
house in Welsh Wales, supported by the Lord Rhys. It had even-
tually seven daughter houses in Wales, and two in Ireland. The
abbey was patronized by both Welsh and Norman families,
and held landed estates, not large though by comparison
with Margam, Neath or Tintern. The buildings were probably
begun *c.* 1151 but there are no records of beginnings or com-
pletions. The abbey suffered in the turmoil of the C13, being
raided by a band of Norman knights in 1257 and damaged by
royal forces mustered there either in 1277 or 1282. It was
accused of support for the Welsh princes, but seems to have
been judicious in its allegiance. In 1291 its estates were valued
at £43 (against the £236 of Neath). This had probably declined
in the C14. In the C15 the abbot supported Owain Glyndwr,
and suffered accordingly, revenues were described as dimin-
ished by 'the ravages of sword and fire'. In the later C15 and
C16 there were between five and eight resident monks. After
the Dissolution, an impressive manor house of Dr John
Vaughan, presumably occupying some part of the former
monastic buildings, is described in 1582 as having twenty-two
rooms, with windows of freestone of up to ten lights. But the
same owner, with Sir John Perrot of Laugharne, was accused
of pilfering building stone. By the mid C17 an iron forge was
operating on the site, using the abbey's watercourses. It ceased
in the 1730s, was reopened by one of the Morgans of the
Carmarthen ironworks, and ran until about 1810. The Morgan
heiress married W. H. Yelverton, who began building a mansion
to the SE in the 1840s, and it was probably then that the last
stones were removed, and the walled garden laid out on the
site of the garth. Archaeological investigation took place in
1921, 1926–8 and 1994–5.

Only footings of the church survive, but the cruciform plan
is clear, and the building appears to have been of mid to later
C12 date. Long nave with narrow aisles, the cruciform bases of

the piers indicating arcades of eight bays. The piers were prob-
ably plain like those at Margam, but a drawing of excavation
in 1838 shows what appear to be clustered attached column
shafts. The E end was of two bays and probably vaulted,
without a differentiated crossing. Fragments of carved stone
suggest that at least one vault had the strange annular orna-
ment on the ribs found at Strata Florida, Cd. Foundations may
indicate that a formal crossing was made in the early C13, the
date suggested by fragments of dogtooth detail and water-
holding bases. The transepts may both have had paired E
chapels, as still on the N transept. The S one is crossed by the
wall of the adjoining garden, which covers the site of the clois-
ter. The footings of a range W of the cloister survive, with scars
of two vaulted undercrofts. W of this, a tall stub of wall still
stands. Further up the valley, traces of fishponds and mill
ponds, with their associated leats.

WHITLAND ABBEY HOUSE. A house had been built for W. H.
Yelverton by 1847, but *H. E. Coe* exhibited a design for one for
him in 1857; his house was still unfinished in 1872 and he was
bankrupt in 1878. The entrance front, with Tudor Gothic porch
suggests that money ran out, the r. side being stuccoed where
the rest is stone, but the story is complex. Old photographs
show the stucco part and the utilitarian garden front between
two gables to have been a riot of timber detail; bays, barge-
boards, even a cross-gabled tower, all removed. Two worth-
while details: the carved stone Tudor arms on the porch are
genuine C16, found on a farmhouse by the abbey, and the
gatepiers have cast-iron caps with unintimidating dragons.

YSTRADFFIN 7816

Remote and wild spot on the old drovers' road at the head of the
Tywi, on the border of three counties. Only the church, two or
three farms and the Llyn Brianne reservoir. At the entrance of
the RSPB nature reserve, NANTYFFIN, much restored C19
cottage, preserving inside the lath-and-plaster fire-hood and the
bracken under-thatch.

ST PAULINUS. Rebuilt reluctantly in 1821 by Lord Cawdor, who
 preferred a new site convenient to his mines at Rhandirmwyn,
 but would have forfeited the right to present the vicar. Small
 single chamber with W porch and bellcote, one wide window
 on the E wall, another on the S, with hoodmoulds. Glazing of
 1900. The roof has bolted-on arched braces. Simple altar rails,
 and plain pulpit with Gothic panels, of 1821.

YSTRADFFIN. Early C19 stone three-bay farmhouse, but with
 some heavy moulded beams and thick walls in the SW corner
 of a larger predecessor. A timber dated 1672 was found inside.
 Despite the isolation, it was a house of importance, the owners
 wealthy from sheep farming. Thomas Williams was High
 Sheriff of all three contiguous counties, on five occasions in

all, 1577–92, and it was home, albeit briefly, 1607–9, and at the respectable end of his life, of the genealogist, scapegrace and wit, Thomas Jones, called Twm Sion Catti.

LLYN BRIANNE RESERVOIR. Branching reservoir for w Glamorgan, of 1968–73, in three counties, capturing the waters of the Tywi and Camddwr. The dam designed by the engineers to the scheme, *Binnie & Partners*, is not architectural, compared to the great masonry or concrete dams of the late C19 and early C20, being stepped back in boulder-faced tiers, but at 300 feet (91 metres) was the highest in Britain. More dramatic, when in use, is the concrete spillway to one side, crossed by two slim concrete bridges. The outflow was subsequently adapted to produce hydroelectric power.

CEREDIGION

ABERAERON

Wales has several planned towns of the C19, but no other that has kept the architectural unity of Aberaeron. Initial overall control was by a single estate, Gwynne of Monachty, and the short period of expansion, 1830–70, was not followed by rapid decline, as at Milford or Pembroke Dock, nor has there been much subsequent development. The architectural form of the town is of short terraces, each stopped with slightly larger hipped-roofed houses. The overall plan a simple grid varied by the line of pre-existing roads, and most charmingly, by the river Aeron and the inner harbour. The houses are well lit by comparison with the earlier C19 regional norm, with large sash windows. This Late Georgian style became so much the standard type for the area that it is hard now to recognize its novelty. Nash's Llanerchaeron (q.v.) of the 1790s brought the type to the region, and Laura Place, Aberystwyth, of 1827 (q.v.) is probably the first urban use. There is some diversity of detail, in part due to the difficulty of keeping local builders to the set pattern. Eaves lines and house sizes establish the standard with variations in the doorways, arched in the first houses, flat-headed later, and there are some idiosyncratic sub-classical timber porches.

The cheerful colours that break up the terraced rows derive more from 'townscape' ideas of the 1960s than authentic restoration. There is no evidence that colour was imposed in early leases, but the present look entertains where the no-more-authentic hard unpainted cements, that replaced the original roughcast in the earlier C20, did not.

The town was founded by Act of Parliament in 1807, having previously been little more than a bridge and an inn. The Rev. Alban Thomas, vicar of Lacock and later of Nately Scures, had gained by marriage two successive local estates: in 1797 the Ty Glyn estate of the Jones family, and then in 1805 the Monachty estate of the Gwynnes, which included Aberaeron. Restyled as the Rev. Alban Thomas Jones Gwynne, he set about the creation of a new port. Some £6,000 was spent on piers and wharfs in 1807–9, but surprisingly little of the town had been built when he died in 1819, and nothing was added before his widow died in 1830.

The plan of the town and the form of the individual buildings were almost certainly established by *Edward Haycock* of

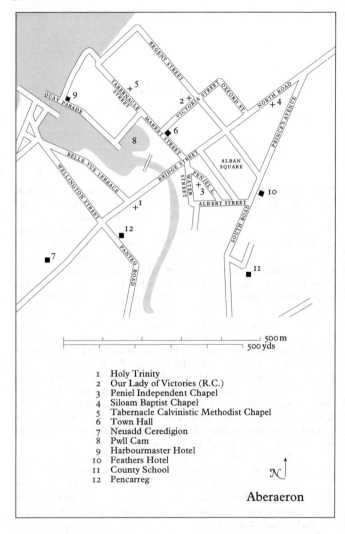

500 m
500 yds

1 Holy Trinity
2 Our Lady of Victories (R.C.)
3 Peniel Independent Chapel
4 Siloam Baptist Chapel
5 Tabernacle Calvinistic Methodist Chapel
6 Town Hall
7 Neuadd Ceredigion
8 Pwll Cam
9 Harbourmaster Hotel
10 Feathers Hotel
11 County School
12 Pencarreg

Aberaeron

Shrewsbury, then at the outset of his extensive career in South-West Wales, as one of the first leases drawn up for Col. A. T. J. Gwynne in the early 1830s mentions 'Mr Haycock's plan'.

Col. Gwynne †1861, the son of the Rev. A. T. J. Gwynne, expanded the town quickly; in 1831–2 leases were being offered for houses 'above the bridge' and on 'the new street between the bridge and the sea'. This is Market Street, on which was built the Market Hall, 1833. In 1833 the first two chapels were built; by 1834 Alban Square was laid out, though building had barely

begun and, in 1835, *Haycock*'s church (later rebuilt) was finished. The street names betoken activity into the mid C19: Waterloo, Regent, Wellington, Queen, Victoria, Albert. The 1845 Tithe Map suggests that building had slowed by then, only the part from the bridge to the harbour was built up, the main road largely empty. N of the road was a row of small houses on the W side of Water Street and only a handful on the lower edges of Alban Square. Portland Place, W of the Bridge, dated 1855, shows that the pattern of the 1830s was maintained well into Victoria's reign.

Shipping and shipbuilding were the basis of prosperity until *c.* 1870, and an edge-tool (later shovel) works in Water Street was the only other industry. The town settled as a small resort, cut off from the railway system until 1911. For geographical reasons it became a seat of the County Council in the later C19, administrative buildings shared with Aberystwyth until 1990 when the then District Council built the present county offices (q.v.) outside Aberaeron.

HOLY TRINITY. *Edward Haycock*'s battlemented Gothic box of 1835, similar to his St Michael, Aberystwyth, was replaced in 1871–2 in hard Early Dec Gothic by *Middleton & Goodman* of Cheltenham. A broad aisleless nave and apsed chancel, with a particularly harsh SW tower added 1878–80 by *Middleton & Son*, nearly detached, and much duller in execution than the surviving design, with broach spire, suggested. The firm, by then *Prothero & Phillot*, replaced the apse with a big Perp chancel in 1897–9. Unimaginative exterior, a gabled chamber and a square, pinnacled tower with over-emphatic Bath stone trimmings. The interior has some merit: broad open-trussed roof, squat, massively scaled shafts to the chancel arch, and dominant five-light E window. – FONT and PULPIT. Heavily shafted stone and marble, 1873, carved by *R. Boulton*. – REREDOS. Timber triptych by *Kempe & Co.*, 1933. – STAINED GLASS. Rich E window, Crucifixion and four saints, 1932, by *Kempe & Co.* Chancel N three brightly coloured C14-style windows, from the original apse, 1875, by *Joseph Bell* of Bristol, who apparently said that he had never sent out better ones. Chancel S window of *c.* 1920, St John and Virgin Mary, Arts and Crafts, figures floating in opaque quarries, possibly by *Mary Lowndes*. Nave N second *c.* 1943 by *G. E. R. Smith*, fourth *c.* 1981, by *G. Maile Studios*, and fifth, 1925 by *Kempe & Co.*, SS Asaph & David. Nave S third, 1925 by *Mary Lowndes*, SS Cecilia & Luke, rich opalescent colours. A good C15 style W four-light window of *c.* 1880, the Four Evangelists.

OUR LADY OF VICTORIES (R.C.), Victoria Street. Small, plain lateral-fronted former Wesleyan Chapel of 1864, abandoned 1924, reused 1958.

PENIEL INDEPENDENT CHAPEL, Water Street. The original chapel of 1833 faced N to Peniel Lane. Rebuilt facing S in 1857, it was given a new stone front in 1897, with centre projection, narrow arched windows and roundel above. The interior, of 1897, has continuous cast-iron work to the gallery, deacons'

seat and pulpit. Organ by *Conacher & Co.*, flanked by two stained-glass windows of 1927, by *John Hall & Sons*, Renaissance style.

FORMER SILOAM BAPTIST CHAPEL, North Road. 1878–9, by *George Morgan*, now a warehouse. Cheap minimal Romanesque stone front and Morgan's typical stepped corbelling.

TABERNACLE CALVINISTIC METHODIST CHAPEL, Tabernacle Street. 1833, altered 1853, but the front, so effective in views down Market Street, was added in 1869 by the *Rev. Thomas Thomas*. A massively overscaled pediment with urns and roundel bears down on a brown sandstone front of four arched windows over two open-pedimented doorways in Bath stone (possibly reflecting an earlier lateral façade). Banks of painted grained pews, probably of 1853, five-sided gallery of 1869 with inset pierced iron panels and platform with double-curved balustrades flanking a fretwork-panelled pulpit. Organ of 1897 by *Vowles*.

67 TOWN HALL, Market Street. Market Hall of 1833–4, then called the Town Hall when described as 'nearly finished' in 1845, then the County Sessions House in the 1850s and the County Hall by 1910. Sturdy and effective, possibly by *Haycock*, built by *William Green* of Aberaeron. Brown sandstone, two storeys, 1–3–1 bays, with hipped roof, timber lantern and centre open-pedimental gable, possibly added, as the stone colour changes. Arched ground-floor windows, originally an open arcade, big sashes above. One-bay wings, set-back of *c.* 1910, extended along Victoria Street *c.* 1950, by *Rhys Jones*.

NEUADD CEREDIGION. On the southern edge of the town. Built 1989–90 as council offices and council chamber, by *Ceredigion District Council Architects*. Brown brick, L-plan pivoted on a big octagonal council chamber whose slate roof with gold weathervane is the dominant accent. Office blocks run N and E banded in yellow brick, with hipped ends. Clumsy pent roof over the main entry in the angle. Decent but unexciting council chamber, lit by narrow slits with pale woodwork, pale brick, and boarded roof. The spectacular sea views are only visible from the bar over the main entry. Unsatisfactory ground floor with unlit committee room encircled by a passage and small offices. Extensions in similar style 1998 and 2002.

ABERAERON COUNTY SCHOOL, South Road. 1897–8, by *L. Bankes-Price*, well-sited on the hillside. Small, stuccoed with gabled window bays and ridge lantern. Additions 1910, by *G. Dickens-Lewis*, 1929, 1940 and in 1990s.

PERAMBULATION

The picturesque harbour area and flanking terraces can be seen from the single-arch BRIDGE of 1911. Downstream is the PEDESTRIAN BRIDGE, 1993, striking laminated timber bow truss. In BRIDGE STREET, to the NE, an irregular three-storey range, *c.* 1832, illustrates what is suggested by the early leases,

that the estate could not bind the builders absolutely to given
plans. However it is clear that at the outset vistas were con-
sidered, for the big three-storey, three-bay house past Water
Street closes the view up Market Street. MARKET STREET,
1832–5, has a near uniform hipped three-storey terrace and the
County Hall (q.v.) on the r. On the l., Nos. 1–6 shows the more
typical pattern of hipped end blocks framing a row. No. 7, five
bays with pediment, closes the view down Victoria Street. VIC-
TORIA STREET was built up, c. 1850, in low two-storey ter-
races, with hipped ends. Beyond, Market Street opens out onto
PWLL CAM, the pretty inner harbour, with houses on two
sides. On the r., Nos. 14–17 MARKET STREET are two-storey,
Nos. 14 and 17 hipped, but Nos. 9–13 three-storey, two-bay
houses with massive square stone chimneys, suggesting that
these are among the earliest houses. In TABERNACLE STREET,
ten pre-1845 houses on the l.; three more, the chapel (q.v.) and
a WAREHOUSE on the r., of rounded beach stones, early C19
altered. CADWGAN PLACE faces SE over the basin, c. 1830–40:
Nos. 3–9 are two-storey, but Nos. 1–2 to the l. three-storey.
This is the corner of QUAY PARADE, which faces SW over the
main harbour, also of the 1830s. An informal group, mostly
two-storey but with some handsome three-storey houses. The
HARBOURMASTER HOTEL forms a fine end-stop, three-
storey, three-bay detached house with pediment, built as the
harbourmaster's house. Pretty twisting stair inside. Set back in
a gap to the r., No. 4½ QUAY PARADE, 1999 by *David Thomas*,
an ingeniously inserted new house, of which only the corner
entrance bay projects, inviting a look at the dramatically com-
posed end wall with deep-curved overhanging roof and oak-
clad jettied upper floors. The sweeping roof is set high to claim
light from above the building in front.

Now returning up Victoria Street, REGENT STREET and
OXFORD STREET, built up in the 1850s and 1860s, small scale
and incomplete, end still in rough ground. On NORTH ROAD,
balanced terraces with end stops of c. 1850, and on the r.,
the former Baptist chapel (q.v.) and plain gabled former
NATIONAL SCHOOL, 1848, by *Jenkin Pugh* of Aberaeron.

ALBAN SQUARE was laid out in 1834, the terraces too small to
give a sense of enclosure to the grassy central space. The range
across the main road, end-stopped and two-storey, reads more
as part of the sequence along North Road than as one side of
a formal square. The r. side tries harder with three three-storey
accents, LONDON HOUSE, the BLACK LION and No. 26, but
the terraces between are uneven. Only the part up to the Black
Lion was built by 1845, and has the smallest, two-bay houses,
suggesting a loss of confidence. Thereafter, a recovery, as all
are three-bay except the terminal single-bay hipped house.
This understatement is because an awkward diagonal junction
with Albert Street disrupts what should be the corner of the
square. In a pleasingly *ad hoc* response to the difficulty, the first
house of Albert Street is made interesting by a pedimental
gable, facing diagonally across the square. At the far end of the

square, the FEATHERS HOTEL, a substantial three-bay hipped block of 1840, not quite large enough for the position and not straight to the square, as the existing Lampeter road was not realigned. The l. side of the square is only of two storeys, but still with three hipped accents. The first, the HSBC BANK, at the l. corner, 1834, has nice timber doorcases on each front, and Nos. 16 and 17 also have columned doorcases. At the r. corner, the POLICE STATION, 1887 by *J. W. Szlumper*, grey stone and black brick, with no concessions to the locality, and in PRINCE'S AVENUE beyond, COTTAGE HOSPITAL, the workhouse of 1838, converted 1914, a standard design by *George Wilkinson*, architect to the Poor Law Commissioners, like those at St Dogmaels and Narberth, Pembs. Stucco, 3–3–3 bays, all a low two storeys, the centre with three acute gablets, spoilt by new windows.

To the S of the square, on SOUTH ROAD, a row of three large hipped, later C19 villas on the r. The NATIONAL WESTMIN- STER BANK was already a bank in 1871, odd in so suburban a position. The third, TANYFRON, was built in 1867, perhaps the date of all three. On the l., the County School (q.v.) and the MEMORIAL HALL, 1923, by *L. Bankes-Price*, with a Venetian centre window. By the Upper Bridge, DOLEAERON, *c.* 1855, asymmetrical villa with tall Gothic bay, on the site of an inn of 1757, built for the Quarter Sessions. Over the bridge, on LAMPETER ROAD, CARDIGANSHIRE WATER COMPANY offices, 1971 by *J. I. Ceri Jones*. A rare piece of modernism, long and low, three bands of rough-faced striated concrete and two recessed window bands with a subtle play of close-set, but not uniformly spaced, smooth mullions. On the other side, THE VICARAGE, 1862, by *R. J. Withers*, more expensive than his other vicarages, with Bath stone dressings, and more overtly Gothic in the pointed blind head of the window under the centre gable. Beyond, an earlier C19 TOLL HOUSE. Up VIC- ARAGE HILL, in PANT-TEG, running back down the w side of the valley, six detached mid-C19 VILLAS.

Returning to Alban Square, and going w an area of smaller scale housing. ALBERT STREET is probably of the 1860s, still formally terraced, but without the hipped accents. Down CHALYBEATE STREET, former WELL HOUSE, in the park by the river, a plain octagonal shelter of 1881. WATER STREET has a stone three-storey former woollen mill of the later C19 and artisan terraces of *c.* 1840.

Back on the main road, SW of the bridge, some of the best set-pieces of the town, though of the 1850s. PORTLAND PLACE is the finest single terrace, seven three-bay houses, well stopped with hipped accents. The first, PORTLAND HOUSE, 1855, is three-storey, echoing the scale of Bridge Street across the river. Past the church (q.v.), PENGARREG, *c.* 1833, intended as an inn, oddly backs onto the road as apparently the road line was changed. Irregular, six-bay hipped range. Behind, CLOS PEN-GARREG, well adapted in 1992 by *James & Jenkins* of Aberys-twyth as craft workshops from an unusual group of five farm

buildings of the 1840s, all half-hipped with rounded corners. On the main road again, GREENLAND TERRACE, of the 1850s, a handsome row of eleven houses climbing the hill and finally NEWFOUNDLAND TERRACE, five houses, mostly spoilt, which is a pity as it marks the entry to the town. Just beyond, below the road, Neuadd Ceredigion (q.v.). Returning on the N side, the terraces are at right angles to the main road. First, WELLINGTON STREET, only five houses, facing the approaching visitor to good effect. Next, BELLE VUE TERRACE, facing NE over the harbour, makes an excellent show from Pwll Cam. Six houses and then three, No. 1 slightly larger and hipped, No. 9 hipped but with late C19 bays. To the r., a later C19 terrace with the typical dormers and bays of the Victorian seaside, their alien fussiness a reminder of how unified Aberaeron is. Then VULCAN TERRACE, a single six-bay block of three houses, and beyond, by the outer harbour, a small WEIGH-HOUSE, hipped and square, the Aberaeron style in miniature.

ABERARTH
Llanddewi Aberarth

4864

An unusually attractive village in the deep valley of the River Arth, with three narrow lanes running down towards the sea. Strata Florida Abbey (q.v.) had a port here in the Middle Ages. On the beach are crescent-shaped rows of boulders, said to be medieval, used until the C20 to trap water and fish on a receding tide. Six limekilns on the cliff-edge have been lost to the eroding sea. Handsome broad single-arch stone BRIDGE of 1849, built by *David Morris*, the plans probably by *R. K. Penson*. On the main road, mid- to later C19 houses in the Aberaeron Late Georgian style, the most attractive, BRYNDEWI, *c.* 1850, set back by the river E of the bridge. On the W bank, small terraced cottages down to Bethel chapel. ABERARTH MILL, on the E bank, originally of 1819, for J. Brooks of Neuadd, Oakford, remodelled with new machinery in 1864, and with parallel sawmill of 1902. Across the main road, behind Y Glyn, on the same leat system, hipped whitewashed stone WOOLLEN MILL of 1865, an early example, the scale still small.

ST DAVID, ½ m. S. Isolated on a hilltop with spectacular views over Cardigan Bay. Medieval tower, corbelled battlements, tiny bell-openings, a pointed vault within, probably C15. The rest was rebuilt in 1860 by *David Williams*, carpenter. Single-roofed nave and chancel with large pointed windows, the chancel narrower. Repairs are recorded in 1883, and reroofing in 1931, by *W. Ellery Anderson* of Cheltenham. Inside, thin roof trusses, and a plain plastered chancel arch one bay forward of the narrowing. Patterned leading in the windows of 1931. Chancel FITTINGS, 1948–9, small gilded-wood reredos, panelling and rails. – STAINED GLASS. E window, 1948, by *G. E. R. Smith*.

In the churchyard, well-lettered slate-topped table tombs, notably the Rev. A. T. J. Gwynne †1819, founder of Aberaeron, and his wife †1830.

The former SCHOOL, adjacent, of 1837, by *Thomas Lewis* of Aberaeron, has pointed windows, three bays original, one added.

BETHEL CALVINISTIC METHODIST CHAPEL 1848–9. Quite large lateral front of extreme but still attractive plainness, roughcast with bracketed eaves and with two big centre sashes, outer doors and gallery-lights. Crowded interior of painted grained box pews but no gallery.

TY GLYN. *See* Cilcennin.

3542

ABERBANC
Henllan

The VILLAGE, prettily set looking N up the wooded Nant Gwylan valley, has a row of three mid-C19 Bronwydd estate cottages on the main road, the chapel above and, overlooking the valley, WAR MEMORIAL, 1923, by *E. J. Jones*, a white marble standing soldier. Beyond, the old SCHOOL, 1848 by *Charles Davies* of Cenarth, with dormer gables and thick bargeboards to the house, and T-plan school behind.

In the valley, PONT AFON RHYD, 1857, bridge with inscription noting that it was built through the co-operation of the rich and the poor, i.e. for the Bronwydd estate by estate workers. PONT FELIN CWRRWS, ½ m. SW, 1840, tall single-arched bridge with a smaller N arch for a mill-leat.

Y DRINDOD CALVINISTIC METHODIST CHAPEL. A handsome sandstone gabled front, of 1864, with long recessed arched windows, and an intricate fanlight over the door. Interior without galleries, big plaster ceiling rose, four satellite roses, and an arched niche behind the pulpit. The first chapel of *c.* 1790 was endowed by the Lloyds of Bronwydd as a counter to Unitarianism in the area, hence the dedication to the Trinity.

BRONWYDD. *See* Llangynllo.

6979

ABERFFRWD
Llanbadarn y Creuddyn

Hamlet in a fold of hillside S of the Rheidol. There were lead mines on the steep S escarpment to the E, notably PANTMAWR MINE, 1½ m. ESE, exploited from the 1850s; the scars are visible where the minor road joins the main road. Lost in the wooded escarpment SE of Rheidol Falls are the RHEIDOL UNITED MINES, developed at great cost from the early C19 by Durham mine-owners, Sir George and Thomas Alden, described to George Borrow in 1854 as 'the first people who really opened

Wales'. No structure survives.

ABERFFRWD CALVINISTIC METHODIST CHAPEL. 1835. Roughcast lateral-fronted chapel with a big Georgian arched window each side of the porch. Slightly offset façade, perhaps to allow for an end-wall pulpit, which would be early for the date, so possibly remodelled (see the different end-wall windows).

ABERMEURIG 5756
Llanfihangel Ystrad/Gartheli

A small hamlet in the upper Aeron valley under the slopes of the Gartheli uplands.

ABERMEURIG CALVINISTIC METHODIST CHAPEL. 1825, altered 1890. Stone side, originally the front, with four arched windows, the outer ones stepped up. Plain stuccoed gable entrance of 1890 facing the hillside. Gallery at the entrance end, with pierced cast-iron panels. Attractively set E of a stream crossed by two single-slab stone bridges.

ABERMEURIG, ¼ m. N. Three-storey, three-bay, roughcast house with broad sashes, presumably early C19, and a timber eaves cornice with the flat Greek Doric mutules. The porch has a Greek Doric cornice, though Roman Doric columns. Stair gable with lunette behind. The house is said to have been built in the 1770s for John Edwardes, but remodelled after a fire c. 1800. A low wing to the r., with apsed end, once a dairy, may be of the earlier date, as it has scarfed cruck roof trusses. Interior detail of c. 1800; stair with thin column newels and stick balusters.

GWASTAD GWRDA. ½ m. N behind Gwastad Farm. Stone house in two parts with central chimney, the eaves raised in the C18. The chimney is an insertion into a C16 cruck-roofed range with three fine raised crucks.

ABERPORTH 5881

Large coastal village that grew around two small shipbuilding beaches. From the later C19 a holiday trade developed and the character now is mostly C20 sprawl. Some later C19 sandstone fronts on BANC Y DYFFRYN above Ship Beach. Between the beaches, the SHIP INN, mid C19, whitewashed stone. Overlooking Plas Beach, DOLEWEN, early C19, four-bay, with later dormers. Prominent on the hilltop, TRECREGYN, a sandstone villa of the 1860s with three eaves gables. On the Blaenannerch road, above the church, VICARAGE of 1913 by J. H. Morgan. White roughcast with red-tiled hipped roof, small-paned transomed windows, the upper ones breaking the eaves, and the shallow-arched entry off-centre.

ST CYNWYL. 1855–7 by R. J. Withers, in the angular mode of his first Welsh churches (cf Llanfair Nant Gwyn and Llanllawer,

Pembs.), steep-pitched roofs and bellcote. Porch of 1939. Pwntan sandstone, well-cut, with a high battered plinth and buttresses. The interior has open rafter roofs and minimal detail. – FONT. High Victorian panelled octagon on shafted drum base. – STAINED GLASS. E window Resurrection panel by *Alfred Bell*, 1856, in patterned glass by *N. W. Lavers*. Chancel S window 1939 by *A. L. Wilkinson*. Chancel FITTINGS, 1939, by *E. A. Roiser*.

In the churchyard, three monuments to the Jones family of Pennar. Rev. J. Jones †1795, of a rudimentary classicism, sandstone surround to a long arched plaque with concave-sided pediment. Anne Jones, more sophisticated, a lighter sandstone frame to a marble plaque, and capped by an elegant cast-iron urn dated 1826. Finally, Dr W. D. Jones of Lancych †1869, typically Victorian sandstone obelisk, pedestal with Gothic angle shafts. Also numerous mid-C19 pedimented slate memorials, some with traces of the original painting and gilding. E of the church, the former SCHOOL of 1853, by *Charles Davies*, missing one porch.

BANC CALVINISTIC METHODIST CHAPEL (Yr Hen Gapel), S of Plas Beach. Large bleak cement exterior of 1901, remodelling a long-wall chapel of 1833 and 1859. Good interior, tightly compressed with a long U-shaped gallery, the rear gallery seats steeply raked. Thickly-patterned cast-ironwork to the gallery front, pulpit sides and great seat, by the *Priory Foundry*, Carmarthen. Arcaded timber pulpit front. Glynarthen Chapel (*see* Glynarthen) is very similar.

BRYNSEION CALVINISTIC METHODIST CHAPEL. S of Ship Beach. Now a crafts centre. 1882–3, unusual for the two-colour gable front: South Pembrokeshire grey limestone with dressings of brown Pwntan sandstone.

BRYNMAIR INDEPENDENT CHAPEL. ½ m. SSE, off B4332. Hipped square chapel, 1833, the detail and interior of 1897. Gallery front curved at the corners with pretty latticed long cast-iron panels by the *Priory Foundry*.

PRIMARY SCHOOL, N of the church. 1957, by *G. R. Bruce*, County Architect. The most interesting of the schools of its period in Cardiganshire, a generous two storeys with broad window bands on the seaward side, the entrance end a fully-glazed stair hall, light and cheerful with minimal detail. The school of 1916 adjoins.

PENRALLT. ½ m. SW of the church. 1906–7, by *J. H. Morgan* of *George Morgan & Son*, like a large Thames-side villa of the 1890s, asymmetrical with red-tiled roofs, half-timbering, and pretty white-painted timber bays, balconies and verandas. Teak staircase under a coved roof with rich Arts and Crafts armorial glass, probably by *T. W. Camm & Co*. The dining-room is heavily beamed, the drawing-room has a ribbed plaster ceiling, both a little fussy.

ABERPORTH RANGE. A sprawling complex on the Parcllyn headland, developed as a missile testing range from 1939, with an associated airfield at Blaenannerch.

ABERYSTWYTH

Aberystwyth, now the largest town in Mid Wales, grew with the popularity of sea-bathing from the late C18, though founded with the English castle of 1277. It is set not on the mouth of the Ystwyth, as the name suggests, but on the Rheidol just to the N, the name deriving from the first Norman castle, an earthwork overlooking the Ystwyth built in 1109 on Tanycastell hill (Llany-chaiarn), well S of the present town. A second castle site called Aber-rheidol may have briefly existed N of the Rheidol, possibly at Plas Crug, before Edward I saw greater security in the present site close to the sea. The new castle was known as Llanbadarn Castle in the early days, from being within the parish of Llan-badarn Fawr. Gradually, however, the name Aberystwyth took hold, though Llanbadarn Fawr remained the parish church until the C19.

Although the castle declined in the C16, the little town grew with the exploitation of the lead and silver in the hills behind. In 1637 Charles I permitted Thomas Bushell, lessee of the mines, to mint silver coinage at Aberystwyth Castle, a very profitable enterprise, ended by the Civil War. The castle was garrisoned by Royalists, surrendered in 1646, and was thoroughly dismantled in 1649 together with almost all the town walls. The town's for-tunes then followed those of the lead mines, declining after the Civil War, reviving in the early C18. The silting of the port impeded trade, but still some 3–4,000 tons of lead ore were exported in 1759, and the Customs House was moved from Aber-dovey in 1763. The port itself was not improved until 1836–8, by which time the character of the town had wholly changed.

The beginnings of the fashionable resort lie in the taste for the wild and picturesque, which brought visitors to the Welsh moun-tains, where accommodation was sparse and spartan. Aberyst-wyth offered sea-bathing and even, from 1779, a chalybeate spring. The development was slow and haphazard, despite the involvement of Thomas Johnes of Hafod and Sir Uvedale Price, two of three Herefordshire neighbours (with Richard Payne Knight) who threw their wealth into the creation of the Pic-turesque ideal. Johnes began work at Hafod (q.v.) in 1786 and in 1788 Price bought land to build Castle House, a picturesque tri-angular villa, on the sea-front at Aberystwyth. Both were gestures of faith; Price's villa was the first in a town called, by a traveller in 1787, a 'poor, petty place', accessible with extreme difficulty from England. Nevertheless, the two together publicized the little-known centre of Wales.

By the early C19 the visitor to Aberystwyth was said to be wealthier and more fashionable than those to any other Welsh town. Sea-front building began about 1807. Prior to that visitors had lodged in the existing inns, the Talbot or the Gogerddan Arms. The first St Michael's church was opened in 1787, a small building that had taken over twenty years to build. Marine Terrace, developed piecemeal 1807–25 with stuccoed terraces of three and four storeys, became the model for Aberystwyth

lodging houses into the later C19. Two- and three-storey bow windows were an early feature, mostly replaced by canted bays of *c.* 1900, applied throughout the town by municipal ordinance as the first leases expired. Laura Place, next to the church, developed by the Powells of Nanteos in the 1820s, is architecturally more notable, but the fine two-storey houses of generous size were not imitated. A bath-house on the sea-front came in 1808, a temporary theatre in 1813, and Assembly Rooms in 1820. The theatre was replaced in 1828, St Michael's church rebuilt 1830–3 and houses expanded beyond the line of the old walls, the number multiplying threefold between 1801 and 1851.

Expansion from the 1830s was steady, though the tide of fashion ebbed. The arrival of the railway in the 1860s did not initiate a boom, despite the hopes of Thomas Savin, the railway promoter, of developing a popular holiday resort, with his Castle Hotel of 1864 the centrepiece. Savin's bankruptcy in 1866 unexpectedly made Aberystwyth a focus of intellectual life in Wales, reflecting the geographical difficulty of finding a suitable capital for Wales. Cardiff, by far the largest town, was too new, too Anglophone, and too far to the South, to speak for the rising aspirations of Welsh-speaking Wales. Aberystwyth, for all its isolation, was central, and there were no other suitable candidates. The Castle Hotel being available, the new University College came to the town in 1872, small and impoverished, but carrying great expectations. The National Library of Wales followed, proposed in 1873, built from 1911 above the town, and the crowning of Penglais hill behind with new University buildings became a goal in the C20. Unexecuted formalized plans of 1930 and 1935 for the Penglais site reflect this monumental aim, lost in the 1957 Holford replanning, but regained to some extent in the 1964–5 redesign.

In the later C19 the town expanded E; most of the modern development, hampered by the slopes, has been to the S, across the bridge in Penparcau. The old industrial area by the station has extended, with warehousing and supermarkets, along the Rheidol flood-plain, destroying a green corridor into the town.

CHURCHES AND CHAPELS

ST MICHAEL. 1889–90, by *Nicholson & Son* of Hereford, W end and tower to a modified design (there was to have been a spire), 1905–6, by *Nicholson & Hartree*. A large and prosperous Late Victorian town church, of Yorkshire stone with Bromsgrove dressings and Westmorland green slates. In English Dec style, it makes few concessions to Wales save in the broad, triple-roofed plan that echoes Tenby. Old-fashioned for the date, with conventional Dec tracery and thin quatrefoil arcade piers banded in red sandstone. Elaborate leaf-carved capitals and other details by *R. Boulton & Sons* of Cheltenham, who also made the Ancaster stone Last Supper REREDOS and the FONT. Oak carving by *Geflowski* presumably including the stalls and pulpit, but not the eagle LECTERN, by *Clarke* of

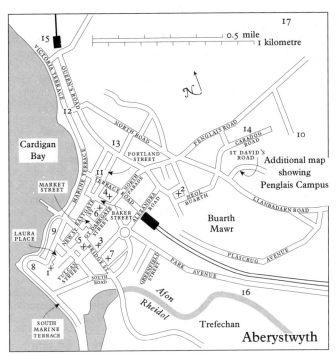

1 St Michael
2 Holy Trinity
3 St Mary
4 Bethel Baptist Chapel
5 St Paul's Welsh Wesleyan
 Chapel
6 Seion Independent Chapel
7 Tabernacle Calvinistic
 Methodist Chapel
8 Castle
9 Old College
10 National Library
11 Ceredigion Museum
12 County Hall
13 Town Hall
14 Bronglais Hospital
15 Cliff Railway
16 Police Station
17 Plas Penglais

Hereford to Nicholson's design. – CHANCEL SCREENS and
hanging ROOD of 1921–7 by *W. D. Caröe*, delicate and unin-
trusive. – STAINED GLASS. By *A. O. Hemming*, good E window
(Resurrection) and N aisle E window (Crucifixion), both 1889.
The five-light E window radiates rich colours from the scarlet
ground of the Christ figure, deep blue behind the angels and
earthier colours behind the disciples. The NE window is more
static, finely drawn in the manner of Clayton & Bell. Also by
Hemming, the four S aisle windows of 1903, without the same
intensity. NE chapel N, 1962 by *Lawrence Lee*, heavily etched
hieratic figures. N aisle window, 1914 by *Powell*, late Art
Nouveau with foliage trails. – MONUMENTS. A few of the early
C19 removed to the W porch. N aisle W, Martha Davies †1815,
mourning female relief by *Francis Chantrey*.

This is the third church in the area of the castle: a C15 church
of St Mary by the sea edge was ruinous by 1748; the first St
Michael, a small church of 1765, finished only in 1785–7, was
replaced by a big plain cruciform church of 1829–33 by *Edward*

Haycock. The w vestry of this survives, roofless, w of the present church.

HOLY TRINITY, Stanley Road. A surprisingly large church to be built at the same time as the parish church, and a gesture of faith for the suburb it serves was barely begun. By *J. H. Middleton*, of *Middleton & Son*, Perp, in contrast to the Early French used by his father. Nave 1883–6, crossing and transepts 1887–8, chancel 1897–9, but the crossing tower with pyramid roof not built. Long traceried windows, more elaborate in the transepts, and the w pair divided by a buttress. Broad, aisleless interior with hammerbeam trusses carried low on corbels, the arches of the crossing ornate with shafting and Perp panelling, and the chancel roof with niches under the corbels. Black and white marble chancel floor. – PULPIT, 1889, a delicate Arts and Crafts design in wood, hexagonal on egg-cup stem. – STALLS, 1905. – REREDOS, elaborate carved and painted wood triptych under a crocketed spire, 1932 by *W. Ellery Anderson* of Cheltenham. – STAINED GLASS, E window 1934 by *Powell*, deep colours and strong lines. Two w windows: 1928 signed *H. J. Constance*, and 1950, *Powell*.

ST MARY (SANTES FAIR), Gray's Inn Road. 1865–6, by *William Butterfield*, built for the Rev. E. O. Phillips, later Dean of St David's, as the Welsh church, for £2,212. Butterfield quarrelled so severely with Phillips that he abandoned this job and refused to work at Llanbadarn Fawr where Phillips was on the restoration committee, writing 'I cannot undertake to act with him again in any way.'

The church is well placed in a square of modest houses then being built by the Nanteos estate, the ground sloping so that the E end rides high, the best feature of the building. Clerestoried nave with aisles, chancel, w bellcote, and N porch, in the dark local stone with ashlar Dec tracery. Simple whitewashed plaster, even to the arcades, accentuating the focus to the E. Broad low chancel arch on short corbelled shafts. Unusual roofs: gawky and angular in the nave, the sides in two pitches and the trusses arch-braced with spandrels and apex infilled. The curious schematic wind-bracing, more flat panels than emphasized structure, suggests an unconventional attitude to form and function. The chancel roof is slightly enriched: the truss carried on a short column shaft, and the bay over the sanctuary panelled. – REREDOS. Stone with circular panels, painted in geometric patterns, and centre cross under a cusped arched head. Other simple fittings by Butterfield: STALLS with cusped open panels, panelled timber PULPIT, octagonal FONT on a quatrefoil shaft, gilded and painted. – ORGAN. In a Gothic case, *c.* 1840 by *T. J. Robson* of London, from St Michael. – STAINED GLASS. E window 1861 by *Heaton, Butler & Bayne*, originally in St Michael, re-set here in 1892 by *John Davies* of Shrewsbury. Three big pictorial scenes, without the quality of their work in the later 1860s, though the faces show a Gothic sensibility. Chancel s window by *John Davies*, 1892, old-fashioned. N aisle, first window to the Rev. E. O. Phillips †1897,

C15 style; second 1925 by *H. Wilkinson,* conventional C15 style, but well handled, and third, by *A. O. Hemming,* 1903.

OUR LADY AND ST WINEFRIDE (R.C.), Queen's Road. 1874–5, by *George Jones & Son* of Aberystwyth. Local stone, with big four-light Dec. W window and squat base of an unfinished SW tower and spire. Thin roof trusses, the E wall rebuilt in 1953. Contemporary fittings include a carved stone REREDOS by *R. Boulton* of Cheltenham, stone PULPIT and drum FONT. – ORGAN. Mahogany late C18 or early C19 instrument from a private house.

BETHEL BAPTIST CHAPEL, Baker Street. 1888–9, by *T. E. Morgan* of Aberystwyth. Derived from Richard Owens' Tabernacle Chapel (*see* below), with big pedimented frontispiece flanked by balustraded wings, but richer. Owens' slight Gothic within a classical frame is taken further, with Gothic porches and traceried roses to the main window heads. Rock-faced Llanddewi Brefi stone with Grinshill sandstone dressings and pink granite outer pilasters. The interior also rich, with ribbed coved ceiling, curved-ended GALLERY on florid columns, iron-railed great seat and pulpit platform backing onto a big pilastered aedicule with small rose window.

ENGLISH BAPTIST CHAPEL, Alfred Place. 1869–70, by *Richard Owens* of Liverpool, round-arched detail varied with a crude dose of Gothic. Big centre wheel window and gabled hoods over the outer windows. Interior with single end gallery.

ENGLISH CONGREGATIONAL CHURCH (former), Lower Portland Street. 1865–6, by *Paull & Ayliffe* of Manchester. Now subdivided and without the bell-stage and spire of the tower. It was a High Victorian work of some character. Stone with minimal polychromy, and an angular slate spire derived from G. E. Street's St James the Less, Vauxhall Bridge Road, London.

ENGLISH PRESBYTERIAN CHURCH (now St David's United Reformed Church), Bath Street. 1871–2, by *Richard Owens.* Thoroughly Gothic, as the English preferred, tall gable between two thin, high pinnacled turrets, and outer stair-towers with canted angles and steep hipped roofs. Harsh, and sometimes odd, as in the squat colonnette in each turret buttress. Transepts added 1905, by *G. Dickens-Lewis.* Low, T-plan interior with elliptical panelled roof; W gallery in pitch pine with punched roundels. – STAINED GLASS. 1988 by *John Petts,* two windows with lettering on a pink and blue ground.

Large SCHOOLROOM. 1902, by *J. Arthur Jones,* stone and yellow terracotta, with asymmetrical turret.

ST PAUL'S METHODIST CENTRE, Queen's Road. 1991–2, by *Cornfield, Crook & Walsh* of West Bromwich, taking the corner with a big octagonal entrance block, in yellow brick, deep-eaved and with brown brick wings. It replaces a Gothic spired English Wesleyan Chapel of 1869–70 by *W. H. Spaull.*

ST PAUL'S WELSH WESLEYAN CHAPEL (former), Upper Great Darkgate Street. 1878–80, by *W. W. Thomas* of Liverpool, for the exceptional sum of £6,000. Reused 1999 as the Academy

public house. Monumental classical front in rock-faced blue-grey Llanddewi Brefi stone with beige Stourton sandstone dressings. Centre recessed giant Corinthian columns frame heavily moulded windows and doors, all a little cramped. The more generous wings with big arched windows to each floor, once had French pavilion roofs behind balustrades. The design seems based on the Manchester Great Synagogue of 1857 by Thomas Bird, though that had domes instead of French roofs. Gallery on iron fluted columns. Round apse, originally for the organ, into which the pulpit has been lifted. The organ pipes reappear as backing to the bar in the adjoining SCHOOLROOM, 1903, by *J. Lewis Evans* of Aberystwyth.

SALEM CALVINISTIC METHODIST CHAPEL, Lower Portland Street. 1895, by *T. E. Morgan*. Gothic gable façade, divided in three by pinnacled buttresses, transepts added 1907.

102 SEION INDEPENDENT CHAPEL, Baker Street. 1877–8, by *Richard Owens*. Unified Italianate detail, without the Gothic tinge of Tabernacle or Bethel. Two-storey pedimented façade, made monumental by paired giant pilasters framing the centre. The interior is a surprise, a curved GALLERY on thin iron columns repeated above and carrying a thin upper arcade. The ceiling is ribbed from short iron columns corbelled out between the arcade arches. Gallery front in long horizontal panels, balustraded deacons' seat and pulpit platform. Large organ of 1900 by *Norman & Beard*.

TABERNACLE CALVINISTIC METHODIST CHAPEL, Powell Street. Disused. The fourth chapel on the site since 1785. 1878–9, by *Richard Owens* in a style he called Italo-Lombard. Dark stone with sandstone dressings. Pedimented classical centre like Seion (*see* above), between balustraded wings, but weaker in emphasis, with thinner pediment, single pilasters at first-floor level, and three doors confusing the ground floor. Gothic plate tracery in the window heads startles in so classical a frame, but clearly impressed locally, as can be seen at T. E. Morgan's very similar Bethel Chapel (*see* above). Very large interior with coffered plaster ceiling and U-shaped gallery on florid fluted columns. The organ in a Gothic case dates from 1905.

Outside, fine bronze WAR MEMORIAL, 1923, by *Mario Rutelli*, a winged youth carrying an armful of olive branches.

ABERYSTWYTH CASTLE

On the rocky promontory dividing the bay from the Rheidol estuary. This was the southern castle in the ring built to encircle Llewelyn the Last's Gwynedd stronghold after Edward I's devastating campaign of 1276–7. The castle, long called Llanbadarn Fawr, was begun in 1277 on a new site more easily provisioned by sea, replacing the earlier Norman castle of 1109, 2 m. S on the far side of the Ystwyth. A large workforce from England under *Ralph of Broughton*, possibly succeeding *Henry of Hereford*, built the castle and the town walls by 1280. A report by the justiciar

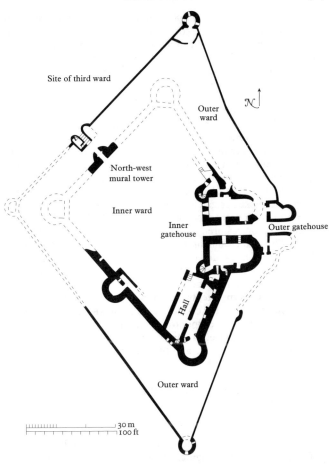

Aberystwyth Castle.
Plan

of West Wales, Bogo de Knovill, in 1280 however found such faults that a *Master Thomas* was sent from Bristol to remedy defects, but little was done before the castle and town were taken in Llywelyn's final revolt of 1282, and the castle was severely damaged. The repairs were put directly under *Master James of Saint George*, the Savoyard Master of Works, supervised by *Master Giles of St George*, and completed by 1289. Some £4,300 was spent between 1277 and 1289. The site proved its worth during a siege in 1294, when Madoc ap Llywelyn was unable to prevent relief from coming by sea.

By 1320 the castle was recorded as being in poor condition. Another survey in 1343 found roofs and chimneys damaged by storm, the 'long chamber' collapsed, and the walls and towers of the 'third bailey' all but destroyed by the sea. It was besieged by Owain Glyndwr in 1402, captured in 1404, when the town was

burnt, and recaptured in 1408, with the aid of cannon fire. There were C15 repairs but by 1561 all was in decay, though the hall retained its roof. Sufficient buildings were standing for Thomas Bushell to mint silver coinage from 1637 to 1643 and for a Royalist garrison. Besieged and taken in 1645–6, the castle was thoroughly slighted in 1649 and remained a stone quarry until the C19 when walks were laid out and the dry moat filled in.

The castle conformed to Edward's other new works (cf. Rhuddlan, Harlech, Beaumaris) in having an enlarged gatehouse as the principal accommodation, rather than a keep, and it has close-spaced double curtain walls to the same unusual diamond plan as at Rhuddlan. The Civil War slighting makes Aberystwyth disappointing compared to the more substantial North Wales survivors but the plan of inner and outer walls, with round angle towers and close-set gatehouses, can easily be traced. From the site of the outer gatehouse, on the E, which had rounded towers, fragmentary or restored outer walls run up to N and S round towers. The outer walls on the W are more fragmentary still, but the remains of a NW gatehouse into the outer bailey can be seen below the postern tower of the inner ward. The inner ward has the gatehouse-keep on the E with double rounded towers, the l. one now more complete, but the inner walls are much depleted. The N and W corner towers have gone. The SE wall with remains of the great hall, the S corner tower and the base of a mural tower on the SW wall survive. The best surviving feature stands alone, but was on the NW wall: a D-plan mural tower over a postern gate, complete to full height, with taller stair-turret. Excavation has revealed another long range against the NE wall, and traces have been found of Civil War earthworks.

PUBLIC BUILDINGS

TOWN HALL, Queen's Road. 1961–2, by *S. Colwyn Foulkes*. Neo-Georgian with thin Adamesque portico set against a high white wall, stepped down to plain, low wings. Flat parapets and minimal ornament in the way of more cautious municipal buildings since the 1930s. Full-height entrance hall within. The plan was dictated by the remains of the previous Town Hall, burnt out in 1957, by *William Coultart*, 1848–51, which had a florid Ionic portico and single-storey wings.

COUNTY OFFICES, Albert Place. Built as the Queen's Hotel at the N end of the sea-front at the same time as the Castle Hotel (see Old College) was being built at the S end. 1864–6, by *C. F. Hayward* with *H. D. Davis* of London, the plans signed by Davis. Contemporary with Hayward's Duke of Cornwall Hotel in Plymouth, though altogether more stolid. Heavyweight High Victorian detail, occasionally Gothic: a big thirteen-bay sea-front dominated by mansard roofs with an array of chimneys and dormers, and a pavilion tower near the S end. Entertaining geological panels of different stones and quartz under the ground-floor windows. Inside, coarse

detail: bald entrance hall and stair with some stained glass, N dining room aisled with arched trusses. The hotel failed and was sold 1877. Altered as county offices, 1950, by *G. R. Bruce*, and used as County Hall until the new offices were built at Aberaeron.

NATIONAL LIBRARY OF WALES, Penglais. The most important cultural building in Wales, sited in Aberystwyth as central to both North and South Wales, also because of the strength of the Welsh language here, and the presence of the University College. Cardiff was given the National Museum in compensation. The impact of the great white stone building, Aberystwyth's 'Parthenon', alone on the hill, has been dissipated since the University took the heights above.

Sydney K. Greenslade won the competition in 1909 with an understated astylar classical design, relying on mass for effect. His plan was a cross within a square: the cross being circulation space with centre rotunda; the square the W front administration block, N main reading room, S exhibition gallery over print room, and rear low manuscript room masked by a bookstack block behind. The ends of the N and S ranges were brought forward and emphasized each with a very large arched window, while the administration block between had an odd syncopation of panelled piers, the detail a wayward Beaux-Arts classical.

The wings and manuscript block were built 1911–16. Greenslade resigned in 1927, and the front range was built to a modified design in 1935–7 by *Adams, Holden & Pearson*, who had come second in the 1909 competition. Holden regularized the façade with even giant pilasters, and the wider centre bay has a pair of recessed giant Ionic columns closely flanking a pillared porch, a contrast of scale reminiscent of C. R. Cockerell. Portland stone with painted metal windows, on a Cornish granite high basement, with terraces and monumental flight of granite steps up to the porch. The cruciform circulation space was only built 1950–5, omitting the rotunda. Instead a pillared and clerestoried spine hall, a touch of Glasgow Greek, opens onto a bland staircase. Infilling a courtyard, Drwm, a stainless-steel clad oval lecture hall, 2003, by *James & Jenkins*. Rear bookstack blocks of 1928 (completed 1965), 1969 (completed 1982) and 1995–7, the last by *Burgess Partnership* of Cardiff.

Greenslade's principal interiors are the N Readers Room, and S Gregynog Gallery. The 175-ft (53.3-metre) READERS ROOM is impressively tall, with coffered curved ceiling, cross-vaulted at the centre, carried on tall paired square piers; the aisles behind are shelved and galleried on three levels. The concrete piers were intended to be oak-panelled and the crude wood gallery rails to be temporary. As abandoned, they give a spurious modernism. Marble STATUE of Sir John Williams, 1923, by *Mario Rutelli*. The GREGYNOG GALLERY in the S wing, at first-floor level, has a similar ceiling, cross-vault and aisles, the piers here stuccoed. The Print Room has recently

been restored, and the manuscript block at the rear is no longer in public use. In a courtyard, DRWM, neatly-inserted cylinder lecture room, 2004, by *James & Jenkins*.

Holden's most interesting interior is the first-floor Council Chamber, with inventive yellow and white marble surrounds to the electric fires each end and big four-globe bronze hanging lamps. Surprising details, as so often with Holden, the timber cornice paying no attention to the alternating wall bays, and the front wall articulated by semi-cylindrical recesses, as if columns have been purloined.

In the cross hall, busts by *Sir W. Goscombe John*: Henry Owen 1907, Sir John Rhys 1909, Sir Evan Jones 1924, Sir John H. Lewis 1927, Sir John Williams 1896. Also Sir Daniel C. Thomas by *H. B. Pegram*, 1939.

At the N end is a sympathetic addition for the BOARD OF CELTIC STUDIES, 1992, by *John G. Roberts* of the *Welsh School of Architecture*. Two storeys, like a Modernist classical villa, 2–3–2 bays, the centre broad entry with inset columns. Bust of Edward Lhuyd by *J. M. Morris*, 2000.

PUBLIC LIBRARY, Corporation Street. 1905–6, by *Walter G. Payton* of London. Attractive free C17 classical dressings of red sandstone against brown local rubble. Sober ground floor under a playful upper storey with a steep gable between grandly Ionic outer bays. Period interior with glazed tiles.

POLICE STATION, Park Avenue. 1992–3, by *Graham Bailey* of *Alex Gordon Partnership*. Quite a striking design, breaking from the anonymity of post-war Modernism. Two-storey ranges in smooth blockwork and render under big deep-eaved roofs, hinged on a conical-roofed corner tower. A touch of Scots Baronial, and a hint of C. R. Mackintosh. The entrance, not in the tower, set in a concave wall of glass bricks.

CEREDIGION MUSEUM, Terrace Road. The former Coliseum, 1904, by *J. Arthur Jones*. A cheerful grey stone and yellow ter-racotta theatre in Edwardian classical mode: domed cupolas flanking a gable with pilasters and Edward VII in a niche at the top. The ground floor was unusually a T-plan shopping arcade (all altered) with the auditorium on the first floor. A late example of the music-hall type, two curved galleries with con-tinuous pierced cast-iron fronts.

UNIVERSITY COLLEGE. *See* University, below.

BOARD SCHOOL (former), Alexandra Road. 1872–4, by *Szlumper & Aldwinckle*, a competition victory. Gothic, with steep gabled wings flanking a five-bay hall with spired timber lantern. It held 600 even before the long rear additions of 1910. These have a stepped array of gables to Park Road and cheerful flat-capped and onion-domed roof ventilators. Converted to offices, 1994, by *James & Jenkins*.

PENGLAIS SCHOOL, Cefnllan. Built as Dinas Secondary Modern School in 1954, by *G. R. Bruce*, County Architect. Brick and roughcast with copper roofs. Larger new buildings of 1973–5 in red brick with opposed metal-clad monopitch roofs.

PENWEDDIG SCHOOL, Llanbadarn Road. The former County School. 1897, by *T. E. Morgan*. Ardwyn, a villa of *c*. 1875, is the l. wing of a balanced E-plan composition with a gabled centre hall. An odd sequence: Victorian domestic villa with matching copy, the hall with old-fashioned Gothic lancets, but Northern Renaissance detail in the gable.

PLAS CRUG PRIMARY SCHOOL, Plas Crug. 1970. With the split roofs typical of the 1960s and banded metal windows. It replaces Plas Crug Farm, an intriguing building with one hollow square tower, possibly a mid-C18 folly, and possibly on the site of a C12 Norman fort.

BRONGLAIS HOSPITAL, Caradoc Road. 1966. Two five-storey blocks in sequence, such that the symmetry of the gridded elevations is unappreciable, and thin marble cladding fails to dignify the mean entrances and boardroom oriel. On the site of the workhouse of 1839–41, by *W. Coultart*. A low two-storey addition of 1997 to Penglais Road, by *Estate Care Design* of Cardiff provides a more welcoming curved courtyard entry.

WAR MEMORIAL, by the Castle. 1923, by *Mario Rutelli*. A tall tapering octagonal shaft in tooled stone capped by a winged Victory. On the base, a buxom bronze female surges forward, 'Humanity emerging from the horrors of War'. Unexpectedly sensual for a Nonconformist country. 115

ABERYSTWYTH HARBOUR. On the estuary of the Rheidol, w of the bridge, but with the Ystwyth flowing in at the beginning of the s pier. Two stone piers, w and s, 1836–40 by *George Bush*, engineer, repaired 1867. At the end of the w quay, LIFEBOAT STATION of 1994.

ABERYSTWYTH PIER. Remnant of the 800-ft (243.8-metre) original, by *Eugenius Birch*, of 1865. The short stub that remains carries the PAVILION of 1896 by *George Croydon Marks*. Iron nave-and-aisles design, with curved roofs and keel-like dormers. The original detail largely lost, but the iron roofs survive above the present ceilings.

TREFECHAN BRIDGE. 1887, by *James Szlumper*. Rock-faced stone, three arches, replacing *John Nash*'s five-arched bridge of 1797–1800, destroyed by flood.

RAILWAY STATION, Alexandra Road. Neo-Georgian front building, 1924, by *Harris & Shepherd*, built for the G. W. R. Not prepossessing, despite the size. Imitation stone, two storeys, with parapet, festoons over the end pavilions, and clock turret at one end, to upset the symmetry. Behind is the original station of *c*. 1864–7, red brick with sandstone dressings like Borth station (q.v.), possibly by *George Jones*, for Thomas Savin. Platform canopy of 1893–4, with Gothic brackets. Disused platform opposite with iron columns stamped *J. Morris*, Welshpool.

CLIFF RAILWAY, Constitution Hill. 1895–6, by *George Croydon Marks*, of the Aberystwyth Improvement Co. which remodelled the pier and built the Hotel Cambria (q.v.). It cost £60,000, and was worked by water-balance, replaced by winding gear in 1921. At the top was Luna Park, a pleasure garden with camera 3

obscura, reading-room, dance-hall, fairground, switchback-railway and other attractions. It failed, reputedly because no drink was sold. Station building in cheerful red brick and stone with Prince of Wales feathers in the gable. On top, CAMERA OBSCURA of 1985, with a 14-in. (35.6-cm.) rotating lens projecting images of the outside onto a screen within.

SCIENCE PARK, Cefnllan. On the edge of the University, developed as small office units, 1978–80, by *Dale Owen* of *Sir Percy Thomas & Partners*. Single-storey, brown brick with bright green steel verandas. Informal layout, but turning its back on the spectacular sea view. Two cedar-clad buildings with curved roofs added behind in 2004 by *Dilwyn Roberts*.

THE UNIVERSITY

THE OLD COLLEGE

This most exotic of High Victorian buildings has an extraordinary history to match, its construction achieved against enormous odds. On the sea-front site, and remaining embedded in the later buildings until 1897, was Castle House, a stuccoed triangular marine villa, built for the theorist of the Picturesque, Sir Uvedale Price, by *John Nash* in 1791–4. This was an experimental building, more a fantasy from the landscapes of Claude than a castellated villa. The centre was bow-fronted with a hemispherical balcony canopy above. At the corners were diagonally set square ground-floor rooms, carried up as octagonal towers with small bedrooms, three each floor. Arched windows, roundels, and no battlements, i.e. without medieval detail outside, and the interior was a Neoclassical play on geometrical room shapes. Price, then writing his *Essay on the Picturesque*, determined the design with a painterly eye. The villa was set on the rocks of the foreshore, relating to the castle and the craggy backcloth of Constitution Hill. Price wanted to skew one room N for the view up the coast, but he, or Nash, still looked for symmetry, so the other two corners were servants' hall and kitchen. Nash, later, would be more archaeological and asymmetrical; here the influence of romantic classicism was still evident.

Castle House was bought in 1864 by Thomas Savin, promoter of the newly arrived railway, as the core of a tourist hotel. Hotel building was a mania of the 1860s; Savin also built a hotel at Borth (q.v.), and planned others at Towyn and Aberdovey, and the 83-bedroom Queen's Hotel (q.v.) was built in Aberystwyth at the same time, equally ill-fated. Savin chose as architect *J. P. Seddon* and work began immediately, even before plans were complete. A 100-ft (30.5-metre) dining room was added to the s of Castle House, of rendered brick. A bedroom storey followed, in timber frame, as the lower walls were not strong, with flat roof, wall-face chimneys and a conical end tower. It looked odd and North German, odder when in 1872 a big mansard roof was added for the college gymnasium. Seddon was pleased to rebuild the whole range in 1887. This overtakes the story of the N wing,

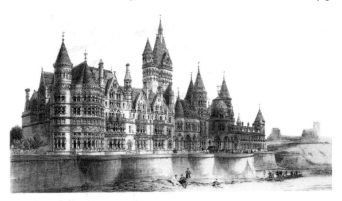

The Old College, by J. P. Seddon, 1871, design.
Engraving

started later in 1864, on a far more ambitious scale: a massive stone Gothic pile, with bedroom and sitting-room suites on the American plan and lavish public rooms. The suites had sitting rooms on the sea-front with bedrooms in a centre spine, across a top-lit corridor, and on the landward side were cheaper bedrooms only. Seddon again had no time – there was a basic wooden model and details were drawn as required – but the concept was epic, ascending from two storeys of public rooms by Castle House to a massive six storeys at the N end. A play of curving shapes in plan, the façade was to be a jagged outline of gables, chimneys and roofs, overtopped from behind by a sheer tower of complex curved plan, under a vertiginous slate roof. Sculpted detail climbed upwards, thinning towards the upper heights. Much of the effect intended was achieved, but the 1871 perspective, on display within, shows how much was not.

In 1866 Savin was bankrupt, having spent £80,000, and the hotel was finally sold for £10,000 to the promoters of the University College of Wales, high in hopes, but short of capital. Seddon was retained. His 1871 perspective represents more hope than expectation, showing not just the completion of the N wing and the sublime roof of the tower, but also the remodelling of Castle House. The college opened in 1872 with three staff and twenty-six students, but even these could not all be housed, as there was no money for furniture. The gymnasium was added to the S range in 1871–2 and Seddon completed some unfinished details, but so little money was raised that closure and a move to Bangor was proposed. Seddon was nearly ousted for *T. W. Aldwinckle*, whom the authorities hoped might be cheaper, but survived and was revising his plans for economy in 1885 when fire gutted the whole N range. Only Castle House and the S wing remained, both of which, ironically, Seddon intended for rebuilding.

Looking for economy, the college held a competition in 1886 for an undecided new site, which was won with a dull design by

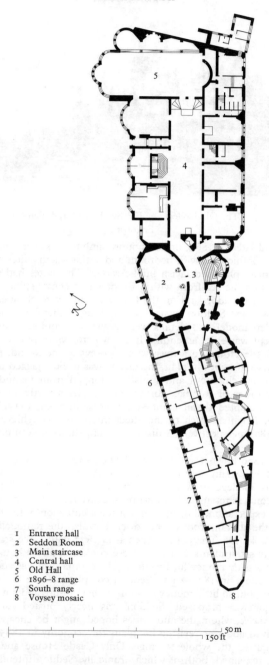

1 Entrance hall
2 Seddon Room
3 Main staircase
4 Central hall
5 Old Hall
6 1896–8 range
7 South range
8 Voysey mosaic

The Old College, by J. P. Seddon, 1871.
Plan

F. Boreham, but Seddon managed to persuade the college that restoration would be cheaper. The decision was welcomed by *The Builder* which called the N wing 'one of the most original and characteristic monuments of the Gothic Revival'. Seddon's new plans greatly simplified the N wing internally, and proposed a sadly plainer and lower N end gable. The structurally suspect S wing would be refaced in stone, and eventually Castle House would be replaced by a great hall.

From 1887–9 Seddon, with *J. Coates Carter*, rebuilt the S wing as science laboratories, in stone with a conical-roofed end tower. The N wing lost a gable to the r. of the finial gable, but Seddon was fortunately able to complete this to the height originally proposed, if to a simpler design: the trilobe front, untouched since 1866, was capped at two storeys, and the gable above built flat-fronted with a big window for the library. The interior was cleared behind the front rooms for a broad full-height great hall. Costs still overran and Seddon was ousted in 1890 in favour of *C. J. Ferguson* of Carlisle, who fitted out the library in 1891–2, and replaced Castle House in 1896–8, with a four-storey Gothic range, the final element in the story.

Exterior

THE N RANGE. Seddon, like other leading Gothic architects, struggled with the opposing evils of 'copyism' and 'singularity' (seeking after novelty for its own sake). His way forward was to take inspiration from the forms of nature, and use ornament organically and not as if applied, a typically Ruskinian approach. Seddon's originality lies in his very fluid use of curves and complex geometrical forms, and in the blurring of angles and joins, a syncopation that has something of Art Nouveau. Form does follow function, in that staircases are expressed, principal rooms given different scales of detail, and ornament is confined to leading structural elements. But this explains little of the sheer excitement of the building, especially when set against other large hotels of the period, where four-square mass is varied only by exotic rooflines.

Seddon's detail mixes E.E. and Early French with Venetian Gothic in some of the fenestration. Cefn sandstone from Ruabon is the main walling stone, with Bath stone dressings, and column-shaft window mullions of different coloured stones. In the work of 1887–9 Seddon, always a pioneer in this respect, introduced imitation stone and concrete, outside as well as in, showing outside as a grey chequer on the upper gables.

THE N WING. The sea-front begins on the r. with the oval belly of the bar and billiard-room block, actually a complex triple curve as the front appears to have swallowed two round side turrets in bellying out. Strong horizontals keep control, under a lampshade roof between conical spires. Next is an ascent, first three storeys, then higher with two dormer gables, then,

416 ABERYSTWYTH
after an extraordinary octagonal chimney, to four storeys. All this is as originally designed; there was next a bigger gable (removed after the fire) before the massive final section which was to have had a trilobe front, abandoned in 1866. The trilobe was capped in 1887–9 at the second floor (equivalent to three storeys elsewhere), and a flat gable built above with a big five-light window to light the library. The round tower on the end wall was intended to be conical-roofed, but was capped flat after Seddon's dismissal.

87 On the landward side, the short section of porch, entrance and stair tower behind the bar and billiard room, is the most extreme part of the whole building. The elevations result from an unparallelled multiplicity of staircases (there were three just within the entry, product of the wildly different levels both within the new work and as related to Castle House). A porch, triangular in plan, twin-gabled and massively detailed, is set onto a wall that is subtly in two planes, the left side canted back, and traversed by a lovely eaves gallery with trefoiled arches and a parapet. A second gallery above, in timber, is an addition by *Ferguson*. All this is dwarfed by the tower to the right, actually a double stair-tower, the main part subtly lobed in plan with Gothic windows marking the two-storey real extent of the stair, and the next four storeys simply storage rooms, accessible via the narrow circular service stair to the r., apparently of nine storeys. There is a baldness to these giant pipe shapes, because they were to carry complex slated roofs. Even in 1887 Seddon hoped for a full belfry (excused as an observatory) with steep roof and Sainte-Chapelle flèche.

The six-storey bedroom range to the right is sheer and severe, reminiscent of Deane & Woodward's Meadows Building at Christ Church, Oxford, the collegiate look enhanced by long windows apparently lighting staircases, but actually employed simply to vary the otherwise overly horizontal lines. Splendid array of gables and clustered cylindrical chimneys on the wall-head.

THE CENTRE RANGE. *Ferguson*'s brief in 1896–8 cannot have been easy, to replace Castle House with something that would link Seddon's disparate N and S ranges with an effective centre-piece. Without being strident he achieved a transition that works. On the seaward side the bald four storeys of tall grouped windows is varied by minor changes in the detail between the gabled l. side and the r. side which has three dormer gables. The emphasis here is on window where Seddon's is on mass and wall, and the trickery with detail disguises a well-lit class-room stack akin to those of the London Board Schools. On the landward side Ferguson is commendably curvaceous, with a round tower embedded in the sheer wall jutting out from Seddon's front and then a big shallow-curved bay with tall late Gothic windows, two floors joined vertically and the top floor with an ogee-headed arcade and parapet.

THE S WING. Seddon's 1887–9 redesign gives the seaward front a long even nine-bay range of two-light upper windows over

large pointed ground-floor windows, with odd tracery, radiat-
ing like fanlights. The emphasis is on smooth walling, carried
without a break to the end tower. This is five-sided on the lower
two floors and cylindrical in the big top stage, clasped by two
small tourelles. There was a small answering turret at the l.
end, lost when Ferguson's block was built. The severe geome-
try of this range shows influence of William Burges.

On the curve of the tower, three large MOSAIC PANELS,
1887–8, by *C. F. A. Voysey*; a seated God-like patriarch, offered
a locomotive and ship by kneeling youths – technology
acknowledging pure learning. Voysey was forced to remove a
downcast pope, symbol of superstition, from under the feet of
the main figure. Boldly delineated with broad areas of colour,
an intriguing early work by so important a designer.

The Interiors

The interiors have suffered neglect and need some spirited colour
decoration, but still have a robust and quirky power. A
rib-vaulted ENTRANCE HALL leads onto a curving passage
squeezed behind the SEDDON ROOM, the oval former hotel
bar. Ashlar late Gothic screen wall by *Ferguson*. Originally a
double row of columns between passage and bar gave views
through to the sea. The first row of paired columns has been
replaced by the screen wall, and the pair of triple columns
beyond are now within the Seddon Room. They carried a triple
arcade answering the stair screen opposite. A very shallow
timber-ribbed vault within, on corbels, has been removed or
covered by a modern flat ceiling. At each end, a massive semi-
circular hooded fireplace of splendid strength. On the other
side of the passage, behind a screen of paired columns, rises
the MAIN STAIRCASE, a tour de force of Gothic design. A 87
single first flight branches to two cantilevered return flights
with hefty stone balustrades. The landing is trilobed in plan,
and from the newels two single ringed shafts carry a densely
ribbed vault. On the upper landing, a triple arcade. All this
gave access only to first floor billiard and smoking rooms, both
modernized.
The ground floor passage leads E to the CENTRAL HALL created
in 1887–9, a tall and narrow space with massively corbelled gal-
leries, in concrete, the different levels l. and r. reflecting the
difference in floor levels. Open timber roof, completed 1890,
to a most un-medieval curved form, panelled, the centre panels
glazed and the trusses cusped. On the l. side, a triple-arched
screen to a stone staircase, cantilevered, dividing, and bridged
at first-floor level. The Gothic balustrades and corbels are
again of concrete. In the hall, STATUES of T. E. Ellis by *W.
Goscombe John*, 1903, and Lord Aberdare, 1890, the plaster
original of *H. Hampton*'s bronze in Cathays Park, Cardiff. The
walls originally a terracotta colour. The OLD HALL at the E
end (the hotel drawing room) is very Gothic, trefoiled in plan
each end and with vaulted recesses for musicians along the E

wall. The flat ceiling is a disappointment, presumably a timber vault was intended. The LIBRARY above has a trefoiled end bay, behind a triple arcade, and E wall recesses. The roof is Seddon's, trilobe with boarded panelling. Ferguson's fittings of 1892, a screen across the centre, and the recessed bookcases on the W wall under a gallery, are in an attractive, and lighter, C17 vein.

The interiors of the S wing and the centre block are unremarkable, but in the centre block, in the former Principal's House, a late C18 marble CHIMNEYPIECE from Castle House.

Outside, facing the sea, STATUES of T. C. Edwards, the first Principal, by *W. Goscombe John*, 1920s, and Edward, Prince of Wales (Edward VIII), as Chancellor of the University, 1922, by *Mario Rutelli*, an implausible marriage of youthful looks and academic gravity.

ALEXANDRA HALLS, Victoria Terrace. 1896–8, by *C. J. Ferguson*. A women's hall of residence, at the extreme end of the Promenade. Four to five storeys, stone, somewhat barrack-like, but with five shaped gables for variety. Disused and decaying in 2004.

SCHOOL OF ART, Buarth Mawr. Built as the Edward Davies Memorial Laboratories, 1905–7, by *A. W. S. Cross*. Prominent on the hillside in views across the town, with its big segmental pediment and cupola. Wren-influenced, but the heavyweight ashlar detail works better from a distance. Grandly planned interior with tunnel-vaulted first-floor laboratories off a top-lit stair. Adapted very well in 1995 as the School of Art, when the extension of *c.* 1970 was completely reclad and given a pitched roof.

THE PENGLAIS CAMPUS

The main campus of the University occupies a magnificent W-facing hillside site bought in 1929. A first intention to employ *S. K. Greenslade*, architect of the National Library, came to nothing, as did a grand formalized classical scheme of 1930 by *H. V. Lanchester*. This was replaced in 1935 by a still formal but less axial plan by *Percy Thomas*, with strictly Neo-Georgian halls of residence facing over the drive to the National Library, and the main academic buildings in two long ranges further up. These were to be in a weak moderne style, with hipped unbroken roofs and lines of horizontally banded metal windows, the front range centred on a tall-roofed hall with cupola, the rear range articulated by towers in the mode of the Hoover Factory, Perivale, West London. Of all this only the halls of residence, 1948–60, the N end of the front range, 1937, now the Institute of Rural Science, and the swimming pool, 1939, were completed, in amusingly contrasting styles: Neo-Georgian, Moderne, International Modern. The Biology Building followed in the 1950s, at the other end of the intended front range, but to a modified design.

In 1957 the 1935 plan was jettisoned for a quite different, informal layout by *Sir William Holford & Partners*, *Ward Shennen*

partner-in-charge, with a scatter of long four-to-six-storey blocks informally related. Only the Penbryn Halls of Residence (1960–5) were built. The Percy Thomas firm continued on the site with the Physics and Llandinam Buildings, 1955–60, following the new fashion for curtain-walled ranges interspersed with point blocks.

In 1964–5 a new overall scheme was adopted. This was by *I. Dale Owen*, of *Percy Thomas Partnership*, who continued as the principal co-ordinating architect until 1990, and to whom the refocusing of the site is due. The earlier lack of unity, and the unsatisfactory relationship between buildings and the Penglais site generally, were to be remedied. The new plan has affinities with new universities elsewhere in Britain: emphasis on landscape setting, flexibly extendable teaching blocks and a core piazza or concourse. The Aberystwyth plan responded to the steep site with emphatically horizontal terraced blocks parallel to the contours, broken for broad viewing platforms. The student housing was to be in point blocks at the top. Greater unity would be achieved by a single colour for external cladding – grey Cornish granite aggregate and grey brick – while the fingers of landscaping, lawn and trees, would emphasize the horizontal theme.

When the plan was revised in 1974, the density was greatly reduced. The new buildings were now to be predominantly on the upper part of the site, only occupied so far by the Penbryn Halls. The existing science buildings below to the w were unaffected, while to the s a green swathe would be left open to provide a setting for the new centre. This was to be terraced above the entrance drive so that the views out were not obscured, with the new main piazza as the centrepiece of the entire site. New halls of residence were to be at the upper NE corner.

The 1974 plan was mostly complete by 1980. A proposed student village on top of the slope to the SE was abandoned, and the Science Park (q.v.) is now on the site. The student village when built in 1992–4, was sited N of Penglais Road. Since 1990 there has been no co-ordinating architect, to some ill effect, as in the lower quality extension to the Hugh Owen Building.

The overall effect now is of one strongly linear band of buildings above the main drive which bisects the site. The row is terminated in the piazza with the Great Hall, a bold and dominant focus, offset by the slim bell-tower, the identifying feature from afar. Grey aggregate panels and shuttered concrete are the dominant materials, banded with windows and built out over walkways. The car parks beyond are reserved for future expansion. Below, the pre-1965 buildings are, as expected, amorphous, but brought into some relation by strips of planting (landscaping by *J. R. Ingleby*). Above, the residential sites are more informal.

1. The Main Concourse

Approached from the drive by a broad steep flight of stairs under a walkway, this is the core of the new University, all of 1967–70, by *I. Dale Owen*. The initial impact is sudden and impressive,

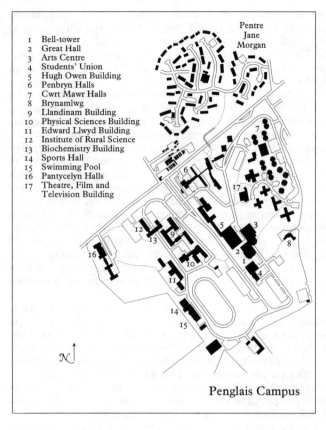

1 Bell-tower
2 Great Hall
3 Arts Centre
4 Students' Union
5 Hugh Owen Building
6 Penbryn Halls
7 Cwrt Mawr Halls
8 Brynamlwg
9 Llandinam Building
10 Physical Sciences Building
11 Edward Llwyd Building
12 Institute of Rural Science
13 Biochemistry Building
14 Sports Hall
15 Swimming Pool
16 Pantycelyn Halls
17 Theatre, Film and
 Television Building

Pentre
Jane
Morgan

Penglais Campus

⌐————————————————————————————⌐ 1 km
⌐————————————————————————————⌐ 1000 yds

and the view W stunning. Off-centre on the platform is the slim
BELL-TOWER, a boiler-flue clad in light grey granite aggregate
panels, well handled in the opposed angled cut-offs. The
GREAT HALL succeeds as a monumental centrepiece, the
façade essentially a great overhanging grey rectangle framing
a curtain of glass. Symmetry is dispelled by an off-centre upper
overhang, in paler granite aggregate, biting into the glazed
area. In plan, the building is a square hall on four massive
corner piers: chapel-like galleries with sloping undersides are
thrown out on three sides, but wrapped in a rectangular enve-
lope. It is one of the side galleries that shows on the front
façade, while the rear gallery provides the drama of the inte-
rior concourse. This is reached via a recessed and neutral
entrance hall, with ill-lit art gallery to the r. Designed as a
cloakroom, this was converted in 1986 to hold an excellent col-
lection of studio pottery collected in the 1920s for the School

of Art on the advice of S. Greenslade. From here, broad steps rise into a main space beautifully lit from the glass curtain façade. This area is a deep foyer, the open space pushed down to the Great Hall entrance on the r. by the aggregate-clad underslope of the rear gallery. Opposite, plain white concrete stairs rise to a mezzanine level, return and rise again, the last rise across the glass curtain. A narrow restaurant takes the space between the Great Hall and the glass curtain, roofed by the underside of the side gallery. Cast aluminium SCULPTURE, 1970 by *David Tinker*, on the screen wall to the Great Hall. The Hall interior is coolly elegant, square, with the galleries raking back from flush panelled side walls; the ceiling grid is the only competition to the overall smoothness. The chapel reminiscence in the galleries is intentional.

Behind the Great Hall is the THEATR Y WERIN, a 400-seat auditorium of 1971–3, by *Alex Gordon and Partners*, a severely functional cube with blockwork interior. Originally linked by a corridor, the internal relation was bleak but in 1998–9 the whole complex was transformed by *Peter Roberts* into an integrated ARTS CENTRE. The two existing buildings are now linked by generous new circulation space with new cinema, studio theatre, exhibition space, craft workshop and University bookshop, open to a sheltered s-facing lawn behind the Great Hall with easy access to the car parks. The new 1990s approach lays stress on the flow of outside spaces to inside, uses softer materials and, notably, delights in round or freely curving shapes. The transition from the heroic grandeur of the Great Hall to the new work with its sinuous flow of space is effortlessly handled. Externally, Roberts's building is far from reticent, harking to a quite different heroic aesthetic: that of late c18 Neoclassicism. From the lawn a great flight of steps with massive stone side wall rises through the curving glass wall of the foyer as if the lighter structure had been superimposed on a Piranesian relic. To the r. is a broad circular building with superimposed shallow domes separated by a glazed band. A metal-clad cylinder of comic-book space-rocket form breaks the seriousness. Ground-floor craft workshops open directly onto the lawn behind a colonnade, allowing classes to spill out into the open air. The workshops ring a circular cinema, with studio theatre under the clerestoried dome above. The cylinder contains an acoustic lobby to the studio theatre. To the l. of the steps the glass wall is two-storey with entrance to the lower level, the glass held inside by white-painted metal arms from tall timber poles, elegant and nautical. The upper level is set back on massive, smooth concrete mushroom piers. The lower level gives access to the craft workshops, cinema and bookshop to the r., the Great Hall to the l. and a double-height exhibition space straight ahead, built alongside the 1971 theatre. This double height allows viewing from a balcony at foyer level. Reception desks, bars and fittings (by *Angela Giddens*) are streamlined and curving, with natural wood dominant.

Returning to the main piazza, the STUDENTS' UNION, 1971–3, by *Dale Owen* with *John Vergette*, lies low to the r., a single band of large windows the main accent, the interior levels split at the entrance. Rear addition with curved roof and oak cladding, 2001, by *Gareth Lewis*. On the third side, the HUGH OWEN BUILDING, 1973–6, for the library and arts departments, by *Dale Owen* with *John Vergette* and *Neil Graham*. The library, a forceful rectangle, faces over the concourse, the aggregate-panelled upper floor with narrow vertical slot windows shading the window band of the reading room. The whole is carried over a walkway on pilotis. The original design was followed for the Arts Building, 1974–6, to the l., strongly horizontal, banded windows, and silver-grey brick, enclosing a narrow court. Matching N side added 1976–7, but unfortunately disparate extension behind the further corner, 1992, by *Alex Gordon Tweedale*, with pitched roof and an unhappy green aggregate band around the eaves.

2. The North and East

On the slope behind the theatre, MEDIA STUDIES BUILDING, 1999, by *Patel Taylor*. Red brown brick, in contrast to the silver-grey of the 1970s. The building houses two full-height studios separated by a central staircase that climbs regally from front to back, with pod-like offices to one side, stacked like dockside containers, and rehearsal rooms in front of the r. studio. Quirks of design promote unease to little obvious purpose: the entrance screen follows a slightly different line from the tall thin posts that carry the roof, such that two posts are within, two without, and the steel frame of the glazing runs out to the r. beyond the glass, like the carriage of a manual slide projector. The aesthetic within is Machine-Age, neither entrance hall nor stair promoting congregation. To the N, against Penglais Road, the PENBRYN HALLS, 1957–60, by *Ward Shennen* of *Sir William Holford & Partners*. A spidery plan of some seven blocks, all linked, neither formal nor picturesque. Above and E are the CWRT MAWR HALLS, 1967, by *Dale Owen*, a cluster of three-storey residential blocks, in brown brick. BRY-NAMLWG, to the S, on the site perimeter, is a conversion of 1973–4, by *Dale Owen* with *Neil Graham*, of an L-shaped farm range with modern boxy windows and dormers.

3. The Lower Slope

Below the main drive, INTERNATIONAL POLITICS BUILDING, to be completed in 2006, by *Ellis Williams Architects*, a major new addition. Below, to the NE, some of the pre-1965 muddle. The LLANDINAM BUILDING to the N and PHYSICS BUILDING to the S, 1958–60, by *Bill Marsden* of *Sir Percy Thomas & Son*, are sprawling layouts of curtain-walled blocks part-enclosing uncertain open spaces or car parks. Both have a short point block as main accent, typical of the era. The Llandinam Build-

ing tower is square, six-storey, cantilevered above one corner of the horizontal ranges; the Physics Building plays with curves, concave point block over a fan-shaped stone-clad lecture hall extended out in front. Below, BIOLOGY BUILD-ING, 1955, by *Bill Marsden*, is a long, flat-roofed, three-storey block with stone ends and windows in bands. Corner wings 1972. At the N end, the INSTITUTE OF RURAL SCIENCE, 1937, by *Sir Percy Thomas*, part of the 1935 design; a weak Geor-gian–modern mix, grey stone with flush Portland stone mul-lioned windows and hipped roof. Entertaining low-relief of agricultural figures sculpted around the door. The original axis is cut by the BIOCHEMISTRY BUILDING, 1963 by *Bill Marsden*, a rectangular slab. To the S, SPORTS HALL, *c.* 1965 by *Bill Marsden*, adjoining the SWIMMING POOL, 1939, by *Sir Percy Thomas*. Originally a neat International Modern cube with horizontally glazed window-wall set against windowless grey stone. Spoilt in the 1990s by reglazing and boxing of the eaves.

At the lowest, NW, corner of the site, above the National Library drive, are the PANTYCELYN HALLS, 1948–60 to a 1939 design, by *Sir Percy Thomas*, the most Neo-Georgian part of his 1935 plan. Thomas had to inflate Georgian models to command the site and, as at Carmarthen County Hall, made the main ele-ments the long, steep, hipped roofs, above broad masses of grey Forest of Dean stone. Two H-plan ranges of 3–9–3 bays flank a recessed square centre block of seven bays. All are an even three storeys with hipped dormers, low on the parapets. Only the N block, 1950, has the big stone chimneys intended, an economy that makes for blandness.

4. North of Penglais Road

PLAS PENGLAIS. A neat hipped three-bay villa with bracket eaves and curved dormers, mid to later C18, remodelled in 1841–2 for the Richardes family. An C18 elevation, attributed to *T. F. Pritchard* shows the façade of Shrewsbury flanked by tiny pavilions. Rebuilt as Vice Chancellor's residence in 1951 by *Sir Percy Thomas*, with new side elevation of 1–2–1 bays with three hipped roofs, the centre recessed.

PENTRE JANE MORGAN. A student village, 1992–4, by *James & Jenkins*, showing how far ideas had changed since 1970. Instead of blocks of single bedrooms, a large estate of small houses in short terraces picturesquely disposed on the hill-slope, more Milton Keynes than new university. Yellow brick and stucco alternate for the façades, and the overall plan separates cars and pedestrians.

PERAMBULATIONS

1. The Old Town

The medieval town plan is marked by Bridge Street and Pier Street as the S–N axis, crossed E–W by Great Darkgate Street. The

line of the walls, clockwise from the bridge, follows South Road, King Street, Baker Street, Chalybeate Street and Mill Lane. The older part of the town consists of narrow, tightly built-up streets, mostly faced in earlier C19 stucco.

1a. Bridge Street to New Street

By the Bridge (q.v.), were the medieval s gate and mill. On the l., low down by the river, a three-storey hipped WAREHOUSE, whitewashed rubble, perhaps with part of the corn-store used 1813 to 1825 as the town theatre, rebuilt in 1860. In BRIDGE STREET, some good three-storey Late Georgian houses (cf. North Parade below) with bracket eaves and columned or pilastered doorcases. No. 43, THE OLD BANK HOUSE, stuccoed with corniced eaves, looks no earlier, though in 1762 the Banc y Llong (Ship Bank), the first in Wales, was established here. Refounded in 1806 as the Aberystwyth & Cardiganshire Bank, it was taken over by the North & South Wales Bank in 1836. Paired Doric doorcase to the right, one door to the bank, one to the house above, with fluted pilasters and delicate overlights. No. 35, WESTMINSTER HOUSE, is particularly handsome, in stone, four bays with a well-detailed Ionic porch; the town house of the Pughs of Abermad. No. 26, CEREDI-GION, the town house of the Pryses of Gogerddan, early C19, tall five-bay roughcast front, with broad Ionic doorcase, double doors and fanlight. A wide entrance hall, the hall arch on paired Doric columns, leads through to an open-well stair. Further up, No. 19, stone, with a particularly nice double bowed shopfront. Opposite, set back, the OLD BLACK LION, late C18, stucco with bracket eaves, the doorcase columns with spiral reeding. On the corner of Queen Street, No. 12, COM-MERCE HOUSE, with a bold curve under bracket eaves. On the corner of Princess Street, an excessively busy stone and terra-cotta building of *c.* 1900. Nos. 1 and 3, the corner to Great Darkgate Street, tall and plain, early C19, four-storey with parapet. The streets in the SE quadrant of the medieval town, on the hill to the E of Bridge Street around Butterfield's church, were developed with artisan housing from 1864 by the Powells of Nanteos.

W of Bridge Street, in the SW quadrant, small streets built up between 1790 and 1834. PRINCESS STREET has two Late Georgian houses with good C19 shopfronts on the N, facing YR HAFAN, sheltered housing, 1985 by *Ceredigion District Council.* This takes a cue from the early C19, but scatters heavy details to fussy effect. Nos. 14 and 16, adjoining, have a pair of Doric columned doorcases. In ST JAMES SQUARE, MARKET of 1823, plain whitewashed stone, hipped, the metal roof trusses later, and the former LIBERAL CLUB, 1901, tall and gabled. HIGH STREET had small cottages of *c.* 1820, mostly rebuilt in the late C19. In VULCAN STREET, the former SION INDEPENDENT CHAPEL, 1823, a lateral front, originally stone, heavily stuccoed since, and further down, PARISH HALL, by *G. T. Bassett,*

1914, large with freely styled Edwardian detail in brown terra-cotta, broad arched entry and mullion windows. On the site of the 1812 Grammar School. Opposite, Nos. 12 and 14, a three-storey early C19 pair. Three streets lead down to South Road, mostly rebuilt in the late C19. In SOUTH ROAD, Nos. 18–32, to the E, a three-storey, early to mid-C19 terrace, and Nos. 34–44, *c.* 1900, with elaborate stucco decoration. Opposite is the CASTLE HOTEL, *c.* 1910, red brick and terracotta, with Baroque detail. The w end of South Road is part of a development of 1890–1 which included SOUTH MARINE TERRACE, facing the sea, built as holiday apartments, stucco and conservative. The NEW PROMENADE was extended around the CASTLE (*see* above), 1901–3, by *Rees Jones*, the Borough Engineer.

Around the castle, on the point, the WAR MEMORIAL (*see* above), then the OLD COLLEGE (*see* University, above). The area behind, now St Michael's churchyard and public gardens, was the heart of the Georgian seaside resort. Castle House, the first encroachment on the town commons, was allowed in 1788, and the ground in front of the castle was laid out as walks by John Probert *c.* 1790. Shortly after, W. E. Powell of Nanteos pro-posed building houses along the E side. Assembly Rooms on the N with formal gardens replacing the walks were proposed in 1810. The Rooms came in 1818 and the Laura Place houses not until 1827–30. St Michael's church followed in 1833, between the gardens and the castle, i.e. to the w of the present church (*see* above) which covers the gardens, spoiling the orig-inal plan.

LAURA PLACE, begun about 1827, has two blocks, of three and four houses, on the E side, and a pair on the N, beyond the Assembly Rooms. They are the finest Georgian houses of the town, two-storey with deep-eaved hipped roofs, and the broad proportions of the villa rather than the town house. Stuccoed, lined as ashlar to the ground floors, with very large sash windows, columned porches, and finely traceried overlights. All have good simple Late Georgian interior detail. The ASSEMBLY ROOMS, built by subscription, 1818–20, by *George Repton*, are plain but elegant, stuccoed. Hipped centre with three big tripartite arched windows to the main hall, and ped-imented pavilions, for the card and billiards rooms, the whole raised on a basement. Simple, three-bay s entrance front, with arched porch added *c.* 1830. Inside, the main room has a coved cornice and a little minstrels' gallery over the door, and the side rooms similar coving. Nos. 11 and 12 Laura Place were the Powell town house and estate office. No. 12 has the best interior; hall cornice with paterae and brackets, open stair lit by a long rear window. Behind the Assembly Rooms, some early C19 houses in UPPER GREAT DARKGATE STREET, No. 64 with bowed first-floor windows and, at the corner, a tall, four-storey house, with later C19 ornate stucco.

To the E of Laura Place, in NEW STREET, early C19 stucco ter-races with late C19 bays. The former LITTLE CHAPEL, a

coach-house of No. 6 Laura Place, was given a pretty stucco front, supposedly in 1906 when it became a Unitarian Chapel, but the detail looks more of the 1850s. No. 1 was the North & South Wales Bank, 1870, single-storey, stucco, Italianate.

1b. Pier Street to Eastgate Street

PIER STREET begins at the medieval central crossroads. The first Town Hall stood here, replaced 1857 by an Italianate clock tower (by *E. Trevor Owen*), demolished 1957, and replaced in 2000, by a simpler Italianate tower, by *Ceredigion County Council Architects*. Sentimental cast-iron Temperance plaque from the former tower, made by *Coalbrookdale*. Three-storey terraced houses with bracketed eaves, the best on the w side: No. 8, with pretty curved bow windows of *c.* 1800; No. 30, three broad bays with rusticated ground floor and Ionic door-case, and Nos. 32–36, six bays, all of the 1830s. No. 38, *c.* 1800, is remarkably intact with two full-height bow windows and columned porch. On the corner of Eastgate Street, opposite, ST DAVID'S CLUB, plain Late Georgian with fine curved Doric porch on the side wall. Nothing early is visible but this was Ty Mawr, the C17 town house of the Pryses of Gogerddan.

EASTGATE STREET led down to the medieval walls. It was partly built up in the C18, and keeps some small rear courtyards. WINDMILL COURT, behind the late C19 DOWNIE VAULTS pub, has a restored row of small C18 stone cottages. The windmill, prominent in early views, survived as apartments into the late C19. The CONSERVATIVE CLUB, *c.* 1900, red brick and terracotta, adjoins the railed forecourt of CRYNFRYN HOUSE, late C18 former town house of the Bonsalls of Fronfraith. Three bays with overall pediment, but all the detail *c.* 1900 except the corniced doorcase. Further down, tall and narrow WARE-HOUSE, *c.* 1880, stone and yellow brick, with centre hoist gable. On the s side, some early C19 houses at the E end have remnants of early shopfronts.

1c. Baker Street and Great Darkgate Street

Baker Street and Alfred Place mark the line of the town walls, the first leases dating from 1797. In ALFRED PLACE, the English Baptist Chapel (*see* above), with the Public Library (*see* above), closing the upper end. UPPER PORTLAND STREET running down to Terrace Road has some earlier C19 houses with good doorcases, No. 2 with fluted columns, Nos. 4 and 6 with spiral fluting, and paired doorcases on Nos. 12 and 14. At the lower end, the WHITE HORSE has a small but colourful glazed tile front of *c.* 1900. In BAKER STREET, Bethel and Seion chapels (*see* above), and Nos. 9–11, 1890s ironmonger's in grey stone and yellow brick. Across Great Darkgate Street, CHALYBEATE STREET follows the line of the medieval walls. No. 5, 1902, in red brick, has a lunette under a shaped gable, and No. 6, opposite, *c.* 1870, is stone and Gothic.

GREAT DARKGATE STREET. The main street, a number of early C19 stucco fronts, spoilt by modern shopfronts. On the S side, the POST OFFICE, 1901 by *T. E. Morgan*, brick and terracotta with cheerful tiled fascia. On the N, HSBC BANK, 1908–9, by *Woolfall & Eccles* of Liverpool for the North & South Wales Bank. Edwardian Baroque, in only three bays, with a recessed centre framed by paired columns and topped by a broken curved pediment against an attic with stepped parapet. Further W, MARKET STREET, cut through 1830–2 on the site of the old Talbot Hotel, the framing buildings with chamfered angles and bracket eaves. Most of the street is of the same date, including the rebuilt TALBOT HOTEL. On the site of the corn market, the PANTYFEDWEN TRUST building, 1967–70, the overhanging finned upper floors and broad blank chamfered corner conspicuously bleak. At the top of Great Darkgate Street, Nos. 39 and 41, low two-storey front, with C19 detail, but an early C18 staircase in No. 39, which also has a good jeweller's shopfront of *c.* 1900. On the corner of Bridge Street, PADARN HOUSE, now shops, was the Gogerddan Arms, the main coaching inn, first built *c.* 1727, rebuilt *c.* 1800 and extended in 1869 by *George Jones*. Three-storey, five-bay, with bracket eaves, the columned porch a poor replacement. In UPPER GREAT DARKGATE STREET, W of Pier Street, the former St Paul's Welsh Wesleyan Chapel (*see* above).

2. The Sea-front to Alexandra Road

2a. The Sea-front

The first terraced houses facing the sea were built S W of Pier Street *c.* 1807, but MOUNT PLEASANT, the pair by the Old College, with stucco three-storey, three-bay fronts are of the 1830s; both have good interior plasterwork. On the corner of Pier Street, the former HOTEL CAMBRIA, 1896, built with the pier by *George Croydon Marks*, engineer to the Aberystwyth Improvement Co. The hotel failed and was a Calvinistic Methodist theological college from 1906 to 2001. Large, in rock-faced stone with three Dutch gables, the big entrance doorway with delicate Bath stone reliefs of dragons.

E of Pier Street, MARINE TERRACE curves expansively around to the N, the array of stucco fronts uninterrupted until the heavily Victorian former Queen's Hotel (*see* County Offices above). Better from a distance than close to, where the extent of alteration becomes clear. Building started *c.* 1809; it had reached the Bellevue Hotel by 1822, and the part beyond Terrace Road was built up by 1834. The first houses are four storey, the detail all of the later C19, Nos. 7–12 rebuilt in 1867, and the bay windows date from *c.* 1900 as elsewhere. Early views show a two-storey terrace up to No. 12. The BELLEVUE HOTEL was a hotel in 1830, remodelled in the 1850s. BELGRAVE HOUSE is the centre of a five-bay composition on the corner of Terrace Road, the outer bays pedimented. On Terrace Road,

a doorcase with Egyptian capitals. Beyond Terrace Road, LLYS
BRENIN by *Dilwyn Roberts*, a drum of sea-front flats, 1995, on
the site of the King's Hall of 1934, which itself replaced the
Waterloo Hotel, burnt 1919. The long curving row, Nos. 32–52,
is on the 1834 map, but the detail is all mid Victorian. Nos.
57–62 , up to the Queen's Hotel, are of *c.* 1868.

3 Past the Hotel, VICTORIA TERRACE broke dramatically with the
stucco until tamed in the mid C20. *J. P. Seddon* proposed a
crescent here in 1865, as part of a large town improvement
scheme, modified in 1868 to a row of twenty-five houses. They
were to be polychrome Gothic, in three colours of brick, with
generous top-lit stairs, and first floor drawing room for the sea
views. Only three were built by 1871. They were probably too
expensive, the largest costing £2,000. VICTORIA HOUSE, orig-
inally the first two, should be a striking counterblast of Gothic
truth to the stucco of the rest of the promenade, the corner
house rising to six floors, including basement and attic. All
Seddon's polychrome is painted out, leaving ungainly asym-
metrical fronts, with two-storey bays, one to the sea, one to the
side, and the Gothic doorways. The third, and last, house is
half of the GLENGOWER HOTEL, also painted over. The
terrace was continued N after 1874 and a further twelve houses
were built, in rubble stone with ashlar details, four-storey, with
three-storey bays, still Gothic but mechanically so, probably by
Szlumper & Aldwinckle. The first five and last two, all of three
bays, were built first. The remaining five, each of two bays, were
not built until 1890. A large section, the Caerleon and Pum-
lumon Halls of Residence, was burnt down in 1998. The unity
of the terrace was restored in 1999–2000 with a similar but
stuccoed block with cast-stone detail by *Harry James*. It con-
ceals the first timber frame of such a scale in Britain, the rear
elevations to a courtyard frankly modern with panels of
maroon and cream. At the far end, the Alexandra Halls (*see*
above) and the Cliff Railway (*see* above).

2b. *Queen's Road to Terrace Road*

QUEEN'S ROAD, behind the County Hall, marked a halt to the
expansion, in the 1870s. The streets to the NE were built up
early in the C20. From TREFOR ROAD, BRYN ROAD climbs
the cliff to CASTELL BRYCHAN, *c.* 1910, prominent Arts and
Crafts roughcast house, the gable clasped by square turrets,
the big side wing was added for a R.C. school in the 1920s.
On the hillside further SE, BRYN ABEROEDD, Cae Melyn,
119 International Modern house of 1968 by *Ifan Prys Edwards*, of
spare elegance in glass, brick and white aluminium. The main
floor is raised on a brown brick base, and fully glazed to the
front, with balcony between two box-like projections outflung
to overhang the view. Open-plan interior linked to the lower
floor by a spiral stair. Back in Queen's Road, the former
Queen's Hotel STABLES, a big enclosed courtyard of 1866 by
George Lumley, the R.C. church (*see* above), and the former

LIFEBOAT HOUSE of *c.*1870. EDLESTON HOUSE, 1898 by *George Jones & Son,* a stucco villa, has a very handsome colo-nial-style two-storey iron veranda, made by *Coalbrookdale.* In BATH STREET, built up in the 1870s, the St Paul's Methodist Centre and the English Presbyterian Church (*see* above), and the Gothic former MANSE and SCHOOLS to the English Congregational Chapel, Portland Street, 1876–80. Then one of the yellow terracotta side entries to the Phillips Arcade, part of the 1904 Coliseum (*see* Ceredigion Museum, above). The cinema on the r. replaces public baths of 1880 by *T. W. Aldwinckle.* In LOWER PORTLAND STREET, an informal square opposite the Town Hall, then, on the l., Salem Chapel (*see* above) and some early C19 houses, with columned door-cases. Opposite, the former English Congregational Chapel (*see* above) and another side façade of the Phillips arcade.

2c. Terrace Road and North Parade

TERRACE ROAD running s from the sea-front, is now a main shopping street, but was built up in the early C19, as remnants of stucco houses above the shopfronts show. No. 56, on the corner of Corporation Street, with one Georgian bow window and one Late Victorian, illustrates the effects of the lease renewals. The street was much altered *c.* 1900. On the E, the Coliseum (*see* Ceredigion Museum, above), and on the W, Nos. 34–36, W. H. SMITH, 1895, by *T. E. Morgan,* originally the Cambrian News. Red brick and terracotta, with free Renais-sance details, but the two Dutch gables shorn. On the corner to North Parade, No. 26, BARCLAYS BANK, 1904–6, Portland stone palazzo with curved corner, typical of banks since the 1850s, but some English Baroque detail to give the date away. Opposite, the thirteen-bay white glazed-tile front of the former BURTON'S shop, 1938, in the house style, and No. 37, 1910, nicely free styled, with lunette and open pediment over a tall oriel.

NORTH PARADE begins further up, at the corner with Baker Street, and runs NE, comfortably broad, and still with a number of good early C19 houses. On the corner of Baker Street, NATIONAL WESTMINSTER BANK, 1903, by *W. W. Gwyther* of London, for the National Provincial Bank. More progressive than the Barclays building, with round arched hoods over the upper windows, and mullioned windows below, i.e. free C17 details. TERRACE ROAD continues across North Parade, largely rebuilt *c.* 1900–14. Corner buildings of that period, on the l. with a spirelet, on the r. with red brick Dutch gables and a cupola. LLOYDS BANK, further down, is dated 1902, red brick and terracotta, with a corner cupola, echoed beyond on CAMBRIAN CHAMBERS, the best of the sequence, red brick and plentiful terracotta, 1902, by *J. Arthur Jones.* Returning to NORTH PARADE, the best houses are on the N. Nos. 18–26 are similar to houses in Bridge Street (*see* above), with fine columned porches (bowed on No. 20) and overlights

matched in Laura Place (*see* above), the date therefore proba-
bly *c.* 1825. Beyond, a group of the 1890s in stone and yellow
brick and the final terrace of four, of *c.* 1900, with Queen Anne
detail. Opposite, Nos. 33–43 are also early C19, with some
columned doorcases, No. 43 with a Gothic porch. On QUEENS
ROAD, SANDMARSH COTTAGE, on r., said to be of 1790 but
perhaps *c.* 1810, a very pretty marine villa, the only one in
Aberystwyth. Small, two-storey, stuccoed, with two bow
windows and delicate Regency detail inside, especially the
staircase. QUEEN'S TERRACE, beyond, *c.* 1880, heavily detailed
stone and brick Gothic, derived from Victoria Terrace.

2d. Alexandra Road and Environs

Thespian Street runs s from North Parade to Alexandra Road.
In SKINNER STREET, to the l., the former SKINNER STREET
SUNDAY SCHOOL, *c.* 1850, stuccoed with three arched
windows. Around Holy Trinity church (*see* above), THE
BUARTH, a hillside suburb laid out in the 1880s but mostly
built at the turn of the century. In BUARTH ROAD, houses with
red or yellow brick trimming to stone gabled fronts by *G. T.
Bassett*, 1902–4, who was much involved in the development of
the area. More of similar date at the E end of ALEXANDRA
ROAD. The JOB CENTRE, 1994, by *Dilwyn Roberts*, yellow brick
and deep eaved, replaces Green's Foundry, specialists in
mining equipment for the lead mines. Opposite the station (*see*
above), a mixed group: the corner to Terrace Road, with angle
cupola, 1903 by *J. Arthur Jones*; an attractive narrow front in
red brick and terracotta, *c.* 1910, and then the heavily half-
timbered CAMBRIAN HOTEL, *c.* 1880. No. 10 is a pretty
remodelling of *c.* 1900 of an earlier corner house, roughcast,
with small-paned windows and ogee dome. At the far end,
SALVATION ARMY HALL, originally English Wesleyan Chapel
of 1844. Stuccoed lateral front, once hipped, the gable added
later. Opposite, the former Board School (*see* above). PARK
AVENUE, running s, was an industrial area with gas works,
slaughterhouse and iron foundries. At the top, former GAS
COMPANY OFFICES, now a car showroom, 1901 by *G. T.
Bassett*, red brick and terracotta, restrained. At the far end, the
Police Station (*see* above). In GLYNDWR ROAD, to the w,
DRILL HALL, 1903, a broad gable-end with arcaded windows.
In GREENFIELD STREET, pre-1914 Borough Council terraced
houses, by *Rees Jones*, Borough Engineer.

<div align="center">OUTER ABERYSTWYTH</div>

1. South of the Bridge, Trefechan, Penparcau and Pen Dinas

TREFECHAN. Just over the bridge, Trefechan was a port area,
with cottages, warehouses, industries and limekilns. The build-
ing of the South Pier 1834–6 made possible the expansion of
operations to serve the lead mines. Most of the visible evidence

has gone, though lead was smelted in the harbour area, and some 13,000 tons were exported at the peak in 1855. On the l., the FOUNTAIN INN, a broad gabled early C19 front with lunette, and opposite, mid-C19 MALTHOUSE with gable hoist to the street, and a large bottle-shaped brewery malting KILN behind. By the harbour, two square LIMEKILNS. On the N side, TANYCAE PUMPING STATION, *c.* 1990, red brick with blind arches outlined in black, more characterful than the S side 1980s housing or the E side 1990s office block.

PENPARCAU. A separate village, now mostly C20 suburb. The Rheidol flood-plain below, has been largely built over in the late C20 with retail warehouses and supermarket.*

ST ANNE, Penparcau. 1909–10, by *G. T. Bassett*, plain and small, like a church hall. One STAINED-GLASS window by *Celtic Studios*, 1953.

WELSH MARTYRS (R.C.). 1968–70 by *Tom Price*. An interesting design, let down by poor finish and detail. A quadrant with altar at the apex and an entrance loggia along one side connected to a much smaller quadrant meeting room, linked apex-to-apex with the main body. White roughcast with slot windows on the curved walls and pale brick interior facing.

PEN DINAS. The bald ridge of Pen Dinas separates the Rheidol and Ystwyth estuaries, the double summit closing views to the S from the town. A very large Iron Age HILL-FORT spans both knolls. The N part probably fortified first with timber-revetted oval earth bank. The S part has stone revetments to a similar-sized oval enclosure with N and S entries. Further defences added later, three banks on the E, one on the steeper W side, with a stronger stone wall linking the two forts with an E gate. Dates of S fort and refortification are suggested as *c.* 250–200 B.C., and *c.* 100 B.C. House platforms of circular or D-shaped huts were found in the S fort, also a Bronze Age round barrow, Iron Age pottery and a Roman C4 coin. The 55-ft (17-metre) high stone column in the S fort is the WELLINGTON MONUMENT, begun 1853, erected by Major W. Richardes of Bryneithin, Llanychaiarn. It has a winding stair, now blocked.

2. The Eastern Suburbs

The corner of LLANBADARN ROAD and PENGLAIS ROAD was first built up after 1850 with artisan terraces, a slate works and militia barracks. The large detached or semi-detached villas followed much later in the C19. The first villas of the 1880s are stone and gabled with a Gothic angularity. The majority are of *c.* 1900, in red brick, roughcast, half-timber and terracotta. On CARADOG ROAD, to the l., large plain stone semi-detached villas, of the 1890s, but looking of the 1870s. Bronglais Hospital (*see* above) is on the site of the workhouse. On ST DAVID'S

* A toll-house of 1771 that stood at the division of the Lampeter and Cardigan roads is re-erected at the Welsh Folk Museum, St Fagans.

ROAD, the corner house, CARREGWEN, is half-hipped with some frilly ironwork of *c.* 1880, and the two semi-detached pairs and Ardwyn, the core of the present Penweddig School (*see* above), are of similar date. The next villa on Llanbadarn Road, with two-storey iron veranda and ironwork in the gable looks of a date but is not on the 1889 map. CLYWEDOG and IRFON, a red brick pair, and BETWS with some half-timber, all *c.* 1900. Then a pair and LLWYNCADFAN, old-fashioned stone and yellow brick, an iron veranda on Llwyncadfan, all post 1889. LLYS HAFAN and PANTEG are similar but pre 1889, with bargeboards and heavy bays. DELFRYN and TREFRIW are early C20, red brick with round gables and bay windows with curved roofs, then FRONHYFRYD, 1890s, stucco with two-storey ironwork. On the S, ST PADARN R.C. SCHOOL, overlooks the sports ground, a hipped stone former vicarage of the 1860s. Steep-roofed LODGE of 1873 to the cemetery, by *W. H. Spaull.* Spaull's cemetery chapels of 1863 have gone. On the N, some terraced houses, HALES GREEN, 1903, a very smart red brick and roughcast villa with terracotta and half-timber, HENGWRT, Italianate stone hipped villa on a terrace, of the 1880s, and then CARREGLWYD and BRYNEITHIN, *c.* 1905, a dissimilar Arts and Crafts pair, one with a slate-hung gable. LULWORTH and MAESHYFRYD are coarser, *c.* 1900, stone and red brick with half-timber. Above the road, CYNCOED, *c.* 1880, stone and red brick broad gabled front, deep-eaved in a Swiss way.

3142

ADPAR
Llandyfriog

The Ceredigion part of Newcastle Emlyn, N of the Teifi. Later C19 terraces on the Aberporth road.

CILGWYN, in wooded grounds above the Lampeter road. A bleak house of 1881–5, by *Middleton & Son* of Cheltenham: Middleton died in Newcastle Emlyn apparently after a fierce argument with the client, E. C. L. Fitzwilliams. The house is on the site of Emlyn Cottage, a little known work of 1792 by *John Nash*, and may echo Nash's ground plan. It was one of Nash's most intriguing designs, the front treated as a kind of Gothic temple, with pediment over a loggia of three tall Gothic arches, apparently in timber, fronting the main room, between hipped ends to single-storey side ranges, the W one with a Gothic timber porch, the E one with a curved bow to a circular dressing room between two bedrooms. Gothic presumably was chosen as the riverside site looks across to the ruins of Newcastle Emlyn Castle.

Middleton's house in eroding grey Cilgerran stone has tall bays flanking an entrance tower, now cut down. The roof-line had the details of interest, a pyramid cap to the tower and half-timbered dormers and gables. Designed around a large stair

hall that may be on the footprint of Nash's main room. Two pairs of Ionic columns at the foot of the imperial staircase look alien, perhaps reused. The staircase is said to have been bought in Paris at an exhibition in the 1870s, but the detail, twisted balusters and heavy newels, seems unremarkably English.

Two identical LODGES, half-timbered gables over the carriageways, the E lodge 1884, by *Middleton*, the W lodge a copy of 1897.

NEWCASTLE EMLYN BRIDGE. *See* Newcastle Emlyn, Cms.

CASTLE MOTTE (SN 310 400). A small Norman castle site.

BANGOR TEIFI 3741

The church stands high above a bow of the Teifi, between Henllan and Llandysul.

ST DAVID. Rebuilt three times, 1812, 1855 and 1931, each predecessor having decayed. In 1855 plans by *Daniel Thomas* of Llandysul were rejected in favour of *R. K. Penson*, but it seems unlikely that his were used. The design of 1931 is by *D. Davies & Son* of Penrhiwllan, in rock-faced sandstone, very old-fashioned. Paired lancets, traceried E window, W porch and square, pyramid-capped bellcote. 1812 and 1855 datestones and a bit of older walling at the W end. Interior quite without a hint of the C20. – FONT. C12 and splendidly crude, octagonal bowl with thick corner lobes, embellished on the N face only with zigzag and two raised diagonal crosses, and the lobes here crudely striated.

In the churchyard, big lion-footed marble sarcophagus MONUMENT of 1853 to Arthur Lloyd Davies of Blaendyffryn and Alltyrodyn.

THE OLD RECTORY, E of the churchyard. 1857, still Late Georgian in style, three-bay and hipped.

BLAENDYFFRYN HALL, 2m. NE. Stuccoed three-bay house of the 1830s, overwhelmed by a taller bay-windowed addition of *c.* 1880, rising to three floors. Gothic rusticated stone porches on both parts. In the older part, a stone stair.

PONT ALLTCAFAN. 1838–42. Monumentally impressive, high single-arch bridge over the Teifi, with pilaster piers. The pierced roundels in the spandrels are on the model of the Edwards' bridges (cf. Cenarth Bridge, Cms., 1786), but much cruder in proportion. Built for £1,100 through the efforts of John Lloyd Davies of Blaendyffryn, who owned mills (mostly demolished in 1993) on the Carmarthenshire side.

BETHANIA 5764
Llanbadarn Trefeglwys

Crossroads 4m. E of Pennant, at the southern end of the bleak Mynydd Bach ridge. High plateau and moorland around.

BETHANIA CALVINISTIC METHODIST CHAPEL. s of the village. 1832, lateral front with arched windows. Remodelled in 1872–3, by *James Williams* of Aberystwyth, with heavy stucco detail and five-sided gallery, fronted in long panels.

BETWS BLEDRWS

On the Lampeter to Tregaron road, mostly an estate village to Derry Ormond (*see* below). By the church, the OLD RECTORY, 1838, by *Rees Davies* of Llandysul. Large, two-storey, three-bay, with bracketed eaves, Gothick windows on the end walls and columned porch. In the village, NEW LODGE, mid C19. Square, pretty, with triangular-headed windows and a gabled lunette on each front, in echo of Derry Ormond.

ST BLEDRWS. The comical small square tower with long lancets set low and broached to a hexagon dates from 1831, probably by *Rees Davies*. The rest was rebuilt 1887, by *D. E. Thomas* of Haverfordwest, without flair, except for the bell-cast hexagonal slate spire. Nave and chancel with paired lancets. Interior with boarded roofs and thick corbelled chancel arch. Patterned tiling around the sanctuary. – FONT. C12 small square bowl with the lower corners chamfered and a band of lightly incised roundel ornament, like Henfynyw and Llansantffraed (Llanon). – STAINED GLASS. An unusually good set of 1886–7, by *Carl Almquist* of *Shrigley & Hunt* of Lancaster. E window a three-light Crucifixion with Morris-like foliage backgrounds. w single light of 'the Christian Warrior', a large and dramatic Renaissance-style figure in classical armour. In the nave side windows, delicate silver and gold angel panels in opaque quarries. Chancel N patterned glass, of the 1850s, possibly one of the two 'exquisite' w and E windows inserted in 1854 by *Thomas Ward* (the E window now at Llangybi). – MONUMENT. Chancel N, mourning female and portrait relief, 1836, to John Jones of Derry Ormond, by *R. Westmacott Jun*.

DERRY ORMOND, ½ m. N, demolished in 1953, was built in 1824, by *C. R. Cockerell* for John Jones. It replaced a late C18 house built by John Jones Sen., London surgeon and partner in the 1806 Aberystwyth & Cardiganshire Bank. Cockerell's house, which cost over £6,000, was a restrained three-bay villa in ashlar with deep eaves and open pediments over lunettes to the main façades, but had been much enlarged. There were fine late C19 parterre gardens and a curved-roofed conservatory. The grounds were landscaped with a string of lakes. Over the lower one a fine single-arched BRIDGE with giant circular flood holes, by *Cockerell*. Some later C19 OUTBUILDINGS and a WALLED GARDEN by the house site.

DERRY ORMOND COLUMN, prominent on the ridge to the w. A 140-ft (47-metre) stone column on a pedestal, built 1821–4, by *Charles James* of Llanddewi Brefi, for John Jones, to relieve unemployment in the district. There was an internal stair to a viewing platform, now capped.

Derry Ormond, 1872 view.
Engraving

BETWS IFAN

Small village between Newcastle Emlyn and the coast road.

ST JOHN. Small church of 1869–70, rebuilt for £421 10s. 3d., in the simple Dec style of *R. J. Withers*'s plainest churches, though only the name of *David Jones*, carpenter, of Cwm Cou, is recorded. Of the former tiny, single-chamber church, repaired 1828–30 by *Henry Evans*, some old stonework shows on the w front, contrasting with the Pwntan sandstone of the new work. Two-bay nave and single-bay chancel, w porch, battered bellcote. Simple interior with boarded panelled roofs. Oak chancel fittings of 1950–1. – FONT. C14, octagonal, deeply chamfered below, chamfered rim, gloss-painted. – STAINED GLASS. E window, Ascension and angels on clear grounds, by *Celtic Studios*, 1950.

BRYNGWYN INDEPENDENT CHAPEL, Bryngwyn. 1900, stucco front with main arch, probably by *David Davies*. Galleried interior.

GLAN MEDENI, ½ m. s. Hipped stone villa, once roughcast, of 1835–6 for two spinsters, the Misses Walters. A charmingly odd front, quite unrelated to the internal plan. Long arched window each side, one false, the other crossed by the stair. Arched doorway, in a C20 porch, with arched window over and blank oval panels each side, not aligned with the windows below. The whole façade is not quite central either. Late C19 bays on the s side.

WATCHTOWER HOUSE, just N of Glan Medeni. Former Watchtower Calvinistic Methodist Chapel, built in 1865, by Jane Walters, apparently as a peace offering for rough handling

by rioters in the 1843 Rebecca rising. Sandstone gable front with two large arched windows and centre arched door.

PLAS TROEDYRAUR. *See* Beulah.

BETWS LLEUCU

The church is by the roadside on the lane that runs down the s side of the upper Aeron valley from Llangeitho. E of the church a whitewashed cob-walled cottage.

ST LUCIA. Rebuilt 1875–6 for £600, but looks cheaper. Plain stone and yellow brick small church, nave and chancel with pyramid-roofed wooden bell-turret.

GLANMARCH, just W of the church. Later c18 whitewashed farmhouse of three bays, the façade offset for the bigger s end kitchen chimney.

FEDW FAWR, on the road to Llangeitho. Three-bay, earlier c19 front with small tripartite sashes, but the big external stack to the l. the end of a later c17 or earlier c18 house, now the rear wing.

TAL FEDW, just beyond Fedw Fawr. Small cob-walled early c19 three-bay two-storey house with heavy scarfed feet to the collar-trusses. Cross-wing of 1880.

BEULAH
Llandygwydd/Betws Ifan

Crossroads village on the Newcastle Emlyn to Aberporth road.

BEULAH INDEPENDENT CHAPEL. 1884. Large sandstone gable front with arched openings and rose, plain but the stonework handsome. Gallery with long, narrow cast-iron panels, on columns by the *Priory Foundry*, Carmarthen.

PLAS TROEDYRAUR. ½ m. E. A long stuccoed range with varied hipped roofs, on the side of a small valley. The view from the Brongest road is of the rear, the front facing N into the bank. The core is a square, three-bay hipped house of *c.* 1800–10, built for the Rev. Thomas Bowen. N front with metope eaves, arched lower windows and heavy timber Roman Doric enclosed porch, the latter probably of the 1840s, as also the arched hoodmoulds. Across the E end, a hipped, three-bay matching range, added after 1842 for James Bowen, with veranda. Tailing off to the w, service ranges which may include parts of an c18 house. Inside, N square hall, flanked by an ante-room to the E wing to the l. and by an apsidal cantilevered timber stair to the r., the curve backing uncomfortably on the windows. In the E wing, dining room with Ionic columns to an end-wall sideboard recess, mahogany doors and thick gilt pelmets.

Outbuildings to the sw below: hipped early c19 COACH-HOUSE, BARN with brick dove-holes tiered in the gable, apparently earlier c19, but with a 1734 datestone.

BLAENANNERCH/BLAENANERCH
Aberporth

A ribbon of houses on the main coast road. RHYD HOUSE, to the w, is a stone villa of the later Victorian type, built as late as 1905, by *James Jones* of Rhydlewis.

BLAENANNERCH CALVINISTIC METHODIST CHAPEL. 1838. Stone lateral façade with arched windows. Remodelled in 1896 by *James Jones* with typical late C19 glazing and handsome gallery of 1896 in a theatrical curve, fronted in curved-profile pierced ironwork by *Macfarlane* of Glasgow. The charismatic religious revival of 1904–5 that swept much of South Wales took wing here on 29 September 1904 when Evan Roberts was seized with the spirit at a service conducted by the Rev. Seth Joshua.

BLAENANNERCH AIRFIELD, just N of the main road. Built in association with the Aberporth Testing Station in 1939. Concrete PILLBOX at the road junction to the N. The airfield has become a technology park, PARC ABERPORTH. Eight light industrial units, 2003–5, by *B3 Burgess* of Newtown, with outward sloping glazed fronts and turfed roofs, designed to minimize energy loss and solar gain.

BLAENPENNAL

Upland parish W of Sarn Helen, the Roman road N, now the A485. Some Roman causeway is still visible opposite Taihirion Rhos, where the Roman road diverges NNE from the main road. The church stands alone, W of the upper Aeron valley, high moorland of the Mynydd Bach to the N.

ST DAVID. 1903, by *William Williams* of Brecon. Rock-faced grey stone with W bellcote and S porch, a single roof and utilitarian lancets.

PENIEL CALVINISTIC METHODIST CHAPEL, ½ m. E. 1867. Rubble stone and yellow brick, arched-windowed with bracketed eaves and open-pedimental end gables. Later C19 render to the façade and added porches. No galleries, simple panelled great seat and pulpit.

BLAENPLWYF
Llanychaearn

A row of houses on the main Aberystwyth road, with the chapel and a small, stone and brick former MISSION CHURCH of 1878, now a house.

BLAENPLWYF CALVINISTIC METHODIST CHAPEL. 1878–80. Large chapel by *David Williams* of Aberystwyth, emphatically Victorian in its harsh colours and hard detail. Brown stone, yellow and black brick, and some yellow terracotta. Three-bay

gabled front, black brick piers, triangular heads lined in yellow, brick surrounds to arched windows with terracotta hoods. A single end gallery and impressive Corinthian pilastered aedicule behind the heavily detailed pulpit.

BLAENPORTH

On the main road above Aberporth, a cluster of houses, one the former SCHOOL of 1861.

ST DAVID. 1864–5, by *R. J. Withers*. The best of his small churches, sandstone, nave and chancel with w bell-turret. The turret, carried on a wall-face projection, has a steep stone pyramid cap broken by sharp gablets over the little bell-lights, all very geometrical, as if carved from the solid. Plate-traceried windows, three-light to the E. Inside, nave and chancel roofs contrasted, the chancel with scissor-rafters cusped beneath. – FONT. Octagonal bowl, half-turned on the stem. Simple stone PULPIT, and inlaid REREDOS. – STAINED GLASS. E window of 1864 by *Lavers & Barraud*, a splendid work, exceptionally richly coloured in deep reds and turquoise blues, the crucified Christ against a circle of scarlet. Chancel s window, 1904 by *Lavers & Westlake*.

CASTELL GWITHIAN (SN 266 488), ½ m. E. An oval motte, built *c.* 1110, by Gilbert de Clare as part of the ring of small castles with which he sought to hold the newly conquered Ceredigion. Mentioned as early as 1114, when briefly taken by Gruffudd ap Rhys ap Tewdwr of Deheubarth.

GLANEIRW, 1 m. E. Bleak, sandstone, mid-C19 house of four bays, the fourth gabled, with large plate-glass sashes.

TYLLWYD, 1½ m. ESE. Low two-storey, five-bay, roughcast s front with mid-C19 eaves gablets and tent veranda each side of a Tudor porch, once castellated. The core is earlier as some roof trusses of a lower C18 roof remain. Otherwise the interior detail is earlier to mid C19, including an apsidal stair at the E end. Behind, a four-sided farm courtyard, mostly C19.

BORTH

A long, single street, between sand and marshes, the silhouette reminiscent of the American West in its arbitrariness. Borth had a few fishermen's cottages before its promotion as a holiday resort in the 1860s when Thomas Savin built the station and a hotel, as part of his railway tourist enterprise (cf. the Old College, Aberystwyth). Progress was always faltering, and the place still has an insubstantial look, with flimsy cottages edging the main street, and the more solid buildings sea-battered and roughly altered.

ST MATTHEW. Isolated to the E of the town, across the railway, standing well – if inconveniently – on a small rocky mound,

with a scatter of Scots pines. Built 1878–9, by *Penson & Ritchie*, for £2,000. Nave, chancel and spired bellcote on a mid buttress, influenced perhaps by Butterfield's w end at Llangorwen. N porch and paired N organ chamber and vestry gables, the vestry with circular chimney. Varied tracery as Ritchie liked it, the windows with unfoiled circles in the heads. Decent interior unusually with stained glass in all the windows. – Gothic timber REREDOS of 1911. PULPIT, STALLS and RAILS of 1922, conventional Gothic (stalls with mythical beasts in the bench ends). – STAINED GLASS. Much by *Celtic Studios*: w window of 1967 more animated than their average with swirling lines; nave s four windows 1972, 1967, 1979 and 1965, and one on the N of 1962. Also on the N, one of the 1930s, in staring childish colours, if conventionally drawn, by *Shrigley & Hunt*, a third of 1935 by *Powell*, weak C15 style. Chancel s three-light of *c*. 1920 by *Kempe & Co.*, single light of 1892 by *A. J. Dix*. Fine three-light E window by *Powell*, 1925, a concentrated design with much silver and gold. Abraham, Christ and Moses, the last in a most visionary pose.

OUR LADY STAR OF THE SEA (R.C.), E of the main street. Originally MORFA INDEPENDENT CHAPEL, 1864, possibly by the *Rev. Thomas Thomas*. A triplet of lancets framed in grey limestone and two pointed doors.

SUAR CONGREGATIONAL CHAPEL, E of the main street 1869–70 by *George Jones*, converted to a house. Unusually careful Gothic, steep-roofed, with two colours of slates in lozenges, traceried windows and a little canted apse.

GERLAN CHAPEL, on the main street. Built as Libanus Calvinistic Methodist Chapel in 1866, altered 1892. Stucco pilastered front with arched windows, porch of 1892. No galleries, the pews slightly raked; behind the pulpit an ornate plaster arch encloses a smaller arch and roundel.

Behind the concrete storm wall, the main street backs onto the sea in the older, s end, opening up only at the N end. Here are the remains of Borth's attempt at status. On the N side of the short street to the station was Savin's Grand Hotel of 1864, demolished in the 1970s. It was a big, stucco three-storey, nine-bay Italianate composition. *George Jones* was clerk of the works and *J. P. Seddon* was consulted. The attractive STATION of 1864, probably by *George Jones*, is similar to the one at Aberystwyth, red brick with arched sandstone windows. Single-storey with projecting two-storey hipped wings to the same roof height. Facing the hotel site, CAMBRIAN TERRACE, twelve houses of *c*. 1865–70, possibly by *W. H. Spaull* of Oswestry. Originally red brick and stone, since painted or stuccoed, each with a three-storey bay with detached cast-iron Gothic columns. Further N, MOORLANDS, one of two seaside-modern houses built at Borth in 1935 by *R. H. Franks*, much altered with curved bow on a flat-roofed white box. The other, BROCKHILL, at the N end of the row, has a two-storey bow. s from Cambrian Terrace, the main street ignores the sea. First, on the r., a group of Late Georgian-style three-storey houses

with bracket eaves, of which BOSTON HOUSE is the best; they probably date from the 1850s. Further down a few fragments of interest, some low single-storey and two-storey cottages from the pre-tourist era, and some houses with the bracketed eaves of the upper group, heavily altered. The prettiest build-ing, the National School, 1842, with Tudor windows and bellcote, was demolished in 1995 for a surgery. Further s, a warehouse occupies the remains of SHILO WESLEYAN CHAPEL, a stuccoed front of 1912 on a rear of 1871. On the headland at the s end, early C20 houses with spectacular views over the bay, and the WAR MEMORIAL, dramatically on the cliff-top beyond: massive, rock-faced stone pedestal with cross.

6285

BOW STREET
Llangorwen

A long ribbon village on the main road N of Aberystwyth, the name taken from the London magistrates' court and applied in jest to a local one.

Y GARN CALVINISTIC METHODIST CHAPEL. Originally a large, plain, lateral-fronted chapel of 1833, unusual in having three gallery lights. Bwlchgwynt Chapel, Tregaron, also of 1833, was to the same design. Refronted in stucco with some flair in 1900, the architect unknown; *Thomas Jones* of Dolau was the builder. Pilasters and a pedimental gable tightly frame the two big centre windows, now arched, while the centre gallery window has become a roundel with big keystones. The doors were given pediments and the outer angles are also pilastered. Original slate-hung sides and rear. Three-sided gallery with long timber panels, of 1866, by *William Jones* of Dolau.

NODDFA INDEPENDENT CHAPEL, to the W, on the lane to Llangorwen. 1903. Stucco gable front with painted terracotta dressings to a splayed doorcase with broken pediment and banded rustication, i.e. a touch of Edwardian Baroque.

3245

BRONGEST
Troedyraur

Village in the Ceri valley. A derelict early C19 water-powered CORN-MILL with hipped roof by the bridge. SCHOOL of 1876, similar to that at Rhydlewis, on the hill to the W, the simplified Gothic school house in the style of R. J. Withers, spoilt by new windows.

SALEM CALVINISTIC METHODIST CHAPEL, on the hill to the SE. Rebuilt in 1885 by *David Davies* of Penrhiwllan for just £385. Plain stuccoed gable front. Galleried on three sides, but the gallery stopped halfway down. Long panels to the gallery

front, curved corners and florid iron columns. The pulpit has fretwork panels.

BRONGWYN 2944
2 m. NW of Newcastle Emlyn

ST MARY. Prettily isolated above the valley of the Nant Gwrog. A small, single-chamber church which shows the mostly forgotten early C19 first phase of church rebuildings, when so many decaying churches were cheaply rebuilt. A simple box with pointed windows, rebuilt 1828 by *John Morris*. A cheap restoration of 1875 added bellcote, timber tracery and the ugly w porch/vestry, and also the thin roof and matchboard panelling. Coloured glass in the E window. – MEMORIAL. Oval plaque to Thomas Jones of Newcastle (Emlyn), †1796. *See* also Cwm Cou.

BRONNANT *see* LLEDROD

BRYNHOFFNANT 3351
Penbryn

BRYNMORIAH INDEPENDENT CHAPEL. 1882–4, an extraordinarily late example of the lateral façade, here with the rock-faced stone and thick timber mullions of the later C19. Gallery with long horizontal panels, on iron columns made by the *Woodward Engineering Co.*, Cardigan. Fretwork panels to the pulpit.

BLAENIGAU HILL-FORT. ¾ m. SE. Small embanked hill-fort on the steep E bank of the Ceri.

BWLCH-LLAN *see* NANTCWNLLE 3846

BWLCHYGROES
4 m. NNW of Llandysul

Crossroads village on the New Quay road.

BWLCHYGROES INDEPENDENT CHAPEL. 1880, by *David Davies*. Rock-faced sandstone front with narrow arched recess

and arched windows, similar to Davies's Bryngwenith, Llandyfriog. The broad centre window with two uncomfortable roundels. Gallery in long horizontal panels on iron columns by *Bright & Garrard* of Carmarthen.

CAPEL BANGOR
Llanbadarn Fawr

In the Rheidol plain, where the Melindwr runs down from the lead-mining hills to the E. The main settlement is along the A 44 London road, re-routed through here in 1812. BRONCASTELL, on the N, is a stuccoed three-bay hipped villa of Late Georgian type, but as late as the 1860s. By the church, just s of the road, the former NATIONAL SCHOOL, 1852, by *Roderick Williams* of Aberystwyth. By contrast with Moffatt's National School at Lampeter of 1850, uninfluenced by Gothic asymmetry. Single long schoolroom, central chimney between two pairs of cast-iron lattice-glazed mullion windows, and a porch each end. The teacher's house, TY'R EGLWYS, behind, keeps the same steep roof-line, but is of two storeys. SE of the church, mid-C19 OLD VICARAGE, stuccoed with hipped roof. S of the main road, in DOLYPANDY, altered terrace of mid-C19 lead miners' single-storey cottages.

ST COMGALL. Built 1837–9, to plans of 1833, probably by *George Clinton*; though only the builder, *Richard James*, is recorded. Classical, the only church in the county of the type, albeit minimal in detail, with pilastered sides and arched windows. The masonry suggests it was roughcast or stuccoed, and it was whitewashed in 2003 to protect the stone. Nave and short chancel with pedimented w bellcote. Arched windows, now with ugly ashlar tracery of 1909 by *G. T. Bassett*. The interest is in the restoration of 1932–3 by *W. D. Caröe*, a model of how to achieve much with little. Externally, he added the w porch only, but the interior is transformed. Caröe panelled the plain ROOFS and added limed oak fittings in a more classicizing vein of his inventive late Gothic to classical manner. A SCREEN of square piers on a fielded-panelled base creates a much larger chancel space than the stunted original. Neatly built into its l. end is a panelled PULPIT; the r. end is enclosed for a vestry. STALLS and RAILS of exemplary simplicity, with Caröe's trademark scrolls for brackets and bench ends. ALTAR with riddel-posts and curtains. – STAINED GLASS. Dull E window of *c.* 1925, and one N window, *c.* 1960, both by *Powell*.

PENLLWYN CALVINISTIC METHODIST CHAPEL, Penllwyn. 1850. Stuccoed with an elegant five-bay front, four arched windows and a little lunette aligned with the window heads in the centre, over the door. Despite the long front, the interior is aligned on an end-wall pulpit and completely filled with painted grained box pews, seating some 500. Twelve rows to the r. of the door are raked, the ramped ends descending in a pleasing cascade.

Outside, bronze BUST of 1911, by *Sir W. Goscombe John*, of Dr Lewis Edwards, 1809–87, Principal of Bala College.

GLANRHEIDOL, ¾ m. SE. Built for George Bonsall *c.* 1800, two-storey square villa of four bays on each front, which puts the big arched entrance off-centre. Elegant large fanlight over a columned doorcase. Parapet removed in mid C20 for a hipped red-tiled roof.

PENLLWYN ROMAN FORT, ¼ m. N of the chapel (SN 650 806). A small fort on the road N from Trawsgoed, Llanafan, found from crop marks in 1976.

See also Cwmrheidol.

CAPEL CYNON 3849

Bleak moorland on all sides of the small wooded valley with the church. A Late Georgian former inn, No. 1 RHYD, and altered single-storey cottages, to the W, on the corner of the Llandysul road.

ST CYNON. Long, low and single-roofed, with rough bellcote, apparently rebuilt in 1820–3. *W. D. Caröe* restored the church, very carefully, in 1929, replacing the S windows with pretty Perp tracery, and adding the chancel with low projections each side and three narrow cusped lancets to the E. Windowless N side but for a roundel added by Caröe to light the pulpit, echoing an existing W roundel. The interior charm is due to Caröe. Simple whitewashed walls and chancel arch, arched recess for the harmonium on the N and vestry with stone doorcase on the S. Open nave roof trusses and plastered panels over the sanctuary, which has stepped slate paving. Attractive FITTINGS, including cover and stand for the C12 grey stone bowl FONT. Limed-oak Gothic PULPIT, LECTERN, READING DESK, ALTAR and RAILS.

CAPEL DEWI 4543
Llandysul

ST DAVID. Crude Gothic of 1835, by *Rees Davies* of Llandysul, with chancel and interior of 1886 by *Middleton, Prothero & Phillot*. Short W tower partly on the ridge, short transepts, and angle buttresses capped flat at the gable shoulders. Minimal detail. The intersecting tracery survived the remodelling, but big Perp Gothic transept windows were added, to match the new chancel. Inside, a good single open barrel roof of 1886. Moulded stone transept arches without capitals. – FITTINGS. Of 1886; FONT, PULPIT and LECTERN, by *Jones & Willis*. Also by them, the chancel side STAINED-GLASS windows, 1904. E window of 1901, unsigned, the design taken from Gustave Doré.

Below the church, the former National School, now HALL, a plain earlier C19 stone building.

BETHEL WESLEYAN METHODIST CHAPEL, across the river to
w. 1901, rendered gable front with arch on pilasters, presum-
ably by *David Davies*. Behind is CAPEL ENOCH, 1833, a plain
and whitewashed lateral-fronted building. Simple timber gal-
leries and pulpit added, and the door moved to the end wall,
1869.

PRIMARY SCHOOL, ½ m. E. 1912–14, by *G. Dickens-Lewis*,
roughcast with a little cupola.

PONT DOLFOR. By Dolbantau Mills. Humped single-arch
bridge over the Clettwr, late C18 or early C19.

WOOLLEN MILLS. A group of later C19 mills of the Teifi valley
type, plain stone buildings of two or three storeys. ROCK
MILLS, across the river, 1896, still functioning, with unusual,
double-width iron water wheel, made by the *Bridgend Foundry*,
Cardigan. CHESTNUT MILL, ½ m. downstream on the E
bank, 1880s, three-storey, with big wheel from the *Priory
Foundry*, Carmarthen. BRONEINON MILL, ½ m. NE, 1870s,
has a larger wheel, made by the *Mwldan Foundry*, Cardigan.
DOLBANTAU MILLS, 1½ m. S, 1885, has been doubled in size,
1998, the parallel range echoing the old, in render and yellow
brick.

ALLTYRODYN. *See* Rhydowen.

CAPEL SEION
Llanbadarn y Creuddyn

SEION CALVINISTIC METHODIST CHAPEL. 1873, clumsy ren-
dered Tudor Gothic, with two porches and broad four-light
window.

MORIAH BAPTIST CHAPEL, Moriah, ¾ m. E. Roadside row of
chapel house, vestry and chapel. Chapel of 1829, roughcast
with two arched windows but only one door, indicating an inte-
rior redone with end pulpit in 1888. No gallery.

CARDIGAN/ABERTEIFI

Cardigan is a Norman foundation of the early C12, dating from
Gilbert de Clare's expedition of 1110, although Norman control
of Ceredigion was not fully established until the Edwardian con-
quest of 1277–82. In the mid C12, first Ceredigion and then, in
1165, Cardigan itself, fell to the Lord Rhys (Rhys ap Gruffudd)
of Deheubarth. He refortified the castle in stone *c.* 1171–6, and
welcomed here the gathering of the bards of Wales, Ireland,
Scotland and England in 1176, which stands as the first
eisteddfod. No certain remnants survive of this heyday, that
ended in internecine conflict before the Lord Rhys died in 1197.
Royal control was regained in the C13; in 1241–54 the castle was
rebuilt, and in 1279 Cardigan became the administrative centre
for Ceredigion, subordinate to Carmarthen, with military control
shared with the new castle at Aberystwyth.

Cardigan town initially comprised a small walled area on the ridge behind the castle, with a S gate by the bridge, a N gate by the present Guildhall, and an E gate near the present crossing of St Mary Street and Carrier's Lane. The bridge, of wood until the C17, existed as early as 1231. A market cross stood at the crossing of St Mary Street and High Street, with the parish church of Holy Trinity possibly adjoining, on the present Shire Hall site. Despite the insecurity of the C12, the town extended beyond the walls to the E towards the Priory church of St Mary, founded by the de Clares soon after 1110. A grant of houses to the Knights Hospitaller by Roger de Clare of *c.* 1158 may relate to the Angel Hotel site in St Mary Street, also outside the walls.

In the C13 the town grew as an Anglo-Norman settlement; the market was confirmed in 1227, trading privileges in 1230, a guild of merchants in 1249, and the borough charter in 1284. The Priory church grew in influence, with the holy relic of the taper of the Virgin Mary attracting pilgrims, while the parish church declined and probably disappeared in the C14. Momentum then seems to have declined; there were some 130 burgages in the C13, not greatly different from the town shown in Speed's map of 1610, where extramural houses appear only in St Mary Street.

While the medieval plan is easily discernible, only the castle and church survive of the buildings, though part of the line of the walls has been established by excavation. During the C17 and C18 the town expanded little. St Mary Street became the area of the principal town houses of the local landed gentry. Wharfs developed on both banks of the Teifi, serving trade not just along the coast but across the Irish Sea. Little of the C17 and C18 remains, and the character of the town today is predominantly

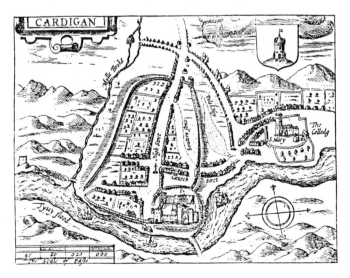

Cardigan.
Map drawn by John Speed, 1610

C19. The typical mix of stone and stucco is varied by local red brick, made at brickworks behind the present theatre from the 1860s. Some expansion N along Pendre occurred in the C18. Priory Street was cut through from the church to the new Guildhall in 1858, small-scale terraced housing extended N, along North Road in the 1870s and 1880s, and there was limited industrial expansion, along the Mwldan river below the High Street, and in Bridgend, S of the Teifi.

Cardigan industry was initially maritime: shipbuilding, wharfage, timber yards and warehousing. From the 1830s ironfounding began at Bridgend and Mwldan, initially as an adjunct to shipbuilding, though it later served the farms, woollen mills and building trades of the hinterland. The last ships built at Cardigan were launched in the 1870s but the industry was in decline, with the port, from the 1840s.

Trade in corn, fish and slates had been quite extensive in the C17 and C18. Fifty thousand bushels of corn were cleared through Cardigan Customs House in 1754, and in 1835, Cardigan was still the second port in Wales after Beaumaris, for the number of ships registered. Trade declined steadily in the C19 because of competition and the silting of the river.

The C20 has seen the town expand only moderately, with housing estates on both sides of North Road. A Townscape Heritage Initiative scheme from 1998 has seen much needed restoration of buildings in the historic core, beginning a reversal of neglect, and in 2003 Ceredigion County courageously purchased the castle site, which a trust hopes to restore.

CHURCHES AND CHAPELS

St Mary. The church of a small Benedictine priory, dependent on Chertsey Abbey, Surrey, established in the early C12. Rhys ap Gruffudd confirmed the endowment in 1165. From the C13, Cardigan Priory was a place of pilgrimage for the relic of the taper of the Virgin Mary, which burned without being consumed. By 1536 there were only two monks, and in 1539 the ancillary buildings were sold, and lost in subsequent rebuildings of the house since called The Priory. The church became the parish church, and has been much rebuilt but there is some medieval stonework in the nave, and a handsome late C15 chancel of Cilgerran stone.

50 The big W tower, in Cilgerran stone, was rebuilt in two phases, 1711 and 1745–8, having collapsed in 1705. The mouldings show the late date, but otherwise it is a very creditable piece of medievalism, with stepped diagonal buttresses and stair-tower. The aisleless nave externally tells little. One S three-light window, flat-headed without cusping, the rest replaced in the C19. A 1639 plaque in the porch may refer to general restoration; the window style is crude enough to be this late. The porch was rebuilt again in 1861, though the head stops are said to be Bishop Owen of St David and Archbishop Davidson of Canterbury, i.e. early C20. The two-centred inner doorway looks late medieval.

The three-bay chancel, though conventional in detail, with large Perp windows, pinnacled buttresses and battlements, has an architectural character otherwise unknown in the county, more akin to the C15 work at Tenby, Pembs. The tracery is restored, probably in 1906, but the limestone pinnacles, three now on the ground, with their crude crockets and schematic lily-pot are surely much older. Could they be genuine medieval work? The E end has a big five-light window between two square stair-towers, one of which could be a pre-C15 survival.

Plaques in the porch refer to work in 1639 and to the body of the church being rebuilt in 1702–3. Meyrick, in 1810, describes the recently lost chancel roof. Later restorations, generally cheap, took place in 1856 under *Henry Woodyer*, 1876–7, when the beefy organ chamber was added, 1882–3, 1906 when the chancel was repaired by *Lewis Lewis* of Cardigan, and 1923–6 by *W. D. Caröe*.

Simple, five-sided plaster nave ceiling, possibly early C18. Medieval corbelling over the blocked N door and by the S door. By the N door, a moulded triangular-headed recess, possibly a reset door-head. The tall tower arch was presumably rebuilt with the tower in the C18; there was a gallery across from 1821 to 1924. Exceptionally broad C15 chancel arch, a little crude with chamfers each side of a hollow moulding and half-octagonal piers. Rood stair door to the l. The chancel, as wide as the nave, has two fine C15 carved corbels which appear to pre-date the chancel arch, a female head and a grotesque with spread mouth and a finger to one eye. Meyrick in 1810 recorded eight corbels – five heads and three shields – and also six dismantled shield-bearing angels, carved in wood, suggesting a roof of exceptional richness. Panelled ceiling of 1926. Two doors to corner stair towers, one Tudor-arched, the other two-centred. C15 crocketed ogee PISCINA with Tudor rose base. N wall C19 organ arch, vestry door and recess, possibly a remodelled Easter sepulchre. – FONT. C15 octagonal with quatrefoil panels. – Sanctuary FITTINGS and REREDOS in oak of the 1920s by *Caröe*, PULPIT of 1926 by *W. D. Caröe* and LECTERN of 1931 by *Alban Caröe*. – STAINED GLASS. Chancel E and S windows of 1924 and 1925 by *Horace Wilkinson*, the E window with fragments of C15 glass in the top lights left from the E window that was removed to Hafod (q.v.) by Thomas Johnes and destroyed in the 1807 fire there. Chancel side windows with floral glass of 1906. Four-light nave S window of 1910 by *Clayton & Bell*. – MONUMENTS. In the chancel, war memorial, 1924, by *Caröe*, finely carved, mixed Gothic and Renaissance frame. Various urn-topped memorials, three signed *Wood* of Bristol: Margaret Thomas †1782; Edward Savage †1802; Hannah Thomas †1832. Also David Rowlands †1846, sarcophagus by *W. Behnes*; Rev. Thomas Morgan †1813; Anna Bailie †1870 by *Gaffin*, old-fashioned mourning female; and Thomas Davies †1832, columned, by *H. Phillips* of Haverfordwest.

In the churchyard, W gatepiers, early C19, with cast-iron urns, similar to ones on the gatepiers at Cardigan Castle and Glandovan, Cilgerran, Pembs.

OUR LADY OF THE TAPER (R.C.), North Road. 1970, by *Weightman & Bullen* of Liverpool. One of the very few modern churches of the area. A broad octagon of pale brown brick, the glazing in a band under a flat roof, and an odd metal-clad vent to light the sanctuary, the glazing hidden at the back. A second vent over the detached shrine of Our Lady of the Taper, which flanks the forecourt; both unpleasing in outline. The expected drama of the hidden light source does not materialize inside, as the clerestory admits too even a light. Flat ceiling on big laminated beams. The presbytery is part of the design.

BETHANIA BAPTIST CHAPEL, William Street. One of the best chapels of the region, 1847 by *Daniel Evans* of Cardigan, who was paid £2 for the design. Ponderous Early Victorian unpainted stucco front, but a good composition: big Doric porch, and broad segmental arch under an open pedimental gable. Three arched upper windows, the centre one with a stucco fan in the tympanum, cf. Hermon, Fishguard, Pembs., 1832. Leaded lights of 1908, though original small panes survive on the side windows. Good interior: box pews and a panelled, three-sided gallery on raised iron columns by *T. Lloyd* of Cardigan. Ornate plasterwork by *Thomas Rees* of Fishguard, a lozenge framing a little domelet, and a fleshy frieze with acanthus and urns. PULPIT, ORGAN, and GREAT SEAT, 1900. Rear vestry in grey stone, 1882, by *John Owen* of Liverpool.

CAPEL MAIR INDEPENDENT CHAPEL, Feidrfair. Rebuilt 1869–70, by the *Rev. Thomas Thomas* for £1,500. Grey rock-faced Pembrokeshire limestone with stucco dressings, the gable front pedimented with urns and long arched windows, a pair each side and three over the centre door. Innovative door detail, the arched hoodmould squeezed between ball-capped pedestals, and an unconventional pediment, divided vertically into three. Inside, a colourful three-sided gallery, curved at the angles and fronted with pierced cast-iron panels, matched in the great seat. Behind the ornate pulpit, a large Gothic organ, *c.* 1900. Chapel house and vestry, 1886–7 by *David Davies*.

MOUNT ZION ENGLISH BAPTIST CHAPEL, Priory Street. 1878, by *George Morgan*, for £1,200. Red brick with pressed brick decoration made at the Cardigan brickworks. Minimal Romanesque, with a winged façade contrived on a rectangular plan. The centrepiece is a big arched window over a double doorway with vine-leaf carving in the stone tympanum. Single end gallery.

TABERNACLE CALVINISTIC METHODIST CHAPEL, Pendre. The ferociously varied stuccoed front with a projecting centre and outsize Gothic rose over six lights is actually a toning down of an embellishment of 1902. The centre pediment was lowered and side pediments and a steep pyramid roof were removed in 1986, by *Llwyd Edwards*. All this disguises the original long-wall chapel of 1832, altered 1864. Interior mostly of 1864. Box pews and panelled gallery with curved angles, on thin fluted iron columns by *T. Thomas* of Cardigan. Elaborate acanthus ceiling rose. The Gothic window of 1902 is invisible within, blocked by the organ (by *Griffin & Stroud* 1904) for which the

whole projection was designed. Pulpit of 1902. Vestry behind of 1933.

HOPE ENGLISH CONGREGATIONAL CHAPEL, Carrier's Lane. The 1836–7 chapel survives in Carrier's Lane, as a warehouse. Half-hipped roof. Its Gothic successor of 1879, by *Peter Price* of Cardiff, in Pendre, was demolished in the 1970s.

PUBLIC BUILDINGS

CARDIGAN CASTLE. On a rocky cliff overlooking the bridge. A stone castle was built by the Lord Rhys *c.* 1171–6. New work was begun by the Marshals of Pembroke in 1240 but taken over by the Crown in 1241. From 1244–54 the castle was rebuilt by *Robert Waleran*, constable of works from 1248. The principal new feature was a keep, probably the N tower as no evidence has been found for a central building, apart from the unreliable illustration on Speed's map of 1610. Repairs are *p. 445* recorded in the C14, but no extensive new works. In 1810 the inner ward was landscaped for John Bowen, of the Priory, who appears to have built a new outer wall forward of the old, and infilled behind. In 1827 Castle Green House was built, backing onto the N tower.

Derelict and neglected for many years, Cardigan Castle is one of the few that has escaped the restorer in the C20, and its condition does not argue well the case for leaving ruins alone. Much eroded and crudely repaired, it is the height of the original rock more than the medieval masonry that gives character to the face towards the bridge, crowned by the Second World War PILLBOX.

The W side shows nothing medieval. An early C19 gateway with cast-iron urns is probably on the site of the gatehouse.

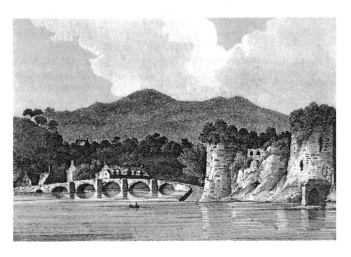

Cardigan Castle and Bridge.
Engraving, 1786

The walls were concealed by houses on Bridge Street until the 1930s, and partly collapsed in 1984, the s end masonry long propped by metal buttresses. The e side has two medieval towers and perhaps part of a NE bastion. The SE TOWER is rounded without special features; the e tower, also rounded has spur feet, and two flights of steps within, leading down to garderobes. The N TOWER, now detached and incorporated in the rear of Castle Green House, is more substantial, a broad drum tower with spur feet and vaulted basement. Excavation is needed to establish how this was linked to the rest, but has shown that there was a ditch and bank to the N.

CASTLE GREEN HOUSE. Large three-bay stuccoed villa, with deep eaves and a trellis porch, built for Arthur Jones in 1827 by *David Evans*. Meyrick in 1810 says that John Bowen was building a house on the site of the keep. The style of the present house suggests the later date but wall thicknesses inside show at least two phases. At the rear, the drum tower, cut down and capped with a curved hipped roof. A long hipped three-storey service wing runs E, and there is a detached cottage behind this. All derelict, as also a STABLE COURT, built before 1834, down below the e tower. Iron gates by *Moss* of Carmarthen.

GUILDHALL and MARKET, Guildhall Square. Well set at the centre crossing of the town; a surprising building. Built 1858–60 by *R. J. Withers*, it may be the first municipal building in Britain to follow Ruskin's precepts as set out in *The Stones of Venice* (1851–4). The emphasis on structural decoration and on sheer wall faces uninterrupted by extraneous decorative motifs speaks of Ruskin, even if, as at the Oxford Museum, the detail is not north Italian. Mild polychromy: brick bands and some Bath stone contrast with grey Cilgerran stone. The exterior expresses interior function, and many functions there were. The main range under the big hipped roof with its splendid cresting was an assembly hall over a corn exchange. Severe Gothic arches below and long two-light plate traceried windows above linked by pointed hoodmoulds. The female heads are cast-iron tie-rod ends of the 1860s. Main entrance and stair in a narrow recessed bay to the l. capped by a clock turret of 1892 (by *Richard Thomas* of Cardigan). The l. cross-wing contained the grammar school below and news room and council room above: small-paned timber windows under brick Gothic relieving arches. The side to College Lane had a big chimney, now truncated, and a lower range with the school entry. Further down the slope is the very fine two-storey Market, entered at ground level from College Lane, or at upper level from the courtyard behind the hall. All this was achieved for £4,055 os.8d. Withers's detail is economical and well considered. The main hall has a canted panelled roof, echoed in miniature over the stair, which has a massive stone handrail. It is within the Markets that to modern eyes Withers excels: the lower market vaulted with pointed arches dying into a forest of circular grey piers. Centre light well fringed on the upper

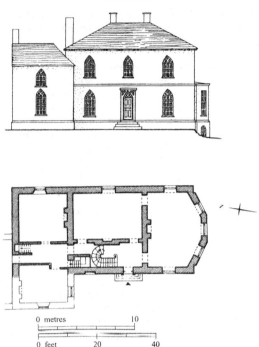

The Priory, as designed by John Nash, 1788.
Elevation and plan

level by Gothic arcading, all unmoulded and massive. The
fortress-like outside rear wall has a single band of broad
pointed windows at the lower level.

THE SHIRE HALL, High Street. *See* Perambulation.

CARDIGAN MEMORIAL HOSPITAL, E of the church. A sad story
of civic zeal overwhelming architecture. The decision to site
the War Memorial Hospital at The Priory, the principal house
of Cardigan since the Dissolution, has left the 1788 house
a barely recognizable hulk in an all-too-prominent riverside
position.

The house, made from the original monastic buildings, was
by the mid C18 owned by the Pryses of Gogerddan, MPs for
the Cardigan Boroughs. In 1774 it was sold to Thomas Johnes,
whose son, the creator of Hafod, had won the seat that year.
The house was rebuilt in 1788–9 by *John Nash* as a three-bay
villa with hipped roof, deep eaves, a shallow bowed s front with
sash windows, and pointed windows on the w side. The 1922
conversion, by *J. Teifion Williams*, added an extra storey, and
subsequent recladding, dire windows and additions have
completed the ruin. The best surviving detail is the cramped
but delicate staircase with an inlaid rail.

CARDIGAN BRIDGE. A medieval timber bridge was replaced in
stone in 1639 but 'broken down' in the Civil War. The present

bridge in Cilgerran stone of five shallow arches with full-height cutwaters is illustrated in a Buck engraving of 1741. A plaque records one arch being rebuilt in 1726. Widened on the w side in 1872.

POLICE STATION, Priory Street. 1895. Pembrokeshire limestone with black brick dressings, gaunt, Gothic and old-fashioned. Adjoining court house with glazed tile front of 1935.

CARDIGAN COMPREHENSIVE SCHOOL, on the corner of Gwbert Road. Built as the Intermediate School, 1895–8, by *George Morgan & Son*. Red brick with pretty Queen Anne timber lantern, painted aesthetic green, the front long, low and generously windowed. Additions in 1935–6, jointly planned by the county architects for Cards. and Pembs., *Rhys Jones* and *Owain Thomas*, around two courtyards, and more, 1957–9, by *G. R. Bruce*, and later.

CARDIGAN PRIMARY SCHOOL, Napier Street. 1953, by *G. R. Bruce*.

NATIONAL SCHOOL (former), now part of Coleg Ceredigion, opposite the churchyard. 1847, by *W. L. Moffatt*, the early partner of George Gilbert Scott. Shorn of chimneys and dormer gable tops. This was an expensive building, costing £1,473 17s. 3d., and showed Gothic Revival thinking in an area where such things came late. The promoter was the Rev. Robert Miles, of the Bristol banking family, owner of The Priory. Stone, Tudor Gothic, T-plan, with two high storeys of classrooms (girls above boys), the staircase and master's house in the cross-wing.

THEATR MWLDAN, Bath House Road. The former slaughter-house of 1858–9 by *R. J. Withers*. A banded stone building with half-hipped roof, became a theatre in 1985. This has been dwarfed by a new theatre on the slope behind, 2002–4, by *LAWRAY* of Cardiff, that echoes the roof form of the original. Across the Mwldan river, at Bath House Farm, an unusual later C19 model cow-house with hipped ventilator to a steep roof has been well converted to a media centre.

PERAMBULATIONS

Starting from the bridge, BRIDGE STREET curves upwards, with one remaining wharf to the l., the entrance lane crossed by PANTYWYLAN, a warehouse of 1830. Behind, No. 1 CAMBRIAN QUAY has a handsome mid-C19 stone front. There were houses on the castle side of Bridge Street until the 1930s, but opposite an attractive row survives; the GROSVENOR HOTEL, low, with late C18 or early C19 pediment and lunette, and CASTLE CHAMBERS, early C19 three-bay, three-storey stucco front with cambered headed windows. Formerly both buildings were Bridge House, the headquarters of the Davies family's mercantile interests, established on the other side of the river in 1785. Nos. 6–7 are an earlier C19 pair in stone. On the corner of Quay Street, MANCHESTER HOUSE, 1884–5, by *George Morgan*, a large stuccoed, pilastered draper's emporium.

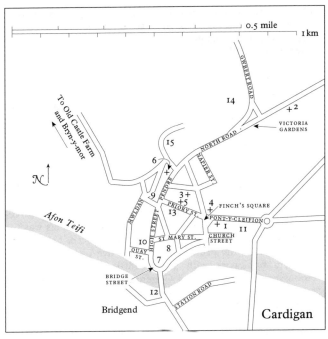

1	St Mary's Church	9	Guildhall and Market
2	Our Lady of the Taper (R.C.)	10	Shire Hall
3	Bethania Baptist Chapel	11	Memorial Hospital
4	Capel Mair Independent Chapel	12	Cardigan Bridge
5	Mount Zion English Baptist Chapel	13	Police Station
6	Tabernacle Calvinistic Methodist Chapel	14	Comprehensive School
7	Cardigan Castle	15	Theatr Mwldan
8	Castle Green House		

Opposite, GREEN STREET, a short lane to the castle entrance
with pair of colour washed c18 cottages, restored 2004 as the
first part of the castle restoration. QUAY STREET has earlier
c19 houses, three-storey at the upper end, Nos. 24–26 in stone,
with columned double doorcase and bowed shop-window.
Opposite, No. 1, earlier c19 with columned doorcase and
bracket eaves, the bays later. Also, ROCK TERRACE, two pairs
of 1886–7, by *Richard Thomas*, with typical decorative Car-
digan brickwork. MWLDAN below was once an industrial area.
A four-storey, three-bay stone WAREHOUSE survives, earlier
c19 but raised a storey, probably a sail-loft.
Back at the top of Quay Street, HIGH STREET begins with the
former SHIRE HALL, on the l., the ungainly façade possibly
of 1827–30, by *David Evans*. A big two-storey arch in Cil-
gerran stone and low attic with cornice and parapet, clock
dated 1844 on the side wall, and timber cupola on the roof,
restored from old photographs, 2003. The interior is more
interesting. Building began in 1764, with further works in 1797.

The ground floor was a corn exchange, with steps up to a raised upper end with six massive columns. Above was an assembly room opening at the far end into a handsome octagon, probably of 1764. Doric columns to the three bays open to the main room, three windows on the far end, modillion cornice and a shallow octagonal dome with centre rose. The assembly room has a similar cornice with shallow plaster vault and a panelled triple arcade at the street end, presumably where the original stairs entered. These are almost the only surviving pre-C19 civic interiors in South-West Wales. The row opposite is late C18 to C19, three-storey, stucco, and much altered. No. 37, of five bays, has later C19 stucco and shopfront but is early C19 within; Nos. 35–36, on the corner of St Mary Street, mid C19 (before 1853), have a curved corner, bracketed eaves and pediments, the late date shows in the inflated scale. Beyond St Mary Street, a mixed stuccoed row, mostly three-storey, apart from the low No. 34, on the corner. This was the White Lion inn in 1830, brick beneath the stucco. The BLACK LION HOTEL, the principal inn, has a five-bay front entirely of early brickwork with good C18 lead rainwater heads, embossed with the lions of Gogerddan. The façade probably *c.* 1780, though the inn is recorded from the earlier C18. The porch is a recent facsimile.

On the W side: TY MAWR, *c.* 1884, probably by *George Morgan*, heavily detailed stucco house, with large oriel and arched dormer. No. 4, the NATIONAL WESTMINSTER BANK, has an early to mid-C18 staircase to the upper floor, with heavy rail, twisted balusters and crude splat balusters at the top. Nos. 7–8 have two first-floor bowed tripartite sash windows, one a restoration of 2002; Nos. 9–10 are earlier C19, Cilgerran stone, across a narrow lane from the HSBC BANK, 1914, Portland stone. French late C18 style, single-storey with columns, and bullseye dormers behind a balustrade. Next door, No. 12, 1906 by *L. Lewis* of Cardigan, old-fashioned with oriel bays; then LLOYDS BANK, 1888–9, by *George Morgan*, the Brecon Old Bank, sizeable, but not grandiose, red brick above a stone-mullioned bank front, with pretty stained glass. No. 18, W. H. SMITH, 1863 by *R. J. Withers*, much altered, seems to have introduced the brickwork fashion of nogged, slightly pointed window heads, though its discreet polychrome banding was too reticent for the local copyists. The end building, No. 20, *c.* 1885, shows Cardigan patterned brick as commonly used, extravagantly, to enliven an uneventful elevation.

On the E side, after the Black Lion, Nos. 28–29, earlier C19 stone with bracket eaves; the POST OFFICE, 1905, stucco; No. 26, Cardigan brick, with a good early C20 curved-glass shopfront, and No. 23, *c.* 1870, echoing No. 18 opposite, with original shopfront. No. 21 faces over Guildhall Square, with small lunette and carved stone plaque, D. JONES, SADDLER 1800. It was restored in 2002, having lost all other features, an important achievement because of the prominent site. The medieval N gate was nearby.

GUILDHALL SQUARE is an *ad hoc* space with six streets or lanes coming in. Late C19 red brick pair opposite the Guildhall (*see* above). PRIORY STREET, cut through in 1858, was built up slowly. On s, two widely separated stone buildings with subtle brick banding, GRAYSTONES and BROYAN HOUSE, suggest a trained hand varying the Late Georgian pattern. The chimneys have a Victorian punch; could *Withers* have been involved? Between are the Police Station and court house and, opposite, Mount Zion Chapel (qq.v.). At the foot, overlooking MORGAN STREET, a red brick gabled terrace of 1900, with old-fashioned Gothic porches. In FINCH'S SQUARE, the LAMB INN, still on a cottage scale, and a cut through to CHURCH STREET, which ends at the churchyard. IMPERIAL HOUSE, on the l., three-bay stone villa of *c.* 1830, with bracketed eaves and arched ground-floor windows in arched recesses. Tent-roofed porch on one end, and a Gothic stair light.

ST MARY STREET runs back to High Street: No. 26, two-storey, has moulded eaves that could be mid C18. Nos. 19–22 are earlier C19, three-storey, stuccoed with tripartite ground floor sashes. No. 17 has a C17 moulded beam inside. The ANGEL HOTEL opposite has a stone front of five bays, mid-C19. It may be on the site of houses granted to the Knights Hospitaller in 1158. No. 39, offices of the Tivy-side newspaper, is early C19 with reeded doorcase. No. 40, though with three-bay stone front that looks Late Georgian, is earlier C18. The moulded oak doorcase looks late C17, but the staircase with pulvinated string and oak roof trusses are earlier C18. Behind, in Carrier's Lane, the former Hope Chapel (*see* above). This part of St Mary Street has lost the houses opposite, to road widening, above Carrier's Lane both sides are intact. On the l., No. 43, modest, early C19, with wrought-iron gate to the castle grounds, and the OLD STABLES, earlier C19 with hipped roof. Opposite, No. 9, plain roughcast, five cramped bays and three storeys, presumably C18, but without datable detail. In the early C19 it was the town house of the Gowers of Castell Malgwyn, Cilgerran. No. 7 is the best of the Cardigan town houses. Said to have been the town house of the Brigstockes of Blaenpant, Llandygwydd, but owned in 1834 by Lewis Evans, solicitor. Cilgerran stone two-storey, four-bay front with pediment over the centre two. The façade has been lime-rendered with quoins, 2005, a bold restoration by *Cliff Blundell*. The columned porch is on the l. side, the column entasis thoroughly misunderstood. Early C19 detail inside, with open-well stair. Opposite, the OLD CUSTOM HOUSE, early C19, single-storey, but on a bold scale, three big arched recesses and bracketed eaves. CHANCERY LANE runs back to the Guildhall, the drop below marking the line of the medieval walls.

From the Guildhall, PENDRE runs N with mostly stucco later C19 fronts. No. 1, on the corner of Priory Street, 1916, by *J. Teifion Williams*, has a modern touch with squared-off bays. Behind the stucco front opposite, CANOLFAN TEIFI,

shopping development, 1992–3 by *Llwyd Edwards* of Cardigan, the tall façade to the Mwldan red brick with arched windows, crudely warehouse-derived. Further up, Tabernacle Chapel (q.v.) and, behind the Central Cafe, the shell of the first Bethania Chapel of 1775. On the E side, Nos. 44–47, mid C19, have an unusual scale and dignity unusual in the town, two pairs of three-storey houses in the banded stone more typical of St Dogmaels. WILLIAM STREET was cut through in 1846, its two-storey houses effectively dominated by Bethania Chapel (q.v.), but very few keep their original sashes and doorcases, the best is No. 12.

Pendre opens into NORTH ROAD. On the l., some houses with later C19 Cardigan brick decoration. The brickworks were just behind. Set back, Stanley House and the Highbury Hotel are on the site of *John Nash*'s gaol of 1791–7, closed in 1880. The gaol had a pedimented three-bay centrepiece, with pyramid-roof and near-detached three-bay wings also pyramid-roofed. STANLEY HOUSE, *c.* 1880, replaces the l. wing, the governor's house. It is just possible that its three-bay arched-windowed front is the Nash front under a new roof. The old front is unrecorded. The HIGHBURY HOTEL, a pair of villas of 1898, is built onto the front of the prison centre block, of which the pyramid roof, rear wing and some blocked windows on the N side survive. Opposite is PRIORY TERRACE, *c.* 1875–80, probably by *W. Woodward*, owner of the brickworks, hence the display of Cardigan brick. Five houses with gabled centrepiece, serious female keystones and much moulded and pressed brick decoration. Modest C19 terraces continue outwards, framing the diminutive VICTORIA GARDENS, 1897, and the WAR MEMORIAL, 1922, a much reduced Whitehall Cenotaph. Some houses have outsize bricks, actually a remarkable hollow L-section block, made at Cardigan from *c.* 1860. In NAPIER STREET, MASONIC HALL, the former VICARAGE, 1886, by *George Morgan*, large and stuccoed. Further up North Road, the R.C. church (*see* above), a terrace similar to Priory Terrace, and TESCO SUPERMARKET, 1993 by *Wigley Fox Partnership*. A scattering of villas of after 1900 along GWBERT ROAD, one pair, THE CEDARS and LLUEST, 1911 by *J. Teifion Williams*, given a seaside gaiety with two small ogee domes, and THE CHESTNUTS, beyond, a slightly Arts and Crafts cottage, with red-tiled roof.

OUTER CARDIGAN

South of Cardigan Bridge

Bridgend grew as an industrial suburb in the C18. By the bridge, the CASTLE INN, early C19 with pediment lunette, perhaps by *Daniel Evans*, 'architect and innkeeper' who died here in 1852. Opposite, two large stone warehouses. First, BRIDGE WARE-HOUSE, perhaps part of the quay with limekilns and store-houses begun in 1830 by *David Evans*. Impressive square,

five-storey, five-bay hipped block with small windows, the interior construction still all of timber. Beyond, BRIDGEND WAREHOUSE, which, despite the mid-C19 look of its brick-headed windows, incorporates in the lower two floors the shell of a warehouse built in 1745 for the Parrys of Noyadd Trefawr, that is prominent in early views of the castle. In the earlier C19 the Davies family developed the wharf and established the Bridgend Foundry and sawmills upstream, in the present builders' yard, STATION ROAD. Brick sawmills attached to a stone building with arched furnace entries. Of the STATION, 1885–6 by *J. B. Walton*, there remains one stone range, the goods station.

North-west of the Town

OLD CASTLE FARM, 1 m. W, on the N bank. The reputed site of Dinas Geraint, the first Cardigan Castle, built 1093 in haste by Roger de Montgomery, though the evidence is far from clear that Roger's site was different from Gilbert de Clare's in 1110. A small promontory site, protected by a single ditch. No evidence to link it to the Norman period. On the riverbank below, a fine earlier C19 square LIMEKILN.

BRYNYMOR, 1 m. NW. Superbly set by the estuary, best seen from the W bank. A mariner's retreat, built *c.* 1802 for Captain Samuel Jones, and so, exceptionally for the county, facing the water. Plain square three-storey, three-bay house, with deep bracket eaves and a hipped roof. The yellow-ochre limewash is part of an exemplary restoration after 1985 for Mr and Mrs Young.

ABERDARE, 2 m. N, off the Gwbert road. Stone villa of *c.* 1830, three bays with pediment and lunette.

CELLAN

6149

A largely modern village with two chapels, the church some ¾ m. beyond.

ALL SAINTS. A small medieval church, with paired windows in brick, thin and angular, by *Herbert North* of Llanfairfechan, 1909. Are these an Arts and Crafts cry against false mediev-alism? By North also, the rough W bellcote with openings of different sizes, and a slate saddleback roof. Big S porch, possibly C17, with stone seats and reused oak collar-truss that could be late medieval.

Inside, the only significant Arts and Crafts work in the county. Plain boarded roofs, painted white with stencilled vine and rose trails in red and green, some blue in the chancel. By North also, the simple oak SCREEN, entirely appropriate, just plain chamfers and shouldered arched heads. – FONT. Medieval, of indeterminate date. A heavy square bowl with two tray-like thick rounded bands over a rather classical coved moulding. – STAINED GLASS. E window, 1908, with shields.

Across the road, plain mid-to-later C19 NATIONAL SCHOOL, a single room, extended w.

CAERONNEN WESLEYAN CHAPEL. 1846, with ugly cement gable front of 1925. The old lateral façade was slate-hung with two sashes and outer doors, now blocked.

YR ERW INDEPENDENT CHAPEL. 1863, with stone front of 1933. Small-paned arched side windows. Single end gallery.

BOARD SCHOOL, Pentrefelin. 1899, by *David Davies*. Stone, T-plan, paired gable windows.

CAER CADWGAN HILL-FORT, above the Ffrwd Cynon valley to S (SN 622 479). Oval enclosure, open to SE.

CARREG HIRFAEN STANDING STONE, 2 m. S, on the county boundary (SN 625 465).

CARREG Y BWCI (SN 646 479), on the county boundary. A disturbed tumulus next to SARN HELEN, the Roman road from Carmarthen, suggested also as a Roman watch tower.

CHANCERY/RHYDGALED

5877

Llanychaiarn

Each side of the main Aberystwyth road is a short mid-C19 row of single-storey estate COTTAGES, whitewashed stone with simple Gothic windows. In contrast, the former LLANYCHAIARN BOARD SCHOOL, 1876, by *Szlumper & Aldwinckle*, spiky Gothic in stone and yellow brick with timber flèche.

FFOSRHYDGALED (Conrah Hotel), just S. Hipped stucco villa built for James Davies, *c.* 1865, originally near identical to Pen-pompren, Talybont. Altered 1909, by *G. T. Bassett*, for Morris Davies. Burnt and reinstated, 1911. Three-bay deep-eaved front with large half-round bay. Added canted bays, and a little curved bow above the main bay. Inside, woodwork of 1911, stair arch with paired columns.

See also Blaenplwyf and Llanfarian.

CILCENNIN/CILCENNEN

Compact village with some mid-C19 fronts, in Late Georgian style, down the hill from the COMMERCIAL INN, by the church.

ST CENWYN. Rebuilt 1889–91, by *Archibald Ritchie*, for £739 4s. od., keeping the single vessel of 1823, and adding a hipped W end porch/vestry, and typical heavy plate tracery. Plain interior with open roof trusses and C19 fittings. The previous church was drawn by Dineley in 1684, a very rare illustration of a small country church of the period. – STAINED GLASS. E window of the 1950s. – MEMORIALS. Mary Hughes †1763, with good lettering; Thomas Winwood †1838, plaque by *Wood* of Bath; F. J. Saunders †1870, long plaque by *Tyley* of Bristol.

p. 38

Across the road, small earlier C19 SCHOOLROOM. Downhill, the former VICARAGE, 1865, by *Charles Davies*, hipped, stucco, of three bays, with niche in place of the centre door.

SION INDEPENDENT CHAPEL. 1859, possibly a remodelled building of 1835. Roughcast lateral façade with eaves brackets, small-paned arched windows and arched doors. Three-sided gallery with plain upright panels on iron columns.

ORFA DDU, ¼ m. N. Single-storey, one room cottage of stone and earth. Inside a plastered fireplace hood. Probably early C19.

TY MAWR, ½ m. SW. Substantial three-bay villa, *c.* 1840 for F. D. Saunders, originally roughcast. Low gable to centre with eaves brackets, over a tripartite sash with false shallow fanlight. Inside, square toplit stair hall with open-well stair. *C. R. Cockerell*'s diary records making plans in 1826, but nothing further.

TY GLYN, 1½ m. W. A dignified mid- to later C18 house, the best of its type in the county. Plain white roughcast five-bay front with eaves cornice and hipped dormers. A sundial dated 1620, was set in 1768 on the stable end wall, perhaps when the new house was built for Henry Jones. His daughter married the Rev. Alban Thomas in 1797 (*see* Aberaeron). Thomas added one of the two wings in 1809 as a chapel: just two sash windows to the front, a S end stone bellcote and dedication SAN'O ALB'O ANGLIAE PROTOMAR. The other wing is a two-storey service range. A good C18 open-well stair, with turned balusters and thick rail. The chapel has a shallow-curved plaster ceiling and very simple end gallery on two wooden posts.

N E of the house, an C18 BREWHOUSE with large chimney. In the farmyard, a timber C19 GRANARY on staddle stones, exceptional in West Wales, almost a folly. Said to have a pencilled date of 1834, which seems too early. The BARN is probably late C18, with scarfed roof trusses and brick entrance arch.

TY GLYN AERON, 1 m. WSW. Three-bay stuccoed house of 1836, possibly by *Edward Haycock*, for Thomas Winwood. Stone columned porch flanked by gables, and garden front with canted centre. Wing of 1876. After a fire in 1985 the windows were replaced in plastic and the chimneys removed.

PLAS CILCENNIN, ¾ m. E. The site of one of the larger C16 to C17 houses of the county, of the Stedman and Vaughan families. It had nine hearths in 1672, but had gone by the late C18.

PONT NEWYDD, ½ m. SW of Ty Mawr. Two-arched C18 stone bridge over the Aeron. Asymmetrical arches, widened in C19 leaving one upstream cutwater.

TRICHRUG ROUND BARROWS, 2 m. E (SN 541 599). On the summit of the hill, three very large barrows, probably Bronze Age.

CILIAU AERON

Church and chapel uphill to S of the modern village in the Aeron valley, with gabled SCHOOL of 1876.

St Michael. Small single-chamber church with w bellcote, rebuilt before 1755, restored for £400 in 1905 by *E. V. Collier*. The arched side windows are original; Gothic e window of 1905. Plain interior with mid-c18 collar trusses. – stained glass. e window, 1905, by *Percy Bacon*.

In the churchyard, an iron-railed burial enclosure, and nearby, finely lettered tomb of David Davies of Foelallt †1755, recording that 'The building of a meeting house and the rebuilding of this church will perpetuate his memory to future ages.'

Unitarian Chapel. 1899, by *A. S. Tayler* of London. Quite churchy, with chancel and Gothic porch, but bland.

Pont Newydd, *See* Cilcennin.

Foelallt, w of the church. Attractive whitewashed mid-c18 house of three bays, the centre window smaller and raised over a lean-to porch. Built for David Davies †1755.

Tanyrallt, ¾ m. e, in the valley. Three-bay farmhouse of *c.* 1840 with Gothic windows.

Pontfaen, ½ m. w. Early c19 Llanerchaeron estate farm, hipped barn with three big front arches.

Blaencamel, ½ m. s. By the side of the three-bay stone house, a subtle extension of 1998, by *David Lea*. A deep square in plan with two pitched roofs separated by three strips of roof-lights. One roof covers a living-room, glazed at one end, and open to top-lit narrow circulation spaces each side, a reverse of the dark corridor. Simple external materials, white render, stone and glass.

CRIBYN

Llanfihangel Ystrad

Elongated village, wrapped around the Gaer Maesmynach hill-fort, an oval encampment with entry from the s. The village grew with the woollen industry in the late c19, but there are some older earth-walled cottages.

Mission Church. 1894, probably by *David Davies*. Stone and yellow brick.

Cribyn Unitarian Chapel. 1851. Plain stucco lateral façade with arched openings, the glazing altered. Three-sided panelled gallery of 1887, on wooden posts.

war memorial, Cribyn. White marble soldier, 1923, by *E. J. Jones*.

Troedrhiwfallen, by the war memorial. Whitewashed cottage of unusual size, stone ground floor with earth-walling above. Restored in 2003–4 by *Greg Stevenson* with *Bruce Pitt*. The thatched roof with conical thatched chimney over a 'wicker' (lath-and-plaster) chimney hood replicates a traditional local feature. A notable restoration.

Felin Hafodwen, ½ m. sw. Very small later c19 stone corn-mill, remarkable as a very late last example of Vitruvian, or

direct-drive machinery, where the inner pit-wheel drives the iron stone-nut directly. Water wheel by the *Priory Foundry*, Carmarthen.

TROEDYRHIW INDEPENDENT CHAPEL. 1¼ m. NW. An attractive stone chapel of 1861, still with lateral façade and small-paned arched windows. No galleries, but raked box pews and three-sided ceiling edged in painted fretwork. It cost £220.

CASTELL MOEDDYN, 1 m. W of Troedyrhiw (SN 475 519). Oval embanked hill-fort dramatically sited on a spur.

CROSS INN 3957
New Quay

HOLY TRINITY. Dated 1904, but 1871 on corner stone. Utilitarian, stone and yellow brick.

MAENYGROES INDEPENDENT CHAPEL, 1902, 1 m. N, and BRYNRHIWGALED INDEPENDENT CHAPEL, 1898, 1½ m. S, similar arched-window designs, probably by *David Davies*. The mother chapel, PENRHIWGALED, 1828, survives at Maes-newydd farm, now a bee-keeping museum. Plain rubble stone long-wall façade with centre flat-headed windows.

CEFN GWYDDIL, ½ m. N. An unspoilt farmstead of the C19. 9
Whitewashed buildings around a broad earthen yard. The barn is small by comparison with arable areas, part of a range with cart-sheds and lofted stable. The early C19 farmhouse, across the top end, is typically three-bay, with small upper windows and service range to one side.

FELIN SYNOD, 2 m. S. Late C19 stone corn-mill with large Cardigan-made iron wheel. FELIN BOMPREN, of 1852, which was 1 m. downstream, and much more primitive-looking, is now re-erected at the Museum of Welsh Life, St Fagans.

CWM COU 2942
Brongwyn

On the old road from Cardigan to Newcastle Emlyn. The older settlement by the Teifi is called Drewen.

Y DREWEN INDEPENDENT CHAPEL. 1921, by *J. Howard* 109
Morgan. In an unusual Free Style, white-painted stone with cast-stone dressings. The chapel side wall is set back between gables, to the l. with stepped stair lights, to the r. larger with big arched mullion window lighting a transept. Flat roof between the gables with Arts and Crafts flat-capped octagonal piers framing the door. A third gable to the r. marks the vestry. Inside, a typical Morgan roof with much timbering. Semicircular great seat and matching pulpit, in front of an arch with folding doors to allow use of the vestry behind as part of a stage, the pulpit front movable.

FELIN DREWEN, below the chapel. Small stone watermill on the Nant Gwrog, dated 1791, though the building probably raised a storey in the C19. Complete later C19 line-shaft drive to two stones, but the mill wheel missing.

ABERCERI, on the main road. Three-bay, stucco hipped villa of 1827, built picturesquely above the Teifi for Robert Moseley Thomas, barrister. Late C19 bay windows, original lean-to wings and open-well stair.

FELIN GERI, ½ m. NE. Small watermill on the Ceri, built for the Cilgwyn estate, Adpar. A simple C18 stone building, raised a storey in 1805, and with two parallel wheels of 1872 and the 1880s, the outer one to power a sawmill. Line-shaft machinery of 1872.

TROEDYRHIW, 1 m. NW. Small farmhouse with steep hipped roof and lobby-entry against a big central stack, a most unusual plan form in the area. No datable detail, the type is late C17.

PARC Y CASTELL, 1 m. NW. Iron Age hill-fort.

CWMRHEIDOL
Capel Bangor

RHEIDOL HYDRO-ELECTRIC SCHEME. Opened in 1964 to supply electricity to South Wales. The stone-faced TURBINE-HALL and the neatly landscaped surroundings of the reservoir to the W give little hint of the scale of the enterprise. Water is collected at the Nantymoch reservoir, 5 m. N, from a vast area of hill W of Plynlimon, carried by a 2½-m. tunnel to the Dinas Reservoir, N of Ponterwyd, and then a further 2½-m. tunnel brings the water at some 25,000 litres a second into the Cwm Rheidol power station. Two turbines here each generate 18,000 kilowatts, and smaller stations at Dinas and at the reservoir dam bring the total power to 49,000 kilowatts. The valley is kept free of pylons by siting the main switching station on the far side of the ridge, near Llywernog.

BETHEL WESLEYAN CHAPEL, 1 m. SE. Small lateral-fronted chapel of 1872 with arched windows and 1895 porch.

CAEGYNOG MINE, ¾ m. SE (SN 718 784). Lead mine worked from 1854, with ruins of crusher house, sheds and manager's house.

CWM RHEIDOL MINE, 2 m. SE (SN 730 783). Large mine site with deep-yellow wastes from iron oxide in the ores. A level was driven from here into the Ystumtuen Mine to the N, begun in 1824 by the Alderson brothers, mining entrepreneurs from Yorkshire, but they were bankrupted by the venture. Eventually driven through, and on to connect other mines around Ystumtuen. The mine was worked in the early C20 for zinc blende, the product carried across the river by aerial ropeway to the Vale of Rheidol railway on the S side. Ruins of a mid-C19 crusher-house above an early C20 dressing plant. The mouth of the 1824 level is at the top of the site.

CWMSYMLOG *see* PENRHYNCOCH

CWMYSTWYTH
Llanfihangel y Creuddyn

CWMYSTWYTH CALVINISTIC METHODIST CHAPEL. 1870. A minor work of *Richard Owens*. Stone and orange brick, with recessed arched openings.

In the village, stuccoed SCHOOL, 1904, by *J. Arthur Jones*, by the chapel. To the W, HAFOD LODGE, 1837–9, built as the Hafod estate school for the Duke of Newcastle, probably by *W. Coultart*, gabled two-storey house between schoolroom wings, the house with massive side-wall stacks, one pierced for the school bell. It stands at the head of a disused Hafod drive, on the site of a lodge of 1813–4. Later C19 GATES.

CWMYSTWYTH LEAD MINE, 1 m. NE. The steep-sided Ystwyth valley is scarred with waste piles, workings and derelict buildings, principally on the N side, under the rocky crag of Graig Fawr and Copper or Copa Hill beyond. The origins of mining are very obscure, stone hammers and querns have been found at Copper Hill that could be prehistoric, but are undatable. There is a possibility of Roman mining, and a probability of some medieval working for the monks of Strata Florida, where smelting slag has been found. Hard evidence is lacking but the Copper Hill spoil heaps are so much larger than can be accounted for from records that extensive Roman working may be an explanation. Leland in the 1530s saw evidence of great workings in the past, abandoned he thought because all the trees needed for smelting had gone. The site in 1583 was reported 'so wet, so windie and so ruinous' that it was unsafe, but was worked intermittently before the Civil War, with both Sir Hugh Myddelton and Thomas Bushell involved. In 1813 pumps were found underground thought to be some two hundred years old. Morgan Herbert of Hafod and John Jones of Nanteos were involved in the 1660s, with Jones' son-in-law the Cologne-born engineer Cornelius Le Brun. William Waller worked it for the Company of Mine Adventurers from 1704–9, and his map of the site shows a stamping mill with waterwheel, a forge, store-houses and a group of single-storey houses called 'the town we have built for our miners'. Waller claimed to have raised over 580 tons by 1708 from the main site on Copper Hill and explored six other sites unproductively, but the fraud associated with the Company make any figures unreliable. Records of working after Waller's dismissal in 1709 are sporadic. Thomas Powell of Nanteos drove off some miners at gunpoint in 1731. In the 1760s Chauncey Townsend MP, owner of smelting works at Neath, engaged the Derbyshire engineer Thomas Bonsall, who ultimately took over the lease and garnered most from the mine, one of several in which he had an interest. He was the first to exploit the reserves of blende for zinc, and is said to have made some £2,000 profit per annum. Bonsall's Level Fawr of *c.* 1780 is driven into Graig Fawr, and

both Graig Fawr and Copper Hill have scars of hushing, the washing away of topsoil by means of collected water, a practice Bonsall used. Bonsall worked mostly below Graig Fawr, more than on Copper Hill, by then probably exhausted. In 1803 Malkin reported 'the squalid garb and savage manners of the male and female miners' as beyond belief. After Bonsall's death in 1807 mining declined until 1822 when leased by the Alderson brothers and James Raw, all from Yorkshire. The Aldersons were bankrupt in 1834, but Raw remained, working for Lewis Pugh of Aberystwyth, who reputedly made a fortune before 1844. Pugh's shaft at the sw edge of the workings was the deepest reaching 324 ft. From 1848 mining was under John Taylor & Sons, still with Raw as mine captain until his death in 1864. Yields declined but the mine was expensively re-equipped in 1873–7. In 1880 there were 173 employees, adults and children. In 1887 a new venture, the Kingside Mining Co., reopened workings just below Copper Hill, with a new 40ft wheel and extensive buildings on a steep slope, but that venture failed in 1893. Another costly new start by Henry Gamman in 1899 rebuilt the dressing-mill, driven by water-turbine, and expended a great deal on processing zinc blende before 1911, but failed. Mining ceased in the 1920s, with desultory interest in picking over the spoil heaps continuing into the 1940s.

The adits and levels tunnel endlessly, some 84 recorded, the longest said to extend in some two miles. The surviving buildings at the w end are largely later C19 or early C20 – the platform where Gamman's corrugated-iron clad mill stood, and the ruins of the manager's office and crusher house of the 1870s. Beyond the Nantygraig stream are remains of an early C19 office, later used as housing, and the stone portal to Bonsall's Level Fawr is further E. Above was the site of the mine buildings of 1887. The line of the tramway running E is paralleled by the courses of water leats. Over the next stream, Nant yr Onnen, is Copper Hill, the lower workings, known as Pengeulan, recorded from the C17, and the site of Waller's workings of 1704–9 further up the stream, with massive dumps probably indicating much earlier use. On the slopes of Copper Hill can be seen retaining dams for the hushing process, and the leats that fed them. Further back on the s side of valley was the South Cwmystwyth mine, possibly an ancient site, unsuccessfully re-opened for the loss of some £40,000 in 1874–84.

TYLLWYD, Blaenycwm, 2½ m. E. Substantial farmhouse, built in the early C19 as both farm and inn by James Raw, mine captain 1822–64.

PONT BLAEN, Blaenycwm, 3 m. E. 1783, by *Thomas Baldwin* of Bath for Thomas Johnes of Hafod. Single arch with 42-ft (12.8-metre) span, the parapets stepped up over carved Bath stone plaques with Johnes's arms. The old road from London ran

through Cwmystwyth until superseded by the present route via Llangurig in the early C19.
See also Hafod.

CWRTNEWYDD
Llanwenog

4948

Later C19 hamlet, with stone and yellow brick terraced houses, built for the woollen industry. The mill of *c.* 1870 has gone.

SEION BAPTIST CHAPEL. Dated 1824, 1881, 1929 and 1955. The plain gable front of 1881.
Y BRYN UNITARIAN CHAPEL, at the SW edge of the village. 1881–2, rock-faced stone gable front, with pointed main arch. Panelled end gallery, coved and ribbed ceiling, and plaster arch behind the pulpit.

DEVIL'S BRIDGE/PONTARFYNACH
Llanfihangel y Creuddyn Uchaf

7377

The spectacular natural scenery of the cascading falls of the Mynach down to the Rheidol has long been one of the picturesque wonders of Wales. There were already guided walks for tourists in the later C18 and the hotel (*see* below) was first built in 1803.

DEVIL'S BRIDGE. Three superimposed bridges over the crevasse-like gorge of the Mynach. The lowest is an obtusely pointed stone arch which may be medieval, but refaced; the next is a single arch of 1753, with slightly Gothic cast-iron rails in pierced panels, of 1814, made at the Aberdare ironworks for Thomas Johnes; the topmost was of 1901, by *R. Lloyd*, on flat girders, replaced in the later C20. Below the falls, steeply bowed iron bridge of 1867, made at the Aberystwyth Foundry, by *Thomas Stooke*, engineer.
HAFOD ARMS HOTEL, by the bridge. The original hotel was of 1803, rebuilt 1814, both for Thomas Johnes of Hafod. Rebuilt in its present form, with eminently picturesque roof swept far out on very large brackets in 1838–9, for the Duke of Newcastle, then owner of Hafod. The supposedly Swiss design was reputedly by the Duke himself. However, a letter from the contractor, *S. Heath*, suggests that Heath was altering 'very incorrect' plans by *William Coultart*. Beneath the roof, the five-bay, three-storey stone front may incorporate some of the original. Extended behind, 1862–4, by *H. D. Davis*, with pyramid-roofed billiard room, part of a failed attempt to revitalize the commercial attractions. The lower part of the stair is of 1862, the upper part of 1838, with thin square balusters.

VALE OF RHEIDOL RAILWAY. Narrow-gauge line from Aberystwyth to Devil's Bridge, opened in 1902, partly for the lead mines, but with tourism also in mind. Engineered by *Sir James & William Szlumper*. Small corrugated-iron STATION.

MYNACH CALVINISTIC METHODIST CHAPEL, S of the station. 1858. An ungalleried chapel typical of the lead-mining region. Unusual triangular heads to the two windows and centre door. Solid ranks of yellow-grained box pews, raked down to a similar great seat, tightly arranged around a simple balustraded platform. Just one set of steps, leading up to a hinged section of balustrade, and the pulpit front plainly panelled.

CAPEL SALEM, Mynyddbach, 1½ m. W. Disused lateral-fronted chapel and vestry of 1844, altered in late C19. Raked box pews and no gallery.

See also Trisant.

₄₈₅₆ DIHEWID/DIHEWYD

ST VITALIS or GWYDDALIS. Simple early C19, single-roofed church of *c.* 1828 with W porch, bellcote and large pointed windows with later C19 glazing. Later C19 fittings. – FONT. Medieval square bowl chamfered below. – STAINED GLASS. E window of 1927. – MEMORIAL. Rustic slate tablet with trumpeting angels, to John Evans †1813.

BETHLEHEM INDEPENDENT CHAPEL, just N of the church. 1909, with the big stucco arch to the gable typical of *David Davies*.

TREBERFEDD, 1 m. SE. Dated 1802. Three-bay whitewashed farmhouse, quite substantial for the date. Long façade with a little 'clom' or earth-walling showing at the eaves. Tiny sash windows upstairs, and a tin roof, a reminder that thatch not slate was typical of the county until the late C19.

YNYS FELEN, 1 m. SE. Abandoned rubble and clom farmhouse, formerly thatched. Inside three pairs of scarfed crucks, the end pair embedded in the chimney wall, suggesting that this was a medieval or C16 open hall.

TROEDYRHIW INDEPENDENT CHAPEL. *See* Cribyn.

₆₉₉₅ EGLWYS FACH
 Ysgubor y Coed

Settlement along the main road to Machynlleth, the church at the S end. TY MAWR, just N, is early C18, altered, with large end chimney. PLAS MAWR in the centre, is earlier to mid C19, substantial three-bay stone village house. At the N end, CAPEL BACH, 1900, roughcast and red brick chapel.

ST MICHAEL. 1833, by *George Clinton*. A three-bay stone box, dignified by tall Tudor-arched windows, big Tudor W porch,

and bellcote. The canted-ended chancel, which is so much in keeping, was added in 1913 by *G. T. Bassett*. Interior still pre-Victorian, white plaster, with some box pews, simple Gothic pulpit, and panelled W GALLERY, on thin Gothic iron columns. The dramatic black paint to all the woodwork including the organ dates from the incumbency of the poet, the Rev. R. S. Thomas, vicar 1954–67. – Painted Commandments, Creed and Lord's Prayer BOARD. – FONT. Plain ashlar bowl, retooled and undatable. – STAINED GLASS. In the chancel, mid-C20 conventional glass.

Tudor-style stone LYCHGATE, to match the church, the lean-to sides for storing the bier. Just N, corrugated-iron CHURCH HALL, with bellcote, *c.* 1900.

YNYSHIR, ½ m. W. Rendered two-storey house with storeyed porch, all the detail later C19, but the porch and massive N end chimney showing that this is a remodelling of the C17 house of the Lloyd family.

CYMERAU, I m. NE. The site of the principal slate quarry of the county, operating 1887–1909. Slate-dressing sheds below Cymerau farmhouse.

See also Furnace and Glandyfi.

EGLWYS NEWYDD *see* HAFOD

ELERCH

6786

In the upper Leri valley, the original settlement was Bontgoch, by the bridge. The Rev. Lewis Gilbertson, first vicar of Llangorwen and later Vice-Principal of Jesus College, Oxford, commissioned first a school-cum-church in 1856, then the church in 1865–8 and finally the vicarage in 1874, a distant outpost of Oxford Movement ideals in remote country. Since the late 1990s a WIND FARM on Mynydd Gorddu dominates the landscape to the S.

ST PETER. As at Llangorwen, Gilbertson employed *William Butterfield* for the church, built 1865–8. The result is a thoughtful response to the hilly site, massed about a squat, pyramid-roofed crossing tower, buttressed by varied lean-to roofs on the N side. An exemplary High Victorian compositon, of carefully related geometric shapes, each smaller element carrying the horizontal line a step higher in a controlled rhythm. The chancel lean-to on the far l. adjoins a higher lean-to giving solidity to the tower base and the hipped stair-tower then carries the line up to the tower bell-stage, varied by a big wall-face corbelled chimney. The hipped roofs are also picked up in the hipped N porch. Butterfield's taut control of vertical planes also deserves attention, the varied roof shapes growing from a

single wall line. On the s side, a high, short transept provides the corresponding buttressing. Dark stone with ashlar dressings, but unfortunately all but the N side since rendered. Aisleless interior with four-sided rafter roofs, the line uninterrupted by trusses. Simple punched detail to the timber PULPIT, STALLS and RAILS. Tiled REREDOS. Inset bench SEDILIA. – FONT. Massive tapered square bowl in grey fossil marble, with rounded angles, and shaft with marble columns. – STAINED GLASS. E window by *Alexander Gibbs*, 1868, an excellent piece, well composed in three lights, with a fine hierarchy of colour from the deep tones of the small lower panels, and drapery of the larger figures, but white predominating in the crucified Christ and patterned quarry backgrounds.

SCHOOL. 1856, opposite. Small and sadly derelict. Only the battered chimney and decayed steep slated bellcote show that it is the work of a major Victorian architect, *G. E. Street*.

VICARAGE, to the s. 1874, by *John Prichard*. Asymmetrical, the roof half-hipped at one end, but without medievalisms, the windows in plain black brick frames.

CEFNGWYN, ½ m. NW. 1818, built for W. C. Gilbertson. Attractive two-storey, three-bay stuccoed square villa with hipped roof, French windows and veranda on three sides. Unusual diamond latticed cast-iron glazing bars set in wooden sash windows and overlights.

LEAD-MINING sites in the hills all around. To the NW, CEFNGWYN (SN 679 869), exploited in the 1850s and 1870s, on both banks of the Leri below the house, much overgrown. 1½ m. W, under the wind farm, MYNYDDGORDDU (SN 668 860), of which great expectations were held in the 1870s but little was found before it closed in 1882. Further W in the same valley was BROGYNIN (SN 661 860), linked to COURT GRANGE or PENYCEFN on the s side of the road (SN 656 856). Known in the late C17, Court Grange was expansively promoted in 1849 by Matthew Francis, but to the financial ruin of the backers. Reopened in the 1870s and 1880 but closed *c*. 1882. In the upper Leri valley to the SE: LLANERCHCLWYDAU (SN 696 858), worked in the C17 and then abandoned, and LLAWRYCWMBACH (SN 708 854). This is the best site to visit, for its eery isolation accessible only on foot. Worked mainly from 1848 to the late 1870s. Extensive waste heads and remains of a crusher-house. From here the ascent to the Craigypistyll reservoir (*see* below) can be made. Over the back of the high ridge to the s is LLETYEVANHEN (SN 695 849), worked from the 1840s to 1854 by Matthew Francis, and from 1868 to 1881 by John Taylor & Sons. There are remains of a crusher house and viaduct, and a roofless powder magazine. Another mine site (SN 686 848) is in the valley s of Llety Ifan Hen Farm.

Most impressive, if reduced for much of its length to a shallow horizontal depression in the hillsides, was the LEAT SYSTEM that brought the waters of the upper Leri to the mines in the Nant Silo valley (*see* Penrhyncoch). The system began above Llawrycwmbach, at Craigypistyll gorge. As first built, from 1840

by John Horridge to serve Cwmsebon mine, the leat looped for several miles around the Llety Ifan Hen spur and the far larger spur to the s. A parallel, higher leat to serve Cwmsymlog was built in the 1850s, and the supply to Craigypistyll was augmented with a leat from far to the n. Ultimately, some 19 m. of leat connected Llyn Conach to the last of ten mines served, Bronfloyd, near Penrhyncoch. CRAIGYPISTYLL reservoir was made in 1880 to increase the supply to Court Grange mine.

PENYCASTELL HILL-FORT (SN 689 848), on a spur SE of Llety Ifan Hen. Oval enclosure, entered from the E.

PENDINAS HILL-FORT (SN 677 877), on a hilltop W of the Leri. A complex fort with oval enclosure at the summit and extensive, possibly later ramparts below, principally to the N and S. Access was from the S.

FFOSYFFIN see HENFYNYW

FURNACE/FFWRNAIS
Eglwys Fach

6894

Named for the iron furnace, sited by the C18 single-arched BRIDGE over the Einion. Opposite, late C19 LODGE to Ynyshir, Eglwys Fach. To the N, Y GRAIG CALVINISTIC METHODIST CHAPEL, 1868, plain stone and brick.

DYFI FURNACE. Iron-smelting furnace built c. 1755 by the Kendall family, West Midlands iron-masters with widespread interests in England and Scotland. This site was chosen for smelting ore from Cumbria, as not yet denuded of oak for charcoal, and the pig-iron was then shipped out from a quay on the Dyfi. The enterprise had failed before 1810, probably because charcoal was no longer competitive with coal. Massive tapered square furnace tower with hipped roof and squat square stack. Behind, built into the cliff, a two-storey range with bellows-floor under the charging-floor, which had direct access from the storage BARN behind. The constant draught was created by two massive bellows, operated alternately by cams turned by a water wheel. The lower bellows chamber and counterweight chamber behind are tunnel vaulted in brick and stone. The charging-floor is cobbled; pointed arch into the furnace. A casting-house to the S has gone, exposing the broad brick arch to the furnace itself. The present 30-ft (9-metre) water wheel on the N is a reconstruction of a late C19 wheel, added when the building was used as a sawmill. The original wheel was smaller. The BARN above, and FURNACE HOUSE, to S, the iron-master's house, are both shown in an 1804 drawing.*

*Silver-mills set up in the 1620s by Sir Hugh Myddelton were probably on the furnace site. As drawn by Waller in 1704 the building was very large with five furnaces and a separate water-powered stamping mill.

PLAS EINION, ¼ m. S. Stuccoed villa of 1904 with crow-stepped
gables, built as Lapley Grange.

YNYS GREIGIOG, ¾ m. WSW. On one of the insular rock out-
crops above the marsh. Unique in the county, an earlier C17
gentry house with the high three-storey parlour end more
typical of Monmouthshire, though without here the refinement
of mullions and hoodmoulds. The parlour has a lateral
chimney with tall tapering shaft, the uphill kitchen end a
massive gable chimney. The Pryses of Ynys Greigiog were a
branch of the Gogerddan family.

YNYS EIDIOL, ½ m. SW. Altered longhouse, the present three-
bay house originally had the entrance into a lobby between the
house and the lofted outbuilding to the r.

BRYNDYFI LEAD MINE (SN 683 934), 1 m. S, ENE of Cefn-
gweirog. A failed mine of 1881–3, and the most instructive
mine-site in the county because nearly everything survives,
albeit roofless on the open hillside. The mine itself was ½ m.
N, linked by a tramway which brought the ores to the two half-
conical bins above the dressing floors at the top end. Below
this a large crusher-house with deep wheel-pit where the ore
was crushed on rollers, then an open-fronted building over-
looks the two levels at which ore was extracted from the slimes.
At the upper level shallow round 'buddles' where the ore was
separated, the mechanism driven by belts from a wheel-pit to
one side, and below, a grid of rectangular settlement tanks. On
the other side of the track, domestic-looking, the mine office.
On the slope between the site and the mine are three water
reservoirs and a powder-magazine.

YSTRAD EINION LEAD MINE (SN 707 938), 1½ m. ESE. In a
clearing in the forestry S of the Einion valley road. The mine,
worked in the 1870s and 1880s had three water wheels in line,
the wheel-pits to the r. of a tall square roofless crusher-house.
Behind a metal grille allows a view down the mine shaft. A
16-ft (5-metre) water wheel for pumping the shaft remains
entombed underground.

See also Eglwys Fach and Tre'r Ddol.

GARTHELI

The church stands alone on the bank N of the road, in the valley
of the Nant Meurig. Further along, on the S, TYNANT, colour-
washed stone cottage, with earth-walled upper floor, added in the
C19. The main settlement is at LLWYNYGROES, ¾ m. E, with
disused CALVINISTIC METHODIST CHAPEL, 1901, minimal
Gothic.

ST GARTHELI. 1875, replacing a small building 'lately rebuilt' in
1810. Plain nave and chancel, S porch and bellcote in squared
stone with ashlar lancets. Scissor-rafter roofs, and single
STAINED GLASS light in the E triplet, the Risen Christ, 1950,
by *Celtic Studios*.

COUNCIL SCHOOL, to E. 1913, by *G. Dickens-Lewis*. By contrast with the Board Schools of the 1870s, in the softer style of the early C20. Roughcast with sash windows and octagonal lantern.

TREFYNOR ISAF, to the SW. The present mid-C19 three-bay farmhouse faces down the yard with the original, probably C18, earth-walled house to one side, facing an earth-walled barn. The house, formerly thatched, has an off-centre entry into a kitchen open to the roof, with remnant of a chimney-hood: a beam supporting a plastered structure of woven branches. Narrow unheated parlour formerly with sleeping-loft, or *croglofft*, over. Two rough scarfed roof trusses.

See also Abermeurig.

GILFACHREDA *see* LLANARTH

GLANDYFI
Ysgubor y Coed

6997

GLANDYFI CASTLE. On the escarpment facing over the Dyfi, best seen from across the estuary. The only Georgian castellated house in the county, built for George Jeffreys, after 1812. Local slaty stone in long blocks. To the estuary, a two-storey square block between an octagonal three-storey tower to the l. and a massive SW diagonal buttress capped as if it were a minor turret. This feature suggests *J. H. Haycock* of Shrewsbury as architect, as similar to his Stanage Park, Radn.. Hoodmoulded large cross-windows. A single-storey drawing room to the r., subtly triangular in plan with a round corner tower, is a late C19 addition. Set back to the l. of the main block, a plainer range ended in a thin square tower. Some unexplained straight joints suggest a more complex story, but as yet no evidence has been found for a medieval castle reputedly on the site, nor indeed of a Jeffreys house prior to 1812. The family had come from Shrewsbury in the mid C18 in connection with the lead-smelting works at Garreg.

The entrance front has less movement: two battlemented blocks, the l. one with baronial porch to the l. of an understated square stair tower, the range to the r. slightly taller, of two bays and three storeys. The porch has an octagonal corner turret to the l. and triple-chamfered doorway with corbelling above, more convincingly Gothic than the rest.

RANGER LODGE, opposite the Castle gate. Remodelled from a small late C18 or early C19 house in the 1840s for the Glandyfi estate, with ornate zigzag bargeboards and Gothic mullion-and-transom windows.

VOELAS, s of the Castle. Stone, long two-storey house unified by windows with minimally Gothic glazing. It seems to be a later C19 remodelling for the Glandyfi estate of a 'manufactory' of 1794, extended with a big SE addition and remodelled inside shortly after 1906.

GARREG, ½ m. N. Main road settlement with an industrial history. In 1700–7 the Company of Mine Adventurers built a lead-smelting plant and loading quay here. The principal building, some 200-ft (61-metre) long, is the site of the present PARK TERRACE. The enterprise was unsuccessful, but the buildings seem to have been reused in the mid C18 by Henry Bowdler of Shrewsbury, in partnership from 1768 with Edward Jeffreys.

DOMEN LAS (SN 687 969), at N end of the Ynyshir bird reserve. C12 motte on the edge of the Dyfi, just W of the confluence with the Einion. Probably the Aberdyfi Castle built by the Lord Rhys in 1156 against Owain Gwynedd, captured and rebuilt by Roger de Clare in 1158 and retaken by the Lord Rhys in the same year. A substantial earth motte surrounded on three sides by a rock-cut ditch, the marsh on the fourth side.

GLYNARTHEN
Penbryn

3149

GLYNARTHEN INDEPENDENT CHAPEL. The large, gable-fronted, stuccoed chapel dated 1901 is a remodelling of a lateral-façade building of 1842. Curved-cornered gallery with continuous pierced cast-iron front in a diamond pattern, by the *Priory Foundry*, Carmarthen. Pulpit with timber Gothic tracery. The interior is similar to Banc Chapel, Aberporth.

Facing across the graveyard, two-storey SCHOOLROOM of 1848. In the graveyard, one of the ferociously scrolled wrought-iron grave enclosures, of *c.* 1840, that seem special to this area (*see* Manordeifi, Pembs.).

PRIMARY SCHOOL, on the hill to the W. 1877, by the same hand as Penmorfa School, Penbryn.

FELIN WNDA. 1½ m. SSE, on the Ceri. Small, early C19 stone corn-mill with hipped roof, one storey to the back, two to the river. Overshot iron wheel and machinery.

GOGINAN
Melindwr

6981

Lead-mining village on the A 44, on the S slope of the Melindwr valley. This was the site of the GOGINAN SILVER AND LEAD MINE (SN 692 817), one of the most profitable in Wales. Roman coins have been found here. Sir Hugh Myddelton and Thomas Bushell worked it profitably in the early C17 for silver, and the Company of Mine Adventurers invested heavily in the early C18. John Taylor & Sons revived it from 1836, such that by 1847 twelve water wheels were at work, 400 men were employed and over 11,000 tons of ore had been raised. Thereafter it declined, closing in the 1870s. The site has been landscaped, leaving only the cut-stone portal of the inclined shaft sunk by the Taylors. In the village, some C19 terraces and, at the W end, MOUNT PLEAS-ANT, stucco three-bay, mid-C19 house with pillared porch, said

to be a mine-manager's house. Two storeys to the road, four to the rear. In the valley below are the two chapels.

ST MATTHEW, SE of the village. Disused. 1871, by *Roderick Williams* of Aberystwyth. A cheap lancet Gothic chapel of ease with low porch tower. Timber bell-stage and slated spirelet.

DYFFRYN CALVINISTIC METHODIST CHAPEL. 1864. Large and plain, gable fronted with two long arched windows, a shorter centre one and a broad arched doorway. Still the Georgian thin glazing bars and a big fanlight. No galleries. Disused, but the previous chapel of 1845 is back in use, much altered.

JEZREEL BAPTIST CHAPEL, opposite Dyffryn Chapel. 1842, derelict 2006. Stuccoed lateral façade of some size. Four arched windows, the outer ones stepped up; two doors in ugly later porches. No gallery, but box pews densely raked around the pulpit, in the way typical of N of the county.

CASTELL. ½ m. N (SN 694 818). Iron Age hill-fort on the high spur between the valley and the lane to Cwmerfyn. Roughly trapeze-shaped with ditch to the E.

LEAD MINES. For GOGINAN, *see* above. The lane to Cwmerfyn passes the site of BRYNPICA, in the steep valley, explored in the C17 and C18, and by the Taylors from 1850. This mine was linked both to Goginan and Bwlch (*see* Penrhyncoch) on the ridge above. CWMBRWYNO, in the bend of the main road E of Goginan, was a mining settlement. The site is at the head of the valley (SN 714 805), past the site of a Wesleyan chapel of 1858. John Taylor & Sons ran the mine 1850–66, very profitably, water power being brought right around the hill from Llywernog Pond on the high ground to the NE. It continued to 1888, having at one time four water wheels and two crushing-houses. NANTYRARIAN MINE (SN 705 814) is at the head of the lane running E from Dyffryn Chapel. An ancient site, reopened unprofitably in the 1880s and again after 1900.

GWBERT
Verwig

An unachieved seaside resort, proposed as a new Brighton in 1890, and connected to Cardigan by a 'marine drive' in 1898. The CLIFF HOTEL, much altered, is of the early C20, otherwise a scatter of C20 bungalows and houses.

CARDIGAN ISLAND, just offshore, has the apparent remains of an Iron Age settlement. A roughly oval enclosure with four hut-circles to the E of the turf bank which bisects the island, and a larger enclosure, also with hut-platforms, much eroded by the sea at the N end of the bank.

GWNNWS

Upland area NW of Ystrad Meurig, the parish also known as Llanwnnws. Tynygraig is the only settlement, the church standing isolated ½ m. W.

St Gwnnws. An otherwise unknown dedication. 1874, replacing a church of 1829. *George Jones* made plans, but what was built is much simpler, a broad plain box, with paired lancets, and thin tower on the s side, with pyramid cap. Bald interior, with thin hammerbeam roof. – PULPIT and STALLS painted dark green; could they be the ones made for Holy Trinity, Aberystwyth, in 1886? Elaborate later C19 octagonal FONT. A broken medieval font is in the vestry; square, chamfered below. In the porch, remarkable C7 INSCRIBED STONE, a ringed cross in crude ribbon bands, inscribed in the surviving top corner XPS and below, QCUNQ EXPLICAVIT H NO DET BENEDIXIONEM PRO ANIMA Hiroidil filius Carotinn, translated as 'Whoever [shall] explain this name, let him give blessing for the soul of Hiroidil, son of Carotinn' (the 'name' presumably refers to the XPS).

Capel Caradog, Tynygraig. 1889. Stucco gable front with arched windows.

HAFOD

3 m. SSE of Devil's Bridge

7673

With the demolition of Hafod in 1956, the county lost its most famous country house, and with the disappearance also of the planted landscape, woods and walks was lost one of the key sites of the Romantic movement. Thomas Johnes (1748–1816) strove to create an ideal estate in the remote and primitive hills of Wales. With his cousin Richard Payne Knight and Uvedale Price, he was one of the trio of Herefordshire landowners who set out the theory and practice of the Picturesque. Johnes's achievement was the greatest, if short lived. The ideal was Arcadian, radical and romantic; to create in this wild place an earthly paradise, a house of beauty in a sublime landscape, the hand of nature improved with the eye of taste and the inhabitants redeemed through improved agriculture. Enormous plantations, in millions of trees, were to add beauty and utility to the hills, and at the heart of the enterprise would be a gentleman scholar in the Virgilian mould, as much at home in the library as in the fields and woods.

The estate was of 14,000 acres, but of little value. It had passed to Johnes's family from the Herberts in the early C18, but he was brought up at Croft Castle, Herefs., his mother's family house. He first visited Hafod in 1783, and determined to improve the derelict estate, beginning by enclosing some eight square miles of the Ystwyth valley. The house, begun 1786, was in an exotic Georgian Gothic by *Thomas Baldwin* of Bath, prettily battlemented, with pinnacles and a curved pointed centrepiece. At the corners were square pavilions. *John Nash* made large additions in 1793–4, principally an octagonal top-lit galleried library, and a 300-ft (91-metre) conservatory. The house disastrously burnt in 1807, destroying Johnes's magnificent collections of books, manuscripts and paintings. Johnes wrote, 'All Nash's

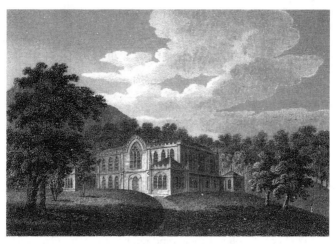

Hafod.
Engraving, 1810

buildings are gone, and you will say no loss. But Baldwin's stand
firm. I shall employ him again for he is an able, and, I believe,
an honest man,' and *Baldwin* rebuilt the house in 1807–10, retain-
ing, however, Nash's library.

Johnes created the romantic walks to the gorges and waterfalls,
with bridges and viewpoints, captured in mezzotints after J.
'Warwick' Smith. He built a home farm, lodges and cottages, and
rebuilt the church in 1803, but the drain on his wealth, and the
early death of his only child Mariamne in 1812, halted the project
before he died, a broken man, in 1816.

The house was empty until sold in 1833 to the fourth Duke of
Newcastle, for whom it was repaired in 1835–41, probably by
William Coultart, though the Duke had consulted *Thomas Hopper*.
The principal external change was the Moorish dome with a glass
finial added to Nash's library. The Duke also built a school at
Cwmystwyth (q.v.), altered the church, and rebuilt the hotel at
Devil's Bridge (q.v.). Sir Henry de Hoghton, owner from 1846,
is said to have wanted a new Italianate mansion by *Anthony
Salvin*, but Salvin built instead a very large extension, with cam-
panile tower, 1846–51, left unfinished to be partly fitted up for
John Waddingham, owner from 1872. Waddingham altered the
house, rebuilt the stables NE of the house in 1882, and probably
the Lower Lodge. The estate declined in the early C20, though
the house was not abandoned until 1942. The trees were then
mostly cut down, replaced by conifers. Recently the Hafod Trust
with the Forestry Commission has begun to reclaim parts of the
Johnes landscape.

Johnes's importance lies as much in his remodelling of the
landscape and in his role as an improving landowner as in the
architecture but of these more can be gleaned from books than

on the ground. Of the large numbers of trees planted by Johnes,
only a handful survive.

The estate runs for some three miles S of the Pontrhydy-
groes–Cwmystwyth road. The principal drive ran E from the
Lower Lodge at Pontrhydygroes (q.v.), past the mansion, S of the
Cefn Creigiau outcrop to the Upper Lodge, NE of the church.
A secondary drive (the public road before the 1790s) diverged
behind the mansion, past Pendre, the home farm, to just W of
the church. In 1813–14 Johnes built a last drive from Cwmystwth
village, to provide employment in a bad winter. This has largely
disappeared.

There were three main walks: the Lady's Walk, the Gentle-
man's Walk, both complete by 1789, and the New Walk
1796–1805. The Lady's Walk ran along the N bank of the Ystwyth
to the Peiran falls, one of the picturesque highlights of the estate,
returning past the churchyard and model farm. The longer Gen-
tleman's Walk crossed the Ystwyth on a wooden 'Alpine Bridge'
S of the house (replaced 1996), and ran E to the Nant Gau ravine
and Cavern Cascade, dramatically approached through a rock-
cut tunnel, before returning at higher level along the Ystwyth,
past cascades on the Nant Bwlchwallter to cross the Ystwyth by
a suspension bridge (replaced) to the kitchen gardens SW of the
house. The New Walk was cut with difficulty along the Ystwyth
gorge E of the Peiran in a loop from Pont Dologau to the Chain
Bridge of 1805 (replaced), now gone. The narrowest part was
overlooked by a Gothic eyecatcher.

To visit now, the MANSION site is a platform of broken stones
overlooking fields with the STABLES of 1882 and a late C19 HAY-
BARN behind. The walls of the stable yard may date from Johnes's
time. SW of the house, by the rebuilt Alpine Bridge, a late C18
ICE HOUSE and the walled KITCHEN GARDENS of c. 1790 with
remains of later C19 greenhouses. To the NE, Johnes's crescent-
shaped model farmyard at PENDRE has been replaced by a mid-
to later C19 farmhouse. By the farmyard entrance a formerly
open-bayed low stone range with centre gable over an arch, pos-
sibly of Johnes's time.

The modern trail SE from the mansion passes MARIAMNE'S
GARDEN, created in 1795–6 for Johnes's daughter, a talented
botanist, on a bluff to the l. The marble urn centrepiece, by
Thomas Banks, 1803, is at the National Library of Wales. In front,
the BEDFORD MONUMENT, 1803–5 by *W. F. Pocock*, an elegant
part-fluted obelisk with urn on top, and inscription by Johnes to
another improving landlord, the fifth Duke of Bedford. Further
E, a modern forestry road diverts to SE, bisecting MRS JOHNES'
GARDEN, 1786, replanted as an American Garden, 1794. Some
walls and two arched doorways, 1989 replicas of Coade stone
originals. The main track crosses the Nant Peiran on a single-
arched BRIDGE, before descending to PONT DOLOGAU, 1786, a
much larger single arch over the cascades of the Ystwyth, with
primitive rustic stonework, the parapets gone.

Outlying remnants of the estate are the cruciform Italianate
LOWER LODGE, of the 1870s, and the pair of estate houses at

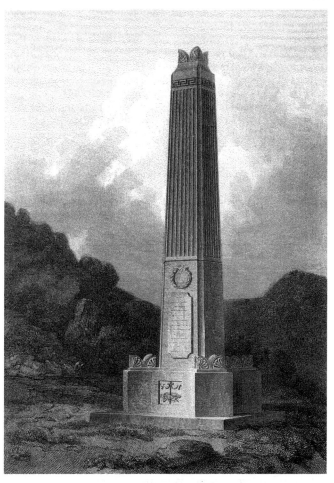

The Bedford Monument, Hafod.
Engraving, 1803

Pontrhydygroes (q.v.), and the plain rubble UPPER LODGE near
the church. Just E, CHURCH HALL, 1891, in stone and red brick,
built for the Waddinghams. At the end of the Cwmystwyth drive,
HAFOD LODGE, *see* Cwmystwyth, built 1837–9 as a school for
the Duke of Newcastle, on the site of a lodge of 1813. Beyond
Pont Dologau, in the forestry, NANTYCAE, square gabled
forester's cottage, probably of the 1830s, but perhaps incorpo-
rating a late C18 building. SW of the church, on the Cefn Creigiau
ridge, PENCREIGIAU, rebuilt 1839 as a gamekeeper's cottage,
pretty Tudor windows and bargeboarded dormers.

N of Pontrhydygroes, on the B 4343, PANTYCRAF, square
hipped estate cottage with just one window each floor. On the B
4574, 2 m. N, large Gothic rustic stone JUBILEE ARCH across

what was then the main road from London, 1809, the design
made in 1806 by Johnes's friend *George Cumberland*, based on
a sketch of General Conway's arch over the Bath road at Park
Place, Berks. *Charles James* of Llanddewi Brefi, termed the
'inventor' of the 'romantic arch' at Hafod, was presumably the
builder. There was a drive, now a footpath, E from here to
GELMAST, a small model farm built by Johnes in 1803, on unpre-
possessing upland. Three-sided courtyard with farmhouse, stuc-
coed in the C19, a small open hay-barn on one side, service range
on the other. Behind the service range a pyramid-roofed dairy
which may have been detached. The yard is flanked by a long
cow-shed on the r. and a barn on the l. It seems designed as a
dairy farm, but Malkin describes it as a sheep farm.

ST MICHAEL, SW of Upper Lodge. The parish church of Llan-
fihangel y Creuddyn Uchaf, also known as Eglwys Newydd.
Rebuilt 1800–3 for Thomas Johnes by *James Wyatt*, but no
credit to the architect. It was cruciform with parapets, a low
W tower with pointed openings and a slate spire behind battle-
ments. The tower has been raised a storey with bald, square
panels, probably in 1840–1 for the Duke of Newcastle, who
piously paid the debt to Chantrey and installed the monument
to Mariamne Johnes. Remodelled in 1887 by *Archibald Ritchie*,
overlaying Wyatt with poor Victorianism, though Wyatt's
cruciform plan remained, with windows and apse by Ritchie.
It was left to *W. D. Caröe* in 1933 to make something of the
church, after it had burnt out in 1932. While Ritchie's interior
was no loss, the fire all but destroyed *Francis Chantrey*'s
masterpiece, the monument to Mariamne, commissioned for
£3,150 in 1812. The monument showed Mariamne at the
moment of death, with book by her hand, lyre and music
beneath her couch, attended by her grieving parents. The
charred remains are all the sadder in the restored church, for
this was one of the great funeral monuments of the era, the
imagery Greek but the emotion Romantic. Caröe kept
Ritchie's tracery but otherwise purified the lines of the inte-
rior, sweeping away the ugly shafting of the transept arches
and the false chancel arch, and substituting a shallow curved
panelled roof and kingpost trusses for Ritchie's steeper open
roof. It is a model transformation, akin to Newcastle Emlyn,
Cms., in successfully redeeming the commonplace. Caröe's
FITTINGS are late Gothic in style, and form a remarkable
period piece: PEWS, PULPIT, SCREEN to the N transept,
LECTERN, STALLS, RAILS, ALTAR and PANELLING. – FONT.
1792, of *Mrs Coade*'s patent stone. Perp Gothic, remarkably
archaeological apart from the little cherub heads around the
underside. On the shaft tiny statuettes of the virtues. –
STAINED GLASS. Some fragments of Johnes's C17 Dutch glass
reset in the chancel side lights. E window of 1933, by *Heaton,
Butler & Bayne*, very conventional.
 In the churchyard, Thomas Johnes's VAULT in a plain railed
enclosure.

HENFYNYW

The reputed site of St David's upbringing, as grandson of Ceredig, putative first ruler of Ceredigion. Mynyw or Menevia is the original name for St Davids, and Henfynyw, Old Menevia, may indicate a first foundation by St David. The church stands on the edge of Ffosyffin, the modern village, s of Aberaeron.

St David. Meyrick in 1810 describes the earlier church as plain, of nave and chancel only. Wholly rebuilt 1864–6, by *R. J. Withers*, in dark stone with ashlar dressings. Nave and chancel, w bellcote. The w front is a neat study in solid geometry. The gable is set back above a strong chamfered course broken by a tapering projection that carries the bell-turret with octagonal spirelet, and pierced by a plate-traceried window. Inside, a cusped ashlar chancel arch dying into squat chamfered piers, the form echoed in the cusping of the chancel trusses. – FONT. C12, of the type of Llansantffraed (Llanon) and Betws Bledrws, square, chamfered below to octagonal, ringed with a band of crudely incised rosettes. – Gothic timber REREDOS, three-bay, the outer bays gabled and crocketed, the panels lattice-patterned within tracery. Simple altar RAILS, plain cusping and roundels. – STAINED GLASS. E window by *Kempe & Co.*, 1922.

By the road, an exceptionally large LYCHGATE with fussy adze marks on the timbers and red tiled roofs, all quaintly English, 1930, by *W. Ellery Anderson*.

Ffosyffin Calvinistic Methodist Chapel, Ffosyffin. 1831. Roughcast with two arched windows, plain outer doors, and upper gallery lights. The interior had densely packed raked and radiating box pews, but has been stripped out.

HENLLAN

The church, isolated by the Teifi, is just downstream from the bridge. Late C19 village to the N, around the railway.

St David. Rebuilt just before 1810 and again *c.* 1849, as a single vessel with bellcote and plain lancets, the design 'suggested by a gentleman considered to have good taste in architecture', not much in evidence. In 1881–2 *Middleton & Son* added the chancel with a heavy traceried E window and inserted Bath stone nave s windows, but the old timber ones remain on the N side. Plain nave roof of 1849 with arch-braced trusses. – FONT. C12 small square bowl, chamfered below, with lobed corners. – STAINED GLASS. Chancel s window of 1967 by *Celtic Studios*.

Henllan Bridge. Three arches with cutwaters, widened on the w side. A datestone of 1774 seems late for so old-fashioned a type, but the arches do not have the keystones or inset arch-rings of the earlier C18.

Prisoner of War Chapel, in the Henllan industrial estate, uphill from the church. A prefabricated timber shed, used as

a chapel by Italian prisoners of war, kept here 1940–4. Inside, the most remarkable home-made Baroque crafted of scrap materials. Painted white, nine bays divided by elliptical arches on marbled pilasters with curly capitals and spandrel paintings, leading the eye to a painted Last Supper in the apse. The capitals, cornices and candlesticks are of beaten tins, the vaults of cement moulded on sacks. The paintings are on roofing felt and the elaborately marbled altars of concrete or batten and roofing felt.

HILL-FORT, E of the former camp, on a bluff over the Teifi. Embanked to the w.

See also Aberbanc.

LAMPETER/LLANBEDR PONT STEFFAN

5748

Lampeter was a small market town at the meeting of roads from Cardigan, Aberaeron, Aberystwyth, Carmarthen and Llandovery, before the College was founded in 1822. The College is the third oldest university in England and Wales, after Oxford and Cambridge.

CHURCHES AND CHAPELS

ST PETER. The best Victorian church in the county, well placed in the hillside churchyard to be a landmark in the bowl of hills, and for once of sufficient scale to impress. 1867–70, by *R. J. Withers*, it cost £3,554 17s. 4d., and replaced a poorly built church of 1836–8 by *W. Whittington* of Neath. Withers has the High Victorian delight in solid geometry, basic forms simple and clean in outline: the s w porch tower is worth studying for the play of splays at the base. It was to have had a spire, but the present pyramid cap over plate-traceried bell-lights works well. Aisled on the s only, this side has paired clerestory roundels after the manner of Butterfield or Street, while the N side has full-height windows. Simple detail inside. Round piers to the arcade and shafts to the chancel arch, the height telling most, with big nave roof trusses, denser scissor-rafters in the chancel, and dominant five-light E window. Sturdy High Victorian PULPIT and FONT, both circular, and stone REREDOS with mosaic panels. – STAINED GLASS. Chancel s, Resurrection, and s aisle fifth single light, St David, 1870 by *Daniel Bell*, of *Bell & Almond*. Presumably also by the same firm the E window, Crucifixion, 1875, and third and fourth aisle windows, SS German & Tysilio, *c.* 1875–8, all in C14 style, with strong colours and clear outlines as developed by the best firms in the 1860s. Chancel N by *Powell*, David and Solomon, 1939, quite modern for the date. Four nave N two-light windows, the first, in a weak Netherlandish style, by *W. Clarke* of Llandaff, 1925; the second, a dramatically coloured Justice and Sacrifice, *c.* 1920, the third by *Shrigley & Hunt, c.* 1920, and the fourth,

93

St Anne teaching the Virgin to read, by *Kempe & Co.*, 1922, in their usual very competent C16 style. S aisle E, and adjoining sixth S window, by *R. Newbery*, c. 1901. The first S window, St Helena, is by *J. N. Comper*, 1939, conventional but good clear colours. The outstanding glass of the church is the W window, the Charge to Peter, of 1938–45 by *Wilhelmina Geddes*, for once interwar glass of real power. Three gigantesque figures, quite without sentimentality – see the rock-like feet and arms – the scale exaggerated by large areas of single colour, and by tiny scenes beneath the main figures. – MONUMENTS. In the porch several reset memorials: Rev. W. Williams †1805, slate with rustic winged cherub head; Rev. Eliezer Williams †1820, marble, with the tools of the academic trade for the founder of the Grammar School, by *Daniel Mainwaring*; Thomas Lloyd †1755 and his wife †1771, slate; M. Morgan †1780; and Judith Leigh †1780; Lady Lloyd †1746; and Baroque stone cartouche to Jane Lady Lloyd of Maesyfelin †1706.

In the churchyard NW corner, over a hundred headstones with just initials and a number, pauper graves of the inmates of the workhouse.

ST MARY, Maestir, 2 m. NW. 1880, designed as his estate church by *J. B. Harford* of Falcondale. Small, minimally Romanesque, with round apse, bellcote and big arched S porch. – STAINED GLASS. Apse windows, c. 1904, by *C. E. Kempe*. – FONT. Originally in Lampeter church. One of the group of carved C12 fonts (cf. Llanfair Clydogau and Llanwenog, Cd., Cenarth and Pencarreg, Cms.) that show a distinct Celtic Romanesque. Square bowl with lively carved Evangelist symbols at the corners, distinctly less crude than those at Llanfair Clydogau. Rope-moulded shaft.

OUR LADY OF MOUNT CARMEL (R.C.), Pontfaen Road. 1940, by *T. H. B. Scott*, prettily set on the slope below the parish church. One of the few attractive mid-C20 churches in West Wales, the group completed by presbytery and outbuilding all in simple whitewashed roughcast with roofs of small slates. Steep-gabled church front with centre projection, and a flash of colour from the Della Robbia-style lunette over the door. An arched link to the Neo-Georgian presbytery, then a wall beyond links to a low outbuilding, the colour echoed again in presbytery shutters and lunette. The interior surprises by its small-scale complexity, all in two tones of brick – sand colour and pale grey. A chancel is defined by two cross walls pierced by broad grey brick arches with open lunettes above, backed by a grey brick apse, giving effects of both light and depth. The model for the interior was T. S. Tait's theatre of 1938 at Garthewin, Clwyd, converted from a barn with similar arches. Small end gallery over three arches, one to the porch, the side ones with wrought iron screens to baptistery and bookstall. Simple FITTINGS, including a low E relief in the style of Eric Gill, by *P. J. Lindsay Clarke*, and woodcarving by *Jaroslav Krechler*, Czech teacher of woodcarving at the Carmelite Friary at Faversham, Kent.

BRONDEIFI UNITARIAN CHURCH, Llanfair Road. 1902–4 in free Gothic, unusual in the area, the dressings in terracotta and the side porch capped by a slated spire in two bell-cast stages.

NODDFA BAPTIST CHAPEL, Bridge Street. 1898, by *George Morgan & Son*. Stucco gable front.

ST THOMAS WESLEYAN CHAPEL, The Common. 1875, rebuilt in 1992 by *Owen Davies Partnership*, cutting back the gable for a diamond-shaped window.

SILOH CALVINISTIC METHODIST CHAPEL, Temple Terrace. 1874, by *Richard Owens*, minimal Romanesque. The removal of a starved side tower with spire in 1992 was no great loss.

SOAR INDEPENDENT CHAPEL, The Common. 1874. Tall gable front with unusual Italian Renaissance touch, the centre pediment rising over flanking half-pediments. More conventional arched windows and centre arch in unpainted stucco, enlivened by panels of white quartz chippings.

LAMPETER MOSQUE. Behind the Bishop Burgess Hall, College Road. Simple rectangular former chapel of the theological hall.

PUBLIC BUILDINGS

TOWN HALL, High Street. 1880–1, by *R. J. Withers*, a not altogether happy foray into Queen Anne by a lifelong Gothicist, replacing a simple two-storey building of 1813 by *P. F. Robinson*. In outline it is successful, the big hipped roof and pretty timber lantern, once painted green, sailing over the town. But the façade seems altogether too busy, in grey stone with much red brick and Bath stone. Three large upper windows with many subdivisions, originally timber also painted green, but, since 1992, plastic, which is disastrous. Three big arches below, the centre with stone balcony over, the others glazed with broad fanlights over shopfronts.

VICTORIA HALL, Bryn Road. 1904, by *L. Bankes-Price*. Stuccoed with curved gable.

WAR MEMORIAL, Bryn Road. 1921, bronze soldier by *W. Goscombe John*, in a memorial garden by *L. Bankes-Price*.

POST OFFICE, College Street. 1933, by *H. E. Seccombe* for the Office of Works. Good Neo-Georgian as used by the Post Office between the wars. Ashlar ground floor, two roughcast upper floors with parapet and steep hipped roof. Twin Corinthian doorcases.

PONT STEFFAN. 1932. Three-arched bridge over the Teifi, stone-faced concrete, by *John Davies*, County Surveyor, with *L. G. Mouchel & Partners*.

PRIMARY SCHOOL, Bryn Road. Built as the Central School, 1903, by *L. Bankes-Price*, red brick.

SECONDARY SCHOOL, Peterwell Terrace. 1949, by *G. R. Bruce*. Rendered, with flat-roofed entrance tower next to the hall block. Low-pitched roofs and long windows, cf. Tregaron and Aberaeron.

MAESTIR SCHOOL, 1880 by *John Thomas* of Lampeter, has been re-erected at the Museum of Welsh Life, St Fagans.

LAMPETER UNIVERSITY

Founded as St David's College by Bishop Burgess to offer university level education primarily but not exclusively to ordinands for the Anglican Church in Wales. Burgess initially planned in 1806 to build at Llanddewi Brefi, hallowed by association with St David. Plans were drawn up in 1809 by a 'celebrated architect', possibly John Nash, but a chance meeting with the Bristol banker, J. S. Harford, led to the offer of the Lampeter site, far more practical both geographically and academically, as the Rev. E. Williams's noted Grammar School was already there. New plans were made by *C. R. Cockerell*, 1819–21, initially for a low, one-and-a-half storey quadrangle based on English almshouses (Ewelme particularly), but then expanded to the present, more conventional, Oxford quadrangle design, which was built 1822–7 by *John Foster* of Bristol for £21,000, an exceptional sum in the context of early C19 West Wales.

Despite the cost, the Tudor Gothic quadrangle (now St David's Building) looks economical compared to medieval prototypes. Unpainted stucco with minimal ashlar dressings, cast-iron window frames and cast-iron decorative bosses under the eaves. It follows an Oxford model with hall and chapel across one end, and accommodation and teaching rooms on staircases on the other three. It differs in having the (former) principal's house at the NW corner and the library placed over the passage between hall and chapel. The library was extended in a gable-end forward of the N façade in 1837, with wings making a T-plan not completed until the 1960s. Cockerell's detail can be thin, most obviously in the cloister walk along the N side, and the rather cardboard battlements of the central entrance tower, but the composition has a quiet dignity saved from the routine by

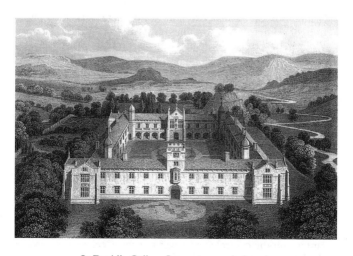

St David's College Lampeter, as designed.
Engraving

advancing the end gables of each range to give a rebated corner,
66 important in the park-like setting with its angled views. In the
quad, octagonal corner turrets with ogee domes contrast with
homely roughcast on the three residential sides. The N range has
a centre gable, flanked by chimney-like terminals to the but-
tresses, a device seemingly borrowed from the unarchaeological
1805–10 restoration of Margam Abbey, Glamorgan. Two big
library windows and centre niche with St David STATUE, 1952
by *P. J. Lindsay Clark*. To each side, cloister ranges in front of the
hall and chapel. The hall, to the r., has Cockerell's iron mullion-
and-transom windows, while the chapel, to the l., has pointed
Perp tracery introduced in 1878–9 by *T. G. Jackson*.

The HALL has the dais against the cross-passage, an arrangement
that gives a very lowly entry at the far end for the students.
The floor is raised on iron beams. BUSTS of Thomas Phillips,
1846, by *J. E. Thomas*, and Bishop Thirlwall, by *Edward Davis*,
1846. Brass CHANDELIERS, 1990.

In the CHAPEL, Jackson worked hard to create a more medieval
interior in 1878–9. He sank the floor 12 ft (3.7 metres) into the
basement, added a N aisle, and introduced collegiate fittings,
a nice example of Late Victorian church decoration of the
school of Norman Shaw, in the colour scheme of green,
red and gold (repainted since with too much gloss). Organ
SCREEN, canopied STALLS and PEWS in late Gothic style. The
chancel was not then refitted, but kept the big Italian PAINT-
ING, a copy of a *Correggio*, that Harford had given for the
opening in 1827. This was displaced in 1934 by *W. D. Caröe*'s
large and intricate Gothic REREDOS of pale oak. By Caröe also,
the PULPIT and READING DESK, 1928, ALTAR FRONT, 1936,
and WAR MEMORIAL. Brass CHANDELIERS, 1990.

The FOUNDER'S LIBRARY above the centre was built to contain
Bishop Burgess's books, extended for the heterogeneous collec-
tion of some 22,000 volumes sent in 1834–52 by Thomas
Phillips, East India Company surgeon (cf. Llandovery College,
Cms.). The bookcases are set laterally after the collegiate model,
but the interior was simplified in the 1960s after dry rot.

Just NE of the quadrangle, the grassed MOTTE of the early C12
Norman castle.

The later buildings of the college are all post-1960, after the college
was reconstituted with state sponsorship, becoming part of the
University of Wales in 1971. A range of 1887 by *Middleton,
Prothero & Phillot* was demolished for the new CANTERBURY
BUILDING of 1971–3 by *Alex Gordon Partnership*, low, with the
first floor treated as a mansard. The plain flat-roofed LIBRARY
of 1966, by *Verner Rees*, was unsatisfactory and was remodelled
with the principal rooms and bookstacks in a new E extension,
1984 by *I. Dale Owen* of *Percy Thomas Partnership*. The main
façade faces E, nine bays, in pale brick, with a playful ogee glazed
lantern on the central stair-tower to echo Cockerell's work. In
the library, BUSTS of J. S. Harford, 1847 by *L. Macdonald*, and
Sir D. J. James, 1951 by *K. Wojnarowski*.

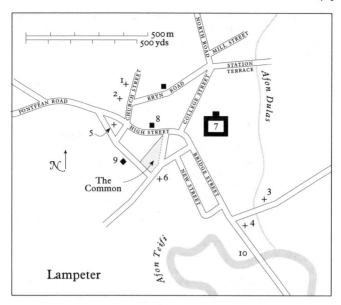

Lampeter

1	St Peter's Church	6	Soar Independent Chapel
2	Our Lady of Mount Carmel (R.C.)	7	Lampeter University
3	Brondeifi Unitarian Chapel	8	Town Hall
4	Noddfa Baptist Chapel	9	Secondary School
5	Shiloh Calvinistic Methodist Chapel	10	Pont Steffan

NE of the old buildings, on the site of the vice-principal's house and college stables, LLOYD THOMAS HALL AND REFECTORY, by *Elidyr Davies*, 1969. A failed flat roof, reclad in the 1980s with pitched roof and asbestos slate-hanging. The refectory has a very sad echo of Cockerell's already skimpy cloister design. By the river, the ARTS BUILDING, 1971, low brown brick with hipped square accents and a bleak paved S courtyard. In brown brick also, five bleak HALLS OF RESIDENCE on the hill across the river, of the 1970s by *Percy Thomas Partnership*. More lively, the STUDENTS' UNION, 1985, by *TACP* of Wrexham, below, with diagonally applied boarding and various glazed shelters. Three further HALLS OF RESIDENCE, 1992–3, by *Alex Gordon Partnership*, of brick with big glazed centre stairwells under timber gables. All have primary colour paintwork typical of the period.

PERAMBULATION

Lampeter has three main streets of modest C19 character: High Street, Bridge Street and College Street, meeting at HARFORD SQUARE, with grey stone obelisk FOUNTAIN of 1862. Behind, No. 17, probably of the 1840s, hipped and roughcast, still Late Georgian. The restoration of this key building and of the

fountain in 1991–2 marked a turn in the tide of thoughtless damage that had been the pattern of repairs in the town, as shown by the row in Bridge Street behind No. 17, once part of the same composition. BARCLAYS BANK, c. 1903, is Italianate with ashlar details, three storeys, with first floor big pedimented oriels.

BRIDGE STREET runs down to the Teifi. Mostly later C19 low terraces; near the foot, the MARK LANE MILL of 1911, which was powered by gas from the nearby gasworks. Overlooking the bridge approach, a Second World War PILLBOX. Behind Bridge Street and High Street, THE COMMON, a big open space surrounded by low terraces, given distinction by the tall Italian front of Soar Chapel (see above). On COLLEGE STREET, the Post Office and College (see above), but little else of interest. The SHEIKH KALIFA BUILDING, 1998, for the university theology departments, has stucco window dressings from Welsh terraced houses and an apologetic ogee entrance arch, more Indian restaurant than subcontinent. On the corner, BISHOP BURGESS HALL, red brick Temperance Hotel of c. 1900. STATION ROAD, opposite, has terraced houses of the 1870s. The railway arrived in 1866, the hipped stone goods station converted to MART OFFICE, 1984. The walled garden N of Station Road marks the site of Maesyfelin, a gentry house of the Lloyd family prominent in the C17 and C18. On NORTH ROAD, THE BRYN, a big red villa, built as judges' lodgings in 1891 by *David Jenkins* of Llandeilo.

Returning to Harford Square, in HIGH STREET, a mixture of stucco fronts. On the S side, LLOYDS BANK, a tall, Late Georgian, three-storey, three-bay front, the porch late C19, replacing something much simpler, and the columns now plastic. Further on, the BLACK LION HOTEL, a distinguished design of c. 1835, three storeys, five bays, under a single deep-eaved roof, the outer bays slightly advanced, with tripartite sashes in two-storey arched recesses. The buildings each side nearly match, both with a bargeboarded gable. Opposite, the ROYAL OAK, dated 1842, but the stucco cladding as late as 1905, presumably to match the mid-C19 NATIONAL WESTMINSTER BANK next door. Beyond the Town Hall (see above), Nos. 30–32, an unexpectedly handsome stone terrace of c. 1830–40, the stone pointed as ashlar. Three storeys, three bays each, No. 32 with cast-iron columns to the porch. Behind No. 18, opposite, the former TABERNACLE chapel, 1806, converted to cottages in 1874 when Shiloh was built, and since gutted. Half-hipped roof and lateral façade with arched windows, the window heads and wall-plate suggesting a later roof-raising. At the far end, CHURCH HALL, built as the National School in 1850, by *W. L. Moffatt*, former partner of G. G. Scott (cf. the National School, Cardigan). A pretty L-plan design in sandstone, with corner turret, the house facing S and the school with big mullion-and-transom windows facing CHURCH STREET. In Church Street, Nos. 1 and 2, an early C19 three-storey pair, and the tiny former GRAMMAR SCHOOL of 1823,

single storey with arched windows (spoilt by later glazing). This was built for one of the most noted schools of that time in West Wales, founded 1805 by the Rev. Eliezer Williams. On PONT-FAEN ROAD, college cricket PAVILION, 1909 by *L. Bankes-Price*. A funny half-timbered design with short timbered tower, owing little to historical precedent despite the involvement in the design of the antiquarian, Professor E. Tyrrell-Green. Further out, PONTFAEN COTTAGE, single-storey former toll-house.

PETERWELL, ½ m. w. Fragmentary ruins of the extraordinary house of Sir Herbert Lloyd stand in a field at the end of a lime avenue. It was near square with diagonally set corner towers capped with domes, possibly pre-dating the remodelling of Newton House (*see* Dinefwr, Cms.), which was similar to a larger scale. Built after Lloyd inherited in 1755, and focus of the reign of terror that this violent man exercised over the region. The house barely survived its builder. Lloyd killed himself in 1769, and it was ruinous by 1798.

FALCONDALE, 1 m. N. Rebuilt in 1859 for J. B. Harford of Blaise Castle, Bristol, who acquired the Peterwell estate from his former partner R. Hart Davis *c.* 1819. Davis had already built a new house, which Harford enlarged. *T. Talbot Bury*, normally a Gothicist, was architect, but here he provided an outsize Italianate villa with a two-storey centre (presumably the orignal house) set between taller wings with deep-eaved hipped roofs. White stucco with brown painted dressings concentrated in two-storey tripartite features on the wings. Ponderous detail, combining rustication, pilasters and bracket corbels. Entry by a hipped porch on the w end. Large N service ranges. SW room with a heavily coffered ceiling.

HOME FARM, to the w. A big stone and yellow brick two-storey range dated 1885. Barn at an angle linked by an open bay to the earlier farmhouse.

 Two lodges of *c.* 1860 on the A482: NORTH LODGE, stucco Italianate, cross-plan with verandas, and GLYNCOED, further s. Gothic, stone, with cross-wing to the r. and roof to the l. overhanging on timber brackets.

ALLT GOCH HILL-FORT, 2 m. NE (SN 593 501). A big, oval Iron Age fort on the ridge above the Teifi, enclosed by a single bank, with two eroded banks to the E. A slight bisecting bank suggests that the original fort was smaller at the N end.

CASTELL OLWEN, ¾ m. N (SN 580 493). Iron Age hill-fort on a spur above the Dulas river. A broad curving bank facing W and N, and the interior bisected to a round N half and oval s.

LLANAFAN

6972

The village runs NE from the church. On the l., WOMEN'S INSTITUTE HALL, stone cottage of 1832, given to the village by the Lisburne estate in 1918. RHYDYGARREG, at the top end, is an

extended early C19 cottage. Both had lath-and-plaster chimney-hoods, typical of the county. W of the church, PRIMARY SCHOOL and school house, of 1856, the house with lattice pattern sashes, the school with wing of 1875.

ST AFAN. Church of 1836–41, by *William Coultart*. Nave, chancel and S transept; low-pitched roofs and lancets. It cost £450. Altered 1862–7 for the fifth Earl of Lisburne by *William Butterfield* for £1,105, without imposing his personal stamp. His are the W-end bay, S porch and E wall, the W end with a centre projection carrying a bellcote. Earlier C19 nave roof, two W trusses added by Butterfield. The S transept with floor raised over a vault was the family pew of the Vaughans, Earls of Lisburne. – FITTINGS by Butterfield include the massive, plain octagonal FONT, PEWS, plain pine PULPIT, cast-iron chancel RAILS and stone REREDOS. – STAINED GLASS. Excellent E window, *c.* 1865, possibly by *Clayton & Bell*. Angular figures in C14 style. By *Powell* of Whitefriars: nave N windows, 1945 and 1925; W window 1923. S transept window, *c.* 1900, by *Shrigley & Hunt*, in the style of Kempe. Two later C19 HATCHMENTS, of the fourth and fifth Earls. Two PAINTINGS, the Resurrection and the Virgin, C19 copies of Italian works, given by the fifth Earl.

In the churchyard, HEADSTONE, *c.* 1970, to Rosemary Christie with a lighthouse carved by her partner, *Douglas Hague*, historian of lighthouses.

AFAN CALVINISTIC METHODIST CHAPEL, S of the church. 1856. Pleasant stucco gable front with two arched windows. Porches added in 1930 when the interior was refitted in plain pitch pine.

PONT LLANAFAN, ¾ m. S. Early C19 broad single-arched bridge over the Ystwyth.

TRAWSGOED, 1 m. W. The Vaughans of Trawsgoed rose from minor gentry with Sir John Vaughan (1603–74), parliamentarian and Chief Justice of the Common Pleas. His grandson gained the only title in the county before the C20, Viscount Lisburne, in 1695, raised to an earldom in 1776. The Vaughan house, rebuilt after Civil War damage, and illustrated by Thomas Dineley in 1684, was a three-sided court, open to the SW. It had a formal three-bay centre with crudely classical detail, and more old-fashioned side ranges with gables and mullion windows. From the court, steps led down to a formal walled garden with four squares of lawn. Dineley exaggerates the scale of the house, which survives, albeit hard to see as the library range of *c.* 1840 infills the court and the rest is refaced or rebuilt. The name was anglicized as Crosswood from the C18 to the early C20.

p. 490 The present FRONT on the NE was the rear: 3–3–3 bays, stuccoed with raised pediment and rusticated ground floor. It refaces C17 work, as evidenced by the uneven bay spacing and is probably late C18, for the first Earl, who died in 1800. A drawing of 1756 shows an irregular array of mullion and cross-

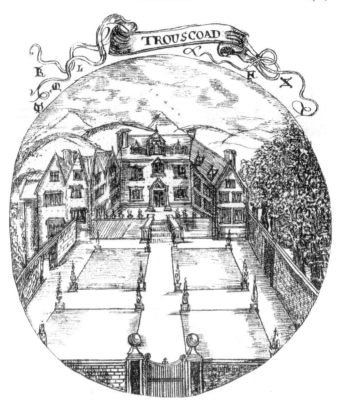

Trawsgoed, by Thomas Dineley, 1684.
Engraving

mullion windows with two gables, and an early C18 hipped pro-
jection to the r. Documents mention work in 1775 and 1795.
The big raised pediment across the centre three bays could be
of 1795, but the porch with paired Ionic columns each side
must be later. It could be of *c.* 1840 like the SW garden front,
added for the fourth Earl, who inherited in 1831.

The SW FRONT, of 2–5–2 bays, is distinctly Early Victorian;
unpainted stucco, with low roofs behind a parapet. The five-
bay centre (the infill of the old court) is a cramped composi-
tion of large arched windows on two floors, the middle three
bays bowed out. Most typical of the date, the pierced stone
parapet, which is continued over the former C17 wings. These
are refaced to match, but show distinctly lower floor levels. C17
chimneys survive on the r. side wall.

Attached along the NW side, projecting forward of the
entrance front, is the hipped range shown in the 1756 drawing,
but remodelled as the new staircase hall in 1891 as part of the
substantial (and expensive, at £13,973) additions for the sixth
Earl, by *T. W. Aldwinckle*. In the same style, the large new

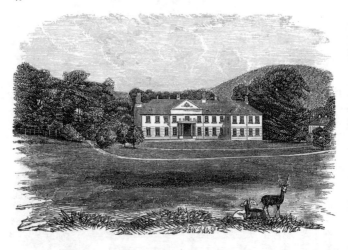

Trawsgoed, entrance front.
Engraving, 1872

service range to the r., with tall pavilion roofs and mullion-
and-transom windows in François Premier style. It is too large
to accord happily with the entrance façade, but not good
enough to stand as a separate design.

The INTERIORS, ravaged by neglect and dry rot since the
1990s, are here described as if intact. There are small traces of
the C17 or early C18: a stone mural stair in one s end first-floor
room, and a secondary staircase, with twisted balusters, pulv-
inated string, and a reused C17 finial. Broad entrance hall with
plain earlier C19 detail and a late C19 marble fireplace. Two SE
rooms within the C17 wing, made into one. The r. room has
an early C18 central round panel with radiating ribs patterned
with oak leaf. Two fluted Corinthian columns between the
rooms and the Rococo ornament of the l. room may be of
1900, as an estimate from *Maples* of London suggests exten-
sive work here and in the library.

The LIBRARY is a splendid Empire salon with marbled
Corinthian columns dividing off the two ends, and a deep cof-
fered ceiling with ornate plasterwork, gilding and painted dec-
oration. The rich classicism suggests the opulent schemes
of the 1840s and 1850s: Roman columns, Greek overdoors,
anthemion acroteria to the bookshelves and overmantel
mirror, and Italian Raphaelesque painted *grotteschi*. The fire-
place is boldly architectural: two corniced piers, plain and
unadorned, rising higher than the marble shelf. Rich brass and
iron grate, huge overmantel mirror. The ceiling has Neo-Grec
to Rococo plasterwork around a shallow-domed centre and
Raphaelesque painting to the heraldic spandrels. This was a
style popular both in Germany and Britain in the Early Victo-
rian period, the taste of Prince Albert, and is of a date with the
Neo-Grecian elements that have a Victorian fleshiness. Coves

and walls have some wonderfully rich High Victorian reds, greens and golds, suggestive of Owen Jones and the taste of the 1860s. What of all this was done by Maples? The outer bay ceilings have a high-relief classical plaster figure of the earlier C19, with added painted decoration.

The main stair of 1891 in the NW range was made up of bits bought in London, a single long flight to a landing with mixed Gothic and classical detail.

Upstairs, remnants of C18 panelling, one room with bolection-moulded fireplace, and one with an early C17 stone fireplace with carved spandrels, possibly reused. Some C12–13 stones with roundel pattern from Strata Florida Abbey were found built into a window reveal.

Late C19 formal GARDEN to the SW with big fountain basin. LODGE dated 1893 on the modern drive to W. Good earlier C19 cast-iron GATES at the foot of the disused main S drive.

BIRCHGROVE, across the Ystwyth from Trawsgoed. Former dower house to Trawsgoed. Earlier C19, stone, four-bay hipped front, the entrance on the end wall. Inside a fine chimneypiece of the 1830s with paired yellow marble columns and arms of the Duke of Newcastle, removed from Hafod (q.v.) in the 1950s.

ABERMAGWR, 1¼ m. W. The Trawsgoed estate SAWMILL, long hipped range, open-sided below a boarded loft, with water wheel marked *Durie & Davies*, Aberystwyth, 1868. Adjoining, the estate FORGE; mid-C19 stone house attached to an earlier C19 single-storey smithy.

TRAWSGOED ROMAN FORT (SN 671 728). Slight visible traces E of the mansion of a large square Roman fort, found in 1959, on Sarn Helen, the road to North Wales from Carmarthen and Llanio. The site is bisected by the modern B 4340. Probably occupied from 80 to 120 A.D. Traces have been found of an infant town, or vicus, to the W.

WENALLT, ½ m. SW. Earlier C19 three-bay house, extended in the later C19 for the Trawsgoed agent. At the farm, to the N, early C19 hipped BARN with roofs carried down over lean-tos all around.

COED TY'N Y CWM HILL-FORTS, 1 m. N (SN 687 737 and 687 740). Two small Iron Age promontory forts separated by a stream, both roughly rectangular and embanked to the E.

GWAITH GOCH LEAD MINE, 1 m. E of Pont Llanafan, on the N bank. Remains of a 1916 project to process waste from Frongoch (Trisant), the spoil brought here by aerial ropeway.

LLANARTH

4258

A substantial village. Houses in the Late Georgian mode on the E side of the main road, are called Alma Street, presumably late 1850s. The centre, is spoilt by road-widening which cleared buildings on the W side. On the steep hillside to the W, TALYBRYN, mid C19, one-storey W front, three-storey rear, and scattered houses up to the church (q.v.) on the hilltop.

ST DAVID. Originally dedicated to the otherwise unknown St Fyllteg or Bylltyg. W tower with stepped battlements and stair-turret. The roll-moulded door in the steep battered base, and small two-light w window look earlier but the bell-openings are C15. Parapet corbelled out on round beach stones. The rest neatly rebuilt within the old walls in 1871–2 by *R. J. Withers*, with simple cusped ogee tracery. Withers raised the original single roof-line, and gave the tower a pyramid slate roof. In the tower, a rough vault. Broad nave and chancel with a wide chancel arch, the walls stripped of plaster in 1984, revealing various blocked openings. – On the tower floor, disused and battered, an exceptional C12 FONT, the bowl square with trapezoid sides outlined in incised lines, chamfered into base ringed by four splendid crouching lions. – By Withers, the stone REREDOS and PULPIT, unfortunately gloss-painted, and ashlar octagonal FONT. Simple timber pews, stalls and rails. – STAINED GLASS. E window, 1925, in C15 style. Nave S window, 1955 by *Celtic Studios*. – INSCRIBED STONE. Relief Latin cross C9 or C10 but with eroded C5 or C6 letters on the cross and Ogham strokes on the left arm. – MONUMENTS. Reset in the tower: Lloyd of Wern Newydd, mid-C18 marble with open pediment and flat side scrolls; Edward Longcroft of Llanina, †1812, marble oval; Jane Davies, †1753, Baroque scrolled pediment on pilasters, with cartouche and affixed shells and sunflowers.

VICARAGE, W of the church. 1862, by *R. J. Withers*. Quite elaborate asymmetrical composition, narrow two-gable S front and long sides. Good chimneys and slightly pointed sash windows, i.e. of the Street and Butterfield school, with minimal period detail.

CHURCH HALL, on the New Quay road. Former National School, 1859–60 by *Withers*. Separate school and house in stone banded in red brick. The influence of Butterfield shows in the house, LLANARTH VILLA, half-hipped gables, plain sashes under pointed arches, and battered chimneys. The school, extended to a T-plan by Withers in 1867, has been spoilt by loss of its original glazing, a spirelet and the chimneys.

FRONWEN CALVINISTIC METHODIST CHAPEL, E of main road. 1857. Disused. Gable front in dark stone, arched windows still with small-paned glazing and a small rose window over the door.

PENCAE INDEPENDENT CHAPEL, ¾ m. SE. 1856. Unpainted stucco gable front with three arched windows and arched door, all in rusticated frames.

GWYNFRYN, at SW edge of the village. Built in the 1890s for Bishop D. L. Lloyd of Bangor, †1899. Substantial sandstone three-storey house with heavy battered corner tower to the r., and two gables to the l., one with mullioned stair windows, the outer one with two-storey canted bay. Early C20 conical spirelet and pretty sailing-ship vane.

FRONWEN, ½ m. SE. Built for John Jordan Jones before 1815. Long, two-storey, three-bay front, still with the original rough-

cast. Old-fashioned in the proportion of small upper windows to wall. Dog-leg stair with square thin balusters.

PLAS Y WERN, 1m. NW. Known as Wern Newydd after the late C17 rebuilding. A medieval site, Henry Tudor stayed here on the way to Bosworth in 1485. He was guest of Einon ap Dafydd Llwyd, whose descendants, the Lloyds, owned the house until the late C19, but moved to Nantgwyllt, Radnorshire, thereby saving it from alteration. The rubble stone rear wing may be C15 or C16, without dateable detail. The main range is *c.* 1670, 40 up-to-date with hipped roofs, stucco walls and generous windows, roughly contemporary with Gogerddan at Penrhyn-coch, and Lodge Park at Tre'r Ddol. Not quite formally symmetrical, the result of being added to an existing house. Roughly square, of two almost equal storeys with tall, hipped valley roof, swept out at the eaves. Three-bay S front with roof hipped to the l. Four-bay W side with two hipped roofs, the r. part with C20 painted false windows and massive stone chimney. The long C18 sashes probably replace timber ovolo-moulded cross-windows, if the rear basement window is typical. The S front has the door in the r. bay, reflecting the plan of hall and stair to the r. of the two principal rooms. C17 door with oval mid-panel, and C17 canopy consoles, though the pilasters look later.

The older range, to the E, has an irregular S front; three-storey l. bay with the door and sashes, then a projection, pos-sibly an outshut hall bay, and then two bays at two storeys, with an ovolo-moulded three-light mullion window to ground floor. Massive E end stack. In the angle behind, a lean-to against the rear of the newer house may have been an outshut parlour bay to the older range, raised and reroofed. Small but-tressed N outbuilding with bellcote, 1936, by *J. Greenidge*, for Alastair Graham, friend of Evelyn Waugh.

Inside, the best late C17 work in the county. Passage hall to a broad dog-leg staircase with twisted balusters, and two main rooms to the l., both panelled with heavy bolection moulding, echoed on the fireplaces. The SW dining room has a deeply panelled plaster ceiling with a centre circle and outer panels divided by broad ribs, the panels with low relief roses. Double doors through to the NW drawing room, flat ceiling with low relief mouldings, an oval centre panel around a rosette, a sur-rounding square with half circle each side, and an outer border, with plant sprays in the corners, crude but rich. The two upstairs rooms are similarly panelled, the NW room was the library, with fitted bookcases. Both have remarkable beamed ceilings of four plastered, false diagonal beams meeting on a centre beam, like a Union Jack missing the vertical bar.

In the E range, ground-floor room with large end fireplace and outshut on the S, the l. part, with mullion window, pro-jecting less than the r. On the N, a square winding stone stair around a solid stone pier. The first floor has chamfered beams. The attic was altered in 1936 to a music room with gallery. The roof has triple through-purlins and slightly arched collars to

the three trusses, comparable to the C15 roof at Pentre Ifan, Nevern, Pembs. N of the stair is a narrow two-storey and attic parlour block, whose upper room was reputedly Henry Tudor's room in 1485. But it seems more likely that the sequence is of an original C15 first floor hall to which was inserted, in the C16, a loft floor, the big E end chimney, the outshut on the S, and the stone stair with parlour behind. The late C17 part may replace a C15 W end of the hall.

The house is in a hollow, and was originally approached by a formal avenue from the far side of the stream. The present drive has a row of outbuildings above the house, a long COW-HOUSE, converted after a fire, and a C19 lofted STABLE with single cart-entry. A small stone cottage, TYDDYN HEN, formerly thatched, has a single full cruck truss, of some size, which may be C15 (though no comparable examples exist in the region). Small C19 BARN opposite, with late C19 iron water wheel, by *Kelly* of Cardigan.

GILFACHREDA, 1½ m. NW. Behind the village street, DOLDEG, late C18 or early C19, whitewashed stone cottage, originally thatched. The present two heated rooms and unused loft may be a later C19 alteration. A straight joint suggests originally only one room, perhaps with loft over the entry passage. WERN INDEPENDENT CHAPEL, above the village, 1851. A late lateral façade cf. Llwyncelyn and Nanternis. Four arched windows, all still small-paned and bracketed eaves. Pretty interior: painted grained box pews, and later C19 gallery with acanthus panels of cast iron.

See also Llanina, Llwyncelyn, Mydroilyn, and Oakford.

LLANBADARN FAWR

Llanbadarn Fawr is the mother settlement of Aberystwyth, founded in the C6, by St Padarn. It was a pre-eminent Celtic monastic centre, and a centre of Welsh learning well into Norman times. Although ultimately eclipsed by Aberystwyth, Llanbadarn was long the name for both settlements. The vast parish was only gradually broken down into the seventeen successor parishes. Aberystwyth was not separated until the C19.

The village is largely C19 or early C20. In the centre by the war memorial, the GARREG FAWR, a large flat stone used as a platform by itinerant preachers from at least the C17. Photographs of the 1880s still show single-storey thatched cottages around the church. Around the village are fairly large later C19 houses built for the Aberystwyth professional classes (*see* below).

ST PADARN. The Celtic *clas* church of Llanbadarn was noted as a Welsh scriptorium in the C11 and C12 under the dynasty of Sulien, Bishop of St Davids. It was at Llanbadarn that his son, Rhigyfarch †1099, wrote the life of St David, and here that the *Song of Roland* was translated into Welsh. It continued outside the Norman orbit with difficulty through the C12, Gerald of

Wales found it in decline in 1188. The *clas*, with its secular canons and married clergy, succumbed to the changes in the wider church, and the Welsh princes transferred their allegiance to the Cistercian communities. Strata Florida became both scriptorium and burial place for the princes of Deheubarth, and the Llanbadarn monastery had dissolved by the mid C13. The lands and living passed to the crown, and from the mid C14 the church was appropriated to Vale Royal Abbey, Cheshire. Dafydd ap Gwilym's famous poem on ogling the girls at mass in Llanbadarn church was probably written in the 1340s.

The present church appears C13, large, cruciform with central tower, all of extreme and impressive plainness, unbuttressed; the windows simple flush lancets, except for three late C15 Perp chancel windows. One of these has the rebus of William Stratford, Abbot of Vale Royal 1476–1516, and gives a date for the chancel reconstruction.

Much was restored under *J. P. Seddon*, who was selected in 1867 after the first choice, Butterfield, resigned, rather than work again with the Rev. E. Phillips, vicar of Aberystwyth (cf. St Mary, Aberystwyth). The work spanned many years (nave and porch 1869–70, tower and transepts 1876–80, chancel 1880–4). Seddon replaced the roofs to an original pitch and added the s porch. He proposed remodelling the crossing arches to match the s doorway and planned a spire on the crossing tower, was checked by the Rev. Basil Jones, whose sober advice tuned well with necessary economy.

The outstanding detail of the church is the s doorway, 30 with three orders of keeled shafts and stiff-leaf capitals of the early C13, the arch mouldings also keeled, a richness unparalleled in Cardiganshire, the nearest equivalent being the Abbey Cwmhir arcade, now at Llanidloes, Montgomeryshire. It is said to have been moved from Strata Florida (q.v.) without evidence.

Inside, the scale impresses. Seddon's roofs are panelled and boarded, emphasizing line, and the tower arches remain quite plain, plastered. More complex ceilings to the crossing and chancel, the latter said to hide some C15 arch-braced collar-trusses. – FONT. C13, octagonal with shallow pairs of Gothic panels. – FITTINGS. All post restoration. Two screens and a screened pew mentioned by Meyrick in 1810 had all been destroyed by 1862. By Seddon, the ornate circular stone PULPIT of 1879, carved saints by *Hugh Stannus*, the fine mosaic and encaustic tile FLOORS of the crossing, and the low REREDOS in red sandstone and marble. Also the PEWS and STALLS. In the N transept, limed oak FITTINGS of 1938 by *Caröe & Passmore*. The s transept was fitted up as a MUSEUM by *Peter Lord* in 1989, with white-tiled floor outlined in red, and rough Cornish granite prie-dieu and altar. In the screen attractive GLASS PANELS of the Seasons with verses by Dafydd ap Gwilym, by *Peter Lord*. In the Sulien room, incised slate floor slab and lettered texts by *Ieuan Rees*. – CELTIC CROSSES.

Two, formerly in the churchyard. The taller LLANBADARN CROSS, late C10, has six panels below the head, one fierce male figure with spiral pattern drapery, of Irish inspiration. The bottom panel has two crossed figures, possibly Jacob wrestling with the angel. The rear is panelled in Celtic interlace. The second, much smaller, is crudely cruciform with an incised border, thought to be of the C10. – STAINED GLASS. By *Seddon* himself all the chancel windows. Five-light E window, the Transfiguration, 1884, by Seddon, the design modified to suggestions by the painter *F. J. Shields*, according to contemporary accounts. Confusingly the window is marked by the maker, *S. Belham & Co.*, and inscribed 'H. G. Murray del.'. An impressive design with the Christ figure in a vesica surrounded by musician angels, and unusual turquoise and green colouring. N three-light, 1885; S two-light, 1884, showing Renaissance influence in the drawing. S single-light, 1880, in an oddly thick drawing style; N transept E two-light, c. 1878, similar – somewhat classical figures on clear grounds. N transept N, two good lancets c. 1885, and dull W window c. 1930 by *Heaton, Butler & Bayne*. In the S transept, W lancet of 1985 by *Celtic Studios* with scenes of the Burma Railway, three S lancets of 1930 by *Heaton, Butler & Bayne*; E lancet, 1989, by *Elizabeth Edmundson*, with lively scenes from Celtic manuscripts. Nave W three lancets of 1894 by *Heaton, Butler & Bayne*, C15 style. Nave S, two dull early C20 lancets by *William Morris Studios*, not the famous Morris firm, and a fine piece of Arts and Crafts glass in cloudy colours by *Hugh Arnold*, 1904. Nave N, first window, 1887, in deep colours, second by *Roy Lewis*, 1963, bright turquoise with spiky forms, third by *John Petts*, 1985, musical symbols in blues and reds.

MONUMENTS. The best collection in Cardiganshire, described here topographically. – Nave: S wall, M. D. Williams †1833, kneeling child, by *E. H. Baily*. – Chancel N wall: E. L. Pryse of Peithyll †1888, Early Renaissance-style shrine with marble angel opening the door, an accomplished work; Margaret Pryse †1798, two cherubs and an urn; Katherine Chichester †1739, a slate plaque framed by fluted pilasters; Lewis Pryse of Gogerddan †1779, a splendidly architectural piece in grey and white marble with rusticated base, and obelisk top with finely carved urn and cherub heads. – Chancel E wall: Thomas Pryse †1745, pilastered, with broken pediment and triglyph frieze; Cornelius Le Brun †1703 and John Jones of Nanteos †1708, two Baroque cartouches, crude and vigorous; Sir Thomas Powell of Nanteos †1706, an elaborately festooned swan-neck pediment over a draped plaque, the base gadrooned and with books and scrolls, signed by *Robert Wynne* of Ruthin, but the design by *William Townesend* of Oxford. – Chancel S wall: Rev. William Powell †1780, polychrome marble with an Adamesque urn; Thomas Powell of Nanteos †1797, plaque with urn; William Powell †1735, long plaque in crude grey stone frame; John Pugh Pryse †1774, extravagantly cherubed above and below, one holding the portrait, possibly

53

by *Van der Hagen* of Shrewsbury; Harriet Pryse †1813, by *John Flaxman*, a cloaked mourning man in contemporary dress, in a Gothic frame, understated but of high quality. 55

To SE, stone gabled LYCHGATE with arched entries and good iron gates of 1814.

SARON CALVINISTIC METHODIST CHAPEL, Chapel Street. 1842. Two arched windows and two outer doors with Georgian glazing, probably an original long-wall façade, given a plain gable when the rest was rebuilt in 1879. No galleries, platform and great seat with heavy turned woodwork.

SOAR INDEPENDENT CHAPEL, Primrose Hill. 1900, by *T. E. Morgan*. Gothic gable front in dark stone and yellow brick, with nothing to suggest the new century.

LLANBADARN CAMPUS, Primrose Hill. An extensive site, housing Coleg Ceredigion (former Cardiganshire College of Further Education), the College of Librarianship and the Welsh College of Agriculture. 1969–71 by *Percy Thomas Partnership*. All in silver-grey brick, of a sparkly granite aggregate. Stepped up the hillside, the basic form is of linear three-storey ranges with recessed ground floors, banded windows and split pitched roofs. The focal square has the THOMAS PARRY LIBRARY on the N, the SOCIAL CENTRE, with monopitch roofs, on the W, and linked residential blocks to S and E. The square library has a formal elegance, *piano nobile* over low ground floor, with hipped roof behind a parapet. Within this Neo-Georgian form there is a nice variety of wall to window proportion. The main floor evolves from a fully open balconied bay at the SW corner, through big gridded reading-room windows, to narrow lights, on both S and W fronts. The halls of residence run NE in right-angled steps to define the lower end of the site. The College of Librarianship occupies an L-shaped range N of the library facing the drive, though with no dominant accent to greet the incomer. Behind are teaching blocks, the open spaces infilled with new buildings, 1995, by *James & Jenkins*. This is a pity as the balance of open space to buildings was well conceived. At the rear of the site, College of Agriculture LIBRARY, similar in style, with glazed N wall.

GLYNPADARN, S of the church. Stone Gothic villa of *c.* 1879, attributed to *J. P. Seddon*, and with some interior detail to support this. Bargeboards, oriel and iron verandas. Inside a very Gothic hall arch and staircase. Doorcases with notched zigzag ornament. Refurbished 1991 as sheltered housing by *Ceredigion District Council Architects*. The new ranges behind are grouped around an effective pyramid-roofed block with timber-framed lantern.

PLAS MANNAW, ¼ m. W of church. Former vicarage, 1866, by *R. J. Withers*, after Butterfield refused the job. One of Withers's simplified Gothic designs, stone with minimal brick banding. The upper storey has asymmetrical gables on the S front, and a central one on the E side. Georgian twelve-pane sash windows, Gothic only in their shallow-pointed heads. Altered 2003 by giving the roof overhanging gables.

BRONPADARN, Primrose Hill, below the Llanbadarn Campus. 1879. Asymmetrical Gothic house of stone with gabled cross-wing to the r., in the style of *J. P. Seddon*, cf. the ring-shafted colonnettes of the porch and bay window, but without the controlled composition of Abermad, Llanilar. Stone chimneys, each with a pair of yellow terracotta Gothic column shafts. Terracotta quoins. Heavy Gothic detail to the entrance hall. Gothic timber staircase with ring-shafts and butterfly panel joints, both Seddon details.

LLUEST GWILYM, reached by a drive ¼ m. N of the Llanbadarn Campus. Villa of 1881 in brown stone with black brick quoins: gable to the r., the windows projected as bays or oriels with bell-cast slate roofs.

LLWYNFFYNNON, ½ m. E. Alarmingly crude villa of 1906 by *George Jones & Son*, in stone with two colours of brick and corner pencil turret. Two-storey Gothic entrance hall with timber gallery.

NANTCEIRO, 1 m. E. Stuccoed villa of 1847 for John Morgan, surgeon, by *Charles Hatchard* of London, who seems to have used the floor plan of a Gothic design of 1842 by *W. F. Pocock*. Two-storey, five-bay, hipped s front, the centre slighly recessed and the ground floor French windows pedimented. Entrance on the E side. Rear NW addition, 1878, by *George Jones & Son*. At the corner of the grounds, above the A 44, a squat late C19 square tower.

FRONFRAITH, 1½ m. NE. The house was demolished in 1982. It was of five bays, three storeys, built *c.* 1788 for Sir Thomas Bonsall, who came from Staffordshire to work the Cwmyst-wyth lead mine. A large C19 farm court survives N of the site.

FRONGOG, 1 m. ENE. Stone villa of 1885 by *John Middleton & Son*. Entrance front with three three-storey gables, the outer pair half-hipped, all with bargeboards. The garden front pairs a half-hipped bay with a big rounded bay, both two-storey. Ashlar mullion-and-transom windows and a little Renaissance detail above the door.

DOLAU, 1½ m. E. Early C19 villa with rendered two-storey centre and Roman Doric porch. Mid-C19 gabled wings. Outbuilding range behind includes a late C18 cottage with large fireplace and spit-rack over.

LOVESGROVE, 2 m. E. 1882–3, by *John Macvicar Anderson* for Sir Gruffydd Pugh Evans, barrister in India and brother of Lewis Pugh Pugh of Abermad, Llanilar. Blue Llanddewi Brefi stone with Bath stone dressings. Reminiscent of a Scottish shooting lodge, long and low with bargeboarded gables over mullioned bays. Prominent chimneys. Aesthetic Movement detail within: hall with Jacobean-style fireplace, one panel dated EB 1639, and double-arch opening to staircase with classicizing figures of the Four Seasons in stained glass. Drawing room with deep inglenook. Library with 'Queen Anne'-style white-painted shelves and arcaded overmantel.

LLANBADARN ODWYN

Upland parish with no village, the isolated church down a lane overlooking the upper reaches of the Aeron.

ST PADARN. Originally no more than nave and bellcote, with plain, pointed windows of the earlier C19. In a 'deplorable state' in 1843, 'desolate' in 1872. The timber tracery and equally plain chancel are of 1872 by *John Jones*. The rough stone walls battered out at the base may be medieval, but the cambered head of the narrow W door looks early C19. One S window is in a blocked doorway. Plain and bare interior of 1872 lined in C20 blockwork.

LLWYNPIOD CALVINISTIC METHODIST CHAPEL, ½ m. NE. 1881, stone and yellow brick, with two black brick porches.

SARN HELEN. The B 4578 follows the course of the Roman road from Carmarthen to North Wales, named after the legendary Welsh wife of the usurping Roman Emperor Magnus Maximus (Macsen Wledig) †388.

LLANBADARN TREFEGLWYS *see* PENNANT

LLANCYNFELYN/LLANGYNFELYN

The church stands on the last rocky hillock before the marshes of Cors Fochno. TAN-Y-LLAN just beyond the church and NEUADD-YR-YNYS, ½ m. SE, have later C19 open-sided hay-barns, rare in the county.

ST CYNFELYN. 1844–6. Steep-roofed single vessel; S porch, W bellcote and short N transept. The plans were given free 'by a member of the Oxford Architectural Society'. Credible local tradition names him as the young *Basil Jones* of Gwynfryn, later Bishop of St Davids. *John E. Jones* was the builder. The lancet Gothic attempts correctness, but the knobbly bellcote, crude buttresses and bulky hoodmoulds show a gap between design and execution. The older N transept has one very eroded lancet. On the S, porch, buttresses, two nave lancets and a win-dowless chancel bay. More ornate E and W windows. Inside open timber roof, echoing that in the transept. Crude poppy-head BENCH ENDS. Fragment of a C15 screen over the carved wood reredos of 1922, just the heads of four cusped panels each with two quatrefoils over. – FONT. C14 octagonal grey stone bowl, chamfered below. – STAINED GLASS. Two S lancets both good of their kind, one of 1854 by *Hardman*, the design by *J. H. Powell*, two medallions in rich colours, the other by *Martin Travers*, 1938, an elongated Angel of Justice, with a child outweighing a tiny devil in the balances.

CEMETERY, ¼ m. E. Given by Bishop Jones in 1877, with Gothic lychgate.

GWYNFRYN, ½ m. S. Family home of Basil Jones, Bishop of St Davids, †1897, originally built in 1814. Successively extended

through the C19 to a stuccoed, roughly square plan without coherent façade. The entrance front has to the l. a bowed projection with curved iron veranda. This is on the end of a three-bay side façade with stepped-out centre, that looks mid C19, and had an ornate veranda. To the l. again is a taller three-bay range, possibly the original house, altered. The r. half of the entrance front and r. side is all later C19 with tripartite sashes.

LLANCYNFELYN LEAD MINE, s of road to Tre'r Ddol (SN 651 922). Worked in the 1740s and then revived unsuccessfully in 1846 and 1854. Of 1854 the round stone and brick chimney.
See also Tre'r Ddol and Tre Taliesin.

LLANDDEINIOL

5672

The church is on the steep slope above the village. Just below is the former NATIONAL SCHOOL, now Church Hall and Aber-ffrwd, a pretty group of 1827 and 1852. Rubble stone, the schoolroom single-storey with four arched windows and date plaque. The teacher's house, to the r., was originally of two bays with big arched windows, with delicate iron tracery to the two upper ones. Enlarged, 1852, with a pedimented two-bay section to the r. In front, disused drive to Carrog (*see* below), with a high embankment and BRIDGE across the gully. In the valley bottom, Elim Chapel and NODDFA, mid-C19 three-bay stone manse with Georgian sashes, the minister's cart-shed in the basement.

ST DEINIOL. Gawky w tower with recessed bell-stage and crude battlements, and broad nave, 1832–5, by *George Clinton*. The High Victorian apsed chancel, rising impressively from the sloping churchyard, of 1882–3 by *Middleton & Son*, who added a steeper nave roof and paired cusped lancets in Bath stone. Inside, one of Middleton's happier transformations, due to the clean lines of the timber ceilings, seven-sided and panelled in the nave, and delicately ribbed in the apse. Moulded Bath stone chancel arch with corbelled shafts. Curious tower construction at the ringing floor level; it was open to the front and sides (since roughly infilled), with just square piers to take the weight. Small cast-iron Gothic posts may be remnants of a gallery. – FITTINGS. Mostly 1883. Timber Gothic PULPIT, elegant STALLS. Wrought-iron and brass ALTAR RAILS, and ENCAUSTIC TILES in the chancel, by *Godwin*. – STAINED GLASS. Three E windows, C15 style, 1883 by *Clayton & Bell*. In the vestry screen, some pretty floral panels in coloured glass, by Middleton, cf. Llandysul.

In the churchyard, a tall, slender Celtic CROSS in white granite, to Mrs Sinnett of Carrog †1904.

ELIM CALVINISTIC METHODIST CHAPEL. 1832, the character of 1899 when it was stuccoed and one of the two doors altered to a third arched window. No gallery, but an ornate pulpit with Gothic panelled front.

Carrog, nne of the church. Stone, four-bay house of *c.* 1835, built for the Rev. Thomas Richards, †1852. End-wall porch with panelled doorcase and fan-tracery in a rectangular frame.
farm buildings. The Carrog estate built some substantial stone farm buildings, generally of the lofted cart-shed and stable type with well-turned arches: a large group at Carrog Farm, 2 m. n, and good ranges at Benglog and Meillio-nen, on the lane e of village, all of 1840s or 1850s.

LLANDDEWI ABERARTH *see* ABERARTH

LLANDDEWI BREFI
6655

The church of Llanddewi Brefi stands on a hallowed site, a mound that rose out of flat ground while St David was speaking to the assembled multitude at the Synod of Brefi, *c.* 550. There was a Celtic *clas* here, a brotherhood of married priests, with a church, as evidenced by a reference of *c.* 1200 to the 'pum allor Brefi', the five altars of Brefi, in a poem of Gwynfardd Brychein-iog. This was refounded by Bishop Bek of St Davids in 1287 as a college of secular canons that survived until the Reformation. The history of this remote site appealed to Bishop Burgess and, in 1809, he considered founding his new training college here, and plans were made by a 'celebrated architect', possibly *Nash.* In the event, the offer of land at Lampeter proved irresistible.

The village, clustered around the church in irregular lanes, has character; most of the houses are c19. Fenton, in the early c19, called the village a 'disgrace to a Christian country'. In front of the church, a small square formed by a row of three three-bay houses to the s, and the Foelallt Arms to the n, the windows all spoilt.

St David. The large c14 crossing tower indicates the importance of the medieval church, one of three such towers in the county. The church had transepts, the n one demolished in the late c18, the s one in 1833. The present character of nave and chancel is due to *R. J. Withers,* who proposed a complete restoration in 1873, nave remodelled in 1873–4 and chancel in 1885–6; the transepts were not rebuilt for lack of funds. *W. D. Caröe* again proposed their rebuilding in 1911. The nave walls are of 1833, by *Charles James* of Llanddewi Brefi, but the steep roof, new windows and big w porch are of 1872–3. The nave work cost £1,100, the chancel, possibly reusing some part of the medieval walls, cost £450, which seems very economical. Withers's design echoes Llanbadarn Fawr in its simple lancets and clear outline, the porch a well-considered addition adding scale to the whole.

The tower is similar to Tregaron and Llanfihangel y Creud-dyn; broad, with corbelled battlements, paired tiny bell-lights and ne stair-tower, but there are no clearly datable features. The crossing arches, as exposed on the transepts, are of rough

stone, without ashlar. The infill of the arches must be of 1833, as shown by the Georgian Gothic sash and door. The slate pyramid spire is Victorian. In the s transept infill, r. of the door, a broken Roman STONE inscribed . . . MIBV . . . TAST. In the NW corner of the nave two pieces of the C7 inscribed STONE, the burial stone of one Idnert, killed PROPTER PREDAM SANCTI DAVID, i.e. because of the despoiling of the sanctuary of David. Broken up in the early C19, it had fortunately been transcribed by Edward Lhuyd in 1699, as this is the earliest reference to St David.

Inside, the tower has a pointed vault of rough stone. A window on the W side opens into the roof, presumably denoting a lower original roof-line. The rest of the church is attractively simple, white plaster and open rafter roofs, the panelled PEWS given 1843–6 by Queen Adelaide, widow of William IV, whose doctor, Sir David Davies, was native of the parish. PULPIT and READING DESKS by *A. D. R. Caröe*, 1953–5. Admirably simple Gothic altar RAILS by *Withers*. Also by him the elaborate wooden ALTAR and the heavy stone REREDOS. – Patterned TILES in the sanctuary. Under the tower, C6 or C7: on the s, St David's Staff, a tall stone with a cross inscribed CENLISINI BT DS (Benedicat Dominus); and one with a linear cross bifurcated at the foot. On the N two stones with linear crosses, one split in half, and one inscribed DALLUS DUMELUS. – Ashlar STATUE of St David in the nave SW corner, signed *Frederick Mancini*, 1959. – STAINED GLASS. E three-light by *Powell* of Whitefriars, 1962, mosaic effect of small pieces of glass and heavy black leading.

BETHESDA CALVINISTIC METHODIST CHAPEL, in the village. 1873, quite large, in rock-faced local stone. Raised piers carried up into the pediment. Arched windows, a triplet in the centre, and paired doors in Gothic shafted surrounds. Three-sided gallery curved at the angles, with long, cast-iron panels in a pattern of roundels. Similar ironwork to the great seat. Pulpit with fretwork panels, a plaster arch behind.

BETHLEHEM INDEPENDENT CHAPEL, just W. 1904. Rough-cast, plain gable front.

WAR MEMORIAL, The Cemetery. White marble soldier, 1921, by *E. J. Jones*.

78 PONT GOGOYAN, ½ m. W. Handsome five-arch bridge over the Teifi, plain and unadorned but quite steeply humped; the elliptical arches increase in height and breadth to a broad centre span. Probably earlier C19, as there are no cutwaters and the arches have well-cut voussoirs.

PONT LLANIO, ½ m. N. Narrow three-arch bridge over the Teifi, 1805, with cutwaters and raised piers. Widened in concrete.

LLANIO ROMAN CAMP, Llanio Isaf, SW of Pont Llanio. An auxiliary fort, called Bremia, on Sarn Helen, the road N from Carmarthen, between the larger forts at Pumsaint, Cms., and Trawsgoed. Probably built towards the end of the C1 A.D. A typical Roman military site, square in plan, covering some four acres. Aerial photography has shown the site to be diagonally

across the field behind the farmhouse. The old course of the road was to the w. sw of the farmhouse are exposed the remains of a small Roman BATH-HOUSE, just a square depression with some stone lining, marking the site of the caldarium. Some Roman inscribed stones were found in the Llanio Isaf farm buildings. One, now lost, inscribed VERIONI, another taken to Aberystwyth inscribed ARTI, M, ENNIUS PRIMUS. A third, now lost, was legible in 1878 as COH II Ae S, but in the early C19 interpreted as 'cohors secundo Augustae fecit quinque passus'.

TOMEN LANIO, ½ m. NE of Pont Llanio. A small Norman motte, probably C12.

QUAKER BURIAL GROUND, behind Werndriw, ½ m. WSW. A small walled enclosure with a single late C18 pedimented monument to the Jenkins of Werndriw.

See also Soar y Mynydd.

LLANDRE

6286

Llanfihangel Geneu'r Glyn

In a tributary valley of the Leri, the church on the w escarpment. In the valley, the former STATION, on the line from Borth to Aberystwyth built by Thomas Savin in 1865. Stone with shallow hipped wings facing w, and a curved-ended projection on the E platform side. To the E, on the slope, early C19 former SCHOOL, with pointed windows and bellcote.

ST MICHAEL, the parish church of Llanfihangel Geneu'r Glyn. 1885, by *Archibald Ritchie*, replacing a cruciform church, partly medieval, with crossing cupola of 1793. The new church cost £1,950, and has Ritchie's typical uncusped tracery and varied window forms. Nave, chancel, w bellcote, s porch and s vestry. Open timber roofs. – FITTINGS. Early C20 heavy Gothic STALLS, timber REREDOS of 1913. – STAINED GLASS. Two windows by *Roy Lewis*, in nave. The s second window, 1962, is striking, with china-white figures against deep blue, and thick black drawing lines. Brash compared to the sparsely coloured N third window, 1963: SS Cecilia & Francis, simple and tender, against bubbled clear glass with pale blue border. By *Celtic Studios*: nave s first, 1950, and third, 1954; N first, 1966, and second, 1980. Chancel s single light and much better E window, both 1935 by *Powell*, the E window with crowded figures on a deep blue ground. N window, 1932. – MONUMENT. Chancel N, delicate Gothic plaque to the Rev. L. Evans, by *E. H. Baily*, 1842.

Stone arched LYCHGATE, difficult to date, possibly C17 or earlier C18.

BETHLEHEM CALVINISTIC METHODIST CHAPEL, w of station. 1875, rebuilt 1903, plain roughcast Gothic.

CASTELL GWALLTER, on the crest above the church. A remarkably well-defined C12 motte-and-bailey castle, defended by

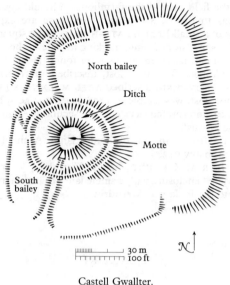

Castell Gwallter.
Plan

natural precipices to the E and N. Built after 1110 by Walter de
Bec, follower of Gilbert de Clare, it fell to the princes of
Gwynedd in 1137, and then to the princes of Deheubarth in
1153. Not recorded thereafter. Motte, with ditch and bank,
between two baileys, an unusual feature. Irregular rectangular
bailey to the N, and a less obvious enclosure to the S, crossed
by the probable approach from the SW.

CAER PWLLGLAS (SN 633 866), on the hilltop W of the A 487.
Oval Iron Age hill-fort with double bank on all but the steep
SE side.

At DOLYBONT, ½ m. N, a steeply humped C18 BRIDGE over the
Leri, and BABELL CALVINISTIC METHODIST CHAPEL,
1876, Gothic with Pembrokeshire grey limestone dressings.

LLANDYFRIOG

Teifi valley village, the church and school isolated by the river to
the E.

ST TYFRIOG. An otherwise unknown dedication, possibly a con-
flation of Ty Friog, the house of Briog or St Brieuc. Rebuilt
1888–90 by *Middleton, Prothero & Phillot*. Nave and chancel
with Perp detail, and SW porch tower, subsequently shortened.
Interior of some character, with steps up to the chancel, and
a wall-passage to the pulpit. – STAINED GLASS. E window 1928,
W windows 1925 and 1927, all by *Clayton & Bell*, without a
hint of former glory. – MONUMENTS. Plaques of 1818, 1849
etc. to the Hall family, ancestors of the Fitzwilliams of Cilgwyn

(*see* Adpar), for whom the church was rebuilt; moved from Paddington church, London. Plaque by *Norbury* of Liverpool, to three Fitzwilliam brothers killed 1898–1902. – HATCH-MENT. Early C19 with Hall arms.

In the churchyard to NW, the gravestone of Thomas Heslop, killed in a duel in 1814, inscribed ALAS POOR HESLOP.

E of the churchyard, a pretty stone SCHOOL of 1883, by *Middleton & Son*, with timber bell-turret.

ST MARY, Llanfair Trefhelygen, 2 m. NNE (SN 344 441). In a field, the outline of a single-cell church, measuring 44 ft by 22 ft (13.4 metres by 6.7 metres). It was ruinous in 1810. Nearby, a small Norman castle MOTTE.

BRYNGWENITH INDEPENDENT CHAPEL, 1½ m. NNE. 1883, by *David Davies*. Severe rock-faced stone front with giant arch. Panelled gallery fronts.

LLWYN CADFOR, 1 m. NE. Early C19 three-bay, two-storey front range with four-flight stair. Paired arches at the foot, one to the cellar stair. The rear wing is an older house, remodelled. Heavy C17 ovolo-moulded beams and deep fireplace. Mid-C19 whitewashed barn and lofted cow-shed ranges.

LLANDYGWYDD

2444

The village, just off the Teifi valley, had something of the quality of a Victorian estate village, for the Blaenpant and Penylan estates, lost with the demolition of the church* at the centre.

Framing the churchyard gate are two altered SCHOOLROOMS. The S one, *c.* 1846, by *Charles Davies*, is the church hall. The N one, now the parish CHURCH, 1856, by *R. J. Withers*, has tall windows under gables with raked sides. – STAINED GLASS. From the old church: E window by *Jones & Willis*, *c.* 1928, W window, 1882, by *Bell*. Just W, vicar's COACH-HOUSE, with stable beneath, being set into a bank, *c.* 1857, probably by *Withers*. Half-hipped roof, two bays, the slight shouldering to the posts of the coach-house echoed in the stone frames at basement level. In the churchyard, the ground plan of the church, and one of big arch-headed stone memorials local to this area, to T. Makeig †1766. CHURCH COTTAGE, N of the churchyard, of the 1840s, is a little double-fronted house with minimal Tudor detail, the first building taken on by the Landmark Trust. 1966 restoration by *L. Bedall-Smith*. S of the churchyard, the OLD SCHOOL HOUSE, the teacher's house, sandstone with centre gable, *c.* 1860. W of the village, the OLD VICARAGE, 1847, by *Charles Davies*, picturesque Tudor with thick bargeboards, hoodmoulds and paired arch-headed windows with delicate Early Victorian glazing. Extended to the r., 1889 by *Middleton, Prothero & Phillot*. Several Blaenpant

*The church, 1856–7, by *R. J. Withers* was a good work, E. E., with tower and broach spire. It had rich fittings: marble pulpit and reredos by *J. Middleton*, 1874, and stained glass of 1857 by *Clutterbuck* and *Lavers* in the E and W windows. The medieval church had been replaced in 1804.

estate cottages on the lane E of the churchyard: on the r., OAK-
FIELD, with bargeboarded porch of *c.* 1860; on l., FERN
COTTAGE/CLYDFAN, mid-C19 centre framed by added gabled
wings, and PARCGWEYDD, earlier C19, with one end canted, like
a toll-house.

CAPEL TYGWYDD, I m. SSE of Pont Hirwaun. Anglican chapel
of ease, 1882, red brick with pressed brick decorative panels
from the Cardigan brickworks.
BETHESDA INDEPENDENT CHAPEL, Pont Hirwaun. 1840–1,
by *John Jones*, local carpenter. Hipped with arched centre and
outer windows. Five-sided gallery, added probably in the
1840s, with painted grained panels and marbled timber
columns.
Y DREWEN INDEPENDENT CHAPEL. *See* Cwm Cou.

COUNTRY HOUSES

The parish had an unusual number of gentry houses, mostly
quite modest, but three, Blaenpant, Penylan and Noyadd Trefawr
(*see* below), to a larger scale. Of the smaller ones, three are the
typical three-bay model with hipped roofs: MANOREIFED, *c.*
1839, with centre chimney; PARK-Y-GORS, *c.* 1836, with later
veranda; and ABERCERI, 1827 (*see* Cwm Cou). Demolished are
LLWYNDURIS of *c.* 1800, though the service wing remains;
STRADMORE, a two-storey double-pile house of 1808; and
PENWENALLT, a five-bay mid-C18 house.

BLAENPANT, ¾ m. NE. Mid-C18 house of the Brigstocke family,
with two-storey S front in slaty stone, unusually of six bays,
a broad pediment over four with horseshoe lunette. A large
three-storey five-bay NE rear wing was demolished in the
1980s, leaving only the cut-down first bay, the entrance hall of
c. 1835, with big arched doorway. NW two-storey library in cut
Cilgerran stone, with canted W front. Inside, the entrance hall
opens into a full-height stair hall, of similar date, with plaster
barrel ceiling, glazed each end. The staircase was replaced in
the 1980s, reused Edwardian. In the mid-C18 front range, two
main rooms with fielded panelling in large panels and fluted
pilasters.
 In the dell to the S were a picturesque bridge clad in split
logs and a SWISS COTTAGE, the one gone, the other altered,
but still recognizable.
 STABLE, to NE. Mid C18, in eroding grey stone. A striking
design with seven first-floor lunettes and centre gable. Blind
centre lunette and arched doorway in a raised frame, the stable
openings each side square-headed.
 BLAENPANT FARM, to E. Extensive FARM BUILDINGS. An
C18 barn at the top of the first range. Mid-C19 four-sided court
to the E, high and forbidding, the lofts on the taller S and E
ranges lit by sloping dormers, and the entrances at SW and NE
under elliptical arches. Behind, a pair of long arcaded cow-
houses opening onto walled yards, since roofed over.

Noyadd Trefawr, Neuadd Cross. The house of the Parry family, prominent in the C17 and early C18. The house appears to be C17 and C18, altered *c.* 1825 for Rear Admiral W. H. Webley-Parry. A long stone E front of seven bays with end chimneys, extended by one bay to the r. The gabled Tudor porch and array of shouldered dormer gables, two to the l. and three to the r. of the bigger centre gable, are of 1820–30, but the centre gable had a perilous-looking chimneystack that replaced a lateral chimney over the front door. Small-paned sash windows, the spacing different each side of the porch, suggesting a complex history. Inside, the r. side has mid-C18 fielded panelling, the l. early C19 detail, though there are heavy encased beams throughout. The central, hipped stair block behind may be C18, but the open-well staircase and thin ramped rail look early C19, with reused bobbin-turned balusters. The NW service wing may be earlier, perhaps the original stair gable. The balancing SW parlour wing is earlier C19. The roof trusses are plastered over, but possibly late C17.

To the N, nicely understated early C19 OUTBUILDINGS around three linked courts, successively domestic, with the kitchen on one side, then stable, then a more open farmyard. On the N side of the last, a mid-C18 BARN with thick battered walls.

Penylan, ½ m. W. 1854, by *Edward Haycock*, for Morgan Jones, a cousin of Morgan Jones Jun. of Cilwendeg (*see* Capel Colman, Pembs.), and a beneficiary of the Skerries Lighthouse fortune. Italianate, in stucco with low hipped roofs and grey Cilgerran stone corniced chimneys. W entrance front of 2–2–2 bays, the centre slightly projected. Typically thick detail from the Osborne model: quoins, surrounds, string course and an eaves cornice with heavy scroll brackets. Centre pair of arched windows over a three-bay balustraded porch with arched windows and door. S garden front of 2–3–2 bays, the centre a three-sided bay.

The interiors are basically of 1854, expensively refitted *c.* 1900 by *Morant & Co.* with gilded decoration and painted floral panels by *A. Ludovici Jun.* The original work has a strong character, the hall stone-paved, with bracket cornice and scroll pediments to the doors. Arches through to the stair, cantilevered on three sides of a square top-lit hall. Iron stair rail, arcaded upper gallery with marble balustrades. Stencilled ceiling decoration. The drawing room has a rich cornice, Baroque pedimented doorways, marble fireplace with gilded overmantel mirror, and gilded pelmets presumably all of 1854. The green papered panels with gold stars, and painted decoration are of *c.* 1900. The music room, former dining room, has damask wall panels with floral painting in narrow panels, giant mirrors and very elaborate plaster ceiling with painted cherubs. The ballroom is confusingly dated 1864 on a doorcase but the rich cornice and rose are presumably of 1854. Could the dense painted decoration be of two later dates?

Outbuildings behind; tall, hipped three-bay CART-HOUSE, early to mid C19, perhaps the original coach-house, with ped-

iment and octagonal lantern. BARN dated 1839. OAKHILL, now a house, was the coach-house and stable from the 1850s, arcaded ground floor and pediment, faced in cut Cilgerran stone.

LLANDYSILIOGOGO

The church stands alone by Cae'rllan Farm above the deep valley running down to the sea at Cwm Tydu. By the beach at Cwm Tydu, a C19 circular LIMEKILN. Modern settlements at Caerwedros, Llwyndafydd and Nanternis (q.v.).

ST TYSILIO. Rebuilt in 1825–6, *Elias Davies* and *Henry Parry*, builders. Plain whitewashed stone nave and chancel with pointed W door and windows. Bellcote and cheap wooden tracery from the 1890 restoration by *David Davies* of Penrhiwllan. – FONT. Ashlar octagonal, coved below, probably C15. A C12 font said to come from here is at Cenarth, Cms.

LLWYNDAFYDD BAPTIST CHAPEL, Llwyndafydd. 1829, with lateral façade, altered 1898, when one door was blocked and the interior refitted with an end gallery.

PENSARN CALVINISTIC METHODIST CHAPEL, ½ m. S of Caerwedros. 1833, whitewashed lateral façade and arched windows.

CASTELL BACH, ½ m. N, NW of Penygraig (SN 360 581). Iron Age promontory fort with a very small double-banked cliff-edge enclosure, and an outer bank some 350 ft (106.7 metres) away.

CASTELL CAERWEDROS, Caerwedros (SN 376 557). Small Norman motte, recorded as destroyed by the Welsh in 1137.

GLANYRAFON, Penbontrhydyfothau, 1 m W of Llwyndafydd. Single-storey lofted cottage, early C19 but with earlier rear wing. Restored in the 1990s, reproducing the thatched chimney-cone once typical of the region. It caps a 'wicker' chimney, of wattle and plaster.

LLANDYSUL

Llandysul, an important Teifi crossing, grew with the woollen industry in the later C19. A long main street climbs the slope from the river, which the town, apart from the church, ignores.

ST TYSUL. An important Celtic church site, St Tysul being reputedly a contemporary and cousin of St David. The substantial medieval church is recorded from the C13, but is C15 in surviving detail. Nave with aisles, the only medieval example in the county, chancel and large W tower, with battered base, NE stair-tower and corbelled parapet. The tower is similar to Llanwenog, reputedly late C15, with similar Celtic gargoyle heads which must therefore be late medieval, despite their echo of early fonts. The rest is much restored, but in the S aisle a blocked C17 window with crudely incised outlines, over the E

window a tiny bearded head, late medieval, and by the N door a C12 cross in a roundel, both reset. Repaired in 1829–31 by *Rees Davies* of Llandysul, who inserted the Y-traceried aisle windows. W window dated 1847. Restored in 1873–4 by *Middleton & Goodman*, who rebuilt the chancel and replaced the other roofs.

Interior stripped of plaster in 1873. Massive three-bay arcades of pointed arches on square piers, similar arches to the chancel and tower. Crease-lines of lower nave and chancel roofs, the nave line suggesting that the arcades have been raised, but at what date? High stone vault to the tower. Rood-loft stair and squint. Good roofs of 1874, the chancel roof on angel corbels. – FONT. Medieval four-lobe bowl, thoroughly retooled. – FITTINGS. By Middleton of 1874, the elaborate stone PULPIT, carved by *R. Boulton*, the tower SCREEN with coloured glass, the PEWS and STALLS. – STAINED GLASS. E window by *Kempe & Co.*, 1919. N aisle E window *c.* 1935. – MONUMENTS. In the nave, white marble plaques to Eliza Lloyd †1805, and David Lloyd †1822, of Alltyrodyn, variants on the draped urn theme, the earlier one particularly delicate, the later one signed by *Daniel Mainwaring*. In N aisle, John Lloyd of Alltyrodyn, †1841, Gothic. – INSCRIBED STONES. In the tower, one inscribed VELVOR FILIA BROHO, C6, in debased Roman lettering, a rare inscription to a woman. Some reset fragments in the N aisle altar: the top stone inscribed with a linear cross, and the front with two small crosses and an eroded but fine tiny Crucifixion, C14 or C15, removed from the tower.

In the graveyard, some iron-railed enclosures, and good pedimented slate headstones. Stone LYCHGATE, 1933.

EBENEZER BAPTIST CHAPEL, Wind Street. Used as a print store. 1833, stone lateral façade with arched windows.

GRAIG UNITARIAN CHAPEL, Graig Road. 1884, by *John Wills* of Derby, stone, Gothic. Big traceried end window and side porch tower with a pyramid roof. The later Hall next door echoes the traceried window, but in wood.

SEION INDEPENDENT CHAPEL, Seion Hill. 1870–1, by the *Rev.* 100 *Thomas Thomas* (Thomas Glandwr), the first of his works in the area to use the giant arch breaking into the pediment, a Renaissance classical device which became a commonplace of Welsh chapel design, particularly in this area, where *David Davies*, the builder here, used it for another four decades, as at Penybont Chapel, Pontweli, Cms., just across the bridge. The full-length windows do not acknowledge the galleries within, and show an early use of 'Florentine' glazing, twin arched lights with a roundel. A handsome interior, the gallery fronts with long, pierced cast-iron panels by *Macfarlane*, also used in the great seat which curves around a pulpit with luxuriant carved fruit panels. The pulpit may be of 1900, the date of the very large organ behind.

TABERNACLE CALVINISTIC METHODIST CHAPEL, Bridge Street. 1832. Disused. Lateral façade with arched windows like Ebenezer but stuccoed later. The interior seems of 1833, box pews, canted angles to the galleries.

YSGOL DYFFRYN TEIFI, on the hill above Seion Chapel. Built as the Intermediate School in 1897 by *J. H. Phillips* of Cardiff. Stone with red brick, not architecturally notable except for the tower. The cap with pyramid roof was altered in 1939, when the adjoining range was given a Neo-Georgian tinge by *Rhys Jones*, the County Architect. Physics laboratory, 1952, canteen and hall, 1962 by *G. R. Bruce*, County Architect, and subsequent additions.

TYSUL HALL, New Road. 1955 by *John Davies*, County Surveyor.

PERAMBULATION

The BRIDGE, 1837 by *James Hughes*, County Surveyor, spans the wooded ravine with a single arch between flat buttresses. Circular holes each side. In BRIDGE STREET, CAERGLYN, partly of 1821, presents a big canted bay with hipped roof to the bridge, and four bays to the right. BRIDGE HOUSE, on the r., has a simple early C19 three-bay front, little altered, while DINARTH HALL, on the l., has the Aberaeron-influenced big windows of the mid to later C19, as does ROCK HOUSE opposite. Bridge Street becomes WIND STREET, with some attractive shopfronts of *c.* 1900, and then LINCOLN STREET, the buildings occasionally rising to three storeys. The MIDLAND BANK has some misconceived carved detail in Bath stone on red brick, *c.* 1900. As the street becomes KING STREET, on the left, RICHMOND HOUSE, a surprisingly grand double villa in stucco of *c.* 1870–80, more coastal resort than Mid Wales. Adjoining, NO. 5 BARLEY MOW, mid-C19 warehouse with pointed loading door under a centre gable. On King Street, LLOYDS BANK, 1913 by *D. R. Thomas*, brick and stone ground floor with a touch of the Queen Anne. Beyond, the scale diminishes as the name changes again, to HIGH STREET. At the far end, a late C19 Gothic iron veranda made by the *Old Foundry*, Carmarthen. Further out, SPRING GARDENS, three houses under a hipped roof, actually the Market Hall of 1838, remodelled 1893 by *J. R. Thomas* of Llandysul. The PORTH HOTEL, below, has late C19 stucco on a front called new in 1863. There were assembly rooms in the left end, and a large warehouse behind looks like a woollen mill. CAMBRIAN TERRACE to the N also has a late C19 former woollen mill. In CHURCH STREET, by the churchyard entry, the OLD VICARAGE of *c.* 1845, three-bay, hipped, in long blocks of grey-blue stone. On the corner of WESLEY HILL, CARREGLLYS, later C19, still in the Georgian mode and with a warehouse of equal height attached. The former PENIEL WESLEYAN CHAPEL, of 1844 and 1902, is now a youth club, plain stucco front with steel and glass addition of 1999.

ABERCERDIN MILL, ½ m. NE. Stone and brick, three-storey former woolen mill, of the 1870s, now a house.

PANTOLWEN MILLS, 1 m. N. Early C19 stone corn mill with three-storey woollen mill of 1895 behind, plain stone with brick window heads.

LLANFAIR, 1½ m. E. Small country house with four-bay stucco front and off-centre gable, *c.* 1840–50 in detail, but possibly a refacing as a rear wing is dated 1797. A large square farm-court has 1796 and 1846 datestones but was not completed until the late C19. Two archways opposite each other at the E ends.

PLAS GILFACHWEN, 1½ m. W. One of a group of early C19 villas closely influenced by John Nash's local works in the 1790s. Stucco hipped three-bay square house, built for the Rev. Thomas Lloyd, extended by a bay in 1980. The narrow tripartite ground-floor sashes in arched reveals with false fanlights are a motif from Nash's Llanerchaeron. Garden front raised on a basement with blind centre windows. Behind, three-bay lofted stable, and a two-entry high-door barn.

See also Capel Dewi, Pontsian, Prengwyn, Rhydowen, Tregroes.

LLANERCHAERON

Small parish inland of Aberaeron, principally the Llanerchaeron estate.

ST NON. Rebuilt for Col. Lewis of Llanerchaeron in 1798, presumably by *John Nash*. Originally stuccoed, with battlemented nave and W tower, it was a simple Georgian rural church, distinguished only in the squat dome and pinnacles on the tower, and quatrefoil panels in the nave W wall. Alterations, in 1878 by *F. Fowler* of Brecon and in 1895 by *David Davies* of Penrhiwllan, stripped the stucco, removed the battlements, raised the roof pitch and reglazed the windows with wooden tracery. The dome is a C20 restoration, the bases of the finials remain. The interior and fittings are all of 1895. – FONT. Found at

St Non's Church.
Engraving, 1810

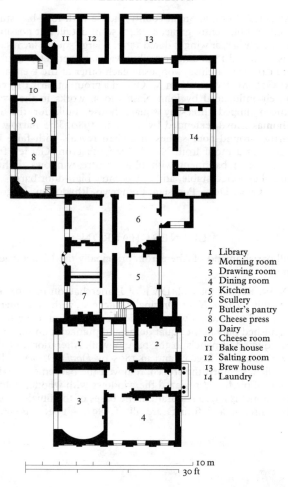

1 Library
2 Morning room
3 Drawing room
4 Dining room
5 Kitchen
6 Scullery
7 Butler's pantry
8 Cheese press
9 Dairy
10 Cheese room
11 Bake house
12 Salting room
13 Brew house
14 Laundry

Llanerchaeron House.
Plan

Llanerchaeron house and restored 1895. – STAINED GLASS. E
window by *A. F. Erridge*, 1952.

LLANERCHAERON, ¼ m. E. Country house rebuilt *c.* 1793–5 for
Col. William Lewis, by *John Nash*, incorporating the shell of
the C17 house of the Parrys. This had six hearths in 1670, large
for the region. Lewis's father had commissioned plans *c.* 1762
from *William Chambers* for a classical villa, presumably for this
site, a quite exceptional patronage for West Wales at this date.
The house was given to the National Trust in 1990 and the
restoration of house and outbuildings was completed in 2004.

Nash's design, original in its way, marks a progression in his
work from the houses like Ffynone, Pembs., and Llysnewydd,
Cms. with main floor raised above basement services, to those

with services to the rear or side, both less formal and more integrated to the landscape. Llanerchaeron is conceived as a house in an emparked landscape, designed to be seen in oblique views, with the park including the church. Lewis was a friend of Thomas Johnes of Hafod, appearing with another improving landlord, David Stevenson of Dol-llan, Cms., in Romney's portrait group of the Johnes family in a rustic cottage setting.

Essentially unostentatious, the house is near-square, two storeys, with hipped, deep-eaved roofs, and ochre-washed roughcast walls. Of the three façades, the simplest is the five-bay s garden front, with a minimal arcade containing the lower windows. The e and w sides are of three more widely spaced bays, and the lower windows are amplified to Palladian within an arched frame, elegantly detailed with pilaster jambs to the side lights and radial fluting in the outer arch. The National Trust, owners since 1990, regularized an upper window each side, that had been lowered to reflect the lower floor level in the back part, the shell of the c17 house, and removed a c19 bay on the r. of the e entrance front. This façade has a recessed centre, infilled with an ashlar Doric balustraded porch with paired columns, rather heavy for the house, but apparently original. Within, a broad arched entry with traceried fanlight. Attached to the rear n side, a lower service block, with hipped double roof, and then a charming single-storey cobbled n courtyard with deeply overhanging roofs, Italian in feel. Dairy and cheese rooms on the w, laundry on the e, and bakery and brewhouse on the n. The n range was apparently added in the 1820s. The whole courtyard is matched by one at Alltyrodyn, Rhydowen, so closely as to suggest that it was copied from Llanerchaeron. 60

The interior plan is sophisticated but resulting in oddities, like the remarkable number of dummy windows, one of two on the e, two of five on the w, and all the fanlights of the Palladian windows. An entrance hall leads to a square centre hall with stair off to the n, and two long principal rooms, a three-bay dining room to the se, and drawing room to the w. Small and square nw and ne rooms, with lower ceilings. Nash's invention shows in the dog-leg plan of the halls and stair, designed to reveal the stair as a surprise. The square centre hall has arches on all sides, infilled with doors to the main rooms on s and w, open to e and n, and with squinches to a circular ceiling panel. The n arch opens onto a fine ashlar imperial staircase, rather grander than the space allows. The present top lighting is an alteration of the 1920s, Nash reserving his lighting to a top light in the centre of the first floor, so that the stairs would have been mysteriously lit. The stairs are cantilevered, with mahogany rail on scrolled wrought-iron balusters. Nash's problems with the c17 lower ceilings of the rear shows in a floor line that cuts the top of the stair-hall arch. The main rooms have panelled doors and delicate cornices, the best in the drawing room, with acanthus and guilloche. Here, the s end wall is curved. Had it been at the n it would not have

blocked the two windows, but the arrangement is elegant with a Neo-Grec white marble fireplace of the 1820s. The National Trust took the decision to restore the rooms more or less as found, as the original furnishings were all gone, the character dating mainly from a refurbishment of *c.* 1920, with dark-stained woodwork and plain mid-C19 fireplaces. However, in the halls, the pink colourwash and blue balustrade are based on originals found by paint-scrapes.

61 Upstairs, the square arcaded centrepiece is repeated, this time with the circular ceiling border framing a conical glazed lantern. The corner bedrooms are separated by three narrow rooms, the most inventive interiors of the house. Those to the E and W are delightfully curved-ended, with curved doors. The E room, a sewing room, has an oval ceiling with entwined rope moulding, and four elliptical-arched recesses. The W dressing room is similar but slightly more complex, with the four niches, but elliptical half-domes each end and squinches to a flat circular centre panel. The S dressing room has a coved ceiling. The bedrooms have a character of the 1920s. Under the rear of the house are barrel-vaulted C17 cellars.

In the service range, the kitchen and scullery are on the E and butler's and housekeeper's rooms on the W of the centre passage. The courtyard beyond has been particularly well restored. Curved high ceilings over the dairy and laundry, servants' bedrooms in lofts elsewhere.

Behind the courtyard, a detached BILLIARD ROOM of 1843, by *William Coultart*. A neat design in stone, with hipped roof and roof-light. Arched window in arched recess each side of a gabled porch.

The extensive and characterful HOME FARM buildings have been rescued from dereliction. Rubble stone buildings, some whitewashed, arranged in a series of courtyards N of the walled gardens. The first, the cobbled stable-court, created *c.* 1800 from two smaller exisiting ranges. Triple-arched COACH-HOUSE to S, and hipped lower ranges each side, with blind arched end windows. STABLES to E, and range to W possibly a barn, later stables, the N end lastly a BATTERY-HOUSE, the electricity generated from the water wheel. In the second court, garden sheds against the back of the walled garden, and on the W, the rear of the farmhouse and of the long cow-byre, with hipped roof swept down over lean-tos. The main farm court has the late C18 COW-BYRE on the W, extended to the N *c.* 1800 with heavy-horse STABLE, and the three-bay hipped FARM-HOUSE, built as a bailiff's house, 1863, to the l. On the N, a handsome GRANARY raised on high stone piers above a cart-store open to N, the rear to the courtyard screened by a range of KENNELS and PIG-STIES, the W end C18, the rest *c.* 1800. On the S are open-fronted mid-C19 STOCK-SHEDS. On the E side, a fine, high-door double BARN with two tall entries each side, double row of doveholes, and hipped roof, *c.* 1800, with an earlier shed to S and lofted carpenter's shop to l. of similar date to the barn, extended to N with a gun shed. Behind the

barn, stone circular bases for hay-ricks, and a SAW-PIT. Further N, a 14-ft (4-metre) WATER WHEEL, from the *Eagle Foundry*, Aberystwyth, which drove the sawmill, powered the farm buildings through underground shafting, and in the C20, generated electricity.

The landscape setting of the house was principally grazed parkland running down to the Lampeter to Aberaeron main road, with some specimen trees, the church visually part of the park, separated by a ha-ha. Some ornamental tree-planting between the house and the long WALLED GARDENS. These are late C18, mostly brick-walled, with restored C19 greenhouse in the W of the two gardens. To the SE was an oval lake, with island, badly silted up (2004).

ESTATE COTTAGES. ABERMIDYR, W of the church, is perhaps by *Nash*, or at least the l. half, which was a little Gothic lodge with veranda and centre chimney rising from a conical thatched roof. Extended to r. and reroofed in slate. To W, CLWYD DDU, in angle to the main road, a hipped square lodge of *c.* 1800. On the main road, to N, DDOLWEN and ALLTWEN, a two-storey house and a single-storey cottage, both of similar date, with Gothic windows. The cottage has an overhanging front roof carried on iron posts. On the main road to the s of Clwyd Ddu, THE FORGE, whitewashed two-storey early C19 house with smithy attached. On a lane opposite, MINAFON, earlier C19 two-storey hipped house and PONTDRENMIDYR, C18 whitewashed earth-walled and thatched end-entry cottage. PONTFAEN, further down the main road, is an estate farm with hipped barn.

WIGWEN FACH, ½ m. WNW, N of the river over the old railway line. Small lofted cottage in whitewashed stone, refacing earth walls, visible at rear. The roof was thatched. Inside, a chimney-hood of plastered lath.

LLANFAIR CLYDOGAU

Church and chapel sit well each side of PONT LLANFAIR, C18 stone two-arch bridge over the Teifi.

ST MARY. Rebuilt in 1885–8, by *Middleton, Prothero & Phillot* using a shell apparently remodelled in the 1840s – see the Tudor-arched nave windows. Nave and chancel in one. Of 1885–8, the bellcote, thick Perp tracery and small W rose in a square frame. Inside, a nice open wagon roof of 1885–8, with moulded arched trusses and purlins, and a well-carved vestry screen. Encaustic tiled sanctuary. – FONT. C12 with the crude vigour found at Silian and Llanwenog, battered circular bowl with projecting roughly carved Evangelist symbols: a massively unangelic face, a raven-like eagle, a goat-like bull and an owl-like lion. – PULPIT. Mid C19, painted grained Gothic. – STAINED GLASS. E window, 1958, and chancel s, 1977, both by *Celtic Studios*, the former with stronger colouring.

CAPEL MAIR INDEPENDENT CHAPEL. 1825, rebuilt 1845; stone lateral façade, with a nice rhythm of five openings rather than the usual six, the large centre window and outer doors arched, and two big square gallery windows. The stone heads of the doors may date from the 1825 chapel. Inside, grained box pews and panelled three-sided gallery of *c.* 1861, cutting across the front window. Grained canted pulpit front.

CASTELL GOETRE, 1½ m. w (SN 603 510). Iron Age hill-fort on the same ridge as Alltgoch, Lampeter. A wide oval divided into fields, with single bank, ditch and counterscarp bank.

LLANFAIR ORLLWYN *see* PENRHIWLLAN

LLANFAIR TREFHELYGEN *see* LLANDYFRIOG

5977

LLANFARIAN
Llanbadarn y Creuddyn Isaf

Main road settlement on the Ystwyth, the bridge brutally modern. Around are a group of small country houses, reflecting the position near to Aberystwyth.

GOSEN CALVINISTIC METHODIST CHAPEL, Rhydyfelin, ½ m. N. 1867. Stone with yellow brick arched openings. Stone finials on the outer piers and a moulded band.

ABERLLOLWYN, in a small park below the main road. Rendered hipped three-bay house, possibly late C18, called a 'fine mansion' in 1809, remodelled in 1878. An ancient site.

CWMCOEDWIG, ¼ m. W. Tall gaunt stone house of 1870 with Bath stone bands and steep gables over the upper windows, echoed in the very Gothic timber porch. Built for the Davies family of Ffosrhydgaled, Chancery.

TY'N LON, Rhydyfelin, behind the chapel. Four-bay mid-C19 stone villa with pyramid roof, the crowning brick stack pierced with arches.

CRUGIAU, Rhydyfelin, ¾ m. N. Low four-bay stone house of the mid C18 raised and remodelled in the earlier C19 for the Davies family, later of Tanybwlch, Llanychaiarn. Inside, low ground-floor ceilings of the C18, some fielded panelling in the N room. In the entrance hall, early C19 shallow arches framing two blank bays alternated with the stair opening and a rear door. On the main road, a square early C19 hipped LODGE with ogee blank window.

See also Llanychaiarn.

LLANFIHANGEL GENEU'R GLYN *see* LLANDRE

6676

LLANFIHANGEL Y CREUDDYN

A rare thing in the county, a nucleated village around a substantial medieval church. Prettily set in a valley between the

Ystwyth and Rheidol valleys. An attractive row of whitewashed stone houses opposite the church, and then LISBURNE HOUSE, a substantial late C18 village house of a type rare in the county. Whitewashed stone with steep hipped roof and big stone end chimneys, three bays with small-paned sashes. A shop-window in the side wall. Beyond, PRESWYLFA, utterly altered outside, but with two spindly cruck trusses, a tiny open hall, possibly C16. Below the church, SCHOOL, 1838 enlarged 1875, and with a little spired lantern of 1901.

ST MICHAEL. A cruciform church of exceptional plainness but great dignity from the scale of the C14 crossing tower, one of three in the county, with Llanddewi Brefi and Llanbadarn Fawr. Quite without detail, just rebuilt battlements and plain cambered bell-lights. The top is said to have been lowered by some 6 or 8 ft (2–2.5 metres), presumably when the octagonal short slate spire was added. Chancel and N transept were rebuilt in 1835 or 1846 (records are vague); *R. K. Penson* was involved in 1870–4, and *Caröe & Passmore* undertook repairs in 1932–3. Nave, chancel, short transepts and large C19 S porch, the roofs overhanging with bargeboards, a Penson touch. Plain two-light square-headed windows with no tracery, a C17 to early C18 type, renewed or copied in red stone in 1933. By then such things were of interest, whereas in the 1850s Sir Stephen Glynne had called the originals 'rude . . . and poor'. The cambered-headed E window of three lights, which Glynne saw as C15, now looks C19. He also noted a cusped single light to chancel N, since covered by a vestry of 1905. In the porch, C15 chamfered S door with bar stops.

An interior of extreme simplicity. Plastered walls and fine late medieval barrel nave roof with moulded longitudinal ribs, presumably originally with plaster panels. The tower rests on four plastered pointed arches with very slight imposts to the piers. In the N transept, door to the tower stair. Close-boarded barrel roof in the chancel, all renewed. – FONT. Small broken medieval octagonal bowl on round base, next to the later C19 octagonal replacement. – REREDOS. A large piece in carved oak, 1919, by the Belgian carver, *Jules Bernaerts*, the Last Supper; Baroque drama. Pine pews, pulpit and rails by Penson, the rails with heavy trefoil-cusped piercings. In the tower, a massive oak bell-frame.

CAPEL CYNON, 1 m. W. Mid-C19 chapel and house in line, the chapel with long-wall front of big square-headed windows and a single plain outer door. Painted grained box pews in the typical North Cardiganshire arrangement, raked back from an end wall pulpit with simple great seat. The chapel is dated 1829 but must have been rebuilt in the 1850s.

PLAS Y CREUDDYN, ¼ m. E. The former vicarage, 1869, by *R. J. Withers*. A neat stone house, four-bay, but just two upper windows in gables, all sashes, but the scent of Gothic in segmental-pointed heads, subtle asymmetries and the pitch of the roof.

CNWC COCH, 1 m. SE. Hamlet with small cottages climbing the hill, a late C18 squatter settlement associated with the lead mines. THE TERRACE is a row of four, one with end entry, the last one with low upper floor. LLWYNCELYN and DELFRYN are single-storey, Delfryn with some earth walling. ARGOED, by contrast, is a later C19 builder's display, with three colours of brick and cast-iron window columns.

PENYWERN, 2 m. W. Country house of 1859, for F. R. Roberts, by *R. K. Penson*. An oddly gawky design, perhaps remodelling an older house, but which Penson thought enough of to exhibit at the Royal Academy. Rubble stone with painted ashlar dressings. Two-storey spine with Picturesque asymmetrical cross-wings of three storeys. Entry in the r. wing, a Gothic gabled porch against a hipped projection; in the angle to the l. wing, a square turret for the service stair, with pyramid roof. On the garden front, the l. cross-wing has the main stair, with steep hipped roof, the r. one is gabled. Inside, a long passage behind the stair hall and interlinked front rooms. Remarkably extensive fireproof cellars with brick vaults on iron girders. Attractive cobbled SERVICE COURT to NE with entrance arch and L-plan stable and coach-house.

See also Llantrisant.

LLANFIHANGEL YSTRAD *see* YSTRAD AERON

6259

LLANGEITHO

The centre of the village is a pleasant irregular square, with an unnecessary roundabout, a marble soldier WAR MEMORIAL, 1922 by *E. J. Jones*, and a yew tree raised in a stone enclosure. On the s side, a pair of houses, PLAS, later C18, incorporating an earlier range behind, and DROVERS HOUSE, earlier C19. The chapel is on the edge of the village to the NE, and the church across the Aeron, to the NW.

ST CEITHO. Llangeitho was the scene of extraordinary religious activity from 1735 during the curacy of Daniel Rowland (1713–90), one of the founders of Welsh Methodism. Thousands of worshippers came to the open-air services that Rowland held outside the village. When finally suspended from clerical duties in 1763, he moved his activities to the new chapel across the river. Such was his influence that Holy Communion was not administered in Llangeitho church for nearly fifty years.

Rebuilt twice since Rowland's day, the present utilitarian lancet Gothic church of 1898, by *William Williams* of Brecon, reuses the nave walls of the Georgian Gothic church of 1819–21. Nave and chancel, s porch, w bellcote. Inside, the best feature is a slate MEMORIAL to Daniel Rowland's parents, †1731 and 1736, with moon-faced winged cherub head and painted rose-trails in the spandrels. – STAINED GLASS. E

window, 1930, by *A. K. Nicholson*. W single light, by *Celtic Studios*, 1951, S single light, by *Powell*, 1963, and one N single light *c.* 1920.

GWYNFIL CALVINISTIC METHODIST CHAPEL, NE of the square. 1813–15, altered 1861–3. Rowland's first chapel of 1760 was replaced in 1764 by a double-roofed building with a row of stone pillars between the two halves. The present building is the shell of the chapel of 1813–15, but the character from the remodelling in 1861–3 by *John Lumley* of Aberystwyth. Rough-cast, with bracketed eaves and hipped roof. The original entry on the three-bay N façade changed to the short two-bay W end. Arched ground-floor openings, three windows on N and two doors on W, and upper windows square-headed apart from the arched centre one on the N. Two arched W end doors. Attractive glazing with small panes and Y-tracery. Atmospheric interior with dark-grained gallery, with canted angles, and front in long raised panels. Plain grained box pews. Pulpit platform raised high with serpentine balustrading each side of a pan-elled pulpit with bulbous angle columns. In the plaster arch behind, a door to the outside, to allow the preacher a dramatic entry?

The chapel forecourt is enclosed by the three-bay CHAPEL HOUSE of 1857, and vestry and stable range of 1902. White marble STATUE of Daniel Rowland, 1883, a stiff work by *Edward Griffiths* of Chester.

PENUWCH CALVINISTIC METHODIST CHAPEL, 2 m. NW. 1867, altered 1888. A late long-wall façade, stone, with two long centre windows and shorter gallery lights, all arched. Thick tracery of 1888, when both doors were blocked, the new entry being through the vestry. Single panelled gallery of 1888.

CWRTMAWR, 2 m. N. Square, hipped, three-bay, three-storey, roughcast house of *c.* 1845, with bulbous-columned porch. Later C19 matching rear wings. The FARMYARD below, mostly later C19, has a very large lath-and-plaster chimney-hood in a corner range that may be part of an C18 house, otherwise gutted.

LLANGOEDMOR 2046

Teifi valley parish, just outside Cardigan. The church is on a ridge between two streams, with the OLD SCHOOL adjacent, 1849, by *William Jenkins* of Llangoedmor, two-storey with classroom on each floor and teacher's house adjoining. Slate hoodmoulds.

ST CYNLLO. An oddly shaped church, nave and chancel of equal length divided by a steeple. The plan was the same in 1810, with even then a small steeple, according to Meyrick. Every-thing rebuilt since, firstly by *David Evans* of Cardigan, 1830–2, then remodelled to Victorian taste by *R. J. Withers* in 1859–60. Evans's steeple in cut and moulded grey Cilgerran stone is a most unexpected Neoclassical miniature: two Roman Doric tiers, with Grecian acroteria and then a slim obelisk on a

pedestal. It is indeed a miniature, Dr Giles Worsley points out,
of the spire of F. Bedford's St John, Waterloo Road, London,
of 1822–4. Restored 1993 by *Llwyd Edwards* of Cardigan, the
original columns and piers replaced in shinier slate.

Withers added heavy plate tracery but the low roof pitches
and the steeple defeated his attempt to impose High Victorian
seriousness. Only the vestry chimney shows flair. Bald w bell-
cote dated 1891. The interior is more Withers than Evans. The
best feature is the E window STAINED GLASS, 1859, by *Lavers
& Barraud*, three big medallion scenes in C14 style, brightly
coloured. Possibly also by them, the less good W window, 1859.
Nave S window by *William Glasby*, 1930, chancel N of 1932,
signed 'W', and two S windows, 1887 and 1883 by *Cox Bros,
Buckley & Co.* (the 1883 one the better). Ornate Bath stone
PULPIT of 1903. – FONT. Plain ashlar cushion, looking
Victorian, but matching that described in 1810. Inside is a
small medieval octagonal stone bowl with four lobes. –
MONUMENTS. Behind the pulpit a nicely crude lettered slate
to Margaret Lewis of Llwyngrawys †1729. N wall: Elizabeth
Mitchell †1827, a fine low-relief kneeling woman; Rees Price
†1827, stele with urn; and Jonathan Jenkins of Cilbronnau
†1851 and his son †1870, marble scroll, by *M. W. Johnson*. S
wall: Evan Davies of Treforgan †1832, classical urn, but Gothic
piers. In the chancel: Owen Ford Lloyd of Abertrinant †1812,
by *Barlow*; plaques of 1857 by *Read* of Pimlico to two Thomas
Lloyds of Coedmor †1810 and 1857; a Lloyd HATCHMENT;
and H. M. Vaughan of Plas Llangoedmor, †1855, by *S.
Manning*, military emblems.

In the churchyard to NW, burial enclosure with iron rails by
Moss of Carmarthen, 1830s.

BLAENWENEN BAPTIST CHAPEL, 2 m. NE. 1838, remodelled
1938. Minimal, centre porch and two arched windows.

PLAS LLANGOEDMOR, I m. E of Cardigan on the B 4570. A
house of two periods, the front range of 1833 by *Edward
Haycock*, for Col. Herbert Vaughan, built across the façade of
a house of *c.* 1760, built for John Lloyd, Clerk of the Cheque
at Plymouth Dockyard. The C18 house had a pediment lunette
(reused at the back of the house), and was itself added to an
earlier C18 house at right-angles, demolished in the 1830s.
Neoclassical front range, 2–1–2 bays, with deep eaves, centre
pediment and giant pilasters in Cilgerran stone. Effective con-
trast of roughcast wall and well-cut pilasters and architraves,
with entry recessed in a Greek Doric porch. Inside, central
entrance hall with altered library to the l. and drawing room
to the r., with acanthus friezes to cornice and doorcases, and
a fine marble matching fireplace. The earlier range behind was
not altered in 1833. Stair with column-on-baluster rails rising
to the attic in four flights. Service rooms to l., dining room★

★ A lavish carved wood fireplace, made in London, is now in the Museum of Welsh
Life, Saint Fagans. It has an overmantel with picture panel framed by festooned
piers and console brackets, and broken pediment.

to the r., a rarity in the county, panelled in large panels, with pedimented doors and scroll pediments over serving recess and the entry-wall panel.

PLAS TREFORGAN, ¼ m. N of the church, on the B 4570. A clear example of the influence of John Nash, but almost certainly built – for Evan Davies – after Nash's departure from Wales, probably c. 1810. Treforgan follows the square plans of Nash's Llanerchaeron, Llysnewydd (Cms.), and Ffynone (Pembs.), but less effectively. Big hipped roof and centre stack. Three-bay S front with centre recess and inset columned porch in timber. Three-bay W façade, with two shallow full-height bows, the tripartite sashes with columns as Nash used at Llysnewydd. Inside, Nash's Llanerchaeron plan with entrance hall leading into a square space with circular ceiling panel at the centre of the house, a fine cantilever, apsidal stone stair off to the r. and principal rooms disposed around: SW dining room, NW drawing room, N library and SE study. Access to the rooms is clumsy; only the dining room is reached from the centre square, the drawing room is approached by an additional hall space which cuts uncomfortably into the library. Upstairs, the same centre square is repeated, but instead of Nash's glazed lantern, a great hollow cone reaches through the roof space to grasp light from a circular skylight. This quite extraordinary device occurs also at Glandwr, Tresaith, and Plas Trefilan, Trefilan, presumably by the same hand. All but one of the upper rooms are uncomfortably shaped. The plasterwork is similar to Nash's at Ffynone.

NOYADD WILYM, 1 m. NW of Llechryd, on the A 484. Externally, all of 1894 by *George Morgan*, though he extended an existing house. Stucco with bargeboarded gables and a tourelle oriel. It was home to a group of Breton Benedictine monks, 1905–17, but plans for a chapel and cloister came to nothing.

COEDMOR, 2 m. S. One of the Lloyds of Cilgwyn inherited the estate in 1714, the old house was near the walled garden ½ m. NW. The present house stands picturesquely and precipitously above the Teifi gorge, opposite Cilgerran Castle. Close to, it shows nothing pre-C19 in all its agglomerative bulk, swollen by the service court, which is the more entertaining part. Two storeys, the house stuccoed, the service court of rubble stone. The plain three-bay W end may be the Regency original, extended to make a two-storey, five-bay S front to the river with bowed centre, and the N end subsumed into an irregular entrance façade in the 1860s. The heavy corniced architraves of the W side and N front are reminiscent of Haycock's work at Penylan, Llandygwydd. The drama of the river front is in two later accents: next to the original range, a big three-storey, octagonal tower, in pink stucco, finished in 1867, and capped with a slightly mid-European slate roof in two pitches. To the r., the plain rear of the service court links to an equally large square corner block with pyramid roof and lantern.

In the service court, a substantial two-storey stable with centre arch on the W side, the pyramid-roofed SE corner block

and, at the NE end, an oddly proportioned gable with slate roundel (for a clock) and another timber lantern.

Inside the house, the panelled library of 1867 at the top of the tower is the only room of interest.

ALMA GRANGE, ½ m. E. Square villa of 1870, by *W. Woodward* of Cardigan, engineer and owner of the brickworks. Old-fashioned, three-bay Late Georgian type with hipped roof.

LLWYNGRAWYS, ½ m. E. Small three-bay stuccoed house with pediment lunette. Possibly of 1753, original seat of the Lewis family, later of Clynfyw, Pembs.

PANTGWYN, 1 m. E. Three-bay hipped villa with long axial centre stack, probably of the 1830s, for G. W. Griffiths. Ochre rough-cast with a timber Roman Doric porch, of columns paired with square piers. Well-planned interior with L-plan stair at the back and simple Regency reeded borders to ceilings and doors.

LLANGORWEN

In the wooded valley of the Clarach, below Plas Cwmcynfelin. The church lies N of PONT LLANGORWEN, a late C18 or early C19 single-arched bridge. LLANGORWEN COTTAGE, on the S bank, is a good example of the single-storey two-room cottage, with door in the end wall.

ALL SAINTS. Here is a church that provides a snapshot of the architectural thinking of those at the centre of the Anglican revival of the 1830s, the Oxford Tractarians around J. H. Newman. For the Tractarians, the architectural path back to the true Gothic opened quickly, but in 1839, the year this church was begun – and the year of the foundation of both the Oxford and Cambridge societies for the study of Gothic architecture – there was room for experiment and error. M. D. Williams of Cwmcynfelin, builder of the church, was brother of Isaac Williams, poet, Tractarian, and Newman's curate at the newly built Littlemore, Oxon. His intention was evangelical – to serve a district distant from the parish church at Llanbadarn Fawr. The consecration service was given in Welsh, a new departure, and the architecture was a correct Gothic then quite unknown in West Wales. Williams used the architect that Newman had used in 1835 at Littlemore, *H. J. Underwood* of Oxford, a man soon overtaken by more scholarly talents, but whose Littlemore design was still being promoted as exemplary as late as 1845. The church is E.E. in style, nave and chancel with careful buttressing and string coursing, and respectably steep roof pitches, all marking it out from the cruder lancet Gothic of the 1830s. It cost the exceptionally large sum of £3,000. Only the coursed sandstone (tooled below the sill-course, smooth above) departs from the rougher textures soon mandatory for rural churches. A tower was intended but was too expensive, and the first vicar, Lewis Gilbertson (*see* Elerch), turned to *William Butterfield* to

disguise the baldness, with a new W front and S porch in 1849–50.

Butterfield's front is altogether more sculptural, the bellcote rising from a mid buttress, which begins pointed in plan, turns square, but then splays out with little diagonal arches to support the slim octagonal spirelet. The porch has a cusped rafter roof and small trefoil side windows. Inside, Underwood's roofs are thin and oddly low, given the outside roof pitch. The nave roof is to a C15 pitch with heavy tie-beams, arch-braced from corbels, the chancel roof is a very starved hammerbeam. The stone ALTAR was the first in Wales since the Reformation, its fine setting based on Salisbury Cathedral, with triplet of tall Bath stone shafted lancets above a full-width blind arcade. – Underwood's FITTINGS would not pass muster by the mid 1840s: plain altar RAILS, a chancel SCREEN that is just two lengths of balustraded rail with octagonal posts, plain timber PULPIT. The READING DESK is an odd little essay in over-complicated woodwork. – LECTERN. A carved wood eagle perched on the rail of the pulpit steps, said to have been a gift of Newman or John Keble, the other having given the bronze chandeliers. – The CHANDELIERS are of quite exceptional Gothic Revival metalwork, very exuberant, the hefty centre shafts octagonal with little crocketed gables, the arms, in two tiers, sinuous and foliar. They seem to be based on the C15 chandeliers at Llanarmon yn Ial and Llandegla, Clwyd, but are not copies. Few firms could do such work in 1840. Could Hardman and Pugin have been involved? – STAINED GLASS. Fine E window of the 1850s, nine medallion scenes in vesica-shaped panels, with red and blue backgrounds, probably by *Wailes*. W windows, 1889, by *C. Evans & Co.*, painterly in a Renaissance drawing style. In the nave, five windows of 1950 by *Celtic Studios*, and one by *C. C. Powell*, 1938.

CHURCH HALL, ¼ m. NE, on the lane to Bow Street. 1871, former school by *George Jones* of Aberystwyth. Steep hipped roof and very Victorian colours, stone, yellow brick moulded eaves and red brick pointed windows.

PLAS CWMCYNFELIN, on the hillside to the S. Built 'from designs of a Mr *Dixon* in London' according to *C. R. Cockerell*, who designed the stables. Probably of the 1770s, Joseph Dixon Sen. and his brother and partner, Richard, were bankrupt in 1778. Cockerell called the house unfinished. Plain, five bays, in squared sandstone, with cornice and low parapet, two storeys to the front and three to the rear. Square-columned porches both front and rear. A W cross-wing of an uneven five bays looks early C19, but a downpipe is dated 1875. Inside, stair with square thin balusters, up two sides of the entrance hall.

The STABLES are heavily altered, but the bones of Cockerell's design remain. Square, hipped, around an open court, since roofed over. The sides have tall arched openings, originally blind apart from lunettes, linked by a raised band, and the entrance bay projects with a giant arch under an open pedimental gable, as at Derry Ormond, Betws Bledrws.

WALLOG, 1 m. NW. Unusually sited, on the shore, facing out to
sea, but the house does little justice to the site. Plain stucco
core, perhaps early C19, between later C19 gables. Late C19
stone and yellow brick FARM BUILDINGS; in the same harsh
materials an octagonal LODGE.

On the beach just S, an exceptionally handsome, square
LIMEKILN with well-made arches each side and corbelled
coping.

RHOSCELLAN FAWR, N of Wallog Lodge. Early C19 Cwmcyn-
felin estate farmhouse, Wallog sandstone, with stone-coped
gables and stone crow-stepped porch. Three bays, made more
imposing by service wing and lofted stable wing.

LLANGRANNOG/LLANGRANOG

The village is an attractive ribbon down the steep valley of the
Hawen to the sea, the older settlement having been around the
church. One cottage by the stream halfway to the sea dated 1782.
The seashore had no buildings until small-scale shipbuilding
started in the later C18. The SHIP INN, with stone chimneys, was
reputedly the first, c. 1765, though it looks of the early C19.
Otherwise the stuccoed houses have a late C19 character.
Circular C19 LIMEKILN SW of the beach.

ST CARANOG. Rebuilt in 1885–8 by *E. H. Lingen Barker* for
£1,030, leaving nothing but a little stonework on the N side.
The previous church was a long single chamber. Nave, chancel,
bellcote and porch, heavily Dec E window, the rest flat-headed.
This contrast deliberate as Barker explained the flat-headed
window as a C14 local response to low wall-heights preventing
proper arching, but his examples, in Bath stone, strike no local
chord. Inside, open roofs on carved corbels (by *Herridge* of
Cardiff), ashlar chancel arch. – FONT. C12 square bowl. –
SCREEN. 1917, echoing the E window. – PULPIT, 1920, more
thickly traceried. – STAINED GLASS. E window, 1928 by
Christopher Webb, late Gothic figures on a clear ground. W
window, c. 1902, by *J. Dudley Forsyth*. Nave N window by *Celtic
Studios*, 1952, chancel S lancet, c. 1900 by *Jones & Willis*. –
MEMORIALS. Elizabeth Price †1829 and George Price †1830,
of Pigeonsford, both by *Tyley* of Bristol, 1830s, Neo-Grecian.

ST DAVID, Blaencelyn, 1½ m. E. 1894, chapel of ease in stone
and yellow brick, probably by *David Davies*.

BANCYFELIN CALVINISTIC METHODIST CHAPEL, just below
the church. 1863. A large, late lateral façade, all arched
windows and small-paned glazing. It cost £410. Converted to
a house in 1998. It had a five-sided gallery, of 1872, panelled
in pierced cast iron. Gothic SCHOOLROOM of 1888, also now
a house.

CRANOG INDEPENDENT CHAPEL, beyond Bancyfelin Chapel.
1888–9, by *David Davies*. Stucco gable front with major arch,
no galleries. It cost £434 10s.

PENDINAS LOCHTYN HILL-FORT. Oval Iron Age fort on a flat-topped hill, prominent for miles. Little visible defences, as naturally protected on the seaward side, but the banks scarped at the back. Traces of round houses have been found. Ugly, false-mansarded building of 1990 for tracking missiles from Aberporth.

PIGEONSFORD, ½ m. E. Stuccoed house of the Price family. The original three-bay house of 1755 survives, altered, as the service wing, to the l. of a Late Georgian pyramid-roofed villa, of two bays each façade, with a trellis porch. N front extended by *D. Davies & Son*, 1910, and more so after 1926, for D. O. Davies, M.P. The interiors were mostly of the 1920s, but staircase, fireplaces and panelling were removed illegally in 1993.

See also Pentregat, Plwmp and Pontgarreg.

LLANGWYRYFON 6071

Village in the Wyre valley, below the Mynydd Bach range, lined by a large WIND FARM since 1993. The church is on the hill to the SW, with the former NATIONAL SCHOOL, 1861, opposite and Tabor chapel just below.

ST URSULA. 1879–80, by *Archibald Ritchie*. Nave and chancel with bellcote between, and s porch. Lancets, traceried E window. Conventional interior with open roofs on stone corbels. – STAINED GLASS. E window, and one nave N window of 1965.

TABOR CALVINISTIC METHODIST CHAPEL. 1820, rebuilt 1860, in a row with vestries and schoolroom of 1846, enlarged in 1870s. Plain but handsome stone long-wall chapel with square-headed openings. Interior possibly of *c.* 1870. Painted three-sided gallery with curved angles, in long panels divided by pilasters. Painted grained pulpit, still of the narrow kind, with angle columns and curving stairs. Jacobean detail to the newels and the pierced back of the elders' seat.

BETHEL CALVINISTIC METHODIST CHAPEL, Trefenter, 2 m. S. 1834, altered 1870. Long-wall rendered chapel with arched windows and doors, joined by vestry of 1910 to three-bay chapel house of 1850. Interior of the 1870s without galleries. Great seat and platform pulpit with much turned work, the pulpit front with carved floral panels.

WERN FACH, 1½ m. SW. Later C18 farmhouse, of vernacular type, though of minor gentry status, and a rare survival. Three bays, whitewashed stone, the interior divided by painted plank partitions. Pine joists, one dated 1793 but oak collar-truss roof.

LLANGYBI 6153

On the Lampeter to Tregaron road, with a long C19 terrace on the S side, the church set back on the N by the single arched

BRIDGE. To the W, FFYNNON GYBI, or Ffynnon Wen, a cura-
tive spring under a heavy slate slab, opposite Maesyffynnon
chapel. The OLD SCHOOL INN was the Board School, *c.* 1875,
stone and yellow brick.

ST CYBI. Single-roofed nave and chancel, the chancel wall
 slightly inset, and probably medieval, though all the visible fea-
 tures are C19. Pretty nave windows with intersecting glazing
 bars, and pointed W door, all early C19. Later porch. The ashlar
 E window is dated 1850 or 1856, the ugly E bellcote may date
 from repairs in 1895. In the nave walls, the ends of oak beams,
 but inside all is early C19, plastered with three-sided ceilings
 and moulded cornices. The pointed chancel arch is clad in soft-
 board. Box pews. – FONT. Small and octagonal, said to be
 medieval, but retooled. – STAINED GLASS. E single broad light
 with three octofoil panels, Nativity, Crucifixion and Ascension,
 good colours, 1854 by *Thomas Ward*, moved from Betws
 Bledrws church in 1886.
EBENEZER INDEPENDENT CHAPEL. 1834, repaired 1890. Ren-
 dered lateral front with two arched windows and outer doors.
 Inside, a three-sided gallery probably of the 1860s on plain iron
 columns by *T. Bright* of Carmarthen; bracketed cornice under
 a panelled front. Pews of 1890.
MAESYFFYNON CALVINISTIC METHODIST CHAPEL. 1881.
 Rendered gable front, centre triplet under an arch, and arched
 side windows. No galleries.
CILGWYN WESLEYAN CHAPEL. 1840. Small, lateral façade with
 two arched windows and outer doors. Now a youth club.
CASTELL GOETRE HILL-FORT *see* Llanfair Clydogau.

3544 LLANGYNLLO

An isolated church above the Nant Gwylan valley, opposite the
site of Bronwydd (*see* below). Modern settlements at Coedybryn
and Maesllyn.

ST CYNLLO. The best example in the county of a Victorian estate
 church, built 1867–70, by *John Middleton* for the Lloyds of
 Bronwydd and the Tylers of Mount Gernos. Elaborate Dec
 Gothic, with steep red-tiled roofs and a retained squat S porch
 tower, on which Middleton added a broached, slated spire. The
 tower was called 'modern' in 1867 – the church had been
 rebuilt in the 1820s – but the canted, short stair projection
 looks older. Rich Bath stone tracery, carved heads to every
 hoodmould, and carved floral band to the chancel eaves. Lean-
 to SW vestry, 1897, reusing at the W end the nave S window.
95 The interior has something of the feeling of Middleton's much
 better-funded English works (All Saints, 1868, and St Stephen,
 1873, in Cheltenham), displaying the full punch of his exces-
 sive sculptural detail (by *Boulton* of Cheltenham), set against

polychrome walls. A classic High Victorian hierarchy. First the nave in three colours of brick and some Bath stone, with massive foliate roof corbels. Then a chancel arch of exceptional richness: trios of angels as corbels to columns with marble shafts and outsize carved capitals, carrying the arch banded in grey, with hoodmould, and then a radiance of three-colour voussoirs. The chancel is all stone, a subtler polychromy of Bath stone banded in purple, the E window marble-shafted. The roof is ceiled with stencilled panels. More angels, corbels to the organ chamber, and under the roof. In the chancel, encaustic TILES, by *Minton*, miniature-shafted PISCINA, and AUMBRY. The original vestry was altered to an organ chamber, 1897, and replaced at the nave SW corner. – FONT. 1869, massive, on a squat granite shaft with capital of tropical succulence, the octagonal bowl with carved panels in varied roundels. – PULPIT. Very rich, Caen stone, marble and alabaster, neurotically animated. Sculpted St Paul preaching, angels and saints, the corner figures under nodding Gothic arches. Marble and alabaster detail. – REREDOS. 1871, diapered stone, with white marble cross on an alabaster vesica panel, and alabaster angels in roundels. – STAINED GLASS. E window, 1878 by *J. H. Powell* of *Hardman & Co.*, excellent C14 Gothic style. Three small chancel lights, 1909, by *Hardman*. Nave N window, 1928, by *A. L. & C. E. Moore*; W window, 1919, by *A. L. Moore*, deep-coloured war memorial. – MEMORIALS. Henrietta Lady Lloyd †1871, statue of Ruth, in richly crocketed niche. Two pairs of reset and damaged Lloyd family plaques with urns: the second pair of the 1790s by *Foster & Walker* of Bristol. Mary Lloyd †1830, urn, weeping tree and fulsome inscription. Thomas Lloyd †1845, crocketed Gothic, by the *Marble Works*, Westminster.

COEDYBRYN CALVINISTIC METHODIST CHAPEL, Coedybryn. 1886. Plain Gothic in rock-faced sandstone.

PRIMARY SCHOOL, Coedybryn. 1934, by *Rhys Jones*, County Architect. Red brick, mansarded roof over a veranda, low entrance range across one end.

BRONWYDD, ½ m. S. Now demolished, Bronwydd was the most fanciful Victorian Gothic house of the region, based on the Rock of Cashel, with circular and square corner towers, gables, and patterned tiled roofs. It was not very large, the drama of the roofscape disguised this, and was remodelled from a Georgian house in 1853–6 by *R. K. Penson*. Built for Sir Thomas Lloyd, whose resounding medieval title of twenty-fifth Lord Marcher of Kemes (Cemaes in North Pembrokeshire) gave good excuse for Gothic fantasy. He partly rebuilt Newport Castle, Pembs., the ancient seat of the Lords Marcher, but exhausted the family wealth.

MOUNT GERNOS, ½ m. N of Maesllyn. Two Bath stone bay windows remain in a field, by Gernos Farm, from an early C19 five-bay house of the Lewis family, remodelled 1870 by *John Middleton* for Gwinnett Tyler. Middleton added the bays and

some High Victorian Gothic internal detail. GERNOS LODGE, Coedybryn, plain, stone, L-plan, is by *Middleton*.

MAESLLYN MILL, Maesllyn. Disused. 1881–4, possibly by *John Middleton*, if so, unique in his work. The most impressive of the Teifi valley woollen mills, though externally a plain two storeys and eleven bays, with heavy slab lintels in Yorkshire stone. Built by Gwinnett Tyler of Mount Gernos, who sought to revive the fortunes of his house by going into manufacture. Double-span weaving floors with a fine range of fat iron columns down the centre. In the gabled section to the r., a later insertion of massive, slate-slab staircase winding around a stone lift shaft. Two iron Pelton wheels, probably later. On the drive, MILL TERRACE, four late C19 mill-workers' houses.

6275 LLANILAR

Village in the Ystwyth valley, the church in a large rounded churchyard at the head of a short street of attractive Late Georgian style houses: the FALCON INN and BRYNILAR, earlier to mid C19, on the l.; GLANADAIR and a pair of houses, later C19, opposite, and Capel Carmel further down. N of the church, VICARAGE, 1833, by *George Clinton*, minimally Tudor, with cross-mullioned windows.

ST ILAR or ST HILARY. The church has a squat regularity that belies its interest. The broad and short W tower is medieval, vaulted within, but cut down, and the parapet replaced with the plainest crenellation. Single nave and chancel with harsh plate-traceried windows and S porch, from the restoration of 1874–6 by *R. K. Penson*. Two blocked doors on the S, one on the N, looking more early C19 than medieval. Tiny N chancel lancet, possibly C14. Inside, the principal interest is the late medieval roof, one of the very few in the county, although said to have been re-erected in 1746, and much restored in 1874. Eleven close-set, arch-braced trusses, with high collars and kingposts, and wind-bracing in three tiers. The last two bays C19 and plainer, Penson planned to restore a panelled barrel ceiling here, of which two bosses survive. – INSCRIBED STONE. In the porch, a stone with Celtic interlace, possibly part of a cross shaft, C9 or C10, from Gaer Maesmynach, Cribyn. – FONT. Unusual C13 or C14 seven-sided panelled bowl, coved below, of conglomerate stone. – FITTINGS. Mostly of 1874–6 by Penson, in simple Gothic, including pulpit, pews, stalls and rails. Altar and panelling by *Jones & Willis*, 1895. – STAINED GLASS. E window, 1961, and S window and N lancet, 1967, all by *Celtic Studios*. – MEMORIALS. Rev. Moses Roberts, 1735, slate with incised crude winged head. Rev. John Morgan †1762, slate plaque. Williams family of Castle Hill, crocketed Gothic of the 1860s. Lewis Pugh Pugh †1908, Arts and Crafts style beaten copper.

CARMEL CALVINISTIC METHODIST CHAPEL. 1879, by *Richard Owens*. A large chapel with plain but imposing grey

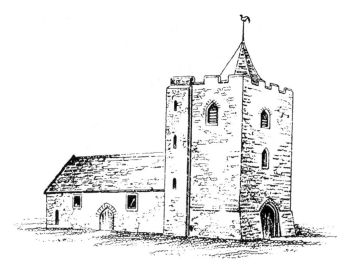

Church of St Ilar, N side, pre-restoration.
Engraving

stone front behind ornate iron railings. Three arched windows above, the centre one with side lights, and cambered-headed openings below. Inside, three-sided gallery canted at the angles, panelled in long and short panels. Great seat with turned balustrading and ball finials, matched on the pulpit steps, the pulpit heavily panelled with carved brackets and some pierced fretwork.

CASTLE HILL, just S of the village. Three-storey, five-bay N front in dark squared stone with cornice and parapet, flanked by low two-storey pedimented wings, i.e. an unusually formal composition for the region. Built in 1777 for John Williams, though the pedimented porch with triglyphs looks early C19, the columns late C20. The wings have minimal pediment and simple Palladian three-light ground floor window each. Three-bay stuccoed rear with later C19 square bays and cast-iron trellis veranda. Service wing of c. 1862 to S, with Italianate turret. The interior detail looks early C19, with simple square balusters to the stair. Vernacular early C19 half-hipped LODGE, E of Llanilar.

TY CNWC, ½ m. E. 1905. Prefabricated timber bungalow, made by *Harrison, Smith & Co.* of Birmingham, with mock half-timbering.

LLIDIARDAU, 1 m. E. 1854, by *R. K. Penson* for G. W. Parry. In what was called the Old English style, actually refreshingly styleless. Rubble stone with brick-framed windows. The S front balances a gable to the l. with a big canted bay to the r. of the stair light, and the entrance is in the E side, giving an offset approach to the centre stair hall. The detail of the doorcases and open-well stair faintly echoes past styles, again well re-thought. GATEPIERS with iron gates, 1876, by *Roderick Williams*.

ABERMAD, 2 m. w. 1870–2, by *J. P. Seddon*, for Lewis Pugh Pugh, whose grandfather had bought the estate in 1852 with a fortune made from the Copa Hill lead mine, Cwmystwyth. The best High Victorian house in the region, and one of the most interesting of its period, for this is a compact demonstration of modern Gothic, the functional ideas of Pugin, by contrast with Seddon's fantastical Castle Hotel, Aberystwyth of the same period. Local dark stone with yellow Doulting dressings and Shap granite porch columns. A subtle asymmetrical design, two storeys and attic, four and a half bays, the three to the r. near symmetrical with centre porch and two massive chimneys framing this bay, but at attic level just two gables, not three. To l., change of levels for the service end, a narrow half-bay with stair light, and the end bay, with an attic gable balancing the other two. Fenestration follows function as Pugin advocated: mullioned windows with relieving arches for the bedrooms, richer plate-traceried Gothic for the principal ground floor rooms. The rose window to r. of the porch marks the library; this quite unmedieval placing states that this is modern Gothic with its own parameters. The porch is muscular High Victorian, single fat columns carry ponderous masses of masonry, scarcely lightened by primaeval foliage. Form may not appear to follow function in the attic gables, with pointed windows apparently at variance with their humble status, but the plate-traceried l. window lights the billiard room.

The three-bay garden front has similar detail, two dormers and a columned loggia to the l. blending into the drawing-room bay, with column shafts. To the rear, a twin-gabled projection to the l. with a bay marking the dining room. Set back, in centre, the Gothic window of the main stair, and to the r. another balancing gable. The minor w end has a nice play of diagonals, a hipped lean-to against a higher twin-gable, against the main wall with a wall-face chimney, the sides sloped in.

Inside, much serious modern Gothic detail in pitch pine: notched and chamfered doorcases, quatrefoil panels and boarded dados. In the square hall, a corbelled fireplace (of iron-hard local stone), and the principal rooms off: dining room to N, library to E and drawing room NE connected by sliding doors. A big, pointed roll-moulded arch to NW opens into the stair hall, with office to S. In the library, seven excellent small satellite roundels by *Seddon*, made by *F. V. Hart*, wholly appropriately of the Seven Lamps of Architecture. Unfortunately the big centre roundel has gone. Above the E window, some attractive glass to a Morris-type pattern. In the drawing room, marble shafting to the bay, and pink marble panels to the chimneypiece. Splendid stair hall, open full height to a ribbed boarded ceiling. The stair has sturdy detail, never finicky, with squat balusters and punched trefoils. Stained glass in the window head by *Hart*, three finely drawn figures, the smaller pair holding a sun and a moon. The attic corridor crosses the stairwell in an enclosed timber bridge. Open screen at the first floor landing, with quatrefoils. Inventive detail upstairs to minor chimneypieces, doors and door-

fittings. In the office, full-height cupboards and shelves, typical of Seddon's inventive woodwork. Extensive, partly vaulted cellars, originally with an ice house, now the lift shaft.

Off the drive, HOME FARM, courtyard, with half-court to N, in stone and yellow brick, contemporary, but probably not by Seddon.

HENBLAS ABERMAD, just W of Abermad. Three-storey, three-bay stuccoed house of *c.* 1800, with deep-eaved hipped roof and modern columned porch. It was the predecessor of Seddon's Abermad. An older house may be incorporated; see the heavy beam in the dining room.

ST MICHAEL, Rhostie, 2 m. S, W of Rhosygarth (SN 623 728). Roofless shell of a church of 1881–2 by *Penson & Ritchie*. Single vessel with hipped W porch-cum-vestry. The isolated site is luckless, this church replaced a ruinous church of 1816, itself replacing one in ruins.

GAER FAWR, 3 m. SSE (SN 649 716). Iron Age hill-fort, double-banked to N and E, with entrances at E and W.

LLANINA

4059

Just the church and Llanina House, on a wooded headland on New Quay Bay.

ST INA. Small and picturesque, called 'newly erected' in 1810 by Meyrick, but the battlemented bellcote, charmingly over-scaled, and plain pointed door and windows, look later. Work is recorded in 1855. Plastered interior with pine dado panelling and fittings of 1905. – FONT. Medieval, circular, the rim pinched to octagonal. Across the nave, a reused BEAM with serpentine leaf carving, part of a late medieval rood beam. – STAINED GLASS. E window, *c.* 1950, conventional.

LLANINA HOUSE. C17 to C19 minor gentry house, rescued from total ruin in the 1990s. It was an agglomerate composition with heavy chimneys, and elevations of roughcast, stone and hung slates, nowhere an architectural whole. There was a low panelled dining room and heavy early C18 stair. Rebuilt substantially to the same exterior form to initial plans by *R. Clive-Powell*.

Garden building with semicircular flight of steps, though no formality to the plain four-bay front, the scarfed cruck roof probably C18. By the churchyard, a small roofless Gothic SUMMER-HOUSE.

LLANLLWCHAIARN *see* NEW QUAY

LLANON
Llansantffraed

5167

Almost a small town, a long ribbon on the coast road with mid- to later C19 houses of the Late Georgian type of Aberaeron, following Aberaeron in painting the grey renders in bright

colours. In STRYD FAWR, at the s end, GLANCLEDAN, in pale blue with overhanging eaves. Indicative of the later C19 dates are the bulbous columns of the doorcases of RHIWLAS and BRYN-LLYS in the terrace further up on the r. The three-storey CENTRAL HOTEL beyond is later C19. E of the main road a network of lanes with some surviving single-storey cottages. In HEOL NON, ruins of NEUADD, long thought to be a Chapel of St Non, but on doubtful evidence. A carving from the site, said to be of the Virgin and Child or St Non with St David (in Ceredigion Museum) has been identified as a sheila-na-gig. Beyond, LLANON COTTAGE, a good and exceptionally intact example of the partially lofted single-storey thatched house that was, until the early C20, the most common building type of the county. Probably early to mid C19, whitewashed, with tin roof and end chimneys indicating that both rooms were heated. In the full-height kitchen, a plastered lath chimney hood, in this region more common than the stone chimney, and ladder access to the *croglofft*, or sleeping loft, over the entry passage and parlour/bedroom. Cobbled floors, crude scarfed cruck roof trusses and straw-rope underthatch.

Llansantffraed, the older settlement by the coast, around the church, has a separate character: altered low cottages and some larger, Late Georgian style houses, one, CONVOY, dated as late as 1879. MORFA ESGOB, to s, is laid out in medieval strip-fields, never common in Wales. In 1841 there were 207 strips, or slangs, in the 108 acres (43.7 hectares). On the coast, ¾ m. NE, CRAIGLAS LIMEKILNS, an impressive group of four big square kilns, built before 1824, set into the bank, with a walled enclosure behind.

ST FFRAED, Llansantffraed. Sturdy, late medieval w tower with high battered base and small, single bell-lights. Said to still have a medieval bell-frame. The rest is of 1839–41 by *David Francis* of Llanon, in plain preaching-house style, a three-bay box with long Tudor-arched windows and pilaster strips. Later slate-hanging on the s and Perp tracery in imitation stone. A pleasant chapel-like interior with box pews, w gallery and flat plaster ceiling. Chancel fittings, 1965, by *W. Clarke* of Llandaff. – FONT. C12, rectangular with a band of rosettes, the lower angles chamfered (similar to Henfynyw and Betws Bledrws). – STAINED GLASS. E window, 1975, and s window, 1973, both by *Celtic Studios*.

CAPEL MAWR, Stryd y Capel. Calvinistic Methodist chapel of 1844, altered 1865. Broad imposing gabled front, stuccoed. Gabled when the walls were raised in 1865 to accommodate the gallery. Originally a four-bay lateral façade with arched windows. Five-sided painted grained panelled gallery front on iron columns. Painted grained gallery pews. Massive tiered and panelled early C20 pulpit-and-organ structure on the entrance wall, blocking two windows.

SILOH INDEPENDENT CHAPEL, Stryd Fawr. 1864–5, the stucco gable façade an alteration after 1900, the small paned

side windows original. Interior with single gallery, and box pews.

ALLTLWYD (Plas Gwyn Residential Home), 1 m. NE. White-washed stone house, originally roughcast, above the main road, 1832–4 by *Edward Haycock*,* for John Hughes, Aberystwyth lawyer. An inventive design, hipped, with deep bracketed eaves and pediments. The long 1–1–2–1–1 bay W front is articulated by slightly projected pediments one bay in from each end. On the ground floor just two broad ground-floor curved pilastered bows. Narrow, three-bay S entrance front, the centre broken forward under a pediment and lacy cast-iron uprights to verandas each side.

Inside, a spine corridor with a broad stair hall off to the right, the stairs of timber with thin twisted balusters, one long flight, a short return and long landing. The ceiling is divided into lozenge panels by rope mouldings with a small oval rose patterned like sweetcorn in an acanthus salad. Three main rooms with simple marble fireplaces, in different-coloured marbles. In the N dining room, a plaster-vaulted recess with rope moulding.

CWM PERIS, ½ m. E of Llanon. Georgian Gothic small house, probably of the 1820s. Square, with pyramid roof and centre stack, of two storeys, three bays.

NEBO INDEPENDENT CHAPEL, 2 m. SE. 1914, by *D. Davies & Son*. To Davies's standard design with major arch and arched windows, in unpainted stucco. Galleries with continuous pierced cast-iron front, in a pattern of circles.

Y BWTHYN, Nebo, just S of the bridge. Single-storey C19 cottage with large kitchen chimney and a little triangular-headed window in a gable over the door.

LLECH GRON, Nebo (SN 542 648). The largest standing stone in the country, 4 m. high.

LLANRHYSTUD

5469

The narrow coastal plain that runs N from Llanon here ends in a folded landscape of rounded hills, where the church spire is as focal as in a painting by Samuel Palmer. The village itself has been badly treated by highway improvers. By the particularly harsh bridge, the BLACK LION, three-bay, earlier C19, with columned porch, dormers added in 1910. Attached behind, in CHURCH STREET, a short whitewashed terrace, then a later C19 row in stone, the date showing in window size and quality of stone masonry rather than in obviously Victorian detail. Two villas further down show how long the Late Georgian type persisted; CLARENCE is dated 1895, and the larger LOIS HOUSE is of the 1860s. Over the bridge, on the minor road to the E, MOELIFOR TERRACE, 1886, a neat stone and yellow brick row.

*A design for a modest Scots baronial house of 1832 by *William Burn* is in the Alltlwyd papers, presumably for this site.

An altered mid-C19 row opposite, with three deep-eaved houses of the Aberaeron type. Further NE, across a ford, FELIN GANOL, an early C19 complex altered in the later C19: three-bay house, drying-kiln, and gable-fronted small mill. Complete later C19 machinery and kiln. On the main road to the S, NEUADD GOFFA, war memorial hall, 1927, corrugated iron behind a nicely detailed roughcast front with lunette window.

ST RHYSTUD. Expensively rebuilt, for £2,367, by *R. K. Penson* 1852–4, a thoroughgoing example of correct ecclesiology, relatively early in the county. Dec, with a great deal of strident and heavily foiled Bath stone tracery. Nave with E bellcote, chancel, parallel-roofed S aisle, and a most alien broad-broached spire, of stone, built on top of an almost unrecognizable medieval W tower. This is one of the group of broad Cardiganshire towers (cf. Llanbadarn Fawr, Llanfihangel y Creuddyn, and Llanilar) but only one small W light is obviously medieval, for the original masonry was clustered with new buttresses, raised a storey with very large bell-lights, and capped with the spire. The previous church was low, with the only medieval Sanctus bellcote in the county. Archdeacon Allen asked, 'What person with any sense of fitness and local character can view without regret the proposed transformation?' But advice was ignored, and the result is certainly striking in a county without spires.

Inside, the tower has a plastered medieval vault. Penson's church has an ashlar five-bay arcade of alternate round and octagonal piers, a big open nave roof and panelled chancel roof. Under the arcade E respond, a delicately carved head. – FONT. Late medieval, retooled plain octagonal bowl. Penson's heavy timber chancel RAILS are now in the S aisle. Chancel fittings of the 1960s. – STAINED GLASS. E window, death-date 1865, Entombment, Resurrection, and Angel at the Tomb, attributed to *Clayton & Bell*. Lovely Gothic drawing, on deep blue and deep red backgrounds. S aisle E, c. 1945, by *G. Maile Studios*. Nave N, c. 1902, St George and a cannon. – MEMORIALS. Mary Anne Hughes †1834, with broken rose above, by *Wallace & White* of Edinburgh.

In the churchyard, small SCHOOLROOM of 1809, with bellcote, arched openings and later C19 glazing.

SALEM BAPTIST CHAPEL, Church Street. Whitewashed stone lateral front of 1823 with yellow brick arched windows of later C19. No galleries.

RHIWBWYS CALVINISTIC METHODIST CHAPEL, ½ m. SE. 1832, façade raised in 1871 by *Richard Owens*. Roughcast with two arched small-paned windows, outer doors and gallery windows. Interior of 1871 with five-sided panelled gallery, on iron columns. Balustraded pulpit platform and great seat, also of 1871. Pews and lobbies of 1926, and probably, the tall, pedimented pulpit-back with outsize acroterial ears.

PENRHIW CALVINISTIC METHODIST CHAPEL, Joppa. 1859, altered 1883. Stone and yellow brick gable front.

MABWS, 1½ m. ESE. A severe and imposing seven-bay stone house, C17 core, rebuilt after 1750 for James Lloyd of Ffosybleiddiaid, enlarged in early C19. Regular sash windows under an exceptionally broad hipped roof, the hip slopes different l. and r. Three storeys, dropping to four on the l., with the slope of the site. Similar, five-bay E front, but the W end dramatically narrow and windowless, the house being L-plan. The mid-C18 house was two-storey, comprising the E front and four bays of the S, to which the three bays to the l. and the top floor were added in the early C19. Roof with typical deep-bracketed eaves. Documentary dates are vague, a 'new Mabws' is mentioned in 1723, and there was work in 1816. Inside, cross-passage S to N, with stair to l., drawing room and dining room on r. The detail is old-fashioned mid C18: fielded panelled doors, a good open-well stair up to the second floor (former attic) with pulvinated string and thick turned and twisted balusters; and some fireplaces with lugged timber surrounds and centre tablet in the SE drawing room and some bedrooms. In the basement, Victorian kitchen fittings.

CEFN MABWS, E of Mabws. Mabws estate farm, probably early C19. Roughcast, three-bay, three-storey house with just one window in the top floor, and attached outbuildings stepped down the slope: lofted two-bay coach-house, high-door barn, and two later stable ranges.

CAER PENRHOS, 1 m. E (SN 552 696). The earthworks of a Welsh fort on the ridge S of the Wyre, probably built after 1148 by Cadwaladr ap Gruffudd. Of the ringwork type, well preserved.

LLANSANTFFRAED see LLANON

LLANWENOG 4945

A small settlement around the church, the later C19 woollen-manufacturing village at Cwrtnewydd (q.v.), and C19 villages at Cwmsychbant and Drefach on the main road, at Alltyblaca and Rhuddlan in the Teifi valley and Gorsgoch on the moor N of Cwrtnewydd.

ST GWENOG. One of the best medieval churches in the county, carefully restored 1998 by *Roger Clive-Powell*. Sheer and substantial late C15 W tower, the more impressive for being on higher ground than the C14 nave. The tower plinth is deeply splayed with roll-moulded pointed door inset, and the tower has a pronounced batter up to plain battlements with a coved moulding and primitive carved heads at the corners, like those at Llandysul. NE stair-turret, and small, hoodmoulded paired bell-openings. The roll-moulded door has carved heads to the hoodmould. A C15 plaque with portcullis above, and a flat-headed three-light window, with hoodmould stepped over a shield with the arms of Sir Rhys ap Thomas †1525, who reputedly built the tower to commemorate the battle of Bosworth.

Llanwenog Church.
Engraving, 1903

Nave and chancel under one roof, with parallel-roofed SE chapel and gabled C19 N organ chamber. The one original nave window, on the S side, has two-light ogee tracery, possibly late C14. The two SE chapel S windows look C15, though very crude. Inside, the tower is rough vaulted. Broad slate steps down into the nave giving an excellent view of the slightly wavy C15 barrel roof, in seventy-two panels with simply moulded oak ribs and a coved cornice. Two plastered arches to the SE chapel, which has a C19 roof. – FONT. In the SE chapel. Rough bowl ringed with twelve crude and magnificent mask-like faces, quite without Christian imagery, probably C12. – STOUP. In the tower, a rounded square bowl in a roll-moulded niche. – WALL PAINTINGS. Two black-lettered panels, the Commandments and part of the Creed in Welsh, C17 or early C18. – The church is filled with elaborately carved WOODWORK of 1889 to 1924, designed by *Herbert & Mary Davies-Evans*, owners of Highmead (*see* below), and made by Col. Davies-Evans, assisted by the vicar and curate. However, the best work was made by *Joseph Reubens* of Bruges, a refugee at Highmead 1914–19. His is the SCREEN, 1915, five-bay, with intricate, unconventional tracery, deep-coved cornice and sunburst cresting, achieving a medieval vigour missed by the more correct screens of Caröe and Coates Carter. Thirty-four BENCH ENDS of 1915–19, designed by Mary Davies-Evans, the innumerable symbols and mottoes referring to local history, local families, saints, and the war. Col. Davies-Evans designed and made the more gauche, hexagonal open PULPIT, the Welsh dragon LECTERN, 1922, and the two overdone chairs in the sanctuary. Of the same period, the nave W DOORCASE, coved top on octagonal shafts. Bland, sub-classical sanctuary FIT-TINGS, 1959, probably by *A. D. R. Caröe*, with, inset in the

33

17

altar, an eroded small C15 CARVING, the Crucifixion, from the
SE chapel gable. Similar to pieces at Llandysul and Llanwnen.
– STAINED GLASS. Tower W window designed and made by
Col. Davies-Evans, c. 1900, with pretty patterned quarries. In
the SE chapel, late C19, crude lithograph-style Baptism
window. – MONUMENTS. In the nave: Herbert and Anne Evans
of Highmead, 1807, by *Foster & Co.*, Bristol, with an encomium
of Anne Evans's agricultural improvements, white marble with
small sarcophagus; Lady Anne Griffies Williams, early C19,
white marble sarcophagus and well-carved urn; and opposite,
Gothic wood monument to Col. and Mrs Davies-Evans and
their faithful servant, 1931 by *Joseph Reubens.* – In the chancel:
Thomas Bowen of Waunifor †1805, by *Foster & Co.*, in a simple
Regency surround.
 Hipped stone LYCHGATE, 1935, by the same hand as that at
Llandysul.

ALLTYBLACA UNITARIAN CHAPEL, Alltyblaca. An important *p. 55*
 chapel in the area so noted for Unitarianism that it was called
 the '*smotyn du*' or 'black spot' by other denominations. 1837,
 altered 1892. Centre arched window, outer arched doors and
 square gallery windows. Harshly stuccoed and reglazed in
 1892, the date of the interior. Panelled three-sided gallery, the
 iron columns from the *Priory Foundry*, Carmarthen.
BRYNHAFOD BAPTIST CHAPEL, Gorsgoch. 1861. Minimal ren-
 dered gable front, but the interior characterful with painted
 graining in three shades to the panelled gallery fronts.
BRYNTEG INDEPENDENT CHAPEL, Brynteg. Dated O. C., i.e.
 Oed Crist 1838, O. B. (*Oed Byd*) 5842, the date from the
 Creation in 4004 B.C. Lateral façade not in the least special,
 but a luminous interior, with box PEWS, panelled three-sided
 GALLERY and PULPIT embellished with twisted corner posts,
 all painted. Similar woodwork at Llwynrhydowen, Rhydowen.
 Despite its primitive charm, probably of 1862.
CWMSYCHBANT UNITARIAN CHAPEL, Cwmsychbant. 1907.
 Painted stucco gable front.
DREFACH INDEPENDENT CHAPEL, Drefach. 1880. Painted
 stone gable front.
HIGHMEAD, ½ m. E of Rhuddlan. An extraordinarily long
 Victorian façade, impressive when seen from the S side of the
 Teifi, but disappointing any closer. The core is a three-storey,
 five-bay house built for Herbert Evans, in 1777, by *John Calvert*
 of Swansea. Only a hint of this is visible at the back, the rest
 being later C19 in appearance. Refaced and extended from the
 1860s, first by the addition of wings with outer gables, then by
 the W end organ hall, which was converted in 1873 from a
 riding school, the new façade with Germanic twin turrets.
 Finally, the original house was given gables and a two-storey
 porch. Inside, a full-height stair hall has ornate Neo-Jacobean
 carved staircase and coloured marble fireplace, of the later C19,
 but the space is ill proportioned.
 ESTATE BUILDINGS. LAX LODGE, to the W, is T-plan gabled
 mid C19; BLAENDOLAU, to the E, is heftier, later C19, of

rock-faced stone. At HENDY, to the W, WALLED GARDENS and tall L-plan FARM BUILDINGS, mid C19. HIGHMEAD COTTAGES, at Rhuddlan, to the W, are mid to later C19, with end gables.

p. 67 LLANVAUGHAN/LLANFECHAN, 1½ m. E. Mostly demolished, which is a pity as it was probably by *John Nash*. Built *c.* 1790 for Admiral John Thomas and burnt in the mid C19. It resembled Llanerchaeron in having a deep-eaved hipped roof and indented front flanked by over-arched Venetian windows, with round-arched windows above.

BWLCHBYCHAN, Brynteg. 1850–1, built for John Pugh Pryse, a younger son of Gogerddan. Six-bay, hipped sandstone S front with two ground-floor curved bays, which recall those at Haycock's Alltlwyd, Llanon. Presumably stuccoed originally, as the bays have crude steps for cornices. Similar rounded E end porch. Inside, a spine hall with stair hall to the N and two main rooms facing S. Late Georgian detail, somewhat thickened, and iron rails to the stone staircase.

Attractive hipped COACH-HOUSE and STABLE, dated 1850.

RHIWSON UCHAF, ½ m. N of Drefach. The best example in the county of a longhouse, the house and byre in one range. Late C17 or early C18. Whitewashed stone with irregular windows, formerly thatched. Parlour at the upper end, kitchen at the lower with main entry by the kitchen fireplace from a passage through the byre. Chamfered beams and a massive fireplace bressumer. Traces of painted C18 decoration in almost abstract scrolls of black and yellow in N end. Oak roof trusses of scarfed-cruck form and plank partitions. Scarfed crucks also in the byre, which had traces of gorse underthatch.

5347

LLANWNEN

On the crossroads, two mid-C19 buildings in Late Georgian style, the POST OFFICE, three bays with a chamfered corner, and the GRANNELL HOTEL, of four, though altered. N of the Post Office, two pairs of C19 cottages, overlooking a green strip. By the river, to SE, a small C12 RING MOTTE.

ST LUCIA AND ST GWYNIN. Small W tower, added to an earlier nave, see the battered base of the nave within. The tower with battered base looks C15 but was called modern in 1875. Restored 1850–2 by a *Mr Davies*, probably *Charles Davies*, but the detail all of 1875–7 by *R. J. Withers*. Over the W door, small eroded C15 CARVED PLAQUE, possibly a Virgin and Child, and a piece of blank ogee C15 tracery. No tower vault. Perp tracery of 1877, a blocked nave S door, and a tiny relief of the Crucifixion on a SW corner stone. Plain plastered interior with open waggon roofs. A small medieval STOUP in the nave W wall. – of 1877 the octagonal FONT, REREDOS with gold mosaic panels, SEDILIA, PISCINA and FITTINGS. – STAINED GLASS. E window, *c.* 1930, old-fashioned. In the graveyard, ungainly

trapezoid MEMORIAL to Sarah Hughes of Castell Du †1840.

Y GROES UNITARIAN CHAPEL, Capel y Groes. 1890, *David Davies* of Lampeter, builder, according to the plaque. A copy, but in unpainted stucco, of Capel y Bryn, Cwrtnewydd (q.v.) with pointed giant arch. The parish was so strongly Unitarian that in the early C19 only one household was Anglican.

PRIMARY SCHOOL, w of crossroads. 1908 by *G. Dickens-Lewis*, Arts and Crafts influenced, with half-timbering, a little porch tower, and a copper flèche. Of the same date, the school house to S.

CASTELL DU, ¼ m. SW. Hipped, roughcast three-bay house of 1831 (dated on a roof truss). Massive end stack of the rear wing is almost certainly also of 1831: where kitchens were concerned, old patterns survived long. Early C19 stair in the rear wing.

A good group of OUTBUILDINGS. Facing the rear wing, a range incorporating a C17 building: a door arch of two chamfered stones, and oak beams, one with thin moulding. Behind, a lofted early C19 STABLE, with bellcote, the stables accessed from a centre coach-entry. Whitewashed FARM BUILDINGS, around a big yard – cart-house and barn range at the upper end, with four-bay open shed to l., once thatched. At right angles, a long range with heavy-horse stable, small cow-house, loose-box, and a lean-to duck-house on the end.

FELIN YR ABER, ½ m. SE. C18 water mill, remodelled in the C19, one of the millstones dated 1856. Oak collar-trusses, but floor level and machinery are later C19, as also the broad 4-ft (1.2-metre) wide iron wheel. Drying-kiln added to the S.

PONT ABERCERDINEN, Capel y Groes. 1843, two-arch bridge with raised flat piers.

NEUADD FAWR, Capel y Groes. Rendered main block with two canted bays, dated 1851 and 1897. The hipped whitewashed rear, with a rough stone string course may be early C19. To the NW, the previous house, HENDY, dated 1743, altered. In the front range two early C18 heavy scarfed crucks with broad pegged collars, and in the rear wing two chamfered collar trusses. In the grounds, a chest tomb of T. H. Jones †1847, over a vault that he designed for himself.

LLANYCHAIARN/LLANYCHAEARN

The church stands alone by the Ystwyth, s of the Tanycastell outcrop.

ST LLWCHAIARN. Rebuilt 1878–80 by *Archibald Ritchie*, single-roofed with bellcote and plate tracery, each window different on the s side. – REREDOS. 1879, marble-shafted, five-gabled, flanked by bright embossed TILES by *Maw & Co.* – Round stone PULPIT, 1879. – STAINED GLASS. Excellent E window of 1879 by *Heaton, Butler & Bayne*. Dramatically composed

Ascension in vivid colours, a far cry from the nave N windows of 1912 and later by the same firm. – FONT. Late medieval, octagonal with 1630 graffito. – MONUMENTS. At the W end, T. Hughes of Aberllolwyn †1768, open pedimented marble plaque, and Morgan Evans †1792, rustic slate plaque, the edge bordered like a carpet. – On the N wall, John Bowen of Aberllolwyn †1815, draped urn over an oval plaque, by *Reeves* of Bath. – On the S wall Marianne Richards †1849, a cherub with a dove. In the chancel, General Lewis Davies of Tanybwlch †1828, marble banners and sword, by *Reeves*, after 1833.

BRYNEITHIN, ½ m. SW. T-plan roughcast house, with deep hipped roofs, of Regency character, achieved piecemeal. At the rear, a small villa of 1820, added to an earlier farmhouse, for Major W. Richards, Waterloo veteran and promoter in 1853 of the Wellington Monument on Pendinas (*see* Aberystwyth). The five-bay front range with canted centre was built in three phases. The ground floor was added by Richards in 1854 for a library and two rooms, with big Gothic windows, within an Anglo-Indian deep veranda with fretted screens. The floor above came only *c.* 1920–30, when the veranda lost its exotic detail, and the hipped roof is of 1965, replacing a flat one.

High circular perimeter wall with round two-storey SUMMER-HOUSE, all built by Richards.

TANYBWLCH, ½ m. NW. Spectacular site above the Ystwyth. Dark rock-faced stone with yellow terracotta dressings, all part of an unappealing recasing in 1891 by *Arthur Flower* of London, for M. L. Vaughan-Davies M.P., later Lord Ystwyth. This does not entirely disguise the proportions of the original low and deep-eaved Regency villa built for Major-General Lewis Davies *c.* 1825–8. This was stuccoed square, with a canted bay on the NE garden front. Remarkably, the interior preserves all of the original Greek Doric detail, of unusual quality for the region. From the stone-flagged entrance hall, paired Greek Doric pillars to the top-lit stair hall, which has a fine cantilevered stone stair with iron balusters. Good Neo-Grec detail throughout, especially the doorcases, window-surrounds and cornices of the three garden-front rooms, the two flanking the centre room with deep coved ceilings.

TANYCASTELL, E of Tanybwlch (SN 585 790). Medieval ringwork and bailey on a prominent outcrop, partly wooded over. Presumed to be the first Aberystwyth Castle, overlooking the mouth of the Ystwyth. Built in 1109 by Gilbert de Clare, abandoned when the present Aberystwyth Castle was built in 1277 on the new site N of the Rheidol.

See also Blaenplwyf, Chancery and Llanfarian.

2244

LLECHRYD

The village climbs the slope NW from the bridge, with the old church to E and the new church in the village. Overlooking the

bridge, two later C19 houses with the central pedimental gable that is a local feature from *c.* 1800. Closely around the village, a sequence of minor Teifi-side gentry houses.

St Tydfil. 1877–8, by *Middleton & Son*. Small and angular with w bellcote, the ornament reserved for the thickly traceried E and w windows and the porch timberwork. Interior of mildly polychrome brick now painted over. Steep open roof and gawky drum FONT. – STAINED GLASS. s window by *Celtic Studios*, 1953.

Holy Cross, just E of the bridge. Abandoned because of flooding, and long derelict, the shell tidied in 1996. Nave and transept probably of the mid to later C18 (a transept beam was dated 1766), with brick-framed pointed windows of the 1830s, of which date were the box pews and two-decker pulpit. It remains an instructive glimpse of the barn-like appearance of many a local church before the Victorian restorations.

Llwynadda Calvinistic Methodist Chapel, at NW end of the village. 1829. Lateral façade with hipped roof, stuccoed and rewindowed in 1878, of which date the interior with three-sided gallery on florid iron columns. Pitch-pine woodwork with zigzag moulding under the gallery cornice and to the pulpit back.

Yr Hen Gapel, behind the Seven Stars Inn. Independent chapel, founded 1709, rebuilt 1830. Lateral front with hipped roof, plain outer doors, arched centre and gallery windows, with early C20 glazing and stucco frames. The interior is crowded and atmospheric, with painted grained box pews and a pretty five-sided gallery on marbled wooden columns, of the 1830s, the clock dated 1839. Some woodwork from the first chapel, inscribed COEDMORE PEW 1709.

Tabernacle Independent Chapel, on the hill above the bridge. 1881. Stuccoed gable front with long arched windows and a wider centre window, still with intersecting glazing bars, though of the heavier Victorian type.

Llechryd Bridge. The best of the Teifi bridges, of five low arches with full-height cutwaters. C17, there was a datestone variously recorded as 1638, 1655 or 1659 on an E cutwater, but George Owen mentions a bridge in 1603. It survived plans in 1856 and 1927 to replace it, the latter by *Sir Owen Williams*.

Glanarberth, E of the old church. The stuccoed Italianate house of the 1850s is demolished. It was in the style of *Edward Haycock*, with pediments to each side bay. The stable block, with a nicely cut centre arch and timber lantern survives. Also a small stone pump-house tower.

Pengraig, behind the new church. Hipped three-bay house called 'newly erected' in 1838; added taller range behind. Pretty coach-house with pedimental gable and hexagonal lantern (like the one at Glanarberth).

Glanolmarch, NW of the new church. 1883–5, by *George Morgan* of Carmarthen, for John Stephens. Grey Cilgerran stone and Bath stone, slightly Gothic with mullioned bays.

Three-bay front with two steep gables and outsize barge-
boards. The long side elevation, containing the service wing, is
relieved only by another gable. Stable court beyond. Inside, a
broad stair hall with stained glass and pine ribbed ceilings.
Bargeboarded Gothic LODGE on the main road.

GLANHELYG, on the NW edge of the village. 1860, a twin-gabled
villa, the painted front built of large hollow terracotta blocks,
L-shaped in cross-section, made at the Cardigan brickworks.

LIMEKILN, in the woods, SW of the village, off the lane to
Coedmor. A very large stone mid-C19 kiln, with sloping front.
A reminder that the Teifi was navigable up to here until blocked
by quarry spoil from Cilgerran.

6570
LLEDROD

The village, mostly C19, is in the upper Wyre valley, with the
church on the hillside to the S. Bronnant is on the main road to
the S, the altered three-storey house was an inn.

ST MICHAEL. 1826–7 by *Edward Lumley* of Aberystwyth, single
vessel with bellcote. Remodelled in 1884 by *Archibald Ritchie*,
adding, as at Cilcennin, a hipped W end porch and vestry. –
STAINED GLASS. Notable E window, 1902 by *Sylvester Sparrow*,
exceptionally rich colours, let down by the draughtmanship. In
the porch, disused FONT, small plain and square, medieval.
In the churchyard, the tiny former SCHOOL, 1850.

RHYDLWYD CALVINISTIC METHODIST CHAPEL, ½ m. N.
1899, stucco end façade with pedimented doorcase. The date-
stone of the previous chapel of 1833 is reset in the side wall.

CWMLLECHWEDD ISAF, 1½ m. E. Farmhouse of C17 origins,
see the massive external chimney-breast to the r. Three-bay
rubble front with irregularly spaced windows.

BRONNANT CALVINISTIC METHODIST CHAPEL, Bronnant.
1870–2, steep gabled stone façade with big arched centre
window and side porches.

BRONNANT PRIMARY SCHOOL, Bronnant. 1911, roughcast with
red-brick dressings to a twin-gabled front, cupola on the main
ridge. The touch of the Arts and Crafts marks it as a design by
G. Dickens-Lewis.

4459
LLWYNCELYN
Llanarth

On the coast road between Llanarth and Ffosyffin.

LLWYNCELYN INDEPENDENT CHAPEL. 1855, designed by one
of the deacons, *Thomas Evans* of Pontbrenddu. Lateral façade,
nicely detailed in stone. Arched centre windows, and arched
doors with both overlights and fanlights. Old-fashioned and
harmonious interior with plain panelled gallery, yellow grained
box pews and small panelled pulpit.

LLWYNDAFYDD see LLANDYSILIOGOGO

MAESTIR see LAMPETER

MWNT *1952*

A remarkable site, just the white church above a cliff-enclosed bay.

HOLY CROSS. Reputedly a pilgrimage church on the coastal route to St Davids. C14, whitewashed single chamber with W bellcote and pointed low S door. Alterations 1853, 1917, by *G. T. Bassett*, and repaired 1952 by *A.D.R. Caröe*. Old photographs show that it had a slightly lower chancel, and pointed nave S windows, presumably of 1853, removed in 1917. The significant survival is the six-bay roof, probably C15, with arch-braced collar-trusses, a short kingpost and trefoil cusping in the apex. The truss, found in South-West Wales, only here and at Penbryn nearby (a third, in a cottage at Cenarth, has gone) is a North-West Wales type, dated there from the C15 to the early C16 (Dolbenmaen, Llanengan, Llangian, Llangwnadl). A rood stair in the N wall was opened up in 1917, when two sections of a carved rood beam were found, probably late C14 with the heads of figures in niches, stiff and primitive. – FONT. C12, square and scalloped.

Above the beach, a large LIMEKILN.

MYDROILYN *4656*
Llanarth

A nucleated village, largely later C19, the houses mostly to the Late Georgian pattern. Behind the chapel, Y FELIN, a small C19 corn-mill, the wheel in an added wheel house.

HOLY TRINITY. 1991, by *Andrew Davies*. Minimal Gothic, replacing a corrugated-iron church of 1890.

MYDROILYN INDEPENDENT CHAPEL, E of the bridge. 1898, by *David Davies*, with his typical façade arch and arched openings.

Y FICAR WESLEYAN CHAPEL, 1 m. NW. 1849. Lateral front with centre porch and two plain windows. Surprising, almost square interior, densely filled with pews.

NANTCWNLLE *5758*

The church is in a big rounded churchyard, at the head of a wooded valley, with the school to the E, and TIRBACH, a mid-C19 three-bay farmhouse, on the slope above. The school is abandoned and the church closed. Daniel Rowland (cf. Llangeitho) was curate here and at Llangeitho from 1735 until deprived in 1764.

Earth-walled buildings were once typical of the Aeron valley, but more remnants are visible than complete buildings. Examples are PENYGAER, just s of the church, single-storey, C18, originally thatched, and TANYRALLT UCHAF, with Georgian Gothic windows, earlier C19, on the Llangeitho road.

ST GWYNLLEU. 1887, by *Archibald Ritchie*. Disused, to be stripped of fittings 2005. The nave reuses the walls of the church of 1838 by *David Jones*, with new chancel, hipped s vestry, s porch and w bellcote. Of some character, the outsize porch and vestry grouping well. – PULPIT. Pine, with a large open cinquefoil. – STAINED GLASS. Three richly coloured windows of 1911–13 by *Camm & Co.*, densely drawn with a rather primitive urgency, like Victorian children's book-illustration. The s window, the life of St Woolos, is a subject rare outside Gwent. E Ascension, against a turquoise-streaked sky.

By the churchyard, the former SCHOOL, 1860s, similar to that at Trefilan. Hoodmoulded windows under two shallow gables and porch to the r. Inside, a panelled PULPIT on a column stem, preserved as the one from which Daniel Rowland preached, but probably from the 1838 rebuilding.

PENUEL CALVINISTIC METHODIST CHAPEL, Bwlch-llan. Remodelled 1876 by the *Rev. T. Thomas*. Rock-faced stone with roughcast gable. Four arched windows and two arched doors, presumably the form of the previous lateral façade. No galleries, pulpit with fretwork front panels.

HAFOD, ½ m. s. Early C19. Plain stone, three-storey, three-bay house of the Rogers family, later of Abermeurig. Rear Gothic stair light.

THE WOODLANDS, 1 m. E of Hafod, on the B 4342. Former vicarage, 1866 by *R. J. Withers*. Stone, rather altered, but typical of Withers in suggesting the Gothic without Gothic detail. The garden front is raised high on a basement with an off-centre gable and cambered-headed sashes.

CILPYLL, 1½ m. E of Hafod, on the B 4342. A minor gentry house, built for John Morgan in 1768. Two-storey, three-bay front, spoilt by sand paint and new windows; rear wing with big kitchen chimney. Inside, C18 fielded panelled doors and closed-string stair.

Later C18 farmyard buildings: a long barn and stable range, and cow-house with cart-sheds each end.

FELIN FACH, E of Cilpyll. Late C18 or early C19 corn-mill. Arched gable window, and a late C19 iron wheel, made by the *Eagle Foundry*, Aberystwyth.

BRYNELE, 1½ m. NW of Bwlch-llan. 1903, by *F. H. Shayler* of Shrewsbury. Gabled stone villa in a remote site, slightly Arts and Crafts in detail.

NANTEOS

2½ m. SE of Aberystwyth

Nanteos is the major Georgian country house of the county. Its building history is most puzzling, though the basic dates are set

by a foundation stone of 1739 and rainwater heads of 1757. The
house was built for Thomas Powell M.P. who, in 1720, had
married the wealthy sister of Sir John Frederick, Lord Mayor of
London, which might suggest some London involvement in the
building, but the uncertainties of plan and detail point to a
provincial builder. Three storeys with a cramped three-bay ashlar 46
centre between two bays of squared local stone. The relatively
sophisticated centre has arched first-floor windows, blank
roundels above, and a balustrade with urns, up-to-date with work
of the 1730s. By contrast the wings look of a generation earlier,
with provincial Baroque scroll pediments to the first-floor
windows, plain parapet and urns. The pediments are a puzzle,
but the explanation seems to be that they are reused. There are
matching pediments on the five-bay W side, but to both first and
attic floors, some with the original moulded sills. It is as if the
architect or builder had had unwillingly to find place for four-
teen pediments and chose to use as few as possible on his main
façade.

Nanteos was a house of the Jones family, wealthy in the later
C17 from lead-mining. The Jones heiress married the German
mining engineer Cornelius Le Brun and their daughter married
William Powell of Llechwedd Dyrys, the adjoining estate, son of
Sir Thomas Powell (1631–1705), Baron of the Exchequer. While
there is no documentation of a significant early C18 house at
either Nanteos or Llechwedd Dyrys, it is possible that one or
other house was dismantled for the new one. Llechwedd Dyrys,
within the Nanteos park, was marked as 'remains' on a map of
1764.

The next important phase was under the ownership of W. E.
Powell, from 1809 to 1854. Despite extreme debt, plans from the
office of *John Nash* were made for improving the house, adding
porches on each façade and a conservatory on the E, *c.* 1814, and
for picturesque lodges and cottages. Nothing came of this, but
work was done after 1830 and through the 1840s. The work of
the 1830s is not well documented but was extensive. The stables
were demolished in 1827 and had been replaced by 1835, and the
remodelling of the interiors suggests the 1830s rather than the
next decade. *Edward Haycock* was paid for unspecified work in
the 1830s but no clear involvement can be found before 1846–9.
Then he added the three-bay Roman Doric porch and the NW
dining room, with square ashlar bay. For this, he extended the N
wall, unbalancing the W façade, and added a plain two-storey
service range to the N.

Before this in 1841, *William Coultart* of Aberystwyth had made
plans for two-storey, two-bay wings, of which the E one was built,
and added a hipped two-storey NE service range. For W. T. R.
Powell, the billiard room E of the E wing was added in the 1860s,
possibly by *R. K. Penson*, who designed the Italianate W lodge in
1857. The brief era of George Powell, 1878–82, left no mark.
Aesthete, poet and Icelandic scholar, friend of Swinburne
and Wagner, he might have done remarkable things.

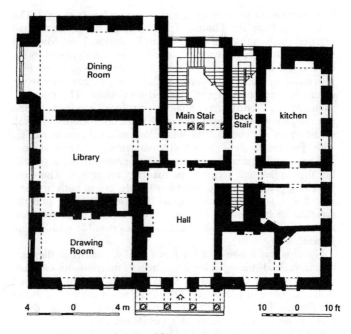

Nanteos.
Plan, courtesy of RCAHMW

The Interior

The original plan largely survives: entrance hall, with stair hall to the N, but very oddly not quite in line, reception rooms off the hall to SW and SE, and two further rooms on the W, back stairs and kitchen to the NE. Modified in 1846–7 when Haycock replaced the small NW room with a dining room. The SE room, which Nash's plan shows as a dining room, was subdivided into three small rooms. The recurring question inside is how much of the detail is of the mid C18 and how much was carefully added or altered by Haycock in the 1830s or 1840s.

The entrance hall has a dado rail and large moulded wall panels of C18 character, and a fine mid-C18 stone chimneypiece, probably by *Sir Henry Cheere*. Based on a William Kent design of the 1720s, with lattice frieze, floral ornament on the centre panel, and on each pier. Distinctive side scrolls with grotesque heads. It would seem to have lost an overmantel. The four side doors are C18, the doorcases with cornices on coved friezes, probably added by Haycock, as must be the handsome end doorcase to the stair hall. This has fluted Roman Doric columns, the triglyph frieze which appears on Haycock's porch, and a broken pediment. The Greek Doric of the frieze is echoed in the mutules of the cornice. The drawing room to the SW has characteristic Haycock details: the rope-scroll in the cornice and the minimal chimneypiece of coloured marble outlined in flush black.

Elliptical-arched E sideboard recess – was this a dining room originally? To the N, a small square lobby with plaster ribbed vault and doors to library and garden. The library was enlarged, probably in the 1840s, with rich cornice and panelled hardwood doors. The NW dining room of 1845–7 has a plaster coffered ceiling, grey marble chimneypiece and corniced doorcases, all with a distinctly Victorian weight.

The stair hall is the principal space of the house, the door from the entrance hall opening into the l. side of the space under the landing, with a colonnade to the main stair hall. The stair is of the 1750s, the hall altered in the 1840s. The columned screen that carries the landing is C18. A pair of Roman Doric columns in the centre and half-column responds, make a two-bay feature, the l. bay aligning the entrance door with the foot of the staircase. The columns have entablature blocks and modillion cornices, matching the cornice under the landing. Handsome broad mid-C18 stair in oak rising in three flights. Ramped rail, scrolled at the foot, scrolled tread-ends, and turned balusters. The dado looks C18 as possibly also the big wall panels. The heavy plaster coffered ceiling must be of the 1830s or 1840s. Two long C19 windows with armorial glass by *David Evans* of Shrewsbury, 1837.

47

E of the stair hall, the back stairs, probably mid C18 but notably old-fashioned by contrast. Thick turned balusters, but open string. The kitchen has a broad stone fireplace arch at the N end. The SE room is divided into three small rooms.

The first floor: On the landing, the colonnade is repeated, opening onto a broad axial gallery, but here the cornices are the Doric of the entrance hall. The gallery is in three parts separated by arches. Handsome and severe four-bay main part, the colonnade echoed on the S wall opposite, and an arched opening or blind panel in each outer bays, half-pilasters in the angles and broad arches with pilasters and keystones E and W. The outer galleries have large wall panels with broken pediment and pulvinated frieze, mid C18 in style.

The Music Room, or Saloon, is the finest room of the house, a Rococo apartment with exceptionally rich plasterwork. How much is mid to later C18, how much mid-C19 skilful revival? The floor is recorded as being replaced in 1799 and there is said to be an earlier ceiling above the present one. N end antechamber with low ceiling, separated by a three-bay arcade, with painted columns. N door with pediment on consoles and leaf-scroll frieze. Wall mirrors in plaster frames with ribbon ties in the curved corners.

In the main room the plasterwork has a vigour not found elsewhere in the house. Rich modillion cornice with leaf-scroll frieze, modillions and rosettes. Ceiling oval surrounded by four long panels and four corner roundels, the long panels with cartouches and thick leaf sprays, the roundels with fruit. The oval encloses an acanthus pendant encircled with trails of fruit and flowers. The ceiling work is at once more formally enclosed and richer

than the little Rococo work found in Wales, which tends to be of
c. 1770, as at Cresselly House, Pembs. or Llanwern, Monmouths.
(dem.). The wall treatment also raises questions: the very large
wall panels echo the mirror panels in the antechamber but are
large for the mid to later C18, as are the oval overmantel mirror
and the bigger mirror opposite. The more delicate rococo plaster
scrolls that surround the mirrors and the arches of the arcade are
convincing, if possibly more symmetrical than usual in the later
C18. While the balance of probability tips towards the work being
by Haycock, the absence of such a style in his previous work and
the accomplishment of the result leaves doubts. Most probably
there is an overlay of Haycock on genuine C18 work. The elegant
coloured marble fireplace is by *Sir Henry Cheere*, with carved
relief of Aesop's fox and goose, and husk drop on the piers.

The SW bedroom has Rococo branches around the ceiling,
framing relief heads of Shakespeare and Milton, said to be in
papier mâché. The eared marble and timber chimneypiece with
fruit festoon looks later C18, with 'Ironbridge' grate from *Coal-
brookdale*, of *c*. 1790. Above, an eared overmantel picture-panel
with broken pediment and flower vase. The dressing room to the
N has marble fireplace with panelled piers and lintel. The NW
bedroom has simple mid-C19 detail. In the NE corner, a bedroom
with fielded panelled walls, mid C18, and more typical of the
county at that period. The subdivided SE room has early C19
Gothick arcading to the cornices in the two front rooms.

The second-floor rooms have some C18 fielded panelling and
doors in the front rooms. There were further rooms in the roof,
removed in 1958 when the triple roof was rebuilt flat.

Outbuildings and Grounds

STABLE COURT, on the slope to the E of the house. Roughly
shown on a map of 1835, payments to builders in 1837–9, so
probably by *Haycock*. Six single-storey stable ranges, two on each
side, those on the N and S separated by big hipped lofted coach-
houses with deep-eaved roofs, the pair on the W with a squat
cupola. The real surprise is open E end, treated as a Neoclassi-
cal screen – a centre triumphal arch linked by low walls to blind
temple fronts on the gable ends of the courtyard ranges. The arch
is flanked by advanced pairs of Roman Doric columns, the
cornice with triglyph frieze, stepped forward over the columns.
There were stone eagles on these and a horse on top of the arch,
illegally sold in the 1980s. The gable ends have applied ashlar
pilasters and shallow pediments, the pilasters framing blank
windows, which is odd. Is this Doric dress applied to existing
buildings? It is possible that the screen post-dates the buildings
slightly. To add a decorative screen facing away from any main
viewpoint when the estate was deeply in debt does seem charac-
teristic of W. E. Powell's tenure.

On the S side of the court, a hipped mid-C19 laundry with
veranda. NE of the court, ruined circular DOVECOTE, 1816. E of

the stables, WALLED GARDEN, present on the 1764 map but being rebuilt 1814–17, when John Nash's cousin John Edwards was agent.

The grounds took shape slowly from 1739, emparked after the turnpike road was rerouted S of the demesne in 1789. Opposite the house, a ruined mid-C18 eyecatcher FOLLY on the hill, a single wall, collapsed in the centre, but with the remnant of a blind Palladian feature each side. There is a plan of 1791 by *John Davenport* for an extremely expensive landscaping of the park. The present lake W of the house may be all that was done of the string of lakes proposed. It was there by 1819. W. E. Powell's plans by *John Nash* and *George Repton* of *c.* 1814 for lodges, and other buildings, are linked with improvements to the drives and minor alterations to the gardens. The LODGE, on the drive to the W, is of 1857, by *R. K. Penson*, but may replace one by Nash. Italianate, stuccoed, with triplets of arched windows to the first floor and a belvedere tower.

GLANPAITH, 1 m. W. Square stuccoed three-bay house of *c.* 1839, built for John Parry, with pyramid roof. Late C19 canted bays on the garden front.

BEULAH INDEPENDENT CHAPEL, on B 4340 SE of Glanpaith. Disused small lateral-fronted chapel of 1842, with tiny chapel house in line.

NANTERNIS
Llandysiliogogo

3757

An attractive ribbon of Late Georgian-style small houses on the steep hill from the chapel down to the river and up the other side, almost all dating from the 1850s and later.

NANTERNIS INDEPENDENT CHAPEL. 1867. A late example of the lateral façade, in the classic form of centre main windows, outer doors, and smaller windows above. All arched, and still small-paned. Painted grained pews and three-sided panelled gallery on iron columns. Prettily cobbled forecourt.

NEUADD CALVINISTIC METHODIST CHAPEL, ½ m. SW. 1867. Plain rendered gable front.

NEUADDLWYD
Henfynyw

4759

A pretty row above the Aeron valley, with the chapel at the head, then older vestry and cottages beyond.

NEUADDLWYD INDEPENDENT CHAPEL. An important and influential chapel, rebuilt three times between 1760 and 1819, the present one of 1906. Typical pilastered façade with major arch over arched windows, presumably by *David Davies*. More notable the white marble angel outside, a MONUMENT of 1914 to early C19 ministers and missionaries to Madagascar.

NEW QUAY/CEI NEWYDD

The name pre-dates by a century the pier of 1835 that created the modern town. Like Aberaeron, New Quay prospered on coastal trade, small-scale shipbuilding and the earnings of deep-sea captains. The years of prosperity extended from the 1840s to the 1880s. Terraces of houses similar to those in Aberaeron climb the slopes above the harbour, mostly of the 1850s and 1860s, despite their Late Georgian look. Decline of shipbuilding and the port from 1880–1900 arrested development until C20 tourism and retirement added an outer ring, still relatively small.

ST LLWCHAIARN. The parish church of Llanllwchaiarn, on the E edge of the town. Rebuilt 1863–5 by *R. J. Withers*. High Victorian Gothic, with plate tracery, and slightly bulbous ashlar W spirelet, propped by large W buttresses that oversail the hipped W porch. Inside, chancel arch on squat ringed shafts, High Victorian PEWS and FONT, though the broken square basin of the original C12 FONT survives, with two carved corner heads and crude incised arcading on two sides. PULPIT and chancel FITTINGS all of 1935–6 by *W. D. Caröe*, who added vestry and organ chamber, limed oak Gothic to Renaissance motifs, more conventional in the REREDOS but inventive in the panelled STALLS and PULPIT. – STAINED GLASS. E window of 1928, chancel N window of 1937 by *Shrigley & Hunt*, chancel S window, 1960, by *John Hayward*, strong colours and heavily etched.

BETHEL BAPTIST CHAPEL, Margaret Street. 1849. Pleasant gable front in local brown sandstone with small-paned arched windows, and arched door. The broader centre window echoes the door. Inside, painted panelled gallery with splayed angles and timber columns.

TABERNACLE CALVINISTIC METHODIST CHAPEL, Glanmor Terrace. A big, hipped square chapel, of 1837, enlarged 1861. Large, wide-spaced arched windows to the rear, the front partly masked by a vestry of 1892 and pedimented porch of 1927. Interior of 1927, a period relatively uncommon in West Wales chapels. Most obviously modern, the unsupported galleries and unstained woodwork. Semicircular great seat, pulpit with organ of 1896, by *Vowles*, behind. Panelled ceiling. – STAINED GLASS. One window of 1927 by *John Hall & Sons*; patterned leaded glass otherwise, in place of the original sashes.

TOWYN INDEPENDENT CHAPEL, Towyn Road. 1860–1, by a local builder, *Thomas Jones* of Cross Inn. Fine grey-brown squared stonework, with classical gable front in two storeys with raised piers, entablature and, oddly, a cement cornice. Large arched windows with attractive small-paned glazing. Late C19 front porch and large vestry attached to the r. Rear apse for the organ, 1909 by *F. W. Child*. Low, painted three-sided gallery, canted at the angles, 1865, by the *Rev. Thomas Thomas*. Balustraded curved platform pulpit, in front of organ loft in thickly detailed flattened arch of 1909.

New Quay Pier. 1835, by *Daniel Beynon*, local builder, though
John Rennie was consulted in the 1820s. A picturesque stone
curve in two high tiers. A pepperpot lighthouse of 1859 at the
far end was lost in a storm in 1938. Stone mid-C19 WARE-
HOUSE, with painted C19 board of port charges.

PERAMBULATION

The town faces E across the bay, wrapped around the Penwig
promontory, from which the pier runs out, sheltering the N side
of the harbour. Terraces, mostly facing out to sea, characterize
the town, built to the Late Georgian model taken from Aber-
aeron, of two-storey houses, with deep bracketed eaves, large sash
windows and panelled doors. At New Quay such buildings run
from c. 1840 to the 1870s, when the type began to be displaced
by later Victorian fashions. Around 1900, the older houses were
transformed by hard cement finishes, plate glass and new glazed
timber porches, often with etched and coloured glass. Intact
earlier houses are the exception, and to see the town's character
as a hillside Aberaeron requires soft-focus vision.

N of the headland are the two earliest terraces, ROCK STREET
and MARINE TERRACE above, both of the 1840s. No. 7
Marine Terrace is particularly nice, with an Ionic columned
porch, the porch on No. 8 Rock Street is also notable, vigor-
ously incorrect classical. No. 19 Rock Street seems an earlier
survival, with smaller proportions, and low upper floor. LEWIS
TERRACE, above Marine Terrace, is of the 1850s. CHURCH
STREET, the old road up from the harbour, was built up from
the later 1850s, mainly in the 1860s, but the group at the foot,
around the DOLAU INN, is earlier, with the smaller propor-
tions of the early C19. Further down, THE CAPTAIN'S TABLE,
1857, four-storey sail-loft in the local stone, hipped roof.
Behind, Nos. 1–4 HIGH STREET, a sandstone-fronted row,
and Nos. 1–2 IVY PLACE, behind again, are of c. 1850, but
still to the earlier pattern, with small windows and squeezed
attics.
SOUTH JOHN STREET curves round the horn behind the pier,
with TREASURES, a large stuccoed sail-loft of c. 1870, and two
big three-storey hipped-roof houses overlooking the harbour,
both of c. 1860. GLANMOR TERRACE along the front is mostly
Late Victorian, the BLACK LION of c. 1850 has a three-storey
front and older, lower rear. The slope to W has terraced rows;
HIGH TERRACE, begun 1848, has consistently the best sur-
viving examples, notably Nos. 8, 11 and 16. Further terraces in
PICTON PLACE, above, c. 1870, and PARK STREET and HILL
STREET c. 1860–70. Hill Street connects back to the top of
Church Street. On the main road, FRONDOLAU, the town's
only substantial villa, complete with lodge, c. 1860, stone,
asymmetrical with small-paned sashes. Above, Neo-Georgian
COUNCIL HOUSES, c. 1953, formally grouped with crescent
entry, but plastic windows replace the carefully designed

sashes. NEUADD, further out, is a farmhouse dated 1806, altered, only the pedimental gable with original glazing.

COYBAL, 1 m. SW. Completely altered early C19 house. Hipped, five bays with pedimental gable. The unusual formalized enclosed farm court in front survives, though infilled, dated 1836.

OAKFORD/DDERWEN-GAM

4558

Llanarth

A compact village with a harmonious character from a few mid-C19 houses in the Aberaeron mode. The best is the POST OFFICE on the corner.

NEUADD, ½ m. W. 1807–10, built for John Brooks for £1,278 6s. 6d., which seems large for a modest hipped three-bay house. *Richard James*, of Aberystwyth, was paid for carpentry. Garden front with blind arches over the ground-floor side windows, a central pair under a shallow arch, one a dummy (a device from *p. 313* Nash's Llysnewydd, Cms.). Two-bay entrance front with dummy fanlight over the ground-floor window and another peeping oddly over the columned porch.

Reused in the entry to the service yard is the former porch door, an ovolo-moulded timber doorcase with early C17 stone inscription in two panels above: HEB DW HEB DIM DWA DIGON (Without God, without all, God is enough), and ASKE & HAVE. SEKE AND FINDE KNOKE AND IT SHALE BE OPENED UNTO YOU with the arms of Tydwal Gloff and Cadifor ap Dinawal, ancestors of the Lloyds of Castell Hywel, suggesting a previous house of some importance. C18 outbuilding behind, with a massive stone chimney on the ridge.

RHIWBREN FAWR, 1 m. E. Dated 1799, built for W. Herbert. Three-storey, three-bay roughcast front, but the top windows merely blanks under the eaves as if the intention changed in building. Scarfed cruck roof trusses.

PENBRYN

2952

No village, but a pretty scatter of houses in the Hoffnant valley, the church on the hill above to the W, Llanborth Farm in the valley, and Troedyrhiw well set against beech woods on the E slope.

ST MICHAEL. One of the most appealing small churches of Cardiganshire, enhanced by the isolated site. Circular churchyard on the shoulder of a hill, sheltered from the sea. Nave and chancel with W double bellcote and big, possibly C17, W porch. The rest is medieval but datable with difficulty. No tracery survives and the N wall has been rebuilt. Cambered-headed windows on the S, possibly C18, formerly shuttered. A remnant

of a hoodmould seems to be C15, also a C15 N two-light window, and two narrow slits opened in 1957. A restoration in 1887–8 by *David Davies* was relatively light, adding timber tracery and an E window. Inside, much is owed to the 1957 restorer, *A. D. R. Caroe*, who exposed the medieval roof and painted the 1887 pews grey, in harmony with the dark slate floor and whitewashed walls. The eight-bay roof of c. 1500 resembles the one at Mwnt, with arched braced collar-trusses, the collars carrying kingposts and the top triangles cusped. This roof type seems to derive from late medieval roofs in the Llyn peninsula, Gwynedd. Piscina recess on S wall. Plain plastered chancel arch with simple imposts. The chancel is not aligned, suggesting a building of two phases. Deep tomb recess on the S wall. – FONT. Square C12, chamfered below, on short pillar. In the porch another C12 square font, limestone, scalloped, from Sarnau church, but originally from Cenarth, Cms. – STAINED GLASS. E window 1887. – MONUMENTS. In the chancel floor lettered brass plate to Dame Bridgett Lewis of Abernantbychan †1643, the only pre-Victorian brass in the county. In the chancel arch slate plaque to George Lloyd of Llanborth †1678. Nave S: Jane Jenkins of Dyffrynbern †1816, white marble Neo-Grecian urn with slightly crude lopped tree above. Nave N: Abel Walters of Perthgerent †1841, a flat draped marble urn, by *H. Phillips* of Haverfordwest.

The churchyard has some half-dozen of the very local memorials of c. 1780–1820, with massive Pwntan sandstone arched frames to slate or sandstone plaques.

PENMORFA CALVINISTIC METHODIST CHAPEL, ¾ m. E. 1846 by *Timothy Timothy* of Rhydser, but almost entirely rebuilt in 1938–9 by *T. Edmund Rees* of Merthyr Tydfil. Lateral façade with arched windows, in Pwntan sandstone, giving a handsome solidity. Two imitation-stone, heavy-arched porches of 1939. The interior is a period piece of the 1930s, with deeply coffered timber ceiling in two tones of wood, five-sided cantilevered gallery and pulpit with modernistic patterning in dark strips. – STAINED GLASS. Two uninspired windows by *William Morris Studios*, 1939.

PENMORFA PRIMARY SCHOOL, ¼ m. S of the chapel. 1877, T-plan, with detached school house.

PENCWM, below the church to SE. Remodelled c. 1925 by *Clough Williams-Ellis* for his brother, from a plain three-bay farmhouse with service wing. Ellis raised the service wing and replaced the sashes with metal arched windows, attractively small. After a fire in 1939 the original thatch was replaced with attractive small graded slates. Until recently the stonework was whitewashed.

BRYNTELOR, beyond Pencwm. Former National School, 1858, by *R. J. Withers*, converted to a villa in 1932, but the bold chimney hints at its origin.

CWMYFELIN, by the lane to the beach. Former Llanborth Mill, early C19 half-hipped corn-mill, set precariously above a waterfall. Iron water wheel.

LLANBORTH, at the head of the valley from the beach. Large farmhouse of 1860, the date evident from the brick window heads, though the sashes are still of Georgian type. Pretty lofted cart-house in the yard.

TROEDYRHIW, on the hillside NE of Llanborth. Earlier C19. Hipped, three-bay square villa with deep bracketed eaves, remarkably still with the original roughcast and ochreous whitewash.

13 CORBALENGI STONE (SN 289 515), ½ m. S of the church, in a field. C6 stone inscribed CORBALENGI IACIT ORDOUS, the last word possibly meaning Ordovician, i.e. of the North Wales tribe known from Roman times. The stone has been re-erected. In 1804 an urn and coins, including an *aureus* of Titus A.D. 79–81, were found beneath. The lettering is similar to that on the Sagranus Stone in St Dogmaels church, Pembs.

CASTELL BACH, 1 m. N. Iron Age coastal fort, roughly rectangular with single bank.

CASTELL NADOLIG, by the main road 1 m. S. Iron Age hill-fort, with oval embanked centre set in a large oval outer enclosure.

See also Brynhoffnant, Glynarthen, Sarnau, and Tresaith.

5163 PENNANT
 Llanbadarn Trefeglwys

The older village centre is on the N bank of the Arth: a well-built stone bridge, PONT PENNANT, 1850, by *R. K. Penson*, the whitewashed SHIP INN, with late C19 windows but dated 1754 on the fireplace; the chapel, and a single-storey cottage. A newer settlement on the crossroads to the N, with LLAIN, N of the crossing, a good example of the single-storey thatched cottages once common. Old photographs show that this had the typical 'wicker' chimney, actually a plastered ring of woven hazel or similar material, indicative of a woven chimney-hood within.

ST PADARN, ½ m. W. The parish church of Llanbadarn Trefeglwys, in an ancient circular churchyard. A plain single chamber, roughcast, with overscaled ashlar bellcote. Described in 1850 as rebuilt about 1650 but all historical features were lost in restorations in 1855–6 and 1905–6; the former apparently removed the chancel, and the latter, by *E. V. Collier*, replaced the windows with Perp tracery and redesigned the bellcote. Plain interior, refitted in 1957, by *W. Clarke* of Llandaff, as a memorial to fourteen men of the parish who became ministers. – STAINED GLASS. three-light E window, Crucifixion, 1906, quite good C15 style. Nave S two-light, 1958, by *Celtic Studios*, effective deep colours. – MONUMENT. Large marble slab to Col. A. T. J. Gwynne of Monachty †1861, and his nine children.

By the churchyard, the tiny former SCHOOL, 1829, single storey, built for £33.

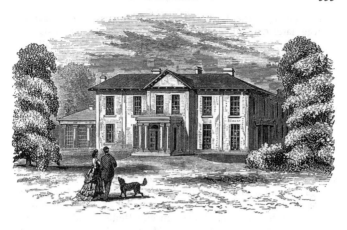

Monachty; front range.
Engraving, 1872

PENNANT CALVINISTIC METHODIST CHAPEL, by the bridge.
1832, altered 1883. Stuccoed lateral front; four arched windows,
one arched door (formerly two). Fussily delicate glazing bars
of 1883, when the interior was rearranged with a single gallery,
its front a showy piece of artisan woodwork, with rows of little
turned balusters. Coloured glass in the lobby window below.
More turned balustrading to pulpit and deacons' seat, and a
bold stucco Corinthian arch behind.

PONTRHYDSAESON CALVINISTIC METHODIST CHAPEL, Pont-
saeson, 2½ m. E. 1871, stucco gable front with arched open-
ings. No gallery, grained pews.

MONACHTY, 1 m. S. Ancient seat of the Gwyn family, later
Gwynne. Front range of c. 1835, probably by *Edward Haycock*,
the rear range mid C18, altered in 1807. Col. Alban T. Jones
Gwynne (*see* Aberaeron), was at Monachty from 1805, but the
front range dates from after he came into the full inheritance
in 1830. The detail is similar to houses at Aberaeron, being laid
out by Haycock in the 1830s. Hipped, stuccoed, two-storey,
2–2–2-bay front, with pedimented centre projection. The rela-
tion of the two-bay centre to single-entry flat porch is a little
crude, as is the articulation by plain raised strips, but this was
an economical work by comparison with Haycock's Plas Llan-
goedmor, Llangoedmor, of 1833. Plain six-bay earlier range
behind. Interiors of the front range of the 1830s. Square, stone-
flagged hall with elegant stone cantilevered stair and iron
balustrade. The rooms each side have acanthus cornices and
plain fireplaces. Mid-C18 staircase in the rear range, with thick
ramped rail and turned balusters; also some fielded panelled
doors and shutters.

Low, single-storey, hipped E-plan outbuildings of the 1830s,
framing two courtyards, domestic and stable, with only the
gabled coach-house to a larger scale. Behind, is a large rec-
tangular FARMYARD, mostly mid to later C19, incorporating on

the S side an earlier barn with oak scarfed trusses. In the centre, large, later C19 sunken dung-pit with roof on brick posts.

Although the house stands close to the road, a small picturesque landscape was created by sweeping the drive around the slope to the pretty SOUTH LODGE, *c.* 1835, with deep hipped roof. Bargeboarded Victorian NORTH LODGE, stripped to stone, but no doubt originally stuccoed.

WERNDDU, ½ m. SE. Plain, roughcast, three-bay farmhouse, spoilt by plastic windows, but an early C18 gentry house as shown by the 1726 date on the massive fireplace beam, with initials of the Rev. Henry Lloyd. BARN dated 1792, long range opposite with triple-arched cart-shed.

GORSFACH, ¼ m. NE. An accretion of white walled low buildings around a taller octagonal main room. It was the holiday house of *Alexander & Margaret Potter*, he having been professor of architecture at Khartoum and Belfast, and the couple having written and illustrated *Houses* and *Interiors*, popular books of the 1950s. The house built over many years, 1974–92, rooms added on an *ad hoc* basis, generating a marvellous intricacy.

DINEIRTH CASTLE, 1 m. W of Monachty (SN 495 624). Promontory fort on a wooded spur at the confluence of the Arth and the Nant Erthig, refortified with a motte, probably by the Normans after 1116. Frequently exchanged between the Normans and the Welsh princes of both South and North Wales, it was destroyed in 1211 by Maelgwn ap Rhys to prevent it falling to Llywelyn the Great. A long rectangular enclosure with additional bank to the E, protecting the NE entry, an irregular mound with ditch to one side.

See also Bethania.

2148

PENPARC/PENYPARC
Verwig

A modern cluster N of Cardigan. The conical sandhill of Banc-y-Warren is reputedly Crug Mawr where, in a rare pitched battle, a Norman force was routed in 1136 by Owain and Cadwaladr ap Gruffudd.

PENYPARC BAPTIST CHAPEL. 1838. Hipped roof with modernized front. Attractive galleried interior with all the woodwork grained. Iron columns signed *Moss & Sons*, Carmarthen.

PENPARCAU *see* ABERYSTWYTH

PENRHIWLLAN
Llanfair Orllwyn

3742

A long village on the Newcastle Emlyn to Lampeter road. The church of Llanfair Orllwyn and mid-C19 OLD RECTORY are isolated on a hillside to the S.

ST MARY, Llanfair Orllwyn, ½ m. s. Georgian Gothic, with charming domed bell-turret. Short nave and chancel with large pointed windows, and rendered square turret. Said to have been built in 1808 for just £173, but not finished inside until 1842–4, then by *Rees Davies*. Windows altered in 1887. Plain white interior with three-sided plaster ceiling. – FONT. C12 and remarkable. Square bowl chamfered below, with the angles shaved to pentagons. On each side, three bosses over interlaced incised lines. Crude original base, monolith octagonal plinth and round shaft, the junction very uncomfortable.

GWERNLLWYN INDEPENDENT CHAPEL, ¼ m. NE. 1903 by *David Davies* of Penrhiwllan. Stuccoed, with pilasters and giant arch in the form derived from the Rev. Thomas Thomas's Seion Chapel, Llandysul, 1870, on which Davies worked. Inside, gallery with long, pretty cast-iron panels, made, like the columns, by the *Priory Foundry*, Carmarthen.

CASTELL NANTYGARAN (SN 369 421), just N of the village. Small Norman motte.

PENRHYNCOCH
Trefeurig

6484

Large, mostly modern village, where two valleys from the lead-mining hills to the E join in the broad Clarach valley.

ST JOHN THE DIVINE. 1880–2, by *R. J. Withers*. A characterful small church with white-painted, weatherboarded W turret and pyramid roof. Lancet windows and gabled S door. The turret and red-tile roofs have a sweetness not present in Withers's earlier High Victorian works. Some nice external detail, see the way the roof is hipped around the base of the turret. Inside, seven-sided rafter roofs, opened up with trusses under the turret. Chancel arch on corbels. Still High Victorian the simple timber PULPIT, STALLS and RAILS, and the fine FONT, two heavy ashlar drums squeezing a squat red sandstone shaft. Unexpected is the lively glazed ceramic eagle and dragon LECTERN, made for Llanbadarn Fawr, 1880, probably by *Doulton*. – REREDOS. Rich alabaster Last Supper in memory of Sir E. Webley-Parry-Pryse †1918. – STAINED GLASS. Three-light E window to Pryse Pryse Pryse †1900: good colours, if somewhat lifeless drawing, by *Hardman*. Chancel S window to Sir Pryse Pryse †1906, also by *Hardman*, anaemic. N lancet, 1979, by *Celtic Studios*, Christ the Teacher, with a Sunday School scene below.

w of the church, a plain SCHOOLROOM,* 1863.

HOREB BAPTIST CHAPEL, ½ m. E. 1856. Rendered gable front with arched windows and later porch. Box pews, and a pretty gallery with canted angles and Gothic cusping to arched panels.

SALEM INDEPENDENT CHAPEL, Salem, 1½ m. E. 1864. An attractive lateral front of four long arched windows and a centre door, the arched sequence maintained by a lunette plaque over the porch. Similar to Capel Penllwyn, Capel Bangor, of 1850, and indeed the interior has the same old-fashioned serried ranks of painted grained box pews, ramped up to the back. The pulpit with shaped newels, perhaps contemporary.

PLAS GWYN, ½ m. W. A. Gogerddan dower house, formerly Gloucester Hall. Later C18 whitewashed three-bay front, with hipped cross-wing to the l.

COURT VILLA, ¾ m. w. Gothic Gogerddan estate cottage, earlier C19, with tiny-paned casements and pretty intersecting tracery in the window heads. It was formerly known as Court-my-fancy or Cwrt-y-ffansi.

PLAS GOGERDDAN, 1 m. W. Now the Institute of Grassland and Environmental Research (I.G.E.R.). As one of the two most influential houses of the county, Gogerddan is a disappointment. The Pryses were, with the Vaughans of Trawsgoed, the leading county family from the C17, owning vast acreages of upland, valueless until the lead-mining potential was realized in the C17. John Pryse was M.P. 1553–5. Sir Richard Pryse, the first baronet, began the struggle with the Crown for the control of the mines in the 1630s. Sir Carbery Pryse †1694, fourth baronet, impelled by the discovery of the Esgair Hir silver-lead mine in the remote NE hills, succeeded in overturning the royal monopoly. Thereafter, the family received a percentage on every ton of ore. The baronetcy died with Sir Carbery, but was revived in 1866 for Sir Pryse Pryse †1906. The house was sold in 1949 to the University College of Wales as a home for the Welsh Plant Breeding Station.

There was a substantial C15 house, as is demonstrated by the survival of a vine-carved 20-ft (6-metre) beam now at the Museum of Welsh Life, St Fagans, and probably still there in 1670 when the house was assessed at sixteen hearths, the largest in the county. The present house facing s in its valley setting, probably built for Sir Carbery Pryce before 1694, is late C17, two-storey with hipped roofs, but heavily stuccoed when the long range running E was added in 1860, for Sir Pryse Pryse, by *George Jones* of Aberystwyth. s front of three bays, with a short entrance wing set back to the r. The outline is late C17 but the detail of 1860. Two canted bays have been added to the w front, and there have been some unhappy C20 alterations. The long C19 service range to the E has plain stucco detail, niches between the ground floor windows and a gabled

* Presumably not the chapel-cum-school designed by *William Butterfield* in 1862.

centre projection marking the servants' hall.

Inside, the only early feature of interest is the NE stair with twisted balusters, more mid C18 than late C17, possibly added behind the original entrance hall. Earlier C19 painted glass in the stair lights. In the C19 wing there were service rooms on the ground floor but some family bedrooms above and a top-lit billiard room with glazed clerestory under an oval roof-light. On the service stair, a BUST of Sir Pryse Pryse, by *J. E. Thomas*, 1856, originally in Aberystwyth Town Hall.

Stone bridge to the W, over the canalized Clarach, 1743.* To the N, a mid-C19 LODGE with three Gothic windows in each gable front.

The earlier college buildings are not special. LORD MILFORD LABORATORIES of the 1950s, W of the mansion, stuccoed, stripped Georgian style. 1970s and 1980s blocks S of the road, W of the WILLIAM DAVIES LABORATORIES, 1991–2, by *Alex Gordon Partnership, Dick Evans* partner-in-charge. This is a tall single range with smooth industrial lines. The walls are clad in horizontal, grey metal panels, the windows in two very narrow bands to diminish solar gain. Metal-clad pitched roof, longer to the rear, and slightly lifted in the centre for the air-conditioning outlet. Across the E end, a lower wing with entrance hall, stairs and a lecture theatre projecting to the N. At the N end the roof is carried out on two slim piers. To the E, VENLO GLASSHOUSES, 1993, computer controlled greenhouses with ridge-and-furrow roof-line.

COUNTRYSIDE COUNCIL FOR WALES, just E of the I.G.E.R site. 1993, by *Alex Gordon Partnership*. White-rendered, L-plan hipped office block with a faint chapel reminiscence in the blank arches of the end walls.

PEITHYLL, Capel Dewi, 2 m. SW. 1844 for J. P. Pryse. Three-bay roughcast house with deep eaves and pillared porch. Good plasterwork in the ground-floor rooms and a narrow winding stair. Noted when built for its modern farm buildings, 'adapted for an improved system of agriculture'. These are altered.

BROGYNIN, 1 m. E. The reputed birthplace of the poet Dafydd ap Gwilym in the early C14. PLAS BROGYNIN is a five-bay later C19 house with centre Palladian window.

LEAD-MINING AREAS

A road runs E some five miles to a series of mine reservoirs: Llyn Pendam, the reservoir for the Cwmsymlog mine (*see* below), Llyn Blaenmelindwr, both in the forestry, and Llyn Rhosgoch to the S before running SE through empty hills to Ponterwyd. Parallel to the S is the Nant Silo valley. On the S bank, BRONFLOYD MINE (SN 659 835), worked from the C17 to mid C18, reopened by Matthew Francis in 1850 and worked intermittently to 1892. It was expensively equipped with steam engines and an aerial

* In unexecuted landscape plan of 1765 by *William Combs* the river was to have been given a serpentine course.

ropeway to carry dressed ores up the hill to the s. Further E, at
PENBONT-RHYDYBEDDAU, TREFEURIG SCHOOL, 1874, by
George Jones & Son, a good example of a rural Board School.
Larger than average, to take the mine-workers' children, a single,
long range with two Gothic porches, and detached teacher's
house, set back. E of the village, CAPEL BACH, was the
Abercwmsymlog School, 1868, a Nonconformist school and
chapel. The Banc-y-Daren ridge looms over the village to the s,
scarred by waste from the CWM DARREN MINE (*see* below).
 To the E, two valleys divide, the upper one to Cwmsymlog, the
lower to Cwmerfyn. On the Cwmsymlog road there are mine sites
at CERRIG YRWYN (SN 684 834) s of the road, abandoned since
the C18 and, N of the stream, WEST CWMSYMLOG (SN 689 839),
worked from 1862 to *c.* 1880. CWM CANOL is a farmhouse
of 1852 with paired brick chimneys, probably built for the
Gogerddan estate.

CWMSYMLOG, 3½ m. E of Penrhyncoch, at the head of the
 valley. The settlement is little more than a scatter of houses and
 a chapel amid the waste heaps. Cwmsymlog mine was 'the
 richest in lead and silver of any in His Majesty's dominions',
 according to Lewis Morris in the C18. There were two mine
 sites, one at the village, the other at Blaen Cwmsymlog further
 E. They were worked by Germans in the C16, and most prof-
 itably by Sir Hugh Myddelton in the 1620s, who is said to have
 gained some £24,000 a year from Blaen Cwmsymlog in silver
 alone. From 1636 Thomas Bushell spent some £11,000
 draining Myddelton's shafts and still extracted profit. Sir
 Humphrey Mackworth leased the mines in 1698, and his
 Company of Mine Adventurers worked Blaen Cwmsymlog
 from 1705 without great success into the 1740s. After a prof-
 itable lode was found in 1749 and worked to 1777, the mine
 was worked fitfully until the 1850s when John Taylor linked it
 to the leat that brought water from the headwaters of the Leri
 at Craigypistyll (SN 720 857). Taylor & Sons worked it from
 1845–82, extracting some 25,000 tons of lead and 415,000
 ounces of silver.
 The main works were amid the spoil heaps s of the road. To
 the N, a single, stone C19 CHIMNEY on the site of one of the
 main shafts. Just behind is the neat Late Georgian-style
 MANAGER'S HOUSE, three bays, with iron columned porch,
 probably of the 1840s. Behind, across the stream, a few houses
 and TABERNACLE BAPTIST CHAPEL, 1860, a small long-wall
 chapel with window each side of the porch. With the pulpit at
 the gable end and box pews raked up in front, it marks a tran-
 sition between long-wall and gable-end chapel plans. Blaen
 Cwmsymlog is up the track at the very head of the valley,
 mostly under forestry.
In the Cwmerfyn valley, on the s scarp, traces of CWM DARREN
 MINE (SN 681 833) where Lewis Morris found evidence in the
 C18 of mining with stone tools from 'the beginning of time'.
 CWMSEBON MINE (SN 684 830), further on, was the original

mine served by the great leat from Craigypistyll (*see* Elerch)
built for the owner, John Horridge, in the 1840s. The mine was
worked to 1893.

CWMERFYN. The mine site on the valley floor has been land-
scaped. The mine was worked in the early C17; Morris thought
it originated as an 'Antient British Open Cast'. There was a
period of great profit after 1862, when 110 men were employed.
At the entry to the village, BETHLEHEM CALVINISTIC
METHODIST CHAPEL, 1866, small and roughcast with
painted grained box pews. Further E, overlooking the stepped
waste tip of the Bwlch Mine, is SILOA INDEPENDENT
CHAPEL, built in 1868, for £300, by *Thomas Jones* of Dole. A
pretty chapel and house under a single roof, the chapel a lateral
front of two arched windows and central porch, the house of
two bays. Inside, the orientation is to the end wall, despite the
lateral entry. Grained pews raked up at the back and each side
of the pulpit, benches in the centre, and a painted arch behind
the pulpit. BWLCH MINE, to SE, on the saddle between
Cwmerfyn and Goginan, was exploited from the C17, reopened
1847–53 by Matthew Francis and worked to 1884. The works
in the valley bottom have been cleared, but the road winds
through the waste. Further workings are to the E along the
ridge. In the valley below was CAENANT MINE (SN 708 827)
worked in the C18, and further E, on the watershed, with spec-
tacular views, was PENCRAIGDDU MINE (SN 711 824),
worked by the Company of Mine Adventurers in the earlier
C18.

DARREN MINE (SN 677 828), 1 m. W of Cwmerfyn. Mine wastes
on the crest of the escarpment, next to an Iron Age HILL-
FORT, but the main site was S of the road, at Darren Farm.
Lewis Morris thought it had been worked by the Romans as
opencast, and there are scars by the hill-fort of possibly Iron
Age date. Worked from 1731 to great profit, closed in 1798,
but revived 1839–1867 and 1870–84. The dressing floors
were down in the valley at Penbont-Rhydybeddau, reached by
tramway.

PENTREGAT
Llangrannog

3552

Settlement on the main Aberystwyth road.

Y FFYNNON CALVINISTIC METHODIST CHAPEL (now a
house). 1848–9, by *Charles Davies* of Cenarth. In careful
Gothic, exceptional in chapels at this date. Pwntan sandstone
gable front with a big Perp timber window, Gothic door and
buttresses. The buttresses were originally pinnacled.

WERVIL BROOK, ½ m. NW. Late C18 three-bay house, altered in
1921, and given a Neo-Georgian refit with pedimental gable in
1996.

PLWMP
 Llandysiliogogo

On the main road, above Llangrannog.

Y CRUGIAU INDEPENDENT CHAPEL. 1897, probably by *David Davies* of Penrhiwllan, with his typical stucco gable front and centre arch.
ST MARK, Gwenlli, 2 m. E. 1896–7 by *David Davies*. Plain mission church in stone and yellow brick.

PONTERWYD
 Ysbyty Cynfyn

Village on the new main road of 1812 from Llangurig to Aberystwyth, replacing the old turnpike through Devil's Bridge. The humped old BRIDGE, mid to later C18, pre-dates the 1812 road, a narrow single arch, in front of the chapel. W of the village, overlooking a waterfall, the GEORGE BORROW INN, built in 1832 as the Gogerddan Arms, much used by travellers across the mountains. Substantial stuccoed Late Georgian building with deep eaves of the Aberaeron type, the windows altered.

PONTERWYD CALVINISTIC METHODIST CHAPEL. Attractive stuccoed gable-fronted chapel of 1854, plain and large, possibly an expansion of the 1821 predecessor. Two arched windows and two outer doors. Near-square interior densely packed with box pews raked up to the back wall in nine rows, all painted grained in yellow. Later pulpit and great seat. To the S, on the main road, former BRITISH SCHOOL, 1860, still Late Georgian in style.

LLYWERNOG MINE, 1 m. W. Now a museum. An old mine site, active in the C18, but the remaining buildings date from the 1860s and 1870s. Water was a problem; a long leat was made from N of Ponterwyd, and a huge 50-ft (15-metre) wheel was installed in 1875, but the mine closed in 1878. The principal building is the COUNT HOUSE, 1869–70, a stone and yellow-brick hipped building of two storeys, which held the offices, steam-engine, carpenters' shop and smithy. Adjoining is the wheel-pit for the lost giant wheel, and a restored CRUSHER-HOUSE of *c.* 1860, with pyramid roof. Inside is a roll-crusher rescued from Llawrycwmbach mine, Elerch. To l. is a 14-ft (4.3-metre) WATER WHEEL made by the *Eagle Foundry*, Aberystwyth, next to the open JIGGER-SHED, where ore was separated. Behind, open-fronted ORE-DRESSING SHED, with ore-bin behind. The main SHAFT above has a reconstructed head-frame; the shaft reached 432 ft (131.7 metres) in 1872. Further round the slope to the l. are two reinstated WATER WHEELS, one a 14-ft (4.3-metre) wheel made by the *Central Foundry*, Aberystwyth, the other an 11-ft (3.4-metre) wheel made by the *Cardigan Foundry*. The latter stands between round BUDDLES – circular shallow tanks where slime was

combed for residue ore. Beyond, the path winds up to ruins of a late C18 MINE OFFICE close to the C18 opencast site. Above is the mine RESERVOIR and circular stone GUNPOWDER-STORE.

The landscape of great wheels, stone engine houses and crushing-mills in bare piles of spoil is only partly re-created here. Gone is the paraphernalia of water-troughs, tramways, flat-rods and cables that linked mine shafts and dressing floors sometimes over great distances, crossing the road where necessary on trestles.

LEAD-MINING SITES. PONTERWYD MINE (SN 741 807), ¼ m. W, advertised as the California of Wales in 1853, ran intermittently to 1882. BOG MINE (SN 738 813), on the slopes to the N, was worked from 1830 to the 1880s and shows remains of wheel-pits. CLARA MINE (SN 737 807), S of the main road, ran from the 1850s to 1882. For LLYWERNOG MINE, see above. To the W, on the S slope, POWELL MINE (SN 728 808), worked from the early C19 by Sir Thomas Bonsall, and continued to the 1890s.

NE of Ponterwyd, BRYNGLAS MINE (SN 753 815), by the main road, active in the C18 and 1855–60. Further E, DYFFRYN CASTELL INN, rebuilt in 1837–9 for W. E. Powell of Nanteos, Late Georgian style, altered windows. Remnants of the CASTELL MINE (SN 775 813) on the S side of the valley. Worked 1785–1803 by Sir Thomas Bonsall, it was reopened several times in the mid to late C19. The prominent remains are part of a crusher-house and wheel-pit of 1898. Further NE, ESGAIRLLE MINE (SN 792 828), producing intermittently between 1850 and 1892. In 1853 the company built nine houses in two rows in 1853, which remain as farm buildings by the main road at EISTEDDFA GURIG. From here a footpath runs N for 2 m. through an empty valley towards Pumlumon, passing the remains of PLYNLIMON MINE (SN 795 856), worked 1866–78, one of the bleakest mine sites in Wales.

N of Ponterwyd a lane runs up the Rheidol valley past the Dinas Reservoir towards the reservoir at Nantymoch, both part of the Rheidol Hydroelectric scheme opened in 1964 (see Cwmrheidol). 1 m. N, HIRNANT CIRCLE (SN 753 839), sixteen small stones that may have formed a kerb of a flat Bronze Age ritual or burial site. Other kerbed platforms, or ring cairns, have been found on the summit of DISGWYLFA FAWR, 1½ m. W (SN 737 847) and at MAESNANT-FACH (SN 762 867) by Nantymoch Reservoir. One lost under the reservoir has been re-created at ABERCAMDDWR, NW of the dam. Remains radio-carbon-dated to 1260 B.C. were found here.

NANTYMOCH RESERVOIR. A crescent-shaped reservoir formed by damming the confluence of the upper Rheidol and Camddwr rivers in what had been bare moorland, overlooked by the Plynlimon range to the E. Part of the Rheidol hydro-electric scheme (see Cwmrheidol), built 1957–64, to supply electricity, mainly to South Wales. At Nantymoch there are 679 acres (275 hectares) of water, held back by a mass-concrete

buttress DAM, 1,152-ft (351-metres) long and 171-ft (52-metres) high, which carries the road. Water is pressure-piped underground for 2½ m. to Dinas power station and intermediate reservoir, and thence another 2½ m. underground to Cwmrheidol. The net output overall is 49,000 KW.

MINE SITES are numerous on the W of the reservoir. The extraordinary long leat finally of some 17 m. constructed from the 1850s by John Taylor to bring water from the Rheidol headwaters N of the reservoir to the mines at Cwmsymlog E of Penrhyncoch follows the contours N and W of the W arm before diverging SW to the remote BWLCHYSTYLLEN MINE (SN 732 862), recorded in the C18, worked again 1855–63. In the forested slope by the end of the NW arm, HENFWLCH MINE (SN 737 882), joined with the HAFAN MINE (*see* Talybont) over the crest to the SW (SN 728 879). On the N end of the W arm, by the water, site of the dressing floors of the CAMDWRBACH MINE, the mine sites up the two valleys to N and NE once linked by tramroad. To SE, on the shore, BRYNYRAFR MINE (SN 746 879), worked 1879–1912 and, beyond the Nant y Barracks stream, named for the isolated miners' housing, CAMDWRMAWR MINE (SN 751 877). By the roadside N of the N arm, EAGLEBROOK MINE (SN 735 892), known before 1708, worked 1850–74.

WINDFARMS. On the hills around are three windfarms, Rheidol to the S, 1997, Ponterwyd to the NW, and Cefn Croes to the E, 2005, the latter with the largest wind turbines in Wales.

3354

PONTGARREG
Llangrannog

A largely modern village in Cwm Hawen, E of Llangrannog.

Y WIG INDEPENDENT CHAPEL, ½ m. ENE. 1848–9. A handsome gable front in Pwntan sandstone, with open pedimental eaves and Venetian window under a main arch, an architectural display rare at that date. Later 'Florentine' window tracery. Attractive interior perhaps of *c.* 1900 with pierced cast-iron gallery panels, balustraded pulpit and matching great seat.

7367

PONTRHYDFENDIGAID
Strata Florida

The uppermost of the Teifi settlements, at the N end of the Cors Caron bog. Iron Age HILL-FORT on the Pen-y-Bannau ridge to E. The village is substantial, a droving centre, expanded in the later C19 by the lead mines. Terraced houses leading in from the S, with the church, the WAR MEMORIAL, 1922, a white marble female with wreath, and mid-C19 POST OFFICE, four bays, Late Georgian style with columned porch and C19 shopfront. Inside, still complete C19 shop fittings. Further down, hump-backed late

C18 single-arch BRIDGE. In the centre, Rhydfendigaid Chapel, with ISLWYN, an early C19 colourwashed two-storey cottage opposite. Further up, pair of large turn-of-the-century gabled villas opposite the Pantyfedwen Halls, and Carmel. Just E of the village, on the road to Strata Florida, DOLTEIFI and DOLGOED, two later C19 stone villas still in Late Georgian style, the first hipped, the second gabled, and of 1872, both with small-paned sashes.

ST DAVID. 1898–1900, by *Telfer Smith* of Builth Wells, though the foundation stone reads 1888. Plain, stone, single-roofed church with bellcote and lancets in pairs or threes.

CARMEL BAPTIST CHAPEL. 1872. Grey stucco gable front with three arched windows over a three-bay porch. Galleried interior.

RHYDFENDIGAID CALVINISTIC METHODIST CHAPEL. 1859–60. Handsome late classical design. Stone gable front with deep bracketed eaves, and arched windows in arched recesses. Interior altered in 1907, old-fashioned for the date. Large curved-ended pitch-pine gallery with long panels each divided by a roundel, the wood selected for its figured grain. Great seat with balustraded back. Pulpit platform balustraded each side of a panelled front with Neoclassical low-relief decoration. Between the rear windows, mosaic panel of 1907, inscription with dove and bible above. – MEMORIAL. Catherine James †1939, fine bronze portrait relief by *Gilbert Bayes*.

PANTYFEDWEN HALLS. 1956. Large community centre given by Sir David James, philanthropist, who was born at Pantyfedwen, Strata Florida. Roughcast and brown brick, single storey, like a primary school of the period. Library, added at one end, with large STAINED-GLASS window of 1964 by *Hardman*. Dominant central roundel portrait of Lady Grace James surrounded by cherubs, the design more of the 1890s than 1960s.

LEAD MINES. There was extensive mining to E and NE, especially NE of Ffair Rhos. FAIRCHANCE MINE (SN 746 685), pumped by a very early rotary water-pressure engine, 1785–91, and reopened 1859 with three water wheels, lies W of the track to the remote ESGAIR MWYN MINE (SN 755 692). Rediscovered in 1752 by Lewis Morris, agent to the Crown, and focus of a historic conflict between the Crown and county landowners, particularly the Earls of Lisburne and the Powells of Nanteos. Worked profitably in the later C18, and intermittently worked thereafter. From the 1890s to 1927 the main shaft was taken down to 145 fathoms, with further access to 165 fathoms, the deepest in the county. A wheel-pit of the 1850s, and a corrugated-iron dressing-plant of 1947, built to process the waste tips for lead and zinc, remain. Even more remote, to the NE, is ESGAIR DDU MINE (SN 768 697), worked in the 1760s and 1857. CWM MAWR MINE, just NE of the village (SN 736 673), was called an old mine in 1848, but substantially worked from 1911–17. BENDIGAID MINE, just S (SN 731 660), on the edge of the bog, was worked in the 1840s.

PONTRHYDYGROES
Ysbyty Ystwyth

Pontrhydygroes grew up around the offices and plant of the Lisburne Mines, with stone and yellow brick houses, notably the row of six by the chapel. In the village mid to later C19 POST OFFICE and STORES, with shop in the slate-hung gabled centre, house in wing to left, and lofted stores to right, lane to the chapel to r. Further S, below the bend in the road, a platform where the dressing floors for the Lisburne Mines were situated. The mines were accessed by the 'Level Fawr' started in 1785, ultimately the longest mine-drainage tunnel in Mid Wales, draining the Logaulas, Penygist and Glog mines. The level did not reach the first seam until 1824. Under the bend in the road is the entry, the cut stone arch with crossed pick-axes and inscription in the keystone. The dressing floor around the Level Fawr entry dates from after 1834, when the Logaulas mine became the second most prosperous in the county, after Frongoch, Trisant. The whitewashed adjacent building, GWYNFRYN, was the Lisburne Mines accounting house, c. 1840. Built against the bank, two storeys, hipped, with the office entry at the rear first floor. SW of the Post Office, on the lane to Llanafan, on l., LISBURNE HOUSE, mid-C19 mine stores building with slightly Gothic cart entries. The upper floor with big sash windows said to have been a mine apprentices' school. MOUNT HAZEL, down a track to l. ½ m. SW, was a mine manager's house, mid C19, with Late Georgian-type sashes but the doorcase with outsize brackets very Victorian.

N of the village, PONT RHYDYGROES, 1893, by *R. Lloyd*, stone bridge over the Ystwyth, replacing one rebuilt for Thomas Johnes (*see* Hafod). The Hafod estate began on the N bank. A pair of mid-C19 Hafod estate houses face over the bridge, YSTWYTH VILLA and HAFOD HOUSE, simplified Tudor style, with stable and former smithy. To r., HAFOD LOWER LODGE, c. 1875, cruciform stuccoed Italianate lodge to Hafod. The drive was the old road to Cwmystwyth, diverted later around the estate. The lodge replaces one of the 1790s possibly by Nash, and possibly a successor of c. 1835, for the Duke of Newcastle.

BETHEL WESLEYAN METHODIST CHAPEL. Converted to a house. 1873–4. Large scale, reflecting the late C19 mining population. Stone with yellow brick trim to the arcading framing the openings. Giant centre arch over a lunette plaque, paired upper windows and paired doors.

PONTSAESON *see* PENNANT

PONTSIAN
Llandysul

Village largely created by D. Evans, agricultural merchant, called 'Y Siopwr Mawr' (the Great Shop-keeper). In 1879 he built the

STORES, a long stone and yellow brick range comprising house, shop, stores, warehouse and woollen mill, the latter at the E end added after 1890 and turbine-powered. Low building opposite for the sale of bulk grain and seed. For Evans also, CLETTWR VILLA, 1877, to the l., CLETTWR TERRACE, workers' housing round the corner to the r., and GWYNFRYN, his own stuccoed villa added in the 1890s, appropriately on the hill above.

ST JOHN, ½ m. N. The church has the simplicity of a child's drawing. 1854–5, dated 5858 O.B., i.e. *oed byd*, the age of the world from its creation in 4004 B.C. Tower with corbelled parapet, nave with pyramid-capped angles and Y-tracery windows. Plain interior with thin roof. Stone, four-lobed FONT.
 A stone LYCHGATE and later C19 SUNDAY SCHOOL complete the group.

PANTMOCH, ¼ m. SW. At the farm, a large, late C19, three-storey corn-mill. Iron wheel by *T. Thomas* of Cardigan.

In the twin valleys of the Clettwr Fawr and Clettwr Fach, a scattering of C19 farmhouses, of the typical three-bay form with service wings and extensive stone outbuildings. In the Clettwr Fawr, PANTIORLECH, dated 1838; PWLLFEIN, slightly earlier with small upper windows and outshut rear; CRIBOR FAWR, dated 1841; and GWARLLWYNEOS, dated 1830, the house spoilt but the broad yard enclosed by good traditional ranges of low whitewashed outbuildings. In the Clettwr Fach, GLANCLETTWR, c. 1840, colourwashed yellow; and GWARALLTYRYN, of similar date, with outbuildings each end and an impressive mid-C19 range opposite, including a high-door barn, relatively rare in this area.

CASTELL HYWEL, 1½ m. N. Altered, large stuccoed farmhouse, apparently late C18 or early C19 but with traces of a more ancient past: a fragment of a corbelled chimney on one wall, massive reused floor beams within. Seat of the Lloyd family from the C14 to 1620, but tenanted thereafter. The Rev. David Davies, 1745–1827, kept a renowned school here from 1782.

CASTELL WMPHRE (or HYWEL), 1 m. N, by the roadside. C12 earth motte set steeply over the Clettwr valley, with ditch to E. Built c. 1110, probably by one Humphrey, a follower of Gilbert de Clare, taken and retaken frequently before fading from the record at the end of the C12. Held before 1150 by the poet Hywel, son of Owain Gwynedd, prince of North Wales, who took it in 1137.

PRENGWYN

4244

Llandysul

Crossroads village on the ridge between the Clettwr and Cerdin valleys.

PANTDEFAID UNITARIAN CHAPEL. 1836. Stuccoed, near-square with hipped roof. All the detail of 1898: long, two-light

windows and roundels. Boarded roof, end gallery with pierced cast-iron panels, balustraded great seat and Gothic panels to the pulpit. – STAINED GLASS. One window signed *John Hall & Sons* of Bristol, in the style of the 1890s, but as late as 1929. Stone and yellow brick chapel house and vestry of 1898.

CARMEL CALVINISTIC METHODIST CHAPEL, ½ m. N. 1832. Lateral façade of two big arched windows, outer doors and gallery lights. Grained woodwork of 1863, the pretty gallery with pierced cast-iron panels must be later C19.

GELLIFAHAREN, ½ m. S. Three-bay farmhouse dated 1795, built for J. Jones; the bay windows look early C20. Unusually large MODEL FARM of 1872. Covered cattle-yard behind an L-plan range of buildings stepped down the hill to imposing, if gaunt, effect at the SW angle.

COEDFOEL, ½ m. S. Dated 1832. Three-bay farmhouse with big kitchen chimney. Small detached outside kitchen. Long stable, barn and cart-shed dated 1821.

PANTYDEFAID, ½ m. E. Dated 1700, earlier than any other surviving farmhouse, but the tall, rendered three-bay front with C19 dormers gives little away. The rear stair-tower looks C18.

RHOSTIE see LLANILAR

3547
RHYDLEWIS
Troedyraur

107 The village is in the Ceri valley, behind the coast. In the centre, dark red corrugated-iron POST OFFICE and STORES, *c.* 1900, reminiscent of a colonial outpost, with curved iron awnings. The older settlement is at Hawen to the S.

HAWEN INDEPENDENT CHAPEL, Hawen. 1838. Pretty white-washed, roughcast long-wall façade. Arched centre windows, outer doors, and gallery lights, the glazing small-paned. Refitted in 1878. Long cast-iron panels in the gallery front, patterned in traceried circles, and marbled iron columns. The pulpit has fretwork panels and a plaster arch behind.

TWRGWYN CALVINISTIC METHODIST CHAPEL, on the hill to the NW. Lateral façade of 1846, spoilt in 1932 by a restoration that added the stucco and removed the small-paned glazing. The interior has a turn-of-the-century heaviness. Cast-iron gallery front in theatrical double-curve profile, densely patterned (cf. Penybont Baptist Chapel, Pontweli, Cms., of 1907). Big pulpit with Gothic trim.

RHYDLEWIS PRIMARY SCHOOL, 1 m. N. 1883, similar to the one at Brongest. Plain and altered school, the detached teacher's house to the l. is in a neat simplified Gothic, like *R. J. Withers*'s vicarage at Tremain, on a smaller scale. A single gabled window over the centre door, and sashes with shallow pointed heads, the ridge chimney off-centre to break the symmetry.

RHYDOWEN
Llandysul

Around a crossroads on the main Lampeter road: the old chapel, the stuccoed early C19 ALLTYRODYN ARMS, a stone stable building with well-cut Latin inscription over the door, and a whitewashed farm building.

CAPEL LLWYNRHYDOWEN (old chapel). 1834. The successor to the first Unitarian chapel in Wales, founded in 1734 at Llwynrhydowen, just s. Substantial stone lateral-fronted chapel with arched openings and half-hipped roof. The slightly Gothic eaves cornice is unusual, likewise the long back windows. Atmospheric tightly packed interior, refitted in 1862. Painted grained gallery on thin iron columns, panelled in vertical panels with a delicate Gothic moulding under the top rail. Small platform pulpit with balustraded sides and panelled front, similar Gothic moulding.

Disused since 1876 when the congregation was evicted after a notorious struggle between the landlord, John Lloyd of Alltyrodyn, and the minister, William Thomas, 'Gwilym Marles', over Lloyd's eviction of Liberal-voting tenants in the 1868 election. Thus the chapel preserves an atmosphere of the mid C19 in a manner lost elsewhere.

LLWYNRHYDOWEN UNITARIAN CHAPEL, ½ m. N. 1878–9, by *Watkin Davies* of Llandysul. Built for the evicted congregation with funds collected all over Britain. Rock-faced Llanddewi Brefi grey stone with beige sandstone dressings. The gable front with the giant arch so popular in Wales from the 1860s, framing a triplet of arched windows. Attractive interior with single gallery on fluted iron columns and coved ceiling. Scrolled cast-iron uprights to the rail around the pulpit platform, by the *Old Foundry*, Carmarthen. The Rev. William Thomas, 'Gwilym Marles', is buried outside.

TOMEN RHYDOWEN, on the w bank of the river, s of the bridge (SN 444 447). Eroded Norman motte.

ALLTYRODYN, ¾ m. s. A Lloyd family estate from the C17, the largest in South Cardiganshire in the mid C19. Large and severe three-storey, seven-bay roughcast sw front with deep-eaved hipped roof. Probably built for John Lloyd, who inherited in 1822: there was a date of 1827 on a kitchen overmantel. However, a straight joint in the left end wall indicates at least two phases. The front has a paired-columned Doric porch and a single arched window above. Behind, single-storey outbuildings surround a rear court with veranda on iron columns, very similar to *Nash*'s Llanerchaeron of *c.* 1793. Massive bakehouse chimney, raised high as the house, is cut into a rock bank.

Nash's influence is apparent inside, though the planning is more rigid. A wide entrance hall with well-detailed Greek frieze, and Regency fluted pilasters to the doorcases. A broad doorway with fanlight, matching the front door, opens through an exceptionally thick spine wall, into the rear stair hall.

Elliptical arch to the stair hall. The stair is spacious, in two flights with half-landing, but not remarkable in detail.

N of the house, STABLE COURT, dated 1840 (and A.M. 5844, the 'anno mundi' – the age of the world since the creation). Shallow three-sided court with two-storey wings, the rear of the home farmhouse to l., coach-house to r., framing single-storey nine-bay stable. The ashlar centrepiece with steep raised pediment, more rustic than classical. In the farmyard beyond, a similar, but less formal arrangement of taller wings framing a long main range. The end blocks are a lofted granary and a barn fronted by a gable with arched openings for doves, dated 1834; (cf. the more fantastical pigeon-house at Cilwendeg, Capel Colman, Pembs., of 1832–5).

On the N drive, a stone rustic BRIDGE and a roofless Gothic BATH-HOUSE with tiny pool within. Overgrown extensive WALLED GARDENS opposite. By the S drive, a restored lake with serpentine escape channel and mid-C19 pyramid-roofed SOUTH LODGE.

SARNAU
Penbryn

Main road village on the ridge behind the coast. Former CHURCH OF ST JOHN, of 1887–9, is very plain, stone with yellow brick, by *David Davies*. The medieval font, originally from Cenarth, is now at Penbryn.

SILIAN

Chapel and church in a small valley NW of the Lampeter to Tregaron road.

ST SULIEN. Rebuilt in 1872–3, by *R. J. Withers*, using the walls of a church rebuilt in 1839. His work cost only £505: nave and chancel with hooded lancets, but the W end with its small spired bell-turret a nice example of Withers' stone geometry. The gabled W doorcase carries a ringed shaft up to the corbelled base of the turret, which is broached to octagonal and capped by a stone spirelet. C5 or C6 INSCRIBED STONE at the l. end of the nave S wall – . . . BANDUS IACIT, the first letters obscured by a later cross. Open timber roofs, corbelled chancel arch and bold circular FONT of 1873. On the floor, C12 FONT, small rough bowl with four wedge-nosed oval faces at the corners, one bearded, of the type of the fonts at Cenarth and Pencarreg, Cms. – STAINED GLASS. E window, 1936, by *A. E. Lemmon* of Bromsgrove, late Arts and Crafts. Interesting streaky colours, and three quite charming small scenes (one of St Margaret with rustic chickens). Two nave N windows by *Celtic Studios*, Dorcas, 1961, and the Good Shepherd, slightly earlier, with more forceful dark colours. Nave S window of

c. 1950. In the vestry, C9 or C10 STONE with knotwork similar to that on the stone at Llanilar (q.v.) on one side, and a form of Greek key ornament on the other.

BETHEL BAPTIST CHAPEL. 1831. Small lateral façade with two sash windows and outer doors. Pleasantly crowded interior with panelled gallery on reeded wooden posts, the lower cornice marbled. Grained box pews raked against the back wall and to one side of the pulpit, which has a very serpentine top rail and turned balusters.

GLANDENYS, on the main road. Gabled stone and brick house of *c.* 1855, built for William Jones. The only striking feature is a pyramid-capped turret, part of later C19 additions.

FRONFELEN, on the hillside to the w. Hipped, roughcast three-bay villa of *c.* 1845.

SOAR Y MYNYDD *7854*
Llanddewi Brefi
8 m. wsw of Tregaron

SOAR Y MYNYDD CALVINISTIC METHODIST CHAPEL. Stand- 73 ing in superb isolation in the empty moorland, the chapel is a monument to rural piety, serving a scattered population on marginal smallholdings. 1828. Long whitewashed range of chapel, house and stable, the chapel with two arched windows and outer doors, the glazing later C19. No galleries but the tightly packed, slightly raked box pews typical of county chapels up to the 1860s. Later C19 pulpit with turned newels and finials.

STRATA FLORIDA/YSTRAD FFLUR *7566*

Strata Florida has a special appeal as one of the cultural centres of native Wales, a burial place of the princes of Deheubarth, and of the poet Dafydd ap Gwilym.

The beautiful setting, in the secluded and wooded valley where the Teifi first emerges from the mountains, is characteristic of Cistercian sites. By the abbey ruins, the former SCHOOL now houses a collection of carved stones from the ruins. Just N is the parish church in its large graveyard with ancient yew, tradition-ally the burial place of Dafydd ap Gwilym, fl. 1340–70. To the s is Great Abbey Farm, built partly with stones from the Abbey.

STRATA FLORIDA ABBEY

Although founded in 1164 by Robert FitzStephen, vassal of the de Clares charged with subduing Ceredigion, the link to the Normans was short-lived, for Rhys ap Gruffudd, the Lord Rhys of Deheubarth, began his challenge in the same year and by 1166 FitzStephen was a prisoner. The Lord Rhys confirmed the foun-dation in 1184, saying that he had 'begun to build the venerable

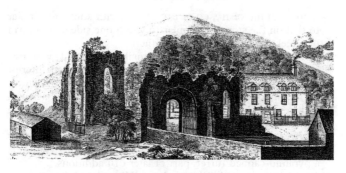

Abbey ruins and Great Abbey Farm.
Engraving by S. & N. Buck, 1741

Abbey entitled Strat-flur'. Thereafter the abbey was seen as his foundation and became the burial place of his heirs.* The Abbey was important to more than the princes of South Wales, for it was to Strata Florida that Llywelyn the Great summoned the Welsh magnates in 1238 to swear loyalty to his son Dafydd. The new abbey superseded Llanbadarn Fawr as the leading centre of Welsh culture, and was probably the scriptorium for the royal annals. Its association with the Welsh princes was such that King John resolved in 1212 that it should be destroyed, the decision commuted to a large fine.

Building may indeed have begun anew just before 1184, as the foundation of 1164 is said to have been on a different site, to the w, at Old Abbey Farm, though the archaeological evidence is uncertain. The monks took possession in 1201. The great bell was consecrated in 1255, indicating perhaps the completion of a central tower. The church was extensively repaired after 1300 as it was damaged in the war of 1282–3, burnt down, apart from the presbytery, when lightning struck the belfry in 1284 or 1286, and burnt again by English soldiers in the great revolt of 1294–5. In 1406–7 and 1415 English forces were billeted in the abbey during the wars against Owain Glyndwr, and the church was said to be all damaged except the walls. There was some revival in the C15, attested by bardic praise of the works of Abbots Rhys †1441 and Morgan (1444–86). Dafydd Nanmor refers to the 'great belfry, lime-dressed, big and white' and Guto ap Siencyn to a fine room with 'glass windows and flowery ornement'. It would seem that the cloister was rebuilt then. The community, however, remained small. By 1535 there were seven monks and buildings including the refectory and infirmary were ruinous.

After the Dissolution in 1539 the estates were leased to the Devereux family, and by 1567 the abbey site was owned by the Stedmans who built Great Abbey Farmhouse. In the C18 their

* Recorded as buried here are Rhys's brother Cadell †1175 and sons Gruffudd †1201, Hywel Sais †1204, Maelgwn †1231 and Morgan †1251; Gruffudd's wife Matilda de Braose †1209, and sons Rhys Ieuanc †1222 and Owain †1235; Owain's son Maredudd †1265, and grandson Owain †1275; Maelgwn's son Maelgwn Fychan †1257, grandson Rhys †1255 and grand-daughter Gwenllian †1255.

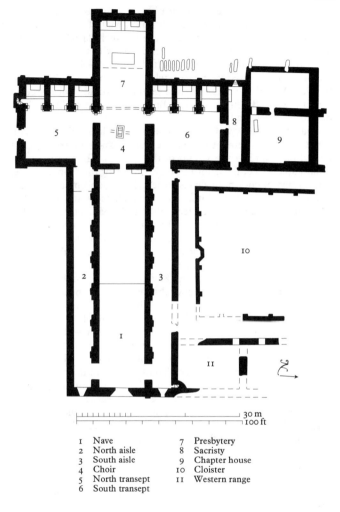

1	Nave	7	Presbytery
2	North aisle	8	Sacristy
3	South aisle	9	Chapter house
4	Choir	10	Cloister
5	North transept	11	Western range
6	South transept		

Strata Florida Abbey.
Plan

estate passed to the Powells of Nanteos. The Buck print of 1741 shows the abbey and Great Abbey Farm, the abbey with N transept walls, subsequently lost. Excavated 1887–90 by the architect, *S. W. Williams*, the ruins were entrusted by the Church in Wales to the Office of Works in 1931. Now in the care of Cadw.

The PLAN, as established by excavation, is to the Cistercian cruciform model, square-ended with three chapels on the E side of each transept. The E end was built first, though modified later, the nave added before 1201. This was aisled, but with the arcades raised on walls some five feet high, a feature not found elsewhere in England or Wales but known in Ireland. Evidence for a cross-

ing tower includes the crossing piers, fragments of the arches found by Williams, a mural stair in the N wall of the N transept, and the documentary evidence of the fire of 1284 which started in the belfry and burnt the roofs. In the early C13 the presbytery was extended by one bay and vaulted, and there is evidence for the floor being raised in the C14, when it was paved with encaustic tiles. A further raising of the sanctuary probably occurred in the C15, when the high altar was brought forward and two altars placed on the E wall.

Apart from the W wall, the remnants are all low wall-bases with some moulded detail to the bases of crossing piers, transept chapel piers and to the W end of the arcades. The W DOOR is a remarkable piece, far from the mainstream of the Romanesque. Five orders of continuous rolls (originally six, an inner order lost in repairs) are carried right around the arch without capitals, but interrupted regularly by thirteen ribbon-like bands terminated in a scroll – four across the uprights each side and five radiating around the arch, the centre band ended in a double scroll interlaced with leaves; there is also a scroll-ended hoodmould. Pointed aisle lancet to r., and evidence for three lancets over the arch.

The carved stones found in 1887 confirm the vaulting of the transept chapels with ribbed vaults, and a vault inserted in the presbytery when it was extended. The ribs of the latter were square-section ornamented with a double row of wheel-shaped forms on the face and sides (similar fragments have been found at Whitland Abbey, Cms.). Capitals were of a Transitional type, more stiff-leaf than scallop – and, interestingly, with a certain amount of Celtic interlace (see also the bosses in the exhibition). The nave arches were pointed and the arch mouldings of the crossing showed a round moulding to the earlier E arch, while the other three were square with an angle roll moulding. Three suggested forms to the nave piers: a thick quatrefoil cluster with shafts in the clefts (see the respond at the W end of the S arcade); a cross with steps in the angles, the corners roll moulded; and a round with four attached shafts. Details suggest similarities with the nave at St Davids Cathedral. The crossing, and in a minor form the transept chapel piers, were square with half-round responds and rebated angle-shafts.

Analysis of stones found in the 1887 excavation suggested a very poor quality lime mortar used with the local stone. There seem to have been dressings of four types: a millstone grit (apparently reused from an earlier building, as there was moulding reversed in the main wall), Bath limestone for the main dressings and quoins, some Bristol Channel yellow sandstone, and some purple Caerbwdy stone from St Davids, which Williams thought was used in banding the piers of the crossing and transept chapels.

Remarkable survivors are the early C14 TILES, with which the chancel and transept chapels were paved. Some are simply impressed with the decoration, some overlaid with white slip. The patterns are mostly geometrical, but there is a man in elaborate C14 dress with a mirror, a dragon and a griffin.

The monastic buildings were around a cloister, s of the church. On the E side, a narrow SACRISTY and BOOK-ROOM parallel to and of one build with the s transept. The CHAPTER HOUSE to the s may have been added in the early C13. Initially large, some 54 ft by 27 ft (16.5 metres by 8 metres), with a moulded and carved triple arcade on the W, of which fragments of stiff-leaf capitals have been recovered. It was halved in size in the C14, an indication of the reduced status of the abbey. The chapter house was the burial place for the descendants of the Lord Rhys, the large grave slab (a replica) covers a multiple grave, perhaps a reburial when the building was reduced in size. The base of the C15 N CLOISTER wall shows a five-bay range with five-light windows and a central reading alcove. The W range is almost all gone – this was probably the lay brothers' section – and the s range is lost, partly covered by Great Abbey Farmhouse. Against the fence, piles of moulded stones, in need of protection.

In the angle between the presbytery and the s transept are numerous medieval flat grave-slabs, some with incised crosses, some with small cross head and footstones. These may be of the family of the Lord Rhys. Some have been replaced in replica.

ST MARY. In the Abbey graveyard, near the great yew. A small stone church of c. 1815, replacing a barn-like structure shown in the Buck 1741 engraving of the abbey. A single vessel, with bellcote layered in slate (cf. Ysbyty Cynfyn). Windowless W wall with low arched door, and pointed windows with leaded wooden Y-tracery. G. T. Bassett, the restorer in 1914, preferred to keep the wooden windows. The lower part of the W wall and door arch are of squared yellow stones plundered from the abbey, one with a scratched date, 1759, and the abbey was perhaps the source of the monumental flags that form the string course below. In the N wall one of the stones with raised roundels from the abbey vaulting ribs. Against the E wall an INSCRIBED STONE, possibly C10 with linear cross. The interior still has a Georgian simplicity despite the C20 stained glass. Plastered ceiling, panelled W GALLERY on two turned columns and pretty turned altar RAILS. Panelled PULPIT, dated 1724; its odd shape suggests some reworking. Bleak Victorian reredos. – FONT. Medieval. Very small round bowl on a round shaft. – STAINED GLASS. A series of over-bright windows of 1961–7 by *Powell* of Whitefriars, given by Sir David James. – MONUMENTS. Nicely lettered slate plaques to Lt. John Morice †1821, Richard Edward of Ty Gwyn †1722, and Avarina Stedman †1734. In the NE corner a fine grey and white marble monument to Anne Lloyd †1778, wife first of Richard Stedman and then of the notorious Sir Herbert Lloyd (*see* Peterwell, Lampeter).

In the churchyard, a well-lettered memorial: THE LEFT LEG AND PART OF THE THIGH OF HENRY HUGHES, COOPER, WAS CUT OFF & INTERRED HERE JUNE THE 18TH 1756. Over-dominant monument of polished black Norwegian marble to Sir David James †1967, and his family. Hexagonal obelisk with

flaming ball finial. James, director of the Odeon cinemas, founded the Pantyfedwen Trust, for the support of Welsh-language causes.

GREAT ABBEY FARM. The Buck illustration of 1741 shows essentially the present four-bay house of two storeys, though with dormers and a square porch with strapwork cresting that have gone. The stonework shows that a large part of the r. side has been refaced in the C19, with brick window heads, but this is just a refacing, the missing first floor window is still evident inside. Double gable to rear l., the gables rebuilt in the late C20. Numerous stones from the abbey built into the house and the forecourt wall. Detached outside kitchen to r. Inside, consistent beams suggesting a single build. The ground floor r. room has earlier C18 panelling in large fielded panels and panelled cupboard. Overmantel painting of Youth tempted by Vice (semi-naked, with beard and asses ears). The l. kitchen has a large fireplace with spit-rack. Stair in the NE rear gable, open-well with turned balusters, moulded rail and closed string, mid C18. The topmost flight to the attic lost in a fire. Was the original stair in the gable to r., now small rooms?

Across the lane, C19 courtyard of FARM BUILDINGS, the barn range to W, a very long range of lofted cart-sheds and stables to the N, and cow-house to E.

PANTYFEDWEN, ¾ m. S. Stuccoed three-bay house, the character from early C20 alterations, but the front range early C19, the rear wing older with heavy beam. To r., an attractive early C19 lofted COACH-HOUSE, hipped, three-bay, the centre keyed roundel flanked by scroll-carved stones from the abbey. John Davies of Pantyfedwen instigated the first excavations of the abbey in 1847.

LEAD MINE. Prominent on the N side of the valley (SN 744 661) are the spoil heaps of the ABBEY CONSOLS or FLORIDA LEAD MINE, exploited from 1856, the wheel fed by a leat from the Teifi Pools in the hills to the NE.

6966 SWYDDFFYNNON
 Ystrad Meurig

The village has some character, a narrow street running SW down to the bridge. Altered SCHOOL of 1896.

SWYDDFFYNNON CALVINISTIC METHODIST CHAPEL, 1837. Lateral façade with bracketed eaves and four arched windows, unfortunately cement-faced and rewindowed. Pair of earlier C19 stone chapel cottages adjoining, just two bays with big centre chimney.

BETHEL BAPTIST CHAPEL, down lane to S of the school. 1868, the plain stone front altered in 1898.

FFOS, ½ m. NW. Long colourwashed farmhouse range of two storeys, apparently later C18 altered in late C19, but probably incorporating parts of Ffosybleiddiaid, seat of the Lloyd family from the C16 to mid C18.

St Bridget's Well, Gwenhafdre, ½ m. NW. Behind the farmhouse is a holy well in a dry-stone vaulted chamber.

TALGARREG
Llandysiliogogo
4251

In a fold of the bare upland s of Llanarth. At the N end, Plas, hipped three-bay small gentry house of 1824, built for the Lloyd-Williams of Gwernant.

St David. 1898–9. Plain stone chapel of ease with bellcote.

Pisgah Independent Chapel, ½ m. NW. 1871. Plain stone gable front, but attractive painted grained pews and panelled gallery front.

Bwlchyfadfa Unitarian Chapel, 1 m. S. 1905–6 by *David Davies* of Penrhiwllan, more or less a copy of John Wills's Graig Unitarian Chapel in Llandysul of 1884. Gothic with a squat tower, but as late as 1906 Davies was praised for having the 'courage to deviate', that is from the Italianate norm. Bleak interior with Gothic roof trusses, no gallery.

TALSARN *see* TREFILAN

TALYBONT
6589

Surprisingly large village, mostly later C19, for there were woollen mills on the Leri and the Ceulan, and lead mines in the hills behind. In the centre, a triangular green, a rare sight in this county. On the N side, the Black Lion, mid-C19, five bays, in grey stone, with arched windows, Gothick glazing bars and porch with octagonal columns. Stable yard on the E side of the green. On the main road to the N, later C19 terraced houses, still with the bracketed eaves and small-paned sashes of the early C19. On the r., Neuadd Goffa, war memorial hall, 1923.

St David, on N edge of the village. 1909–10, by *Deakin & Howard-Jones*. Harsh materials, dark green stone and brown terracotta. Squat W tower, with pyramid roof behind battlements. Nave and chancel under one roof, but the chancel narrower. – Stained glass. E window, Good Shepherd, Modernist glass in deep colours, 1959, by *Kenneth Baynes*.

Bethel Independent Chapel, N of centre. Stuccoed Gothic long-wall façade, dated 1830, but probably rebuilt in 1859, and remodelled in 1882. Four bays, two large centre Gothic windows, with vigorous timber tracery of 1882 in muscular High Victorian mode, and matching heads only also over the outer porches. The interior of 1882 is unexpectedly rich, with pitch-pine galleries on four sides, the detail in quatrefoils and fretwork. Pulpit on the back wall, with organ gallery above, behind a triple arch on big ringed iron columns. The pulpit has

ornate incised and notched decoration, the influence clearly from J. P. Seddon.

TABERNACLE BAPTIST CHAPEL, adjoining Bethel Chapel. Disused. Dated 1812, but rebuilt in 1834, and refronted in 1931 by *J. Lewis Evans*. The original long-wall front is disguised by Beaux-Arts-derived classical stucco detail. Two-bay pedimented and pilastered centrepiece framing the main arched windows, channelled base, broken by the pedimented outer doors, and roundel lights above with elongated keystones and pendants. The interior had a painted-grained five-sided gallery and densely packed pews, now gone.

NAZARETH CALVINISTIC METHODIST CHAPEL, W of main road. Dated 1868 but the stucco front looks of the 1920s, with echoes of Tabernacle (*see* above). Channelled rustication and cornice on a pair of pilasters. The chapel house may be of the 1860s, but still has Georgian sashes.

SOAR INDEPENDENT CHAPEL, Penysarnddu, 1m. NE. 1867. Small gable-fronted chapel with arched windows.

POLICE STATION, N of centre. 1903, now community centre. Deep red terracotta, two gables, the lower stepped forward with a bulbous-columned Palladian window, the other two-storey with variants on the tripartite window each floor. Possibly by *J. Arthur Jones*.

LERI MILLS. In the Leri gorge below the bridge, an extensive disused woollen-mill complex that in part goes back to a lead stamping mill of Thomas Bushell's of *c.* 1640. As finally developed, the Leri Tweed Mills were three separate sites: the main site, called Middle Factory, *see* below, then downstream on the N bank, CWM FACTORY, a plain stone single-storey five-bay mill with water-wheel dated 1858, and the Lower Factory, now YR HEN FELIN, a private house, mid to later C19.

The MIDDLE FACTORY group comprises two stone ranges parallel to the river with a leat between, and one at right angles. The upper range appears the older, with rough stonework and big external chimney-breast, but little datable detail. The top floor, accessed from the track, is clearly a C19 addition as a drying-floor. The range at right angles is probably a mill of 1809, with half-hipped roof and small-paned windows with iron glazing bars. Later C19 13-ft water-wheel and extension at the upper end. The lower range along the river is a later C19 flannel mill, but on an older site, two storeys, five bays with brick window heads. A partly collapsed dyeing-shed just beyond appears to be converted from something much older, with oak beam and internal lintels.

CEULAN MILLS, in the village, E of the main road. Late C19 woollen factory. Stone, two-storey, seven-bay range with brick window heads. At one end a very large water-wheel, the hub cast by *J. Edgar* of Dublin, the rim dated 1891, made by *Griffith Ellis & Co.* of Aberystwyth. At the other end, an early C20 Pelton wheel which for some years generated electricity for the village.

PENPOMPREN HALL, ½ m. NE. Mid-C19, stuccoed and hipped villa, with bracket eaves, and spoilt windows. The stretched proportions indicate a late date for such late-Georgian-style buildings. The garden front with a big curved drawing-room bay in the centre is near-identical to Ffosrhydgaled, Chancery, of 1865, before it was altered.

BEDD TALIESIN *see* Tre Taliesin.

THE LEAD MINES

NE of Talybont

On the footpath runnning W and N from Penpompren were PEN-POMPREN MINE (SN 658 901), then ERGLODD MINE (SN 657 904), and finally, on the ridge, PENYBANC MINE (SN 661 906). All were known in the C18 and probably earlier, and large amounts were spent in the mid C19, but no structures survive.

Cwm Ceulan and Nantymoch

E from Talybont, the Nantymoch road follows Cwm Ceulan up into the bare hills. At the head of the valley are the spoil-heaps of BLAENCEULAN MINE (SN 716 905), worked 1852–84. At the N-most point of the road a forestry track diverts E to the ESGAIR HIR MINE (SN 735 912). This was a famous site, the 'Welsh Potosi', that in the late C17 and early C18 was supposed to rival the South American mine for wealth in silver. It never did; the Company of Mine Adventurers struggled from 1693 to 1708, opening a second mine further on at ESGAIR FRAITH (SN 741 912). The next major undertakings were in the 1840s and 1850s, the company sometimes named the Welsh Potosi Company, but more money was lost. Another attempt from 1877 was bankrupt in 1882. Copper ore was mined at Esgair Fraith, the only such mine in the county. At Esgair Hir, there are spoil heaps and remnants of later C19 buildings, notably the offices and engine-house opposite each other. The Esgair Fraith site is further on into the forestry, with the wheel-pit still visible by the track.

Cwm Cyneiniog

From Talybont again, following the Leri valley E, the Cyneiniog valley, or Cwm Tynant, runs E past BETHESDA CHAPEL, a small stone chapel of *c.* 1855, to the BWLCHGLAS MINE (SN 710 878) with massive spoil-heaps on the S side of the valley. This was a very late mine, worked 1909–16 by the Scottish Cardigan Co. Concrete foundations remain of the corrugated-iron buildings. Opposite, on the N slope, ALLTGOCHYMYNYDD farm, a rare C18 vernacular farm-house, whitewashed stone, irregular, with steep slate roof and end chimneys, the larger kitchen chimney to the left with tiny

fire-window. At the very end of the valley, the HAFAN MINE,
SN 728 879, worked from the C17, and in the C19 worked with
Henfwlch (*see* Ponterwyd) over the ridge above the Nantymoch
reservoir. Large spoil-heaps, and a wheel-pit of 1853. From
Hafan ran the Plynlimon & Hafan Tramway, opened in 1897,
to carry lead down to the railway at Llandre. There was an
inclined plane up to stone quarries above Hafan, of which
traces can be seen. The enterprise failed within two years.

SW of Talybont

On the forested hill to the SW was ALLTYCRIB MINE (SN 653
895) worked by Thomas Bushell in the 1640s. His adit crossed
an even earlier 38-fathom shaft. It was largely worked out
before the C19, but several times restarted.

TANYGROES
2849
Penbryn

Main road village on the coastal ridge NE of Cardigan. In the hill
E of the main road was the quarry for the Pwntan sandstone,
much used locally.

TANYGROES CALVINISTIC METHODIST CHAPEL. Dated 1849
and 1882. Handsome front in tooled sandstone. An early gable-
end façade with arched small-paned windows and outer doors.
Nicely scrolled date plaque. Interior of 1882, the pulpit still
backing on the entry wall, presumably the original arrange-
ment. Gallery front with pierced cast-iron strips, and arch-
panelled pilasters. Pulpit with fretwork panels.

TREFILAN
5557

Church, school and vicarage stand just by CASTELL TREFILAN,
a C12 Norman motte, where the broad valley running N from the
Aeron narrows. The larger settlement is at TALSARN, by the
Aeron. PONT TALSARN is probably late C18, a three-arch bridge
with low cutwaters. Three-bay, three-storey, Late Georgian
painted front to the RED LION, just N, and a small early C19
SMITHY, with hipped roof, opposite. This has a double main
hearth for heating the iron tyres of cart-wheels and another single
hearth. Two large bellows survive. N of the inn, TY MAWR has
large external stacks that indicate an early date, and indeed a
piece of wood dated 1524 was found in the wall under one of the
main beams. Late C19 yellow brick heads to the windows. Inside,
re-sited, a later C17 oak doorcase with a crude leaf border and
bead-and-reel outer moulding.

ST HILARY. Rebuilt 1880–2 by *Archibald Ritchie*, replacing a
church of 1806 and 1834. One of his better designs, strongly
detailed without fussy variety. Dark stone with Doulting stone

tracery. Nave, s porch and chancel, with the bellcote on the e end of the nave. Lancet windows, a pair at the w end with an ashlar circle over-pierced by four plain roundels. Open timber roofs on corbels, carved stone three-bay REREDOS and over-done octagonal FONT. – LECTERN. 1881, a characterful swan-like eagle, made by *David Davies* of Perthneuadd, local farmer. – STAINED GLASS. e window, 1881 by *Heaton, Butler & Bayne*, three-light, muted colours. Nave s lancet, 1994 by *Janet Hardy*, early medieval-style figures. – COFFIN TABLE. Of the 1840s perhaps, with vine scroll carving on the top rail. – BELL. Dated 1760, given by Sir Herbert Lloyd of Peterwell.

Across the road, a pretty lofted STABLE and BIER HOUSE, early C19. To the w, TREFILAN SCHOOL, *c.* 1860 (cf. Nantcwnlle), with hoodmoulds at the eaves under small gables. Originally two-bay, a third added to the w. Windows spoilt by modern glazing.

HERMON CALVINISTIC METHODIST CHAPEL, 1 m. NNW. Dated 1881, a late example of the simplest chapel type. Chapel and house in a single range: two windows and a door for the chapel, a door and a window to the house, with no differentiation or decoration. The interior is correspondingly bare.

PLAS TREFILAN, SE of the church. Former rectory of 1828–30, unusually substantial. Well-proportioned square villa with pyramid roof on bracketed eaves, the original roughcast removed. Rectangular light with diamond tracery over the door, the diamond pattern repeated in the trellis porch. Rooms around a central stair hall, the curved staircase rising to a central landing lit bizarrely by a tall, plastered conical shaft through the loft to a skylight near the roof apex. This curious feature also appears at Glandwr, Tresaith, of 1809, and Treforgan, Llangoedmor, of *c.* 1810.

GELLI, ½ m. N of Talsarn. At the head of the drive, an early C19 picturesque thatched LODGE, reconstructed from ruin in 1978. Roughcast octagon with Gothic windows and a pointed door, under a great round bonnet of thatch carried on a veranda of rough pine posts. Central octagonal stone stack. The best example in the county of the cottage lodge associated with *John Nash.* Nash's name has been suggested as architect of the s range of the house, built for the Rogers family *c.* 1800, on the end of a house of *c.* 1700. The front range is a neat, hipped three-bay villa. On the ground floor are Palladian windows, the centre arched light glazed, the sides with fixed louvred shutters; mullions with fluted consoles. The doorway has an arched fanlight. Pretty timber Gothic porch of two thin quatrefoil columns and a flat cornice. All this detail is surprisingly good, but not consistent with any design by Nash. The rear wing is one of the very few surviving gentry houses of the *c.* 1700 in the county. Modest in scale; whitewashed, five-bay, with small timber cross windows, still with some original leaded glazing. Projecting rear gable, with a lunette and long stair window.

Inside, the front range has an open-well stair and Regency

panelled doors, but nothing to suggest Nash in planning or detail. In the older part, a broad oak stair with closed string and twisted balusters, *c.* 1700 and scarfed roof trusses.

In the farmyard, one outbuilding, latterly a stable, with big stone chimney, lath-and-plaster fire-hood inside and scarfed roof trusses. The cow-house, externally C19, has three heavy oak scarfed cruck trusses that may be C17. The garden wall is of earth, spectacularly eroded on the N side.

FELIN COED, 1 m. E of Talsarn. A good example of the *clom* or earth-walled cottage once typical of the Aeron valley. Quite large, with two rooms and centre passage, the rooms markedly stepped downhill, the lower parlour earth-floored. Thatched roof under zinc. It is probably C18; the roof trusses appear to be scarfed crucks.

BRYNOG and LLANLLYR. *See* Ystrad Aeron.

6859 TREGARON

The market town for the eastern uplands, under the hills crossed by the lonely drovers' road to Builth Wells. NW of the town is Cors Caron, a great area of raised bog remaining from a moraine-blocked shallow lake. The town itself is on the river Brennig and was part of the lands of Strata Florida Abbey. It developed as a cattle and horse market on an important drovers' road across the hills to Builth Wells.

ST CARON. A strong C14 W tower is all that remains obviously medieval; the rest was rebuilt 1878–9 by *Archibald Ritchie*. Nave and chancel under a single roof; plate tracery to the E window, otherwise a variety of grouped lancets. The tower is one of the largest in the county: typical battered base, tiny paired bell-lights and rough corbels to an embattled parapet. Higher NE stair-tower. Carved stone rainwater spout, 1995, part of the restoration, by *Roger Clive-Powell*. A tall stone vault within.

The rest is a broad single space, with six-bay roof, slightly elaborated over the chancel.* – FONT. Possibly C14, the bowl seven-sided with raised angle fillets. – Heavy stone PULPIT of 1879, REREDOS of 1886, thin iron SCREEN of 1924. – STAINED GLASS. All C20, four by *Shrigley & Hunt*; E window of 1922, competent late Gothic; nave N third *c.* 1932, with a certain gloomy mystery; chancel S, *c.* 1936, and nave S first, 1944, both poor. Two windows by *Celtic Studios*, 1952, nave N first and nave S third. The latter with elongated figures and finely drawn faces.

BWLCHGWYNT CALVINISTIC METHODIST CHAPEL, Lampeter Road. A large chapel of 1833, built to the same design as the contemporary Capel Y Garn, Bow Street. Lateral façade with arched openings; two centre windows, outer gallery

* Three inscribed stones described by Meyrick in 1810 were removed by him to his house, Goodrich Court, Herefs., where one remains, the other two are in the National Museum of Wales.

Tregaron Church.
Engraving

windows and doors. Later C19 stucco and glazing. Slate-hung
sides. Handsome interior: tightly packed, painted grained box
pews, slightly raked under the galleries and curving at the front
to echo the line of the great seat. Gallery of 1865, long hori-
zontal panels divided by arch-panelled strips. VESTRY and
MANSE of 1904.

MEMORIAL HOSPITAL, Dewi Road. Built as the workhouse in
1876 by *G. Jones & Son.* Plain, rendered three-storey barrack
block with an apologetic centre gable. Refreshingly humane
low single-storey addition of 1982.

TREGARON COUNTY SCHOOL, Lampeter Road. 1898–9 by *L.
Bankes-Price* of Lampeter. Single storey, very economical, in
grey stucco. Gabled wings flank a four-bay centre with two
gables. Additions behind 1909. New buildings across the road,
1949–50, by *G. R. Bruce*, flat-roofed, with a brick tower to one
side.

PRIMARY SCHOOL, Station Road. 1912–13, by *G. Dickens-Lewis.*
The bones of an interesting design remain, but spoilt by new

windows. Double-gabled front with a canted bay recessed under a broad cambered arch, and classical copper cupola.

PERAMBULATION

E of the river, THE SQUARE, a triangular space of some charm. In the centre, bronze STATUE of Henry Richard (1812–88), M.P. for Merthyr, and called the 'Apostle of Peace' for his role as secretary of the Universal Peace Society. 1893, by *Albert Toft*, an unpompous figure in ordinary dress holding spectacles and a sheaf of papers marked 'Peace'. On the N side, the MEMORIAL HALL, 1875, by *Roderick Williams*, built as a Market Hall by the Powell family of Nanteos, and altered in 1922. Hipped, grey roughcast, four windows upstairs over three broad openings below. There was a central gablet in the roof. Painted roughcast mid-C19 houses to the l. and BARCLAYS BANK, 1911, by *Deakin & Howard-Jones* of Borth, grey stone with yellow terracotta. The TALBOT HOTEL effectively fills the SE side, the main part of *c.* 1850 (George Borrow stayed there in 1854). Stuccoed, three storeys, with bracketed eaves and a broad wooden porch elaborated with some fretwork. The two-storey wing to the l., may be the original late C18 inn, whitewashed, four bays, with an external chimney-breast and some heavy beams within. The r. wing was the stable range, mid C19. The large plate-glass shopfront on the SW side was THE EMPORIUM, 1887. The church is on a mound to the W, above the river.

S of the square, on DEWI ROAD, the former NATIONAL SCHOOL, 1873, by *Roderick Williams*. Plain stone and yellow brick Gothic with a timber bell-turret, and a memorial garden in the remains of the WESLEYAN CHAPEL, 1873. Further out, the hospital (*see* above). E of the square, PENTRE, an area of small cottages, now mostly later C19, though the early C19 PLAS BACH, at the NE end of the winding lane, is a good example of the small single-storey stone houses of the region.

W of the square, across the C20 bridge, the NATIONAL WESTMINSTER BANK, 1924 by *Palmer & Holden*, architects to the National Provincial Bank. As the only piece of authentic timber framing W of the mountains, the design evokes surprise; one can only imagine that it was intended for Powys and strayed. But in its own terms it is an attractive structure imbued with Arts and Crafts handwork. Single-storey, box-framed, with roof of pale graded slates, leaded mullion-and-transom windows and a big, central canted bay overhung by a timbered gable. On STATION ROAD, to the N, TREFELIN, a late C18 vernacular house, whitewashed with horizontally sliding windows, a type exceptionally rare in the county. Further out, the Primary School (*see* above). To the SW, on the LAMPETER ROAD, Bwlchgwynt Chapel and Tregaron School (*see* above). Tregaron parish extends over many miles of upland to the E. The drovers' road follows Cwm Berwyn up and over to the

Camddwr headwaters in the bare grassland called the Desert of Wales and over another pass to the upper Tywi valley, which is the county boundary with Powys. But the whole area is almost without buildings. On the roadside in Cwm Berwyn, CAPEL Y RHIW, 1866, built as a schoolroom-cum-chapel. Simple stone lateral front, two arched windows and a door. Inside are still the reversible desk-pews.

Just NE of the town, the VICARAGE, early C19, remodelled quite well in the 1930s, with two bay windows and steep slate roof. Further on, BLAENCARON CALVINISTIC METHODIST CHAPEL, 1875. Plain stucco with arched windows. Painted grained pews, slightly raked, inside and no gallery. Further into the hills, on a high outcrop, CASTELL RHYFEL (SN 654 632), Iron Age hill-fort with single bank.

In the plain, to the SW, TRECEFEL BRIDGE, by *Nash*, 1793, has gone, as has its successor, replaced by a bland piece of concrete. TRECEFEL is a later C18 farmhouse, said to have had a date of 1787, three storeys and three bays with modillion eaves cornice.

NW of the town the A485 skirts the bog, crossing the Teifi at PONT EINON, 1805, three-arched stone bridge. At Ty'n-yr-eithin, Y BERTH CALVINISTIC METHODIST CHAPEL, 1908, bleak design in black brick with hipped wings to the façade. Further NW, CASTELL FLEMISH (SN 654 632), Iron Age enclosure on an outcrop with sweeping views across to the hills. Two large banks on the N and one to the S. There is an eroded Norman MOTTE overlooking the bog from the high ground behind Llwyn-gwinau (SN 668 634).

TREGROES
Llandysul

4145

Small village in the Cerdin valley.

ST FFRAED. A small church of 1858, but unusually neat, evidence of a careful architect on a limited budget. Lancets, apsed E end, and a single roof with pretty slated timber spirelet on the ridge, marking the chancel, also defined by a narrowing of the walls. *R.J. Withers* is the most likely designer, but *G.E. Street* made designs for a church for Llandysul in 1855 to the same plan though more elaborate. Plain plastered interior. – FONT. Battered small, square medieval bowl.

DYFFRYN LLYNOD, ½ m. N. The house, dated 1785, is altered. The long whitewashed outbuilding has a later C19 iron water wheel.

CWM HYAR, 1 m. NW. Dated 1790. Plain three-bay house with small-scale outbuildings dated 1799 and 1826. It was a house of the Lewis family, illustrative of how close to farmsteads such gentry seats could be.

DINAS CERDIN, 2 m. NW. A low three-bay farmhouse, dated 1795, under the shadow of DINAS CERDIN HILL-FORT.

TREMAIN

The parish spreads over the coastal ridge, with no village centre.

St Michael, s of the main road. A new church on an old site, 1846–8, one of the first ecclesiologically correct new churches in the county. The architect was *John Jones* (1810–69), the bard 'Talhaiarn', an assistant in the office of Scott & Moffatt in London, the partnership that built the National School in Cardigan for the same patron, the Rev. Robert Miles of The Priory. The church, economically detailed in lancet style, has something of the pattern book in its regular buttressing, and steep roof pitches, though the w end mid-buttress, and little turret on the n aisle (in fact a vestry) give character, as does the spectacular lichen growth on the Pwntan sandstone. Inside, the same neatness, grey stone two-bay n arcade and matching chancel arch, set against plaster walls and open rafter roofs. – Fittings of extreme plainness; chancel stalls with outsize poppyheads and simple panelled pulpit. Two brass coronae, still unelectrified, and oil wall-lights survive. Stamped quarries for the chancel glazing. – Font. Heavy scalloped c12 square bowl on a thick round shaft, like the one at Mwnt.

Ffynnonbedr Independent Chapel, ½ m. n. 1865, unusually late example of the square hipped type, with long arched windows. External and internal detail of 1889, probably by *David Davies*.

Dolcoed, on the main road. Built as the vicarage, 1867, by *R. J. Withers*. A model of simple Victorian house design, in grey Cilgerran stone with small-paned sashes. Three bays with centre gable breaking the eaves and a ridge chimney to break the symmetry.

Treprior, n of the main road. An interesting small model farm of the 1860s, presumably for the Priory estate, Cardigan. Two outbuildings, a small barn and a cow-shed, use the unusual hollow L-shaped interlocking bricks made by the Cardigan brickworks, which the estate owned. The light touch of Gothic suggests the architect may have been *R. J. Withers*. Stone three-bay c19 farmhouse with half-dormers; typical regional lofted cart-shed and stable.

TRE'R DDOL
Llancynfelyn

Small village off the main road to Machynlleth. Single arched bridge over the Cletwr.

Soar Wesleyan Methodist Chapel, at the s end. 1874–7, in the style of *Richard Owens*, similar to his Siloh, Lampeter, but *David Williams* of Aberystwyth is the only name so far associated. Romanesque round-arched manner with stilted arches and plate tracery but no historicist carved detail. A low hipped

stair-tower on one side is balanced by a tall octagonal turret with candle-snuffer roof. No galleries inside, though it is clear that they were intended. Pulpit with arcaded front, the arched panels in contrasted wood, set against an arched recess framed in ornate pilasters and entablature.

YR HEN GAPEL, at the N end. Now a museum. The original Soar, 1845, a simple stone chapel of some size, built into the slope to give an end basement. It was here that the Rev. Humphrey Jones, newly returned from America, sparked the religious revival of 1859. Asymmetrical, four-bay lateral front of large sashes and door in the third bay. Interior is aligned on an end-wall pulpit with pews raked up towards the rear. Simple pulpit platform with panelled pulpit and plain balusters each side.

DOLCLETTWR, ¼ m. W. A small gentry house of the mid C16, assessed at three hearths in 1670. Externally plain, rendered and partly rebuilt after a fire in 1996. An early storeyed house, of which the heavy ground floor beams, and a massive oak bressumer in the N room survive. An unglazed diamond-mullion window by the fireplace and two raised cruck trusses were lost in the fire.

LODGE PARK, I m. N. On a wooded outcrop above the Dyfi marshes. An intriguing house, which originated, as early as 1600, as a Gogerddan estate hunting lodge with an enclosed deer park. It was tenanted in the early to mid C17 by those dynamos of the lead and silver mines, Sir Hugh Myddelton and Thomas Bushell. The present house looks later C17, though altered, square with double-valley roof, giving three hips each side, and two large axial chimneys with remnants of diagonal shafting. The chimneys equal the six hearths for which Thomas Pryse was taxed in 1670. Two storeys on a high basement, three-bay stuccoed front, with Late Georgian sashes. The big stucco porch, up a flight of slate steps, looks mid C19. The Gogerddan accounts have payments for an extensive refit in 1787–91, which would include the surprisingly massive kingpost trusses in two of the roofs. The interior plan of the central hall, principal room each side and stair to rear reveals little; the little surviving detail there is Late Georgian to Early Victorian.

The deer park, existing in 1637, is enclosed by stone-faced earth banks with an inner ditch, principally on the N and W, the C17 leases refer to hedge and ditches elsewhere.

TRESAITH
Penbryn

A seaside village in four parallel terraces, on a steep slope overlooking a small bay. In 1852 J. S. Harford of Falcondale, Lampeter, proposed a new resort with hotel, villas and cottages, later to have a church, schools and a market. *R. K. Penson* was his architect, but nothing came of it. Some later C19 stuccoed

villas with bay windows; only the Ship Inn, since altered, and a single-storey cottage, once thatched, SE of the beach are earlier. There was some small-scale shipbuilding in the late C18 and early C19 on the beach. Behind the beach, the remains of a circular LIMEKILN.

BRONMOR, at the top of the village, is a picturesque stone villa of 1889, with some half-timbering and a swept roof. Built for Mrs Puddicombe, the novelist 'Allen Raine', by *T. L. Worthington* of London.

GLANDWR, down a drive ¼ m. S. A villa of 1809 built for the Lloyd Williams family of Gwernant, Troedyraur. Pyramid roofed, three bays, with Gothic ground-floor windows, influenced by *Nash*. The most interesting feature, a centralized plan with square landing lit by a conical roof-light up through the roof space, appears also at Treforgan, Llangoedmor and Plas Trefilan, Trefilan, houses of *c.* 1810 and 1828–30.

TRE TALIESIN
6591
Llancynfelyn

A long ribbon village on the steep edge of the Cors Fochno marshes, that grew with lead-mining. C19 stone terraces, the later ones with yellow brick, the earlier ones with red brick, twelve-pane sashes and bracket eaves, i.e. *c.* 1860–70. At the N end of the village, altered BOARD SCHOOL of 1873 and, unaltered, the former NATIONAL SCHOOL, of 1856, stone, single long classroom with centre chimney and end porches, to the same design as the one at Capel Bangor, so probably by *Roderick Williams*.

REHOBOTH CALVINISTIC METHODIST CHAPEL. 1899–1900, unpainted stucco with heavy arched triplet over a three-bay porch. Plaque of 1830 from the earlier chapel.

LEAD MINES. Two mines on the ridge E of the village, near Bedd Taliesin. BRYNARIAN MINE (SN 664 915), past Gwarcwm Isaf farm, where three successive firms altogether lost some £21,000 between 1849 and the 1860s. The building that remains, built in a failed reopening in 1869–71 – two small chambers flanking a long narrow wheel-pit – ought to be a crusher house, but has no sign that machinery was ever installed. Nearby, W of the farm drive, PENSARN MINE (SN 668 912), worked with Brynarian.

BEDD TALIESIN (SN 671 912), 1 m. E. The reputed grave of the C6 bard Taliesin, but probably a Bronze Age kerb cairn. In 1781 it was said that it had been 'within these five years, entirely plundered and the broken stones are now converted into gateposts'. A 6-ft (1.8-metre) long stone-lined grave with the side slabs tilting inwards and the capstone dislodged at one end.

TRISANT
Llanfihangel y Creuddyn Uchaf

Upland between the Ystwyth and Rheidol valleys, the church isolated on a hill-top two miles SW of Devil's Bridge.

LLANTRISANT CHURCH. An ancient site, abandoned in the C17, when a new church was built at Hafod, and not rebuilt until 1882. Plain nave and chancel with bellcote and lancets, gloomily rendered. Thin roof trusses. Against the church hall, an INSCRIBED STONE with Latin cross, the foot dagger-pointed.

TRISANT CALVINISTIC METHODIST CHAPEL, 1 m. NW. 1850. Gable-fronted chapel similar to others in the lead-mining area (Ponterwyd and Ystumtuen), plain exterior with arched small-paned windows and ranks of painted grained box pews within.

SALEM CHAPEL, Mynyddbach, 1½ m. NW. Lateral fronted chapel of 1844, altered and rendered in the late C19, but the box pews probably of 1844.

LEAD MINES. FRONGOCH MINE (SN 723 745), 1 m. S, was one of the most successful in the county, exploited by John Taylor for the Earl of Lisburne from 1834. Before 1910 the mine had produced some 107,000 tons of ore. Along the side of the hill, remains of a CRUSHER-HOUSE, and two ENGINE-HOUSES for steam engines introduced 1841 and 1868. To the SW, by the main road, the massive substructure of a DRESSING-MILL, and, along the road to W (SN 707 744), very large stone shell of a hydro-electric POWER-HOUSE, both built in 1898 by the Société Anonyme Metallurgique de Liège. Beyond the power-house, on the S side of Cwm Newydion, GRAIGGOCH MINE (SN 703 740), worked 1840–89. In a waste of broken stone, the walls of a large CRUSHER-HOUSE and long WHEEL-PIT.

TROEDYRAUR

An isolated church on a crossroads above the Ceri valley, the main settlements being at Brongest (q.v.), and Rhydlewis (q.v.).

ST MICHAEL. 1850–1, by *Charles Davies* of Cenarth, not a correct Gothicist at all, but the result has charm. Grey Cilgerran stone. Steep-roofed single nave and SE vestry to matching scale, giving a double-nave effect at the E end. The wooden windows show the date, neither Georgian small panes, nor correct Gothic stone tracery. S porch in the dressed Pwntan sandstone of the lychgate (*see* below), but of 1850. Inside, open timber roofs and plastered walls, the altar RAILS and ORGAN both rustic Gothic, the organ may be reused early C19. Odd square C12 or C13 FONT with short inset angle shafts, like a column section (cf. Henllan); incised lines on one face. – MONUMENTS. Earlier C19 marble plaques. Nave N: John Enoch †1833, and John Lloyd Williams, F.R.S. †1838, of Gwernant, both sarcophagus shaped. Others to the Bowens of Plas Troedyraur; Sarah Bowen †1798, wreathed oval with urn; John

Bowen †1736, late C18, with urn; and Rebecca Bowen †1794, draped urn, all by *King* of Bath. Also, Frances Bowen †1834, big marble plaque with curvaceous head and roundels, by *D. Mainwaring*.

In the churchyard, W of the path, the Rev. E. Morris †1825, the slate plaque in a big arched sandstone frame, a local type (cf. Penbryn). Under the yews E of the path, two table tombs of *c.* 1800 with rustic borders, winged cherub heads and sunbursts.

Classical LYCHGATE, 1831. Rusticated Pwntan sandstone in diminishing courses, with arch, angle piers and open pediment. A handsome and highly unusual structure, presumably connected to the Gwernant mansion. The iron work with exuberant scrolls in the arch is local, by *Thomas Jones* of Hawen, Rhydlewis.

GWERNANT, ½ m. NE. Ruins of a large mansion of *c.* 1805, built for John Lloyd Williams F.R.S., who made a fortune as a doctor in India and Bath. The big square main block, all but gone, had the oddity of four bays to the three-storey S garden front, pedimented across two. The two-storey N entrance front was more conventional, of 1–3–1 bays, also pedimented. Scale of an old-fashioned Palladian type, was achieved by L-plan wings on the S front ending in hipped pavilions with blank Venetian windows, which survive. It had an elliptical staircase with niches.

GWERNANT HOME FARM, to the W, has an enclosed farm-court with arched entry under a pyramid-roofed stone tower. Hipped barn range opposite the entry.

CALDERBROOK LODGE, to the E, is a pretty blue-and-white timber cottage, prefabricated, and imported from Sweden in 1903. The Lloyd Williams family retreated here when they could no longer afford Gwernant. Shallow hipped roof, horizontal boarding in panels, the top panels under the eaves decorated in raised stars.

PLAS TROEDYRAUR. *See* Beulah.

VERWIG/Y FERWIG

The only non-Welsh parish name in the county, a variation of Berwick, presumably a Norse coastal settlement.

ST PEDROG. A disappointing work by a major Victorian architect, *Henry Woodyer*, 1853–4. A short featureless W tower, kept but unrestored in 1853, was demolished in 1968, and was replaced by a concrete-block W wall. Nave, chancel and S porch, in cut grey Cilgerran stone. Bath stone tracery, elaborate and angular, as Woodyer liked it. Inside, big arch-braced collar trusses, a chancel arch on heavy corbels, and an elaborate shafted and hoodmoulded chancel seat with diaper-work in the gable. – STAINED GLASS. E window roundel, *Bell* of Bristol, 1853. Chancel S two-light, *c.* 1950; nave two-light, 1958, by *A. L. Wilkinson*. – FITTINGS. Plain stone PULPIT, ornate

and ugly FONT, and pierced timber RAILS, all presumably of 1853.

SILOAM BAPTIST CHAPEL. 1831. Lateral façade with two windows and outer doors, all modernized.

BLAENCEFN CALVINISTIC METHODIST CHAPEL, 1½ m. E. 1837. Attractive lateral front in stone with arched centre windows, outer doors and gallery lights. Three-sided gallery of 1884 with canted angles.

CRUG, 1 m. N. A small Victorianized house, on the site of Crug Bychan, a gentry house from the late C14 to mid C17. Heavy roof timbers, apparently late medieval collar-trusses re-used in the C17. Large earlier C19 stone barn opposite.

BRYNPEDR, ½ m. SW. Outbuildings of c. 1865, of the unusual large hollow bricks made at Cardigan and used predominantly on Priory estate farms, cf. Treprior, Tremain.

See also Gwbert.

YSBYTY CYNFYN

7579

1½ m. N of Devil's Bridge

ST JOHN THE BAPTIST. 1827, single vessel in rendered stone with a curved-topped bellcote like the one at Strata Florida. Stone Y-tracery windows, possibly replacements for timber. Simple plastered interior. Painted Commandments, Creed and Lord's Prayer on boards, unusually in Welsh, of 1836. – FONT. A small but extraordinarily densely carved wooden font with boxwood panels in crocketed frames, presumably a mid-C19 exhibition piece, but from where? – STAINED GLASS. E window by *Celtic Studios*, 1952.

In the churchyard wall are five large stones, said since the early C19 to be part of an ancient circle, but oddly unrecorded previously. The largest is some 12 ft (3.7 metres) high.

The path from the church leads to the deep Rheidol gorge, crossed by the modern PARSON'S BRIDGE. There was a single plank crossing, much lower down, a favourite picturesque site in the early C19.

TEMPLE LEAD MINE (SN 749 793), just upstream of Parson's Bridge. A dramatic site on the W side of the Rheidol, with massive stonework rising from the river edge to terrace the dressing floors with ore-slides, wheel-pit and round buddles. The mine was worked only from 1876–81 and 1886–7.

YSBYTY YSTWYTH

7371

Lead-mining village S of Pontrhydygroes. In the village, two churches, the old one abandoned when the new was built in 1876, but restored as a schoolroom c. 1900.

ST JOHN THE BAPTIST. 1874–6 by *R. J. Withers*. Sizeable but bleak on its hilltop, a single broad vessel with lancets and NW

tower based on local types (cf. Llanwnen and Llanarth), with Withers's favourite slate pyramid roof. The interior is broad and bald, with open rafter roofs and a truss to mark the chancel. High Victorian circular FONT, stone PULPIT and carved stone REREDOS. – STAINED GLASS. E window and chancel N, *c.* 1970.

Below is the OLD CHURCH, small, plain rubble stone with a thick W bellcote and modern windows. Inside, octagonal medieval FONT.

MAESGLAS CALVINISTIC METHODIST CHAPEL. The stone and yellow brick chapel of 1874, probably by *David Williams*, has been demolished. The congregation now uses the previous chapel of 1845, which had been a schoolroom. Much altered lateral front with two arched windows.

LEAD MINES. In the hills to the E the series of mines linked to the great level, or Level Fawr, Pontrhydygroes, begun in 1785, which eventually drained four mines, collectively known as the Lisburne Mines, reaching the last, Glogfawr, some 5,000 feet into the rock in the 1870s. The level was started to drain LOGAULAS MINE (SN 743 717), worked in the later C18. Rich seams were found in the 1820s by the Williams family and the 1830s by the Taylors. Between 1834 and 1891 the mine produced the second highest amount of ore after Frongoch, Trisant. PENYGIST (SN 747 716), GLOGFAWR and GLOG-FACH (SN 747 707) are further S, the latter two below a large mine reservoir, fed from a long leat constructed in the 1830s back to Llyn Fyrddon, some three miles due E. The mines were worked by the Taylors in the 1830s and 1840s, the Glogfawr and Glogfach mines reopening in 1859–60, closing finally in 1920. Remains of a CRUSHER-HOUSE of the earlier period at Glogfawr and a wheel-pit N of the reservoir at Glogfach.

See also Pontrhydygroes.

5256

YSTRAD AERON
Llanfihangel Ystrad

In the Aeron valley, along the main Lampeter road. Opposite Llanfihangel Ystrad church, two mid-C19 inns, the BRYNOG ARMS and the VALE OF AERON. SE along the main road are the modern settlements of Felinfach and Temple Bar.

ST MICHAEL. The parish church of Llanfihangel Ystrad. Rebuilt 1877–8, by *John Middleton*, within the walls of the previous church, but not keeping the original double-nave plan with centre arcade, the only example of this church plan then left in the county. The Incorporated Church Building Society protested, refusing a grant. Middleton countered that there were no features of interest, and the arcade had no mouldings. His view, commonly held, explains how in a county without the stone for carved detail, genuine medieval work was so easily destroyed. The church is serious if a little gaunt, a high-gabled

nave and chancel, lower gabled N aisle, and bellcote on the S porch. Early Dec tracery. Inside, the plaster has been stripped and the ashlar painted. Four-bay arcade on round piers, and a triple-shafted chancel arch with naturalistic flowers on the capitals. Open timber nave and aisle roofs, panelled chancel roof. – FONT. C12 scallopped heavy square bowl on a squat round shaft, like those at Mwnt and Penbryn. – STALLS with High Victorian punched detail. Stone triple-gabled REREDOS and good ENCAUSTIC TILES in the chancel. – Good STAINED GLASS. Three-light E window, Crucifixion, large figures, and rich colours, in the aesthetic taste of the 1880s. Four-light W window, 1877, the Sermon on the Mount, a crowded but well-handled composition. The style suggests *Lavers & Barraud*. Nave S second window, 1915. – MONUMENTS. Captain J. C. Vaughan †1855, sarcophagus with military emblems, by *S. Manning*. – In the chancel, crude and old-fashioned painted slate tablet to Dorothea, Dowager Viscountess Lisburne, †1791.

RHYDYGWIN UNITARIAN CHAPEL, S of Temple Bar. 1848. Chapel and house under a single roof, the chapel an attractive roughcast lateral façade with black painted quoins and window heads. A single big central arched window set low between arched doors, the heads with Gothic glazing bars. First floor outer sash windows and centre round plaque. Inside, pulpit on the rear wall between two similar windows, backed by a trompe-l'œil columned arch. Five-sided gallery crossing the front window, inserted 1873, with long horizontal panels. Balustraded pulpit platform.

TYNYGWNDWN INDEPENDENT CHAPEL, ½ m. SE of Felin-fach. 1835. A lateral façade with four arched windows, the heads at the same level, but the outer pair short, and outer doors. Stucco front and thick window bars of 1892. Three-sided gallery, 1861, simply fronted in upright panels, and ornate pulpit platform, possibly 1892, with brass corner lamps, and balustraded curved sides.

BRYNOG. On the N side of the Aeron, reached by a long straight drive from an altered lodge on the main road. David Lloyd of Brynog was the principal accused in the Lisburne paternity dispute of the mid C18, and left the estate to the children of Edward Vaughan of Greengrove (*see* below), who may have been his son. The three-bay front was added *c.* 1860, the stonework in long split sandstone blocks. Attractive reused early C19 four-column porch with reeded columns, and pilastered doorcase with fanlight. The earlier house, much altered, survives behind. The HOME FARM has a mid-C19 four-sided courtyard with pyramid-roofed former turbine house attached at one side.

GREENGROVE, ¾ m. NW. A modest gentry house, probably mid to later C18. Dorothea, Dowager Viscountess Lisburne, bought the estate with her son, Edward Vaughan, after he lost the Trawsgoed inheritance in a paternity suit, finally settled in 1754. Two-storey, four-bay low, roughcast front, with simple

columned porch, and a rear stair gable. Dates of 1765 and 1771
are said to be on the roof trusses; a date of 1666 said to have
been briefly uncovered on an inside wall. Three-sided late C18
to C19 FARM COURT behind, with scarfed roof trusses.

LLANLLYR, just s of Pont Talsarn. An ancient site, of a Cister-
cian nunnery founded by the Lord Rhys c. 1180, with remains
of moats w of the present house. A substantial C16 to C17 house
was illustrated by Dineley in 1684.

The present stuccoed house is earlier C19, a villa built for John
Lewes, whose family owned the estate from 1720. The minimal
Tudor detail was echoed in enlargements of 1872–4 by *George
Jones*. Three-bay hipped e front with later veranda, Tudor gable
on the n entrance front with Tudor porch. Cross-windows with
hoodmoulds, possibly renewed in the 1870s. Open-well stair
with square balusters under a coved top light, Regency type, but
the Tudor hall arch and four-panel doors look more of the 1840s
than 1820s. In the 1870s the service wing to the r. was raised a
storey with Tudor gables over the upper windows.

WALLED GARDENS surrounded by *clom*, or earth, walls. In
the gardens, an eroded INSCRIBED STONE, broken down the
length, but with half of an incised cross and an inscription in
Irish minuscules, deciphered as reading TESQUITUS DITOS
MADOMNUAC OCTON FILIUS ASAITGEN DEDIT ('the small
waste place of Ditos (which) Octon son of Asaitgen gave to
Madomnuac'), C7 or C8. Another incised cross on the r. side.
Impressive modern gardens

Early C19 single storey LODGE, like a toll-house with short
wings flanking a three-sided centre.

PONT TALSARN *See* Trefilan.

FFYNNON OER, ½ m. s of Temple Bar. *Clom* cottage and byre,
probably late C18, carefully restored in 2002–3 by *Bruce Pitt*,
with *Greg Stevenson*, the owner. The thatch, which remained
under corrugated iron, has been replaced, preserving the gorse
underthatch within, and a wicker chimney reconstructed.
Some of the new byre walls are of earth or *clom*.

See also Cribyn.

YSTRAD MEURIG

On the hillside above the upper end of the Cors Caron bog. The
village is a staggered meeting of four roads, with the church and
school in the centre, and some mid-C19, Late Georgian-style
houses. BRONLLAN, facing e, three-bay, the brick window heads
indicating a relatively late date.

ST JOHN THE BAPTIST. 1897–9, by *Harold Hughes* of Bangor, in
an Arts and Crafts late Gothic, rare in the area. Grey local
stone laid in thin courses with dressings in red Hollington
sandstone. Hughes intended a w tower with pyramid slate roof,
but the w bellcote twinned with a chimney is a nice piece of
asymmetric design. The porch is a crude afterthought. Single-
roofed nave and chancel with the chancel wall slightly inset.

Perp tracery, most elaborate in the broad five-light E window. Hipped N vestry and organ chamber. Roll-moulded chancel arch, with low ashlar screen walls and a neat arrangement of arches on the N side, all in pink stone, effectively set against white plaster. A doorway each side of the N jamb of the chancel arch, giving access from chancel to pulpit. The large segmental-pointed arch to the r. to the organ chamber. Boarded roofs with well-detailed arched trusses. Hughes intended both roof and fittings to be stained green. – PULPIT and FONT by Hughes, the pulpit broad and plain, in a late C17 manner, in oak on a red stone base, the font octagonal with broad roll mouldings. Wrought-iron altar RAILS. – STAINED GLASS. E window, 1963 by *J. Wippell* of Exeter. An ambitious piece in acid colours, with numerous figures against clear grounds. Chancel S window, 1920. – MEMORIAL. In vestry, an eroding C18 plaque recording Edward Richard's foundation of the school. The church is a memorial to him.

Just W, in the churchyard, is the former SCHOOL, founded by Edward Richard in 1735 and noted throughout Wales for classical teaching. As with the Grammar School at Lampeter (q.v.), the small scale surprises for a school whose reputation was so large, and the present building of 1812 is a replacement of a smaller original. Badly treated; it was of rubble stone, five-bay, with four pointed windows, leaded glazing and a narrow pointed door in the second bay. The C20 has spoilt it with hard render, an extension, and altered glazing.

PLAS BRONMEURIG, just E of the village. Large house of Early Victorian character, but apparently used from at least the early C19 as the vicarage and a boarding house for boys at the school. Stone, five-bay E front with entry at the S end and lower SW wing. Inside, a cellar under S end with oak beams and a former kitchen with spit-rack. Mahogany stair with square balusters.

YSTRAD MEURIG CASTLE. On a spur to the SW, in front of Henblas, are the minimal remains of a C12 motte and bailey. Established by Gilbert de Clare *c.* 1115, it passed between the Welsh and the Normans, and was finally burnt in 1208 by Maelgwn ap Rhys to prevent it from falling to Llywelyn the Great. A large earth enclosure, within which foundations of a stone tower have been found.

PENYFFRWD-LWYD HILL-FORT (SN 709 688). Iron Age hill-fort on the craggy crest of the moorland ridge NNE of the village. Double bank and ditches around a long oval area, and an additional bank to the NE.

See also Swyddffynnon.

YSTUMTUEN
Ponterwyd

Small lead-mining settlement in the hills N of the Rheidol.

EBENEZER WESLEYAN METHODIST CHAPEL. 1858. Large and plain chapel, very similar to Ponterwyd and Trisant chapels.

Arched end windows, but here a side porch. This opens into the central division between the painted grained box pews raked up to the back wall and the pulpit on the front wall. The pulpit is of the early type, not a platform, with single flight of steps up. The congregation, said to date from 1811, was the first Wesleyan cause in the county, founded by Cornish miners.

LEAD MINES. The extensive wastes E and NE of the village are of the PENRHIW, BWLCHGWYN and LLWYNTEIFI MINES, the first two active in the earlier C18, the third later C18, but all worked together in the C19 and served by the reservoir to the NE. Remains of masonry above the Penrhiw engine-shaft (SN 737 787). The mines worked intermittently through the later C19 and in 1856 were connected to the deep level begun in 1824 to drain the YSTUMTUEN MINE (SN 733 788), NW of the village. This was an early mine, taken over in 1705 by the Company of Mine Adventurers and worked to 1727. Lewis Morris mapped it in the mid C18 and Sir Thomas Bonsall worked it in the early C19. The level of 1824 came out at the Cwm Rheidol mine site, Cwmrheidol, where the dressing floors were situated. 2 m. NW was the BWADRAIN MINE (SN 712 797), worked from the late 1830s, and powered by flat-rods ascending the precipitous valley side from a water-wheel in the Rheidol valley.

ARCHITECTURAL GLOSSARY

Numbers and letters refer to the illustrations (by John Sambrook) on pp. 606–13.

ABACUS: flat slab forming the top of a capital (3a).

ACANTHUS: classical formalized leaf ornament (3b).

ACCUMULATOR TOWER: *see* Hydraulic power.

ACHIEVEMENT: a complete display of armorial bearings.

ACROTERION: plinth for a statue or ornament on the apex or ends of a pediment; more usually, both the plinth and what stands on it (4a).

AEDICULE (*lit.* little building): architectural surround, consisting usually of two columns or pilasters supporting a pediment.

AGGREGATE: *see* Concrete.

AISLE: subsidiary space alongside the body of a building, separated from it by columns, piers, or posts.

AMBULATORY (*lit.* walkway): aisle around the sanctuary (q.v.).

ANGLE ROLL: roll moulding in the angle between two planes (1a).

ANSE DE PANIER: *see* Arch.

ANTAE: simplified pilasters (4a), usually applied to the ends of the enclosing walls of a portico *in antis* (q.v.).

ANTEFIXAE: ornaments projecting at regular intervals above a Greek cornice, originally to conceal the ends of roof tiles (4a).

ANTHEMION: classical ornament like a honeysuckle flower (4b).

APRON: raised panel below a window or wall monument or tablet.

APSE: semicircular or polygonal end of an apartment, especially of a chancel or chapel. In classical architecture sometimes called an *exedra*.

ARABESQUE: non-figurative surface decoration consisting of flowing lines, foliage scrolls etc., based on geometrical patterns. Cf. Grotesque.

ARCADE: series of arches supported by piers or columns. *Blind arcade* or *arcading*: the same applied to the wall surface. *Wall arcade*: in medieval churches, a blind arcade forming a dado below windows. Also a covered shopping street.

ARCH: Shapes *see* 5c. *Basket arch* or *anse de panier* (basket handle): three-centred and depressed, or with a flat centre. *Nodding*: ogee arch curving forward from the wall face. *Parabolic*: shaped like a chain suspended from two level points, but inverted. Special purposes. *Chancel*: dividing chancel from nave or crossing. *Crossing*: spanning piers at a crossing (q.v.). *Relieving* or *discharging*: incorporated in a wall to relieve superimposed weight (5c). *Skew*: spanning responds not diametrically opposed. *Strainer*: inserted in an opening to resist inward pressure. *Transverse*: spanning a main axis (e.g. of a vaulted space). *See also* Jack arch, Triumphal arch.

ARCHITRAVE: formalized lintel, the lowest member of the classical entablature (3a). Also the moulded frame of a door or window (often borrowing the profile of a classical architrave). For *lugged* and *shouldered* architraves *see* 4b.

ARCUATED: dependent structurally on the arch principle. Cf. Trabeated.

ARK: chest or cupboard housing the

tables of Jewish law in a syna-
gogue.

ARRIS: sharp edge where two
surfaces meet at an angle (3a).

ASHLAR: masonry of large blocks
wrought to even faces and square
edges (6d).

ASTRAGAL: classical moulding of
semicircular section (3f).

ASTYLAR: with no columns or simi-
lar vertical features.

ATLANTES: see Caryatids.

ATRIUM (plural: atria): inner court
of a Roman or C20 house; in
a multi-storey building, a toplit
covered court rising through all
storeys. Also an open court in
front of a church.

ATTACHED COLUMN: see Engaged
column.

ATTIC: small top storey within
a roof. Also the storey above the
main entablature of a classical
façade.

AUMBRY: recess or cupboard to
hold sacred vessels for the Mass.

BAILEY: see Motte-and-bailey.

BALANCE BEAM: see Canals.

BALDACCHINO: free-standing can-
opy, originally fabric, over an
altar. Cf. Ciborium.

BALLFLOWER: globular flower of
three petals enclosing a ball (1a).
Typical of the Decorated style.

BALUSTER: pillar or pedestal of
bellied form. *Balusters*: vertical
supports of this or any other form,
for a handrail or coping, the whole
being called a *balustrade* (6c).
Blind balustrade: the same applied
to the wall surface.

BARBICAN: outwork defending the
entrance to a castle.

BARGEBOARDS (corruption of
'vergeboards'): boards, often
carved or fretted, fixed beneath
the eaves of a gable to cover and
protect the rafters.

BAROQUE: style originating in Rome
c. 1600 and current in England
c. 1680–1720, characterized by
dramatic massing and silhouette
and the use of the giant order.

BARROW: burial mound.

BARTIZAN: corbelled turret, square
or round, frequently at an angle.

BASCULE: hinged part of a lifting
(or bascule) bridge.

BASE: moulded foot of a column or
pilaster . For *Attic* base see 3b.

BASEMENT: lowest, subordinate
storey; hence the lowest part of a
classical elevation, below the
piano nobile (q.v.).

BASILICA: a Roman public hall;
hence an aisled building with a
clerestory.

BASTION: one of a series of defens-
ive semicircular or polygonal pro-
jections from the main wall of a
fortress or city.

BATTER: intentional inward inclin-
ation of a wall face.

BATTLEMENT: defensive parapet,
composed of *merlons* (solid) and
crenels (embrasures) through
which archers could shoot; some-
times called *crenellation*. Also used
decoratively.

BAY LEAF: classical ornament of
overlapping bay leaves (3f).

BAY: division of an elevation or
interior space as defined by
regular vertical features such
as arches, columns, windows,
etc.

BAY WINDOW: window of one or
more storeys projecting from the
face of a building. *Canted*: with a
straight front and angled sides.
Bow window: curved. *Oriel*: rests
on corbels or brackets and starts
above ground level; also the bay
window at the dais end of a med-
ieval great hall.

BEAD-AND-REEL: see Enrichments.

BEAKHEAD: Norman ornament
with a row of beaked bird or beast
heads usually biting into a roll
moulding (1a).

BELFRY: chamber or stage in a
tower where bells are hung.

BELL CAPITAL: see 1b.

BELLCOTE: small gabled or roofed
housing for the bell(s).

BERM: level area separating a ditch
from a bank on a hill-fort or
barrow.

BILLET: Norman ornament of small
half-cyclindrical or rectangular
blocks (1a).

BLIND: see Arcade, Baluster,
Portico.

BLOCK CAPITAL: see 1a.

BLOCKED: columns, etc. interrupted by regular projecting blocks (*blocking*), as on a Gibbs surround (4b).

BLOCKING COURSE: course of stones, or equivalent, on top of a cornice and crowning the wall.

BOLECTION MOULDING: covering the joint between two different planes (6b).

BOND: the pattern of long sides (*stretchers*) and short ends (*headers*) produced on the face of a wall by laying bricks in a particular way (6e).

BOSS: knob or projection, e.g. at the intersection of ribs in a vault (2c).

BOW WINDOW: see Bay window.

BOX FRAME: timber-framed construction in which vertical and horizontal wall members support the roof (7). Also concrete construction where the loads are taken on cross walls; also called *cross-wall construction*.

BRACE: subsidiary member of a structural frame, curved or straight. *Bracing* is often arranged decoratively e.g. quatrefoil, herringbone (7). See also Roofs.

BRATTISHING: ornamental crest, usually formed of leaves, Tudor flowers or miniature battlements.

BRESSUMER (*lit.* breast-beam): big horizontal beam supporting the wall above, especially in a jettied building (7).

BRICK: see Bond, Cogging, Engineering, Gauged, Tumbling.

BRIDGE: *Bowstring*: with arches rising above the roadway which is suspended from them. *Clapper*: one long stone forms the roadway. *Roving*: see Canal. *Suspension*: roadway suspended from cables or chains slung between towers or pylons. *Stay-suspension* or *stay-cantilever*: supported by diagonal stays from towers or pylons. *See also* Bascule.

BRISES-SOLEIL: projecting fins or canopies which deflect direct sunlight from windows.

BROACH: see Spire and 1c.

BUCRANIUM: ox skull used decoratively in classical friezes.

BULLSEYE WINDOW: small oval window, set horizontally (cf. Oculus). Also called *oeil de boeuf*.

BUTTRESS: vertical member projecting from a wall to stabilize it or to resist the lateral thrust of an arch, roof, or vault (1c, 2c). A *flying buttress* transmits the thrust to a heavy abutment by means of an arch or half-arch (1c).

CABLE or ROPE MOULDING: originally Norman, like twisted strands of a rope.

CAMES: see Quarries.

CAMPANILE: free-standing bell tower.

CANALS: *Flash lock*: removable weir or similar device through which boats pass on a flush of water. Predecessor of the *pound lock*: chamber with gates at each end allowing boats to float from one level to another. *Tidal gates*: single pair of lock gates allowing vessels to pass when the tide makes a level. *Balance beam*: beam projecting horizontally for opening and closing lock gates. *Roving bridge*: carrying a towing path from one bank to the other.

CANTILEVER: horizontal projection (e.g. step, canopy) supported by a downward force behind the fulcrum.

CAPITAL: head or crowning feature of a column or pilaster; for classical types see 3a; for medieval types see 1b.

CARREL: compartment designed for individual work or study.

CARTOUCHE: classical tablet with ornate frame (4b).

CARYATIDS: female figures supporting an entablature; their male counterparts are *Atlantes* (*lit*: Atlas figures).

CASEMATE: vaulted chamber, with embrasures for defence, within a castle wall or projecting from it.

CASEMENT: side-hinged window.

CASTELLATED: with battlements (q.v.).

CAST IRON: hard and brittle, cast in a mould to the required shape. *Wrought iron* is ductile, strong in tension, forged into decorative patterns or forged and rolled into

e.g. bars, joists, boiler plates; *mild steel* is its modern equivalent, similar but stronger.

CATSLIDE: *See* 8a.

CAVETTO: concave classical moulding of quarter-round section (3f).

CELURE or CEILURE: enriched area of roof above rood or altar.

CEMENT: *see* Concrete.

CENOTAPH (*lit.* empty tomb): funerary monument which is not a burying place.

CENTRING: wooden support for the building of an arch or vault, removed after completion.

CHAMFER (*lit.* corner-break): surface formed by cutting off a square edge or corner. For types of chamfers and *chamfer stops see* 6a. *See also* Double chamfer.

CHANCEL: part of the E end of a church set apart for the use of the officiating clergy.

CHANTRY CHAPEL: often attached to or within a church, endowed for the celebration of Masses principally for the soul of the founder.

CHEVET (*lit.* head): French term for chancel with ambulatory and radiating chapels.

CHEVRON: V-shape used in series or double series (later) on a Norman moulding (1a). Also (especially when on a single plane) called *zigzag*.

CHOIR: the part of a cathedral, monastic or collegiate church where services are sung.

CIBORIUM: a fixed canopy over an altar, usually vaulted and supported on four columns; cf. Baldacchino. Also a canopied shrine for the reserved sacrament.

CINQUEFOIL: *see* Foil.

CIST: stone-lined or slab-built grave.

CLADDING: external covering or skin applied to a structure, especially a framed one.

CLERESTORY: uppermost storey of the nave of a church, pierced by windows. Also high-level windows in secular buildings.

CLOSER: a brick cut to complete a bond (6e).

CLUSTER BLOCK: *see* Multi-storey.

COADE STONE: ceramic artificial stone made in Lambeth 1769–c.1840 by Eleanor Coade (†1821) and her associates.

COB: walling material of clay mixed with straw. Also called *pisé*.

COFFERING: arrangement of sunken panels (coffers), square or polygonal, decorating a ceiling, vault, or arch.

COGGING: a decorative course of bricks laid diagonally (6e). Cf. Dentilation.

COLLAR: *see* Roofs and 7.

COLLEGIATE CHURCH: endowed for the support of a college of priests.

COLONNADE: range of columns supporting an entablature. Cf. Arcade.

COLONNETTE: small medieval column or shaft.

COLOSSAL ORDER: *see* Giant order.

COLUMBARIUM: shelved, niched structure to house multiple burials.

COLUMN: a classical, upright structural member of round section with a shaft, a capital, and usually a base (3a, 4a).

COLUMN FIGURE: carved figure attached to a medieval column or shaft, usually flanking a doorway.

COMMUNION TABLE: unconsecrated table used in Protestant churches for the celebration of Holy Communion.

COMPOSITE: *see* Orders.

COMPOUND PIER: grouped shafts (q.v.), or a solid core surrounded by shafts.

CONCRETE: composition of *cement* (calcined lime and clay), *aggregate* (small stones or rock chippings), sand and water. It can be poured into *formwork* or *shuttering* (temporary frame of timber or metal) on site (*in-situ* concrete), or *pre-cast* as components before construction. *Reinforced*: incorporating steel rods to take the tensile force. *Pre-stressed*: with tensioned steel rods. Finishes include the impression of boards left by formwork (*board-marked* or *shuttered*), and texturing with steel brushes (*brushed*) or hammers (*hammer-dressed*). *See also* Shell.

CONSOLE: bracket of curved outline (4b).

COPING: protective course of masonry or brickwork capping a wall (6d).

CORBEL: projecting block supporting something above. *Corbel course*: continuous course of projecting stones or bricks fulfilling the same function. *Corbel table*: series of corbels to carry a parapet or a wall-plate or wall-post (7). *Corbelling*: brick or masonry courses built out beyond one another to support a chimney-stack, window, etc.

CORINTHIAN: *see* Orders and 3d.

CORNICE: flat-topped ledge with moulded underside, projecting along the top of a building or feature, especially as the highest member of the classical entablature (3a). Also the decorative moulding in the angle between wall and ceiling.

CORPS-DE-LOGIS: the main building(s) as distinct from the wings or pavilions.

COTTAGE ORNÉ: an artfully rustic small house associated with the Picturesque movement.

COUNTERCHANGING:of joists on a ceiling divided by beams into compartments, when placed in opposite directions in alternate squares.

COUR D HONNEUR: formal entrance court before a house in the French manner, usually with flanking wings and a screen wall or gates.

COURSE: continuous layer of stones, etc. in a wall (6e).

COVE: a broad concave moulding, e.g. to mask the eaves of a roof. *Coved ceiling*: with a pronounced cove joining the walls to a flat central panel smaller than the whole area of the ceiling.

CRADLE ROOF: *see* Wagon roof.

CREDENCE: a shelf within or beside a piscina (q.v.), or a table for the sacramental elements and vessels.

CRENELLATION: parapet with crenels (*see* Battlement).

CRINKLE-CRANKLE WALL: garden wall undulating in a series of serpentine curves.

CROCKETS: leafy hooks. *Crocketing* decorates the edges of Gothic features, such as pinnacles, canopies, etc. *Crocket capital*: *see* 1b.

CROSSING: central space at the junction of the nave, chancel, and transepts. *Crossing tower*: above a crossing.

CROSS-WINDOW: with one mullion and one transom (qq.v.).

CROWN-POST: *see* Roofs and 7.

CROWSTEPS: squared stones set like steps, e.g. on a gable (8a).

CRUCKS (*lit.* crooked): pairs of inclined timbers (*blades*), usually curved, set at bay-lengths; they support the roof timbers and, in timber buildings, also support the walls (8b). *Base*: blades rise from ground level to a tie- or collar-beam which supports the roof timbers. *Full*: blades rise from ground level to the apex of the roof, serving as the main members of a roof truss. *Jointed*: blades formed from more than one timber; the lower member may act as a wall-post; it is usually elbowed at wall-plate level and jointed just above. *Middle*: blades rise from halfway up the walls to a tie- or collar-beam. *Raised*: blades rise from halfway up the walls to the apex. *Upper*: blades supported on a tie-beam and rising to the apex.

CRYPT: underground or half-underground area, usually below the E end of a church. *Ring crypt*: corridor crypt surrounding the apse of an early medieval church, often associated with chambers for relics. Cf. Undercroft.

CUPOLA (*lit.* dome): especially a small dome on a circular or polygonal base crowning a larger dome, roof, or turret.

CURSUS: a long avenue defined by two parallel earthen banks with ditches outside.

CURTAIN WALL: a connecting wall between the towers of a castle. Also a non-load-bearing external wall applied to a C 20 framed structure.

CUSP: *see* Tracery and 2b.

CYCLOPEAN MASONRY: large irregular polygonal stones, smooth and finely jointed.

CYMA RECTA and CYMA REVERSA: classical mouldings with double curves (3f). Cf. Ogee.

DADO: the finishing (often with panelling) of the lower part of a wall in a classical interior; in origin a formalized continuous pedestal. *Dado rail*: the moulding along the top of the dado.

DAGGER: *see* Tracery and 2b.

DEC (DECORATED): English Gothic architecture *c.* 1290 to *c.* 1350. The name is derived from the type of window Tracery (q.v.) used during the period.

DEMI- or HALF-COLUMNS: engaged columns (q.v.) half of whose circumference projects from the wall.

DENTIL: small square block used in series in classical cornices (3c). *Dentilation* is produced by the projection of alternating headers along cornices or string courses.

DIAPER: repetitive surface decoration of lozenges or squares flat or in relief. Achieved in brickwork with bricks of two colours.

DIOCLETIAN or THERMAL WINDOW: semicircular with two mullions, as used in the Baths of Diocletian, Rome (4b).

DISTYLE: having two columns (4a).

DOGTOOTH: E.E. ornament, consisting of a series of small pyramids formed by four stylized canine teeth meeting at a point (1a).

DORIC: *see* Orders and 3a, 3b.

DORMER: window projecting from the slope of a roof (8a).

DOUBLE CHAMFER: a chamfer applied to each of two recessed arches (1a).

DOUBLE PILE: *see* Pile.

DRAGON BEAM: *see* Jetty.

DRESSINGS: the stone or brickwork worked to a finished face about an angle, opening, or other feature.

DRIPSTONE: moulded stone projecting from a wall to protect the lower parts from water. Cf. Hoodmould, Weathering.

DRUM: circular or polygonal stage supporting a dome or cupola. Also one of the stones forming the shaft of a column (3a).

DUTCH or FLEMISH GABLE: *see* 8a.

EASTER SEPULCHRE: tomb-chest used for Easter ceremonial, within or against the N wall of a chancel.

EAVES: overhanging edge of a roof; hence *eaves cornice* in this position.

ECHINUS: ovolo moulding (q.v.) below the abacus of a Greek Doric capital (3a).

EDGE RAIL: *see* Railways.

E. E. (EARLY ENGLISH): English Gothic architecture *c.* 1190–1250.

EGG-AND-DART: *see* Enrichments and 3f.

ELEVATION: any face of a building or side of a room. In a drawing, the same or any part of it, represented in two dimensions.

EMBATTLED: with battlements.

EMBRASURE: small splayed opening in a wall or battlement (q.v.).

ENCAUSTIC TILES: earthenware tiles fired with a pattern and glaze.

EN DELIT: stone cut against the bed.

ENFILADE: reception rooms in a formal series, usually with all doorways on axis.

ENGAGED or ATTACHED COLUMN: one that partly merges into a wall or pier.

ENGINEERING BRICKS: dense bricks, originally used mostly for railway viaducts etc.

ENRICHMENTS: the carved decoration of certain classical mouldings, e.g. the ovolo (qq.v.) with *egg-and-dart*, the cyma reversa with *waterleaf*, the astragal with *bead-and-reel* (3f).

ENTABLATURE: in classical architecture, collective name for the three horizontal members (architrave, frieze, and cornice) carried by a wall or a column (3a).

ENTASIS: very slight convex deviation from a straight line, used to prevent an optical illusion of concavity.

EPITAPH: inscription on a tomb.

EXEDRA: *see* Apse.

EXTRADOS: outer curved face of an arch or vault.

EYECATCHER: decorative building terminating a vista.

FASCIA: plain horizontal band, e.g. in an architrave (3c, 3d) or on a shopfront.

FENESTRATION: the arrangement of windows in a façade.

FERETORY: site of the chief shrine of a church, behind the high altar.

FESTOON: ornamental garland, suspended from both ends. Cf. Swag.

FIBREGLASS, or glass-reinforced polyester (GRP): synthetic resin reinforced with glass fibre. GRC: glass-reinforced concrete.

FIELD: see Panelling and 6b.

FILLET: a narrow flat band running down a medieval shaft or along a roll moulding (1a). It separates larger curved mouldings in classical cornices, fluting or bases (3c).

FLAMBOYANT: the latest phase of French Gothic architecture, with flowing tracery.

FLASH LOCK: see Canals.

FLÈCHE or SPIRELET (*lit.* arrow): slender spire on the centre of a roof.

FLEURON: medieval carved flower or leaf, often rectilinear (1a).

FLUSHWORK: knapped flint used with dressed stone to form patterns.

FLUTING: series of concave grooves (flutes), their common edges sharp (arris) or blunt (fillet) (3).

FOIL (*lit.* leaf): lobe formed by the cusping of a circular or other shape in tracery (2b). *Trefoil* (three), *quatrefoil* (four), *cinquefoil* (five), and multifoil express the number of lobes in a shape.

FOLIATE: decorated with leaves.

FORMWORK: see Concrete.

FRAMED BUILDING: where the structure is carried by a framework – e.g. of steel, reinforced concrete, timber – instead of by load-bearing walls.

FREESTONE: stone that is cut, or can be cut, in all directions.

FRESCO: *al fresco*: painting on wet plaster. *Fresco secco*: painting on dry plaster.

FRIEZE: the middle member of the classical entablature, sometimes ornamented (3a). *Pulvinated frieze* (*lit.* cushioned): of bold convex profile (3c). Also a horizontal band of ornament.

FRONTISPIECE: in C16 and C17 buildings the central feature of doorway and windows above linked in one composition.

GABLE: For types *see* 8a. *Gablet*: small gable. *Pedimental gable*: treated like a pediment.

GADROONING: classical ribbed ornament like inverted fluting that flows into a lobed edge.

GALILEE: chapel or vestibule usually at the W end of a church enclosing the main portal(s).

GALLERY: a long room or passage; an upper storey above the aisle of a church, looking through arches to the nave; a balcony or mezzanine overlooking the main interior space of a building; or an external walkway.

GALLETING: small stones set in a mortar course.

GAMBREL ROOF: see 8a.

GARDEROBE: medieval privy.

GARGOYLE: projecting water spout often carved into human or animal shape.

GAUGED or RUBBED BRICKWORK: soft brick sawn roughly, then rubbed to a precise (gauged) surface. Mostly used for door or window openings (5c).

GAZEBO (jocular Latin, 'I shall gaze'): ornamental lookout tower or raised summer house.

GEOMETRIC: English Gothic architecture *c.* 1250–1310. *See also* Tracery. For another meaning, *see* Stairs.

GIANT or COLOSSAL ORDER: classical order (q.v.) whose height is that of two or more storeys of the building to which it is applied.

GIBBS SURROUND: C18 treatment of an opening (4b), seen particularly in the work of James Gibbs (1682–1754).

GIRDER: a large beam. *Box*: of hollow-box section. *Bowed*: with its top rising in a curve. *Plate*: of I-section, made from iron or steel plates. *Lattice*: with braced framework.

GLAZING BARS: wooden or sometimes metal bars separating and supporting window panes.

604ARCHITECTURAL GLOSSARY

GORSEDD CIRCLE: modern stone circle; one is erected annually at different Welsh sites in connection with the national Eisteddfod.

GRAFFITI: *see* Sgraffito.

GRANGE: farm owned and run by a religious order.

GRC: *see* Fibreglass.

GRISAILLE: monochrome painting on walls or glass.

GROIN: sharp edge at the meeting of two cells of a cross-vault; *see* Vault and 2b.

GROTESQUE (*lit.* grotto-esque): wall decoration adopted from Roman examples in the Renaissance. Its foliage scrolls incorporate figurative elements. Cf. Arabesque.

GROTTO: artificial cavern.

GRP: *see* Fibreglass.

GUILLOCHE: classical ornament of interlaced bands (4b).

GUNLOOP: opening for a firearm.

GUTTAE: stylized drops (3b).

HALF-TIMBERING: archaic term for timber-framing (q.v.). Sometimes used for non-structural decorative timberwork.

HALL CHURCH: medieval church with nave and aisles of approximately equal height.

HAMMERBEAM: *see* Roofs and 7.

HEADER: *see* Bond and 6e.

HEADSTOP: stop (q.v.) carved with a head (5b).

HELM ROOF: *see* IC.

HENGE: ritual earthwork.

HERM (*lit.* the god Hermes): male head or bust on a pedestal.

HERRINGBONE WORK: *see* 6e (for brick bond). Cf. Pitched masonry.

HEXASTYLE: *see* Portico.

HILL-FORT: Iron Age earthwork enclosed by a ditch and bank system.

HIPPED ROOF: *see* 8a.

HOODMOULD: projecting moulding above an arch or lintel to throw off water (2b, 5b). When horizontal often called a *label*. For label stop *see* Stop.

HUSK GARLAND: festoon of stylized nutshells (4b).

HYDRAULIC POWER: use of water under high pressure to work machinery. *Accumulator tower*: houses a hydraulic accumulator which accommodates fluctuations in the flow through hydraulic mains.

HYPOCAUST (*lit.* underburning): Roman underfloor heating system.

IMPOST: horizontal moulding at the springing of an arch (5c).

IMPOST BLOCK: block between abacus and capital (1b).

IN ANTIS: *see* Antae, Portico and 4a.

INDENT: shape chiselled out of a stone to receive a brass.

INDUSTRIALIZED or SYSTEM BUILDING: system of manufactured units assembled on site.

INGLENOOK (*lit.* fire-corner): recess for a hearth with provision for seating.

INTERCOLUMNATION: interval between columns.

INTERLACE: decoration in relief simulating woven or entwined stems or bands.

INTRADOS: *see* Soffit.

IONIC: *see* Orders and 3c.

JACK ARCH: shallow segmental vault springing from beams, used for fireproof floors, bridge decks, etc.

JAMB (*lit.* leg): one of the vertical sides of an opening.

JETTY: in a timber-framed building, the projection of an upper storey beyond the storey below, made by the beams and joists of the lower storey oversailing the wall; on their outer ends is placed the sill of the walling for the storey above (7). Buildings can be jettied on several sides, in which case a *dragon beam* is set diagonally at the corner to carry the joists to either side.

JOGGLE: the joining of two stones to prevent them slipping by a notch in one and a projection in the other.

KEEL MOULDING: moulding used from the late C12, in section like the keel of a ship (1a).

KEEP: principal tower of a castle.

KENTISH CUSP: see Tracery and 2b.

KEY PATTERN: see 4b.

KEYSTONE: central stone in an arch or vault (4b, 5c).

KINGPOST: see Roofs and 7.

KNEELER: horizontal projecting stone at the base of each side of a gable to support the inclined coping stones (8a).

KNOTWORK: see Interlace. Used on early Christian monuments.

LABEL: see Hoodmould and 5b.

LABEL STOP: see Stop and 5b.

LACED BRICKWORK: vertical strips of brickwork, often in a contrasting colour, linking openings on different floors.

LACING COURSE: horizontal reinforcement in timber or brick to walls of flint, cobble, etc.

LADY CHAPEL: dedicated to the Virgin Mary (Our Lady).

LANCET: slender single-light, pointed-arched window (2a).

LANTERN: circular or polygonal windowed turret crowning a roof or a dome. Also the windowed stage of a crossing tower lighting the church interior.

LANTERN CROSS: churchyard cross with lantern-shaped top.

LAVATORIUM: in a religous house, a washing place adjacent to the refectory.

LEAN-TO: see Roofs.

LESENE (lit. a mean thing): pilaster without base or capital. Also called pilaster strip.

LIERNE: see Vault and 2c.

LIGHT: compartment of a window defined by the mullions.

LINENFOLD: Tudor panelling carved with simulations of folded linen. See also Parchemin.

LINTEL: horizontal beam or stone bridging an opening.

LOGGIA: gallery, usually arcaded or colonnaded; sometimes free-standing.

LONG-AND-SHORT WORK: quoins consisting of stones placed with the long side alternately upright and horizontal, especially in Saxon building.

LONGHOUSE: house and byre in the same range with internal access between them.

LOUVRE: roof opening, often protected by a raised timber structure, to allow the smoke from a central hearth to escape.

LOWSIDE WINDOW: set lower than the others in a chancel side wall, usually towards its W end.

LUCARNE (lit. dormer): small gabled opening in a roof or spire.

LUGGED ARCHITRAVE: see 4b.

LUNETTE: semicircular window or blind panel.

LYCHGATE (lit. corpse-gate): roofed gateway entrance to a churchyard for the reception of a coffin.

LYNCHET: long terraced strip of soil on the downward side of prehistoric and medieval fields, accumulated because of continual ploughing along the contours.

MACHICOLATIONS (lit. mashing devices): series of openings between the corbels that support a projecting parapet through which missiles can be dropped. Used decoratively in post-medieval buildings.

MANOMETER or STANDPIPE TOWER: containing a column of water to regulate pressure in water mains.

MANSARD: see 8a.

MATHEMATICAL TILES: facing tiles with the appearance of brick, most often applied to timber-framed walls.

MAUSOLEUM: monumental building or chamber usually intended for the burial of members of one family.

MEGALITHIC TOMB: massive stone-built Neolithic burial chamber covered by an earth or stone mound.

MERLON: see Battlement.

METOPES: spaces between the triglyphs in a Doric frieze (3b).

MEZZANINE: low storey between two higher ones.

MILD STEEL: see Cast iron.

MISERICORD (lit. mercy): shelf on a carved bracket placed on the underside of a hinged choir stall seat to support an occupant when standing.

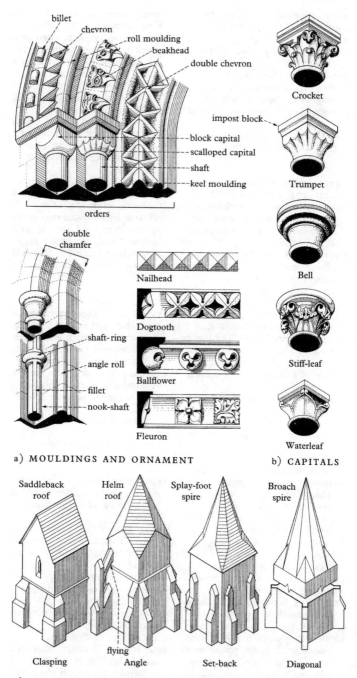

billet
chevron
roll moulding
beakhead
double chevron

block capital
scalloped capital
shaft
keel moulding

orders

double chamfer

shaft-ring
angle roll
fillet
nook-shaft

Nailhead

Dogtooth

Ballflower

Fleuron

a) MOULDINGS AND ORNAMENT

Crocket

impost block

Trumpet

Bell

Stiff-leaf

Waterleaf

b) CAPITALS

Saddleback roof Helm roof Splay-foot spire Broach spire

flying

Clasping Angle Set-back Diagonal

c) BUTTRESSES, ROOFS AND SPIRES

FIGURE 1: MEDIEVAL

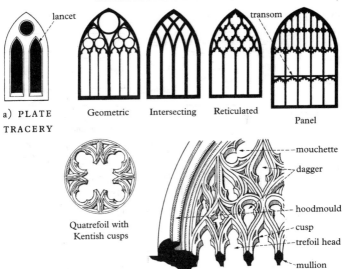

a) PLATE TRACERY

Geometric Intersecting Reticulated Panel

b) BAR TRACERY

Quatrefoil with Kentish cusps

Curvilinear

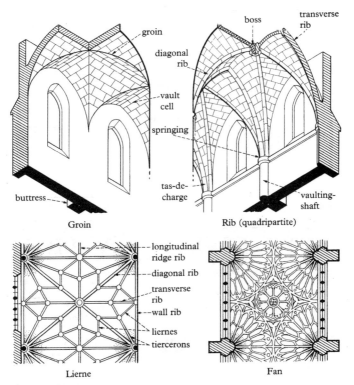

Groin

Rib (quadripartite)

Lierne Fan

c) VAULTS

FIGURE 2: MEDIEVAL

ORDERS

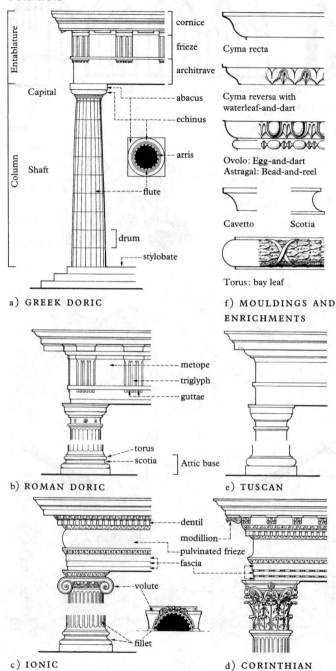

a) GREEK DORIC

Entablature
- cornice
- frieze
- architrave

Capital
- abacus
- echinus

Column
- Shaft
- arris
- flute
- drum
- stylobate

f) MOULDINGS AND ENRICHMENTS

Cyma recta

Cyma reversa with waterleaf-and-dart

Ovolo: Egg-and-dart
Astragal: Bead-and-reel

Cavetto Scotia

Torus: bay leaf

b) ROMAN DORIC
- metope
- triglyph
- guttae
- torus
- scotia] Attic base

e) TUSCAN

c) IONIC
- dentil
- modillion
- pulvinated frieze
- fascia
- volute
- fillet

d) CORINTHIAN

FIGURE 3: CLASSICAL

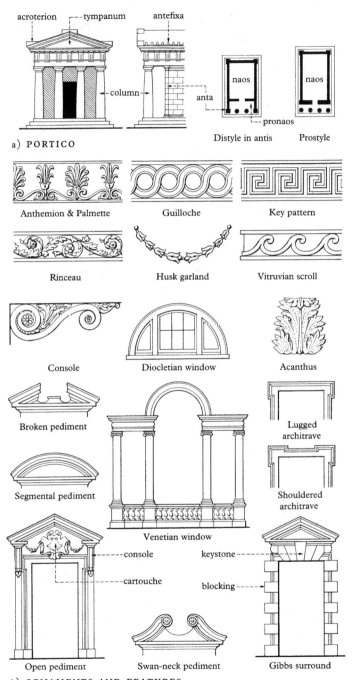

a) PORTICO

Anthemion & Palmette
Guilloche
Key pattern

Rinceau
Husk garland
Vitruvian scroll

Console
Diocletian window
Acanthus

Broken pediment
Lugged architrave

Segmental pediment
Shouldered architrave

Venetian window

Open pediment
Swan-neck pediment
Gibbs surround

b) ORNAMENTS AND FEATURES

FIGURE 4: CLASSICAL

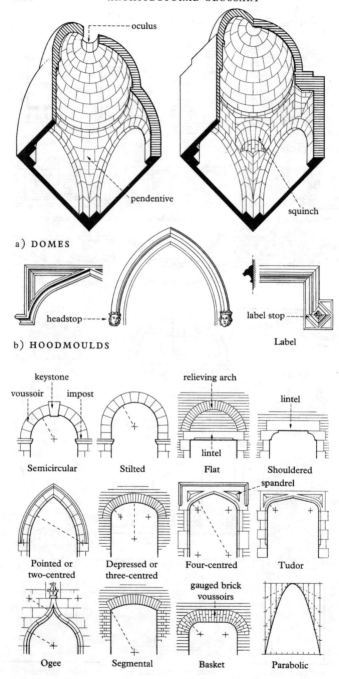

a) DOMES

b) HOODMOULDS Label

c) ARCHES

FIGURE 5: CONSTRUCTION

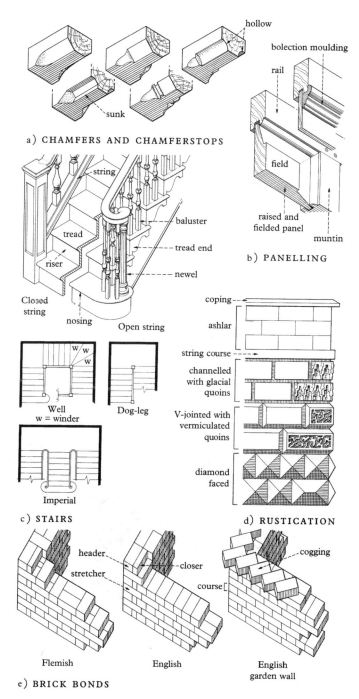

a) CHAMFERS AND CHAMFERSTOPS

hollow

sunk

bolection moulding

rail

field

raised and
fielded panel

muntin

b) PANELLING

string

baluster

tread

tread end

riser

newel

Closed
string

nosing

Open string

Well
w = winder

Dog-leg

Imperial

c) STAIRS

coping

ashlar

string course

channelled
with glacial
quoins

V-jointed with
vermiculated
quoins

diamond
faced

d) RUSTICATION

header

closer

stretcher

course

cogging

Flemish

English

English
garden wall

e) BRICK BONDS

FIGURE 6: CONSTRUCTION

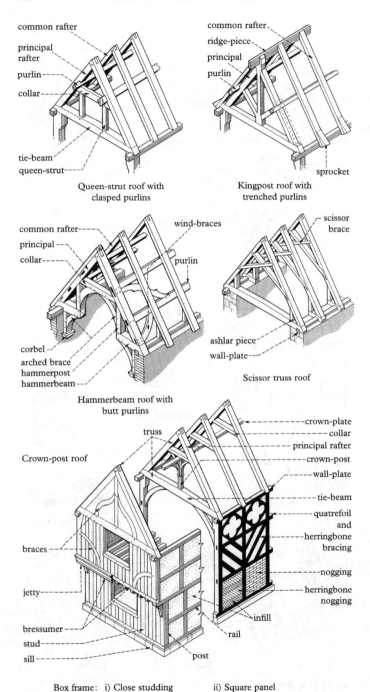

Queen-strut roof with
clasped purlins

Kingpost roof with
trenched purlins

Hammerbeam roof with
butt purlins

Scissor truss roof

Crown-post roof

Box frame: i) Close studding ii) Square panel

FIGURE 7: ROOFS AND TIMBER-FRAMING

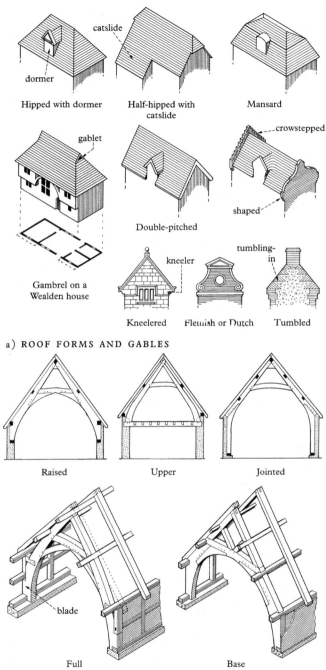

a) ROOF FORMS AND GABLES

b) CRUCK FRAMES

FIGURE 8: ROOFS AND TIMBER-FRAMING

MIXER-COURTS: forecourts to groups of houses shared by vehicles and pedestrians.

MODILLIONS: small consoles (q.v.) along the underside of a Corinthian or Composite cornice (3d). Often used along an eaves cornice.

MODULE: a predetermined standard size for co-ordinating the dimensions of components of a building.

MOTTE-AND-BAILEY: post-Roman and Norman defence consisting of an earthen mound (motte) topped by a wooden tower within a bailey, an enclosure defended by a ditch and palisade, and also, sometimes, by an internal bank.

MOUCHETTE: see Tracery and 2b.

MOULDING: shaped ornamental strip of continuous section; see Cavetto, Cyma, Ovolo, Roll.

MULLION: vertical member between window lights (2b).

MULTI-STOREY: five or more storeys. Multi-storey flats may form a *cluster block*, with individual blocks of flats grouped round a service core; a *point block*: with flats fanning out from a service core; or a *slab block*, with flats approached by corridors or galleries from service cores at intervals or towers at the ends (plan also used for offices, hotels etc.). *Tower block* is a generic term for any very high multi-storey building.

MUNTIN: see Panelling and 6b.

NAILHEAD: E.E. ornament consisting of small pyramids regularly repeated (1a).

NARTHEX: enclosed vestibule or covered porch at the main entrance to a church.

NAVE: the body of a church w of the crossing or chancel often flanked by aisles (q.v.).

NEWEL: central or corner post of a staircase (6c). Newel stair *see* Stairs.

NIGHT STAIR: stair by which religious entered the transept of their church from their dormitory to celebrate night services.

NOGGING: *see* Timber-framing (7).

NOOK-SHAFT: shaft set in the angle of a wall or opening (1a).

NORMAN: *see* Romanesque.

NOSING: projection of the tread of a step (6c).

NUTMEG: medieval ornament with a chain of tiny triangles placed obliquely.

OCULUS: circular opening.

OEIL DE BOEUF: *see* Bullseye window.

OGEE: double curve, bending first one way and then the other, as in an *ogee* or *ogival arch* (5c). Cf. Cyma recta and Cyma reversa.

OPUS SECTILE: decorative mosaic-like facing.

OPUS SIGNINUM: composition flooring of Roman origin.

ORATORY: a private chapel in a church or a house. Also a church of the Oratorian Order.

ORDER: one of a series of recessed arches and jambs forming a splayed medieval opening, e.g. a doorway or arcade arch (1a).

ORDERS: the formalized versions of the post-and-lintel system in classical architecture. The main orders are *Doric*, *Ionic*, and *Corinthian*. They are Greek in origin but occur in Roman versions. *Tuscan* is a simple version of Roman Doric. Though each order has its own conventions (3), there are many minor variations. The *Composite* capital combines Ionic volutes with Corinthian foliage. *Superimposed orders*: orders on successive levels, usually in the upward sequence of Tuscan, Doric, Ionic, Corinthian, Composite.

ORIEL: *see* Bay window.

OVERDOOR: painting or relief above an internal door. Also called a *sopraporta*.

OVERTHROW: decorative fixed arch between two gatepiers or above a wrought-iron gate.

OVOLO: wide convex moulding (3f).

PALIMPSEST: of a brass: where a metal plate has been reused by turning over the engraving on the back; of a wall-painting: where one overlaps and partly obscures an earlier one.

PALLADIAN: following the examples and principles of Andrea Palladio (1508–80).

PALMETTE: classical ornament like a palm shoot (4b).

PANELLING: wooden lining to interior walls, made up of vertical members (*muntins*) and horizontals (*rails*) framing panels: also called *wainscot. Raised-and-fielded*: with the central area of the panel (*field*) raised up (6b).

PANTILE: roof tile of S section.

PARAPET: wall for protection at any sudden drop, e.g. at the wall-head of a castle where it protects the *parapet walk* or wall-walk. Also used to conceal a roof.

PARCHEMIN PANEL:with a vertical central rib or moulding branching in ogee curves to meet the four corners of the panel; sometimes used with linenfold (q.v.).

PARCLOSE: *see* Screen.

PARGETTING (*lit.* plastering): exterior plaster decoration, either in relief or incised.

PARLOUR: in a religious house, a room where the religious could talk to visitors; in a medieval house, the semi-private living room below the solar (q.v.).

PARTERRE: level space in a garden laid out with low, formal beds.

PATERA (*lit.* plate): round or oval ornament in shallow relief.

PAVILION: ornamental building for occasional use; or projecting subdivision of a larger building, often at an angle or terminating a wing.

PEBBLEDASHING: *see* Rendering.

PEDESTAL: a tall block carrying a classical order, statue, vase, etc.

PEDIMENT: a formalized gable derived from that of a classical temple; also used over doors, windows, etc. For variations *see* 4b.

PENDENTIVE: spandrel between adjacent arches, supporting a drum, dome or vault and consequently formed as part of a hemisphere (5a).

PENTHOUSE: subsidiary structure with a lean-to roof. Also a separately roofed structure on top of a C20 multi-storey block.

PERIPTERAL: *see* Peristyle.

PERISTYLE: a colonnade all round the exterior of a classical building, as in a temple which is then said to be *peripteral*.

PERP (PERPENDICULAR): English Gothic architecture *c.* 1335–50 to *c.* 1530. The name is derived from the upright tracery panels then used (*see* Tracery and 2a).

PERRON: external stair to a doorway, usually of double-curved plan.

PEW: loosely, seating for the laity outside the chancel; strictly, an enclosed seat. *Box pew*: with equal high sides and a door.

PIANO NOBILE: principal floor of a classical building above a ground floor or basement and with a lesser storey overhead.

PIAZZA: formal urban open space surrounded by buildings.

PIER: large masonry or brick support, often for an arch. *See also* Compound pier.

PILASTER: flat representation of a classical column in shallow relief. *Pilaster strip*: *see* Lesene.

PILE: row of rooms. *Double pile*: two rows thick.

PILLAR: free-standing upright member of any section, not conforming to one of the orders (q.v.).

PILLAR PISCINA: *see* Piscina.

PILOTIS: C20 French term for pillars or stilts that support a building above an open ground floor.

PISCINA: basin for washing Mass vessels, provided with a drain; set in or against the wall to the S of an altar or free-standing (*pillar piscina*).

PISÉ: *see* Cob.

PITCHED MASONRY: laid on the diagonal, often alternately with opposing courses (*pitched and counterpitched* or herringbone).

PLATE RAIL: *see* Railways.

PLATEWAY: *see* Railways.

PLINTH: projecting courses at the

foot of a wall or column, generally chamfered or moulded at the top.

PODIUM: a continuous raised platform supporting a building; or a large block of two or three storeys beneath a multi-storey block of smaller area.

POINT BLOCK: see Multi-storey.

POINTING: exposed mortar jointing of masonry or brickwork. Types include *flush*, *recessed* and *tuck* (with a narrow channel filled with finer, whiter mortar).

POPPYHEAD: carved ornament of leaves and flowers as a finial for a bench end or stall.

PORTAL FRAME: C20 frame comprising two uprights rigidly connected to a beam or pair of rafters.

PORTCULLIS: gate constructed to rise and fall in vertical gooves at the entry to a castle.

PORTICO: a porch with the roof and frequently a pediment supported by a row of columns (4a). A portico *in antis* has columns on the same plane as the front of the building. A *prostyle* porch has columns standing free. Porticoes are described by the number of front columns, e.g. tetrastyle (four), hexastyle (six). The space within the temple is the *naos*, that within the portico the *pronaos*. *Blind portico*: the front features of a portico applied to a wall.

PORTICUS (plural: porticūs): subsidiary cell opening from the main body of a pre-Conquest church.

POST: upright support in a structure (7).

POSTERN: small gateway at the back of a building or to the side of a larger entrance door or gate.

POUND LOCK: see Canals.

PRESBYTERY: the part of a church lying E of the choir where the main altar is placed; or a priest's residence.

PRINCIPAL: see Roofs and 7.

PRONAOS: see Portico and 4a.

PROSTYLE: see Portico and 4a.

PULPIT: raised and enclosed platform for the preaching of sermons. *Three-decker*: with reading desk below and clerk's desk below that.]

Two-decker: as above, minus the clerk's desk.

PULPITUM: stone screen in a major church dividing choir from nave.

PULVINATED: see Frieze and 3c.

PURLIN: see Roofs and 7.

PUTHOLES or PUTLOG HOLES: in the wall to receive putlogs, the horizontal timbers which support scaffolding boards; sometimes not filled after construction is complete.

PUTTO (plural: putti): small naked boy.

QUARRIES: square (or diamond) panes of glass supported by lead strips (*cames*); square floor-slabs or tiles.

QUATREFOIL: see Foil and 2b.

QUEENSTRUT: see Roofs and 7.

QUIRK: sharp groove to one side of a convex medieval moulding.

QUOINS: dressed stones at the angles of a building (6d).

RADBURN SYSTEM: vehicle and pedestrian segregation in residential developments, based on that used at Radburn, New Jersey, U.S.A., by Wright and Stein, 1928–30.

RADIATING CHAPELS: projecting radially from an ambulatory or an apse (*see* Chevet).

RAFTER: see Roofs and 7.

RAGGLE: groove cut in masonry, especially to receive the edge of a roof-covering.

RAGULY: ragged (in heraldry). Also applied to funerary sculpture, e.g. *cross raguly*: with a notched outline.

RAIL: see Panelling and 6b; also 7.

RAILWAYS: *Edge rail:* on which flanged wheels can run. *Plate rail:* L-section rail for plain unflanged wheels. *Plateway:* early railway using plate rails.

RAISED-AND-FIELDED: see Panelling and 6b.

RAKE: slope or pitch.

RAMPART: defensive outer wall of stone or earth. *Rampart walk:* path along the inner face.

REBATE: rectangular section cut out of a masonry edge to receive a shutter, door, window, etc.

REBUS: a heraldic pun, e.g. a fiery cock for Cockburn.

REEDING: series of convex mouldings, the reverse of fluting (q.v.). Cf. Gadrooning.

RENDERING: the covering of outside walls with a uniform surface or skin for protection from the weather. *Lime-washing:* thin layer of lime plaster. *Pebble-dashing:* where aggregate is thrown at the wet plastered wall for a textured effect. *Roughcast:* plaster mixed with a coarse aggregate such as gravel. *Stucco:* fine lime plaster worked to a smooth surface. *Cement rendering:* a cheaper substitute for stucco, usually with a grainy texture.

REPOUSSÉ: relief designs in metalwork, formed by beating it from the back.

REREDORTER (*lit.* behind the dormitory): latrines in a medieval religious house.

REREDOS: painted and/or sculptured screen behind and above an altar. Cf. Retable.

RESPOND: half-pier or half-column bonded into a wall and carrying one end of an arch. It usually terminates an arcade.

RETABLE: painted or carved panel standing on or at the back of an altar, usually attached to it.

RETROCHOIR: in a major church, the area between the high altar and E chapel.

REVEAL: the plane of a jamb, between the wall and the frame of a door or window.

RIB-VAULT: *see* Vault and 2c.

RINCEAU: classical ornament of leafy scrolls (4b).

RISER: vertical face of a step (6c).

ROCK-FACED: masonry cleft to produce a rugged appearance.

ROCOCO: style current *c.* 1720 and *c.* 1760, characterized by a serpentine line and playful, scrolled decoration.

ROLL MOULDING: medieval moulding of part-circular section (1a).

ROMANESQUE: style current in the C11 and C12. In England often called Norman. *See also* Saxo-Norman.

ROOD: crucifix flanked by the Virgin and St John, usually over the entry into the chancel, on a beam (*rood beam*) or painted on the wall. The *rood screen* below often had a walkway (*rood loft*) along the top, reached by a *rood stair* in the side wall.

ROOFS: Shape. For the main external shapes (hipped, mansard etc.) *see* 8a. *Helm* and *Saddleback*: *see* 1c. *Lean-to*: single sloping roof built against a vertical wall; lean-to is also applied to the part of the building beneath.
Construction. *See* 7.
Single-framed roof: with no main trusses. The rafters may be fixed to the wall-plate or ridge, or longitudinal timber may be absent altogether.
Double-framed roof: with longitudinal members, such as purlins, and usually divided into bays by principals and principal rafters.
Other types are named after their main structural components, e.g. *hammerbeam, crown-post* (*see* Elements below and 7).
Elements. *See* 7.
Ashlar piece: a short vertical timber connecting inner wall-plate or timber pad to a rafter.
Braces: subsidiary timbers set diagonally to strengthen the frame.]
Arched braces: curved pair forming an arch, connecting wall or post below with tie- or collar-beam above. *Passing braces:* long straight braces passing across other members of the truss. *Scissor braces:* pair crossing diagonally between pairs of rafters or principals. *Wind-braces:* short, usually curved braces connecting side purlins with principals; sometimes decorated with cusping.
Collar or *collar-beam:* horizontal transverse timber connecting a pair of rafter or cruck blades (q.v.), set between apex and the wall-plate.
Crown-post: a vertical timber set centrally on a tie-beam and supporting a collar purlin braced to it longitudinally. In an open truss lateral braces may rise to the

collar-beam; in a closed truss they may descend to the tie-beam.

Hammerbeams: horizontal brackets projecting at wall-plate level like an interrupted tie-beam; the inner ends carry *hammerposts*, vertical timbers which support a purlin and are braced to a collar-beam above.

Kingpost: vertical timber set centrally on a tie- or collar-beam, rising to the apex of the roof to support a ridge-piece (cf. Strut).

Plate: longitudinal timber set square to the ground. *Wall-plate:* plate along the top of a wall which receives the ends of the rafters; cf. Purlin.

Principals: pair of inclined lateral timbers of a truss. Usually they support side purlins and mark the main bay divisions.

Purlin: horizontal longitudinal timber. *Collar purlin* or *crown plate:* central timber which carries collar-beams and is supported by crown-posts. *Side purlins:* pairs of timbers placed some way up the slope of the roof, which carry common rafters. *Butt* or *tenoned purlins* are tenoned into either side of the principals. *Through purlins* pass through or past the principal; they include *clasped purlins*, which rest on queenposts or are carried in the angle between principals and collar, and *trenched purlins* trenched into the backs of principals.

Queen-strut: paired vertical, or near-vertical, timbers placed symmetrically on a tie-beam to support side purlins.

Rafters: inclined lateral timbers supporting the roof covering. *Common rafters:* regularly spaced uniform rafters placed along the length of a roof or between principals. *Principal rafters:* rafters which also act as principals.

Ridge, ridge-piece: horizontal longitudinal timber at the apex supporting the ends of the rafters.

Sprocket: short timber placed on the back and at the foot of a rafter to form projecting eaves.

Strut: vertical or oblique timber between two members of a truss, not directly supporting longitudinal timbers.

Tie-beam: main horizontal transverse timber which carries the feet of the principals at wall level.

Truss: rigid framework of timbers at bay intervals, carrying the longitudinal roof timbers which support the common rafters. *Closed truss:* with the spaces between the timbers filled, to form an internal partition.

See also Cruck, Wagon roof.

ROPE MOULDING: *see* Cable moulding.

ROSE WINDOW: circular window with tracery radiating from the centre. Cf. Wheel window.

ROTUNDA: building or room circular in plan.

ROUGHCAST: *see* Rendering.

ROVING BRIDGE: *see* Canals.

RUBBED BRICKWORK: *see* Gauged brickwork.

RUBBLE: masonry whose stones are wholly or partly in a rough state. *Coursed:* coursed stones with rough faces. *Random:* uncoursed stones in a random pattern. *Snecked:* with courses broken by smaller stones (snecks).

RUSTICATION: *see* 6d. Exaggerated treatment of masonry to give an effect of strength. The joints are usually recessed by V-section chamfering or square-section channelling (*channelled rustication*). *Banded rustication* has only the horizontal joints emphasized. The faces may be flat, but can be *diamond-faced*, like shallow pyramids, *vermiculated*, with a stylized texture like worm-casts, and *glacial* (frost-work), like icicles or stalactites.

SACRISTY: room in a church for sacred vessels and vestments.

SADDLEBACK ROOF: *see* 1C.

SALTIRE CROSS: with diagonal limbs.

SANCTUARY: area around the main altar of a church. Cf. Presbytery.

SANGHA: residence of Buddhist monks or nuns.

SARCOPHAGUS: coffin of stone or other durable material.

SAXO-NORMAN: transitional Romanesque style combining Anglo-Saxon and Norman features, current *c.* 1060–1100.

SCAGLIOLA: composition imitating marble.

SCALLOPED CAPITAL: *see* 1a.

SCOTIA: a hollow classical moulding, especially between tori (q.v.) on a column base (3b, 3f).

SCREEN: in a medieval church, usually at the entry to the chancel; *see* Rood (screen) and Pulpitum. A *parclose screen* separates a chapel from the rest of the church.

SCREENS or SCREENS PASSAGE: screened-off entrance passage between great hall and service rooms.

SECTION: two-dimensional representation of a building, moulding, etc., revealed by cutting across it.

SEDILIA (singular: sedile): seats for the priests (usually three) on the S side of the chancel.

SET-OFF: *see* Weathering.

SGRAFFITO: decoration scratched, often in plaster, to reveal a pattern in another colour beneath. *Graffiti*: scratched drawing or writing.

SHAFT: vertical member of round or polygonal section (1a, 3a). *Shaft-ring*: at the junction of shafts set *en delit* (q.v.) or attached to a pier or wall (1a).

SHEILA-NA-GIG: female fertility figure, usually with legs apart.

SHELL: thin, self-supporting roofing membrane of timber or concrete.

SHOULDERED ARCHITRAVE: *see* 4b.

SHUTTERING: *see* Concrete.

SILL: horizontal member at the bottom of a window or door frame; or at the base of a timber-framed wall into which posts and studs are tenoned (7).

SLAB BLOCK: *see* Multi-storey.

SLATE-HANGING: covering of overlapping slates on a wall. *Tile-hanging* is similar.

SLYPE: covered way or passage leading E from the cloisters between transept and chapter house.

SNECKED: *see* Rubble.

SOFFIT (*lit.* ceiling): underside of an arch (also called *intrados*), lintel, etc. *Soffit roll:* medieval roll moulding on a soffit.

SOLAR: private upper chamber in a medieval house, accessible from the high end of the great hall.

SOPRAPORTA: *see* Overdoor.

SOUNDING-BOARD: *see* Tester.

SPANDRELS: roughly triangular spaces between an arch and its containing rectangle, or between adjacent arches (5c). Also non-structural panels under the windows in a curtain-walled building.

SPERE: a fixed structure screening the lower end of the great hall from the screens passage. *Spere-truss*: roof truss incorporated in the spere.

SPIRE: tall pyramidal or conical feature crowning a tower or turret. *Broach:* starting from a square base, then carried into an octagonal section by means of triangular faces; and *splayed-foot:* variation of the broach form, found principally in the southeast, in which the four cardinal faces are splayed out near their base, to cover the corners, while oblique (or intermediate) faces taper away to a point (1c). *Needle spire:* thin spire rising from the centre of a tower roof, well inside the parapet: when of timber and lead often called a *spike*.

SPIRELET: *see* Flèche.

SPLAY: of an opening when it is wider on one face of a wall than the other.

SPRING OR SPRINGING: level at which an arch or vault rises from its supports. *Springers:* the first stones of an arch or vaulting rib above the spring (2c).

SQUINCH: arch or series of arches thrown across an interior angle of a square or rectangular structure to support a circular or polygonal superstructure, especially a dome or spire (5a).

SQUINT: an aperture in a wall or through a pier usually to allow a view of an altar.

STAIRS: *see* 6c. *Dog-leg stair:* parallel flights rising alternately in opposite directions, without

an open well. *Flying stair:* cantilevered from the walls of a stairwell, without newels; sometimes called a *Geometric* stair when the inner edge describes a curve. *Newel stair:* ascending round a central supporting newel (q.v.); called a *spiral stair* or *vice* when in a circular shaft, a *winder* when in a rectangular compartment. (Winder also applies to the steps on the turn). *Well stair:* with flights round a square open well framed by newel posts. *See also* Perron.

STALL: fixed seat in the choir or chancel for the clergy or choir (cf. Pew). Usually with arm rests, and often framed together.

STANCHION: upright structural member, of iron, steel or reinforced concrete.

STANDPIPE TOWER: *see* Manometer.

STEAM ENGINES: *Atmospheric:* worked by the vacuum created when low-pressure steam is condensed in the cylinder, as developed by Thomas Newcomen. *Beam engine:* with a large pivoted beam moved in an oscillating fashion by the piston. It may drive a flywheel or be *non-rotative. Watt* and *Cornish:* single-cylinder; *compound:* two cylinders; *triple expansion:* three cylinders.

STEEPLE: tower together with a spire, lantern, or belfry.

STIFF-LEAF: type of E.E. foliage decoration. *Stiff-leaf capital see* 1b.

STOP: plain or decorated terminal to mouldings or chamfers, or at the end of hoodmoulds and labels (*label stop*), or string courses (5b, 6a); *see also* headstop.

STOUP: vessel for holy water, usually near a door.

STRAINER: *see* Arch.

STRAPWORK: late C16 and C17 decoration, like interlaced leather straps.

STRETCHER: *see* Bond and 6e.

STRING COURSE: horizontal course or moulding projecting from the surface of a wall (6d).

STRING: *see* 6c. Sloping member holding the ends of the treads and risers of a staircase. *Closed string:* a broad string covering the ends

of the treads and risers. *Open string:* cut into the shape of the treads and risers.

STUCCO: *see* Rendering.

STUDS: subsidiary vertical timbers of a timber-framed wall or partition (7).

STUPA: Buddhist shrine, circular in plan.

STYLOBATE: top of the solid platform on which a colonnade stands (3a).

SUSPENSION BRIDGE: *see* Bridge.

SWAG: like a festoon (q.v.), but representing cloth.

SYSTEM BUILDING: *see* Industrialized building.

TABERNACLE: canopied structure to contain the reserved sacrament or a relic; or architectural frame for an image or statue.

TABLE TOMB: memorial slab raised on free-standing legs.

TAS-DE-CHARGE: the lower courses of a vault or arch which are laid horizontally (2c).

TERM: pedestal or pilaster tapering downward, usually with the upper part of a human figure growing out of it.

TERRACOTTA: moulded and fired clay ornament or cladding.

TESSELLATED PAVEMENT: mosaic flooring, particularly Roman, made of *tesserae*, i.e. cubes of glass, stone, or brick.

TESTER: flat canopy over a tomb or pulpit, where it is also called a *sounding-board*.

TESTER TOMB: tomb-chest with effigies beneath a tester, either free-standing (tester with four or more columns), or attached to a wall (*half-tester*) with columns on one side only.

TETRASTYLE: *see* Portico.

THERMAL WINDOW: *see* Diocletian window.

THREE-DECKER PULPIT: *see* Pulpit.

TIDAL GATES: *see* Canals.

TIE-BEAM: *see* Roofs and 7.

TIERCERON: *see* Vault and 2c.

TILE-HANGING: *see* Slate-hanging.

TIMBER-FRAMING: *see* 7. Method of construction where the struc-

tural frame is built of interlocking timbers. The spaces are filled with non-structural material, e.g. *infill* of wattle and daub, lath and plaster, brickwork (known as *nogging*), etc. and may be covered by plaster, weatherboarding (q.v.), or tiles.

TOMB-CHEST: chest-shaped tomb, usually of stone. Cf. Table tomb, Tester tomb.

TORUS (plural: tori): large convex moulding usually used on a column base (3b, 3f).

TOUCH: soft black marble quarried near Tournai.

TOURELLE: turret corbelled out from the wall.

TOWER BLOCK: *see* Multi-storey.

TRABEATED: depends structurally on the use of the post and lintel. Cf. Arcuated.

TRACERY: openwork pattern of masonry or timber in the upper part of an opening. *Blind tracery* is tracery applied to a solid wall.
Plate tracery, introduced *c.* 1200, is the earliest form, in which shapes are cut through solid masonry (2a).
Bar tracery was introduced into England *c.* 1250. The pattern is formed by intersecting moulded ribwork continued from the mullions. It was especially elaborate during the Decorated period (q.v.). Tracery shapes can include circles, *daggers* (elongated ogee-ended lozenges), *mouchettes* (like daggers but with curved sides) and upright rectangular *panels*. They often have *cusps*, projecting points defining lobes or *foils* (q.v.) within the main shape: *Kentish* or *split-cusps* are forked (2b).
Types of bar tracery (*see* 2b) include *geometric(al)*: *c.* 1250–1310, chiefly circles, often foiled; *Y-tracery*: *c.* 1300, with mullions branching into a Y-shape; *intersecting*: *c.* 1300, formed by interlocking mullions; *reticulated*: early C14, net-like pattern of ogee-ended lozenges; *curvilinear*: C14, with uninterrupted flowing curves; *panel*: Perp, with straight-sided panels, often cusped at the top and bottom.

TRANSEPT: transverse portion of a church.

TRANSITIONAL: generally used for the phase between Romanesque and Early English (*c.* 1175–*c.* 1200ff).

TRANSOM: horizontal member separating window lights (2b).

TREAD: horizontal part of a step. The *tread end* may be carved on a staircase (6c).

TREFOIL: *see* Foil.

TRIFORIUM: middle storey of a church treated as an arcaded wall passage or blind arcade, its height corresponding to that of the aisle roof.

TRIGLYPHS (*lit.* three-grooved tablets): stylized beam-ends in the Doric frieze, with metopes between (3b).

TRIUMPHAL ARCH: influential type of Imperial Roman monument.

TROPHY: sculptured or painted group of arms or armour.

TRUMEAU: central stone mullion supporting the tympanum of a wide doorway. *Trumeau figure:* carved figure attached to it (cf. Column figure).

TRUMPET CAPITAL: *see* 1b.

TRUSS: braced framework, spanning between supports. *See also* Roofs and 7.

TUMBLING or TUMBLING-IN: courses of brickwork laid at right-angles to a slope, e.g. of a gable, forming triangles by tapering into horizontal courses (8a).

TUSCAN: *see* Orders and 3e.

TWO-DECKER PULPIT: *see* Pulpit.

TYMPANUM: the surface between a lintel and the arch above it or within a pediment (4a).

UNDERCROFT: usually describes the vaulted room(s), beneath the main room(s) of a medieval house. Cf. Crypt.

VAULT: arched stone roof (sometimes imitated in timber or plaster). For types *see* 2c.
Tunnel or *barrel vault:* continuous semicircular or pointed arch, often of rubble masonry.

Groin-vault: tunnel vaults intersecting at right angles. *Groins* are the curved lines of the intersections.

Rib-vault: masonry framework of intersecting arches (ribs) supporting *vault cells,* used in Gothic architecture. *Wall rib* or *wall arch:* between wall and vault cell. *Transverse rib:* spans between two walls to divide a vault into bays. *Quadripartite* rib-vault: each bay has two pairs of diagonal ribs dividing the vault into four triangular cells. *Sexpartite* rib-vault: most often used over paired bays, has an extra pair of ribs springing from between the bays. More elaborate vaults may include *ridge ribs* along the crown of a vault or bisecting the bays; *tiercerons:* extra decorative ribs springing from the corners of a bay; and *liernes:* short decorative ribs in the crown of a vault, not linked to any springing point. A *stellar* or *star* vault has liernes in star formation.

Fan-vault: form of barrel vault used in the Perp period, made up of halved concave masonry cones decorated with blind tracery.

VAULTING SHAFT: shaft leading up to the spring or springing (q.v.) of a vault (2c).

VENETIAN or SERLIAN WINDOW: derived from Serlio (4b). The motif is used for other openings.

VERMICULATION: *see* Rustication and 6d.

VESICA: oval with pointed ends.

VICE: *see* Stair.

VILLA: originally a Roman country house or farm. The term was revived in England in the C18 under the influence of Palladio and used especially for smaller, compact country houses. In the later C19 it was debased to describe any suburban house.

VITRIFIED: bricks or tiles fired to a darkened glassy surface.

VITRUVIAN SCROLL: classical running ornament of curly waves (4b).

VOLUTES: spiral scrolls. They occur on Ionic capitals (3c). *Angle volute:* pair of volutes, turned outwards to meet at the corner of a capital.

VOUSSOIRS: wedge-shaped stones forming an arch (5c).

WAGON ROOF: with the appearance of the inside of a wagon tilt; often ceiled. Also called *cradle roof.*

WAINSCOT: *see* Panelling.

WALL MONUMENT: attached to the wall and often standing on the floor. *Wall tablets* are smaller with the inscription as the major element.

WALL-PLATE: *see* Roofs and 7.

WALL-WALK: *see* Parapet.

WARMING ROOM: room in a religious house where a fire burned for comfort.

WATERHOLDING BASE: early Gothic base with upper and lower mouldings separated by a deep hollow.

WATERLEAF: *see* Enrichments and 3f.

WATERLEAF CAPITAL: Late Romanesque and Transitional type of capital (1b).

WATER WHEELS: described by the way water is fed on to the wheel. *Breastshot*: mid-height, falling and passing beneath. *Overshot*: over the top. *Pitchback*: on the top but falling backwards. *Undershot*: turned by the momentum of the water passing beneath. In a *water turbine*, water is fed under pressure through a vaned wheel within a casing.

WEALDEN HOUSE: type of medieval timber-framed house with a central open hall flanked by bays of two storeys, roofed in line; the end bays are jettied to the front, but the eaves are continuous (8a).

WEATHERBOARDING wall cladding of overlapping horizontal boards.

WEATHERING or SET-OFF: inclined, projecting surface to keep water away from the wall below.

WEEPERS: figures in niches along the sides of some medieval tombs. Also called *mourners.*

WHEEL WINDOW: circular, with radiating shafts like spokes. Cf. Rose window.

WROUGHT IRON: *see* Cast iron.

LANGUAGE GLOSSARY

Adapted, with omissions and a few augmentations, with the permission of the Director General of the Ordnance Survey, from the OS publication *Place Names on Maps of Scotland and Wales*. Crown copyright reserved.

a = adjective
ad = adverb
f = feminine
n = noun masculine

nf = noun feminine
np = noun plural
pl = plural
pr = preposition

abad, *n* abbot
abaty, *n* abbey
aber, *n & nf* estuary, confluence, stream
adeiladu, *verb* to build
aderyn, *pl* adar, *n* bird
ael, *nf* brow, edge
aelwyd, *nf* hearth
aethnen, *nf* aspen, poplar
afallen, *nf* apple tree
afon, *nf* river
ailadeiladu, *verb* to rebuild
allt, *pl* elltydd, alltau, *nf* hillside, cliff, wood
Annibynnol, *a* Independent
ar, *pr* on, upon, over
ardd, *n* hill, height
argoed, *nf* wood, grove

bach, *a* small, little, lesser
bach, *pl* bachau, *nf* nook, corner
bala, *n* outlet of a lake
banc, *pl* bencydd, *n* bank, slope
bangor, *nf* monastery originally constructed of wattle rods
banhadlog, *nf* broom patch
banw, *n* young pig
bar, *n* top, summit
bechan, *a* *see* bychan
bedd, *pl* beddau, *n* grave
Bedyddwyr, *a* Baptist
beidr, *nf* lane, path
beili, *pl* beiliau, *n* bailey, court before a house bailiff
bellaf, *a* far
bendigaid, *a* blessed
betws, *n* oratory, chapel

beudy, *n* cow-house
blaen, *pl* blaenau, *n* end, edge; source of river or stream; highland
bod, *n & nf* abode, dwelling
bôn, *n* stock, stump
bont, *nf* *see* pont
braich, *n & nf* ridge, arm
brân, *pl* brain, *nf* crow
bre, *nf* hill
brith, *f* braith, *a* speckled; coarse
bro, *nf* region; vale, lowland
bron, *pl* bronnydd, *nf* hillbreast (breast)
bryn, *pl* bryniau, *n* hill
bugail, *pl* bugelydd, bugeiliaid, *n* shepherd
bwla, *n* bull
bwlch, *pl* bylchau, *n* gap, pass
bwth, bwthyn, *n* cottage, booth
bychan, *f* bechan, *pl* bychain, *a* little, tiny

caban, *n* cottage, cabin
cader, cadair, *nf* seat, stronghold
cadlas, *nf* close, court of a house
cae, *pl* caeau, *n* field, enclosure
caer, *pl* caerau, *nf* stronghold, fort
cafn, *n* ferry-boat, trough
canol, *n* middle
cantref, *n* hundred (territorial division)
capel, *n* meeting house, chapel
carn, *pl* carnau, *nf* heap of stones, tumulus
carnedd, *pl* carneddau, carneddi, *nf* heap of stones, tumulus

carreg, *pl* cerrig, *nf* stone, rock

carrog, *nf* brook

carw, *n* stag

cas (in Casnewydd etc.), *n* castle

castell, *pl* cestyll, *n* castle; small stronghold; fortified residence; imposing natural position

cath, *nf* cat. (In some names it may be the Irish word cath meaning 'battle'.)

cau, *a* hollow; enclosed

cawr, *pl* ceiri, cewri, *n* giant

cefn, *pl* cefnydd, *n* ridge

cegin, *nf* kitchen

ceiliog, *n* cock

ceiri, *np* *see* cawr

celli, *nf* grove

celynen, *pl* celyn, *nf* holly tree

celynog, clynnog, *nf* holly grove

cemais, *n from np* shallow bend in river, or coastline

cennin, *np* leeks

cerrig, *np see* carreg

cesail, *nf* hollow (arm- pit)

ceunant, *n* ravine, gorge

cewri, *np* *see* cawr

chwilog, *nf* land infested with beetles

cil, *pl* ciliau, *n* retreat, recess, corner

cilfach, *nf* nook

clas, *n* quasi-monastic system of the Celtic Church, existing in Wales, Cornwall and Ireland from the Dark Ages to *c.* 1200. *Clasau* comprised a body of secular canons

clawdd, *pl* cloddiau, *n* ditch, hedge

cloch, *nf* bell

clochydd, *n* sexton, parish clerk

cloddiau, *np see* clawdd

clog, *nf* crag, precipice

clogwyn, *n* precipice, steep rock hanging on one side

clwyd, *pl* clwydydd, *nf* hurdle, gate

clynnog, *nf see* celynog

coch, *a* red

coeden, *pl* coed, *nf* tree

collen, *pl* cyll, coll, *nf* hazel

colwyn, *n* whelp

comin, *pl* comins, *n* common

congl, *nf* corner

cornel, *nf* corner

cors, *pl* corsydd, *nf* bog

craf, *n* garlic

craig, *pl* creigiau, *nf* rock

crib, *n* crest, ridge, summit

crochan, *n* cauldron

croes, *nf* cross

croesffordd, croesheol, croeslon, *nf* cross-roads

crofft, *pl* crofftau, *nf* croft

croglofft, *nf* garret, low cottage with loft under the roof

crug, *pl* crugiau, *n* heap, tump

cwm, *pl* cymau, cymoedd, *n* valley, dale

cwmwd, *n* commote (territorial division)

cwrt, *n* court, yard

cyffin, *n* boundary, frontier

cyll, *np see* collen

cymer, *pl* cymerau, *n* confluence

Cynulleidfaol, *a* Congregational

cywarch, *n* hemp

dan, *pr* under, below

derwen, *pl* derw, *nf* oak

diffwys, *n* precipice, abyss

dinas, *n & nf* hill-fortress (city)

diserth, *n* hermitage

disgwylfa, *nf* place of observation, look-out point

dôl, *pl* dolau, dolydd, *nf* meadow

draw, *ad* yonder

du, *a* black, dark

dwfr, dŵr, *n* water

dyffryn, *n* valley

eglwys, *nf* church

(ei)singrug, *n* heap of bran or corn husks

eisteddfa, *nf* seat, resting place

eithinog, *nf* furze patch

elltyd, *np see* allt

ellyll, *n* elf, goblin

eos, *nf* nightingale

erw, *pl* erwau, *nf* acre

esgair, *nf* long ridge (leg)

esgob, *n* bishop

ewig, *nf* hind

-fa, *nf* *see* ma-

fach, *a* *see* bach

faenor, *nf* Vaynor. cf. maenor

fawr, *a* *see* mawr

felin, *nf* *see* melin

ffald, *pl* ffaldau, *nf* sheep-fold, pound, pen, run

ffawydden, *pl* ffawydd, *nf* beech tree

fferm, *nf* farm

ffin, *nf* boundary

ffordd, *nf* way, road
fforest, *nf* forest, park
ffridd, ffrith, *pl* ffriddoedd, *nf* wood; mountain enclosure, sheep walk
ffrwd, *nf* stream, torrent
ffynnon, *pl* ffynhonnau, *nf* spring, well
fron, *nf* *see* bron
fry, *ad* above

gaer, *nf* *see* caer
ganol, *n* *see* canol
gardd, *pl* gerddi, garddau, *nf* garden; enclosure or fold into which calves were turned for first time
garreg, *nf* *see* carreg
garth, *n* promontory, hill enclosure
garw, *a* coarse, rough
gefail, *nf* smithy
(g)eirw, *np* rush of waters
gelli, *nf* *see* celli
glan, *nf* river bank, hillock
glas, *a* green
glas, glais (as in dulas, dulais), *n &* *nf* brook
glo, *n* charcoal, coal
glyn, *n* deep valley, glen
gof, *n* smith
gogof, *pl* gogofau, *nf* cave
gorffwysfa, *nf* resting place
gris, *pl* grisiau, *n* step
grug, *n* heath, heather
gwaelod, *n* foot of hill (bottom)
gwastad, *n* plain
gwaun, *pl* gweunydd, *nf* moor, mountain meadow, moorland field
gwely, *n* bed, resting place, family land
gwen, *a* *see* gwyn
gwerdd, *a* *see* gwyrdd
gwernen, *pl* gwern, *nf* alder tree
gwersyll, *n* encampment
gwrych, *n* hedge, quickset hedge
gwryd, *n* fathom
gwyddel, *pl* gwyddyl, gwyddelod, *n* Irishman
gwyddrug, *nf* mound, wooded knoll
gwyn, *f* gwen, *a* white
gwynt, *n* wind
gwyrdd, *f* gwerdd, *a* green

hafn, *nf* gorge, ravine

hafod, *nf* shieling, upland summer dwelling
hafoty, *n* summer dwelling
helygen, *pl* helyg, *nf* willow
hen, *a* old
hendref, *nf* winter dwelling, old home, permanent abode
heol, hewl, *nf* street, road
hir, *a* long

is, *pr* below, under
isaf, *a* lower (lowest)
isel, *a* low
iwrch, *pl* iyrchod, *n* roebuck

lawnd, lawnt, *nf* open space in woodland, glade
llaethdy, *n* milkhouse, dairy
llan, *nf* church, monastery; enclosure
Llanbedr St Peter's church
Llanddewi St David's church
Llanfair St Mary's church
Llanfihangel St Michael's church
llannerch, *nf* clearing, glade
lle, *n* place, position
llech, *pl* llechau, *nf* slab, stone, rock
llechwedd, *nf* hillside
llethr, *nf* slope
llety, *n* small abode, quarters
llidiard, llidiart, *pl* llidiardau, llidiartau, *n* gate
llom, *a* *see* llwm
lluest, *n* shieling, cottage, hut
llumon, *n* stack (chimney)
llwch, *n* dust
llwch, *pl* llychau, *n* lake
llwm, *f* llom, *a* bare, exposed
llwyd, *a* grey, brown
llwyn, *pl* llwyni, llwynau, *n* grove, bush
llyn, *n &* *nf* lake
llys, *n &* *nf* court, hall
lôn, *nf* lane, road

ma-, -fa, *nf* plain, place
maen, *pl* meini, main, *n* stone
maenol, maenor, *nf* stone-built residence of chieftain of district, rich low-lying land surrounding same, vale
maerdref, *nf* hamlet attached to chieftain's court, lord's demesne (maer, steward + tref, hamlet)
maerdy, *n* steward's house, dairy

maes, *pl* meysydd, *n* open field, plain

march, *pl* meirch, *n* horse, stallion

marchog, *n* knight, horseman

marian, *n* holm, gravel, gravelly ground, rock debris

mawnog, *nf* peat-bog

mawr, *a* great, big

meillionen, *pl* meillion, *nf* clover

meini, *np* *see* maen

meirch, *np* *see* march

melin, *nf* mill

melyn, *f* melen, *a* yellow

menych, *np* *see* mynach

merthyr, *n* burial place, church

Methodistaidd, *a* Methodist

meysydd, *np* *see* maes

mochyn, *pl* moch, *n* pig

moel, *nf* bare hill

moel, *a* bare, bald

môr, *n* sea

morfa, *n* marsh, fen

mur, *pl* muriau, *n* wall

mwyalch, mwyalchen, *nf* blackbird

mynach, *pl* mynych, menych, myneich, *n* monk

mynachdy, *n* monastic grange

mynwent, *nf* churchyard

mynydd, *n* mountain, moorland

nant, *pl* nentydd, naint, nannau, *nf* brook

nant, *pl* nentydd, naint, nannau, *n* dingle, glen, ravine

neuadd, *nf* hall

newydd, *a* new

noddfa, *nf* hospice

nyth, *n & nf* nest, inaccessible position

oen, *pl* ŵyn, *n* lamb

offeiriad, *n* priest

onnen, *pl* onn, ynn, *nf* ash tree

pandy, *n* fulling mill

pant, *n* hollow, valley

parc, *pl* parciau, parcau, *n* park, field, enclosure

pen, *pl* pennau, *n* head, top; end, edge

penrhyn, *n* promontory

pensaer, *n* architect

pentref, *n* homestead, appendix to the real 'tref', village

person, *n* parson

pistyll, *n* spout, waterfall

plas, *n* gentleman's seat, hall, mansion

plwyf, *n* parish

poeth, *a* burnt (hot)

pont, *nf* bridge

porth, *n* gate, gateway

porth, *nf* ferry, harbour

pwll, *pl* pyllau, *n* pit, pool

rhaeadr, *nf* waterfall

rhandir, *n* allotment, fixed measure of land

rhiw, *nf & n* hill, slope

rhos, *pl* rhosydd, *nf* moor, promontory

rhyd, *nf & n* ford

saeth, *pl* saethau, *nf* arrow

sant, san, *pl* saint, *n* saint, monk

sarn, *pl* sarnau, *nf* causeway

simnai, simdde, *nf* chimney

siop, *nf* shop

sticil, sticill, *nf* stile

swydd, *nf* seat, lordship, office

sych, *a* dry

tafarn, *pl* tafarnau, *n & nf* tavern

tai, *np* *see* tŷ

tâl, *n* end (forehead)

talwrn, *pl* talyrni, tylyrni, *n* bare exposed hillside, open space, threshing floor, cockpit

tan, dan, *nf* under, beneath

teg, *a* fair

tir, *n* land, territory

tom, tomen, *nf* mound

ton, *pl* tonnau, *nf* wave

ton, tonnen, *pl* tonnau, *n & nf* grassland, lea

torglwyd, *nf* door-hurdle, gate

towyn, *n* *see* tywyn

traean, traen, *n* third part

traeth, *n* strand, shore

trallwng, trallwm, *n* wet bottom land

traws, *a & n* cross, transverse

tref, *nf* homestead, hamlet, town

tros, *pr* over

trwyn, *n* point, cape (nose)

twr, *n* tower

twyn, *pl* twyni, *n* hillock, knoll

tŷ, *pl* tai, *n* house

tyddyn, ty'n, *n* small farm, holding

tylyrni, *np* *see* talwrn

tywyn, towyn, *n* sea-shore, strand

uchaf, *a* higher, highest

uchel, *a* high

uwch, *pr* above, over

ŵyn, *np* *see* oen

y, yr, 'r (definite article) the
yn, *pr* in
ynn, *np* *see* onnen
ynys, *pl* ynysoedd, *nf* island; holm,
river-meadow

ysbyty, *n* hospital, hospice
ysgol, *pl* ysgolion, *nf* school
ysgubor, *pl* ysguboriau, *nf* barn
ystafell, *nf* chamber, hiding place
ystrad, *n* valley, holm, river-
meadow
ystum, *nf & n* bend shape

INDEX OF ARCHITECTS
AND ARTISTS

Entries for partnerships and group practices are listed after entries for a single surname. Minor differences in title are disregarded.

INDEX OF ARCHITECTS AND ARTISTS 635

Marsden, Bill 103, 422–3
Martin, Howard (glass-stainer) 50,
168, 386
see also Celtic Studios
Martin & Chamberlain 142
Maw & Co. (tile-makers) 47, 130,
539
Mayer & Co (glass-stainers) 134,
163, 167, 257, 345, 372
Medland, Steve 363
Mercer, Charles W. 117, 349
Mercer, G. 290
Mercer & Howells 115
Messenger & Co. (glasshouse manu-
facturers) 329
Metcalfe, Harold 151
Middleton, J. H. 404
see also Middleton & Son
Middleton, John 43, 44, 47, 53, 70,
372, 505n, 526, 527–8, 592, Pl. 95
Middleton & Goodman 161, 393,
509
Middleton & Prothero 213
Middleton, Prothero & Phillot 133,
322, 326, 330, 357, 443, 484, 504,
505, 515
Middleton & Son 44, 134, 295, 325,
326, 341, 393, 404, 432–3, 479,
498, 500, 505, 541
Minter, Muriel (glass-stainer) 326
Minton (tile-maker) 47, 199, 527
Mitchell, Arnold 70, 324
Mitchell (Cedric) Architects 145
Moffatt, William L. 53, 97, 442, 452,
486
Moggridge, Hal (landscape designer)
104, 236, 311
Moore, Albert L. (glass-stainer) 50,
194, 527
see also Moore, A. L. & C. E.
Moore, A. L. & C. E. (glass-stainers)
244, 527
see also Moore, Albert L.
Morant & Co. (decorators) 70, 507
Morgan, David 98, 141, 151, 153,
272, 317, 348, 384
Morgan, Gareth (glass-stainer) 144
Morgan, George 58, 59, 61, 70, 98,
99, 115, 122, 129, 134–5, 136, 137,
145, 147, 148, 150, 153, 154, 167,
194, 217, 229, 242, 250, 257, 279,
294, 297, 311, 316, 317, 319, 321,
337, 338, 344, 353, 358, 368, 373,
374, 385, 387, 394, 448, 452, 454,
456, 521, 541, Pl. 99
see also Morgan (George) & Son
Morgan, J. B. 99, 290
Morgan, J. Howard 60, 61, 70, 99,
134, 136, 137, 152, 194, 203, 216,
218, 245, 253, 260, 302, 307, 314,
317, 320, 338, 344, 357, 373, 399,
400, 461, Pl. 109
see also Morgan (George) & Son

Morgan, John 335
Morgan, Morgan (bridge-builder)
167, 250
Morgan, R. (sculptor) 132
Morgan, T. E. 59, 95, 99, 405, 406,
411, 427, 429, 497
Morgan, W. D. 216
Morgan, W. Vincent 99, 102, 119,
141, 168, 262
Morgan, William (bridge-builder)
374
Morgan, William (Llansteffan) 335
Morgan (George) & Son 95, 96, 97,
124, 134, 137, 143, 145, 148, 150,
151, 152, 154, 155, 169, 216, 243,
250, 279, 307, 317, 319, 351, 400,
452, 482, Pl. 108
see also Morgan, George; Morgan,
J. Howard
Morris, David (bridge-builder) 397
Morris, J. (foundry) 411
Morris, J. M. (sculptor) 410
Morris, John 441
Morris, Joshua 188
Morris, T. (sculptor) 191
Morris, Thomas (sculptor) 244
Morris & Co. (glass-stainers) 49,
268, 276
see also Burne Jones, Sir Edward
Morris (William) Studios (glass-
stainers) 496, 553
Moss, J. (foundry) 10, 88, 167, 229,
231, 520, 556
Mouchel (L. G.) & Partners (engi-
neers) 482
Mowbray, R. 286
Mowlem (John) Engineering 141,
285, 344
Moxham, Glendinning 99, 194, 216
see also Wilson & Moxham
Murray, H. G. (glass-stainer) 496
Mwldan Foundry 444

Nash, John 8, 40, 66–8, 90–1, 94, 98,
115, 128–9, 131, 138–9, 150, 154,
174, 199, 250, 298, 313, 347, 365,
411, 412, 432, 451, 456, 474–5,
501, 511, 512, 515, 521, 538, 545,
549, 552, 569, 581, 585, 588, Pls.
60, 61
Nelson, C. C. 42, 113
Newbery, Robert J. (glass-stainer) 50,
201, 245, 278, 294, 302, 309, 481
Nicholas, Andrew 364
Nicholson, A. K. (glass-stainer) 50,
341, 519
Nicholson, Thomas 331
Nicholson & Hartree 402
Nicholson & Son 44, 402–3
Nicholson & Son (organ-builders)
359
Nollekens, Joseph (sculptor) 51, 376,
Pl. 54

Williams-Ellis (Clough) & Scott 122

Wills, John 509, 577

Wilson, J. Buckley 95, 99, 191, 284, 287
 see also Wilson & Moxham

Wilson, James 58, 59, 93, 99, 130, 147, 280–1, 283, 320, 358

Wilson & Moxham 95, 274, 280, 286, 287, 290
 see also Wilson, J. Buckley; Moxham, Glendinning

Wilson, Willcox & Wilson 44, 47, 124, 290
 see also Wilson, James; Wilson, J. Buckley

Wind's Eye Studio see Hescott (Amber) & David Pearl

Winship, Bertram 387

Wippell & Co. (glass-stainers) 133, 595

Wishlake, T. W. (engineer) 351

Withers, R. J. 42, 43, 44, 47, 48, 49, 53, 93, 95, 100, 307, 358, 363, 396, 399, 435, 438, 450, 452, 454, 455, 479, 480, 482, 492, 497, 501, 502, 505, 517, 519–20, 538, 544, 550, 553, 557, 568, 570, 585, 586, 591, Pls. 89, 93

Wojnarowski, K. (sculptor) 484

Wood, Henry (sculptor) 51, 131, 132, 228, 322, 335, 447, 458

Woodward, William (engineer) 100, 456, 522

Woodward Engineering Co. (foundry) 441

Woodyer, Henry 447, 590

Woolfall & Eccles 97, 252, 427

Wort, W. S. 102, 147

Worthington, T. L. 588

Wyatt, James 40, 477

Wyatville, Jeffry 68, 199–200, Pl. 64

Wynne, Robert (sculptor) 39, 496

INDEX OF PATRONS
AND RESIDENTS

Indexed here are families and individuals (not bodies or commercial firms) recorded in this volume as having owned property and/or commissioned architectural work in Carmarthenshire or Ceredigion. The index includes monuments to members of such families and other individuals where they are of particular interest.

INDEX OF PLACES

Principal references are in **bold** type; demolished buildings are shown in *italic*.
'Cd.' = Ceredigion; 'Cms.' = Carmarthenshire.